Janson's History of Art

Janson's History of Art

THE WESTERN TRADITION

Seventh Edition

VOLUME II

PENELOPE J. E. DAVIES

WALTER B. DENNY

FRIMA FOX HOFRICHTER

JOSEPH JACOBS

ANN M. ROBERTS

DAVID L. SIMON

PEARSON

Prentice Hall

UPPER SADDLE RIVER, NEW JERSEY 07458

LIBRARY OF CONGRESS CATALOGING-IN-PUBLICATION DATA

Janson, H. W. (Horst Woldemar),
 Janson's history of art: the western tradition/Penelope J. E. Davies . . . [et al.]—7th ed.
 p.cm
 Includes bibliographical references and index.
 ISBN 0-13-193455-4
 1. Art—History. I. Title: History of art. II. Davies, Penelope J. E., 1964-III.
Janson, H.W. (Horst Woldemar), 1913–History of art. IV. Title

N5300.J3 2007
709—dc22 2005054647

Editor-in-Chief: **SARAH TOUBORG**
Sponsoring Editor: **HELEN RONAN**
Editor in Chief, Development: **ROCHELLE DIOGENES**
Senior Development Editor: **ROBERTA MEYER**
Development Editors: **KAREN DUBNO, CAROLYN VIOLA-JOHN**
Editorial Assistant: **JACQUELINE ZEA**
Editorial Intern: **AIZA KEESEY**
Media Project Manager: **ANITA CASTRO**
Director of Marketing: **BRANDY DAWSON**
Assistant Marketing Manager: **ANDREA MESSINEO**
Marketing Assistant: **VICTORIA DeVITA**
AVP, Director of Production and Manufacturing: **BARBARA KITTLE**
Senior Managing Editor: **LISA IARKOWSKI**
Senior Production Editor: **HARRIET TELLEM**
Production Assistant: **MARLENE GASSLER**
Manufacturing Manager: **NICK SKLITSIS**
Manufacturing Buyer: **SHERRY LEWIS**
Creative Design Director: **LESLIE OSHER**
Art Directors: **NANCY WELLS, AMY ROSEN**
Interior and Cover Design: **BTDNYC**
Design Layout: **GAIL COCKER-BOGUSZ**
Line Art Coordinator: **MARIA PIPER**
Line Art Studio: **ARGOSY PUBLISHING INC.**
Cartographer: **CARTOGRAPHICS**
Text Research and Permissions: **MARGARET GORENSTEIN**
Pearson Imaging Center
 Manager: **JOSEPH CONTI**
 Project Coordinator: **CORRIN SKIDDS**
 Scanner Operators: **RON WALKO AND CORRIN SKIDDS**
Picture Editing, Research and Permissions:
 LAURIE PLATT WINFREY, FAY TORRES-YAP
 MARY TERESA GIANCOLI, CRISTIAN PEÑA, Carousel Research, Inc.
Director, Image Resource Center: **MELINDA REO**
Manager, Rights and Permissions: **ZINA ARABIA**
Manager, Visual Research: **BETH BRENZEL**
Image Permission Coordinator: **DEBBIE LATRONICA**
Copy Editor: **STEPHEN HOPKINS**
Proofreaders: **BARBARA DEVRIES, NANCY STEVENSON, PATTI GUERRIERI**
Text Editor: **CAROL PETERS**
Composition: **PREPARÉ**
Cover Printer: **PHOENIX COLOR CORPORATION**
Printer/Binder: **RR DONNELLEY**

COVER PHOTO: Andy Warhol. *Gold Marilyn Monroe*. 1962. Synthetic polymer paint, silkscreened, and oil on canvas, 6″11¼″ × 57″. The Museum of Modern Art, New York, Gift of Philip Johnson (316.1962) © 2006 Andy Warhol Foundation for the Visual Arts / ARS, New York. TM/©2005 Marilyn Monroe, LLC by CMG Worldwide Inc., Indianapolis, Indiana, 46256 USA www.Marilyn-Monroe.com.

Credits and acknowledgements borrowed from other sources and reproduced, with permission, in this textbook appear on the appropriate page within text or on the credit pages in the back of this book.

Pearson Education LTD Pearson Education, Canada, Ltd
Pearson Education Australia PTY, Limited Pearson Educación de Mexico, S.A. de C.V.
Pearson Education Singapore, Pte. Ltd Pearson Education-Japan
Pearson Education North Asia Ltd Pearson Education Malaysia, Pte. Ltd

10 9 8 7 6 5 4 3 2 1

ISBN: 0-13-193472-4

Brief Contents

Contents

PART FOUR
THE MODERN WORLD

Preface

WELCOME TO THE SEVENTH EDITION OF JANSON'S CLASSIC TEXTBOOK, officially renamed *Janson's History of Art* to reflect its relationship to the book that introduced many generations of students to art history. For many of us who teach introductory courses in the history of art, the name Janson is synonymous with the subject matter we present.

When Prentice Hall first published the *History of Art* in 1962, John F. Kennedy occupied the White House, and Andy Warhol was an emerging artist. Janson offered his readers a strong focus on Western art, an important consideration of technique and style, and a clear point of view. The *History of Art,* said Janson, was not just a stringing together of historically significant objects, but the writing of a story about their interconnections— a history of styles and of stylistic change. Janson's text focused on the visual and technical characteristics of the objects he discussed, often in extraordinarily eloquent language. Janson's *History of Art* helped to establish the canon of art history for many generations of scholars.

Although largely revamped, this new edition follows Janson's lead in important ways: It is limited to the Western tradition, with the addition of a chapter on Islamic art and its relationship to Western art. (Those of us with early Janson editions will remember that Islamic art was included in the first edition.) It keeps the focus of the discussion on the object, its manufacture, and its visual character. It considers the contribution of the artist as an important part of the analysis. This edition is organized along the lines established by Janson, with separate chapters on the Northern European Renaissance, the Italian Renaissance, Baroque art, and the High Renaissance, with stylistic divisions for key periods of the modern era. This edition also creates a narrative of how art has changed over time in the cultures that Europe has claimed as its patrimony and that Americans have claimed through their connection to Europe.

WHAT'S NEW IN *JANSON'S HISTORY OF ART?*

"The history of art is too vast a field for anyone to encompass all of it with equal competence."

—H. W. JANSON, from the Preface to the first edition of *History of Art*

Janson's History of Art, seventh edition, is the product of careful revision by a team of scholars with different specialties, bringing great depth to the discussions of works of art. We incorporate new discoveries in our fields into the text, including new archeological finds, such as the Charioteer of Motya; new documentary evidence, such as that pertaining to Uccello's *Battle of San Romano;* and new interpretive approaches, such as the importance of nationalism in the development of Romanticism.

New Organization and Contextual Emphasis

Most of the chapters have been reorganized to integrate the media into chronological discussions instead of discussing them in isolation from one another, which reflected the more formalistic approach used in earlier editions. Even though we draw connections among works of art, as Janson did, we emphasize the patronage and function of works of art and the historical circumstances in which they were created. We explore how works of art have been used to shore up political or social power.

Interpreting Cultures

Western art history encompasses a great many distinct chronological and cultural periods, which we wish to treat as distinct entities. So we present Etruscan art as evidence for Etruscan culture, not as a precursor of Roman or a follower of Greek art. Recognizing the limits of our knowledge about certain periods of history, we examine how art historians draw conclusions from works of art. The boxes called *The Art Historian's Lens* allow students to see how the discipline works. They give students a better understanding of the methods art historians use to develop art-historical arguments. *Primary Sources,* a distinguishing feature of Janson for many editions, have been incorporated throughout the chapters to support the analysis provided and to further inform students about the cultures discussed.

Women in the History of Art

Another important feature of this edition of *Janson's* is the greater visibility of women, whom we discuss as artists, as patrons, and as an audience for works of art. Inspired by contemporary approaches to art history, we also address the representation of women as expressions of specific cultural notions of femininity or as symbols.

Objects, Media, and Techniques

Many new objects have been incorporated into this edition to reflect changes in the discipline. Approximately 25 percent of the objects we discuss are new to the book. The mediums we discuss have been expanded to include not only modern art forms such as installations and earth art, but also the so-called minor arts of earlier periods—such as tapestries, metalwork, and porcelain. Discussions in the *Materials and Techniques* boxes illuminate this dimension of art history.

The Images

Not only have new objects been introduced, but every reproduction in the book also has been refreshed and expertly examined for fidelity to the original. We have obtained new photographs directly from the holding institutions to ensure that we have the most accurate and authoritative illustrations. Every image that could be obtained in color has been acquired. To further assist both students and teachers, we have sought permission for electronic educational use so that instructors who adopt *Janson's History of Art* will have access to an extraordinary archive of high quality (over 300 dpi) digital images for classroom use. (See below for more detail on the Prentice Hall Digital Art Library.)

Chapter by Chapter Revisions

With six different specialists examining every chapter, and an exhaustive peer review process, the revisions to the text are far too extensive to enumerate in detail. Every change aims to make the text more useful to instructors and students in art history classrooms. The following list includes the major highlights of this new edition:

INTRODUCING ART

Completely new, this section provides models of art-historical analysis and definitions of art-historical terms, while providing an overview of the important questions in the discipline.

CHAPTER 1: PREHISTORIC ART

Lengthened to include more information on the various contexts in which works of art are found. Expands upon the methods scholars (both art historians and anthropologists) use to understand artwork. Offering a wider range of interpretations, the text clarifies why scholars reconstruct the prehistoric world as they do.

CHAPTER 2: ANCIENT NEAR EASTERN ART

Expanded and reorganized to isolate cultures flourishing contemporaneously in the ancient Near East.

CHAPTER 3: EGYPTIAN ART

Includes an updated discussion of the Egyptian worldview, and relates Egyptian artworks to that view. Incorporates a greater number of works featuring women, such as the extraordinary *Portrait of Queen Tiy*.

CHAPTER 4: AEGEAN ART

Examines how we construct our knowledge of an ancient society through studying works of art and architecture. Focuses also on individuals who contributed to our understanding of these societies, such as Heinrich Schliemann and Sir Arthur Evans.

CHAPTER 5: GREEK ART

Significant new artworks have been added to this chapter, such as the spectacular Charioteer of Motya. The organization is altered radically to adhere more closely to a chronological, rather than medium-based, sequence. Expands discussions of the architecture of the Athenian Akropolis and Hellenistic art as a whole.

CHAPTER 6: ETRUSCAN ART

Discussion of Etruscan art is altered in order to characterize it as a visual culture in its own right rather than as an extension of Greek art or a precursor of Roman art. The palatial architecture at Murlo is included.

CHAPTER 7: ROMAN ART

Features a greatly expanded section on art of the Republic, and a greater discussion of architecture in general. New works, such as the magnificent Theater of Pompey, are included. The organization is also radically altered to follow a chronological, rather than medium-based, sequencing.

CHAPTER 8: EARLY CHRISTIAN AND BYZANTINE ART

Accentuates changes and political dimensions in Early Christian art that occurred when Christianity became an accepted religion of the Roman Empire. Architecture is discussed in greater depth, stressing how the buildings were experienced. The iconography (i.e., meaning) of the forms employed is examined. The chapter expands the discussion of icons and of the iconoclastic controversy.

CHAPTER 9: ISLAMIC ART

Reintroduces Islamic art to the text. Seeks both to give a good general overview of Islamic art and to emphasize the connections between Islamic art and the art of the European West. The many common values of both types of art are examined.

CHAPTER 10: EARLY MEDIEVAL ART

Enlarges discussion of early minor arts. Discusses Irish manuscripts more thoroughly in terms of meaning and in relationship to Roman art. Expands the discussion of Charlemagne's political and social goals and the use of art to further that agenda. Places more emphasis on how women were viewed and represented.

CHAPTER 11: ROMANESQUE ART

Expands discussion of the art of the pilgrimage road, including Sant Vincenç at Cardona and Saint-Genis-des-Fontaines. Focuses on the role of women as subject and patron. Reorganization of chapter allows integration of the various mediums to promote understanding that, despite intrinsic differences, the works demonstrate common aspirations as well as fears.

CHAPTER 12: GOTHIC ART

Reconfigured to remove Italian art (now in Chapter 13) and some International Style monuments (now in Chapter 14). Treats development of Gothic architecture more cogently by the introduction of new examples (e.g., the interiors of Notre-Dame of Laon and Notre-Dame of Paris). Discussion of Sainte-Chapelle and Spanish Gothic art is added.

CHAPTER 13: ART IN THIRTEENTH- AND FOURTEENTH-CENTURY ITALY

Separates the thirteenth-and fourteenth-century Italian situation from the rest of Europe to highlight its specific role as a bridge between medieval and Renaissance art. New works include Simone Martini's *Annunciation* and Andrea da Firenze's *Way of Salvation* in the Spanish Chapel. New section added on northern Italy in the fourteenth century.

CHAPTER 14: ARTISTIC INNOVATIONS IN FIFTEENTH-CENTURY NORTHERN EUROPE

Now placed before the Italian fifteenth-century chapter, the new structure of the chapter integrates works of art of a particular time and place to emphasize historical context. Updates discussions of key works. Treats printmaking and the printed book in detail.

CHAPTER 15: THE EARLY RENAISSANCE IN FIFTEENTH-CENTURY ITALY

Situates art in specific moments or geographic regions and discusses different mediums in relation to their context. Emphasizes role of patronage. Introduces new sections on art outside of Florence. Treats *cassone* panels and other works of art for domestic contexts. Fra Angelico's *Annunciation* at San Marco, Brunelleschi's *Ospedale degli Innocenti,* Piero della Francesca's work for the court of Urbino, and Mantegna's *Camera Picta* in Mantua are included.

CHAPTER 16: THE HIGH RENAISSANCE IN ITALY, 1495–1520

Explains why a group of six key artists continue to be treated in monographic fashion. Focuses on the period 1495–1520, removing late Michelangelo and Titian to Chapter 17. Leonardo's drawing of the *Vitruvian Man* and Michelangelo's Roman *Pietà* are added. Updates discussions of art, including Leonardo's *The Virgin of the Rocks* and Giorgione's *The Tempest*.

CHAPTER 17: THE LATE RENAISSANCE AND MANNERISM IN SIXTEENTH-CENTURY ITALY

Follows a geographic structure, starting with Florence under the Medici dukes, and then moves among the regions of Rome, northern Italy, and Venice. Stresses courtly and papal patronage, as well as the founding of the Accademia del Disegno in Florence. Integrates late Michelangelo and Titian into these discussions. New discussions included for Bronzino, Titian's *Venus of Urbino,* and the work of Lavinia Fontana.

CHAPTER 18: RENAISSANCE AND REFORMATION IN SIXTEENTH-CENTURY NORTHERN EUROPE

Describes works of art in five different geographical regions. Considers the spread of Italian Renaissance style and the development of local traditions, among discussions of the Reformation and other crises. Includes new discussion of the *Isenheim Altarpiece*.

CHAPTER 19: THE BAROQUE IN ITALY AND SPAIN

Examines Caravaggio's and Bernini's roles in the Counter-Reformation. Discusses religious orders and the papacy, and develops an understanding of the role of women, women artists, the poor, street people, and the full nature of seventeenth-century life. New works include Bernini's *Baldacchino* and his *bozzetto* for a sculpture, as well as the portrait of *Juan de Pareja* by Velaszquez and Gentileschi's *Self-Portrait as the Allegory of Painting*.

CHAPTER 20: THE BAROQUE IN THE NETHERLANDS

Examines political and religious differences and artistic connections in the Netherlands. Explores the importance of Rubens through an examination of his workshop. The concept of an open market is treated in a discussion of the Dutch landscape, the still life, and the genre painting of Northern Europe. Works by Judith Leyster and Clara Peeters added, and with Rachel Ruysch the discussion focuses on the new status of these women artists.

CHAPTER 21: THE BAROQUE IN FRANCE AND ENGLAND

Considers concept of classicism in the paintings of Poussin and the architecture of Jones and Wren. New works include Poussin's *Death of Germanicus* and *Landscape with St. John on Patmos,* as well as Le Brun's diagram of facial expressions and Wren's steeple of St. Mary-Le-Bow.

CHAPTER 22: THE ROCOCO

Explores the Age of Louis XV using new examples by Watteau and Fragonard, including *Gersaint's Signboard* and *The Swing*. Pastel painting by Rosalba Carriera and Vigée-Lebrun's *Portrait of Marie Antoinette with Her Children* are introduced. An example of Sevrès porcelain emphasizes the importance of decorative arts in this era.

CHAPTER 23: ART IN THE AGE OF THE ENLIGHTENMENT, 1750–1789

Rewritten to focus more on the time period from roughly 1750 to 1789 than on Neoclassicism in particular. Emphasizes Neoclassicism's reliance on logic, morality, and the Classical past, while also pointing to the burgeoning importance placed on emotion, the irrational, and the sublime. Includes works by Mengs, Batoni, Hamilton, Wright of Derby, Gabriel, and Peyre.

CHAPTER 24: ART IN THE AGE OF ROMANTICISM, 1789–1848

This entirely restructured chapter defines Romanticism and emphasizes the importance of emotion, individual freedom, and personal experience. It examines imagination, genius, nature, and the exotic. Puts Romanticism into the context of the perceived failures of the Enlightenment and French Revolution. More strongly states the idea of nationalism as a Romantic theme.

CHAPTER 25: THE AGE OF POSITIVISM: REALISM, IMPRESSIONISM, AND THE PRE-RAPHAELITES, 1848–1885

Organizes around the concept of Positivism, the reliance on hard fact, and the dramatic social transformations that artists recorded. Expands the photography discussion. Focuses on the use of iron in engineering and architecture, especially in the Crystal Palace and the Eiffel Tower. Associates Rodin with Symbolism. Includes Daumier and Millet in the discussion of Realism.

CHAPTER 26: PROGRESS AND ITS DISCONTENTS: POST-IMPRESSIONISM, SYMBOLISM, AND ART NOUVEAU, 1880–1905

Emphasizes historical context rather than the Modernist tradition. Stresses disturbing psychology of the period and its manifestation in art. Places Frank Lloyd Wright here and into the context of the Chicago School. Photography section now includes Käsebier's *Blessed Art Thou Among Women,* which is dealt with in a feminist context. Includes a work by Lartigue.

CHAPTER 27: TOWARD ABSTRACTION: THE MODERNIST REVOLUTION, 1904–1914

First of three chapters on modern art that are radically restructured using chronology; internally reorganized on a thematic basis. Emphasizes the social forces that resulted in radical formal and stylistic developments between 1904 and 1914 that culminated in abstractionism. Places significant emphasis on Duchamp. Additions include Braque's *The Portuguese* and Duchamp's *Nude Descending a Staircase, No. 2.* Significantly revamps American art.

CHAPTER 28: ART BETWEEN THE WARS

Structured around the impact of World War I and the need to create utopias and uncover higher realities, especially as seen in Surrealism.

Treats Dada chronologically and geographically. Includes lengthy discussion of Duchamp in New York, with *Fountain* added. Represents films as seen in the work of Man Ray and Dali. Integrates discussion of Mondrian and De Stijl architecture, as well as Bauhaus artists and architects.

CHAPTER 29: POSTWAR TO POSTMODERN, 1945–1980

Emphasizes the impact Cage and Rauschenberg had on the development of American Art. Adds Conceptual Art of Brecht and the happenings and environments of Kaprow. Other additions include Ruscha, Flavin, and Serra, with new explorations of Paik and Hesse. Focuses on ethnic identity and gender issues with the newly added artists David Hammons and Judy Chicago.

CHAPTER 30: THE POSTMODERN ERA: ART SINCE 1980

Presents the concept of Postmodernism in clear, simple terms. Emphasizes the period's pluralism and the view of art as having no limits. Adds architects Venturi, Moore, Johnson, Hadid, Libeskind, and Piano; and artists Basquiat, Holzer, Polke, Viola, Gonzalez-Torres, Smith, Hirst, and Cai Guo-Qiang.

The **BIBLIOGRAPHY** has been thoroughly updated by Mary Clare Altenhofen, Fine Arts Library, Harvard College Library.

NEW FEATURES OF EVERY CHAPTER

THE INTRODUCTORY ART HISTORY STUDENT IS TRYING TO MASTER MANY DIFFERENT SKILLS—*Janson's History of Art* assists students with its beautiful reproductions and strong narrative approach. It also includes new boxed features to enhance student learning:

- **MATERIALS AND TECHNIQUES**
- **THE ART HISTORIAN'S LENS**
- **ART IN TIME**
- **PRIMARY SOURCES**
- **SUMMARIES**

MATERIALS AND TECHNIQUES:
Illustrations and explanations of processes used by artists.

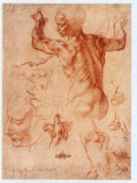

Drawings

Medieval artists had used the technique of drawing to record monuments they had seen or to preserve compositions for future use. These drawings were usually made with pen and ink on parchment. During the Renaissance, the increasing availability of paper expanded the uses of drawings and encouraged artists to use a variety of media in making them.

Pen and ink on paper were used most often, as the liquid ink could be transferred to the paper using a sharp quill pen or stylus. Sometimes the forms drawn with ink were further elaborated with a wash (usually diluted ink) applied with a brush. Some artists preferred to work with liquid media and thin brushes to render all the forms.

Artists also drew on the relatively rough surface of paper using charcoal or chalk. These naturally occurring materials are both dry and crumbly enough to leave traces when the artist applies them to the paper. The lines they leave can be thick or thin, rendered with carefully descriptive marks, or with quick evocative strokes. Artists could smudge these soft media to soften contours and fill in shadows, or to produce parallel lines called hatching to describe shadows. See, for example, the variety of strokes Michelangelo used to make the red chalk study for the *Libyan Sibyl* on the Sistine Chapel ceiling.

More difficult to master was the technique of silverpoint. This entailed using a metal stylus to leave marks on a surface. Silver was the most prized metal for this technique, though lead was also used. Mistakes could not be undone, so it took great skill to work in silverpoint. To make silver leave traces on paper, the paper had to be stiffened up by coating it with a mixture of finely ground bone and size (a gluelike substance). Such coatings were sometimes tinted. When the silver stylus is applied, thin delicate lines are left behind that darken with age.

Renaissance artists also expanded the uses of drawings. Apprentices learned how to render forms using drawings; artists worked out solutions to visual problems with drawings. Drawings were also used to enable artists to negotiate contracts and to record finished works as a kind of diary or model book.

Artists also made cartoons, or full-scale patterns, for larger works such as frescoes or tapestries (see fig. 16.27). Transferring designs from drawings onto larger surfaces could be achieved in a number of ways. A grid

could be placed over the design to serve as a guide for replicating the image on a larger scale. Or cartoons for frescoes could be pricked along the main lines of the design; through these tiny holes a powder was forced to reproduce the design on the wall. This is called *pouncing.*

In the sixteenth century, drawings became prized in their own right and were collected by artists, patrons, and connoisseurs. The drawing was thought to reveal something that a finished work could not: the artist's process, the artist's personality, and ultimately, the artist's genius.

Michelangelo. *Studies for the Libyan Sibyl.* Red chalk, 11⅜ × 8⁷⁄₁₆" (28.9 × 21.4 cm). The Metropolitan Museum of Art, New York. The Purchase, Joseph Pulitzer Bequest, 1924 (24.197.2)

Michelangelo's deep study of ancient sculpture, which he hoped to surpass. Since the cleaning of the frescoes in the 1980s, scholars have come to appreciate the brilliance of Michelangelo's colors, and the pairing of complementary colors he used in the draperies. (See *The Art Historian's Lens,* page 573.)

A similar energy pervades the center narratives. *The Fall of Man* and *The Expulsion from the Garden of Eden* (fig. 16.20) show the bold, intense hues and expressive body language that characterize the whole ceiling. Michelangelo's figures are full of life, acting out their epic roles in sparse landscape settings. To the left of the Tree of Knowledge, Adam and Eve form a spiral composition as they reach toward the forbidden fruit,

while the composition of *The Expulsion from the Garden of Eden* is particularly close to Masaccio's (see fig. 15.18) in its intense drama. The nude youths (*ignudi*) flanking the main sections of the ceiling play an important visual role in Michelangelo's design. They are found at regular intervals, forming a kind of chain linking the narratives. Yet their meaning remains uncertain. Do they represent the world of pagan antiquity? Are they angels or images of human souls? They hold acorns, a reference to the pope's family name, delle Rovere (Rovere means "oak"). The ignudi also support bronze medallions that look like trophies, reminding the viewer of Julius's military campaigns throughout Italy.

CHAPTER 16 THE HIGH RENAISSANCE IN ITALY, 1495–1520 **571**

MATERIALS AND TECHNIQUES

An Artist's Reputation and Changes in Art Historical Methodology

A change in the methodology of art history can sometimes affect scholars' attitudes toward artists, sometimes resurrecting figures who had once been renowned but had gradually disappeared from the history books. A case in point is the American painter John Singer Sargent (1856–1925). In his day, he was one of the most famous and financially successful artists. He can even be considered the quintessential American artist, for he lived and worked in Europe and his art appeared to embrace the European values that so many nouveau riche Americans aspired to emulate.

Sargent was born and raised in Florence, studied at the École des Beaux-Arts in Paris, and by 1879 was winning medals at the salons. In part due to the encouragement of novelist Henry James, he moved permanently to London in 1886. He made his first professional trip to America in 1887, and immediately became the portraitist to high society, painting William Henry Vanderbilt of New York and Isabella Stewart Gardner of Boston, among others. By 1892, he was the most fashionable portraitist in London and perhaps on the Continent as well. Sargent's success was in part based on the luxuriousness of his imagery—expensive fabrics and furnishings—reinforced by his dramatic sensual brushwork.

Sargent was a proponent of the avant-garde. He befriended Claude Monet and acquired his paintings as well as Manet's. His own work reflects the painterly bravura of Manet, and like Manet he admired Velázquez. He also made numerous Impressionist landscapes and urban views, often in watercolor. Ironically, Sargent fell into oblivion because of the Modernism that evolved in the twentieth century. His consummate handling of paint may have had the abstract qualities that the Modernists admired, but his work was perceived as conservative. It failed to offer anything new. Worse yet, his avant-garde brushwork was carefully packaged in the old-fashioned formulas of society portraiture.

Sargent's reevaluation began in the 1950s, with a renewed appreciation of the paint handling in his Impressionist watercolors. In succeeding decades his reputation gradually inched its way up as Modernism was replaced by Post-Modernism and its broader values (see Chapter 30). Representational art became fashionable again, and art historians began to appreciate art for the way in which it reflected the spirit of its age. Sargent's paintings were now perceived as the embodiment of Victorian and Edwardian society and of the later Gilded Age.

For example, gender studies, which began appearing in the 1970s, looked at his daring presentation of women, as can be seen in his 1897 portrayal of New York socialite Edith Stokes in *Mr. and Mrs. I.N. Phelps Stokes*. Instead of giving us a demure and feminine woman, Sargent presents a boldly aggressive Mrs. Stokes, who represents the "New Woman" who emerged in the 1890s (see page 903). In a period when the women's movement was fiercely advocating equal rights, many women were asserting their independence and challenging conventional gender roles. This New Woman was independent and rebelled against the conventional respectability of the Victorian era that sheltered women in domesticity. She went out in public; she was educated, and she was athletic, spirited,

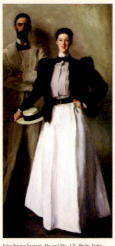

John Singer Sargent, *Mr. and Mrs. I.N. Phelps Stokes*, 1897. Oil on canvas, 84⅜″ × 39⅜″ (214 × 101 cm). Metropolitan Museum of Art, New York. Bequest of Edith Minturn Phelps Stokes (MRS. I. N.), 1938. (38.104)

and flaunted her sexual appeal. Not only did she wear comfortable clothes, the even wore men's attire, or a woman's shirtwaist based on a man's shirt. Instead of self-sacrifice, she sought self-fulfillment. Sargent presents Edith Stokes as just such a woman, even having her upstage her husband. For its time, this was a radical presentation of a woman and a reflection not only of the sitter's personality and identification with women's issues but also of Sargent's willingness to buck portrait conventions and societal expectations.

THE ART HISTORIAN'S LENS:
Topics that provide a glimpse into the working methods of art historians.

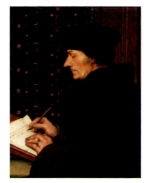

1509, twenty years later Henry was seeking to annul their union, for they had failed to produce a male heir to the throne. Thwarted by the Catholic Church, he broke away from Catholicism and established himself as the head of the Church of England. His desire for a male heir to the throne led Henry into a number of marriages, most of which ended either in divorce or in the execution of his wife. He had three children, who succeeded him as Edward VII, Mary I, and Elizabeth I.

Holbein's *Henry VIII* (fig. 18.27) of 1540 captures the supreme self-confidence of the king. He uses the rigid frontality that Dürer had chosen for his self-portrait to convey the almost divine authority of the absolute ruler. The king's physical bulk creates an overpowering sense of his ruthless, commanding personality. The portrait shares with Bronzino's *Eleanora of Toledo* (fig. 17.7) an immobile pose, an air of unapproachability, and the

18.26. Hans Holbein the Younger, *Erasmus of Rotterdam*, ca. 1523. Oil on panel, 16⅞ × 12⅜″ (42 × 31.4 cm). Musée du Louvre, Paris

The spread of the Reformation disrupted the Humanist circle in Basel. By 1525, followers of Zwingli preached the sole authority of Scripture, while more radical reformers preached that images were idols. To escape this climate, Holbein sought employment elsewhere. He had traveled to France in 1523–1524, perhaps intending to offer his services to Francis I. Hoping for commissions at the court of Henry VIII, Holbein went to England in 1527. He presented the portrait of Erasmus as a gift to the humanist Thomas More, who became his first patron in London. Erasmus, in a letter recommending Holbein to More, wrote: "Here [in Basel] the arts are out in the cold." By 1528, when Holbein returned to Basel, violence had erupted. He witnessed Protestant mobs destroying religious images, a scene Erasmus described in a letter: "Not a statue has been left in the churches . . . or in the monasteries; all the frescoes have been whitewashed over. Everything which would burn has been set on fire, everything else hacked into little pieces. Neither value nor artistry prevailed to save anything." Holbein resolved to return to London.

ENGLAND: REFORMATION AND POWER

Holbein's patron in England was the ambitious Henry VIII, who reigned from 1509 to 1547. Henry wanted England to be a power broker in the conflicts between Francis I of France and the Emperor Charles V, although his personal situation complicated these efforts. Married to Catherine of Aragon in

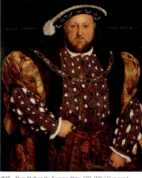

18.27. Hans Holbein the Younger, *Henry VIII*. 1540. Oil on panel, 32⅞ × 29″ (82.6 × 74.5 cm). Galleria Nazionale d'Arte Antica, Rome

ART IN TIME: Frequent chronologies situate the works of art in their era of origin.

Karel van Mander Writes About Pieter Bruegel the Elder

From *The Painter's Treatise (Het Schilder Boeck)* 1604

Van Mander's biography of Pieter Bruegel the Elder remains an important source of information about the artist, whose talent he appreciated fully.

On his journeys Bruegel did many views from nature so that it was said of him, when he traveled through the Alps, that he had swallowed all the mountains and rocks and spat them out again, after his return, on to his canvases and panels, so closely was he able to follow nature here and in her other works. . . .

He did a great deal of work [in Antwerp] for a merchant, Hans Franckert, a noble and upright man, who found pleasure in Bruegel's company and met him every day. With this Franckert, Bruegel often went out into the country to see peasants at their fairs and weddings. Disguised as peasants they brought gifts like the other guests,

claiming relationship or kinship with the bride or groom. Here Bruegel delighted in observing the droll behavior of the peasants, how they ate, drank, danced, capered, or made love, all of which he was well able to reproduce cleverly and pleasantly. . . . He represented the peasants—men and women of the Campine and elsewhere—naturally, as they really were, betraying their boorishness in the way they walked, danced, stood still, or moved.

. . . An art lover in Amsterdam, Sieur Herman Pilgrims, owns a *Peasant Wedding* painted in oils, which is most beautiful. The peasants' faces and the limbs, where they are bare are yellow and brown, sunburnt; their skins are ugly, different from those of town dwellers . . .

. . . Many of his compositions of comical subjects, strange and full of meaning, can be seen engraved; but he made many more works of this kind in careful and beautifully finished drawings to which he had added inscriptions. But as some of them were too biting and sharp, he had them burnt by his wife when he was on his deathbed, from remorse or fear that she might get into trouble and have to answer for them. . . .

SOURCE: DUTCH AND FLEMISH PAINTERS BY KAREL VAN MANDER. TR. CONSTANT VANDE WALL (MANCHESTER, NH: AYER COMPANY PUBLISHERS, 1976)

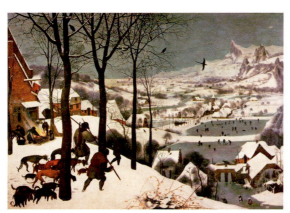

18.37. Pieter Bruegel the Elder. *The Return of the Hunters*. 1568. Oil on panel, 46⅛ × 63¾″ (117 × 162 cm). Kunsthistorisches Museum, Vienna

PRIMARY SOURCES:
Historical documents place art and artists more securely in the context of their time.

SUMMARY

In the last half of the eighteenth century, Western culture entered the modern era. People were continually adapting to shifting political values, changing socioeconomic conditions, and new scientific theories. Political rebellions occurred in America and France, gradually shifting power from a hereditary royalty and into the hands of citizens. Evolving philosophical outlooks spurred land reform, scientific discoveries, and technological advancements—and vice versa—resulting in the Industrial Revolution and France that eventually spread worldwide. Society was progressing, and a burgeoning moneyed middle class demanded new luxuries, including art. The roots of these changes can be traced to the Enlightenment, a new method of critical thinking that developed in the eighteenth century. Enlightenment thought brought about the establishment of basic human rights, a new moral order, and modern science. Rationalism ruled, with theories based on experience and observation. Living in the modern world today, we continue to feel the effects of these powerful upheavals.

Art reflected this complex era. Styles old and new mingled and evolved. Traces of the Rococo and Baroque remained as new trends emerged. The dominant style, Neoclassicism, emphasized logic and rationality and often featured moralistic themes borrowed from the ancient Greeks and Romans. Romanticism, a simultaneous thread in art, advocated emotion, imagination, and the supremacy of Nature.

ROME TOWARD 1760: THE FONT OF NEOCLASSICISM

Rome, home to treasures from antiquity and the Renaissance, held sway as the world's art center. The city attracted not only a flood of artists seeking inspiration but also the wealthy traveling on the "Grand Tour" of Italy. Fueled by recent archeological discoveries, notably those of Herculaneum and Pompeii, a renewed interest in antiquity gripped scholars and artists. In his influential writings, art critic Johann Winckelmann encouraged a new appreciation of Greek art by espousing its moral and aesthetic superiority. The austere brushwork of Anton Raphael Mengs, the strong linearity of Pompeo Batoni's portraits, and the dramatic solemnity of Gavin Hamilton's moralistic themes laid the foundations of the Neoclassical style.

ROME TOWARD 1760: THE FONT OF ROMANTICISM

Meanwhile, Romanticism emerged. Printmaker and publisher Giovanni Battista Piranesi celebrated ancient Roman civilization in dramatic *vedute* (views) of awe-inspiring monumental architecture that embodied the sublime, a quality associated with vastness, obscurity, power, and infinity that produced feelings of awe, fright, even terror. British statesman Edmund Burke defined the sublime in his treatise *A Philosophical Inquiry into the Origin of Our Ideas of the Sublime and Beautiful*. Piranesi and others increasingly embraced the sublime, reflecting a new audience demand for art that evoked intense emotion, even fright or horror, and that transported them emotionally.

NEOCLASSICISM IN ENGLAND

Antimonarchists and many intellectuals of England, steeped in the Enlightenment, identified with the ancient Romans and emulated that civilization's

government, literature, and art. By extension, they invented Neoclassical art. Neoclassicism was not only just gaining popularity, however, and several styles or influences often appeared simultaneously in the same work. Many English artists borrowed themes from Greek and Roman art and literature, although not always those with moralistic messages. Angelica Kauffmann's paintings reflect these dichotomies as she vacillated between erotic and virtuous themes, Rococo grace and Neoclassical austerity.

The tradition of contemporary history painting was born during this period as well. With Enlightenment emphasis on the logical, artists like Benjamin West and John Singleton Copley began conceiving convincing ways to show historic contemporary events through the depiction of accurate costumes and settings. West's *The Death of General Wolfe* and Copley's *Watson and the Shark* offer abundant truthful details mixed with Classical poses, calm dignity, and moral overtones—hallmarks of Neoclassical style.

The Classical revival in architecture appeared in England as early as 1715, with the publication of Colen Campbell's treatise *Vitruvius Britannicus*, and eventually spread to America. Campbell espoused the architecture of the ancients and their descendants, notably Antonio Palladio, and the demand for Palladian-inspired country villas exploded. The Classical revival extended to urban planning, as seen in the resort town of Bath, as well as to décor, embodied in the interiors designed by Robert Adam.

EARLY ROMANTICISM IN ENGLAND

In England, the desire of some people for logic and empiricism coexisted with an equally strong urge for emotion and subjective experiences. In architecture and landscape design, Neoclassical evocations of noble antiquity joined with Romanticism's delight in the exotic and the desire to elicit powerful emotions. The British taste for the sublime translated successfully into garden design, where it combined especially well with the interesting variety of the picturesque and the layered meanings of associationism, both concepts fully developed in England. The concurrent Gothic archival also reflected Romantic sensibilities, with its emphasis on the sublime emotions evoked by melancholic spaces. Painters also felt the dual pull of Neoclassicism and Romanticism. George Stubbs and Joseph Wright often fused both trends, whereas Heinrich Fuseli fully adopted sublime terror, carrying us dramatically into the Romantic era.

NEOCLASSICISM IN FRANCE

France experienced a similar reaction to the Enlightenment, and art began shifting from Rococo flamboyance toward Neoclassical rationalism. First seen in architecture, this Classical revival featured austere geometry and monumental scale, characteristic of structures by Marie-Joseph Peyre and Claude-Nicolas Ledoux. French painters and sculptors formulated their own response to the influential mainstream of thought. Jean-Baptiste Greuze's genre paintings, the sensation of the Paris Salons in the 1760s, embodied Enlightenment emphasis on logic and naturalism, while Jean-Antoine Houdon's sculpted portraits show realistic, classicized versions of the sitter. Yet the climax of French Neoclassicism is the moralizing history paintings of Jacques-Louis David, notably his *Oath of the Horatii*. Building on the tableau vivant made popular by Greuze, David creates a dramatic composition of noble beauty, but one where the undercurrents of horror reflect a taste for the Romantic as well.

SUMMARIES at the end of each chapter highlight key concepts.

Acknowledgments

We are grateful to the following academic reviewers for their numerous insights and suggestions on improving Janson:

Susan Altman, Middlesex County College
Michael Amy, Rochester Institute of Technology
Dixon Bennett, San Jacinto College South
Barbara Bushey, Hillsdale College
Barbara Dodsworth, Mercy College
Karl Fugelso, Towson University
Tessa Garton, College of Charleston
Alyson Gill, Arkansas State University
Andrew L. Goldman, Gonzaga University
Marilyn Gottlieb-Roberts, Miami Dade College
Oleg Grabar, Institute for Advanced Study
William Greiner, Olivet Nazarene University
Anthony Gully, Arizona State University
Jean R. Harry, Luzerne County Community College
Andrew Hershberger, Bowling Green State University
Fredrika Jacobs, Virginia Commonwealth University
Victor Katz, Holyoke Community College
Hee-Young Kim, University of Alabama
Ellen Konowitz, SUNY New Paltz
Marybeth Koos, Elgin Community College
Danajean Mabry, Surry Community College
Marian Mazzone, College of Charleston
Charles Morscheck, Drexel University
Andrew M. Nedd, Savannah College of Art and Design
Andrea Pearson, Bloomsburg University
William H. Peck, Detroit Institute of Art
Rob Prestiano, Angelo State University
Wendy Robertson, Humboldt State University
Cynthia Robinson, Cornell University
Susan Ryan, Louisiana State University
Cathy Santore, New York City College of Technology
Carl Sederholm, Brigham Young University
Stephanie Spencer, North Carolina State University
Esther Tornai Thyssen, Sage College of Albany
Lee Ann Turner, Boise State University
Jens T. Wollesen, University of Toronto

Individual chapters of the text were subjected to a rigorous review process by expert reviewers. We thank the following for their incredibly detailed and careful fact-finding analyses of the manuscript:

Ann Jensen Adams, University of California, Santa Barbara
Bernadine Barnes, Wake Forest University
Susan Cahan, University of Missouri-St. Louis
Maura Coughlin, Brown University
Roger J. Crum, University of Dayton
Sharon Dale, Penn State University-Erie, Behrend College
Michael T. Davis, Mount Holyoke College
Marian Feldman, University of California, Berkeley
Laura Gelfand, The University of Akron
Anne Higonnet, Barnard College
Eva Hoffman, Tufts University
Jeffery Howe, Boston College
Charles T. Little, Metropolitan Museum of Art
Patricia Mainardi; Graduate Center, CUNY
Robert Mattison, Lafayette College
David Gordon Mitten, Harvard University
Robert Mode, Vanderbilt University
Elizabeth Otto, SUNY Buffalo
Nassos Papalexandrou, University of Texas-Austin
Pamela Patton, Southern Methodist University
John Pedley, University of Michigan
Elizabeth M. Penton, Durham Technical Community College
Jane Peters, University of Kentucky
Gay Robins, Emory University
Wendy Roworth, University of Rhode Island
John Beldon Scott, University of Iowa
Kenneth E. Silver, Department of Fine Arts, New York University
Catherine Turill, California State University, Sacramento
Eric R. Varner, Emory University
Nancy L. Wicker, University of Mississippi
Jeryldene M. Wood, University of Illinois

SPECIAL THANKS go to Peter Kalb of Ursinus College and Elizabeth Mansfield of the University of the South for their tremendous contributions as editorial consultants.

THE CONTRIBUTORS WOULD LIKE TO THANK THE FOLLOWING INDIVIDUALS FOR THEIR ADVICE AND ASSISTANCE IN DEVELOPING THIS EDITION:
C. Edson Armi, Lea Cline, Holly Connor, Oleg Grabar, Ann Sutherland Harris, Asma Husain, Anthony F. Janson, Calvin Kendall, Frank Lind, Andrea Pearson, Chris Reed, John Beldon Scott, Sonia C. Simon, and Bruce Weber. We would also like to thank the group of talented editors and staff at Pearson Education for all their hard work in bringing this edition to life. Special thanks go to Sponsoring Editor Helen Ronan and Senior Development Editors Roberta Meyer, Karen Dubno, and Carolyn Viola-John. We are also grateful to Production Manager Lisa Iarkowski, Production Editor Harriet Tellem, and the team responsible for acquiring images. Deep thanks go, too, to Sarah Touborg for overseeing the project and bringing this group of collaborators together.

Faculty and Student Resources for Teaching and Learning with *Janson's History of Art*

PRENTICE HALL is pleased to present an outstanding array of high quality resources for teaching and learning with *Janson's History of Art*. Please contact your local Prentice Hall representative for more details on how to obtain these items, or send us an email at art@prenhall.com.

DIGITAL AND VISUAL RESOURCES

 THE PRENTICE HALL DIGITAL ART LIBRARY. Instructors who adopt *Janson's History of Art* are eligible to receive this unparalleled resource. Available in a two-DVD set or a 10-CD set, *The Prentice Hall Digital Art Library* contains every image in *Janson's History of Art* in the highest resolution (over 300 dpi) and pixellation possible for optimal projection and easy download. Developed and endorsed by a panel of visual curators and instructors across the country, this resource features over 1,600 images in jpeg and in PowerPoint, an instant download function for easy import into any presentation software, along with a zoom feature, and a compare/contrast function, both of which are unique and were developed exclusively for Prentice Hall.

 ONEKEY. is Prentice Hall's exclusive course management system that delivers all student and instructor resources all in one place. Powered by WebCt and Blackboard, OneKey offers an abundance of online study and research tools for students and a variety of teaching and presentation resources for instructors, including an easy-to-use gradebook and access to many of the images from the book.

 ART HISTORY INTERACTIVE CD-ROM. *1,000 Images for Study & Presentation* is an outstanding study tool for students. Images are viewable by title, by period, or by artist. Students can quiz themselves in flashcard mode or by answering any number of short answer and compare/contrast questions.

CLASSROOM REPSONSE SYSTEM (CRS) IN CLASS QUESTIONS. Get instant, classwide responses to beautifully illustrated chapter-specific questions during a lecture to gauge students comprehension—and keep them engaged. Contact your local Prentice Hall sales representative for details.

 COMPANION WEBSITE. Visit www.prenhall.com/janson for a comprehensive online resource featuring a variety of learning and teaching modules, all correlated to the chapters of *Janson's History of Art*.

FINE ART SLIDES AND VIDEOS. are also available to qualified adopters. Please contact your local Prentice Hall sales representative to discuss your slide and video needs. To find your representative, use our rep locator at www.prenhall.com.

 VANGO NOTES: Study on the go with VangoNotes--chapter reviews from your text in downloadable mp3 format. You can study by listening to the following for each chapter of your textbook: Big Ideas: Your "need to know" for each chapter; **Practice Test:** A check for the Big Ideas—tells you if you need to keep studying; **Key Terms:** audio "flashcards" to help you review key concepts and terms; Rapid Review: A quick drill session—use it right before your test. VangoNotes are flexible; download all the material directly to your player, or only the chapters you need.

PRENTICE HALL TEST GENERATOR is a commercial-quality computerized test management program available for both Microsoft Windows and Macintosh environments.

PRINT RESOURCES

 TIME SPECIAL EDITION: ART. Featuring stories like "The Mighty Medici," "When Henri Met Pablo," and "Redesigning America," Prentice Hall's TIME Special Edition contains thirty articles and exhibition reviews on a wide range of subjects, all illustrated in full color. This is the perfect complement for discussion groups, in-class debates, or writing assignments. With the TIME Special Edition, students also receive a three-month pass to the TIME archive, a unique reference and research tool.

UNDERSTANDING THE ART MUSEUM by Barbara Beall. This handbook gives students essential museum-going guidance to help them make the most of their experience seeing art outside of the classroom. Case studies are incorporated into the text, and a list of major museums in the United States and key cities across the world is included.

ARTNOTES PLUS. An invaluable slide and study guide for students, ArtNotes Plus contains all of the images from the book in thumbnail form with caption information to illuminate their "art in the dark" experience. In addition, ArtNotes Plus features study questions and tips for each chapter of the book.

 ONESEARCH WITH RESEARCH NAVIGATOR helps students with finding the right articles and journals in art history. Students get exclusive access to three research databases: The New York Times Search by Subject Archive, ContentSelect Academic Journal Database, and Link Library.

INSTRUCTOR'S MANUAL AND TEST ITEM FILE is an invaluable professional resource and reference for new and experienced faculty, containing sample syllabi, hundreds of sample test questions, and guidance on incorporating media technology into your course.

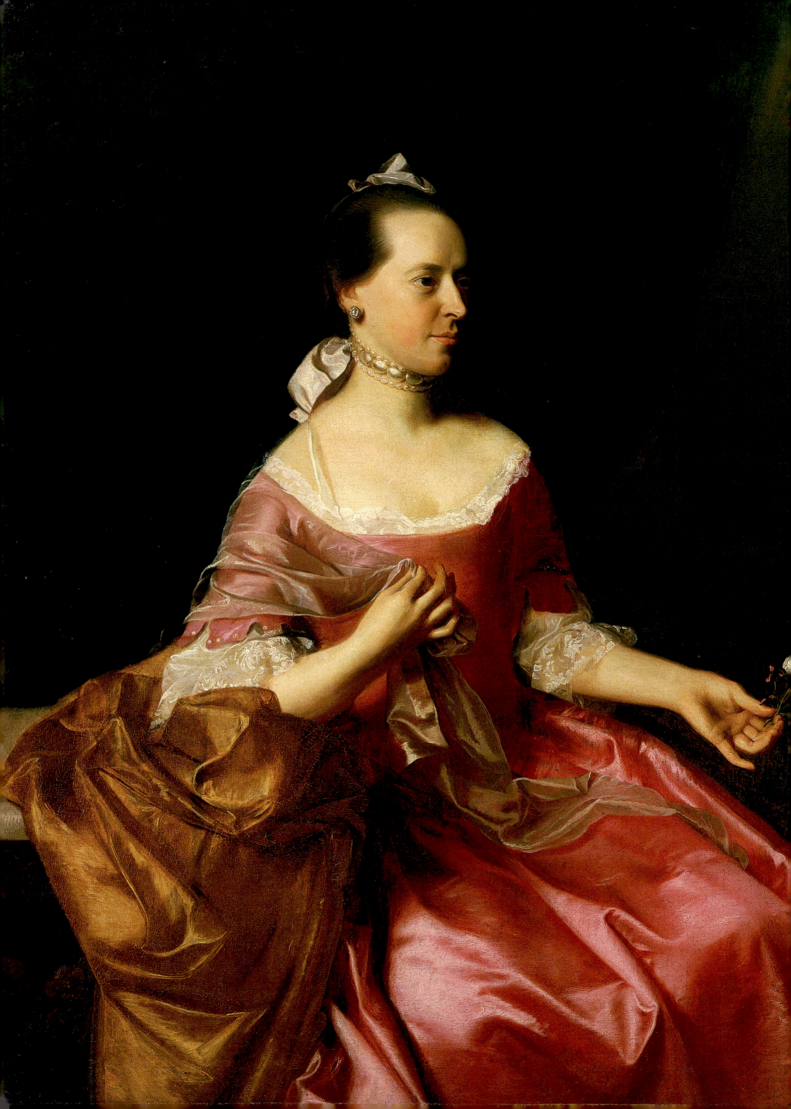

Introducing Art

WHO WAS FREELOVE OLNEY SCOTT? Her portrait (fig. I.1) shows us a refined-looking woman, born, we would guess, into an aristocratic family, used to servants and power. We have come to accept John Singleton Copley's portraits of colonial Bostonians, such as *Mrs. Joseph Scott,* as accurate depictions of his subjects and their lifestyles. But many, like Mrs. Scott, were not what they appear to be. Who was she? Let's take a closer look at the context in which the painting was made.

ART IN CONTEXT

Copley was one of the first American painters to make a name for himself throughout the American colonies and in England. Working in Boston from about 1754 to 1774, he became the most sought after portraitist of the period. Copley easily outstripped the competition of "face painters," as portraitists were derogatorily called at the time, most of whom earned their living painting signs and coaches. After all, no successful British artist had any reason to come to America, for the economically struggling colonies were not a strong market for art. Only occasionally was a portrait commissioned, and typically, artists were treated like craftsmen rather than intellectuals. Like most colonial portraitists, Copley was self-taught, learning his trade by looking at black-and-white prints of paintings by the European masters.

As we can see in *Mrs. Joseph Scott,* Copley was a master at painting textures, all the more astonishing when we realize that he had no one to teach him the tricks of the painter's trade. His illusions are so convincing, we think we are looking at real silk, ribbons, lace, pearls, skin, hair, and marble. Copley's contemporaries also marveled at his sleight of hand. No other colonial painter attained such a level of realism.

I.1. John Singleton Copley, *Mrs. Joseph Scott.* ca. 1765.
Oil on canvas, 69½ × 39½" (176.5 × 100 cm).
Collection of The Newark Museum, Newark, New Jersey. 48.508

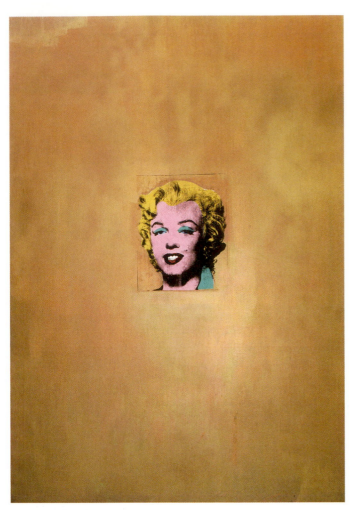

I.2. Andy Warhol. *Gold Marilyn Monroe.* 1962. Synthetic polymer paint, silk-screened, and oil on canvas, 6′11¼″ × 4′7″ (2.12 × 1.39 m). The Museum of Modern Art, New York, Gift of Philip Johnson. © 2006 Andy Warhol Foundation for the Visual Arts/© Artists Rights Society (ARS), New York, ™/© 2005 Marilyn Monroe, LLC by CMG Worldwide Inc., Indianapolis, Indiana 46256 USA.www.MarilynMonroe.com

However, Copley's job was not just to make a faithful copy of what he saw, but to project an image of Mrs. Scott as a woman of impeccable character, limitless wealth, and aristocratic status. The flowers she holds are a symbol of fertility, faithfulness, and feminine grace, indicating that she is a good mother and wife, and a charming woman. Her expensive dress was imported from London, as was her necklace. Copley may have elevated her status a bit more by giving her a pose taken from one of the prints of British or French royalty that he undoubtedly had on hand.

Not only is Mrs. Scott's pose borrowed, but most likely her dress and necklace, as well, for the necklace appears on three other women in Copley portraits. In other words, it was a studio prop. In fact, except for Mrs. Scott's face, the entire painting is a fiction designed to aggrandize the wife of a newly wealthy Boston merchant, who made a fortune selling provisions to the occupying British army. The Scotts were *nouveau riche* commoners, not titled aristocrats. By the middle of the eighteenth century, rich Bostonians wanted to distinguish themselves from their less successful neighbors. Now, after a century of trying to escape their British roots (from which many had fled to secure religious free-

dom), they sought to imitate the British aristocracy, even to the point of taking tea in the afternoon and owning English Spaniels, a breed that in England only aristocrats were permitted to own.

Mr. Scott commissioned this painting of his wife and a portrait of himself, not just to record their features, but to showcase the family's wealth. These pictures were extremely expensive and therefore status symbols, much like a Mercedes or a diamond ring from Tiffany's is today. The portraits were displayed in the public spaces of the house where they could be readily seen by visitors. Most likely they hung on either side of the mantle in the living room, or in the entrance hall. They were not intended as intimate affectionate resemblances destined for the private spaces in the home. If patrons wanted cherished images of their loved ones, they would commission miniature portraits, like the one in fig. 18.28 by Nicholas Hilliard. Miniatures captured the likeness of the sitter in amazing detail and were often so small they could be encased in a locket that a woman would wear on a chain around her neck, or a gentleman would place in the inner breast pocket of his coat, close to the heart. But the scale and lavishness of Copley's portrait add to its function as a status symbol.

If Mrs. Scott's portrait is rich with meaning, so is another image of a woman produced almost 200 years later: Andy Warhol's *Gold Marilyn Monroe* (fig. I.2) of 1962. In a sense, the

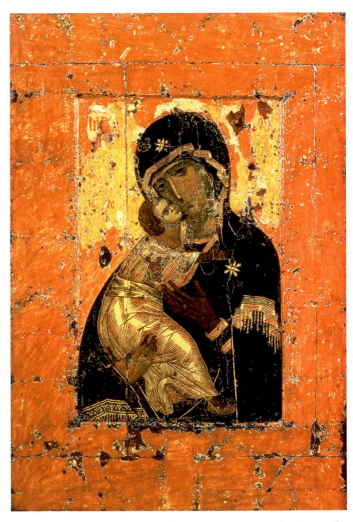

I.3. *Virgin of Vladimir.* Icon, probably from Constantinople. Faces only, 12th century; the rest has been retouched. Tempera on panel, height approx. 31″ (78 cm). Tretyakov Gallery, Moscow

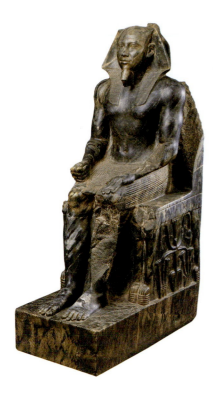

I.4. *Khafra,* from Giza. ca. 2500 BCE. Diorite, height 66″ (167.7 cm). Egyptian Museum, Cairo

painting may also be considered a portrait, because it portrays the famous 1950s film star and sex symbol. Unlike *Mrs. Joseph Scott,* however, the painting was not commissioned by Monroe or her family. Warhol chose the subject himself and made the painting to be exhibited in a commercial art gallery, where it could be purchased by a private collector for display in a home. Of course, he hoped ultimately it would end up in a museum, where a great number of people would see it—something Copley never considered because public museums did not exist in his day. In contrast to Copley, Warhol was not obliged to flatter his subject. Nor did he painstakingly paint this picture to create an illusionistic image. *Gold Marilyn Monroe* has no details and no sense of texture, as hair and flesh appear to be made of the same material—paint. Instead, the artist found a famous newspaper photograph of the film star and silkscreened it onto canvas, a process that involves first mechanically transferring the photograph onto a mesh screen and then pressing printing ink through the screen onto canvas. He then surrounded Marilyn's head with a field of broadly brushed gold paint.

Warhol's painting is a pastiche of the public image of Monroe as propagated by the mass media. He even imitates the sloppy, gritty look and feel of color newspaper reproductions of the period, for the four process colors of printing were often misregistered, that is, they did not align properly with the image. The Marilyn we are looking at is the impersonal celebrity of the media, supposedly glamorous with her lush red lipstick and bright blond hair but instead appearing pathetically tacky because of the garish color (blond hair becomes bright yellow) and grimy black ink. Her personality is impenetrable, reduced to a public smile. The painting was prompted, in part, by Monroe's recent suicide. The real Marilyn suffered from depression, despite her glamorous image. Warhol has brilliantly expressed the indifference of the mass media that glorifies celebrities by saturating a celebrity-thirsty public with their likenesses, but tells

us nothing meaningful about them and shows no concern for them. Marilyn Monroe's image is about promoting a product, much as the jazzy packaging of Brillo soap pads or Campbell's soup cans is designed to sell a product without telling us anything about the product itself. The packaging is just camouflage. Warhol floats Marilyn's face in a sea of gold paint, imitating icons of Christ and the Virgin Mary that traditionally surround these religious figures in a spiritual aura of golden, heavenly light (fig. I.3). But Warhol's revered Marilyn is sadly dwarfed in her celestial gold, adding to the poignancy of this powerful portrait, which so trenchantly comments on the enormous gulf between public image and private reality.

As we examine the circumstances in which *Mrs. Joseph Scott* and *Gold Marilyn Monroe* were created, we begin to understand how important context is to the look and meaning of works of art, and therefore, to the stories they tell. Although Copley and Warhol shared the context of being American artists, they worked in very different times, with diverse materials and techniques, and for a different type of clientele, all of which tremendously affected the look and meaning of their portraits. Because their art, like all art, served a purpose, it was impossible for either of them to make a work that did not represent a point of view and tell a story, sometimes many stories. Like great works of literature or music, memorable works of art tell powerful stories whose meanings become clearer when we explore the layers of context in which the works were made.

Many factors determine the style and meaning of a work of art and contribute to its powerful presence. For centuries, art created with a political or religious agenda had been used by the state and the church to promote an image of superiority and authority. Ancient Egyptian rulers understood art's power and used it to project their own, sometimes clothing their power in benevolence. Monumental stone sculptures typically depicted Egyptian kings and queens with one hand open for mercy, the other closed in a fist (seen in profile in fig. I.4). Religious images, such as Raphael's *Alba Madonna* (see fig. I.5), expressed the idealized, perfected state of existence that its pious patron

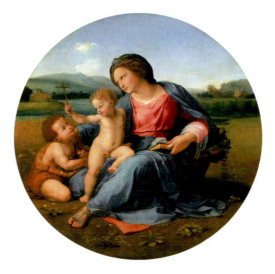

I.5. Raphael. *Alba Madonna.* ca.1510. Oil on panel, diameter 37¼″ (94 cm). National Gallery of Art, Washington, DC. Andrew Mellon Collection

believed was attainable through Catholicism. Art meant for domestic settings, such as many landscape paintings or still lifes of fruit, dead game, or flowers, also carry many messages. Such images are far from simple attempts to capture the splendor and many moods of nature or to show off the painter's finesse at creating a convincing illusionistic image. The carefully rendered natural and man-made objects in Clara Peeters's *Still-Life of Fruit and Flowers* (fig. 20.11) remind a viewer of the pleasures of the senses, but also of their fleeting nature.

Art also has the power to evoke entire historical periods. Images of the pyramids and the Great Sphinx (fig. **I.6**), for example, conjure up the grandeur we associate with ancient Egyptian civilization. Similarly, Grant Wood's famous 1930 painting *American Gothic* (fig. **I.7**) reinforces the perception that humorless, austere, hardworking farmers populated the American Midwest at that time. In the context of popular mythology, the painting has virtually become an emblem of rural America.

Changing Contexts, Changing Meanings

American Gothic has also become a source of much sarcastic humor for later generations, which have adapted the famous pitchfork-bearing farmer and his sour-faced daughter for all kinds of agendas unrelated to the artist's message. Works of art are often appropriated by a viewer to serve in contexts that are quite different from those initially intended, and, as a result, the meanings of such works change radically. The reaction of some New Yorkers to *The Holy Virgin Mary* (fig. **I.8**) by Chris Ofili reflects the power of art to provoke and spark debate, even outrage. The work appeared in an exhibition titled *Sensation: Young British Artists from the Saatchi Collection,* presented at the Brooklyn Museum in late 1999. Ofili, who is British of African descent, made an enormous picture depicting a black Virgin Mary. He used dots of paint, glitter, map pins, and images of genitalia taken from popular magazines to suggest fertility. In African traditions, many representations of females are about fertility. In his painting, Ofili blended an African theme with Christian imagery, inadvertently offending many Westerners unfamiliar with the artist's cultural heritage. Instead of hanging on the wall, this enormous painting rested on two large wads of elephant dung, an arrangement that the artist had used many times for his large canvases since 1991. Elephant dung is held sacred in Zimbabwe, and for Ofili, a devout Catholic, the picture was about the elemental sacredness of the Virgin.

Many art historians, critics, and other viewers found the picture remarkably beautiful—glittering and shimmering with a delicate, ephemeral otherworldly aura. Many Catholic viewers, however, were repulsed by Ofili's homage to the Virgin with its so-called pornographic details. Instead of viewing the work through Ofili's eyes, they placed the painting within the context of their own experience and beliefs. Consequently, they interpreted the depiction of the dung and genitalia (and probably even a black Virgin, although this was never mentioned) as sacrilegious. Within days of the opening of the exhibition, the painting had to be put behind a large Plexiglas barrier. One artist hurled horse manure at the facade of the Brooklyn Museum, claiming "I

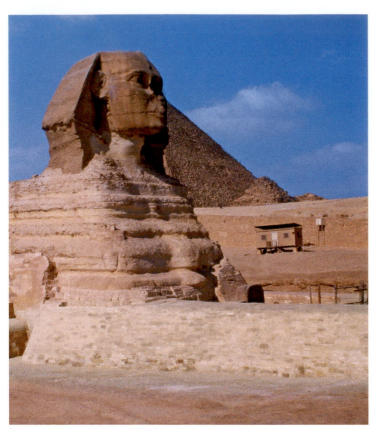

I.6. The Great Sphinx, Giza. ca 2570–2544 BCE. Sandstone, height 65′ (19.81 m)

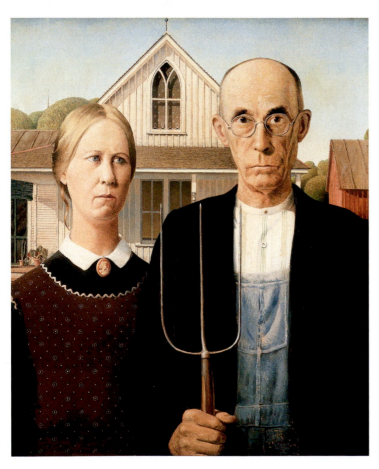

I.7. Grant Wood. *American Gothic*. 1930. Oil on board, 24⅞ × 24⅞″ (74.3 × 62.4 cm). The Art Institute of Chicago, Friends of American Art Collection. Art © Grant Wood/Licensed by VAGA, New York

1.8. Chris Ofili. *The Holy Virgin Mary.* 1996. Paper collage, oil paint, glitter, polyester resin, map pins, and elephant dung on linen, 7′11″ × 5′11⁵⁄₁₆″ (2.44 × 1.83 m). The Saatchi Gallery, London. © Chris Ofili

was expressing myself creatively"; another museum visitor sneaked behind the Plexiglas barrier and smeared the Virgin with white paint in order to hide her. But the greatest attack came from New York's Mayor Rudolph Giuliani, a Catholic, who was so outraged he tried to eliminate city funding for the museum. Ultimately, he failed, but only after a lengthy lawsuit by the museum. The public outrage at Ofili's work is one episode in a long tradition that probably goes back to the beginning of image making. Throughout history, art has often provoked outrage, just as it has inspired pride, admiration, love, and respect. The reason is simple. Art is never an empty container; rather, it is a vessel loaded with meaning, subject to multiple interpretations, and always representing someone's point of view.

Social Context and Women Artists

Because the context for looking at art constantly changes, as society changes, our interpretations and insights into art and entire periods evolve as well. For example, when the first edition of this book was published in 1962, women artists were not included, which was typical for textbooks of the time. America, like most of the world, was male-dominated, and history focused on men. Women of that era were expected to be wives and mothers. If they worked, it was to add to the family's income. They were not supposed to become artists, and the few known exceptions were not taken seriously by historians, who were mostly male. The femi-

nist movement, beginning in the mid 1960s, overturned this restrictive perception of women's roles. As a result, in the last 40 years, art historians—many of them women—have "rediscovered" countless women artists. Many of these women were outstanding artists, held in high esteem during their lifetimes, despite having to struggle to overcome powerful social and even family resistance against women becoming professional artists.

One of these rediscovered women artists is the seventeenth-century Dutch painter Judith Leyster, a follower, if not a student, of Frans Hals. Over the centuries, all of Leyster's paintings were attributed to other artists, including Hals and Gerrit van Honthorst. Or the paintings were labeled "artist unknown." At the end of the nineteenth century, however, Leyster was rediscovered through an analysis of her signature, documents, and style, and her paintings were gradually restored to her name. It was only with the feminist movement that she was elevated from a minor figure to one of the more accomplished painters of her generation, one important enough to be included in the history of art. The feminist movement inspired a new context for evaluating art, one that had an interest in celebrating rather than denying women's achievements, and which was concerned with studying issues relating to gender and how women are portrayed in the arts.

A work like Leyster's *Self-Portrait* (fig. **I.9**), from about 1633, is especially fascinating from this point of view. Because of its size and date, this may have been the painting the artist submitted as her presentation piece for admission into the local painters' guild, the Guild of St. Luke of Haarlem. Women were not encouraged to join the guild, which was a male preserve reinforcing the professional status of men. Nor did women artists generally take

1.9. Judith Leyster. *Self-Portrait.* ca. 1633. Oil on canvas, 29⅜″ × 25⅝″ National Gallery of Art, Washington, DC. (72.3 × 65.3 cm). Gift of Mr. and Mrs. Robert Woods Bliss

on students. Leyster bucked both restrictive traditions as she carved out a career for herself in a man's world. In her self-portrait, she presents herself as an artist, armed with many brushes, suggesting her deft control of the medium, which the presentation picture itself was meant to demonstrate. On the easel is a painting that is a segment of a genre scene (a glimpse of daily life), the type of painting for which she is best known. We must remember that at this time, artists rarely showed themselves working at their easels, toiling with their hands. They wanted to separate themselves from mere artisans and laborers, presenting themselves as belonging to a higher class. As a woman defying male expectations, however, Leyster needed to clearly declare that she was indeed an artist. So she cleverly elevates her status by not dressing as an artist would when painting. Instead, she appears, as her patrons do in their portraits, well dressed and well off. Her mouth is open, in what is called a "speaking likeness" portrait, giving her a casual but self-assured animated quality, as she appears to converse on equal terms with a visitor or viewer. Leyster, along with Artemisia Gentileschi and Elizabeth Vigée-Lebrun, who also appear in this book, was included in a major 1976 exhibition entitled *Women Artists 1550–1950,* which was presented in Los Angeles and Brooklyn, New York, and which played a major role in establishing the importance of women artists.

RECOGNIZING ART

Earlier generations of art historians focused almost entirely on three art forms: sculpture, architecture, and painting, together called the "fine arts." Yet recently, as artists have expanded the materials from which they make art, art historians study a wider variety of media used to express ideas. If we attempt to define art, we realize that it is not simply about a physical form. What we can see or touch in a work of art is only part of the story. The first chapter of this book discusses remarkable prehistoric paintings covering the walls of caves in Spain and France, some dating to ca. 30,000 BCE. The *Hall of the Bulls* (fig. **I.10**) appears on a wall in Lascaux Cave in the Dordogne region of France, and dates from ca. 16,000 BCE. Although we believe these works served some type of function for the people who made them, the animals they so naturalistically depicted on the walls of their caves were produced before the advent of writing, and we have no idea whether people at the time also thought of these expertly painted forms as we do—as works of art. Did they even have a concept of "art": a special category of communication in which the image played a role other than that of a simple everyday sign, such as a hiker's mark for danger carved on a tree?

In addition to its physical form, then, the question "How do we recognize art?" also depends on how we know something is art—either as an abstract idea or through our senses. The theory that art is also an intellectual product is a very old notion in Western culture. When the Italian Renaissance artist Michelangelo was carving the *David* (see fig. 16.13), he believed his role as sculptor was to use his artistic ability to "release" the form hidden within the block of marble he was working on. And the twentieth-

I.10. *Hall of the Bulls,* ca. 15,000–10,000 BCE. Lascaux, Dordogne, France

century Spanish Surrealist painter Salvador Dali once mischievously remarked that the ideas for his dreamlike paintings (see fig. 28.18) traveled down from the surrounding atmosphere through his generous handlebar moustache. Even those of us who know very little about art and its history have ideas about what art is simply because we have absorbed them through our culture. In 1919, the humorous and brilliant Parisian Marcel Duchamp took a roughly 8 by 4-inch reproduction of Leonardo da Vinci's *Mona Lisa* in the Louvre Museum in Paris and drew a mustache on the sitter's face (fig. **I.11**). Below he wrote the letters *L.H.O.O.Q.,* which when pronounced in French is *elle a chaud au cul,* which translates, "She has hot pants." With this phrase, Duchamp was poking fun at the public's fascination with the mysterious smile on the Mona Lisa, which began to intrigue everyone in the nineteenth century and had, in Duchamp's time, eluded suitable explanation. Duchamp irreverently suggests that her sexual identity is ambiguous and that she is sexually aroused. With the childish gesture of affixing a moustache to the Mona Lisa, Duchamp also attacked bourgeois reverence for Old Master painting and the notion that oil painting represented the pinnacle of art.

Art, Duchamp is saying, can be made by merely placing ink on a mass-produced reproduction. It is not strictly oil on canvas or cast bronze or chiseled marble sculpture. Artists can use any imaginable media in any way in order to express themselves. He is announcing that art is about ideas that are communicated visually, and not necessarily about the materials it is made from or how closely it corresponds to current tastes. In this deceivingly whimsical work, which is rich with ideas, Duchamp is telling us that art is anything that someone wants to call art, which is not the same as saying it is good art. Furthermore, he is proclaiming that art can be small; *L.H.O.O.Q.* is a fraction of the size of its source, the *Mona Lisa.* By appropriating Leonardo's famous picture and interpreting it very differently from traditional readings, Duchamp suggests that the answer to the question "How do we recognize art?" is not fixed forever, that it can change and be assigned by artists, viewers, writers, collectors, and museum curators, who use it for their own purposes. Lastly, and this is certainly one of Duchamp's many wonderful contributions to art, he is telling us that art can be fun; it can defy conventional

1.11. Marcel Duchamp. *Mona Lisa (L.H.O.O.Q.).* (1919) Rectified readymade; pencil on a reproduction. 7 × 4⅞″ (17.8 × 12 cm). Private collection. © Artists Rights Society (ARS), New York/ADAGP, Paris/Succession Marcel Duchamp

notions of beauty, and while intellectually engaging us in a most serious manner, it can also provide us with a smile, if not a good laugh.

Art and Aesthetics: Changing Ideas of Beauty

One of the reasons that Duchamp selected the *Mona Lisa* for "vandalizing" had to be that many people considered it the most beautiful painting ever made. Certainly, it was one of the most famous paintings in the world, if not the most famous. In 1919, most people who held such a view had probably never seen it and only knew it from reproductions, probably no better than the one Duchamp used in *L.H.O.O.Q.*! And yet, they would describe the original painting as beautiful, but not Duchamp's comical version. Duchamp called such altered found objects as *L.H.O.O.Q.* "assisted readymades" (for another example, see *The Fountain,* fig. 28.2). He was adamant when he claimed that these works had no aesthetic value whatsoever. They were not to be considered beautiful, and they were selected because they were

aesthetically neutral. What interested Duchamp were the ideas that these objects embodied once they were declared art.

L.H.O.O.Q. and the question of its beauty raises the issue of *aesthetics,* which is the study of beauty, its origins and its meanings, principally by philosophers. In the West, an interest in aesthetic concepts dates back to ancient Greece. The Greeks' aesthetic theories reflected ideas and tendencies of their culture. In calling a sculpture such as the *Kritios Boy* beautiful (fig. **I.12**), the Greeks meant that the statue reflected what was generally agreed to be an embodiment of the morally good or perfect: a well-proportioned young male. Even more, this idealized form, both good and beautiful, was thought to inspire positive emotions that would reinforce the character of the good citizen who admired it—an important function in the frequently turbulent city-states.

In the modern world, art historians, as well as artists, are also influenced by a variety of aesthetic theories that ultimately mirror contemporary interests about the direction of society and culture. As our world has come to appear less stable and more fragmented, aesthetic theories about what is true, good, or beautiful also have come to stress the relative nature of aesthetic concepts rather than seeing them as eternal and unchangeable. Many art historians now argue that a work of art can hold up under several, often conflicting interpretations of beauty or other aesthetic concepts, if

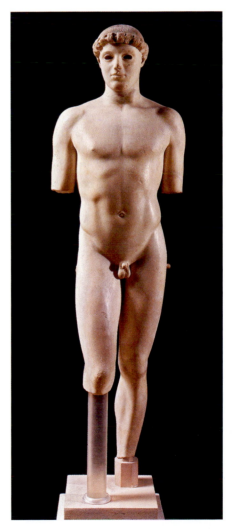

I.12. *Kritios Boy.* ca 480 BCE. Marble. Height 46″ (116.7 cm). Akropolis Museum, Athens

those interpretations can be reasonably defended. Thus, despite his claim, Duchamp's assisted readymades can be perceived as beautiful, in ways, of course, that are quite different from those of Leonardo's *Mona Lisa*. The beauty in Duchamp's works derives from their appeal to the intellect; if we understand his messages, his objects appear clever and witty, even profound. His wit and insights about art transformed a slightly altered cheap black-and-white reproduction into a compelling work of art, in a way that is very different from Leonardo's. The qualities that attract us to the *L.H.O.O.Q.*—its cleverness and wit—differ sharply from the skills and values that are inherent in Leonardo's *Mona Lisa*. The intriguing ideas and wit that surround the *L.H.O.O.Q.* place it above a mere youthful prank, and point to a new way of looking at art. Duchamp's innovative rethinking of the nature of art has had a profound effect on artists and aesthetic theory ever since it was made. Our appreciation of Robert Rauschenberg's *Odalisk* (fig. 29.10), created in the late 1950s out of a combination of found materials, including a pillow and a stuffed chicken, and playfully pasted with discarded materials full of sexual allusion, is unthinkable without Duchamp's work.

Quality: In the Mind or the Hand?

Terms like quality and originality are often used in discussing works of art, especially in choosing which works to include or exclude in a book like this. What is meant by these terms, however, varies from critic to critic. For example, in the long history of art, technical finesse or craft has often been viewed as the most important feature to consider in assessing quality. To debunk the myth that quality is all about technique and to begin to get at what it is about, we return to Warhol's *Gold Marilyn Monroe*. The painting is rich with stories: We can talk about how it raises issues about the meaning of art or the importance of celebrity, for example. But Warhol begs the question of the significance of technical finesse in art making, an issue raised by the fact that he may not have even touched this painting himself! We have already seen how he appropriated someone else's photograph of Marilyn Monroe, not even taking his own. Warhol then instructed his assistants to make the screens for the printing process. They also prepared the canvas, screened the image with the colors Warhol selected, and most likely painted the gold to Warhol's specifications, although we do not know this for sure.

By using assistants to make his work, Warhol is telling us that quality is not about the artist's technical finesse or even the artist's physical involvement in making the work, but about how well the artist communicates an idea using visual language. One measure of quality in art is the quality of the statement being made, or its philosophy, as well as the quality of the technical means for making the statement. Looking at *Gold Marilyn Monroe* in the flesh at New York's Museum of Modern Art is a powerful experience. Standing in front of this 6-foot-high canvas, we cannot help but feel the empty glory of America's most famous symbol of female sexuality and stardom. Because the artist's vision, and not his touch, is the relevant issue for the making of this particular work, it is of no consequence that Warhol most likely never laid a hand to the canvas, except to sign the back. We will shortly see, however, that the artist's touch has often been seen as critical to the perception of originality in a work of art.

Warhol openly declared that his art was not about his technical ability when he called his Manhattan studio "The Factory." He was telling us that art is a commodity, and that he is manufacturing a product, even mass producing his product. The Factory churned out over a thousand, if not thousands, of paintings and prints of Marilyn Monroe, all based on the same newspaper photograph. All Warhol did, for the most part, was sign them, his signature reinforcing the importance many people place on the signature itself as being an essential part of the work. Ironically, most Old Master paintings, dating from the fourteenth through the eighteenth centuries, are not signed, and in fact, artists for centuries used assistants to help make their pictures.

Peter Paul Rubens, an Antwerp painter working in the first half of the seventeenth century and one of the most famous artists of his day, had an enormous workshop that cranked out many of his pictures, especially the large works. His assistants were often artists specializing in flowers, animals, or clothing, for example, and many went on to become successful artists in their own right. Rubens would design the painting, and then assistants, trained in his style, would execute their individual parts. Rubens would come in at the end and finish the painting as needed. The price the client was willing to pay often determined how much Rubens himself participated in the actual painting of the picture; many of his works were indeed made entirely by him. Rubens's brilliant flashy brushwork was in many respects critical to the making of

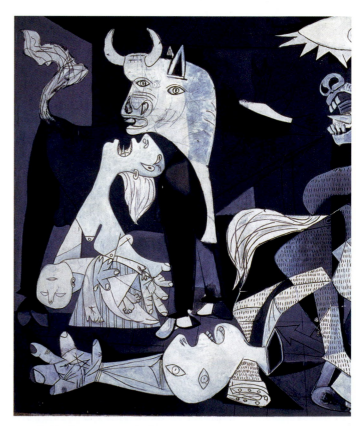

1.13. Pablo Picasso. Detail of *Guernica*. 1937. Oil on canvas, 11′6″ × 25′8″ (3.51 × 7.82 m). Museo Nacional Centro de Arte Reina Sofia, Madrid. On permanent loan from the Museo del Prado, Madrid. © Estate of Pablo Picasso/Artists Rights Society (ARS), New York

the picture. Not only was his handling of paint considered superior to that of his assistants, the very identity of his paintings, their very life so to speak, was linked to his personal way of applying paint to canvas, almost as much as it was to his dramatic compositions. For his buyers, Rubens's brushwork complemented his subject matter, even reinforced it. Despite the collaborative nature of their production, the artworks made in Rubens's workshop were often striking combinations of the ideas and the powerful visual forms used to communicate them. In that combination lies their originality.

Concepts like beauty, quality, and originality, then, do not refer only to physical objects like pretty, colorful pictures or a perfectly formed marble figure. They are ideas that reside in content and in the perception of how successfully the content is communicated visually. Some of the most famous and most memorable paintings in the history of art depict horrific scenes, such as beheadings (see fig. 19.5), crucifixions (see fig. 18.13), death and despair (see figs. 24.18 and 24.20), emotional distress (see fig.29.9), and the brutal massacre of innocent women and children (fig. **I.13**)). Duchamp's *L.H.O.O.Q.* and Warhol's *Gold Marilyn Monroe* are powerful and riveting. Some would even argue that their complex ideas and unexpected presentations make these works beautiful.

Photography as Art

The first edition of this book did not include photography among the media discussed. Now, four decades later, the artistic merit of photography seems self-evident. When photography was invented in 1839, the art world largely dismissed it as a mechanical process that objectively recorded reality. It was seen as a magical way to capture the detailed likenesses of people and objects without undergoing long artistic training. And, although some artists were intrigued by the often accidental and impersonal quality of the images it produced, the new medium was perceived by many critics as not having sufficient aesthetic merit to be seen in the lofty company of the major forms of fine art—painting and sculpture. Anyone, it seemed, could take a photograph. George Eastman's invention of the hand-held Kodak camera in 1888, allowed photography to become every man's and woman's pastime.

Photography has struggled for a long time to shed its popular, mechanical stigma. In the 1890s, some photographers, like Gertrude Käsebier, attempted to deny the hard, mechanical look of their art by making their prints appear soft, delicate, and fluid (see fig. 26.46). But at the beginning of the twentieth century, Paul Strand and others began to embrace black-and-white photography's hard-edge detail and the abstract results made possible by creative cropping. His *Wire Wheel* of 1917 (fig. 28.43) celebrates the machine age as well as the newest movements in the media of painting and sculpture. By the 1940s, black-and-white photography had gained some status as an art form, but it was not until the 1960s, when photography became an important part of the art school curriculum, that black-and-white photography began to take its place as one of the major art forms. It has taken color photography even longer to achieve serious consideration. But now,

along with video and film, both black-and-white and color photography have been elevated to an important medium. Pictures from the nineteenth and twentieth centuries that once had interested only a handful of photography insiders are intensely sought after, with many museums rushing to establish photography departments and amass significant collections. In other words, it has taken well over 100 years for people to get beyond their prejudice against a mechanical process and develop an eye for the special possibilities and beauty of the medium.

We need only look at a 1972 photograph entitled *Albuquerque* (fig. **I.14**) by Lee Friedlander to see how photography may compete with painting and sculpture in artistic merit. In *Albuquerque,* Friedlander portrays a modern America that is vacuous and lifeless, which he suggests is due to technology. How does he do this? The picture has a haunting emptiness. It has no people, and it is filled with strange empty spaces of walkway and street that appear between the numerous objects that pop up everywhere. A hard, eerie geometry prevails, as seen in the strong verticals of the poles, buildings, hydrant, and wall. Cylinders, rectangles, and circles are everywhere. (Notice the many different rectangles on the background building, or the rectangles of the pavement bricks and the foreground wall.)

Despite the stillness and emptiness, the picture is busy and restless. The vertical poles and the strong vertical elements on the house and building establish a vibrant staccato rhythm. The energy of this rhythm is reinforced by the asymmetrical composition that has no focus or center, as well as by the powerful intersecting diagonals of the street and the foreground wall. (Note how the shadow of the fire hydrant runs parallel to the street.) Disturbing features appear throughout the composition. The street sign—which cannot be seen because it is cropped at the top of the print—casts a mysterious shadow on the wall. A pole visually cuts the dog in two, and the dog has been separated from his attribute, the fire hydrant, as well as from his absent owner. The fire hydrant, in turn, appears to be mounted incorrectly, because it sticks too far out of the ground. The car on the right has been brutally cropped, and a light pole seems to sprout strangely from its hood. The telephone pole in the center of the composition is

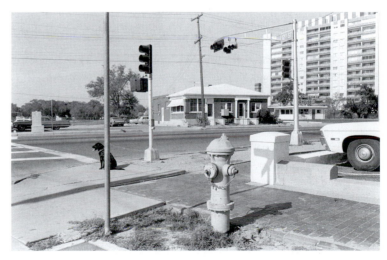

I.14. Lee Friedlander. *Albuquerque.* 1972. Gelatin silver print, 11 × 14″. © Lee Friedlander

crooked, as though it has been tilted by the force of the cropped car entering from outside the edge of the picture (of course, the car is parked and not moving). Why do we assume this empty, frenetic quality is human-made? Because the work is dominated by the human-made and by technology. We see telephone poles, electrical wires, crosswalk signs, an ugly machinelike modular apartment building, sleek automobiles, and a fire hydrant. Cropped in the lower left foreground is the steel cover to underground electrical wiring.

Everywhere, nature has been cemented over, and besides a few scraggly trees in the middle ground and distance, only the weeds surrounding the hydrant thrive. In this brilliant print, Friedlander captures his view of the essence of modern America: the way in which technology, a love of the artificial, and a fast, fragmented lifestyle have spawned alienation and a disconnection with nature and spirituality. As important, he is telling us that modernization is making America homogeneous. The title tells us we are in Albuquerque, New Mexico, but without the title, we are otherwise in Anywhere, U.S.A.

Friedlander did not just find this composition. He very carefully selected it and he very carefully made it. He not only needed the sun, he had to wait until it was in the right position (otherwise, the shadow of the fire hydrant would not align with the street). When framing the composition, he very meticulously incorporated a fragment of the utility cover in the left lower foreground, while axing a portion of the car on the right. Nor did the geometry of the picture just happen; he made it happen. Instead of a soft focus that would create an atmospheric blurry picture, he has used a deep focus that produces a sharp crisp image filled with detail, allowing, for example, the individual rectangular bricks in the pavement to be clearly seen. The strong white tones of the vertical rectangles of the apartment building, the foreground wall, and the utility box blocking the car on the left edge of the picture were probably carefully worked up in the darkroom, as was the rectangular columned doorway on the house. Friedlander has exposed the ugliness of modern America in this hard, cold, dry image, and because of the power of its message he has produced an extraordinarily beautiful work of art.

Architecture as Art

Architecture, although basically abstract and dedicated to structuring space in a functional way, can also be a powerful communicator of ideas. For example, we see Gianlorenzo Bernini expressing complex ideas in 1656 when he was asked by Pope Alexander XVII to design a large open space, or piazza, in front of St. Peter's cathedral in Rome. Bernini obliged, creating a space that was defined by a row of columns (a colonnade) resembling arms that appear to embrace visitors, offering comfort (fig. **I.15**) and encouraging worshipers to enter the building. Bernini's design made the building seem to welcome all visitors into a universal (Catholic) church. At about the same time, the French architect Claude Perrault was commissioned to design the East facade of Louis XIV's palace, the Louvre in Paris (fig. **I.16**). The ground floor, where the day-to-day business of the court was carried out, was designed as a squat podium. The second floor,

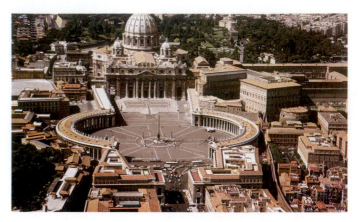

I.15. St. Peter's, Rome. Nave and facade by Carlo Maderno, 1607–1615; colonnade by Gianlorenzo Bernini, designed 1657

where Louis lived, was much higher and served as the main floor, proclaiming Louis's grandeur. Perrault articulated this elevated second story with a design that recalled Roman temples, thus associating Louis XIV with imperial Rome and worldly power. The controlled symmetry of the design further expresses Louis's control over his court and nation.

In the modern era, an enormously wealthy businessman, Solomon R. Guggenheim, indulged his passion for modern art by commissioning architect Frank Lloyd Wright to design a museum in New York City. One of the boldest architectural statements of the mid-twentieth century, Wright's Solomon R. Guggenheim Museum is located on upper Fifth Avenue, overlooking Central Park (fig. **I.17**). The building, erected from 1956 to 1959, is radically different from the surrounding residential housing, thus immediately declaring that its function is different from theirs. Indeed, the building is radically different from most anything built up until that time. We can say that the exterior announces that it is a museum, because it looks as much like a gigantic sculpture as a functional structure.

Wright conceived the Guggenheim in 1945 to create an organic structure that deviated from the conventional static rectangular box filled with conventional static rectangular rooms. Beginning in the early twentieth century, Wright designed houses that related to the landscape and nature, both in structure and material (fig. 26.42). The structure of his buildings, whether domestic or commercial, reflects the very structure of nature, which he saw as a continuous expansion. His buildings radiate out from a central core or wrap around a central void, but in

I.16. Louis Le Vau, Claude Perrault, and Charles Le Brun. East front of the Louvre, Paris. 1667–1670

I.17. Frank Lloyd Wright. The Solomon R. Guggenheim Museum, New York. 1956–1959. David Heald © The Solomon Guggenheim Foundation, New York. © Frank Lloyd Wright Foundation, Scottsdale, AZ/Artists Rights Society (ARS), New York

I.18. Frank Lloyd Wright. Interior of the Solomon R. Guggenheim Museum, New York. 1956–59. Robert Mates © The Solomon Guggenheim R. Foundation, New York. © Frank Lloyd Wright Foundation, Scottsdale, AZ/Artists Rights Society (ARS), New York

either case, they are meant to expand or grow like a leaf or crystal, with one form opening up into another.

The Guggenheim is based on a natural form. It is designed around a spiral ramp (fig. **I.18**), which is meant to evoke a spiral shell. The structure also recalls a ceramic vase. It is closed at the bottom and open at the top, and as it rises it widens, until it is capped by a light-filled glass roof. When referring to the Guggenheim, Wright often cited an old Chinese aphorism, "The reality of the vase is the space inside." For the most part, the exhibition space is one enormous room formed by the spiral viewing ramp. Wright wanted visitors to take the elevator to the top of the ramp, and then slowly amble down its 3 percent grade, gently pulled by gravity. Because the ramp was relatively narrow, viewers could not get too far back from the works of art and were forced to have an intimate relationship with the objects. At the same time, they could look back across the open space of the room to see where they had been, comparing the work in front of them to a segment of the exhibition presented on a sweeping distant arc. Or they could look ahead as well, to get a preview of where they were going. The building has a sense of continuity and mobility that Wright viewed as an organic experience. Looking down from the upper reaches of the ramp, we can see the undulation of the concave and convex forms that reflect the subtle eternal movement of nature. Wright even placed a pool on the ground floor, facing the light entering from the skylight high above. Regardless of their size, no other museum has succeeded in creating a sense of open space and continuous movement as Wright did in the Guggenheim. Nor does any other museum have the same sense of communal spirit; at the Guggenheim everyone is united in one big room (see fig. I.18).

EXPERIENCING ART

This book offers you an introduction to many works of art, and provides reproductions of most of them. Yet your knowledge of the objects will be enlarged when you see the works firsthand. No matter how accurate the reproductions in this book—or any other—are, they are just stand-ins for the actual objects. We hope you will visit some of the museums where the originals are displayed. But keep in mind that looking at art, absorbing its full impact takes time and repeated visits. Occasionally, you might do an in-depth reading of an individual work. This would involve carefully perusing details and questioning why they are there. Ideally, the museum will help you understand the art. Often, there are introductory text panels that tell you why the art in a particular exhibition or gallery has been presented together, and there are often labels for individual works that provide further information. Major temporary exhibitions generally have a catalogue, which adds yet another layer of information and interpretation. But text panels, labels, and catalogues generally reflect one person's reading of the work, and there are usually many other ways to approach or think about it.

Although the museum is an effective way to look at art and certainly the most efficient, art museums are relatively new. Indeed, before the nineteenth century, art was not made to be viewed in museums, but in homes, churches, or government buildings. Today we find works of art in galleries, corporate lobbies and offices, places of worship, and private homes. You may find art in public spaces, from subway stations and bus stops to plazas, from libraries and performing art centers to city halls. University and college buildings are often filled with art, and the buildings themselves are art. The chair you are sitting in and the building where you are reading this book are also works of art, maybe not great art, but art all the same, as Duchamp taught us. Even the clothes you are wearing are art. Wherever you find art, it is telling you something and making a statement.

Art is not a luxury, as many people would have us believe, but an integral part of daily life. It has a major impact on us, even when we are not aware of it; we feel better about ourselves when we are in environments that are visually enriching and exciting. Most important, art stimulates us to think. Even when it provokes and outrages us, it broadens our experience by making us question our values, attitudes, and worldview. This book is an introduction to this fascinating field that is so intertwined with our lives. After reading it, you will find that the world will not look the same.

Art in Thirteenth- and Fourteenth-Century Italy

ALTHOUGH ITALIAN ARTISTS AND PATRONS SHARED CONCERNS WITH their contemporaries elsewhere in Europe, for geographic, historical, and economic reasons, the arts in Italy struck out in a different direction. Many of the innovations that would characterize the Italian Renaissance of the fifteenth and sixteenth centuries have their seeds in thirteenth and fourteenth-century Italy.

Throughout most of Europe in the thirteenth century, political and cultural power rested with landholding aristocrats. Products from their lands created wealth, and the land passed from one generation to the next. Although hereditary rulers controlled large regions, they usually owed allegiance to a king or to the Holy Roman emperor. But Italy had few viable kingdoms or strong central authorities. During most of the Middle Ages, Italian politics were dominated by the two international institutions of the Holy Roman Empire and the papacy. Usually, the emperors lived north of the Alps, and sheer distance limited their control in Italy. For much of the fourteenth century, Rome lacked a pope to command temporal power, as the papacy had moved to France. Hereditary rulers controlled southern Italy and the area around Milan, but much of Italy consisted of individual city-states, competing with each other for political influence and wealth. Among the most important of these were Florence, Siena, Pisa, and Venice.

Geography, particularly the long coastlines on the Mediterranean and Adriatic Seas, and long practice, had made Italy a trading center throughout the Middle Ages. By the thirteenth and fourteenth centuries, trade and paid labor for urban artisans had been long established. As the number of these new groups of merchants and artisans grew in the cities, their political power grew as well. The wealthiest and most influential cities, including Florence and Siena, were organized as representative republics. As a check on inherited power, some cities even excluded the landed aristocracy from participating in their political processes. Tensions erupted frequently between those who supported monarchical and aristocratic power, and thus supported the emperor, and those who supported the papacy and mercantile parties. In the cities of Florence, Venice, Pisa, and Siena, power tended to be concentrated in the hands of leading merchant families who had become wealthy through trade, manufacture, or banking. Members of these families would become the foremost patrons of artists in Italy.

Those artists developed their skills in a context that differed from the rest of Europe. Throughout the Middle Ages, Roman and Early Christian art served as an inspiration for Italian architects and sculptors, as is visible in such works as the Cathedral of Pisa (see fig. 11.33). In the mid-thirteenth century, the Holy Roman emperor Frederick II (1194–1250), who lived for a time in southern Italy, deliberately revived imperial Roman style to express his own political ambitions as heir to the Roman Empire. The other empire, Byzantium, kept a presence throughout Italy, too—through mosaics at Ravenna, Sicily, and Venice, and through the circulation of artists and icons such as the *Madonna Enthroned* (fig. 8.50). Added to these forces was the influence of the French Gothic style, introduced through the travels of artists and patrons.

Detail of figure 13.20, Giotto, *Christ Entering Jerusalem*

Map 13.1. Italy in the Thirteenth and Fourteenth Centuries

One of those travelers, the churchman, scholar, and poet Francesco Petrarch, exemplifies another aspect of fourteenth-century Italian culture: a growing interest in the creative works of individuals. Petrarch and his contemporaries, Dante Alighieri and Giovanni Boccaccio, belong to a generation of thinkers and writers who turned to the study of ancient works of literature, history, and art to seek out beautiful and correct forms. Petrarch also sought to improve the quality of written Latin, and thereby to emulate the works of the Roman authors Vergil and Cicero. This study of ancient thought and art led to a search for moral clarity and models of behavior, a mode of inquiry that came to be known as **humanism**. Humanists valued the works of the ancients, both in the literary and the visual arts, and they looked to the classical past for solutions to modern problems. They particularly admired Roman writers who championed civic and personal virtues, such as service to the state and stoicism in times of trouble. Humanists considered Roman forms the most authoritative, and, therefore, the most worthy of imitation, though Greek texts and ideas were also admired.

The study of the art of Rome and Greece would profoundly change the culture and the art of Europe by encouraging artists to look at nature carefully and to consider the human experience as a valid subject for art. These trends found encouragement in the ideals and theology of the mendicant orders, such as the Dominicans, who valued Classical learning, and the Franciscans, whose founder saw God in the beauty of Nature.

CHURCH ARCHITECTURE AND THE GROWTH OF THE MENDICANT ORDERS

International monastic orders, such as the Cistercians, made their presence felt in medieval Italy as in the rest of Europe. They were among the groups who helped to bring the technical and visual innovations of the French Gothic style to Italy. Italian Cistercian monasteries followed the practice, established in France, of building large, unadorned stone vaulted halls. These contrast starkly with the sumptuously adorned French Gothic cathedrals such as Reims (see fig. 12.29). Cistercians exercised control over the design of their monasteries to a great degree. The church of Fossanova, 60 miles south of Rome, represents the Cistercian plan transmitted to Italy (fig. **13.1**) from the headquarters churches in Burgundy. Consecrated in 1208, it is a vaulted basilica with somewhat abbreviated aisles that end in a squared chapel at the east end, as does the Cistercian church at Fontenay (fig. 11.23). Groin vaults cover the nave and the smaller spaces of the aisles, though the vaults are not ribbed as was the usual practice in Gothic buildings. Fossanova has no western towers and no tall spires. Interior spaces are spare and broadly proportioned rather than richly carved and narrow.

The simplicity of the architecture and the Cistercian reputation for reform made them an inspiration to the new mendicant movements that dominated Italy beginning in the thirteenth century and continuing through the Italian Renaissance. The

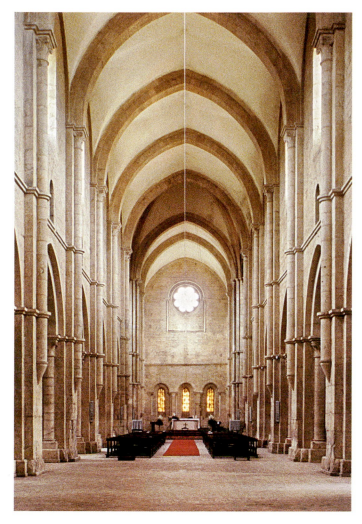

two major mendicant groups were the Franciscans and the Dominicans. They established international "orders," as did their monastic brethren, although their missions took a different form from those of traditional monks. Both orders were founded to minister to the lay populations in the rapidly expanding cities; they did not retreat from the world, but engaged with it. Each order built churches in the cities where sermons could be preached to crowds of people. The Dominicans, founded by Dominic de Guzmán in 1216, were especially concerned with combatting heresy. The Franciscan order, founded by Francis of Assisi in 1209, worked in the cities to bring deeper spirituality and comfort to the poor. Taking vows of poverty, Franciscans were committed to teaching the laity and to encouraging them to pursue spiritual growth. Toward this goal, they told stories and used images to explain and affirm the teachings of the Church. Characteristically, Franciscans urged the faithful to visualize events such as the Nativity in tangible ways, including setting up Nativity scenes (crèches) in churches as an aid to devotion.

The Franciscans at Assisi

The charismatic Francis died in 1226 and was named a saint two years later. His home town was the site of a huge basilica built in his honor. Its construction was sponsored by the pope, and was begun shortly after Francis's canonization in 1228. This multistoried structure became a pilgrimage site within a few years of its completion. The expansive walls of its simple nave (fig. **13.2**) were decorated with frescoes on Old and New Testament themes and a cycle that explained and celebrated the

13.1. Nave and choir, Abbey Church of Fossanova, Italy. Consecrated 1208

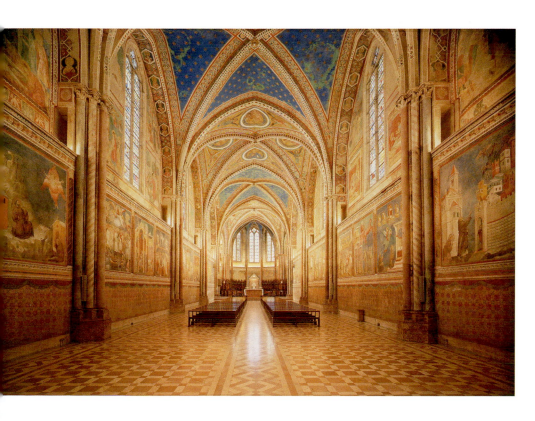

13.2. Interior of Upper Church, Basilica of San Francesco, Assisi. Begun 1228; consecrated 1253

achievements of Saint Francis. (See *Materials and Techniques*, page 442.) Scholars are still debating how many artists worked at Assisi from the 1290s to the early fourteenth century to complete this enormous cycle, but it appears that artists came here from Rome, Florence, Siena, and elsewhere. Assisi became a laboratory for the development of fourteenth-century Italian art. One of the most memorable of the many frescoes at Assisi depicts *Saint Francis Preaching to the Birds*, which was executed as part of a campaign of decoration in the church in the last decade of the thirteenth century or first part of the fourteenth century (fig. **13.3**). The whole cycle delineates Francis's life story based on a biography composed by his associates. One of the themes of Francis' life is his connection to Nature as a manifestation of God's workmanship; the story of Francis preaching to the birds exemplifies his attitude that all beings are connected. This fresco depicts Francis in his gray habit standing in a landscape and speaking to a flock of birds. To the astonished eyes of his companion, Francis appears to communicate to the birds, who gather at his feet to listen.

Trees establish the frame for the image as well as designate the location as outdoors; otherwise the background is a blue color, and little detail is provided. Francis and his companion are rendered naturalistically, as bulky figures in their

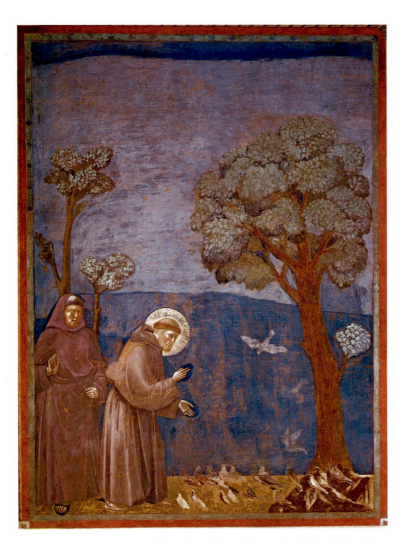

13.3. Anonymous. *Saint Francis Preaching to the Birds*. 1290s (?). Fresco from Basilica of San Francesco, Assisi

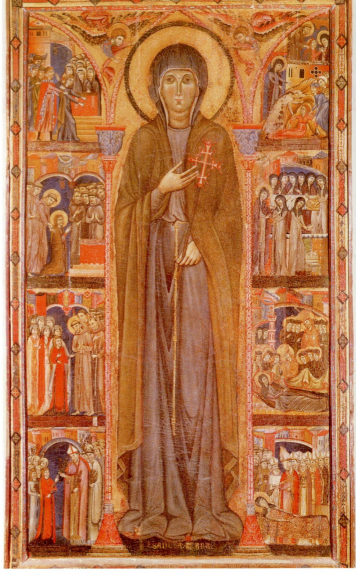

13.4. *Altarpiece of Saint Clare*. ca. 1280. Tempera on panel. $9 \times 5\frac{1}{2}'$ (2.73 × 1.65 m). Convent of Santa Chiara, Assisi

habits, as the artist describes light washing over their forms. Francis's figure becomes the focal point of the image, through his central position, the halo around his head, and his downward glance. His body language—the bent over stance, the movement of his hands—express his intense engagement with the birds as representatives of Nature. The simplicity of the composition makes the fresco easily legible and memorable.

The identity of the artist responsible for the frescoes in the nave of San Francesco is uncertain and controversial. One of the artists mentioned as a primary designer and painter is the Roman Pietro Cavallini, another is the Florentine Giotto di Bondone. But documentary evidence is lacking, and the opinions of connoisseurs fluctuate. Some scholars prefer to assign these frescoes to an anonymous master named for the paintings at Assisi. Whether through mutual influences or through competition with other artists, a new generation of painters comes of age at Assisi.

Franciscan women worshiped God through their vocations as nuns, though their convents and churches were less financially sound than many of the monasteries and churches of the friars. The nuns belonged to the branch of the Franciscans founded by his associate, Saint Clare, who was canonized in 1255. The church and convent she founded are still in service in Assisi, where an early example of an altarpiece to Saint Clare remains in place (fig. 13.4). A tall rectangle of wood, painted in tempera, the altarpiece was executed around 1280. It is dominated by the figure of Saint Clare, dressed in the habit of her order, standing frontally and holding the staff of an abbess. Rather than a portrait with specific features, Clare's face has the large eyes and geometric arrangement of a Byzantine Madonna (see fig. 8.37), while her figure seems to exist in one plane. She is flanked on either side by eight tiny narratives that tell the story of her life, death, and miracles. These vignettes demonstrate her commitment to her vocation, her obedience to Francis and the Church, and her service to her fellow nuns. The narratives make little pretense at three-dimensional form or spatial structure, keeping the focus on the figures and their actions to convey the story. Franciscan preachers wrote sermons and treatises addressed to religious women encouraging them to meditate on Scripture through visualizing the events in very physical terms. (See end of Part II, *Additional Primary Sources*.)

Churches and Their Furnishings in Urban Centers

Franciscan churches began to appear all over Italy as the friars ministered to the spiritual lives of city dwellers. A characteristic example in Florence is the church of Santa Croce (Holy Cross), begun around 1295 (fig. 13.5 and 13.6) The architect was probably the Tuscan sculptor Arnolfo di Cambio. Santa Croce shares some features with Gothic churches in Northern Europe, but has some distinctively Italian elements. This is a basilica with a mostly rectilinear eastern end, such as those found in Cistercian churches. Its proportions are broad and expansive rather than vertical. The nave arcade uses a Gothic pointed arch, while vertical moldings pull the eye up to the

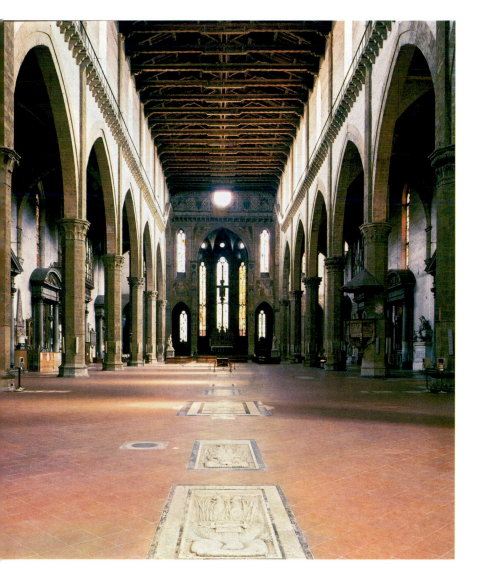

13.5. Nave and choir, Santa Croce, Florence. Begun ca. 1295

13.6. Plan of Santa Croce

Fresco Painting and Conservation

Fresco is a technique for applying paint to walls that results in an image that is both durable and brilliant. Frescoed surfaces are built up in layers: Over the rough wall goes a layer of rough lime-based plaster called *arriccio*. The artist then draws preliminary drawings onto this layer of plaster. Because they are done in red, these drawings are called *sinopie* (an Italian word derived from ancient Sinope, in Asia Minor, which was famous as a source of red brick earth pigment). Then a finer plaster called *intonaco* is applied in areas just large enough to provide for a day's worth of painting—the *giornata* (from *giorno,* the Italian word for "day"). While the plaster is still wet, the artist applies pigments suspended in lime water. As the plaster dries, the pigments bind to it, creating a *buon fresco,* literally a "good fresco." Plaster dries in a day, so only the amount of wet plaster that can be painted during that time can be applied. The work has to be done on a scaffold, so it is carried out from top to bottom, usually in horizontal strips about 4 to 6 feet long. As each horizontal level is completed, the scaffolding is lowered for the next level. To prevent chemical interactions with the lime of the plaster, some colors have to be applied *a secco* or dry; many details of images are applied this way as well. *Fresco secco* does not bond to the plaster as surely as *buon fresco* does, so it tends to flake off over time. Consequently, some frescoes have been touched up with tempera paints.

Although durability is the key reason for painting in fresco, over the centuries wars and floods have caused damage. Modern conservators have developed techniques for removing frescoes from walls and installing them elsewhere. After the River Arno flooded in 1966, many Florentine frescoes were rescued in this way, not only preserving the artworks but greatly increasing the knowledge and technology for this task. When a fresco is removed, a series of cuts are made around the image. Then a supporting canvaslike material is applied to the frescoed surface with a water-soluble glue. The surface to which the canvaslike material has been glued can then be pulled off gently and transferred to a new support to be hung elsewhere, after which the canvas can be removed.

Such removals have exposed many *sinopie,* such as the one shown here. The fresco, attributed to Francesco Traini (see fig. 13.32), was badly damaged by fire in 1944 and had to be detached from the wall in order to save what was left of it. This procedure revealed the plaster underneath, on which the composition was sketched out. These drawings, of the same size as the fresco itself, are much freer-looking in style than the actual fresco. They often reveal the artist's personal style more directly than the painted version, which was carried out with the aid of assistants.

Anonymous (Francesco Traini?). Sinopia drawing for *The Triumph of Death* (detail). Camposanto, Pisa

ceiling. Where one might expect the moldings to support a vaulted ceiling, however, Santa Croce uses wooden trusses to span the nave. The only vaults are at the apse and several chapels at the ends of the transept.

The choice to cover the nave with wood seems deliberate, as no structural reason accounts for it. There may be a regional preference for wooden ceilings, as the great Romanesque cathedral of Pisa also has a wooden roof. Santa Croce's broad nave with high arches is also reminiscent of Early Christian basilicas, such as Old Saint Peter's or Santa Maria Maggiore (see figs. 8.6 and 8.15). The wood roof at Santa Croce may have sprung from a desire to evoke the simplicity of Early Christian basilicas and thus link Franciscan poverty with the traditions of the early church.

One function of the wide spaces at Santa Croce was to hold large crowds to hear the friars' sermons. For reading Scripture at services and preaching, churchmen often commissioned monumental pulpits with narrative or symbolic images carved onto them. Several monumental pulpits were made by members of a family of sculptors from Pisa, including Nicola Pisano (ca. 1220/25–1284) and his son Giovanni Pisano (1265–1314). Though the two men worked at various sites throughout Italy, they executed important pulpits for the cathedral and the baptistery of Pisa.

For the Pisan baptistery, Nicola Pisano carved a hexagonal marble pulpit that he finished around 1260 (fig. **13.7**) Rising to about 15 feet high, so the assembly could both see and hear the speaker, the six sides of the pulpit rest on colored marble columns supporting classically inspired capitals. Above the capitals, carved into leaf shapes, small figures symbolizing the virtues stand between scalloped shaped arches, while figures of the prophets sit in the spandrels of these arches. Surprisingly, one of these figures (fig. **13.8**) is a male nude with a lion cub on his shoulder and a lion skin over his arm. Both his form

and the lion skin identify him as Hercules, the Greek hero, who stands here for the Christian virtue of Fortitude. His anatomy, his proportions, and his stance are probably the product of Nicola Pisano's study of Roman and Early Christian sculpture. Pisano had worked for Frederick II and at Rome, so his knowledge of ancient forms was deep. The nudity is not meant to be lascivious, but serves rather to identify the figure.

Nicola's study of the Roman past informs many other elements in his pulpit, including the narratives he carved for the six rectangular sides of the pulpit itself. These scenes from the life of Christ are carved in relief. The Nativity in figure **13.9** is a densely crowded composition that combines the Annunciation with the Birth of Christ. The relief is treated as a shallow box filled with solid convex shapes in the manner of Roman sarcophagi, which Pisa's monumental cemetery preserved in good numbers. The figures could almost be copied from the

Ara Pacis procession; the Virgin has the dignity and bearing of a Roman matron (see fig. 7.22). Pisano probably knew Byzantine images of the Nativity, for his iconography reflects that tradition. As the largest and most central figure, the reclining Virgin overpowers all the other elements in the composition. Around her, the details of the narrative or setting, such as the midwives washing the child and Joseph's wondering gaze at the events, give the relief a human touch. Nicola uses broad figures, wrapped in classicizing draperies, to give the scene gravity and moral weight.

When his son Giovanni Pisano carved a pulpit about 50 years later for the Cathedral of Pisa, he chose a different emphasis. Though of the same size and material, his relief of the Nativity from the cathedral pulpit (fig. **13.10**) makes a strong contrast to his father's earlier work. Depicting the Nativity and the Annunciation to the shepherds, Giovanni Pisano dwells on the landscape and animal elements: Sheep and trees fill the right edge of

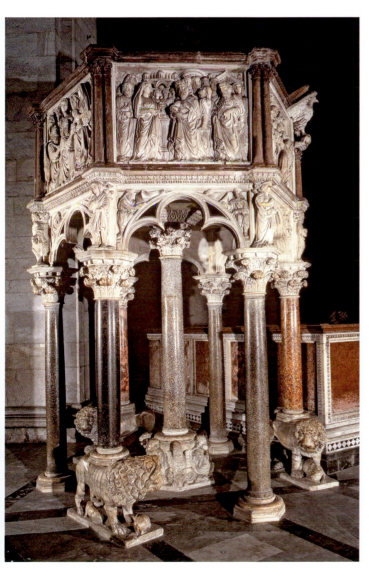

13.7. Nicola Pisano. Pulpit. 1259–1260. Marble. Height 15′ (4.6 m). Baptistery, Pisa

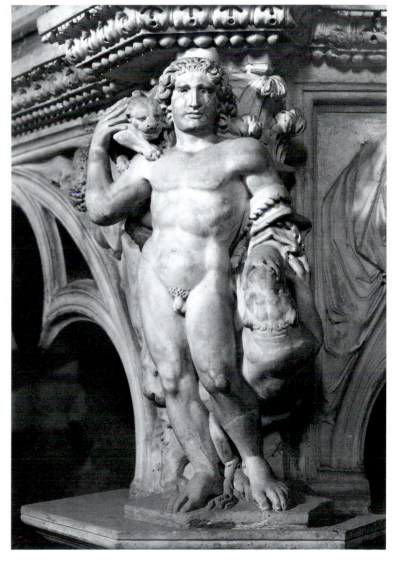

13.8. *Fortitude,* detail of the pulpit by Nicola Pisano. 1260

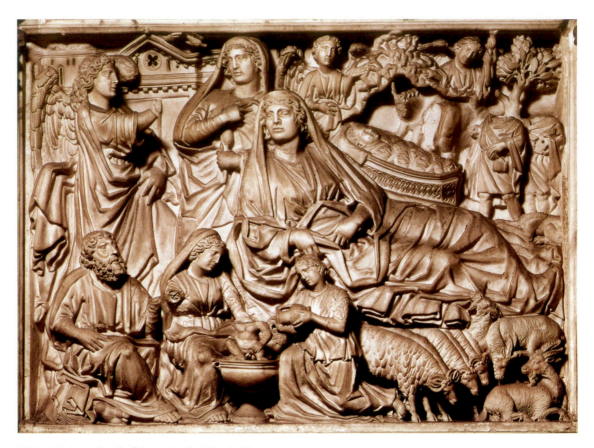

13.9. *Nativity*, detail of the pulpit by Nicola Pisano

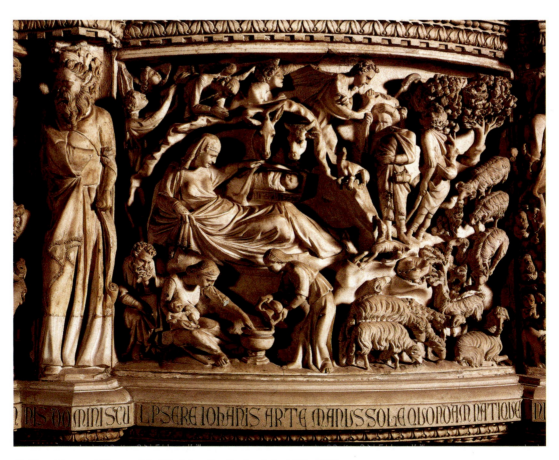

13.10. Giovanni Pisano. *The Nativity*, detail of pulpit. 1302–1310.
Marble. Pisa Cathedral

the composition, while the nativity itself takes place in a shallow cave. The Virgin still dominates the composition, but she is no longer a dignified matron. Instead, she is a young mother tending to her child. Her proportions are elongated rather than sturdy. Rather than echoing Roman or Classical models, Giovanni has studied contemporary French models to bring elegance and a detailed observation of nature to the image. Each of Giovanni's figures has its own pocket of space. Where Nicola's Nativity is dominated by convex, bulging masses, Giovanni's appears to be made up of cavities and shadows. The play of lights and darks in Giovanni's relief exhibits a dynamic quality that contrasts with the serene calm of his father's work.

Expanding Florence Cathedral

East of Pisa along the Arno, the increasing wealth of Florence inspired that town to undertake major projects for its cathedral and baptistery in order to compete with its neighbors. One of Nicola Pisano's students, Arnolfo di Cambio (ca. 1245–1302) was tapped to design a new cathedral for Florence to replace a smaller church that stood on the site. The cathedral was begun in 1296 (figs. **13.11**, **13.12**, and **13.13**). Such a project took the skills and energy of several generations, and the plan was modified more than once. Revisions of the plan were undertaken in 1357 by Francesco Talenti (active 1325–1369), who took over the project

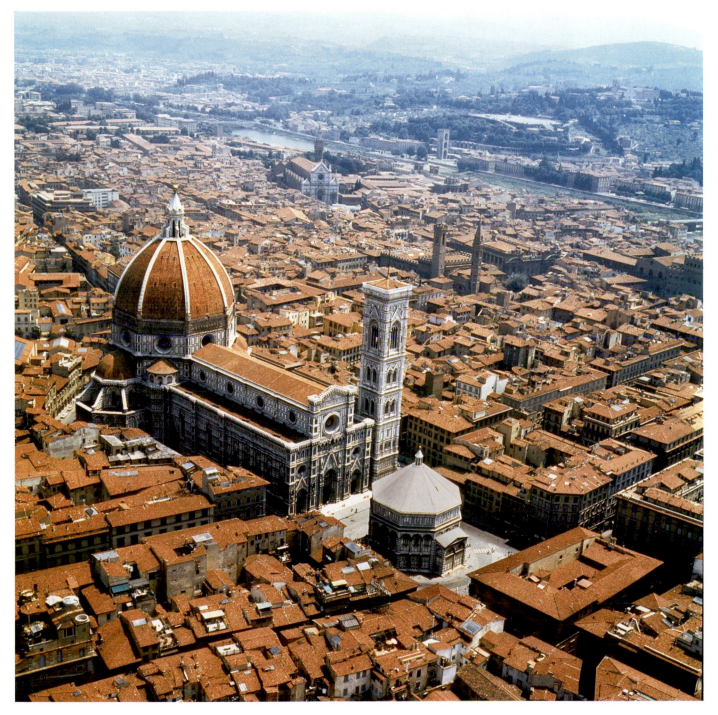

13.11. Florence Cathedral and Baptistery seen from the air. Cathedral begun 1296

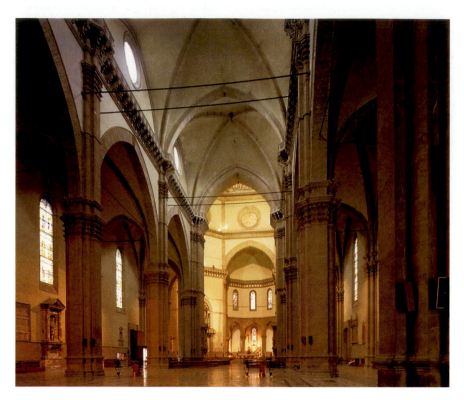

13.12. Nave and choir, Florence Cathedral

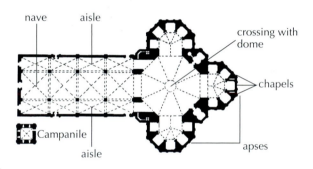

13.13. Plan of Florence Cathedral and Campanile

and dramatically extended the building to the east. By 1367, a committee of artists consulted by the overseers of the construction decided to cover the eastern zone with a high dome. The west facade and other portals continued to be adorned with sculpture throughout the Renaissance period, but the marble cladding on the building was not completed until the nineteenth century. Florence's *Duomo* was intended to be a grand structure that would not only serve as the spiritual center of the city, but as a statement of the city's wealth and importance.

Arnolfo's design was for a capacious basilica with a high arcade and broad proportions that contrast with contemporary Gothic structures in France (compare fig. 13.12 with fig. 12.26). The piers are articulated with leaf-shaped capitals and support flat moldings that rise to the clerestory level. Windows in the clerestory and aisles are relatively small, leaving much more wall surface than in French cathedrals. Although the original plan called for a trussed wooden roof in the Tuscan tradition,

by the mid-fourteenth century the plan had been altered to include ribbed groin vaults closer to the northern Gothic taste. The later plans enlarged the eastern zone to terminate in three faceted arms supporting an octagonal crossing that would be covered by a dome. (This design appears in the fresco in figure 13.33.) The scale of the proposed dome presented engineering difficulties that were not solved until the early fifteenth century. Instead of tall western towers incorporated into the facade, the cathedral has a *campanile* (bell tower) as a separate structure in the Italian tradition. The campanile is the work of the Florentine painter Giotto and his successors. If Florence's cathedral has Gothic elements in its vaults and arches, the foreign forms are tempered by local traditions.

In the heart of the city was the venerable Baptistery of Florence, built in the eleventh century on older foundations; the Florentines of the era believed it to be Roman and saw in its age the glory of their own past. Saint John the Baptist is the patron of Florence, so to be baptized in his baptistery meant that an individual not only became a Christian but also a citizen of Florence. In 1330, the overseers of the Baptistery commissioned another sculptor from Pisa, Andrea da Pisano (ca. 1295–1348; no relation to Nicola or Giovanni) to cast a new pair of bronze doors for the Baptistery. These were finished and installed in 1336 (fig. **13.14**). Cast of bronze and gilded, the project required 28 separate panels across the two panels of the door. They mostly represent scenes from the life of John the Baptist. Each vignette is framed by a Gothic quatrefoil, such as those found on the exteriors of French cathedrals. Yet within most of the four-lobed frames, Andrea provides a projecting ledge to support the figures and the landscape or architectural backgrounds. The relief of the Baptism of Christ demonstrates Andrea's clear compositional technique: Christ stands at the center, framed by

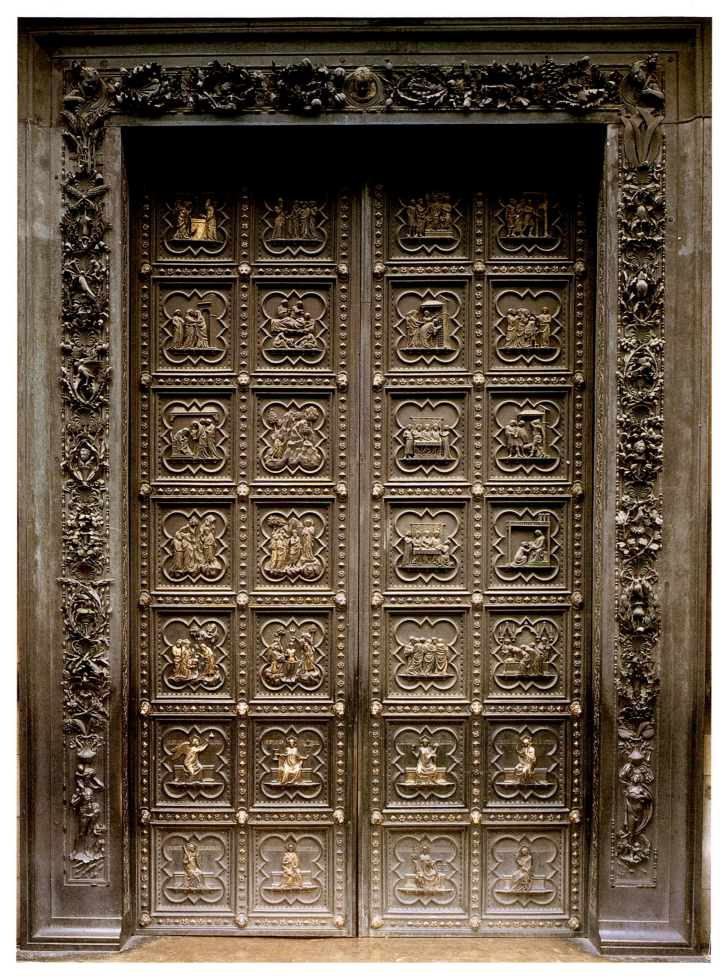

13.14. Andrea da Pisano. South doors, Baptistery of San Giovanni, Florence. 1330–1336. Gilt bronze

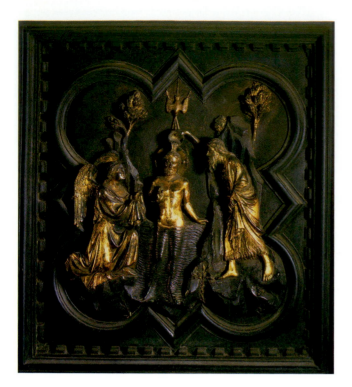

13.15. Andrea da Pisano. *The Baptism of Christ,* from the south doors, Baptistery of San Giovanni, Florence. 1330–1336. Gilt bronze

John on the right in the act of baptism and an angelic witness on the left (fig. **13.15**). The dove of the spirit appears above Christ's head. The emphasis is on the key figures, with little detail to distract from the main narrative; only a few small elements suggest the landscape context of the River Jordan.

Buildings for City Government: The Palazzo della Signoria

While the citizens of Florence were building the huge cathedral, the political faction that supported the papacy instead of the Holy Roman Empire consolidated its power in the city. The pro-papal party was largely composed of merchants who sought to contain the dynastic ambitions of aristocratic families who supported the emperor. The pro-papal group commissioned a large structure to house the governing council and serve as the symbol of the political independence of the city. The Palazzo della Signoria, also known as the *Palazzo Vecchio,* (fig. **13.16**) was probably also designed by Arnolfo di Cambio. It was begun in 1298 and completed in 1310, though it has been subject to later expansion and remodeling.

A tall, blocky, fortresslike structure, similar to fortified castles in the region, the Palazzo's stone walls are solid at the lowest level and rusticated for greater strength. The three stories of the structure are topped by heavy battlements and surmounted by a tall tower that serves not only as a symbol of civic pride, but as a defensive structure. It is slightly off-center for two reasons: The building rests on the foundations of an earlier tower, and its position makes it visible from a main street in the city. Boasting the highest tower in the city, the Palazzo della Signoria dominated the skyline of Florence and expressed the power of the communal good over powerful individual families.

PAINTING IN TUSCANY

As with other art forms in the thirteenth century, Italian painting's stylistic beginnings are different from those of the rest of Europe. Italy's ties to the Roman past and the Byzantine present would inspire Italian painters to render forms in naturalistic and monumental images. Throughout the Middle Ages, Byzantine mosaics and murals were visible to Italian artists. Venice had long-standing trading ties with the Byzantine Empire, and the Crusades had brought Italy in closer contact with Byzantium, including the diversion of the Fourth Crusade to Constantinople itself.

One result of the short-lived Latin occupation of Constantinople, from 1204 to 1261, was an infusion of Byzantine art forms and artists into Italy, which had a momentous effect on the development of Italian Gothic art. Later observers of the rapid changes that occurred in Italian painting from 1300 to 1550 described the starting point of these changes as the "Greek manner." Writing in the sixteenth century, Giorgio Vasari reported that in the mid-thirteenth century, "Some Greek painters were summoned to Florence by the government of the city for no other purpose than the revival of painting in their midst, since that art was not so much debased as altogether lost." Vasari assumes that medieval Italian painting was all but nonexistent and attributes to Byzantine art great influence over the development of Italian art in the thirteenth century. Italian artists were

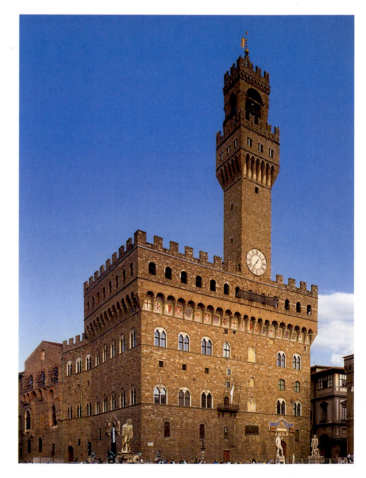

13.16. Palazzo della Signoria (Palazzo Vecchio), Florence. Begun 1298

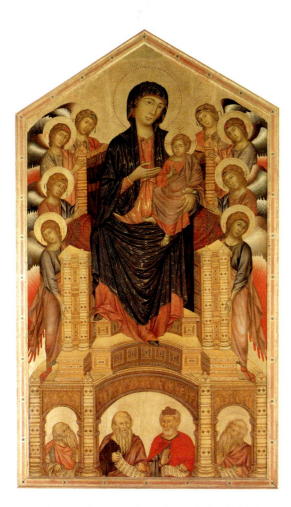

13.17. Cimabue. *Madonna Enthroned*. ca. 1280–1290. Tempera on panel, 12'7 1/2" × 7'4" (3.9 × 2.2 m). Galleria degli Uffizi, Florence

able to absorb the Byzantine tradition far more thoroughly in the thirteenth century than ever before. When Gothic style began to influence artists working in this Byzantinizing tradition, a revolutionary synthesis of the two was accomplished by a generation of innovative and productive painters in Tuscan cities.

Cimabue and Giotto

One such artist was Cimabue of Florence (ca. 1250–after 1300), whom Vasari claimed had been apprenticed to a Greek painter. His large panel of the *Madonna Enthroned* (fig. 13.17) was painted to sit on an altar in the Church of Santa Trinità in Florence; the large scale of the altarpiece—it is more than 12 feet high—made it the devotional focus of the church. Its composition is strongly reminiscent of Byzantine icons, such as the *Madonna Enthroned* (see fig. 8.50), but its scale and verticality are closer to the Saint Clare altarpiece (fig. 13.4) than to any Byzantine prototype. Mary and her son occupy a heavy throne of inlaid wood, which is supported by flanks of angels at either side and rests on a foundation of Old Testament prophets. The brilliant blue of the Virgin's gown against the gold leaf background makes her the focal point of the composition. Like Byzantine painters, Cimabue uses linear gold elements to enhance her dignity, but in his hands the network of gold lines follows her form more organically. The severe design and solemn expression is appropriate to the monumental scale of the painting.

ART IN TIME

1204—Fourth Crusade results in sacking of Constantinople

1226—Death of Francis of Assisi

1260—Nicola Pisano's Pisa Pulpit

1291—Turks expel Crusaders from Holy Land

Later artists in Renaissance Italy, such as Lorenzo Ghiberti (see chapter 15) and Giorgio Vasari (see chapter 16) claimed that Cimabue was the teacher of Giotto di Bondone (ca. 1267–1336/37), one of the key figures in the history of art. If so, Giotto learned the "Greek Manner" in which Cimabue worked. Many scholars believe Giotto was one of the artists working at Assisi, so he probably also knew the work of the Roman painter Pietro Cavallini. Giotto also worked in Rome where examples of both ancient and Early Christian art were readily available for study. Equally important, however, was the influence of the Pisani—Nicolo and Giovanni—with their blend of classicism and Gothic naturalism combined in an increased emotional content. (See figs. 13.9 and 13.10.)

We can see Giotto's relationship to, but difference from, his teacher Cimabue in a tall altarpiece of the *Madonna Enthroned*, which he painted around 1310 for the Church of All Saints (Ognissanti) in Florence (fig. 13.18). Like Cimabue's Santa Trinità Madonna, Giotto depicts the Queen of Heaven and her son

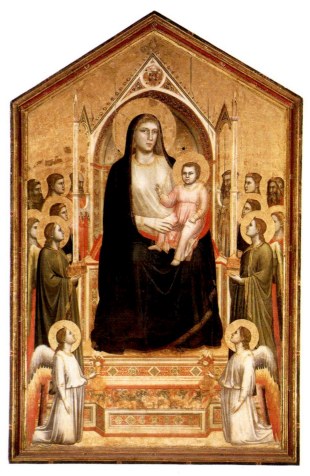

13.18. Giotto. *Madonna Enthroned*. ca. 1310. Tempera on panel, 10'8" × 6'8" (3.3 × 2 m). Galleria degli Uffizi, Florence

enthroned among angels against a gold background. The Virgin's deep blue robe and huge scale bring a viewer's eye directly to her and to the Christ Child on her lap. All the other figures gaze at them, both signaling and heightening their importance. Unlike his teacher, Giotto renders the figures bathed in light, so that they appear to be solid, sculptural forms. Where Cimabue turns light into a network of golden lines, Giotto renders a gradual movement from light into dark, so that the figures are molded as three-dimensional objects.

The throne itself is based on Italian Gothic architecture, though here it has become a nichelike structure. It encloses the Madonna on three sides, setting her apart from the gold background. The possibility of space is further suggested by the overlapping figures, who seem to stand behind one another instead of floating around the throne. Its lavish ornamentation includes a feature that is especially interesting: the colored marble surfaces of the base and of the quatrefoil within the gable. Such illusionistic stone textures had been highly developed by ancient painters (see fig. 7.52), and its appearance here is evidence that Giotto was familiar with whatever ancient murals could still be seen in medieval Rome.

THE SCROVEGNI CHAPEL IN PADUA Giotto's innovations in the area of light and space were accompanied by a gift for storytelling, especially in the fresco cycles he completed. Although scholars are not certain that he was among the artists who painted the nave frescoes at Assisi, his fresco cycles share formal and narrative characteristics with those images. Of

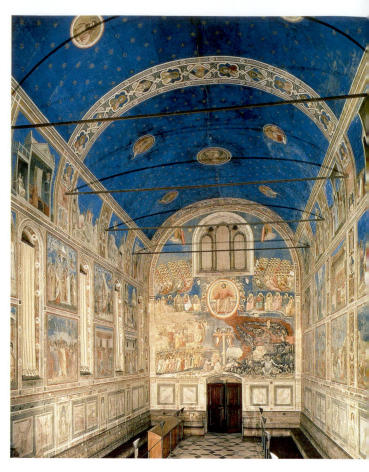

13.19. Interior, Arena (Scrovegni) Chapel. 1305–1306. Padua, Italy

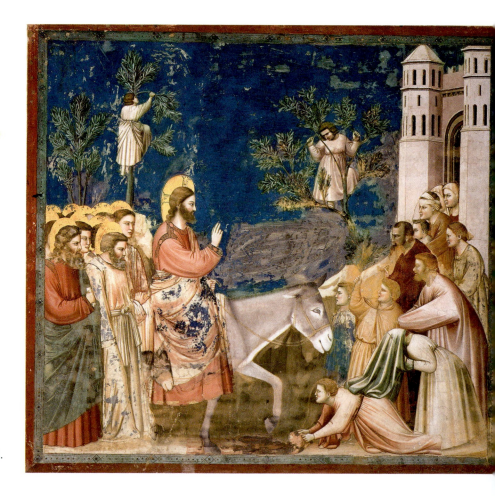

13.20. Giotto. *Christ Entering Jerusalem.* 1305–1306. Fresco. Arena (Scrovegni) Chapel. Padua, Italy

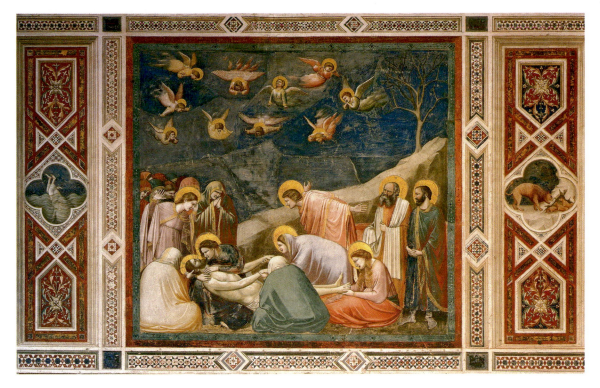

13.21. Giotto. *The Lamentation.* 1305–1306. Fresco. Arena (Scrovegni) Chapel. Padua, Italy

Giotto's surviving murals, those in the Scrovegni Chapel in Padua, painted in 1305 and 1306, are the best preserved and most famous. The chapel was built next to the palace of a Paduan banker, Enrico Scrovegni. (It is also known as the Arena Chapel because of its proximity to a Roman arena.) The structure itself is a one-room hall covered with a barrel vault. (fig. **13.19**)

Giotto and his workshop painted the whole chapel from floor to ceiling in the fresco technique. A blue field with gold stars symbolic of heaven dominates the barrel vault, below which the walls are divided into three registers or horizontal rows. Each register contains rectangular fields for narrative scenes devoted mainly to the life of Christ. The scenes begin at the altar end of the room with the Annunciation and culminate in the Last Judgment at the west end of the chapel. Along the length of the wall, the top register depicts stories of the early life of Mary and her parents; the center register focuses on stories of Christ's public life and miracles; and the lowest register depicts his Passion, Death, and Resurrection. Below the narratives the walls resemble marble panels interspersed with statues, but everything is painted.

Among the scenes from his public life is the *Christ Entering Jerusalem*, the event commemorated by Christians on Palm Sunday (fig. **13.20**). Giotto's handling of the scene makes a viewer feel so close to the event that his contemporaries must have had the sense of being a participant instead of an observer. He achieves this effect by having the entire scene take place in the foreground of his image, and by taking the viewer's position in the chapel into account as he designed the picture. Furthermore, Giotto gives his forms such a strong three-dimensional quality that they almost seem as solid as sculpture. The rounded forms create the illusion of space in which the actors exist.

Giotto gives very little attention to the setting for this event, except for the trees in which children climb and the gate of the city on the right. His large simple forms, strong grouping of figures, and the limited depth of his stage give his scenes a remarkable coherence. The massed verticals of the block of apostles on the left contrast with the upward slope of the crowd welcoming Christ on the right; but Christ, alone in the center, bridges the gap between the two groups. His isolation and dignity, even as he rides the donkey toward the city where he will die, give the painting a solemn air.

Giotto's skill at perfectly matching composition and meaning may also be seen in the scenes on the lowest level register, which focus on the Passion. A viewer gazing at these frescoes sees them straight on, so the painter organizes these scenes to exploit that relationship. One of the most memorable of these paintings depicts the Lamentation, the moment of last farewell between Christ and his mother and friends (fig. **13.21**). Although this event does not appear in the gospels, by the end of the Middle Ages versions of this theme had appeared in both Byzantine and in Western medieval art.

The tragic mood of this Lamentation, found also in religious texts of the era, is created by the formal rhythm of the design as much as by the gestures and expressions of the participants. The low center of gravity and the hunched figures convey the somber quality of the scene as do the cool colors and bare sky. With extraordinary boldness, Giotto sets off the frozen grief of the human mourners against the frantic movement of the weeping angels among the clouds. It is as if the figures on the ground were restrained by their obligation to maintain the stability of the composition, while the angels, small and weightless as birds, are able to move—and feel—freely.

Once again the simple setting heightens the impact of the drama. The descending slope of the hill acts as a unifying element that directs attention toward the heads of Christ and the Virgin,

which are the focal point of the scene. Even the tree has a twin function. Its barrenness and isolation suggest that all of nature shares in the sorrow over Christ's death. Yet it also carries a more precise symbolic message: It refers to the Tree of Knowledge, which the sin of Adam and Eve had caused to wither and which was to be restored to life through Christ's sacrificial death.

Giotto's frescoes at the Arena Chapel established his fame among his contemporaries. In the *Divine Comedy*, written around 1315, the great Italian poet Dante Alighieri mentions the rising reputation of the young Florentine: "Once Cimabue thought to hold the field as painter, Giotto now is all the rage, dimming the luster of the other's fame." (See end of Part II, *Additional Primary Sources*.) Giotto continued to work in Florence for 30 years after completing the Arena Chapel frescoes, in 1334 being named the architect of the Florentine cathedral, for which he designed the *campanile* (bell tower) (see figs. 13.11 and 13.13). His influence over the next generation of painters was inescapable and had an effect on artists all over Italy.

Siena: Devotion to Mary in Works by Duccio and Simone

Giotto's slightly older contemporary, Duccio di Buoninsegna of Siena (ca. 1255–before 1319) directed another busy and influential workshop in the neighboring Tuscan town of Siena. The city of Siena competed with Florence on a number of fronts—military, economic, and cultural—and fostered a distinct identity and visual tradition. After a key military victory and the establishment of a republic directed by the *Nove* (the Nine), Siena took the Virgin Mary as its protector and patron, and dedicated its thirteenth-century cathedral to her. This cathedral, substantially completed by 1260, displays several features of the new style of Gothic architecture from France: Its arcade rests on compound piers like those in French cathedrals, and the ceiling was vaulted. Its facade (see fig. **13.22**) was entrusted to the sculptor Giovanni Pisano in 1284, though he left it incomplete when he departed in 1295. The facade reveals French elements, too, such as the pointed gables over tympanums defining the three portals, the blind arcades above the outer portals, and the sculpted figures of prophets and other figures who stand on platforms between the portals and on the turrets at the outer edges of the facade.

A fine example of Sienese devotion to Mary may be seen in a small panel of the *Virgin and Child* that Duccio painted around 1300 (fig. **13.23**). Still in its original frame, this wonderfully preserved painting has recently entered the Metropolitan Museum of Art in New York from a private collection. Small in scale, the painting depicts the Mother and son in a tender relationship: She supports the Christ

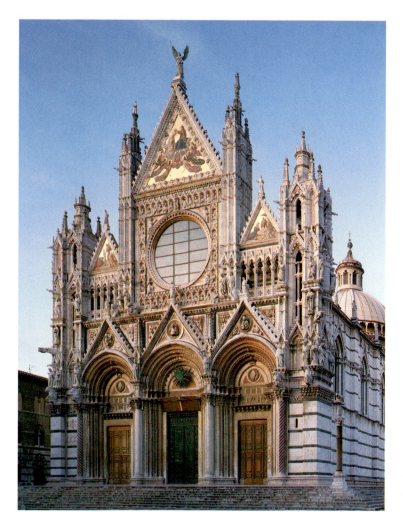

13.22. Siena Cathedral, completed ca. 1260. Facade. Lower sections ca. 1284–1299 by Giovanni Pisano

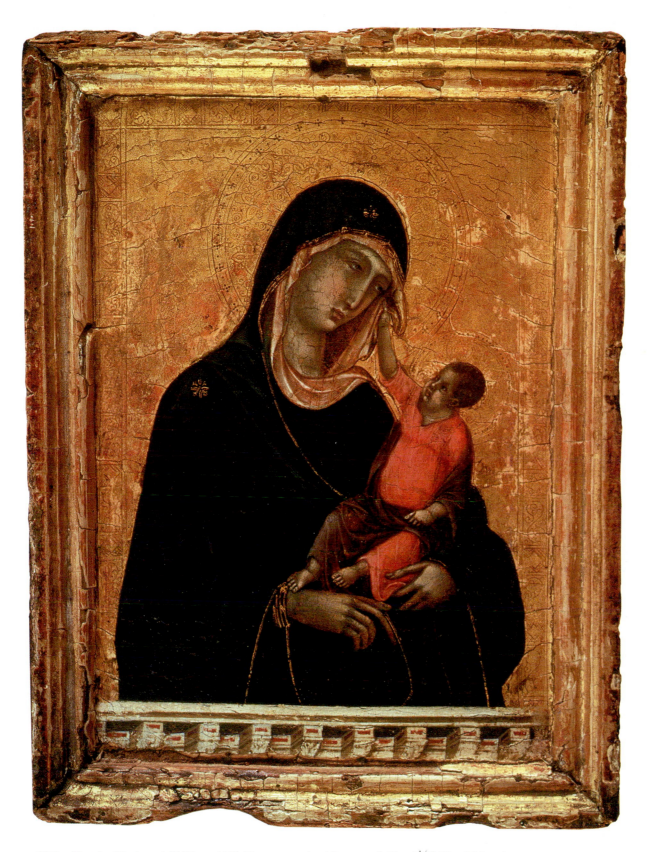

13.23. Duccio, *Virgin and Child*. ca. 1300. Tempera and gold on wood. $11 \times 8\frac{1}{4}''$ (28×20.8 cm) Metropolitian Museum of Art, New York. Purchase Rogers Fund, Walter and Lenore Annenberg Foundation Gift, Lila Acheson Wallace Gift, Annette de la Renta Gift, Harris Brisbane Dick, Fletcher, Louis V. Bell, and Dodge Funds, Joseph Pulitzer Bequest, several members of the Chairman's Council Gifts, Elaine L. Rosenberg and Stephenson Family Foundation Gifts, 2003 Benefit Fund, and other gifts and funds from various donors, 2004. (2004.442)

The Social Work of Images

The report of the celebrations held in Siena when Duccio's *Maestà* was installed in the cathedral attests to the importance of this painting for the entire community. It was a source of pride for the citizens of Siena, but also a powerful embodiment of the Virgin's protection of the city. Although modern audiences expect to find and react to works of art hanging in museums, art historians have demonstrated that art served different purposes in late medieval Europe. Few in the West today believe that a work of art can influence events or change lives. But in fourteenth-century Europe, people thought about images in much more active terms. Art could be a path to the sacred or a helper in times of trouble.

During a drought in 1354, for example, the city fathers of Florence paraded a miracle-working image of the Virgin from the village of Impruneta through the city in hopes of improving the weather. People with illness or health problems venerated a fresco of the Annunciation in the church of the Santissima Annunziata in Florence; they gave gifts to the image in hopes of respite from their problems. When the plague came to Florence, artists were commissioned to paint scenes depicting Saint Sebastian and other saints who were considered protectors against this deadly disease.

Images were also called upon for help outside the sacred space of the church. Continuing a tradition begun in the fourteenth century, street corners in Italy are often adorned with images of the Virgin to whom passersby may pray or show respect. Candles may be lit or gifts offered to such images in hopes of the Virgin's assistance. Art historians are also studying how works of art functioned among late medieval populations to forge bonds among social groups and encourage group identity. For example, outside the confines of monasteries, groups of citizens formed social organizations that were dedicated to a patron saint, whose image would be an important element of the group's identity.

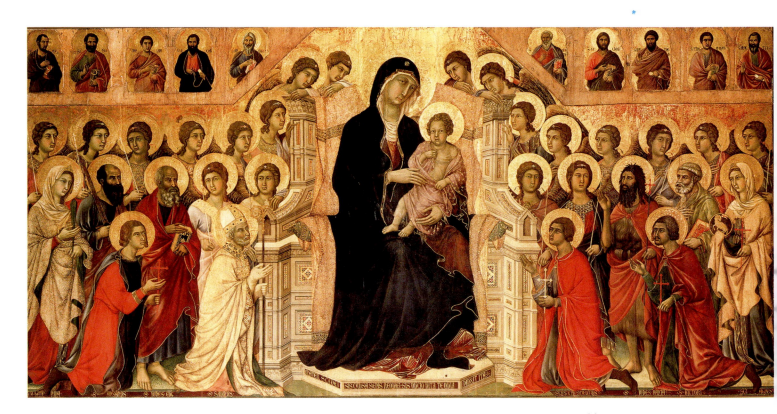

13.24. Duccio. *Madonna Enthroned,* center of the *Maestà Altar.* 1308–1311. Tempera on panel, height 6′10½″ (2.1 m). Museo dell'Opera del Duomo, Siena

Child in her arms as he reaches up to pull on her veil. His small scale in relation to his mother makes him seem very vulnerable. Duccio has washed both figures in a warm light that softens the contours and suggests three-dimensional forms, but he sets these figures against a brilliant gold background that contrasts vividly with the Virgin's blue gown. Her wistful glance at her tiny child gives the painting a melancholy effect.

Duccio was commissioned by the directors of Siena's cathedral to paint the large altarpiece for the high altar, called the *Maestà* as it depicts the Virgin and Child in majesty (fig. **13.24**). Commissioned in 1308, the *Maestà* was installed in the cathedral in 1311 amidst processions and celebrations in the city. (See *Primary Source*, page 456, and *The Art Historian's Lens,* above.) Duccio's signature at the base of the throne expresses his pride in the work: "Holy Mother of God,

be the cause of peace to Siena, and of life to Duccio because he has painted you thus."

In contrast to the intimate scale of the Metropolitan's *Virgin and Child*, here Duccio creates a regal image on a large scale. Members of her court surround the enthroned Virgin and Child in the *Maestà* in a carefully balanced arrangement of saints and angels. She is by far the largest and most impressive figure, swathed in the rich blue reserved for her by contemporary practice. Siena's other patron saints kneel in the first row, each gesturing and gazing at her figure. The Virgin may seem much like Cimabue's, since both originated in the Greek manner, yet Duccio relaxes the rigid, angular draperies of that tradition so that they give way to an undulating softness. The bodies, faces, and hands of the many figures seem to swell with three-dimensional life as the painter explores the fall of light on their forms. Clearly the heritage of Hellenistic-Roman illusionism that had always been part of the Byzantine tradition, however submerged, inspired Duccio to a profound degree. Nonetheless, Duccio's work also reflects contemporary Gothic sensibilities in the fluidity of the drapery, the appealing naturalness of the figures, and the glances by which the figures communicate with each other. The chief source of this Gothic influence was probably Giovanni Pisano, who was in Siena from 1285 to 1295 as the sculptor-

architect in charge of the cathedral facade, although there is evidence that Duccio may have traveled to Paris, where he would have encountered French Gothic style directly.

In addition to the principal scene, the *Maestà* included on its front and on its back numerous small scenes from the lives of Christ and the Virgin. In these panels, Duccio's synthesis of Gothic and Byzantine elements gives rise to a major new development: a new kind of picture space and, with it, a new treatment of narrative. The *Annunciation of the Death of the Virgin* (fig. **13.25**), from the front of the altarpiece, represents two figures enclosed by an architectural interior implied by foreshortened walls and ceiling beams to create and define a space that the figures may inhabit. But Duccio is not interested simply in space for its own sake. The architecture is used to integrate the figures within the drama convincingly. In a parallel scene to the Annunciation (see fig. 13.27, for comparison), this panel depicts the angel Gabriel returning to the mature Virgin to warn her of her impending death. The architecture enframes the two figures separately, but places them in the same uncluttered room. Despite sharing the space, each figure is isolated. Duccio's innovative use of architecture to enhance the narrative of his paintings inspired his younger French contemporary Jean Pucelle, who adapted this composition for the *Annunciation* in the *Hours of Jeanne d'Évreux* (fig. 12.41).

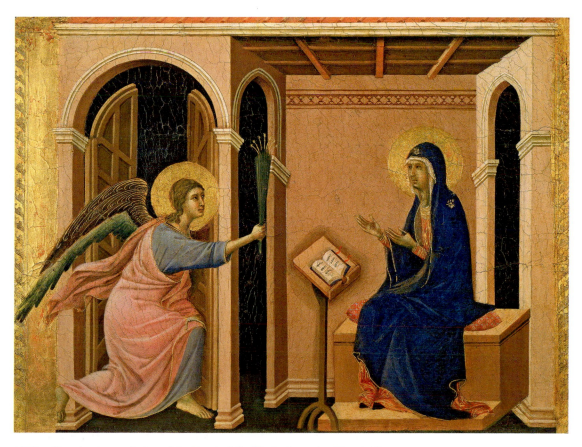

13.25. Duccio. *Annunciation of the Death of the Virgin,* from the *Maestà Altar*

Agnolo di Tura del Grasso

From his Chronicle

Duccio's Maestà *(fig. 13.24) stood on the main altar of Siena Cathedral until 1506, when it was removed to the transept. It was sawed apart in 1771, and some panels were acquired subsequently by museums in Europe and the United States. This local history of about 1350 describes the civic celebration that accompanied the installation of the altarpiece in 1311.*

These paintings [the *Maestà*] were executed by master Duccio, son of Nicolò, painter of Siena, the finest artist to be found anywere at his time. He painted the altarpiece in the house of the Muciatti outside the gate toward Stalloreggi in the suburb of Laterino. On the 9th of June [1311], at midday, the Sienese carried the altarpiece in great devotion to the cathedral in a procession, which included Bishop Roger of Casole, the entire clergy of the cathedral, all monks and nuns of the city, and the Nine Gentlemen [Nove] and officials of the city such as the podestà and the captain, and all the people. One by one the worthiest, with lighted candles in their hands, took their places near the altarpiece. Behind them came women and children with great devotion. They accompanied the painting up to the cathedral, walking in procession around the Campo, while all the bells rang joyfully. All the shops were closed out of devotion, all through Siena many alms were given to the poor with many speeches and prayers to God and to his Holy Mother, that she might help to preserve and increase the peace and well being of the city and its jurisdiction, as she was the advocate and protection of said city, and deliver it from all danger and wickedness directed against it. In this way the said altarpiece was taken into the cathedral and placed on the main altar. The altarpiece is painted on the back with scenes from the Old Testament and the Passion of Jesus Christ and in front with the Virgin Mary and her Son in her arms and many saints at the sides, the whole decorated with fine gold. The alterpiece cost 3000 gold florins.

SOURCE: TERESA G. FRISCH, *GOTHIC ART 1140–C 1450*. (ENGLEWOOD CLIFFS, NJ: PRENTICE HALL, 1971.)

The architecture keeps its space-creating function even in the outdoor scenes on the back of the *Maestà,* such as in *Christ Entering Jerusalem* (fig. **13.26**), a theme that Giotto had treated only a few years before in Padua. Where Giotto places Christ at the center of two groups of people, Duccio places him closer to the apostles and on one side of the composition. He conveys the diagonal movement into depth not by the figures, which have the same scale throughout, but by the walls on either side of the road leading to the city, by the gate that frames the welcoming crowd, and by the buildings in the background. Where Giotto reduces his treatment of the theme to a few figures and a bare backdrop, Duccio includes not only detailed architectural elements but also many children climbing trees to gather palms leaves as well

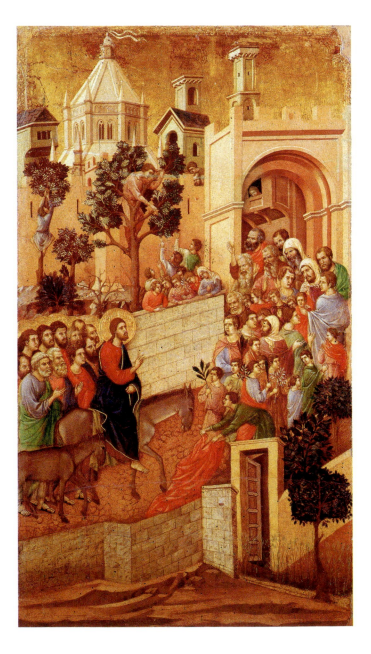

13.26. Duccio. *Christ Entering Jerusalem,* from the back of the *Maestà Altar.* 1308–1311. Tempera on panel, 40½ × 21⅛″ (103 × 53.7 cm). Museo dell'Opera del Duomo, Siena

as figures peering at the crowd in the streets from their first-floor windows. Duccio gives a viewer a more complete description of the event than Giotto, whose work stresses the doctrinal and psychological import of the moment. The goals of the two painters differ, and so do the formal means they use to achieve them.

Duccio trained the next generation of painters in Siena. One distinguished disciple was Simone Martini (ca. 1284–1344), who also worked in Assisi but spent the last years of his life in Avignon, the town in southern France that served as the residence of the popes during most of the fourteenth century. In 1333 the directors of the Siena Cathedral commissioned Simone to make another altarpiece to complement Duccio's *Maestà*. His *Annunciation* (fig. **13.27**) preserves its original pointed and cusped arch format in its restored frame and suggests what has been lost in the dismemberment of the *Maestà*, which had a similar Gothic frame. Simone's altarpiece depicts the Annunciation flanked by two local saints set against a brilliant gold ground. To connect her visually to *Maestà*, Simone's Virgin sits in a similar cloth-covered throne and wears similar garments.

The angel Gabriel approaches Mary from the left to pronounce the words "*Ave Maria Gratia Plenum Dominus Tecum*" ("Hail Mary, full of grace, the Lord is with you"). Simone renders the words in relief on the surface of his painting, covering them in the same gold leaf that transforms the scene into a heavenly vision. Simone adds an element of doubt to this narrative, as the Virgin responds to her visitor with surprise and pulls away from him. The dove of the Holy Spirit awaits her momentous decision to agree to the charge given her to become the mother of the Christ Child and begin the process of Salvation. Like Giotto, Simone has reduced the narrative to its simplest terms, but like Duccio, his figures have a lyrical elegance that lifts them out of the ordinary and into the realm of the spiritual.

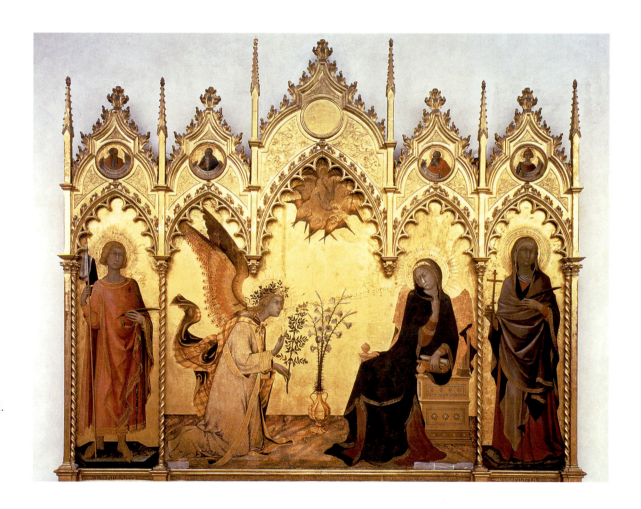

13.27. Simone Martini. *Annunciation*. ca. 1330. Tempera on panel. 10′ × 8′9″ (3 × 2.7 m). Galleria degli Uffizi, Florence.

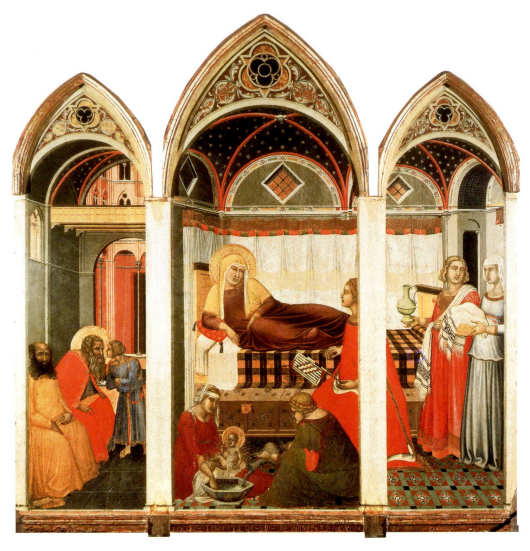

13.28. Pietro Lorenzetti. *Birth of the Virgin.* 1342. Tempera on panel, 6′1½″ × 5′11½″ (1.9 × 1.8 m). Museo dell'Opera del Duomo, Siena

Pietro and Ambrogio Lorenzetti

Another altarpiece commissioned for the cathedral at Siena takes a more down to earth approach. This is the *Birth of the Virgin* (fig. **13.28**) painted in 1342 by Pietro Lorenzetti (active ca. 1306–1348). Pietro and his brother Ambrogio (active ca. 1317–1348) learned their craft in Siena, though their work also shows the influence of Giotto. Pietro has been linked to work at Assisi, and Ambrogio went so far as to enroll in the painter's guild of Florence in the 1330s. Like Simone's, Pietro's altarpiece is a triptych though it has lost its original frame. In this triptych, the painted architecture has been related to the real architecture of the frame so closely that the two are seen as a single system. Moreover, the vaulted room where the birth takes place occupies two panels and continues unbroken behind the column that divides the center from the right wing. The left wing represents a small chamber leading to a Gothic courtyard. Pietro's achievement of spatial illusion here is the outcome of a development that began three decades earlier in the work of Duccio. Pietro treats

the painting surface like a transparent window *through* which—not *on* which—a viewer experiences a space comparable to the real world. Following Duccio's example, Pietro uses the architecture in his painting to carve out boxes of space that his figures may inhabit, but he is also inspired by Giotto's technique of giving his figures such mass and weight that they seem to create their own space. His innovation served the narrative and liturgical needs of Siena Cathedral by depicting another key moment in the life of the Virgin, which was also an important feast day in the Church. Saint Anne rests in her childbed, while midwives attend the newly born Virgin and other women tend to the mother. The figure of the midwife pouring water for the baby's bath seems to derive from the figure seen from the back in Giotto's *Lamentation* (fig. 13.21). The father, Joachim, waits for a report of the birth outside this room. The architectural divisions separate the sexes in the same way the architecture in Duccio's *Annunciation of the Death of the Virgin* (fig. 13.25) separates the angel from Mary.

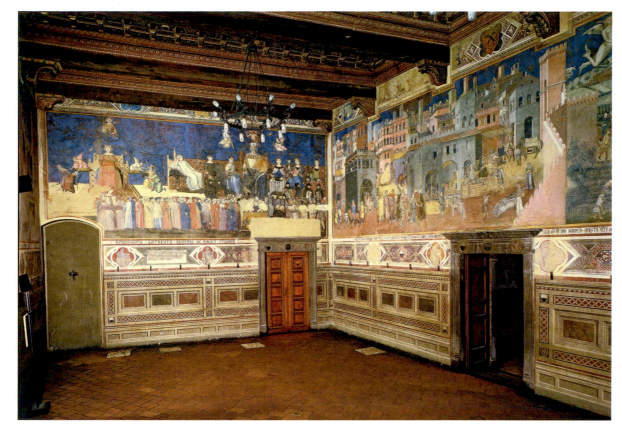

13.29. Ambrogio Lorenzetti. *The Allegory of Good Government* (left). *Good Government in the City,* and portion of *Good Government in the Country* (right). 1338–1340. Frescoes in the Sala della Pace, Palazzo Pubblico, Siena

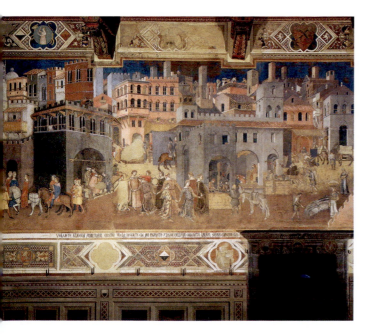

13.30. Ambrogio Lorenzetti. *Good Government in the City*

GOOD AND BAD GOVERNMENT Pietro's brother, Ambrogio Lorenzetti, combined these same influences in a major project for the city hall of Siena, executed between 1338 and 1340. The ruling Council of Nine (Nove) commissioned for their meeting hall an allegorical fresco contrasting good and bad government. The aim of this project was to be salutary, for as they deliberated, they would see in these frescoes the effects of both. While the negative example of the effects of Bad Government has been severely damaged, the frescoes that depict the positive example of Good Government are remarkably well preserved (fig. **13.29**). On the short wall of the room, Ambrogio depicted the *Allegory of Good Government* as an assembly of virtues who support the large enthroned personification of the city. To the left another enthroned figure personifies Justice, who is inspired by Wisdom. Below the virtues stand 24 members of the Sienese judiciary under the guidance of Concord. On the long wall, the fresco of *Good Government in the City* (fig. **13.30**) bears an inscription praising Justice and the many benefits that derive from her. (See *Primary Source,* page 460.) Ambrogio paints an architectural portrait of the city of Siena in this fresco. To show the life of a well-ordered city-state, the artist fills the streets and houses with teeming activity. The bustling crowd gives the architectural vista its striking reality by introducing the human scale. On the right, outside the city walls, *Good Government in the Country* provides a view of the

Inscriptions on the Frescoes in the Palazzo Pubblico, Siena

The first inscription is painted in a strip below the fresco of Good Government (see figs. 13.29 and 13.30), which is dated between 1338 and 1340. The second is held by the personification of Security, who hovers over the landscape in figure 13.28.

Turn your eyes to behold her,
you who are governing, [Justice] who is portrayed here,
crowned on account of her excellence,
who always renders to everyone his due.
Look how many goods derive from her
and how sweet and peaceful is that life

of the city where is preserved
this virtue who outshines any other.
She guards and defends
those who honor her, and nourishes and feeds them.
From her light is born
Requiting those who do good
and giving due punishment to the wicked.

Without fear every man may travel freely
and each may till and sow,
so long as this commune
shall maintain this lady [Justice] sovereign,
for she has stripped the wicked of all power.

SOURCE: RANDOLPH STARN AND LOREN PARTRIDGE, *ARTS OF POWER: THREE HALLS OF STATE IN ITALY, 1300–1600.* (BERKELEY: UNIVERSITY OF CALIFORNIA PRESS, 1992)

Sienese farmland, fringed by distant mountains (fig. **13.31**) and overseen by a personification of Security. It is a true landscape—the first since ancient Roman times (see fig. 7.55). The scene is full of sweeping depth yet differs from Classical landscapes in its orderliness, which gives it a domesticated air. The people here have taken full possession of Nature: They have terraced the hillsides with vineyards and patterned the valleys with the geometry of fields and pastures. Ambrogio observes the peasants at their seasonal labors; this scene of rural Tuscan life has hardly changed during the past 600 years.

Artists and Patrons in Times of Crisis

Ambrogio's ideal vision of the city and its surroundings offers a glimpse at how the citizens of Siena imagined their government and their city at a moment of peace and prosperity. The first three decades of the fourteenth century in Siena, as in Florence, had been a period of political stability and economic expansion, as well as of great artistic achievement. In the 1340s, however, both cities suffered a series of catastrophes whose effects were to be felt for many years.

Constant warfare led scores of banks and merchants into bankruptcy; internal upheavals shook governments, and there were repeated crop failures and famine. Then, in 1348, the pandemic of bubonic plague—the Black Death—that spread throughout Europe wiped out more than half the population of the two cities. It was spread by hungry, flea-infested rats that swarmed into cities from the barren countryside in search of food. Popular reactions to these events were mixed. Many people saw them as signs of divine wrath, warnings to a sinful humanity to forsake the pleasures of this

earth. In such people, the Black Death intensified an interest in religion and the promise of heavenly rewards. To others, such as the merry company who entertain each other by telling stories in Boccaccio's *Decameron,* the fear of death intensified the desire to enjoy life while there was still time. (See end of Part II, *Additional Primary Sources.*)

Late medieval people were confronted often with the inevitability and power of death. A series of frescoes painted on the walls of the Camposanto, the monumental cemetery building next to Pisa Cathedral, offers a variety of responses to death. Because of its somber message, the fresco was once dated after the outbreak of the plague, but recent research has pushed it closer to the 1330s. The painter of this enormous fresco is not known, though some scholars attribute the work to a Pisan artist named Francesco Traini (documented ca. 1321–1363). The huge fresco cycle, which was damaged in 1944 as a result of bombings in the Second World War, included a powerful *Last Judgment* and an image called *The Triumph of Death,* which asserts that death comes to all, rich or poor, saint or sinner. In a particularly dramatic detail (fig. **13.32**), the elegantly costumed men and women on horseback have suddenly come upon three decaying corpses in open coffins. Even the animals are terrified by the sight and smell of rotting flesh. Only the hermit Saint Macarius, having renounced all earthly pleasures, points out the lesson of the scene. His scroll reads: "If your mind be well aware, keeping here your view attentive, your vainglory will be vanquished and you will see pride eliminated. And, again, you will realize this if you observe that which is written." As the hermits in the hills above make clear, the way to salvation is through renunciation of the world in favor of the

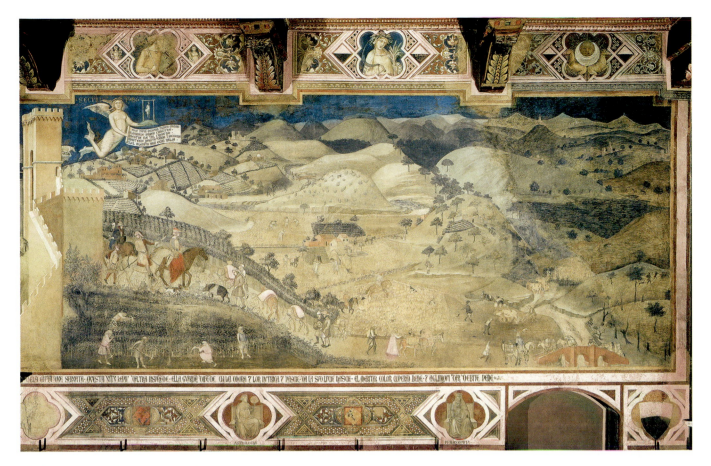

13.31. Ambrogio Lorenzetti. *Good Government in the Country*

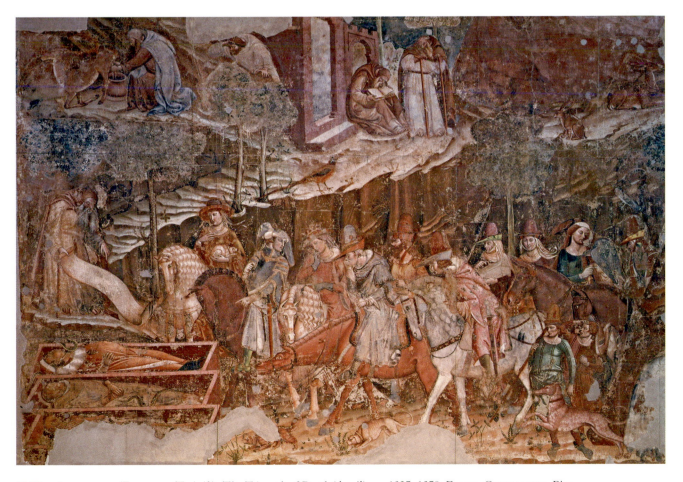

13.32. Anonymous (Francesco Traini?). *The Triumph of Death* (detail). ca. 1325–1350. Fresco. Camposanto, Pisa

spiritual life. In the center of the fresco lie dead and dying peasants who plead with Death, "the medicine for all pain, come give us our last supper." Further to the right are courtiers in a delightful landscape enjoying earthly pleasures as a figure of Death swoops down and angels and devils fight over the souls of the deceased in the sky overhead. The artist's style recalls the realism of Ambrogio Lorenzetti, although the forms are harsher and more expressive.

The Lorenzetti brothers were probably among the thousands of people throughout Tuscany who perished in the Black Death of 1348. Scholars have conjectured about the impact of the plague on the artists and patrons of works of art in the second half of the fourteenth century. We can assume that many painters died, so there weren't as many practitioners of this craft. Documentary research reveals that the number of endowed chapels, tombs, and funeral masses rose as people worried about their mortality. Many such burials and endowments were made in mendicant churches, such as the Franciscan Santa Croce and the Dominican Santa Maria Novella in Florence.

At Santa Maria Novella, a Florentine merchant named Buonamico Guidalotti, who died in 1355, provided funds in his will for a new chapter house for the Dominican community in which he could be buried. The chapel served as a meeting room for the friars and as such was painted with frescoes expressing the role of Dominicans in the struggle for salvation. A fresco on one of the walls of the Guidalotti chapel, painted by Andrea Bonaiuti (also known as Andrea da Firenze, active 1346–1379) between 1365 and 1367, depicts the actions of Dominicans to assure the access of the faithful to heaven, hence its title, *The Way of Salvation* (fig. **13.33**). In the lower section of the fresco, spiritual and temporal leaders gather before a representation of the then unfinished Cathedral of Florence. Groups of Dominicans preach to the laity and convert heretics, amidst black and white dogs (a punning reference to the order—the "Domini canes" or the dogs of the Lord). On the upper right some heedless aristocrats enjoy the pleasures of the senses, while at the center, a Dominican shows the more spiritually minded the path to heaven, whose gate is guarded by Saint Peter. Andrea's fresco reveals the influence both

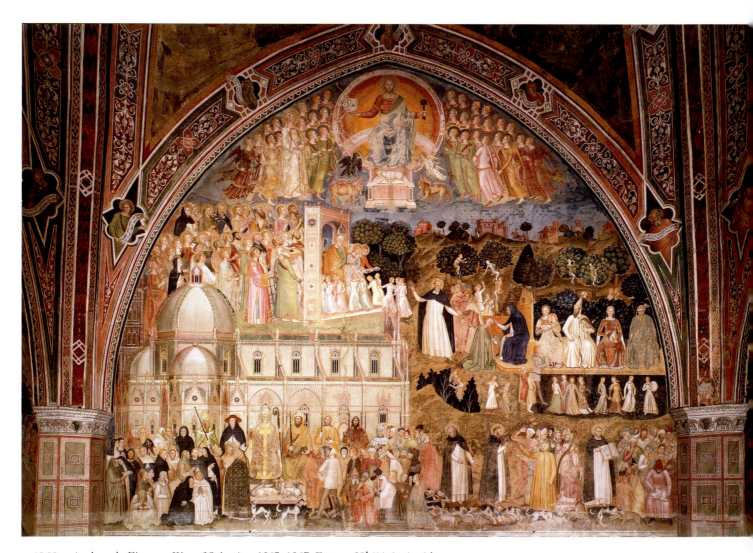

13.33. Andrea da Firenze, *Way of Salvation*. 1365–1367. Fresco. 38′ (11.6 m) wide. Guidalotti Chapel, Santa Maria Novella, Florence

of Ambrogio Lorenzetti's *Good Government* (see fig. 13.29) and the fresco on the walls of the cemetery near Pisa Cathedral (see fig. 13.32), but in its symmetry and sense of order, it seeks clarity rather than illusion and serenity rather than emotion.

Florence, however, did not complete its cathedral in the fourteenth century, and it was not to enjoy the calm atmosphere portrayed in Andrea's fresco. The plague returned in 1363, the political elite clashed with the papacy, and an uprising among the working classes created social and economic turmoil. The wealthier classes restored their power in 1381. Florence overcame these disasters to flourish in the fifteenth century as a center of economic energy, political astuteness, and cultural leadership. As the fifteenth century began, a new generation of Florentine artists would look to the art of Giotto and his contemporaries in their search for new forms of visual expression.

NORTHERN ITALY

Such political struggles did not distress the city of Venice in the fourteenth century. Unlike Florence, riven by warring factions, fourteenth-century Venice enjoyed political stability. Since 1297, the city had closed off membership in the merchant oligarchy that participated in government, and the city's leader (the Doge) was elected from this group. As a result, neither Venetian palaces nor their communal buildings required the defensive architecture seen in Florentine structures, such as the Palazzo della Signoria (fig. 13.16). A somewhat different atmosphere existed in Milan, west of Venice in Lombardy, where an aristocratic government lay in the hands of a single family with great dynastic

ART IN TIME

1305–1378—Papacy in Avignon

1307–1321—Dante composes the *Divine Comedy*

　1311—**Duccio's *Maestà* completed in Siena**

　1341—Petrarch crowned poet laureate in Rome

1347–1348—Black Death ravages Europe

ambitions. In Lombardy, the political and cultural connections were with Northern Europe, with important results for the type and the style of art produced there.

Venice: Political Stability and Sumptuous Architecture

The differing political situations in Florence and Venice affected palace design. Whereas the Florentine palace was stolid and impenetrable, the palace in Venice is airy and open, full of windows and arcades that are anything but defensible. Venetian architects borrowed from Gothic and Islamic precedents in an elegant display of the city's wealth and security. When a larger meeting space was needed for the Great Council, the city decided to enlarge the Doge's Palace near San Marco in 1340 (fig. **13.34**). Work continued here until the mid-fifteenth century. In contrast to the fortresslike Palazzo della Signoria in Florence, the Doge's Palace is open at the base, the weight of its upper stories resting on two stories of pointed arcades. The lower arcade provides a covered passageway around the building, the

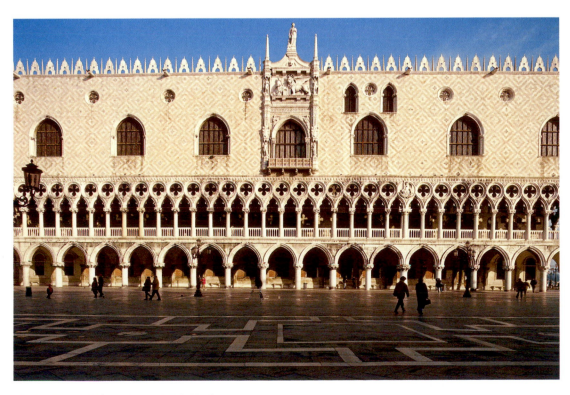

13.34. Doge's Palace. Begun 1340. Venice

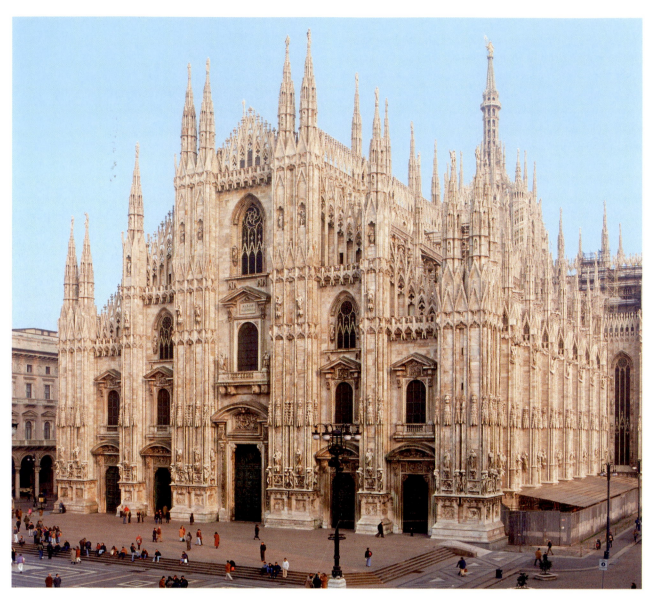

13.35. Milan Cathedral. Begun 1386

upper a balcony. The lavish moldings and the quatrefoils of the arcades give the structure an ornamental feel that is accented by the doubling of the rhythm of the upper arcade. The walls of the structure are ornamented with stonework in a diamond pattern, making them both visually lighter and more ornate.

Milan: The Visconti Family and Northern Influences

To the West and North of Venice, Lombardy had a different political structure and a closer relationship with Gothic France, which found expression in its visual arts. In Lombardy, the Visconti family had acquired great wealth from the products of this richly agricultural region. Besides controlling Lombardy, the Visconti positioned themselves among the great families of Europe through marriage ties to members of the Italian and European nobility. By 1395, Giangaleazzo Visconti had been named Duke of Milan, had married the daughter of the King of France, and wed their daughter to Louis, Duke of Orleans.

Fourteenth-century projects in Milan reflect these ties to Northern Europe. The city, its archbishop, and Giangaleazzo Visconti joined together to build a new cathedral in 1386, though it required more than a century to complete. Milan Cathedral is the most striking translation of French Gothic forms in Italy (fig. 13.35). While local architects began the project, architects from France and Germany, who were experts in raising tall Gothic structures, were consulted about the design and its implementation. Yet the local preferences for wide interior spaces and solid structure resulted in double aisles and a rejection of flying buttresses. (Compare with figs. 12.15 and 12.17.) The facade defines the interior spaces: The stepped heights of the inner and outer aisles can be clearly read, despite the profusion of vertical moldings on the exterior. The continu-

ous solid mass of the aisle walls seems hardly diminished by the mass of triangular points and turrets along the roofline. Later in the fifteenth and sixteenth centuries more antique-inspired elements such as pediments and pilasters were set into the Gothic facade.

The authoritarian nature of Visconti rule in Milan may be seen in a commission of Giangaleazzo's uncle Bernabò Visconti for his tomb (fig. **13.36**). Though now in a museum, Bernabò's *Equestrian Monument* originally stood over the altar of a church in Milan. Completed around 1363 by the local sculptor Bonino da Campione (active ca. 1357–1397), the marble structure includes a sarcophagus that supports a sculpted figure of Bernabò on horseback. The figure stands rather than sits on the horse, forcefully commanding the space over the high altar of the church. The idea of the equestrian image of a ruler goes back to antiquity, with the equestrian portrait of Marcus Aurelius (fig. 7.21) visible in Rome throughout the Middle Ages.

ART IN TIME

1271–1295—Marco Polo travels to China

1277—Visconti control Milan

1386—Milan Cathedral begun

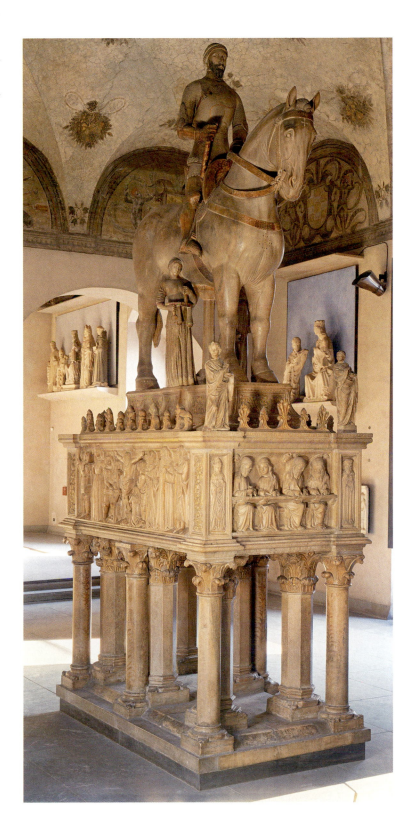

13.36. Tomb of Bernabò Visconti. Before 1363. Marble. 19′8″ (6 m). Castello Sforzesco, Milan

The aristocracy of Europe claimed for themselves the prerogative of equestrian imagery. In this sculpture, Bernabò is rigid and formal in his bearing; originally the figure was covered with silver and gold leaf to further enhance its impressiveness. Yet Bonino's treatment of the horse, with its sensitive proportions and realistically observed anatomy, point to a Lombard interest in the natural depiction of form, which may be a result of Lombard contact with contemporary French art.

While promoting the building of Milan Cathedral and during his own campaign to be named duke, Giangaleazzo Visconti commissioned illuminated manuscripts, as did his French peers. His *Book of Hours* was painted around 1395 by Giovannino dei Grassi (active ca. 1380–1398) with numerous personal representations and references to the duke. The page in figure **13.37** opens one of David's Psalms with an illuminated initial D wherein King David appears. David is both the author of the text and a good biblical exemplar of a ruler. An unfurling ribbon ornamented with the French *fleur-de-lis* forms the D; shields at the corners bear the Visconti emblem of the viper. Below the text appears a portrait of Giangaleazzo in the profile arrangement that was familiar from ancient coins. Although this portrait is naturalistic, it is set into an undulating frame that supports the rays of the sun, another Visconti emblem. Around the portrait Giovannino has painted images of stags and a hunting dog, with great attention to the accurate rendering of these natural forms. Such flashes of realism set amidst the splendor of the page reflect both the patron and the artist's contribution to the developing International Gothic style. Commissioning such lavish books was an expression of the status and power that Giangaleazzo attempted to wield. His ambition to bring most of northern Italy under his control would profoundly affect the arts in Tuscany in the early fifteenth century.

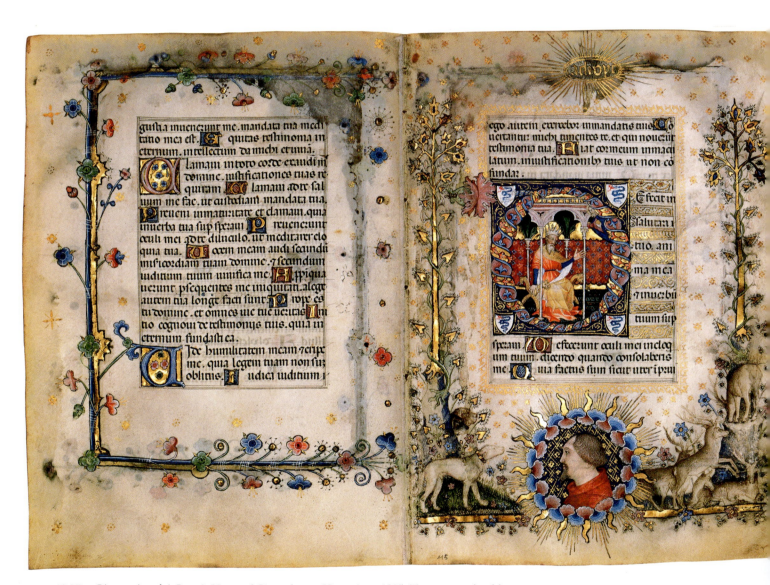

13.37. Giovannino dei Grassi, *Hours of Giangaleazzo Visconti*. ca. 1395. Tempera and gold on parchment. 9¾″ × 6⅞″ (24.7 × 17.5 cm). Banco Rari, Biblioteca Nazionale, 397 folio 115/H, Florence

SUMMARY

Thirteenth- and fourteenth-century Italian art had its roots in both Byzantine forms and Italian artists' contacts with Roman and Early Christian precedents. It is often the product of commissions by mercantile communities and urban patriciates rather than great aristocratic patrons. The activity of the mendicant orders inspired a new spirituality in these urban centers; their vivid preaching accompanied commissions of narrative imagery to speak more directly to their lay audience.

CHURCH ARCHITECTURE AND THE GROWTH OF THE MENDICANT ORDERS

One product of the mendicants' mission to preach was the building of large urban churches where sermons could be delivered. These structures took advantage of Northern Gothic innovations that allowed for large interior spaces and tall proportions, but often followed local preferences for wooden roofs, solid wall surfaces, and facades without towers. Inside these churches, sculpted forms enhanced worshipers' experience by representing sacred stories in direct and legible terms. On pulpits and on portals, sculptors in Italy made narrative scenes that drew inspiration from Roman art forms or from Northern Gothic styles. Inspired by mendicant ideas, they created memorable images of holy figures in human situations to stimulate the devotion of city dwellers.

PAINTING IN TUSCANY

For this same audience, painters developed new techniques to represent the natural world. Starting from the close study of Byzantine painting traditions that were themselves rooted in ancient styles, thirteenth- and fourteenth-century Italian painters explored ways to create images that more closely reflected nature than had earlier medieval art. This generation of artists explored techniques for consistently representing the fall of light on three-dimensional forms and for creating the illusion of space within their paintings. These techniques were used to enhance the spiritual impact of the sacred figures they painted and to tell sacred stories more effectively. The innovations of fourteenth-century painters like Giotto and Duccio provided a visual language of naturalism from which artists all over Europe could profit.

NORTHERN ITALY

The northern Italian centers of Venice and Milan developed individual forms of Gothic art. Venice's political situation and mercantile connections with the Far East and Middle East brought to that city a taste for architectural forms with sumptuous surfaces and open arcades. Ruled by an ambitious dynasty, Milan looked more to Northern Europe. Its cathedral reflects a closer study of French Gothic architecture than any other in Italy, and the artistic commissions of their rulers imitate the tastes of the French aristocracy.

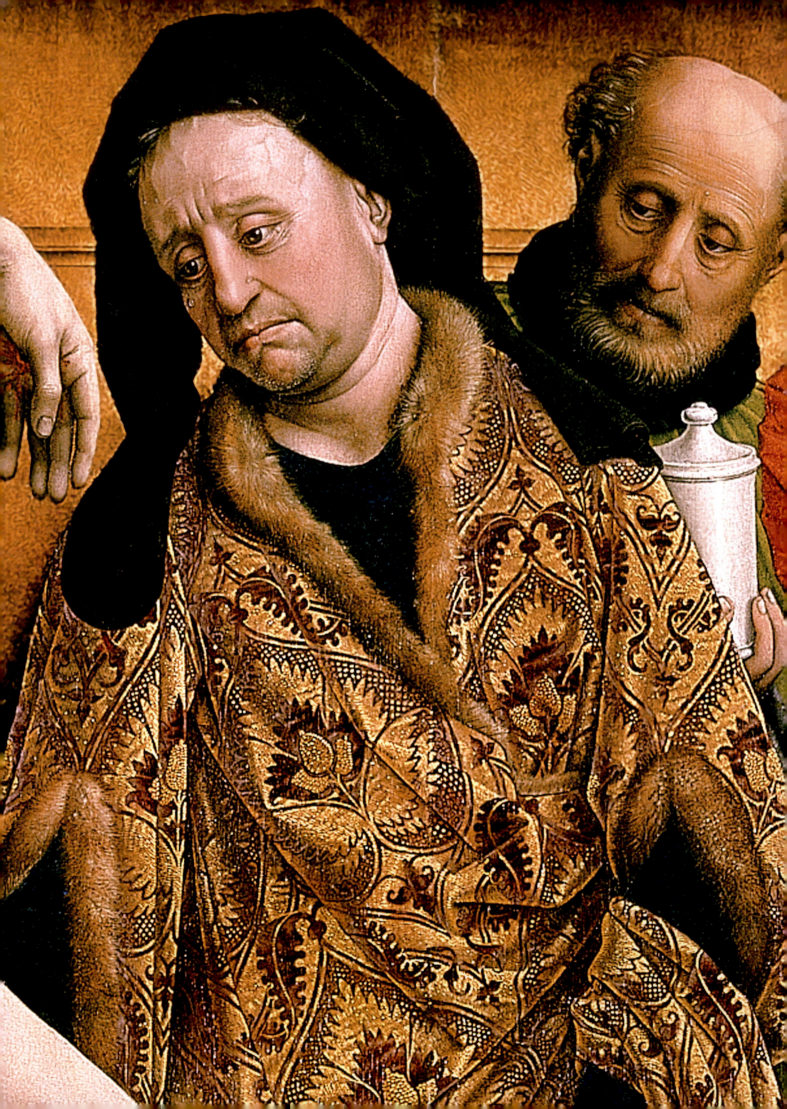

Artistic Innovations in Fifteenth-Century Northern Europe

THE GREAT CATHEDRALS OF EUROPE'S GOTHIC ERA—THE PRODUCTS OF collaboration among churchmen, rulers, and the laity—were mostly completed by 1400. As monuments of Christian faith, they exemplify the medieval outlook. But cathedrals are also monuments of cities, where major social and economic changes would set the stage for the modern world.

As the fourteenth century came to an end, the medieval agrarian economy was giving way to an economy based on manufacturing and trade, activities that took place in urban centers. A social shift accompanied this economic change. Many city dwellers belonged to the middle class, whose upper ranks enjoyed literacy, leisure, and disposible income. With these advantages, the middle classes gained greater social influence and cultural significance than they had wielded in the Middle Ages, when the clergy and aristocracy had dominated. This transformation had a profound effect on European culture, including the development of the visual arts.

Cities such as Paris, London, Prague, Bruges, Barcelona, and Basel were home to artisans, dayworkers, and merchants as well as aristocrats. Urban economies based more on money and wages than landed wealth required bankers, lawyers, and entrepreneurs. Investors seeking new products and markets encouraged technological innovations, such as the printing press, an invention that would change the world. Trade put more liquid wealth into the hands of merchants and artisans, who were emboldened to seek more autonomy from the traditional aristocracy, who sought to maintain the feudal status quo.

Two of the most far-reaching changes concerned increased literacy and changes in religious expression. During the four-

Detail of figure 14.17, Rogier van der Weyden, *Descent from the Cross*

teenth century, the removal of the papacy to Avignon and the election of two popes created a schism in the Church that ended in 1417. But the damage had already been done. Lacking confidence in the institutional Church, many lay people turned to religious movements that encouraged them to read sacred texts on their own, to meditate on Scripture, and to seek a personal relationship with God. One such movement was called the Modern Devotion, but mendicant friars and other clerics also encouraged this new lay piety. The Church was not wholly comfortable with this phenomenon, but it took hold nonetheless. These religious impulses and increasing literacy resulted in a demand for books in vernacular (local) languages, including translations of Scripture. The printing press made books more available, further stimulating the development and spread of knowledge.

In the political sphere, changes were shaping the modern boundaries of European nations. The Hundred Years' War between France and England finally ended in 1453. This allowed the French monarchy to recover, but civil war kept England politically unstable until late in the fifteenth century. French kings, however, had to contend with their Burgundian cousins, who controlled the trading hub of Northern Europe, the rich lands of Flanders in the Southern Netherlands (present-day Belgium) and the Northern Netherlands (present-day Holland). Indeed, Duke Philip the Good of Burgundy, (r. 1419–1467) was one of the most powerful men of the century.

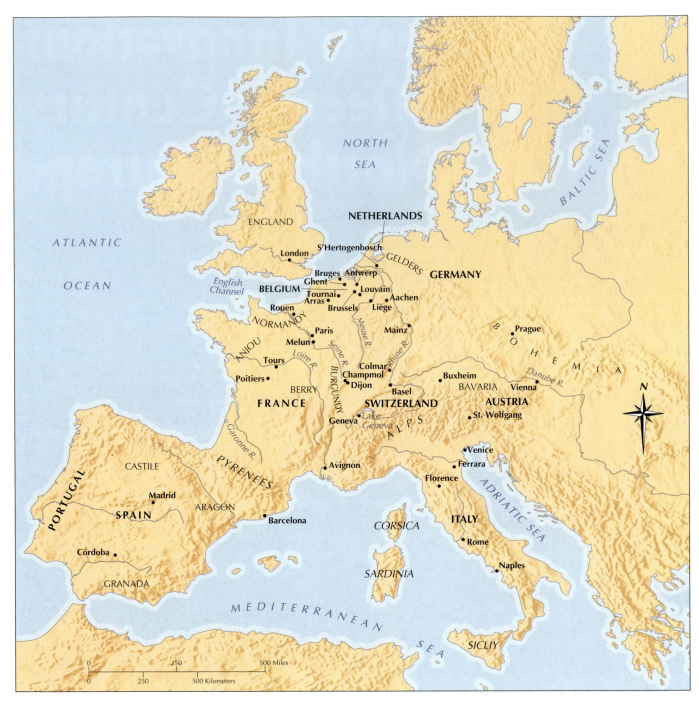

Map 14.1. Europe in the Fifteenth Century

To the east, in central Europe, the Holy Roman emperor had nominal control, but local rulers within this region often flouted his authority. On the Iberian peninsula, a crucial marriage between Queen Isabella of Castile and King Ferdinand of Aragon created a unified Spanish kingdom that became increasingly important. Competition among the powers of Europe for trade routes led to the voyages of Columbus, which would enrich the Spanish crown and change the globe.

A new style of visual art that stressed naturalism accompanied these political and social changes. Aristocrats and churchmen continued to commission works, but the new ranks of society—bureaucrats and merchants—also became

art patrons. For the merchants and middle-class patrons in urban centers, painters made images in a new medium with a new character. Using oil paints, artists in the Netherlands made paintings that still astonish viewers by their close approximation to optical reality. By mid-century, this strongly naturalistic style became the dominant visual language of Northern Europe, attracting patrons from all classes and many countries.

This period of transition out of the Middle Ages was gradual and by no means universal. Faced with a growing middle class, the traditional aristocracy attempted to maintain their privileges and status. Among the aristocratic courts of France,

the Holy Roman Empire, England, and the Burgundian Netherlands, many of which were linked by treaty or marriage, a preference emerged for a highly refined form of Gothic art, which has been termed *International Gothic*. Yet within these courtly images were the seeds of the heightened naturalism that would blossom in the fifteenth century.

COURTLY ART:
THE INTERNATIONAL GOTHIC

As the fourteenth century came to an end, aristocratic patrons throughout Europe displayed a taste for objects made of sumptuous materials with elegant forms, based on the Gothic style. As the Gothic style was associated with the rise and prestige of the French monarchy, its latest manifestation owed a great deal to the forms and traditions of France. Such cosmopolitan courts as Avignon and Paris attracted artists from different regions of Europe where they exchanged ideas. These circumstances produced the style historians call International Gothic. The artists of the International Gothic also adapted some elements from fourteenth-century Italy, including devices to imply spatial settings borrowed from Duccio and Pietro Lorenzetti and certain themes and compositions, such as aristocrats enjoying the countryside (see figs. 13.31 and 13.32). The chronological limits of this style are somewhat fluid, as some objects ascribed to the International Gothic date from the mid-fourteenth century, and other objects may date as late as the mid-fifteenth.

Artists working in this style came from Italy, France, Flanders, Germany, Spain, Bohemia, Austria, England, and elsewhere. They produced works of exquisite craftsmanship, with sometimes very complex iconographies, out of expensive materials for elite patrons. Artists used Gothic techniques, rendering forms on geometric patterns to idealize them (as we saw for example in fig. 12.21, in the work of Villard de Honnecourt), but they added touches of directly observed nature, especially in details. Many scholars see the detailed naturalism that appears in the International Gothic as a key stimulus for the more thoroughgoing naturalism of the early Flemish painters and their followers in the fifteenth century.

Sculpture for the French Royal Family

The French royal family was among the most active patrons of International Gothic, as members of this family dominated ever larger regions of France. One of King Charles V's brothers, Philip the Bold, became the Duke of Burgundy in 1363; then he added the title of Count of Flanders through his marriage to Margaret of Mâle. Through these acquisitions, the Dukes of Burgundy became powerbrokers in the military and economic struggles of the fifteenth century. Works of art helped further his status, providing an important example for his successors.

In his domain of Burgundy, Duke Philip the Bold established a Carthusian monastery, the Chartreuse de Champmol, outside Dijon. Although the monastery was almost completely destroyed in the late eighteenth century, some parts of the building survive in which Philip and his wife Margaret figure prominently. For the building of this monastery, Philip had assembled a team of artists, many of them from the Netherlands. Chief among them was the sculptor Claus Sluter from Brussels. Remnants of Sluter's work include portal sculpture and other sculptural projects.

Executed between 1385 and 1393, the portal of the Chartreuse is framed by jamb figures (fig. **14.1**) such as appear on thirteenth-century Gothic churches (see fig. 12.29). Here, however, the figures

14.1. Claus Sluter. Portal from Chartreuse de Champmol. 1385–1393. Stone. Dijon, France

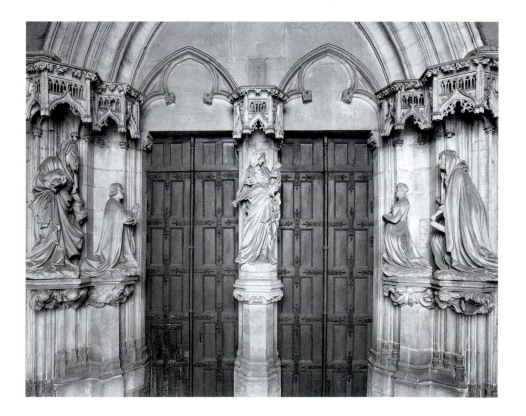

have grown so large that they almost overpower their framework, as their drapery spills over the bases that support them. The figures include a portrait of Philip, with his patron, Saint John the Baptist, on the left, and a portrait of Margaret, with her patron, Saint Catherine of Alexandria. The Duke and Duchess gaze across the space to venerate the Madonna and Child, uniting all five sculptures into one entity. The Virgin, holding her son, twists into a dynamic pose as if conversing with both groups. The deeply carved folds of her garment create patterns that add weight and energy to her figure; she seems a much more substantial figure than the *Virgin of Paris* (see fig. 12.43). The portal commemorates the piety and wealth of the Duke and Duchess, presenting them in close proximity to the Queen of Heaven.

Sluter's other work for the Chartreuse de Champmol includes tombs and pulpits, but the most emblematic of the International Gothic style is *The Well of Moses* (fig. **14.2**). At one time, this hexagonal well, surrounded by statues of Old Testament prophets, was topped by a crucifix, a visual expression of the fulfillment of the New Testatment of the Old. The majestic

Moses has a long flowing beard and flowing drapery that envelops the body like an ample shell. The swelling forms seem to reach out into the surrounding space to interact directly with a viewer. The lifelike feeling created by his size and naturalistic rendering must have been enhanced greatly by the colors added to the stone by the painter Jean Malouel, which have now largely disappeared. To Moses' right stands King David, whose features have all the personality and individuality of the portraits of the duke and duchess on the portal. This attachment to the specific distinguishes Sluter's naturalistic style from that of the thirteenth century and is one of the hallmarks of the International Gothic.

THE ALTARPIECE AT CHARTREUSE DE CHAMPMOL

For the church of the Chartreuse de Champmol, Duke Philip commissioned an altarpiece that was executed between 1394 and 1399. The ensemble included an elaborately carved relief by Jacques de Baerze (showing the Adoration of the Magi, the Crucifixion, and the Entombment) for the central section and wings by the painter Melchior Broederlam (fig. **14.3**). (Their

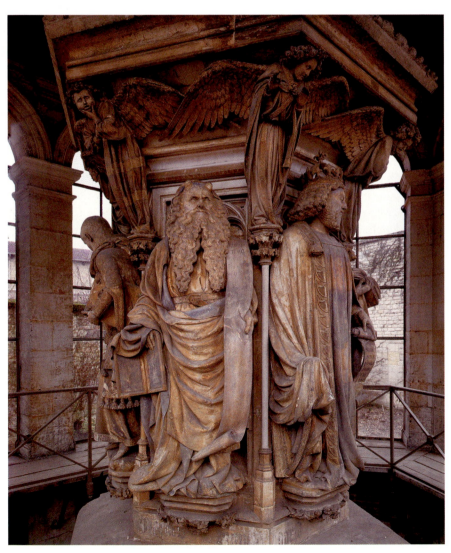

14.2. Claus Sluter, *The Well of Moses*, from Chartreuse de Champmol. 1395–1406. Stone, height of figures approx. 6′ (1.8m)

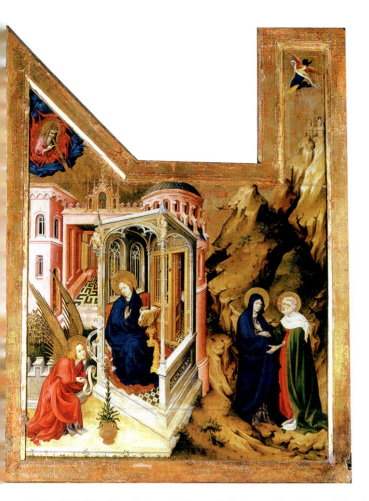 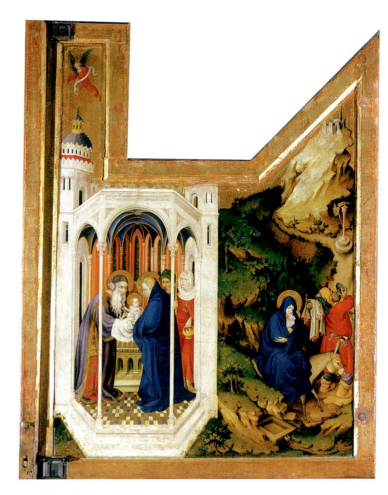

14.3. Melchior Broederlam, *Infancy of Christ* panels, wings of the altarpiece of the Chartreuse de Champmol. 1394–1399. Tempera on panel, each 65 × 49¼ (167 × 125 cm). Musée des Beaux-Arts, Dijon, France

complex shape is the result of the format of the central section.) Each panel of the wings depicts two scenes from the infancy of Christ: The left wing depicts the Annunciation and Visitation; the right, the Presentation in the Temple and the Flight into Egypt. The painter uses landscape and architectural elements to define the narratives and to fill the odd spaces of the panel. The architecture looks like a doll's house, although it is derived from Duccio and the Lorenzetti (see figs. 13.25 and 13.28), while the details of the landscape are out of scale with the figures. Yet the panels convey a strong feeling of depth thanks to the subtlety of the modeling. The softly rounded shapes and the dark, velvety shadows create the illusion of weight, as do the ample, loosely draped garments, reminiscent of the sculpture of Sluter.

Broederlam's panels show another feature of the International Gothic style: the realistic depiction of small details. Similar realism may be seen in some Gothic sculpture (see fig. 12.30) and among some **drôleries** (small designs, often of fables or scenes from everyday life) in the margins of manuscripts such as the *Hours of Jeanne d'Évreux* (fig. 12.41). In Broederlam's Annunciation panel, such realism occurs in the carefully rendered foliage and flowers of the enclosed garden behind Gabriel at the left. In the right panel, touches of naturalistic detail

include the delightful donkey, the tiny fountain at its feet, and the rustic figure of St. Joseph, who looks like a simple peasant to contrast with the delicate, aristocratic beauty of the Virgin. This painstaking detail gives Broederlam's work the flavor of an enlarged miniature rather than of a large-scale painting, even though the panels are more than five feet tall. But these accumulated details do more than endow the image with small flashes of realism: They contribute to its meaning. In the left panel, for example, the lily signifies Mary's virginity, as does the enclosed garden next to her. The contrasting Romanesque and Gothic buildings stand for the Old and New Testaments respectively. Broederlam both enchants and instructs in this painting.

Illuminated Manuscripts: Books of Hours

Although panel painting was growing in importance, book illumination remained an important medium in northern Europe. Among the finest of the many manuscript painters employed by the French courts was the Boucicaut Master, who was named for a book of hours he painted for the aristocratic Marshal Boucicaut around 1410. (The artist may have been the Bruges artist Jacques Coene.) The book has many full-page miniatures, which are framed by gold and surrounded by a decorative spray of delicate ivy leaves, as seen in the Visitation page

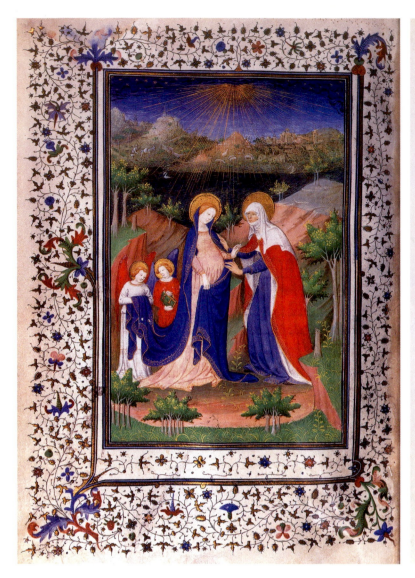

14.4. Boucicaut Master. *Hours of Marshal Boucicaut*, Visitation page. ca. 1408–1410. $10^3/_4 \times 7^1/_2''$ (4.3 × 3 cm). Institut de France-Musée Jacquemart-Andre, Paris

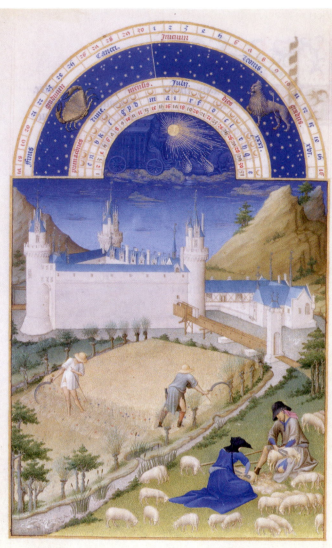

14.5. Limbourg Brothers. *Les Très Riches Heures du Duc de Berry*, July page. 1413–1416. $8^7/_8 \times 5^3/_8''$ (22.5 × 3.7 cm). Musée Condé, Chantilly, France

(fig. **14.4**). In this image, the meeting between the pregnant Virgin and her cousin Elizabeth takes place in a deep, atmospheric space, defined by trees of many sizes, rising hillocks, and the distant horizon. Forms along the horizon lose clarity as atmosphere intervenes between the viewer and far-off objects. This technique is called **atmospheric perspective**. (See fig. 7.55.) The tall, elegant figures of the two women dominate the landscape; accompanied by a pair of angelic assistants, the Virgin stands in a swaying posture reminiscent of the *Virgin of Paris* (fig. 12.43), with similar drapery patterns defining her figure.

A prime example of the courtly International Gothic is the luxurious book of hours known as *Les Très Riches Heures du Duc de Berry (The Very Rich Hours of the Duke of Berry)*, produced for the brother of Philip the Bold and Charles V: Jean, Duke of Berry, the most lavish art patron of his day. The artists were Pol de Limbourg and his two brothers, Herman and Jean. The brothers were introduced to the court by their uncle, Jean Malouel, the painter who had applied the colors to Sluter's *The Well of Moses*. One or more of them must have visited Italy, for

their work includes numerous motifs and whole compositions borrowed from the artists of Tuscany and Lombardy. The brothers shared an appointment as court painters to the Duke, reflecting the high regard they enjoyed.

The *Très Riches Heures* was commissioned about 1413 and left unfinished when the Limbourg brothers died in 1416, probably of the plague. As a result, some pages were completed long after their deaths. The most famous pages in the book are devoted to the calendar and depict human activities and the cycles of nature. Such cycles, originally consisting of 12 single figures each performing an appropriate seasonal activity, were an established tradition in medieval art.

The calendar page for July (fig. **14.5**) demonstrates the Limbourgs' innovative presentation of these traditional themes. Time's passing is noted in several ways on the page: A semicircular section at the top marks the days numerically and includes the astrological signs for the month. Below this, the labor of the month is performed, as peasants harvest wheat and shear sheep in the fields, below a precisely rendered castle, Jean de

Berry's Chateau du Clain (Poitiers), now destroyed but well documented. The page depicts the orderly harvesting of a fruitful earth by the peaceful peasantry for the eyes of the man who owned the castle. This idealized view of the social order of feudalism is achieved by combining the portrait of the castle and naturalistic details of the sheep or the scythes with an artificial space that rises up the picture plane rather than receding into depth. The carefully crafted composition links the three major zones into triangular elements that fit together like a jigsaw puzzle. The jewel-like color and splashes of gold leaf in the calendar zone contribute to the sumptuous effect of the page. The prestige of the patron and the sheer innovation of the images, especially the calendar pages, in the *Très Riches Heures* inspired many later copies.

Bohemia and England

Other courts and regions in Europe shared the French taste for the International Gothic. In central Europe, the city of Prague, the capital of Bohemia, became a major cosmopolitan center thanks to Emperor Charles IV (1316–1378). Charles was educated in Paris at the court of the French King Charles IV, whose daughter he married and in whose honor he changed his name from Wenceslaus. After returning to Prague and succeeding his father as king of Bohemia, Charles was named Holy Roman emperor by the German Electors at Aachen in 1349 and crowned as such in Rome in 1355.

ART IN TIME

1348—Charles IV founds University in Prague

1385—Claus Sluter begins work at Chartreuse de Champmol, Dijon

1387—Chaucer writes *Canterbury Tales*

ca. 1413—Limbourg Brothers begin work on *Les Très Riches Heures du Duc de Berry*

Charles wanted to make Prague a center of learning, and in 1348 he established a university modeled on the one in Paris. Soon, it attracted many of the best minds in Europe. He also became a patron of the arts and founded a guild for artists. In addition to encouraging local talent, Charles brought artists from all over Europe to his city. In his castle of Karlstein, just outside of Prague, he built a chapel dedicated to the Holy Cross that imitated Louis IX's Sainte Chapelle (fig. 12.34). Instead of stained glass, the walls of this chapel were covered in paintings done by Master Theodoric, the first head of the painter's guild of Prague. The paintings were executed between 1357 and 1367.

The painting of *Saint Matthew and the Angel* in fig. **14.6** comes from this project. Here the Evangelist fingers a book while an

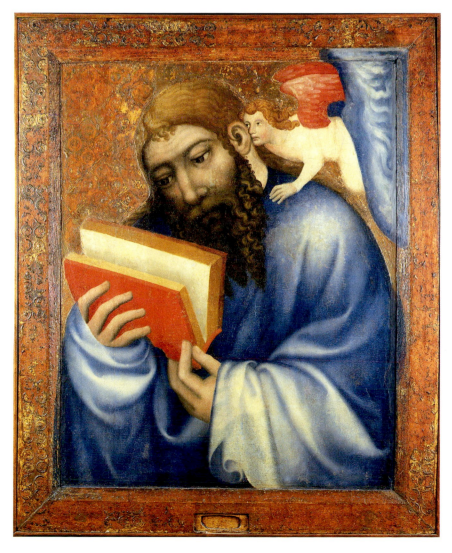

14.6. Master Theodoric. *Saint Matthew and the Angel*. ca. 1360–1365. Panel, 45¼ × 37″ (1.15 × 0.93 m). National Gallery, Prague. © National Heritage Institute, Prague. Inv. No. V0675/200

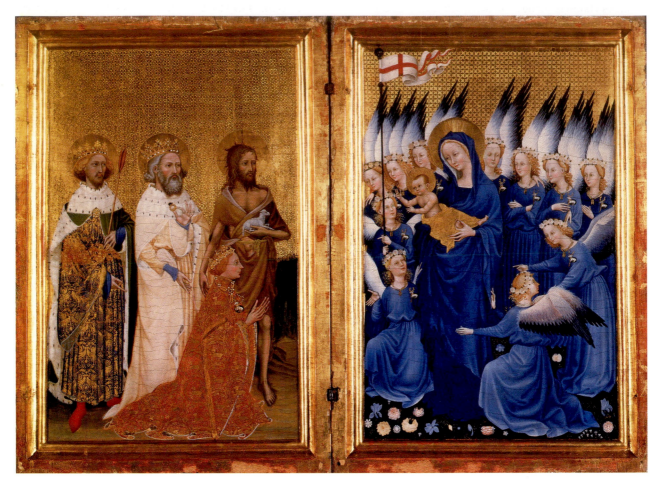

14.7. *The Wilton Diptych.* ca. 1400. Panel, $20^7/_8 \times 14^5/_8''$ (53×37 cm). National Gallery of Art, London

angel whispers in his ear. The traditional medieval symbol for the Evangelist thus becomes an active participant in the work of the saint. Matthew himself is rendered as a three-dimensional figure, whose blue garment falls across his body in softly modeled folds of drapery. This style probably derives from Theodoric's study of Italian artists, either in his native Austria or Prague.

Emperor Charles IV's daughter, Anne of Bohemia, married the English king, Richard II, in 1382. Richard, who ruled from 1377 to 1399, is the figure depicted in a painting called *The Wilton Diptych,* for the collector who once owned it (fig. **14.7**). A **diptych** is a double panel on a relatively small scale that opens on a hinge at the center like a book. This diptych represents King Richard II kneeling before his patron saints to venerate the Virgin Mary and her Child. As in Sluter's portal (fig. 14.1), the gazes of the figures connect across the panels. Angels accompany the elegant figure of the Virgin who appears like a queen surrounded by her palace guard. Her child playfully reaches out toward the king. The sumptuous colors and tall weightless figures stand in an eternal setting defined by a beautifully tooled gold background. Yet the drapery worn by the

angels is modeled in the same natural light as Master Theodoric's *Saint Matthew*. Scholars are still debating whether the artist who achieved this combination of Gothic otherworldliness and natural observation came from France, England, Bohemia, or somewhere else.

URBAN CENTERS AND THE NEW ART

Many of the artists whom the patrons in the courts preferred for their projects came from the cities of the Southern Netherlands: Bruges, Brussels, Ghent, and Tournai. The towns were centers of international commerce in whose streets many languages could be heard as merchants from all over Europe gathered to do business. These cities were very jealous of their status as independent entities with special privileges to govern themselves, set tariffs, and establish militias. Their claims for independence often clashed with the intentions of aristocratic overlords to tax and control the people and the wealth of the cities. Buildings like the Town Hall of Bruges (fig. **14.8**), built between 1376 and 1402, were designed to provide a setting for town councils and to serve as symbols of the independence and

privileges the cities claimed. Bruges' Town Hall is one of the earliest such structures in Northern Europe. Set on a major town square, it looks like an ecclesiastical structure, with its high gabled roof, traceried windows, and vaulted interior. The facade emulates Gothic churches, too, with its many sculpted figures depicting the local rulers, the Counts of Flanders. (The building was damaged during the French Revolution, and the statues on the facade today are modern.) While the interior of the structure functioned as a council hall for self-rule and issuing judgments, the exterior sculpture expressed the status quo of the nominal rule of the Counts of Flanders. Tensions between the holders of this title and the citizens of Flemish cities flared up several times in the fifteenth century. It is in the cities of Flanders that the beginnings of an artistic revolution may be seen. Working either for courts or for citizens, artists began to make images in oil painting that represent sacred figures as if they exist in the natural world, making the spiritual tangible.

Robert Campin in Tournai

An early pioneer of this naturalistic revolution is Robert Campin (1378–1444), the foremost painter of Tournai, an important trade center in southwestern Belgium. Campin ran a busy workshop, from which several other successful painters emerged, including Rogier van der Weyden.

THE *MÉRODE TRIPTYCH* The most famous work attributed to Campin is the *Mérode Triptych* (fig. **14.9**), dated on the basis of style to around 1425. The name derives from an early owner of the painting, but the subject of the central panel is the Annunciation, frequently depicted in earlier Christian art. Typically, those earlier representations of the Annunciation set the event in a church (see fig. 14.3) or other sacred space (see fig. 13.27), but Campin places the Virgin and the angel Gabriel in what appears to be the main room of a bourgeois house, complete with open shutters, well-used fireplace, and a cushioned bench. Despite the supernatural events, a viewer has the sense of actually looking through the surface of the panel into a world that mimics reality. Campin uses several devices to create this effect. He fits the objects and figures into boxes of space, sometimes uncomfortably. But he renders details in such a way as to make every object as concrete as possible in its shape, size, color, and texture. He also paints two kinds of light. One is a diffused light that creates soft shadows and delicate gradations of brightness; the other is a more direct light that enters through the two round windows, casting shadows on the wall. Campin's color scheme, with its muted tonality, unifies all three panels; his bright colors have richness and depth, and he achieves smooth transitions from lights into darks. These effects were made possible by the use of oil (see *Materials and Techniques*, page 479). Although medieval artists were

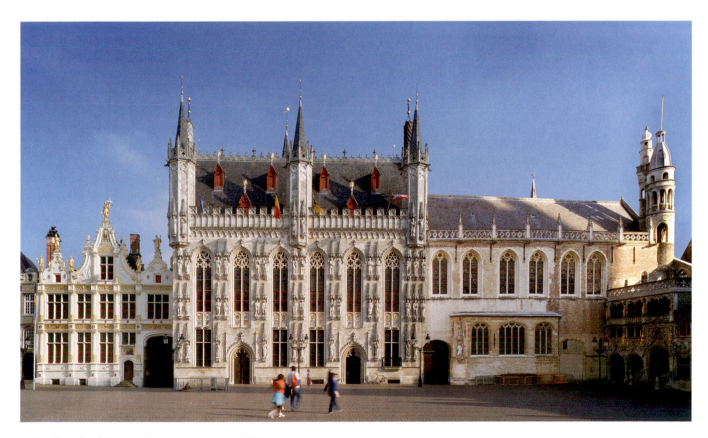

14.8. Facade of Bruges Town Hall. Begun 1376

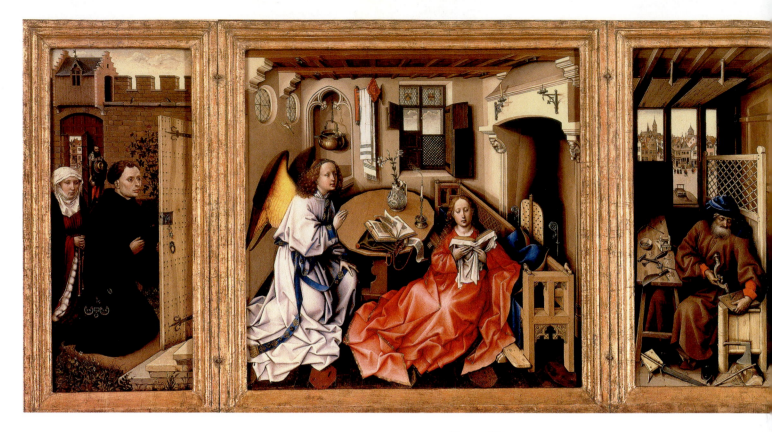

14.9. Robert Campin. *Mérode Triptych*. ca. 1425–1430. Oil on panel. Center $25^{3}/_{16} \times 24^{7}/_{8}''$
$(64.3 \times 62.9$ cm); each wing approx. $25^{3}/_{8} \times 10^{7}/_{8}''$ $(64.5 \times 27.4$ cm).
The Metropolitan Museum of Art, New York, The Cloisters Collection, 1956

familiar with oil paints, Campin and his contemporaries expanded its possibilities for painting on panels. Its use allowed him to create a much more thorough illusion of reality than the flashes of natural detail seen in the work of court artists.

Campin was no court painter but a townsman who catered to the tastes of fellow citizens, such as the two donors piously kneeling outside the Virgin's chamber. Their identities are not known, as the coat of arms in the window of the central panel has not yet been firmly identified, but they were wealthy enough to commission this triptych, probably for their own dwelling, as it is too small for installation in a public church. One result of this may be that the artist could innovate, as he broke with tradition in several ways. This Annunciation takes place in a fully equipped domestic interior with figures that are rendered as real people, with mass and weight. The drapery of their garments falls in deep folds, anchoring the figures to the floor, as in the sculpture of Claus Sluter (see fig. 14.1). Gabriel adopts a not quite kneeling, not quite standing position as he raises his right hand to speak. Mary's red dress draws attention to her as she sits on the floor, book in hand. Between them a table supports another book, a vase of lilies, and a candle. Above and behind Gabriel, the tiny figure of a baby holding a cross, who must be Christ, floats downward toward Mary. On the left wing, the donors kneel in a garden, as though looking through the open door to witness this event. The whole effect is of time frozen: Something important is about to happen. Where Simone Martini had rendered Gabriel and the Virgin as

slim, weightless figures set against an eternal gold ground (see fig. 13.27), Campin depicts their substantial bodies in a recognizably earthly setting for the eyes of the donor couple. The event takes place in their world, not in heaven.

The right wing depicts Joseph, the carpenter, at work, though just what he is making has been a subject of debate. What is the boxlike object on the ledge outside the open window? Scholars have identified it as a mousetrap, an object that the Christian theologian Saint Augustine used metaphorically to explain God's plan for salvation when he said, "The Cross of the Lord was the devil's mousetrap." The mousetrap could be a visual cue to the reason for Christ's incarnation, which is about to occur in the central panel. Equally puzzling is the object in Joseph's hand, identified by some scholars as a fire screen (like the one in the central panel) and by others as part of a press through which grapes are forced to make wine (with Eucharistic meaning).

Such carefully chosen details have persuaded many scholars that Campin used these forms as symbols to convey spiritual messages. The flowers, for example, are associated with the Virgin, as emblems of her purity and other virtues. The smoking candle next to the vase of lilies is more perplexing, and its symbolism obscure. Its glowing wick and the curl of smoke indicate that it was extinguished only moments before. But why had it been lit on a sunny day, and what snuffed out the flame? Does the arrival of the true light (Christ) extinguish mundane ones?

Panel Painting in Tempera and Oil

In the fourteenth and fifteenth centuries, painters worked with liquid pigments on wooden panels. The type of wood used varied from region to region, though oak panels were preferred in the North because they could be sawn into thin planks to serve as supports for the paint. Pine, fruitwoods, and poplar were also used. Once the panels had been formed, and often inserted into a frame by a carpenter, the flat surface would be covered with a film of gesso (a type of fine plaster) to create a smooth surface for the image. Often an underdrawing would be laid onto the gesso as a guide for the painter or his assistants.

Simone Martini's "Gabriel" is painted in tempera, which dries quickly; consequently, the layers of paint do not blend, and individual strokes of the brush are visible on the surface.

Pigments were ground into powders that had to be mixed with some sort of liquid medium to bind them to the panel. The basic medium of medieval panel painting had been tempera, in which the finely ground pigments were mixed ("tempered") with diluted egg yolk. This produced a thin, tough, quick-drying coat that was well suited to the medieval taste for high-keyed flat color surfaces. However, in tempera the different tones on the panel could not be blended smoothly, and the progression of values necessary for three-dimensional effects was difficult to achieve.

While medieval artists had used oil-based paints for special purposes, such as coating stone surfaces or painting on metal, artists like Jan van Eyck and Robert Campin in Flanders exploited it for panel paintings. Oil,

Campin's "Gabriel" is painted with oil, which dries slowly and is translucent. Each layer of color merges with the one below it to create a mirrorlike finish.

a viscous, slow-drying medium, can produce a variety of effects, from thin, translucent films (called *glazes*) to a thick layer of creamy, heavy-bodied paint (called *impasto*). The tones can also yield a continuous scale of hues, including rich, velvety dark shades. Oil painting offers another advantage over egg tempera, encaustic, and fresco: It allows artists to change their minds and rework their paintings. As the use of oil paints spread across Europe, some artists used a mixed technique, using the tempera paints to lay in base layers and covering the tempera with oil glazes. Although pigments continued to be mixed with tempera for some time, oil has been the painter's basic medium until very recently.

The appearance in Campin's picture of so many carefully delineated objects suggests that these details constitute a symbolic program, which either the artist or the patron conceived. Theologians or scholars may have provided Campin with the more learned aspects of the symbolism, but it was the artist who found the means to express these complex ideas in symbolic terms using forms observed in the visible world. Scholars are also debating the reasons why Campin and his contemporaries wanted to record the world with such fidelity. Had philosophies about nature and the natural world changed? Were pragmatic merchants demanding directly observed renderings of things they could see? Did new forms of religious practice stimulate the new style?

The Annunciation has important liturgical and theological import, but it is also a story about the conception of a child, and the couple in the left wing kneel devoutly before it. From their perspective, the triptych may be a celebration of their own desire for children or their reverence for the Holy Family as a model for their own. Such personalized approaches to holy figures and sacred dramas were an important feature of religious life at the end of the Middle Ages. Believers were encouraged in sermons, in passion plays, and in written texts to visualize the sacred in terms they could understand and to meditate on events from Christ's life in order to increase their empathy and devotion. Although monks and nuns had long practiced such contemplation, the religious movement called the Modern Devotion helped to spread these ideas among the laity. New texts, like the *Imitation of Christ* by Thomas à Kempis, provided guidance for lay people wishing to emulate Christ. Artists like Campin may have been responding to the call to see the physical world as a mirror of divine truths and to create moving and pious images of sacred events occurring in everyday environments.

Jan van Eyck in Bruges

The visual revolution achieved in paintings such as the *Mérode Triptych* was recognized and admired not only by patrons in Flanders but also by patrons in Italy. Italian observers provide the earliest external assessments of the Flemish innovators. They recognized that the technical achievement of oil painting contributed to the striking naturalism and evocation of religious feeling in Flemish painting, and they credited the "invention" of oil painting to Jan van Eyck (1390–1441). (See end of Part III *Additional Primary Sources*.) As a result, his is one of the more famous names of fifteenth-century art, and he is a figure about whom we know a good deal.

Jan worked first for the count of Holland and then for the reigning Duke of Burgundy, Philip the Good, from 1425 until Jan's death in Bruges in 1441. Both a townsman and a court painter, Jan was highly esteemed by Philip the Good, who occasionally sent him on diplomatic errands. Unusual for his time, he signed and dated several surviving pictures, which has allowed historians to identify his artistic output and to assign unsigned works to him based on the signed ones.

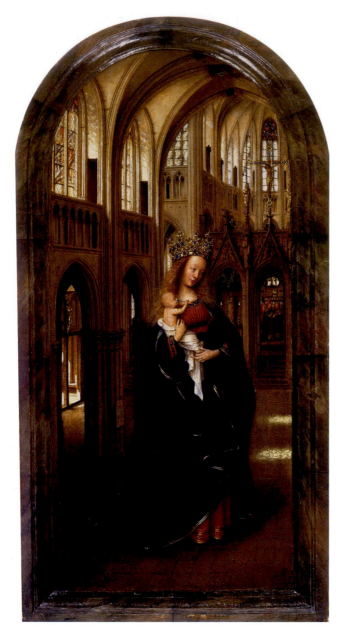

Virgin is out of proportion to everything else. She stands as tall as the triforium of this Gothic church. In another supernatural detail, the light enveloping her enters from north facing windows, a miraculous phenomenon in Northern Europe. Light both creates the form and enriches the content. An inscription on the Virgin's robe from the Song of Songs in the Old Testament confirms the symbolic meaning of the light, as it reads, "She is more beautiful than the sun . . ." Jan van Eyck uses oil painting to create images that mimic everyday reality, but which transform that reality into supernatural events. His "realism" reproduces the world selectively, so that otherwordly figures seem to inhabit human space.

THE *GHENT ALTARPIECE* Van Eyck's fame was assured when he completed the *Ghent Altarpiece* (figs. 14.11–14.14), one of the most famous of early Flemish paintings. From the moment it was installed in a chapel of the Cathedral of Saint John in Ghent (see fig. 14.14), it has drawn a crowd. Albrecht Dürer visited it in 1520, and much later artists like J. A. D. Ingres drew inspiration from it. An inscription that once

14.10. Jan van Eyck. *The Madonna in a Church.* ca. 1425–1430s. Oil on oak panel, $12\frac{1}{4} \times 5\frac{1}{2}''$ (31 × 14 cm). Gemäldegalerie, Staatliche Museen, Berlin.

One small panel attributed to Van Eyck is known as *The Madonna in a Church* (fig. **14.10**), dated by many scholars to the late 1420s. Painted in oil on panel, it is only slightly taller than this page. Despite its small scale, the panel is remarkable in its detailed recreation of the interior of a Gothic church, warmly lit by sun streaming through the clerestory windows. The Virgin herself is reminiscent of sculpted Gothic Madonnas: She is a slightly swaying, three-dimensional figure with a tiny but lively figure of Christ in her arms. In Jan's rendering, it is as if *The Virgin of Paris* had come to life (see fig. 12.43.) A sculpted Virgin appears on the choir screen of the church, and beyond the screen, angels sing from a choir book. There are hints of the miraculous: Despite the realism of the church interior, the

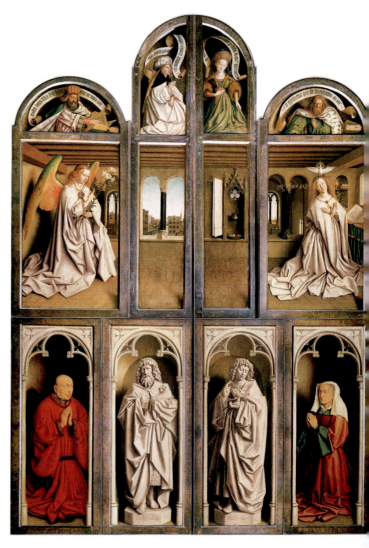

14.11. Hubert and Jan van Eyck. *Ghent Altarpiece* (closed). Completed 1432. Oil on panel, 11'5" × 7'6" (3.4 × 2.25 m). Church of St. Bavo, Ghent, Belgium

appeared on the frame identified Jan van Eyck as the artist who finished this multipaneled altarpiece in May 1432 and alluded to the collaboration of his older brother, Hubert, who died in 1426. The basic form of this complex altarpiece is a **triptych**—a central body with two hinged wings—the standard format of altarpieces in the Southern Netherlands, but here each of the three units consists of four panels. Since the wings are also painted on both sides, the altarpiece has a total of 20 images of various shapes and sizes. Discontinuities among the many panels suggest alterations took place as the work progressed. It appears that Jan took over a number of panels left unfinished by Hubert, completed them, added some of his own, and assembled the whole at the request of the wealthy donor, Jodicus Vijd. Vijd's portrait with that of his wife, Elizabeth Borluut, appears on the outer panels of the altar when the triptych is closed (fig. **14.11**)

Their portraits appear on the lower tier with two other figures, each in a separate niche framed by fictive Gothic tracery. Next to the donors are John the Baptist and John the Evangelist, the patrons of the Cathedral, painted in **grisaille** (a mono-

chrome to imitate the color of statues). The upper tier has two pairs of panels of different width. The artist has made a virtue of this awkward necessity by combining all four into one interior, whose foreshortened timber ceiling crosses all four panels. In addition to the continuous space, Jan heightens the illusion by painting shadows on the floor of the Virgin's chamber as if they were cast by the frames of the panels. Prophets and Sibyls occupy an upper story, their prophecies written in Gothic script in scrolls above their heads.

When the wings are opened (fig. **14.12**) the viewer sees a detailed rendering of a celestial assembly: Across the bottom tier, groups of figures converge on a central image of an altar, upon which stands a haloed Lamb. This assembly includes angels, apostles, popes, theologians, virgin martyrs, hermits, pilgrims, knights, and judges (including, possibly, a reference to Jan's employer, Duke Philip the Good). A verdant landscape provides the setting for this mystic mass, with towers of numerous churches in the skyline. Above this earthly paradise reigns an imposing Court of Heaven, with the Lord in a bright red robe at the center. Flanking him are Mary and John the

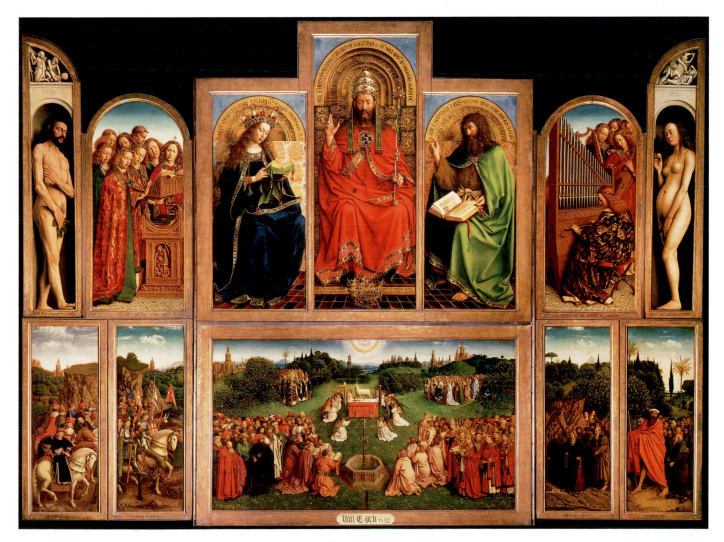

14.12. Hubert and Jan van Eyck. *Ghent Altarpiece* (open). 11′5″ × 15′1″ (3.4 × 4.5 m)

Baptist. To the left and right, choirs of angels sing and play musical instruments. At the outer edges of this upper tier stand Adam and Eve, rendered as nudes in shallow niches, below grisaille images of Abel and Cain. The almost life-size nudes are portrayed with careful attention to their anatomy and caressed by a delicate play of light and shade (fig. **14.13**).

The figures' poses are comparable to those in Gothic manuscripts, but here the artist breathes life into the forms by rendering the textures and colors of the bodies with great accuracy. Seeing this work on the altar of the Vijd Chapel in the Ghent Cathedral (fig. **14.14**), a viewer could not fail to be impressed by the scale and setting of the painting. The tone and majesty of this ensemble is very different from the domestic intimacy of the *Mérode Triptych*. The function of the altarpiece is to elucidate the liturgy performed in front of it. When open, its subject is the Mass itself, here shown in a paradisaical setting. The number of books represented and the many erudite inscriptions celebrating Christian learning suggest to many scholars that a cleric or theologian advised Jan in developing the program. But Jan accomplished the difficult task of bringing the disparate panels together and welding them into an imposing and memorable experience.

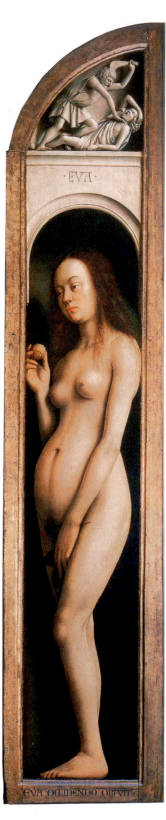

14.13. Hubert and Jan van Eyck. *Adam and Eve*, detail of *Ghent Altarpiece*. Left and right wings

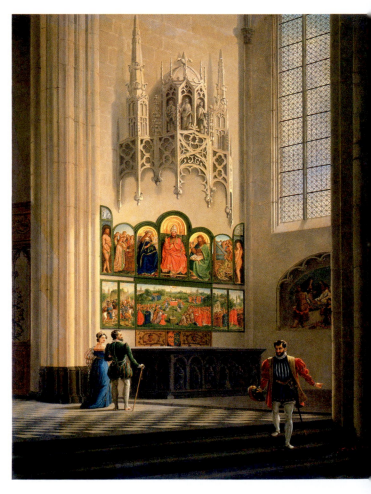

14.14. Painting of *Ghent Altarpiece* in chapel. Rijksmuseum, Amsterdam

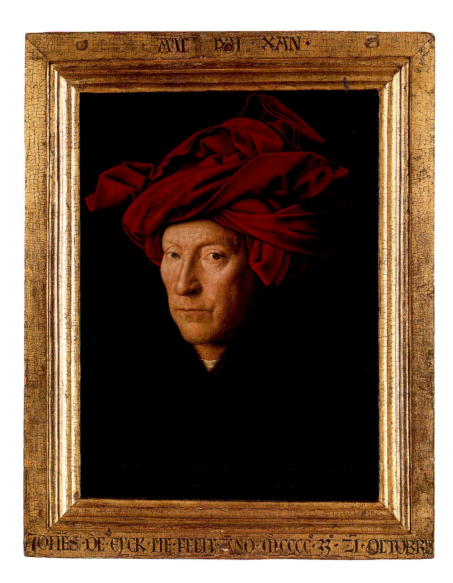

Jan's work is large in scale but full of naturally observed details and glowing color. His technique of building up color in layers of colored glazes results in the highly saturated hues, while the slow methodical application of paint blends brushstrokes to a mirrorlike finish. Jan offers a glimpse into heaven to stimulate devotion. If, as some scholars believe, the whole altarpiece was set into a Gothic architectural frame, one meaning of the image becomes the importance of the Church itself as an institution and as a pathway to the divine.

SECULAR IMAGES Jan van Eyck also made purely secular paintings, fulfilling the commissions of the court and of the middle-class citizens of Flemish towns. Jan's *Man in a Red Turban* (fig. **14.15**), signed and dated 1433, represents a middle-aged man in a three-quarters pose whose face is framed by his dramatic headgear. The distinctive face emerging from the dark background of this painting is bathed in a warm light that reveals every detail of shape and texture with almost microscopic precision. The artist does not explore the sitter's personality, yet the man gazes out of the picture to make eye contact with the viewer. This innovation, and the slight strain about the eyes which may come from gazing into a mirror, suggests that the painting may be a self-portrait. The self-consciousness that such a project demands may relate to the text painted on the frame: An inscription reads "*ALS ICH KAN*" ("As I can," or "As best I can"). This motto appears on other works by Jan, too, perhaps challenging other artists to do better, for he has done all he can. Interestingly, the motto is written in Flemish, but transposed into Greek letters. Was Jan competing with the ancients as well as with his contemporaries? Whatever his reason may have been, we can read the motto as another sign of Jan's self-consciousness about his work as an artist and his place in history.

Jan van Eyck's signatures also challenge modern scholars to interpret his work. One of the most controversial of his surviving images represents a man and a woman standing in a richly furnished room, equipped with a brass chandelier, a mirror, and a canopied bed (fig. **14.16**). Jan signed the painting, not on the frame, as was his normal practice, but in the panel itself. Above the painted mirror in a formal script, the translated signature reads, "Jan van Eyck was here, 1434." The features of the man, if not the lady, are specific enough to be a portrait, and the image is unusual enough that scholars have used later documents to identify him as Giovanni Arnolfini, an Italian

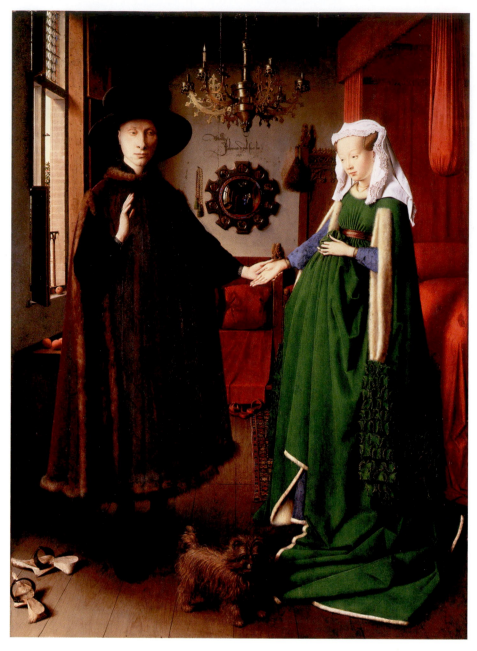

• 14.16. Jan van Eyck. *The "Arnolfini Portrait."* 1434. Oil on panel, $33 \times 22\frac{1}{2}$" (83.7×57 cm). The National Gallery, London. Reproduced by Courtesy of the Trustees

merchant living in Bruges. For many years scholars believed that his companion should be identified as Giovanna Cenami, Arnolfini's wife; recent research, however, makes this doubtful, as that marriage took place much later than 1434.

Whatever their names, the painted couple are represented in the main room of a fifteenth-century house. The two join hands, with the man raising his right hand as if in a solemn oath, seemingly quite alone. In the mirror behind them, however, is the reflection of two men who have entered the room. Because the signature appears right above the mirror, many scholars believe that one of these men must be Jan van Eyck himself, perhaps the figure wearing the red headdress. The combination of the signature, with its flourishes and phrasing, and the image of the men in the mirror suggests to some that Jan acts as a witness to whatever is occurring in the room.

For many years scholars have argued that this panel represents either the wedding or the engagement of the couple represented, either of which would have required a legal and financial contract between their two families. By this reading, the painting commemorates the union of the couple. If so, the second man in the mirror may be the bride's father, who would have made the contract for the marriage of his daughter. The woman's gesture to lift her heavy gown may suggest her wish for children, as the bed behind her may suggest the consummation of the marriage. Given its secular nature, scholars have debated whether the realistic touches serve simply as an accurate record of an event and its domestic setting, or whether the details of the setting carry more symbolic weight. Has the couple taken off their shoes merely as a matter of custom, or to remind us that they are standing on "holy ground"?

(This symbol has its origins in stories of Moses removing his sandals at the burning bush on Mount Sinai, that is, in the presence of God.) Is the little dog a beloved pet, or an emblem of fidelity? (*Fides* is Latin for faithfulness, the origin of the traditional dog name, Fido.) The other furnishings of the room suggest other questions. Why does a candle in the chandelier burn in broad daylight? Why do pieces of fruit sit on the window sill? What is the function of the mirror? Tiny images of the Passion and Resurrection in the small medallions that surround the mirror sound the only unambiguously religious note. What was Jan's purpose in making this painting? For whom was it made? What function did it serve for the patron? The answers to these questions have become more controversial in recent interpretations, as scholars are now much less certain about the meaning of the image than they used to be.

Rogier van der Weyden in Brussels

As a court painter, Jan van Eyck had been exempt from the restrictions that governed other artists in Flemish towns. Regulations for the training of artists and the market for works of art came from the guilds, professional organizations of artists established to protect the interests of their members. Aspiring artists learned the trade as apprentices in the workshop of a certified master. After a fixed period, an apprentice became a journeyman (or dayworker) who could then hire out his services to others but not open his own shop. Journeymen often traveled to learn from artists other than their master. Becoming a master required completing a "masterpiece" that was evaluated by the leaders of the guild. Guilds not only controlled training but limited competition from artists outside their towns, investigated disputes among members, and saw to the social and economic needs of members, such as providing for burials, pensions, and the care of widows. Guilds were both economic and social institutions, assuring the quality of their products and seeing to the well-being of their members.

One illustrious graduate of the guild system was Rogier van der Weyden (1399/1400–1464), a painter who trained with Robert Campin in Tournai, but who certainly knew the work of Jan van Eyck. By 1435, Rogier had established a flourishing workshop in Brussels which took commissions from as far away as Italy and Spain. Perhaps his most influential work is the *Descent from the Cross* (fig. **14.17**), which dates from about 1435. It was commissioned as the center of an altarpiece by the crossbowmen's guild of Louvain (near Brussels) for a church there. For them, Rogier depicted the moment when the body of Christ is lowered from the cross in a composition of mourners crowded into a shallow box of space. His forms are carefully modeled to suggest sculptural presence, and they are detailed enough to show every nuance of texture.

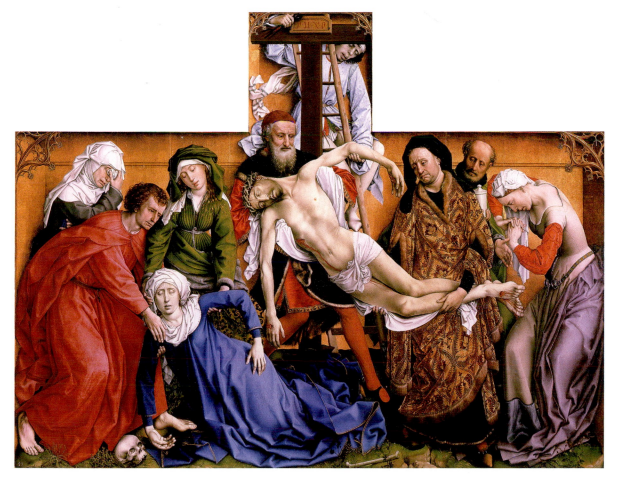

14.17. Rogier van der Weyden. *Descent from the Cross*. ca. 1435. Oil on panel, 7'2⅝" × 8'7⅛" (2.2 × 2.6 m). Museo del Prado, Madrid

Cyriacus of Ancona (1449)

Rogier van der Weyden probably visited Italy, and sources reveal that he made several paintings for prominent Italian patrons, including the Este family of Ferrara. One of Rogier's most discussed images in Italy drew the praise of Cyriacus of Ancona, a Humanist and diplomat who had traveled widely in the service of Italian princes.

After that famous man from Bruges, Johannes the glory of painting, Roger in Brussels is considered the outstanding painter of our time. By the hand of this most excellent painter is a magnificently wrought picture which the illustrious prince Lionello of Este showed me in Ferrara on July 8, 1449. In it one sees our first progenitors, and in a most pious image the ordeal of the Deposition of the God-Incarnate, with a large crowd of men and women standing about in deep mourning. All this is admirably depicted with what I would call divine rather than human art. There you could see those faces come alive and breathe which he wanted to show as living, and likewise the deceased as dead, and in particular, many garments, multicolored soldiers' cloaks, clothes prodigiously enhanced by purple and gold, pearls, precious stones, and everything else you would think to have been produced not by the artifice of human hands but by all-bearing nature itself.

SOURCE: *NORTHERN RENAISSANCE ART 1400–1600: SOURCES AND DOCUMENTS,* ED. WOLFGANG STECHOW. (EVANSTON, IL: NORTHWESTERN UNIVERSITY PRESS, 1989)

Rogier's goal is to increase the expressive content of his pictures. He emphasizes the emotional impact of the Descent from the Cross on its participants. Grief is etched on each figure's face, and their postures express their response to their loss. John the Evangelist on the left and Mary Magdalen on the right are bowed with grief. The Virgin's swoon echoes the pose and expression of her son. So intense are her pain and grief that they inspire the same compassion in a viewer. Rogier has staged his scene in a shallow niche or shrine, not against a landscape. This bold device focuses a viewer's attention on the foreground and allows the artist to mold the figures into a coherent group. Furthermore, the emphasis on the body of Christ at the center of the composition speaks to the celebration of the Eucharist, which takes place before the altarpiece. The source of these grief-stricken gestures and faces is in sculpture rather than in painting. These figures share the strong emotion of the mourners on the

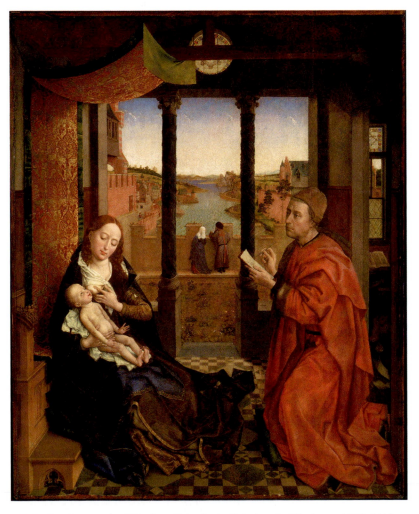

14.18. Rogier van der Weyden. *Saint Luke Painting the Virgin.* ca. 1435–1440. Oil and tempera on panel, $54\frac{1}{8} \times 43\frac{5}{8}''$ (1.38 × 1.11 m). Museum of Fine Arts, Boston. Gift of Mr. and Mrs. Henry Lee Higginson. Photograph © 2006, Museum of Fine Arts, Boston. 93153

Naumberg choir screen (fig. 12.53) or the Virgin in the *Roettgen Pietà* (fig. 12.56). Rogier's painting inspired many copies, in both painting and sculpture.

The heightened emotion with which Rogier imbues his works was noted and admired by the Italian diplomat Cyriacus of Ancona, who saw another painting by Rogier on this theme in 1449. (See *Primary Source*, facing page.) This commentator singled out the naturalism in Rogier's work, as he admired the figures who seemed to come alive in Rogier's painting. Other Italian commentators remarked on Flemish painting's naturalism and piety as well. Viewers in Flanders would have brought their own interest in meditating on the sacrifice of Christ to their experience of Rogier's painting.

Rogier's depiction of *Saint Luke Painting the Virgin*, dated between 1435 and 1440 (fig. **14.18**), reveals his debt to earlier Flemish artists. The figure of Mary nursing her son in this image shows the continuing influence of Campin, while the composition is based on a work by Jan van Eyck. Unlike the *Descent from the Cross*, Rogier creates a deep landscape that moves into the distance. The figures inhabit a room that opens onto a garden protected by fortifications. A man and a woman peer over these battlements toward a busy Flemish city in the distance, where shopkeepers open for the day and citizens walk the street.

The painting represents Saint Luke the Evangelist in another role, as the portrayer of the Virgin and Christ Child. A Byzantine tradition explained that the Madonna appeared miraculously to Luke, so he could paint her portrait. This legend helped to account for numerous miraculous images of the Madonna in the later Middle Ages. Rogier depicts Luke drawing the features of the Virgin in silverpoint as she appears before him. (Such drawings were the starting point for most paintings of the period.) Because of this story, Saint Luke became the patron of painters' guilds throughout Europe. Rogier's painting may have been given to the Brussels Guild of Saint Luke, as later documents describe such a work in their chapel. Since this image depicts the making of an image, Rogier's painting may be a self-conscious statement about the dignity of painting and painters. It was copied numerous times in the fifteenth century, even by Rogier's own workshop. In recent years, scholars have been studying such paintings with new scientific tools that examine the techniques used by the artists. (See *The Art Historian's, Lens*, page 488.)

LATE FIFTEENTH-CENTURY ART IN THE NETHERLANDS

The paintings of Robert Campin, Jan van Eyck, and Rogier van der Weyden offered powerful examples for other artists to follow, in the Netherlands and beyond. In the later fifteenth century, court patrons continued to prefer objects made of expensive materials, particularly gold. They also commissioned illuminated manuscripts and tapestries. At the same time, patronage by the merchant class continued to grow, and painters found work in commissions from the middle class. Nonetheless, the medi-

ART IN TIME

1384—Philip the Bold of Burgundy inherits Flanders
1432—Jan van Eyck finishes the Ghent Altarpiece
1453—End of The Hundred Years' War between England and France

um of painting gained in prestige as the century wore on, attracting interest and patronage in aristocratic circles. Despite the increasing market for paintings, large-scale sculpture continued to find a market in the fifteenth-century Netherlands, though little has survived the ravages of war, social upheavals, and changes of taste. Even rarer are survivals of objects made in precious metals, as the very valuable raw material was easily recycled when money was scarce.

Aristocratic Tastes for Precious Objects, Personal Books, and Tapestries

Aristocratic patrons commissioned small-scale precious objects throughout the fifteenth century. One, whose brilliance makes us mourn the loss of others, is the *Statuette of Charles the Bold,* preserved in the Treasury of the Cathedral of Liège in eastern Belgium (fig. **14.19**). Commissioned from the goldsmith Gerard

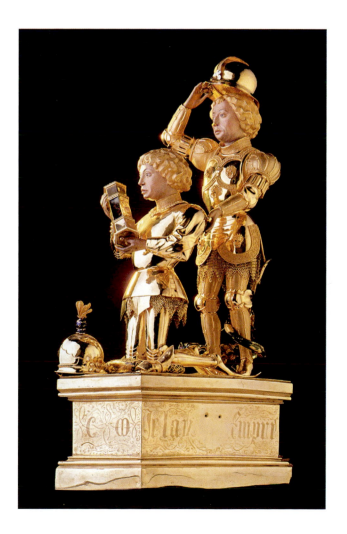

14.19. Gerard Loyet, *Statuette of Charles the Bold.* ca. 1471. 21 × 12½ × 7" (53 × 32 × 17.5 cm). Cathedral Treasury, Liège

Scientific and Technical Study of Paintings

Investigative tools used in the contemporary scientific study of materials are providing new information about the practices of artists in the past. The very materiality of works of art makes them appropriate for the same sort of study as archeological discoveries. Chemical analysis of paints and pigments is providing information on the recipes for making pigments that artists used. This information can be used to examine workshop practices, to establish authenticity, and to suggest methods of conservation.

Modern scholars use a variety of techniques to investigate paintings. *X-radiographic* imaging penetrates painted surfaces and produces a photographic analysis of the use of lead in the painting process. Because lead white was used to lighten pigments, x-radiographs allow an investigator to examine how an artist modeled forms with lighter colors. X-radiographs also reveal details about an artist's brushwork or changes made as the painting progressed. Another technique uses *infra-red light*, which can see through painted surfaces to distinguish dark marks on the white ground of a panel. Aided by special infra-red cameras (a technique called *infra-red reflectography*), analysts can photograph the underdrawings and initial paint layers below painted surfaces; computers match these photos to produce images of the preparatory layers of the painting. This information is invaluable for studying the creative process. It has also aided in determining which of the many versions of Rogier's *Saint Luke Painting the Virgin* (fig. 14.18) was executed first.

Because many Renaissance panels are painted on wood, scholars have been able to determine the number of tree rings on a particular wood panel, a technique known as *dendrochronology*. This number is then compared to a database of tree rings that have been dated to define the time when the tree was probably cut down, which can then provide additional evidence for dating the painting. Such evidence has caused some scholars to date Bosch's *Garden of Earthly Delights* (fig. 14.24) to around 1480. Scientific study is also revealing the composition of the limestone used in Gothic sculpture and the chemical makeup of ancient bronzes.

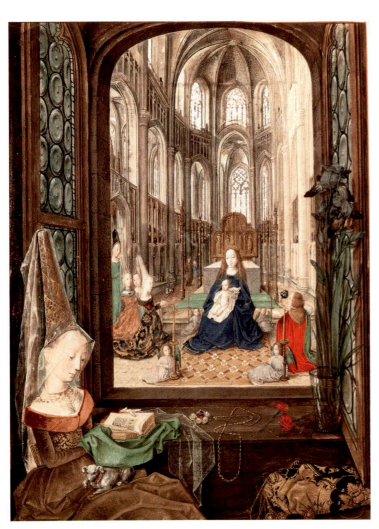

14.20. Master of Mary of Burgundy, Lady at Window, from the *Hours of Mary of Burgundy*. ca. 1480. $7^3/_8 \times 5^1/_8$″ (8.7 × 13.5 cm). Österreichisches Nationalbibliothek, Vienna

Loyet (before 1442–1500), the figure was given by Duke Charles the Bold of Burgundy to the Cathedral in 1471, perhaps to assert his control over that rebellious city. Made of gold and silver gilt with enamel details, the 21-inch high statuette represents Duke Charles holding a reliquary; behind him stands Saint George, Charles's favorite patron saint, who lifts his helmet in greeting. The Duke is dressed in armor, kneeling on a pillow to make his offering. The object demonstrates Loyet's skill and the prestige of such objects in the Burgundian court.

The taste of the court also ran to expensive books. Despite the introduction of the printing press (see pages 497–498), among the traditional elites, the manuscript book—custom-made to celebrate the purchaser's status and interests—retained its appeal. Books of hours, in which prayers were organized into cycles according to the hours of the day, appealed especially to women. A striking example of a complex and lavish illuminated book is the *Hours of Mary of Burgundy*. The book includes the coat of arms of Mary, the daughter of Charles the Bold and the last duchess of Burgundy, evidence that she was the owner of the book before her death in 1482.

Mary herself may be the woman depicted in figure **14.20**. Here the anonymous artist (named after this book of hours) depicts an elegantly dressed young woman reading from a book of hours similar to the *Hours of Mary of Burgundy*. Her costume and surroundings indicate her status: Golden brocades, transparent veils, jewelry, and flowers surround her, and a little dog rests on her lap. She sits in a private chapel, whose windows open onto a view of a light-filled Gothic church. Through the window the viewer sees the Virgin Mary with her child seated in the sanctuary, surrounded by angels. To the right of these sacred figures kneels a group of noble women, whose access to the child and his mother may be what the woman in the foreground is praying for.

The artist creates a picture within a picture here, as the glimpse into the church is completely framed by the architecture of the Lady's chapel. Where earlier manuscript artists (like the Boucicaut Master in fig. 14.4) put floral or other decorative motifs in the border and created a spatial context only for the main image, this artist treats the border as a spatial entity of its own that links the border and the main image. The artist takes care to record the tactile and sensuous quality of the dog's fur, the transparency of the glass vase, and the reflective qualities of the pearls on the ledge. The manuscript page has the impact of a painted panel.

The court was also the key market for the flourishing industry in tapestries. Major workshops practiced in Brussels, Tournai, and Arras, whose name became synonymous with the art form. Woven with colored threads of wool or silk, tapestries were often commissioned by the courtly class or their peers in the

church. The tapestry fragment of *Penelope Weaving* (fig. **14.21**), for example, was part of a series of "Famous Women" commissioned by the Bishop of Tournai around 1480. The image depicts the wife of Odysseus (or Ulysses) working at a loom. According to Homer's *Odyssey*, Penelope fended off her numerous suitors with her weaving; she insisted she would not marry again until she had completed her work, which she unwove every evening. Although a figure from the classical past, Penelope is dressed in the costume of a fifteenth-century lady. The influence of paintings is apparent, in the suggestion of space, the detailed treatment of her gems and garment, and in the figure. On the wall behind Penelope hangs a tapestry within the tapestry, in a two-dimensional pattern of repeated floral forms called *millefleurs*, which was one of the best-selling designs for tapestry in the fifteenth century. The court of Burgundy shared their Italian contemporaries' interest in stories of the ancients as exemplars for the present, but they envisioned them in familiar, not historic terms. The naturalism of the Flemish painters provided a language for the tapestry weavers to satisfy courtly taste.

Panel Paintings in Southern Netherlands

While the court collected precious objects, illuminated manuscripts, and tapestries, the middle-class demand for panel paintings continued to grow. International businessmen invested their money and their reputations in commissioning paintings from Flemish artists like Hugo van der Goes (ca. 1440–1482). Having served as dean of the painter's guild of Ghent, Hugo entered a monastery near Brussels as a lay brother in 1475, where he continued to work until his death in 1482. His best-known work is the huge altarpiece commissioned around 1474 by an agent of the Medici bank in Bruges, who shipped it to Florence (fig. 14.22). The 10-foot wide central panel represents the Virgin, Saint Joseph, and the Shepherds adoring the newborn Christ Child in Bethlehem. In the wings, members of the donor family, including Tommaso Portinari, his wife, Maria Maddelena Baroncelli, and their children, kneel to face the central image. A spacious landscape unites all three wings as a continuous space, with the bare trees and December sky suggesting not the Holy Land but Flanders itself. Objects in the distance have turned the blue of the atmosphere; this use of atmospheric perspective infuses the panel with a cool tonality. Hugo filled this setting with figures and objects rendered with precise detail in deeply saturated colors.

Yet Hugo's realistic renderings of both landscape and figures is contradicted by variations in the sizes of the figures. The angels and kneeling members of the Portinari family are dwarfed by the other figures; the patron saints in the wings are the same size as Joseph, the Virgin Mary, and the shepherds of the Nativity in the center panel. This change of scale contradicts the pictorial space that the artist has provided for his figures. Another contrast occurs between the raucous intrusion of the shepherds and the ritual solemnity of all the other figures. These fieldhands gaze in breathless wonder at the newborn Christ Child, who is the focus of all the gazes of the figures ranged around him. Mary however,

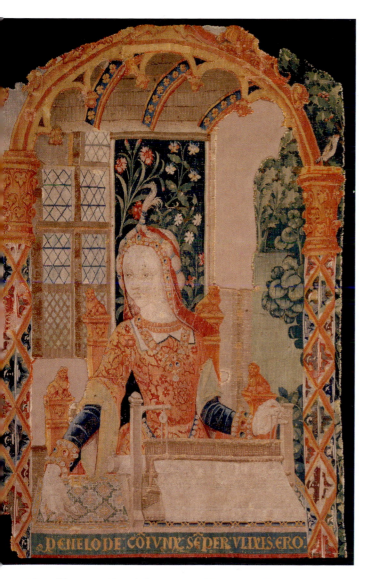

14.21. *Tapestry of Penelope Weaving (Penelope at Her Loom)* A fragment from *The Story of Penelope and the Story of the Cimbri Women*. ca. 1480. $39^3/_8'' \times 59^1/_{16}''$ (100 × 150 cm). Museum of Fine Arts, Boston. Maria Antoinette Evans Fund. Photograph © 2006, Museum of Fine Arts, Boston. 26.54.

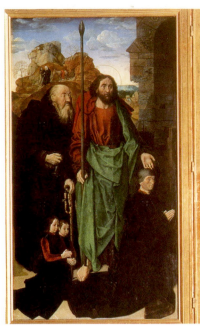
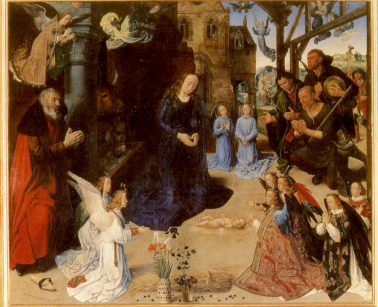
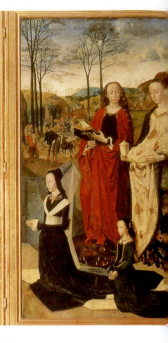

14.22. Hugo van der Goes. *The Portinari Altarpiece* (open). ca. 1474–1476. Tempera and oil on panel, center 8′3¹⁄₂″ × 10′ (2.5 × 3.1 m), wings each 8′3¹⁄₂″ × 4′7¹⁄₂″ (2.5 × 1.4 m). Galleria degli Uffizi, Florence

sits at the physical center of the composition. Such deliberate contrasts between the pictorial and psychological focal points, between the scale of the historical and the contemporary figures, and between the static and kinetic postures of the figures contribute to a viewer's unsettled reaction to the work.

The background is populated with narratives that support the main theme. Behind the figures in the left panel, Mary and Joseph travel toward Bethlehem. Behind the saints on the right wing, the Magi progress toward the center. And in the center, the movement of angels flickers across the surface, lit by both natural and supernatural light. Strategically placed at the front of the picture is a beautiful still life of flowers and a sheaf of wheat. As with so many other realistic details in Flemish paintings, these have been interpreted as symbolic references. The wheat refers to the bread of the Eucharist and the flowers to the Virgin. Portinari brought the triptych to Florence in 1483 and installed it in the family chapel attached to the hospital of Sant' Egidio. There it proclaimed the taste, wealth, and piety of the donor. Judging from their imitation of it, Italian painters who saw the work there especially admired its naturalism and its unidealized representation of the shepherds.

Triptychs were often intended for liturgical spaces. For more domestic spaces, patrons wanted smaller objects. For example, the young up and coming citizen of Bruges, Martin van Nieuwenhove, commissioned a diptych from Hans Memling in 1487 (fig. **14.23**) Born in Germany (ca. 1435–1494), Memling worked in Bruges, where his refined style based on Rogier and Jan van Eyck brought him commissions from patrons from all over Europe. Italians in Bruges especially patronized his workshop, as did local patricians like Van Nieuwenhove. An inscription on the frame of his diptych identifies the patron and gives his age, while his stylish garment and gilt-edged prayer book express his social status.

Behind him a piece of stained glass represents his patron saint, Martin. The young man focuses his gaze to the left panel, where an image of the Virgin and Child appear. Martin's family coat of arms in the window behind them implies that the Virgin and Child are visiting him in his own home. This conceit is further expressed by the reflection in the mirror behind them, where the artist has included the reflections of both the Virgin and young man. Memling has borrowed the concave mirror Jan van Eyck used in *The "Arnolfini Portrait"* (fig. 14.16) to unite the two halves of the diptych.

Memling's image demonstrates a new trend in portraiture: In addition to rendering the features, he creates a setting for the figure. Access to the divine remains a preoccupation for otherwise worldly men; in this light-filled room, Martin kneels in permanent prayer, so that the image becomes an expression of his devotion. But this object also served as a piece of self-promotion, as the many personal references to the patron display his self-assurance and social status.

The Northern Netherlands

The innovations of the early fifteenth-century painters quickly spread to the Northern Netherlands (present-day Holland), where one of the most famous paintings from the fifteenth century, Hieronymous Bosch's *Garden of Earthly Delights* (fig. **14.24**) was made. Bosch (ca. 1450–1516) came from a family of painters and spent his life in the town of 's Hertogenbosch, the seat of a Ducal residence, and from which his name derives. His work attracted the patronage of the Duke of Burgundy, and was collected by King Philip II of Spain in the sixteenth century. It was in Philip's collection that Fray José de Sigüenza encountered Bosch's painting. (See *Primary Source*, page 492.) Sigüenza's account has been an important document

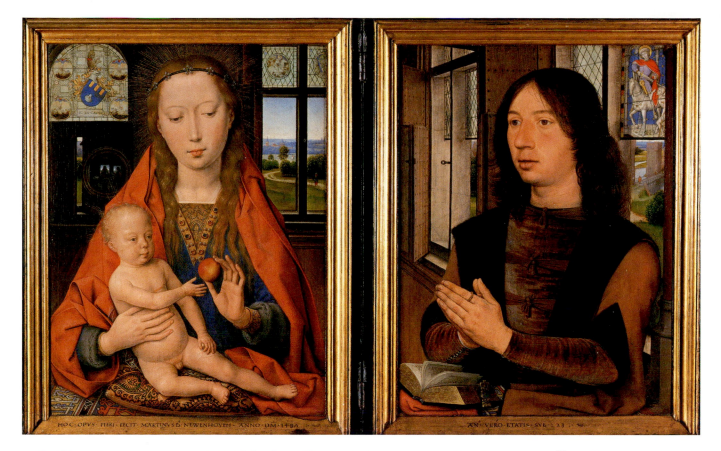

14.23. Hans Memling. *Madonna and Child*, left wing of *Diptych of Martin van Nieuwenhove*. 1487. Panel, 17³/₈ × 13″ (44 × 33 cm). Hans Memling Museum, Musea Brugge, Sint-Jans Hospital, Bruges

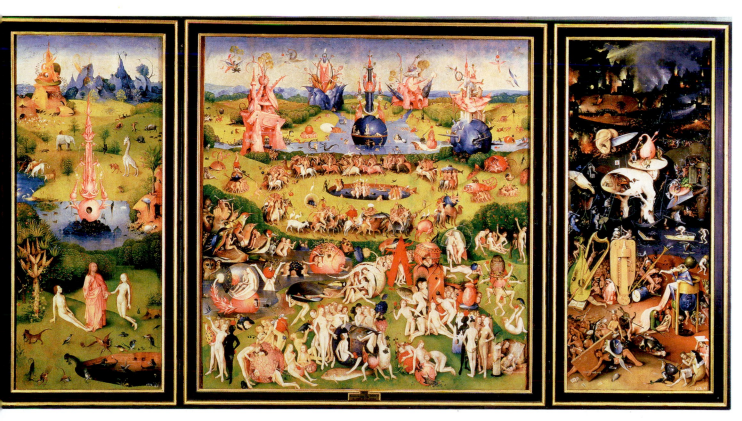

14.24. Hieronymous Bosch. *The Garden of Earthly Delights*. ca. 1480–1515. Oil on panel, center 7′2¹/₂″ × 6′4¹/₂″ (2.19 × 1.95 m); wings, each 7′2¹/₂″ × 3′2″ (2.19 × .96 m). Museo del Prado, Madrid

Fray José De Sigüenza (1544?–1606)

From *The History of the Order of St. Jerome*

The works of Hieronymus Bosch were collected by the Spanish king Philip II (r. 1556–1598) and were displayed in his Escorial Palace near Madrid, where Sigüenza was the librarian. The interpretation of Bosch's work was as difficult then as it is today and caused just as much disagreement. This passage is Sigüenza's attempt to interpret the painting that we call The Garden of Earthly Delights *(see fig. 14.24).*

Among these German and Flemish pictures ... there are distributed throughout the house many by a certain Geronimo Bosch. Of him I want to speak at somewhat greater length for various reasons: first, because his great inventiveness merits it; second, because they are commonly called the absurdities of Geronimo Bosque by people who observe little in what they look at; and third, because I think that these people consider them without reason as being tainted by heresy....

The difference that, to my mind, exists between the pictures of this man and those of all others is that the others try to paint man as he appears on the outside, while he alone had the audacity to paint him as he is on the inside....

The ... painting has as its basic theme and subject a flower and the fruit of [a] type that we call strawberries.... In order for one to understand his idea, I will expound upon it in the same order in which he has organized it. Between two pictures is one large painting, with two doors that close over it. In the first of the panels he painted the Creation of Man, showing how God put him in paradise, a delightful place ... and how He commands him as a test of his obedience and faith not to eat from the tree, and how later the devil deceived him in the form of a serpent. He eats and, trespassing God's rule, is exiled from that wondrous place and deprived of the high dignity for which he was created.... This is [shown] with a thousand fantasies and observations that serve as warnings....

In the large painting that follows he painted the pursuits of man after he was exiled from paradise and placed in this world, and he shows him searching after the glory that is like hay or straw, like a plant without fruit, which one knows will be cast into the oven the next day, ... and thus uncovers the life, the activities, and the thoughts of these sons of sin and wrath, who, having forgotten the commands of God ... strive for and undertake the glory of the flesh....

In this painting we find, as if alive and vivid, an infinite number of passages from the scriptures that touch upon the evil ways of man, ... many allegories or metaphors that present them in the guise of tame, wild, fierce, lazy, sagacious, cruel, and bloodthirsty beasts of burden and riding animals. ... Here is also demonstrated the transmigration of souls that Pythagoras, Plato, and other poets ... displayed in the attempt to show us the bad customs, habits, dress, disposition, or sinister shades with which the souls of miserable men clothe themselves—that through pride they are transformed into lions; by vengefulness into tigers; through lust into mules, horses, and pigs; by tyranny into fish; by vanity into peacocks; by slyness and craft into foxes; by gluttony into apes and wolves; by callousness and evil into asses; by stupidity into sheep; because of rashness into goats....

One can reap great profit by observing himself thus portrayed true to life from the inside.... And he would also see in the last panel the miserable end and goal of his pains, efforts, and preoccupations, and how ... the brief joys are transformed into eternal wrath, with no hope or grace.

SOURCE: *BOSCH IN PERSPECTIVE*, ED. JAMES SNYDER. (NY: SIMON AND SCHUSTER, 1973)

for interpreting this complex and surprising painting, whose subject and meaning has been vigorously debated.

Divided into three panels, the *Garden of Earthly Delights* represents humans in the natural world. A continuous landscape unites the three sections; the high horizon and atmospheric perspective imply a deep vista of the Earth from an omniscient vantage point. Shades of green create an undulating topography marked by thickets of trees and bodies of water. Throughout, small creatures both human and nonhuman swarm, while strange rock formations and other objects appear at intervals. The left wing appears to represent the Garden of Eden, where the Lord introduces Adam to the newly created Eve. The airy landscape is filled with animals, including such exotic creatures as an elephant and a giraffe, as well as strange hybrid monsters. The central panel reveals a world inhabited by tiny humans who frolic among giant fruits, birds, and other creatures. In the middle ground, men parade around a circular basin on the backs of all sorts of beasts. Many of the humans interact with huge birds, fruits, flowers, or marine animals. The right wing depicts an infernal zone, which may be Hell, where strange hybrid creatures torment the tiny humans with punishments appropriate to their sins. Yet the outer wings depict a crystal globe with an image of the earth emerging from a flood, with God watching over the events from above.

Despite its triptych format, this is not a traditional altarpiece but a secular work. It belonged to Count Henry III of Nassau in whose palace in Brussels it was reported to be in 1517, though recent research suggests it may have been painted as early as 1480. Many interpretations have been offered for the painting—that it represents the days of Noah, as shown by the image of a flood on the exterior; that the many swarming nudes express the views of a heretical group that promoted free love; or that the infernal landscape in the right wing demonstrates a moralizing condemnation of carnal sin.

These interpretations have suggested that Bosch was a pessimist sermonizing about the depravity of humankind. This is the way that José de Sigüenza described it, although his text also suggests several "allegories or metaphors" embedded in the painting. Yet the image itself is beautifully painted and as seductive as the sirens in the pool in the middle of the central panel. There is an innocence, even a poetic beauty, in this panorama of human activity that suggests something other than outright condemnation of the acts so carefully depicted. This ambivalence has fueled the numerous interpretations, including a recent proposal that the image depicts an alternative view of history in which the original sin of Adam and Eve does not happen, and therefore humans continue to live in a state of innocence.

Perhaps the most consistent and comprehensive interpretation of this painting links it to the practice of alchemy as an allegory of redemption. The many strangely shaped and outsized formations refer to the tools and vessels used in this medieval approach to understanding the Earth. The alchemical process required four steps: conjunction—or mixing, for which the joining of Adam and Eve is a metaphor; child's play—the slow process of cooking diverse ingredients and letting them ferment, for which the central panel would stand; putrefaction—a step in which material is burned, related to the infernal right wing; and the final cleansing of matter—represented by the exterior flood. Bosch, who had married an apothecary's daughter, consciously used the visual symbols of that science to create an unforgettable glimpse of natural processes.

REGIONAL RESPONSES TO THE EARLY NETHERLANDISH STYLE

Artists in many regions of Europe responded to the formal and technical achievements of the generation of Robert Campin and Jan van Eyck. These regional responses were influenced by local traditions and tastes, but as in the Netherlands, patrons found the naturalism of the new style useful for their religious and social purposes. France, Spain, and Central Europe produced their own variations on this style.

France

The geographic proximity, trade routes, linguistic links, and political relationships between the Burgundian Netherlands and France helped to spread the innovations in technique and

style throughout France. Artists either traveled to Flemish cities or developed their own brand of naturalism in imitation of the effects that Rogier or Hugo had achieved (see figs. 14.18 and 14.22). Yet French art has distinctive features and traditions. In the first half of the fifteenth century, the troubles of the Hundred Years' War limited expenditures on art. Citizens of the war-torn cities commissioned very little, but members of the church and the court continued earlier forms of patronage.

After establishing his rule at the close of the Hundred Years' War, the king of France, Charles VII, appointed Jean Fouquet (ca. 1420–1481) of Tours as his court painter. Both a book illuminator and a panel painter, Fouquet traveled to Italy around 1445, where he learned some of the innovations of contemporary Italian art. His work, however, owes much to Netherlandish style in technique, color, and approach. Charles VII's treasurer, Étienne Chevalier, commissioned Fouquet around 1450 to paint a diptych representing the treasurer and his patron saint, Stephen, in proximity to the Virgin and Child, the so-called *Melun Diptych* (figs. **14.25** and **14.26**). Like his

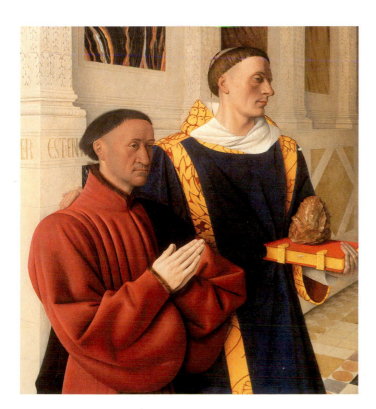

14.25. Jean Fouquet. *Étienne Chevalier and St. Stephen*, left wing of the *Melun Diptych*. ca. 1450. Oil on panel, $36\frac{1}{2} \times 33\frac{1}{2}''$ (92.7 × 85 cm). Staatliche Museen zu Berlin, Gemäldegalerie

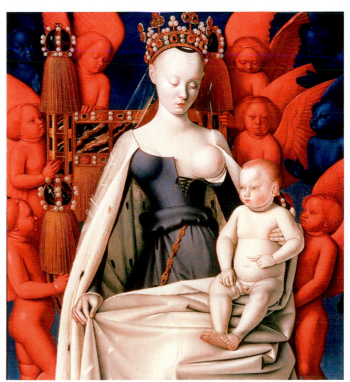

14.26. Jean Fouquet. *Madonna and Child*, right wing of the *Melun Diptych*. ca. 1450. Oil on panel, $36\frac{5}{8} \times 33\frac{1}{2}''$ (94.5 × 85.5 cm). Koninklijk Museum Voor Schone Kunsten, Antwerpen Belgie (Musée Royal des Beaux-Arts, Antwerp, Belgium)

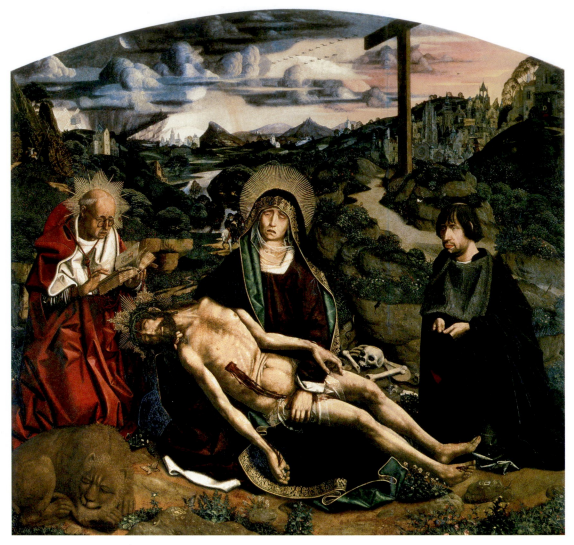

14.27. Bartolome Bermejo. *Pietà*. 1490. Panel, 74³/₈ × 68⁷/₈″ (189 × 175 cm), including frame. Cathedral, Barcelona

Flemish contemporaries, Fouquet records the specific physiognomy of the patron in his fur-lined garment. The head of the saint who carries a book and the stone of his martyrdom seems as individual as that of the donor.

They stand in a room with marbled floors and marble panels on the walls, framed by antique-inspired pilasters that recede to suggest space. The two men gaze across the frame toward an image of the enthroned Virgin and Child. According to an old tradition, the Madonna is also a portrait: of Agnès Sorel, Charles VII's mistress. If so, the panel presents an image of courtly beauty, as befits the Queen of Heaven, seen wearing a crown amid a choir of angels. Fouquet deliberately contrasts the earthly and divine realms. The deep space in the left panel differs vividly from the right panel, organized as a rising triangle, with the cool colors of the Virgin and Child set against the vivid reds and blues of the angels. In contrast to his Flemish counterparts, Fouquet is not interested in suggesting specific textures, and he subordinates details to the overall design. Fouquet does not appeal to the emotions. His images are geometrically ordered and rational rather than expressive.

Spain

Netherlandish naturalism reverberated strongly on the Iberian peninsula in the fifteenth century. Artists traveled between Flanders and Spain, and trade, diplomacy, and a dynastic marriage brought the united kingdoms of Castile and Aragon into increasingly close contact with Flanders. These contacts were echoed in the works of art imported into Spain from Flanders and in works of art produced in Spain by local artists.

A powerful example of the Spanish interpretation of Flemish naturalism is the *Pietà* painted in 1490 by Bartolome Bermejo (ca. 1440–1500) for a deacon of the Cathedral of Barcelona (fig. **14.27**). Bermejo was born in Córdoba, but he worked in many regions of Spain, and may have been trained in Bruges. His *Pietà* sets the image of the Virgin grieving for her dead son in a dark and atmospheric landscape dominated by an empty cross. Instead of the historical mourners called for by the narrative, and included by Giotto (see fig. 13.21), Mary and Christ are flanked by Saint Jerome to a viewer's left (the lion is his attribute) and a portrait of the deacon to the right.

This removes the theme from a strict narrative context and makes the painting function as an image of devotion similar to the *Roettgen Pietà* (fig. 12.56), though the precise detail of the figures and the landscape derive from Flemish models. In contrast to the cool rationality of Fouquet, Bermejo's work is highly emotional and expressive.

Central Europe

Linked by trade and political ties to the Netherlands, artists and patrons in Central Europe were also receptive to the new style, especially in cities along the Rhine (see map 14.1). One such artist, Conrad Witz (1400/10–1445/46) became a citizen of Basel, Switzerland, and a master in the city's guild of painters at just the moment that the Church's Council of Basel concluded. This Church council, or synod, had met from 1431 to 1434 to debate whether the pope alone or councils of bishops had the right to determine doctrine. These controversial issues inform the paintings Witz made in 1444

for the bishop of Geneva, which were destined for the Cathedral of Saint Peter.

The panels represent scenes from the life of Saint Peter, including *The Miraculous Draught of Fishes* (fig. **14.28**). The painting depicts Christ calling Saint Peter to walk across the Sea of Galilee to join him. The solidly modeled figure of Christ dominates the right side of the composition, in part because his red garment contrasts vividly with the green tones of the painting. Saint Peter appears twice, once in the boat among other apostles, who are called to be "fishers of men," and again sinking into the waters upon which Christ seems to float. The technique and style owe much to the Flemings, but Witz devotes his attention to the landscape. In place of the Sea of Galilee, Witz substitutes Lake Geneva, emphasizing local topography, such as the distinctive mountain above Christ's head. He accurately depicts every reflection on the water, so that we can see the bottom of the lake in the foreground and the variety of textures of the water's surface in the background. Witz places the events of the historical past in the setting of the present. Peter's

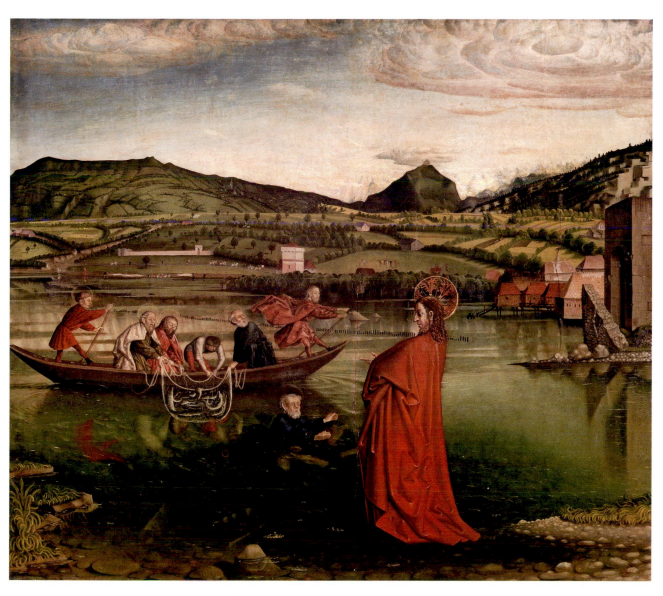

14.28. Conrad Witz. *The Miraculous Draught of Fishes*. 1444. Oil on panel, 51 × 61″ (132 × 154 cm).
© Musée d'Art et d'Histoire, Geneva, Switzerland. 1843.11

From the Contract for the St. Wolfgang Altarpiece

It took Michael Pacher ten years (1471–1481) to complete this elaborate altarpiece for the pilgrimage church of St. Wolfgang. The altarpiece is still in its original location.

Here is recorded the pact and contract concerning the altar at St. Wolfgang, concluded between the very Reverend, Reverend Benedict, Abbot of Mondsee and of his monastery there, and Master Michael, painter of Bruneck, on St. Lucy's day of the year 1471.

ITEM, it is first to be recorded that the altar shall be made conforming to the elevation and design which the painter has brought to us at Mondsee, and to its exact measurements.

ITEM, the predella shrine shall be guilded on the inside and it shall show Mary seated with the Christ Child, Joseph, and the Three Kings with their gifts; and if these should not completely fill the predella shrine he shall make more figures or armored men, all gilt.

ITEM, the main shrine shall show the Coronation of Mary with angels and gilt drapery—the most precious and the best he can make.

ITEM, on one side St. Wolfgang with mitre, crozier, church, and hatchet; on the other St. Benedict with cap, crozier, and a tumbler, entirely gilded and silvered where needed.

ITEM, to the sides of the altar shall stand St. Florian and St. George, fine armored men, silvered and gilded where needed.

ITEM, the inner wings of the altar shall be provided with good paintings, the panels gilded and equipped with gables and pinnacles, representing four subjects, one each. . . .

ITEM, the outer wings—when the altar is closed—shall be done with good pigments and with gold added to the colors; the subject from the life of St. Wolfgang. . . .

ITEM, at St. Wolfgang, while he completes and sets up the altar, we shall provide his meals and drink, and also the iron work necessary for setting up the altar, as well as help with loading wherever necessary.

ITEM, the contract is made for the sum of one thousand two hundred Hungarian guilders or ducats. . . .

ITEM, if the altar is either not worth this sum or of higher value, and there should be some difference of opinion between us, both parties shall appoint equal numbers of experts to decide the matter.

SOURCE: *NORTHERN RENAISSANCE ART 1400–1600*: SOURCES AND DOCUMENTS, ED. WOLFGANG STECHOW. (EVANSTON, IL: NORTHWESTERN UNIVERSITY PRESS, 1989)

sinking into the water, suggesting his need for assistance, may be evidence of the bishop's support of the Council's role to advise the pope.

AN ALTARPIECE IN ITS ORIGINAL SETTING Witz's panels were originally the wings of an altarpiece, many of which had sculptures as their central elements or *corpus*. In German speaking regions, altarpieces were usually made of wood, often large and intricately carved. Protestant reformers in the sixteenth century destroyed many sculpted religious images, so surviving examples are rare. The *St. Wolfgang Altarpiece* (fig. **14.29**) by the Tyrolean sculptor and painter Michael Pacher (ca. 1435–1498) is impressive both because of its scale and because it remains in its original setting.

The surviving contract between the abbot who commissioned it and the painter specifies both the subject matter and the quality of the materials and workmanship (see *Primary Source*, above). This was the normal pattern for contracts given to artists for expensive projects in the period.

Much as Jan van Eyck did in the Ghent Altarpiece, Pacher creates a vision of heaven: The *corpus* depicts the Coronation of the Virgin as Queen of Heaven flanked by the patron saints of the monastery. Carved of soft wood that permits the sculptor to create deep folds and sharp edges, the lavishly gilt and colored forms make a dazzling spectacle as they emerge from the shadows under Flamboyant Gothic canopies. The figures and setting in the central panel seem to melt into a pattern of twisting lines that permits only the heads to stand out as separate elements.

The complexity and surface ornamentation that dominates the *corpus* contrast with the paintings of scenes from the life of the Virgin on the interior of the wings. Here the artist represents large figures, strongly modeled by clear light, and he suggests a deep space for them. He takes a viewer's vantage point into account, so that the upper panels are represented as if seen from below. This kind of perspective must have been inspired by developments in contemporary Italian painting. Pacher almost certainly crossed the Alps and visited northern Italy, where some of his works were commissioned, so he had learned to use the new technique for projecting space. (Compare his perspective to Mantegna's in figure 15.53.) This perspective appears only in the wings, however, where scenes from the past are set into spaces that look like the Austrian present. The interior of the temple where the circumcision takes place, for example, has a vault much like ones in late Gothic churches. Pacher makes the historical scenes in the wings much more down to earth than the spectacle of heaven in the center.

PRINTING AND THE GRAPHIC ARTS

Along with the new techniques of painting, fifteenth-century Europe saw the development of a new medium: printmaking. The invention of movable type and the printed page would have enormous consequences for Western civilization. Tradition has credited Johann Gutenberg (ca. 1397–1468) with inventing movable type, but the roots of printing actually lie in the ancient Near East 5,000 years ago. The Sumerians were the earliest "printers," for their relief impressions on clay, from stone seals, were carved with both pictures and inscriptions (fig. 2.11). From Mesopotamia the use of seals spread to India and eventually to China. The Chinese applied ink to their seals in order to impress them on wood or silk, and in the second century CE they invented paper. By the ninth century they were printing pictures and books from wooden blocks carved in

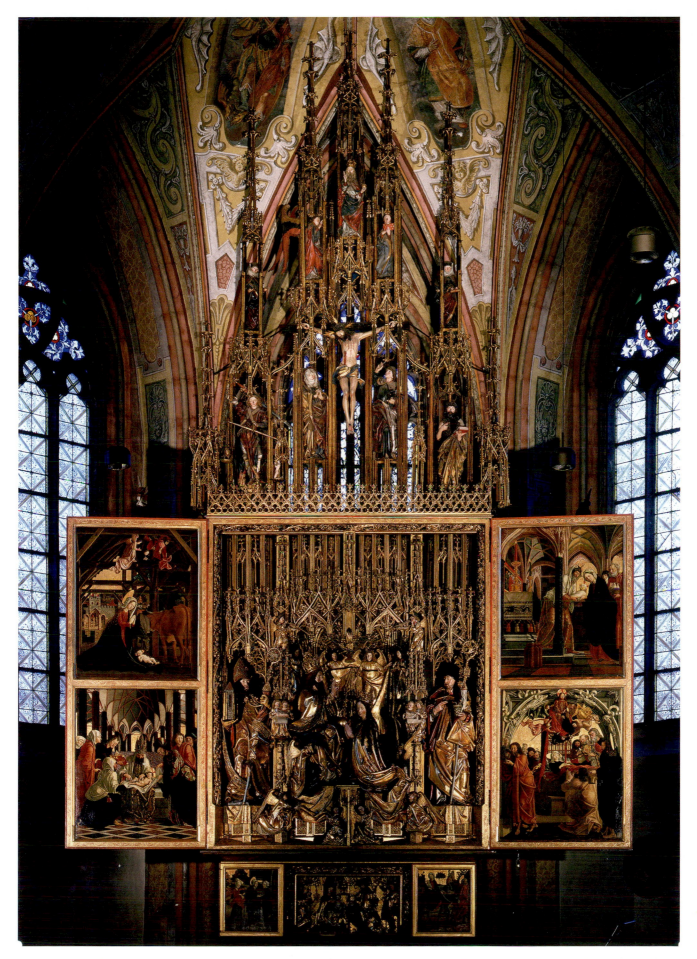

14.29. Michael Pacher. *St. Wolfgang Altarpiece.* 1471–1481. Carved wood, figures about lifesize; wings, oil on panel. Church of St. Wolfgang, Austria

Printmaking

Printmaking is a technique for making multiple copies of the same image. In the fifteenth century, most prints used dark black ink on paper (though some are printed on parchment). Printmakers used one of several techniques to make these images; the two broad categories are **relief** prints (in which the lines to be printed are raised from the block) and **intaglio** (in which the lines to be printed are cut into a plate). Designs (and text) will print as reversed images as they are transferred to the paper by the force of a press. By 1500, printing technology allowed for the reproduction of pictures by several methods, all developed at the same time as the printing of type.

WOODCUT In a woodcut the design is cut into a wood block so that raised ridges will print. The thinner the ridges are, the more difficult they are to carve, so specialists took over this phase of the work. Early woodcuts often include inscriptions, but to carve lines of text backward in relief on a wooden block must have been risky—a single slip could ruin an entire page. It is little wonder, then, that printers soon had the idea of putting each letter on its own small block. Wooden movable type carved by hand worked well for large letters but

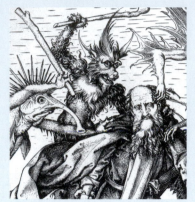

Detail of Schongauer's
The Temptation of St. Anthony.
Engraving, see fig. 14.32

not for small ones, and the technique proved cumbersome for printing long texts such as the Bible. By 1450 this problem had been solved through the introduction of metal type cast from molds, and the stage was set for book production as it was practiced until the late twentieth century. Because the text was carved in relief, it became apparent that accompanying pictures should be carved in relief as well, so that an entire page could be printed with one run of the press over the **matrix**—or form—which held all the information to be printed.

ENGRAVING The technique of engraving—embellishing metal surfaces with incised pictures—had developed in Classical antiquity (see fig. 6.20) and continued to be practiced throughout the Middle Ages (see fig. 10.2). Goldsmiths and designers of armor, in particular, were experts in incising designs on metal surfaces. These skills allowed goldsmiths to engrave a plate that could serve as the matrix for a paper print. Because the lines themselves were incised into the plate, more linear information could be included in the design. In an engraving, lines are V-shaped grooves cut with a special tool, called a **burin**, into a metal plate, usually copper, which is relatively soft and easy to work with. Ink is forced into the grooves made by the burin, the plate is wiped clean of excess ink, and a damp sheet of paper is placed on top of the inked plate; the force of a press transfers the ink—and the design—to the paper.

relief, and 200 years later, they developed movable type. Some of the products of Chinese printing may have reached the medieval West—perhaps through Islamic intermediaries.

The technique of manufacturing paper, too, came to Europe from contact with Islamic regions, though it gained ground as a cheap alternative to parchment very slowly. While printing on wood blocks was known in the late Middle Ages, it was used only for ornamental patterns on cloth. All the more astonishing, then, is the development, over the course of a century, of a printing technology capable of producing editions of several hundred copies of relatively inexpensive books. The new technology quickly spread across Europe, spawning the new industry of bookmaking. Printed books were far less expensive than hand made volumes, but they were useless to those who could not read. Literacy began to rise among the lower classes, a consequence that would have profound effects on Western civilization. To compete with illuminated manuscripts, printed books included printed images, which were often hand colored to imitate the more expensive manuscripts. Ultimately, the printed book almost completely replaced the illuminated manuscript.

The pictorial and the literary aspects of printing were closely linked from the start. The practice of inking pictorial designs carved on wooden blocks and then printing those designs on paper began in Europe late in the fourteenth century. Early surviving examples of such prints, called **woodcuts**, come from France, the Netherlands, and Germany. The designs were

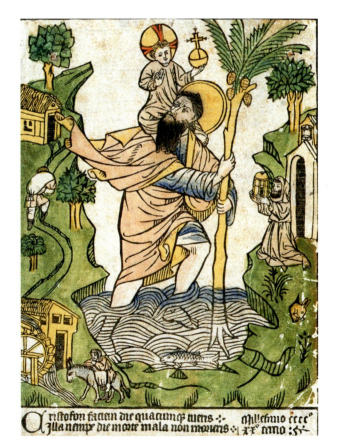

14.30. *Buxheim Saint Christopher.* 1423. Woodcut, $11^{3}/_{8} \times 8^{1}/_{8}$″ (28.8 × 20.6 cm). John Rylands University Library. Courtesy of the Director and the Librarian. The John Rylands University Library of Manchester

14.31. *Woodcut of St. Christopher,* detail from the *Annunciation* by Robert Campin (?) ca. 1435. Musées Royaux de Beaux-Arts de Belgique. Inv. 3937

ART IN TIME

1444—Witz's *The Miraculous Draught of Fishes*
1469—Marriage of Ferdinand of Aragon and Isabella of Castile
1486—Maximilian of Habsburg becomes Holy Roman Emperor
1492—Muslim kingdom of Granada conquered by Spain

engravings, and engravers included initials and dates in their prints. Consequently, many engravers of the late fifteenth century are known to us by name.

Printing Centers in Colmar and Basel

Martin Schongauer of Colmar, Germany (ca. 1435/50–1491) learned the goldsmith's craft from his father, but he became a printmaker and a painter. He studied the paintings of Rogier van der Weyden, which may have influenced the style of his engravings. Their complex designs, spatial depth, and rich textures make them competitors to panel paintings. Some artists found inspiration in them for large-scale pictures. They were also copied by other printmakers. *The Temptation of St. Anthony* (fig. 14.32) is one of Schongauer's most famous works—known

probably furnished by painters or sculptors, but the actual carving of the wood blocks was done by specialists. (For the various techniques of printing, for pictures as well as books, see *Materials and Techniques,* facing page.)

An early dated example of a woodcut is the *Buxheim Saint Christopher* (fig. 14.30), so called because it came from a monastery in that south German town. This single sheet, hand-colored woodcut bears the date 1423 and a prayer to the saint; woodcuts combining image and text like this were sometimes assembled into popular picture books called *block books.* Simple, heavy lines define the forms in the print, including the fall of the garment around the figures and the contours of objects. Vertical lines in parallel rows—called **hatching**—denote shadows or textures of objects, but the composition is strictly two-dimensional, as the landscape forms rise along the picture plane to surround the figures. According to legend, Christopher was a giant who ferried people across a river; he was surprised one day at the weight of a child, who turned out to be Christ. (The saint's name derives from this encounter.)

The forms in the *Buxheim Saint Christopher* owe a great deal to late Gothic style, but the audience for prints were not the aristocrats of the Middle Ages. Fifteenth-century woodcuts were popular art. A single wood block yielded thousands of copies, to be sold for pennies apiece, so that for the first time in history almost anyone could own pictures. A detail from a Flemish *Annunciation* panel of about 1435 in figure 14.31 reveals one use to which people put such prints. A print much like the *Buxheim Saint Christopher* is pinned on the wall in a middle-class household.

From the start, **engravings** appealed to a smaller and more sophisticated public. The oldest surviving examples, from about 1430, already show the influence of Flemish painters. Early engravers were usually trained as goldsmiths, but their prints reflect local painting styles. Their forms are systematically modeled with fine hatched lines and often convincingly foreshortened. Distinctive styles appear even in the earliest

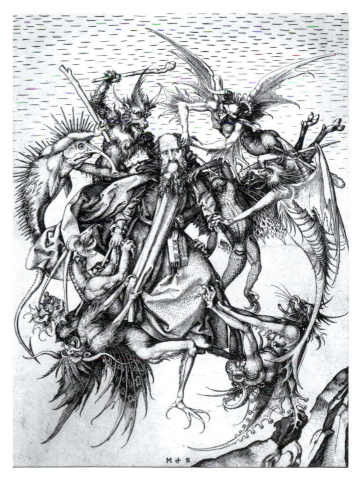

14.32. Martin Schongauer. *The Temptation of St. Anthony.* ca. 1480–1490. Engraving, $11\frac{1}{2} \times 8\frac{5}{8}$" (29.2 × 21.8 cm). The Metropolitan Museum of Art, New York Rogers Fund, 1920

and admired in sixteenth-century Italy. The print represents the climax of Saint Anthony's resistance to the devil. Unable to tempt him to sin, the devil sent demons to torment him. The engraving displays a wide range of tonal values, a rhythmic quality of line, and the rendering of every conceivable kind of surface—spiky, scaly, leathery, furry—achieved by varying the type of mark made on the plate.

Since the time of Witz, the Swiss city of Basel had embraced the new technology for printing books to become a major center for publishing. A group of reform-minded intellectuals and

authors contributed texts for publication, which graphic artists illustrated with woodcuts. One of the best sellers of the period was a satiric text by Sebastian Brant called the *Ship of Fools*, published in Basel in 1494. Brant's text poked fun at many of the ills he perceived in contemporary society, which, as the title implies, he characterized as a boat piloted by Folly. One important theme his text addresses is contemporary dissatisfaction with the Church. This tide of anticlerical feeling was already rising when Luther's critique of the Church was posted in 1517 in Wittenberg (see page 632). But Brant's satirical eye also fell on his own peers, as the woodcut in figure **14.33** reveals. The image depicts a scholar in his study surrounded by books, but rather than read them, he holds a duster to clean them. The man's costume, including a hood with bells on it, identifies him as a fool. Compared with the *Buxheim Saint Christopher*, the unnamed artist who produced this woodcut increases the density of hatching that implies texture and volume and attempts a spatial context for the forms. The practice of coloring prints fell by the wayside as the medium developed its own aesthetic and appeal.

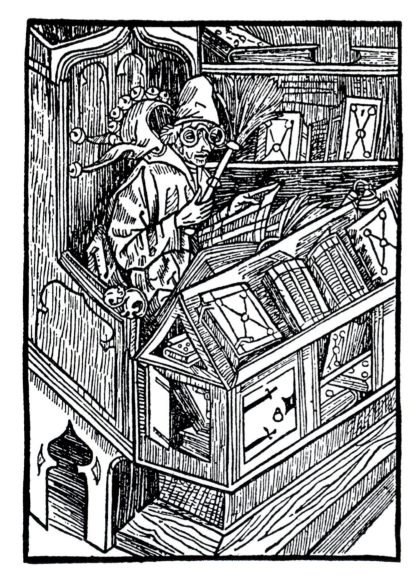

14.33. Woodcut of Scholar in Study, from Sebastian Brant, *Ship of Fools*. Published Basel, 1494

SUMMARY

For all that it depends on the past, the art of Northern Europe in the fifteenth century differs profoundly from the art of previous centuries. Out of the lingering Gothic forms preferred by the aristocracy for its books and precious objects grew a new form of art in the medium of oil painting. The paintings of Robert Campin, Jan van Eyck, and Rogier van der Weyden are exceptional not for the expense of their raw materials, but for the skill with which each painter records the natural world to enhance the spiritual experience of a viewer. The revolution in the visual arts that these artists pioneered spread all over Northern Europe and affected many different media. If we consider the fifteenth century in Northern Europe as a period of artistic and cultural flowering with great implications for the future, then this era must be called a renaissance.

COURTLY ART: THE INTERNATIONAL GOTHIC

Growing out of French Gothic styles, but also incorporating stylistic features from other parts of Europe, the International Gothic style appealed mostly to patrons in the royal courts. These aristocratic patrons commissioned luxury products based on the traditions of Gothic art, but embellished with naturalistic details. Made for elite viewers, these works often have complex and erudite imagery. The international ties among the patrons spread the style to the courts of Europe.

URBAN CENTERS AND THE NEW ART

By contrast, artists in the urban centers of the Southern Netherlands developed techniques and styles to record the natural world and create religious images that spoke directly to the middle-class patrons who commissioned them. In these images made only of wood and oil paint, sacred figures resembled real people, who had bodies with weight and texture and who expressed human emotion vividly. Portraits recorded the features of patrons with great accuracy. Details of settings or garments contribute to the realistic effect of these images, while adding symbolic meaning.

LATE FIFTEENTH-CENTURY ART IN THE NETHERLANDS

The new style of painting spread throughout the Netherlands and by 1500 had an impact on artists working in other art forms, such as manuscripts, tapestries, and sculpture. Although the courts continued to prefer these luxury arts, painting increased in stature and in patronage. International merchants purchased paintings that depicted the patrons in close contact with sacred figures. These works expressed the piety of their patrons, but also served their social ambitions.

REGIONAL RESPONSES TO THE EARLY NETHERLANDISH STYLE

Artists in other regions throughout Europe adapted the technical and stylistic innovations of the Netherlands. The French preference for geometric order and clear design combined with this naturalistic style to produce somber and meditative images, while Spanish artists made more dramatic and expressive images. In Central Europe, artists extended the naturalistic style to include specific local settings for sacred stories, bringing the religious lessons ever closer to a viewer.

PRINTING AND THE GRAPHIC ARTS

Born in Northern Europe, the new technology of printmaking contributed to the spread of these variations on Netherlandish naturalism. Early prints in woodcut and engraving borrowed motifs and compositions from painters, which they had to translate into strictly linear elements. By the end of the century, however, printmakers made original compositions with great skill that competed with the naturalism of painting.

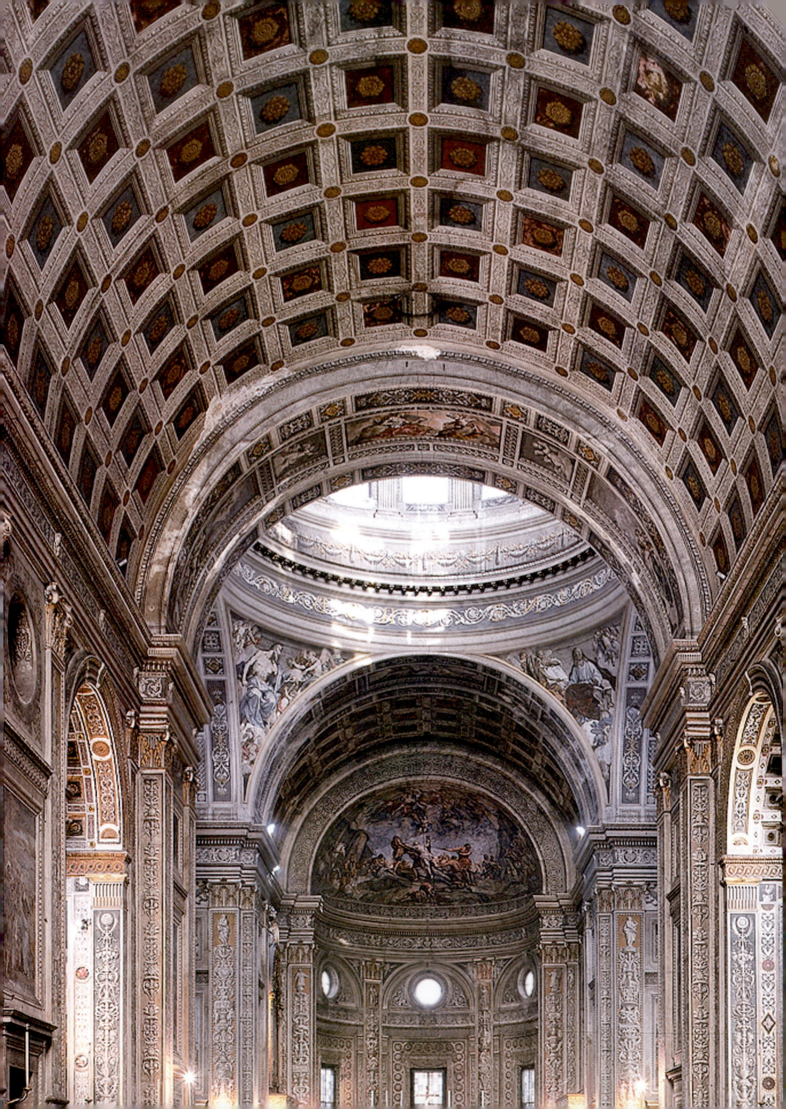

The Early Renaissance
in Fifteenth-Century Italy

NEITHER A SCHOLAR WRITING A HISTORY OF FRANCE IN THIRTEENTH-century Paris nor a notary writing a contract in fourteenth-century Bruges could have imagined that he was living in a "middle" age; he only knew that his age followed the eras of the past. But intellectuals in fifteenth-century Italy thought of themselves as living in a *new* age, one that

was distinct from the immediate past. This consciousness of historical difference separates the thinkers of the fifteenth and sixteenth centuries from their medieval forebears. These thinkers devalued the post-Roman, or medieval world, and believed they could improve their culture by reviving the best features of antiquity, that is, Roman and Greek culture. Their efforts, beginning in the fifteenth century in Italy, sparked a cultural flowering of great significance for the history of Europe.

First called the *rinascimento,* Italian for "rebirth," the period came to be known by its French name, the *Renaissance*. Its original users defined it as the rebirth of classical learning, literature, and art. Modern historians have divided the Italian Renaissance into stages: an early phase in the fifteenth century, the High Renaissance denoting a period of exceptional achievement, and the Late Renaissance, which is primarily a chronological term. Neither the definition of the Renaissance as the revival of Classical forms nor the chronological limits apply easily outside of Italy, but the broader definition of a Renaissance as a cultural or artistic renewal has come to apply elsewhere. In Northern Europe, as we have seen in Chapter 14, scholars and artists did not have the same dedication to reviv-

ing the ancients, though they did study the past. More significant was an economic and cultural expansion that resulted in far-reaching technical and cultural achievements.

The causes of the cultural flowering in Italy are complex, as events, people, ideas, and social shifts came together in a revolution that produced many of the characteristics of modern European civilization. (For this reason, some scholars refer to this era as the "early modern period.") This cultural shift was fundamentally an intellectual one. The followers of the fourteenth-century author Petrarch began to study texts from Greece and Rome both for their moral content and their style. They committed themselves to the *studia humanitatis*—the study of human works, emphasizing rhetoric, literature, history, moral philosophy, and art forms. Although its roots lay in the medieval university, which prized theology, this educational approach, called **humanism**, aimed to create knowledge for practical use in the world—for lawyers, bureaucrats, politicians, diplomats, and merchants. Humanist education shifted intellectual activity out of Church control.

Humanist scrutiny of ancient texts not only deepened their knowledge of Latin authors, but also stimulated the study of the great Greek thinkers such as Aristotle, Plato, Euclid, and Ptolemy. Humanists' analytical approach and empirical observations encouraged new thinking in many fields, including mathematics and natural science. Studying history taught the importance of individuals acting in the world to assure their

Detail of figure 15.50, Leon Battista Alberti, *Interior of Sant' Andrea*

Map 15.1. Italy in the Renaissance

personal fame, yet also encouraged educated people to serve the common good by participating in civic life. Humanist educational ideas spread quickly throughout Italy, aided by the introduction into Italy of the printing press in 1464, which made books more widely available. Governing parties throughout Italy, whether princes, popes, or elected councils, used humanists in their bureaucracies and courts to conduct their business.

Humanist ideas affected artists as well as the patrons who hired them. As humanists studied ancient texts, artists studied ancient artworks, not just to imitate details or motifs, but to understand the principles by which ancient buildings were designed and ancient sculptures achieved their naturalism. Renaissance artists took up the ancient ideal of rivaling nature in their art, but they brought their practical skills to this intellectual aim. They devised techniques such as perspective and mastered new technologies like oil painting and printmaking to further their goal of reproducing the natural world and to spread their ideas.

Artists used these ideas and techniques to make art that served spiritual and dynastic functions for their patrons. Medieval institutions—religious orders, guilds, and the Church—commissioned churches, architectural sculpture, wall

paintings, altar furnishings, and other objects as they had in earlier centuries, though secular patronage increased. The artists earned personal glory along the way, so that by the end of the century the status of the artist had changed. Through much of the Middle Ages, the social and economic position of artists in society was comparable to any other artisan. They were respected for the skill of their hands, but not considered intellectuals. Many artists in fifteenth-century Italy behaved like intellectuals, investigating the past and solving problems scientifically, so the status of the artist rose as a result.

During this period, there was no single political entity called Italy. Regions of different size and political organization competed with each other economically and often on the battlefield. The Kingdom of Naples in the south was a monarchy. Dukes, princes, and despots carved up northern Italy into city-states, including Milan, Mantua, and Urbino. The pope returned to Rome from Avignon to reclaim control of the papal states. And the major trading cities of Venice and Florence formed republics, where mercantile elites controlled political power. Though the cultural flowering we call the Renaissance occurred throughout Italy, for many modern scholars the city of Florence was its birthplace.

In Praise of the City of Florence (c. 1403–1404) by Leonardo Bruni

Though born in Arezzo, Leonardo Bruni (1370–1444) moved to Florence to take up law and humanistic studies. His mentor, Coluccio Salutati, was the Chancellor of Florence, to which post Bruni succeeded in 1406 . An ardent student of Classical literature, he modeled his own writings on those of Greek and Roman authors. He wrote this panegyric to Florence after the death of Giangaleazzo Visconti, which ended the threat to the city from Milan.

Therefore, what ornament does this city lack? What category of endeavor is not fully worthy of praises and grandeur? What about the quality of the forebears? Why are they not the descendants of the Roman people? What about glory? Florence has done and daily continues to do great deeds of honor and virtue both at home and abroad. What about the splendor of the architecture, the buildings, the cleanliness, the wealth, the great population, the healthfulness and pleasantness of the site? What more can a city desire? Nothing at all. What, therefore, should we say now? What remains to be done? Nothing other than to venerate God on account of His great beneficence and to offer our prayers to God. Therefore, our Almighty and Everlasting God, in whose churches and at whose altars your Florentines worship most devoutly; and you, Most Holy Mother, to whom this city has erected a great temple of fine and glimmering marble, where you are at once mother and purest virgin tending your most sweet son; and you, John the Baptist, whom this city has adopted as its patron saint—all of you, defend this most beautiful and distinguished city from every adversity and from every evil.

SOURCE: "PANEGYRIC TO THE CITY OF FLORENCE," TR. BENJAMIN G. KOHL IN *THE EARTHLY REPUBLIC: ITALIAN HUMANISTS ON GOVERNMENT AND SOCIETY.* (PHILADELPHIA: UNIVERSITY OF PENNSYLVANIA PRESS, 1978)

FLORENCE, CA. 1400–1430, ANCIENT INSPIRATIONS FOR ARCHITECTURE AND ARCHITECTURAL SCULPTURE

One reason for the prominence of Florence in histories of the Renaissance is that many early humanists were Florentines who patriotically praised their hometown. Florence was an important manufacturing center, a key center for trade, and a major center for international banking, whose wealth and social dynamism attracted talented individuals. Instead of hereditary aristocrats, bankers and merchants controlled the government. Groups of merchants and artisans banded together in guilds (economic and social organizations) to strengthen their positions. The governing council, called the *Signoria*, consisted of officials elected from members of the guilds and prominent mercantile families. The government was a republic, a word that for Florentines signaled their identity as the heirs of the ancient Roman Republic.

Florentine politicians, such as Coluccio Salutati and Leonardo Bruni, chancellors in succession to the *Signoria,* gave eloquent voice to Florentine aspirations. Urging the city to defy the Duke of Milan as he threatened to invade in 1401–1402, Salutati called on the city's Roman history as a model to follow. After this threat had passed, Leonardo Bruni declared that Florence had been able to defy Milan because of her republican institutions, her cultural achievements, and the origins of her people. In his *In Praise of the City of Florence* (1403–1404), he compared Florence's virtues to those of fifth-century Athens, which had defied the invading Persians. Yet he also praised Florentine piety and devotion, expressed in the building of churches. (See *Primary Source,* above.) Renaissance humanists wished to reconcile the lessons of antiquity with their Christian faith.

Bruni's words may explain why practical Florentines invested so much of their wealth on cultural activity. The *Signoria* and groups delegated by it commissioned numerous public projects to beautify and improve their city. Not only did individuals or families sponsor public projects, but so did merchant guilds who held competitions among artists for their commissions. The successful accomplishment of projects of great visibility enhanced the prestige of sponsoring individuals and groups and drew artists to the city. Many native sons (daughters were forbidden entry to the guilds, so few women became artists) became sculptors, painters, and goldsmiths. In addition to the competitions for work at the Baptistery and Duomo, awarded to Lorenzo Ghiberti and Filippo Brunelleschi, the guilds commissioned sculptures of their patron saints for the exterior niches of the centrally placed structure called Or San Michele. Among the artists who filled the niches were Donatello and Nanni di Banco.

The Baptistery Competition

Andrea Pisano's bronze doors for the Baptistery (fig. 13.14), completed in 1360, were an impressive example of Florentine taste and piety. Their success inspired the overseers of the works at the Baptistery, The Guild of Wool Merchants, to open another competition for a second set of bronze doors. Each competitor was asked to make a design on the theme of the Sacrifice of Isaac; six artists made trial reliefs for this competition, though only two of them survive. One is by Filippo Brunelleschi; the other is by Lorenzo Ghiberti (1381–1455), whom the Guild ultimately chose to execute the second doors of the Baptistery (fig. **15.1**). Ghiberti left a description of the competition, and his acclaim as the victor in his *Commentaries,* written late in his life. (See *Primary Source,* page 506).

Ghiberti's trial relief reveals the strength of his composition, his skill at rendering the human form, and his observation of natural details. The Gothic quatrefoil shape was inherited from Andrea Pisano's first doors for the Baptistery (see fig. 13.15). and presented certain design challenges. How could he fill the four lobes of the quatrefoil, yet convey the narrative succinctly and naturalistically? Ghiberti solved the problem by placing narrative details in the margins and the focal point at the center. Thus, the ram on the mountain

Lorenzo Ghiberti (ca. 1381–1455)

The Commentaries, from Book 2

Ghiberti's incomplete Commentaries *is an important early document of art history. The first book consists largely of extracts from Pliny and Vitruvius; the second is about art in Italy in the thirteenth and fourteenth centuries and ends with an account of Ghiberti's own work (fig. 15.1).*

Whereas all gifts of fortune are given and as easily taken back, but disciplines attached to the mind never fail, but remain fixed to the very end, . . . I give greatest and infinite thanks to my parents, who . . . were careful to teach me the art, and the one that cannot be tried without the discipline of letters. . . . Whereas therefore through parents' care and the learning of rules I have gone far in the subject of letters or learning in philology, and love the writing of commentaries. I have furnished my mind with these possessions, of which the final fruit is this, not to need any property or riches, and most of all to desire nothing. . . . I have tried to inquire how nature proceeds . . . and how I can get near her, how things seen reach the eye and how the power of vision works, and how visual . . . works, and how visual things move, and how the theory of sculpture and painting ought to be pursued.

In my youth, in the year of Our Lord 1400, I left Florence because of both the bad air and the bad state of the country. . . . My mind was largely directed to painting. . . . Nevertheless . . . I was written to by my friends how the board of the temple of St. John the Baptist was sending for well-versed masters, of whom they wanted to see a test piece. A great many very well qualified masters came through all the lands of Italy to put themselves to this test. . . . Each one was given four bronze plates. As the demonstration, the board of the temple wanted each one to make a scene . . . [of] the sacrifice of Isaac. . . . These tests were to be carried out in a year. . . . The competitors were . . . : Filippo di ser Brunellesco, Simone da Colle, Niccolo D'Arezzo, Jacopo della Quercia from Siena, Francesco da Valdambrino, Nicolo Lamberti. . . . The palm of victory was conceded to me by all the expects and by all those who took the test with me. The glory was conceded to me universally, without exception. Everyone felt I had gone beyond the others in that time, without a single exception, with a great consultation and examination by learned men.

. . . The judges were thirty-four, counting those of the city and the surrounding areas: the endorsement in my favor of the victory was given by all, and the by the consuls and board and the whole body of the merchants guild, which has the temple of St. John the Baptist in its charge. It was . . . determined that I should do this bronze door for this temple, and I executed it with great diligence. And this is the first work; with the frame around it, it added up to about twenty-two thousand florins.

SOURCE: CREIGHTON GILBERT, *ITALIAN ART* 1400-1500: SOURCES AND DOCUMENTS. (EVANSTON, IL: NORTHWESTERN UNIVERSITY PRESS, 1992)

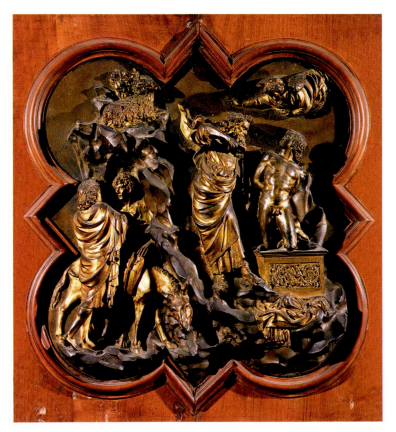

15.1. Lorenzo Ghiberti. *The Sacrifice of Isaac.* 1401–1403. Panel, gilt bronze relief. 21 × 17″ (53.3 × 43.2 cm). Museo Nazionale del Bargello, Florence

appears in the upper left and the foreshortened angel on the right. At the center, Abraham gestures dramatically as he moves to sacrifice his son, bound and naked on an altar. Isaac twists to face the spectator, his beautifully formed torso contrasting with the cascade of drapery worn by his father. A wedge of mountain keeps other figures away from the main scene. Ghiberti's design successfully combines movement, focus, and narrative. At the same time, his interest in the lyrical patterning of the International Gothic tempers the brutality of the scene. Abraham's drapery falls in cascades similar to those of the figure of Moses in Sluter's *Well of Moses* (fig. 14.2). In addition to the design, Ghiberti's entry demonstrated a technical finesse that may have persuaded the judges to select him: Unlike Brunelleschi, he cast his entry in one piece. The casting of the doors kept Ghiberti's workshop busy for 20 years. Many of the most sought-after artists of the next generation spent time in his shop, as he completed the doors.

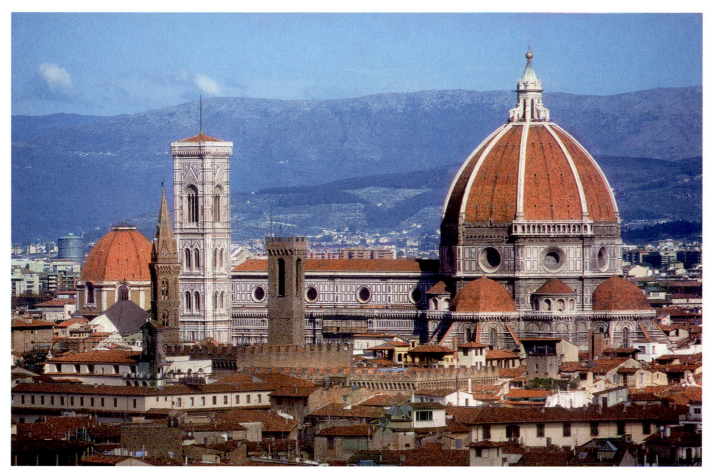

15.2. Filippo Brunelleschi. Dome of Florence Cathedral (Santa Maria del Fiore). 1420–1436. 100′ high (35.5 m), 459′ diameter (140 m)

Brunelleschi and The Dome of the Florence Cathedral

After losing the competition for the Baptistery doors, Filippo Brunelleschi (1377–1446) changed his artistic focus. He went to Rome with his friend, the sculptor Donatello. There he studied ancient structures and reportedly took exact measurements of them. His discovery of linear perspective (discussed later in this chapter), may well have grown out of his search for an accurate way of recording the appearance of those ancient buildings. We do not know what else he did during this period, but between 1417 and 1419 he again competed with Ghiberti, this time for the job of building the dome for the Florence Cathedral (see fig. **15.2**). The dome had been planned half a century earlier, so only details could be changed, and its vast size posed a difficult problem of construction. Brunelleschi's proposals were the fruit of his study of Gothic, Roman, Byzantine, and maybe even Persian buildings, but the building of the dome was as much a feat of engineering as of style. (See *Materials and Techniques*, page 508.) The project occupied him for most of the rest of his life. It would come to symbolize Florentine inventiveness, piety, ambition, and skill.

Soaring hundreds of feet above street level, the dome dwarfs all other structures in Florence. Resting visually on the smaller semidomes that surround the cathedral's eastern end, the ribs of the dome rise upward dramatically, terminating at a small marble cupola or lantern. Brunelleschi designed this lantern to tie the eight exterior ribs together, but it also marks the crescendo of that upward movement. When the cathedral was dedicated on March 25, 1436, the city rejoiced. Florence had demonstrated its devotion to the Virgin Mary, as well as its ambition to overawe its neighbors culturally. Florentines were justifiably proud that a native son had so cleverly accomplished what previous generations had not. Brunelleschi's forms would influence architecture far beyond Tuscany.

Donatello and Nanni di Banco at Or San Michele

While work continued on the dome of Florence Cathedral, another competition played out nearby at Or San Michele. Begun in 1337, this structure served both as a granary and a shrine holding a locally venerated image of the Virgin and Child. The guilds of Florence oversaw the building, with each one taking responsibility for filling a niche on the exterior with sculpture. In 1406, the city set a deadline to complete this work within 10 years. In the decades that followed, the guilds and the sculptors they commissioned competed intensely to create impressive statues of their patron saints. The major guilds commissioned Lorenzo Ghiberti to execute several statues for Or San Michele, while some younger sculptors won commissions from less-powerful guilds.

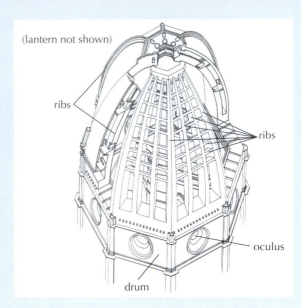

Caption: Isometric view of Brunelleschi's dome. (Drawing by P. Sanpaolesi)

Labels: (lantern not shown), ribs, ribs, oculus, drum

Brunelleschi's Dome

As the basic dimensions and plans for the Cathedral of Florence had been established in the fourteenth century, Brunelleschi first determined to lift the dome on a drum above the level of the nave in order to reduce the weight on the walls. Brunelleschi proposed to build the dome in two separate shells, which was a method more common in Islamic than Italian architecture, especially employed in Persia. Compare the fourteenth-century tomb of the Il-Khan Oljeytu in Sultaniya, Iran (fig. 9.21). These two shells were supported by a series of ribs, eight of them visible on the exterior but others hidden; the vertical ribs were themselves linked by rows of horizontal ribs, a system which may have been inspired by the coffered dome of the Pantheon (see fig. 7.43). Both the use of ribs and the pointed profile reflect Gothic practice. The dual shells of the dome lighten the whole mass since their walls are thin relative to their size. Brunelleschi's brickwork in a herringbone pattern serves both to resist cracks caused by settling and to lessen the weight as the courses of brick get thinner as they rise.

Along with these design features, Brunelleschi proposed innovations in the construction process. The traditional practice had been to construct a wooden centering across the span of the dome to support it during construction, but this required huge pieces of timber. Instead of a centering, Brunelleschi designed new a system by which temporary scaffolding was cantilevered out from the walls of the drum, thereby reducing the size and amount of timber needed during building. And instead of having building materials carried up on ramps to the required level, he designed new hoisting machines. Brunelleschi's entire scheme reflects a bold, analytical mind that was willing to discard conventional solutions if better ones could be devised.

Among them was Ghiberti's former assistant Donatello (1389–1466). Between 1410 and 1417, Donatello carved the *St. George Tabernacle* (fig. **15.3**) for the Guild of Armorers. The niche for the figure is so shallow that the figure seems poised to step out of it. Although dressed in armor, he appears able to move his limbs easily. His stance, with the weight placed on the forward leg, suggests he is ready for combat. (Originally, the right hand held a real sword or lance, and he wore a real helmet, effectively showcasing the guild's wares.) The controlled energy of his body is reflected in his eyes, which seem to scan the horizon for the enemy. St. George is portrayed as the Christian soldier spiritually akin to the St. Theodore at Chartres (see fig. 12.24) and to other figures of chivalry.

Below *St. George*'s niche a relief panel shows the hero's best-known exploit, the slaying of a dragon. (The woman on the right is the princess whom he had come to free.) Here Donatello devised a new kind of relief that is shallow (called **schiacciato**, meaning "flattened-out"), yet he created an illusion of almost infinite depth. In this relief, the landscape behind the figures consists of delicate surface modulations that catch light from varying angles. Every tiny ripple has a descriptive power that is greater than its real depth. The sculptor's chisel, like a painter's brush, becomes a tool for creating shades of light and dark. The energetic figure of the saint on horseback, battling the dragon in the foreground, protrudes from this atmospheric background, while the princess watches. The whole work becomes an image of watchfulness and preparedness for danger.

The Linen Weaver's guild also turned to Donatello to fill their niche with a figure probably completed in 1413 (fig. **15.4**). Their patron, *St. Mark*, stands almost 8 feet high, but that is only one of the features that makes him so imposing. His large, powerful hands grip a book, most likely his Gospel. His body stands in a pose Donatello learned from studying the art of the ancients: One leg is flexed while the other holds the body's weight in a *contrapposto* stance (see fig. 5.29, the *Kritios Boy*). St. Mark's drapery falls in deep folds to reveal and emphasize his posture.

Donatello treats the human body as an articulated structure, capable of movement, and its drapery as a separate element that is based on the shapes underneath rather than on patterns and shapes imposed from outside. Following Classical precedents such as the *Doryphoros* (see fig. 5.33), Donatello carefully balances the composition, so the elements on the left (as a viewer sees it) stress the vertical and the static, while those on the right emphasize the diagonal and kinetic. The deeply carved eyes and undulating beard of the saint maintain control over the whole figure, while the mass of drapery reminds the viewer of the Linen Weavers' products. This work reflects Donatello's deep understanding of the principles that guided the artists of antiquity and his commitment to them. St. Mark reveals what Donatello learned from studying ancient works of sculpture: an emphasis on naturalistic form, the independence of body and drapery, a balanced but contrasting composition, the potential for movement, and psychological presence.

Not only did the guilds compete through these projects, but the artists themselves stimulated each other to new efforts. Donatello's work must have been a revelation to his contemporaries. The Guild of Wood and Stone Carvers hired Nanni di Banco (ca. 1380–1421) to fill their niche at Or San Michele with an image of the Four Crowned Saints, called the *Quattro Coronati* (fig. **15.5**). Carved between 1409 and 1416/17, these figures represent four Christian sculptors who were executed for refusing to carve a pagan statue ordered by the Roman emperor Diocletian. The life-sized saints stand in a Gothic niche as if discussing their impending fate. Their bodies seem to spill out

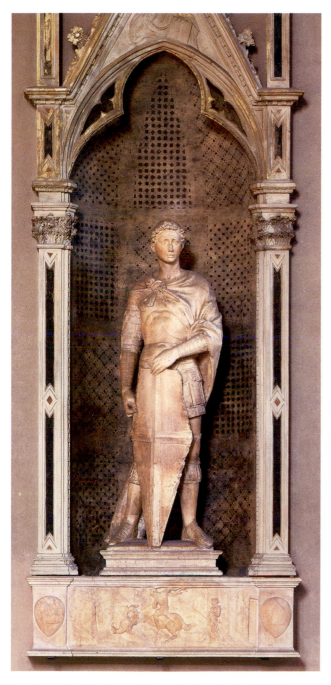

15.3. Donatello. *St. George Tabernacle,* from Or San Michele, Florence. ca. 1410–1417. Marble, height of statue 6'10" (2.1 m). Relief 15 ¼ × 47¼" (39 × 120 cm). Museo Nazionale del Bargello, Florence

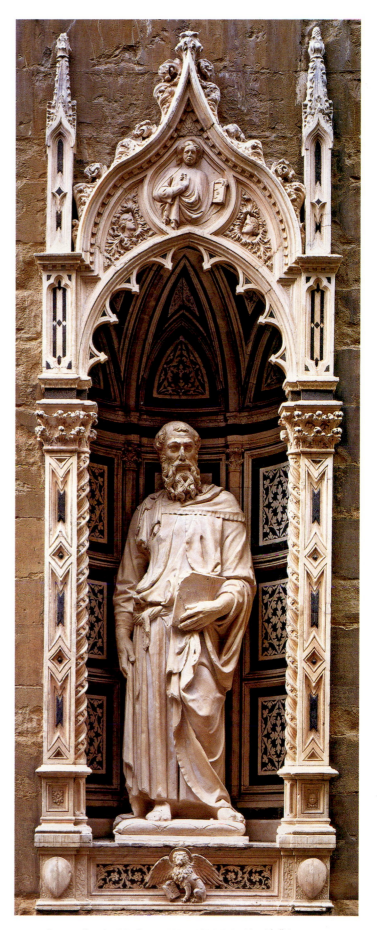

15.4. Donatello. *St. Mark.* ca. 1411–1413. Marble, 7'9" (2.4 m). Or San Michele, Florence (now Museo di Or San Michele, Florence)

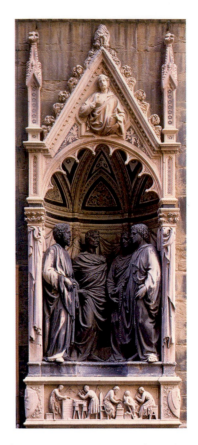

of the confines of the niche, draped as they are in the heavy folds of their togas. These garments and the heads of the second and third of the *Coronati* directly recall Roman portrait sculpture of the first century CE (see fig. 7.12). It is as if Nanni were situating the martyrs in their historical moment. His figures emulate the Roman veristic style (fig. 7.11) and monumentality. The relief below the saints represents sculptors at work, both explaining the story of the martyrs and advertising the skills of the patrons who commissioned the work.

Brunelleschi's Ospedale degli Innocenti

Another guild in Florence sponsored a different sort of public work for the city, intended to address a social problem. The Guild of Silk Manufacturers and Goldsmiths hired Filippo Brunelleschi to design a hospital for abandoned children near the church of Santissima Annunziata. In 1421, construction began on the Ospedale degli Innocenti (Hospital of the Innocents), although building continued long after Brunelleschi's death. The facade of the hospital (fig. **15.6**) consists of a covered walkway, or **loggia**, defined by an arcade raised slightly above ground level. A strong horizontal molding sits above the arcade, and above that is a simple arrangement of pedimented windows.

15.5. Nanni di Banco. *Quattro Coronati (Four Saints).* ca. 1409–1416/17. Marble, 6′ (1.83 m). Or San Michele, Florence (now Museo di Or San Michele, Florence)

In designing this structure, Brunelleschi revived the architectural forms of the ancients, as seen in the columns, their capitals, the arches, and the entablatures. Doing so demanded that he work within rigid rules for designing these elements. Unlike a medieval column, a Classical column is strictly defined; its details and

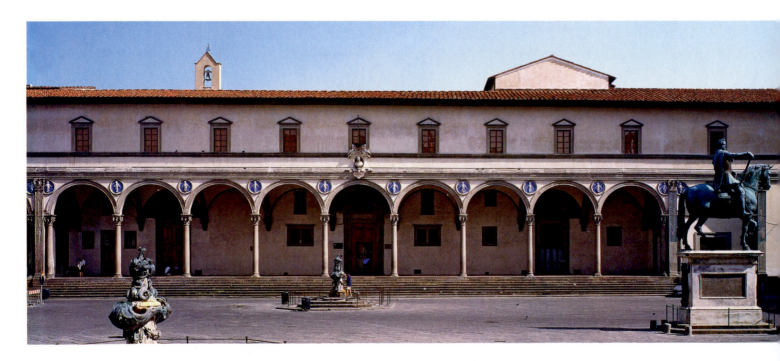

15.6. Filippo Brunelleschi. Ospedale degli Innocenti (Hospital of the Innocents) Florence. Begun 1421

Leon Battista Alberti

From *Treatise on Architecture, 1452*

Modeled on Vitruvius' treatise on architecture from the first century CE, Treatise on Architecture *was completed in 1452 but not published until 1485, after Alberti's death.*

The most expert Artists among the Ancients were of [the] opinion that an Edifice was like an Animal, so that in the formation of it we ought to imitate Nature. It is manifest that in those [animals] which are esteemed beautiful, the parts or members are not constantly all the same, but we find that even in those parts wherein they vary most, there is something inherent and implanted which tho' they differ extremely from each other, makes each of them be beautiful. But the judgment which you make that a thing is beautiful, does not proceed from mere opinion, but from a secret argument and discourse implanted in the mind itself. There is a certain excellence and natural beauty in the figures and forms of buildings, which immediately strike the mind with pleasure and admiration. It is my opinion that beauty, majesty, gracefulness and the like charms, consist in those particulars which if you alter or take away, the whole wou'd be made homely and disagreeable. There is something which arises from the conjunction and connection of these other parts, and gives the beauty and grace to the whole: which we will call Congruity, which we may consider as the original, of all that is graceful and handsome. Wherever such a composition offers itself to the mind either by the conveyance of the sight, hearing, or any of the other senses, we immediately perceive this Congruity: for by Nature we desire things perfect, and adhere to them with pleasure when they are offered to us; nor does this Congruity arise so much from the body in which it is found, or any of its members, as from itself and from Nature, so that its true Seat is in the mind and in reason. This is what Architecture chiefly aims at, and by this she obtains her beauty, dignity and value.

SOURCE: *A DOCUMENTARY HISTORY OF ART,* VOL. I, ED. ELIZABETH GILMORE HOLT, P. 235–237

proportions can vary only within narrow limits. Unlike any other arch (horseshoe, pointed, and so forth), the Classical round arch has only one possible shape, a semicircle. The Classical architrave, profiles, and ornaments must all follow similarly strict rules. This is not to say that Classical forms are completely inflexible. But the discipline of the Greek orders, which can be felt even in the most original Roman buildings, demands regularity and discourages arbitrary departures from the norm. Using such "standardized" forms, Brunelleschi designed the facade of this hospital as a series of blocks of space of the same size, defined by the bays of the arcade. Each bay establishes a square of space that is covered by a dome resting on pendentives. Transverse arches divide the domes inside the arcade. Using contrasting colors of stone, Brunelleschi emphasizes the edges of these units of space without disrupting their rhythmic sequence.

One other principle accounts for the balanced nature of the design. For Brunelleschi, the secret of good architecture lay in choosing the "right" proportions—that is, proportional ratios expressed in simple whole numbers—for all the major measurements of a building. For example, the entablature over the columns sits at twice the height of a column for a ratio of 2:1. The ancients had possessed this secret, he believed, and he tried to discover it when he measured their monuments. What he found, and exactly how he applied it, is uncertain, but his knowledge may have been passed to Leon Battista Alberti. In his *Treatise on Architecture*, Alberti argues that the mathematical ratios that determine musical harmony must also govern architecture, for they recur throughout the universe and thus are divine in origin. (*See Primary Source*, above.) Similar ideas, derived from the theories of the Greek philosopher Pythagoras, had been current during the Middle Ages, but they had never before been expressed so directly and simply. At the Innocenti, Brunelleschi used ratios to dictate relationships: The windows are centered between the columns, the intervals between columns equal the height of the columns, the span between the columns is the distance from the column to the wall. Proportion locks the composition into a balanced whole. The arcade, with its beautifully proportioned columns supporting arches, made of a dark local sandstone called *pietra serena* (literally, "peaceful stone"), gives the facade a graceful rhythm.

Above the spandrels of the arches, terra-cotta reliefs in roundels from the della Robbia workshop depict babies, the "innocents" for whom the structure was named. Brunelleschi's Innocenti not only served Florence's poor, it defined a public square. This loggia establishes one side of a piazza perpendicular to the Church of the Annunziata; it was ultimately closed by the facades of other buildings on the square. Such public spaces were used for social, religious, and political functions, and by echoing the design of the Roman forum, they expressed the Florentine sense of themselves as the heirs to Rome.

In the revival of classical forms, Renaissance architecture found a standard vocabulary. The theory of harmonious proportions gave it a syntax that had been mostly absent in medieval architecture. Similarly, the revival of Classical forms and proportions enabled Brunelleschi to transform the architectural "vernacular" of his region into a stable, precise, and coherent system. Brunelleschi's achievement placed architecture on a firm footing and applied the lessons of Classical antiquity for modern Christian ends. Furthermore, his study of the ancients and his practical application of Classical geometric proportions probably stimulated his discovery of a system for rendering forms in three dimensions. This technique became known as linear or scientific perspective. (See *Materials and Techniques*, page 513.)

CHAPELS AND CHURCHES FOR FLORENTINE FAMILIES, 1420–1430

The building projects in Florence went beyond the cathedral and civic institutions such as the Innocenti. Private patrons and elite families contributed to the flowering of architecture and

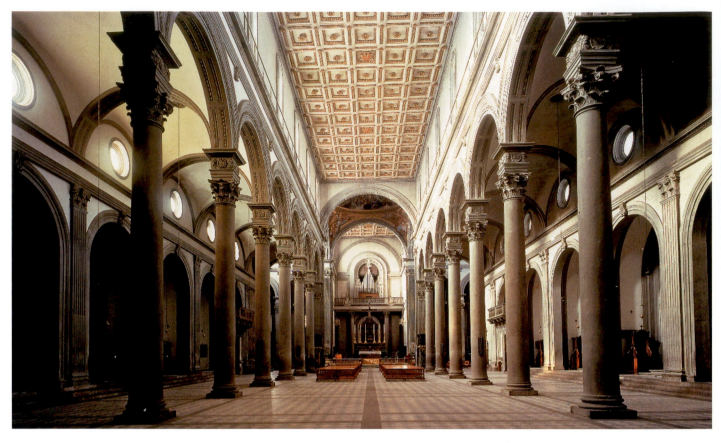

15.7. Filippo Brunelleschi. Nave of San Lorenzo, Florence. ca. 1421–1469

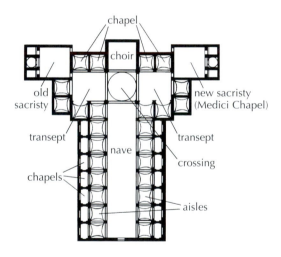

15.8. Plan of San Lorenzo.

other arts in Florence by sponsoring churches and chapels throughout the city. Donors often made such commissions for pious reasons, as endowing funerary chapels assured perpetual masses for the souls of deceased family members. But making substantial gifts to neighborhood churches elevated the donor's social prestige as well. The fortunes of Florentine families may be mapped by their sponsorship of such projects. (See *The Art Historian's Lens*, page 518.)

The Medici family's interest in their parish church, San Lorenzo, led to Brunelleschi's transformation of that structure. The family's bitter rivals, the Pazzi, hired the same architect to build at the Franciscan church of Santa Croce. The Strozzi family built their chapel at Santa Trinità, and turned to Gentile da Fabriano to provide an altarpiece. At both Santa Maria Novella and at the Church of Santa Maria delle Carmine, the young Masaccio found employment in painting frescoes for other prominent families. These artists contributed to the remaking of Florence in the early fifteenth century, and to the revolutionary new style of art that was born there.

Brunelleschi at San Lorenzo

Early in the fifteenth century, the Medici were involved in a project to rebuild their parish church. In 1419, Giovanni di Bicci de' Medici commissioned Brunelleschi to add a sacristy to the Romanesque church of San Lorenzo. The structure would also serve as a burial chapel for the Medici. The family was so pleased with his plans for this sacristy that they asked Brunelleschi to develop a new design for the entire church. Brunelleschi's work began in the 1420s, but construction proceeded in fits and starts; the nave was not completed until 1469, more than 20 years after the architect's death. (The exterior remains unfinished to this day.) Nevertheless, the building in its present form is essentially what Brunelleschi had envisioned about 1420, and it represents the first full statement of his architectural aims (figs. **15.7** and **15.8**).

Perspective

One of the transformative inventions of the Renaissance was linear, or scientific, perspective, sometimes called one-point or center-point perspective. The system is a geometric procedure for projecting the illusion of space onto a two-dimensional surface. Its central feature is the **vanishing point**, a single point toward which any set of parallel lines will seem to converge. If these lines are perpendicular to the picture plane, their vanishing point will be on the horizon. (Such lines are called **orthogonals**.) To further clarify the space, lines parallel to the picture plane, called **transversals** (not shown), are laid in at regular intervals, derived geometrically.

how the forms looked to them, sometimes with excellent results, as in Van Eyck's The "Arnolfini" Portrait (fig 14.16).

In Early Renaissance Italy, **scientific perspective** systematized the projection of space using mathematics and geometry, overturning the intuitive perspective practices of the past. This "scientific" approach to making images (whether paintings, prints, drawings, or reliefs) became an argument for upgrading the fine arts to become one of the liberal arts. In 1435, Brunelleschi's discovery was described in On Painting by Leon Battista Alberti, the first Renaissance treatise on painting. It is a standard element of drawing instruction to this day.

One advantage of this technique is that the artist can adjust the perspectival system to account for the presence of a spectator. The method presupposes that a beholder's eye occupies a fixed point in space, so that

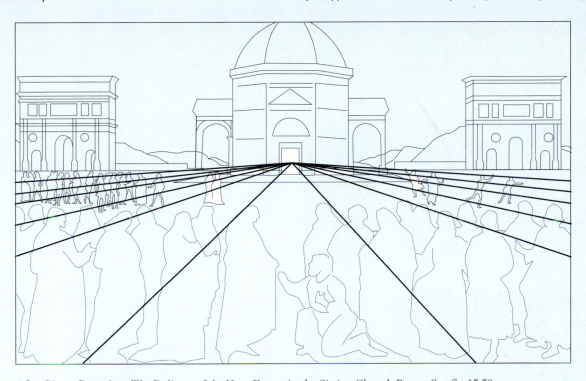

After Pietro Perugino, *The Delivery of the Keys*, Fresco in the Sistine Chapel, Rome. See fig 15.59

Brunelleschi is said to have developed this tool, but at least since the time of the ancients, artists had experimented with techniques to create the illusion of depth on a flat surface. At Pompeii, wall painters sometimes used color to suggest deep space (see fig. 7.55), a technique known as atmospheric or aerial perspective. This method recognizes the eye's inability to perceive color at great distances, and that specific colors become light blue or gray at the horizon line. In addition, the forms themselves often become less clear. (See the lower section of Van Eyck's *Ghent Altarpiece*, fig. 14.11.) Artists also adjusted spatial elements according to

a perspective picture dictates where the viewer must stand to see it properly. Thus the artist who knows in advance that the image will be seen from above or below, rather than at ordinary eye level, can make the perspective construction correspond to these conditions. (See, for example, fig. 15.59.) Sometimes, however, these vantage points are so abnormal (as when a viewer is looking up at an image on the ceiling) that the design must be foreshortened to an extreme degree. In such cases, the artist may create an "ideal beholder" for the image, regardless of a spectator's actual viewpoint.

At first glance, the plan may not seem very novel. Like Cistercian Gothic churches, it terminates in a square east end and eschews ornament (see fig. 13.1), while the unvaulted nave and transept recall Franciscan churches like Santa Croce (see fig. 13.6). Brunelleschi was constrained by the just completed sacristy and the preexisting church. But a new emphasis on symmetry and regularity distinguishes his design for San Lorenzo, accompanied by architectural elements inspired by

the past but organized by attention to proportion, as he had done at the Innocenti. The ground plan demonstrates Brunelleschi's technique of composing with units of space in regular square blocks, so that each bay of the nave is twice as wide as its side aisles, and the crossing and apse are each four times the size of each aisle.

Inside, static order has replaced the flowing spatial movement of Gothic church interiors, such as Chartres (fig. 12.12).

The Theoretical Treatise

The humanist ideal of studying the past to inform the present inspired the writing of treatises on many subjects during the Renaissance. Such primary documents articulate the theoretical concerns shared by artists and Humanists and assist art historians in interpreting works of art from the period. One such treatise provided painters of Masaccio's generation with a theoretical and practical guide to the new techniques of painting. Its author, Leon Battista Alberti (1404–1472), was both a priest and a man of the world. The son of a powerful Florentine family that had been exiled from the city, he was born and raised in Genoa. After studying law, he entered the papal court in Rome and spent the rest of his career in the Church. Alberti was interested in many subjects, including moral philosophy (his treatise "On the Family" was begun 1432) and geography. A treatise he finished around 1435 lays out rules for surveying and mapping that were widely used during the Renaissance.

During a visit to Florence in the 1430s, Alberti became acquainted with the leading artists of his day. As a result, he authored the first Renaissance treatises on sculpture (ca. 1433) and painting (ca. 1435). *On Painting* (which is dedicated to Brunelleschi, refers to "our dear friend" Donatello, and praises Masaccio) includes the first systematic treatment of linear perspective. During a stay at the court of Ferrara in 1438, Alberti was asked to restore Vitruvius' treatise on architecture, then known in various manuscripts. Upon his return to Rome five years later, he began a systematic study of the monuments of ancient Rome that led to the *Ten Books on Architecture* (finished 1452 and published 1485)—the first book of its kind since Vitruvius' treatise, on which it is modeled. (See *Primary Source*, page 511.) Alberti's writings helped to spread Florentine innovations through Italy and increased the prestige of Florentine artists as well. It brought him important commissions as an architect.

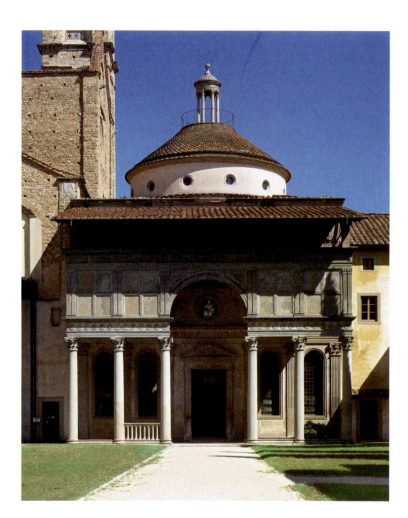

15.9. Filippo Brunelleschi and others. Pazzi Chapel, Santa Croce, Florence. Begun 1442–1465

From the portal, a viewer can clearly see the entire structure, almost as if looking at a demonstration of scientific perspective. The effect recalls the "old-fashioned" Tuscan Romanesque, such as Pisa Cathedral (see fig. 11.34), as well as Early Christian basilicas like Santa Maria Maggiore in Rome (compare with fig. 8.15). To Brunelleschi, these monuments exemplified the church architecture of antiquity. They inspired his use of round arches and columns, rather than piers, in the nave arcade. Yet these earlier buildings lack the lightness and clarity of San Lorenzo; their columns are larger and more closely spaced, so that they tend to screen off the aisles from the nave.

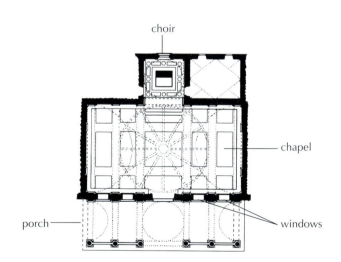

15.10. Plan of the Pazzi Chapel

Only the blind arcade on the exterior of the Florentine Baptistery is as graceful in its proportions as San Lorenzo's, but it has no supporting function (see fig. 11.35). Since the Baptistery was thought to have once been a Classical temple, it was an appropriate source of inspiration for Brunelleschi and for the new generation of Medici patrons.

Brunelleschi at Santa Croce: The Pazzi Chapel

Other families in Florence tapped Brunelleschi for architectural projects, including the aristocratic Pazzi. This family hired Brunelleschi to design a chapel adjacent to the Franciscan church of Santa Croce. Construction began on this chapel (fig. **15.9**) around 1442 and continued until 1465, so the extent of Brunelleschi's participation in the final elements has been controversial. For example, neither the portico nor

the facade in their present form may reflect his design. The plan (fig. **15.10**) shows us that the porch has two barrel vaults, which help to support a small dome, an arrangement that echoes the interior. But the porch blocks light from entering the four windows that Brunelleschi designed for the entry wall of the chapel, suggesting that a later architect altered his original plan.

The interior of the chapel, however, seems to be pure Brunelleschi. The rectangular space is roofed with two barrel vaults on either side of a dome on pendentives. On the interior, this dome sports 12 ribs articulated in Brunelleschi's favorite gray stone, *pietra serena*. The same stone marks each intersection of planes, the roundels that now hold sculpture, the square panels that define the barrel vaults, and the Corinthian pilasters that divide the wall surfaces (fig. **15.11**). Brunelleschi chose capitals and pilasters of a strong Roman character. A second dome on pendentives, half the diameter of the first, covers the square space housing the altar. As in the Ospedale degli Innocenti, proportion controls the design elements. The aim here seems to be to create a centrally planned space out of what is a fundamentally longtitudinal plan, and the intersections of circles and squares are carefully orchestrated by Brunelleschi to combine them into a rational and calm interior.

The restrained use of color and sculpture in the chapel add to the stable effect. The most colorful elements in the room are the large roundels with terra-cotta reliefs of the evangelists in the pendentives of the central dome. These may have been designed by Brunelleschi himself. On the walls are 12 smaller reliefs of the apostles, which Vasari attributed to Luca della Robbia and his shop (see fig. 15.24). Yet the sculptural elements are totally subordinate to the architecture.

The Strozzi Family, Santa Trinità, and Gentile da Fabriano

Building chapels was the mark of a great family. In addition to mendicant churches, chapels were commissioned for parish churches, such as the Gothic church of Santa Trinità. Here the sacristy was endowed by the Strozzi, one of the wealthiest families in Florence. To complete the program, Palla Strozzi commissioned Gentile da Fabriano to paint the altarpiece, *The Adoration of the Magi*, which Gentile signed and dated in 1423

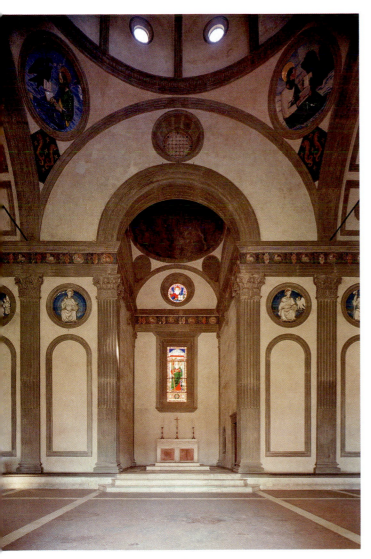

15.11. Filippo Brunelleschi and others. Interior of the Pazzi Chapel

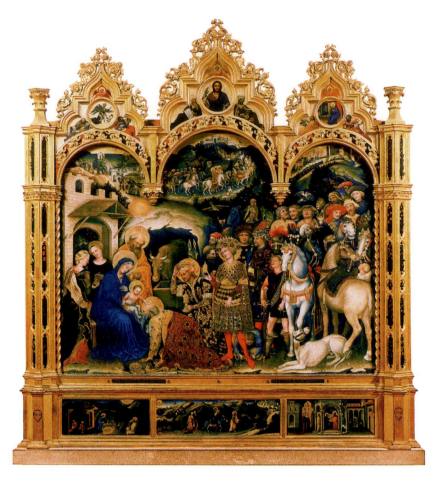

15.12. Gentile da Fabriano. *Adoration of the Magi*. 1423. Tempera on panel, 9'10" × 9'3" (3 × 2.82 m). Galleria degli Uffizi, Florence

(fig. **15.12**). Gentile (ca. 1385–1427) worked throughout Northern Italy in a style informed by some of the same characteristics as the International Gothic in Northern Europe. The lavish, triple-arched gilt frame of the altarpiece, with a **predella** (the base of the altarpiece) and gable figures, encloses a single scene in the central panel: the visit of the Magi to Bethlehem to acknowledge the newborn Jesus as King. A cavalcade of richly dressed people, as well as horses, dogs, and exotic animals (monkeys, leopards, and camels) fills the front plane of the picture as the three kings advance to venerate the child, who sits in his mother's lap to the left. Behind the stable and rock formations that define the frontal plane, the landscape winds upward into the arches of the frame. And in those distant vistas appear the Magi wending their way to Bethlehem; towns and castles mark their route. So despite the apparently unified landscape, several episodes of the narrative appear in the center panel. Other moments in the story—the Nativity, the Flight into Egypt, the Presentation in the Temple—appear in the predella. Small images in the gable above the center panel start the story off with images of the Annunciation.

Gentile's altarpiece imagines the events of the Magi's visit in courtly and sumptuous terms. Not only is the image full of elegant figures, garbed in brilliant brocades and surrounded by colorful retainers, but the panel also shines with gold leaf and tooled surfaces. (The haloes of the Virgin and St. Joseph bear pseudo-kufic inscriptions, attesting to Gentile's contact with Islamic works, probably in Venice.) The kings, also given halos, stand not only for the international acknowledgement of Christ's divinity, but for the three ages of man: youth, middle age, and old age. The artist crowds the space—the festive pageant almost overwhelms the Holy Family on the left—with men and beasts, including some marvelously rendered horses. Despite this crowding, a golden light unites the whole image, illuminating the bodies of the animals, the faces of the humans, and parts of the landscape. These forms are softly modeled to suggest volume for the figures and to counteract the strong flattening effect of all the gold. The predella scene of the Nativity (fig. **15.13**) demonstrates this aspect of Gentile's art further, as it stresses the function of light over line to delineate the forms. What is more, the source for the light that models the figures and the shed in the predella is the mystical light emanating from the Child himself. Gentile's picture reveals his awareness of light as a carrier of meaning.

Masaccio at Santa Maria Novella

Gentile's refined style made him very popular among aristocratic patrons throughout Italy, but it was his approach to light that would strongly influence younger painters. One such artist was Masaccio (Tommaso di Ser Giovanni di Mone

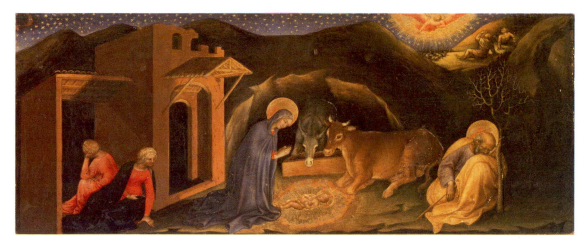

15.13. Gentile da Fabriano, *The Nativity*. Detail of *Adoration of the Magi*, from the predella. 1423. Tempera on panel, 12¼ × 29½″ (31 × 75 cm)

Cassai, 1401–1428). Leon Battista Alberti, a contemporary of Masaccio, celebrated the young painter's work in his treatise "On Painting," finished around 1435. (See *The Art Historian's Lens*, page 514.) Vasari noted that many sixteenth-century artists admired Masaccio, but nonetheless, in the 1560s, he covered up one of Masaccio's most famous works in Santa Maria Novella (fig. **15.14**) when he remodeled the church. Ultimately, this action probably saved Masaccio's work, but much about its commissioning and meaning are still hidden.

Because the fresco originally stood in front of a tomb slab for the Lenzi family, many scholars have concluded that this was the family who commissioned Masaccio to paint the fresco depicting the Holy Trinity in the company of the Virgin, St. John the Evangelist, and the two donors. The lowest section, linked with a tomb below, depicts a skeleton lying on a sarcophagus. The inscription (in Italian) reads, "What I once was, you are; what I am, you will become." With its large scale, balanced composition, and sculptural volume, the style suggests the art of Giotto (figs. 13.20–13.21). Giotto's art was a starting point for Masaccio, though in Giotto's work, body and drapery form a single unit, where Masaccio's figures, like Donatello's, are "clothed nudes," whose drapery falls in response to the body wearing it.

The setting reveals the artist's awareness of Brunelleschi's new architecture and of his system of perspective. (See *Materials and Techniques*, page 513.) The tall pilasters next to the painted columns recall the pilasters Brunelleschi designed for the Pazzi chapel, as do the simple moldings that define the arch and the entablature of this fictive chapel. Masaccio's use of perspective gives the spectator all the data needed to measure

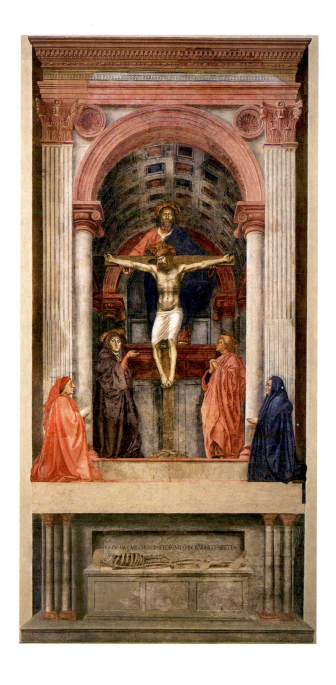

15.14. Masaccio. *The Holy Trinity with the Virgin, St. John, and Two Donors*. ca. 1425. Fresco, detached from wall. 21′10⅝″ × 10′4¾″ (6.67 × 3.17 m) Santa Maria Novella, Florence

Patronage Studies

Seeing a work of art in a museum, a modern viewer may not be aware of its original function or context, nor of the circumstances that brought it into creation. Many art historians find that an important way to investigate these circumstances is to focus on the patronage of artwork. Such studies may include finding evidence in documents indicating who paid the artist for the work; considering what role the patron may have had in determining style or subject matter; evaluating the relationship between the artist and the patron; and drawing conclusions about what the patron wanted the work of art to do.

The relationships between patron and artist in the Renaissance were varied: In princely courts, an artist could be considered a member of the household staff, with many rather mundane tasks to do, or an esteemed member of the prince's circle, with special status and prestige. In urban centers artists may have interacted with patrons on a more socially equal level, but the person buying the work of art still had a great deal to say about the finished product. In gifts made to churches, patrons might want their portraits painted into the work of art or their coat of arms prominently displayed to remind a viewer of the identity of the donor, a practice that was widespread by the end of the Middle Ages. The system of patronage in Italy was part of a larger social network. In Florence, the great families of a neighborhood were often the major patrons of large projects for the entire neighborhood (for example the Medici at San Lorenzo; the Rucellai at Santa Maria Novella). Other families or groups often allied themselves with the great families for political, social, or commercial reasons. In some cases, this resulted in works of art that represented or made reference to the great families. Artists favored by the major patrons could gain other clients among the followers of those patrons. The investigation of these issues has enhanced our understanding of the way works of art functioned in their time.

the depth of this painted interior, to draw its plan, and to envision the structure in three dimensions. This barrel-vaulted chamber is not a shallow niche, but a deep space in which the figures could move freely. The picture space is independent of the figures; they inhabit the space, but they do not create it. Masaccio used Brunelleschi's invention to create an illusion of space where none exists.

To the spectator conversant with perspective, all the lines perpendicular to the picture plane converge toward a point below the foot of the Cross, on the platform that supports the kneeling donors. To see the fresco correctly, we must face this point, which is at an eye level somewhat more than 5 feet above the floor of the church. The figures within the chamber are 5 feet tall, slightly less than life-size, while the donors, who are closer to the viewer, are fully life-size. The framework therefore is "life-size," too, since it is directly behind the donors. The chapel that opens out behind them seems to belong to the same scale: It moves backwards into space, covered by a barrel vault. That vault is subdivided by eight square coffers, an echo of the dome of the Pantheon. The space seems measurable, palpable. However, the position of God the Father is puzzling. His arms support the Cross, close to the front plane, while his feet rest on a ledge attached to a wall. How far back is this structure? If it is against the back wall, then the figure of God destroys the spatial effect. But why should the laws of perspective constrain God? Another possibility is that Masaccio intended to locate the ledge directly behind the Cross, as we can tell by the strong shadow that St. John casts on the wall below. What, then, is God standing on? Again, must natural laws apply to the Creator?

God the Father holds his son while the dove of the Holy Spirit is a further link between them. Masaccio expresses the theme of the Trinity by the triangular composition that begins with the donors and rises to the halo of God. The composition is carefully balanced by colors, too, as opposing reds and blues unite in the garment worn by God. The whole scene has a trag-ic air, made more solemn by the calm gesture of the Virgin, as she points to the Crucifixion, and by the understated grief of John the Evangelist. The reality of death but promise of resurrection is appropriate for a funerary commemoration.

The Brancacci Chapel

Even if we are uncertain about the identity of the donors for the *Trinity* fresco, we do know who paid for the largest group of Masaccio's surviving works. To fulfill a bequest from his uncle Pietro, Felice Brancacci underwrote the frescoes in the Brancacci Chapel in Santa Maria del Carmine (figs. **15.15–15.18**), which depict the life of St. Peter. Work began in the chapel around 1425, when Masaccio collaborated with a slightly older painter named Masolino (1383–ca.1440). The project was left incomplete when both artists were called away to work on other commissions. Masaccio went to Rome, where he died in 1428. The chapel was finally completed by the Florentine painter Filippino Lippi (1457/58–1504), who finished the lower tier on either side in the 1480s. These frescoes transform the space of the chapel into a display of narratives from Scripture.

The most famous of the frescoes is *The Tribute Money* by Masaccio, located in the upper tier (fig. 15.17). It depicts the story in the Gospel of Matthew (17:24–27) as a continuous narrative. In the center, Christ instructs Peter to catch a fish, whose mouth will contain money for the tax collector. On the far left, in the distance, Peter takes the coin from the fish's mouth, and on the right he gives it to the tax collector. Masaccio uses perspective to create a deep space for the narrative, but to link the painting's space to the space of a viewer, Masaccio models the forms in the picture with light that seems to have its source in the real window of the chapel. He also uses atmospheric perspective in the subtle tones of the landscape to make the forms somewhat hazy, seen as well in the *Ghent Altarpiece* by Jan van Eyck (fig. 14.11). The effect also recalls the setting

a decade earlier in Donatello's small relief of St. George (compare with fig. 15.3).

The figures in *The Tribute Money*, even more than those in the *Trinity* fresco, show Masaccio's ability to merge the weight and volume of Giotto's figures with the new functional view of body and drapery. All stand in balanced contrapposto. Fine vertical lines scratched in the plaster establish the axis of each figure from the head to the heel of the engaged leg. In accord with this dignified approach, the figures seem rather static. Instead of employing violent physical movement, Masaccio's figures convey the narrative by their intense glances and a few strong gestures. But in *The Expulsion from Paradise* just to the left (fig. 15.18), Masaccio shows the human body in motion. The tall, narrow format leaves little room for a spatial setting. The gate of Paradise is barely indicated, and in the background are a few shadowy, barren slopes. Yet the soft, atmospheric modeling, and especially the boldly foreshortened angel, convey a sense of unlimited space. Masaccio's grief-stricken Adam and Eve are striking representations of the beauty and power of the nude human form.

In contrast to the fluid grace of Gentile da Fabriano's painting (figs. 15.12 and 15.13), Masaccio's paintings represent a less beautiful reality. Nonetheless, at the Brancacci Chapel and elsewhere, Masaccio worked alongside Masolino, who had been strongly influenced by Gentile. The two painters worked well together and even collaborated on some of the frescoes. (The head of Christ in *The Tribute Money* may be by Masolino.) Nowhere is the contrast between the two artists' styles more striking than in *The Temptation* by Masolino (visible in the

ART IN TIME

- 1417—Great Schism in Catholic Church ends
- 1420—Papacy returns to Rome from Avignon
- **ca.1425—Masaccio's *Trinity* fresco in Santa Maria Novella**
- 1439—Council of Florence attempts to reunite Roman and Byzantine churches

upper right of fig. 15.16). Where Masolino's figures of Adam and Eve are serenely beautiful nudes bathed in a diffuse natural light, Masaccio's figures express powerful emotion through their sheer physicality. Before he could finish the Brancacci Chapel, Masaccio left for Rome to work on another commission; he died there at a very young age, but his work stimulated other painters to experiment with perspectival space.

THE FLORENTINE STYLE SPREADS, 1425–1450

The building of the Florence Cathedral's dome, the work on Or San Michele, and the numerous chapels being rebuilt made Florence a busy place for artists in the second quarter of the fifteenth century. The innovative works made by Brunelleschi, Donatello, and Masaccio profoundly impressed visitors from other cities by their power and authority. Through the travels of patrons and artists the new style born in Florence spread to other cities in

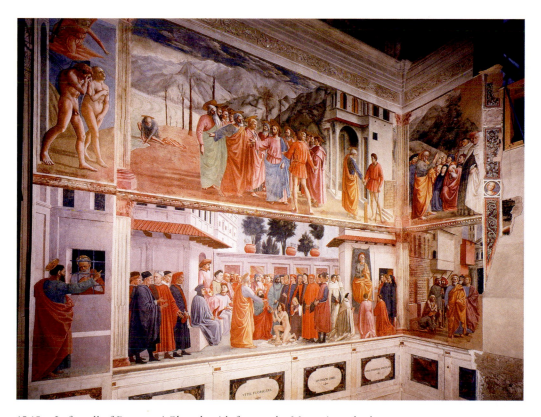

15.15. Left wall of Brancacci Chapel, with frescoes by Masaccio and others. Santa Maria del Carmine, Florence

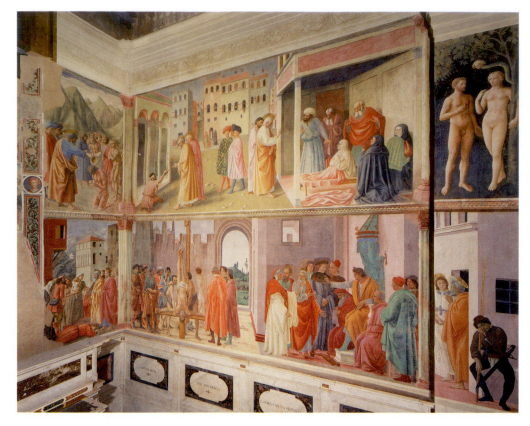

15.16. Right wall of Brancacci Chapel, with frescoes by Masaccio, Masolino, and Filippino Lippi. Santa Maria del Carmine, Florence

Italy. At first, patrons in nearby centers like Pisa and Siena hired Masaccio and Donatello, but soon patrons in more distant centers, such as Padua and Rome, sought their services.

Pisa

Little of Masaccio's work in Rome survives, but he also worked for other patrons outside of Florence. In Pisa, a nearby Tuscan city, he completed an altarpiece in many panels (a **polyptych**) in 1426 for a chapel in the Carmelite church. The surviving panels are now dispersed among various collections. The center panel (fig. **15.19**) represents the *Madonna Enthroned* in a monumental Florentine composition, first introduced by Cimabue and then reshaped by Giotto (see figs. 13.17 and 13.18). Like these earlier paintings, Masaccio's picture includes a gold ground and a large, high-backed throne with angels on each side (here only two appear). Despite these traditional elements, the painting is revolutionary in several respects. The kneeling angels in Giotto's *Madonna* have become lute players seated on the lowest step

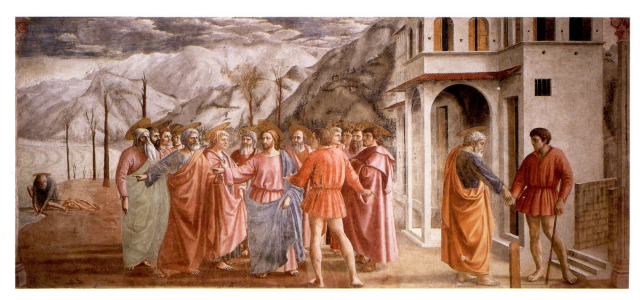

15.17. Masaccio. *The Tribute Money*. ca. 1425. Fresco. 8'1" × 19'7" (1.87 × 1.57 m) Brancacci Chapel

of half-shadows results in a rich scale of transitional hues. This light illuminates the forms, all but eliminating contour lines in the painting. As a result the figures seem like sculpture. Masaccio was only 25 when he executed this picture. His death only three years later cut short the revolutionary direction his painting was taking.

Siena

Elsewhere in Tuscany, too, Florentine artists were being noticed and were earning commissions. In 1416, Lorenzo Ghiberti assembled a group of artists to execute a new baptismal font for the Baptistery of Siena, San Giovanni. One of the panels for the sides of the hexagonal basin was assigned to

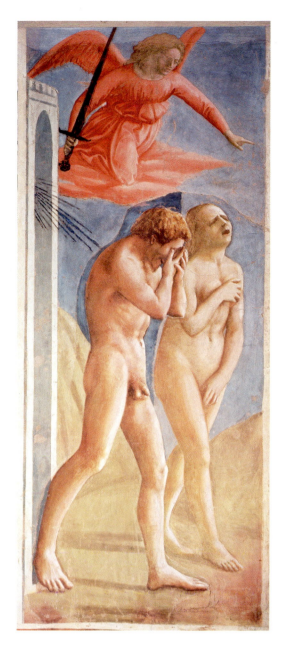

15.18. Masaccio. *The Expulsion from Paradise.* ca. 1425. Fresco. 84¼ × 10′35½″ (214 × 90 cm) Brancacci Chapel

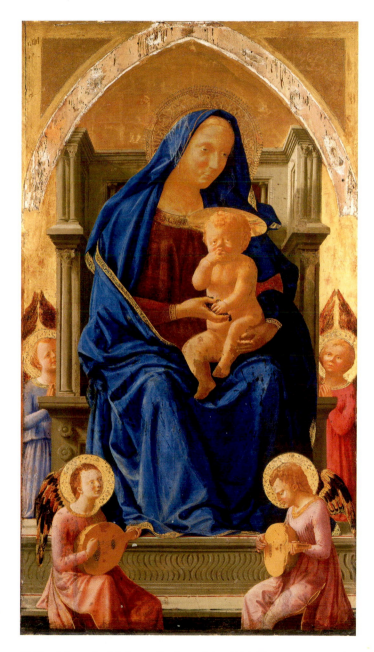

15.19. Masaccio. *Madonna Enthroned.* ca. 1426. Tempera on panel, 56 × 29″ (135 × 73 cm). The National Gallery, London
Reproduced by courtesy of the Trustees

of the throne. The garments of the solidly formed Madonna fall not in graceful cascades, but wrap around her figure like the garments of Donatello's *St. Mark.* Instead of offering a blessing, the childlike Jesus eats a bunch of grapes, referring to wine and the sacrament of the Eucharist. Above all, the powerful proportions of the figures make them much more concrete and impressive even than Giotto's. This is a convincingly human Christ Child. In light of the architecture of the *Trinity* fresco, it is no surprise that Masaccio replaces Giotto's ornate but frail Gothic throne with a solid and plain stone seat in the style of Brunelleschi, or that he makes expert use of perspective. (Note especially the two lutes.)

Adding to these elements is Masaccio's delicate yet precise rendering of the light on the surfaces. Within the picture, sunlight enters from the left, like the glow of the setting sun. He avoids harsh contrasts between light and shade; instead the use

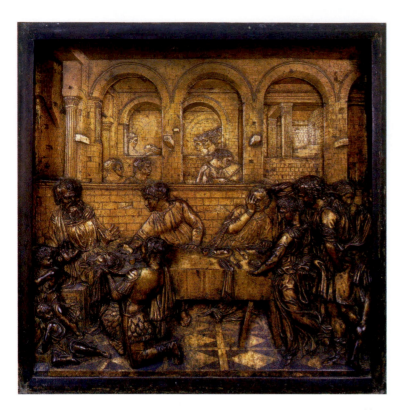

15.20. Donatello. *The Feast of Herod.* ca. 1425. Gilt bronze, 23½″ (59.7 cm) square. Baptismal font, Siena Cathedral

Padua

Donatello's successes in Tuscany led to a commission from the Republic of Venice in 1443. The commander of the Venetian armies, Erasmo da Narni (nicknamed "Gattamelata") had recently died, and Venice sought to honor him with a statue. Donatello produced his largest free-standing work in bronze: the *Equestrian Monument of Gattamelata* (fig. **15.21**), which still stands in its original position on a tall pedestal near the church of St. Anthony in Padua. Having visited Rome, Donatello certainly knew the tradition of equestrian statues exemplified by the *Marcus Aurelius* (fig. 7.23), but he also knew the medieval tradition seen in the monument of Bernabò Visconti in Milan, (fig. 13.36). Like the *Marcus Aurelius*, the *Gattamelata* is impressive in scale and creates a sense of balance and dignity. The horse, a heavy-set animal fit to carry a man in full armor, is so large that the rider must dominate it by force of personality rather than by size. Like the Visconti monument, it belongs to a tradition of representations of military leaders on horseback as funerary monuments. In this vivid portrait of a general, Donatello reenergizes this tradition by the carefully realistic depiction of the armor and fittings and the powerful characterization of Gattamelata's features.

FLORENCE DURING THE ERA OF THE MEDICI, 1430–1494

From 1434 to 1494 the Medici dominated the city of Florence. Across four generations, Medici men were active in government and in business, while Medici women contributed to the social and religious life in the city. The family's wealth came from their mercantile and banking interests and the wise political alliances they struck both within Florence and in other Italian centers. As bankers to the pope, the Medici became leaders in the Florentine pro-papal party, and ultimately became the *de facto* rulers of the city.

Their fortunes were made at the end of the fourteenth century by the shrewd investments of Giovanni di Bicci de' Medici (1360–1429). His son Cosimo (1389–1464) was involved in the factional disputes of the 1430s, resulting in his exile from the city in 1433. But in 1434 his party triumphed, and Cosimo returned as the leader of the Florentine government. Cosimo's sons Piero (1416–1469) and Giovanni followed their father's example; and Piero's son, Lorenzo, called "The Magnificent" (1449–1492), became one of the most celebrated and well-connected men of the century. In addition to creating links to other prominent families in Florence and beyond, the Medici family promoted the literary and educational innovations of Florentine humanists, and actively used works of art to express their political and social status.

Other families either allied themselves with the Medici or competed with them commercially and politically, as well as in the arena of the arts. During this time, too, the city continued to commission artistic projects to add to its luster. This period of Medici domination saw the continued development of the

Donatello, who had worked in Ghiberti's shop. He finished *The Feast of Herod* (fig. **15.20**) about 1425. This gilt bronze relief has the same exquisite surface finish as Ghiberti's panels (see fig. 15.1) but is much more expressive. The focus of the drama—the executioner presenting the head of St. John the Baptist to Herod—is far to the left, while the dancing Salome and most of the spectators are massed on the right. Yet the center is empty. Donatello created this gaping hole to add to the impact of the shocking sight, along with the witnesses' gestures and expressions. Moreover, the centrifugal movement of the figures suggests that the picture space does not end within the panel but continues in every direction. The frame thus becomes a window through which is seen a segment of deepening space. The arched openings within the panel frame additional segments of the same reality, luring the viewer farther into the space.

This architecture, with its round arches, its fluted columns and pilasters, reflects the designs of Filippo Brunelleschi. More importantly, *The Feast of Herod* is an example of a picture space using Brunelleschi's linear perspective. A series of arches set at different depths provides the setting for different figures and moments in the biblical story: In the background, we see the servant carrying the head of the Baptist which he then presents to Herod in the foreground. Donatello used perspective to organize the action as a continuous narrative, unfolding through space as well as time.

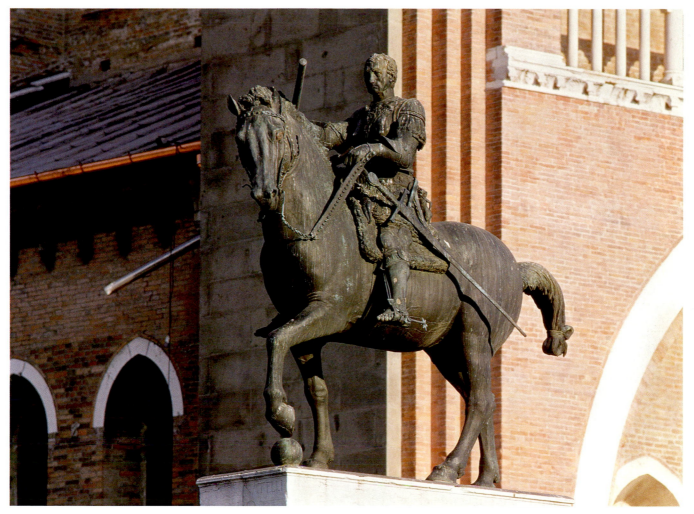

15.21. Donatello. *The Equestrian Monument of Gattamelata*. 1445–1450. Bronze, approx. 11 × 13′ (3.35 × 3.96 m). Piazza del Santo, Padua

stylistic innovations of the early fifteenth century along with new themes in art. Brunelleschian forms dominated Florentine architecture, along with the ideas and designs of Leon Battista Alberti. Sculptors of the first part of the century, including Ghiberti and Donatello, had a strong influence on younger sculptors such as Luca della Robbia, Bernardo Rossellino, Antonio Pollaiuolo, and Andrea del Verrocchio. Religious communities and churches acquired paintings for wall spaces or for altars by painters strongly influenced by the classicism and naturalism of Masaccio and the elegance of Gentile da Fabriano. For wealthy patrons with broad cultural and intellectual interests, artists developed new forms and subjects for painting and sculpture.

Sculpture and Architectural Sculpture

Ghiberti's first set of bronze doors for the Baptistery so impressed the Guild of Wool Merchants, who oversaw the building, that they commissioned him to execute a second pair. These doors, begun in 1425 but not completed until 1452, were ultimately installed in the east entry of the Baptistery, facing the cathedral; this area is called the Paradise, so the doors were

termed the "Gates of Paradise" (fig. **15.22**). The two doors each contain five large panels in simple square frames; these create a larger field than the 28 small panels in quatrefoil frames of the earlier doors. The panels depict scenes from the Old Testament, completing the program of all three doors: One door is devoted to the Life of John the Baptist, one to the Life of Christ, and one to the Old Testament. The program for these doors may have been planned by the humanist Ambrogio Traversari (1386–1439), with the input of the chancellor, Leonardo Bruni (see page 505), who prescribed that the doors should be both significant and splendid. To achieve splendor, Ghiberti completely gilded the bronze and framed the panels with figures in niches, portrait heads in roundels, and foliate decorations. Significance was achieved through the selection of themes and the clarity of the narratives.

In designing these reliefs, Ghiberti drew on the new devices for pictorial imagery he and his rivals had pioneered, including the *schiacciato* relief devised by Donatello for the St. George at Or San Michele and the linear perspective developed by Brunelleschi and employed by Masaccio. The graceful proportions, elegant stances, and fluid drapery of the figures bespeak

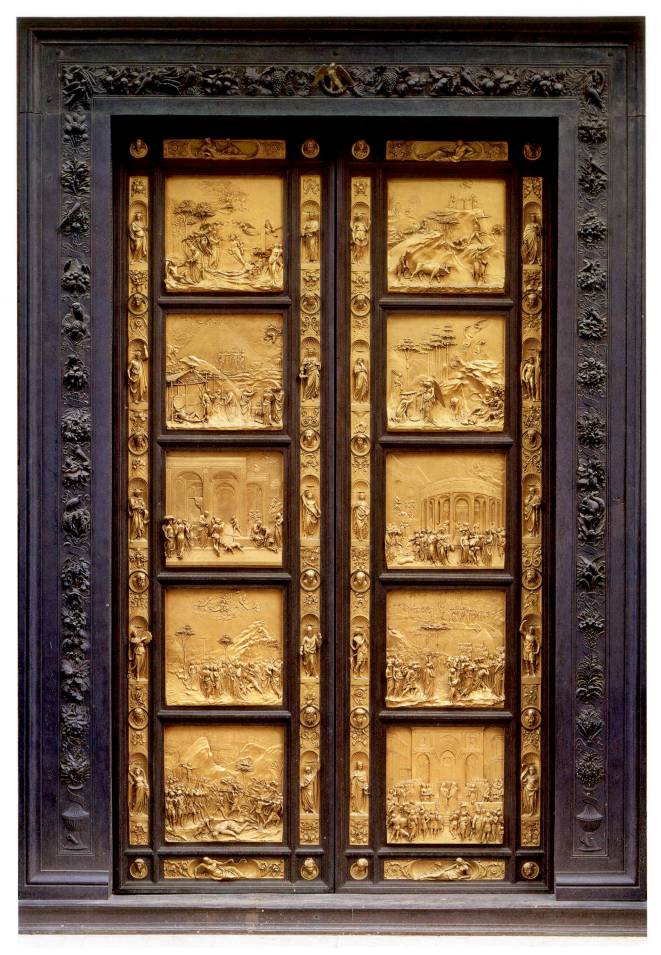

15.22. Lorenzo Ghiberti. *"Gates of Paradise."* Replica of east doors of the Baptistery of San Giovanni, Florence. 1425–1452. Gilt bronze, height 15′ (4.57 m)

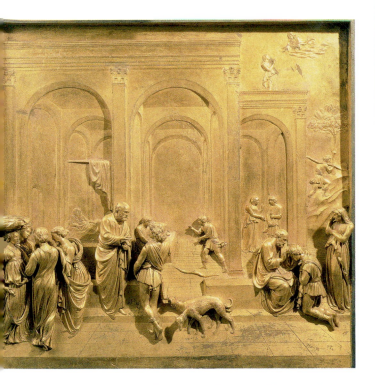

ART IN TIME

1431—Joan of Arc executed at Rouen

1437—Ca' d'Oro completed in Venice

1445—Donatello's *Equestrian Monument of Gattamelata*

15.23. Lorenzo Ghiberti. *The Story of Jacob and Esau*, panel of the "*Gates of Paradise.*" ca. 1435. Gilt bronze, 31¼″ (79.5 cm) square. Baptistery of San Giovanni

Ghiberti's own allegiance to the International Gothic style. The hint of depth seen in *The Sacrifice of Isaac* (see fig. 15.1) has grown in *The Story of Jacob and Esau* (fig. **15.23**) into a deeper space defined by the arches of a building planned to accommodate the figures as they appear and reappear throughout the structure in a continuous narrative. The relief tells the story of Isaac blessing his younger son, Jacob, instead of the elder Esau. The blind Isaac sends Esau off to hunt on the left, but confers his blessing to the disguised Jacob on the right. Isaac's preferring the younger Jacob over the older Esau foreshadowed Christianity replacing Judaism for medieval theologians. Ghiberti's spacious hall is a fine example of Early Renaissance architectural design.

The expense of the *Gates of Paradise* could not be matched for every project in the city, but the terra-cotta sculptures of Luca della Robbia (1400–1482) were an appealing and cheaper alternative. Luca covered the earth-colored clay with enamel-like glazes to mask its surface and protect it from the weather. His finest works in this technique, which include *The Resurrection,* executed to go above a door at the Duomo (fig. **15.24**), demonstrate his ambition to create legible narratives of sacred themes in the new language of antique forms. The figure of Christ dominates this composition as he floats above the sarcophagus that parallels the base of this lunette. Around the sarcophagus Luca places Roman soldiers in

15.24. Luca della Robbia. *The Resurrection.* 1442–1445. Glazed terra cotta, 5′3″ × 7′3½″ (1.6 × 2.22 m). Museo Nazionale del Bargello, Florence

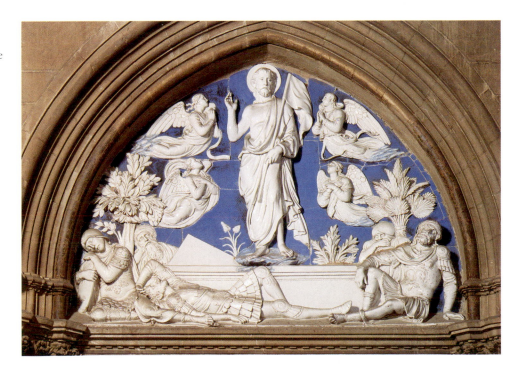

armor inspired by ancient models. The white glaze creates the effect of marble against the deep blue background of the lunette and adds to the legibility of the composition. Such inexpensive substitutes for marble and bronze carvings attracted many buyers, and the della Robbia workshop became a factory, turning out scores of small Madonna panels, altarpieces, and architectural sculpture, still visible throughout Florence and surrounding villages.

Even the most famous artists worked in less expensive materials. Although the circumstances of its commission are unclear, a powerful figure of *Mary Magdalen* by Donatello was carved sometime in mid-century. This life-sized figure (fig. **15.25**) was carved in poplar wood, painted, and gilded.

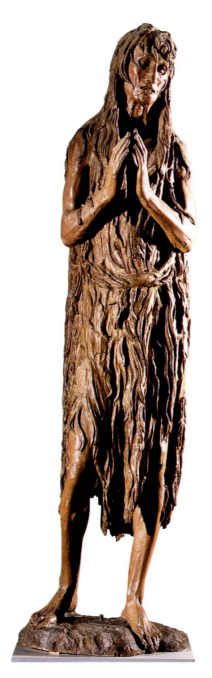

15.25. Donatello. *Mary Magdalen*. ca. 1430–1450. Polychrome and gold on wood, height 6′1″ (1.85 m). Museo dell'Opera del Duomo, Florence

Late medieval enhancements of Mary of Magdala's biography reported that she spent the last years of her life in the desert as a hermit in penitence. In his image of her, Donatello carves the soft wood into complex textures to render her rough garment and her hair, and to give her figure a gaunt, emaciated look. Her limbs and face are painted the ruddy color of someone who lives in the desert, while her hair was originally gilded. The figure has been dated from the 1430s to the 1450s. Many scholars see the *Magdalen* as a work of Donatello's old age, and thus in its spiritual intensity they chart a change of mood for the artist. In any case, the *Magdalen* demonstrates Donatello's range as a sculptor, as he explores the expressive possibilities of another sculpted medium.

A HUMANIST'S TOMB On the death of its illustrious chancellor Leonardo Bruni, the city of Florence honored him with a monument installed in Santa Croce (fig. **15.26**). This humanist and statesman had played a vital part in the city's affairs since the beginning of the century, and when he died in 1444, he received a grand funeral "in the manner of the ancients." The tomb was executed by Bernardo Rossellino (1409–1464), a sculptor from the countryside around Florence. Since Bruni had been born in Arezzo, his native town probably contributed to the project and perhaps favored another former resident, Rossellino, for the commission.

Bruni's contributions to the city as politician, historian, and literary figure forged Florentines' notions of themselves as the heirs to Roman culture, and Rossellino's design paid homage to this theme. The tomb's imagery contains many echoes of Bruni's funeral: His effigy lies on a bier supported by Roman eagles, his head wreathed in laurel and his right hand resting on a book (perhaps his own *History of Florence*). On the sarcophagus, two figures with wings hold an inscription. The only religious element appears in the lunette, where in a roundel the Madonna and Child look down at the effigy. Above the arch a heraldic lion appears in a wreath supported by angels. This symbol of Florence associates Bruni with the city he served and links the city to his goal of reviving Roman virtues.

VERROCCHIO AT OR SAN MICHELE More sculptural commissions were given at Or San Michele in the second half of the century. Sometime after 1462, a sculpture by Donatello was removed and the niche reassigned to the judges of the merchant's guild. This group hired Andrea del Verrocchio (1435–1488) to fill the niche with an image reflecting their activities, using a theme traditionally associated with justice. The architecture of the niche remained as Donatello had designed it, so Verrocchio executed the figures of *The Doubting of Thomas* (fig. **15.27**) without backs to squeeze them into the shallow space. The bronze figures stand close together, as the apostle Thomas seeks proof of the miracle of the Resurrection by probing the wound in Christ's side. Verrocchio was a painter as well as sculptor, and this sculpture shares with contemporary paintings an interest in textures, the play of light and dark in massive drapery folds, and illusionism. The niche can barely

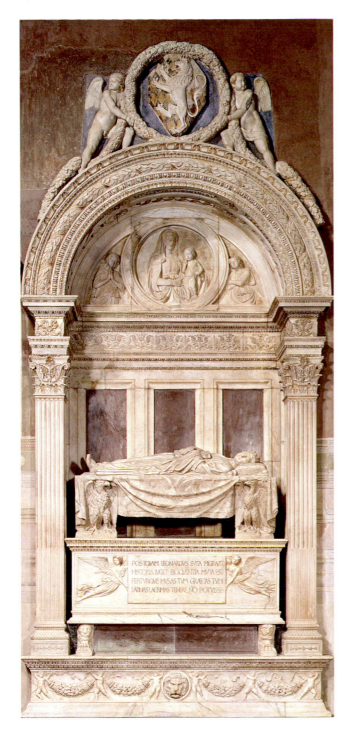

15.26. Bernardo Rossellino. *Tomb of Leonardo Bruni*. ca. 1445–1450. Marble, height 20′ (6.1 m to top of arch). Santa Croce, Florence

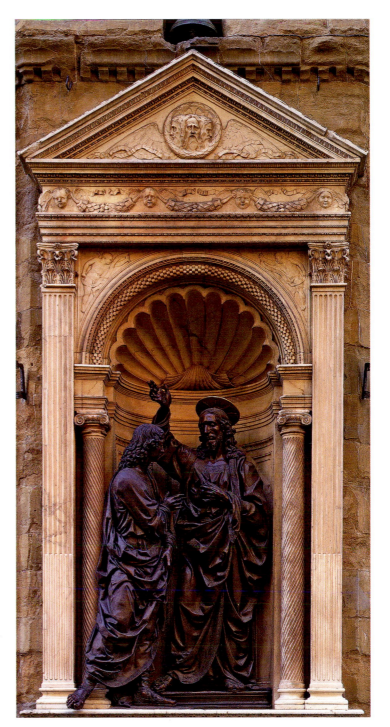

15.27. Andrea del Verrocchio. *The Doubting of Thomas*. 1467–1483. Bronze, Christ 7′6½″ (2.28 m) Thomas 6′6¾″ (2m). Or San Michele, Florence (Copy in niche)

contain the oversized figures, so Thomas's foot projects beyond the limits of the frame, linking the passerby to the scene. His body twists into the composition, leading the viewer to the gentle features of Christ. The eloquent poses and bold exchange of gestures between Christ and Thomas convey the drama of the scene. Verrocchio lets the active drapery, with its deep folds, suggest the calm of Christ and the disturbance in Thomas's mind. Michelangelo admired the *The Doubting of Thomas* for the beauty of the figures; and Leonardo da Vinci learned from his teacher, Verrocchio, to create figures whose actions express the passions of the mind.

Florentine Churches and Convents at Mid-Century

The work at the Cathedral, the Baptistery, and Or San Michele was accompanied by construction and renewal elsewhere in Florence. Throughout the city, churches and convents were rebuilt or enlarged, often with corresponding commissions for their decoration. One important feature of fifteenth-century religious life was a call to restore the practices in monasteries and convents to a stricter observance of the ancient rules of such institutions. The leaders of these observant movements often gained the admiration

and support of private citizens. Renaissance artists and their patrons wished to put the new style to work for their faith. The naturalism and spatial effects now possible could create images that spoke powerfully to believers. Perspective and other devices could connect viewers to religious stories to evoke their empathy. New ideas about proper decorum for pictures coming from the study of the classics inspired artists to create balanced compositions peopled with dignified characters. Yet not all churchmen approved of the increasingly naturalistic and classicizing forms found in religious art in the fifteenth century. The tension between Christian and Classical forms erupted at the end of the century with the condemnation of "pagan" images by the Dominican preacher Girolamo Savonarola.

FRA ANGELICO AT SAN MARCO With the support of Cosimo de' Medici, the Dominicans built a second Dominican convent for friars in Florence in 1436. Among the members of this community was a talented painter from the Florentine countryside, Fra (Brother) Giovanni da Fiesole, called Fra Angelico (ca. 1400–1455). For this new community, Angelico painted altarpieces, books, and many frescoes in the living quarters for the friars. His fresco of the *Annunciation*, executed between 1440 and 1445, is placed prominently at the entry to the dormitory (fig. **15.28**). Angelico sets the two protaganists of this important event into a vaulted space very similar to the real architecture of the convent. A perspectival scheme defines the space, although the figures are too large to stand comfortably in it. The Virgin and the angel Gabriel glance at each other across the space; they humbly fold their hands, expressing their submission to divine will. The forms are graceful, and the overall scene is spare, rather than extravagant. The colors are pale, the composition has been pared to the minimum, the light bathes all the forms in a soft glow. Angelico's composition has the

simplicity and spatial sophistication of Masaccio (see fig. 15.17), though his figures are as graceful as Gentile da Fabriano's (see fig. 15.12). An inscription at the base of the fresco calls on the friars who pass by to say an Ave Maria. The fresco surely enhanced their life of prayer and contemplation, as was the goal of such imagery in religious communities.

CASTAGNO AT SANT' APOLLONIA Florence abounded in convents of women who wished to adorn their establishments too, though few painters in nunneries had the chance to become as skilled at painting as Angelico. Thus professional painters like Andrea del Castagno (ca. 1423–1457) were hired to decorate convent spaces with appropriate imagery. For the Benedictine convent of Sant' Apollonia, Castagno painted his most famous fresco, *The Last Supper* (fig. **15.29**) around 1447. This fresco is the best preserved of a set he painted in the refectory (dining hall) of the convent. He sets the event in a richly paneled alcove framed by classicizing pilasters and other antique decorative elements. By skillfully using perspective, Castagno creates a stagelike space for the event. Strong contrasts of light and dark define sculpturally imagined figures seated around the table. As in medieval representations of the subject, Judas sits alone on the near side of the table. The symmetry of the architecture, emphasized by the colorful inlays, imposes a similar order among the figures and threatens to imprison them. There is little communication among the apostles—only a glance here, a gesture there—so that a brooding silence hovers over the scene. Breaking with the demands of tradition and perspective, Castagno used a daring device to disrupt the symmetry and focus the drama of the scene. Five of the six marble panels on the wall behind the table are filled with subdued colored marble, but above the heads of St. Peter, Judas, and Jesus, the marble's veining is so garish and explosive

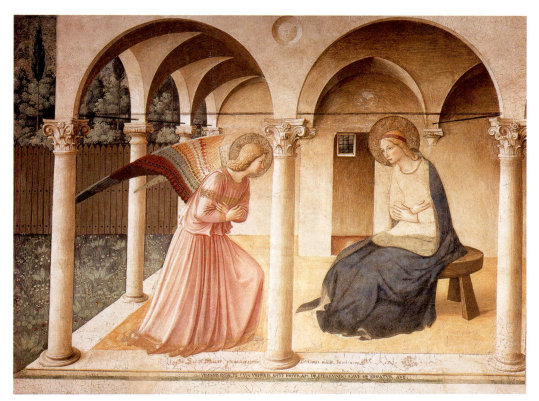

15.28. Fra Angelico. *Annunciation.* ca. 1440–1445. Fresco on dormitory level of the Convent of San Marco, 7′1″ × 10′6″ (2.1 × 3.2 m). Museo di San Marco, Florence

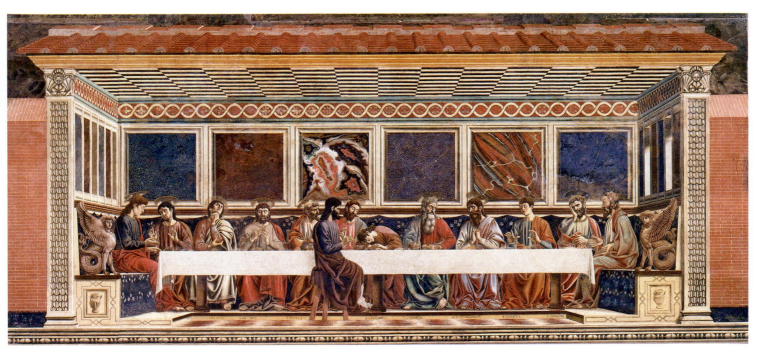

15.29. Andrea del Castagno. *The Last Supper.* ca. 1445–1450. Fresco. Sant' Apollonia, Florence

that a bolt of lightning seems to descend on Judas' head to focus attention on these key figures. The sisters who dined in front of this fresco could see in it examples to follow and to avoid.

DOMENICO VENEZIANO AT SANTA LUCIA DEI MAGNOLI Religious imagery was also needed by the laity to adorn the altars of parish churches. An important shift occurred in the design of altar panels in the 1440s, perhaps at the hands of

Fra Angelico, that was soon adopted by many painters. Earlier altarpieces, like Gentile's *The Adoration of the Magi* (fig. 15.12), were complex ensembles with elaborately carved frames, but the newer altarpieces emphasized gilded carpentry less and geometric clarity more. For the main altar of the church of Santa Lucia dei Magnoli in Florence, the painter Domenico Veneziano (ca. 1410–1461) executed the *Madonna and Child with Saints* around 1445 (fig. **15.30**). As his name suggests, Domenico was

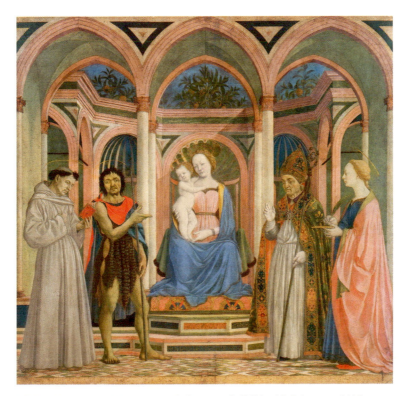

15.30. Domenico Veneziano. *Madonna and Child with Saints.* ca. 1445. Tempera on panel, 6′10″ × 7′ (2.08 × 2.13 m). Galleria degli Uffizi, Florence

from Venice, though he came to Florence in search of work in 1439. A letter he addressed to the son of Cosimo de' Medici in 1438 reveals that he knew a lot about the commissions being awarded there (see *Primary Source*, page 532), and his work shows his study of Florentine artists. The altarpiece he painted for Santa Lucia depicts an enthroned Madonna and Child framed by architecture and surrounded by saints, including Zenobius, a patron saint of Florence, and Lucy, an early Christian martyr, who holds a dish containing her eyes.

The theme of the central Madonna surrounded by saints and sometimes angels is often termed a *sacra conversazione* (sacred conversation), which suggests that the image is not a narrative, but a glimpse of a heavenly court peopled by dignified and decorous courtiers. Domenico imagines this gathering in a light-filled loggia articulated with pink and green marble. The architecture is clear and convincing, yet the space it defines is an ideal one elevated above the everyday world. Domenico may have modeled this space on Masaccio's *Holy Trinity* fresco (fig. 15.14), for his St. John (second from left) looks at us while pointing toward the Madonna, repeating the glance and gesture of Masaccio's Virgin. Domenico's perspective setting is worthy of Masaccio's, although his architectural forms have Gothic proportions and arches. The slim, sinewy bodies of the male saints, with their highly individualized, expressive faces, show Donatello's influence (see fig. 15.3).

Domenico treats color as an integral part of his work, and the *sacra conversazione* is as noteworthy for its palette as for its compo-sition. The blond tonality—its harmony of pink, light green, and white set off by spots of red, blue, and yellow—reconciles the brightness of Gothic panel painting with natural light and perspectival space. The sunlight streams in from the right, as revealed by the cast shadow behind the Madonna. The surfaces reflect the light so strongly that even the shadowed areas glow with color. Color, light, and space come together in this painting to make a heavenly vision in which the faithful may take comfort.

ALBERTI'S FACADE FOR SANTA MARIA NOVELLA

The marbled surfaces of the fictive architecture in Domenico's *Madonna and Child with Saints* is an idealized version of a Florentine church facade. But many important churches in Florence still lacked facades in the fifteenth century, including Santa Maria Novella. The exterior of this Dominican church, built largely between 1278 and 1350, had been left unfinished above the row of polychromed Gothic niches with their Gothic portals. (These were extended by walls on either side.)

Repairing and improving a church was an act of piety— motivation enough for a parish member, Giovanni Rucellai, to have this facade completed around 1458 (fig. **15.31**). Rucellai hired Leon Battista Alberti to design and install a marble skin over the facade. Multicolored marble facades were traditional in Tuscany. Alberti's models for this project included the Cathedral (fig. 15.2) and other churches in Florence, including the Baptistery (fig. 11.35) and San Miniato al Monte (fig. 11.36) from which the emphatic arcades may derive.

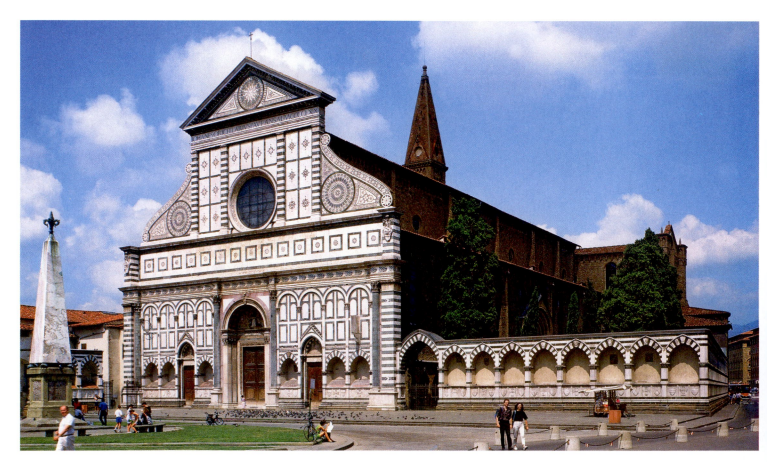

15.31. Leon Battista Alberti. Facade of Santa Maria Novella, Florence. 1458–1470

Other than the doorways and giant *oculus*, which were fixed, Alberti's facade masks its relationship to the rest of the church. Deciding not to be limited by the internal structure of the church, the architect was free to design the facade as a system of squares. Three main squares divide the facade: Two on the lower story flank the extraordinarily classicizing main portal; likewise, the "temple" atop the frieze fits within a square. Mathematical ratios lock these squares into relationships with the whole facade and with the other elements of the composition. Alberti's use of graceful scrolls to bridge the gap between the temple and the frieze was truly innovative and was to prove extremely influential (compare with fig. 17.21). It also helps to disguise the loose fit of the facade with the main body of the church by hiding the clerestory. Just below the pediment on the frieze level of the "temple," Alberti includes an inscription that credits Giovanni Rucellai for bringing the work to completion. It is the patron, not the artist, who gains the glory for the work.

DOMESTIC LIFE: PALACES, FURNISHINGS, AND PAINTINGS, CA. 1440–1490

Patrons like Giovanni Rucellai or Cosimo de' Medici asked artists to create works of art for their families as well as for the Church. As family fortunes rose, palaces needed building or remodeling to provide an appropriate setting for family life and civic display. Furnishings within the home had to express the status of the family. Sculptures and paintings of new sorts, like cassone paintings, proclaimed the alliances between families. Works of art depicted new subjects, many of them inspired by Classical antique art, that displayed the humanist educations of both artists and patrons. In sculpture, the long-lived Donatello was an inspiration for younger sculptors like Pollaiuolo. Painters tacked between the grave simplicity of Masaccio and the idealized elegance of Gentile da Fabriano to find the right language to depict imagery drawn from the ancient world. Architects like Alberti and Michelozzo built family homes endowed with great dignity by their use of Classical forms.

Patrician Palaces

Even before his work at Santa Maria Novella, the Rucellai family had commissioned Alberti to create the design for their Palazzo (fig. **15.32**). Again, Alberti was responsible only for the exterior of the building (perhaps with the assistance of Bernardo Rossellino), which united three medieval structures into one palace. The stone facade attempts to regularize and rationalize the structure across three stories. It consists of three rows of pilasters, separated by wide architraves, in imitation of the Colosseum (see fig. 7.40). Yet the pilasters are so flat that they remain part of the wall, while the facade seems to be one surface onto which the artist projects a linear diagram of the Colosseum exterior.

Here Alberti was trying to resolve what became a fundamental issue of Renaissance architecture: How to apply a Classical system to the exterior of a non-Classical structure. Strong horizontals in the entablatures divide the three stories, but the repetition of pilasters raised slightly above the surface creates a

ART IN TIME

1434—Cosimo de' Medici becomes leader of Florentine government

1450—Francisco Sforza seizes control of Milan

1452—Ghiberti's *Gates of Paradise* (east doors) of Baptistery completed

1453—Constantinople falls to the Ottoman Turks; the Ottoman Empire begins

vertical balance to the horizontality. What is more, the weight of those pilasters lightens both literally, as the pilasters project further at the first floor than at the third, and figuratively, as a Doric order supports the lower story while a Corinthian order supports the top. Alberti treats each element—pilaster, entablature, arch—equally to unify the design. The result is a network of linear forms that emphasizes the wall surface and

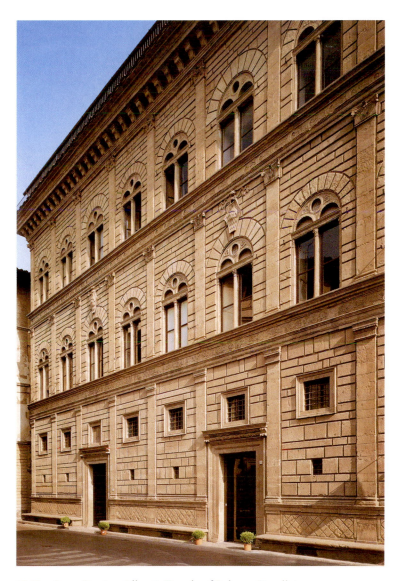

15.32. Leon Battista Alberti. Facade of Palazzo Rucellai, Florence. 1446–1451

PRIMARY SOURCE

Domenico Veneziano Solicits Work

The Venetian painter wrote to Piero de' Medici in 1438 requesting that he be considered for a commission that the family was about to award. The letter reveals Domenico's knowledge of the work to be done, and his arguments for why he should do it.

To the honorable and generous man Piero di Cosimo de' Medici of Florence. . . .

Honorable and generous sir. After the due salutations. I inform you that by God's grace I am well. And I wish to see you well and happy. Many, many times I have asked about you. . . . and having first learned where you were, I would have written to you for my comfort and duty. Considering that my low condition does not deserve to write to your nobility, only the perfect and good love I have for you and all your people gives me the daring to write, considering how duty-bound I am to do so.

Just now I have heard that Cosimo [Piero's father] has decided to have an altarpiece made, in other words painted, and wants a magnifi-

cent work, which pleases me very much. And it would please me more if through your generosity I could paint it. And if that happens, I am in hopes with God's help to do marvelous things, although there are good masters like Fra Filippo [Lippi] and Fra Giovanni [Angelico] who have much work to do. Fra Filippo in particular has a panel going to Santo Spirito which he won't finish in five years working day and night, it's so big. But however that may be, my great good will to serve you makes me presume to offer myself. And in case I should do less well than anyone at all, I wish to be obligated to any merited punishment, and to provide any test sample needed, doing honor to everyone. And if the work were so large that Cosimo decided to give it to several masters, or else more to one than to another, I beg you as far as a servant may beg a master that you may be pleased to enlist your strength favorably and helpfully to me in arranging that I may have some little part of it . . . and I promise you my work will bring you honor. . .

By your most faithful servant Domenico da Veneziano painter, commending himself to you, in Perugia, 1438, first of April.

SOURCE: CREIGHTON GILBERT, *ITALIAN ART 1400–1500:* SOURCES AND DOCUMENTS. (EVANSTON, IL: NORTHWESTERN UNIVERSITY PRESS, 1992)

successfully modifies the Classical forms for domestic use. Without great expense, the palace becomes a statement of the dignity of the Rucellai family.

Given their status in Florence, the Medici required a more lavish palace that would house the family and accommodate political and diplomatic functions as well. Nevertheless, Cosimo de' Medici turned down a design by Brunelleschi for this project, perhaps because he found it ostentatious. The commission went to a younger architect, Michelozzo di Bartolomeo (1396–1472), who had worked as a sculptor with both Ghiberti and Donatello. His design (fig. **15.33**) recalls the fortresslike Florentine palaces of old, and it may have been this conservatism that appealed to Cosimo. (The windows on the ground floor were added by Michelangelo in 1516–1517, and the whole was extended by the Riccardi family in the seventeenth century.)

Michelozzo borrowed the rustication and some of the window design from the Palazzo della Signoria (compare with fig. 13.16), but he lightened the forms significantly. The three stories form a graded sequence: The lowest story features rough-hewn, "rusticated" masonry; the second has smooth-surfaced blocks; and the third has an unbroken surface. On top of the structure rests, like a lid, a strongly projecting cornice such as those found on Roman temples. Inside, the spaces of the palace open to a central courtyard defined by an arcade resting on Brunelleschian classicizing columns (fig. **15.34**). (See figs. 15.6 and 15.7.) The arcade supports a frieze with carved medallions featuring symbols favored by the Medici (the seven balls are on the Medici coat of arms) and **sgraffito ornament** (incised decorative designs). The double-lancet windows of the facade reappear here. The effect of the whole is to provide a splendid setting for Medici affairs: familial, social, commercial, and governmental. Thus the large courtyard that dominates the interior is ceremonial as well as practical.

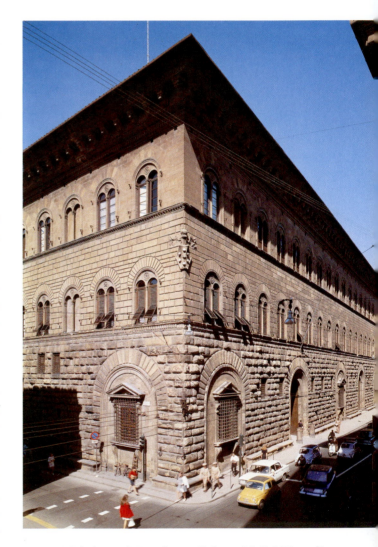

15.33. Michelozzo di Bartolomeo. Palazzo Medici-Riccardi, Florence. Begun 1444

Heroic Images for Florentine Collectors

DONATELLO'S *DAVID* One of the most debated works of the Renaissance, Donatello's bronze *David* (fig. **15.35**) once stood on a high pedestal in the courtyard of the Medici palace. The *David* may be the first free-standing, life-sized nude statue since antiquity. The sheer expense of casting a whole figure of this sort in bronze, with parts gilt as well, required a patron with the wealth of the Medici to pay for it. Using the lost wax method of casting (see *Materials and Techniques*, page 124), Donatello composed the figure to be seen from every side, as the contrapposto stance and high finish of the work demand that a viewer walk around it.

Both the date of the *David,* between the 1420s and the 1460s, and its meaning have sparked controversy. Much in the figure is difficult to square with the biblical story. The young David stands with his left foot atop the severed head of the giant Goliath, whom he has miraculously defeated. But if David has already defeated Goliath, why does he hold a stone? Most untraditionally, Donatello depicts David nude, which may be intended to suggest his status as a hero in the ancient mode. But instead of depicting him as a full-grown youth like the athletes of Greece, Donatello chose to model an adolescent boy with a softly sensuous torso, like Isaac in Ghiberti's competition panel (fig. 15.1). *David*'s contrapposto alludes to ancient sources, but it also creates a languid pose for the nude youth, which some critics have seen as sexually suggestive. The broad-brimmed hat and knee-high boots seem to accent his nudity. David wields Goliath's sword, which is too large for him, and his gaze seems impassive if we consider the terror he has just confronted.

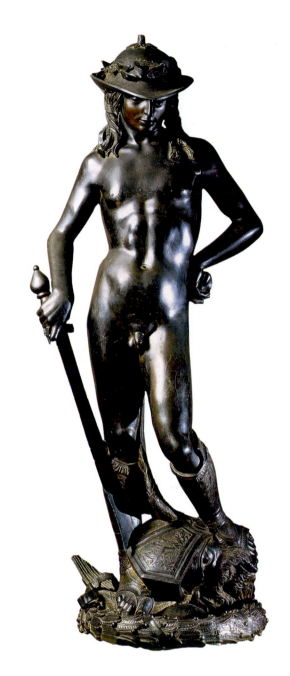

15.35. Donatello. *David*. ca. 1420s–1460s. Bronze, height 62$\frac{1}{4}$″ (158 cm). Museo Nazionale del Bargello, Florence

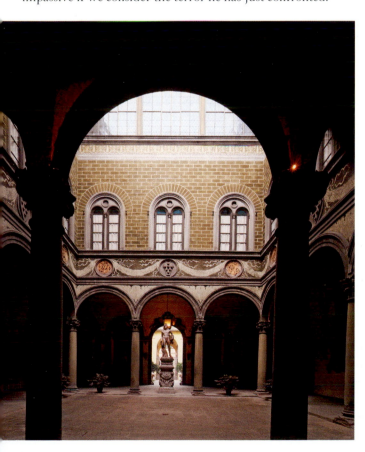

15.34. Michelozzo di Bartolomeo. Courtyard of Palazzo Medici-Riccardi

One key to the meaning of the *David* may be an inscription once written on its base that identified David as the defender of the fatherland. Since David had been venerated as a patron of the city, the Medici appropriated this symbol of Florentine civic virtue and installed it in their residence. (Donatello had earlier sculpted a marble image of David that stood in the Palazzo della Signoria, so even the choice of sculptor may be significant.) But scholars have debated the specific associations of the statue: Does the *David* celebrate a specific Florentine victory? Does it celebrate a Medici political victory? Does it represent Florentine vigilance? Is the *David* a symbol of Republican victory over tyranny? Or does its presence in the Medici palace turn it into a symbol of dynastic power? How does David's youth and nudity affect its meaning? Our understanding of how fifteenth-century Florentines viewed the sculpture is still developing.

HERCULEAN IMAGES The Medici family appears to have made a habit of borrowing Florentine civic imagery for their palace. Sometime around 1475, Antonio del Pollaiuolo (1431–1498) executed the *Hercules and Antaeus* (fig. **15.36**) for the family. This is a table statue, only about 18 inches high, but

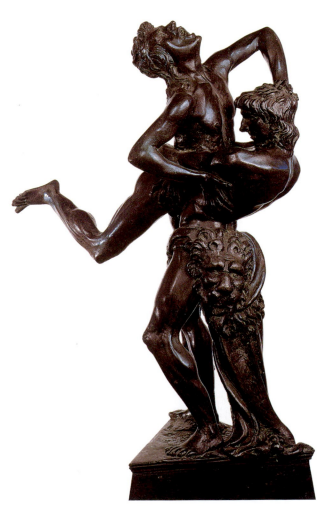

15.36. Antonio del Pollaiuolo. *Hercules and Antaeus*. ca. 1475. Bronze, height with base 17³/₄″ (45.8 cm). Museo Nazionale del Bargello, Florence

it has the force of a much larger object. It represents Hercules—another local patron—battling Antaeus, the son of an Earth goddess. Hercules' foe gains strength from contact with the Earth, so Hercules must lift him off the ground to defeat him. Pollaiuolo had been trained as a goldsmith and metalworker, probably in the Ghiberti workshop, but was deeply impressed by the work of Donatello and Andrea del Castagno, as well as by ancient art. These sources influence the distinctive style that appears in the statuette.

To create a free-standing group of two struggling figures, even on a small scale, was a daring idea. There is no precedent for this design among earlier statuary groups, ancient or Renaissance. Even bolder is the centrifugal force of the composition. Limbs seem to move outward in every direction, so the viewer must examine the statuette from all sides. Despite its violent action, the group is in perfect balance. To stress the central axis, Pollaiuolo in effect grafted the upper part of Antaeus onto the lower part of Hercules as he lifts him in a stranglehold. Pollaiuolo was a painter and engraver as well as a bronze sculptor, and we know that about 1465 he did a closely related painting of Hercules and Antaeus for the Medici.

Few of Pollaiuolo's paintings have survived, and only one engraving, the *Battle of the Ten Naked Men* (fig. **15.37**). As far as we know, this print is Pollaiuolo's most elaborate design. Its subject is not known, though it may derive from an ancient text. One purpose the engraving serves is to display the artist's mastery of the nude body in action and thus to advertise his skill. This may account for the prominent signature in the print; he signs it *Opus Antonii Pollaioli Florentini (The Work of Antonio Pollaiuolo of Florence)*. Between 1465 and 1470, when the print must have been produced, depicting the nude in action was still a novel problem, and Pollaiuolo explored it in his paintings, sculptures, and prints. He realized that a full understanding of movement demands a detailed knowledge of anatomy, down to the last muscle and sinew. These naked men look almost as if their skin had been stripped off to reveal the play of muscles underneath. So, to a lesser extent, do the two figures of Pollaiuolo's statuette *Hercules and Antaeus*.

Paintings for Palaces

The interiors of patrician palaces served not only as private quarters and settings for family life, but as public spaces where family members performed civic roles. A visitor would be likely to find paintings and perhaps sculptures, many on religious subjects, in these places. Indeed, early in the fifteenth century, one of the leading clerics of Tuscany urged that religious images be displayed in private homes. In a treatise written in 1403, Cardinal Giovanni Dominici counseled that images of Christ, Mary, or saints in the home would encourage children to emulate those holy figures. (See *Primary Source*, page 536.)

Patrician homes also showcased **cassoni**, carved or painted chests for storing valuables. The product of collaboration between skilled carpenters, woodworkers, and painters, such

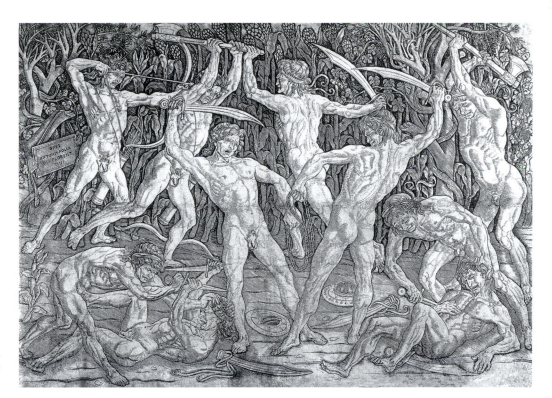

15.37. Antonio del Pollaiuolo. *Battle of the Ten Naked Men.* ca. 1465–1470. Engraving, $15\frac{1}{8}'' \times 23\frac{1}{4}''$ (38.3 × 59 cm). Cincinnati Art Museum, Ohio. Bequest of Herbert Greer French. 1943.118

chests were usually decorated, sometimes with chivalric imagery, like the one in fig. **15.38**, which depicts a tournament taking place on the Piazza Santa Croce. Cassoni were also adorned with mythological scenes, histories, or romances. Pairs of cassoni were usually given to a bride on her wedding; Cassoni mark the union of two families, and thus reflect family status as much as nuptial concerns. Edifying or learned stories on cassoni often derived from studies of ancient authors such as Plutarch,

Ovid, or Vergil. Thus cassone panels displayed a family's wealth, their learning and interest in humanism, sometimes their patriotism, and very often lessons for a bride to take with her to her new home.

Another type of domestic imagery was the circular painting, or **tondo**, which was something of a special taste in Florence. Many of the leading painters of the latter decades of the fifteenth century produced tondi, including Fra Filippo Lippi

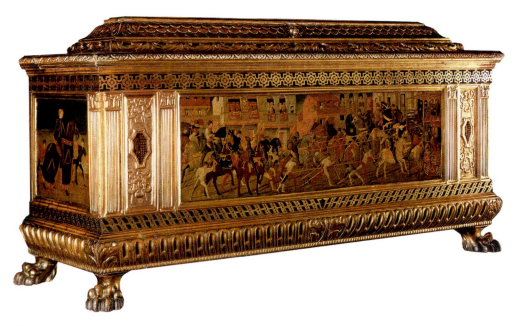

15.38. *Cassone* with tournament scene. ca. 1460. Tempera on panel, chest 40 × 80 × 14″ (103 × 203 × 66 cm); panel 15 × 51″ (38 × 130 cm). National Gallery, London

Giovanni Dominici Urges Parents to Put Religious Images in Their Homes

Florentine by birth, Dominici entered the Dominican order, where he became involved with reform. Among his writings was the Regola del governo di cura familiare *(Rule for the Management of Family Care) of 1403, from which this excerpt is taken.*

Part IV [on the management of children]. In the first consideration, which is to bring them up for God. . .you should observe five little rules. . . . The first is to have paintings in the house, of holy little boys or young virgins, in which your child when still in swaddling clothes may delight, as being like himself, and may be seized upon by the like thing, with actions and signs attractive to infancy. And as I say for painting, so I say of sculptures. The Virgin Mary is good to have, with the child on her arm, and the little bird or the pomegranate in his fist. A good figure would be Jesus suckling, Jesus sleeping on his mother's lap, Jesus standing politely before her, Jesus making a hem and the mother sewing that hem. In the same way he may mirror himself in the holy Baptist, dressed in camel skin, a small

boy entering the desert, playing with birds, sucking on the sweet leaves, sleeping on the ground. It would do no harm if he saw Jesus and the Baptist, the little Jesus and the Evangelist grouped together, and the murdered innocents, so that fear of arms and armed men would come over him. And so too little girls should be brought up in the sight of the eleven thousand virgins, discussing, fighting and praying. I would like them to see Agnes with the fat lamb, Cecilia crowned with roses, Elizabeth with many roses, Catherine on the wheel, with other figures that would give them love of virginity with their mothers' milk, desire for Christ, hatred of sins, disgust at vanity, shrinking from bad companions, and a beginning, through considering the saints, of contemplating the supreme saint of saints. . . . I warn you if you have paintings in your house for this purpose, avoid frames of gold and silver, lest they become more idolatrous than faithful, since, if they see more candles lit and more hats removed and more kneeling to figures that are gilded and adorned with precious stones than to the old smoky ones, they will only learn to revere gold and jewels, and not the figures, or rather, the truths represented by those figures.

SOURCE: CREIGHTON GILBERT, *ITALIAN ART 1400–1500: SOURCES AND DOCUMENTS.* (EVANSTON, IL: NORTHWESTERN UNIVERSITY PRESS, 1992)

(ca. 1406–1469), to whom has been attributed the *Madonna and Child with the Birth of the Virgin* (fig. **15.39**). The Florentine banker Lionardo Bartolini Salimbeni may have commissioned this panel to celebrate a birth in his family. Lippi presents the Madonna and infant Jesus as an ideal mother and child. They recall Masaccio's *Madonna* (fig. 15.19) in several ways, but Fra Filippo's youthful Mary has a slender elegance and gentle

15.39. Fra Filippo Lippi. *Madonna and Child with the Birth of the Virgin.* (The Bartolini Tondo) 1452–1453. Tempera on panel, diameter 53″ (134.6 cm) Palazzo Pitti, Florence

sweetness. The curly edge of the Virgin's headdress and the curved folds of her mantle streaming to the left, which accentuate her turn to the right, add a lyrical quality to her figure. The child Jesus picks seeds out of a pomegranate, an emblem of eternal life. At the same time, the seeds may symbolize fertility, since the secondary theme is St. Anne giving birth to the Virgin.

Behind the Virgin is a stagelike scene that is surprisingly cluttered, created by a perspective scheme with several vanishing points. Different parts of the narrative appear in different sections of the tondo. In the background to the left is a domestic interior showing the Virgin's birth, with St. Anne in childbed. To the right is the meeting of St. Anne and her husband St. Joachim at the Golden Gate of Jerusalem after the angel of the Lord had appeared to them separately and promised them a child. In contrast to all other depictions of this legend, the event in this painting is presented as if it were taking place before the entrance to a private house.

Most likely Lippi learned to use this kind of continuous narrative from reliefs of Donatello and Ghiberti: Compare *The Feast of Herod* (fig. 15.20) and *The Story of Jacob and Esau* (fig. 15.23), which incorporate similarly complex spaces to tell their stories. Lippi quotes from Ghiberti's relief in this tondo in the figure of the maidservant to the Virgin's right. After Masaccio's death, the age, experience, and prestige of Donatello and Ghiberti gave them an authority unmatched by any other painter active at the time. Their influence, and that of the Flemish masters, on Fra Filippo's outlook was of great importance, since he played a vital role in setting the course of Florentine painting during the second half of the century.

UCCELLO'S *BATTLE OF SAN ROMANO* The same family who may have commissioned Lippi's tondo commissioned another set of wall paintings that have a fascinating history.

The Florentine artist Paolo Uccello (1397–1475) painted the *Battle of San Romano* (fig. **15.40**) as one of three panels depicting a battle between Florence and Lucca in 1432. Florence's victory in this battle was one of the factors that led to Cosimo de' Medici's consolidation of power. Uccello depicts the charge of the Florentine forces led by Cosimo's ally, Niccolò da Tolentino, the man on the white horse wielding a general's baton at the center of the painting. Because of the importance of this subject to the Medici, scholars have long believed that they commissioned this painting. The series was identified as one described in Lorenzo de' Medici's bedroom in a document of 1492. Recent research, however, shows that Lionardo Bartolini Salimbeni, who had been a member of the governing council of Florence during the battle, commissioned Uccello to paint these panels for his townhouse in Florence around 1438. After his death, Lorenzo de' Medici sought to obtain them, first by purchase and, when that failed, by force. The sons of the original owner filed a lawsuit for their return. These circumstances suggest the importance of the paintings for both families.

Rather than the violence of war, Uccello's painting creates a ceremonial effect, as the plastic shapes of the figures and horses march across a grid formed by discarded weapons and pieces of armor. These objects form the orthogonals of a perspective scheme that is neatly arranged to include a fallen soldier. A thick hedge of bushes defines this foreground plane, beyond which

appears a landscape that rises up the picture plane rather than deeply into space. The surface pattern is reinforced by spots of brilliant color and lavish use of gold, which would have been more brilliant originally, as some of the armor was covered in silver foil that has now tarnished. Such splendid surfaces remind us of the paintings of Gentile da Fabriano (see fig. 15.12). Uccello's work owes much to International Gothic displays of lavish materials and flashes of natural observation, with the added element of perspectival renderings of forms and space.

PAINTINGS FOR THE MEDICI PALACE: BOTTICELLI
In addition to acquiring paintings in Florence through commission, purchase, or force, the Medici had numerous contacts with Northern Europe, not only through diplomatic exchanges, but

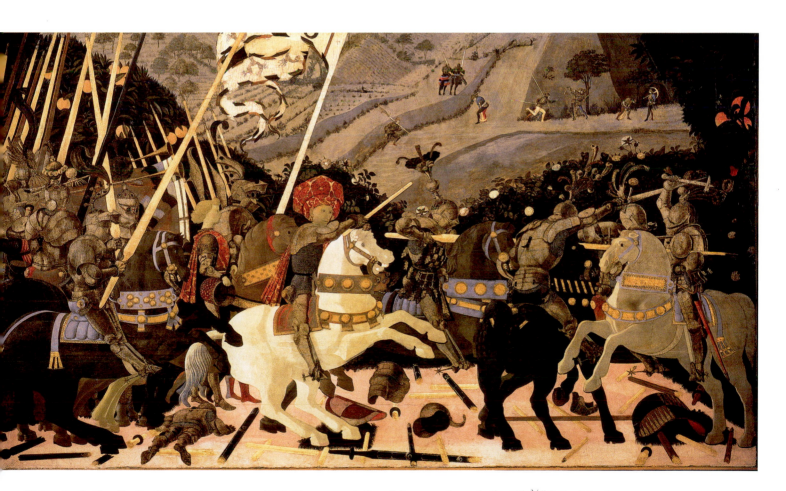

15.40. Paolo Uccello. *Battle of San Romano*. ca. 1438. Tempera and silver foil on wood panel, 6′ × 10′5¾″ (1.8 × 3.2 m). The National Gallery, London. Reproduced by courtesy of the Trustees

through their banking business. Medici agents in Bruges sent many works of art to Florence, as inventories confirm. In this, the Medici behaved as did many of the ruling families of Italy, for Flemish art was widely admired in places as disparate as Naples, Venice, Ferrara, and Milan. Through such acquisitions, the Medici palace was filled with panel paintings and tapestries from the North. These objects made a profound impression on Florentine artists like Uccello, Filippo Lippi, Ghirlandaio, and the young Sandro Botticelli.

Botticelli (1445–1510), who had trained with Verrocchio, became one of the favorite painters of the Medici circle—the group of nobles, scholars, and poets surrounding Lorenzo the Magnificent, the head of the Medici family and, for all practical purposes, the real ruler of the city from 1469 until 1492. The *Primavera (Spring)* (fig. **15.41**) was probably painted for a cousin who grew up in the household of Lorenzo the Magnificent. This work, and two others on the theme of love, may have been commissioned for the young man's wedding, which took place in 1482, the date often proposed for the painting.

Scholars have suggested numerous interpretations for this image. The painting depicts Venus in her sacred grove, with Eros flying overhead. Her companions, the Three Graces and Hermes (the Roman god Mercury), stand on the left; to the right, Zephyr grasps for the nymph Chloris, whom he then transforms into Flora, the goddess of flowers. One interpretation links the *Primavera* to the writings of the Neo-Platonist philosopher Marsilio Ficino (1433–1499), who was widely read and admired at the Medici court. By this reading, the painting is an allegory about Platonic love between two friends: Mercury points the way to divine love in the guise of Venus, who is born of the Three Graces, symbolizing beauty. In contrast is physical love, represented by Flora, whom Zephyr had raped. Other readings of the *Primavera* see it as an allegory about the immortality of the soul (drawing a parallel between the story of Chloris and the Rape of Persephone) or an allegory in which Venus is likened to Mary and the other characters to Christian figures participating in the Last Judgment. Yet, given that the painting was made in connection with a wedding, it may be a celebration of marriage and fertility, as the dense thicket of orange trees and carpet of flowers suggests. The painting inspires different readings, depending on the audience before it.

Often paired with the *Primavera* in the public imagination is Botticelli's most famous image, *The Birth of Venus* (fig. **15.42**). It, too, once hung in a Medici villa, though it may have been painted several years later than the *Primavera*. In this painting, too, the central figure in the composition is Venus, though here

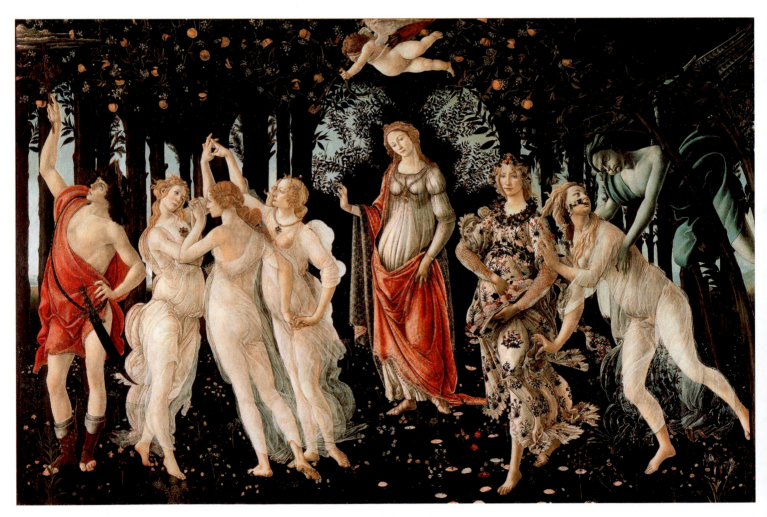

15.41. Sandro Botticelli. *Primavera*. ca. 1482. Tempera on panel. 6′8″ × 10′4″ (2.03 × 3.15 m). Galleria degli Uffizi, Florence

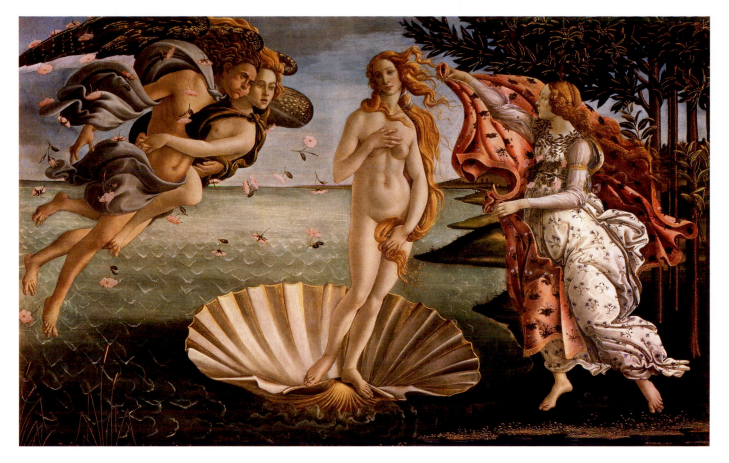

15.42. Sandro Botticelli. *The Birth of Venus.* ca. 1485. Tempera on panel. 5'8⁷⁄₈" × 9'1⁷⁄₈" (1.8 × 2.8 m). Galleria degli Uffizi, Florence

she floats slowly toward the seashore, where a flower-clad woman waits to enfold her in a flowered robe. Her movement is aided by Zephyr accompanied by Chloris (Flora). Unlike the *Primavera,* here the space behind the figures seems to open out into the distance, with the sky and water creating a light, cool tonality for the painting. In the figures, though, the shallow modeling and emphasis on outline produce an effect of low relief rather than of solid, three-dimensional shapes. The bodies seem to be drained of all weight, so that they float even when they touch the ground.

These ethereal figures recreate ancient forms. Botticelli's figure of *Venus* depends on a variant of the *Knidian Aphrodite* by Praxiteles (see fig. 5.60). The subject itself seems related to the Homeric *Hymn to Aphrodite,* which begins: "I shall sing of beautiful Aphrodite . . . who is obeyed by the flowery sea-girt land of Cyprus, whither soft Zephyr and the breeze wafted her in soft foam over the waves. Gently the golden-filleted Horae received her, and clad her in divine garments." Still, no single literary source accounts for the pictorial conception. It may owe something to Ovid and the poet Poliziano, who was, like Botticelli, a member of the Medici circle. But again, the thinking of Marsilio Ficino may play a role here. Among the Neo-Platonists, Venus appears in two guises, a celestial Venus and a mundane Venus; the former was the source of divine love, the latter of physical love. *The Birth of Venus* may be an allegory of the origin of the celestial Venus for an audience attuned to the

nuances of Neo-Platonic philosophy. The elegant forms and high finish of the painting by Botticelli, combined with the erudite subject matter based on ancient thought, exemplify the taste of the Medici court.

Portraiture

Images of history, of contemporary events, or of ancient myths demonstrate the increasing interest in secular themes in the art of the Renaissance. Another genre of image in great demand was the portrait. In addition to dynastic images for kings, or monuments to war heroes, the second half of the fifteenth century saw the spread of portraits of merchants, brides, and artists.

The idea of recording specific likenesses was inspired by the fifteenth century's increasing awareness of the individual, but also by the study of Roman art, where portraits abound. Artists were already making donor portraits like Masaccio's *Trinity* fresco (fig. 15.14), funerary monuments like Bruni's tomb (fig. 15.26), and commemorations of public figures like Donatello's *Gattamelata* (fig. 15.21), but new forms of portraiture developed in the fifteenth century.

Donor portraits had a long history in Italian art, going back to the Early Christian period. But in the fifteenth century they gained new prominence. In a fresco cycle in Santa Maria Novella, the Florentine painter Domenico Ghirlandaio (1449–1494) places portraits of many members of the Tornabuoni family, who sponsored the cycle, in very visible positions. In the *Birth of the Virgin*

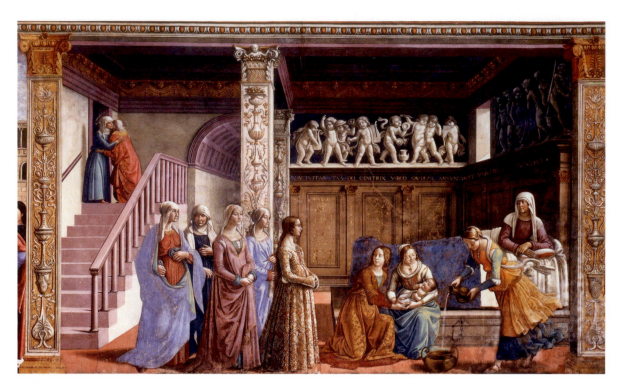

15.43. Domenico Ghirlandaio. *Birth of the Virgin*. ca. 1485–1490. Fresco. Cappella Maggiore, Santa Maria Novella, Florence

(fig. **15.43**), Ghirlandaio uses perspective to construct a doll's house view of an elaborately decorated bedchamber where Saint Anne watches the midwives wash her newborn child. The room is adorned with ornamental pilasters and panels, while a carved frieze of *putti* (little boys), reminiscent of works by Donatello and Luca della Robbia, seems to celebrate the birth. Inscriptions below this frieze praise the birth of the Mother of God, and other writings on the wall below identify Ghirlandaio as the author. (His family name was Bigordi, but his father was a garland maker, and this nickname passed on to his son.) In the 1480s and 1490s, his shop was one of the busiest in Florence, and it was there that the young Michelangelo learned the techniques of fresco.

Ghirlandaio sets contemporary figures into this sacred drama who upstage the historical characters: A group of women in expensive dress and decorous poses witness the birth of the Virgin. The young lady depicted in profile at the center of the composition is the daughter of the patron, Ludovica Tornabuoni. The tall woman in a blue robe at the back of this group is Lucrezia Tornabuoni, who had married into the Medici family (her son was Lorenzo de' Medici). As the *Birth of the Virgin* fresco demonstrates, Ghirlandaio was an accomplished portraitist as well as storyteller. His use of the profile portrait for Ludovica, the central figure, reflects the preference for the profile among Italian artists and patrons in the middle years of the fifteenth century. The profile portrait had been adopted from Roman coins, which always showed emperors from the side. But around 1480, both Ghirlandaio and his younger colleague, Botticelli, began to adopt the three-quarter view in their portraits, and the practice soon became widespread.

Among Ghirlandaio's most touching individual portraits is the panel of *An Old Man and a Young Boy* (fig. **15.44**), usually dated around 1480. Despite the very specific physignomy of the old man, whose nose has been disfigured by rosacea (a skin disorder), the sitters and their relationship to each other are unknown. The familiarity of their gestures suggest that they depict two generations of one family; if so, the painting represents the continuity of the family line. Even though the textures are somewhat generalized and the composition geometrically ordered, Ghirlandaio's attention to detail may reflect his acquaintance with Netherlandish art. The landscape view through the window that breaks up the picture plane was also a Northern European idea. (See Memling's *Portrait of Martin van Niewenhove*, fig. 14.23.) But the most important contribution was the three-quarter view of the human face, which had been used in Flanders since the 1420s.

Leading families like the Tornabuoni included portraits of the Medici family in their commissions as a statement of their alliance with the ruling party. The Medici themselves commissioned numerous family likenesses for their palaces and for their friends. They preferred the **portrait bust**, a shoulder length sculptural likeness, most likely to draw parallels between themselves and Roman families who owned numerous busts of their ancestors (see fig. 7.13). The Florentine busts celebrated the living, however, not the dead, and were made of marble, bronze, or terra cotta by some of the leading sculptors of the century. Around 1480, Andrea del Verrocchio (or his shop) executed such a bust of Lorenzo de' Medici. (fig. **15.45**). The image captures his physical likeness, but the concentrated gaze and drawn mouth give him an intensity that is meant to express his personality. Lorenzo was young to be the head of the ruling political faction, and the bust portrays him with the dignity and gravitas of a Roman elder as if to compensate for his youth.

The court around Lorenzo the Magnificent was learned, ambitious, and very cultivated. Lorenzo was the patron of

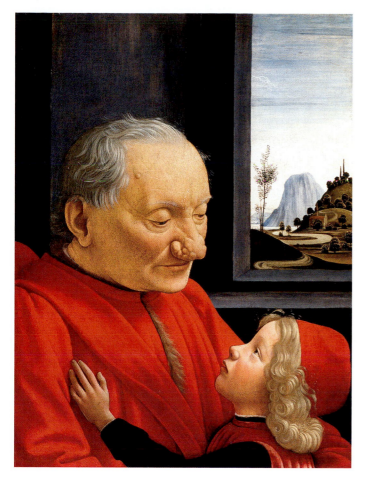

15.44. Domenico Ghirlandaio. *An Old Man and a Young Boy.* ca. 1480. Tempera and oil on wood panel, 24⅛ × 18″ (61.2 × 45.5 cm). Musée du Louvre, Paris

Additionally, patrons throughout Italy saw the advantages of expressing their authority through visual and textual references to antiquity. By mid-century, linear perspective was in widespread use, and Florentine techniques for rendering form through light were being practiced by many artists. Piero della Francesca blended his own fascination with mathematics, the ancient world, and Flemish painting to create a personal style that found favor in several Italian courts. The Florentine humanist and architect Leon Battista Alberti designed influential buildings in northern Italy, including one for the Marquis of Mantua, who had also attracted the services of the painter-archeologist Andrea Mantegna. The city of Venice commissioned Florentine artists, such as Andrea del Verrocchio, for major projects, but their local traditions in architecture and painting remained strong. Venetian painters like Giovanni Bellini developed an influential school of Renaissance painting that rivaled Florentine style. As the papacy regained its control in Rome, Perugino and Luca Signorelli joined local painters like Melozzo da Forlì in projects designed to celebrate papal power.

Piero della Francesca in Central Italy

One of the most distinctive and original artists of the second half of the fifteenth century was Piero della Francesca (ca. 1420–1492), who visited Florence while training with Domenico Veneziano (see fig. 15.30). Piero came from Borgo San Sepolcro in southeastern Tuscany, where he completed

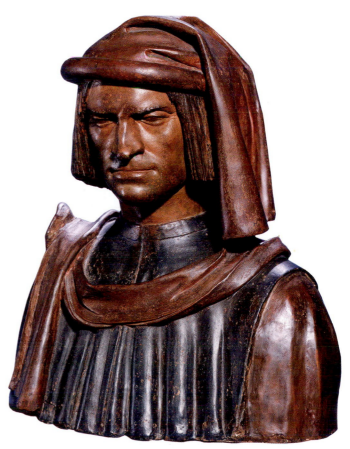

numerous humanists, philosphers, poets, and artists, including the young Michelangelo. Yet this brilliant court did not outlast Lorenzo's death in 1492. His heir, Piero de' Medici, did not share his father's diplomatic gifts. What is more, he faced an increasingly unstable economy (the bank failed in 1494) and invading armies from France and Spain. Piero's inept handling of these crises encouraged an uprising in Florence in 1494, which expelled the Medici faction and sought to restore Republican government. A vacuum of power was filled for a time by the Dominican friar Girolamo Savonarola, who attacked the "cult of paganism" and the materialism he saw in Florentine culture. Savonarola's exhortations to repentence and his strong criticism of corruption not only in Florence but in the Church hierarchy made him many enemies, and he was executed in 1498. As the fifteenth century came to an end, Florence was battling for its life against the stronger powers of the papacy, Spain, and France.

THE RENAISSANCE STYLE REVERBERATES, 1450–1500

Artists from all over Italy and beyond found the innovations being explored in Florence a stimulation to their own work, though they responded to the new styles in individual ways.

15.45. Andrea del Verrocchio. *Bust of Lorenzo de' Medici.* ca. 1480. Painted terra cotta. Samuel A. Kress Collection, National Gallery of Art, Washington, DC. 1943.4.92

some of his important early commissions. He worked for patrons in Tuscany, Rimini, and Ferrara, and executed several important works for Federico da Montefeltro, a *condottiere* (mercenary general) turned prince of Urbino (southeast of Tuscany) around 1470. Piero's early training with Domenico Veneziano may be seen in his colors, while his experience of Masaccio is apparent in the solidity and simplicity of his forms and the solemn character of his compositions. The early fifteenth-century systemization of perspective was critical for Piero, who became such an expert at mathematically determining perspective for space and for rendering figures in space that he wrote a treatise about it. It is likely that Piero made contact with Leon Battista Alberti, with whom he shared patrons, as well as an interest in art theory.

A work that Piero made for his hometown reflects this combination of influences on his art. The city of Borgo San Sepolcro commissioned him to paint a fresco for the Palazzo Comunale of the town, probably around 1460. Befitting the name of the town, which means the "Holy Sepulchre," Piero's theme is Christ Resurrected stepping out of his tomb (fig. **15.46**). The figure of Christ dominates the composition: His frontality and the triangular composition may derive from the *Trinity* fresco by Masaccio (fig. 15.14), but the light of sunrise and the pale colors reflect the art of Domenico Veneziano. Piero pays special attention to the arrangement of the Roman soldiers asleep in front of the sepulchre; they are variations on a theme of bodies in space. The spectator must look up to see the glorified body of Christ, so perfect in his anatomy and so serene in his aspect as he triumphs over death.

Piero's art brought him to the attention of the cultivated Duke Federico da Montefeltro, who had assembled a team of artists from all over Europe for his court at Urbino. There, Piero della Francesca came into contact, and perhaps into competition, with artists not only from Italy but also from Spain and Flanders. From them, Piero learned the new technique of painting with oil glazes and became an early practitioner of this technique in central Italy.

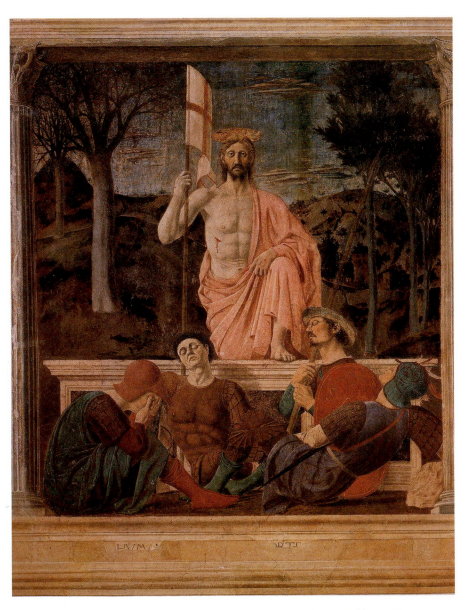

15.46. Piero della Francesca. *Resurrection*. ca. 1463. Fresco, 7′5″ × 6′6½″ (2.25 × 1.99 m). Palazzo Comunale, Borgo San Sepolcro

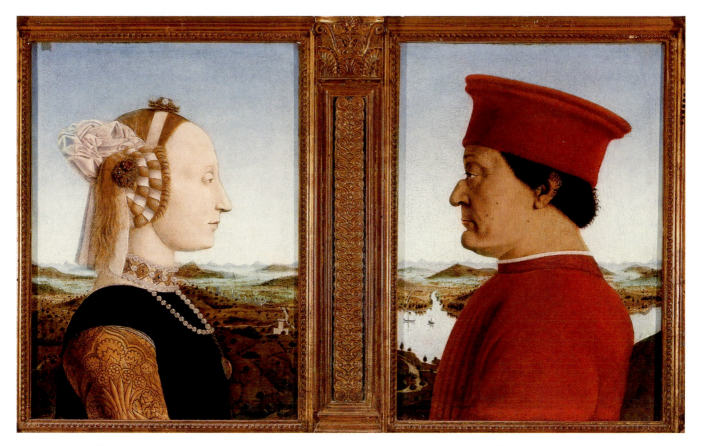

15.47. Piero della Francesca. *Double Portrait of Battista Sforza and Federico da Montefeltro.* ca. 1472. Oil and tempera on panel, each panel 18¹/₂″ × 13″ (47 × 33 cm). Galleria degli Uffizi, Florence

Piero's quiet, spatially complex paintings were thus enriched with more brilliant colors and surface textures in the style of Flemish art. The double portrait of Battista Sforza and Federico da Montefeltro that Piero painted around 1472 (fig. **15.47**) demonstrates his mastery of spacial representation and clarity of form by using the rich hues and varied textures made possible by oil painting. This diptych portrays both the count and his wife in profile facing each other in front of a deep continuous landscape. Federico, whose face had been disfigured in a tournament, shows his good side on the viewer's right. His wife, Battista, had recently died from a fever; Piero gives her the place of honor to the viewer's left. Her pale features are framed by her complicated hairstyle and her gems and brocades. A shadow falls over the landscape behind her, while the landscape behind her husband is well-lit and busy.

At about the same time, Federico called on Piero to execute a larger image that ultimately became the memorial over his tomb (fig. **15.48**). For this painting, Piero drew on the theme of the *sacra conversazione*; here, the Virgin and her sleeping child are surrounded by saints and angels while the patron, Duke Federico, kneels before her. The figures stand as vertically and as still as the pilasters on the wall behind them. Strong light enters from the left, casting broad shadows that fall to the right and define the depth of the apse. Framed by the marble panel

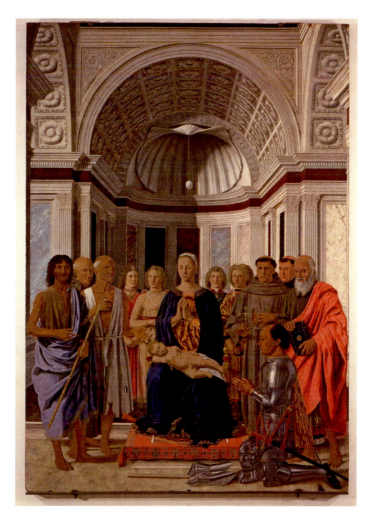

15.48. Piero della Francesca, *Enthroned Madonna and Saints with Federico da Montefeltro.* ca. 1472–1474. Oil on panel, 8′2″ × 5′7″ (2.48 × 1.7 m). Pinacoteca di Brera, Milan

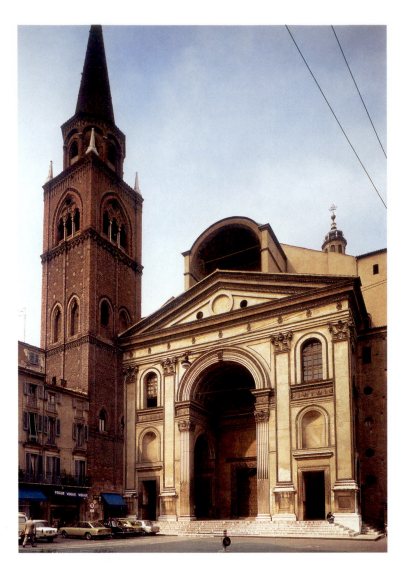

on the far wall, the Virgin's head is as ovoid as the egg that hangs from the shell at the curve of the apse. The architecture of the church has a monumental character, with its marble paneling, classicizing pilasters, and barrel-vaulted apse. Using the oil technique, Piero describes the veining of the marble, the soft texture of the carpet, and the gleam of Federico's armor.

The meaning of this painting is unclear. A viewer looks for Federico's wife, Battista, to complement his kneeling figure, but even though her patron saint, John the Baptist, stands at the left, Battista herself is missing. She died in 1472, which helps to date the painting, and her conspicuous absence may be part of the picture's meaning. Piero depicts Federico venerating the Christ Child, who wears a piece of coral to ward off illness, as if in thanks for the birth of his heir, despite the loss of his wife. Yet the sleeping Child refers to the eventual death of Christ—and his Resurrection—so the funereal theme is maintained. Piero's gift was for making images that convey dignity and melancholy in carefully balanced and spacious compositions.

Alberti and Mantegna in Mantua

Mantua, in the northern Po Valley, had been dominated for more than a century by the Gonzaga family. They created a brilliant court, peopled with humanists, educators, and artists. Marquis Ludovico Gonzaga had married a German princess, Barbara of Brandenburg, and the court was very cosmopolitan. Works such as the *Ten Books on Architecture* (ca. 1452) brought Leon Battista Alberti great prominence and the Gonzaga lured him to their service.

15.49. Leon Battista Alberti. Sant' Andrea, Mantua. Designed 1470

15.50. Leon Battista Alberti. Interior of Sant' Andrea

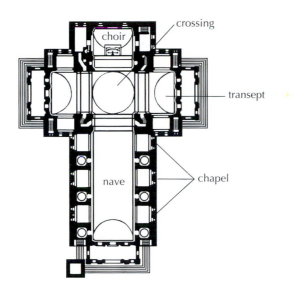

15.51. Plan of Sant' Andrea (transept, dome, and choir are later additions)

By 1470, Alberti had designed the church of Sant' Andrea in Mantua, his last work (fig. **15.49**). The majestic facade expresses Alberti's ultimate goal of merging Classical temple forms with the traditional basilican church. Here, he interwove a triumphal arch motif, now with a huge recessed center niche to serve as the portal, with a Classical temple front. As on the exterior of the Palazzo Rucellai (fig. 15.32), he used flat pilasters that stress the primacy of the wall surface to keep the two competing forms in balance. He used two sizes of pilaster to achieve this balance: The smaller pilasters support the arch over the huge central niche, and the larger ones support the unbroken architrave and the strongly outlined pediment. The larger pilasters form what is known as a **colossal order**, meaning that it is more than one story high. These tall pilasters balance the horizontal and vertical elements of the design.

To further unify the facade, Alberti inscribed the entire design within a square, even though it made the facade much lower than the height of the nave. (The effect of the west wall protruding above the pediment is more disturbing in photographs than at street level, where it can hardly be seen.) While the facade is distinct from the main body of the structure, it offers a "preview" of the interior, where the same colossal order, the same proportions, and the same triumphal-arch motif reappear on the walls of the nave (fig. **15.50**).

Compared with Brunelleschi's San Lorenzo (fig. 15.8), the plan (fig. **15.51**) is extraordinarily compact. Had the church been completed as planned, the difference would be even stronger. Alberti's design had no transept, dome, or choir, all of which were added in the mid-eighteenth century; he planned only a nave ending in an apse. Following the example of the Basilica of Constantine (see figs. 7.68 and 7.69), Alberti replaced the aisles with alternating large and small vaulted chapels and eliminated the clerestory. The colossal pilasters and the arches of the large chapels support a coffered barrel vault of impressive size. (The nave is as wide as the facade.) Here, Alberti has drawn upon his study of the massive vaulted halls in ancient

Roman baths and basilicas, but he interprets these models freely to create a structure that can truly be called a "Christian temple." Such a synthesis of ancient forms and Christian uses was a primary goal of fifteenth-century humanists and their patrician sponsors. Alberti's accomplishment of this goal at Sant'Andrea would inspire many other architects to do the same.

The humanist court at Mantua played host for many years to one of the most intellectually inclined artists of the century, Andrea del Mantegna (1431–1506). Trained in Padua, but aware of artistic currents in Venice, Florence, and Rome, Mantegna became court painter to the Gonzaga in 1460, a position he held until his death at age 75. His interests as a painter, a humanist, and an archeologist can be seen in the panel depicting *St. Sebastian* (fig. **15.52**), probably painted in the 1450s.

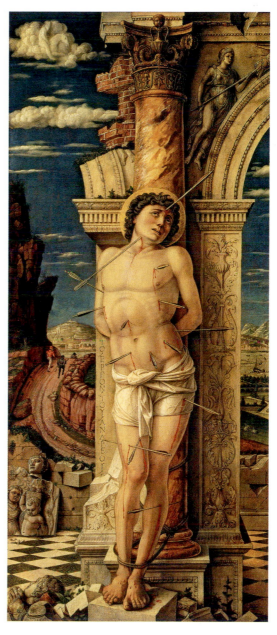

15.52. Andrea Mantegna. *St. Sebastian*. ca. 1450s. Tempera on panel, $26\frac{3}{4} \times 11\frac{7}{8}''$ (68 × 30.6 cm). Kunsthistorisches Museum, Vienna

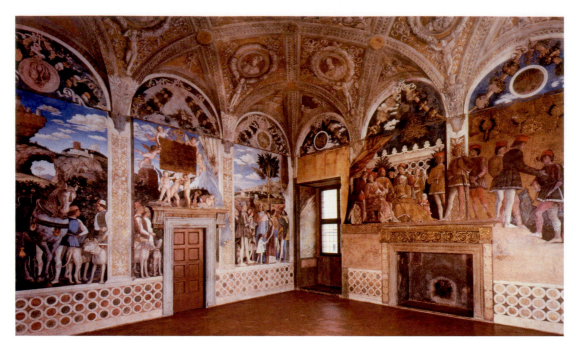

15.53. Andrea Mantegna. *Camera Picta*. 1465–1474. Fresco. Ducal Palace, Mantua

Sebastian was an early Christian martyr who was condemned to be executed by archers. (He recovered from these wounds, which may explain why he was invoked so often against the plague.) Mantegna depicts the anatomically precise and carefully proportioned body of the saint tied to a Classical column. These forms are crisply drawn and modeled to resemble sculpture. Architectural and sculptural Classical ruins lie at his feet and behind him, and next to him, on the left, is the artist's signature in Greek. A road leads into the distance, traversed by the archers who have just shot the saint; through this device, Mantegna lets the perspectively constructed space denote the passage of time. Beyond these men is an atmospheric landscape and a deep blue sky dotted with soft white clouds. The scene is bathed in warm late-afternoon sunlight, which creates a melancholy mood. The light-filled landscape in the background shows Mantegna's study of Flemish paintings, which had reached Florence as well as Venice by 1450, where Mantegna would have encountered them.

Mantegna's patron for the St. Sebastian is unknown, but as a court painter, he served the Marquis of Mantua by painting his villas and palaces. For the Marquis' palace in Mantua, he began painting in 1465 a room that has come to be called the *Camera Picta*, or painted room (fig. **15.53**). This was a multipurpose vaulted room—sometimes bedroom, sometimes reception hall—that Mantegna finished in 1474. On the walls Mantegna painted portraits of the Gonzaga family, their retainers, their children, and their possessions. This room celebrates the Marquis's brilliant court, his dynastic accomplishments, and his wealth, all in a witty display that became an attraction for visiting humanists, politicians, artists, and princes. In such ways, princes used art to improve their social and political positions. The *Camera Picta* also celebrates Mantegna's skill and brought him fame among his contemporaries.

Mantegna used the actual architecture of the room—the corbels supporting the vaults, the mantel over the fireplace—to create an illusionistic glimpse of the Gonzaga family at home. Fictive pilasters serve as window frames through which a viewer sees members of the family out-of-doors; the figures of Ludovico and his son Francesco, recently made a cardinal, are observed by servants with a horse and dogs on the other side of the main door. In addition to the specific features of the people and the naturalism of the details, Mantegna's mastery of perspective allows him to connect the painted world to the real world of the spectator. The centerpiece of this illusion occurs at the crown of the vault, where Mantegna paints a fictive oculus through which a spectator sees the sky. Mantegna uses many devices to suggest illusions here, including drapery that appears to be fluttering in the outside breeze and fictive reliefs of Roman emperors on the vaults. Above the mantel, Ludovico appears again, this time in a more formal setting, surrounded by family and courtiers. The brilliance of the court is wonderfully captured by Mantegna's splendid frescoes.

Venice

While it competed with its neighbors for territory, trade routes, and influence, Venice had a stable republican government throughout the fifteenth century. It was ruled by a merchant aristocracy so firmly established that there was little internal conflict and the Doge's Palace (fig. 13.34) could forgo any fortifications. Similarly, the houses of Venetian patricians were not required to serve as fortresses, so they developed into graceful, ornate structures. The Ca' d'Oro (fig. **15.54**) was built beginning in 1421 for Marino Contarini, whose family had long prospered from trade. To assert his family's status, Contarini spared no expense on his dwelling on the Grand Canal. It received its name ("house of gold") from the lavish gold leaf that once adorned the facade.

The design in part reflects the different functions of the building. The ground floor was used as a shipping center and warehouse, while the second story is devoted mainly to a large reception hall, with several smaller rooms to the right. Private quarters are found mainly on the upper floor. The intersecting ribs of arches form a delicate latticework on the facade, which combine with the brilliant colors and the use of gold to express the family's wealth, position, and ambition.

ECHOES OF DONATELLO'S *GATTAMELATA* The traditions of Venice gave way slowly to the interest in ancient art coming from Florence. Several Florentine artists, including Donatello and Andrea del Castagno, were called to Venice to execute important commissions in the fifteenth century. Flemish painting was admired and collected in Venice, which as a center for international trade housed colonies of merchants from Northern Europe. By the end of the century, Venice had also found the new techniques and references to ancient art useful tools for expressing itself. A good example of this is the commission given by the Republic of Venice to Verrocchio to execute a large bronze equestrian statue commemorating a Venetian army commander, the *condottiere* Bartolommeo Colleoni (fig. **15.55**). Colleoni had requested such a statue in his will, in which he left a large fortune to the Republic of Venice. Colleoni obviously knew the *Gattamelata* statue (fig. 15.21) by Donatello, and wanted the same honor for himself. Verrocchio likely viewed Donatello's work as the model for his statue, yet

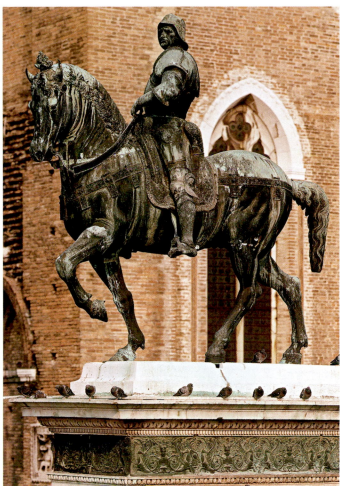

15.55. Andrea del Verrocchio. *Equestrian Monument of Colleoni.* ca. 1483–1488. Bronze, height 13′ (3.9 m). Campo Santissimi Giovanni e Paolo, Venice

he did not simply imitate it. He brought his painter's skill to the rendering of the textures and details of the monument.

Colleoni's horse is graceful and spirited rather than robust and placid; its thin hide reveals veins, muscles, and sinews, in contrast to the rigid surfaces of the armored figure bestriding it. Since the horse is also smaller in relation to the rider than in the *Gattamelata* statue, Colleoni looms in the saddle as the very image of forceful dominance. Legs straight, one shoulder thrust forward, he surveys the scene before him with the same concentration we saw in Donatello's *St. George* (see fig. 15.3). Like Donatello's work, the Colleoni statue also reflects the funereal tradition reflected in the *Tomb of Bernarbò Visconti* (fig. 13.36) and reminds a viewer of the contributions the *condottiere* made to the Republic of Venice.

BELLINI AND OIL PAINTING In addition to the revival of Roman forms, the traditions of Venice were further enhanced late in the fifteenth century by the Venetian exploration of the new medium of oil painting. A crucial intermediary in introducing this technique to Venice was probably Antonello da Messina, a painter from southern Italy who may have traveled to Flanders to learn the technique; he is documented in Venice in the 1470s. In the painting of Giovanni

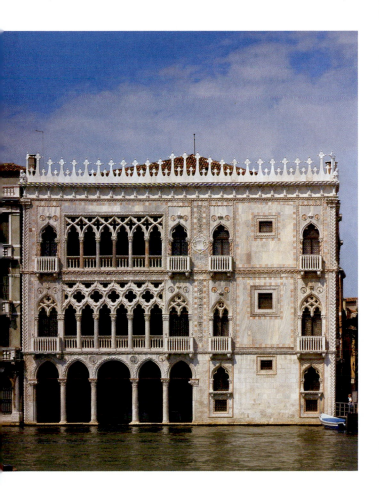

15.54. Ca'd'Oro, Venice. 1421–1440

Bellini (ca. 1430–1507), Mantegna's brother-in-law and a member of a family of painters, the technique of painting in oil pioneered by the Flemish is combined with Florentine spatial systems and Venetian light and color.

Bellini's *St. Francis in Ecstasy* (fig. **15.56**), dating from about 1480, displays the artist's synthesis of these elements to create a wholly original image. In this painting, St. Francis has just stepped out of his hermit's cell, fitted out with a desk under an arbor. He has left his wooden sandals behind and looks up ecstatically to the sky. Some scholars believe the painting shows Francis receiving the stigmata (the wounds of Christ) on the Feast of the Holy Cross in 1224, when a crucified seraph appeared to him on Mount La Verna, in Tuscany. Others have argued that the scene "illustrates" the *Hymn of the Sun*, which Francis composed the next year, after his annual fast at a her-

mitage near his hometown of Assisi. Whichever narrative moment is depicted, the painting expresses Franciscan ideals. For St. Francis, "Brother Sun, who gives the day . . . and . . . is beautiful and radiant with great splendor," was a symbol of the Lord. What he sees in the painting is not the sun itself, which is obscured by a cloud, but God revealed as the light divine. This miraculous light is so intense that it illuminates the entire scene.

In the background is a magnificent expanse of Italian countryside. St. Francis is so small compared to the setting that he seems almost incidental. Yet his mystic rapture before the beauty of the visible world guides a viewer's response to the vista that is displayed, which is ample and intimate at the same time. St. Francis believed that God had created Nature for the benefit of humanity, and Bellini uses the tools of the Renaissance artist to recreate a vision of natural beauty. In this deep space,

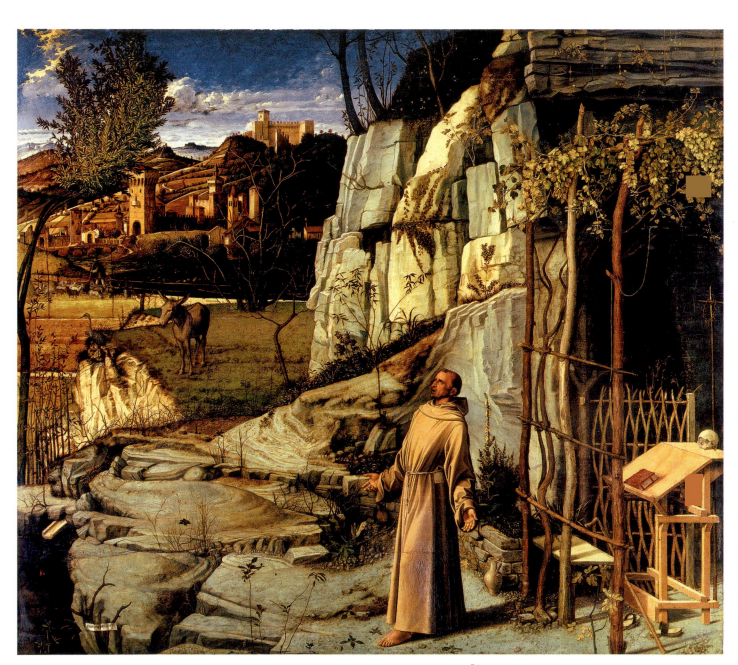

15.56. Giovanni Bellini. *St. Francis in Ecstasy.* ca. 1480. Oil and tempera on panel, $49 \times 55\frac{7}{8}$ ″ (124 × 141.7 cm). The Frick Collection, New York. © copyright the Frick Collection

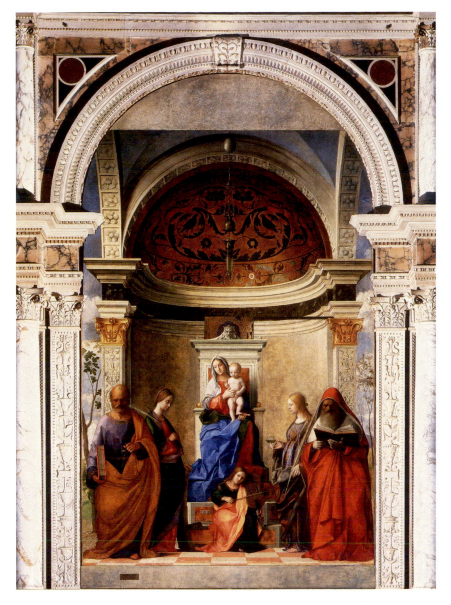

15.57. Giovanni Bellini. *Madonna and Saints*. 1505. Oil on panel, 16′5¹⁄₈″ × 7′9″ (5 × 2.4 m). San Zaccaria, Venice

derived using the rules of perspective, he depicts detailed textures and forms to populate the landscape. Some of these forms may express other Franciscan values. For Francis, the road to salvation lay in the ascetic life of the hermit, symbolized by the cave. The donkey may stand for St. Francis himself, who referred to his body as Brother Ass, which must be disciplined. The other animals—the heron, bittern, and rabbit—are, like monks, solitary creatures in Christian lore. Yet Bellini's soft colors and glowing light infuse the painting with a warmth that makes such a solitary life not only bearable, but enviable.

As the foremost artist of Venice, Bellini produced a number of altarpieces of the *sacra conversazione* type. The latest and most monumental is the *Madonna and Saints* (fig. **15.57**), done in 1505 for the venerable Benedictine convent of San Zaccaria. This Queen of Heaven is raised up on a throne with her Child, while saints Peter, Catherine, Lucy, and Jerome stand before her. The placement of the female saints may reflect the interests of the nuns for whom the altarpiece was made. (When the painting

was fitted with its present frame a decade later, it was cut at the sides, and a piece, since removed, was added at the top.) Compared with Domenico's *sacra conversazione* of 60 years earlier (fig. 15.30), the setting is simpler but even more impressive. Instead of a Gothic canopy, the saints are gathered below a semi-dome covered with mosaic in the Venetian medieval tradition (see San Marco, fig. 8.48). Piero's Urbino Madonna (fig. 15.48) provides a closer model for this painting, but Bellini's figures are more comfortably inserted into the apse and the pyramid composition is more stable. The structure is obviously not a real church, for its sides are open and the scene is flooded with sunlight. The Madonna's high-backed throne and the music-making angel on its lowest step may be compared to those in Masaccio's *Madonna Enthroned* of 1426 (see fig. 15.19).

What distinguishes this altar from earlier Florentine examples is not only the spaciousness of the design but its calm, meditative mood. Instead of "conversation," the figures seem deep in thought, so gestures are unnecessary. The silence is enhanced

by the way the artist has bathed the scene in a delicate haze. There are no harsh contrasts. Light and shadow blend in almost imperceptible gradations, and colors glow with a new richness. Bellini creates a glimpse into a heavenly court peopled by ideal figures in an ideal space.

Rome and the Papal States

Long neglected during the papal exile in Avignon (see page 457), Rome once more became a major artistic center in the late fifteenth century. As the papacy regained power on Italian soil, the popes began to beautify both the Vatican and the city. They also reasserted their power as temporal lords over Rome and the Papal States. These Popes believed that the monuments of Christian Rome must outshine those of the pagan past. To achieve this goal, they called many artists from Florence and the surrounding areas to Rome in the fifteenth century, including Gentile da Fabriano, Masaccio, Fra Angelico, Piero della Francesca, and Sandro Botticelli. Like the other courts of Italy, the papacy saw the value of spending money on adorning both ecclesiastical and domestic structures.

Pope Sixtus IV della Rovere (1471–1484) sponsored several important projects in the last quarter of the century, including the building of the Vatican library. To commemorate this project, Sixtus hired a local painter, Melozzo da Forlì (1438–1498), to paint a fresco depicting himself and his court at the confirmation of Bartolomeo Platina as the official Vatican librarian (fig. **15.58**). The pope sits enthroned, surrounded by his nephews. (Awarding offices to members of one's family was a widespread practice called *nepotism*, from the Italian word for "nephew.") The standing figure at the center is Giuliano delle Rovere, Sixtus's nephew and the future Pope Julius II. Melozzo designed the fresco to illusionistically continue the space of the real structure (now destroyed). A viewer looks up to see the ceilings, the pillars, the windows of the room. Furthermore, the surfaces are very luxurious: Melozzo depicts lots of veining in the marble, elaborate moldings, and decorative forms in the framing elements. (The oak leaves with acorns in the framing pilasters are a reference to the pope's family name: Rovere means "oak.") Platina points to an inscription which lauds Sixtus for his improvements to Rome.

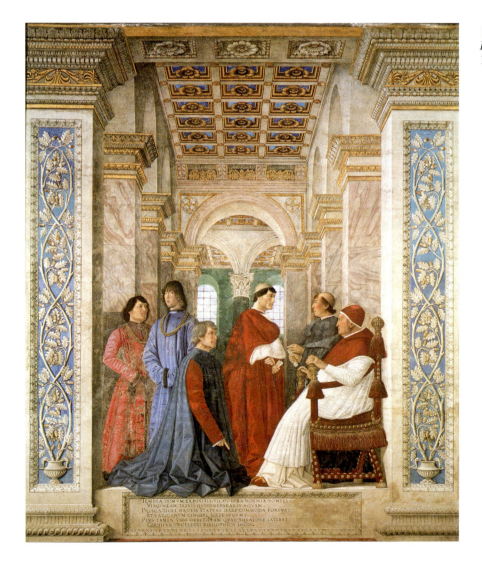

15.58. Melozzo da Forli. *Sixtus IV Confirming the Papal Librarian*. ca. 1480. Detached fresco, 12′ × 10′4″ (3.7 × 3.15 m). Musei Vaticani, Rome

THE SISTINE CHAPEL One of those improvements was the building at the Vatican of a new chapel for the pope, called the Sistine Chapel after Sixtus IV. Around 1481–1482, Sixtus commissioned a cycle of frescoes for the walls of the chapel depicting events from the life of Moses (on the left wall) and Christ (on the right wall), representing the Old and New Testaments. To execute them, he hired most of the important painters of central Italy, among them Botticelli, Ghirlandaio, and Pietro Vanucci, called Perugino (ca. 1450–1523). Born near Perugia in Umbria (the region southeast of Tuscany), Perugino maintained close ties with Florence. He completed the fresco of *The Delivery of the Keys* (fig. **15.59**) in 1482.

The gravely symmetrical design of the fresco conveys the special importance of the subject in this particular setting: The authority of St. Peter as the first pope, as well as of all those who followed him, rests on his having received the keys to the Kingdom of Heaven from Christ himself. The figures have the crackling drapery and idealized features of Verrocchio (see fig. 15.27) in whose shop Perugino spent some time. Along with the other apostles, a number of bystanders with highly individualized features witness the solemn event.

In the vast expanse of the background, two further narratives appear: To the left, in the middle distance, is the story of the Tribute Money; to the right, the attempted ston-

ART IN TIME

1464—First printing press in Italy set up near Rome
1470—Alberti's Sant' Andrea in Mantua begun
1471—Sixtus IV elected pope
ca. **1480—Bellini's *St. Francis***
1492—Columbus sails west

ing of Christ. The inscriptions on the two Roman triumphal arches (modeled on the Arch of Constantine; see fig. 7.63) favorably compare Sixtus IV to Solomon, who built the Temple of Jerusalem. These arches flank a domed structure seemingly inspired by the ideal church of Alberti's *Treatise on Architecture*. Also Albertian is the mathematically exact perspective, which lends the view its spatial clarity. The symmetry and clear space of the image express the character of the rule of the Sixtus IV, not only in spirtual, but in temporal terms.

SIGNORELLI, THE CHAPEL OF SAN BRIZIO Sixtus's claims over the Papal States were taken up by his successor, Alexander VI, who pursued temporal power with armies as well

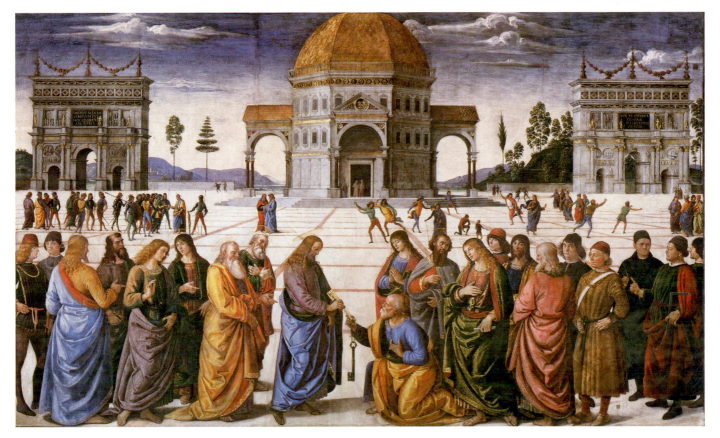

15.59. Pietro Perugino. *The Delivery of the Keys.* 1482. Fresco, 11′5½″ × 18′8½″ (3.5 × 5.7 m). Sistine Chapel, Vatican Palace, Rome

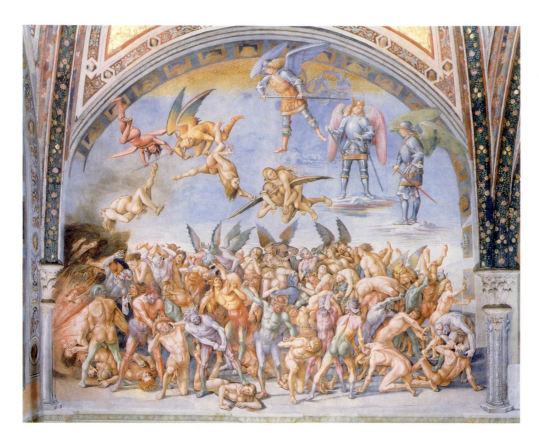

15.60. Luca Signorelli. *The Damned Cast into Hell.* 1499–1500. Fresco, approx. 23' (7 m) wide. San Brizio Chapel, Orvieto

as spiritual weapons. (Such activities drew the censure of other Christians, both in Italy and elsewhere, fueling the anticlerical feelings of the next century.) The city of Orvieto had shown great allegiance to the papacy, and in return, the pope adorned the Chapel of San Brizio in the cathedral of that Umbrian city with a series of frescoes beginning in 1499. The commission for the project went to Luca Signorelli (1445/50–1523), a Tuscan painter who had studied with Piero della Francesca. The theme chosen for the frescoes is the end of the world, as predicted in the book of Revelation, but further elaborated by St. Augustine, Thomas Aquinas, and Dante, as well as the fifteenth-century Dominican preacher Vincent Ferrer. One of the most memorable of these frescoes is *The Damned Cast into Hell* (fig. **15.60**). Signorelli envisions the scene as a mass of bodies pressed forcefully downward to be tormented by devils and licked by the flames of Hell, while the Archangel Michael oversees the punishment. Inspired by the muscular forms of Pollaiuolo, Signorelli uses the nude body as an expressive instrument: The damned twist and turn, their bodies expressing the torments they face. The chaotic composition and compressed space contrasts strikingly with the rational calm of Perugino's *The Delivery of the Keys* (see fig. 15.59). Signorelli's frightening image of the end of time was painted as the year 1500 approached, a date which many believed would signal the end of days.

The late 1490s were a time of great uncertainty in Italy. The Medici were expelled from Florence; the French invaded in 1494; the plague returned to ravage cities; and the Turks continued their incursions into Europe. (The Turks had crushed the Christian forces at Lepanto, Greece, in 1499, a defeat that would be avenged in a second, more famous battle at the same site in 1571.) Fears that the "end of days" were coming were fanned by the sermons of Savonarola and other preachers.

SUMMARY

The world had changed a great deal over the fifteenth century. The printing press spread the new learning of the humanists and allowed philosophers and scientists to build on the wisdom of their predecessors in powerful new ways. The conquest of the eastern Mediterranean by the Turks spurred the Atlantic nations of Portugal and Spain to investigate other routes for trade with Asia, leading to the circumnavigation of Africa and the discovery of the Americas. The schism in the papacy and the worldly character of late fifteenth-century popes continued a process of disaffection

with religious institutions and increased secularity in the culture. Competition and trade spread an economy that became based on capital and money, thereby changing the face of society by expanding the middle class.

Artists of fifteenth-century Italy participated in these changes by developing new means to render the world in their images. Beginning with a study of the past embodied in Rome and its art, the sculptors, painters, and architects of Italy created works of art that united ancient forms with contemporary content. Under the influence of the ancients and their humanist contemporaries, these artists wrote theoretical treatises as if they themselves were scholars, increasing the status of the arts in their culture. Their creation of systems for representing the world through perspective, through naturalism and through the human form, became normative for not only themselves but for most Europeans in subsequent centuries. The Early Renaissance revolutionized the way people in Europe looked at works of art and at the work of artists.

ANCIENT INSPIRATIONS FOR ARCHITECTURE AND ARCHITECTURAL SCULPTURE

The city of Florence placed great value on commissioning public buildings and embellishing them with significant works of art. Competition among artists and among patrons resulted in a series of impressive and innovative monuments, many of them inspired by the study of ancient art. Combining his study of Roman buildings with Gothic building techniques, Brunelleschi transformed the city with his classicizing architecture. His architecture uses Roman forms organized by geometry and proportion to create spaces that are harmonious and rational. The young Donatello modeled his sculpture after ancient works to give his figures great naturalism, but also dignity and the potential for movement.

CHURCHES AND CHAPELS FOR FLORENTINE FAMILIES, 1420 – 1430

Prominent Florentine families paid for the construction and adornment of churches to express piety and social standing. Brunelleschi designed whole churches and individual chapels for the leading families of Florence, while his invention of linear perspective provided a means for artists to create the illusion of space in their pictures. Painters made altarpieces and frescoes to adorn family chapels. Masaccio's religious frescoes take full advantage of perspective, but also display his innovations in modeling forms in light and in the expressive possibilities of the human body.

SPREAD OF FLORENTINE STYLE, 1425–1450

The innovations of Florentine artists spread quickly through Italy. Patrons such as the Bishop of Siena or the Carmelite friars of Pisa probably took advice from their Florentine peers when looking for artists to hire. The artists themselves traveled throughout Tuscany to execute important commissions, bringing their expertise in perspective, modeling, and expressive form along with them. Patrons in other cities, such as Rome and Venice, also sought the talents of Masaccio and Donatello for artistic projects.

FLORENCE DURING THE ERA OF THE MEDICI, 1430–1494

In the middle years of the fifteenth century, Florentine artists continued to explore the lessons of antiquity and the potential for spatial illusion pioneered by Donatello, Ghiberti, Masaccio, and Brunelleschi. Ghiberti worked on a second pair of doors for the Baptistery, which focused on complex narratives from the Old Testament in illusionistic spaces, while Donatello explored many sculptural media. Their influence may be seen on the next generation of sculptors and painters. These artists were commissioned by convents, monasteries, and prominent families to make religious images or to adorn churches. Leon Battista Alberti fused local tradition and Classical architectural theory in his facade for Santa Maria Novella.

DOMESTIC LIFE: PALACES, FURNISHINGS, AND PAINTINGS, CA. 1440–1490

The private dwellings of Florentine families displayed their social rank and civic virtue, which found visual expression in classicizing forms. Adapting elements from Roman structures, Alberti and Michelozzo created palaces that served as stages for family life and public events. These buildings were adorned with furnishings, paintings, and sculptures of both religious and secular themes. The Medici populated their palace with images of Florentine civic patrons, like Donatello's *David* and Pollaiuolo's *Hercules and Antaeus*. Both sculptors made images of nudes, a practice clearly inspired by ancient statues, for these domestic settings. Palaces were also adorned with paintings on painted chests (cassoni) or on circular panels (tondi). Themes from contemporary history and Greek mythology were treated in paintings for palace walls. Portraits of individuals and of families appeared not only as donors in religious commissions or tombs, but as actors in sacred narratives and as separate paintings and portrait busts.

THE RENAISSANCE STYLE REVERBERATES, 1450–1500

The authority of antiquity and the impressiveness of Florentine style inspired artists outside of Florence to emulate and interpret the new styles. Piero della Francesca spent time in Florence, but developed his own style informed by perspective, antiquity, and Masaccio, to which he added the new technique of oil painting. Alberti accepted commissions in the courts of northern Italy, thus bringing his classicizing architecture to other regions of Italy. In Mantua, the artist and humanist Mantegna made paintings inspired by his interest in archeology, while his work as a court painter produced illusionistic frescoes that flattered his employer. Venice adhered to its local traditions in architecture, but hired Verrocchio to sculpt an equestrian portrait of a general that emulated the ancients. Venetian painters were interested in the possibilities for naturalism suggested by the new styles emanating from Florence, but they were also open to the nuances of color and light made possible by oil paints. As the popes rebuilt the city of Rome, they hired artists from Florence and elsewhere to create images that expressed their legitimacy as the heirs of St. Peter and their political power as rulers of the Papal States. Renaissance Naturalism and Classicism proved adaptable to many needs.

The High Renaissance in Italy, 1495–1520

LOOKING BACK AT THE ARTISTS OF THE FIFTEENTH CENTURY, THE ARTIST and art historian Giorgio Vasari wrote in 1550, "Truly great was the advancement conferred on the arts of architecture, painting, and sculpture by those excellent masters…." From Vasari's perspective, the earlier generation had provided artists the groundwork that enabled sixteenth-century

artists to "surpass the age of the ancients." Later artists and critics agreed with Vasari's judgment that the artists who worked in the decades just before and after 1500 attained a perfection in their art worthy of admiration and emulation.

For Vasari, the artists of this generation were paragons of their profession. Following Vasari, artists and art teachers of subsequent centuries have used the works of this 25-year period between 1495 and 1520, known as the *High Renaissance*, as a benchmark against which to measure their own. Yet the idea of a "High" Renaissance presupposes that it follows something "lower," which seems an odd way to characterize the Italian art of the inventive and dynamic fifteenth century. For this and other reasons, this valuation has been reconsidered in the past few decades. Nonetheless, this brief period saw the creation of what are still some of the most revered works of European art in the world. These works were created by the most celebrated names in the history of art, as chronicled in Vasari's book *The Lives of the Most Eminent Painters, Sculptors and Architects of Italy*. Vasari's book placed the biography of the artist at the center of the study of art, and his *Lives* became a model of art historical writing. Indeed, the celebrity of artists is a distinctive characteristic of the early sixteenth century.

Leonardo, Bramante, Michelangelo, Raphael, Giorgione, and Titian were all sought after in early sixteenth-century Italy, and the two who lived beyond 1520, Michelangelo and Titian, were internationally celebrated during their lifetimes. This fame was part of a wholesale change in the status of artists that had been occurring gradually during the course of the fifteenth century and which gained strength with these artists. Despite the qualities of their births, or the variations in their styles or their personalities, these artists were given the respect due to intellectuals and Humanists. Their social status was on a par with members of the great royal courts. In some cases, they were called "genius" or "divine." Some among them were raised to the nobility.

Part of this cult of fame was due to the patrons who commissioned this small number of gifted and ambitious men to make works of art for them. This period saw the coming together of demanding patrons—rulers, popes, princes—and innovative artists. Patrons competed for works by these artists and set the artists in competition with each other, a pattern that had already begun in early fifteenth-century Florence; the skills of the artists were tested against each other to inspire them to produce innovations in technique and in expression. The prestige of the patrons contributed to the mystique that developed around the artists, and the reputations of the artists enriched the prestige of the patrons. What is truly remarkable about this group of artists is their mastery of technique in their

Detail of figure 16.16, Michelangelo, *Awakening Prisoner*

chosen media and in their styles of expression. Each of these artists developed a distinctive visual style that grew out of the ideas of the fifteenth century, but which, through their personal vision, their awareness of intellectual trends of their times, and their hard work, created works of art that their contemporaries claimed surpassed both Nature and the ancients. Their pictorial works share certain features: an approach to the imitation of Nature that idealizes forms even as they are rendered to replicate Nature; an understanding of and reliance on the forms of antiquity; a balance and clarity in their compositions; and an emotional power.

Also remarkable is that works of such authority and harmony were produced during a quarter century of crisis and instability. During this period, Italy was threatened by the Turkish expansion from Istanbul, invaded by the French, and torn apart by internal wars. Florence saw the exile of the Medici, the rise of Girolamo Savonarola, the establishment of a republic, and the return of the Medici. Venice saw its territories stripped away by its rivals. Milan was ruled by a despot, then conquered by the French. The papacy began a program of territorial reclamation and expansion that brought it into conflict with its neighbors; the Roman Church also had to contend with the shock of a theological challenge offered by Martin Luther's critique of Catholic dogma and practice. All of Europe was shocked by reports of new lands and new peoples across the ocean, which challenged their notion of the world itself.

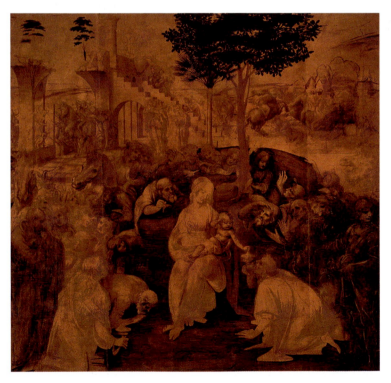

16.1. Leonardo da Vinci. *Adoration of the Magi*. 1481–1482. Monochrome on panel, 8′ × 8′1″ (2.43 × 2.46 m). Galleria degli Uffizi, Florence

THE HIGH RENAISSANCE IN FLORENCE AND MILAN

Florence's reputation as a center for the arts made it a magnet for artists and patrons as the fifteenth century came to a close. The brilliance of the court around Lorenzo de' Medici came to an end with his death in 1492 and the subsequent failure of his son as the leader of the city. Many Florentines heeded the warnings of the preacher Girolamo Savonarola, who encouraged them to reform their faith and their lives; in response, they rejected the worldly culture of the Medici court. Under his influence, "pagan" texts and works of art were burned in bonfires in the Piazza della Signoria; the painter Sandro Botticelli destroyed several of his paintings at these bonfires. Yet the penitential furor that Savonarola urged did not outlive the preacher's execution in 1498. Florence restored its republican form of government, which lasted only until the next generation of Medici politicians took the reins of government in 1512. The political ferment seems to have inspired tremendous artistic innovation, as witnessed in the works of Leonardo da Vinci and Michelangelo Buonarotti.

Leonardo da Vinci in Florence

Leonardo da Vinci was at once a scientist, painter, sculptor, musician, architect, and engineer. The son of a notary, Leonardo was born in the little Tuscan town of Vinci in 1452 and trained as a painter in Florence in Verrocchio's busy workshop. He left Florence around 1482 to work for Ludovico Sforza, the duke of Milan, primarily as a military engineer and only secondarily as an artist. On Sforza's removal by the French in 1499, Leonardo made his way to Venice, Rome, and Florence, where he executed several commissions between 1503 and 1505. From 1506 through 1516 he worked in Rome and Florence and again in Milan, whose French overlord, Francis I, invited him to retire to a chateau in the Loire Valley. Leonardo died there in 1519.

When he left Florence in 1482, Leonardo had been working on an ambitious panel of the *Adoration of the Magi* (fig. **16.1**), commissioned by a group of Florentine monks; but he left it unfinished except for the ground and the underdrawing. While the theme is traditional, the panel otherwise displays Leonardo's inventive approach to rendering form. For the background structures, he deploys an exact perspective and a geometric order that recall Masaccio (see fig. 15.14). He then installs the main figures in a pyramidal arrangement that places the Virgin's head at the apex, surrounded by a sweeping arc of onlookers. There seems little connection between these foreground figures and the background elements, though the tree at the center bridges them. The gracefulness of the Madonna and Child reflects Florentine style in about the year 1480, though much else about the panel is revolutionary.

This is especially true in its execution. Although Leonardo had completed only some of the initial layers of the painting, the forms in the panel seem to materialize softly and gradually, never quite detaching themselves from the dusky atmosphere.

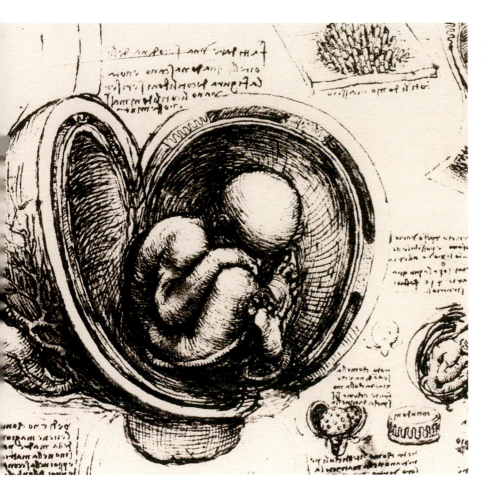

16.2. Leonardo da Vinci. *Embryo in the Womb.* ca. 1510. Detail of pen drawing, $11^{7}/_{8} \times 8^{3}/_{8}''$ (30.4 × 21.5 cm). Windsor Castle, Royal Library. © 1991 Her Majesty Queen Elizabeth II

Leonardo, unlike Filippo Lippi or Botticelli, thought not in terms of outlines but of three-dimensional bodies made visible in varying degrees by the fall of light (compare with figs. 15.39 and 15.42). This method of modeling is called **chiaroscuro**, the Italian word for "light and dark." Starting from a middle tone laid all over the panel, Leonardo renders deep shadows and bright highlights for his forms. Instead of standing side by side in a vacuum, forms share in a new pictorial unity created by the softening of contours in an envelope of atmosphere.

Leonardo seeks emotional continuity as well. Instead of the distracting profusion of people, animals, and things in Gentile da Fabriano's *Adoration of the Magi* of 1423 (fig. 15.12), Leonardo arranges his figures so that all gaze at the Mother and Child at the center of the picture. The figures are remarkable for the expression of emotion through gestures and faces, which Leonardo learned from his study of both Pollaiuollo and Verrocchio (see figs. 15.36 and 15.27). Despite its unfinished state, the panel suggests the direction that Leonardo's art would take, in its technical daring and its emotional depth.

Leonardo in Milan

Instead of completing this panel, Leonardo left Florence for Milan, where he entered the employ of Ludovico Sforza, Duke of Milan. He stayed there until 1499, working as an engineer, court artist, and military designer. As had Brunelleschi before him, Leonardo turned to analysis and research to solve a variety of problems, both artistic and scientific. He believed the world to be intelligible through mathematics, which formed the basis for his investigations. Thus the artist must know not only the rules of perspective, but all the laws of Nature. To him the eye was the perfect means of gaining such knowledge. The extraordinary range of his inquiries can be seen in the hundreds of drawings and notes that he hoped to turn into an encyclopedic set of treatises. He was fascinated by all elements of Nature: animals, water, anatomy, and the workings of the mind. How original he was as a scientist is still a matter of debate, but he created modern scientific illustration, an essential tool for anatomists and biologists. His drawings, such as the *Embryo in the Womb* (fig. **16.2**), combine his own vivid observations with the analytic clarity of diagrams—or, to paraphrase Leonardo's own words, sight and insight. The sheet of studies shown in figure 16.2 depends on his skill at rendering what he saw, and on his dispassionate recording of details both in visual terms and in his notes, written backwards in mirror writing.

Like other fifteenth-century scholars, he read ancient authorities to assist his inquiries. To prepare himself for human dissections, Leonardo read the works of the Greek physician Galen. His interest in architecture and engineering led him to the works of the Roman architect Vitruvius, whose treatise had

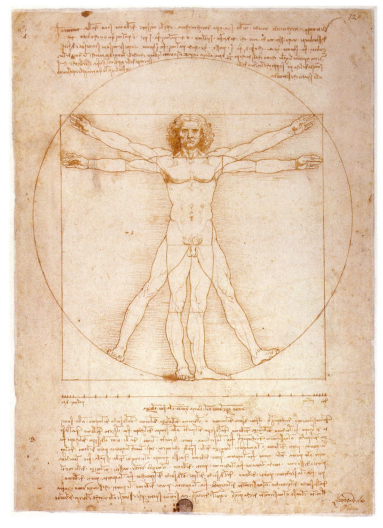

16.3. Leonardo da Vinci. *Vitruvian Man*. ca. 1487. Pen and ink, 13½ × 9½" (34.3 × 24.5 cm). Gallerie dell'Accademia, Venice

Soon after arriving in Milan, Leonardo painted *The Virgin of the Rocks* (fig. **16.5**) for a Confraternity of the Immaculate Conception, which maintained a chapel in San Francesco Grande. The subject—the infant St. John adoring Jesus in the presence of the Virgin—enjoyed a certain popularity in Florence in the late fifteenth century. Speculation on the early life of Jesus and his cousin, the Baptist, led to stories about their meeting as children. Franciscan preachers encouraged believers to meditate on the "human" side of Jesus' life and stories like this were the result. Such tales report the young Baptist spending his life as a hermit, and he is sometimes represented wearing a hair shirt. Leonardo imagines this meeting almost as a vision of Christ appearing to the infant Baptist in the wilderness. The young Baptist kneels on the left and looks toward Jesus, who blesses him. The Virgin Mary is the link between the two boys, as she protectively reaches for the Baptist with one hand and holds an open palm over her son with the other. An angel with a billowing red cloak steadies Jesus and points toward the Baptist, while looking out at the viewer.

The scene is mysterious in many ways. The secluded rocky setting, the pool in the foreground, and the carefully rendered plant life suggest symbolic meanings, but scholars are still

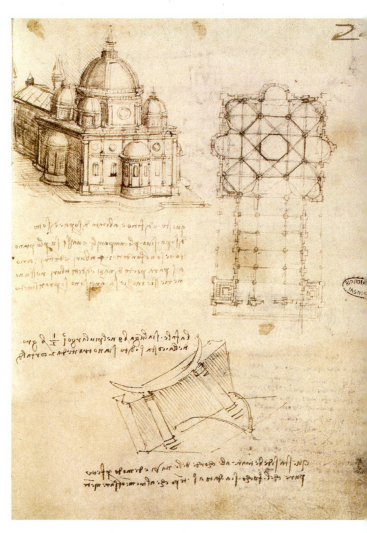

16.4. Leonardo da Vinci. *Project for a Church* (Ms. B). ca. 1490. Pen drawing, 9⅛ × 6¾" (23 × 17 cm). Bibliothèque de l'Arsenal, Paris

inspired Alberti earlier in the century. A drawing from the late 1480s (fig. **16.3**) visualizes Vitruvius' notion that the human body may be used to derive the perfect geometrical forms of the circle and the square. This is a powerful image of the value that humanists and architects placed on these geometric elements, as carriers of profound meaning as well as visual forms. Like other humanists, Leonardo was interested in the place of man in the world.

Leonardo himself was esteemed as an architect. He seems, however, to have been less concerned with actual building than with tackling problems of structure and design. For the most part, the many architectural projects in his drawings were intended to remain on paper. Yet these sketches, especially those of his Milanese period, reveal Leonardo's probing of the design problems faced by his forebears, Brunelleschi and Alberti, and his contemporaries. The domed central-plan churches of the type shown in figure **16.4** hold particular interest to architectural history. In this drawing Leonardo imagines a union of circle and square, controlled by proportion, and articulated by Classical orders. In conception, this design stands halfway between the dome of Florence Cathedral and the most ambitious structure of the sixteenth century, the new basilica of St. Peter's in Rome.

debating the details. The figures emerge from the semidarkness of the grotto, enveloped in a moist atmosphere that delicately veils their forms. This fine haze, called **sfumato** (smokiness), lends an unusual warmth and intimacy to the scene. The light draws attention to the finely realized bodies of the children and the beautiful heads of the grownups. Leonardo arranges the figures into a pyramid of form, so the composition is stable and balanced, but the gestures lead the eye back and forth to suggest the relationships among the figures. The

selective light, quiet mood, and tender gestures create a remote, dreamlike quality, and make the picture seem a poetic vision rather than an image of reality.

Leonardo had much to say about the relation between poetry and painting. He thought sight was the superior sense and that painters were best equipped to represent what the eye could see or imagine. His notebooks include many comments on the *paragone,* or comparison, between painting and poetry. This competition between art forms was rooted in the Roman

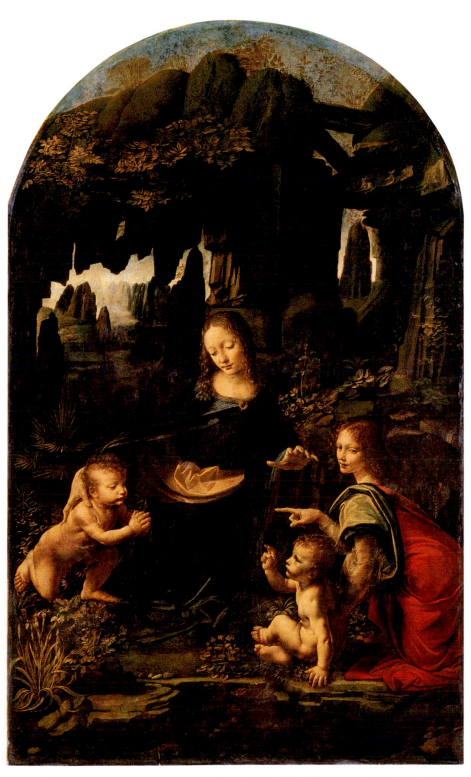

16.5. Leonardo da Vinci. *The Virgin of the Rocks*. ca. 1485. Oil on panel transferred to canvas, 6′6″ × 4′ (1.9 × 1.2 m). Musée du Louvre, Paris

PRIMARY SOURCE

Leonardo Da Vinci (1452–1519)

From his undated manuscripts

Leonardo, the consummate High Renaissance man, wrote on a variety of topics. The comparison of the arts, or paragone*, was a common subject in High Renaissance scholarship.*

He Who Depreciates Painting Loves Neither Philosophy nor Nature

If you despise painting, which is the sole imitator of all visible works of nature, you certainly will be despising a subtle invention which brings philosophy and subtle speculation to bear on the nature of all forms—sea and land, plants and animals, grasses and flowers—which are enveloped in shade and light. Truly painting is a science, the true-born child of nature. For painting is born of nature; to be more correct we should call it the grandchild of nature, since all visible things were brought forth by nature and these, her children, have given birth to painting. Therefore we may justly speak of it as the grandchild of nature and as related to God.

A Comparison Between Poetry and Painting

The imagination cannot visualize such beauty as is seen by the eye, because the eye receives the actual semblances or images of objects and transmits them through the sense organ to the understanding where they are judged. But the imagination never gets outside the understanding; . . . it reaches the memory and stops and dies there if the imagined object is not of great beauty; thus poetry is born in the mind or rather in the imagination of the poet who, because he describes the same things as the painter, claims to be the painter's equal! . . .

The object of the imagination does not come from without but is born in the darkness of the mind's eye. What a difference between forming a mental image of such light in the darkness of the mind's eye and actually perceiving it outside the darkness!

If you, poet, had to represent a murderous battle you would have to describe the air obscured and darkened by fumes from frightful and deadly engines mixed with thick clouds of dust polluting the atmosphere, and the panicky flight of wretches fearful of horrible death. In that case the painter will be your superior, because your pen will be worn out before you can fully describe what the painter can demonstrate forthwith by the aid of his science, and your tongue will be parched with thirst and your body overcome by sleep and hunger before you can describe with words what a painter is able to show you in an instant.

Of the Sculptor and Painter

The sculptor's art requires more physical exertion than the painter's, that is to say, his work is mechanical and entails less mental effort. Compared with painting, there is little scientific research; for the sculptor's work consists in only taking off and the painter's in always putting on. The sculptor is always taking off from the same material, while the painter is always putting on a variety of materials. The sculptor gives all his attention to the lines that circumscribe the material which he is carving, and the painter studies these same lines, but he has besides to study the shade and light, the color and the foreshortening. With respect to these the sculptor is helped throughout by nature, which supplies the shade and light and the perspective. While the painter has to acquire these by dint of his ingenuity and has himself to play the part of nature, the sculptor always finds them ready made.

SOURCE: *THE LITERARY WORKS OF LEONARDO DA VINCI*, ED. JEAN PAUL RICHTER. (LONDON:PHAIDON PRESS LTD., 1975)

poet Horace's statement that poetry is like painting (*ut pictura poesis*), which artists of the High Renaissance reinterpreted to mean that painting ought to conform to poetry. (See *Primary Source*, above.) Leonardo's musings on the competition between poetry and painting further extended to the competition between painting and sculpture. He argued that painting was superior to sculpture primarily because it provided the possibility for creating the sort of illusionary spaces and textures seen in the *Virgin of the Rocks*. Additionally, the painter could dress elegantly while he worked, and not subject himself to the clouds of dust or the brute force needed to make sculpture. Not all of his contemporaries agreed. Michelangelo, for one, defended the art of sculpture as superior to painting, precisely because it created fully three-dimensional forms while painting merely created illusions.

Leonardo's skill at creating such illusions and his experimental approach to achieving them is apparent in *The Last Supper* (fig. **16.6**), executed between 1495 and 1498. Leonardo's patron, Duke Ludovico, commissioned him to decorate the refectory (dining hall) of the Dominican monastery of Santa Maria delle Grazie, which housed the Duke's family

chapel. The resulting painting was instantly famous and copied numerous times by other artists, but a modern viewer can only imagine its original splendor, even though the painting was recently restored. Dissatisfied with the limitations of the traditional fresco technique, Leonardo experimented with an oil-tempera medium on dry plaster that did not adhere well to the wall in the humidity of Milan. What is more, the painting has been diminished by renovations and damage done to the wall. Yet what remains is more than adequate to account for its tremendous impact.

The theme of the Last Supper was conventional for monastic refectories, as a comparison with Castagno's *Last Supper* (see fig. 15.29), painted half a century before, reveals. Monks or nuns dined in silence before images of the apostles and Christ at table. Like Castagno, Leonardo creates a spatial setting that seems like an annex to the real interior of the room, though deeper and more atmospheric than the earlier fresco. The central vanishing point of the perspective system is located behind the head of Jesus in the exact middle of the fresco; it thus becomes charged with symbolic significance. Equally symbolic is the opening in the wall behind Jesus: It

acts as the architectural equivalent of a halo. Rather than Castagno's explosion of marble veining or an artificial disk of gold, Leonardo lets natural light enframe Jesus. All elements of the picture—light, composition, colors, setting—focus the attention on Jesus.

He has presumably just spoken the fateful words, "One of you shall betray me." The disciples ask, "Lord, is it I?" The apostles who flank Jesus do not simply react to these words. Each reveals his own personality, his own relationship to Jesus. In the group to his right, Peter impulsively grabs a knife, next to him John seems lost in thought; and Judas (the figure leaning on the table in the group to Jesus' right) recoils from Jesus into shadow. Leonardo has carefully calculated each pose and expression so that the drama unfolds across the picture plane. The figures exemplify what the artist wrote in one of his notebooks—that the highest and most difficult aim of painting is to depict "the intention of man's soul" through gestures and movements of the limbs.

But to view this scene as just one moment in a psychological drama does not do justice to Leonardo's aims, which went well beyond a literal rendering of the biblical narrative. He clearly wanted to condense his subject, both physically (by the compact, monumental grouping of the figures) and spiritually (by presenting many levels of meaning at one time). Thus Jesus' gesture is both one of submission to the divine will and of offering. His calm presence at the center of the table suggests that in

ART IN TIME

1498—Execution of Savonarola in Florence
1499—France conquers Milan
ca. 1503—Leonardo's *Mona Lisa*
1512—Florentine Republic is dismantled and the Medici family comes back to power

addition to the drama of the announcement, Jesus also institutes the Eucharist, in which bread and wine become his body and blood. Such multiple meanings would serve as spiritual food for the Dominican friars who lived in the presence of this image.

In 1499, the duchy of Milan fell to the French, and Leonardo returned to Florence after brief trips to Mantua and Venice. He must have found the climate very different from what he remembered. Florentines had become unhappy with the rule of Lorenzo de' Medici's son, Piero, and expelled the Medici, and until their return in 1512, the city was briefly a republic again. For a while, Leonardo seems to have been active mainly as an engineer and surveyor. Then in 1503 the city commissioned him to do a mural for the council chamber of the Palazzo della Signoria, but in 1506 he abandoned the commission and returned to Milan.

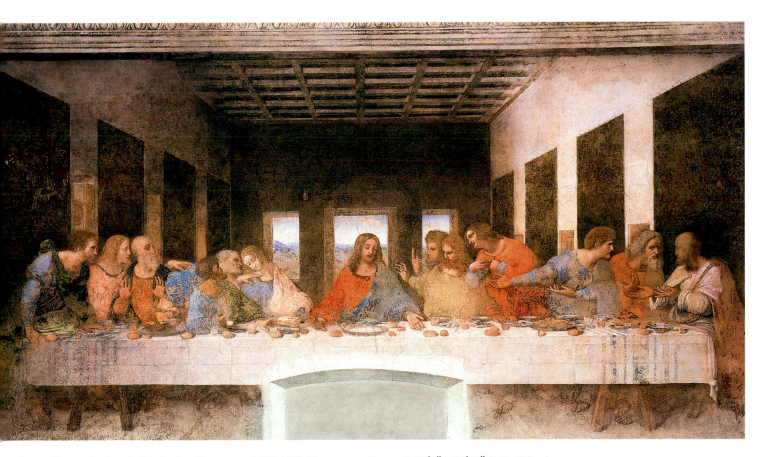

16.6. Leonardo da Vinci. *The Last Supper*. ca. 1495–1498. Tempera wall mural, 15′2″ × 28′10″ (4.6 × 8.8 m). Santa Maria delle Grazie, Milan

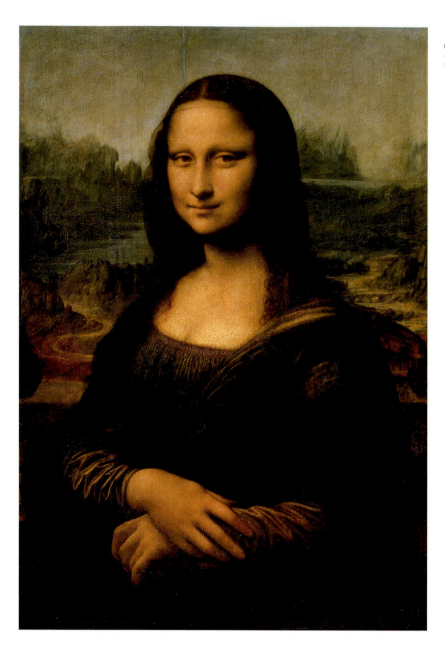

16.7. Leonardo da Vinci. *Mona Lisa*. ca. 1503–1505. Oil on panel, 30¼ × 21″ (77 × 53.5 cm). Musée du Louvre, Paris

Reinventing the Female Portrait

While working on the mural, Leonardo also painted the portrait of a woman, whom Vasari identified as Lisa di Gherardo, wife of Francesco del Giocondo, the so-called *Mona Lisa* (fig. 16.7). If it is indeed Ma[don]na (Lady) Lisa, which is not universally acknowledged, she was about 25 when the portrait was made. For reasons that are unclear, Leonardo kept this painting, and after his death in France, the portrait entered the collection of Francis I. From the royal collection, it became a key possession of the Musée du Louvre. To some extent its fame is a product of its ownership.

But it is also famous for its formal qualities, as Leonardo reinvents the female portrait in this image. In the fifteenth century, portraits were made of women at their marriages, often in a profile format that stressed the woman's expensive garments over her personality or features. Here, Leonardo adopts the Northern European device of the three-quarter pose and represents the lady at half-length, so that her hands are included in the image and the whole composition forms a stable pyramid. Light washes over her, drawing attention to her features. The forms are built from layers of glazes so thin that the panel appears to glow with a gentle light from within, despite the dirty varnish that obscures the painting. The lady sits before an evocative landscape, whose mountainous elements emerge from a cool *sfumato* backdrop, while the rivers and bridges winding through it echo the highlights on her drapery. Where earlier portraits paid as much attention to a woman's jewels as her person, Leonardo concentrates on the fashionably plucked high forehead. The skill with which he renders the lady's veil and the hands give her as much character as the famous smile. Vasari helped to spread the fame of the painting, for he claimed the portrait exemplified "how faithfully art can imitate nature." This skill, for Vasari, was the root of Leonardo's genius. (See end of Part II, *Additional Primary Sources*.)

ROME RESURGENT

By the end of the fifteenth century, the papacy had firmly established itself back in Rome. Along with their spiritual control of the Church, the popes reasserted political and military control over the Papal States in the area around Rome. Rebuilding the city of Rome was an expression of the papal intentions to rule there, as Sixtus IV had demonstrated with his building of the Sistine Chapel, among other projects. Alexander VI, who became pope in 1492, used his papacy to enlarge papal domains through military exploits undertaken by his son Cesare Borgia, and he also made the papal court the peer of any princely court in Italy. On his death, the new pope Julius II (1503–1513) made his aim the physical renewal of the city of Rome, hoping that it would rival the glory of the ancient city. Julius invested vast sums in large-scale projects of architecture, sculpture, and painting, and he called numerous artists to work for him. Under Julius, Rome became the crucible of the High Renaissance.

Bramante in Rome

The most important architect in Julius's Rome was Donato Bramante (1444–1514). A native of Urbino, he began his career as a fresco painter. Influenced by Piero della Francesca and Andrea Mantegna, Bramante became skilled at rendering architectural settings in correct perspective. Leonardo may have had some influence on Bramante too, as both men were colleagues at the court of Milan. Bramante's architectural works take Brunelleschi and Alberti as their main points of departure.

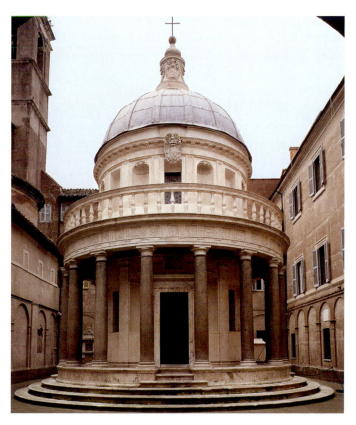

16.8. Donato Bramante. The Tempietto, San Pietro in Montorio, Rome. 1502–1511

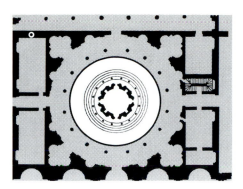

16.9. Plan of Bramante's Tempietto (after Serlio, in *Regole generali di architettura*).

After Milan fell to the French in 1499, Bramante went to Rome, where he experienced Roman buildings firsthand. There, the Spanish-born Pope Alexander VI had begun the process of enlarging and enhancing papal holdings, in which he had the support of the powerful Spanish monarchs, Ferdinand and Isabella. The Spanish kings commissioned Bramante around 1500 to build a structure to mark the supposed site of St. Peter's crucifixion, attached to the church of San Pietro in Montorio (fig. **16.8**). Because of its powerful evocation of Roman circular temples, it was called the Tempietto, or "little temple." This structure serves as a martyrium, a special chapel associated with a martyr.

In early Christian Rome, such structures were often centralized in plan. Bramante, however, seems as much inspired by the precepts of Alberti and the experiments of Leonardo as he is by the experience of Rome itself. A contemporary, Sebastiano Serlio, recorded Bramante's design in an architectural treatise that was published in the 1540s. According to this plan, Bramante intended for the Tempietto to be surrounded by a circular, colonnaded courtyard that entirely responds to the structure. This conception was as bold and novel as the design of the chapel itself (fig. **16.9**), for not only does the chapel's colonnade dictate the courtyard's colonnade, the walls of the courtyard opened into concave niches that echo the facade of the chapel.

This facade, with its three-step platform and the plain Tuscan Doric order, recalls Roman temple architecture more directly than does any fifteenth-century building (compare fig. 7.46). Moreover, the entire design is based on the module of the columns: For example, the distance between the columns is four times their diameter, and they are placed two diameters from the wall. This insistent logic follows the rules of temple design established by Vitruvius. Equally striking is Bramante's use of the "sculptured wall" in the Tempietto itself and the courtyard, as shown in the plan. Deeply recessed niches in the upper story are counterbalanced by the convex shape of the dome and by strongly projecting moldings and cornices. As a result, the Tempietto has a monumentality that belies its modest size. The building, including the sculptural decoration in the metopes and frieze around the base, is a brilliant example of papal propaganda.

16.10.　Donato Bramante. Original plan for St. Peter's, Rome. 1506 (after Geymuller)

The Tempietto proclaims Christ and the popes (considered the successors of St. Peter) as the direct heirs of Rome. Bramante used the language of ancient Rome to express the claims of the modern pope. The publication of the design by Serlio helped spread the specific elements and the underlying design concepts of this building, and it became a very influential structure.

Such work brought Bramante to the notice of Alexander VI's successor, Julius II, who was pope between 1503 and 1513. The nephew of Sixtus IV, represented in the fresco by Melozzo da Forlì in the Vatican (fig. 15.58), Giuliano delle Rovere, as Pope Julius II, was probably the most worldly and ambitious

pope of the Renaissance. He used art and artists as tools in his goal of restoring papal authority over Christendom. This is nowhere more evident than in Julius's decision to replace the Constantinian basilica of St. Peter's, which was in poor condition, with a church so magnificent that it would overshadow all the monuments of imperial Rome. He gave the commission to Bramante and laid the cornerstone in 1506. Bramante's original design is known mostly from a plan (fig. 16.10) and from the medal commemorating the start of the building campaign (fig. 16.11), which shows the exterior in general terms. These reveal the innovative approach that Bramante took in this project, which was grand both in scale and in conception.

The plan and commemorative medal indicate that Bramante planned a huge round dome, similar to the Pantheon's, to crown the crossing of the barrel-vaulted arms of a Greek cross. Four lesser domes, each surmounting a chapel that echoes the main space, and tall corner towers were planned around the central dome. As Alberti prescribed and Leonardo proposed, Bramante's plan is based on the circle and the square. These perfect forms were revered by the ancients and chosen as appropriate symbols for the Christian empire that Julius planned. Bramante envisioned four identical facades dominated by classical forms: domes, half-domes, colonnades, and pediments. The principal dome would have been encircled by a colonnade as well. The whole facade would have been a unified, symmetrical sculptural form, united by proportion and the interplay of geometric elements.

But this logical interlocking of forms would have been accompanied by the structure's huge scale, for Julius's church was intended to be more than 500 feet long. Such a monumental undertaking required vast sums of money, and the construction of St. Peter's progressed so slowly that in 1514, when Bramante died, only the four crossing piers had been built. For the next three decades the project was carried on by architects trained under Bramante, who altered his design in a number of ways. A new and decisive phase in the history of St. Peter's began in 1546, when Michelangelo took charge. It was then altered again in the seventeenth century. Nevertheless, Bramante's original plan for St. Peter's was to put Roman imperial and Early Christian forms at the service of a Renaissance pope's spiritual and temporal ambitions.

Michelangelo in Rome and Florence

Julius's ambitions were also the spur for one of the crucial figures in the history of art, Michelangelo di Lodovico Buonarroti Simoni (1475–1564). Acclaimed by his contemporaries, admired by his successors, hailed as "divine" by Vasari, Michelangelo is one of the most influential and imitated artists in history. Gifted, driven, he has become the archetype of the genius, whose intellect and talents enabled him to work in many media; he was a sculptor, architect, painter, and poet. In his ambition to outdo the artists of antiquity he was encouraged by Pope Julius II, who gave him the opportunities for some of his most inspired and famous works.

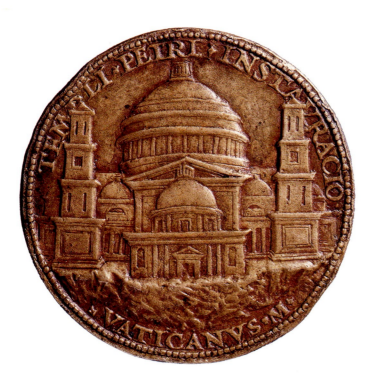

16.11.　Cristoforo Foppa Caradosso. Bronze medal showing Bramante's design for St. Peter's. 1506. The British Museum, London

Michelangelo Interprets the Vatican Pietà

The Pietà *for Cardinal Jean de Villiers de la Groslaye, now in St. Peter's, helped to establish Michelangelo's reputation as a sculptor. In his* Life of Michelangelo Buonarotti, *first published in 1553, Michelangelo's friend and biographer, Ascanio Condivi, quotes the sculptor explaining features of the work.*

A little later on, the Cardinal of Saint-Denis . . . commissioned him to make from one piece of marble that marvelous statue of Our Lady . . . [she] is positioned seated on the rock, in which the cross was sunk, with her dead Son on her lap, and of such and so rare a beauty, that no one sees her without being inwardly moved to pity. An image truly worthy of the humanity which belongs properly to the Son of God and to such a mother; although there are some who make the reproach that the mother is shown as too young, in relation to her Son. But when I was discussing this with Michelangelo one day, he replied to me: "Don't you know that chaste women remain far fresher than those who are not chaste? So much more the Virgin, in whom never has the least lascivious desire ever arisen that might alter her body.

Moreover, let me add this, that besides such freshness and flower of youth being maintained in her in this natural way it may be believed to have been assisted by divine power to prove to the world the virginity and perpetual purity of the mother. This was not necessary in the Son; rather completely the opposite; because to show that, as He did, the Son of God took a truly human body, and was subjected to all that an ordinary man endures, except sin, there was no need for the divine to hold back the human, but to leave it to its order and course, so that the time of life He showed was exactly what it was. Consequently you are not to wonder if for these reasons I have made the most Holy Virgin, mother of God, far younger in comparison with her Son than her age would ordinarily require, and that I left the Son at his own age."

This reflection would be worthy of any theologian . . . When he made this work, Michelangelo would have been 24 or 25 years old. He acquired great fame and reputation from this effort, and indeed it was already everyone's opinion that he had not only surpassed all his contemporaries, and those who came before him, but that he also contended with the ancients.

SOURCE: *MICHELANGELO, LIFE, LETTERS AND POETRY.* ED. AND TR. GEORGE BULL. (OXFORD: OXFORD UNIVERSITY PRESS, 1987)

Unlike Leonardo, for whom painting was the noblest of the arts because it embraced every visible aspect of the world, Michelangelo was a sculptor to the core. More specifically, he was a carver of marble statues. The limitations of sculpture, which Leonardo condemned as mechanical, unimaginative, and dirty, were virtues in Michelangelo's eyes. Only the "liberation" of real, three-dimensional bodies from recalcitrant matter would satisfy Michelangelo. Painting, for him, should imitate the roundness of sculptured forms. Architecture, too, ought to share the organic qualities of the human figure.

Michelangelo's belief in the human image as the supreme vehicle of expression gave him a sense of kinship with ancient sculpture, more so than with any other Renaissance artist. Among Italian masters, he admired Giotto, Masaccio, and Donatello more than his contemporaries. Although his family came from the nobility, and therefore initially opposed his desire to become an artist, Michelangelo was apprenticed to Ghirlandaio, from whom he learned techniques of painting. He came to the attention of Lorenzo de' Medici, who invited him to study the antique statues in the garden of one of the Medici houses. This collection was overseen by Bertoldo di Giovanni (ca. 1420–1491), a pupil of Donatello, who may have taught Michelangelo the rudiments of sculpture. From the beginning, however, Michelangelo was a carver rather than a modeler. He rarely worked in clay, except for sketches; he preferred harder materials, especially marble, which he shaped with his chisel.

The young artist's mind was decisively shaped by the cultural climate of Florence during the 1480s and 1490s, even though the troubled times led him to flee the city for Rome in 1496. Lorenzo de' Medici's death in 1492 put an end to the intellectual climate he had fostered. The subsequent expulsion of the Medici, and the rise to power of the fiery preacher Girolamo Savonarola, brought calls for a spiritual awakening and a rejection of "paganism" and materialism. Both the Neo-Platonism of Marsilio Ficino and the religious reforms of Savonarola affected Michelangelo profoundly. These conflicting influences reinforced the tensions in his personality, including violent mood changes and his sense of being at odds with himself and with the world. Just as he conceived his statues as human bodies released from their marble prisons, so he saw the body as the earthly prison of the soul—noble perhaps, but a prison nonetheless. This dualism of body and spirit endows his figures with extraordinary pathos. Although outwardly calm, they seem stirred by an overwhelming psychic energy that finds no release in physical action.

PIETÀ Having left Florence after the Medici were exiled, Michelangelo worked in Bologna and then Rome, where he was commissioned in 1498 by a French cardinal to carve a *Pietà* for his tomb chapel attached to St. Peter's (fig. **16.12**). In the contract, Michelangelo promised to carve "the most beautiful work of marble in Rome." The subject of the *Pietà* was more familiar in Northern Europe than in Italy, appearing in such works as the *Roettgen Pietà* (fig. 12.56), although the theme of the Virgin's Lamentation for her dead son had appeared in works such as Giotto's Arena Chapel frescoes (see fig. 13.21). Michelangelo, however, imagines the farewell between Mother and Son as a calm and transcendent moment rather than a tortured or hopeless one. The composition is stable; the overlarge figure of the Virgin with her deeply carved robe easily supports her dead son.

The figures are beautiful rather than tormented. The Virgin is far too young to be holding her grown son, so perhaps

the image is an echo of the Madonna and Child, as well as the Pietà itself. Michelangelo himself intended her youth to express her perpetual Virginity, according to his friend and biographer, Ascanio Condivi (see *Primary Source*, page 565). Michelangelo doesn't merely tell a story, but offers viewers the opportunity to contemplate the central mystery of Christian faith—Christ as God in human form who sacrificed himself to redeem original sin—with the same serenity as Mary herself. When the *Pietà* was first displayed in 1499 some controversy surrounded its authorship; Michelangelo put it to rest by carving his name on the Virgin's sash. The inscription proudly asserts his authorship and his origin in Florence. At 24, his fame was assured.

DAVID When this project was completed, Michelangelo returned to Florence, which had reestablished a republican form of government. There, in 1501, directors of the works for Florence Cathedral a commissioned him to execute a figure to be placed on one of the buttresses. The 18-foot high block of marble for this project had been partly carved by an earlier sculptor, but Michelangelo accepted the challenge to create something memorable from it. The result was the gigantic figure of the *David* (fig. **16.13**). When it was completed in 1504, a committee of civic leaders and artists decided instead to put it in front of the Palazzo della Signoria, the seat of the Florentine government. They placed a circlet of gilt bronze leaves around the statue's hips and put a gilt bronze wreath on David's head. The city of Florence claimed the figure as an emblem of its own republican virtues.

Michelangelo treated the biblical figure not as a victorious hero, but as the ever vigilant guardian of the city. Unlike Donatello in his bronze *David* for the Medici (fig. 15.35), Michelangelo omits the head of Goliath; instead David nervously fingers a slingshot, as his eyes focus on an opponent in the distance. Although both Donatello and Michelangelo rendered David as nudes, the style of the later sculpture proclaims an ideal very different from the wiry slenderness of Donatello's youth. Michelangelo had just spent several years in Rome, where he had been deeply impressed with the emotion-charged, muscular bodies of Hellenistic sculpture, which

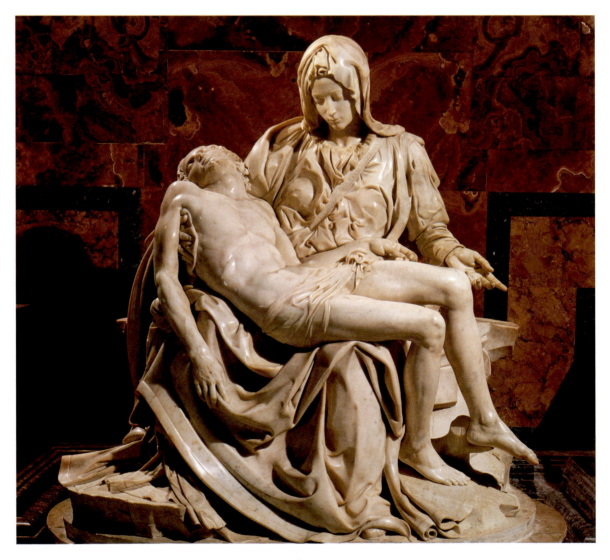

16.12. Michelangelo. *Pietà*. ca. 1498. Marble, height 68½″ (173.9 cm). St. Peter's, Rome

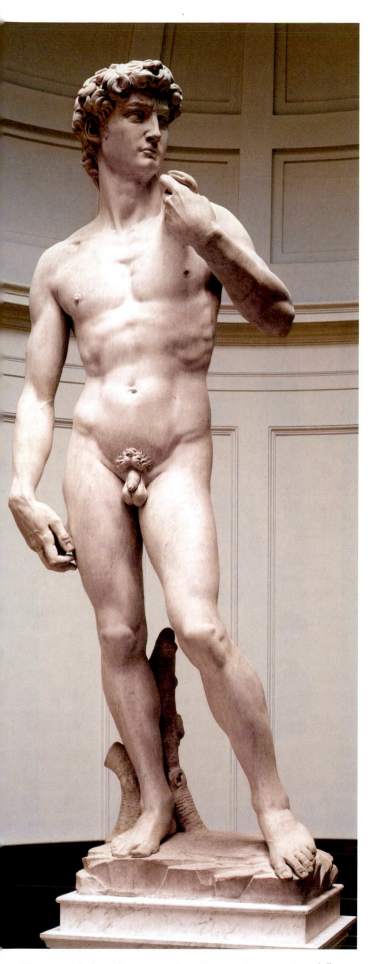

were being avidly collected there (see *The Art Historian's Lens*, page 156). Their heroic scale, their superhuman beauty and power, and the swelling volume of their forms became part of Michelangelo's own style and, through him, of Renaissance art in general. In the *David*, Michelangelo competes with antiquity on equal terms and replaces its authority with his own. Instead of the emotionally wrought figures he saw in Hellenistic works, Michelangelo crafted the *David* to be at once calm and tense, active yet static, full of the potential for movement rather than its actual expression.

Michelangelo in the Service of Pope Julius II

The ambition to create powerful works of art is a hallmark of Michelangelo's career. It is seen again in the project he undertook for the Tomb of Julius II, planned for the new St. Peter's. The commission was given in 1505, but Julius interrupted it, then died in 1513, leaving the project incomplete. His heirs negotiated with Michelangelo over the next 30 years to produce a reduced version of the original plan. The initial plan, reconstructed in figure **16.14**, combined sculpture and architecture into a grand statement of the glory of the pope. Julius's sarcophagus was to sit at the apex of this architectural mass, intended in the first plan to enclose a burial chamber.

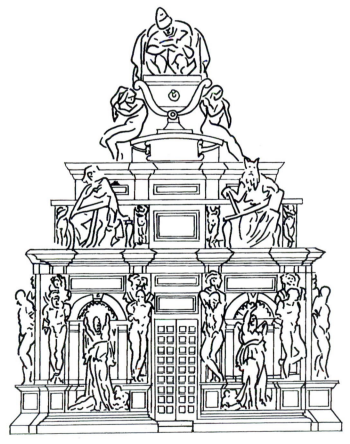

16.13. Michelangelo. *David*. 1501–1504. Marble. Height 13′5″ (4.08 m). Galleria dell'Accademia, Florence

16.14. Reconstruction of Michelangelo's plan (ca. 1505) of the Tomb of Pope Julius II (after Tolnay).

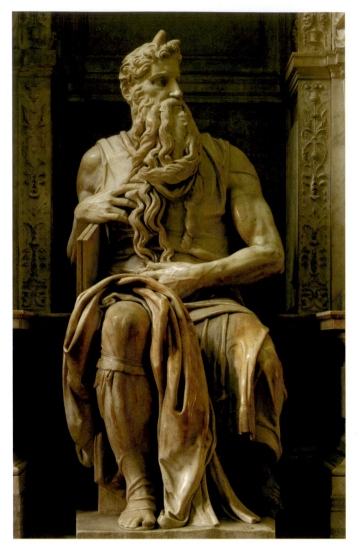

making of a work of art was both joyous and painful, full of surprises, and not mechanical in any way. It appears that he started the process of carving a statue by trying to perceive a figure in the block as it came to him from the quarry. (At times he may even have visualized figures while picking out his material on the spot.) He may have believed that he could see "signs of life" within the marble—a knee or an elbow pressing against the surface. This attitude is expressed in one of his most famous sonnets, written around 1540:

Not even the best of artists has any conception
That a single marble block does not contain
within its excess, and *that* is only attained
by the hand that obeys the intellect.

<div style="text-align: right">Source: James Saslow's translation, from The Poetry of Michelangelo.
New Haven, CT: Yale University Press, 1991, p. 302.</div>

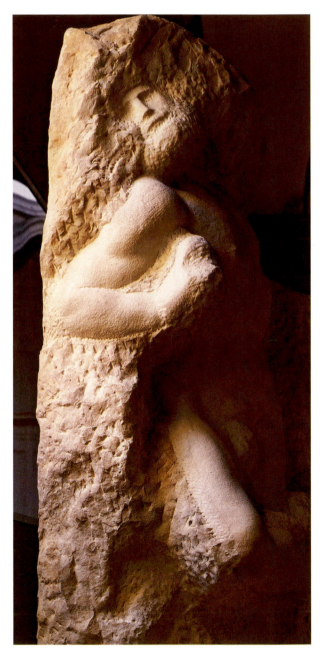

16.15. Michelangelo. *Moses*. ca. 1513–1515. Marble. Height 7′8¹⁄₂″ (2.35 m). S. Pietro in Vincoli, Rome

On lower levels of the structure Michelangelo planned a figure of St. Paul and an installation of the *Moses* (fig. **16.15**), which was completed about 10 years later. The *Moses,* meant to be seen from below, has the awesome force Vasari called *terribilità*—a concept similar to the "sublime." His pose, both watchful and meditative, suggests a man capable of wise leadership as well as towering wrath. Moses has just received the Ten Commandments, which he holds close to his massive torso. The horns, a traditional attribute based on a mistranslation of the Hebrew word for *light* in the Vulgate (Latin Bible), which is also seen in Sluter's *Well of Moses* (see fig. 14.2), signify the divine favor bestowed on Moses, whose face shone after he came down from Mount Sinai (Exodus 34). The powerful figure of the Moses was to be accompanied by figures of bound men, whose meaning is still obscure, and figures personifying the active and contemplative life. Some of these figures, including the *Moses*, were assembled into the monument for Julius installed in the church of San Pietro in Vincoli in Rome, on a scale much reduced from the initial plan.

One later figure for the tomb, the unfinished *Awakening Prisoner* (fig. **16.16**), provides invaluable insights into Michelangelo's artistic personality and working methods. For him, the

16.16. Michelangelo. *Awakening Prisoner.* ca. 1525. Marble. Height 8′11″ (2.7 m). Galleria dell'Accademia, Florence

To get a firmer grip on this dimly felt image that he believed was inside the stone, Michelangelo made numerous drawings, and sometimes small models in wax or clay, before he dared to assault the marble itself. His practice was to draw the main view on the front of the block. Once he started carving, every stroke of the chisel would commit him more and more to a specific conception of the figure hidden in the block. The marble would permit him to free the figure only if his guess about its shape was correct. Sometimes the stone refused to give up some essential part of the figure within it, and he left the work unfinished. Michelangelo himself may have appreciated the expressive qualities of incomplete works. Although he abandoned *Awakening Prisoner* for other reasons, every gesture seems to record the struggle for the liberation of the figure.

Pope Julius interrupted Michelangelo's work on the tomb at an early stage. The pope's decision to enlarge St. Peter's, a commission he gave to Bramante in 1506, altered his patronage priorities, and this so angered Michelangelo that he left Rome. Two years later, the pope half forced, half coaxed him to return to paint frescoes on the ceiling of the Sistine Chapel in the Vatican.

FRESCOES FOR THE SISTINE CHAPEL CEILING

The Sistine Chapel takes its name from Pope Sixtus IV, Julius's uncle, who had it built and adorned between 1477 and 1482. Driven by his desire to resume work on the tomb, Michelangelo finished the ceiling in only four years, between 1508 and 1512 (fig. **16.17**). In this brief period of intense creation in a medium that he never felt was his own, Michelangelo produced a work of truly epochal importance.

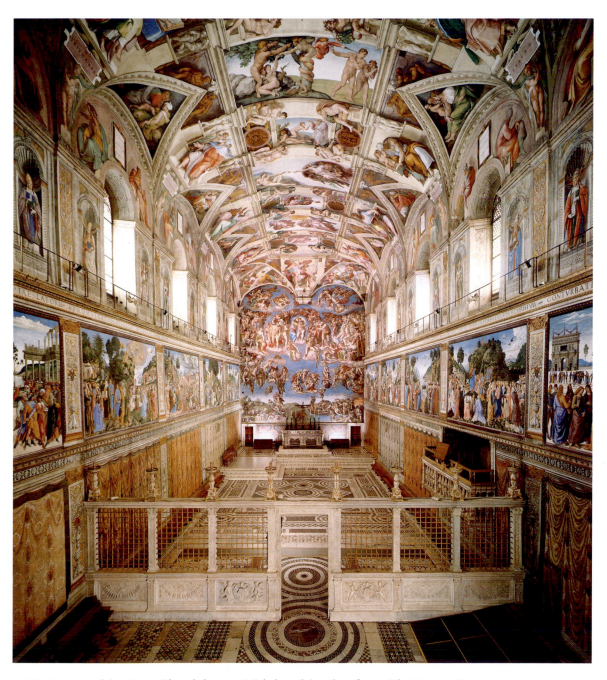

16.17. Interior of the Sistine Chapel showing Michelangelo's ceiling fresco. The Vatican, Rome

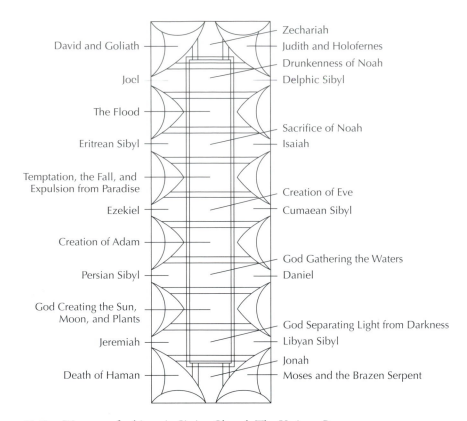

David and Goliath — Zechariah
— Judith and Holofernes
— Drunkenness of Noah
Joel — Delphic Sibyl

The Flood
— Sacrifice of Noah
Eritrean Sibyl — Isaiah

Temptation, the Fall, and
Expulsion from Paradise — Creation of Eve
Ezekiel — Cumaean Sibyl

Creation of Adam
— God Gathering the Waters
Persian Sibyl — Daniel

God Creating the Sun,
Moon, and Plants — God Separating Light from Darkness
Jeremiah — Libyan Sibyl
— Jonah
Death of Haman — Moses and the Brazen Serpent

16.18. Diagram of subjects in Sistine Chapel. The Vatican, Rome

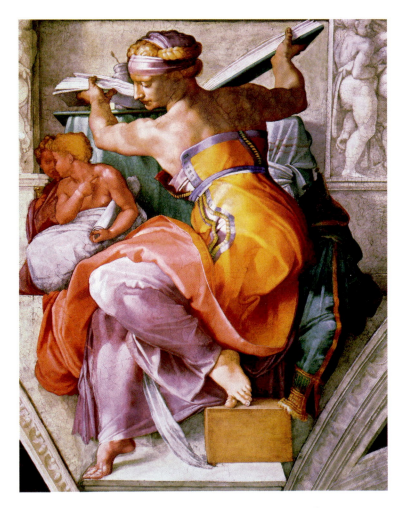

16.19. *Libyan Sibyl* portion of the Sistine Chapel ceiling

The ceiling is a shallow barrel vault interrupted over the windows by the triangular spandrels that support it. Michelangelo treated this surface as a single entity, with hundreds of figures distributed rhythmically within a painted architectural framework. Several different themes intersect throughout this complex structure (see figure **16.18**). In the center, subdivided by ten illusionistic transverse arches, are nine scenes from the book of Genesis, from the Creation of the World (at the altar end) to the Drunkenness of Noah (near the entry door); large figures of prophets and sibyls flank these narratives. In the triangular spandrels sit the ancestors of Christ, who also appear in the lunettes flanking the windows. Further narrative scenes occur at the corner pendentives, focusing on the Old Testament heroes and prophets who prefigured Christ. Scholars are still debating the theological import of the whole program and whether Michelangelo consulted with advisors in the development of the themes. While the Creation and Fall of Man occur at the center of the ceiling, the prophets and ancestors predict the salvation of humanity in Christ. Except for the architecture, these themes are expressed almost entirely by the human figure.

The Sistine Chapel ceiling swarms with figures, most of them in the restless postures seen in the Moses. For example, as seen in figure **16.19**, the *Libyan Sibyl* (a sibyl was a pagan prophetess, in whose prophecies Christians saw evidence for the coming of Christ) barely sits on her throne, but twists backwards to hold her book. Her muscular forms derive from Michelangelo's model drawing of young men. (See *Materials and Techniques*, page 571.) These figures also stem from

Drawings

Medieval artists had used the technique of drawing to record monuments they had seen or to preserve compositions for future use. These drawings were usually made with pen and ink on parchment. During the Renaissance, the increasing availability of paper expanded the uses of drawings and encouraged artists to use a variety of media in making them.

Pen and ink on paper were used most often, as the liquid ink could be transferred to the paper using a sharp quill pen or stylus. Sometimes the forms drawn with ink were further elaborated with a wash (usually diluted ink) applied with a brush. Some artists preferred to work with liquid media and thin brushes to render all the forms.

Artists also drew on the relatively rough surface of paper using charcoal or chalk. These naturally occurring materials are both dry and crumbly enough to leave traces when the artist applies them to the paper. The lines they leave can be thick or thin, rendered with carefully descriptive marks, or with quick evocative strokes. Artists could smudge these soft media to soften contours and fill in shadows, or to produce parallel lines called hatching to describe shadows. See, for example, the variety of strokes Michelangelo used to make the red chalk study for the *Libyan Sibyl* on the Sistine Chapel ceiling.

More difficult to master was the technique of *silverpoint*. This entailed using a metal stylus to leave marks on a surface. Silver was the most prized metal for this technique, though lead was also used. Mistakes could not be undone, so it took great skill to work in silverpoint. To make silver leave traces on paper, the paper had to be stiffened up by coating it with a mixture of finely ground bone and *size* (a gluelike substance). Such coatings were sometimes tinted. When the silver stylus is applied, thin delicate lines are left behind that darken with age.

Renaissance artists also expanded the uses of drawings. Apprentices learned how to render forms using drawings; artists worked out solutions to visual problems with drawings. Drawings were also used to enable artists to negotiate contracts and to record finished works as a kind of diary or model book.

Artists also made cartoons, or full-scale patterns, for larger works such as frescoes or tapestries (see fig. 16.27). Transferring designs from drawings onto larger surfaces could be achieved in a number of ways. A grid could be placed over the design to serve as a guide for replicating the image on a larger scale. Or cartoons for frescoes could be pricked along the main lines of the design; through these tiny holes a powder was forced to reproduce the design on the wall. This is called *pouncing*.

In the sixteenth century, drawings became prized in their own right and were collected by artists, patrons, and connoisseurs. The drawing was thought to reveal something that a finished work could not: the artist's process, the artist's personality, and ultimately, the artist's genius.

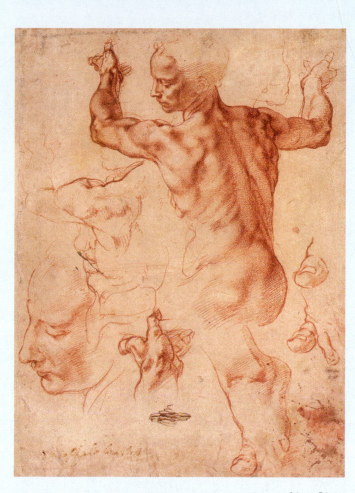

Michelangelo. *Studies for the Libyan Sibyl*. Red chalk, $11\frac{3}{8} \times 8\frac{7}{16}''$ (28.9 × 21.4 cm). The Metropolitan Museum of Art, New York. The Purchase, Joseph Pulitzer Bequest, 1924 (24.197.2)

Michelangelo's deep study of ancient sculpture, which he hoped to surpass. Since the cleaning of the frescoes in the 1980s, scholars have come to appreciate the brilliance of Michelangelo's colors, and the pairing of complementary colors he used in the draperies. (See *The Art Historian's Lens*, page 573.)

A similar energy pervades the center narratives. *The Fall of Man* and *The Expulsion from the Garden of Eden* (fig. **16.20**) show the bold, intense hues and expressive body language that characterize the whole ceiling. Michelangelo's figures are full of life, acting out their epic roles in sparse landscape settings. To the left of the Tree of Knowledge, Adam and Eve form a spiral composition as they reach toward the forbidden fruit, while the composition of *The Expulsion from the Garden of Eden* is particularly close to Masaccio's (see fig. 15.18) in its intense drama. The nude youths (*ignudi*) flanking the main sections of the ceiling play an important visual role in Michelangelo's design. They are found at regular intervals, forming a kind of chain linking the narratives. Yet their meaning remains uncertain. Do they represent the world of pagan antiquity? Are they angels or images of human souls? They hold acorns, a reference to the pope's family name, delle Rovere (Rovere means "oak"). The ignudi also support bronze medallions that look like trophies, reminding the viewer of Julius's military campaigns throughout Italy.

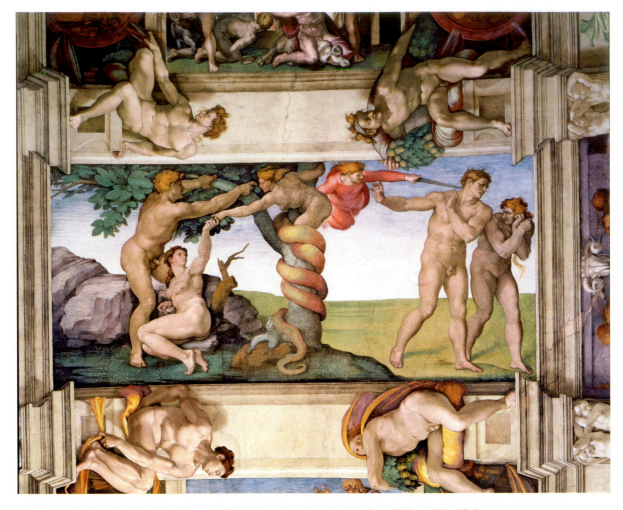

16.20. Michelangelo. *The Fall of Man* and *The Expulsion from the Garden of Eden*. 1508–1512. Portion of the Sistine Chapel ceiling. The Vatican, Rome

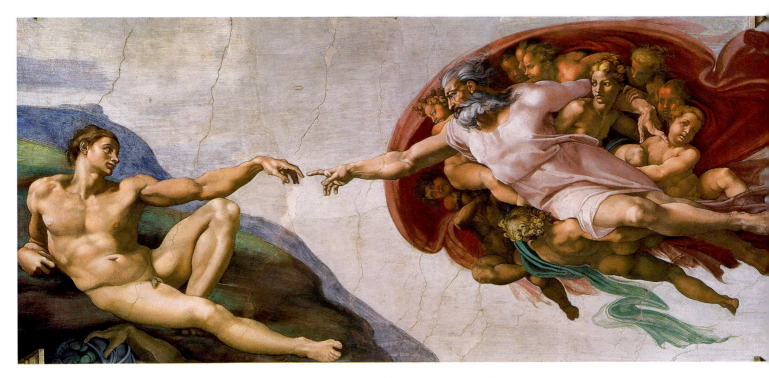

16.21. Michelangelo. *The Creation of Adam*. 1508–1512. Portion of the Sistine Chapel ceiling

Cleaning and Restoring Works of Art

One of the most controversial topics in contemporary art history is whether and how to clean venerable but soiled works of art. Heated exchanges, accusations, and lawsuits regularly accompany cleaning and restoration projects. Cleaning means just that—removing soot, grime, pollutants, and sometimes layers of varnish or other protective materials earlier generations of owners put on a work. Restoration sometimes involves replacing missing elements in a work to suggest to the viewer what an object looked like on its completion. Both processes are being debated today.

Many of the most famous images from the Renaissance have been at the center of these controversies: Masaccio's Brancacci Chapel, Leonardo's *Last Supper*, Michelangelo's frescoes at the Sistine Chapel, and most recently (in 2004) Michelangelo's *David*. Questions arise because of the jarring outcomes that can result from cleaning projects. For example, when the Sistine Chapel ceiling was cleaned in the 1980s, critics complained that the cleaning process removed the top layer of the paint, leaving only "garish" underpainting. Michelangelo's reputation as a colorist has been permanently changed by the cleaning of the ceiling frescoes.

The techniques of cleaning vary according to the medium and condition of the work, but conservators try to use the least damaging solvents possible, and they document every step they take. Work can be very slow, as in the case of the *Last Supper*. The project took 20 years, as clean-ers had to contend with the work of earlier "restorers," who had filled in missing sections of the image with new paint. Current cleaning removed overpaints, and filled in missing areas with removable water-based pigment. Modern restorers are careful to add only materials that can be removed without damaging the original object.

Museums routinely clean objects in their care to conserve them. Major museums keep large conservation laboratories to treat works of art. Often the impetus and funding for such projects comes when an object is requested for an important exhibition. In the case of the Sistine Chapel ceiling, a corporation underwrote the cleaning of the ceiling in exchange for the rights to make a film about the process. Philanthropic and corporate donors have supported many recent cleaning projects.

The *David* offers a good example of why objects need cleaning. The statue stood in the Piazza della Signoria for almost four centuries, subjected to pollutants and humidity, until it was removed to the Galleria dell'Accademia in Florence in 1873. (A copy now stands in the Piazza.) In 2003, a cleaning program was undertaken, again amidst protests: Critics wanted a minimally invasive dry cleaning (like a careful dusting), but the curators used a distilled water, clay, and cellulose paste to draw pollutants out of the marble. Mineral sprits were used to remove wax on the marble.

Perhaps the one object from the High Renaissance most in need of cleaning today—but unlikely to receive it—is Leonardo's *Mona Lisa*. The directors of the Louvre have said that no such cleaning will ever be done.

The most memorable of the center narratives is *The Creation of Adam* (fig. **16.21**). The fresco depicts not the physical molding of Adam's body, but the passage of the divine spark—the soul—and thus achieves a dramatic relationship unrivaled by any other artist. Michelangelo's design contrasts the earth-bound Adam, who has been likened to an awakening river god, with the dynamic figure of God rushing through the sky. Adam gazes not only toward his Creator, but toward the figures in the shelter of God's left arm. The identity of these figures has been vigorously debated: The female may be Eve, awaiting her creation in the next panel; another proposal is that she may be Mary, with Jesus at her knee, foreordained to redeem fallen humanity. The entire image has come to be seen as the perfect expression of Michelangelo's view of his own artistic creativity.

After the death of Julius II in 1513, Michelangelo returned to his work on the pope's tomb. But when Leo X (the son of Lorenzo de' Medici) acceded to the papacy, he sent Michelangelo back to Florence, to work on projects for the Medici family, which had been restored to power. There his style developed and changed, until his eventual return to Rome in the 1530s.

Raphael in Florence and Rome

If Michelangelo represents the solitary genius, Raphael of Urbino (Raffaello Sanzio, 1483–1520) belongs to the opposite type: the artist as a man of the world. The contrast between them was clear to their contemporaries, and both enjoyed great fame. Vasari's book, with its championing of Michelangelo, helped to inspire later generations' veneration of Michelangelo over Raphael, in part because of the two men's biographies. Where Michelangelo's dramatic conflicts with his art and with his patrons made good stories, Raphael's career seems too much a success story, his work too marked by effortless grace, to match the tragic heroism of Michelangelo. Raphael's gifts were in his technical brilliance, his intelligent approach to composing pictures, and his dialogue with the other artists of his time. He is the central painter of the High Renaissance. During his relatively brief career he created the largest body of Renaissance pictorial work outside of Titian's, one that is notable for its variety and power. He also oversaw a lively and large workshop, from which many artists of the next generation emerged, effectively putting his stamp on the whole period.

RAPHAEL'S EARLY MADONNAS Raphael had a genius for synthesis that enabled him to merge the qualities of Leonardo and Michelangelo. His art is lyrical and dramatic, pictorially rich and sculpturally solid. These qualities are already present in the Madonnas he painted in Florence (1504–1508) after his apprenticeship with Perugino. The meditative calm of the so-called *La Belle Jardinière (Beautiful Gardener)* (fig. **16.22**) still reflects the style of his teacher; the forms are, however,

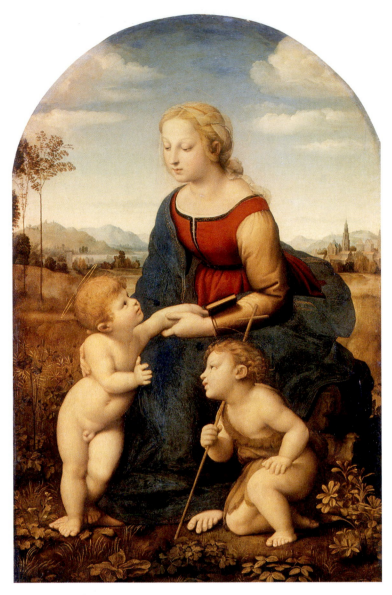

16.22. Raphael. *La Belle Jardinière*. 1507. Oil on panel, 48 × 31½″ (122 × 80 cm). Musée du Louvre, Paris

Michelangelo began to paint the Sistine Chapel ceiling, Julius II summoned Raphael from Florence at the suggestion of Bramante, who also came from Urbino. At first Raphael mined ideas he had developed under his teacher Perugino, but Rome utterly transformed him as an artist, just as it had Bramante, and he underwent an astonishing growth.

FRESCOES FOR THE STANZA DELLA SEGNATURA

The results can be seen in the Stanza della Segnatura (Room of the Signature, fig. 16.23), the first in a series of rooms he was called on to decorate at the Vatican Palace. The frescoes painted by Raphael in this room show an almost endless fertility in the creation of daring narrative compositions. The "Room of the Signature" derives its name from its later function as the place where papal bulls were signed, though originally it housed Julius II's personal library. Beginning in 1508, Raphael painted a cycle of frescoes on its walls and ceiling that refer to the four domains of learning: theology, philosophy, law, and the arts. In general, the Stanza represents a summation of High Renaissance humanism, for it attempts to represent the unity of knowledge in one grand scheme. Raphael probably had a team of scholars and theologians as advisors, yet the design is his alone.

Theology is the subject of the earliest wall fresco in the room (fig. 16.24). Since the seventeenth century it has been called *The Disputà,* or *The Disputation Over the Sacrament.* The subject of the discussion is the doctrine of the Transubstantiation, which states that the wine and host of the Eucharist become the body and blood of Christ. Raphael divides the lunette into two regions, one earthly where theologians are gathered around an altar, and one heavenly. In the upper zone, Christ sits enthroned in heaven between the Virgin and St. John the Baptist. God the Father is above him, with saints and prophets to either side. The dove of the Holy Spirit hovers over the Eucharist below. Around the altar in the lower zone are doctors of the church, popes, artists, poets (Dante is represented), and other personages.

The participants are not so much disputing, however, as bearing witness to the Eucharist and its central place in the Catholic faith. The host in its monstrance on the altar is the fulcrum of the composition, dictating the arrangement of figures in both the earthly and heavenly zones. The round form of the monstrance is echoed in the halo around the dove, and in the mandorla around Christ in the vertical center of the composition. The presence of God the father above Christ adds a Trinitarian element to the meaning. And the curving arrangement of the heavenly court echoes the curve of the lunette. On the earthly realm, Raphael creates a space like that in Perugino's *Delivery of the Keys* nearby in the Vatican (see fig. 15.59), while the landscape makes subtle use of atmospheric perspective to emphasize the host. Through both heaven and Earth, books and the written word are featured, appropriately for a room intended as a library.

In the lunette over the door to the left are personifications of *The Three Legal Virtues*—Fortitude, Prudence, and Temperance. Beneath are *The Granting of Civil Law* (left) and

more ample and the chiaroscuro expertly rendered. The young Jesus and John the Baptist have perfect little bodies, posed in graceful postures to interact with each other and the Virgin. For this image, Raphael reworks a composition by Leonardo, but he replaces the enigmatic gestures in *The Virgin of the Rocks* by a gentle, rhythmic interplay. Raphael replaces the intricate grouping with a stable pyramid whose severity is relieved by Mary's billowing cape. Equally striking is the carefully observed landscape, whose bright light and natural beauty provides an appropriate setting for the figure group.

One of the reasons *La Belle Jardinière* looks different from *The Virgin of the Rocks,* to which it is otherwise so clearly indebted, is Michelangelo's influence, which is seen in the figural composition. The full force of this influence can be felt only in Raphael's Roman works, however. In 1508, at the time

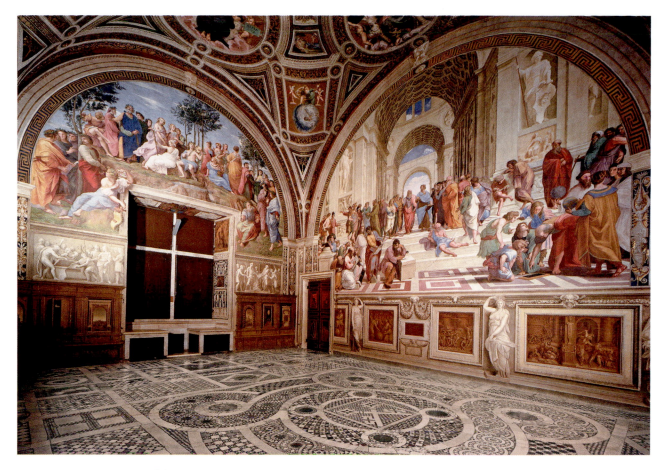

16.23. Raphael. Frescoes of the Stanza della Segnatura. 1508–1511. Vatican Palace, Rome

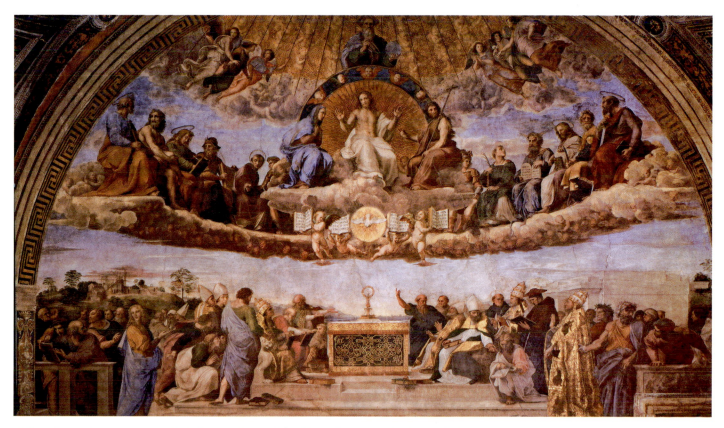

16.24. Raphael. *Disputà*. 1508–1511. Fresco, height 19′ (5.79 m). Portion of the Stanza della Segnatura

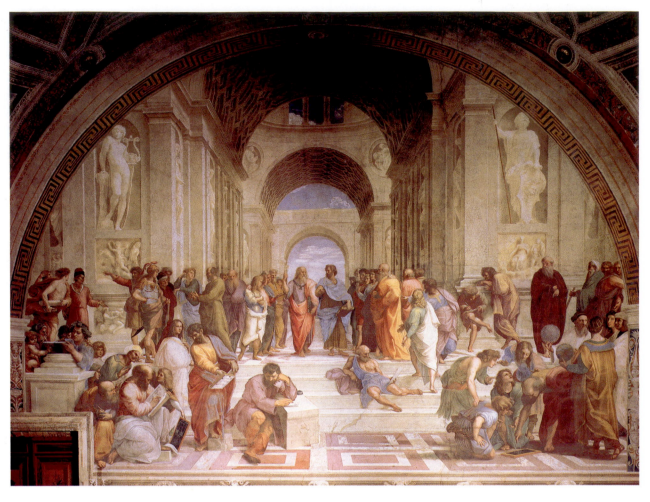

16.25. Raphael. *The School of Athens.* 1508–1511. Fresco. Stanza della Segnatura. Vatican Palace, Rome

The Granting of Canon Law (right), representing legal learning. The opposite doorway depicts *Parnassus,* the sacred mountain of Apollo. The Muses appear in the company of the great poets from antiquity to the artist's own time, for Humanists had regarded artistic inspiration as a means of revelation since the time of Dante and Petrarch. The painting reflects the papal court's dream of a Golden Age under Julius II, in which the Vatican Hill would become the new Parnassus. The message of the Stanza della Segnatura is that the philosophy of antiquity, along with knowledge and the arts, are forms of revelation that emanate from God. They lead to religious truth but are subordinate to it.

Of all the frescoes in the Stanza della Segnatura, *The School of Athens* (fig. **16.25**), facing the *Disputà,* has long been acknowledged as Raphael's masterpiece and the embodiment of the Classical spirit of the High Renaissance. Like the *Disputà,* this title was assigned later, and the subject has been much debated. The fresco seems to represent a group of famous Greek philosophers gathered around Plato and Aristotle, each in a characteristic pose or activity. Raphael may have already studied parts of the Sistine Chapel ceiling, then nearing completion. He owes to Michelangelo the expressive energy, the physical power, and dramatic grouping of his figures. Yet

Raphael has not simply borrowed Michelangelo's gestures and poses. He has absorbed them into his own style and thus given them a different meaning. Body and spirit, action and emotion are balanced harmoniously, and all members of this great assembly play their roles with magnificent, purposeful clarity.

The conception of *The School of Athens* suggests the spirit of Leonardo's *The Last Supper,* as Raphael organizes his figures into groups like Leonardo's. He further distinguishes the relations among individuals and groups, and links them in a formal rhythm. (The artist worked out the poses in a series of drawings, many from life.) Also in the spirit of Leonardo is the symmetrical design, as well as the interdependence seen between the figures and their architectural setting. Like Leonardo's work, an opening in the building serves as a frame for the key figures. But Raphael's building plays a greater role in the composition than the hall does in *The Last Supper.* With its lofty dome, barrel vault, and colossal statuary, it is Classical in spirit, yet Christian in meaning. Inspired by Bramante, who, Vasari informs us, helped Raphael with the architecture, the building seems like an advance view of the new St. Peter's, then being constructed. Capacious, luxurious, overpowering, the building is more inspired by Roman structures, such as the Basilica of Maxentius and Constantine (see fig. 7.68), than by

anything Greek. Yet two fictive sculptures of Greek divinities preside over this gathering of learned men of the Greek past: Apollo, patron of the arts with his lyre to the left, and Athena, in her guise as Minerva, goddess of wisdom, on the right.

The program of *The School of Athens* reflects the most learned Humanism of the day, which is still being elucidated by scholars. Since Vasari's time, historians have attempted to identify the figures inhabiting this imposing space. At center stage, Plato (whose face resembles Leonardo's) holds his book of cosmology and numerology, *Timaeus,* which provided the basis for much of the Neo-Platonism that came to pervade Christianity. To Plato's left (a viewer's right), his pupil Aristotle grasps a volume of his *Ethics,* which, like his science, is grounded in what is knowable in the material world. The tomes explain why Plato is pointing rhetorically to the heavens, Aristotle to the earth. The figures represent the two most important Greek philosophers, whose approaches, although seemingly opposite, were deemed complementary by many Renaissance Humanists. In this composition, the two schools of philosophy come together.

Some scholars believe that Raphael organized the array of philosophers to reflect the two camps: the idealists and the empiricists. To Plato's right is his mentor, Socrates, who addresses a group of disciples by counting out his arguments on his fingers. Standing before the steps are figures representing mathematics and physics (the lower branches of philosophy that are the gateway to higher knowledge). Here appears the bearded Pythagoras, for whom the truth of all things is to be found in numbers. He has his sets of numbers and harmonic ratios arranged on a pair of inverted tables that each achieve a total of the divine number ten. On the other side of the same plane, Raphael borrowed the features of Bramante for the head of Euclid, seen drawing or measuring two overlapping triangles with a pair of compasses in the foreground to the lower right. Behind him, two men holding globes may represent Zoroaster the astonomer and Ptolemy the geographer. Vasari tells us that the man wearing a black hat behind these scientists is a self-portrait of Raphael, who places himself in the Aristotelian camp.

Despite the competition between them, Raphael added Michelangelo at the last minute (as revealed by his insertion of a layer of fresh plaster or *intonaco* on which to paint the new figure), whom he has cast as Heraclitus, a sixth century BCE philosopher, shown deep in thought sitting on the steps in the Platonic camp. (Heraclitus was often paired with Diogenes the Cynic, shown lying at the feet of Plato and Aristotle.) Scholars have remarked that this figure is not only a portrait of the sculptor, but is rendered in the style of the figures on the nearby Sistine Chapel ceiling. The inclusion of so many artists among, as well as in the guise of, famous philosophers is testimony to their recently acquired—and hard-won—status as members of the learned community.

PAPAL AND PRIVATE COMMISSIONS After Julius II died in 1513, Raphael was hired by his successor, Leo X, who ordered Raphael to finish painting the Stanze for the papal

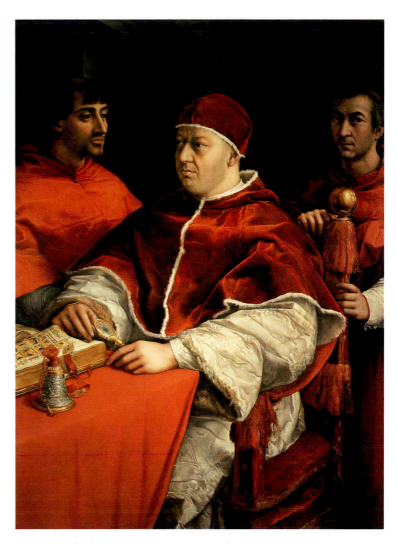

16.26. Raphael. *Portrait of Pope Leo X with Cardinals Giulio de' Medici and Luigi de' Rossi.* ca. 1517. Oil on panel, $60\frac{5}{8} \times 46\frac{7}{8}''$ (154 × 119 cm). Galleria degli Uffizi, Florence

apartments. The Pope also sat for portraits. In the *Portrait of Pope Leo X with Cardinals Giulio de' Medici and Luigi de' Rossi* (fig. **16.26**), painted about 1517, Raphael did little to improve the heavy-jowled features of the pope, or the faces of his associates. (Giulio de' Medici, on the left, became pope himself in 1523, as Clement VII.) The three men are gathered around a table, on which rests a beautifully worked bell and an illuminated manuscript. Rather than a spiritual being or a warrior, the pope is represented as a collector and connoisseur, shown examining a precious object. The textures of the brocades and fur-lined garment only add to the sensual experience. Light enters this space from a window on the right whose shape is reflected in the brass ball of the chair's finial. This meditation on the sense of sight owes a debt to Netherlandish art.

Raphael's work clearly pleased the new pope. After Bramante's death in 1514, Raphael was named the architect of Saint Peter's and subsequently superintendent of antiquities in Rome. In 1516, Pope Leo X sent Michelangelo to Florence to work on the Medici Chapel, leaving Raphael as the leading artist in Rome. Now he was flooded with commissions, and of necessity depended increasingly on his growing workshop.

In 1515–1516, the pope commissioned Raphael to design a set of tapestries on the theme of the Acts of the Apostles for the Sistine Chapel. The commission placed him in direct competition with Michelangelo, and consequently Raphael designed and executed the ten huge cartoons (See *Materials and Techniques*, page 571) for this series with great care and enthusiasm. The cartoons were sent to Flanders to be woven, and thus they spread High Renaissance ideas from Italy to Northern Europe. One of the most influential of these cartoons is the *Saint Paul Preaching at Athens* (fig. **16.27**), which demonstrates Raphael's synthesizing genius. For the imposing figure of St. Paul, Raphael has adapted the severity and simplicity of Masaccio's Brancacci Chapel frescoes (see figs. 15.16, 15.17). The power of the saint's words is expressed not only by his gestures, but by the responses of the voluminously clad audience. The architecture that defines the space is inspired by Bramante; the plain Tuscan order of the columns in the round temple in the background recall the Tempietto (fig. 16.8). Instead of allowing the eye to wander deeply into the distance, Raphael limits the space to a foreground plane, into which a viewer is invited by the steps in the foreground. The simplicity and grandeur of the conception conveys the narrative in bold, clear terms that are only enhanced by the large scale of the figures.

Raphael's busy workshop was engaged by the powerful Sienese banker, Agostino Chigi, for his new villa in Rome, now called the Villa Farnesina after a later owner. The building was a celebration of Chigi's interests: in the antique, in conspicuous display, and in love. Throughout the villa he commissioned frescoes on themes from the pagan past. For this setting, Raphael painted the *Galatea* around 1513 (fig. **16.28**). The beautiful nymph Galatea, vainly pursued by the giant Polyphemus, belongs to Greek mythology, known to the Renaissance through the verses of Ovid. Raphael's *Galatea* celebrates the sensuality of pagan spirit as if it were a living force. Although the composition of the nude female riding a seashell recalls Botticelli's *The Birth of Venus* (see fig. 15.42), a painting Raphael may have known in Florence, the very resemblance emphasizes their profound differences. Raphael's figures are vigorously sculptural and arranged in a dynamic spiral movement around the twisting Galatea. In Botticelli's picture, the movement is not generated by the figures but imposed on them by the decorative, linear design that places all the figures on the

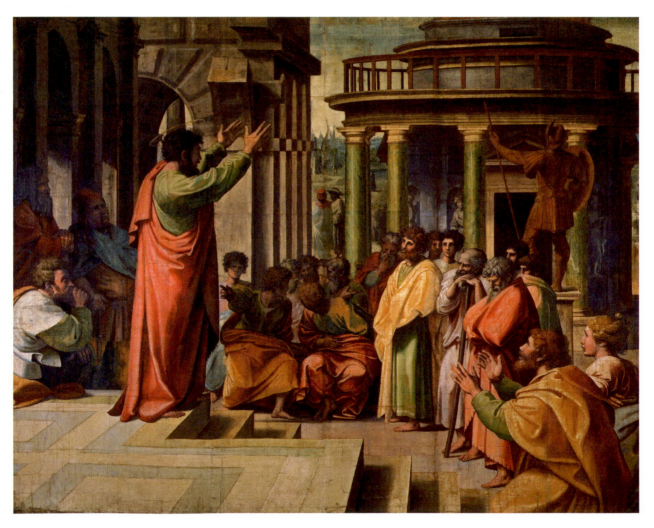

16.27. Raphael. *Saint Paul Preaching at Athens*. 1515–1516. Cartoon, gouache on paper, 11'3" × 14'6" (3.4 × 4.4 m). Victoria & Albert Museum, London

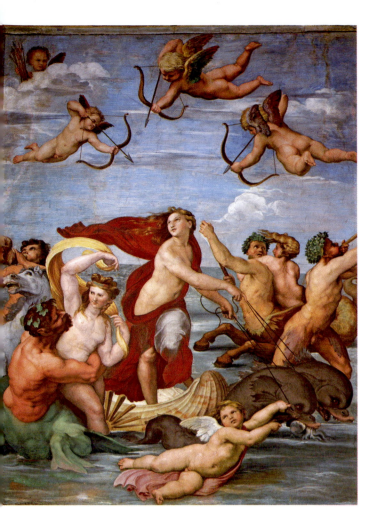

16.28. Raphael. *Galatea*. ca.1513. Fresco, 9'8¹/₈" × 7'4" (3 × 2.2 m). Villa Farnesina, Rome

ART IN TIME

1503—Pope Julius II assumes papal throne. Rome and the papacy prosper during his reign.

1508—Michelangelo begins painting the ceiling of the Sistine Chapel.

ca. 1510—Raphael's *The School of Athens*

1517—Luther posts his *Ninety-five Theses*, sparking the Reformation

same plane. Like Michelangelo, Raphael uses the arrangement of figures, rather than any detailed perspective scheme, to call up an illusion of space and to create a vortex of movement.

Raphael's statuesque, full-bodied figures suggest his careful study of ancient Roman sculpture which, like Michelangelo, he wanted to surpass. An even more direct example of his use of antique sources is his design for the engraving of *The Judgment of Paris* by Marcantonio Raimondi, executed about 1520 (fig. **16.29**). Collectors increasingly desired to own Raphael's drawings, so he used the skills of the engraver to record and to spread his designs. This design is based on a Roman sarcophagus panel then in a Roman collection, which Raphael has interpreted rather than copied. The engraving depicts the Judgment of Paris witnessed by the Olympian gods in heaven and a group of river gods on the lower right. The statuesque figures are firmly defined in the engravings through the strong contours and *chiaroscuro*, and they occupy a frontal plane across the images. In images like this, Raphael translated the art of antiquity for generations of artists to come.

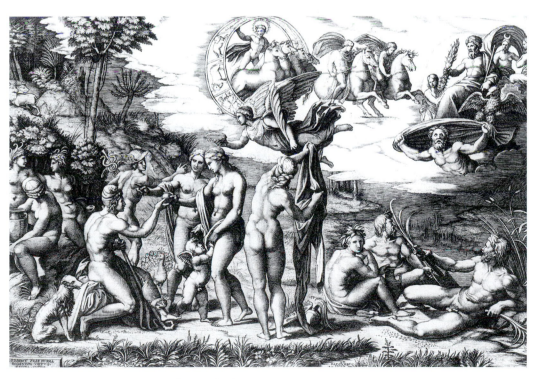

16.29. Marcantonio Raimondi, after Raphael. *The Judgment of Paris*. ca. 1520. Engraving. The Metropolitan Museum of Art, New York. Rogers Fund, 1919. (19.74.1)

On Raphael's Death

Raphael died in Rome in April of 1520. In a letter to Isabella d'Este, the Duchess of Mantua, the Humanist Pandolfo Pico della Mirandola tells her about the artist's death and the reaction of Rome to his loss.

. . . now I shall inform you of . . . the death of Raphael of Urbino, who died last night, that is, on Good Friday, leaving this court in the greatest and most universal distress because of the loss of hope for the very great things one expected of him that would have given glory to our time. And indeed it is said about this that he gave promise for everything great, through what one could already see of his works and through the grander ones he had begun. . . . Here one speaks of nothing else but of the death of this good man, who at thirty-three years of age has finished his first life; his second one, however, that of fame which is not subject to time and death, will be eternal, both through his works and through the men of learning that will write in his praise. . .

SOURCE: KONRAD OBERHUBER, *RAPHAEL. THE PAINTINGS.* (MUNICH AND NEW YORK: PRESTEL: 1999, P. 9.)

Raphael's life was cut short in 1520, when he died after a brief illness. Roman society mourned him bitterly, according to the reports of witnesses. (See *Primary Source*, above.) Befitting the new status assigned to artists, he was buried in the Pantheon. Significantly, many of the leading artists of the next generation emerged from Raphael's workshop and took his style as their point of departure.

VENICE

While Rome became the center of an imperial papal vocabulary of art, Venice endured the enmity of its neighbors and the dismantling of its northern Italian empire. Having gradually expanded its influence over northeastern Italy, the Republic of Venice was threatened by the League of Cambrai, an international military alliance aimed against it in 1509. Yet, by 1529 Venice had outlasted this threat and reclaimed most of its lost territory. Resisting the invasions of Europe by the Turks, Venice's navy fought determinedly in the eastern Mediterranean to hold off this threat. In the midst of this turmoil, artists in Venice built on the traditions of the fifteenth century and the innovations of Giovanni Bellini to create a distinct visual language. Two artists in particular, Giorgione and Titian, created new subject matters, approaches to images, and techniques.

Giorgione

Giorgione da Castelfranco (1478–1510) left the orbit of Giovanni Bellini (see fig. 15.57) to create some of the most mysterious and beguiling paintings of the Renaissance. Although he painted some religious works, he seems to have specialized in smaller scale paintings on secular themes for the homes of wealthy

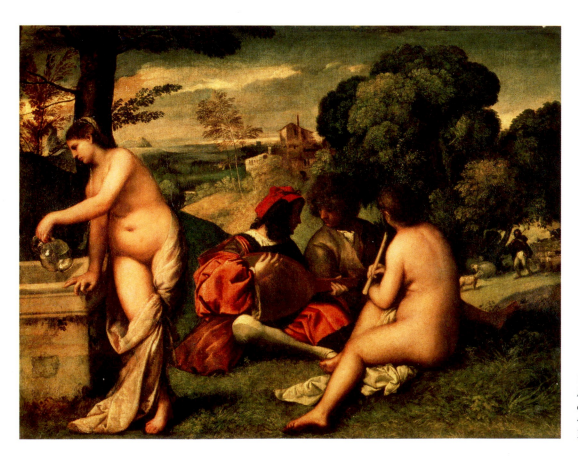

16.30. Giorgione (and Titian?). *Fête Champêtre (Pastoral Concert).* ca. 1509–1510. Oil on canvas, $43\frac{1}{4} \times 54\frac{3}{8}$" (105 × 136.5 cm). Musée du Louvre, Paris

collectors. His death at a young age, probably from the plague, left the field open for his young colleague, Titian, who worked in his shop for some time. Some of the works traditionally ascribed to Giorgione have, in fact, been argued for Titian in recent years.

One such work, the so-called *Fête Champêtre* or *Pastoral Concert*, (fig. 16.30) has been on display in the Louvre since the nineteenth century, where it had arrived from the French royal collection. The painting depicts a group of young people gathered in a lush landscape to make music when a shepherd and his flock come upon them. Attempts to find a narrative subject to attach to this image have proven fruitless: No single literary source seems to account for it. Most puzzling are the nude women, one of whom is about to play a recorder, while another dips water from a fountain. They have been identified as the Muses, ancient female divinities who inspire the arts. The forms are rendered in a soft chiaroscuro technique so that they emerge from the atmospheric landscape as soft round shapes. The landscape moves from dark to light to dark passages, receding into the atmospheric distance. Instead of telling a story, the painting seems designed to evoke a mood.

Giorgione's *The Tempest* (fig. 16.31) is equally unusual and enigmatic. The picture was first recorded in the collection of the merchant Gabriele Vendramin, one of Venice's greatest patrons of the arts. Scholars have offered many proposals to explain this image, which depicts a stormy landscape inhabited by a shepherd on the left and a nursing mother on the right. It is the landscape, rather than Giorgione's figures, that is the key to interpretation. The scene is like an enchanted idyll, a dream

ART IN TIME

ca. 1505—Giorgione's *The Tempest*
 1509—League of Cambrai formed against Venice
 1513—Machiavelli writes *The Prince*.
 1521—Hernan Cortez captures Mexico for Spain
 1526—Titian's *Madonna with the Members of the Pesaro Family*

of pastoral beauty soon to be swept away. In the past, only poets had captured this air of nostalgic reverie. Now it entered the repertory of the artist. Indeed, the painting is very similar in mood to *Arcadia* by Jacopo Sannazaro, a poem about unrequited love that was popular in Giorgione's day. Thus *The Tempest* initiates what was to become an important new tradition in art, the making of pictorial equivalents to poetry (*Poesie*) instead of narratives.

Vasari criticized Giorgione for not making drawings as part of his process of painting (see end of Part II, *Additional Primary Sources*.) Steeped in the Florentine tradition of Leonardo, Michelangelo, and Raphael, Vasari argued that drawing or *disegno* was fundamental to good painting. The Venetians, however, valued light and color above all to create their sensual images. Vasari dismissed this as *colore*, which he argued was secondary to the process of drawing. This competition between *disegno* and *colore* provided the grounds for criticizing or praising paintings well beyond the sixteenth century.

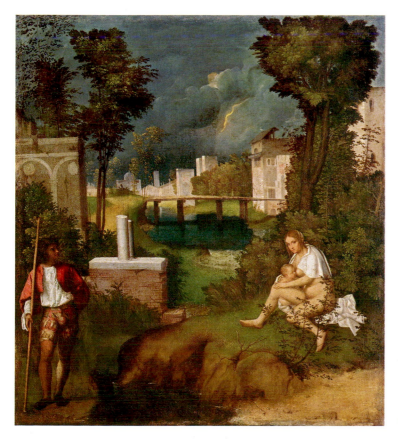

16.31. Giorgione. *The Tempest*. ca. 1505. Oil on canvas, 31$\frac{1}{4}$ × 28$\frac{3}{4}$″ (79.5 × 73 cm). Galleria dell'Accademia, Venice

Titian

Giorgione died before he could fully explore the sensuous, lyrical world he had created in *The Tempest*. This task was taken up by Titian (Tiziano Vecellio, 1488/90–1576), who trained with Bellini and then with Giorgione and even repainted some of their works. Titian would dominate Venetian painting for the next half-century. Throughout his long life, he earned commissions from the most illustrious patrons in Europe; he trained many of the Venetian artists of the century.

Titian's interpretation of the legacy of Giorgione may be seen in the *Bacchanal* (fig. **16.32**), commissioned around 1518 by Alfonso d'Este, the duke of Ferrara, for his Camerino d'Alabastro (little room of alabaster). In this painting Titian attempted to remake a Roman painting known only from descriptions by the Roman author Philostratus. The theme is the effect of a river of wine on the inhabitants of the island of Andros. Titian depicts a crowd of figures in various stages of undress hoisting jugs of wine and generally misbehaving. He thus competed both with antique art and with literature. Titian's landscape, rich in contrasts of cool and warm tones, has all the poetry of Giorgione, but the figures are of another breed.

Active and muscular, they move with a joyous freedom that recalls Raphael's *Galatea* (fig. 16.28).

By this time, many of Michelangelo's and Raphael's compositions had been engraved, and from these reproductions Titian became familiar with the Roman High Renaissance. At least one figure, the man bending over to fill his jug in the river, may be copied from Michelangelo. A number of the figures in his *Bacchanal* also reflect the influence of Classical art. Titian's approach to antiquity, however, is very different from Raphael's. He visualizes the realm of ancient myths as part of the natural world, inhabited not by animated statues but by beings of flesh and blood. The nude young woman who has passed out in the lower right corner is posed to show off her beautiful young body for the viewer's pleasure. The figures of the *Bacchanal* are idealized just enough to persuade us that they belong to a long-lost Golden Age. They invite us to share their blissful state in a way that makes the *Galatea* seem cold and remote by comparison.

Titian's ability to transform older traditions can also be seen in his *Madonna with Members of the Pesaro Family* (fig. **16.33**), commissioned in 1519 and installed in 1526 on the altar of the

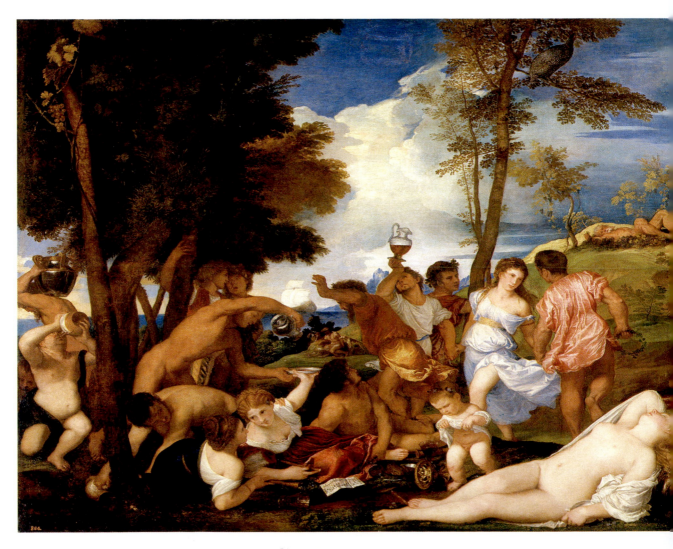

16.32. Titian. *Bacchanal.* ca. 1518. Oil on canvas, 5′8⅝″ × 6′4″ (1.7 × 1.9 m). Museo del Prado, Madrid

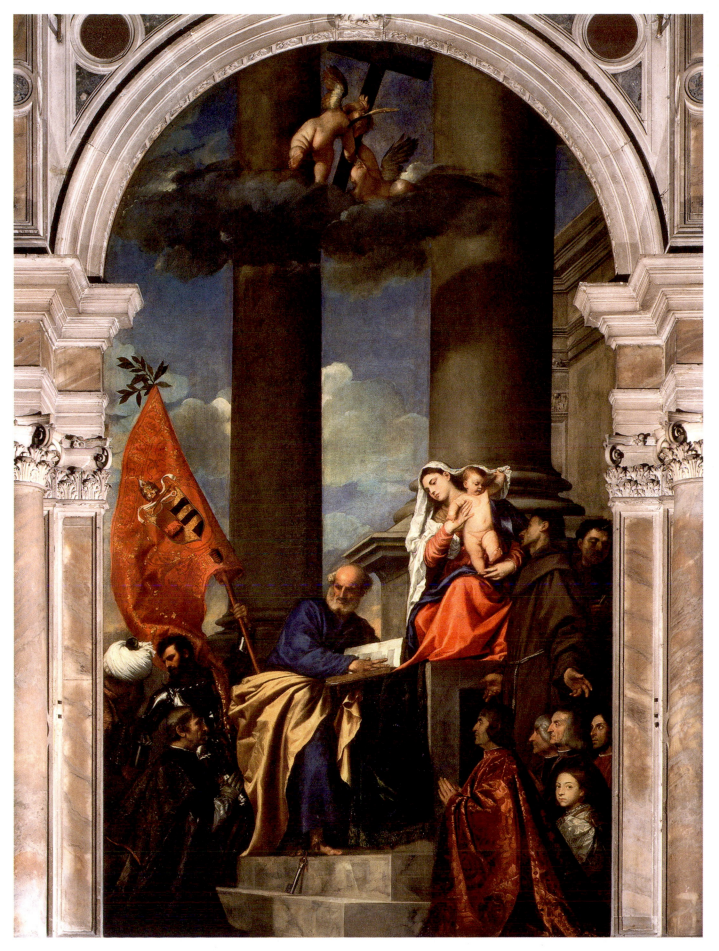

16.33. Titian. *Madonna with Members of the Pesaro Family.* 1526. Oil on canvas, 16′ × 8′10″ (4.9 × 2.7 m). Santa Maria Gloriosa dei Frari, Venice

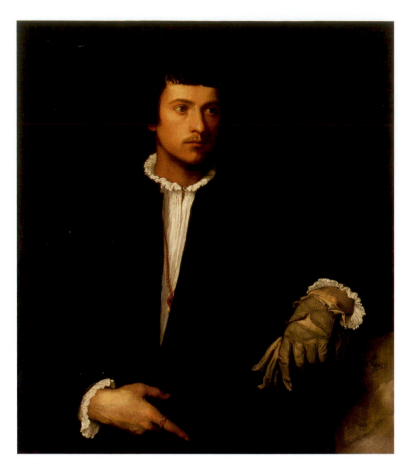

16.34. Titian. *Man with the Glove.* ca. 1520. Oil on canvas, 39$^{1}/_{2}$ × 35″ (100.3 × 89 cm). Musée du Louvre, Paris

Immaculate Conception of the Franciscan church of Santa Maria Gloriosa dei Frari. Here he takes a *sacra conversazione* in the tradition of Domenico Veneziano and Giovanni Bellini (figs. 15.30 and 15.57) and reimagines both the composition and the figures. He sets the Virgin and Child at the apex of a triangular arrangement of figures, but replaces the familiar frontal view with an oblique one that is far more active. The Infant Jesus is as natural as the child in the *Bacchanal,* pudgy and innocently playing with his mother's veil. More solemnly, the Virgin and St. Peter turn to the donor, Jacopo Pesaro, seen kneeling in devotion at the left. On the other side are the donor's brothers and sons with saints Francis and Anthony.

The Virgin is enthroned on the steps of a monumental church. The elevated columns, which are the key to the setting, represent the gateway to heaven, traditionally identified with Mary herself; the painting celebrates her as the Immaculate Conception, who was born without original sin. Because the view is diagonal, open sky and clouds fill most of the background. Except for the kneeling donors, every figure is in motion. The officer with the flag bearing the coats of arms of Pesaro and of Pope Alexander VI seems almost to lead a charge up the steps. He is probably St. Maurice, namesake of the battle at Santa Mauro. There, the papal fleet commanded by Pesaro, bishop of Paphos, and the Venetian navy, under his cousin

Benedetto Pesaro, defeated the Turks in 1502—note the turbaned figure beside him. St. Peter, identified by the key near his foot, represents the Catholic Church victorious over Islam and, as Pesaro's patron saint, acts as his intercessor with the Madonna. The design remains harmoniously self-contained, despite the strong drama. Brilliant sunlight makes every color and texture sparkle, in keeping with the joyous spirit of the altar. The only hint of tragedy is the Cross held by the two little angels. Hidden by clouds from the participants in the *sacra conversazione*, it adds a note of poignancy to the scene.

After Raphael's death, Titian became the most soughtafter portraitist of the age. His immense gifts, evident in the donors' portraits in the *Pesaro Madonna*, are equally striking in the *Man with the Glove* (fig. **16.34**). The dreamy intimacy of this portrait, with its soft outline and deep shadows, reflects the soft chiaroscuro of Giorgione. This slight melancholy in his features has all the poetic appeal of *The Tempest.* In Titian's hands, the possibilities of the oil technique—rich, creamy highlights, deep dark tones that are transparent and delicately modulated—now are fully realized, and the separate brushstrokes, hardly visible before, become increasingly free. Titian's handling of oil became increasingly painterly in his later work, and established yet another tool for artists of future generations to explore.

SUMMARY

For a brief time in the early sixteenth century, highly skilled and insightful artists not only coexisted but competed with each other to excel in their chosen arts. This time, the High Renaissance, has since been seen seen as a high water mark for European art. Leonardo's inquisitive mind and insightful handling of light, Bramante's ambitious blending of antique forms with modern uses, Michelangelo's powerful renderings of the human body, Raphael's consummate compositions, Giorgione's sensitive evocation of moods, and Titian's brilliant handling of color and paint have been celebrated ever since.

Their activity occurred in a tumultuous period of intense creativity encouraged by a few key patrons. The loss of the patrons and the death or dispersal of the artists defused the competition. By 1520, Leonardo, Bramante, Giorgione, and Raphael were dead. The Catholic Church, which had been such a munificent patron, found itself challenged by the young Martin Luther in Wittenberg, as the Reformation gathered strength. The two artists who outlived the High Renaissance, Michelangelo and Titian, continued working in the changed conditions after 1520.

THE HIGH RENAISSANCE IN FLORENCE AND MILAN

The restored Republic of Florence was the home to two of the most influential artists of the Renaissance, Leonardo da Vinci and Michelangelo Buonarotti. Trained in the artistic innovations of the fifteenth century, these two men developed great technical virtuosity in their preferred media of painting and sculpture. Their achievements attracted other artists to Florence, including Raphael of Urbino. Leonardo da Vinci's mastery of chiaroscuro and his restless study of Nature led him to create emotionally rich and superbly naturalistic representations of religious and secular subjects. Michelangelo's dedication to the human figure led him into a deep study of ancient sculpture, giving his works not only tremendous naturalism, but also strong emotional impact.

ROME RESURGENT

Pope Julius II's commitment to renewing the city of Rome brought Michelangelo, Bramante, Raphael, and other artists to work there. Julius desired to rebuild the ancient city as a Christian capital that would outshine its pagan past. To further this goal, Bramante designed a huge new church of Saint Peter's intended to rival the ancient Pantheon. Julius found Michelangelo's powerful human forms appropriate for his tomb and for the monumental project of the Sistine Chapel ceiling. Raphael's accomplishment in Rome was to bring together the innovations of Leonardo in painting with the massive figural style of Michelangelo's sculpture. He did this by submerging both strains under his own personal gifts for harmonious composition and depth of meaning.

VENICE

Despite the uncertain political conditions of Venice in the early sixteenth century, patrons commissioned the painters Giorgione and Titian to produce lively and sumptuous paintings on both religious and secular themes. Working in a technique that stresses color and light, Giorgione created paintings that evoke a mood of poetic reverie. Titian exploited the traditions of Venetian art to create images that are astonishingly lifelike and sensual.

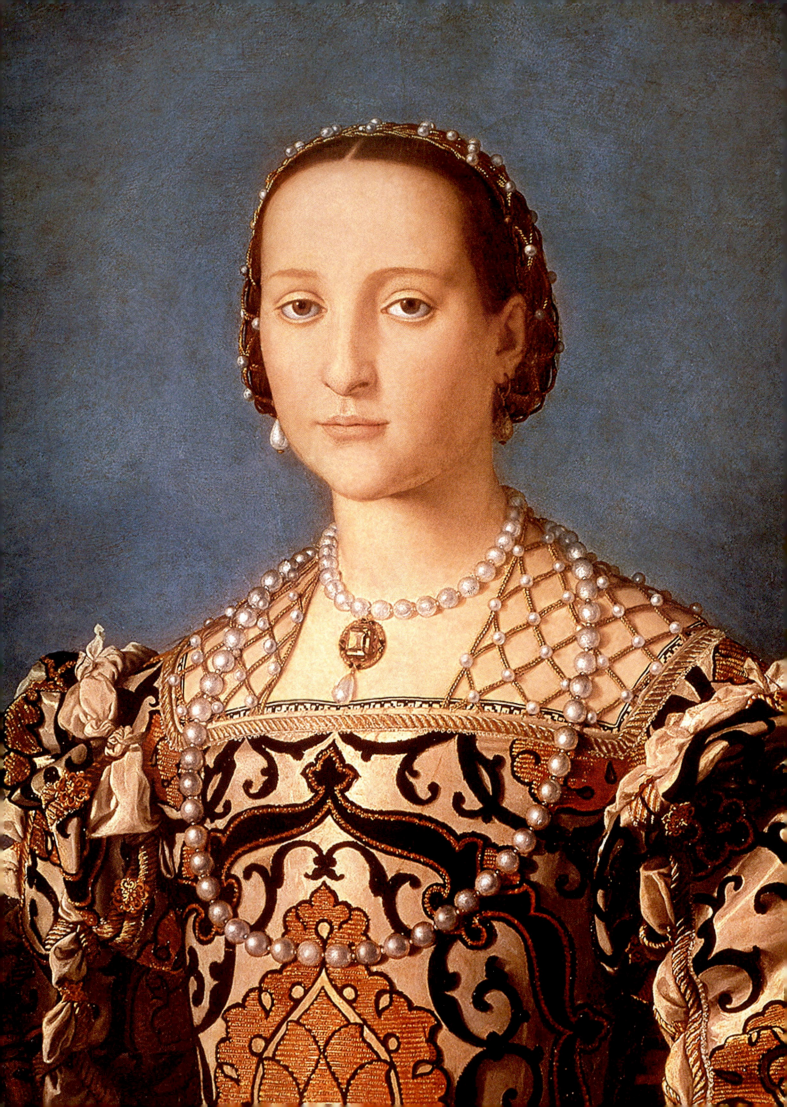

The Late Renaissance and Mannerism in Sixteenth-Century Italy

FROM THE MOMENT THAT MARTIN LUTHER POSTED HIS CHALLENGE TO THE Roman Catholic Church in Wittenburg in 1517, the political and cultural landscape of Europe began to change. Europe's ostensible religious unity was fractured as entire regions left the Catholic fold. The great powers of France, Spain, and Germany warred with each other on the Italian peninsula, even

as the Turkish expansion into Europe threatened all. The spiritual challenge of the Reformation and the rise of powerful courts affected Italian artists in this period by changing the climate in which they worked and the nature of their patronage. No one style dominated the sixteenth century in Italy, though all the artists working in what is conventionally called the Late Renaissance were profoundly affected by the achievements of the High Renaissance.

The authority of the generation of the High Renaissance would both challenge and nourish later generations of artists. In the works of Leonardo, Raphael, Bramante, and Giorgione, younger artists could observe their elders' skillful rendering of *chiaroscuro*, perspective, and *sfumato,* as well as the elder generation's veneration of antiquity. The new generations imitated their technical expertise, their compositions, and their themes. At the same time, the artists of the High Renaissance continued to seek new ways to solve visual problems. Indeed, two of the key figures of the older generation lived to transform their styles: Michelangelo was active until 1564 and Titian until 1576 (see map 17.1).

The notion of the artist as an especially creative figure was passed on to later generations, yet much had changed. International interventions in Italy came to a head in 1527 when Rome itself was invaded and sacked by imperial troops of the Habs-

burgs; three years later, Charles V was crowned Holy Roman Emperor in Bologna. His presence in Italy had important repercussions: In 1530, he overthrew the reestablished Republic of Florence and restored the Medici to power. Cosimo I de' Medici became duke of Florence in 1537 and grand duke of Tuscany in 1569. Charles also promoted the rule of the Gonzaga of Mantua and awarded a knighthood to Titian. He and his successors became avid patrons of Titian, spreading the influence and prestige of Italian Renaissance style throughout Europe.

The Protestant movement spread quickly through Northern Europe, as Luther, Zwingli, Calvin, and other theologians rejected papal authority and redefined Christian doctrine. Some of the reformers urged their followers to destroy religious images as idolatrous, leading to widespread destruction of images, stained glass, and other religious art. Italy itself, home of the Roman Catholic Church, resisted the new faiths. Nonetheless, through the first half of the sixteenth century, pressures for reform in the Catholic Church grew. The Roman Church had traditionally affirmed the role of images as tools for teaching and for encouraging piety, and the Reformers affirmed this position as official Catholic Church policy (see end of Part III, *Additional Primary Sources.*) But with its authority threatened by the Protestant Reformation, the Catholic Church asserted control over the content and the style of images to assure doctrinal correctness. As the Catholic Church sought to define itself against the Protestant Reformation, religious imagery became increasingly standardized.

Detail of figure 17.7, Agnolo Bronzino, *Portrait of Eleanora of Toledo and Her Son Giovanni de' Medici*

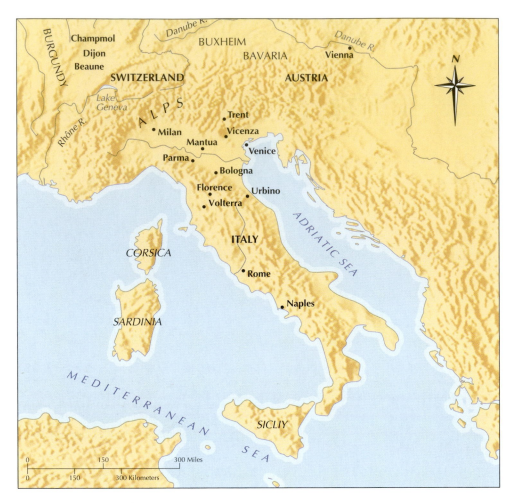

Map 17.1. Italy in the Sixteenth Century

Artists responded to all these phenomena. The Sack of Rome in 1527 scattered Roman-based artists throughout Italy and Europe. Commissions came mostly from the princely courts, so artists' works reflected the taste and concerns of this powerful elite. The connections among the courts helped to spread a new style, usually labeled *Mannerist*, which lasted through much of the century. The style was typically used for paintings and sculptures, though some works of architecture exhibit Mannerist tendencies.

The term derived from the word *maniera*, meaning manner or style, that was used approvingly by contemporaries. Building on the achievements of Raphael and Michelangelo, above all, artists of the 1520s and later developed a style that emphasized technical virtuosity, erudite subject matter, beautiful figures, and deliberately complex compositions that would appeal to sophisticated tastes. Mannerism became a style of utmost refinement, which emphasized grace, variety, and virtuoso display instead of clarity and unity. Mannerist artists self-consciously explored definitions of beauty: Rather than repeat ancient forms, they experimented with proportions, ideal figure types, and unusual compositions. Like the artists of the High Renaissance, they aimed for originality and personal expression, which they considered their due as privileged creators.

Just what mannerism represented continues to spark scholarly debate. Some have argued that it signified a decline, because it rejected the standards of the High Renaissance. (These critics, of course, prefer the "Classical" works of the High Renaissance.) But the reasons that artists rejected the stability, assurance, and ideal forms of the High Renaissance are not well understood. Perhaps the new generation was attempting to define itself as different from its elders. Or, mannerism may be seen as an expression of a cultural crisis. Some scholars relate it to the spiritual crises brought on by the Reformation and the Catholic Counter-Reformation, while others see mannerism as the product of an elite class's expression of its own identity and taste. Even as scholars debate its origins and meanings, it is clear that mannerism's earliest products appear in Florence in the 1520s, which was very different from the Florence of 1505.

LATE RENAISSANCE FLORENCE: THE CHURCH, THE COURT, AND MANNERISM

Under Medici rule, from 1512 to 1527, Florentine artists absorbed the innovations of the High Renaissance. Pope Leo X sent Michelangelo from Rome to Florence to work on projects for the Medici. The artistic descendants of Raphael came to the city as well. Having contributed so much to the development of the Early and High Renaissance, Florentine artists developed a new style of Renaissance art that seems to reject the serenity

and confidence of High Renaissance art. Using the techniques of naturalism, chiaroscuro, and figural composition learned from Leonardo, Michelangelo, and Raphael, this generation of artists made images that are less balanced and more expressive than those of the earlier generation. In works of the 1520s, a group of Florentine artists created images of deep spiritual power in this new style. This spiritual resurgence may be a reaction to the challenges of the Reformation, or it may be due to the legacy of the fiery preacher Savonarola, who had preached repentence in Florence in the 1490s.

Florentine Religious Painting in the 1520s

An early expression of the new style is *The Descent from the Cross* (fig. **17.1**) by Rosso Fiorentino (1495–1540), whose style is very idiosyncratic. A society of flagellants, Catholics whose penitential rituals included whipping themselves to express penitence, hired Rosso to paint this altarpiece in 1521. The Company of the Cross of the Day in the Tuscan city of Volterra chose the theme of the lowering of the body of Christ from the Cross, the subject of Rogier van der Weyden's painting of 1438 (fig. 14.17). To reference the name of the sponsoring group, Rosso has given a great deal of emphasis to the Cross itself.

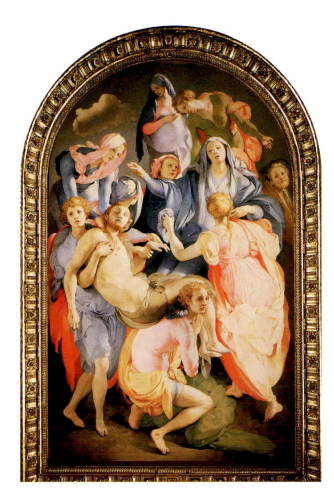

17.2. Jacopo da Pontormo. *The Entombment*. ca. 1526–1528. Oil on panel, 10′3″ × 6′4″ (3.1 × 1.9 m). Santa Felicita, Florence

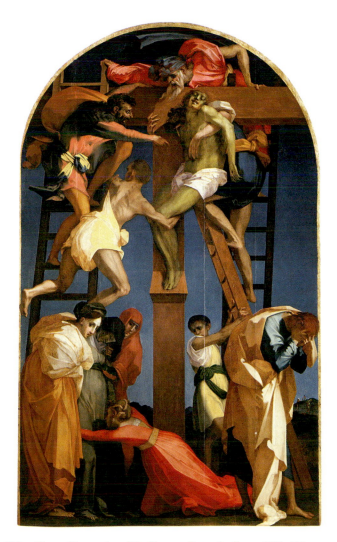

17.1. Rosso Fiorentino. *The Descent from the Cross*. 1521. Oil on panel, 11′ × 6′5½″ (3.4 × 2 m). Pinacoteca Comunale, Volterra

While the composition looks back in part to Early Renaissance art, such as Masaccio's *Trinity* fresco (fig. 15.14), the composition is much less stable than the triangle used by Masaccio. Instead of moving slowly and carefully back into space, the forms all appear on the same plane. The muscular bodies of the agitated figures recall Michelangelo, but the draperies have brittle, sharp-edged planes. The low horizon line sets the figures against a dark sky, creating a disquieting effect. The colors are not primaries but sharply contrasting, and the brilliant light seems to fall on the bodies irrationally. Unlike the orderly calm and deep space of Leonardo's *Last Supper* (fig. 16.6), Rosso creates an unstable composition within a compressed space staffed by figures that move frantically to lower the body of Christ. Only his figure appears serene in the midst of this emotionally charged image. The Mannerist rejection of High Renaissance ideals allows Rosso to create in *The Descent from the Cross* a work that was especially appropriate to the piety of the confraternity members who commissioned it. Rosso himself left central Italy after the Sack of Rome in 1527 by the troops of the Habsburg Charles V, ultimately being lured to France to work for Francis I at his palace of Fontainbleu (see Chapter 18).

Rosso's friend and contemporary, Jacopo da Pontormo (1494–1556), developed his own version of Mannerist style. He executed *The Entombment* (fig. **17.2**) for the Capponi family chapel in the venerable church of Santa Felicita in Florence

around 1526. The painting contrasts sharply with Rosso's *The Descent from the Cross*. This painting lacks a cross or any other indications of a specific narrative, so its subject is unclear. The Virgin swoons as two androgynous figures hold up the body of Christ for a viewer's contemplation. Unlike Rosso's elongated forms, Pontormo's figures display an ideal beauty and sculptural solidity inspired by Michelangelo, yet Pontormo has squeezed them into an implausibly confined space.

In Pontormo's painting, everything is subordinated to the play of graceful rhythms created by the tightly interlocking forms. The colors are off-primary: pale blues, pinks, oranges, and greens that may have been inspired by the colors of the Sistine Chapel ceiling (see fig. 16.17). Although they seem to act together, the mourners are lost in a grief too personal to share with one another. In this hushed atmosphere, anguish is transformed into a lyrical expression of exquisite sensitivity. The entire scene is as haunted as Pontormo's self-portrait just to the right of the swooning Madonna. As the body of Christ is held up for a viewer, much as the host is during the Mass, the image conveys to believers a sense of the tragic scale of Christ's sacrifice, which the Eucharist reenacts. Pontormo may have rejected the values of the High Renaissance, but he endows this image with deeply felt emotion.

The Medici in Florence: From Dynasty to Duchy

In the chaos after the Sack of Rome of 1527, the Medici were again ousted from Florence and the Republic of Florence was reinstated. But the restoration of relations between the pope and the emperor of the Holy Roman Empire allowed the Medici to return to power by 1530. The Medici Pope Clement VII (1523–1534) promoted his family interests, and worked to enhance the power of his family as the rulers of Florence. Although he was an ardent republican, Michelangelo was continually used by this court, executing works intended to glorify the Medici dynasty in Florence.

THE NEW SACRISTY Michelangelo's activities centered on the Medici church of San Lorenzo. A century after Brunelleschi's design for the sacristy of this church (see the plan of San Lorenzo, fig. 15.8), which held the tombs of an earlier generation of Medici, Pope Leo X decided to build a matching structure, the New Sacristy. It was to house the tombs of Leo X's father, Lorenzo the Magnificent, Lorenzo's brother Giuliano, and two younger members of the family, also named Lorenzo and Giuliano. Aided by numerous assistants, Michelangelo worked on the project from 1519 to 1534 and managed to complete the architecture and two of the tombs, those for the later Lorenzo and the later Giuliano (fig. **17.3**); these tombs are nearly mirror images of each other. Michelangelo conceived of the New Sacristy as an architectural-sculptural ensemble. The architecture begins with Brunelleschian pilasters and entablatures and uses *pietra serena* to articulate the walls, as Brunelleschi had done before. Then, however, Michelangelo took liberties with his model, treating the walls

themselves as sculptural forms in a way Brunelleschi never would. The New Sacristy is the only one of the artist's works in which the statues remain in the setting intended for them, although their exact placement remains problematic. Michelangelo's plans for the Medici tombs underwent many changes while the work was under way. Other figures and reliefs for the project were designed but never executed. The present state of the Medici tombs can hardly be what Michelangelo ultimately intended, as the process was halted when the artist permanently left Florence for Rome in 1534.

The tomb of Giuliano remains an imposing visual unit, composed of a sarcophagus structure supporting two sculpted nudes above which sits an armored figure, all framed by Michelangelo's inventive reimagining of Classical architecture.

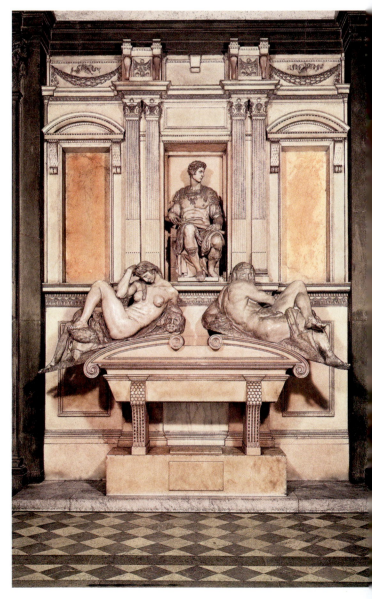

17.3. Michelangelo. Tomb of Giuliano de' Medici. 1519–1534. Marble. Height of central figure 71″ (180.5 cm). New Sacristy, San Lorenzo, Florence

The central niche, which barely accommodates the seated figure, is flanked by paired pilasters that support an entablature that breaks over them. On either side, blank windows are topped by curving pediments supported by volutes; these forms echo the shape of the sarcophagus below. The triangle of statues is held in place by a network of verticals and horizontals whose slender, sharp-edged forms contrast with the roundness and weight of the sculpture.

The design shows some kinship with such Early Renaissance tombs as Rossellino's tomb for Leonardo Bruni (see fig. 15.26), but the differences are marked. There is no outright Christian imagery, no inscription, and the effigy has been replaced by two allegorical figures—*Day* on the right and *Night* on the left. Some lines penned on one of Michelangelo's drawings suggest what these figures mean: "Day and Night speak, and say: We with our swift course have brought the Duke Giuliano to death . . . It is only just that the Duke takes revenge [for] he has taken the light from us; and with his closed eyes has locked ours shut, which no longer shine on earth." The reclining figures, themselves derived from ancient river gods, contrast in mood: *Day*, whose face was left deliberately unfinished, seems to brood, while *Night* appears restless. Giuliano, the ideal image of the prince, wears Classical military garb and bears no resemblance to the deceased. ("A thousand years from now, nobody will know what he looked like," Michelangelo is said to have remarked.) His beautifully proportioned figure seems ready for action, as he fidgets with his baton. His gaze was to be directed at the never completed tomb of Lorenzo the Magnificent. Instead of a commemorative monument that looks retrospectively at the accomplishments of the deceased, the Tomb of Giuliano and the New Sacristy as a whole was to express the triumph of the Medici family over time.

Michelangelo's reimagining of Brunelleschi at the New Sacristy inspired Vasari to write that "all artists are under a great and permanent obligation to Michelangelo, seeing that he broke the bonds and chains that had previously confined them to the creation of traditional forms." However, Michelangelo's full powers as a creator of architectural forms are displayed for the first time in the vestibule to the Laurentian Library, adjoining San Lorenzo.

THE LAURENTIAN LIBRARY Clement VII commissioned this library (fig. **17.4**) in 1523 to house, for the public, the huge collection of books and manuscripts belonging to the Medici family. Such projects display the Medici benificence to the city and their encouragement of learning. The Laurentian Library is a long narrow hall that is preceded by the imposing vestibule, begun in 1523 but not completed until much later.

According to the standards of Bramante or Vitruvius, everything in the vestibule is wrong. The pediment above the door is broken. The pilasters flanking the blank niches taper downward, and the columns belong to no recognizable order. The scroll brackets sustain nothing. Most paradoxical of all are the recessed columns. This feature flies in the face of convention. In the Classical post-and-lintel system, the columns (or pilasters) and entablature must project from the wall in order to stress

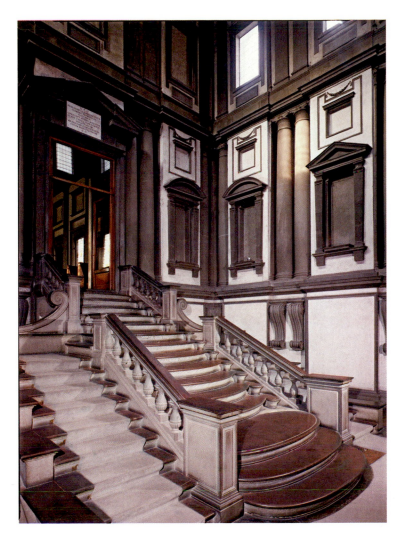

17.4. Michelangelo. Vestibule of the Laurentian Library, Florence. Begun 1523; stairway designed 1558–1559

their separate identities, as they do in the Roman Temple of Portunus (see fig. 7.2). The system could be reduced to a linear pattern (as in the Palazzo Rucellai, fig. 15.32), but no one before Michelangelo had dared to defy it by inserting columns into the wall. In the confined space of the entryway, Michelangelo gives the wall a monumental dignity without projecting the columns and letting them intrude into the vestibule. The grand staircase, designed later by Michelangelo and built by Bartolommeo Ammanati, activates the space through its cascading forms.

THE PALAZZO PITTI AND THE UFFIZI In concentrating their patronage at San Lorenzo, this generation of Medici followed the patterns of the fifteenth century. But the Medici dukes were not content to live in the Palazzo Medici built by Michelozzo. The family of Cosimo I de' Medici moved into the Palazzo della Signoria at the center of the city in 1540 (see fig. 13.16). Where earlier generations of Medici rulers separated their private residence from the seat of government, the Medici dukes did what they could to unite them. Consequently, the interior of the former town hall was remodeled to create a residential space, and new spaces for both court and government were created.

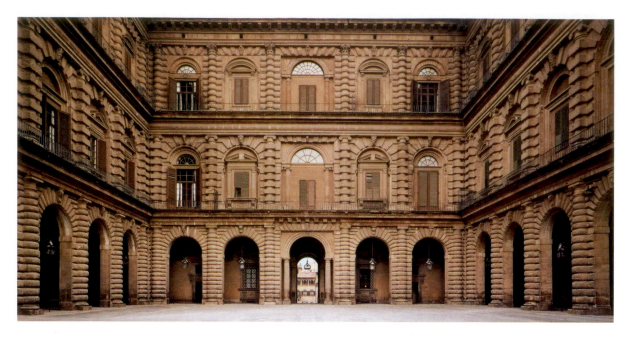

17.5. Bartolommeo Ammanati. Courtyard of the Palazzo Pitti, Florence. 1558–1570

In their search for appropriate settings for the court, the Medici acquired the Palazzo Pitti, across the Arno River, which had been built in the fifteenth century. The palazzo was enlarged by the sculptor Bartolommeo Ammanati (1511–1592), who built the courtyard between 1558 and 1570 (fig. **17.5**). Like Michelozzo's palace (fig. 15.33), the courtyard enframes a space that is both utilitarian and ceremonial, but where the fifteenth-century palace seems ornate and delicate, this courtyard has a fortresslike character. The three-story scheme of superimposed orders, derived from the Colosseum, has been overlaid with an extravagant pattern of rustication that "imprisons" the columns and reduces them to a passive role, despite the display of muscularity. The creative combination of a Classical vocabulary with the unorthodox treatment of the rustication creates a raw expression of power. The Palazzo Pitti functions today as a museum displaying many of the works collected by the Medici family.

Cosimo I de' Medici commissioned a new administrative structure to house the bureaucracies of his court in 1560. This project was assigned to Giorgio Vasari (1511–1574), a painter, historian, and architect. The building of the Uffizi, finished around 1580, consists of two long wings that face each other across a narrow court and are linked at one end by a loggia, or *testata* (fig. **17.6**). (It was originally conceived as a huge square, but this plan was deemed too grandiose by Cosimo.) Situated between the Palazzo della Signoria and the Arno, it served to restructure both the city space and the widely

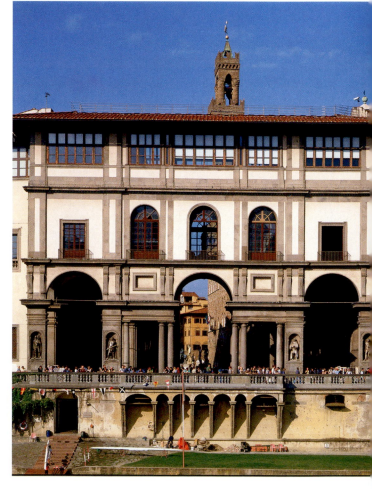

17.6. Giorgio Vasari. Facade of Uffizi, Florence. Begun 1560

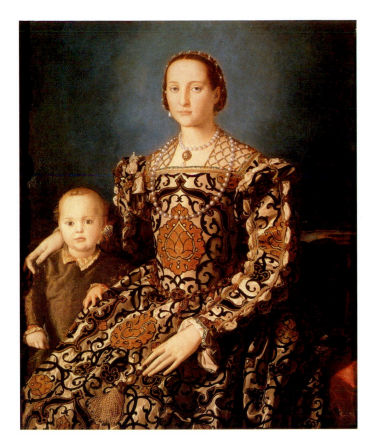

17.7. Agnolo Bronzino. *Portrait of Eleanora of Toledo and Her Son Giovanni de' Medici.* ca. 1550. Oil on panel, $45^1/_4 \times 37^3/_4''$ (115 × 96 cm). Galleria degli Uffizi, Florence

dispersed Florentine ministries. Although strongly marked by Michelangelo's architecture at San Lorenzo, the courtyard also makes reference to the Roman Forum and thus links Cosimo to Roman emperors.

PORTRAITURE AND ALLEGORY. The Medici court had refined tastes and a good sense of how to use the visual arts to express their new status. As in the fifteenth century, this generation of Medici patrons used portraiture as a means to this end. The *Portrait of Eleanora of Toledo and Her Son Giovanni de' Medici* (fig. **17.7**) by Agnolo Bronzino (1503–1572) exemplifies a new form of court portrait. This is a highly idealized portrayal of Eleanora, the wife of Cosimo I, who had blond hair (here darkened) and specific features that have been perfected in the portrait. She appears as an ideal of beauty, even as her husband was admired for his virile good looks and courage.

An important message of the portrait is the continuity of the Medici dynasty, as Eleanora's arm enframes the male heir, Giovanni (born in 1543), who, however, would not outlive her. (She bore 11 children, including eight sons, before her death from tuberculosis in 1562 at about the age of 43.) The dynastic message of the image requires the formality of the portrait with its frozen poses and aloof glances. Eleanora sits rigidly with her arm resting on her silent, staring child; she wears a complicated brocaded dress and jewelry that demonstrates her wealth and status. Bronzino depicts the pair almost like a Madonna and Child, subtly comparing Eleanora to the Virgin: This reference

ART IN TIME

ca. 1526—Pontormo's *The Entombment*

 1537—Cosimo I ruler in Florence

 1542—Portuguese become first Europeans to visit Japan

 1563—Founding of Florence's Accademia del Disegno

may account for the lightening of the blue background around Eleanora's face that suggests a halo. The image contains a complex set of allusions as flattering as the improvements in her looks. Bronzino's painting describes the sitter as a member of an exalted social class, not as an individual personality. This kind of formal, distant, and allusive court portrait quickly became the ideal of court portraiture throughout Europe. (See, for example, fig. 18.29, the *Portrait of Elizabeth I*.)

Bronzino was Eleanora's preferred painter and held a court appointment. His passion for drawing and his gift for poetry came together in many of his works. Nowhere is this better seen than in his *Allegory of Venus* (fig. **17.8**), which Duke Cosimo presented to Francis I of France. From these sources, Bronzino creates a complex allegory whose meanings art historians are still probing, through the approaches called iconography and iconology. (See *The Art Historian's Lens,* page 594.)

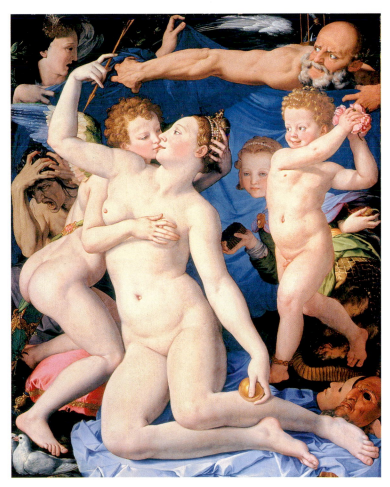

17.8. Agnolo Bronzino. *Allegory of Venus.* ca. 1546. Oil on panel, $57^1/_2 \times 45^5/_8''$ (146.1 × 116.2 cm). The National Gallery, London. Reproduced by courtesy of the trustees

Iconography and Iconology

Much of the practice of art history involves some form of the interpretation of works of art, attempting to decode what their meanings and messages were for their contemporary audiences. Among the methods that art historians rely on to further this process are iconography and iconology. *Iconography* deals with the study of the subject matter or content of works of art, identifying subjects, characters, or symbols used by artists to communicate their ideas.

Iconology is concerned with interpretation, too, but in a different way. It seeks to understand the relationship between works of art and their historical moment: how certain themes carry meaning at particular times, why certain subjects appear in art and then disappear. In this def-

inition, iconology examines the relationship between form, content, and historical context. Where the practitioner of iconography may use dictionaries of saints' attributes, or symbols to put a label on a motif, the scholar interested in the iconology of a work will consider other products of the same cultural moment to identify the deeper cultural meanings associated with a theme, a motif, or a particular representation.

The term *iconology* was coined by the scholar Erwin Panofsky, whose many studies of Renaissance art continue to be very influential. One of the topics that most concerned him was the use of Classical themes during the Renaissance. His interpretations of works such as Titian's *Danaë* inquired why such themes were selected, the relationship between the painted image and literary texts on similar themes, the cultural evaluations of antiquity in the period, and other issues of context.

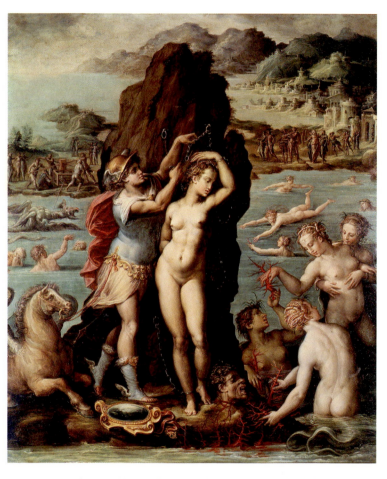

17.9. Giorgio Vasari. *Perseus and Andromeda*. 1570–1572. Oil on slate, 45$\frac{1}{2}$ × 34″ (115.6 × 86.4 cm). Studiolo, Palazzo Vecchio, Florence

Into a narrow plane close to the surface of the painting, Bronzino crowds a number of figures who have been identified only tentatively: The bald Father Time tears back the curtain from Fraud, the figure in the upper left-hand corner, to reveal Venus and Cupid in an incestuous embrace, much to the delight of the child Folly, who is armed with roses, and to the dismay of a figure tearing his hair, who has been identified as either Jealousy or Pain; on the right, Pleasure, half woman and half snake, offers a honeycomb. The moral of Bronzino's image may be that folly and pleasure blinds one to the jealousy and fraud of sensual love, which time reveals.

With its extreme stylization, Bronzino's painting proclaims a refined erotic ideal that reduces passion to a genteel exchange of gestures between figures as polished and rigid as marble. The literary quality of the allegory reflects Bronzino's skill as a poet. The complexity of the conceit matches the complexity of the composition; the high quality of the technique matches the cleverness of the content. In Bronzino, the Medici found an artist whose technical virtuosity, complex imagery, and inventive compositions perfectly matched their taste and exemplify the Mannerist style. Cosimo's gift of a painting of such erudite imagery and accomplished technique to the king of France demonstrated his realm's achievements in the literary and visual arts.

Such complex and learned treatments occur also in the *Perseus and Andromeda* (fig. **17.9**) by Giorgio Vasari, who was responsible for several major projects in the Palazzo della Signoria. This painting is part of Vasari's decorative scheme executed for the study of Cosimo's son, Francesco I de' Medici of Florence. (The program, devoted to what the ancients considered the four elements: water, wind, earth, and fire, was devised by the Humanist Vincenzo Borghini.) To represent water, the artist depicts the story of coral, which according to legend was formed by the blood of the monster slain by Perseus

when he rescued Andromeda. The subject provided an excuse to show voluptuous nudes, as the water nymphs or Nereids, lighthearted versions of Raphael's mythological creatures in the *Galatea* (fig. 16.28), frolic with bits of coral they have discovered in the sea. The central figure of Andromeda passively awaits her rescue by Perseus. Her figure with its long tapering proportions and elegant pose reflects the ideal of beauty preferred by the Medici court.

THE *ACCADEMIA DEL DISEGNO* One of the goals of the grand duke was to promote the arts in Tuscany, a goal shared by Giorgio Vasari, who had dedicated his collection of biographies, first published in 1550, to Cosimo I. Cosimo sponsored the *Accademia del Disegno* (Academy of Design) in 1563, intended to improve the training of artists and to enhance the status of the arts. Bronzino and Giorgio Vasari were founding members of the academy. Training in the academy stressed drawing and the study of the human figure, which was deepened not only by life drawing from the figure but also by dissections. Both nature and the ancients were esteemed, and the art of Michelangelo was held to be the highest achievement of the moderns. The academy emphasized the study of history and literature as well as the skills of the artist. The specifically Tuscan emphasis on drawing (*disegno*) reflected the patriotic aims of the founders, who stressed art as an intellectual activity, not mere craft.

To the academy came Jean de Bologne (1529–1608), a gifted sculptor from Douai in northern France, who had encountered Italian styles in the court of Francis I. He found employment at the granducal court and, under the Italianized name of Giovanni Bologna, became the most important sculptor in Florence during the last third of the sixteenth century. To demonstrate his skill, he chose to sculpt what seemed to him a most difficult feat: three contrasting figures united in a single action. When creating the group, Bologna had no specific theme in mind, but when it was finished the title *The Rape of the Sabine Woman* (fig. **17.10**) was proposed and accepted by the artist. The duke admired the work so much he had it installed near the Palazzo della Signoria.

The subject proposed was drawn from the legends of ancient Rome. According to the story, the city's founders, an adventurous band of men from across the sea, tried in vain to find wives among their neighbors, the Sabines. Finally, they resorted to a trick. Having invited the entire Sabine tribe into Rome for a festival, they attacked them, took the women away by force, and thus ensured the future of their race. This act of raw power and violence is sanitized in Bologna's treatment, as the figures spiral upward in carefully rehearsed movements. Bologna wished to display his virtuosity and saw his task only in formal terms: to carve in marble, on a massive scale, a sculptural composition that was to be seen from all sides. The contrast between form and content that the Mannerist tendency encouraged could not be clearer.

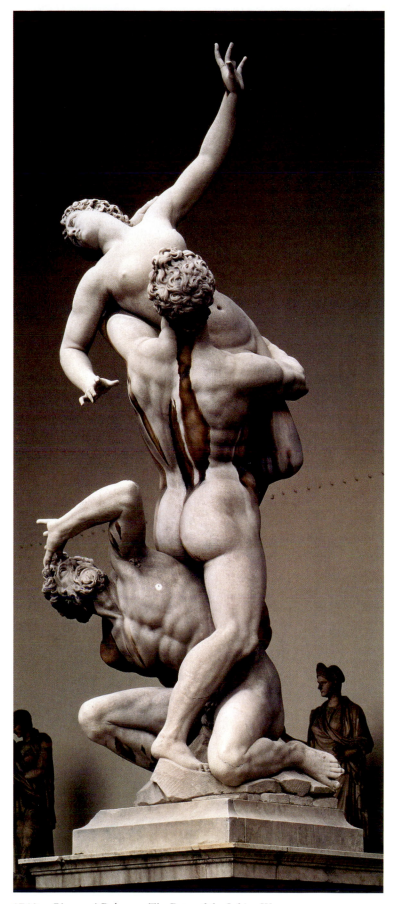

17.10. Giovanni Bologna. *The Rape of the Sabine Woman.* Completed 1583. Marble, height 13′6″ (4.1 m). Loggia dei Lanzi, Florence

ROME REFORMED

While the Medici were consolidating their power in Florence, in Rome, popes Julius II and Leo X sought to join their religious authority with secular power. Naturally, conflicts arose between the papacy and the princes of Europe. The contest between the papacy and the Holy Roman Empire resulted in the Sack of Rome in 1527 by Habsburg troops. Pope Leo X's cousin, Clement VII (1523–1534) fled, and much destruction ensued. Despite this shock to both the dignity of the city and to the papacy, Clement ultimately crowned Charles V as emperor, and returned, once again, to his project of promoting the Medici family. When Clement died in 1534, the cardinals turned to a reform-minded member of a distinguished Roman family to restore the papacy. They chose Alessandro Farnese, a childhood friend of Leo X who had been educated in the palace of Lorenzo the Magnificent. As Pope Paul III, he encouraged Charles V's efforts to bring German princes back to the Roman Church, while at the same time trying to reassure Charles's enemy, Francis I, that Germany would not overpower France.

Paul III was very concerned with the spiritual crisis presented by the Reformation. Martin Luther had challenged both the doctrine and the authority of the Church, and his reformed version of Christianity had taken wide hold in Northern Europe (see Chapter 18). To respond to the challenge of the Protestant Reformation, Paul III called the Council of Trent, which began its work in 1545 and issued its regulations in 1564.

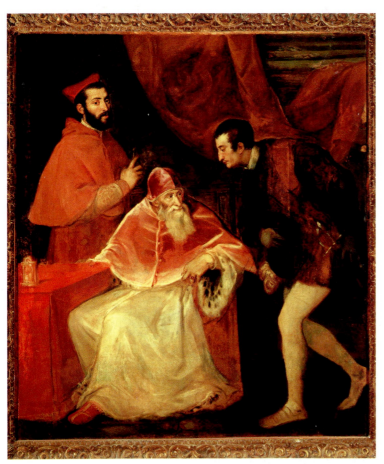

17.11. Titian. *Pope Paul III and His Grandsons*. 1546. Oil on canvas, 6′10″ × 5′8″ (2.1 × 1.7 m). Museo e Gallerie Nazionale di Capodimonte, Naples

The council reaffirmed traditional Catholic doctrine and recommended reforms of liturgy, Church practices, and works of art. (See end of Part III, *Additional Primary Sources*.)

The Catholic Church's most far-reaching and powerful weapon for combating what it considered heresy was the Inquisition, established in Italy in 1562 to investigate unapproved or suspect religious activities. Those found guilty of engaging in such heresy could be imprisoned or executed. To further control the spread of unorthodoxy, the Church compiled the Index of Prohibited Books in 1557. Texts by suspect authors or on subjects deemed unhealthful could be seized or denied publication.

Titian captured the character of Pope Paul III in his portrait *Pope Paul III and His Grandsons* (fig. **17.11**), painted in 1546 during a brief visit by the Venetian painter to Rome. The pope is depicted with the grandsons (sometimes called nephews) whose careers he sought to promote, and their dependence on him is reflected by the composition. The composition derives from Raphael's *Pope Leo X* (fig. 16.26). Yet rather than the sensual and smoothly blended brushstrokes of Raphael's portrait of the Medici pope, Titian's quick, slashing strokes give the entire canvas the spontaneity of a sketch. (In fact, some parts are unfinished.) The tiny figure of the pope, shriveled with age, manages to dominate his tall grandsons with awesome authority.

Michelangelo in Rome

Like his predecessors, Paul III saw the value in commissioning large-scale projects from the leading artists of his day. Thus he recalled Michelangelo to Rome to execute several key projects for him. Rome remained Michelangelo's home for the rest of his life. The new mood of Rome after the Sack of 1527 and during the Catholic Reformation may be reflected in the subject chosen for a major project in the Sistine Chapel. Beginning in 1534, Michelangelo painted for Paul III the powerful vision of *The Last Judgment* (fig. **17.12**). It took six years to complete this fresco, which was unveiled in 1541.

To represent the theme of the Last Judgment (Matthew 24:29–31) on the altar wall of the Sistine Chapel, Michelangelo had to remove not only the fifteenth-century frescoes commissioned by Sixtus IV but also parts of his own ceiling program in the upper lunettes. Traditional representations such as Giotto's at the Arena Chapel in Padua (see fig. 13.19) depict a conception of Hell as a place of torment. In envisioning his fresco, Michelangelo must have looked partly to Luca Signorelli's work for Orvieto Cathedral (fig. 15.60), with its muscular nudes set into vigorous action. Michelangelo replaces physical torments with spiritual agony expressed through violent physical contortions of the human body within a turbulent atmosphere. As angelic trumpeters signal the end of time, the figure of Christ sits at the fulcrum of a wheel of action: As he raises his arm, the dead rise from the Earth at the lower left to yearn toward heaven where the assembly of saints crowds about him. The damned sink away from heaven toward Charon, who ferries them to the underworld. Throughout the fresco, human figures bend, twist, climb, fall, or gaze at Christ, their forms almost superhuman in their muscular power. The nudity of the figures, which expresses

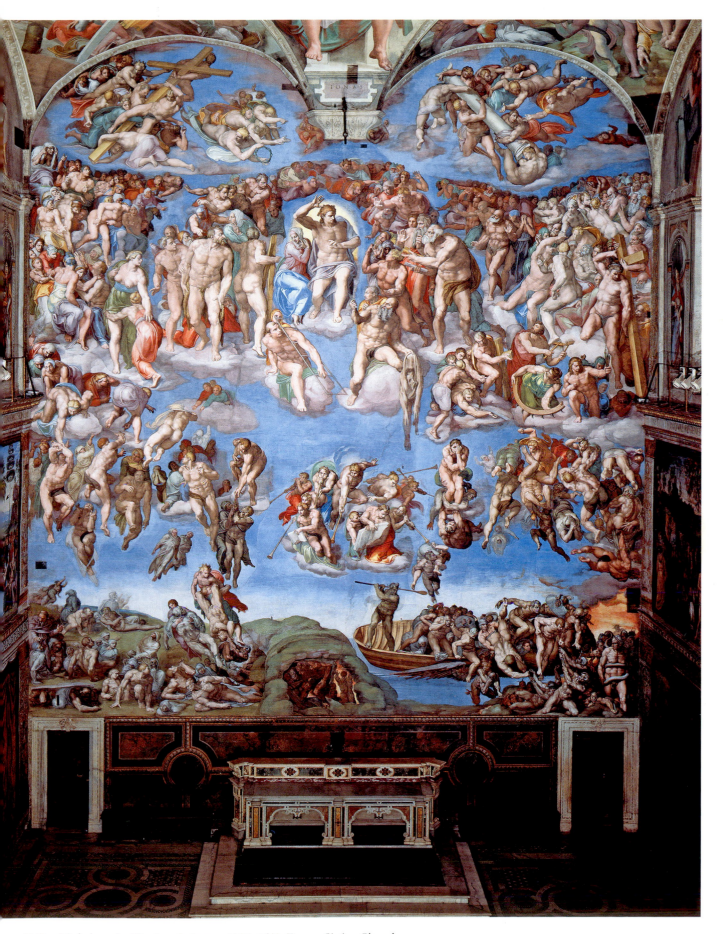

17.12. Michelangelo. *The Last Judgment*. 1534–1541. Fresco. Sistine Chapel

Michelangelo the Poet

Michelangelo's prodigious creativity was manifested in many different art forms: sculpture, painting, architecture, and poetry. Allusive and dense with imagery, his poems do not explain his works in visual media, but they sometimes treat parallel themes. This poem uses metaphors that appear visually in the Sistine Chapel's The Last Judgment. *It was a gift to his friend and reported lover, Tommaso Cavalieri, a Roman nobleman.*

The smith when forging iron uses fire
to match the beauty shaped within his mind;
and fire alone will help the artist find
a way so to transmute base metal higher

to turn it gold; the phoenix seeks its pyre
to be reborn; just so I leave mankind
but hope to rise resplendent, new refined,
with souls whom death and time will never tire.
And this transforming fire good fortune brings
by burning out my life to make me new
although among the dead I then be counted.
True to its element the fire wings
its way to heaven, and to me is true
by taking me aloft where love is mounted.

SOURCE: MICHELANGELO BUONAROTTI, *LIFE LETTERS AND POETRY*, ED. AND TR. G. BULL. (OXFORD: OXFORD UNIVERSITY PRESS, 1987, P. 142.)

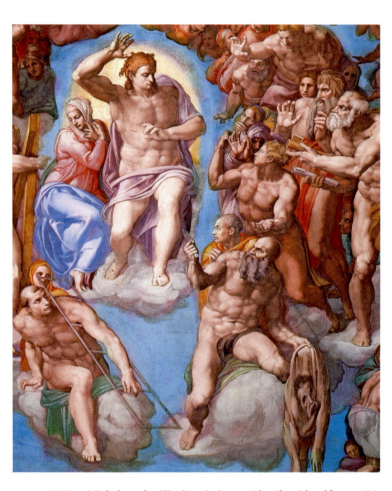

17.13. Michelangelo. *The Last Judgment* (detail, with self-portrait)

Michelangelo's belief in the sanctity of the human body, disturbed his contemporaries, and shortly after he died in 1564 one of his assistants was commissioned to add bits of cloth to the fresco to mask the nudity. The fresco was cleaned in 1994, bringing out the brilliant colors, the compressed space, and dramatic composition. These features link the work to the Mannerist style, though Michelangelo defies such labels.

That the fresco expresses Michelangelo's personal vision of the end of days is suggested by one detail: Straddling a cloud just below the Lord is the apostle Bartholomew, holding a human skin to represent his martyrdom by flaying (fig. **17.13**). The face on that skin, however, is not the saint's but Michelangelo's. In this grim self-portrait, so well hidden that it was recognized only in modern times, the artist represents himself as unworthy to be resurrected in the flesh, which is a key theme of the image. Already in his sixties, Michelangelo frequently meditated on death and salvation in his poetry of the period as well as in his art. Some parallel ideas and metaphors may be seen in a poem he composed around 1532 (see *Primary Source*, above).

These concerns also appear in his *Pietà*, begun around 1546 (fig. **17.14**). Here Michelangelo used his features again, this time for the hooded figure of Nicodemus, who holds the broken body of Christ. He intended this sculptural group for his own tomb. By casting himself as a disciple tending the body of Christ, Michelangelo gives form to a conception of personal, unmediated access to the divine. The Catholic Church may have found such an idea threatening during the Catholic Reformation, when the authority of the Roman Church was being reaffirmed as Protestantism spread throughout Europe. For whatever reason, Michelangelo smashed the statue in 1555, and left it unfinished. Compared with his 1499 *Pietà* (fig. 16.12), this work is more expressive than beautiful, as though the ideals of his youth had been replaced by a greater seriousness of spiritual purpose. Many of Michelangelo's latest sculptures remained unfinished, including the tomb of Julius II, as his efforts turned to architecture.

RESHAPING THE CAMPIDOGLIO While in Rome during the last 30 years of his life, Michelangelo's main pursuit was architecture. Among his activities were several public works projects. In 1537–1539, he received the most ambitious commission of his career: to reshape the Campidoglio, the top of Rome's Capitoline Hill, into a piazza and frame it with a

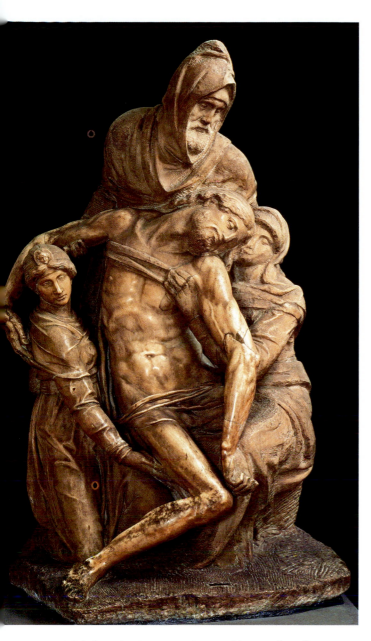

monumental architectural ensemble worthy of the site, which once had been the symbolic center of ancient Rome. This was an opportunity to plan on a grand scale. Pope Paul III worked with the civilian authorities of Rome (the Conservators) to renovate this site and made Michelangelo its designer. Although not completed until long after his death, the project was carried out essentially as Michelangelo designed it. The Campidoglio remains the most imposing civic center ever built, and it has served as a model for countless others. Pope Paul III transferred the equestrian monument of Marcus Aurelius (see fig. 7.21) from the Lateran Palace to the Campidoglio and had it installed on a base that Michelangelo designed. Placed at the top of a gently rising oval mound that defines the space, the statue became the focal point of the entire scheme. (The sculpture was recently removed to an interior space to protect it.) As the sculpted figure was thought to represent Constantine, the first Roman emperor to promote Christianity and the source of the papacy's claim to temporal power, by placing it at the center of the seat of secular government, the pope asserted papal authority in civic affairs.

Three sides of the piazza are defined by palace facades. An engraving based on Michelangelo's design (fig. **17.15**), imperfectly conveys the effect of the space created by the facades. The print shows the symmetry of the scheme and the sense of progression along the main axis toward the Senators' Palace, opposite the staircase that gives entry to the piazza. However, the shape of the piazza is not a rectangle but a trapezoid, a peculiarity dictated by the site. The Senators' Palace and the Conservators' Palace on the right were older buildings that had to be preserved behind new exteriors, but they were placed at an angle of 80 instead of 90 degrees. Michelangelo turned this problem into an asset. By adding the "New Palace" on the left, which complements the Conservators' Palace in style and placement, he makes the Senators' Palace look larger than it is, so that it dominates the piazza.

17.14. Michelangelo. *Pietà*. ca. 1546, Marble. Height 92″ (2.34 m). Museo del Opera del Duomo, Florence.

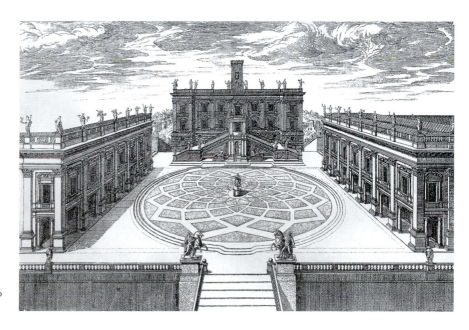

17.15. Michelangelo. The Campidoglio (engraving by Étienne Dupérac, 1569)

The whole conception has the effect of a stage set. All three buildings are long but relatively narrow, like a show front with little behind it. However, these are not shallow screens but three-dimensional structures (fig. **17.16**). The "New Palace" and its twin, the Conservators' Palace, combine voids and solids, horizontals and verticals with a plasticity not found in any piece of architecture since Roman antiquity. The open porticoes in each structure further link the piazza and facades, just as a courtyard is related to the arcades of a cloister.

The columns and beams of the porticoes are contained in a colossal order of pilasters that supports a heavy cornice topped by a balustrade. Alberti had experimented with the colossal order at Sant'Andrea in Mantua (see fig. 15.49), but Michelangelo fully exploited this device. For the Senators' Palace he used a colossal order and balustrade above a tall base, which emphasizes the massiveness of the building. The single entrance at the top of the double-ramped stairway (see fig. 17.15) seems to gather all the spatial forces set in motion by the oval mound and the flanking structures. It thus provides a dramatic climax to the piazza. Brunelleschi's design for the facade of the Innocenti in Florence (fig. 15.6), with its slim Tuscan columns and rythmic arcade, seems a delicate frame for a piazza compared with the mass and energy of the Campidoglio. Michelangelo's powerful example of molding urban spaces was important for subsequent city planners throughout Europe.

ST. PETER'S Michelangelo used the colossal order again on the exterior of St. Peter's (fig. **17.17**). The project had been inherited by several architects after Bramante's death. Michelangelo took over the design of the church in 1546 upon the death of the previous architect, Antonio da Sangallo the Younger, whose work he completely recast. Returning to a centrally focused plan, he adapted the system of the Conservators' Palace to the curving contours of the church, but with windows instead of open loggias and an attic instead of the balustrade.

Unlike Bramante's many-layered elevation (fig. 16.11), Michelangelo uses a colossal order of pilasters to emphasize the compact body of the structure, thus setting off the dome more dramatically. The same desire for compactness and organic unity led him to simplify the interior spaces (fig. **17.18**). He brought the complex spatial sequences of Bramante's plan (see fig. 16.10) into one cross and square, held in check by the huge piers that support the central dome. He further defined its main axis by modifying the eastern apse and adding a portico to it, although this part of his design was never carried out. The dome, however, reflects Michelangelo's ideas in every important respect, even though it was built after his death and has a steeper pitch.

Bramante had planned his dome as a stepped hemisphere above a narrow drum, which would have seemed to press down on the church. Michelangelo's, in contrast, has a powerful thrust that draws energy upward from the main body of the

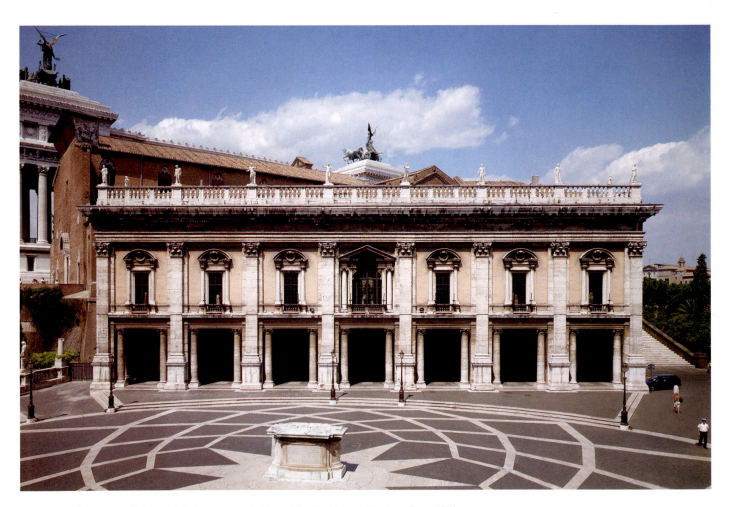

17.16. Michelangelo. Palazzo dei Conservatori, Campidoglio, Rome. Designed ca. 1545

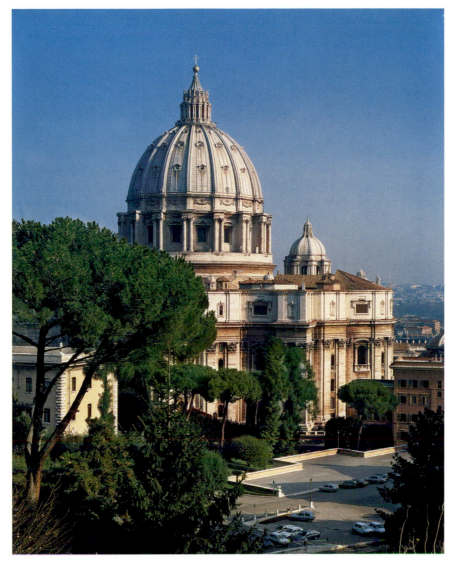

17.17. Michelangelo. St. Peter's, Rome, seen from the west. 1546–1564; dome completed by Giacomo della Porta, 1590

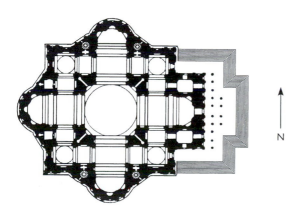

17.18. Michelangelo. Plan for St. Peter's

structure. Michelangelo borrowed not only the double-shell construction but also the Gothic profile from the Florence Cathedral dome (see fig. 15.2 and *Materials and Techniques*, page 508), yet the effect is very different. The smooth planes of Brunelleschi's dome give no hint of the internal stresses.

Michelangelo, however, gives sculptured shape to these forces and visually links them to the rest of the building. The vertical impetus of the colossal pilasters is taken up by the double columns of the high drum. It continues in the ribs and the raised curve of the cupola, then culminates in the tall lantern. The logic of this design is so persuasive that almost all domes built between 1600 and 1900 were influenced by it.

The Catholic Reformation and Il Gesù

Michelangelo's centralized plan for St. Peter's still presented problems for a reformed Catholic Church that was reasserting its traditions as the Council of Trent finished its deliberations in 1564. The liturgies propounded by the council worked best within a basilical structure. The council decreed that believers should see the elevation of the Host at the heart of the Mass, and this was best accomplished in a long basilical hall with an unencumbered view of the altar. Among the number of reforming religious orders established in the middle of the

ART IN TIME

1527—Habsburg army sacks Rome

1534—Michelangelo begins *The Last Judgment*

1540—Ignatius of Loyola founds Society of Jesus (Jesuits)

1541—John Calvin founds Reformed Church in Geneva

1545—Council of Trent opens. Catholic Reformation begins

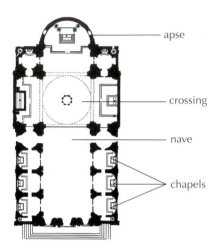

apse

crossing

nave

chapels

17.19. Giacomo Vignola. Plan of Il Gesù, Rome. 1568

sixteenth century, one of the most ambitious and energetic was the Society of Jesus, or Jesuits, founded by Ignatius of Loyola and promoted by Paul III. The order was approved in 1540 and by 1550 their church, Il Gesù in Rome, was being planned. Michelangelo once promised a design for this project, though apparently never furnished it; the plan that was adopted came from one of Michelangelo's assistants, Giacomo Vignola (1507–1573) in 1568. The facade was designed by Giacomo della Porta (ca. 1540–1602) but not completed until 1584. As the mother church of the Jesuits, its design must have been closely supervised so as to conform to the aims of the order. The Jesuits were at once intellectuals, mystics, and missionaries, whose charge was to fight heresy in Europe and spread Christianity to Asia and America. They required churches that adhered to the precepts of the Council of Trent—churches that would have impressive grandeur while avoiding excessive ornament. Their church of Il Gesù may be seen as the architectural embodiment of the spirit of the Catholic Reformation.

Il Gesù is a compact basilica dominated by its mighty nave (fig. 17.19). The aisles have been replaced by chapels, thus assembling the congregation in one large, hall-like space directly in view of the altar. The attention of the audience is strongly directed toward altar and pulpit, as a representation of the interior shows (fig. 17.20). (The painting depicts how the church would look from the street if the center part of the facade were removed. For the later decoration of the nave vault, see fig. 19.12.) The painting also depicts a feature that the ground plan cannot show: the dramatic contrast between the dim nave and the amply lighted eastern part of the church, thanks to the large windows in the drum of the dome. Light has been consciously

exploited for its expressive possibilities—a novel device, theatrical in the best sense of the term—to give Il Gesù a stronger emotional focus than we have as yet found in a church interior.

The facade by Giacomo della Porta (fig. 17.21) is as bold as the plan. It is divided into two stories by a strongly projecting entablature that is supported by paired pilasters that clearly derive from Michelangelo, with whom Della Porta had worked. The same pattern recurs in the upper story on a somewhat smaller scale, with four instead of six pairs of supports. To bridge the difference in width and hide the roof line, Della Porta inserted two scroll-shaped buttresses. This device, taken from the facade of Santa Maria Novella in Florence by Alberti (fig. 15.31), forms a graceful transition to the large pediment crowning the facade, which retains the classic proportions of Renaissance architecture: The height equals the width.

Della Porta has masterfully integrated all the parts of the facade into a single whole: Both stories share the same vertical rhythm, which even the horizontal members obey. (Note the way the broken entablature responds to the pilasters.) In turn, the horizontal divisions determine the size of the vertical members, so there is no colossal order. Michelangelo inspired the sculptural treatment of the facade, which places greater emphasis on the main portal. Its double frame—two pediments resting on coupled pilasters and columns—projects beyond the rest of

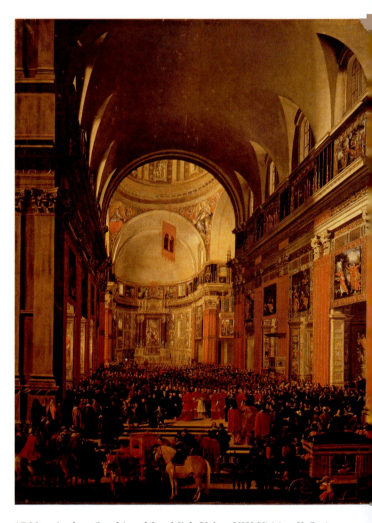

17.20. Andrea Sacchi and Jan Miel. *Urban VIII Visiting Il Gesù.* 1639–1641. Oil on canvas. Galleria Nazionale d'Arte Antica, Rome

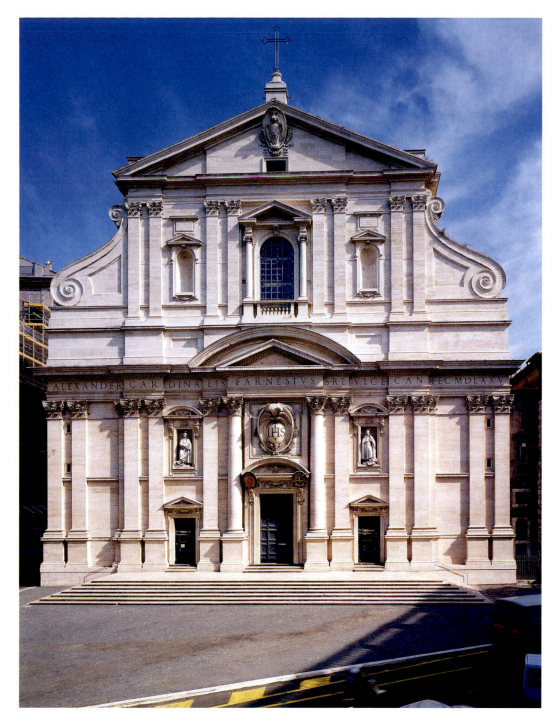

17.21. Giacomo della Porta. Facade of Il Gesù, Rome. ca. 1575–1584

the facade and gives strong focus to the entire design. Not since Gothic architecture has the entrance to a church received such a dramatic concentration of features. This facade and the freedom to add movement and plastic dimension to the facade were an important precedent for church architecture built by the Jesuits and by others during ensuing centuries.

MANTUA OF THE GONZAGA

Northern Italy was divided into a number of principalities that were smaller than the Grand Duchy of Tuscany or the Papal States. One of the most stable of these principalities was Mantua, where the Gonzaga family retained the title of Marquis into the sixteenth century. Mantua was host to major artists in the fifteenth century, including Alberti and Mantegna. The family's traditions of patronage extended to women as well as men, as Isabella d'Este, the wife of Francesco II Gonzaga, was one of the most active patrons of the early sixteenth century. Her son, Federico, became Marquis in 1519, a title he held until Charles V named him Duke in 1530. Campaigns for such titles were often accompanied by displays of wealth and taste expressed through the arts.

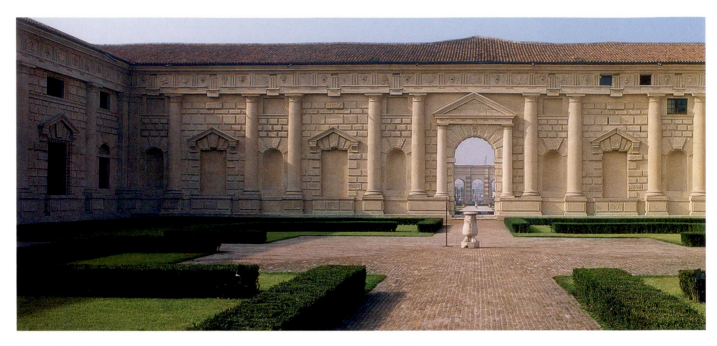

17.22. Giulio Romano. Courtyard of the Palazzo del Te, Mantua. ca. 1527–1534

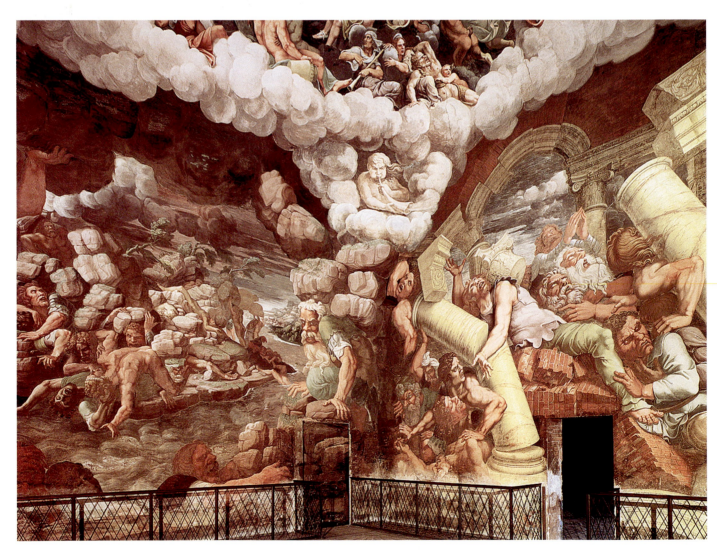

17.23. Giulio Romano. *Fall of the Giants from Mount Olympus*, from the Sala dei Giganti. ca. 1530–1532. Palazzo del Te, Mantua

The Palazzo del Te

As part of his campaign, Federico II Gonzaga commissioned Giulio Romano (ca. 1499–1546) to design a villa for him outside the city itself, called the Palazzo del Te, where he could house his mistress and receive the emperor. Giulio had been Raphael's chief assistant in Rome, but came to Mantua to follow in the footsteps of Mantegna and Alberti in 1524.

He designed the Palazzo del Te as a low structure appropriate to the flat landscape. For the courtyard facade (fig. 17.22), Giulio used a vocabulary familiar to patrons of villas and palaces, such as the rusticated blocks and the smooth Tuscan order of engaged columns that support a projecting entablature. As Michelangelo did at the Laurentian Library, Giulio subverts the conventions of traditional Classical architecture. The massive keystones of the blank windows appear ready to burst the triangular lintels above them. The only true arch spans the central doorway, but it is surmounted by a pediment, a violation of the Classical canon. The triglyph midway between each pair of columns "slips" downward in defiance of all logic and accepted practice, thereby creating the sense that the frieze might collapse before our eyes. Giulio broke the rules of accepted practice as if to say that the rules do not apply to him, or to his patron.

What is merely a possibility on the exterior of the Palazzo del Te seems to come to pass on the interior, where Giulio painted a series of rooms with illusionistic frescoes on themes drawn from antiquity. Unlike the frescoes of Raphael in Rome, these are not images of a distant and beautiful Golden Age, but vivid and dramatic expressions of power. In the Room of the Giants in the Palazzo (fig. **17.23**), Giulio painted a fresco of the gods expelling the giants from Mount Olympus as a cataclysm of falling bodies and columns. A viewer seems to see an entire temple collapsing. The huge figures of the giants are about to be crushed by the falling architectural elements, which are being toppled by the winds, whose figures appear in the upper corners of the wall. As if witnessing the power of the new Olympian gods, a viewer feels transported into the terror of the event. Of course, the duke himself was imagined as Zeus (Jupiter) in this conceit, so the whole illusion speaks to the power of Duke Federico.

This conceit was also applied to paintings for the duke's palace in Mantua, which he commissioned from Antonio Allegri da Correggio (1489/94–1534), called Correggio, about the same time. This gifted northern Italian painter, who spent most of his brief career in Parma, absorbed the influences of Leonardo, the Venetians, Michelangelo, and Raphael into a distinctive and sensual style. Duke Federico commissioned a series of the Loves of Jupiter, among which is the *Jupiter and Io* (fig. **17.24**). As Ovid recounts, Jupiter changed his shape numerous times to seduce his lovers; here, the nymph Io, swoons in the embrace of a cloudlike Jupiter. The use of *sfumato*, combined with a Venetian sense of color and texture, produces a frank sensuality that exceeds even Titian's *Bacchanal* (see fig. 16.32). Correggio renders the vaporous form of the god with a remarkable degree of illusionism. The eroticism of the image reflects a taste shared by many of the courts of Europe, visible in Bronzino's *Allegory* (fig. 17.8) and Titian's *Danaë* (fig.17.31).

PARMA AND BOLOGNA

The larger political entities in Italy aimed to swallow up the smaller ones. The cities of Parma and Bologna in north central Italy were both part of the Papal States as the sixteenth century unfolded. Forms of art and patronage established by courts in Rome, Florence, and Milan were emulated by the citizens of these cities.

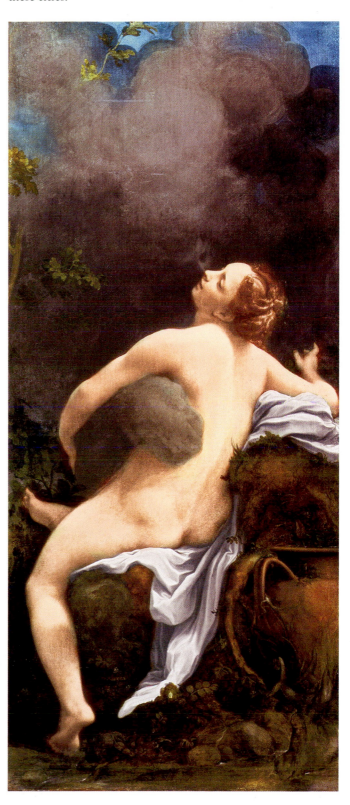

17.24. Correggio. *Jupiter and Io.* ca. 1532. Oil on canvas, $64^{1}/_{2} \times 27^{3}/_{4}''$ (163.8 × 70.5 cm). Kunsthistorisches Museum, Vienna

Correggio and Parmigianino in Parma

Correggio spent much of his career in the city of Parma, which had recently been absorbed into the Papal States. This new affiliation brought the city new wealth and inspired local patrons of art and architecture, and more than once Correggio was the artist chosen for their projects. He put his skills to work at the dome of Parma Cathedral where he painted the fresco of *The Assumption of the Virgin* between 1522 and 1530 (fig. **17.25**). The surfaces of the dome are painted away by Correggio's illusionistic perspective. A viewer standing below the dome is transported into the heavens, as the sky opens to receive the body of the Virgin rising into the light.

Correggio here initiates a new kind of visionary representation in which heaven and Earth are joined visually and spiritually through the magic of perspective and the artist's skill. Not since Mantegna's *Camera Picta* in Mantua (fig. 15.53) has a ceiling been so totally replaced by a painted illusion; the concept would reverberate in the works of other artists in the

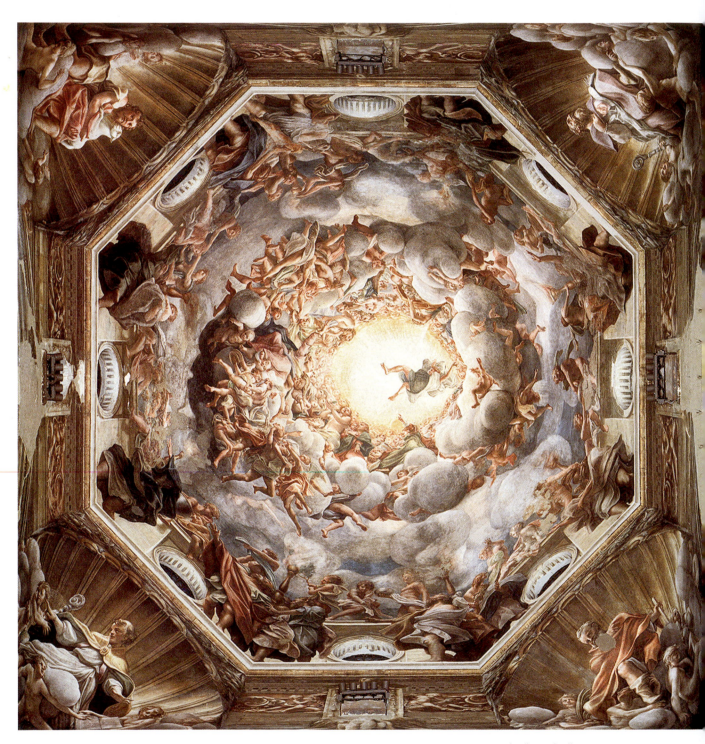

17.25. Correggio. *The Assumption of the Virgin*. ca. 1522–1530. Fresco, diameter of base of dome 35′10″ × 37′11″ (10.93 × 11.56 m). Dome of Parma Cathedral, Parma, Italy

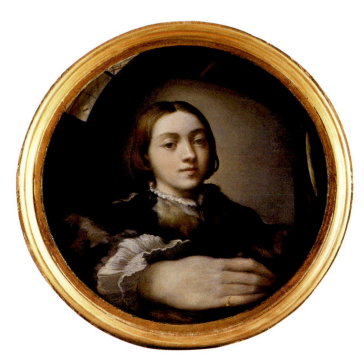

17.26. Parmigianino. *Self Portrait*. 1524. Oil on panel, diameter 9⅝″ (24.7 cm). Kunsthistorisches Museum, Vienna

ART IN TIME

1522—Plague returns to Italy

1530—Coronation of Charles V as Holy Roman Emperor in Bologna

1532—Correggio's *Jupiter and Io*

1535—Parmigianino's *The Madonna with the Long Neck*

1543—Vesalius publishes first text on human anatomy

1543—Copernicus publishes *On the Revolutions of the Celestial Orbs*

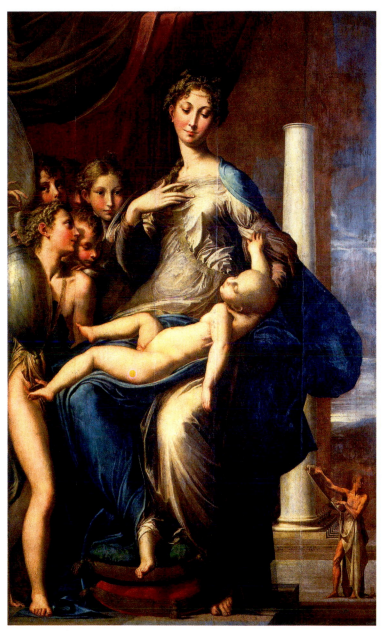

17.27. Parmigianino. *The Madonna with the Long Neck*. ca. 1535. Oil on panel, 7′1″ × 4′4″ (2.2 × 1.3 m). Galleria degli Uffizi, Florence

seventeenth century, when ceilings would disappear through illusionistic devices, as can be seen in the work of Pietro da Cortona (fig. 19.11) and Gaulli (fig. 19.12). Correggio also gave the figures themselves the ability to move with such exhilarating ease that the force of gravity seems not to exist for them, and they frankly delight in their weightless condition. Reflecting the influence of Titian, these are healthy, energetic beings of flesh and blood, which makes the Assumption that much more miraculous.

Parma was the birthplace of yet another gifted painter, Girolamo Francesco Maria Mazzola (1503–1540), known as Parmigianino. Precocious and intelligent, Parmigianino had made his reputation as a painter in Rome, Florence, and elsewhere before returning to Parma in 1530. His *Self Portrait* (fig. **17.26**), done as a demonstration piece, suggests his self-confidence. The artist's appearance is bland and well groomed. The features, painted with Raphael's smooth perfection, are veiled by a delicate Leonardoesque *sfumato*. The picture records what Parmigianino saw as he gazed at his reflection in a convex mirror, including the fishbowl distortions in his hand. Parmigianino substitutes his painting for the mirror itself, even using a specially prepared convex panel. The painting demonstrates his skill at recording what the eye sees, yet at the same time it shows off his learning by a subtle allusion to the myth of Narcissus, who according to Greek legend, looked in a pool of water and fell in love with his own reflection.

Parmigianino's skill is evident in his most famous work, *The Madonna with the Long Neck* (fig. **17.27**), commissioned in 1535 by a noblewoman of Parma for a family chapel in the church of Santa Maria dei Servi. Despite his deep study of

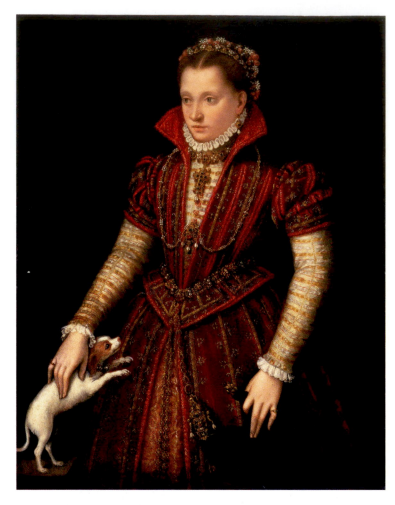

17.28. Lavinia Fontana. *Portrait of a Noblewoman*. ca. 1580. Oil on canvas, 45¼" × 35¼" (114 × 89.5 cm). National Museum of Women in the Arts, Washington, DC. Gift of Wallace and Wilhelmina Holladay

Raphael and Correggio, Parmagianino has a different ideal of beauty, which he establishes with the large amphora offered by the figure at the left. In his painting, the perfect oval of Mary's head rests on a swanlike neck, while her body swells only to taper to her feet, which mimics the shape of the amphora. By contrast, Raphael's *Belle Jardiniere* (fig. 16.22) seems all circles and cubes, and her features are sweet rather than haughty. Nor does Parmigianino attempt to replicate Raphael's stable compositions. Here, the sleeping Christ Child balances precariously on the Madonna's lap, as she lifts a boneless hand to her breast. The composition is as unbalanced as the postures: heavily weighted to the left, open and distant to the right. All the figures have elongated limbs and ivory-smooth features, and the space is compressed. In mannerist fashion, these elements draw attention to the artist's skill and his inversion of Raphael's ideals.

These choices may reflect the meaning of the image. The large Christ Child in his mother's lap recalls the theme of the *Pietà*, which shows that Jesus is already aware of his fate. Nor is the setting as arbitrary as it may seem. The gigantic column is a symbol often associated with the Madonna as the gateway to heaven and eternal life, as well as the Immaculate Conception. At the same time it may also refer to the column on which Jesus endured the flagellation during the Passion, which the tiny figure of a prophet foretells on his scroll. *The Madonna with the Long Neck* is a vision of unearthly perfection, with a cold and memorable elegance.

Lavinia Fontana in Bologna

Parmagianino had stopped for a period in Bologna, an important city north of Florence. Long a part of the Papal States, Bologna was not ruled by a prince, but controlled from Rome in conjunction with a senate composed of local aristocratic families. Its cultural character was also shaped by the presence of its ancient university. While painting in Bologna had not achieved the level of acclaim it had in Florence or Venice, the city was home to several women artists during the sixteenth century. One of the most important of these was Lavinia Fontana (1552–1614), whose reputation was great in her lifetime, though it became obscured later.

Fontana was the daughter of the painter Prospero Fontana, a distinguished painter and frequent head of the painter's guild. Her upbringing allowed her to learn an art form that increasingly was being restricted by the new training in the academies. Her style was formed by her studies with her father, and her experience of the works of Raphael, Correggio, and Parmigianino in Bologna. She developed a network of patrons, many of them among the noblewomen of the city, for whom she painted religious paintings and portraits.

A good example is the *Portrait of a Noblewoman,* dated to the 1580s (fig. **17.28**). Against a dark background, a young woman stands in the finery she wore on her wedding day. The light pouring in from the left distinguishes the forms. Fontana takes care in rendering the details of the dress, the jewelry, and the headdress. The young woman faces her married future as a decorous and decorative figure, her eyes averted from the spectator as if to demonstrate her modesty. With one hand she caresses a little dog, perhaps a pet, or perhaps a symbol of fidelity; with the other she holds a fur pelt attached by a jewel to her waist, another symbol, this time associated with fertility. Fontana's skill at composing such flattering and sumptuous images made her one of the most sought after artists of her city.

VENICE: THE SERENE REPUBLIC

Despite the attacks it endured at the beginning of the sixteenth century, Venice regained much of its territory and wealth by 1529. Its aristocracy reasserted their political and cultural power throughout the century, contributing to a distinctive situation

for artists and for patrons. Instead of a court, Venice remained a nominal republic, controlled by ancient families, such as the Loredan, the Vendramin, and the Barbaro. In addition to religious works of art, these families commissioned works for their homes in town and for their villas in the country, so artists had a wide variety of themes to depict. The city itself expressed its status through public works projects commissioned by the civic fathers and intended to beautify the Most Serene Republic (*Serenissima*). One example of this is the refashioning of the heart of the city—the piazzetta between San Marco and the Canal of San Marco—with a pair of buildings in the 1530s.

Sansovino in Venice

To design these structures, the Council of Ten who controlled the city held a competition in 1535 to design a new home for the state mint (fig. **17.29**, left). They selected Jacopo Sansovino

(1486–1570), a Florentine sculptor who left Rome for Venice after the Sack of Rome in 1527 and established himself as the chief architect of the city. Not surprisingly, his buildings are sculptural in character. In the spirit of earlier Venetian structures such as the Ca' d'Oro (fig. 15.54) and the Doge's Palace (fig. 13.34) nearby, Sansovino composed the facade to have numerous openings formed by arches and huge windows. The supporting arches and columns, however, are given greater stress through the rustication used throughout, which adds to the imposing effect of the building. (The top story was added around 1560.)

The Procurators of San Marco then hired Sansovino to build the Library of San Marco (fig. **17.29**, right) as a public library and a repository for a rich collection of Greek and Latin manuscripts. Situated next to the mint, the library uses a much more elegant architectural vocabulary. It is a long, two storied structure, composed as a series of arcades supporting heavy cornices.

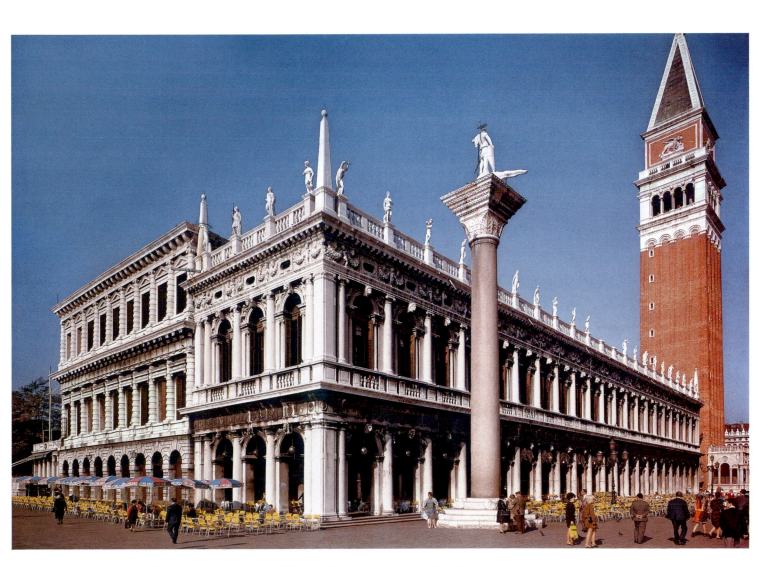

17.29. Jacopo Sansovino. Mint (left) and Library of St. Mark's, Venice. Begun ca. 1535/37

Oil on Canvas

For much of the Middle Ages and Renaissance, painters worked either directly on walls or on solid wood supports. Wood panels were formed of planks that had to be attached together, so seams are sometimes visible. While durable, wood is also heavy and susceptible to warping. In the fifteenth century, some artists both in Italy and in Northern Europe painted on cloth supports, usually canvas or linen, as a less expensive substitute for wood. Canvas is also lighter, and more easily portable. Painted canvases from Flanders, called *panni dipinti*, were imported in good numbers to Italy.

In the humid climate of Venice, where neither fresco nor wood panels would easily survive, artists preferred to work on canvas supports, especially on large-scale projects. By the middle of the sixteenth century, canvas began to replace wood as

Detail of Titian, *Danaë*

the support of choice. By 1600, oil on canvas was the preferred medium for most painters and for patrons who were not commissioning frescoes. Once the canvas itself had been stretched on a wooden framework, it would be covered with a gluelike material to seal the fibers. Then several priming coats would be applied and allowed to dry before the painting commenced.

Working on a large scale also inspired Venetian painters to experiment with the oil medium itself. Instead of building up layers of tinted glazes over large surfaces, artists loaded the brush with more opaque color and laid it on with broad strokes. Sometimes the thick paint looked pastelike, a technique called **impasto**. In such cases, the surface is not a mirrorlike smoothness, but it is rough, and unevenly catches the light. Titian is one of the innovators of this technique. His example was the inspiration for the painterly artists of the Baroque, including Rubens, Rembrandt, and Velasquez.

The street-level arcade is enframed by a Roman Doric order inspired by the Colosseum, while the upper story shows an elaborate treatment of the Ionic order (including triple engaged columns) surmounted by a garlanded entablature. The structure is capped off by a balustrade, with life-size statues over every column cluster and obelisks at each corner. The extravagant ornamentation of both structures creates an effect of opulence that proclaims the Venetian republic as a new Rome.

Titian

Titian dominated painting in Venice throughout the sixteenth century. Like Michelangelo, he lived a long life, and he had numerous pupils to spread his ideas and techniques. His fame was such that by the 1530s Titian's work was sought by the most elite patrons of Europe. For example, in 1538, Titian was commissioned by the duke of Urbino, Guidobaldo II della Rovere, to execute the so-called *Venus of Urbino* (fig. **17.30**). The painting, based on models by Giorgione, depicts a nude young woman lying on a bed in a well-furnished chamber. In the background, two women search in a *cassone* for something, perhaps for a garment. Details such as the presence of the *cassone* and the little dog lead some scholars to suggest that this may have been an image intended to celebrate a marriage. However, the owner referred to the picture only as "the naked woman." Titian's use of color records the sensuous textures of the woman's body, which has been placed on display for a viewer whose gaze she meets. It may have been intended as an erotic image, not a Classical theme.

Whether or not this is Venus, the sensuously depicted female nude became a staple product of Titian's workshop, which was supported by the patronage of other powerful men.

For Phillip II of Spain (the son of Charles V), Titian made series of images of the Loves of Jupiter based on Ovid's *Metamorphoses*. And the *Danaë* (fig. **17.31**), painted for Ottavio Farnese and delivered during a stay by the painter in Rome, shows Jupiter in the guise of a gold shower seducing a young woman, who had been locked in a tower by her father to keep away all suitors. By varying the consistency of his pigments, the artist was able to capture the texture of Danaë's flesh with great accuracy, while distinguishing it clearly from bed sheets and covers. To convey these tactile qualities, Titian built up his surface in thin, transparent glazes. The interaction between these layers produces unrivaled richness and complexity of color; yet the medium is so filmy that it becomes nearly as translucent as the cloud trailing off into the sky.

The figure shows the impact of Michelangelo's *Night* on the Tomb of Giuliano de' Medici, which Titian probably knew from an engraving. After seeing the canvas in the artist's studio, Michelangelo is said to have praised Titian's coloring and style but to have criticized his drawing. Michelangelo's practice was to make detailed drawings before carving his figures; such preliminary drawings for Titian's works have not survived. Although an excellent draughtsman, Titian apparently worked directly on the surface of his canvases and made adjustments as he went along, building forms out of layers of color. This emphasis on color rather than drawing was one of the distinctive aspects of Venetian painting, always criticized by the Florentine academy and its successors.

Titian experimented with many different forms, including prints, but his most enduring innovations were in the technique of painting on canvas (see *Materials and Techniques*, above). His late works demonstrate his most free brush work. Titian

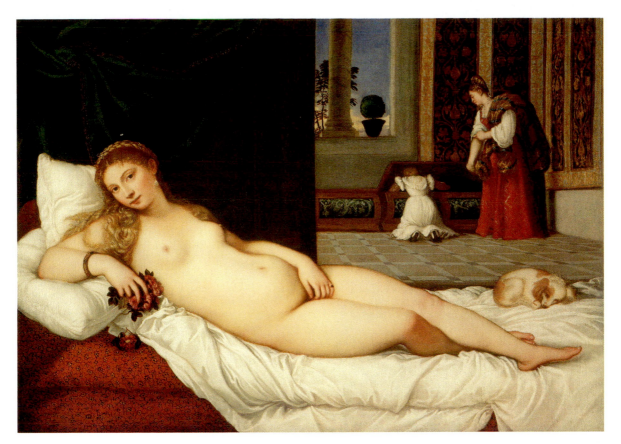

17.30. Titian. *Venus of Urbino.* ca. 1538. Gallerie degli Uffizi, Florence

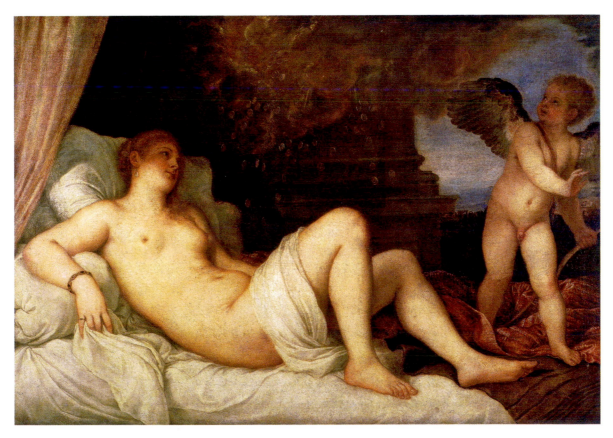

17.31. Titian. *Danaë.* ca. 1544–46. Oil on canvas, 47$\frac{1}{4}$ × 67$\frac{3}{4}$″ (120 × 172 cm).
Museo e Gallerie Nazionale di Capodimonte, Naples

intended the *Pietà* (fig. **17.32**), for his own tomb in the Franciscan church of Santa Maria Gloriosa dei Frari; incomplete at his death in 1576, it was finished by one of his students. Like Michelangelo's late *Pietà* (fig. 17.14), Titian depicts the body of Christ in his mother's arms as friends and followers mourn. The figures of Moses and a sibyl flank a heavily rusticated niche reminiscent of the facade of Sansovino's mint (fig. 17.29). This large canvas owes it power not only to its large scale and dramatic composition, although these are contributing factors, but also to Titian's technique. The forms emerging from the semi-darkness consist wholly of light and color. The artist applies the color in thick masses of paint, yet despite this heavy impasto, the surfaces have lost every trace of material solidity. The gesture of

Mary Magdalen and the sorrow in the features of the Virgin add poignancy to the scene. A kneeling figure, possibly St. Jerome, stands in for Titian himself and reaches over to touch the body of Christ in reverence. The quiet, almost resigned mood is enhanced by the painting's ethereal forms.

Titian's Legacy

Titian's creative output and reputation drew many artists to work in his shop, but he had a tremendous influence even on those who did not. From the island of Crete (then owned by Venice), the young Domenikos Theotokopoulos, called El Greco, came to study in Titian's shop before heading to Spain

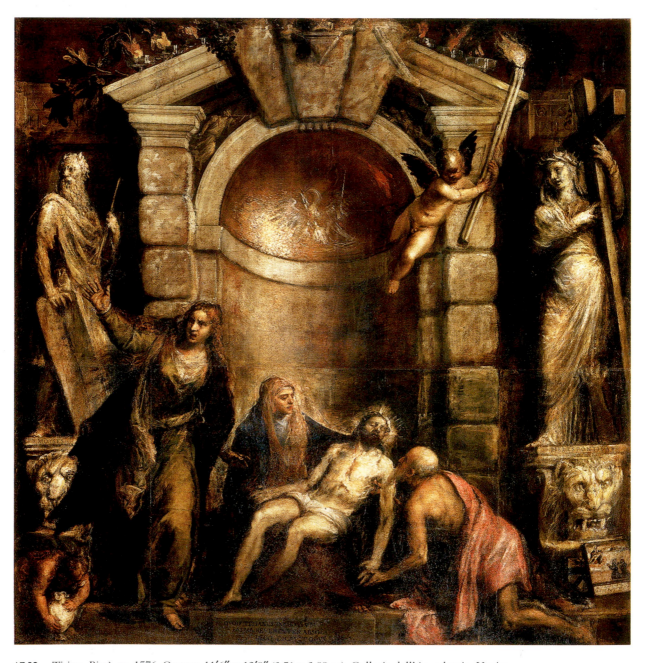

17.32. Titian. *Pietà.* ca. 1576. Canvas, 11′6″ × 12′9″ (3.51 × 3.89 m). Gallerie dell'Accademia, Venice

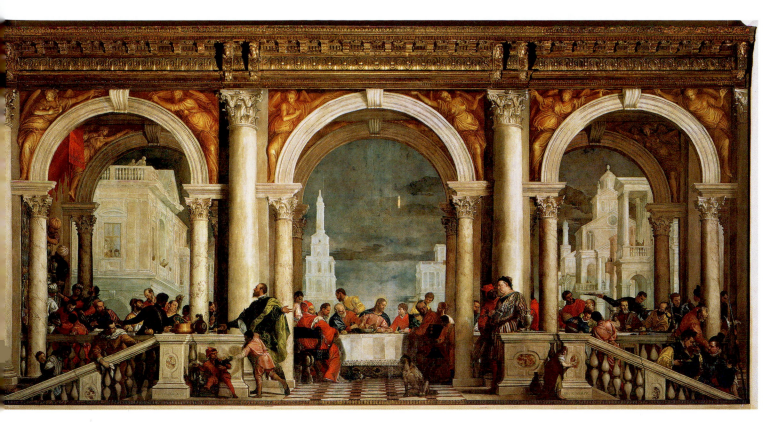

17.33. Paolo Veronese. *The Feast in the House of Levi*. 1573. Oil on canvas, 18′2″ × 42′ (5.5 × 12.8 m). Gallerie dell'Accademia, Venice

(see Chapter 18). The two leading painters in Venice after Titian, Veronese and Tintoretto, developed in different directions. Where Veronese made images that depend on early Titian works like the *Pesaro Madonna* (fig. 16.33) and aimed for naturalism, Tintoretto exploited the drama and fluid brushwork of Titian's later work, like the *Pietà*.

PAOLO VERONESE The paintings of Paolo Cagliari (1528–1588), called Paolo Veronese, who was born and trained in Verona, start from the naturalism inherent in Titian's style, but add an interest in details of everyday reality, as seen in animals, textiles, and foodstuffs—and in grand architectural frameworks. In his huge canvas called *Feast in the House of Levi* (fig. **17.33**), Veronese avoids all reference to the mystical. His symmetrical composition harks back to paintings by Leonardo and Raphael, while the festive mood of the scene reflects examples by Titian of the 1520s, so that at first glance the picture looks like a High Renaissance work born 50 years too late. Veronese, however, is less interested than Leonardo was in conveying spiritual or psychological depth. Originally commissioned for the refectory of a Dominican monastery, the painting depicts a sumptuous banquet, a true feast for the eyes. As with his contemporaries elsewhere in Italy, Veronese was deliberately vague about which event from the life of Jesus he originally meant to depict. He gave the painting its present title

only after he had been summoned by the religious tribunal of the Inquisition on the charge of filling his picture with "buffoons, drunkards, Germans, dwarfs, and similar vulgarities" unsuited to its theme. The account of the trial shows that the tribunal thought the representation of the *Last Supper* was irreverent (see *Primary Source*, page 614). In the face of their questions, Veronese settled on a different title, *The Feast in the House of Levi*, which permitted him to leave the offending incidents in place. He argued that they were no more objectionable than the nudity of Jesus and the Heavenly Host in Michelangelo's *Last Judgment*. Nevertheless, the tribunal failed to see the analogy, on the grounds that "in the Last Judgment it was not necessary to paint garments, and there is nothing in those figures that is not spiritual." Veronese claimed the privilege to "paint pictures as I see fit".

TINTORETTO Jacopo Robusti (1519–1594), called Tintoretto, took a less worldly attitude. Tintoretto reportedly wanted "to paint like Titian and to design like Michelangelo." He did not imitate the High Renaissance phases of those artists' careers, however, but absorbed their later styles, which are more expressive and less realistic in their effects. In a number of large-scale paintings for Venetian confraternities, groups of lay people organized for religious activities, he assimilated the visionary effects of Titian's late paintings and the energetic

From a Session of the Inquisition Tribunal in Venice of Paolo Veronese

Because of the liberal religious atmosphere of Venice, Veronese was never required to make the various changes to his painting of the Last Supper (see fig. 17.33) asked for by the tribunal of the Inquisition in this interrogation. All parties seem to have been satisfied with a mere change of title to Supper in the House of Levi *(now* Feast in the House of Levi*).*

Today, Saturday, the 18th of the month of July, 1573, having been asked by the Holy Office to appear before the Holy Tribunal, Paolo Caliari of Verona, questioned about his profession:

A: I paint and compose figures.

Q: Do you know the reason why you have been summoned?

A: No, sir.

Q: Can you imagine it?

A: I can well imagine.

Q: Say what you think the reason is.

A: According to what the Reverend Father, the Prior of the Convent of SS. Giovanni e Paolo, told me, he had been here and Your Lordships had ordered him to have painted [in the picture] a Magdalen in place of a dog. I answered him by saying I would gladly do everything necessary for my honor and for that of my painting, but that I did not understand how a figure of Magdalen would be suitable there.

Q: What picture is this of which you have spoken?

A: This is a picture of the Last Supper that Jesus Christ took with His Apostles in the house of Simon.

Q: At this Supper of Our Lord have you painted other figures?

A: Yes, milords.

Q: Tell us how many people and describe the gestures of each.

A: There is the owner of the inn, Simon; besides this figure I have made a steward, who, I imagined, had come there for his own pleasure to see how things were going at the table. There are many figures there which I cannot recall, as I painted the picture some time ago.

Q: In this Supper which you made for SS. Giovanni e Paolo what is the significance of the man whose nose is bleeding?

A: I intended to represent a servant whose nose was bleeding because of some accident.

Q: What is the significance of those armed men dressed as Germans, each with a halberd in his hand?

A: We painters take the same license the poets and the jesters take and I have represented these two halberdiers, one drinking and the other eating nearby on the stairs. They are placed there so that

they might be of service because it seemed to me fitting, according to what I have been told, that the master of the house, who was great and rich, should have such servants.

Q: And that man dressed as a buffoon with a parrot on his wrist, for what purpose did you paint him on that canvas?

A: For ornament, as is customary.

Q: Who are at the table of Our Lord?

A: The Twelve Apostles.

Q: What is St. Peter, the first one, doing?

A: Carving the lamb in order to pass it to the other end of the table.

Q: What is the Apostle next to him doing?

A: He is holding a dish in order to receive what St. Peter will give him.

Q: Tell us what the one next to this one is doing.

A: He has a toothpick and cleans his teeth.

Q: Did anyone commission you to paint Germans, buffoons, and similar things in that picture?

A: No, milords, but I received the commission to decorate the picture as I saw fit. It is large and, it seemed to me, it could hold many figures.

Q: Are not the decorations which you painters are accustomed to add to paintings or pictures supposed to be suitable and proper to the subject and the principal figures or are they for pleasure—simply what comes to your imagination without any discretion or judiciousness?

A: I paint pictures as I see fit and as well as my talent permits.

Q: Does it seem fitting at the Last Supper of the Lord to paint buffoons, drunkards, Germans, dwarfs, and similar vulgarities?

A: No, milords.

Q: Do you not know that in Germany and in other places infected with heresy it is customary with various pictures full of scurrilousness and similar inventions to mock, vituperate, and scorn the things of the Holy Catholic Church in order to teach bad doctrines to foolish and ignorant people?

A: Yes, that is wrong.

After these things had been said, the judges announced that the above named Paolo would be obliged to improve and change his painting within a period of three months from the day of this admonition and that according to the opinion and decision of the Holy Tribunal all the corrections should be made at the expense of the painter and that if he did not correct the picture he would be liable to the penalties imposed by the Holy Tribunal. Thus they decreed in the best manner possible.

SOURCE: *A DOCUMENTARY HISTORY OF ART*, VOL. 2, ED. ELIZABETH GILMORE HOLT. (PRINCETON, NJ: PRINCETON UNIVERISITY PRESS, 1982)

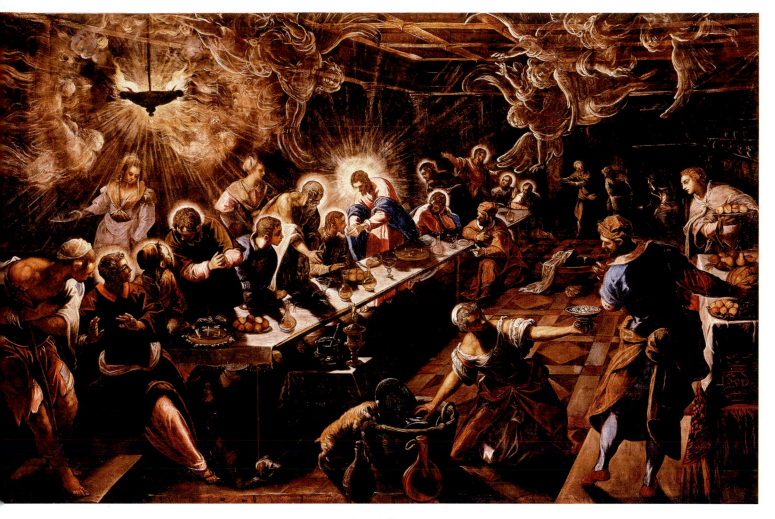

17.34. Jacopo Tintoretto. *The Last Supper.* 1594. Oil on canvas, 12′ × 18′8″ (3.7 × 5.7 m). San Giorgio Maggiore, Venice

compositions of the late Michelangelo. Tintoretto's final major work, *The Last Supper*, finished in 1594, is spectacular (fig. **17.34**). It seems to deny in every possible way the balance and clarity of Leonardo's version of the theme painted almost exactly a century before, which yet underlies Veronese's picture. Jesus, to be sure, is at the center of the composition, but his small figure in the middle distance is distinguished mainly by the brilliant halo. Tintoretto barely hints at the human drama of Judas' betrayal, so important to Leonardo. Judas can be seen isolated on the near side of the table across from Jesus (as Castagno had arranged him in his fresco in Sant'Apollonia, fig. 15.29), but his role is so insignificant that he could almost be mistaken for an attendant. The table is now placed at a sharp angle to the picture plane in exaggerated perspective. This arrangement had a purpose. It was designed to relate the scene to the space of the chancel of San Giorgio Maggiore in Venice, for which it was commissioned. It was seen on the wall near where the Benedictine friars knelt at the altar rail to

receive Communion; from that angle the scene recedes less sharply than when viewed head on.

Tintoretto gives the event an everyday setting, cluttering the scene with attendants, containers of food and drink, and domestic animals. There are also celestial attendants who converge upon Jesus just as he offers his body and blood, in the form of bread and wine, to the disciples. The smoke from the blazing oil lamp miraculously turns into clouds of angels, blurring the distinction between the natural and the supernatural and turning the scene into a magnificently orchestrated vision. The artist's main concern has been to make visible the miracle of the Eucharist—the Transubstantiation of earthly into divine food—in both real and symbolic terms. (The central importance of this sacrament to Catholic doctrine was forcefully reasserted during the Catholic Reformation.) The painting was especially appropriate for its location in San Giorgio Maggiore, which played a prominent role in the reform movement.

Andrea Palladio (1508–1580)

From *The Four Books of Architecture*

Published in 1570, Palladio's The Four Books of Architecture *made an enormous impression on his European contemporaries. His book provided the basis for much French and English architecture of the seventeenth and eighteenth centuries.*

Guided by a natural inclination, I gave myself up in my most early years to the study of architecture: and as it was always my opinion, that the ancient Romans, as in many other things, so in building well, vastly excelled all those who have been since their time, I proposed to myself Vitruvius for my master and guide, who is the only ancient writer of this art, and set myself to search into the reliques of all the ancient edifices, that, in spight of time and the cruelty of the Barbarians, yet remain; and finding them much more worthy of observation, than at first I had imagined, I began very minutely with the utmost diligence to measure every one of their parts; of which I grew at last so sollicitous an examiner, (not finding any thing which was not done with reason and beautiful proportion) that I have very frequently not only travelled in different parts of Italy, but also out of it.

Whereupon perceiving how much this common use of building was different from the observations I had made upon the said edifices, and from what I had read in Vitruvius, Leon Battista Alberti, and in other excellent writers it seemed to me a thing worthy of a man, who ought not to be born for himself only, but also for the utility of others, to publish the designs of those edifices, (in collecting which, I have employed so much time, and exposed myself to so many dangers) and concisely to set down whatever in them appeared to me more worthy of consideration; and moreover, those rules which I have observed, and now observe, in building; that they who shall read these my books, may be able to make use of whatever will be good therein, and supply those things in which I shall have failed; that one may learn, by little and little, to lay aside the strange abuses, the barbarous inventions, the superfluous expence, and (what is of greater consequence) avoid the various and continual ruins that have been seen in many fabricks.

SOURCE: ANDREA PALLADIO, *THE FOUR BOOKS OF ARCHITECTURE.* REPRINT OF 1738 EDITION. (NY: DOVER PUBLICATIONS, 1965)

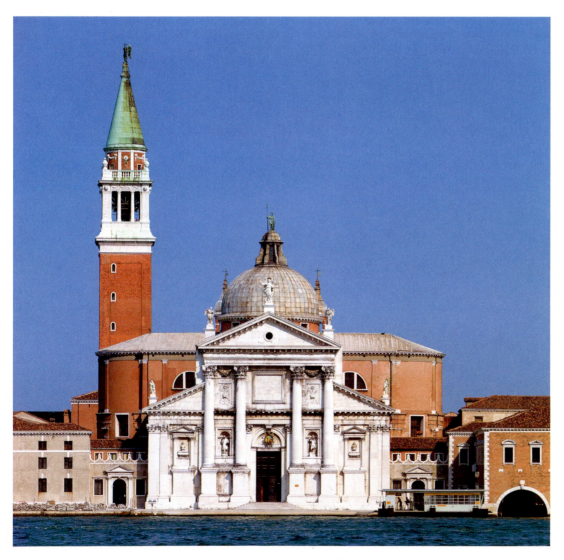

17.35. Andrea Palladio. San Giorgio Maggiore, Venice. Designed 1565

Andrea Palladio and Late Renaissance Architecture

The commission for San Giorgio Maggiore was awarded to one of the most influential architects of the Renaissance, Andrea Palladio (1508–1580) in 1565. Although Palladio's career centered on his native Vicenza, a town near Venice, his buildings and theoretical writings brought him international renown. Palladio believed that architecture must be governed by reason and by rules exemplified by the buildings of the ancients. He shared Leon Battista Alberti's faith in the significance of proportion (see *Primary Source*, page 511). The two architects differed in how they related theory and practice, however. With Alberti, this relationship had been flexible, whereas Palladio believed quite literally in practicing what he preached. This view stemmed in part from his earlier career as a stonemason and sculptor before entering the Humanist circles of Count Giangiorgio Trissino of Vicenza, where he studied Vitruvius and other ancient authors and was introduced to elite patrons of the Veneto.

His first great project in Venice itself was the Benedictine church of San Giorgio Maggiore (fig. **17.35**), begun in 1565. Like his predecessors, Palladio acknowledged that round temples are ideal because the circle is a symbol of uniformity and eternity; yet he and his patrons chose a basilican plan as the only one appropriate for Christian worship. The plan for San Giorgio Maggiore (fig. **17.36**) reflects the church's twofold purpose of serving a Benedictine monastery and a lay congregation. The main body of the church is strongly centralized—the transept is as long as the nave and a dome marks the crossing—

ART IN TIME

1538—Titian's *Venus of Urbino*

1570—Palladio's *Four Books on Architecture* published

1571—Venetian and Spanish navies defeat Turkish fleet at Lepanto

1596—Shakespeare's *Romeo and Juliet*

but the longitudinal axis reasserts itself in the separate compartments for the main altar and the large choir beyond, where the monks worshiped. On the facade, Palladio wished to express the dignity of the church using the architectural language of the ancients. He designed a flattened-out temple porch to the entrance on the grounds that "Temples ought to have ample porticos, and with larger columns than other buildings require; and it is proper that they should be great and magnificent . . . and built with large and beautiful proportions. They must be made of the most excellent and the most precious material, that the divinity may be honored as much as possible." To achieve this end, Palladio superimposed a tall, narrow temple front on another low, wide one to reflect the different heights of nave and aisles in the basilica itself. The interlocking design is held together by the four gigantic columns, which function as a variant of Alberti's colossal order.

Much of Palladio's architecture consists of town houses and country villas. The Villa Rotonda (fig. **17.37**), one of Palladio's finest buildings, exemplifies his interpretation of the ancients. This country residence, built near Vicenza, beginning in 1567, for the humanist cleric Paolo Almerico, consists of a square block surmounted by a dome, with identical porches in the shape of temple fronts on all four sides. Alberti had defined the ideal church as a symmetrical, centralized design of this sort, but Palladio adapted the same principles for the ideal country house. He was convinced, on the basis of Vitruvius and Pliny, that Roman private houses had porticoes like these. (Excavations have since proved him wrong.) Palladio's use of the temple front here is more than an expression of his regard for antiquity; he considered this feature both legitimate and essential for decorum—namely, appropriateness, beauty, harmony, and utility—befitting the houses of "great men." This concept was embedded in the social outlook of the later sixteenth century, which required the display of great wealth and taste to assert status. Palladio's design also takes advantage of the pleasing views offered in every direction by the site. Beautifully correlated with the walls behind and the surrounding vistas, the porches of the Villa Rotonda give the structure an air of serene dignity and festive grace that is enhanced by the sculptures on the facades.

His buildings alone would make Palladio an important figure in the history of art, but his influence extended beyond Italy, indeed beyond Europe, through his publications. Palladio's most important work in this field was his treatise of 1570, *The Four Books of Architecture* (excerpted in the *Primary Source*, facing page). While several architects, including Alberti,

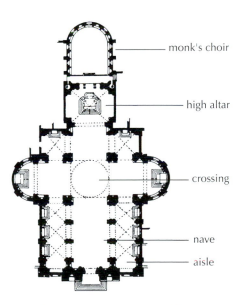

17.36. Plan of San Giorgio Maggiore

labels: monk's choir · high altar · crossing · nave · aisle

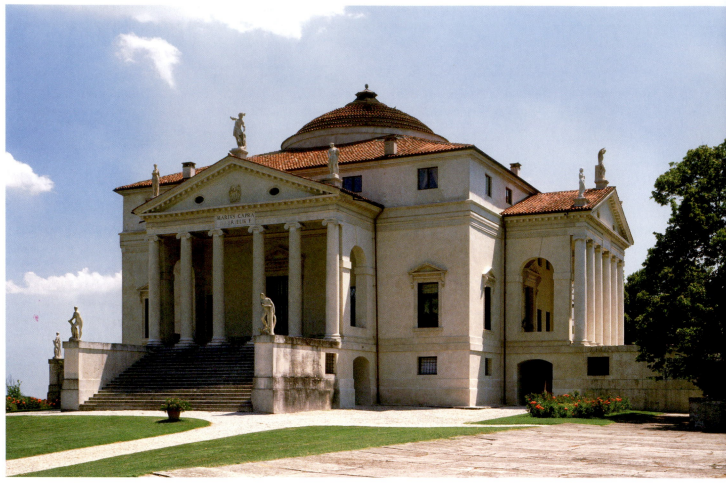

17.37. Andrea Palladio. Villa Rotonda, Vicenza. ca. 1567–1570

wrote treatises in the fifteenth century, sixteenth-century print-ed books on architecture by Sebastiano Serlio and Palladio became best sellers. Palladio's treatise was more practical than Alberti's, which may account for its great popularity among architects, and his many buildings are linked more directly with his theories. Some have claimed that Palladio designed only what was, in his view, sanctioned by ancient precedent. Indeed, the usual term for both Palladio's work and theoretical attitude is *classicizing*. This term denotes a conscious striving for qualities found in ancient art, although the results may not look like ancient works. Whenever later architects sought to express ideas through ancient forms, they consulted Palladio's *Four Books*. Thomas Jefferson, for instance, once referred to it as "the bible" and based several of his designs for buildings on its examples. Such treatises, with their rules for designing beautiful buildings, formulae for correct proportion, and extensive drawings, including ground plans and elevations in woodcut, were a treasure trove for architects elsewhere in Europe and later throughout the world.

SUMMARY

The later sixteenth century saw the growing power of princes and popes over the once independent cities of Italy. Courts were the major patrons of the arts, and princes and dukes shared a taste for erudite, complicated, and beautifully executed forms. This tendency has been labeled Mannerist, as it depended so much on the artifice or manner of the highly skilled artist. For these artists, often the subject matter or function of the object was less impor-tant than the quality of the execution.

LATE RENAISSANCE FLORENCE: THE CHURCH, THE COURT, AND MANNERISM

Ducal Florence was an important center for this development, as artists rejected the clarity and balance of the past in favor of more complex and sometimes puzzling images. The Medici rulers of the city built chapels and palaces, established an academy for training artists, and sent works of art as diplomatic presents. Their highly skilled and celebrated artists made portraits and religious works, as well as allegories based on Classical literature and art.

Florence's fame as a cradle of art was assisted by the international demand for works from Michelangelo, by the travels of artists to other courts, and by the publication of Vasari's *Lives of the Artists*.

ROME REFORMED

The complex, often erotic, and worldly representations made for princes clashed with calls for spiritual and moral renewal coming from the Catholic Church. The challenge of the Reformation and the shock of the Sack of Rome in 1527 encouraged the popes to expand both their spiritual and temporal authority. Papal projects included works in the Vatican and in the center of Rome itself. Michelangelo is the key figure for sixteenth-century Rome, in painting, sculpture, and architecture. His works were steeped in his reverence for antiquity, yet he freely manipulated a vocabulary borrowed from the ancients. The Catholic Reformation inspired new religious orders such as the Jesuits to commission large basilicas to serve their needs, instead of the centrally planned churches of the earlier Renaissance.

MANTUA OF THE GONZAGA

Courts throughout Italy and beyond Italy's borders hired artists who had trained in Florence or Rome to make visual statements of the local prince's power. The unexpected breaking of the rules of architecture in the Palazzo del Te by Giulio Romano is but one way he flatters his patron's wit and sophistication. Images of Greek and Roman gods stand in for the prince himself in paintings and sculptures of great technical virtuosity.

PARMA AND BOLOGNA

Smaller cities, like Parma and Bologna, had social structures that allowed patronage by elite families, who nonetheless were not princes. While some works made in these cities, such as Parmigianino's *The Madonna with the Long Neck*, reflect Mannerist innovations, patrons in these cities also commissioned works of great naturalism closer to the values of the High Renaissance.

VENICE: THE SERENE REPUBLIC

Venice remained a republic and clung to the traditions of the fifteenth century. Civic buildings blend the arcades of fourteenth- and fifteenth-century Venice with monumental pilasters and wall treatments inspired by Rome. Titian's long and productive life made his style dominant in the city, even as his technique and outlook changed over time. His followers expanded the Venetian preference for color and naturalism into large-scale canvases that overwhelm the spectator. The restrained architecture of Palladio placed the forms of antiquity at the service of wealthy patrons and the Church.

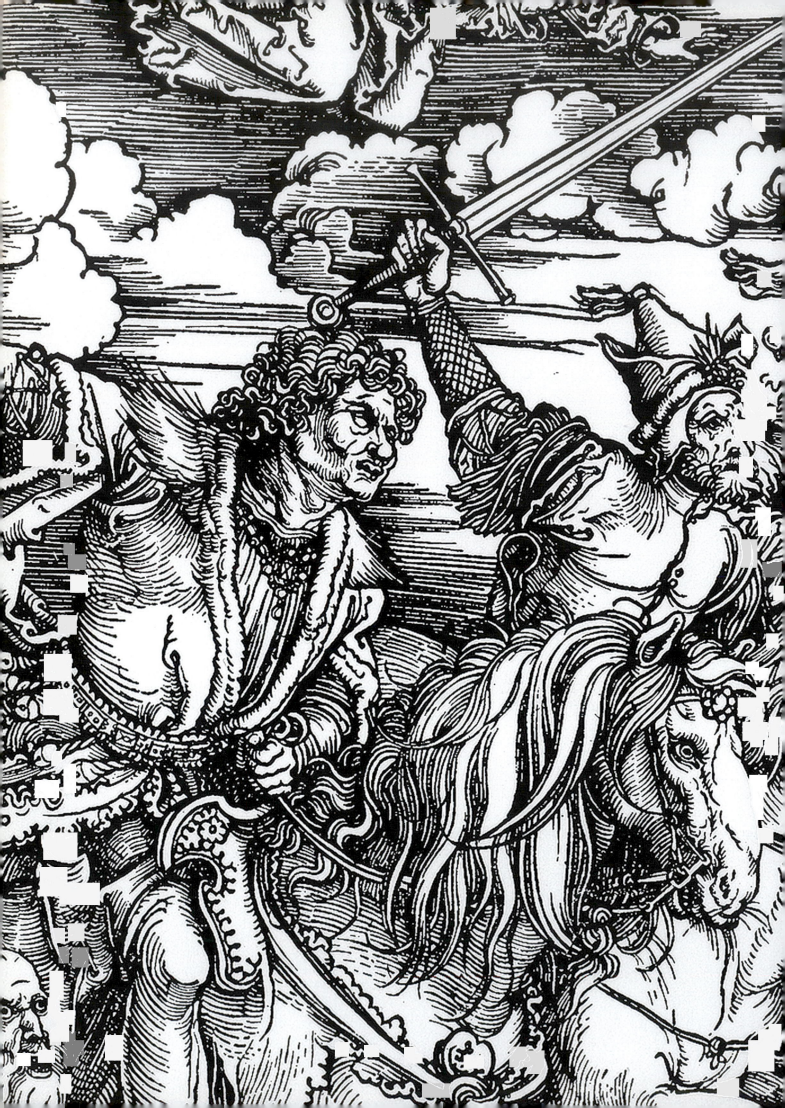

Renaissance and Reformation in Sixteenth-Century Northern Europe

EUROPEANS BEYOND THE ITALIAN PENINSULA CONFRONTED THE SAME breaks with tradition that Italians did in the sixteenth century. In addition to the religious challenge of the Reformation and the new cultural expressions of the Renaissance, Northern Europeans witnessed the growing power of large centralized states in France, England, Spain, and the Holy

Roman Empire, and the expansion of Europe's economic reach around the globe. As Northern Europe experienced the birth pangs of the modern era, artists reconciled local traditions with these new conditions.

The challenge of the Reformation to the Roman Catholic Church would fundamentally change the map of Europe. Proponents of religious reform including Luther, Ulrich Zwingli, John Calvin, and others attracted many adherents, and whole communities, cities, and even states were converted, fracturing the religious unity of Europe. Catholic Europe faced off against Protestant Europe, with great loss of life. While France and Spain remained loyal to the Roman Catholic Church, Germany, England, and the Netherlands were divided by religious sectarianism. The more radical reformed faiths deplored the Catholic tradition of religious images and relics and encouraged the destruction of images in the areas that converted to their beliefs.

Under such conditions, artists had to find new ways to pursue their craft and new markets for their products. Those markets would continue the trends established in the fifteenth century. A growing capitalist economy brought wealth and population to the cities, while landowning declined as a mea-

Detail of figure 18.17, Albert Dürer, *The Four Horsemen of the Apocalypse*

sure of wealth. Manufacturing and trade grew, especially with the new Atlantic trade routes and colonial settlements in the Americas and Asia. Even as the cities increased in economic and social importance, increasingly authoritarian rulers asserted control over their domains.

The arts in Northern Europe responded to these pressures. In part because of the Protestant Reformers' suspicion of sculptural expression, the medium of painting increased in importance. As religious patronage waned, artists turned to secular themes, which appealed to patrons in the cities and in the courts. To compete on the open market, artists began to specialize in particular subjects or themes. The achievements of the Italian Renaissance also challenged Northern artists, who absorbed Italian compositions, ideal figure types, and admiration of antiquity. Patrons in the courts found Italian style particularly useful for expressing their power, as they built monumental palaces. Catholic rulers often used Italianate forms to affirm their faith.

FRANCE: COURTLY TASTES FOR ITALIAN FORMS

France was fertile ground for the importation of Italian ideas. French kings had been intervening in Italy for centuries, which brought them into contact with developments in Italian

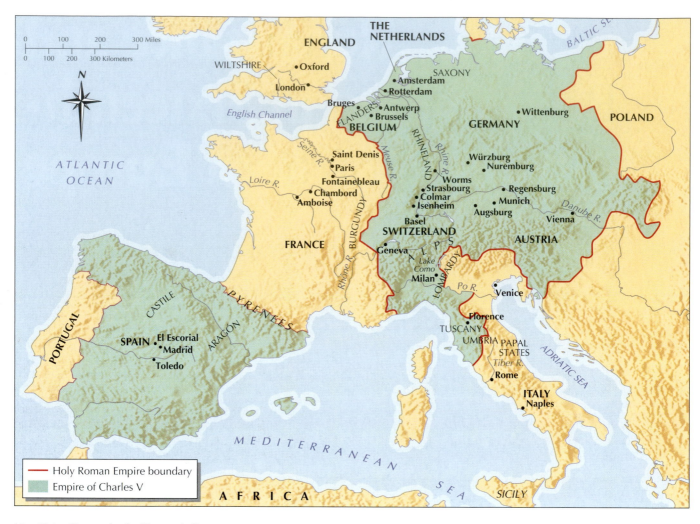

Map 18.1. Europe in the Sixteenth Century

art and architecture. Charles VII of France had invaded Milan in 1499, and his successors continued to meddle in the Italian peninsula. Francis I (r. 1515–1547) showed his admiration for Italian art by inviting Leonardo da Vinci to work for him in the Loire Valley. Leonardo had provided designs for a never constructed château for the king before dying in Amboise in 1519. Francis's appreciation for Italian art and his propensity for spending money made his court a magnet for many artists from Italy and from elsewhere in Europe. Rosso Fiorentino, Francesco Primaticcio, Benvenuto Cellini, and others found work there. French traditions were maintained, as well, as local architects interpreted Italian ideas for royal structures.

Châteaux and Palaces: Translating Italian Architecture

During the Renaissance, French castles lost their fortified aspect and became palaces for enjoying country life. The influence of Italian architectural design came into play in the design of many of these newer structures. An important early example is the Château of Chambord in the Loire Valley (fig. **18.1**),

begun in 1519 for Francis I as a hunting lodge. The design of the château combines traditional French castle architecture with Italianate organization. The plan of the center portion (fig. **18.2**) comprises a square block flanked by round towers, whose source is the *keep*, which is the central, most fortified section of medieval castles. Yet the space is arranged as a Greek cross that divides the interior into four sections, each subdivided into a suite of one large and two smaller rooms, and a closet. This functional grouping, imported from Italy, became a standard pattern in France. The focal point of the four corridors is a monumental double-spiral staircase; the arrangement centralizes the plan as contemporary Italian architectural theory promoted. Even though elements such as applied pilasters and balustrades emulate Italian models, however, the vertical massing of walls, turrets, high-pitched roofs, elongated windows, and tall chimneys reflect traditional castle design and Gothic proportions.

Italian influence is more apparent in the château that Francis I built south of Paris amid the forest of Fontainebleau. In 1528, he decided to expand the medieval hunting lodge that was once the haunt of King Louis IX. What began as a modest

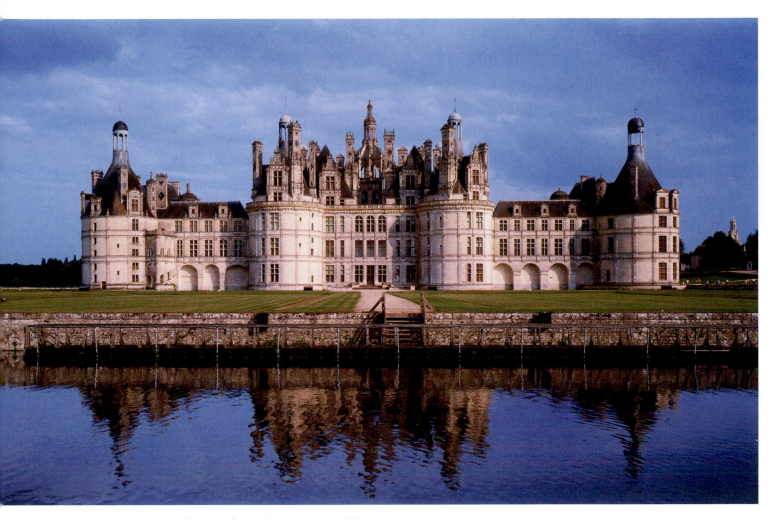

18.1. The Château of Chambord (north front), France. Begun 1519

enlargement soon developed into a sprawling palace. The original design, much altered over the years, was largely the work of the stonemason Gilles Le Breton (d. 1553), whose father, Jean (d. 1543/44) had helped design Chambord. Fontainebleau set a fashion for French translations of Italianate architecture followed for nearly all French châteaux for the next 250 years.

The Cour du Cheval Blanc (Court of the White Horse) is typical of the project as a whole (see fig. 18.3). The design must have evolved in an organic fashion, with new generations of patrons and architects adding to it over time. (The Italianate staircase that now dominates the courtyard was built by Jean Androuet Du Cerceau in 1634.) The round towers at Chambord have been replaced by rectangular pavilions at regular intervals. The facade employs a vocabulary from Italian architecture: pilasters mark each story, entablatures tie the whole facade together horizontally, and the lowest level uses rusticated pilasters such as those used by Sansovino at the Mint in Venice (see fig. 17.29). But these elements are blended with vertical proportions, especially in the windows and along the roofline.

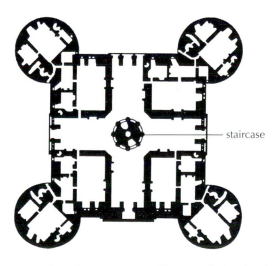

staircase

18.2. Plan of center portion, Château of Chambord (after Du Cerceau)

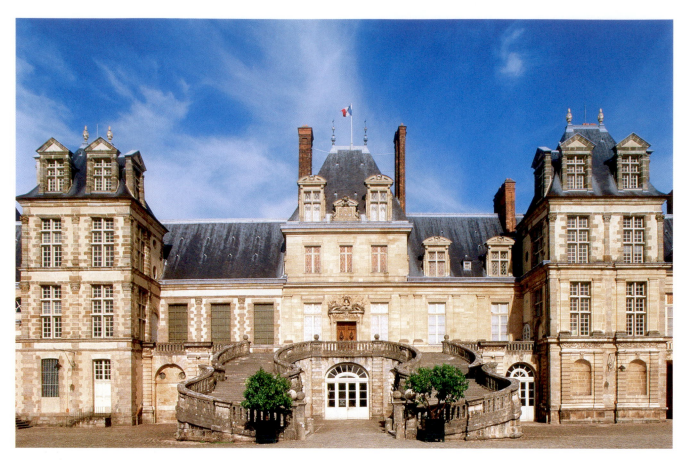

18.3. Gilles Le Breton. Cour du Cheval Blanc (Court of the White Horse), Fontainebleau. 1528–1540

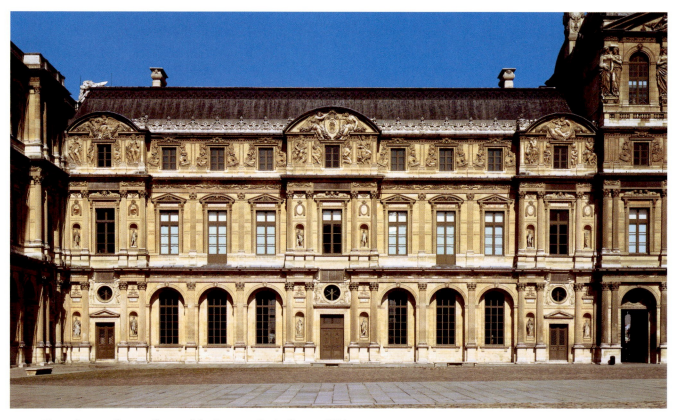

18.4. Pierre Lescot. Square Court of the Louvre, Paris. Begun 1546

THE LOUVRE Despite a variety of wars and other entanglements, Francis I had a great appetite for commissioning large-scale projects. In 1546 he decided to replace the Gothic royal castle in Paris, the Louvre, with a new palace on the old site. The project had barely begun at the time of his death, but his architect, Pierre Lescot (ca. 1515–1578), continued and enlarged it under his successor, Henry II. This scheme was not completed for more than a century. Lescot built the southern half of the court's west side (fig. **18.4**) in a more thoroughly Italianate style than seen either at Chambord or Fontainebleau.

The design represents a genuine synthesis of the traditional French château with the Italian palazzo. The superimposed Classical orders, the pedimented window frames, and the arcade on the ground floor are Italian. Three projecting pavilions, however, have replaced the château turrets to interrupt the continuity of the facade. The high-pitched roof is also French. The vertical accents, and the tall, narrow windows counteract the horizontal elements. The whole effect is symmetrical and well organized, yet sumptuous in the ornate carvings of the pilasters and their capitals and the relief sculpture that covers nearly all of the wall surface of the third story. These reliefs, beautifully adapted to the architecture, are by Jean Goujon (ca. 1510–1565), a French sculptor of the mid-sixteenth century with whom Lescot often collaborated.

Art for Castle Interiors

If the king showed a preference for Italian style, some members of the French court continued to commission works of art following the patterns established during the Middle Ages. Long after the invention of the printing press, French aristocrats continued to commission lavish books of hours and other illuminated books. French church architecture took the possibilities of the Gothic style to new heights. Stained glass windows remained an important medium, as did tapestry, for elite patrons. The walls of their dwellings were lined with sets of these woven hangings, often depicting secular or allegorical themes. Tapestry weaving was an important industry in the Netherlands and in France. (See *Materials and Techniques*, page 626.)

A famous survival of this art form is the set of tapestries depicting the *Hunt for the Unicorn*, woven around 1500 in the Southern Netherlands or northern France. *The Unicorn in Captivity* (fig. **18.5**) is the culmination of a series of images describing the hunt for and death of the unicorn, the mythical one-horned equine who could only be captured by a virgin. In this set of seven tapestries the unicorn is hunted, killed, and is then resurrected. The theme depicts the courtly pastime of hunting, but the unicorn itself has been read as symbolizing Christ (details in the imagery suggest this) and as a secular bridegroom. This panel, 12 by 8 feet, shows the unicorn fenced in below a pomegranate tree against a verdant background enlivened by numerous flowering plants. While specific elements like the plants and flowers are wonderfully detailed and naturalistic, the whole tapestry creates a sumptuous two-dimensional effect. The brilliant white body of the unicorn itself is the focal point at the center of the field of flowers.

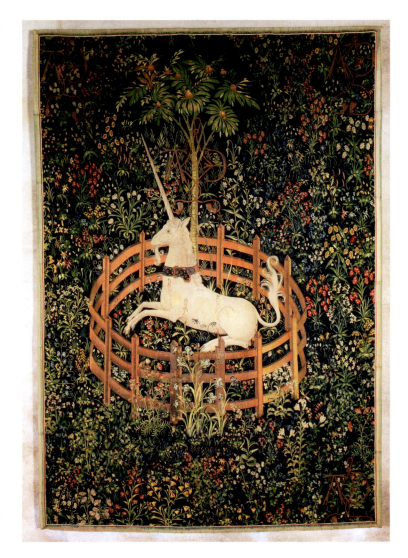

18.5. *The Unicorn in Captivity.* ca. 1500. Tapestry, from the Unicorn Tapestries. South Netherlandish or French. Wool warp, wool, silk, silver, and gilt weft, 12′1″ × 8′3″ (3.68 × 2.52 m). Metropolitan Museum of Art, New York. Gift of John D. Rockefeller, Jr. 1937.37. (37.80.6)

Details like the pomegranates—a symbol of fertility and of eternity—combine with the numerous plants and animals to suggest the theme of Christian salvation, but also marriage and procreation. Some scholars have suggested that these tapestries were created to celebrate a marriage, perhaps of the individuals whose initials (A and a backwards E) intertwine in the tree branches. Despite exhaustive research, their identification is still uncertain. Tapestries continued to be an important art form in France, given an important boost by the establishment of the royal factory of Gobelins in the seventeenth century.

THE SCHOOL OF FONTAINEBLEAU Francis I's preference for Italian art is apparent throughout the château at Fontainebleau. The king called upon Italian artists, most of them working in a Mannerist style, to work there, and these artists initiated the so-called School of Fontainebleau.

Making and Conserving Renaissance Tapestries

Tapestries—woven images hung on walls—were a major art form from the Middle Ages through the Baroque period. Elite patrons of Europe commissioned and purchased them to decorate the stone walls of their palaces and châteaux. In Flanders, the principal tapestry-making centers were in Arras, Tournai, and Brussels. In France, Louis XIV cemented the association of royalty with tapestry making by establishing the Royal Workshop of Gobelins in Paris, which dominated French tapestry production until the eighteenth century.

The textiles were woven on looms, such as the one pictured in the Penelope tapestry in figure 14.21. Before the weaving could begin, the patron and the master of the workshop would choose a design, which was worked up into a **cartoon**, a full-scale drawing for the weaver to follow.

To weave the textile, the weaver stretched supporting threads, called the *warp*, across the frame of a loom to the size desired. These warp threads are made of strong fibers, usually wool or linen. Colored threads of wool, silk, or spun metals are used to produce the design; these threads, called the *weft*, are then interwoven with the warp on the loom.

Renaissance tapestries are designated "high warp" and "low warp" according to the arrangement of the loom: The high-warp technique stretches the warp threads vertically on the loom, while the low-warp technique stretches the threads horizontally. The figure of Penelope uses a small low-warp loom, as was common in Flanders.

Once the warp threads are stretched on the loom, the cartoon is placed below the loom. The weaver pushes the weft threads through the warp threads, alternating colors to create the design, and then tamps the weft threads into place to form a tight weave. Because the weaver works on the back side of the tapestry as he follows the cartoon, so that different colors may be joined and threads knotted, the front (or visible side) of the tapestry reproduces the cartoon design in reverse.

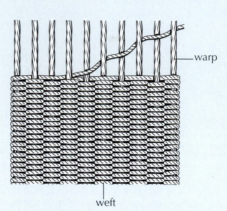

warp

weft

The weaver intertwines the horizontal threads (weft) with vertical threads (warp)

Increasingly from the fifteenth century, the designs for tapestries came from painters, and as the pictorial ambitions of the painters grew, so did the techniques of the weavers to match them. The increasing illusionism in the cartoons inspired weavers to work with finer threads to make the tapestries more complex. Woven of wool, silk, and gilt threads, *The Unicorn in Captivity* (fig. 18.5) displays tremendously detailed images of flowers, foliage, and animals. One scholar estimates that it took one hour per square inch to weave these dense designs; at this rate, a team of weavers would have been able to complete only one tapestry per year.

Conservators worked on the Unicorn Tapestries recently, removing the linen backing of the tapestries in order to replace them. This made it possible to see the back of the tapestry, revealing the incredibly rich colors with which it was woven, but which have faded with the passage of time on the front. The tapestries were then immersed in purified water to be cleaned, before being allowed to dry. A new backing was then sewn into place.

To decorate the Gallery of Francis I, the king summoned Rosso Fiorentino from Italy. Between 1531 and 1540, Rosso executed frescoes framed by stucco *putti*. The combination of painting and sculpted imagery inspired another Italian emigré, Francesco Primaticcio (1504–1570), who replaced Rosso as the chief designer at the royal château. The influence of Parmigianino is clear in Primaticcio's most important surviving work, the decorations for the room of the king's mistress, the Duchesse d'Étampes (fig. **18.6**). Primaticcio follows Rosso's general scheme of embedding paintings in a luxuriously sculptured stucco framework, which nearly swallows them. However, the figures are subtly elongated in the style of Parmigianino. The four females in this detail have no specific allegorical significance, although their role recalls the nudes of the Sistine Chapel ceiling. These willowy figures (reminiscent of the caryatids in ancient Greek architecture) enframe paintings devoted to Alexander the Great that were executed by assistants from Primaticcio's designs.

The scene in figure 18.6 shows Apelles painting the abduction of Campaspe by Alexander, who gave his favorite concubine to the artist when he fell in love with her. Roman texts of this subject characterized this gift as a mark of Alexander's great respect for his court artist. Such mixtures of violence and eroticism appealed greatly to the courtly audience for which Primaticcio worked. The picture draws a parallel between Alexander and Francis I, and between Campaspe and the duchess, the king's mistress, who had taken Primaticcio under her protection. The artist may have seen himself in the role of Apelles.

Another Italian drawn to Fontainebleau between 1540 and 1546 was Benvenuto Cellini (1500–1571), a Florentine goldsmith and sculptor who owes much of his fame to his colorful autobiography. The gold saltcellar (fig. **18.7**) made for Francis I while Cellini worked at Fontainebleau is his only important work in precious metal to survive into the modern world. The famous object was stolen in 2003, and has yet to be recovered. The main function of this lavish object is clearly as a

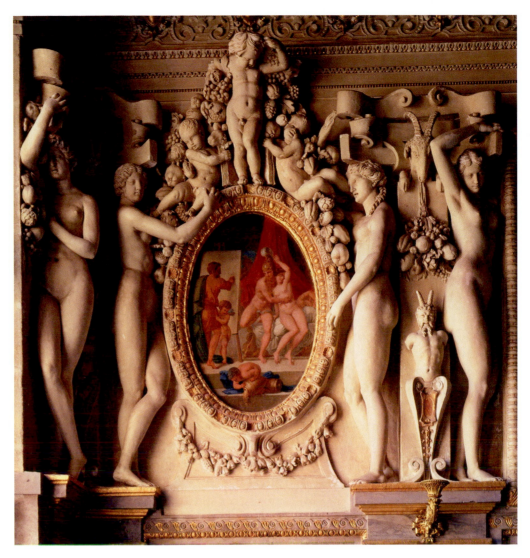

18.6. Francesco Primaticcio. *Stucco Figures*. ca. 1541–1545. Gallery of Francis I, designed for the Room of the Duchesse d'Étampes, Château of Fontainebleau, France

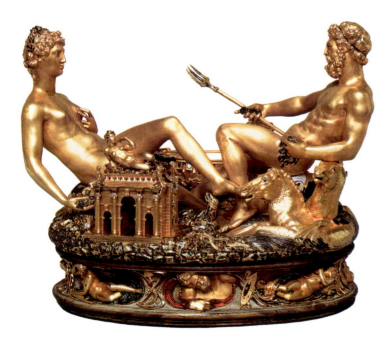

18.7. Benvenuto Cellini. *Saltcellar of Francis I*. 1540–1543. Gold with enamel, $10\frac{1}{4} \times 13\frac{1}{8}''$ (26 × 33.3 cm). Kunsthistorisches Museum, Vienna. (Stolen in 2003)

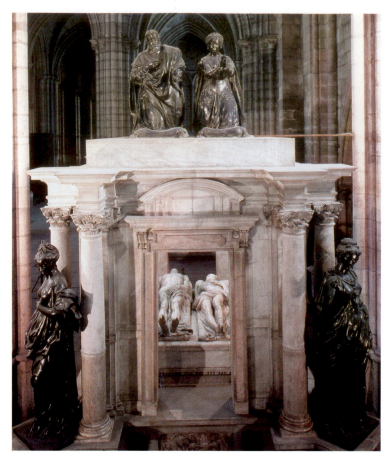

18.8. Francesco Primaticcio and Germain Pilon. *Tomb of Henry II and Catherine de' Medici.* 1563–1570. Abbey Church of Saint-Denis, Paris

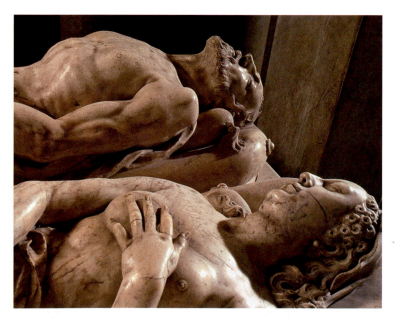

18.9. Germain Pilon. *Gisants* of the king and queen, detail of the *Tomb of Henry II and Catherine de' Medici*

conversation piece. Because salt comes from the sea and pepper from the earth, the boat-shaped salt container is protected by Neptune. The pepper, in a tiny triumphal arch, is watched over by a personification of Earth who, in another context, might be the god's consort Amphitrite. On the base are figures representing the four seasons and the four parts of the day. Such references remind the viewer of the Medici tombs, as does the figure personifying Earth. Cellini wants to impress with his ingenuity and skill. In his autobiography (see *Primary Source*, page 631), he explained how he came to design the model for the saltcellar and its iconography. He had designed the figure of the Earth as "a woman whose beautiful figure was as full of as much loveliness and grace as I was able and knew how to produce. . . ." In good Mannerist fashion, the allegorical significance of the design is simply a pretext for this display of virtuosity. Cellini then modestly reports the reaction of Francis I to his design: "This is a magnificent piece of work by this man! He should never stop working!"

ROYAL TOMBS AT SAINT-DENIS The presence of so many Italian artists at Fontainebleau made the château a laboratory of Italian style, which many French artists absorbed. For example, the sculptor Germain Pilon (ca. 1535–1590) created monumental sculpture that is informed not only by the elegance of the School of Fontainebleau, but also by elements taken from ancient sculpture, the Gothic tradition, and Michelangelo. His main works are tombs, such as the *Tomb of Henry II and Catherine de' Medici* (fig. 18.8) executed for the French royal pantheon at Saint-Denis. Primaticcio designed the architectural framework, a free-standing chapel on a platform decorated with bronze and marble reliefs. He also designed the corner figures of virtues as elegant young women. Pilon executed the sculpture. On the top of the tomb are the bronze figures of the king and queen kneeling in prayer, while inside the chapel the couple reappear as recumbent marble **gisants**, or corpses (fig. 18.9). The concept derives from the tomb of Francis I and his wife, Claude of France, in the same church, commissioned by Henry in 1547.

This contrast of effigies had been a characteristic feature of Gothic tombs since the fourteenth century and remained in vogue through the sixteenth. The *gisants* expressed the transient nature of the flesh, usually by showing the body in an advanced stage of decay, sometimes with vermin crawling through its open cavities. Pilon reverses the concept: instead of portraying decaying flesh, they are idealized nudes. While the likenesses of the royal couple kneeling atop the structure record their features in life, the *gisants* represent them as beautiful beings: The queen is in the pose of a Classical Venus and the king is represented similarly to the dead Christ. They evoke neither horror nor pity. Instead, they have the pathos of a beauty that continues even in death.

Henry II's death in 1559 left his minor son to inherit the throne, so his widow, Catherine de' Medici, acted as regent during a troubled period. Increasing conflicts between Catholic and Protestant groups, called Huguenots, erupted into massacres and warfare between 1562 and 1598, when a policy of official toleration was announced by Henry IV.

SPAIN: GLOBAL POWER AND RELIGIOUS ORTHODOXY

ART IN TIME

ca. 1527—Francis I commissions château in Fontainebleau

 1536—John Calvin publishes the "Institutes of the Christian Religion"

ca. 1540—Cellini's *Saltcellar of Francis I*

 1562—Wars of Religion begin

Several events came together in the early sixteenth century to make Spain a major power in European politics. In 1500, Charles V was born to the son of Maximilian of Habsburg and the daughter of Ferdinand and Isabella. He thus became heir to the thrones of Spain, Aragon, and the Burgundian territories; the title of Holy Roman Emperor was his birthright as well. Charles also asserted a Spanish claim to rule the kingdom of Naples in southern Italy. Spain was thus integrated more fully into European power struggles than it had been in previous centuries. At the same time, the colonization of the lands Columbus had claimed in the Americas brought massive wealth into Spanish hands. Charles V's efforts to promote and rule his vast holdings so exhausted him that in 1556 he divided his territory in half and abdicated to his son Philip and his brother Ferdinand. Ferdinand took control of the traditional Habsburg territories in Central Europe. Reigning as king of Spain, the Netherlands, and New Spain in the Americas from 1556 to 1598, Philip inherited the problems that had bedeviled his father. Having succeeded in preventing the Turkish advance into Europe in 1571, he turned his attention to the religious upheavals that the Reformation had brought to Christian Europe. Pious and ardent in his orthodoxy, he tried to quash the rebellion of the Calvinist Northern Netherlands, and unsuccessfully attempted to invade England in 1588, when the Spanish Armada suffered a disastrous defeat in the English Channel.

The Escorial

Philip also inherited a taste for collecting works of art from his father; not only did he commission works from Titian and other Italian artists, he sought out fifteenth-century Flemish works, especially paintings by Bosch. Many of these objects were brought to his new palace and monastery complex outside Madrid, called the Escorial, built to commemorate Philip's victory over the French in 1557. This massive complex (see fig. **18.10**) was begun in 1563 by Juan Bautista de Toledo

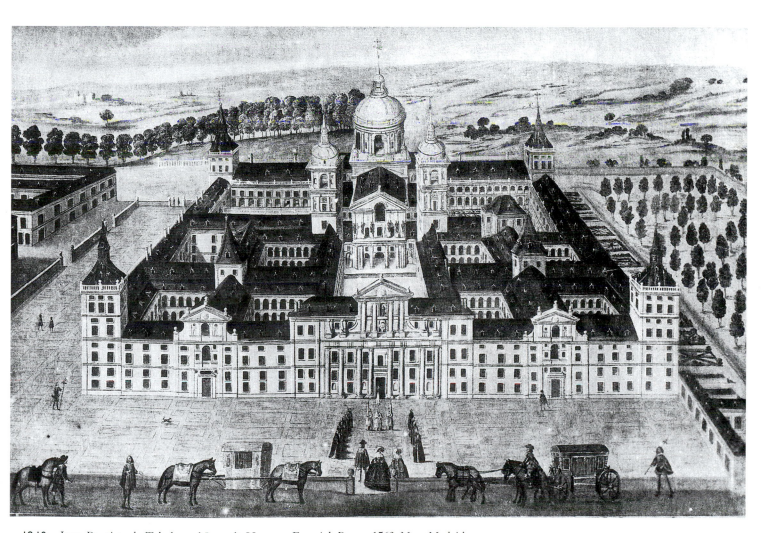

18.10. Juan Bautista de Toledo and Juan de Herrera. Escorial. Begun 1563. Near Madrid

(d. 1567), who had worked with Michelangelo in Rome. The symmetrical massing of the buildings and the focus on the Church of San Lorenzo at the center reflect Italian Renaissance models, but the scale and the simplicity of the facades were dictated by King Philip. In consultation with leading Italian architects, including Palladio and Vignola, Juan Bautista de Toledo's successor at the Escorial, Juan de Herrera, expanded the design and introduced classicizing details like the temple fronts on the facades of the main portal and the Church of San Lorenzo. These however, use a very plain Doric order and the whole facade exhibits a severity and seriousness that may express Philip's commitment to the ideals of the Catholic Reformation. The complex includes a monastery and church, a palace, a seminary, a library, and a burial chapel for the Spanish kings. Philip himself spent his last years here.

El Greco in Toledo

Philip did not much care for the work of the best known painter of sixteenth-century Spain, Domenikos Theotokopoulos (1541–1614), called El Greco. Born on Crete, which was then under Venetian rule, he probably trained there to become an icon painter. Some time before 1568 he arrived in Venice and quickly absorbed the lessons of Titian and Tintoretto, but he also knew the art of Raphael, Michelangelo, and the Italian Mannerists. He went to Spain in 1576/77 and settled in Toledo for the rest of his life. El Greco joined the leading intellectual circles of the city, then a major center of learning, as well as the seat of Catholic reform in Spain. El Greco's painting exhibits an exalted emotionalism informed by his varied artistic sources. His work seems to be a response to the mysticism that was especially intense in the Spain of Theresa of Ávila. The spiritual

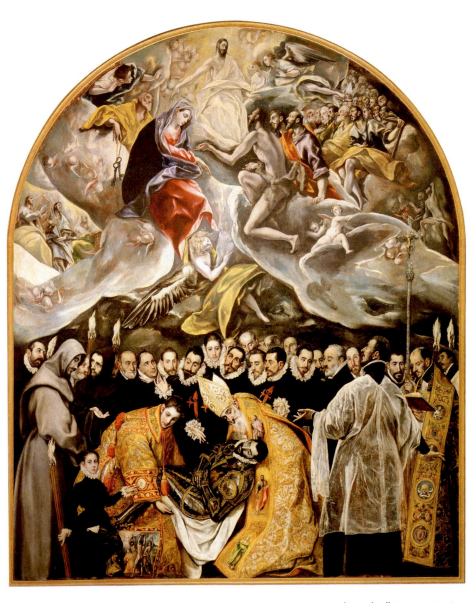

18.11. El Greco. *The Burial of Count Orgaz.* 1586. Oil on canvas, 16′ × 11′10″ (4.9 × 3.6 m). Santo Tomé, Toledo, Spain

Benvenuto Cellini (1500–1571)

From *The Autobiography*

The Florentine sculptor wrote his autobiography between 1558 and 1566. Cellini's book retells the story of his early life, training, and artistic triumphs. It was not published until the eighteenth century, when it inspired artists of that era and of the nineteenth century. This excerpt focuses on the design and reception of the Saltceller of Francis I. *Cellini took the advice of several courtiers in approaching the project, but ultimately made his own decision about what to render in the model.*

I made an oval shape the size of more than half an armslength—in fact, almost two thirds of an armslength—and on it, as if to show the Sea embracing the Land, I placed two nicely executed figures larger than a palm in size, seated with their legs intertwined in the same fashion as certain long-branched arms of the sea can be seen running into the land; and in the hand of the male figure of the Sea I placed a lavishly wrought ship, within which a great deal of salt could easily and well be accommodated; underneath this figure I placed four seahorses, and in the hand of this figure of the Sea I placed his Trident. The Land I had represented as a woman whose beautiful figure was as full of as much loveliness and grace as I was able and knew how to produce, in whose hand I had placed a rich and lavishly decorated temple which rested upon the ground, and she was leaning on it with her hand; I had created the temple in order to hold the Pepper. I had placed a Horn of Plenty adorned with all the beautiful things I knew to exist in the world. Under this goddess and in the part that portrayed the earth, I had arranged all the most beautiful animals that the earth produces. Under the part devoted to the sea god I represented all the beautiful kinds of fishes and small snails that tiny space could contain; in the widest part of the oval space I created many extremely rich decorations. . . . I uncovered the model [before the King], and, amazed, the King said: "This is something a hundred times more divine than anything I might have imagined. This is a magnificent piece of work by this man. He should never stop working." Then he turned to me with an expression full of delight, and told me that this was a work that pleased him enormously and that he wanted me to execute it in gold.

SOURCE: *MY LIFE (VITA)* BY BENVENUTO CELLINI TR. JULIA CONAWAY BONDANELLA AND PETER BONDANELLA, (NY: OXFORD UNIVERSITY PRESS, 2002.)

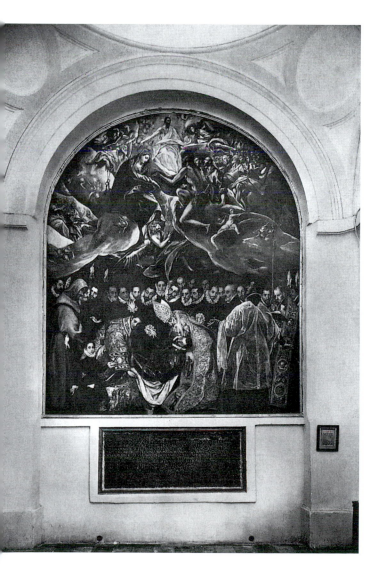

18.12. Chapel with *The Burial of Count Orgaz.* 1586. Santo Tomé, Toledo, Spain

writings of this sixteenth-century nun and reformer, informed by her visions, urge prayer to achieve closer union with God (see fig. 19.30).

Among the most impressive of El Greco's commissions is *The Burial of Count Orgaz* (figs. **18.11** and **18.12**) executed in 1586 in the Church of Santo Tomé in Toledo. The program, which was dictated in the commission, emphasizes the Roman Catholic position that good works are required to achieve salvation and that saints serve as intercessors with heaven. This huge canvas honors a medieval benefactor so pious that St. Stephen and St. Augustine miraculously appeared at his funeral and lowered the body into its grave. Although the burial took place in 1323, El Greco presents it as a contemporary event and even portrays many of the local nobility and clergy of his time among the attendants. The display of color and texture in the armor and vestments reflects El Greco's Venetian training. Above, the count's soul (a small, cloudlike figure like the angels in Tintoretto's *Last Supper,* fig. 17.34) is carried to heaven by an angel. The celestial assembly in the upper half of the picture is painted very differently from the group in the lower half: Every form—clouds, limbs, draperies—takes part in the sweeping, flamelike movement toward the figure of Christ. El Greco's compressed space, unearthly light, and weightless bodies share stylistic features with Italian Mannerist works such as Rosso's *Descent from the Cross* (fig. 17.1).

Only when the work is seen in its original setting (fig. 18.12) does its full meaning become clear. Like a huge window, the painting fills one entire wall of its chapel. The bottom of the canvas is 6 feet above the floor, and as the chapel is only about 18 feet deep, a viewer must look sharply upward to see the upper half of the picture. The violent foreshortening is

calculated to achieve an illusion of boundless space above, while the figures in the lower foreground appear as on a stage. The large stone plaque set into the wall also belongs to the ensemble. It represents the front of the sarcophagus into which the two saints lower the body of the count, which explains the action in the picture. A viewer, then, perceives three levels of reality. The first is the grave itself, supposedly set into the wall at eye level and closed by an actual stone slab; the second is the reenactment of the miraculous burial; and the third is the vision of celestial glory witnessed by some of the participants. This kind of mysticism is very similar in character to parts of the *Spiritual Exercises* of Ignatius of Loyola, the founder of the Jesuits. Serving the aims of the Catholic Reformation, Ignatius taught believers to meditate in steps so that they might achieve visions so real that they would seem to appear before their very eyes. Such mysticism could be achieved only through strenuous devotion. That effort is mirrored in the intensity of El Greco's work, which expresses strenuous spiritual struggle.

CENTRAL EUROPE: THE REFORMATION AND ART

While France, Spain, and Italy adhered to the Catholic faith, the religious and artistic situation was more complex elsewhere in Europe. In addition to Spain, Charles V had inherited the many different political units that comprised what is now Germany, Austria, Hungary, and the Czech Republic. Governing so many disparate regions posed many challenges, which were passed along to Charles's brother Ferdinand when Charles stepped down as ruler in 1556. Though linked in many cases by language and cultural ties, as well as by trade, these were independent regions only nominally under control of the Holy Roman emperor. What unity they may have had suffered another blow after 1517, when religious unity was fractured by the Reformation.

In October 1517, Martin Luther, a former Augustinian friar who had become professor of theology at the University of Wittenberg, issued a public challenge to both the theology and the institutional practices of the Catholic Church. In his now famous *Ninety-five Theses*, which he nailed to the church door at Wittenberg Castle, Luther complained about the Catholic practice of selling indulgences—promises of redemption of sins; he argued too against the veneration of Mary and the saints. Most fundamental to his critique of Catholicism, Luther claimed that the Bible and natural reason were the sole bases of religious authority, and that the intervention of clerics

and saints was unnecessary for salvation, which was freely given by God. It followed then, that religious authority was transferred from the pope to the individual conscience of each believer. The Catholic Church responded by condemning him in 1521. But Luther's critique was accepted by many Christians in Europe, which eventually fueled political instability, rebellions, and wars. Many areas of northern Germany converted to the reform, while southern regions, like Bavaria, remained Catholic. In rethinking these basic issues of faith, Luther was joined by other religious reformers.

The Swiss pastor Ulrich Zwingli wanted to reduce religion to its essentials by stressing access to scriptures and preaching. As a result of his literal reading of the Bible, he denounced not only the sale of indulgences, but the visual arts as well. Zwingli interpreted the Eucharist as a symbolic, rather than actual, communion of bread and wine, which led to a split with Luther that was never healed. What concerned the reformers above all were the twin issues of grace and free will in attaining faith and salvation. By the time of Zwingli's death at the hands of the Catholic forces in 1531, the main elements of Protestant theology had nevertheless been defined. John Calvin of Geneva codified these tenets around midcentury; his vision of a moral life based on a literal reading of Scripture was to prove very influential. The spread of the reformed faiths led to decades of violence, including a Peasants' Revolt in 1525 and wars in regions that were converting to the Protestant confessions. From 1546 until 1555, German principalities fought with the emperor Charles V, until the Peace of Augsburg in 1555. By this compromise, the rulers of individual regions of Germany chose the faith for that region's inhabitants. This furthered the spread of the reformed faiths, but also fostered the political divisions of the area.

The repercussions for art were equally dramatic. Although Luther's own attitude toward the visual arts was ambivalent, he saw the value of art as a tool for teaching. (See end of Part III, *Additional Primary Sources*.) Some of the more radical reformers saw the many forms of Medieval and Renaissance religious art as nothing short of idolatry that needed to be cleansed. Inspired by reformers' zeal, civic leaders, artisans, and workers attacked religious images in the cities. Several waves of image destruction, called *iconoclasm*, resulted in great losses of works of art from earlier periods. And, as large areas of central Europe converted to the new confessions, art forms that had been the bread and butter for artists disappeared, as churches were whitewashed and religious commissions dried up. Artists in many media had to find new styles, new subjects, and new markets for their work.

Humanism and the new technology of printing played a vital role in the Reformation. The spirit of inquiry and respect for original texts inspired the writings of such famous intellectuals and teachers as Desiderius Erasmus of Rotterdam, Philip Melancthon in Germany, and Thomas More in England. Latin texts published in printed editions spread new ideas all over Europe. As a result, the printing press was an important factor in both the development and in the dispersion of Refor-

mation thought. Individual access to scripture was a funda-
mental tenet of the reformers, so they wanted good texts of the
Bible and translations of it into vernacular languages. Luther
himself translated the Bible into German. Printed images con-
tributed to the spread of Reformation ideas; inexpensive
woodcuts satirized the Catholic hierarchy while making
heroes of the reformers. Prints also illustrated the tenets of the
new faiths.

Grünewald's Isenheim Altarpiece

Yet not all regions of German-speaking Europe converted to
the reformed faiths, and it was not until the 1520s that the
Reformation took wide hold, so some traditional objects were
created in the sixteenth century to serve Catholic patrons. One
of the most memorable of these objects was an altarpiece exe-
cuted by the painter Matthias Gothart Nithart, who was
known for centuries only as Grünewald (ca. 1475–1528). This
nickname was given to him by a seventeenth-century author;
when German artists in the modern period began searching for
roots, they discovered the artist through his nickname and it
has stuck. Grünewald was born in Würzburg in central Ger-
many and worked for the archbishop of Mainz. His most
famous work is a transforming triptych called the *Isenheim
Altarpiece*, similar in structure to the *St. Wolfgang Altarpiece* by
Pacher (fig. 14.29). It was painted between 1509/10 and 1515 for
the monastery church of the Order of St. Anthony at Isenheim,
in Alsace, not far from the former abbey that now houses it in
the city of Colmar.

This church served the monks of this order and the patients
of the hospital attached to their monastery. The monks spe-
cialized in tending people who suffered from a disease called
St. Anthony's Fire, which was a disorder caused by eating
spoiled rye. This disease produced painful symptoms, includ-
ing intestinal disorders, gangrenous limbs, and hallucinations.
Treatment consisted mostly of soothing baths and in some cases
the amputation of limbs. The altarpiece stood on the high altar
of the monastery church, where it would have been seen by
both monks and the sick in the hospital. This extraordinary
altarpiece encases a huge shrine carved in wood by Nicolas
Hagenau around 1505. Enclosing the carved central section are
nine panels organized in two sets of movable wings. These
open in three stages or "views." The first of these views, when
all the wings are closed, shows *The Crucifixion* in the center
panel (fig. **18.13**). This is the view that was visible during the
week. The wings depict *St. Sebastian* (left), who was invoked
against the plague (compare with fig. 15.52) and *St. Anthony
Abbot* (right), who was revered as a healer. The central image
of the *Crucifixion* draws on the late medieval tradition of
the Andachtsbild (compare with fig. 12.56) to emphasize the
suffering of Christ and the grief of his mother. The figure of
Christ, with its twisted limbs, its many wounds, its streams
of blood, matches the vision of the fourteenth-century mystic
St. Bridget as described in her book of Revelations, which had
been published in a German edition in 1501/02.

Grünewald renders the body on the cross on a heroic scale,
so that it dominates the other figures and the landscape. The
Crucifixion, lifted from its familiar setting, becomes a lonely
event silhouetted against a ghostly landscape and a blue-black
sky. Despite the darkness of the landscape, an eerie light bathes
the foreground figures to heighten awareness of them. On the
left, Mary's white garment enfolds her as she swoons at the
sight of her tortured son; the red of St. John's robe accents her
paleness. Below the cross, Mary Magdalen, identified by her
ointment jar, kneels in grief to lament. On the right, John the
Baptist points to the Crucified Christ with the words, "He
must increase, and I must decrease," indicating the significance
of Christ's sacrifice. Behind him a body of water recalls the
healing power of baptism. The lamb at his feet bleeds into a
chalice, as does the lamb in the central panel of the *Ghent Altar-
piece* (fig. 14.12). The bleeding lamb is a reminder of the sacra-
ment of the Eucharist, celebrated before the altarpiece. In the
predella below, a tomb awaits the tormented body while his
mother and friends bid farewell. The predella slides apart at
Christ's knees, so victims of amputation may have seen their
own suffering reflected in this image.

On Sundays and feastdays the outer wings were opened
and the mood of the *Isenheim Altarpiece* changed dramatically
(fig. **18.14**). All three scenes in this second view—*The Annunci-
ation*, the *Madonna and Child with Angels*, and *The Resurrection*
(fig. **18.15**)—celebrate events as jubilant as the Crucifixion is
somber. Depicting the cycle of salvation, from the Incarnation
to the Resurrection, this view of the altarpiece offered the
afflicted a form of spiritual medicine while reminding them of
the promise of heaven. Throughout these panels, Grünewald
has rendered forms of therapy recommended for sufferers at
the hospital: music, herbs, baths, and light. The contrast of the
body of the dead Jesus in the predella with the Resurrected
Christ in the right panel offers consolation to the dying.

Grünewald links the panels through color and composi-
tion. Reds and pinks in *The Annunciation* panel on the left are
carried through the central panels to come to a crescendo with
the brilliant colors surrounding the Risen figure of Christ on
the right. The figure of the dead Jesus held by his mother and
friends in the predella adds poignancy to the figure of the
Child Jesus in his mother's arms in the central panel. The sim-
ple Gothic chapel in which the Annunciation takes place gives
way in the next panel to a fanciful tabernacle housing choirs of
angels who play stringed instruments and sing. Beneath that
tabernacle appears a figure of the Virgin, crowned and glow-
ing like a lit candle. The aureole surrounding this figure antic-
ipates the brilliant figure of the Resurrected Christ in the
right-hand panel, whose body seems to dissolve into light.
The central image of the Madonna holding her child in a
tender embrace gives way to a vision of heaven, also made of
pure light.

These elements lead the eye to the right panel, where the
body of Christ appears to float above the stone sarcophagus
into which it had been placed in the predella. The guards set to
watch the tomb are knocked senseless by the miracle. Their

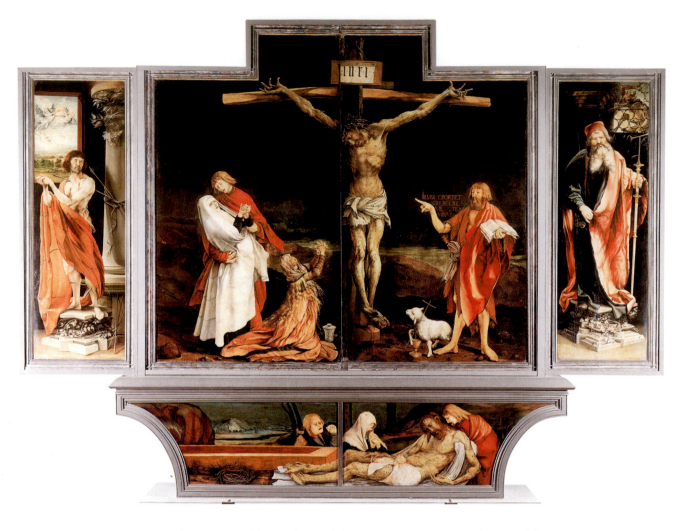

18.13. Matthias Grünewald. *St. Sebastian; The Crucifixion; St. Anthony Abbot;* predella: *Lamentation. Isenheim Altarpiece* (closed). ca. 1509/10–1515. Oil on panel, main body 9′9½″ × 10′9″ (2.97 × 3.28 m), predella 2′5½″ × 11′2″ (0.75 × 3.4 m). Musée d'Unterlinden, Colmar, France

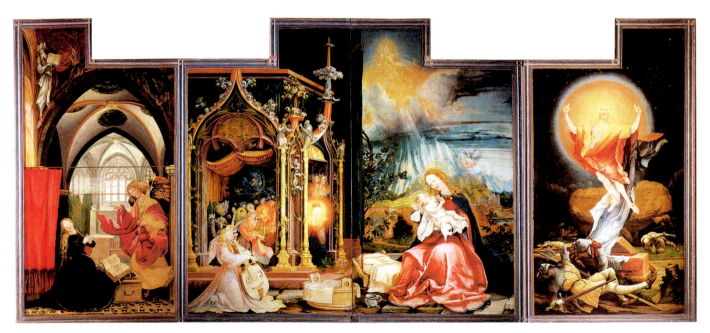

18.14. Matthias Grünewald. *The Annunciation; Madonna and Child with Angels; The Resurrection.* Second view of the *Isenheim Altarpiece.* ca. 1509/10–1515. Oil on panel, each wing 8′10″ × 4′8″ (2.69 × 1.42 m), center panel 8′10″ × 11′2½″ (2.69 × 3.41 m). Musée d'Unterlinden, Colmar, France

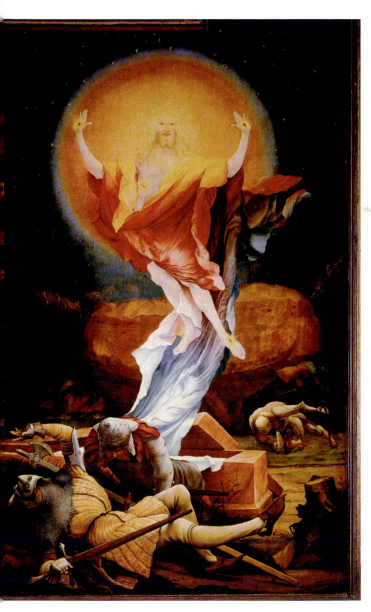

18.15. Matthias Grünewald. *The Resurrection*, from second view of the *Isenheim Altarpiece*. Musée d'Unterlinden, Colmar, France

figures, carefully arranged in a perspectival display, contrast to the weightless and transfigured body of Christ. He holds his hands up and allows the shroud to fall to reveal the wounds he suffered in death, now as brilliant as the halo that engulfs him. This figure differs dramatically from the figure on the Cross; his body bears no scars and the proportions are closer to the Italian ideal seen in Piero della Francesca's *Resurrection* (fig. 15.46).

Grünewald's strikingly individual approach to form is based on the traditions of the Northern European Renaissance established in the fifteenth century. His oil technique, his brilliant use of color, and the detailed rendering of objects draw from that tradition, but he must have learned from the Italian Renaissance too. The low horizon lines suggest a deep space for his fig-

ures and the rendering of the tomb from which Christ rises is a study in perspective. Yet Grünewald does not try to convince the viewer of the weight and substance of his figures; his aim is to create an emotional response with the impact of a vision.

Albrecht Dürer and the Northern Renaissance

The key figure for the Renaissance in Germany is Grünewald's contemporary Albrecht Dürer (1471–1528). Dürer's style was formed in the tradition of Northern European realism (which we explored in Chapter 14), but he delved deeply into the innovations and possibilities of Italian art. After training as a painter and printmaker in his native Nuremberg, Dürer traveled in Northern Europe and Venice in 1494/95 before returning home to start his career. His travels not only expanded his visual repertoire, but changed his view of the world and the artist's place in it. (He returned to Italy in 1505.) Dürer adopted the ideal of the artist as a gentleman and humanistic scholar, and took the Italian view that the fine arts belong among the liberal arts, as artists like Mantegna and Alberti had argued (see Chapter 15). By cultivating his artistic and intellectual interests, Dürer incorporated into his work an unprecedented variety of subjects and techniques. His painting technique owes much to the Flemish masters, but making copies of Italian works taught him many of the lessons of the Italian Renaissance. He was able to synthesize these traditions in his paintings and prints. As the greatest printmaker of the time, he had a wide influence on sixteenth-century art through his woodcuts and engravings, which circulated all over Europe. His prints made him famous and wealthy—so much so that he complained about the relatively poor reward he earned for his paintings.

Dürer's debt to the legacy of Jan van Eyck and Rogier van der Weyden is clear in the many drawings and watercolors he made in preparation for his works. The watercolor of the *Hare* he made in 1502 (fig. **18.16**) demonstrates the clarity of his vision and the sureness of his rendering. This small representative of the natural world was treated with the dignity due to Nature herself, much as Van Eyck had painted the small dog in the foreground of The *"Arnolfini Portrait"* (fig. 14.16). Dürer uses the watercolor technique to render each hair of the fur, the curve of the ears, the sheen on the eyes. His monogram at the base of the page identifies Dürer as the creator of this image; this monogram was the signature he used on his mature prints.

Dürer's ability as a draftsman also informed his work as a printmaker. Having been trained in both woodcut and engraving, he pushed the limits of both media. As a mass medium, prints were not commissioned by individual patrons, but were made for the open market, so Dürer had to invest his own time and materials in these projects. This entrepreneurial spirit served him well, as his prints sold widely and quickly. Signs and portents, such as the threat of invasion by the Turks and the birth of malformed animals, worried Europeans as they awaited the approach of the year 1500. As this year approached, many people believed that the Second Coming of Christ was imminent, and prepared for the Millennium. Thus, with an eye

to the market for things pertaining to popular fears about the end of time, Dürer produced a woodcut series illustrating the Apocalypse in 1498. This series was his most ambitious graphic work in the years following his return from Italy. The gruesome vision of *The Four Horsemen of the Apocalypse* (fig. **18.17**) offers the viewer a frightening visualization of the text of the book of Revelation. The image depicts War, Fire, Famine, and Death overrunning the population of the Earth. During his trip to Italy in 1494, Dürer had encountered prints by Mantegna, which he carefully copied. He especially admired the sculptural quality Mantegna achieved in paintings like the St. Sebastian (fig. 15.52). The physical energy and full-bodied volume of the figures in the Apocalypse woodcuts series is partly owed to Dürer's experience of Italian art, although he eliminates logical space in favor of an otherworldly flatness. Dürer has redefined his medium—the woodcut—by enriching it with the linear devices of engraving. Instead of the broad contours and occasional hatchings used to define form in earlier woodcuts, Dürer's wide range of hatching marks, varied width of lines, and strong contrasts of black and white give his woodcuts ambitious pictorial effects. (Compare, for example, the Buxheim St. Christopher of 1425 shown in fig. 14.30 with Dürer's woodcuts.) He set a standard that soon transformed the technique of woodcuts all over Europe.

Dürer's fusion of Northern European and Italian traditions is apparent in his engraving entitled *Adam and Eve* of 1504 (fig. **18.18**), for which the watercolor *Hare* was a preliminary study. Here the biblical subject allows him to depict the first parents as two ideal nudes: Apollo and Venus in a densely wooded forest. Unlike the picturesque setting and the animals in it, Adam and Eve are not observed from life; they are constructed according to what Dürer believed to be perfect proportions based on Vitruvius (see *Primary Source*, page 637). Once again, Dürer enlarged the vocabulary of descriptive marks an engraver could use: The lines taper and swell; they intersect at varying angles; marks start and stop and dissolve into dots, called *stipples*. The result is a monochrome image with a great tonal and textural range. The choice of animals that populate the Garden is very deliberate: The cat, rabbit, ox, and elk have been interpreted as symbols of the medieval theory that bodily fluids, called humors, controlled personality. The cat represents the choleric humor, quick to anger; the ox the phlegmatic humor, lethargic and slow; the elk stands for the melancholic humor, sad and serious; and the rabbit for the sanguine, energetic and sensual. In this moment before the fall, the humors coexist in balance and the humans retain an ideal beauty. The composition itself is balanced and unified by the tonal effects. Dürer's print, which he signed prominently on the plaque by Adam's head, was enormously influential. His ideal male and female figures became models in their own right to countless other artists.

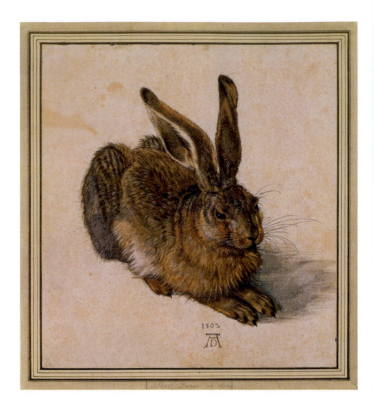

18.16. Albrecht Dürer. *Hare*. 1502. Watercolor. $9\frac{7}{8} \times 8\frac{7}{8}$. Albertina, Vienna

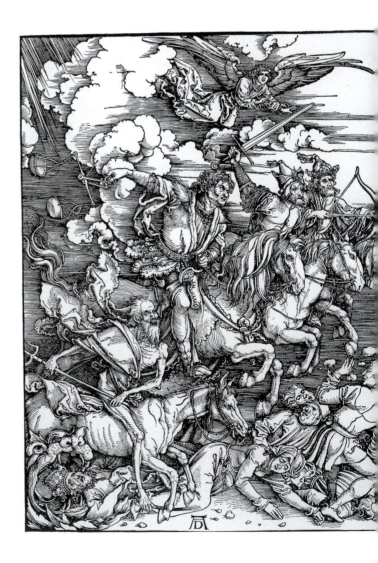

18.17. Albrecht Dürer. *The Four Horsemen of the Apocalypse*. 1498. Woodcut, $15\frac{1}{2} \times 11\frac{1}{8}''$ (39.3 × 28.3 cm). The Metropolitan Museum of Art, New York. Gift of Junius S. Morgan, 1919

Albrecht Dürer (1471–1528)

From the draft manuscript for *The Book on Human Proportions*

Dürer made two trips to Italy and was exposed to the new art theories being discussed there, which impressed him greatly. He did not accept them uncritically, however. His rethinking of Italian ideas often appears only in preliminary form, in drafts such as this one, written in 1512–1513.

How beauty is to be judged is a matter of deliberation. . . . In some things we consider that as beautiful which elsewhere would lack beauty. "Good" and "better" in respect of beauty are not easy to discern, for it would be quite possible to make two different figures, neither of them conforming to the other, one stouter and the other thinner, and yet we scarce might be able to judge which of the two may excel in beauty. What beauty is I know not, though it adheres to many things. When we wish to bring it into our work we find it very hard. We must gather it together from far and wide, and especially in the case of the human figure. . . . One may often search through two or three hundred men without finding amongst them more than one or two points of beauty which can be made use of. You therefore, if you desire to compose a fine figure, must take the head from some and the chest, arm, leg, hand, and foot from others. . . .

Many follow their taste alone; these are in error. Therefore let each take care that his inclination blind not his judgment. For every mother is well pleased with her own child. . . .

Men deliberate and hold numberless differing opinions about these things and they seek after them in many different ways, although the ugly is more easily attained than the beautiful. Being then, as we are, in such a state of error, I know not how to set down firmly and with finality what measure approaches absolute beauty. . . .

It seems to me impossible for a man to say that he can point out the best proportions for the human figure; for the lie is in our perception, and darkness abides so heavily within us that even our gropings fail. . . .

However, because we cannot altogether attain perfection, shall we therefore wholly cease from our learning? This bestial thought we do not accept. For evil and good lie before men, wherefore it behooves a rational man to choose the better.

SOURCE: THE WRITINGS OF ALBRECHT DÜRER. TR. AND ED. BY WILLIAM MARTIN CONWAY. (NY: PHILOSOPHICAL LIBRARY, 1958)

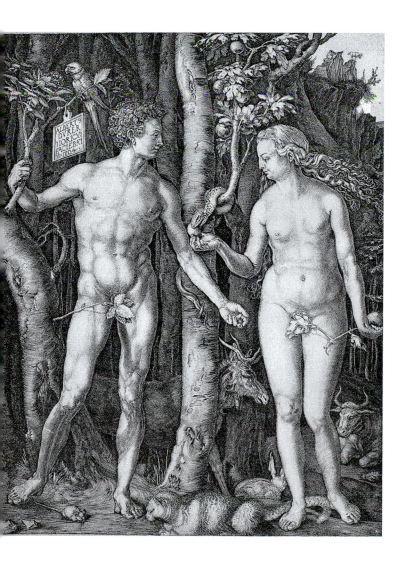

18.18. Albrecht Dürer. *Adam and Eve.* 1504. Engraving, $9\frac{7}{8}''\times 7\frac{5}{8}''$ (25.2 × 19.4 cm). Museum of Fine Arts, Boston. Centennial gift of Landon T. Clay

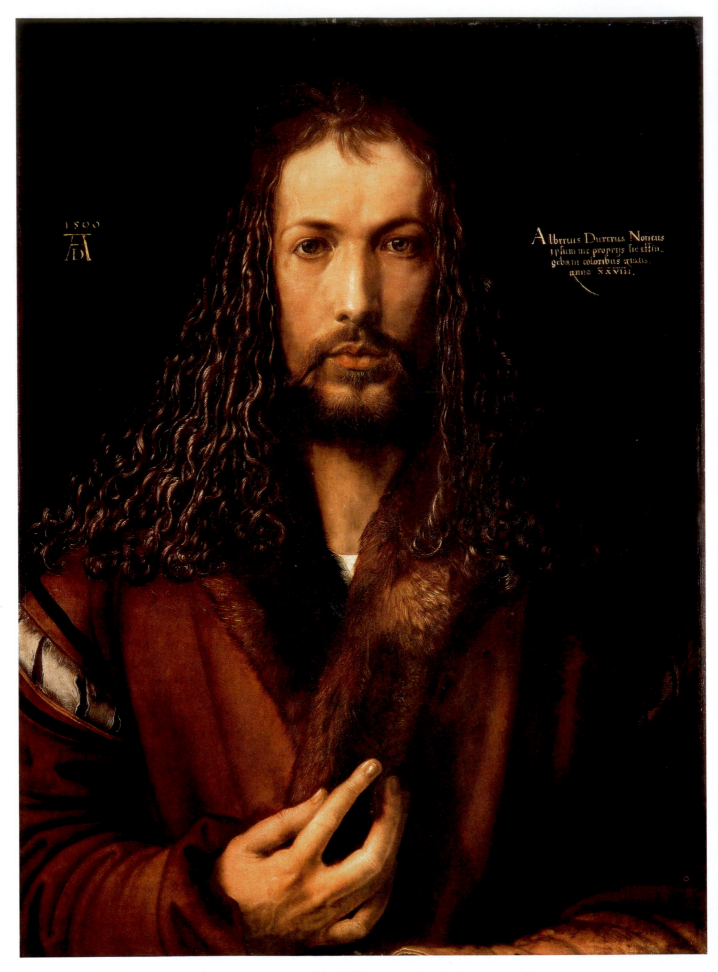

18.19. Albrecht Dürer. *Self-Portrait*. 1500. Oil on panel, 26$\frac{1}{4}$ × 19$\frac{1}{4}$″ (66.3 × 49 cm). Alte Pinakothek, Munich

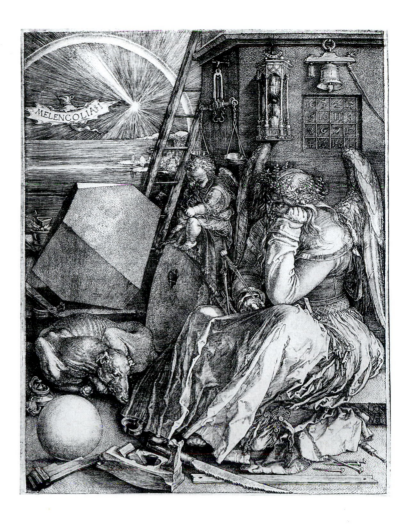

18.20. Albrecht Dürer. *Melencolia I*. 1514. Engraving, $9\frac{3}{8} \times 7\frac{1}{2}''$ (23.8 × 18.9 cm). Victoria and Albert Museum, London

IMAGES ABOUT ARTISTRY Although best known for his prints, Dürer was also a gifted draftsman and skilled painter. One of his earliest works, a drawing made at 13, is a self-portrait that foreshadowed his fascination with his own image throughout his career. Most impressive, and very revealing, is the painted *Self-Portrait* of 1500 (fig. **18.19**). In pictorial terms, it belongs to the Flemish tradition of Jan van Eyck's *Man in a Red Turban* (see fig. 14.15), but the solemn pose and the idealization of the features have an authority not found in most portraits up to this time. Instead of a conventional three-quarters pose, Dürer places himself frontally in the composition, a pose usually reserved for images of the divine. The panel looks, in fact, like a secularized icon, for it is patterned after images of Christ. It reflects both Dürer's deep piety and the seriousness with which he viewed his mission as an artist and intellectual.

The status of the artist may also be the theme of one of Dürer's most famous and puzzling prints. This is an engraving labeled *Melencolia I* (fig. **18.20**), one of a trio of prints that Dürer sold or gave away together. Dated 1514, the image represents a winged female holding a compass, surrounded by the tools of the mathematician and the artist. She holds the tools of geometry, yet is surrounded by chaos. The figure is probably a

personification, though her identity is controversial: Is she Melancholy? Is she Geometry? Is she Genius? Her face in shadow, she sits in a pose long associated with melancholy, which itself was associated with intellectual activity and creative genius. Compare her pose to Raphael's depiction of Michelangelo as Heraclitus in *The School of Athens* (fig. 16.25). Like Raphael, Dürer shrouds the face of Genius in shadow, as though the figure is lost in thought. Dürer's figure thinks but cannot act, while the infant scrawling on the slate, symbolizing practical knowledge, can act but not think. Dürer makes a statement here about the artistic temperament and its relationship to the melancholic humor.

The Italian Humanist Marsilio Ficino viewed melancholia (to which he was himself subject) as the source of divine inspiration. He tied it to Saturn, the Mind of the World, which, as the oldest and highest of the planets, he deemed superior even to Jupiter, the Soul of the World. His notion of the melancholic genius was widespread in Dürer's time, and the printmaker includes details that make reference to Saturn, to Jupiter, to divine inspiration, and to geometric theory. The print claims for the visual artist (and perhaps for Dürer himself?) the status of divinely inspired, if melancholic, genius.

A REFORMATION ARTIST Dürer became an early and enthusiastic follower of Martin Luther, although, like Grünewald, he continued to work for Catholic patrons. His new faith can be sensed in the growing austerity of style and subject in his religious works after 1520. The climax of this trend is represented by *The Four Apostles* (fig. **18.21**). These paired panels have rightly been termed Dürer's artistic testa-

ment. He presented them in 1526 to the city of Nuremberg, which had joined the Lutheran camp the year before. These four men are fundamental to Protestant doctrine. John and Paul, Luther's favorite authors of Scripture, face one another in the foreground, with Peter and Mark behind. Quotations from their writings, inscribed below in Luther's translation, warn the city not to mistake human error and pretense for the will of

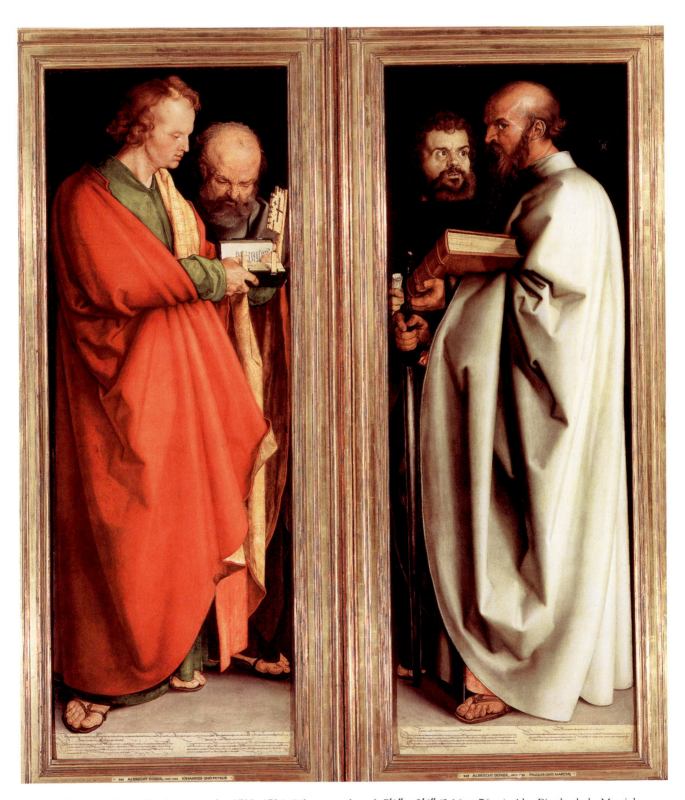

18.21. Albrecht Dürer. *The Four Apostles.* 1523–1526. Oil on panel, each 7′1″ × 2′6″ (2.16 × .76 m). Alte Pinakothek, Munich

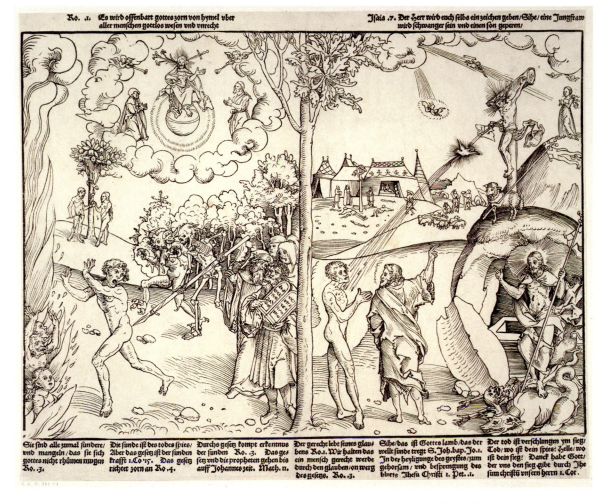

Ro . I. Es wird offenbart gottes zorn von hymel vber aller menschen gotteos wesen vnd vnrecht

Isaia .7. Der Herr wird euch selbs ein zeichen geben/Sihe/eine Jungfraw wird schwanger sein vnd einen son geberen/

Sie sind alle zumal sünder/ vnd mangeln/das sie sich gottes nicht rhümen mügen Ro .3.

Die sünde ist des todes spies/ Aber das gesetz ist der sünden krafft 1.Co 15. Das gesetz vnd die propheten gehen bis richtet zorn an Ro .4.

Durchs gesetz kompt erkentnus der sünden Ro .3. Das gesetz vnd die propheten gehen bis auff Johannes zeit. Math. 11.

Der gerecht lebt seines glaubens Ro.1. Wir halten das ein mensch gerecht werde durch den glauben/on werg des gesetzes. Ro .3.

Sihe/das ist Gottes lamb/das der welt sünde tregt S. Joh.bap. Jo.1. In der heyligunge des geystes/zum gehorsam/ vnd besprengung des bluts Jhesu Christi 1. Pet. .1.

Der tod ist verschlungen ym sieg/ Tod/ wo ist dein spies: Helle/wo ist dein sieg: Danck habe Gott/ der vns den sieg gibt durch Jhe sum christu vnsern herrn 1. Cor.

18.22. Lucas Cranach the Elder. *An Allegory of Law and Grace*. ca. 1530. Woodcut, $10^5/_8 \times 1'3/_4''$ (27 × 32.4 cm). British Museum, London

God. They plead against Catholics and Protestant radicals alike. But in another, more universal sense, the figures represent the Four Temperaments and, by implication, the other cosmic quartets—the seasons, the elements, the times of day, and the ages of life. The apostles have a sculptural solidity that brings to mind Nanni di Banco's *Quattro Coronati* (fig. 15.5). The heavily draped figures have the weight and presence of Raphael's figures in the tapestry cartoon of *Saint Paul Preaching in Athens* (fig. 16.27), which Dürer probably saw on a trip to the Netherlands in 1521. Through the power of his paintings, the portable medium of prints and his workshop, Dürer was the most influential artist of sixteenth-century Germany.

Religious and Courtly Images in the Era of Reform

The realignment of German culture and society produced by the Reformation required artists to adapt their styles and subject matters for the reformed faiths. Prints were an important tool for spreading the tenets of the Protestant confessions. For courtly patrons, artists made images on classicizing themes, for

which they used local visual traditions that emphasized detail, texture, and the natural world.

In Reformation Germany, painters had to contend with the Protestant leaders' ambivalence toward religious images. When a faith places the Word above the Image, the image becomes subordinate to the text; though Luther himself tolerated images (see end of Part III, *Additional Primary Sources*), the works that most deliberately address Lutheran themes are often literal illustrations of texts.

LUCAS CRANACH: REFORMER AND COURT ARTIST

Lucas Cranach the Elder (1472–1553), a close friend of Martin Luther, attempted to solve the problem of casting Luther's doctrines into visual form. Cranach made numerous prints and paintings to express the tenets of the reform. A woodcut of ca. 1530 entitled *An Allegory of Law and Grace* (fig. **18.22**) contrasts the difference between the fate of a Catholic and a Lutheran. The left side depicts the Catholic doctrine that the children of Adam and Eve, stained by original sin, must perform specific deeds according to the Law of Moses; when this is unsuccessful, the soul is consigned to hell at the Last Judgment. The right side

depicts the believer washed in the blood of Christ's Crucifixion; faith in Christ alone is needed to assure salvation, which is Luther's position. Compared to the complexity of Dürer's woodcuts, this image is rather simple and straightforward, without complex tonalities, illusions of space, or an emphasis on textures. Cranach makes the image almost as legible and accessible as the text.

In addition to images with Lutheran content, Cranach excelled in portraits and mythological scenes painted for aristocratic patrons, both Catholic and Protestant, in Saxony and elsewhere in Germany. In *The Judgment of Paris* (fig. **18.23**) of 1530, Cranach retells a story from Greek mythology in which the Trojan prince Paris selects the most beautiful goddess of Olympus. He depicts Paris as a German knight clad in the fashionable armor of the nobles at the court of Saxony. The sinewy figures of the goddesses are displayed for the judgment of the prince, who confides his choice to Mercury, also dressed in armor. Like many of his Italian contemporaries working for aristocratic patrons, Cranach gives his Classical subject an overtly erotic appeal, inviting a viewer to identify with Paris as the privileged observer of the female nudes. Yet the detailed, miniaturistic technique and the weightless bodies of the women are distinctive to Cranach. One of the striking features here is the landscape, whose lush vegetation recalls Dürer's *Adam and Eve* (fig. 18.18), though Cranach exaggerates its foliage into a sensual fantasy of natural beauty.

ALTDORFER'S *BATTLE OF ISSUS* Both Cranach and Dürer played a critical role in the development of the Danube School of landscape painting, which appeared in southern Germany and Austria in the first half of the sixteenth century. The key figure in this school, however, was Albrecht Altdorfer (ca. 1480–1538), a slightly younger artist who spent most of his career in Bavaria. Although he made prints and paintings on a variety of themes, Altdorfer's work is dominated by his fascination with landscape, which he used to great expressive effect. His most famous work is *The Battle of Issus* (fig. **18.24**). The painting, made in 1529, is one of a series of images depicting the exploits of historic heroes, commissioned for the Munich palace of William IV, Duke of Bavaria. In a sweeping landscape, Altdorfer depicts Alexander the Great's victory over Darius of Persia, which took place in 333 BCE at Issus. This victory was the subject of a composition attributed to the Greek painter Apelles, preserved in a mosaic at Pompeii (fig. 5.79). To make the subject clear, Altdorfer provided an explanatory text on the tablet suspended in the sky, inscriptions on the banners (probably written by the Regensburg court Humanist, Aventinus), and a label on Darius's fleeing chariot. The artist has tried to follow ancient descriptions of the actual number and kind of combatants in the battle and to record the geography of the Mediterranean.

Altdorfer adopts an omniscient point of view, as if looking down on the action from a great height to fit everything into the picture. From this planetary perspective, a viewer must search to find the two leaders lost in the antlike mass of their

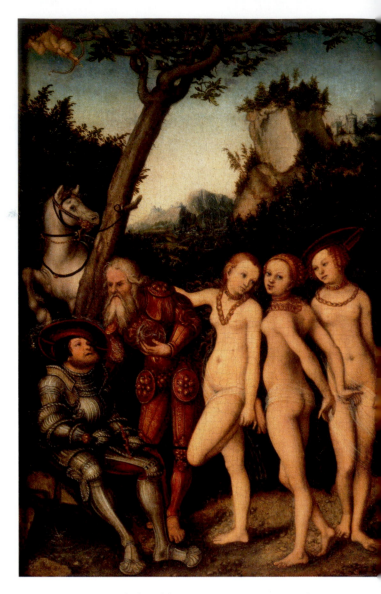

18.23. Lucas Cranach the Elder. *The Judgment of Paris.* 1530. Oil on panel, $13\frac{1}{2} \times 9\frac{1}{2}''$ (34.3 × 24.2 cm). Staatliche Kunsthalle, Karlsruhe, Germany

own armies. The drama of Nature is more elaborated than the human actors: One can almost feel the rotation of the globe as the sun sets in the distance and the moon rises. The curve of the earth, the drama of the clouds, the craggy mountain peaks overwhelm the mass of humanity. Such details suggest that the events portrayed have an earth-shaking importance, which arguably, was the case for this historical event. However, the soldiers' armor and the fortified town in the distance are unmistakably of the sixteenth century, which encourages us to look for contemporary significance. The work was executed at the moment the Ottoman Turks were trying to invade Vienna after gaining control over much of Eastern Europe. (Though the imperial forces repelled the Turks this time, they were to threaten Europe repeatedly for another 250 years.) Altdorfer's image suggests that the contemporary battle between Europeans and Turks has the same global significance as Alexander's battle with Darius.

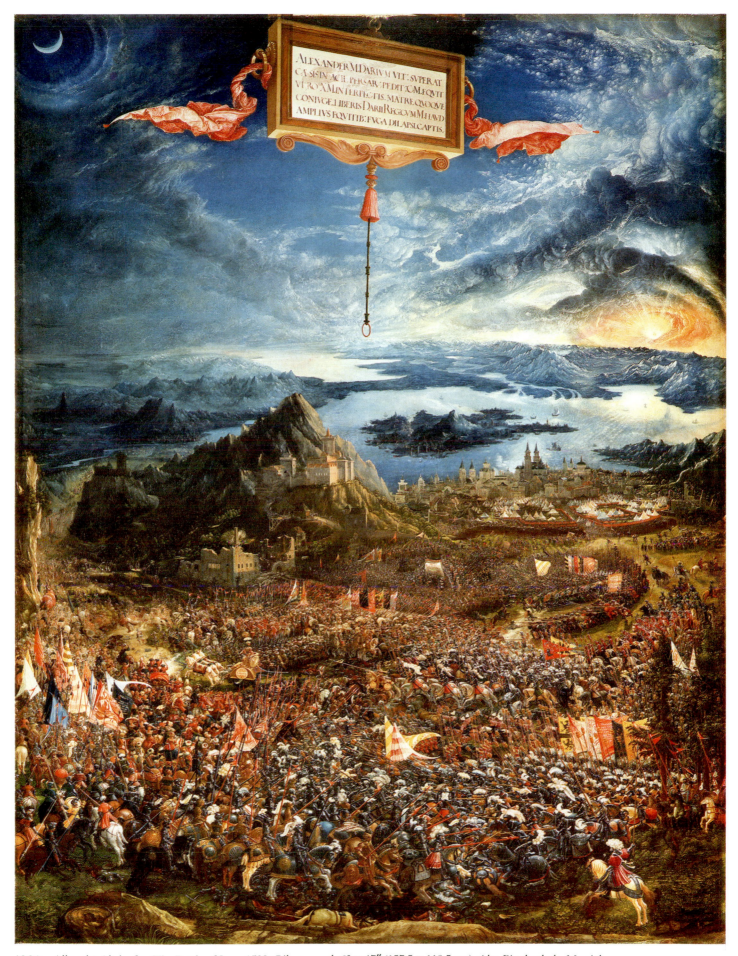

18.24. Albrecht Altdorfer. *The Battle of Issus*. 1529. Oil on panel, 62 × 47″ (157.5 × 119.5 cm). Alte Pinakothek, Munich

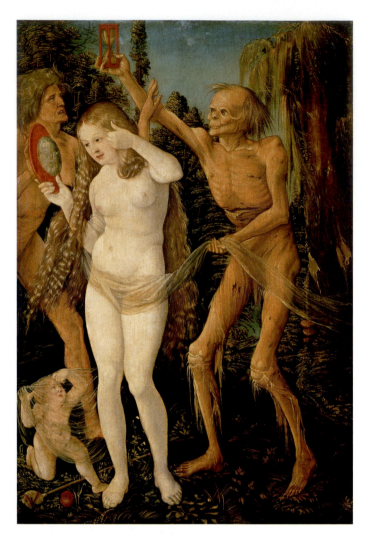

18.25. Hans Baldung Grien. *Death and the Maiden*. ca. 1510. Oil on panel, 15³⁄₄ × 12³⁄₄″ (40 × 32.4 cm). Kunsthistorisches Museum, Vienna

Painting in the Cities: Humanist Themes and Religious Turmoil

Cities along the Rhine River, especially Strasbourg and Basel, were centers of commerce, publishing, and humanism. The ancient city of Strasbourg's commercial success was due to its location and its industry. Further down the Rhine, Basel had a university as well as an early printing press. It was in Basel that Sebastian Brant's *Ship of Fools* was published in 1494 (see fig. 14.33). As elsewhere, the spread of the Reformation and Humanist ideas to these cities profoundly affected the arts, visible in the work of Hans Baldung Grien and Hans Holbein.

HUMANISM AND MORALITY: HANS BALDUNG GRIEN'S DEATH AND THE MAIDEN The impact of humanism on German artists may be seen in the work of the painter and printmaker Hans Baldung Grien (1484/85–1545). This former apprentice of Dürer spent much of his career in Strasbourg. Although he made some religious works, Baldung Grien made numerous secular images that explore themes of

witchcraft, magic, and death. A characteristic example is his *Death and the Maiden* (fig. **18.25**) of about 1510. The painting depicts a self-absorbed, nude young woman who stares at her reflection in a mirror, while the skeletal figure of Death holds an hourglass triumphantly over her head. The young woman's companions are versions of herself at different ages: A child plays with the diaphanous veil that wraps around the woman, and an elderly woman moves abruptly to ward off death. The three ages of life—infancy, adulthood, old age—are visible in the mirror. Yet, although the three heads stare out forlornly at the young woman, she obliviously toys with her long hair. The young woman personifies the vice of Vanity, which must give way to death. Images of the fragility of beauty and the inevitability of death—called Vanitas emblems—were quite popular in a time when sudden death was frequent. Baldung's sources for this image include Dürer's Eve from the *Adam and Eve* engraving and Jan van Eyck's representations of mirrors (see fig. 14.16). The landscape has the lush fantastic quality that also appears in Cranach's work. Although the patron for this image is not known, its imagery allows a viewer to meditate on the proximity of death while enjoying the spectacle presented by the display of the young woman's body.

HANS HOLBEIN IN REFORMATION BASEL The son of a painter, Hans Holbein the Younger (1497–1543) was born and raised in Augsburg, but it was in Basel that Holbein sought to make his career. Basel, in what is now Switzerland, was another center of learning, publishing, and commerce. By 1520, Holbein was established there as a painter and a designer of woodcuts. He had also become a member of the Humanist circle that included the writer Desiderius Erasmus (1466–1536).

Holbein took Dürer as his point of departure, but he developed his own distinctive style informed by Netherlandish realism and Italian compositional techniques. He is best known for his portraits, such as the likeness of *Erasmus of Rotterdam* (fig. **18.26**). This was painted soon after the famous author had settled in Basel. Erasmus was one of the most prolific Humanists of the era, who corresponded with many of the leading thinkers of his day. Holbein's portrait reflects Erasmus's authority and status. Holbein depicts the scholar in profile busily engaged in the act of writing. This kind of profile view had been popular during the Early Renaissance in Italy (see fig. 15.47), although Holbein depicts the sitter in action. Even while using an older Italian format, Holbein renders the figure and his setting with an eye for realistic detail. The composition is simple to keep the focus on the concentration of the sitter. A representation of the very ideal of the scholar, this portrait of Erasmus exudes a calm rationality that lends him an intellectual authority formerly reserved for doctors of the Church. The similarity is probably intentional. Erasmus greatly admired St. Jerome, who translated the Bible into Latin (called the Vulgate) and who was the role model for Erasmus' own great work: the production of a printed edition of the Bible that included a Greek text and his own fresh Latin translation. This edition by Erasmus appeared in Basel in 1516 and was used by Luther to produce his German translation.

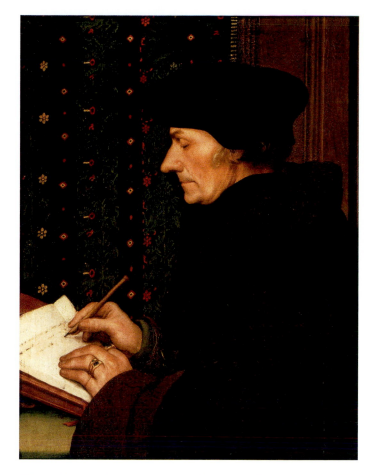

18.26. Hans Holbein the Younger. *Erasmus of Rotterdam*. ca. 1523. Oil on panel, 16½ × 12½″ (42 × 31.4 cm). Musée du Louvre, Paris

The spread of the Reformation disrupted the Humanist circle in Basel. By 1525, followers of Zwingli preached the sole authority of Scripture, while more radical reformers preached that images were idols. To escape this climate, Holbein sought employment elsewhere. He had traveled to France in 1523–1524, perhaps intending to offer his services to Francis I. Hoping for commissions at the court of Henry VIII, Holbein went to England in 1527. He presented the portrait of Erasmus as a gift to the humanist Thomas More, who became his first patron in London. Erasmus, in a letter recommending Holbein to More, wrote: "Here [in Basel] the arts are out in the cold." By 1528, when Holbein returned to Basel, violence had replaced rhetoric. He witnessed Protestant mobs destroying religious images, a scene Erasmus described in a letter: "Not a statue has been left in the churches . . . or in the monasteries; all the frescoes have been whitewashed over. Everything which would burn has been set on fire, everything else hacked into little pieces. Neither value nor artistry prevailed to save anything." Holbein resolved to return to London.

ENGLAND: REFORMATION AND POWER

Holbein's patron in England was the ambitious Henry VIII, who reigned from 1509 to 1547. Henry wanted England to be a power broker in the conflicts between Francis I of France and the Emperor Charles V, although his personal situation complicated these efforts. Married to Catherine of Aragon in

ART IN TIME

1502—Peter Henlein of Nuremberg invents pocket watch

ca. 1509—Grünewald's *Isenheim Altarpiece*

1521—Diet of Worms condemns Luther

1525—Peasants' War ignited by Reformation

1526—Albrecht Dürer's *Four Apostles* presented to city of Nuremberg

1555—Peace of Augsburg between Catholics and Lutherans

1509, twenty years later Henry was seeking to annul their union, for they had failed to produce a male heir to the throne. Thwarted by the Catholic Church, he broke away from Catholicism and established himself as the head of the Church of England. His desire for a male heir to the throne led Henry into a number of marriages, most of which ended either in divorce or in the execution of his wife. He had three children, who succeeded him as Edward VII, Mary I, and Elizabeth I.

Holbein's *Henry VIII* (fig. 18.27) of 1540 captures the supreme self-confidence of the king. He uses the rigid frontality that Dürer had chosen for his self-portrait to convey the almost divine authority of the absolute ruler. The king's physical bulk creates an overpowering sense of his ruthless, commanding personality. The portrait shares with Bronzino's *Eleanora of Toledo* (fig. 17.7) an immobile pose, an air of unapproachability, and the

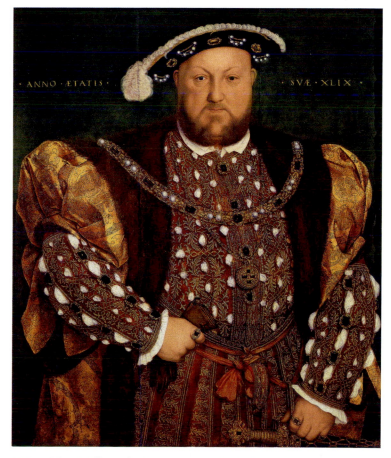

18.27. Hans Holbein the Younger. *Henry VIII*. 1540. Oil on panel. 32½ × 29″ (82.6 × 74.5 cm). Galleria Nazionale d'Arte Antica, Rome

precisely rendered costume and jewels. Holbein fashioned for Henry VIII a memorable public image of strength and power. Holbein's portraits of the king and his courtiers molded British taste in aristocratic portraiture for decades.

Henry's daughter Elizabeth came to the throne in 1558 at the age of 20, and through her shrewdness and some good luck ruled until 1603. She managed to unite a country that had been bitterly divided by religious differences, and increased the wealth and status of England through her diplomacy, her perspicacious choice of advisers and admirals, and her daring. Her most important victory was the defeat of the Spanish Armada, sent to invade England in 1588, but the Elizabethan age is also rightly famous for its music and literary arts.

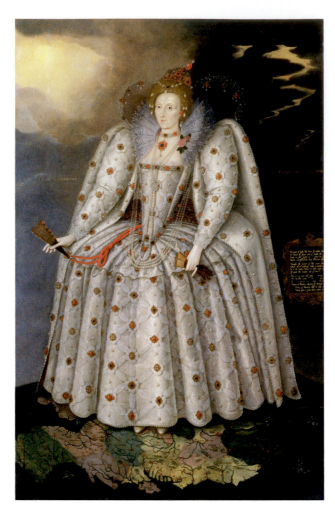

18.29. Marcus Gheeraerts the Younger. *Portrait of Elizabeth I (The Ditcheley Portrait).* ca. 1592. Oil on canvas, 95 × 60″ (241.3 × 152.4 cm). The National Portrait Gallery, London. Reproduced by Courtesy of the Trustees

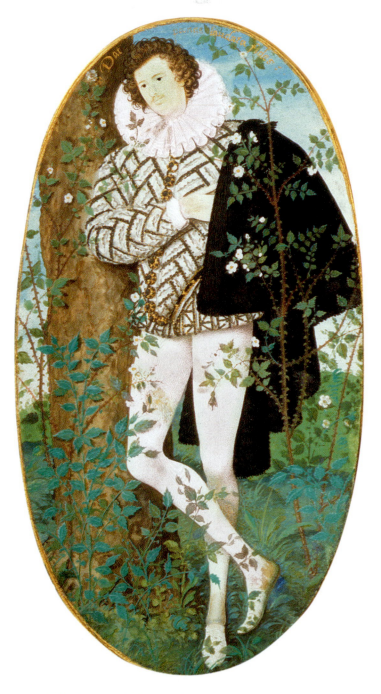

18.28. Nicholas Hilliard. *A Young Man Among Roses.* ca. 1588. Oil on parchment, 5⅜ × 2¾″ (13.7 × 7 cm). Victoria & Albert Museum, London

The influence of Elizabethan poetry may be seen in a miniature portrait by the English painter Nicholas Hilliard (1547–1619), usually called *A Young Man Among Roses* (fig. **18.28**). Inspired by ancient cameos, these portable portraits on parchment were tiny keepsakes often worn as jewelry. Hilliard's style reveals the influence of Holbein in the even lighting and careful detail. However, the tall, slender proportions, elegant costume, and languorous grace may reflect the impact of Italian mannerism, probably by way of Fontainebleau; compare the courtier's stance to that of Primaticcio's stucco figures from the French palace (fig. 18.6). In tremendous detail on a very small scale (the miniature is just over 5 inches high), Hilliard records the costume, features, tree, and flowers that surround the young man. An inscription suggests that he is suffering for his love. Other details—the black and white costume, the type of rose—imply that Elizabeth is his beloved, inspiring speculation about the man's identity. The image may represent Robert Devereaux, Earl of Essex, Elizabeth's one-time favorite. The floral imagery and the lovesick poet are frequent motifs in Elizabethan sonnets, such as those of Edmund Spenser or William Shakespeare. Many images from the Elizabethan era carry texts or symbols that have parallels in Elizabethan court rituals and literature. (See *Primary Source,* page 648.)

Like her father, Henry VIII, Elizabeth had a gift for managing her image. She had no Holbein in her employ to dominate the artistic life of the court, but she dictated to the many artists around her how she should be represented. She even imprisoned people for making unsanctioned images of her. A portrait by the Flemish artist Marcus Gheeraerts the Younger, called *The Ditcheley Portrait* (fig. **18.29**), exemplifies her carefully controlled iconography. The portrait represents Elizabeth standing on a map of her realm, which she dominates by her size and frontality. Sir Henry Lee, one of Elizabeth's courtiers, probably commissioned this portrait; Ditcheley was his estate near Oxford. Elizabeth wears one of the elaborate dresses that she favored, significantly in white, the color of virginity; Elizabeth steadfastly refused to marry, claiming that she was married to England. One side of the background is dark and gloomy: A storm has just passed and the sun shines again. A fragmentary sonnet expresses thanks for a grace given. The whole image is one of supreme and serene authority.

One hypothesis about this painting is that it commemorates a visit that Elizabeth paid to Sir Henry at his estate of Ditcheley. Such visits, called *progresses*, were ritual events in Elizabethan England expressing the relationship between the sovereign and the subject. In some cases, the host built an entire mansion solely for the purpose of receiving the Queen and her court. Robert Smythson (ca. 1535–1614) designed several such houses, including Longleat House (fig. **18.30**) in Wiltshire. The project went through several building campaigns and used the talents of Smythson and a French sculptor, Allen Maynard (active 1563–ca. 1584), who carved the chimney pieces and ornamentation. The plan (fig. **18.31**) shows that the house is perfectly symmetrical on all four sides, with spaces arranged around a

ART IN TIME

1509—Europe launches African slave trade with the New World

1515—Thomas More publishes *Utopia*

1534—Henry VIII breaks with Rome and forms Church of England

1572—Longleat House begun in Wiltshire

1588—England defeats the Spanish Armada

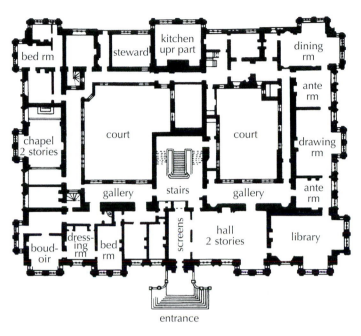

18.31. Plan of Longleat House, Wiltshire (after a plan from Sir Bannister Fletcher's *A History of Architecture*)

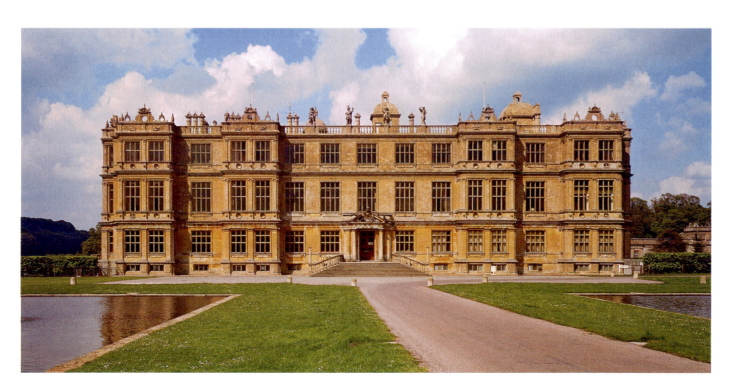

18.30. Robert Smythson, Allen Maynard, and others. Longleat House, Wiltshire, England. 1572–1580

Elizabethan Imagery

The poets and playwrights of Elizabethan England produced some of the most memorable literature in the English language. The sonnet, given authority as a poetic form by Petrarch, was the form chosen by both Edmund Spenser and William Shakespeare for their own love poetry. Spenser (ca. 1552–1599) is best known for his epic poem "The Faerie Queen," an allegory of Elizabeth I. Though best known for his plays, William Shakespeare (1564–1616) wrote many sonnets whose imagery is as vivid as the paintings of Nicholas Hilliard.

Edmund Spenser, Sonnet Sixty-four, from the Amoretti *(1595)*

Coming to kiss her lips, such grace I found
Me seemed I smelt a garden of sweet flowers
That dainty odours from them threw around
For damzels fit to deck their lovers' bowers:
Her lips did smell like unto gillyflowers;
Her ruddy cheeks like unto roses red;
Her snowy brows like budded bellamours
Her lovely eyes like pinks but newly spread;
Her goodly bosom like a strawberry bed;

Her neck like to a bunch of columbines;
Her breast like lilies, ere their leaves be shed;
Her nipples like young blossomed jessamines:
Such fragrant flowers do give most odorous smell,
But her sweet odour did them all excel.

William Shakespeare, Sonnet Eighteen (The Sonnets were published in 1609, though often dated to the 1590s)

Shall I compare thee to a summer's day?
Thou art more lovely and more temperate:
Rough winds do shake the darling buds of May,
And summer's lease hath all too short a date:
Sometime too hot the eye of heaven shines,
And often is his gold complexion dimmed;
And every fair from fair sometime declines,
By chance, or nature's changing course, untrimmed:
But thy eternal summer shall not fade,
Nor lose possession of that fair thou ow'st;
Nor shall Death brag thou wand'rest in his shade,
When in eternal lines to time thou grow'st.
So long as men can breathe or eyes can see,
So long lives this, and this gives life to thee.

pair of interior courtyards. The facade is beautifully proportioned and uses a limited vocabulary of Italian forms, such as balustrades and entablatures. French rather than Italian in character, Longleat House reflects the taste of its owner, John Thynne. Nestled in its country park, Longleat is a perfect stage on which rituals of Elizabethan power could be performed.

THE NETHERLANDS: WORLD MARKETPLACE

Such displays of aristocratic power were controversial in the sixteenth-century Netherlands. This region, comprising present-day Holland and Belgium, had the most turbulent history of any country north of the Alps. Once united under the Burgundian rulers of the fifteenth century, the Netherlands passed to Habsburg control through the marriage of Mary of Burgundy to Maximilian I. When the Reformation began, it was part of the empire under Charles V, who was also king of Spain. Protestantism quickly gained adherents in the Northern Netherlands, and attempts to suppress the spread of reformed confessions led to a revolt there against Spanish rule that resulted in the provinces of the Northern Netherlands declaring their independence in 1579. After a bloody struggle, the Northern Provinces (present-day Holland) emerged at the end of the century as an independent state in all but name.

The Southern Provinces (roughly corresponding to present-day Belgium) remained in Spanish hands and committed to Roman Catholicism. Both Charles V and Philip II of Spain appointed regents to govern the Netherlands who established courts in the southern cities. The momentous changes in the political and religious situation were accompanied by economic changes. In the Southern Netherlands, the once thriving port of Bruges silted up and was replaced as a commercial center by Antwerp, with its deep harbor and strategic location. Antwerp became the commercial and artistic capital of the Southern Netherlands. In the Northern Netherlands the city of Amsterdam became a center of international trade.

One byproduct of the religious strife was the destruction of works of art in waves of iconoclasm, inspired by the reformers' suspicion of images. In both the Northern and Southern Netherlands vast numbers of medieval and earlier Renaissance works of art were lost, especially religious works and sculpture, as zealous reformers confiscated or burned images they considered idolatrous. The market for sculpture in the Netherlands was changed for the rest of the early modern period, as painting and other two-dimensional art forms dominated artistic production. Although some reformers allowed painted or printed images that taught the faithful about doctrine, the Catholic practice of commissioning large-scale sculpted works of saints or of the Virgin to install in churches was eliminated

in reformed regions. Artists' practices changed under these conditions; as religious commissions dried up, especially in the Northern Netherlands, artists no longer waited for patrons to hire them, but made works of art to sell in the open market. (See *The Art Historian's Lens*, page 650.) One result was the development of new genres of art that would supplement, and eventually replace, traditional religious subjects.

Netherlandish artists were also being challenged by the new Italianate style, which was gaining favor in the courts. Responses to Italian art varied. Some artists saw no reason to change the Northern European visual tradition they had inherited; some grafted Italianate decorative forms to their traditional compositions and techniques; and others dove deeply into Italian style. These artists had been inspired by the example of Dürer, by works of Michelangelo and Raphael they had seen in the Netherlands, and by their own experience of Italy.

The City and the Court: David and Gossaert

The city of Bruges in the Catholic Southern Netherlands remained an important center for commerce into the sixteenth century, though much of its trade and prosperity transferred to Antwerp early in the period. The distinguished tradition of Bruges painting that we saw in the work of Van Eyck and Memling was carried on by Gerard David (ca. 1460–1523). David's workshop dominated to the middle of the sixteenth century. In 1509, David made a gift of a large panel to the Carmelite nunnery in Bruges. This painting (fig. **18.32**) depicts the Virgin and Child surrounded by virgin saints; two angels serenade this assembly of women, while portraits of David and his wife, Cornelia Cnoop, appear in the corners. In traditional Flemish fashion, the forms exhibit detailed renderings of textures, layers of colors that create brilliant effects, and symbolic forms to enhance the meaning, such as the grapes held by the Christ Child and the attributes of the saints. Yet David's cool colors and soft modeling endows these figures with a calm and dignity that is enhanced by the balanced composition. These silent virgins gather around the mother and son as the nuns of the convent would gather for prayer.

David worked for individual patrons and for the open market, but some of his contemporaries found employment in the aristocratic courts of the Netherlands, including Jan Gossaert (ca. 1478–1532), nicknamed "Mabuse," for his hometown. His early career was spent in Antwerp, but in 1508 he accompanied Admiral Philip of Burgundy to Italy, where the Italian Renaissance and antiquity made a deep impression on him. He also worked for the regent of the Netherlands, Margaret of Austria. His work fuses the lessons of Italian monumentality with the detailed technique of the Netherlandish tradition. For courtly

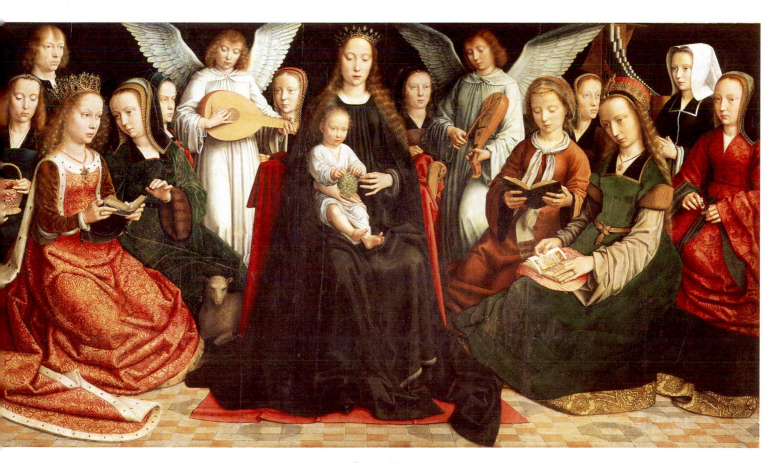

18.32. Gerard David. *Virgin Among Virgins*. 1509. Oil on panel. 46⁷/₈ × 83¹/₂″. Musée des Beaux Arts, Rouen

The Economics of Art

As trade, specialization, and a money economy came to dominate Northern Europe after the Middle Ages, the business of making and of selling art changed. The patron–artist relationship, where a contract specified the work to be produced and the money to be paid, gave way to the market system. Artists began to make their goods for sale on the open market. In recent years, art historians have been researching and writing about this change in the economics of art, focusing on centers such as Bruges, Antwerp, Delft, Haarlem, and Amsterdam.

Scholars have used documents, chronicles, and the study of the works themselves to explore the institutions that arose in response to these economic changes. The study of guilds and their regulation of the art trade illuminates one facet of the economics of art: Since the Middle Ages these organizations had regulated the training of artists and their commercial activity and controlled competition in their locales. The new technology of prints allowed artists to mass produce images that were not regulated by the guilds; prints were sold at trade fairs along with other commodities, sometimes by monks and nuns who sold them to support their monasteries. Dürer financed his trip from Nuremberg to Antwerp in 1521 by selling prints along the way.

By tracking the fluctuations in prices of works of art in the early modern period, scholars have been able to compare them to other commodities and to examine the impact of economic changes in the art trade on the artists themselves. Researchers have also explored the records and the physical arrangements of the market places and neighborhoods where the artists displayed their work for buyers to examine and purchase. Along with economic changes in the art trade a new player entered the art market—the dealer, who served as the middleman between the artist and the purchaser.

For art historians, an important issue is how these new economic changes and circumstances for making and selling art would affect the art works themselves. Evidence indicates that artists and workshops standardized their production techniques, subcontracted specific elements of projects, and specialized in particular forms or subjects. The choices made for subject matter in works of art responded to economic changes, too; images such as Aertsen's *The Meat Stall* (fig. 18.36) represent and comment on the market itself.

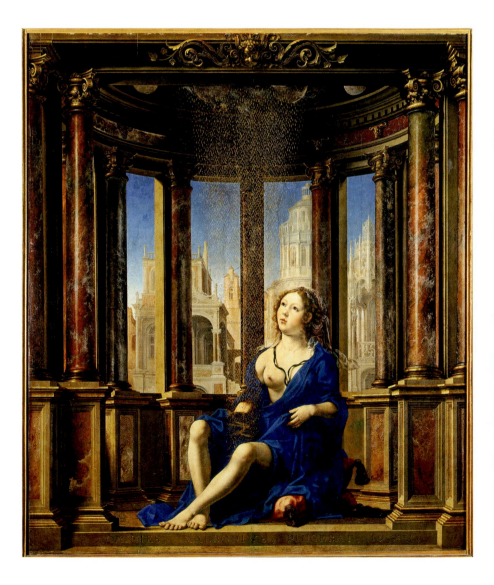

18.33. Jan Gossaert. *Danaë.* 1527.
Oil on panel, 44½ × 37⅜″ (113 × 95 cm).
Alte Pinakothek, Munich

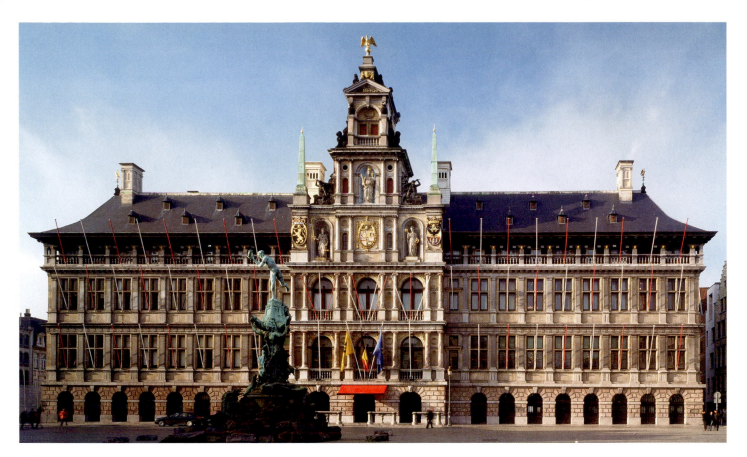

18.34. Cornelis Floris and Willem van den Broek, Town Hall, Antwerp. 1561–1566

patrons he made images of mythological subjects such as the *Danaë* (fig. **18.33**), signed and dated by Gossaert in 1527. Danaë has been locked away from male eyes, yet Jupiter finds a way to seduce her by disguising himself as a shower of gold. The picture may be seen as a counterpart to Correggio's *Jupiter and Io* (see fig. 17.24), painted only a few years later. Where Correggio's full-bodied Io seems to lose herself in the embrace of the Jovian cloud, Gossaert's Danaë gazes passively at the shower of gold falling toward her. Correggio focuses attention on Io, inferring the spatial context rather than defining it; Gossaert carefully constructs a round temple (perhaps an allusion to the Roman temple of the Vestal Virgins) and an architectural backdrop that competes for a viewer's attention. The figure of Danaë resembles Gossaert's images of the Madonna, complete with the blue robe traditional to the Virgin. Gossaert's *Danaë* displays the painter's fascination with antiquity and Italianate perspective, as well as his skill at rendering textures, details, and rich color.

Antwerp: Merchants, Markets, and Morality

Antwerp's rise as a center for commerce brought it new wealth and the desire for a new expression of that wealth. As with earlier Netherlandish cities, the town hall was the most important civic structure of the city, and in midcentury, the city held a competition for a new design. Cornelis Floris (1514–1575), a local sculptor and architect, won the commission and began work in 1561. Floris had traveled to Italy and had studied both antiquity and contemporary Italian architecture. In the design

for the Antwerp Town Hall, he combined the precepts of Italian Renaissance architecture with Northern European traditions to create the large and imposing structure that was completed by 1566 (fig. **18.34**). The building uses Italian devices: The base is a rusticated arcade, like Ammanati's Palazzo Pitti (fig. 17.5); the three stories above are articulated with Doric, Ionic, and Corinthian columns, like Alberti's Rucellai palace (fig. 15.32); a central pavilion mixes sculpture and architecture, like a Roman triumphal arch (see fig. 7.63). Yet the proportions are vertical, the roofline more in keeping with Netherlandish practice, and rich carvings on the central pavilion add a focal point at the tall mass of this section of the facade. The Antwerp Town Hall integrates Italian ideas differently from the way those ideas would be expressed in France, Spain, or England (compare with figs. 18.4, 18.10, and 18.30). Antwerp had become a world market by this point, trading a variety of goods, from textiles to foodstuffs, all over the world, including the Americas and Asia. The visual arts participated in this market in a variety of ways. Tapestries were exported through Antwerp; there was a thriving market in prints; and the Plantin-Moretus Press produced editions of books that were sent all over the world. Painters in particular developed new genres of art to tap into this expanding market. Still life, landscape, and genre paintings (images of daily life) had been explored by Flemish artists since the International Gothic Style and had become even more important during the fifteenth century as backdrops for religious themes. Some Antwerp artists of the sixteenth century specialized in these themes as subjects in themselves, perhaps in response to the loss

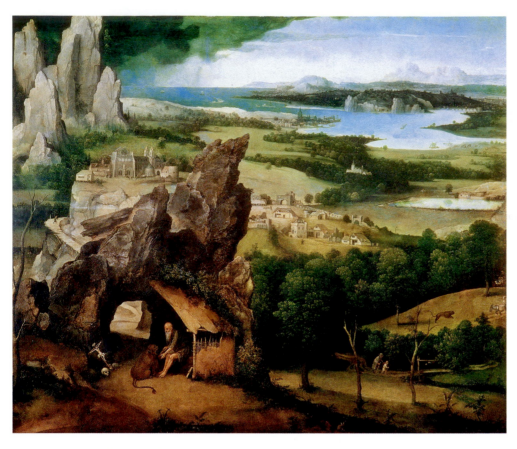

18.35. Joachim Patinir. *Landscape with St. Jerome Removing the Thorn from the Lion's Paw.* ca. 1520. Oil on panel, $29\frac{1}{8} \times 35\frac{7}{8}''$ (74 × 91 cm). Museo del Prado, Madrid

of religious patronage, or perhaps as a way to gain market share. These images often carry multiple meanings, at once depicting the pleasures of the world, while warning about those same pleasures.

PATINIR: LANDSCAPE AS ALLEGORY Joachim Patinir (ca. 1480–1524) of Antwerp was an early specialist in landscape, whose work Dürer had seen and praised when he visited Antwerp in 1521. His *Landscape with St. Jerome Removing the Thorn from the Lion's Paw* (fig. **18.35**) of about 1520 shows that Patinir had studied the work of Hieronymous Bosch both for his treatment of nature and his choice of subject. The landscape dominates the scene in Patinir's painting, but the figures are central to both its composition and subject. St. Jerome's biography reports that he once removed a thorn from the paw of a lion that had entered his hermitage; as a result, the lion became his companion. In the lower left of the foreground, St. Jerome appears as a hermit with the lion's paw in his hand. Jerome's hermitage abuts a strange rock formation that isolates him from the rest of the landscape. But this narrative is completely subordinate to the deep vista of the Earth, whose fields, forests, mountains, seas, and sky fill most of the panel. The human presence is very small in this landscape. Some tiny figures wander through this world, and villages, cities, even ships can be distinguished in the distance. Significantly, the structures nearest Jerome's hermitage are ecclesiastical, though he seems unaware of them.

This kind of landscape, which became very popular among European collectors in the sixteenth century, has been called a "world landscape," because of the focus on deep vistas into the distance. Like Altdorfer, Patinir uses a high viewpoint to allow the distant view, yet he also provides a shelf of space in the foreground for the narrative. Creating a smooth relationship between the foreground and the distance is of less interest to Patinir than describing the blue mountains and the verdant forests. How such landscapes were interpreted in Patinir's time is not entirely clear. On the one hand, the vista itself invites careful perusal, and viewers could study the picture and imagine the distant lands then being explored instead of traveling there themselves. At the same time, the painting has a religious subject that may have a moralizing message. Perhaps Patinir was commenting on the dangers of life in the world compared with the hermit's saintly rejection of worldly things.

AERTSEN'S *THE MEAT STALL* A moralizing meaning has also been ascribed to the still lifes painted by the North Netherlandish painter Pieter Aertsen (1507/08–1575). He spent his early career in Antwerp, then returned to Amsterdam in 1557, where he saw firsthand the destruction of religious images by iconoclasts in 1566. *The Meat Stall* (fig. **18.36**), done in 1551 while the artist was still in Antwerp, seems at first glance to be a purely secular picture. In the foreground, we see the products for sale in a butcher's shop in overwhelming detail, with tiny figures in the background almost blotted out by the food.

A sign to the upper right also advertises a farm for sale, so the power of the market economy is reflected in the imagery.

The still life so dominates the picture that it seems independent of the religious subject in the background. But in the distance to the left we see the Virgin and Child on the Flight into Egypt giving bread to the poor, who are ignored by the worshipers lined up for church. To the right is a tavern scene where the excesses of the senses are for sale. (The many oyster shells refer to its rumored qualities as an aphrodisiac.) The eye meanders over the objects on display: some of them items of gluttony; some, like the pretzels, eaten during Lent. Some of the products may be read as Christian symbols, such as the two pairs of crossed fish signifying the Crucifixion. The two background scenes suggest different choices a viewer could make: a life of dissipation or a life of almsgiving. The foreground with its emphasis on items for sale may implicate Antwerp's principal economic activity in these choices.

PIETER BRUEGEL THE ELDER Aertsen's younger contemporary and fellow Antwerp resident, Pieter Bruegel the Elder (1525/30–1569) used this same device of "inverted"

ART IN TIME

1509—Erasmus publishes *In Praise of Folly*

1568–1648—Dutch Wars of Independence from Spain

1565—Pieter Bruegel the Elder's *The Return of the Hunters*

1579—Establishment of Dutch Republic

perspective—putting the apparent subject of the picture in the background of many of his images. He explored landscape, peasant life, and moral allegory in his paintings. Although his career was spent in Antwerp and Brussels, he may have been born near 's Hertogenbosch, the home of Hieronymus Bosch. Certainly Bosch's paintings impressed him deeply, and his work is similarly ambiguous. Bruegel's contemporaries admired his wit and his ability to mimic nature, though solid personal information about Bruegel is scarce.

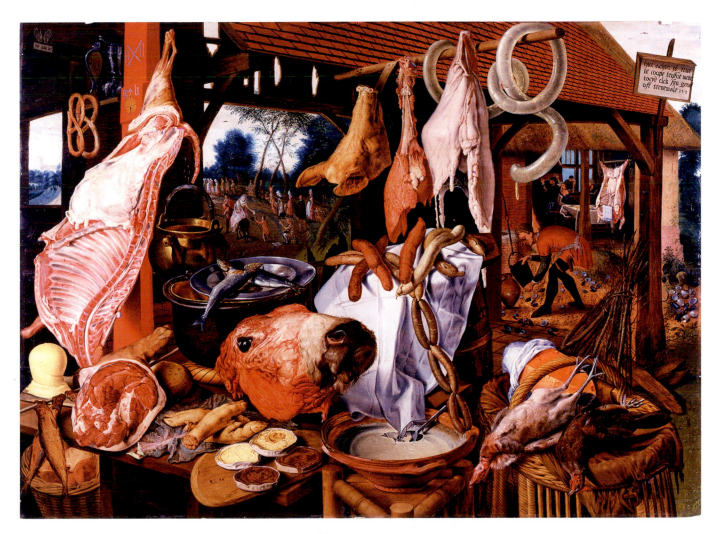

18.36. Pieter Aertsen. *The Meat Stall.* 1551. Oil on panel, $48\frac{1}{2} \times 59''$ (123.3 × 150 cm). University Art Collections, Uppsala University, Sweden

Karel van Mander Writes About Pieter Bruegel the Elder

From *The Painter's Treatise (Het Schilder Boeck) 1604*

Van Mander's biography of Pieter Bruegel the Elder remains an important source of information about the artist, whose talent he appreciated fully.

On his journeys Bruegel did many views from nature so that it was said of him, when he traveled through the Alps, that he had swallowed all the mountains and rocks and spat them out again, after his return, on to his canvases and panels, so closely was he able to follow nature here and in her other works....

He did a great deal of work [in Antwerp] for a merchant, Hans Franckert, a noble and upright man, who found pleasure in Breugel's company and met him every day. With this Franckert, Breugel often went out into the country to see peasants at their fairs and weddings. Disguised as peasants they brought gifts like the other guests, claiming relationship or kinship with the bride or groom. Here Breugel delighted in observing the droll behavior of the peasants, how they ate, drank, danced, capered, or made love, all of which he was well able to reproduce cleverly and pleasantly.... He represented the peasants—men and women of the Campine and elsewhere—naturally, as they really were, betraying their boorishness in the way they walked, danced, stood still, or moved.

...An art lover in Amsterdam, Sieur Herman Pilgrims, owns a *Peasant Wedding* painted in oils, which is most beautiful. The peasants' faces and the limbs, where they are bare are yellow and brown, sunburnt; their skins are ugly, different from those of town dwellers ...

... Many of his compositions of comical subjects, strange and full of meaning, can be seen engraved; but he made many more works of this kind in careful and beautifully finished drawings to which he had added inscriptions. But as some of them were too biting and sharp, he had them burnt by his wife when he was on his deathbed, from remorse or fear that she might get into trouble and have to answer for them....

SOURCE: *DUTCH AND FLEMISH PAINTERS* BY KAREL VAN MANDER. TR. CONSTANT VANDE WALL. (MANCHESTER, NH: AYER COMPANY PUBLISHERS, 1978)

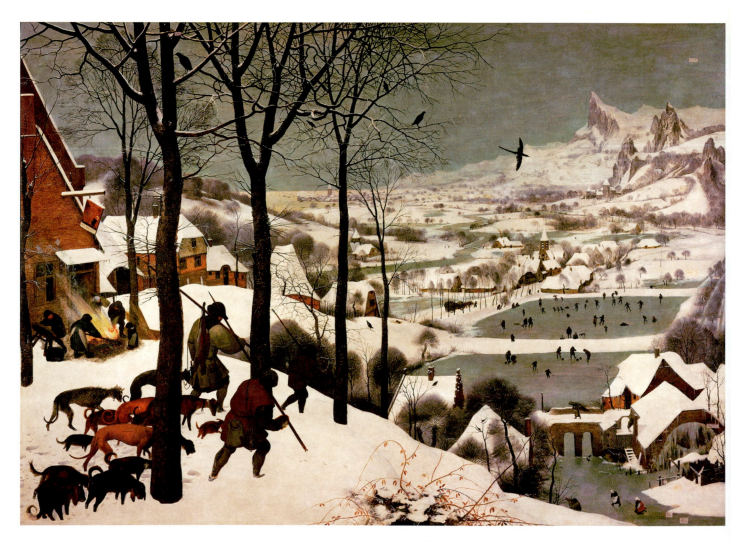

18.37. Pieter Bruegel the Elder. *The Return of the Hunters.* 1568. Oil on panel, $46\frac{1}{2} \times 63\frac{3}{4}''$ (117×162 cm). Kunsthistorisches Museum, Vienna

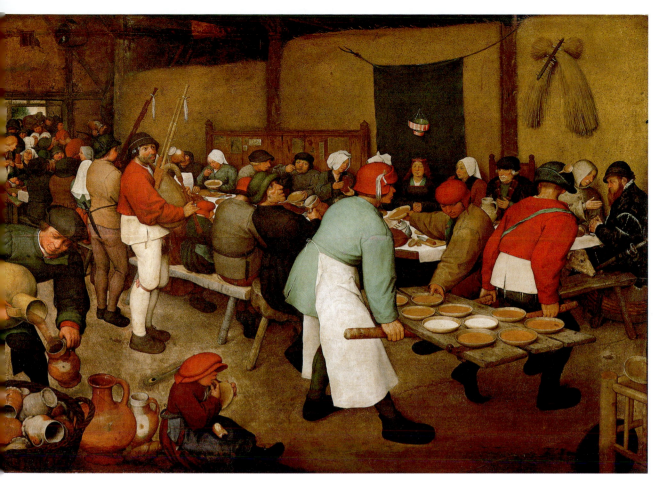

18.38. Pieter Bruegel the Elder. *Peasant Wedding.* ca. 1568. Oil on panel, 44⁷⁄₈ × 64″ (114 × 162.5 cm). Kunsthistorisches Museum, Vienna

Working as a painter and a designer of prints, he made pictures that demonstrate his interest in folk customs and the daily life of humble people. Bruegel himself was highly educated and the friend of humanists, who, with wealthy merchants, were his main clients. Urban elites collected images of the country and the people who worked the land. He also made images that many scholars have seen as political commentary about the Habsburg rule over the Southern Netherlands. Members of the Habsburg court also collected his work, but during the turbulent climate of the 1560s when Philip II of Spain attempted to quash the Protestant rebellion in the Netherlands, Bruegel became fearful that his politically barbed imagery might cause trouble for his family. (See *Primary Source*, page 654.)

Like his contemporaries who followed Dürer's example, Bruegel traveled to Italy in 1552–1553, visiting Rome, Naples, and the Strait of Messina. The famous monuments admired and sketched by other Northern European artists, however, seem not to have interested him. He returned instead with a sheaf of magnificent landscape drawings, especially Alpine views. Out of this experience came the sweeping landscapes of Bruegel's mature style. *The Return of the Hunters* (fig. **18.37**) is

one of a set of paintings depicting the months. (He often composed in series; those in this group were owned in 1566, a year after they were painted, by Niclaes Jonghelink, an Antwerp merchant.) Such scenes had their origin in medieval calendar illustrations, such as those in the *Tres Riches Heures* of Jean de Berry (see fig. 14.5). In Bruegel's work, however, Nature is more than a setting for human activities. It is the main subject of the picture.

Like Patinir, Bruegel provides in *The Return of the Hunters* a shelf of space in the foreground that moves precipitously into the distance toward a far horizon. In the snow covered landscape, human and canine members of a hunting party return to their village with their skimpy catch in the grey of a northern winter. They move down a hill toward a village, where the water has frozen and become a place of recreation and where people rush to get back indoors. Human activity is fully integrated into the natural landscape in Bruegel's image.

The *Peasant Wedding* (fig. **18.38**), dated around 1568, is one of Bruegel's memorable scenes of peasant life. His biographer, Karel van Mander, reported that Bruegel and his patron Hans Franckert often disguised themselves as peasants and joined in their revelries so Bruegel could observe and sketch them

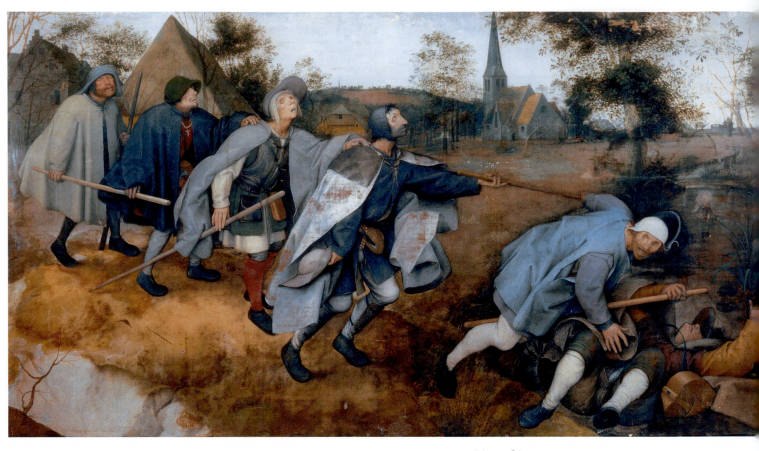

18.39. Pieter Bruegel the Elder. *The Blind Leading the Blind.* ca. 1568. Oil on panel, $34\frac{1}{2} \times 60\frac{5}{8}''$ (85 × 154 cm). Museo e Gallerie di Capodimonte, Naples

(see *Primary Source*, page 654). In this painting Bruegel depicts a gathering of rustic folks in a barn that has been decorated for a wedding. He has totally mastered Italian perspective, so the viewer enters a capacious room dominated by the table at which the wedding guests are gathered. The bride sits before a green curtain to distinguish her, though it is more difficult to identify the groom. Food is being distributed in the foreground, while the many empty jugs in the lower left suggest that much liquid has already been consumed. Far from the varieties of meats and fish depicted in Aertsen's *The Meat Stall*, the food here is simple porridge. Bagpipers stand ready to play, but the noise level already seems high with so many figures talking amid the clattering of pottery. Bruegel's technique is as precise and detailed as many of his Flemish predecessors, and his figures have a weight and solidity that adds to the impression of reality.

Interpreting Bruegel's images of peasants has challenged art historians. Some scholars have seen Bruegel's peasant pictures as brutal caricatures of rural folk for the consumption of town dwellers; by this reading, urbane townsfolk could chuckle at the foibles of their country cousins. Still, Bruegel treats this country wedding as a serious event, and if Bruegel records the peasants' rough manners, he also records their fellowship. He treats the least of the least, like the child licking a bowl in the foreground, as worthy of observation and remembrance. For Bruegel, the common man occupies an important place in the scheme of things.

Many of Bruegel's pictures offer ambivalent lessons, some of them based on the proverbial wisdom that permeates Netherlandish literature. One of his last pictures, *The Blind Leading the Blind* (fig. **18.39**), presents such a visual interpretation of verbal wisdom. Its source is the Gospels (Matthew 15:12–19). Jesus, speaking of the Pharisees, says, "And if the blind lead the blind, both shall fall into the ditch." This parable recurs in humanistic as well as popular literature, and it appears in at least one earlier work. However, the tragic depth of Bruegel's image gives urgency to the theme. Bruegel uses the detailed rendering of the Netherlandish tradition to record the infirmities and the poverty of the blind beggars who march across this village landscape. The pose of each figure along the downward diagonal is more unstable than the last, leaving little doubt that everyone will end up in the ditch with the leader. Above the gap between the two groups, Bruegel places a village church, suggesting to some critics that the blindness comes from the ecclesiastical establishment. But other readings are possible. Could the presence of the church refer to the men's spiritual blindness? Perhaps he found the meaning of the parable especially appropriate to his time, which was marked by religious and political fanaticism. The ambiguity of Bruegel's pictures has inspired critics and artists for centuries.

SUMMARY

Northern Europe in the sixteenth century had to absorb the breakdown of traditional certainties and the emergence of innovations from many quarters. The knowledge of the world was expanding through explorations and colonization of Asia and the Americas. The Catholic religious order was challenged and fractured. Political boundaries were being redrawn and nations being formed. Scientists and Humanists were developing new ideas about the universe and man's place in it. Older forms of wealth were giving way to capitalist economies. And visual artists felt the need to respond to the new visual language that was developing in Italy.

FRANCE: COURTLY TASTES FOR ITALIAN FORMS

French patrons and architects were particularly receptive to Italian influence. French courtly architecture, principally palaces, follow Italian ideas about composition and the use of ancient orders on the exterior of buildings, though the proportions of French structures tend to be more vertical than those in Italy. The presence of Italian Mannerists at the royal court of Fontainebleau established a courtly taste for slim, elegant nudes and antique subject matter.

SPAIN: GLOBAL POWER AND RELIGIOUS ORTHODOXY

Enriched by gold from the New World and the vast European holdings of its Habsburg rulers, Spain became a global power in the sixteenth century and maintained a fierce allegiance to Catholicism. Spanish patrons commissioned religious art that was strongly affected by Italian models or made by artists trained in Italy. Philip II's grand monastic complex at the Escorial shows the impact of sixteenth-century Italian ideas. The art of El Greco blends Mannerist compositional techniques with Venetian color to create visionary religious images.

CENTRAL EUROPE: THE REFORMATION AND ART

The Reformation profoundly affected the art of the German-speaking regions of Europe. The antipathy of some of the Protestant faiths to images resulted in iconoclasm and reductions in commissions to produce religious art. Where Catholicism still prevailed, artists made religious images that drew on the Northern European traditions of realism with the added influence of Italian art. Dürer is the preeminent German artist of the Renaissance, because of his powerful fusion of Northern European and Italian traditions, his commitment to the ideal of the artist as an intellectual, and his mastery in the popular medium of printmaking, which spread his influence all over Europe. Prints also assisted in the spread of Reformation ideas. In the absence of Church commissions, artists specialized in more secular subjects, such as landscapes, classical mythology, and portraits.

ENGLAND: REFORMATION AND POWER

Portraiture was the dominant art form in the England of Henry VIII and Elizabeth I, as the English Reformation also diminished the market for religious art. Artists from the Continent brought with them the styles of Germany, the Netherlands, France, and Italy. Holbein's portraits are informed by Northern European traditions and Italian art. Art in the Elizabethan era drew from Holbein's achievements, but added complex iconographies that flattered the queen. In architecture, the Elizabethan country house was conceived as a stage for royal visits.

THE NETHERLANDS: WORLD MARKETPLACE

The naturalism that distinguishes the art of the fifteenth-century Netherlands is the starting point for the styles of the sixteenth century. Again, the impact of the Reformation was important, resulting in iconoclasm and political division between the Northern and Southern Netherlands. While some artists in the Catholic Southern Netherlands continued to make religious art on commission, many artists chose to sell their work on the open market. New subjects, such as landscapes, still lifes, and genre scenes, became more prominent, as artists sought to appeal to a wide clientele. Humanist inspired themes could be expressed in styles informed by the Italian Renaissance, or, in the case of Bruegel, in a style deeply rooted in the local traditions of the Netherlands.

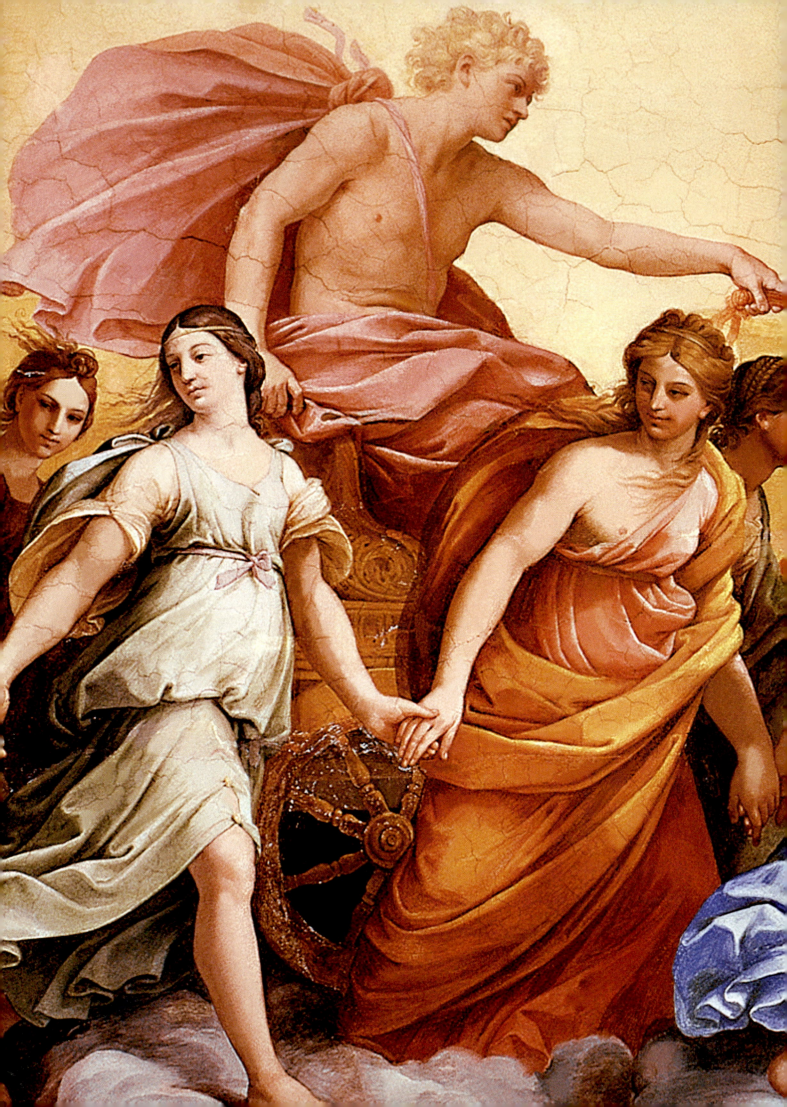

The Baroque in Italy and Spain

THE TERM BAROQUE MAY COME FROM THE PORTUGUESE WORD *BARROCCO*, referring to an irregular pearl; it means contorted, even grotesque, and was intended as a disparaging description of the grand, turbulent, dynamic, overwhelming style of seventeenth-century art. Art historians remain divided over its definition. Should the term Baroque only be used for the

dominant style of the seventeenth century, or should it include other tendencies, such as classicism, to which it bears a complex relationship? Should the time frame also include the period 1700 to 1750, known as the *Rococo*? More important, is the Baroque distinct from both the Renaissance and the Modern eras? Although a good case can be made for viewing the Baroque as the final phase of the Renaissance, we shall treat it as a distinct era. It is the beginning of the Early Modern Period, as so many of the same concerns—issues of gender, class, and sexuality—are explored. The desire to evoke emotional states by appealing to the senses and to persuade, often in dramatic ways, underlies Baroque art. Some of the qualities that characterize the Baroque are grandeur, sensual richness, emotional exuberance, tension, movement, and the successful unification of the various arts.

The expansive, expressive quality of the Baroque paralleled the true expansion of European influence—geographical, political and religious—throughout the seventeenth century. The exploration of the New World that began in the sixteenth century, mobilized primarily by Spain, Portugal, and England (See map 19.1), developed in the seventeenth century into colonization, first of the eastern coasts of North and South America,

and then to Polynesia and Asia. The Dutch East India Company developed trade with the East and was headquartered in Indonesia. Jesuit missionaries traveled to Japan, China, and India, and settled in areas of North and South America. In style and spirit, the reach of the Baroque was global.

The Baroque has been called a style of persuasion, as the Catholic Church attempted to use art to speak to the faithful and to express the spirit of the Counter-Reformation. In the sixteenth century, the Church tried to halt the spread of Protestantism in Europe, but by the seventeenth century, the Church declared this effort a success and celebrated its triumph. Private influential families, some who would later claim a pope as a member, other private patrons, and ecclesiastical orders (Jesuits, Theatines, Carmelites, and Oratorians) each built new and often large churches in Rome in the seventeenth century. And the largest building program of the Renaissance—the rebuilding of St. Peter's—would finally come to an end, and with its elaborate decoration, profoundly reflect the new glory of the Church.

This remastering of the Church began a wave of canonizations that lasted through the mid-eighteenth century. The religious heroes of the Counter-Reformation—Ignatius of Loyola, Francis Xavier (both Jesuits), Theresa of Ávila, and Filippo Neri—were named saints. (Carlo Borromeo had already been made one in 1610.) In contrast to the piety and good deeds of these reformers, the new princes of the Church were vigorous

Detail of figure 19.9, Guido Reni, *Aurora*

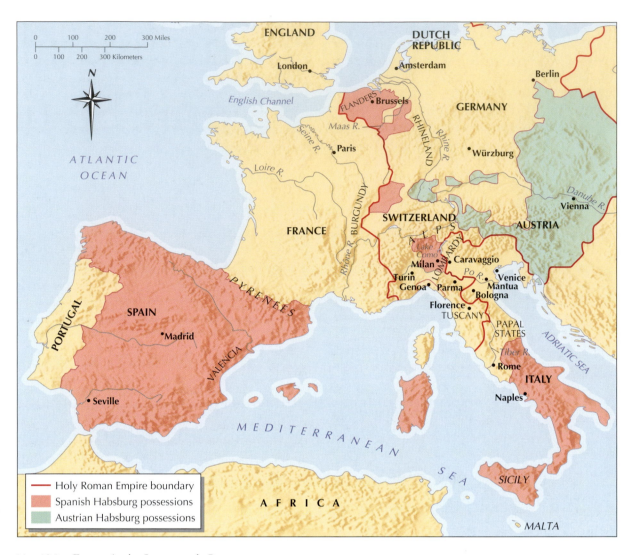

Map 19.1. Europe in the Seventeenth Century

patrons of the arts, both for the glory of the Church and for the posthumous fame of their own families.

During the first half of the the seventeenth century, Europe was torn by almost continual warfare, which involved almost every European nation in a complex web of shifting alliances. The Thirty Years' War (1618–1648) was fueled by the ambitions of the kings of France, who sought to dominate Europe, and the Habsburgs, who ruled not only Austria and Spain but also the Southern Netherlands, Bohemia, and Hungary. Although fought largely in Germany, the war eventually engulfed nearly all of Europe. After the Treaty of Westphalia in 1648 ended the war and formally granted their freedom, the United Provinces—or The Dutch Republic as the independent Netherlands was known—entered into a series of battles with England and France that lasted until 1679. Yet, other than in Germany, which was fragmented into over 300 little states, many in financial ruin, there is little correlation between these rivalries and the art of the period. In fact, the seventeenth century has been called the Golden Age of painting in France, Holland, Flanders, and Spain.

The Baroque has also been identified as "the style of absolutism," reflecting the centralized state ruled by an autocrat of unlimited powers. In the latter half of the seventeenth century, Baroque palaces were built on an increasingly monumental scale to display the power and grandeur of their owners. Architecture emphasized massiveness, dramatic spaces and lighting, rich interior decoration from floor to ceiling, and luxurious material; and it was meant as a reflection of political and economic power. Absolutism reached its climax during the reign of Louis XIV in the late seventeenth century, and is seen in his palace at Versailles, with its grandiose combination of architecture, painting, decoration, and extensive gardens. But we can also associate absolutism with the Vatican and the power of the pope and his claim of authority won and reestablished through the Counter-Reformation. The power of absolutism suggests a style that will overwhelm and inspire awe in the spectator. And that is the art—the painting, sculpture, and architecture—of the Baroque.

The new style was not specifically Italian, even though it was born in Rome during the final years of the sixteenth century.

Nor was it confined to religious art. Baroque elements of dramatic lighting and sweeping gestures entered the vocabulary of Northern European art. But the introduction of new subject matter—the still life, the genre scene, and the landscape—quickly entered the art world of the Protestant North through etchings and paintings. Still-life paintings and landscapes were informed by the scientific observation of Nature.

A recognition of the subtle relationship between Baroque art and science is essential to an understanding of the age. The complex metaphysics of the Humanists, which gave everything religious meaning, was replaced by a new physics. The change began with Nicholas Copernicus, Johannes Kepler, and Galileo Galilei, and culminated in René Descartes and Isaac Newton. Their cosmology brought scientific understanding to sensory perception. By placing the sun, not the Earth (and humanity), at the center of the universe, it contradicted what our eyes (and common sense) tell us: that the sun revolves around the Earth. Scientists now defined underlying relationships in mathematical and geometrical terms as part of a simple, orderly system of mechanics. Not only was the seventeenth century's worldview fundamentally different from the Renaissance's, but its understanding of visual reality was forever changed by the new science, thanks to advances in optical physics and physiology. Thus we may say that the scientists and artists of the Baroque literally saw with new eyes.

These scientists knew, or corresponded with, each other and with the artists of their time, and their views and discoveries were known to the larger intellectual and artistic community. Newton's mathematics were known to Sir Christopher Wren and were possibly used in his rebuilding both of London and St. Paul's Cathedral (see Chapter 21). Vermeer, who experimented with optical effects (see pages 728–729), would have known the developer of the microscope, Anthony van Leewenhoek, and the philosopher and scientist Descartes had his portrait painted by Frans Hals. Descartes postponed the publication of his own controversial work *The World* until after his death, as he had learned of Galileo's imprisonment and was also concerned for his own eternal soul, for he, too, was a Catholic. Galileo's scientific and religious adversaries were the Jesuits, who considered Galileo's views to be the antithesis of the Church's teachings. Opposing Galileo as well was Pope Urban VIII (Barberini), the same pope who envisioned a new Rome, and who was the most significant patron of Bernini. The ceiling paintings, filled with astronomical and astrological figures so prominent in the Baroque, were executed to convey the all-encompassing power of the patron, who by implication controlled even the very heavens above.

The rise of science also had the effect of displacing natural magic, a precursor of modern science that included both astrology and alchemy. Unlike the new science, natural magic tried to control the world through prediction and manipulation; it did so by uncovering nature's "secrets" instead of natural laws. Yet, because it was linked to religion and morality, natural magic lived on in popular literature and folklore well beyond the seventeenth century.

Folklore, literature, and plays became subject matter in the Baroque, usually depicted as a **genre scene**—a scene from everyday life—which became a popular theme in the seventeenth century. These genre paintings include scenes of people eating, playing board games, drinking, smoking, and playing musical instruments. But sometimes they illustrate proverbs, plays, and the senses. They are often moralizing; that is, they often warn against the very things they are depicting! Such paintings were already executed in the sixteenth century (see Bruegel, page 653), but they develop into a major force, along with landscape and still-life painting, in the seventeenth century in nearly every European country—in Italy, Spain, Flanders, The Dutch Republic, and France. Paintings of foods—plain and exotic—and landscapes of rural, urban, or far-off places were popular. There were also paintings of ordinary people often in domestic situations. All of this subject matter provides us with a gateway into the Baroque world. Turkish carpets, African elephants and lions, Brazilian parrots, Ming vases, and peoples from Africa, India, and South America can be found in seventeenth-century art. In part, this list represents "exotica"—but the exotic was a major part of the seventeenth century as people, many of them artists, traveled to faraway places.

In the end, Baroque art was not simply the result of religious, political, intellectual, or social developments: The strengthened Catholic faith, the absolutist state, the new science, and the beginnings of the modern world combined in a volatile mixture that gave the Baroque era its fascinating variety. What ultimately unites this complex era is a reevaluation of humanity and its relation to the universe. Philosophers gave greater prominence to human passion, which encompassed a wider range of emotions and social levels than ever before. The scientific revolution leading up to Newton's unified mechanics in physics responded to this same new view of humanity, which presumes a more active role for people through their ability to understand and affect the world around them. Remarkably, the Early Modern World remained an age of great religious faith, however divided people may have been in their loyalties. The interplay of passion, intellect, and spirituality may be seen as forming a dialogue that has never been truly resolved.

PAINTING IN ITALY

Around 1600, Rome became the fountainhead of the Baroque, as it had of the High Renaissance a century before, by attracting artists from other regions. The papacy and many of the new Church orders (Jesuits, Theatines, and Oratorians), as well as numerous private patrons from wealthy and influential families (Farnese, Barberini, and Pamphili) commissioned art on a large scale, with the aim of promoting themselves and making Rome the most beautiful city of the Christian world "for the greater glory of God and the Church." This campaign had begun as early as 1585 (indeed, we may even date this revitalization to the reign of Julius II), and by the opening of the seventeenth century, Rome attracted ambitious young artists, especially from northern Italy. It was they who created the new style.

Caravaggio and the New Style

Foremost among the young artists was a painter of genius, Michelangelo Merisi (1571—1610), called Caravaggio after his birthplace near Milan. After finishing his training under a minor Milanese painter, he came to Rome sometime before 1590 and worked as an assistant to various artists before setting out on his own. His style of painting, his new subjects, his use of lighting, and his concept of naturalism changed the world of painting. Caravaggio's style was the initial stamp of Baroque and caused a stir in the art world (see end of Part III *Additional Primary Sources*.) He had numerous followers and imitators, and critics, both Italian and Northern European, wrote of his work, so Caravaggio and his paintings became internationally known almost immediately.

Caravaggio's first important public commission was a series of three monumental canvases devoted to St. Matthew that he painted for the Contarelli Chapel in San Luigi dei Francesi from 1599 to 1602 (fig. **19.1**). The Church for the French Community (dei Francesi) in Rome, founded in 1518 by Cardinal Giulio de' Medici (later Pope Clement VII) and designed by Giacomo della Porta, was finished in 1589. The Chapel of

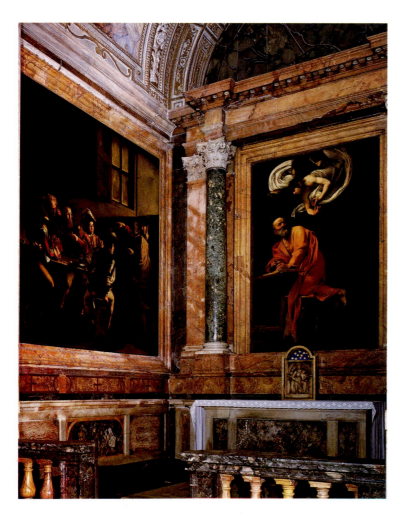

19.1. Contarelli Chapel, San Luigi dei Francesi, Rome

St. Louis (Luigi) was endowed by the French Cardinal Mathieu Contrel (Contarelli) in 1565, but the decoration was not immediately completed. Caravaggio finally received the commission to complete the work years later through the intervention of his patron, Cardinal del Monte.

As decorations, the Contarelli paintings perform the same function that fresco cycles had in the Renaissance. Our view of the chapel includes two of the three paintings. In the chapel view we see *St. Matthew and the Angel*, in which the tax collector Matthew turns dramatically for inspiration to the angel who dictates the gospel. The main image on the left in the chapel illustrates *The Calling of St. Matthew* (fig. **19.2**). The third canvas is devoted to the saint's martyrdom. Caravaggio's style is remote from both mannerism and the High Renaissance. His naturalism is a new and radical kind. According to contemporary accounts, Caravaggio painted directly on the canvas, as had Titian, but he worked from a live model. He depicted the world he knew, so that his canvases are filled with ordinary people. They are not idealized as High Renaissance figures, nor given Classical bodies, clean clothes, and perfect features. But neither are they distorted, elogated, or overtly elegant as in Mannerism. This was an entirely new conception that was raw, immediate, and palpable.

For Caravaggio, naturalism was not an end in itself but a means of conveying profoundly spiritual content. *The Calling of St. Matthew* (fig. 19.2), shows these qualities. Never before have we seen a sacred subject depicted so entirely in terms of contemporary lowlife. Matthew, the well-dressed tax collector, sits with some armed men, who must be his agents, in a common, sparse room. The setting and costumes must have been very familiar to Caravaggio. Two figures approach from the right. The arrival's bare feet and simple biblical garb contrast strongly with the colorful costumes of Matthew and his companions.

Caravaggio's paintings have a quality of "lay Christianity" that spoke powerfully to both Catholics and Protestants. Stripped of its religious context, the men seated at the table would seem like figures in a genre scene. Indeed, Caravaggio's painting would become a source for similar secular scenes. Likewise, fanciful costumes, with slashed sleeves and feathered berets, will appear in the works of Caravaggio's followers. Figures seen in half-length (showing only the upper half of their bodies), will also be a common element in other works by Caravaggio and his followers (see fig. 20.15).

Why do we sense a religious quality in this scene and not mistake it for an everyday event? What identifies one of the figures on the right as Christ, who has come to Matthew and says "Follow me"? It is surely not his halo, the only supernatural feature in the picture, which is a thin gold band that we might easily overlook. Our eyes fasten instead on his commanding gesture, borrowed from Michelangelo's Adam in *The Creation of Adam* (see fig. 16.21), which bridges the gap between the two groups of people and is echoed by Matthew, who points questioningly at himself.

The men at the right at the table seem not to be engaged in the drama enfolding, while the ones at the left concentrate on

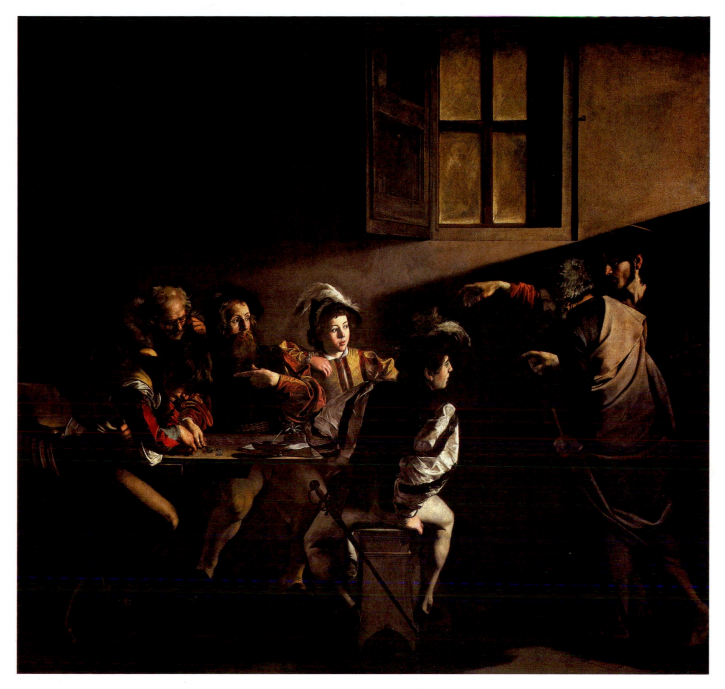

19.2. Caravaggio. *The Calling of St. Matthew.* ca. 1599–1600. Oil on canvas, 11′1″ × 11′5″ (3.4 × 3.5 m). Contarelli Chapel, San Luigi dei Francesi, Rome

the money being counted. In shadows, they are blind to the entrance of Christ—one even wears eyeglasses. Caravaggio uses the piercing light in this scene to announce Christ's presence, as Christ himself brought light: "I am the light of the world; he that followeth me shall not walk in darkness, but shall have the light of life." (John: 8:12.)

The beam of sunlight in the darkness above Jesus is most decisive in meaning and style. The dark painting is referred to as *tenebristic* (dark). This strong beam of light in the dark background is known as a tenebristic effect, or **tenebrism**. Caravaggio illuminates Christ's face and hand in the gloomy interior so

that we see the *moment* of his calling to Matthew and witness a critical piece of religious history and personal conversion. Without this light, so natural yet so charged with meaning, the picture would lose its power to make us aware of the divine presence. Caravaggio gives direct expression to an attitude shared by certain saints of the Counter-Reformation: that the mysteries of faith are revealed not by speculation but through an inner experience that is open to all people. What separates the Baroque from the early Counter-Reformation is the externalization of the mystic vision, which appears to us complete and without any signs of spiritual struggle.

This intense, extreme, and vivid tenebrism, the cornerstone of Caravaggio's style, can be seen to dramatic effect in his *The Conversion of St. Paul* (fig. **19.3**). He employed it to heighten the drama and to suggest divine light at the same time. The painting is one of a pair (the other is *The Crucifixion of St. Peter*) to the left and right of the rich, colorful altarpiece of *The Assumption of the Virgin* by Annibale Carracci, which Caravaggio would have seen before he executed this work.

In contrast to that altarpiece, Caravaggio uses muted tones and a nearly black background. He uses neither color nor line (indeed, there are no known drawings by him) to indicate his narrative. Rather, he uses light to spotlight, even shock a viewer. A fallen Saul (to become St. Paul at this conversion) lies foreshortened on his back, helpless, being struck by the light of God, which also reveals the flank and mane of his huge horse, which takes up most of the space. The intense raking

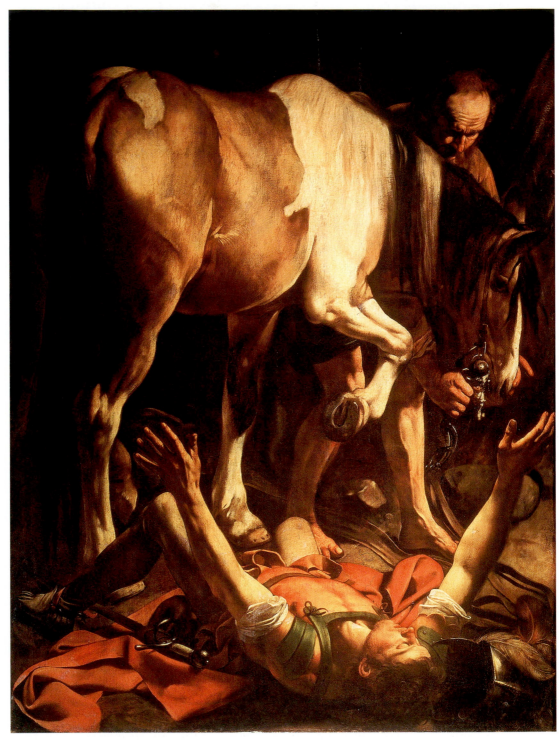

19.3. Caravaggio. *The Conversion of St. Paul.* ca. 1601. Oil on canvas, 7'6" × 5'7" (2.3 × 1.75 m). Cerasi Chapel, Santa Maria del Popolo, Rome

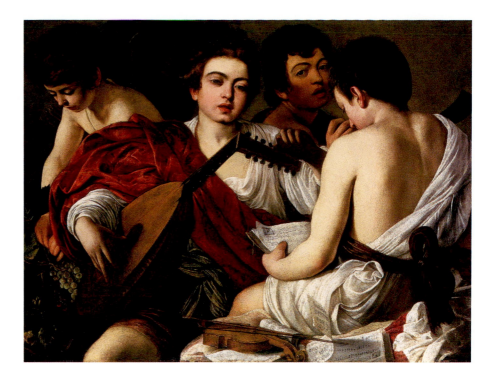

19.4. Caravaggio. *The Musicians.* ca. 1595. Oil on canvas, $36\frac{1}{4} \times 46\frac{5}{8}''$ (92.1 × 118.4 cm). The Metropolitan Museum of Art, New York. Rogers Fund, 1952

light from an unseen source at the left is used to model forms and create textures. The figures are nearly too big for the space. They overwhelm us as we imagine them larger and only partly revealed by the light. The selective highlighting endows the life-size figures with a startling presence and theatricality typical of the Baroque.

Another aspect of Caravaggio's work is his focus on the sensual and erotic nature of both music and young men, who are depicted as seducing and soliciting. We see these elements in *The Musicians* (fig. **19.4**), with the four androgynous, seminude youths. Actually, it may be two youths seen from two points of view. The musicians are half-length, but life-size; their blushed cheeks and full lips suggest erotic, sensual pleasures, enjoyed with each other and offered to a particular viewer. That viewer (the patron) was Cardinal del Monte, the influential patron who arranged the St. Matthew commission for Caravaggio and who commissioned other homoerotic paintings from Caravaggio. The lute, the violin, and the music sheets surrounding these half-draped men, and even the grapes being plucked on the side, suggest a contemporary bacchanal. The subject may be disturbing or unsettling, but this is part of the sensuality and passion—both physical and erotic—that will be explored in the Baroque and frequently imitated in later works of art.

An interest in pleasure, in the sensual and erotic, can be seen in Caravaggio's personality. Highly argumentative, Caravaggio carried a sword and was often in trouble with the law for fighting. When he killed a friend in a duel over a game, Caravaggio fled Rome and spent the rest of his short life on the run. He first went to Naples, then Malta, then returned briefly to Naples. He died on a journey back to Rome, where he had hoped to gain a pardon. In Italy, Caravaggio's work was praised by artists and connoisseurs—and also criticized. Conservative critics regarded Caravaggio as lacking decorum: the propriety and reverence that religious subjects demanded. And many who did not like Caravaggio the man were influenced by his work and had to concede that his style was pervasive. The power of Caravaggio's style and imagery lasted into the 1630s, when it was absorbed into other Baroque tendencies.

Artemisia Gentileschi

Most men who were artists had fathers who were also artists, and this was true for most of the few women artists of the seventeenth century as well. Born in Rome, Artemisia Gentileschi (1593–ca. 1653) was the daughter of Caravaggio's friend and follower Orazio Gentileschi, and she became one of the major painters of her day. She took great pride in her work but found the way difficult for a woman artist. In a letter of 1649 (see *Primary Source*, page 667), she wrote that "people have cheated me" and that she had submitted a drawing to a patron only to have him commission "another painter to do the painting using my work. If I were a man, I can't imagine it would have turned out so . . ." Her characteristic subjects are heroines: Bathsheba, the tragic object of King David's passion, and Judith, who saved her people by beheading Holofernes. Both themes were popular during the Baroque era, which delighted in erotic and violent scenes. Artemisia's frequent depictions of these biblical heroines (she often showed herself in the lead role) suggest an ambivalence toward men that was rooted in her turbulent life. (Artemisia was raped by her teacher, Agostino Tassi (see fig. 19.10), who was acquitted in a jury trial but expelled from Rome.)

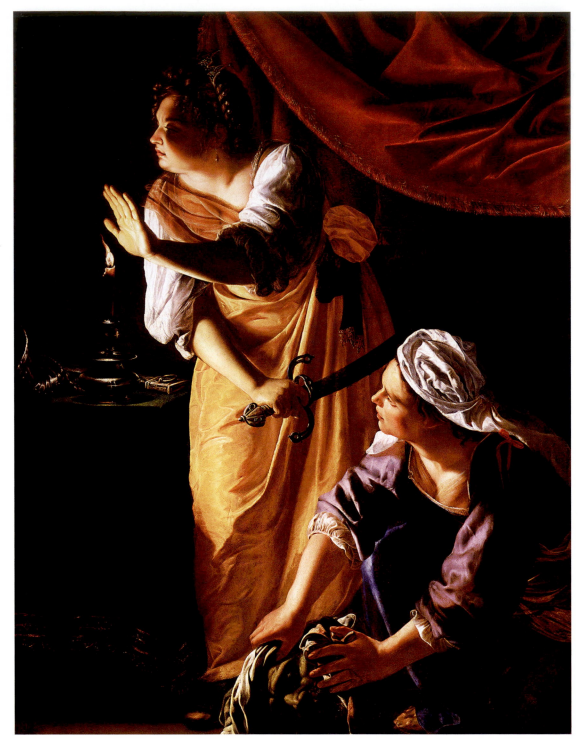

19.5. Artemisia Gentileschi. *Judith and Her Maidservant with the Head of Holofernes.* ca. 1625. Oil on Canvas, 6′1⁄2″ × 4′7″ (1.84 × 1.41 m). The Detroit Institute of Arts. Gift of Leslie H. Green

Artemisia's *Judith and Her Maidservant with the Head of Holofernes* (fig. **19.5**) is a fully mature, independent, dramatic, and large work, no less powerful for its restraint. The theme is the apocryphal story of the Jewish widow Judith, who saved her people by traveling with her maid to the tent of the Assyrian General Holofernes, got him drunk, and then cut off his head with his own sword; it yields parallels to the story of David and Goliath—might conquered by virtue and innocence.

However, with the theme of Judith slaying Holofernes, the victor was not always seen positively, but with some suspicion since her triumph was one of deceit: The unspoken promise of sexual activity was never realized. Rather than the beheading itself, the artist shows the instant after. Momentarily distracted, Judith gestures theatrically as her servant stuffs Holofernes's head into a sack. The object of their attention remains hidden from view, heightening the air of suspense and intrigue.

Artemisia Gentileschi (1593–ca. 1653)

From a letter to Don Antonio Ruffo

Artemisia Gentileschi's letter of November 13, 1649, to her patron reveals the relationship of the painter to her patron and issues of originality, of price, of working with models—and, throughout, the letter discloses her acute awareness and even contempt for those who treated her less fairly because she is a woman.

I have received a letter of October 26th, which I deeply appreciated, particularly noting how my master always concerns himself with favoring me, contrary to my merit. In it, you tell me about that gentleman who wishes to have some paintings by me, that he would like a Galatea and a Judgment of Paris, and that the Galatea should be different from the one that Your Most Illustrious Lordship owns. There was no need for you to urge me to do this, since by the grace of God and the Most Holy Virgin, they [clients] come to a woman with this kind of talent, that is, to vary the subjects in my painting; never has anyone found in my pictures any repetition of invention, not even of one hand.

As for the fact that this gentleman wishes to know the price before the work is done, . . . I do it most unwillingly. . . I never quote a price for my works until they are done. However, since Your Most Illustrious Lordship wants me to do this, I will do what you command. Tell this gentleman that I want five hundred ducats for both; he can show them to the whole world and, should he find anyone who does not think the paintings are worth two hundred scudi more, I won't ask him to pay me the agreed price. I assure Your Most Illustrious Lordship that these are paintings with nude figures requiring very expensive female models, which is a big headache. When I find good ones they fleece me, and at other times, one must suffer [their] pettiness with the patience of Job.

As for my doing a drawing and sending it, I have made a solemn vow never to send my drawings because people have cheated me. In particular, just today I found. . . that, having done a drawing of souls in Purgatory for the Bishop of St. Gata, he, in order to spend less, commissioned another painter to do the painting using my work. If I were a man, I can't imagine it would have turned out this way. . . .

I must caution Your Most Illustrious Lordship that when I ask a price, I don't follow the custom in Naples, where they ask thirty and then give it for four. I am Roman, and therefore I shall act always in the Roman manner.

SOURCE: GENTILESCHI'S LETTERS IN *THE VOICES OF WOMEN ARTISTS*, ED. THE WENDY SLATKIN (ENGLEWOOD CLIFFS, NJ: PRENTICE HALL, 1993)

The hushed, candlelit atmosphere—tenebrism made intimate—creates a mood of mystery that conveys Judith's complex emotions with unsurpassed understanding. Gentileschi's rich palette was to have a strong influence on painting in Naples, where she settled in 1630.

We know that for possibly a few years (ca. 1638–1640), Artemisia also worked in London where her father was court painter to Charles I of England from 1626 to 1639. Indeed several of her paintings were recorded in the king's inventory after his execution. Among them was her most daring and creative *Self-Portrait as the Allegory of Painting* (fig. **19.6**), one of the most innovative self-portraits of the Baroque period.

Artemisia was able to execute here what no male artist could: She depicted herself as the female allegorical figure of Painting, *La Pittura*. The dress and activity of the subject conforms to Cesare Ripa's description of *La Pittura* in his popular *Iconologia* (1593), a book of allegories and symbolic emblems for artists. There, the allegorical figure of Painting is described, in part, as a beautiful woman, with disheveled black hair, wearing a gold chain which hangs from her neck, and holding a brush in one hand and a palette in the other. Thus, the painting asserts Artemisia's unique role as a woman painter—representing not just herself, but all of Painting and reflecting the new, elevated status of artists.

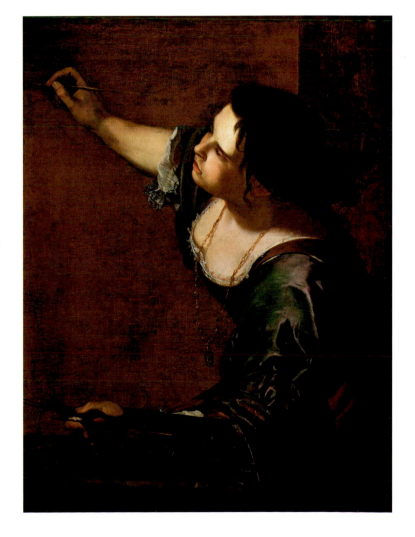

19.6. Artemisia Gentileschi. *Self-Portrait as the Allegory of Painting (La Pittura)*. ca. 1638–1639. Oil on canvas, $38^7/_8 \times 29^5/_8$″ (98.6 × 75.2 cm). The Royal Collection, © 2005 Her Majesty Queen Elizabeth II

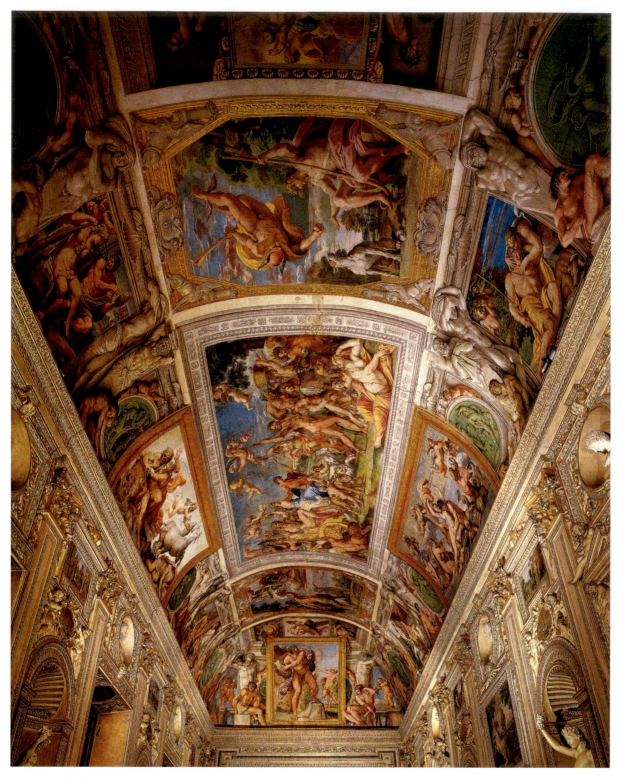

19.7. Annibale Carracci. *Loves of the Gods*. 1597–1601. Ceiling fresco. Gallery, Palazzo Farnese, Rome

Ceiling Painting and Annibale Carracci

The conservative tastes of many Italian patrons were met by artists who were less radical than Caravaggio, and who continued a more Classical tradition steeped in High Renaissance ideals. They took their lead instead from Annibale Carracci (1560–1609), who arrived in Rome in 1595. Annibale came from Bologna where, in the 1580s, he and two other members of his family formed an "Academy" (also see Vasari, page 595,

and Goltzius, page 711) and evolved an anti-Mannerist style based on northern Italian realism and Venetian art. He was a reformer rather than a revolutionary. Athough we do not know completely what this "Academy" entailed, it seems to have incorporated life-drawing from models and drawing after ancient sculpture. As with Caravaggio, who admired Annibale, his experience of Roman classicism transformed his art. He, too, felt that painting must return to Nature, not unlike the

theory underlying Caravaggio's work, but his approach emphasized a revival of the classics, which to him meant the art of antiquity. Annibale also sought to emulate Raphael, Michelangelo, Titian, and Correggio. In his best work, he was able to fuse these diverse elements.

Between 1597 and 1601 Annibale produced a ceiling fresco, *Loves of the Gods*, in the gallery of the Farnese Palace (fig. **19.7**), his most ambitious work, which soon became so famous that it ranked behind only the murals of Michelangelo and Raphael. Although we have seen ceiling painting in the Renaissance—from the fifteenth through the sixteenth centuries, with works by Mantegna, Correggio, and of course Michelangelo, whose painting of the ceiling of the Sistine Chapel would become the work against which all others would be judged—it is the Baroque period which is most associated with this form of painting.

Executed in chapels, churches, and private residences—in entranceways, hallways, and dining rooms—ceiling painting was meant to convey the power, domination, or even extravagance of the patron. One could not enter such a painted room without an element of awe. The styles from the beginning of the seventeenth century to the end become increasingly extravagant and contest even the majesty of Michelangelo. The Farnese Palace ceiling, commissioned to celebrate a family wedding, wears its humanist subject, the Loves of the Classical Gods, lightly. As on the Sistine Chapel ceiling, the narrative scenes are surrounded by painted architecture, simulated sculpture, and nude youths, which are carefully foreshortened and lit from below so that they appear real. But the fresco does not rely solely on Michelangelo's masterpiece. The main panels are presented as easel pictures, a solution adopted from Raphael. The "framed" painting, "medallions," and "sculpture" on the ceiling in *trompe l'oeil*, is known as *quadri riportati*, pictures transported to the ceiling (singular is *quadro riportato*) without account for our point of view. (When the viewpoint of the spectator is considered, then the artist is using "*di sotto in su*"—literally, "from below to above," as in the works of Mantegna fig. 15.53 and Correggio, fig. 17.25.) This ceiling reflects the collection of the Farnese that was actually in that room. The figure of Polyphemus, seen on the short wall, hurling the stone in the "easel painting" is based on the "Farnese Hercules," a Hellenistic sculpture owned by the family and displayed in the courtyard. The ceiling is held together by an illusionistic scheme that reflects Annibale's knowledge of Correggio (see fig. 17.25) and Veronese (see fig. 17.33). Each of these levels of reality is handled with consummate skill, and the entire ceiling has an exuberance that sets it apart from both Mannerism and High Renaissance art.

The sculptured precision of the Farnese Gallery shows us only one side of Annibale Carracci's style. Another important aspect is seen in his landscapes, such as the *Landscape with the Flight into Egypt* (fig. **19.8**). Its pastoral mood and the soft light and atmosphere hark back to Giorgione and Titian (see figs. 16.30 and 16.31). The figures, however, play a minor role here. They are as small and incidental as those in any Northern European landscape (compare with fig. 18.35). The landscape only hints at the suggestion of a Flight into Egypt (there are some camels on the hillside). The landscape would be

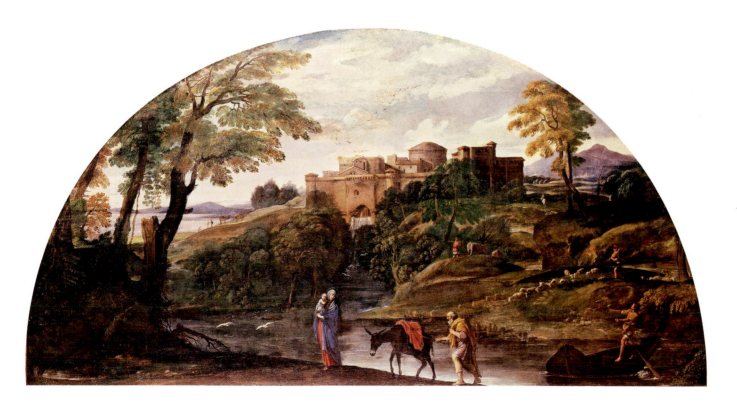

19.8. Annibale Carracci. *Landscape with the Flight into Egypt.* ca. 1603. Oil on canvas, 4′1¼″ × 8′2½″ (1.22 × 2.50 m). Galleria Doria Pamphili, Rome

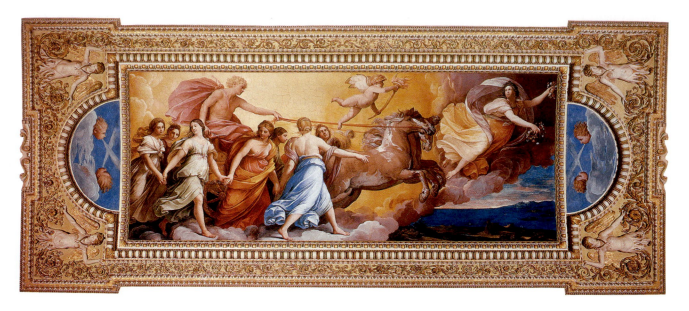

19.9. Guido Reni. *Aurora*. 1613. Ceiling fresco. Casino dell'Aurora, Palazzo Rospigliosi-Pallavinci, Rome

equally suitable for almost any story. The old castle, the roads and fields, the flock of sheep, the ferryman with his boat, all show that this "civilized," hospitable countryside has been inhabited for a long time. Hence the figures, however tiny, do not appear lost or dwarfed. Their presence is implied by the orderly, domesticated quality of the setting. This firmly constructed "ideal landscape" evokes a vision of Nature that is gentle yet austere, grand but not awesome.

GUIDO RENI AND GUERCINO Baroque ceilings, which began with the Annibale Carracci's illusionistic ceiling of the Farnese Palace, continued in Rome with Annibale's Bolognese followers Guido Reni (1575–1642) and Giovanni Francesco Barbieri (1591–1666), called Guercino, who were inspired by him. Guercino exercised leadership of the Bolognese School of painting, but both he and Reni worked in Rome and executed ceilings in the second and third decades of the seventeenth century.

The Farnese Gallery seemed to offer two alternatives to them and others inspired by it. Using the Raphaelesque style of the mythological panels, they could arrive at a deliberate "official" classicism; or they could take their cue from the illusionism of the framework. The approach varied according to personal style and the specific site. Among the earliest examples of the first alternative is Reni's *quadro riportato* ceiling fresco *Aurora* (fig. **19.9**), which shows Apollo in his chariot (the Sun) led by Aurora (Dawn). Here grace becomes the pursuit of perfect beauty. The relieflike design with glowing colors and dramatic light gives the painting an emotional force that the figures alone could never achieve. This style is called Baroque Classicism to distinguish it from all earlier forms of Classicism, no matter how much it may be indebted to them.

The *Aurora* ceiling (fig. **19.10**), painted less than ten years later by Guercino, is the very opposite of Reni's. Here architec-tural illusionistic framework (painted by Agostino Tassi), known as *quadratura*, combined with the pictorial illusionism of Correggio (see fig. 17.25), and the intense light and color of Titian, converts the entire surface into one limitless space, in which the figures sweep past as if driven by the winds. Rather than viewing Aurora in profile as in Reni's, we are clearly below, looking up, seeing even the underbelly of the horses as they gallop over our heads. With this work, Guercino continued and expanded the tradition descended from Correggio and started what became a flood of similar visions characteristic of the dynamic fulfillment of this style, the High Baroque, after 1630.

PIETRO DA CORTONA AND THE BARBERINI CEILING The most overpowering of these illusionistic ceilings is the fresco by Pietro da Cortona (1596–1669) in the great hall of the Barberini Palace in Rome (fig. **19.11**). This enormous painting combines all three illusionistic systems—*quadratura* in its painted architectural framework, *quadri riportati* in the scenes on the sides and *di sotto in su* in setting our point of view to fully understand the ceiling. This work, a complex allegory, glorifies the reign of the Barberini pope, Urban VIII. The allegorical female figure of *Divine Providence*, its central theme, dominates the ceiling, proclaiming that the pope was chosen by her and not by political favor. Indeed, a swarm of bees (part of the Barberini coat of arms featured prominently in the ceiling) was said to have descended on the Vatican just prior to his election. Urban VIII was the first pope elected by the new secret ballot system in the College of Cardinals. Allegorical figures emphasize the pope's divine position: The Barberini bees are surrounded by the Theological Virtues: Faith, Hope, and Charity, while the papal tiara is carried by Rome and the Keys of St. Peter by Religion. As in the Farnese Gallery, the ceiling area is subdivided by a painted framework that simulates architecture and

sculpture, but beyond it we now see the limitless sky, as in Guercino's *Aurora*. Clusters of figures, perched on clouds or soaring freely, swirl above as well as below this framework. They create a dual illusion: Some figures appear to hover inside the hall, close to us, while others recede into the distance.

Cortona's frescoes were the focal point for the rift between the High Baroque, the exaggerated, triumphal style of the age, and the Baroque Classicism that grew out of the Farnese Gallery ceiling. The Classicists insisted that art serves a moral purpose and must observe the principles of clarity, unity, and decorum. And, supported by a tradition based on Horace's adage *ut pictura poesis*, they maintained that painting should follow the example of tragic poetry in conveying meaning through a minimum of figures whose movements, gestures, and expressions can be easily read. Cortona, while not anti-Classical, presented the case for art as epic poetry, with many actors and episodes that expand on the central theme and create a magnificent effect. He was also the first to argue that art has a

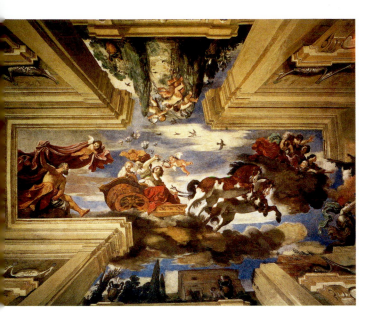

19.10. Guercino and Agostino Tassi. *Aurora*. 1621–1623. Ceiling fresco. Villa Ludovisi, Rome

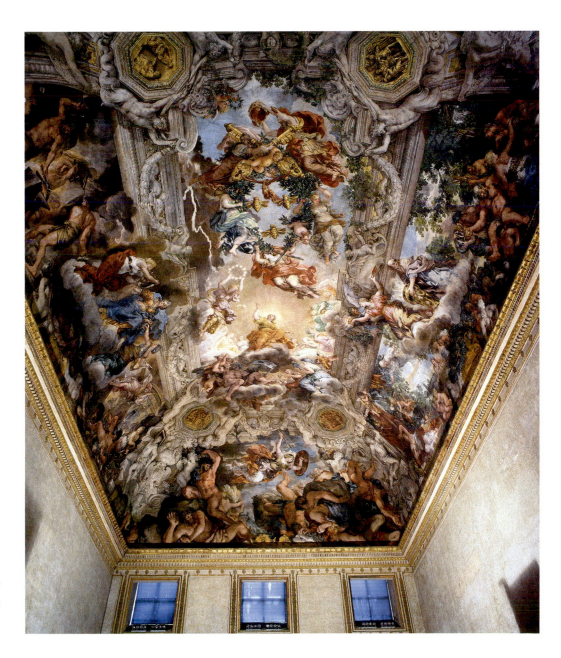

19.11. Pietro da Cortona. *Allegory of Divine Providence*. 1633–1639. Ceiling fresco from intended viewpoint. Palazzo Barberini, Rome

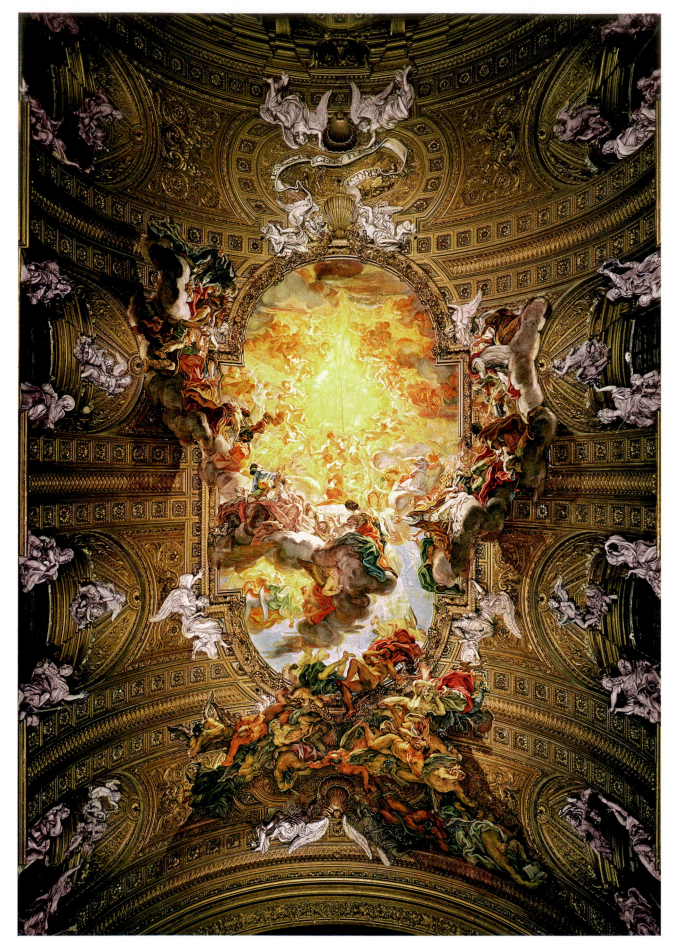

19.12. Giovanni Battista Gaulli. *Triumph of the Name of Jesus*. 1672–1679. Ceiling fresco. Il Gesù, Rome

sensuous appeal which exists as an end in itself. Although it took place largely on a theoretical level, the debate over illusionistic ceiling painting involved more than opposing approaches to telling a story and expressing ideas in art. The issue lies at the very heart of the Baroque. Illusionism allowed artists to overcome the apparent contradictions of the era by fusing separate levels of reality into a pictorial unity of such overwhelming grandeur as to sweep aside any differences between them. Despite the intensity of the debate, in practice the two sides rarely came into conflict over easel paintings, where the differences between Cortona's and Carracci's followers were not always so clear-cut. Surprisingly, Cortona found inspiration in Classical art and Raphael throughout his career. The leader of the reaction against the "excesses" of the High Baroque was neither a fresco painter nor an Italian, but a French artist living in Rome: Nicolas Poussin (see page 737), who moved early on in the same antiquarian circle as Cortona but drew very different lessons from it.

GIOVANNI BATTISTA GAULLI AND IL GESÙ It is a strange fact that few ceiling frescoes were painted after Cortona finished his *Divine Providence*. Ironically, the new style of architecture fostered by Francesco Borromini and Guarino Guarini (see pages 676–682) provided few opportunities for decoration. But after 1670 such frescoes enjoyed a revival in older buildings, and this revival reached its peak in the interior of Il Gesù (fig. 19.12), the Mother Church for the Jesuit Order. Although his role in this case was only advisory, it is clear that Gianlorenzo Bernini, the greatest sculptor-architect of the century (see page 674) must have planned this work. At his suggestion, the commission for the ceiling frescoes went to his young protégé Giovanni Battista Gaulli (1639–1709), known as Il Baciccio. A talented assistant, Antonio Raggi (1624–1686), made the stucco sculpture. The program, which proved extraordinarily influential, shows Bernini's imaginative daring. As in the Cornaro Chapel (see fig. 19.31), the ceiling is treated as a single unit that evokes a mystical vision. The nave fresco, with its contrasts of light and dark, spills dramatically over its frame, then turns into sculptured figures, combining painting, sculpture, and architecture. Here Baroque illusionism achieves its ultimate expression. The subject of the ceiling painting is the illuminated name of Jesus—the IHS—in the center of the golden light. It is a stirring reference both to the Jesuit Order, dedicated to the Name of Jesus and to the concept that Christ is the Light of the World. The impact of his light and holiness then creates the overflowing turbulance that tumbles out of the sky at the end of days and spreads the word of the Jesuit missionaries: "That at the name of Jesus, every knee should bow . . ." (Epistle of St. Paul to the Philippians, 2:10).

ARCHITECTURE IN ITALY

The Baroque style in architecture, like that of painting, began in Rome, which was a vast construction site from the end of the sixteenth through the middle of the seventeenth century.

ART IN TIME

1597—Carracci's *Loves of the Gods*

1599–1600—Caravaggio's *The Calling of St. Matthew*

1609—Galileo Galilei refines astronomical telescope

The goals of the Counter-Reformation caused the Church to embark on a major building campaign. New churches were constructed and the new St. Peter's was finally completed. Although many of the building projects began during Renaissance, they developed distinctly different characteristics as they were completed during the Baroque. Some architects continued to use a Classical vocabulary but expanded or stretched it, so that the idea of perfection was not considered a circle, but an oval or ellipse (a modern concept that was frequently the object of astonomical discussions). They incorporated domes based on Michelangelo's (fig. 17.17) but which had a steeper profile to suggest greater drama in punctuating the sky; others designed buildings based on amorphic shapes that used Classical ornamentations but not its principles.

The Completion of St. Peter's and Carlo Maderno

Carlo Maderno (ca. 1556–1629) was the most talented young architect to emerge in the vast ecclesiastical building program that commenced in Rome toward the end of the sixteenth century. In 1603, he was given the task of completing, at long last, the church of St. Peter's (fig. 19.13). Pope Clement VIII had decided to add a nave and narthex to the west end of Michelangelo's building, thereby converting it into a basilica plan. The change of plan, which had already been proposed by Raphael in 1514, made it possible to link St. Peter's with the Vatican Palace to the right of the church (fig. 19.14).

Maderno's design for the facade follows the pattern established by Michelangelo for the exterior of the church. It consists of a colossal order supporting an attic, but with a dramatic emphasis on the portals. The effect can only be described as a crescendo that builds from the corners toward the center. The spacing of the supports becomes closer, the pilasters turn into columns, and the facade wall projects step by step. This quickened rhythm had been hinted at a generation earlier in Giacomo della Porta's facade of Il Gesù (see fig. 17.21). Maderno made it the dominant principle of his facade designs, not only for St. Peter's but for smaller churches as well. In the process, he replaced the traditional concept of the church facade as one continuous wall surface, which was not yet challenged by the facade of Il Gesù, with the "facade-in-depth," dynamically related to the open space before it. The possibilities of this new treatment, which derives from Michelangelo's Palazzo dei Conservatori (fig. 17.16), were not to be exhausted until 150 years later. Recent cleaning of the facade of St. Peter's revealed it to be of a warm cream color, which emphasized its sculptural qualities.

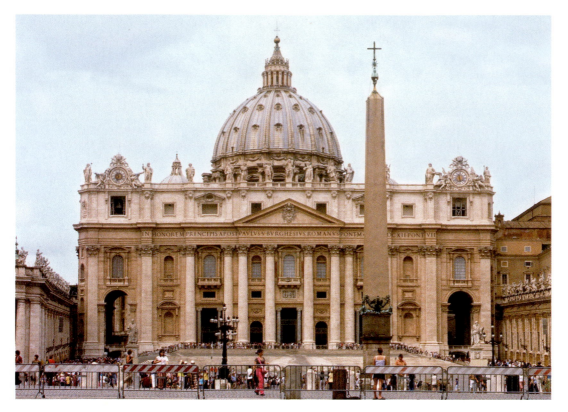

19.13. Carlo Maderno. Facade of St. Peter's. Rome. 1607–1612

Bernini and St. Peter's

After Maderno's death in 1629, his assistant Gianlorenzo Bernini (1598–1680) assumed the title "architect of St. Peter's." Considering himself Michelangelo's successor as both architect and sculptor, Bernini's directed the building campaign and coordinated the decoration and sculpture within the church as well. Given these tasks, the enormous size of St. Peter's posed equal challenges for anyone seeking to integrate architecture and sculpture. How could its vastness be related to the human scale and given a measure of emotional warmth? Once the nave was extended following Maderno's design, Bernini realized that the interior needed an internal focal point in this vast space. His response was to create the monumental sculptural/architectural composite form, known as the *Baldacchino* (fig. **19.15**), the

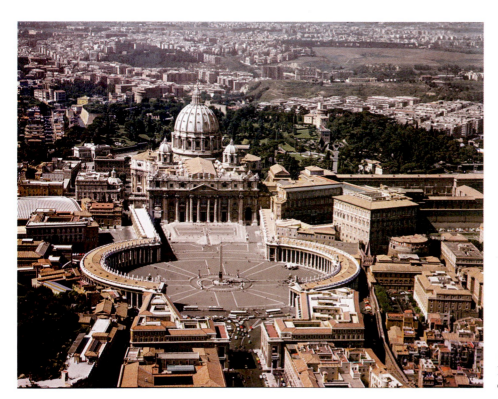

19.14. Aerial view of St. Peter's. Rome. Nave and facade by Carlo Maderno, 1607–1612; colonnade by Gianlorenzo Bernini, designed 1657

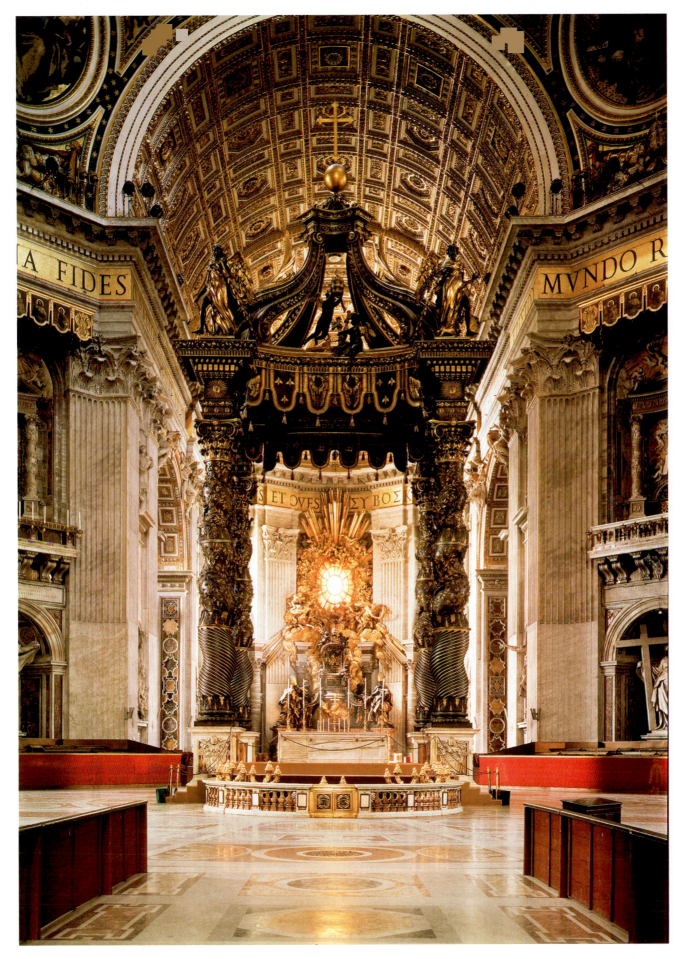

19.15. Bernini, *Baldacchino*. 1624–1633. At crossing. St. Peter's, Rome

"canopy" for the main altar of St. Peter's, at the very crossing of the transept and the nave, directly under Michelangelo's dome (see fig. 17.17) and just above the actual crypt of St. Peter where the Pope would celebrate the mass. This nearly 100-foot sculptural/architectural piece created mostly in bronze stripped from the ancient Pantheon (see fig. 7.39, stands on four twisted) columns, reminiscent of those from the original St. Peter's (and thought, too, to replicate those of Solomon's Temple). Rather than an architectural entablature mounted between the columns, Bernini inventively suggests fabric hanging between them. The *Baldacchino* is a splendid fusion of sculpture and architecture. At its corners are statues of angels and vigorously curved scrolls, which raise a cross above a golden orb, the symbol of the triumph of Christianity throughout the world. The entire structure is so alive with expressive energy that it may be considered as the epitome of Baroque style. In a related tribute, we see through the columns of the *Baldacchino* to the sculptural reliquary of the throne of St. Peter, the *Cathedra Petri* in the apse of the church, also designed by Bernini.

The papal insignia—the triple crown and crossed keys of St. Peter—and the coat of arms of the pope under whose patronage this structure was created—the Barberini bees of Urban VIII—are significant elements of decoration in the *Baldacchino*. These same identifiers can also be seen in Cortona's Barberini ceiling (see fig. 19.11). Bernini's *Baldacchino* honors not just the power and majesty of God, but that of his emissary on Earth, the pope. Bernini's relationship with the pope was one of the most successful and powerful ones in the history of patronage. Indeed, upon elevation to the papacy, Urban VIII was said to have told the artist: "It is your great good luck, Cavaliere, to see Maffeo Barberini pope; but We are even luckier in that Cavaliere Bernini lives at the time of our pontificate." (However, the artistic aims of this pope drained the papal treasury and both the pope and, by association, Bernini were blamed for the excesses after Urban's death.) As Bernini directed our attention within the church, he also (later, under the patronage of Pope Alexander VII (1655–1667) orchestrated our entrance into St. Peter's. Thus he molded the open space in front of the facade into a magnificent oval piazza that is amazingly sculptural (see fig. 19.14). This "forecourt," which imposed a degree of unity on the sprawling Vatican complex, acts as an immense atrium framed by colonnades, while screening off the surrounding slums. This device, which Bernini himself likened to the motherly, all-embracing arms of the Church, is not new. It had been used at private villas designed by Jacopo Vignola for the Farnese in the 1550s; but these were, in effect, *belvederes* opening onto formal gardens to the rear. What is novel is the idea of placing it at the main entrance to a building. Also new is the huge scale. For sheer impressiveness, this integration of architecture and grandiose setting can be compared only with the ancient Roman sanctuary at Palestrina (see fig. 7.6). Bernini's one major failure in the visual effect of St. Peter's was his inability to execute the bell towers that were initially planned

by Bramante (see fig. 16.10). He began construction, but they were found to be structurally unsound and physically damaging to the facade; they had to be dismantled. This failure would haunt him, but would provide a competitive resource for his rival Borromini in Italy and later Wren in England.

Architectural Components in Decoration

The huge scale, the dynamic sculptural vitality, and the ornamentation of Baroque architecture were expressed in the decorative arts as well. The five foot high clock seen in figure **19.16** is made of colorful marble, lapis lazuli, black ebony, and gilt bronze with an oil on copper painting.

Clocks in the seventeenth century were not yet accurate, certainly not silent, and not readible at night. This clock was known as an *orologio della notte* (nocturnal clock)—a clock that would work even at night, an innovation that was designed by Pier Tommaso Campani (active ca. 1650–1700). A nocturnal clock had been seen by Bernini in France in 1665 and was considered a true marvel. This clock was made for Pope Alexander VII, a known insomniac, who requested a clock that could display time even in darkness and run without sound. The time here is expressed in Roman numerals, pierced so that light from a hidden oil lamp could pass through them; a drum was used to quash the ticktocking sound of a pendulum.

The clock was encased in an elaborate architectural structure with paired columns, scrolled feet, and resembles a tabernacle. It shows the influence of both Bernini and Borromini. The painting at its center, by Francesco Trevisani (1656–1746), is the *Flight into Egypt*. This theme is a pun on time—as time also flees (flies). Trevisani was a well-known Roman painter, and this was no small commission. Indeed, we know that Gaulli, the painter of the ceiling of Il Gesù (fig. 19.12), also executed paintings for such clocks.

A Baroque Alternative: Francesco Borromini

As a personality, Bernini represents a type we first met among the artists of the Early Renaissance, a self-assured person of the world. His greatest rival in architecture, Francesco Borromini (1599–1667), was just the opposite: a secretive and emotionally unstable genius who died by suicide. The Baroque heightened the tension between the two types. The contrast between these two would be evident from their works alone, even without the accounts by their contemporaries. Both represent the climax of Baroque architecture in Rome. Yet Bernini's church designs are dramatically simple and unified, while Borromini's structures are extravagantly complex. And whereas the surfaces of Bernini's interiors are extremely rich, Borromini's are surprisingly plain. They rely on Borromini's phenomenal grasp of spatial

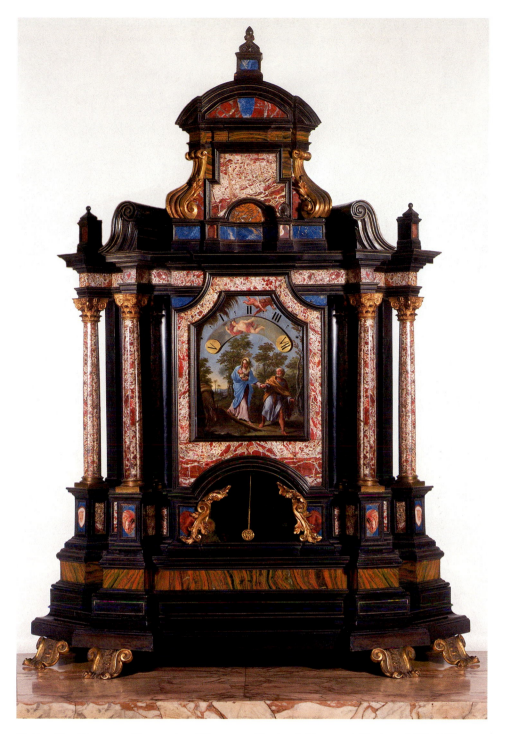

19.16. Pier Tommaso Campani and Francesco Trevisani. *Nocturnal Clock*. ca. 1680–1690. Ebony and other types of hardwood, oil on copper, gilt bronze, colored stones, 63 × 45$\frac{1}{4}$ × 18$\frac{1}{2}$″ (160 × 115 × 47 cm). Pinacoteca Capitolini, Rome

geometry to achieve their spiritual effects. Bernini himself agreed with those who denounced Borromini for flagrantly disregarding the Classical tradition, enshrined in Renaissance theory and practice, that architecture must reflect the proportions of the human body. Surely, of the two, Bernini, even at the height of the Baroque, was the one more tied to a Classical vocabulary. But perhaps Bernini's criticism of Borromini only represented all-too-human rivalries.

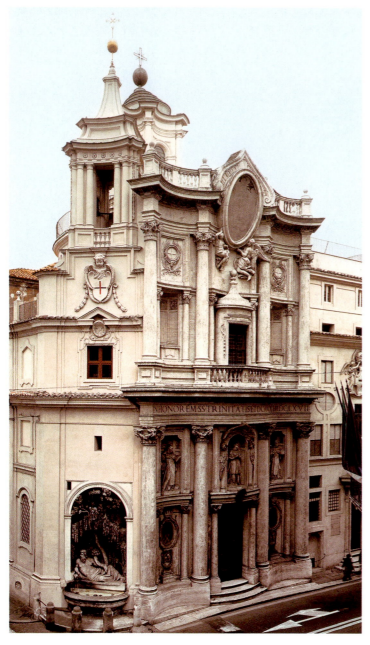

SAN CARLO ALLE QUATTRO FONTANE Borromini's first major project was the church of San Carlo alle Quattro Fontane (figs. **19.17**, **19.18**, and **19.19**), a small structure on a difficult-to-fit corner, yet it is the syntax, not the vocabulary, that is new and disquieting. The ceaseless play of concave and convex surfaces makes the entire structure seem elastic, as if pulled out of shape by pressures that no previous building could have withstood. The plan (fig. 19.18) is a pinched oval that suggests a distended and half-melted Greek cross. The inside of the coffered dome (fig. 19.19), like the plan, looks "stretched": If the tension were relaxed, it would snap back to normal. Light coming from the windows, partially hidden at the base of the dome, and a honeycomb of fanciful coffers make the dome appear weightless. The symbol of the Trinity appears in the vault of the lantern in this church, built for the Trinitarians, an order dedicated to the mysteries of the Holy Trinity.

On the facade (fig. 19.17), designed almost 30 years later, the pressures and counterpressures reach their maximum intensity. Borromini merges architecture and sculpture in a way that must have shocked Bernini. No such union had been attempted since Gothic art. The statues above the entrance appear to emerge like actors entering a stage from behind a thin screen. The sculptures, interestingly enough, are by Bernini's assistant Antonio Raggi, who also worked on the ceiling of Il Gesù (fig. 19.12). San Carlo alle Quattro Fontane established the architect's fame. "Nothing similar," wrote the head of the religious order for which the church was built, "can be found anywhere in the world. This is attested by the foreigners who ... try to procure copies of the plan. We have been asked for them by Germans, Flemings, Frenchmen, Italians, Spaniards, and even Indians."

SANT' IVO Borromini's church of Sant'Ivo alla Sapienza (figs. **19.20** and **19.21**) was built at the end of an existing cloister for a university, which soon became the University of Rome. It is more compact than San Carlo, but equally daring. Sant'Ivo is a small, central-plan church based on a star-hexagon. The six-pointed star plan represents Sapienza (wisdom), although as the church was first built under Pope Urban VIII (Barberini) it was suggested by contemporaries that the plan represented the Barberini bee, also seen in Bernini's *Baldacchino* and Cortona's ceiling (figs. 19.15 and 19.11). In designing this unique church, Borromini may have been thinking of octagonal structures, such as San Vitale in Ravenna (fig. 8.21), but the result is completely novel. Inside, it is a single, unified, organic experience, as the walls extend the ground plan into the vault, culminating in Borromini's unique, spiral lantern. It continues the star-hexagon pattern up to the circular base of the lantern. The stars on the wall refer to the Chigi family of Pope Alexander VII, who was reigning when the building was completed.

19.17. Francesco Borromini. Facade of San Carlo alle Quattro Fontane, Rome. ca.1665–1667

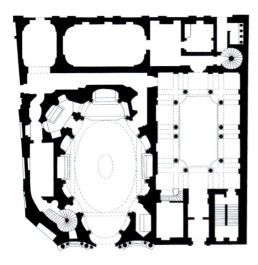

19.18. Plan of San Carlo alle Quattro Fontane. 1638–1641

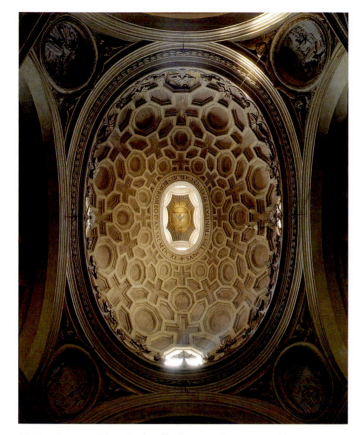

19.19. Dome of San Carlo alle Quattro Fontane. 1638–1641

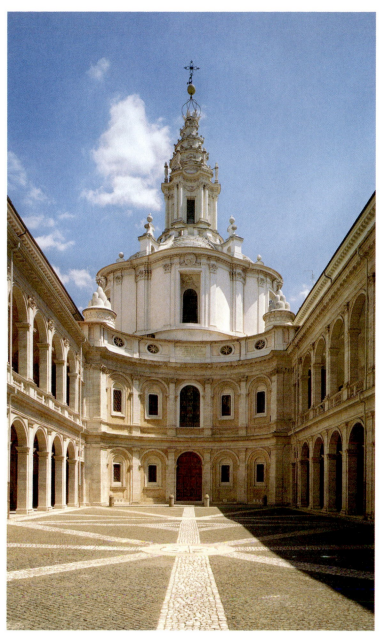

19.20. Francesco Borromini. Exterior of Sant'Ivo. Rome.
Begun 1642

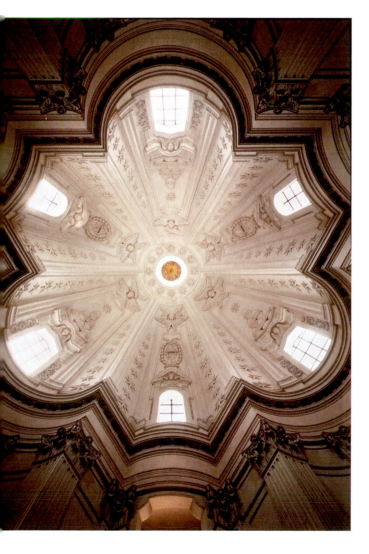

19.21. Dome of Sant'Ivo

SANT'AGNESE A third project by Borromini, Sant'Agnese in Piazza Navona (figs. **19.22** and **19.23**), is of special interest as a critique of St. Peter's. There were two problems that Maderno had been unable to solve at St. Peter's. Although his facade forms an impressive unit with Michelangelo's dome when seen from a distance, the dome is gradually hidden by the new facade as we approach the church. It appears to "sink." Furthermore, the towers he planned for each end posed formidable structural difficulties. After his first attempt to overcome these

problems failed, Bernini proposed making the towers free-standing, but he was forced to abandon the plan when it was severely criticized. The facade of Sant'Agnese is a brilliant solution to both of these issues. Borromini took over the project, which had been begun by another architect, Carlo Rainaldi (1611–1691), the year before, and he completely recast it without completely abandoning the Greek-cross plan. The design is essentially a central-plan (fig. 19.23), and the dome is not set back at all. The facade's lower part is adapted from the facade of St. Peter's, but it curves inward, so that the dome (a tall, slender version of Michelangelo's) functions as the upper part of the facade. As the dome is nearly at the entranceway, the problem of a "sinking" dome is solved—but of course without the inherent difficulty found in St. Peter's and its Latin-cross plan. The dramatic juxtaposition of concave and convex, so characteristic of Borromini, is emphasized by the two towers, which form a monumental group with the dome. Once again Borromini joins Gothic and Renaissance features—the two-tower facade and the dome—into a remarkably elastic compound.

The Baroque in Turin: Guarino Guarini

The new ideas introduced by Borromini were developed further not in Rome but in Turin, the capital of Piedmont, which became the creative center of Baroque architecture in Italy toward the end of the seventeenth century. In 1666, Guarino Guarini (1624–1683), Borromini's most brilliant successor, was called to Turin as an engineer and mathematician by Duke Carlo Emanuele II. Guarini was a Theatine priest whose genius was grounded in philosophy and mathematics. His design for the facade of the Palazzo Carignano (figs. **19.24** and **19.25**) for the cadet branch of the House of Savoy repeats on a larger scale the undulating movement of San Carlo alle Quattro Fontane (see fig. 19.17), using a highly individualized vocabulary. Incredibly, the exterior of the building, in the local tradition, is almost entirely of brick, but was probably meant to be stuccoed in imitation marble.

Even more extraordinary is Guarini's dome of the Chapel of the Holy Shroud, a round structure attached to Turin Cathedral (fig. **19.26**). The dome and the tall drum, with its alternating windows and niches, consists of familiar Borrominian motifs. Yet it ushers us into a realm of pure illusion completely unlike anything by the earlier architect. Here, the surface has disappeared in a maze of ribs that is both unusual and exotic, created though the manipulation of repeated geometric forms. As a result, we find ourselves staring into a huge kaleidoscope. Above this seemingly infinite funnel of space hovers the dove of the Holy Spirit within a 12-point star inside the chapel, which holds one of the most precious relics of Christendom, the Shroud of Christ.

Guarini's dome retains the symbolic meaning of the dome of heaven. It repeats architecturally what Correggio achieved in painting in his *Assumption of the Virgin* (fig. 17.25). A concentric structure of alternating rings of light and shadow enhances the illusion of great depth and features brilliant light at its center, and it also recalls the passion of Christ. The objective harmony of the Renaissance has become subjective, a compelling

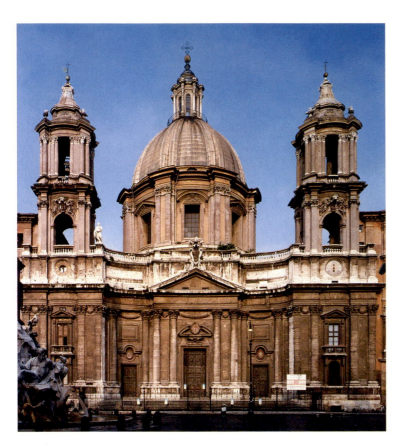

19.22. Francesco Borromini. Sant'Agnese in Piazza Navona, Rome. 1653–1663

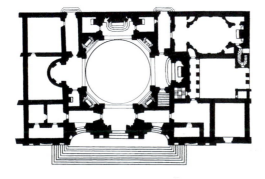

19.23. Francesco Borromini. Plan of Sant'Agnese

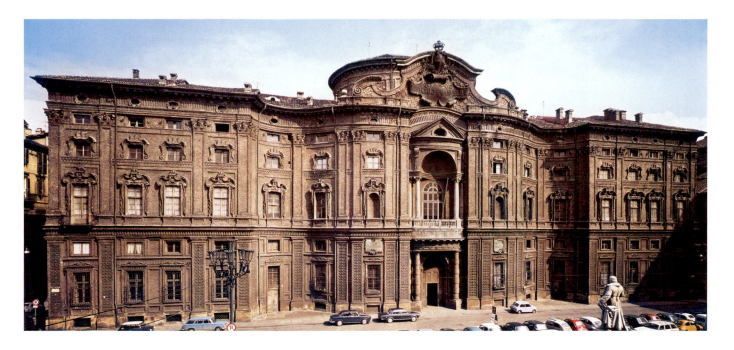

19.24. Guarino Guarini. Facade of Palazzo Carignano. Turin. Begun 1679

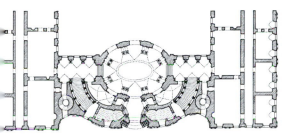

19.25. Plan of Palazzo Carignano

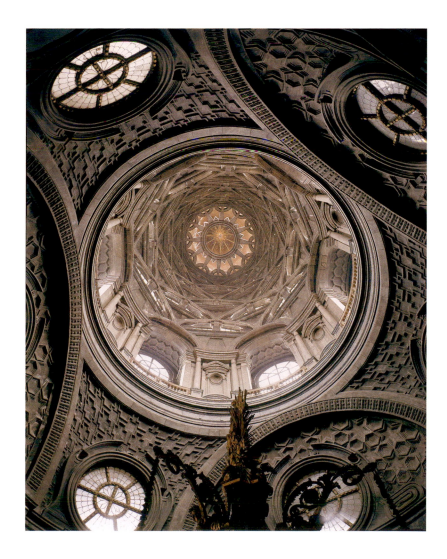

19.26. Guarino Guarini. Dome of the Chapel of the Holy Shroud. Turin Cathedral. 1668–1694

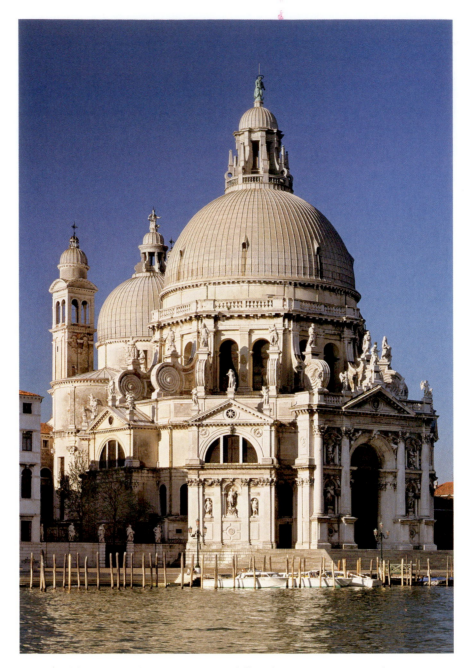

19.27. Baldassare Longhena. Santa Maria della Salute. Venice. 1631–1687

experience of the infinite, close to the Gothic mysticism of Abbot Suger's infinite (see pages 388–389). If Borromini's style at times suggests a fusion of Gothic and Renaissance, Guarini takes the next step. In his writings, Guarini contrasts the "muscular" architecture of the ancients with the effect of Gothic churches, which appear to stand only by means of some kind of miracle, and he expresses equal admiration for both. This attitude corresponds exactly to his own practice. Guarini and Borromini were obsessed with originality and were willing to break architectural rules to achieve it. By using the most advanced mathematical techniques of his day, he achieved wonders even greater than the seeming weightlessness of Gothic structures. The dome itself, for example, is on three pendentives instead of the usual four—a completely fresh approach to a traditional form.

The Baroque in Venice: Baldassare Longhena

At the head of the Grand Canal in Venice, the church of Santa Maria della Salute (fig. **19.27**) was commissioned by the Republic to commemorate the end of the plague of 1630. It was built by Baldassare Longhena (1598–1682). Begun in 1631 and consecrated in 1687, after Longhena's death, it took the heart of the century to complete and rivals the masterpieces of Rome. "*Salute*" ("Health") dominates the Grand Canal and has since become a focal point on the Venice skyline—unique, graceful, Classical, yet ornate.

The most important aspect of the building is that its plan is that of a regular octagon whose distinctive shape can be seen on its multiple facades, with a dome rising from its center. Each face

is a double-columned triumphal arch whose columns stand on high pedestals. The entablature is joined to the drum in a series of large sculptural volutes that are both elegant and distinctive. The details—drum, double columns, and octagonal shape—all have their sources in the early Church, and in works by Bramante and Palladio, but they became the hallmark of the Baroque in Venice.

SCULPTURE IN ITALY

Baroque sculpture, like Baroque painting, was vital, energized, and dynamic, suggesting action and deep emotion. The subject matter was intended to evoke an emotional response in the viewer. The sculpture was usually life-size, but with a sense of grandeur that suggested larger than life-size figures; and many figures were indeed monumental. Deeply cut, the facial expressions and clothing caught the light and cast shadows to create not just depth but drama.

Early Baroque Sculpture: Stefano Maderno

Baroque sculpture began with the delicate naturalism of *Santa Cecilia* (fig. **19.28**) by Stefano Maderno (ca. 1576–1636). Rather than standing as a living saint, as with almost all depictions of saints, Maderno created *Santa Cecilia* as a recumbent dead body. This fifth-century saint's body had been found, uncorrupted, just a year before in the church of Santa Cecilia in Trastevere. The recovery of her body prompted numerous depictions in the Baroque of Santa Cecilia, the patron saint of music, but always showing her young, alive, engaged, and often playing a musical instrument. Here she lies on her right

side, on a slab of marble, her dress pulled between her knees and down to her toes as if lying on a bed rather than a morgue slab. The cut in her neck and her head twisted away indicate she is dead. She lies somehow vulnerable even in her death, evoking pathos. The poignancy of this depiction is one of the characteristics of the Baroque.

The Evolution of the Baroque: Gianlorenzo Bernini

Bernini was a sculptor as well as an architect, and sculpture and architecture are never far apart in his work as we have seen in the *Baldacchino* (fig. 19.15). He was trained by his father, Pietro Bernini (1562–1629), a sculptor who worked in Florence, Naples, and Rome, but was also influenced by Giovanni Bologna (see fig. 17.10). Bernini's style was thus a direct outgrowth of Mannerist sculpture in many ways, but this debt alone does not explain his revolutionary qualities, which emerged early in his career.

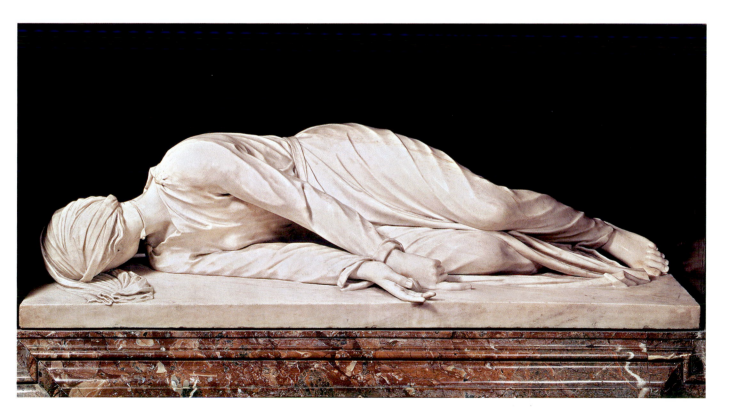

19.28. Stefano Maderno. *Santa Cecilia*. 1600. Marble, life-size. Santa Cecilia in Trastevere, Rome

DAVID As in the colonnade for St. Peter's (see fig. 19.14), we can often see a strong relationship between Bernini's sculpture and antiquity. If we compare Bernini's *David* (fig. **19.29**) with Michelangelo's (see fig. 16.13) and ask which is closer to the Pergamon frieze or *The Laocoön* (see fig. 5.74 and page 179), our vote must go to Bernini, whose sculpture shares with Hellenistic works that union of body and spirit, of motion and emotion, which Michelangelo so consciously tempers. This does not mean that Michelangelo (who had witnessed the unearthing of *The Laocoön*) is more Classical than Bernini. It shows, rather, that both the Baroque and the High Renaissance drew different lessons from ancient art.

Bernini's *David* suggests the fierceness of expression, movement, and dynamism of *The Laocoön* (see *Materials and Techniques* page 687). In part, what makes it Baroque is the implied presence of Goliath. Unlike earlier statues of David, including Donatello's (see fig. 15.35), Bernini's is conceived not as a self-contained figure but as half of a pair, his entire action focused on his adversary. His *David* tells us clearly enough where he sees the enemy. Consequently, the space between David and his invisible opponent is charged with energy—it "belongs" to the statue.

Bernini's *David* shows us the distinctive feature of Baroque sculpture: its new, active relationship with the surrounding space. But it is meant to be seen, as is most other Baroque sculpture, from one primary point of view. Bernini presents us with "the moment" of action, not just the contemplation of the killing—as in Michelangelo's work—or the aftermath of it, as in Donatello's. Baroque sculpture often suggests a heightened vitality and energy. It rejects self-sufficiency in favor of the illusion of a presence or force implied by the action of the statue. Because it so often presents an "invisible complement" (like the Goliath of Bernini's *David*), Baroque statues attempt pictorial effects that were traditionally outside the realm of monumental sculpture. Such a charging of space with energy is, in fact, a key feature of Baroque art. Caravaggio had achieved it in his *St. Matthew* with the aid of a sharply focused beam of light. And as we have seen in Gaulli's ceiling of Il Gesù (fig. 19.12), both painting and sculpture may even be combined with architecture to form a compound illusion, such as that seen on a stage.

THE CORNARO CHAPEL: *THE ECSTASY OF ST. THERESA* Bernini had a passionate interest in the theater and was an innovative scene designer. A contemporary wrote that Bernini "gave a public opera wherein he painted the scenes, cut the statues, invented the engines, composed the music, writ the comedy, and built the theatre." Thus he was at his best when he could merge architecture, sculpture, and painting (see end of Part III *Additional Primary Sources*.) His masterpiece in this vein is the Cornaro Chapel in the church of Santa Maria della Vittoria, containing the famous group *The Ecstasy of St. Theresa* (figs. **19.30** and **19.31**). Theresa of Ávila, one of the great saints of the Counter-Reformation and newly canonized only in 1622, had described how an angel pierced her heart with a flaming golden arrow: "The pain was so great that I screamed aloud; but at the same time I felt such infinite sweetness that I wished the pain to last forever. It was not physical but psychic pain, although it affected the body as well to some degree. It was the sweetest caressing of the soul by God."

Bernini has made Theresa's visionary experience as sensuously real as Correggio's *Jupiter and Io* (see fig. 17.24), and the saint's rapture is obvious. (In a different context the angel could be Cupid.) The two figures on their floating cloud are lit from a hidden window above, so that they seem almost dematerialized. A viewer thus experiences them as visionary. The "invisible complement" here, less specific than *David*'s but equally important, is the force that carries the figures toward heaven and causes the turbulence of their drapery. Its divine nature is suggested by the golden rays, which come from a source high above the altar. In an illusionistic fresco by Guidobaldo Abbatini on the vault of the chapel, the glory of the heavens is revealed

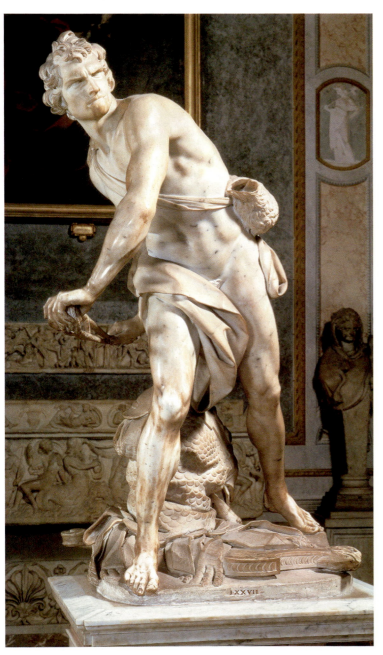

19.29. Gianlorenzo Bernini. *David*. 1623. Marble, life-size. Galleria Borghese, Rome

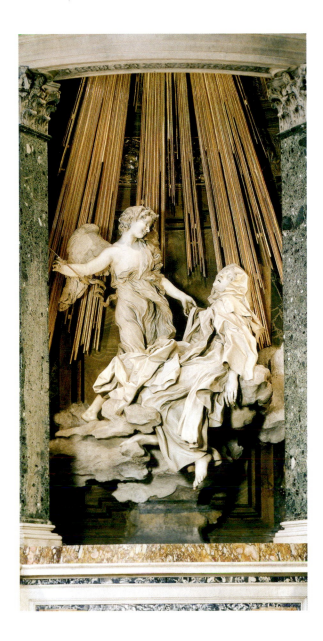

19.30. Gianlorenzo Bernini. *The Ecstasy of St. Theresa* (detail of sculptural group). 1645–1652. Marble, life-size. Cornaro Chapel, Santa Maria della Vittoria, Rome

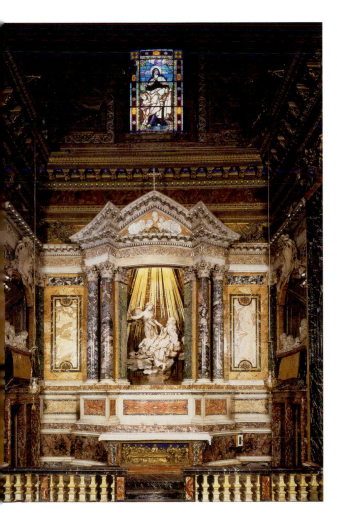

19.31. Gianlorenzo Bernini. *The Ecstasy of St. Theresa* (full chapel view). 1645–1652. Marble, life-size. Cornaro Chapel, Santa Maria della Vittoria, Rome

as a dazzling burst of light from which tumble clouds of jubilant angels. This celestial explosion gives force to the thrusts of the angel's arrow and makes the ecstasy of the saint fully believable.

To complete the illusion, Bernini even provides a built-in audience for his "stage." On the sides of the chapel are balconies resembling theater boxes that contain marble figures depicting members of the Cornaro family, who also witness the vision. Their space and ours are the same, and thus are part of everyday reality, while the saint's ecstasy, which is framed in a niche, occupies a space that is real but beyond our reach, for it is intended as a divine realm.

Finally, the ceiling fresco represents the infinite space of heaven. We may recall that *The Burial of Count Orgaz* and its setting also form a whole that includes three levels of reality (see fig. 18.12). Yet there is a fundamental difference between the two chapels. El Greco's mannerism evokes an ethereal vision in which only the stone slab of the sarcophagus is "real,"

ART IN TIME

1607—First opera, *L'Orfeo* by Claudio Montverdi, performed

1622—Ignatius Loyola, founder of the Jesuit Order and Francis
 Xavier, Theresa of Ávila, Philip Neri, all canonized

1645—Bernini's *The Ecstasy of St. Theresa*

in contrast to Bernini's Baroque staging, where the distinction nearly breaks down. It would be easy to dismiss *The Ecstasy of St. Theresa* as a theatrical display, but Bernini also was a devout Catholic who believed (as did Michelangelo) that he was inspired directly by God. Like the *Spiritual Exercises* of Ignatius of Loyola, which Bernini practiced, his religious sculpture is intended to help a viewer identify with miraculous events through a vivid appeal to the senses. Theatricality in the service of faith was basic to the Counter-Reformation, which often referred to the Church as the theater of human life: It took the Baroque to bring this ideal to life.

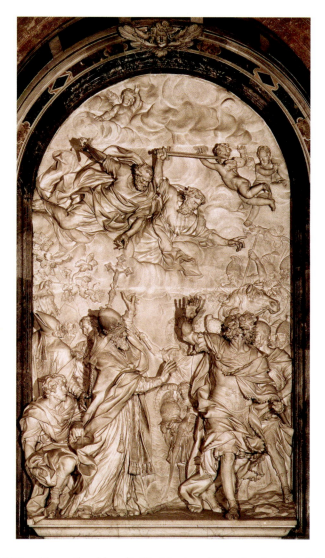

19.32. Alessandro Algardi. *The Meeting of Pope Leo I and Attila*.
1646–1653. Marble, 28′1³/₄″ × 16′2¹/₂″ (8.5 × 4.9 m).
St. Peter's, The Vatican, Rome

Bernini was steeped in Renaissance humanism. Central to his sculpture is the role of gesture and expression in arousing emotion. While these devices were also important to the Renaissance (as we have seen with Leonardo), Bernini uses them with a freedom that seems anti-Classical. However, he essentially followed the concept of decorum (which also explains why his *David* is not completely nude), and he planned his effects carefully by varying them in accordance with his subject. Unlike the Frenchman Nicolas Poussin (whom he respected, as he did Annibale Carracci), Bernini did this for the sake of expressive impact rather than conceptual clarity. The approaches of the two artists were diametrically opposed as well. For Bernini, antiquity served as no more than a point of departure for his own inventiveness, whereas for Poussin it was a standard of comparison. It is nevertheless characteristic of the Baroque that Bernini's theories were far more orthodox than his art. Thus he often sided with the Classicists against his fellow High Baroque artists, especially Pietro da Cortona, who, like Raphael before him, also made an important contribution to architecture and was a rival in that sphere.

A Classical Alternative: Alessandro Algardi

It is no less ironic that Cortona was the closest friend of the sculptor Alessandro Algardi (1598–1654), who is regarded as the leading Classical sculptor of the Italian Baroque. His main contribution is *The Meeting of Pope Leo I and Attila* (fig. **19.32**), done when he took over Bernini's role at St. Peter's during the papacy of Innocent X. It introduces a new kind of high relief that soon became widely popular. Bernini avoided doing reliefs (his studio executed this area of projects when he had to do them), but Algardi liked working in this more pictorial sculptural form.

The scene depicts the Huns under Attila being driven away after threatening an attack on Rome in 452, a fateful event in the early history of Christianity, when its very survival was at stake. (The actual event was very different: Leo persuaded the Huns not to attack, just as he did with the Vandals three years later. Both protagonists were on horseback, not on foot as seen here.) The subject revives one that is familiar to us from antiquity: the victory over barbarian forces. Now, however, it is the Church, not civilization, that triumphs, and the victory is spiritual rather than military.

The commission was given for a sculpture because water condensation caused by the location in an old doorway of St. Peter's (and through most of the church) made a painting impossible. But the viewing problems for a painting were also difficult for relief sculpture. Never before had an Italian sculptor attempted such a large relief—it stands nearly 28 feet high (nearly twice the height of Ghiberti's bronze doors, *The Gates of Paradise*, fig. 15.22). The problems posed by translating a pictorial conception (it had been treated by Raphael in one of the Vatican Stanze) into a relief on this gigantic scale were formidable. If Algardi has not succeeded in resolving every detail, his

Bernini's Sculptural Sketches

Small sketches in sculpture—for large-scale sculpture or architecture—serve as models, practice-pieces, or as presentation pieces for the artist to show a patron. These sculptural models are called *bozzetti* or *modelli*. A *bozzetto* (singular) means a sketch, and *bozzetti* are generally smaller and less finished than *modelli*, which may be closer to the final product, or in some other way "finished" as a work for a patron to see before the completion of the final project.

Artists may do several drawings as well as several *bozzetti* for a completed piece. And, indeed, Bernini did both drawings in pen and ink, in red or black chalk, or even in combinations of chalk and pen in preparation for a project, as well as making *bozzetti*. Bernini's *bozzetti* and *modelli* are made in clay (terra cotta), although the completed sculptures were executed in marble. This is not just a difference in medium, but in technique. Marble sculpture is created through a subtractive process—marble is chiseled away. But clay can be worked with both additive and subtractive methods, and we know that Bernini's work in clay was primarily additive.

We can see multiple methods and evidence of a variety of tools used by Bernini in his clay *bozzetto* of the life-size *Head of St. Jerome*, created for a life-size, full-length marble sculpture of the saint. Analysis of the clay sculpture has shown that this piece, as many others, was made from wedged clay—that is, fresh clay that is rolled, smashed, and rolled repeatedly to expel air from the clay, and then subsequently "worked." The clay is worked on by hand, with fingers (most probably the thumbs, index fingers, and middle fingers), with fingernails creating tracks, and with tools that often have teeth.

The idea that the clay is worked on by the artist with his own hands—his own fingers—is a tantalizing one. Large-scale sculpture and complex sculptural and architectural projects may employ several assistants chiseling marble. But here in a *bozzetto* we may be seeing the handwork—the very fingerprints—of the artist. Several of Bernini's *bozzetti* have been examined for fingerprints in the clay, and indeed many have been found. Of the fifteen Bernini *bozzetti* at the Fogg Art Museum (the largest single collection of his *bozzetti*), thirteen have fingerprints and multiple examples of them. Thirty-four fingerprints have been found and some of the same prints have been found in works executed years apart. Therefore, it is most likely that these prints are Bernini's own. He smoothed surfaces, added clay, created lines and edges with his nails, wiped and depressed the clay with his own fingers.

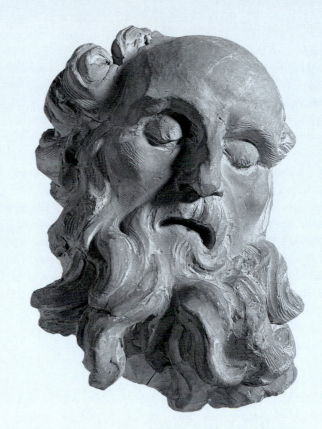

Gianlorenzo Bernini, *Head of St. Jerome*, ca. 1661. Terra cotta, height 14¼″ (36.2 cm). Courtesy of the Fogg Art Museum, Harvard University Art Museum, Cambridge, MA. Alpheus Hyatt Purchasing and Friends of the Fogg Art Museum Funds, 1937.77

The *Head of St. Jerome* reveals Bernini's fingerprints, evidence of nail edging, texturing from tined tools as he added more clay to represent the hair and nose. We know that the clay was hollowed out from the back, after being scooped out with fingers. As clay would be added to the face and hair, chances of cracking and breaking off increased. And we see much evidence of cracking in this *bozzetto*. It is apparent that areas were specifically smoothed over to prevent this. There is further evidence that a cloth was placed over the *Head* to keep the clay moist for continued work and to prevent further cracking.

The *Head of St. Jerome* is enormously expressive, looking tortured, pained, with his deep-set eyes, hollow cheeks, gaunt face, but it is the textures in clay that make this visage most memorable.

achievement is stupendous nonetheless. By varying the depth of the carving, he nearly convinces us that the scene takes place in the same space as ours. The foreground figures are in such high relief that they seem detached from the background. To emphasize the effect, the stage on which they are standing projects several feet beyond its surrounding niche. Thus Attila seems to rush out toward us in fear and astonishment as he flees the vision of the two apostles defending the faith. The result is surprisingly persuasive in both visual and expressive terms.

Such illusionism is quintessentially Baroque. So is the intense drama, which is heightened by the twisting poses and theatrical gestures of the figures. Algardi was obviously touched by Bernini's genius. Strangely enough, the relief is partly a throwback to an *Assumption of the Virgin* of 1606–1610 in Santa. Maria Maggiore by Bernini's father, Pietro. Only in his observance of the three traditional levels of relief carving (low, middle, and high, instead of continuously variable depth), his preference for frontal poses, and his restraint in dealing with the violent action can Algardi be called a Classicist, and then purely in a relative sense. Clearly we must not draw the distinction between the High Baroque and Baroque Classicism too sharply in sculpture any more than in painting.

Politics, art, and a common bond of loyalty to the Catholic Church connected Italy and Spain in the seventeenth century. Spain, still in the throes of the Inquisition (a medieval institution that was established separately in Spain in 1478 to enforce religious orthodoxy and revived in Italy in 1542), was staunchly conservative and unflinching; their king was titled "The Most Catholic Majesty." Spain restricted the Church to only those who professed their unaltering loyalty, and imprisoned, executed, or expelled those who did not, while the Vatican used its resources to bring reformers and the disaffected back to the Church. The Counter-Reformation, or Catholic Reform, began in Rome with a style—Baroque— intended to convince viewers of the dynamism and power of the Catholic Church, its patrons, and defenders. And, at the beginning of the seventeenth century, the largest city on the Italian mainland, Naples, was under the rulership of Spain. So the impact of Baroque Roman art on Neopolitan and Spanish art was profound.

At the height of its political and economic power during the sixteenth century, Spain had produced great saints and writers, but no artists of the first rank. Nor did El Greco's presence stimulate native talent. The Spanish court and most of the aristocracy held native artists in low esteem, so that they preferred to employ foreign painters whenever possible—above all Titian. Thus the main influences came from Italy and the Netherlands, which was then ruled by Spain. Jan van Eyck (see pages 479–485) visited Spain and inspired followers there, Titian worked for Charles V of Spain, and in the seventeenth century Rubens visited at least twice and his work was very much admired. Spanish Baroque art was heavily influenced by the style and subject matter of Caravaggio—directly and via Naples—but with a greater starkness. Spanish naturalism may throw a harsher, stronger light on its subjects, but it is ultimately at least as sympathetic.

Spanish Still Life: Juan Sánchez Cotán

Inspired by the example of Aertsen and other Netherlandish painters, Spanish artists began to develop their own versions of still life in the 1590s, and connoisseurs acquired vast collections of them. We see the distinctive character of this new subject in the example (fig. 19.33) by Juan Sánchez Cotán (1561–1627). This minor religious artist, who became a Carthusian monk, is remembered today as one of the first and most remarkable members of the Toledo school of still-life painters. Cotán's painting has a clear order and stark simplicity completely controlled by the artist, who hung the vegetables with a fine string at different levels to coordinate the design while other vegetables sit on a ledge or window sill. A window frames the still life: This orchestration of still life in direct sunlight against impenetrable darkness is the hallmark of early Spanish still-life painting. The painstaking realism and abstract form creates a memorable image of the humble fruits and vegetables.

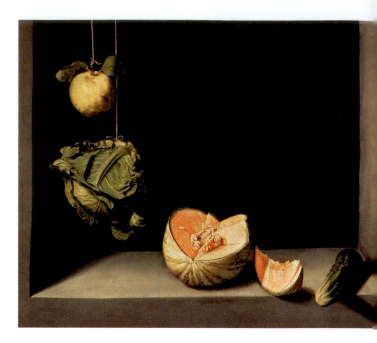

19.33. Juan Sánchez Cotán. *Quince, Cabbage, Melon, and Cucumber.* ca. 1602. Oil on canvas, $27\frac{1}{8} \times 33\frac{1}{4}$ " (68.8 × 84.4 cm). San Diego Museum of Art. Gift of Misses Anne R. and Amy Putnam

Although he probably used northern Italian paintings as his point of departure, Sánchez Cotán's still lifes make one think of Caravaggio, whose effect on Spanish art, however, is not found until considerably later. We do not know exactly how Caravaggism was transmitted. The likeliest source was through Naples, where Caravaggio had fled to safety, which was under Spanish rule. His principal follower there was Jusepe Ribera.

Naples and the Impact of Caravaggio: Jusepe de Ribera

Caravaggio's main disciple in Naples, then under Spanish rule, was the Spaniard Jusepe de Ribera (1591–1652). Ribera settled there after having seen Caravaggio's paintings in Rome. Especially popular were Ribera's paintings of saints, prophets, and ancient beggar-philosophers. Their asceticism appealed strongly to the otherworldliness of Spanish Catholicism. Such pictures also reflected the learned humanism of the Spanish nobility, who were the artist's main patrons. Most of Ribera's figures possess the unique blend of inner strength and intensity.

His *The Club-Footed Boy* (fig. 19.34) smiles openly and endearingly out at us, with a dimpled cheek, although we may be somewhat discomforted by his peasant dress, his begging, and his handicap. The words on the paper he holds state (in translation): "Give me alms for the love of God." In Counter-Reformation theory, this plea for charity indicates that only through good works may the rich hope to attain salvation. The painting, indeed, was made for the Viceroy of Naples, a wealthy collector who would have seen this as a testament to the importance of Christian charity and mercy to the poor.

The boy seems almost monumental here as he stands against the broad sky with a low horizon line, like a musketeer; but instead of a weapon held across his shoulder, it is his crutch. His deformed foot appears in shadow and one doesn't quite see it at first, but as the leg is lit, clearly Ribera directs our attention to it. The deformity may in fact not be a clubfoot but an indication of cerebral palsy. In either case, in the seventeenth century, such a deformity would have committed one to a life of begging.

Ribera executed other large paintings of beggars, of the poor, and of the blind. These were also the subjects of Pieter Bruegel the Elder (*The Blind Leading the Blind*, fig. 18.39), who made prints and drawings of beggars using various crutches. As with Bruegel's works, *The Club-Footed Boy* is made with a moral

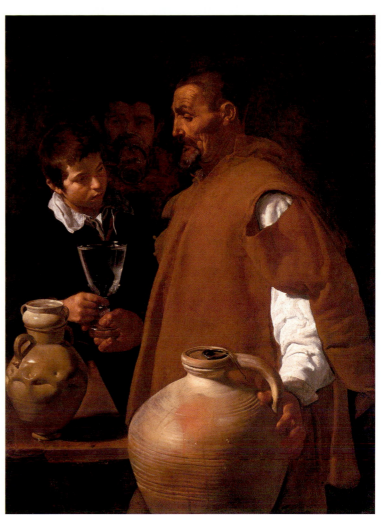

19.35. Diego Velázquez. *The Water Carrier of Seville*. ca. 1619. Oil on canvas, $41\frac{1}{2} \times 31\frac{1}{2}''$ (105.3 × 80 cm). Wellington Museum, London Crown Copyright Reserved

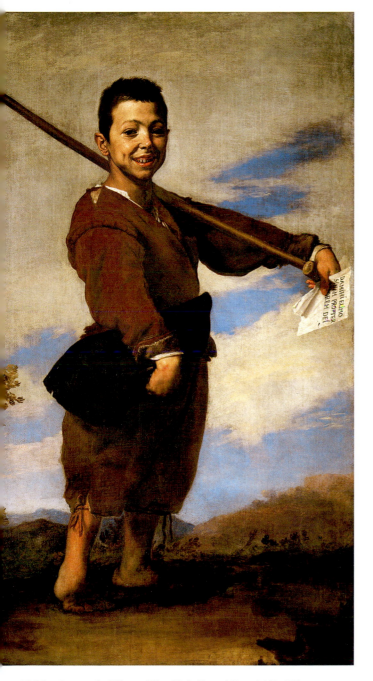

19.34. Jusepe de Ribera. *The Club-Footed Boy*. 1642. Oil on canvas, $64\frac{1}{8} \times 36\frac{5}{8}''$ (164 × 93 cm). Musée du Louvre, Paris

purpose. The boy himself seems an embodiment of joy as he smiles, even laughs. This was considered as a way for the subject to withstand misfortune, for he has the ability to dispense grace: the opportunity for others to do good. Ribera's use of naturalism is a hallmark of Spanish and Neapolitan painting and etching, and it extends Caravaggio's impact. The impact of Caravaggism was felt especially in Seville, the home of the most important Spanish Baroque painters before 1640: Diego Velázquez.

Diego Velázquez:
From Seville to Court Painter

Diego Velázquez (1599–1660) painted in a Caravaggesque vein during his early years in Seville. His interests at that time centered on scenes of people eating and drinking rather than religious themes. Known as *bodegónes* they evolved from the paintings of table-top displays brought to Spain by Flemish artists in the early seventeenth century. *The Water Carrier of Seville* (fig. **19.35**), which Velázquez painted at age 20 under the

apparent influence of Ribera, already shows his genius. His powerful grasp of individual character and dignity gives this everyday scene the solemn spirit of a ritual. The scene is related to Giving Drink to the Thirsty, one of the Seven Acts of Mercy, a popular theme among Caravaggesque painters of the day. Velázquez's use of focused light and the revelation of shapes, textures, surfaces—from the glass of water to the sweat of water on the pottery jug—is almost miraculous. He must have thought so, too, as he gave this painting to his sponsor, a royal chaplain from Seville, no doubt in hopes of attaining royal attention.

In the late 1620s, Velázquez was appointed court painter to Philip IV, whose reign from 1621 to 1665 was the great age of painting in Spain. Much of the credit must go to the duke of Olivares, who largely restored Spain's fortunes and supported an ambitious program of artistic patronage to proclaim the monarchy's greatness. Upon moving to Madrid, Velázquez quickly displaced the Florentines who had enjoyed the favor of Philip III and his minister, the duke of Lerma. A skilled courtier, the artist soon became a favorite of the king, whom he served as chamberlain. Velázquez spent most of the rest of his life in Madrid painting mainly portraits of the royal family.

The earlier of these still have the strong division of light and dark and the clear outlines of his Seville period, but his work soon acquired a new fluency and richness.

SURRENDER AT BREDA During his visit to the Spanish court on a diplomatic mission in 1628, the Flemish painter Peter Paul Rubens (see pages 699–704) helped Velázquez discover the beauty of the many Titians in the king's collection. We see this most immediately in Velázquez's *Surrender at Breda* (fig. **19.36**), a dramatic and lush painting with color as rich as Titian's. It, too, would have been in the royal collection, intended as part of a series for the Buen Retiro Palace. The subject is an interpretation of an event in the war between the United Provinces (the Netherlands) and Spain which took place in 1625, just a few years before the painting's execution. Although the surrender indeed occurred, it did not transpire in this elegant fashion. Here the two generals, Justin of Nassau on the left, bows to give the keys of the city to General Ambrogio de Spinola, who has just gotten off his horse to meet the Dutch general, even to comfort him, as he places his hand on the shoulder of the vanquished officer. Smoke comes from the left

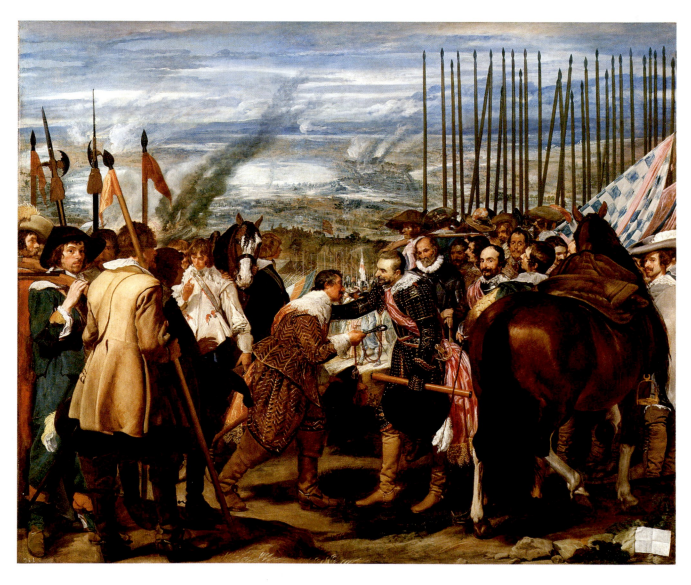

19.36. Diego Velázquez. *Surrender at Breda*. 1634–1635. 10 × 12' (3.07 × 3.7 m). Museo del Prado, Madrid

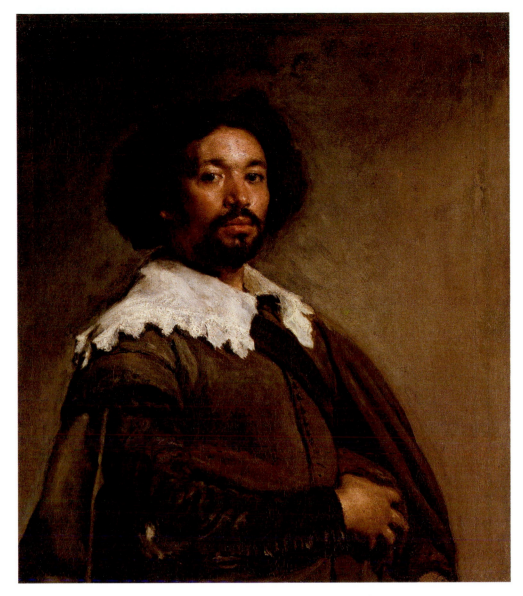

19.37. Diego Velázquez, *Juan de Pareja*. 1650. Oil on canvas, $32 \times 27\frac{1}{2}''$ (81.3×69.9 cm). The Metropolitan Museum of Art, New York. Purchase, Fletcher and Rogers Funds, and Bequest of Miss Adelaide Milton de Groot (1876–1967), by exchange, supplemented by gifts from Friends of the Museum, 1971. (1971.86)

over the heads of the Dutch soldiers who seem a bit dazed and forlorn, signaling the defeat of Breda. On the right are the Spanish troops who, by standing before the lances, seem to be standing more erect. More lances can be seen in the middle distance and one expects that they outnumbered the Dutch.

In truth, the Netherlands' revolt against Spain had ended by about 1585, with a truce in 1609, but battles continued to flare up. There were no keys to the city, and the general probably did not get off his horse. But by having the two generals confront each other not with hate but with acquiesence, Velázquez transforms a military drama into a human one. The scene Velázquez set may have been one from a contemporary play in which Spinola states "Justin, I accept them [the keys] in full awareness of your valor; for the valor of the defeated confers fame upon the victor."

THE PORTRAIT OF JUAN DE PAREJA At court, Velázquez was famed as a portrait painter. And so when Philip IV dispatched Velázquez to Rome in 1648 to purchase paintings and antique sculpture, he also gave permission for the artist to paint Pope Innocent X. But Velázquez's reputation seemed not to have preceeded him when he arrived in 1649, and he was left waiting. It was during this interlude that he painted the portrait of his Sevillian assistant and servant of Moorish descent, Juan de Pareja (ca. 1610–1670), who accompanied him to Rome and was an artist himself (fig. **19.37**). The portrait, stunningly lifelike, was acclaimed when exhibited at an annual art show in the Pantheon in Rome in March 1650. It was said that of all the paintings, this one was "truth." Juan de Pareja is shown half-length, turned at a three-quarter view, but facing us—a triangular format developed by Raphael and

Antonio Palomino (1655–1726)

From El museo pictórica y escala óptica: On Velázquez

In 1724, Palomino wrote a biography of Spanish artists with a focus on Velázquez, who he revered above others. The following is a description of Velázquez's The Maids of Honor, *with the identification of the figures and comments on its reception.*

Among the marvelous pictures done by Velázquez was a large canvas with the portrait of the Empress (then the Infanta of Spain), Margarita María of Austria, as a young child. . . . Kneeling at her feet is María Agustina, maid of honor of the Queen, giving her water in a small vessel. On the other side is Isabel de Velasco, also a maid of honor, who seems to be speaking. In the foreground is a dog lying down and next to it Nicolas Pertusato, a dwarf, who is stepping on it to show that it is a gentle animal in spite of its ferocious appearance. These two figures are in shadow and impart great harmony to the composition. Behind is Mari-Bárbola, a formidable-looking dwarf, and slightly farther back and in darker colors are Marcela de Ulloa, attendant to the ladies-in-waiting, and a bodyguard. On the other side is Diego Velázquez painting; he holds the palette in his left hand and a brush in his right. Around his waist he wears the key to the King's Chamber and on his breast, the Cross of the Order of Santiago that was added at His Majesty's orders after Velázquez died,

because Velázquez was not a member of this Order when the picture was painted. . . .

The canvas on which he is painting is large, and nothing of what he paints can be seen because only the back part is visible.

Velázquez proved his great genius because of the clever way in which he reveals the subject of what he is painting. He makes use of the mirror at the rear of the gallery to show us the reflection of our Catholic kings, Philip and Mariana. In this gallery, which is called the Room of the Prince, where he used to paint, several pictures can be seen indistinctly on the walls. These are known to be by Rubens and represent stories from Ovid's *Metamorphoses*. This gallery has several windows that are shown in perspective to make the room seem large. The light comes from the [picture's] left but enters only through the front and rear windows. . . . To the left of the mirror is an open door where stands Joseph Nieto, the Queen's Marshal. He can be clearly seen in spite of the distance and poor light. Between the figures there is atmosphere. The figure painting is superior, the conception new, and in short it is impossible to overrate this painting because it is truth, not painting. Velázquez finished it in 1656. . . .

The painting was highly esteemed by His Majesty and he frequently went to look at it. It was placed in the King's lower suite, in the office, along with other excellent works. In our own day, Luca Giordano was asked by Charles the Second what he thought of it and he answered, "Sir, this is the theology of Painting."

SOURCE: *ITALIAN & SPANISH ART, 1600–1750: SOURCES AND DOCUMENTS.* ED. BY ROBERT ENGGASS AND JONATHAN BROWN. (EVANSTON, IL: NORTHWESTERN UNIVERSITY PRESS, 1999)

Titian in the High Renaissance, simplifying, but using the *Mona Lisa* (fig. 16.7) as their point of departure. The same format used here is a powerful one, riveting our attention to his face. The feathery lace collar, brilliantly painted, picks up the white highlights of his face creating the formidable sculptural visage. A white patch, a tear in his clothing at the elbow, reminds a viewer of his class, a device Velázquez had used earlier in *The Water Carrier of Seville* (fig. 19.35). The success of this portrait and Velázquez's new fame in Rome may have prompted the pope to sit for him, which he did, soon after.

THE MAIDS OF HONOR Velázquez's mature style is seen at its fullest in *The Maids of Honor* (fig. **19.38**). Both a group portrait and a genre scene, it might be subtitled "the artist in his studio," for Velázquez depicts himself at work on a huge canvas. In the center is the Princess Margarita, who has just posed for him, among her playmates and maids of honor. The faces of her parents, King Philip IV and Queen Maria Anna, appear in the mirror on the back wall. Their position also suggests a slightly different vantage point than ours, and indeed there are several viewpoints throughout the picture. In this way, the artist perhaps intended to include a viewer in the scene by implication, even though it was clearly painted for the king and hung in the office of his summer quarters at the Alcázar Palace. Antonio Palomino, the first to discuss *The Maids of Honor*, wrote ". . . the name of Velázquez will live from

century to century, as long as that of the most excellent and beautiful Margarita, in whose shadow his image is immortalized." Thanks to Palomino (see *Primary Source*, above), we know the identity of every person in the painting. Through the presence of the princess and the king and queen, the canvas commemorates Velázquez's position as royal painter and his aspiration to the knighthood in the Order of Santiago—a papal military order to which he gained admission only with great difficulty three years after the painting was executed. In the painting, he wears the red cross of the order, which was added later after his death.

Velázquez had struggled for status at court since his arrival. Even though the usual family investigations (almost 150 friends and relatives were interviewed) assisted his claim to nobility, the very nature of his profession worked against him. "Working with his hands," conveyed on Velázquez the very antithesis of noble status. Only by papal dispensation was he accepted. *The Maids of Honor*, then, is a response to personal ambition; it is a claim for both the nobility of the act of painting and that of the artist himself. The presence of the king and queen affirm his status. The Spanish court had already honored Titian and Rubens (although not to the same order), and as these artists were both held in high regard, they served as models for Velázquez. They continued to have a significant impact on Velázquez, as men and because of their painterly style.

The painting reveals Velázquez's fascination with light as fundamental to vision. The artist challenges us to match the mirror image against the paintings on the same wall, and against the "picture" of the man in the open doorway. Although the side lighting and strong contrasts of light and dark still suggest the influence of Caravaggio, Velázquez's technique is far more subtle. The glowing colors have a Venetian richness, but the brushwork is even freer and sketchier than Titian's. Velázquez explored the optical qualities of light more fully than any other painter of his time. His aim is to represent the movement of light itself and the infinite range of its effects on form and color. For Velázquez, as for Jan Vermeer in Holland (see pages 728–730), light *creates* the visible world.

ART IN TIME

1605—Miguel de Cervantes Saavedra writes *Don Quixote*

1642—Ribera's *The Club-Footed Boy*

1656—Velázquez's *The Maids of Honor*

Monastic Orders and Zurbarán

Francisco de Zurbarán (1598–1664) began, as did Velázquez, as a painter from Seville, and he stands out among his contemporaries for his quiet intensity. His most important works, done for monastic orders, are filled with an ascetic piety that is

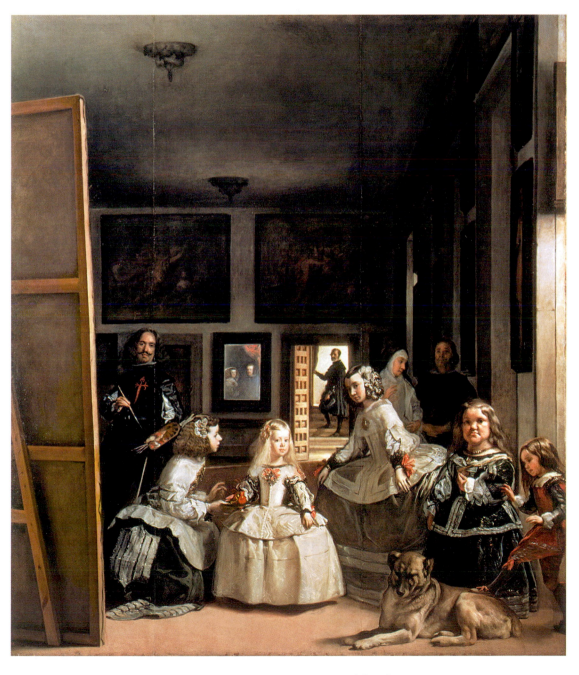

19.38. Diego Velázquez. *The Maids of Honor.* 1656. Oil on canvas, 10′5″ × 9′ (3.2 × 2.7 m). Museo del Prado, Madrid

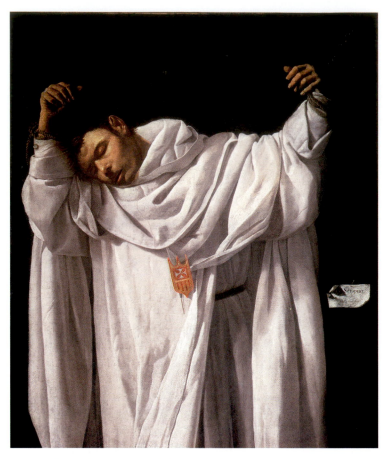

19.39. Francisco de Zurbarán. *St. Serapion.* 1628. Oil on canvas, 47½ × 41″ (120.7 × 104.1 cm). Wadsworth Atheneum, Hartford, Connecticut. Ella Gallup Sumner and Mary Catlin Sumner Collection

uniquely Spanish. *St. Serapion* (fig. **19.39**) shows an early member of the Mercedarians (Order of Mercy) who was brutally murdered by pirates in 1240 but canonized only a hundred years after this picture was painted. The canvas was placed as a devotional image in the funerary chapel of the order, which was originally dedicated to self-sacrifice.

Zurbarán's painting reminds us of Caravaggio. Shown as a life-size, three-quarter–length figure, St. Serapion fills the picture plane: He is both a hero and a martyr. The contrast between the white habit and the dark background gives the figure a heightened visual and expressive presence, so that a viewer contemplates the slain monk with a mixture of compassion and awe. Here pictorial and spiritual purity become one, and the stillness creates a reverential mood that complements the stark realism. As a result, we identify with the strength of St. Serapion's faith rather than with his physical suffering. The absence of rhetorical pathos is what makes this image deeply moving.

Culmination in Devotion: Bartolomé Esteban Murillo

The work of Bartolomé Esteban Murillo (1617–1682), Zurbarán's successor as the leading painter in Seville, is the most cosmopolitan, as well as the most accessible, of any of the Spanish Baroque artists. For that reason, he had countless followers, whose pale imitations obscure his real achievement. He learned as much from Northern European artists, including Rubens and Van Dyck, as he did from Italians such as Reni and Guercino. *The Virgin and Child* (fig. **19.40**) unites the influences of Northern European and Italian artists in an image that nevertheless remains unmistakably Spanish in character. His many religious images, especially *The Virgin and Child* and *The Virgin of the Immaculate Conception* were hallmarks of the insistence of Spanish art to promote the Virgin into the visual vocabulary of the seventeenth century, and they were much copied. The insistence on Virgin imagery defied the Protestant influence in much of Europe. The haunting expressiveness of the faces has a gentle pathos that is more emotionally appealing than Zurbarán's austere pietism. This human warmth reflects a basic change in religious outlook. It is also an attempt to inject new life into standard devotional images that had been reduced to formulas in the hands of lesser artists. The extraordinary sophistication of Murillo's brushwork and the subtlety of his color show the influence of Velázquez. He succeeded so well that the vast majority of religious paintings in Spain and its South American colonies were derived from his work for the next 150 years.

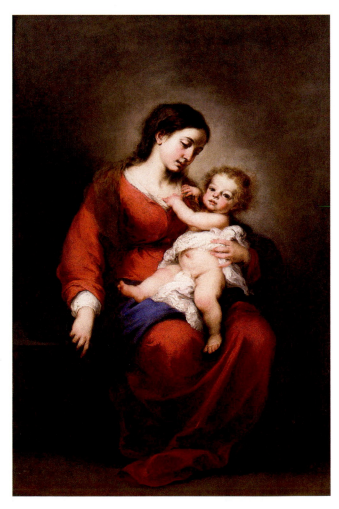

19.40. Bartolomé Murillo. *The Virgin and Child.* ca. 1675–1680. Oil on canvas, 65¼ × 43″ (165.7 × 109.2 cm). The Metropolitan Museum of Art, New York. Rogers Fund, 1943. (43.13)

SUMMARY

The Baroque—the pervasive, dramatic style of the seventeenth century—began in Italy and spread throughout Europe, through the travel of artists and patrons. It conveyed dynamism and strong emotion and was used as the style of the Counter-Reformation, to proclaim the triumph of the Church over Protestantism. Its effects were seen in paintings, sculpture, architecture, the minor arts, and the ornate complex decorations of the age.

This period also marks the colonization of the Americas and the East by governments and religious orders who had explored these lands in the sixteenth century and now began settling them in the seventeenth. Issues of class, gender, science, medicine, and exotica, became central to life and art in this period, now known as the **Early Modern World.**

PAINTING IN ITALY

Caravaggio was the most significant Baroque painter because of his innovations at the beginning of the seventeenth century and his long influence. He had many followers in Italy, among them Artemisia Gentileschi, and throughout Europe, especially in Holland and Flanders. His innovations were found in his subject matter: the introduction of genre painting, usually half-length, life-size figures set behind a table against neutral background. Innovations were also seen in his style: dramatic, lighting and the suggestion of momentary action. His altarpieces were truly revolutionary.

Ceiling painting, too, became an important Baroque choice for a variety of wealthy private patrons and for Church orders—to suggest their dynamic rule over the heavens. Many artists produced illusionistic ceiling paintings that defied space, as figures seemed to fall from the heavens, or that suggested sculpture or architecture that was really painted in fresco. Among the many artists to execute and continually create innovations in this area were Annibale Carracci, Guercino, and Pietro da Cortona.

ARCHITECTURE IN ITALY

The new St. Peter's (begun at the turn of the sixteenth century) was completed during the Baroque period and became the greatest symbol of the revival and vitality of the Church. The central sculptural/architectural focus of the interior decoration was the *Baldacchino* (central altar) executed by Bernini. The exterior, a monumental, elliptical arc and piazza also designed by Bernini, was a remarkable development, suggesting the all-encompassing arms of the Church. Smaller churches, organic and irregularly shaped, with complex domes by Borromini, also became typical of the time.

SCULPTURE IN ITALY

Baroque sculpture suggested action, vitality, and emotion—with a single figure or with more complex sculptural and theatrical productions, such as Bernini's *Ecstasy of St. Theresa.* Bernini was the most significant sculptor, both for his own works and, as coordinator of the decoration plan for St. Peter's, for creating assignments for other artists.

PAINTING IN SPAIN

Spanish Baroque art was largely influenced by Italian art and Caravaggio, through Naples. Ribera, who worked there, executed genre scenes (*The Club-Footed Boy*) and religious paintings that suggest his admiration for naturalism.

Paintings suggesting strong religious piety were frequently commissioned by monastic orders, as in the case of Zurbarán. Velázquez, the most important artist of this Golden Age of Spain, was court painter to Philip IV of Spain in Madrid, but he began his career in Seville, in a style which owed a debt to Caravaggio. Titian, whose paintings were in the Spanish royal collection, and Rubens, a major Flemish artist who traveled to Spain and advised Velázquez to study the works of Titian, also influenced Spanish art and the work of Velázquez. Although genre painting and still life were also popular, the promotion of the Virgin in Spanish art as a significant subject as in the work of Murillo, defined Spain's Catholic and conservative art and its role in defying the Reformation of Northern Europe.

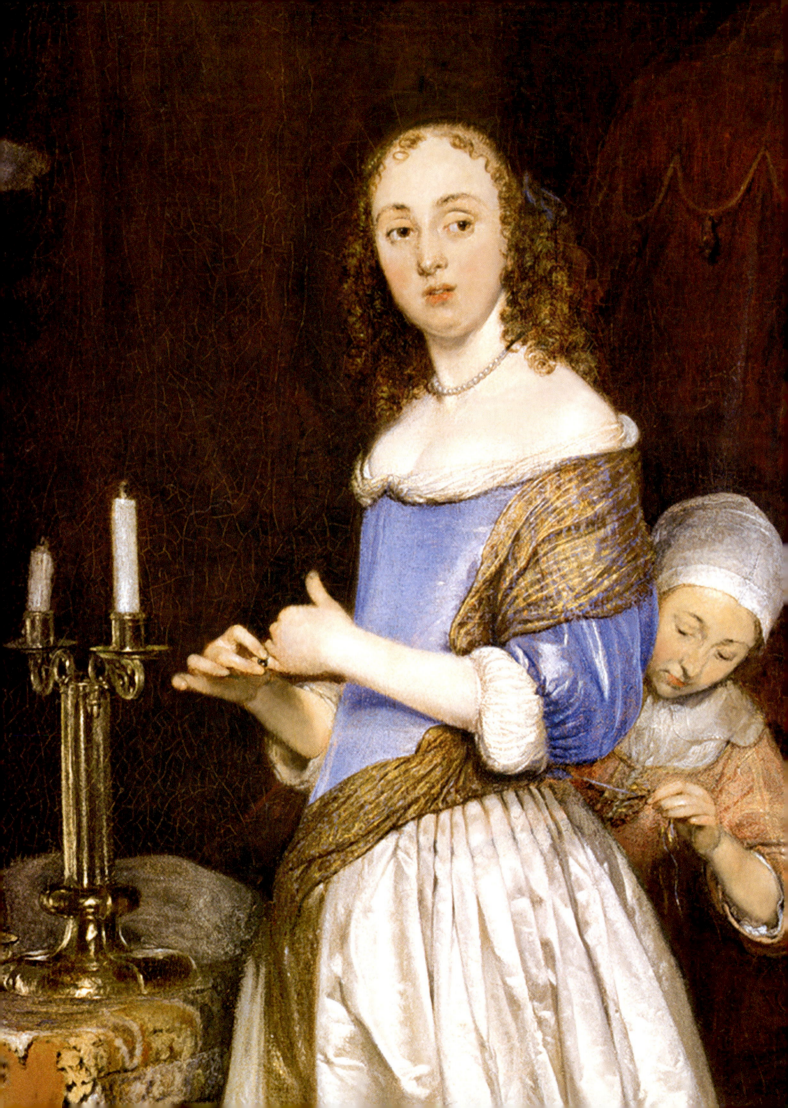

The Baroque in The Netherlands

THE SEVENTEENTH CENTURY BROUGHT A DIVISION OF THE NETHERLANDS
into two parts: the Northern Netherlands (present-day The Netherlands)
and the Southern Netherlands (present day Belgium and part of France).
(See map 20.1.) Each is often known by the name of its most important
province: Holland (North) and Flanders (South). The Catholic Spanish Habsburgs had

ruled the Netherlands in the sixteenth century but Philip II's repressive measures against the Protestants and his attempts to curtail their local government led to a rebellion that lasted 15 years. In 1581, the northern provinces of the Netherlands, led by William the Silent of Nassau of the House of Orange, declared their independence from Spain. Spain soon recovered the Southern Netherlands, and Catholicism remained the official religion. After a long struggle, the seven major provinces of the North, whose inhabitants were predominantly of the Reformed Church, became the United Provinces and gained their autonomy, which was recognized by the truce declared in 1609. Although hostilities broke out once more in 1621, the freedom of the Dutch was never again seriously in doubt. Their independence was finally ratified by the Treaty of Münster, which ended the Thirty Years' War in 1648. The Dutch Republic was formally recognized by the rest of Europe as an independent state.

The division of the Netherlands had very different consequences for the economy, social structure, culture, and religion of the North and the South. At the same time throughout the seventeenth century, people crossed back and forth between the two regions providing some social and cultural fluidity. After being sacked by Spanish troops in 1576, Antwerp, the leading

port of the Southern Netherlands, lost half its population. Many migrated to the Northern Netherlands. The city gradually regained its position as Flanders's commercial and artistic capital, although Brussels was the seat of government. As part of the Treaty of Münster, however, the Scheldt River leading to Antwerp's harbor was closed to shipping, thus crippling trade for the next two centuries. Because Flanders continued to be ruled by Spanish regents, the Habsburgs, who viewed themselves as the defenders of the "true" (i.e., Catholic) faith, its artists relied primarily on commissions from Church and state, but the aristocracy and wealthy merchants were also important patrons.

Holland, in contrast, was proud of its hard-won freedom. Although the predominant religion was the Reformed Church, the Dutch were notable for their religious tolerance. Even Catholicism continued to flourish, and included many artists among its ranks, while Jews found a haven from persecution. While the cultural links with Flanders remained strong, several factors encouraged the quick development of Dutch artistic traditions. Unlike Flanders, where all artistic activity radiated from Antwerp, Holland had a number of local schools of painting. Besides Amsterdam, the commercial capital, there were important artists in Haarlem, Utrecht, Leiden, Delft, and other towns that established local styles centered on the teachers of the community. Thus Holland produced an almost bewildering variety of masters and styles.

Detail of figure 20.36, Gerard ter Borch, *Lady at Her Toilet*

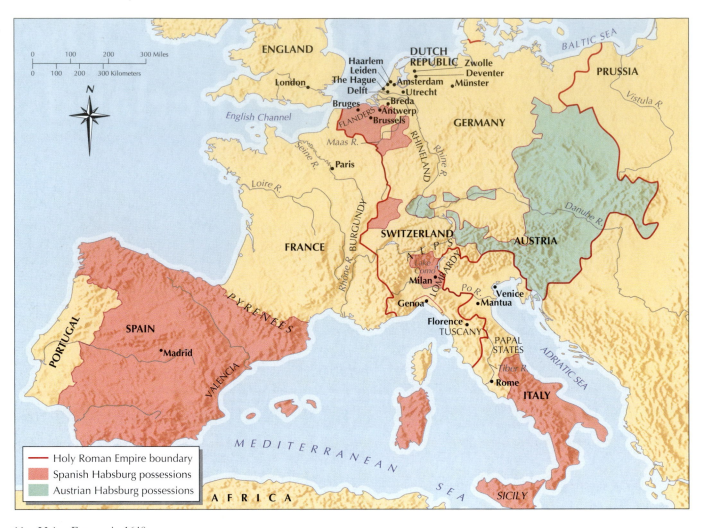

Map 20.1. Europe in 1648

The new nation was one of merchants, farmers, and seafarers, who may have earned their living from local commerce such as the fishing trade, but who had the opportunity to have more distant adventures with the development of the famous Dutch East India Company (known as the VOC from its Dutch initials) established in 1602 and its counterpart, established in 1621, the Dutch West India Company. These companies developed trade in East Asia (China, Japan, and Indonesia), and in the Americas, bringing home exotic wares, strange creatures, and fabulous flora and fauna, as well as engaging in exploration, map making, and the creation of colonial settlements. These adventures rippled though the economy: The sailors experienced them, but they also had a direct impact on the directors and governors of the companies, who made their fortunes from these ventures. Even the townspeople, who stayed home, were able to purchase or at least see some of the wonders brought back from faraway places. From this time forward the Dutch could never again be considered provincial; even the those who did not travel could be considered, and would consider themselves, worldly.

As the Reformed Church was iconoclastic, Dutch artists rarely had the large-scale church altarpiece commissions that were available throughout the Catholic world. While the House of Orange in The Hague and city governments and civic bodies such as militias provided a certain amount of art patronage, their demands were limited. As a result, private collectors became the painters' chief source of support. This was true before 1600, but the full effect of such patronage can be seen only after that date. There was no shrinkage of output. On the contrary, the public developed such an appetite for pictures that the whole country became gripped by a kind of collector's mania. During a visit to Holland in 1641, the English traveler John Evelyn noted in his diary that "... tis an ordinary thing to find, a common Farmor lay out two, or 3000 pounds in this Commodity, their houses are full of them, and they vend them at their kermas'es [fairs] to very great gaines." Although it was unlikely farmers' houses were filled with paintings, or Evelyn even visited them, there is no doubt paintings were not only made for the church and the court class. In the Northern Netherlands (as well as the Southern Netherlands) a new class of patron arose—the wealthy merchant.

FLANDERS

Art in seventeenth-century Flanders was defined by the art of Peter Paul Rubens. Rubens brought Flanders, really Antwerp, to international notice and the art of the western world to Flanders. He did this through his own travels (bringing ideas back to Antwerp), his commissions, and his own extensive workshop.

Baroque art in Flanders was based on commissions. Its many churches could now, with the peace, be rebuilt and redecorated. The Habsburg archduke and archduchess, their family, and private patrons provided these commissions. Rubens's own interests were largely within the realm of painting, but his role in sculpture and sculptural decoration, architecture, costumes, and illustrated books (published by the famous Plantin Press in Antwerp) was significant. All these art forms were directly affected by Rubens and the art of Rubens.

The subjects of Flemish art, and the subjects of Rubens's paintings, were primarily religious—they were frequently large altarpieces with life-size figures, but portraits also accounted for many works. Although Rubens also executed landscapes, other artists, including Frans Snyders, Clara Peeters, Jan de Heems, and Jan Brueghel the Elder, frequently painted still lifes, or game pieces. Rubens's one-time assistant Anthony van Dyck excelled in portraits, religious and mythological painting, as did Jacob Jordaens, who also painted genre scenes. But all artistic efforts were influenced by Rubens.

Peter Paul Rubens and Defining the Baroque

Although the Baroque style was born in Rome, it soon became international. The great Flemish painter Peter Paul Rubens (1577–1640) played a role of unique importance in this process. He epitomized the Baroque ideal of the virtuoso artist, acting diplomat and advisor, with entrée to the courts of Europe. He was widely read and widely traveled, with a knowledge of Classical literature and several languages. He was acclaimed for his intellect, and for a vitality that enabled him to unite the natural and supernatural and to attain a Baroque theatricality and drama that we have also seen in Bernini (see Chapter 19). He finished what Dürer had started a hundred years earlier and was continued with Jan Gossaert and Cornelis Floris (see Chapter 18): the breakdown of the artistic barriers between Northern and Southern Europe. Rubens's father was a prominent Antwerp Protestant who had fled to Germany to escape Spanish persecution during the war of independence. The family had returned to Antwerp after his death, when Peter Paul was 10 years old, and the boy had grown up a devout Catholic. Trained by local painters, Rubens became a master in 1598, but he developed a personal style only when he went to Italy two years later.

During his eight years in Italy, in the art and patronage centers of Mantua, Genoa, Florence, and Rome, he absorbed the Italian tradition far more completely than had any Northern European before him. He eagerly studied ancient sculpture, the masterpieces of the High Renaissance, and the work of Caravaggio and Annibale Carracci. In fact, Rubens competed

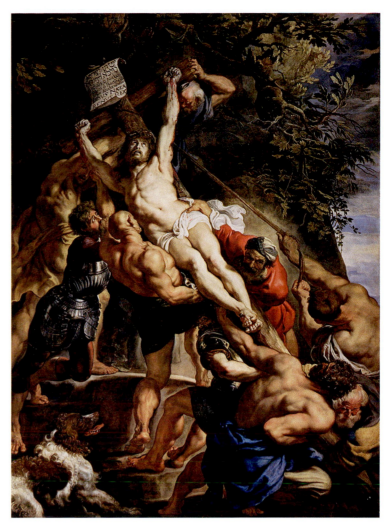

20.1. Peter Paul Rubens. *The Raising of the Cross.* 1610–1611. Center panel of a triptych, 15'1" × 11'9⅝" (4.6 × 3.4 m). Antwerp Cathedral, Belgium

on even terms with the best Italians of his day and could well have made his career in Italy. Indeed, he had major commissions there for both portraits and altarpieces.

RUBENS AND THE ALTARPIECE *The Raising of the Cross* (central panel, fig. **20.1**), whose very subject speaks to the dynamism of the Baroque, was the first major altarpiece Rubens painted after his return to Antwerp in 1609, and it shows how much he was indebted to his Italian experience. The muscular figures, modeled to show their physical power and passionate feeling, recall the antique, Hellenistic sculpture that Rubens saw, drew, and collected (see *Primary Source*, page 701), and the figures from the Sistine Chapel ceiling that he also copied (fig. **20.2**). These works of art served as models for his heroic figures throughout his life. He also gathered inspiration from the Farnese Gallery, while the lighting suggests Caravaggio's work (see figs. 19.1–19.4). The composition of the altarpiece recalls that of Rosso's *Descent from the Cross* (fig. 17.1), yet, the painting is more heroic in scale and conception than any previous Northern European work. Its rich color and luminosity is ultimately due to the influence of Titian (compare with fig. 16.32). Thus, the panel owes much of its success to Rubens's

20.2. Peter Paul Rubens. *Drawing after Michelangelo's Ignudi from the Sistine Chapel Ceiling*. ca. 1601–1602. Red chalk with touches of red wash. 15$\frac{1}{3}$″ × 11″ (38.9 × 27.8 cm.). British Museum, London

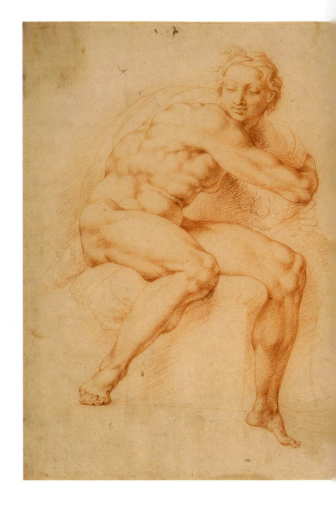

20.3. Peter Paul Rubens. *Sketch for the Raising of the Cross*. ca. 1610. Oil on panel, three panels, 26$\frac{1}{3}$″ × 10″; 26$\frac{3}{4}$ × 20″; 26$\frac{1}{3}$″ × 10″ (67 × 25 cm.; 68 × 51 cm.; 67 × 25 cm.). MNR 411. Musée du Louvre, Paris

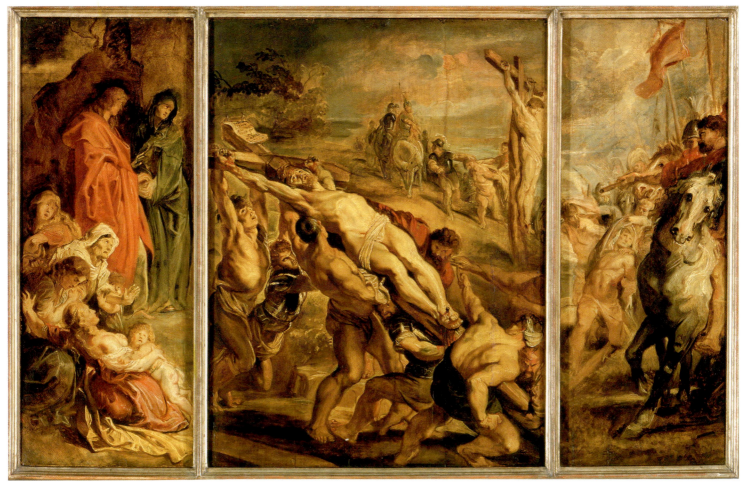

Peter Paul Rubens (1577–1640)

From a Letter to Sir Dudley Carleton

In 1618, Rubens began correspondence with Sir Dudley Carleton (1573–1632), the English Ambassador to The Hague, in order to arrange an exchange of the Englishman's antique sculptures for paintings by Rubens. Well-traveled and with diplomatic appointments to Paris and Venice (he was later made Secretary of State), Carleton had acquired a notable collection of antique sculpture during his time in Italy (1610–1615). Rubens, too, had a collection that he began to amass during his own stay in Italy (1600–1608). In his first letter, Rubens proposed the exchange for "pictures by my hand," and in this letter explains that the paintings he proposes to offer are the "flower of his stock," implying that many paintings by Rubens were not in fact executed for specific commissions but kept by him (he lists 12 paintings in his house). The deal went through, and Rubens then had the greatest collection of antique sculpture in Northern Europe, until he in turn sold part of it a few years later. In the end, 123 marbles from Carleton were exchanged for nine paintings by Rubens, and three paintings by Tintoretto, as well as a set of tapestries from Rubens's collection.

Most Excellent Sir:

By the advice of my agent, I have learned that Your Excellency is very much inclined to make some bargain with me concerning your antiquities; and it has made me hope well of this business, to see that you go about it seriously, having told him the exact price that they cost you. In regard to this, I wish to place my complete trust in your knightly word. . . . Your Excellency may be assured that I shall put prices on my pictures, just as if I were negotiating to sell them for cash; and in this I beg you to rely upon the word of an honest man. I find that at present I have in the house the flower of my stock, particularly some pictures which I have kept for my own enjoyment; some I have even repurchased for more than I had sold them to others. But the whole shall be at the service of Your Excellency, because I like brief negotiations, where each party gives and receives his share at once. To tell the truth, I am so burdened with commissions, both public and private, that for some years to come I cannot commit myself. Nevertheless, in case we agree as I hope, I will not fail to finish as soon as possible all those pictures that are not yet entirely completed, even though named in the list here attached. [*In the margin*: The greater part are finished.] Those that are finished I would send immediately to Your Excellency. In short, if Your Excellency will resolve to place as much trust in me as I do in you, the matter is settled. I am content to offer Your Excellency of the pictures by my hand, enumerated below, to the value of 6,000 florins, at current cash prices, for all those antiquities in Your Excellency's house, of which I have not yet seen the list, nor do I even know the number, but in everything I trust your word. Those pictures which are finished I will consign immediately to Your Excellency, and for the others that remain in my hands to finish, I will furnish good security to Your Excellency, and finish them as soon as possible. . . .

From Your Excellency's most affectionate servant,
Peter Paul Rubens

Antwerp, April 28, 1618

SOURCE: *THE LETTERS OF PETER PAUL RUBENS*, ED. AND TR. RUTH SAUNDERS MAGURN. (CAMBRIDGE, MA: HARVARD UNIVERSITY PRESS, 1971)

ability to combine Italian influences with Netherlandish ideas, thereby creating something entirely new. Rubens is also a Flemish realist in such details as the foliage, the armor of the soldier, and the curly haired dog in the foreground. These varied elements are integrated into a composition of tremendous force. The unstable pyramid of bodies, swaying precariously under the strain of the dramatic action, bursts the limits of the frame in a typically Baroque way, making a viewer feel like a participant in the action.

OIL SKETCHES *The Raising of the Cross* was created for the high altar of the Church of St. Walburga (now destroyed), but we can see from his early oil sketch for this painting (fig. **20.3**) that the dynamic elements characteristic of Baroque style were not yet there. The sketch is more crowded, less focused, and the body of Christ lies nearly perpendicular to the picture plane. In the painting, however, Christ is parallel to the plane, so that we fully see him being raised to the crucifixion. The very concept of "the raising" is a Baroque one; it implies movement and action that is happening at that moment. The entire scene is also dramatic, powerful, and monumental. The oil sketch, which is one of hundreds he produced as preparation in light and color for his finished works, only suggests what is to come—an altarpiece that would be 35 feet high in its final form—a triptych (the wings are not shown here) with a now lost painting of God the Father above, which explains Christ's heavenward imploring glance. The painting was placed on the high altar at the top of 19 steps, so the entire altarpiece ensemble would have towered above all else.

Rubens's epic canvases defined the scope and the style of High Baroque painting. They possess a seemingly boundless energy and inventiveness, which, like his heroic nudes, express life at its fullest. And his portraits were equally inventive and dramatic.

RUBENS AS PORTRAITIST Rubens was one of the greatest and most influential portraitists of the seventeenth century, recording the vast wealth and stature of his often noble patrons. He painted several portraits while in Italy and maintained contacts with his Genoese patrons for years after he left. His resplendent portrait of *Marchesa Brigida Spinola Doria* (fig. **20.4**), a member of the ruling class of Genoese banking families, who invested in trade with Africa and the East, was painted in 1606, probably in celebration of her wedding at age 22.

Although a large painting, it was even more monumental in the seventeenth century—perhaps 9 feet high—before it was

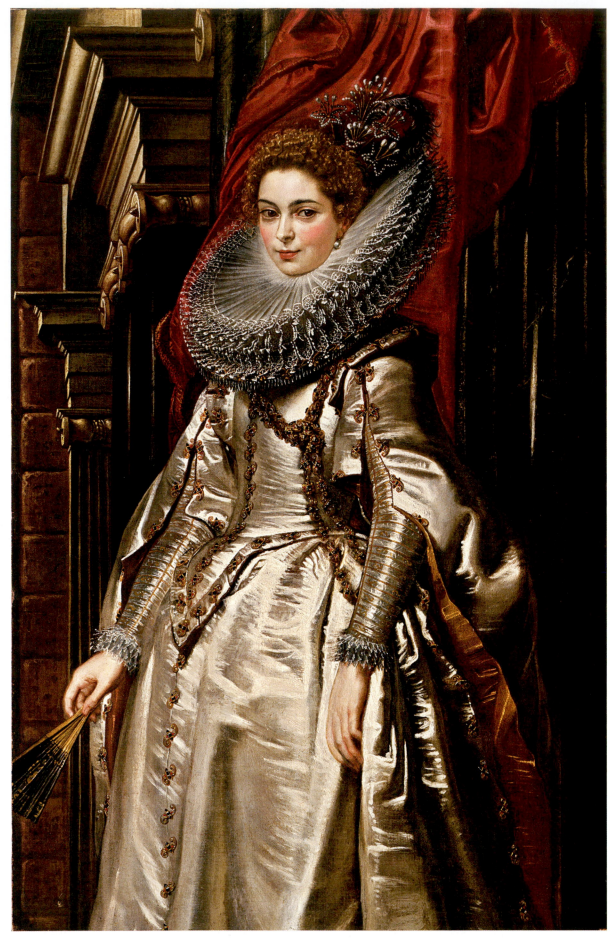

20.4. Peter Paul Rubens. *Marchesa Brigida Spinola Doria*. 1606. Oil on canvas, 5′ × 3′2⁷⁄₈″ (152.2 × 98.7 cm). The National Gallery of Art, Washington, DC. Samuel H. Kress Collection. 1961.9.60.

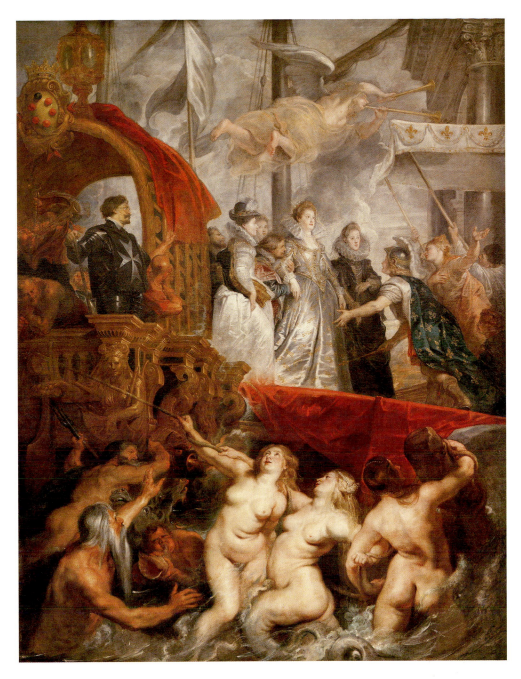

20.5. Peter Paul Rubens. *Marie de' Medici, Queen of France, Landing in Marseilles (3 November 1600)*. 1622–1625. Oil on canvas, 12'11½" × 9'7" (3.94 × 2.95 m.). Musée du Louvre, Paris

later cut down on all four sides. A nineteenth-century lithograph of the painting shows that the Marchesa was originally full length, and was shown striding from the terrace of her palazzo. She is sumptuously dressed in white satin, with a matching cape, bejeweled with a rope of gold set with gems of onyx and rubies. Her huge, multilayered ruff, typical of her time and class, frames her face, and her red hair is arranged with decorative combs of pearls and feathers. The vast flowing red cloth, which unfurls behind her, sets the color contrast with her dress and heightens the color of her face. The diagonal movement of this drapery also suggests her forward stride. The size, full-length view, elements of movement, and color against her face are just a few of the aspects that will influence Rubens's student and assistant Anthony van Dyck (see fig. 20.7 and

fig. 20.8) in his portraits. Later stately portraits of the eighteenth and nineteenth centuries will also reflect these influences.

MARIE DE' MEDICI CYCLE Rubens exhibited his virtuoso talent in portraits and monumental historical works in the 1620s with his famous cycle of paintings glorifying the career of Marie de' Medici, widow of Henry IV and mother of Louis XIII, in the Luxembourg Palace in Paris. The cycle consists of 21 paintings at least 13 feet high, with some as much as 28 feet wide. Our illustration shows one episode: the young queen landing in Marseilles (fig. **20.5**). This is hardly an exciting subject, yet Rubens has turned it into a spectacle of unparalleled splendor, combining both reality and allegory. As Marie de' Medici walks down the gangplank (she actually walked up, not

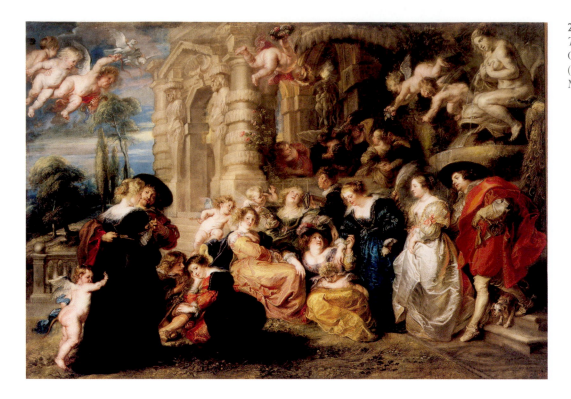

20.6. Peter Paul Rubens. *The Garden of Love*. ca. 1638. Oil on canvas, 6′6″ × 9′3½″ (2 × 2.8 m). Museo del Prado, Madrid

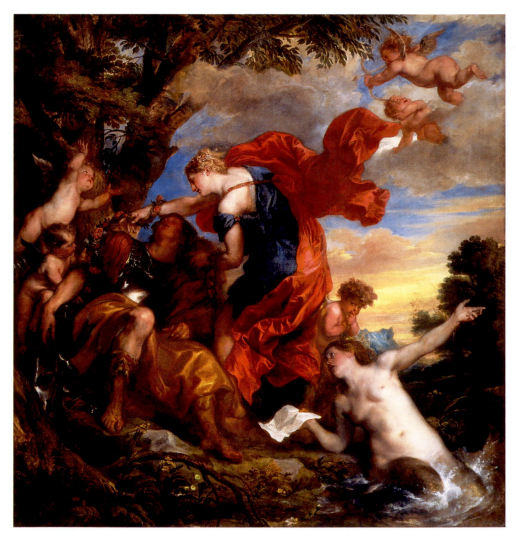

20.7. Anthony van Dyck. *Rinaldo and Armida*. 1629. Oil on canvas, 7′9″ × 7′6″ (2.36 × 2.24 m). The Baltimore Museum of Art, Baltimore, MD. The Jacob Epstein Collection

down—Rubens altered reality to create a diagonal) to enter France, having already married Henry IV by proxy in Florence, she had not yet met her husband. Accompanied by her sister and aunt as Fame flies overhead sounding a triumphant blast on two trumpets, she is welcomed by France, represented allegorically by a figure draped in a *fleur-de-lis* cape. Neptune and his fish-tailed crew, the Nereids, rise from the sea; having guarded the queen's journey, they rejoice at her arrival. Everything flows together here in swirling movement: heaven and Earth, history and allegory.

RUBENS'S WORKSHOP To produce these large paintings, painting cycles, ceilings, and altarpieces, Rubens had a large workshop and most of the Flemish artists that we will discuss in this chapter studied with Rubens. They often traveled as he did, worked on paintings he began or sketched, or began paintings he completed.

Rubens worked as painter and as royal emissary. Diplomatic errands gave him entry to the royal households of the major powers, where he received numerous commissions. He visited the courts of Europe, which took him to Paris, London, and Madrid—having already been to Italy—and he went to the Northern Netherlands to find an engraver for his work. He was truly an international artist.

LATE RUBENS In the 1630s, after Rubens remarried at the age of 53, his art turned inward with the many paintings of his beautiful young wife, his home, and children. He even wrote of being "at home, very contented." Rubens's *The Garden of Love* (fig. **20.6**) is a glowing tribute to life's pleasures. There are couples, cupids, and a lifelike statue of Venus (at the upper left) in a garden in front of a building, much like Rubens's own Italianate house in Antwerp. Suggestions have been made that the male figure on the left is Rubens, and several of the women (mostly, the center-seated one) look like his new wife, Hélène Fourment. Certainly, the sensuality of the *Garden of Love* parallels his life. This painting (and several copies and drawings for it) and the Paris Marie de' Medici cycle would influence eighteenth-century rococo painting (see page 759).

Anthony van Dyck: History and Portraiture at the English Court

Besides Rubens, only one other Flemish Baroque artist won international stature: Anthony van Dyck (1599–1641). He was that rarity among painters: a child prodigy. Before he was 20 he had become Rubens's most valued assistant. And, like Rubens, he developed his mature style only after a stay in Italy.

As a history painter, Van Dyck was at his best in lyrical scenes of mythological love. *Rinaldo and Armida* (fig. **20.7**) is taken from Torquato Tasso's immensely popular poem about the Crusades, *Jerusalem Freed* (1581), which gave rise to a new courtly ideal throughout Europe and inspired numerous operas, as well as paintings (a popular subject of Tiepolo). Men and women at court masques played the roles of Christian Knight and Bewitching Sorceress in acting out this love and adventure story. Van Dyck similarly shows the sorceress falling in love

with the Christian Knight she had intended to slay. The canvas reflects the conception of Charles I, the English monarch for whom it was painted, and who also found parallels in his own life with Tasso's epic. The English monarch, a Protestant, had married the Catholic Henrietta Maria, sister of his main rival, the king of France. Charles saw himself as the virtuous ruler of a peaceful realm much like the Fortunate Isle where Armida had brought Rinaldo. (Ironically, Charles's reign ended in civil war.) The artist tells his story of ideal love in the pictorial language of Titian and Veronese, with an expressiveness and opulence that would have been the envy of any Venetian painter. The picture was so successful that it helped Van Dyck gain appointment to the English court two years later.

Van Dyck's fame rests mainly on the portraits he painted in London between 1632 and 1641. The *Portrait of Charles I Hunting* (fig. **20.8**) shows the king standing near a horse and two grooms in a landscape. Representing the sovereign at ease, the painting might be called a "dismounted equestrian portrait," and it is vastly different in effect from Holbein's *Portrait of*

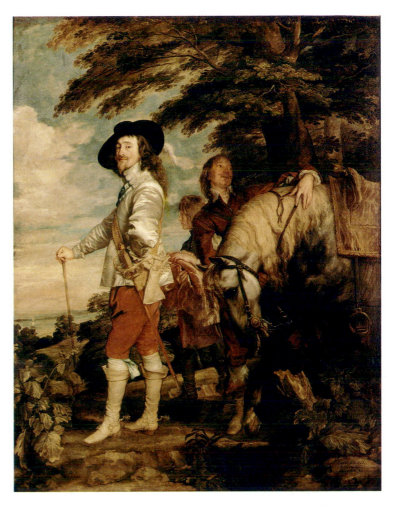

20.8. Anthony van Dyck. *Portrait of Charles I Hunting.* ca. 1635. Oil on canvas, 8′11″ × 6′11½″ (2.7 × 2.1 m). Musée du Louvre, Paris. Inv.1236

Henry VIII (fig. 18.27). It is less rigid than a formal state portrait, but hardly less grand, for the king remains in full command of the state, symbolized by the horse, which bows its head toward its master. The fluid movement of the setting complements the self-conscious elegance of the king's pose, which continues the stylized grace of Hilliard's portraits (compare with fig. 18.28). Charles's position, however, was less secure than his confidence suggests. Charles I's reign ended in civil war, and he was beheaded in 1649. Charles was succeeded by the Puritan leader Oliver Cromwell and his followers, known as the "Roundheads" in reference to their short cropped hair. In contrast, note that in the painting Charles I's tresses drop below his shoulder in the French (Catholic) manner. However, Charles's son, Charles II, assumed the throne later in the period known as the Restoration.

Van Dyck has brought the court portrait up to date by using Rubens and Titian as his points of departure. He died eight years before the beheading of Charles I and so never worked for the subsequent courts. But he created a new aristocratic portrait tradition that continued in England until the late eighteenth century and which had considerable influence on the Continent as well.

Local Flemish Art and Jacob Jordaens

Jacob Jordaens (1593–1678) was the successor to Rubens and Van Dyck as the leading artist in Flanders, and he outlived both of them. Unlike his predecessors, he did not travel to Italy, and his patrons were mostly of the middle class. Although Jordaens was never a student of Rubens, he was a member of his workshop, and he collaborated with Rubens, turning to

him for inspiration throughout his career. Jordaens's most characteristic subjects are mythological themes depicting the revels of nymphs and satyrs. Like his eating and drinking scenes, which illustrate popular sayings, his mythological paintings reveal him to be a close observer of people. The dwellers of the woods in *Homage to Pomona (Allegory of Fruitfulness)* (fig. **20.9**) inhabit an idyllic realm, untouched by human cares. The painterly execution shows a strong debt to Rubens, but the monumental figures lack Rubens's heroic vigor; there is softness, roundness, and plainness to his figures, which distinguishes his work.

The Bruegel Tradition

The leader of the preceding generation, Jan Brueghel the Elder (1568–1625) was the principal heir to the tradition of his illustrious father, Pieter Bruegel the Elder (see Chapter 18), whom he hardly knew but whom he copied. Jan Brueghel was one of the developers of the "art collection" paintings unique to Flanders that provide us with a view into the depth and variety of European "art collections," which developed in the princely quarters of Antwerp in the seventeenth century. These eclectic collections were known as *kunstkammern* (literally "rooms of art") or *wunderkammern* ("rooms of wonder"), and they provide us with a glimpse of the vast collections of exotica, from sea shells, insects, and rare flowers to scientific instruments and paintings, that were accumulated by the aristocracy and the wealthy at that time.

His *Allegory of Sight* (fig. **20.10**) from a set of *The Five Senses*, executed with Rubens, shows such a *wunder-* or *kunstkammer.* The *Allegory of Sight*, viewed in an art gallery

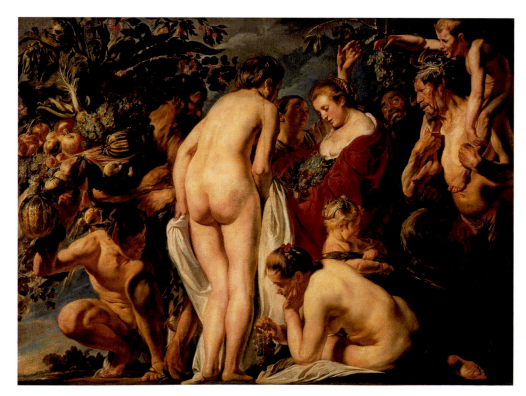

20.9. Jacob Jordaens. *Homage to Pomona (Allegory of Fruitfulness).* ca. 1623. Oil on canvas, 5′10⅞″ × 7′10⅞″ (1.8 × 2.4 m). Musées Royaux d'Art et d'Histoire, Brussels. Inv. 119

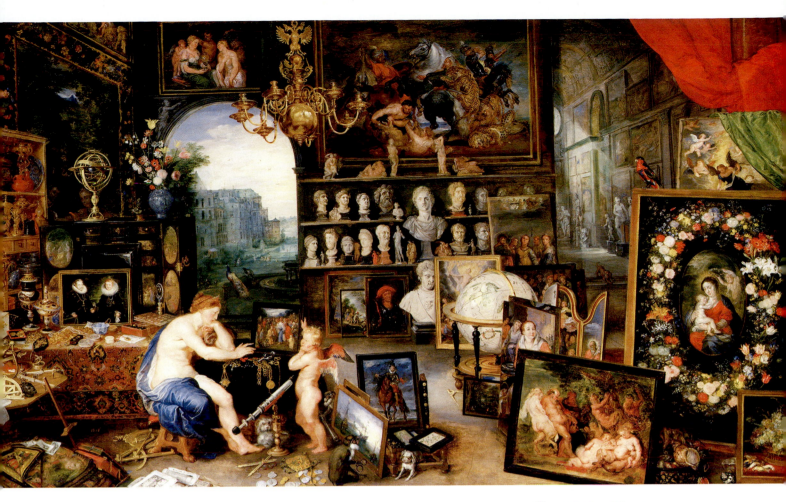

20.10. Jan Brueghel the Elder and Peter Paul Rubens. *Allegory of Sight*. ca. 1617–1618. Oil on panel. 25⅝ × 43″ (65 × 109 cm). Museo del Prado, Madrid

and appreciated only by seeing, is, of course, meant as a visual pun. Jan Brueghel also painted other allegories—*The Seasons* and *The Four Elements*—and was so successful at this and similar paintings that he was appointed by the Antwerp city fathers to direct the efforts of talented painters, including Rubens and Frans Snyders, to create two paintings entitled *The Five Senses* as a gift to the archduke. The collection seen here is that of the Habsburg archduke and archduchess (Albert and Isabella), depicted in a double portrait on the left (by Rubens). They were Catholic rulers who would have associated this homage to the visible world as one connected to spiritual insight (explaining the painting of the Virgin and Child in the foreground). We only glimpse part of the collection in the foreground as the background at right indicates other rooms with more items, but the collection of paintings is prime here. We see scientific instruments (telescopes, globes), a Persian carpet (suggesting the bounty of the world), Roman portrait busts, and large and small paintings: portraits, mythological scenes, and still lifes. Some of the paintings are recognizably by Rubens and indicate his wide range—from a mythological scene of Silenus at the lower right to a lion and

tiger hunt at top left. The large painting seen at right of the *Virgin and Child*, encircled by a wreath of flowers, like this one, is a collaborative effort between Jan Brueghel and Rubens, where Rubens did the figures. Jan Brueghel also collaborated with other artists and was a noted flower painter.

Still-Life Painting

Still-life painting in seventeenth-century Flanders took many forms—in paintings of flowers, game, food, and precious objects. Even Jan Brueghel's *Allegory of Sight* (fig. 20.10) enters into this realm. We usually do not know who commissioned these works and presume they were for private patrons for their homes.

The century opens with predominantly simple paintings, but by mid-century this genre explores the elaborate and dramatic explosion of objects collected at that time.

EARLY STILL LIFE: CLARA PEETERS Probably born in Antwerp, and most closely associated with that city, Clara Peeters (active 1607–ca. 1621) may have also worked in Haarlem, in The Netherlands. Her name, however, is not listed in

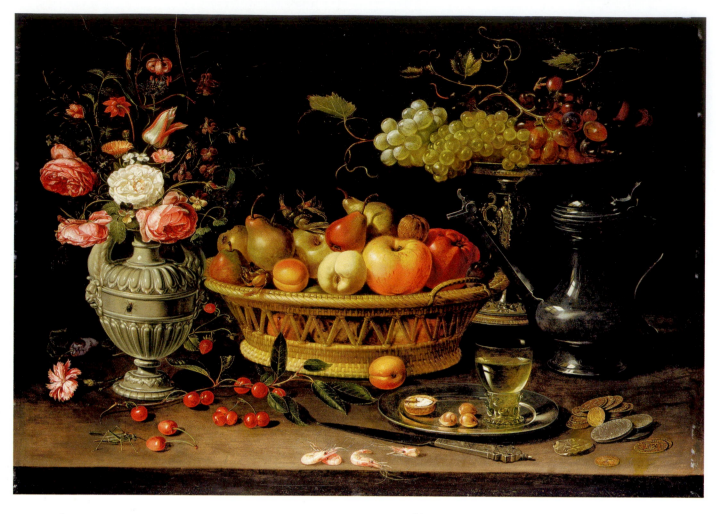

20.11. Clara Peeters. *Still Life with Fruit and Flowers*. ca. 1612. Oil on copper, 25$\frac{1}{5}$ × 35″ (64 × 89 cm) Ashmolean Museum, Oxford

any archival record of these cities, even though the guild in these cities began to admit women and the number of signed works by her indicate that she was a professional artist. Little is known of her life, patrons, or teachers. Nevertheless, she created some of the earliest still-life paintings. *Still Life with Fruit and Flowers* (fig. **20.11**) is an early work that combines studies of both flowers and fruit and displays several different containers, exploring a variety of textures. In the center is a basket of fruit (apples, pears, plums, apricots, and filberts), flanked on the left by a bouquet of colorful flowers (roses, a tulip, columbine, marigold, a cornflower, borage, wild pansies, forget-me-nots, and lilies) in a white pottery vase. On the right is a pewter wine tankard (with a reflection of Peeters) and a silver *tazza* (an Italian-made plate) holding a bunch of grapes. Also on the right is a pewter plate with a glass of white wine and some nuts. Strewn across the wooden table top are prawns, a carnation, a plum, cherries, a grasshopper, a strawberry, some gold and silver coins, and a knife.

Although the natural life here is plentiful, it is the coins and knife that are particularly important for both dating and determining the possible use or meaning of the painting. The coins

have been dated to the reign of the Archduke Albert and Archduchess Isabella (1598–1621), and, based on the painting's style, a date of 1612 has been suggested. The knife (with its matching fork not seen here) is quite special and is a type given as a wedding or betrothal gift. The same knife appears several times in her paintings and was probably copied from an actual one. It is inscribed in Latin with words meaning "fidelity" and "temperance," and is illustrated by small allegorical figures with hearts and clasped hands. Such a knife would often be inscribed with the bride's name, and here it is inscribed "Clara Peeters." Thus, it has been suggested that she painted the work in celebration of her own wedding—and all the fruits and flowers represent the bounty and hopefulness of this event. Such paintings were frequently hung in the dining room of houses and complemented the meals and festivities. Many of Clara Peeters's paintings still remain in private collections today.

GAME STILL LIFE: FRANS SNYDERS A frequent collaborator of Rubens, Frans Snyders (1579–1657) studied with Pieter Brueghel the Younger (1564–1638), brother of Jan Brueghel the Elder and another son of Pieter Bruegel the

Elder. Snyders concentrated on elaborate tabletop still lifes, piled high with foods. His splendid *Market Stall* (fig. **20.12**), an early picture and a masterpiece of its kind, is a frank appeal to the senses. The artist revels in the virtuoso application of paint to create the varied textures of the game. The youth picking the old man's pocket and the hens fighting in the foreground, as a cat looks on from its safe retreat beneath the low bench, further enliven the scene.

Even here Rubens's influence can be found: The composition descends from one Snyders painted with Rubens, based on the latter's design, shortly after they had returned from Italy around 1609. *Market Stall* can be considered an updated version of *The Meat Stall* of Pieter Aertsen (see fig. 18.36). Unlike Aertsen, Snyders subordinates everything to the ensemble, which is characteristically Baroque in its lavishness and immediacy. The painting celebrates a time of peace and prosperity after the truce of 1609, when hunting was resumed in the replenished game preserves.

THE FLAMBOYANT STILL LIFE: JAN DE HEEM By mid-century, still-life paintings were often a lavish display, known as the *pronk* still life for its visual splendor, as *pronk* means "showy" or "ostentatious." This type reached its peak in

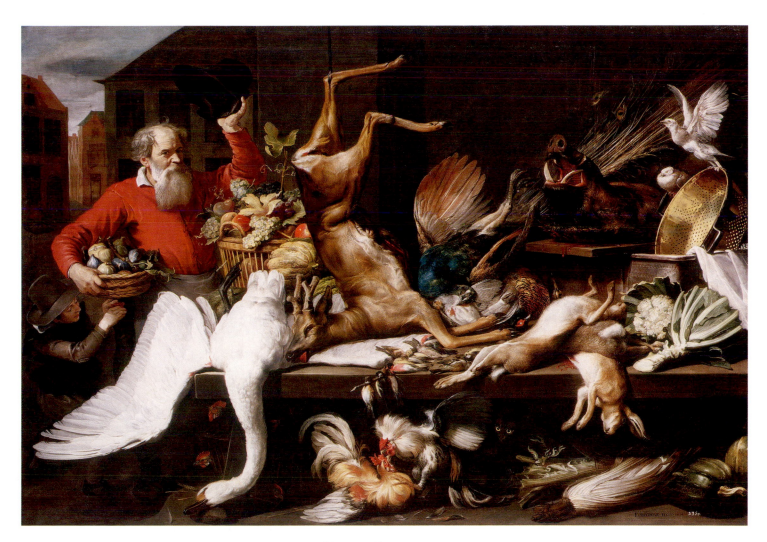

20.12. Frans Snyders. *Market Stall.* 1614. Oil on canvas, 6'11⁷⁄₈″ × 10'3⁵⁄₈″ (2.1 × 3 m).
© 1991 The Art Institute of Chicago. Charles H. and Mary F. S. Worcester Fund, 1981.182

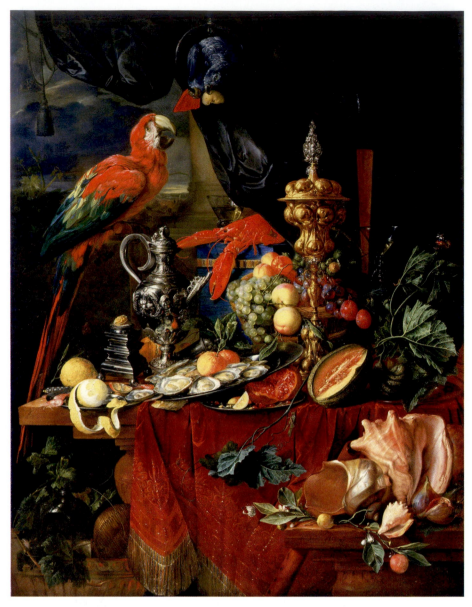

20.13. Jan de Heem. *Still Life with Parrots*. Late 1640s. Oil on canvas, $59\frac{1}{4} \times 45\frac{1}{2}''$ (150.5 × 115.5 cm). Bequest of John Ringling. Collection of the John and Mable Ringling Museum of Art, the State Art Museum of Florida, Sarasota, Florida

the work of Jan de Heem (1606–1684). De Heem began his career in Holland but he soon moved to Flanders where he transformed the still life into his unique, flamboyant style. In *Still Life with Parrots* (fig. **20.13**), he depicts delicious food, exotic birds, and luxurious goods from around the world: The conch and nautilus shells, the parrots, and the lobsters are probably from the New World, and the Seville oranges, plums, grapes, lemons, melons, pomegranates, and oysters are all imported, commanding high prices in the marketplace.

The food is piled up on pewter platters that are unstable and suggest extravagance. Unlike the even, horizontal composition of Peeters, early in the century, the silver, pewter, glass, and gilt ware is set in varying heights, building up to a crescendo topped by the parrots. De Heem intends this to be theatrical, drawing back a curtain for us to see. Even the column in the background is meant to suggest a heroic work. The result is a stunning display of virtuosity and defines the elements of a *pronk* still life.

THE DUTCH REPUBLIC

Art in the Dutch Republic, unlike the art of Flanders, was not based largely on church or state commissions, but was one exercised primarily though private patronage and the open art market. Pictures became a commodity, and their trade followed the law of supply and demand. Many artists produced for the market rather than for individual patrons. They were lured into becoming painters by hopes of success that often failed to materialize, and even the greatest masters were sometimes hardpressed and could not fully support themselves with the money earned from their art. It was not unusual for an artist to keep an inn or run a small business on the side. Yet they survived— less secure, but freer as a community of artists.

And there were many artistic communities—in Haarlem, Utrecht, Amsterdam, and Delft—to name but a few. Artists frequently traveled between these cities and may have known

each other's work, but most artists are usually associated with only one place—Goltzius and Frans Hals in Haarlem; Terbrugghen in Utrecht; Rembrandt in Amsterdam, and Vermeer in Delft. Some of the paintings were religious in nature, but most were not. There were portraits, group portraits commissioned by civic groups, landscapes, cityscapes, architectural paintings, still lifes, and genre paintings.

There were many types of paintings, and they ranged from large to small—small enough to hold in your hand or for ordinary people to hang on the walls of their homes.

The Haarlem Academy: Hendrick Goltzius

Like Rubens, Van Dyck, and even Jan Brueghel the Elder, many Dutch artists learned of the greatness of contemporary art in Rome and of its roots in antiquity by going there. And some, like Hendrick Goltzius (1558–1617), made numerous prints and drawings on their sojourn and brought them back for their own and others' use. Goltzius (with two other artists, Karel van Mander and Cornelis Cornelisz van Haarlem) created an "academy" in Haarlem in 1585. We know little about it, but copying from prints, from antiquity, and from each other, was part of their program. The academy also established teachers for the next generation and made the city of Haarlem a focal point for early Dutch painting, printmaking, and drawing.

The collaborative efforts in the academy seem to be limited to Goltzius's engravings of the works of his colleagues, based on their designs or paintings. He was a masterful engraver, whose injured hand (burned in a childhood accident) may have created the force behind his deep curvilinear cuts in the metal (see *Materials and Techniques*, page 498). He also executed woodcuts and only began painting after 1600.

The engraving of the *Farnese Hercules* (fig. **20.14**) illustrates the back of the Hellenistic sculpture owned by the Farnese family, housed in their palace, and also immortalized in a painting in the ceiling (fig. 19.7). It is seen here in its monumental, heroic scale, being viewed by two Dutch men—probably Goltzius's two companions in Italy during his trip of 1590–1591. In many ways, it is an allegory for the wide-eyed Dutch experience in Rome—filled with ruins, architecture, and sculpture of an ancient past. (Indeed, the Dutch would later decide to keep as ruins those buildings nearly destroyed by the Spanish—to have their own ruins of a heroic past.) This *Hercules*, as are others in his series, is also a very large print—a Herculean effort. Goltzius's trip to Italy was taken before Caravaggio and the Baroque, and thus the impact upon him grew from the art of the past, rather than from contemporary Italian works.

The Caravaggisti in Holland: Hendrick Terbrugghen

The Baroque style came to Holland from Antwerp through the work of Rubens, and from Rome through contact with Caravaggio's followers. Although most Dutch painters did not go to Italy, the majority of those who went in the early years of the century were from Utrecht, a town with strong Catholic traditions. One of the artists from Utrecht, Hendrick Terbrugghen (1588–1629), worked in Italy for several years and was one of the first of the "Caravaggisti" to return to the North. He adapted Caravaggio's style for religious painting, but also for the single figure, genre painting. Terbrugghen's *Singing Lute Player* (fig. **20.15**) is inspired by Caravaggio's painting of the same subject, by his *Musicians* (fig. 19.4), and by others like it, such as the young men in Caravaggio's *The Calling of St. Matthew* (fig. 19.2), who wear slashed doublets and feathered berets. Terbrugghen's portrayal of a life-size, half-length figure, filling the entire canvas, became a common one in Utrecht painting and became popular elsewhere in Holland. The Utrecht School transmitted the style of Caravaggio to other Dutch masters, such as Frans Hals.

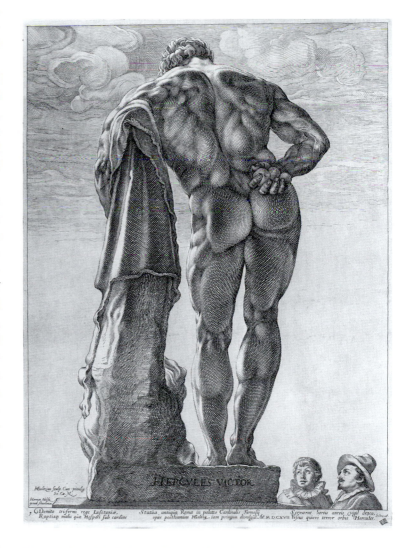

20.14. Hendrick Goltzius. *Farnese Hercules*. ca. 1592. Engraving. $16\frac{1}{2} \times 11\frac{3}{4}''$ (418 × 301 cm). The Metropolitan Museum of Art, New York. Gift of Henry Walters, 1917. (17.37.59)

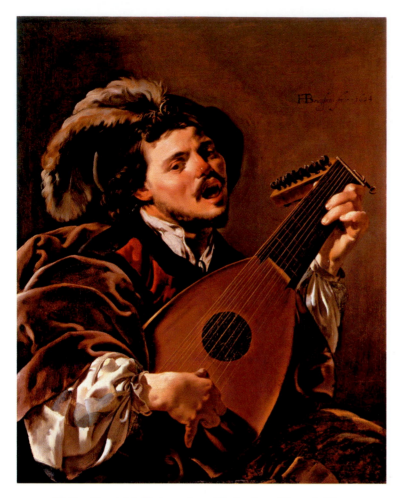

20.15. Hendrick Terbrugghen. *Singing Lute Player*. 1624.
Oil on canvas. $39\frac{5}{8} \times 31''$ (100.5 × 78.7 cm).
The National Gallery, London. Trustees of the National Gallery

The Haarlem Community and Frans Hals

One of the first to profit from these new ideas permeating the Dutch Republic was Haarlem artist Frans Hals (ca. 1585–1666), who was born in Antwerp. Hals captured his contemporaries in both portraiture and genre painting, and he excelled at combining both—animating his portraits and setting their poses in somewhat relaxed or even casual stances. His genre painting, usually of single figures, portrayed characters that seem to be drawn from real life.

HALS AND THE CIVIC GUARD Hals's six group portraits of the Civic Guards allowed him to provide multiple enlivened portraits into single dynamic paintings. The Civic Guards, founded in the fourteenth century, were local voluntary militia groups that were instrumental in defending their cities through military service. They also had civic and religious duties, and they began having their portraits painted in the early sixteenth century. Although they had successfully defended their cities from the Spanish in the 1580s and, indeed, were proud of this accomplishment, with the truce of 1609, the Civic Guards became more like civic fraternities, with annual banquets, as seen in the *Banquet of the Officers of*

the *St. George Civic Guard* (fig. **20.16**). The military aspects are indeed subordinated to the sense of general prosperity orchestrated in ritual. The captain in the center back wields a knife, but not as a military weapon; he is about to cut the roast. As is the custom, the colonel at the left raises his wine glass at the entrance of the standard bearer walking in with an unfurled banner. The highest ranking officers are seated, while the men of lower rank and the servants stand at the back. The men turn and face each other and the viewer, surrounding a table laden with food on a white damask tablecloth. But 12 men around a table beg comparison with Leonardo's *Last Supper* (fig. 16.6). This is an undeniably secular painting, yet the event depicted is steeped in ceremony.

Although the painting vividly suggests a moment in time at an actual gathering, art historians do not believe that Hals painted an actual event. The officers did not pose for this seating. The realism comes from the life-size scale, their gestures, the three-dimensional modeling created by paint applied "wet-in-wet" with strokes of varied width and length. This modeling creates its own vibrancy, making the men as "speaking likenesses." The Civic Guard painting would become a staple in Haarlem and also in Amsterdam. Rembrandt's *Night Watch* (fig. 20.23) represents another form of this standard.

In Hals's painting, the black-and-white fashions and the setting vibrates with the red-and-white sashes, creating a brilliant tableau. These men, the officers of the company, were wealthy citizens (in the case of Haarlem, they were brewers and merchants) who may have used this civic service to further their careers in government. Some even engaged Hals to execute individual portraits of themselves and family members, and Hals himself became a member of this company in 1612.

A WEDDING PORTRAIT Hals's only double portrait, *Married Couple in a Garden, Portrait of Isaac Massa and Beatrix van der Laen* (fig. **20.17**) probably commemorates the wedding in 1622 of Isaac Massa (1586–1643) and his wife Beatrix van der Laen. It combines the relaxed informal atmosphere of genre painting with the likeness and formal attire of portraiture. This life-size couple seem to enjoy each other and they modestly display their affection by sitting close to each other. Her arm is loped over his elbow displaying her ring (customary on the index finger); they smile broadly, their eyes twinkling, as they sit in a garden—an imaginary Garden of Love—surrounded by ivy, a symbol of steadfast love, faithfulness, and fidelity. Indeed, they seem in love with each other. His right hand touches his chest (his heart) as a show of his intended affection. This painting can be seen in sharp contrast to Jan van Eyck's *The Arnolfini Portrait* (fig. 14.16), and whether we interpret that earlier couple's presence as a betrothal, wedding, or contract, we can see that the emotional tie between the Arnolfini couple was not Van Eyck's concern. This is more than a difference in personal artistic style; it is the difference between the Renaissance and the Baroque, occurring over the course of 200 years. Between Van Eyck and Hals also stood Rubens, who had also executed a wedding portrait of himself and his first wife that may have served as an example to Hals.

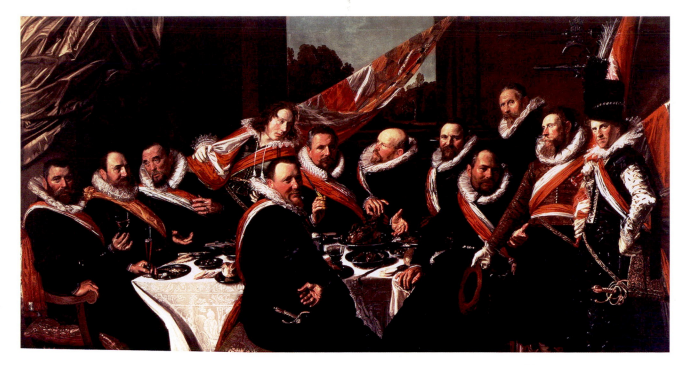

20.16. Frans Hals. *Banquet of the Officers of the St. George Civic Guard*. 1616. Oil on canvas, 5'9 × 10'7½" (175 × 324 cm). Frans Hals Museum, Haarlem

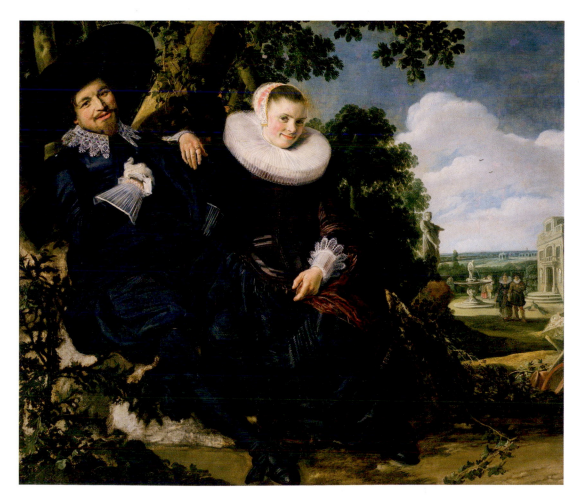

20.17. Frans Hals. *Married Couple in a Garden, Portrait of Isaac Massa and Beatrix van der Laen*. ca. 1622. Oil on canvas. 55 × 65½" (140 × 166.5 cm). Rijksmuseum, Amsterdam

Ingeniously, Hals set the couple off center, which adds to the sense of spontaneity, punctuated by the sense that Massa is open-mouthed and speaking to us. They wear expensive lace cuffs; his is a lace collar customary for men and she wears a millstone collar, with an embroidered and ribboned cap, usually worn indoors or under another hat. Her skirt is of silk and her *vlieger* (bodice) of velvet.

Hals painted Isaac Massa, an important and wealthy diplomat, at least two more times as a single figure. Massa had an adventurous life: He was a geographer and a cartographer of Siberia. He traveled to Russia in 1600 and lived there for 8 years where he became fluent in the language. He was active in the fur trade and influential in establishing trade routes between The Netherlands and Russia. But his worldliness is only suggested in this wedding portrait set in his own garden.

HALS AND GENRE PAINTING Hals's mature style is seen in *The Jolly Toper* (fig. **20.18**), which perhaps represents an allegory of Taste, one of the Five Senses, among the most popular themes in the seventeenth century. The painting combines Rubens's robustness with a focus on the "dramatic moment" that must be derived from Caravaggesque painters in Utrecht. Everything here conveys complete spontaneity: the twinkling eyes and half-open mouth, the raised hand, the teetering wine-glass, and—most important of all—the quick way of setting down the forms. Hals worked in dashing brushstrokes, each so clearly visible that we can almost count the total number of "touches." With this open, split-second technique, the completed picture has the immediacy of a sketch. The impression of a race against time is, of course, deceptive. Hals spent hours on this life-size canvas, but he maintains the illusion of having done it all in the wink of an eye.

Hals, like Rembrandt van Rijn and Jan Vermeer who we will meet in this chapter, is most closely identified with a period referred to as the Golden Age of Dutch Art. Individually these three artists develop and create from their Northern heritage, the unique style of seventeeth-century Dutch art in Haarlem, Amsterdam, and Delft respectively. Neither Hals, Rembrandt, nor Vermeer traveled to Italy.

The Next Generation in Haarlem: Judith Leyster

The most important follower of Hals was Judith Leyster (1609–1660), who was responsible for a number of works that once passed as Hals's own, although she also painted works most unlike his: candle-light scenes and paintings that explored the relationship between men and women. She painted portraits and still lifes, but mostly genre paintings. Her *Self-Portrait*

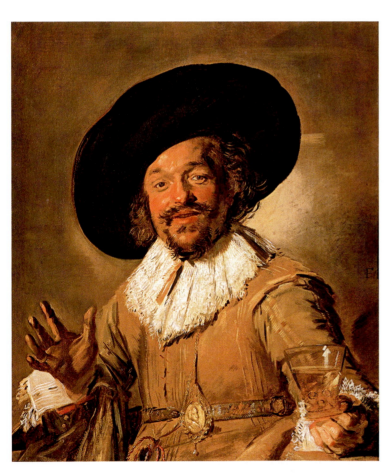

20.18. Frans Hals. *The Jolly Toper*. ca. 1628–1630. Oil on canvas. $31\frac{7}{8} \times 26\frac{1}{4}$" (81 × 66.6 cm). Rijksmuseum, Amsterdam

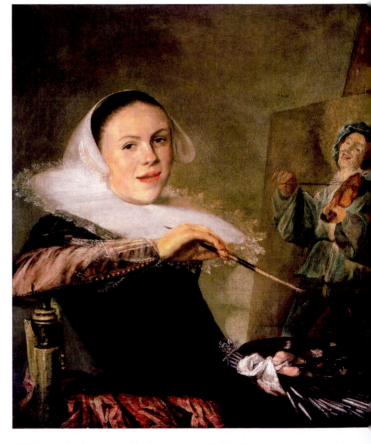

20.19. Judith Leyster. *Self-Portrait*. ca. 1633. Oil on canvas. $29\frac{3}{8} \times 25\frac{5}{8}$" (72.3 × 65.3 cm). National Gallery of Art, Washington, DC. Gift of Mr. and Mrs. Robert Woods Bliss

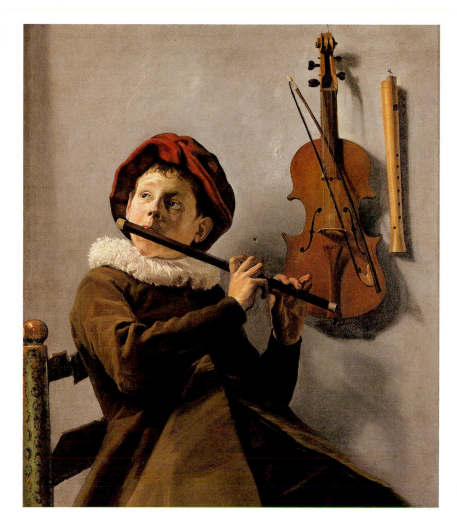

20.20. Judith Leyster. *Young Flute Player.* ca. 1635. Oil on canvas, $28^3/_8 \times 24^3/_8''$ (72.1 × 61.9 cm). National Museum, Stockholm

(fig. **20.19**) shows Leyster as both a portrait and genre painter and was executed no doubt to show her mastery of both. It was probably her presentation piece to the Guild of St. Luke in Haarlem in 1633, as her master's piece, when she became a master and had her own students. The painting on the easel is a detail of a popular work of hers, and so she is advertising her diverse talents. It reveals her technical skill as she wields numerous brushes and a palette, as she sits in her studio, open-mouthed and casually conversing with us. Many women artists, as Leyster does here, showed themselves painting—indicating their new professional status and their unique position. Indeed, Artemisia Gentileschi's *Self-Portrait as the Allegory of Painting (La Pittura)* (fig. 19.6), executed about the same time, also explores this same theme.

Leyster did not come from a family of artists, but married into one, when she married a fellow student of Hals's, Jan Miense Molenaer (ca. 1610–1668), who also excelled in genre and portrait painting. Together, the couple moved from Haarlem to Amsterdam. Leyster's *Young Flute Player* (fig. **20.20**) is signed on the recorder on the wall with her monogram, a conjoined J, L, and star, punning on her name, which means "leading star." Indeed, she was referred to during her lifetime as a "leading star" in art. Her rapt musician, possibly representing the Sense of Hearing, is a memorable expression of lyrical mood and is not surprisingly related to Terbrugghen's *Singing Lute Player* (fig. 20.15), as she had spent some time in Utrecht. Leyster explored the poetic quality of light pouring in from the left with an intensity that suggests her work bridges the generation between the Caravaggisti and Jan Vermeer (see figs. 20.34 and 20.35).

Rembrandt and the Art of Amsterdam

Like Hals and Leyster, Rembrandt van Rijn (1606–1669) was influenced indirectly by Caravaggio through the Utrecht School. Rivaling Rubens as the most famous artist of his age, Rembrandt is an artist perhaps better known to us today. A painter, draughtsman, and printmaker, he is equally significant in each medium and established himself in the growing and prosperous center city of Amsterdam. Rembrandt is known both for the intimacy and poignancy of images that convey personal relationships and emotions (see end of Part III, *Additional Primary Sources*)—an aspect seldom explored before—as well as for producing large group portraits and history pieces. He had an active workshop (see *Art Historian's Lens*, page 716) for four decades and many of his followers became significant artists in his native Leiden or in Amsterdam.

Authenticity and Workshops for Rubens and Rembrandt

Rubens and Rembrandt are among the many artists who ran workshops employing other artists. Anthony van Dyck, Frans Snyders, and Jan Breughel the Elder worked with Rubens as well as independently. Frequently, paintings by Rubens will be attributed to "Rubens and Workshop." On the other hand, the idea of collaboration with Rembrandt in a workshop has been slow to develop. The notion of Rembrandt as a solitary genius remained through the twentieth century and has only recently been examined. Paintings found to be not wholly by Rembrandt have been "demoted" and attributed to an artist of his workshop. Art historians have thus begun to rethink workshop practices.

According to some art historians, Rembrandt's *oeuvre* (the number of paintings produced) grew to almost a thousand; other historians thought he had produced a few hundred. In the 1960s, as exhibitions celebrating the three hundredth year after his death were being organized (for 1969), it was clear that art historians had different views of who Rembrandt was and what he did. As such, in 1968, the Rembrandt Research Project was developed, in which a team of art historians who would use scientific methods as well as connoisseurship to establish the authenticity of works attributed to Rembrandt. They would study the wood and canvas supports, date the wood (a process called dendochronology), take x-rays, use infrared photography, examine paints and ground samples, and view the paintings in teams and see works in raking (strong) light. The researchers made their reports and jointly issued three volumes, *The Corpus of Rembrandt Paintings*, reporting on works painted in 1625–1631, 1631–1634, and 1635–1642. At present, because of deaths and retirements, the committee's personnel has changed, but the project continues.

Although their deliberate and scientific examination has been incredibly useful and a model for others, their analysis of the attributions of Rembrandt works into three categories, A, B, and C, has been most controversial: "A" for authentic works by Rembrandt; "B" for paintings that cannot be either accepted or rejected as authentic (recently, the "B" category has been sarcastically labeled as "Bothersome"); and "C" for works rejected as authentic and to be attributed to others, usually to named followers of Rembrandt. What is missing from this list is the notion of collaboration—the usual workshop method we have seen in the work and workshop of Rubens. Although Rembrandt and Rubens both had active workshops over the course of their careers, art historians have viewed the art from these workshops differently.

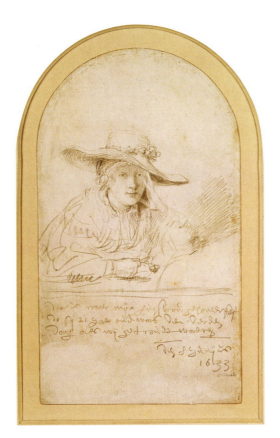

20.21. Rembrandt van Rijn. *Portrait of Saskia van Uylenburgh.* 1633. Silverpoint on white prepared parchment, arched at the top. 7¼ × 4″ (185 × 107 mm.). Staatliche Museen Preussischer Kulturbesitz, Kupferstichkabinett, Berlin. Inv. Kdz 1152

REMBRANDT'S DRAWINGS The poignancy of his drawings can be seen in many of his studies "from life"—that is, with the model before him. He drew in pen and ink, wash, red or black chalk, silverpoint, and combinations of these. Rembrandt's drawing of his wife in the *Portrait of Saskia van Uylenburgh* (fig. **20.21**), upon their engagement, is executed in silverpoint, an unforgiving drawing tool (before the invention of the pencil) that requires precision and a sure hand, on parchment. It is clearly meant as a very special drawing to commemorate their betrothal. The inscription states (in Dutch) "this is drawn after my wife, when she was 21 years old, the third day of our betrothal, the 8ᵗʰ of June 1633." They were married a year later; the drawing shows a dreamy-eyed Saskia looking very much in love with the viewer (artist). She wears a straw hat, usually associated with shepherdesses and pastoral, amorous scenes. The flowers in her hat and hands further embellish this idea. Saskia came from a well-to-do family and was the niece of Rembrandt's art dealer. Her features appear in many of his paintings and studies for etchings, until her death at the age of 30 in 1642.

REMBRANDT'S PAINTINGS Rembrandt's earliest paintings are small, sharply lit, and intensely realistic. Many deal with Old Testament subjects, a lifelong preference. (See end of Part III, *Additional Primary Sources*; see also fig. 20.26.) They show both his greater realism and his new emotional attitude. Rembrandt and, indeed, many seventeenth-century Protestants, viewed the stories of the Old Testament in much the same lay Christian spirit that governed Caravaggio's approach to the New Testament—as direct accounts of God's ways with his human creations. Some of these paintings were produced for the

national court in The Hague (despite the Reformation, the use of such images died hard), as well as for private patrons.

How strongly these stories affected him is clear in *The Blinding of Samson* (fig. 20.22). Painted in the Baroque style he developed in the 1630s after moving to Amsterdam, it shows Rembrandt as a master storyteller. The artist depicts the Old Testament world as full of Oriental splendor and violence, and he is directly influenced by Caravaggio through the Utrecht Caravaggisti. The theatrical light pouring into the dark tent heightens the drama to the pitch of *The Raising of the Cross* (see fig. 20.1) by Rubens, whose work Rembrandt sought to rival. But Rembrandt's decision not to travel to Italy to see the art of antiquity or the Renaissance may have limited his opportunities (see end of Part III, *Additional Primary Sources*). Instead, he brought the outside world to himself. Rembrandt was an avid collector of Near Eastern objects, which often served as props in his pictures.

REMBRANDT AND THE CIVIC GUARD By the 1640s, Rembrandt had become Amsterdam's most sought-after portrait painter, and a man of considerable wealth. His famous group portrait known as *The Night Watch* (fig. 20.23), because

of its old darkened varnish (now cleaned off), was painted in 1642. It shows a military company in the tradition of Frans Hals's Civic Guard groups (fig. 20.16), possibly assembling for the visit of Marie de' Medici of France to Amsterdam. Although the members of the company had each contributed toward the cost of the huge canvas (originally it was much larger), Rembrandt did not give them equal weight pictorially. He wanted to avoid the mechanically regular designs of earlier group portraits—a problem only Frans Hals had solved successfully. Instead, he made the picture a virtuoso performance filled with movement and lighting, which captures the excitement of the moment and gives the scene unique drama. The focus is on Captain Frans Banning Cocq, whose hand extends toward us and even creates a shadow across the yellow jacket of his lieutenant, while some figures are plunged into shadow and others are hidden by overlapping. Legend has it that the people whose portraits he had obscured were not satisfied with the painting, but there is no evidence for this claim. On the contrary, we know that the painting was much admired in its time, and Rembrandt continued to receive some major public commissions in the 1650s and 1660s.

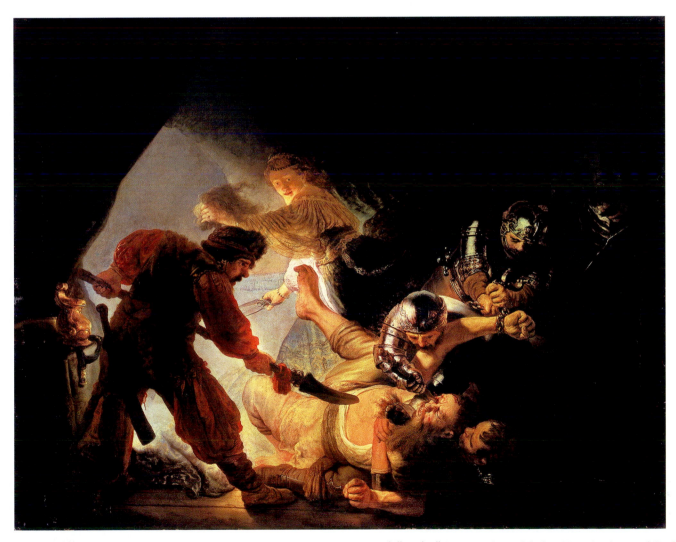

20.22. Rembrandt van Rijn. *The Blinding of Samson.* 1636. Oil on canvas, 7'9" × 9'11" (2.4 × 3 m). Städelsches Kunstinstitut und Stadtische Galerie, Frankfurt

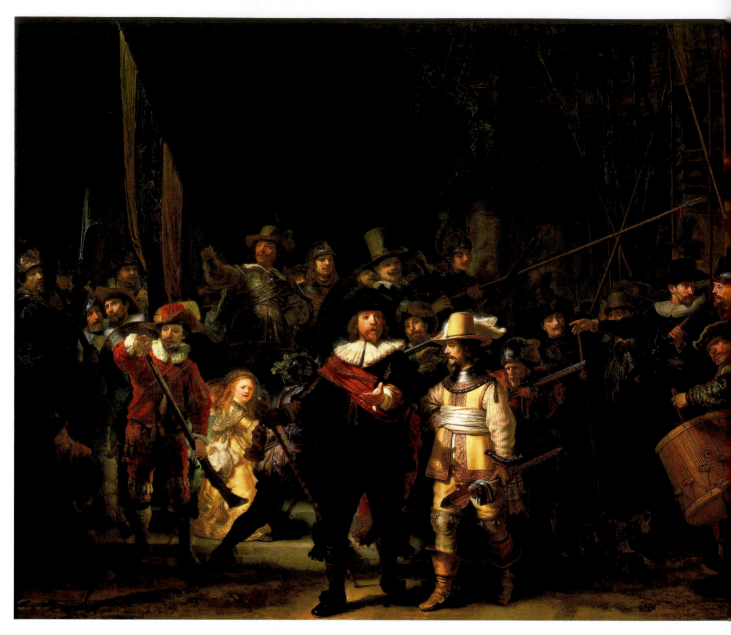

20.23. Rembrandt van Rijn. *The Night Watch (The Company of Captain Frans Banning Cocq).* 1642. Oil on canvas, 12′2″ × 14′7″ (3.8 × 4.4 m). Rijksmuseum, Amsterdam

REMBRANDT AS PRINTMAKER Rembrandt's etchings, such as his famed *The Hundred Guilder Print* (fig. **20.24**), executed in stages over many years, show a new depth of feeling not seen yet in the paintings we have examined. The etching, which has been interpreted as a depiction of the entire nineteenth chapter of the Gospel of St. Matthew, combines various aspects of Christ's preachings, including the healing of the multitudes, and the gathering of children and those who had forsaken all to come to him. This is crystallized in the phrase from a contemporary poem: "The Son of God in a world of sorrow. . . ." The print is poignant and filled with pathos, revealing a humble world of bare feet and ragged clothes. The scene is full of the artist's deep compassion for the poor and outcast, who make up the audience in the print. Rembrandt had a special sympathy for the Jews, both as heirs of the biblical past and as victims of persecution, and they were often his models and also his patrons. The setting of this print suggests some corner in Amsterdam where the Jews had found a haven; they are used here to provide an "authentic" setting for Christ's teachings. Rembrandt incorporates observations of life from the drawings he made throughout his career; several of these drawings have been identified as studies for this work. Here, as in Caravaggio's *The Calling of St. Matthew* (see fig. 19.2), it is the magic of light and dark that gives the *The Hundred Guilder Print* its spiritual significance.

The print derives its name from a story that 100 guilders was the great price paid for it at a contemporary auction. It is a virtuoso combination of etching and drypoint (see *Materials and Techniques*, page 721), which creates a velvety tone that can only be suggested in the reproduction here. Rembrandt's importance as a graphic artist is second only to Dürer's, although we get no more than a hint of his virtuosity from this single example.

SELF-PORTRAITURE Rembrandt painted many self-portraits over his long career. They are experimental in the early Leiden years, theatrically disguised in the 1630s, and frank toward the end of his life. (There have been many suggestions for the reasons behind their execution—as models for other paintings, as explorations of different expressions, and as possible advertisements for his craft.) While our late example (fig. **20.25**) is partially indebted to Titian's portraits (compare with fig. 16.34), Rembrandt examines himself with a typically Northern European candor. The bold pose and penetrating look bespeak a resigned but firm resolve that suggests princely nobility. A comparison with Holbein's *Henry VIII* (fig. 18.27) suggests the similar concept of power, but Holbein's interest in

the detail of fabric and jewels dominates while Rembrandt's display of *chiaroscuro* suggests its mood. There is also a marked difference in technique, as Rembrandt uses impasto, which is the layering of paints and glazes to achieve textured and atmospheric effects. Rembrandt painted several large self-portraits, including this one, toward the end of his life, and the acquisition of a "large mirror" (its breaking is documented) may have allowed him to do this.

ART IN TIME

1602—Dutch East India Company founded

1616—Hals's *Banquet of the Officers of the St. George Civic Guard*

1626—New Amsterdam (New York City) founded by the Dutch West India Company

1642—Rembrandt's, *The Night Watch*

1648—Treaty of Münster legally recognizes the Dutch Republic

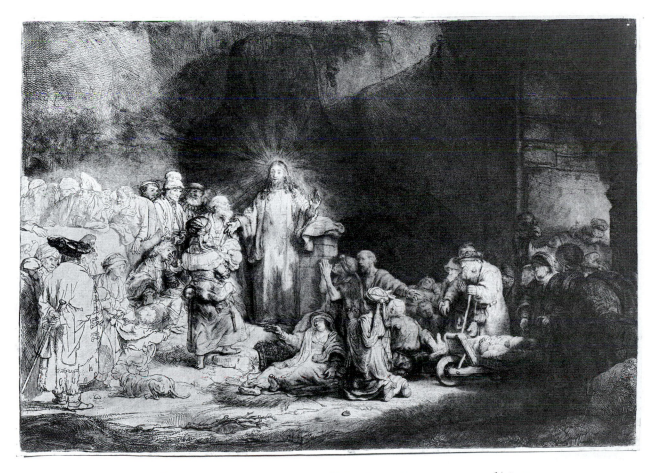

20.24. Rembrandt van Rijn. *The Hundred Guilder Print*. ca. 1647. Etching and dry point. $11 \times 12\frac{3}{4}$ ″ (27.8 × 32.4 cm). The Metropolitan Museum of Art, New York. H.O. Havemeyer Collection, Bequest of Mrs H.O. Havemeyer, 1929 (29.107.35)

Etching, Drypoint, and Selective Wiping

Etching is a form of intaglio printing. The modern technique calls for a metal plate to be cut by the artist using acid. The process begins with the metal plate initially being coated with a waxy substance. Instead of gouging grooves directly in the metal, the artist can lightly "draw" on the plate with a stylus, thereby removing the waxy coating and revealing the metal beneath. The plate is then placed in an acid bath, and the revealed metal will react with the acid, which will burn away the metal creating grooves. The plate is then removed, wiped off, and covered in ink. The excess ink is then wiped off, leaving ink only in the grooves. As with engraving, dampened paper is used to cover the plate. This is then rolled through a press. But, because the acid continues to burn the metal, the etched lines may be uneven, and depending on the length of time in the acid bath, the grooves may be deeper. With etching, therefore, the actual creation is much like drawing (artists may even carry prepared plates with them), but the finished process also includes a component of chance.

The possibilities for creating greater tonal qualities increased with the introduction of different varieties of paper. In the seventeenth century, several printmakers, including Rembrandt, used papers ranging in quality and origin, from fine laid to a creamy, nubby oatmeal paper, to tan Chinese and Japanese papers, which seemed to make the blacks even blacker. Rembrandt also printed on vellum and even on pigskin.

The range of blacks were further explored by the use of **drypoint**. Drypoint is the process of picking out the metal on a plate with a fine, hard needle and leaving the burr, the metal filings, which will then gather up the ink. This process has the possibility of creating areas of higher black density, as in Rembrandt's *The Hundred Guilder Print* (see fig. 20.24). Drypoint is often used in combination with etching and engraving.

Another option for creating greater tonal range is not to wipe the plate completely clean. This is called **selective wiping**. It can achieve an overall dark tone, creating *chiaroscuro* effects. In some cases, Rembrandt seems to have hardly wiped the plate at all, keeping it mostly inked. This very selective wiping was used to create nocturnal *tenebristic* effects. Rembrandt's dark printed images created an enthusiasm for these dark etchings, and a new form of etching was developed in the late seventeenth century, called mezzotint. This is a process of creating many indentations in the metal so that the entire plate (called a "rocked" plate) will print dark and only some areas, smoothed out by the artist, will print light. This process has recently been revived with the availability of prepared "rocked" plates.

In each of these processes, changes are possible. The initial print is called a *state*. In each case, after printing one example, the artist can make a change. The second printing, using the same plate or block, is called a *second state*. There can be many states for a single print. The block or plate is therefore quite valuable and can be used many years later—even after the artist's death, thereby providing family members or others with income. The block or plate can be purchased, and those who make new prints can even produce new states. Sometimes the artist will deface a plate (called "striking" it) to prevent unauthorized people from using it.

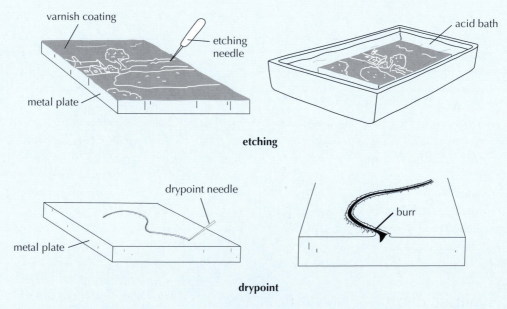

Etching and drypoint

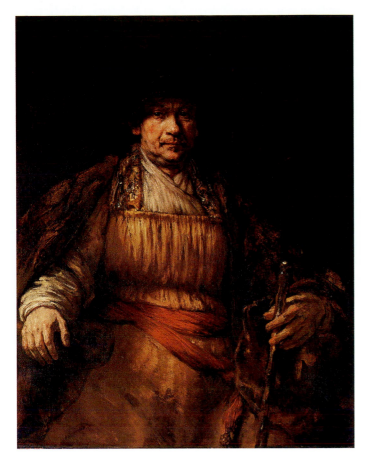

20.25. Rembrandt van Rijn. *Self-Portrait*. 1658. Oil on canvas, 52⅝ × 40⅞″ (133.6 × 103.8 cm). The Frick Collection, New York. Copyright the Frick Collection

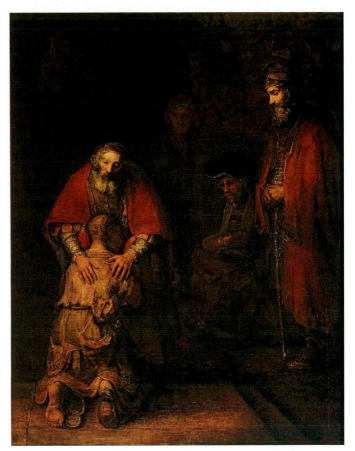

20.26. Rembrandt van Rijn. *The Return of the Prodigal Son.* ca. 1669. Oil on canvas, 8′8″ × 6′7¾″ (2.6 × 2.1 m). Hermitage Museum, St. Petersburg. Inv. GE-742

REMBRANDT'S LATE WORK Rembrandt's work toward the end of his life is punctuated by many religious paintings. *The Return of the Prodigal Son* (fig. **20.26**), created just before his death, may be his most moving painting. It is also his quietest—a moment stretching into eternity. So pervasive is the mood of tender silence that a viewer feels a kinship with this group. That bond is perhaps stronger and more intimate in this picture than in any earlier work of art. In the seventeenth century, artists often explored a different aspect of the adventures of the prodigal son, who is frequently seen spending his inheritance on drink and women. Here, the money has run out; the son has been impoverished and humiliated, and then returns home—to a welcome embrace. In Rembrandt, understanding accumulated over a lifetime achieves a universal expression of sorrow and forgiveness.

THE MARKET: LANDSCAPE, STILL-LIFE, AND GENRE PAINTING

While Italian art was dominated by private patronage or that of the Church, art in Northern Europe was largely made for an open market. Of course, portraits and group portraits, like those for the Civic Guards, were commissioned works, but a great number of paintings were made "on spec"—that is, with the hope that they would be purchased on the open market

from dealers, fairs, stores, and lotteries. We know (see *Primary Source*, page 701) that Rubens kept paintings in stock for his own use, and that these were not commissioned works. Perhaps with princely patrons in mind, Rubens painted many large works, but in Holland, paintings were often small, cabinet size, and with subjects suitable for a middle-class home. Most art buyers in Holland preferred subjects within their own experience: landscapes, architectural views, still lifes, and genre (everyday) scenes. These subjects, we recall, emerged in the latter half of the sixteenth century (see Ch. 18, page 652). As the subjects became fully defined, artists began to specialize. Although this trend was not confined to Holland, Dutch painting was its fountainhead in both volume and variety.

The richest of the newly developed "specialties" was landscape, both as a portrayal of familiar views and as an imaginative vision of nature. Landscapes—frequently with only small human figures or none at all—became a staple of seventeenth-century Dutch painting. We can see the beginnings of this in the work of Pieter Bruegel the Elder (see fig. 18.37) and in Italy as well, in such paintings as Carracci's *Landscape with Flight into Egypt* (see fig. 19.8). But in The Netherlands, the sense of reality, almost a "portrait of the land," was a common theme. A contemporary said of these landscapes: ". . . nothing is lacking except the warmth of the sun and the movement caused by the gentle breeze."

20.27. Jan van Goyen. *Pelkus Gate Near Utrecht.* 1646. Oil on panel, $14\frac{1}{2} \times 22\frac{1}{2}''$ (36.8 × 57.2 cm). The Metropolitan Museum of Art, New York. Gift of Francis Neilson, 1945. (45.146.3)

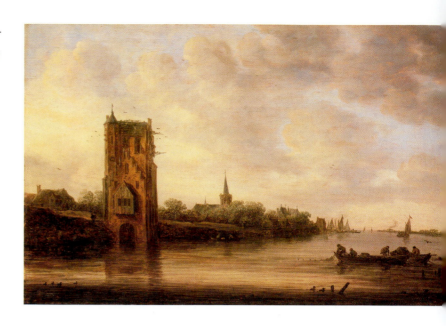

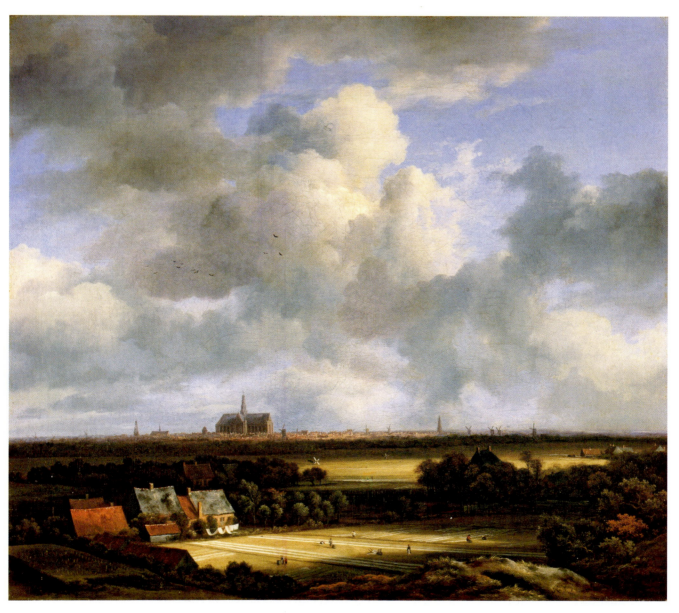

20.28. Jacob van Ruisdael. *Bleaching Grounds Near Haarlem.* ca. 1670. Oil on canvas. $21\frac{2}{3} \times 24\frac{1}{2}''$ (55.5 × 62 m). Royal Cabinet of Paintings, Mauritshuis, The Hague. Inv. 1.55

Landscape Painting: Jan van Goyen

Jan van Goyen's (1596–1656) *Pelkus Gate Near Utrecht* (fig. **20.27**), a seascape or marine painting, is the kind of landscape that enjoyed great popularity because its elements were so familiar: the distant town, seen with a low horizon line, under an overcast sky, through a moist atmosphere across an expanse of water. The painting is characteristic of Van Goyen's ability to combine the familiar with the picturesque, creating a melancholic mood of these "nether lands," ever threatened by the sea, but also in need of it.

Like other early Dutch Baroque landscapists, Van Goyen frequently used only grays and browns, highlighted by green accents, but within this narrow range he achieved an almost infinite variety of effects. The tonal landscape style in Holland was accompanied by radically simplified compositions, and we see this effect in the monochromatic still-life painting (fig. 20.31) of the same time. As he worked in several cities (Haarlem, Leiden, and The Hague), Van Goyen was especially influential and extremely prolific; he is credited with over 1,200 paintings and 800 drawings. His family is also evidence of the interrelationship of artists—his daughter married the genre painter, Jan Steen (see pages 726–728).

City Views Painting: Jacob van Ruisdael

Identifiable city views—panoramic landscapes with their outlying countryside and picturesque sand dunes, showing Amsterdam, Haarlem, Deventer—became popular throughout the century. In the art of Jacob van Ruisdael (ca. 1628–1682) these views become testaments to the city skyline—and to the sky. The sky might occupy three-quarters of the painting, as it does in this painting of Haarlem (fig. 20.28). Ruisdael did many paintings of Haarlem, known as *Haarlempjes* (little views of Haarlem). The church spires, windmills, and ruins are all identifiable, as is the major church, the *Grote-Kerk* (Big Church), known before the Reformation as St. Bavo (see fig. 20.30). In the foreground are the bleaching fields, where both domestic and foreign linen was washed and set out to be bleached by the sun. Haarlem water was well known for its purity and so the city was famous for its linen bleaching and beer production.

A heightened sense of drama is the core of Ruisdael's *The Jewish Cemetery* (fig. **20.29**), for which several drawings of the site exist. Natural forces dominate this wild scene, which is imaginary except for the tombs from the Jewish cemetery near Amsterdam. As we have seen in Rembrandt's work (fig. 20.24), Jews had been living in Amsterdam through the

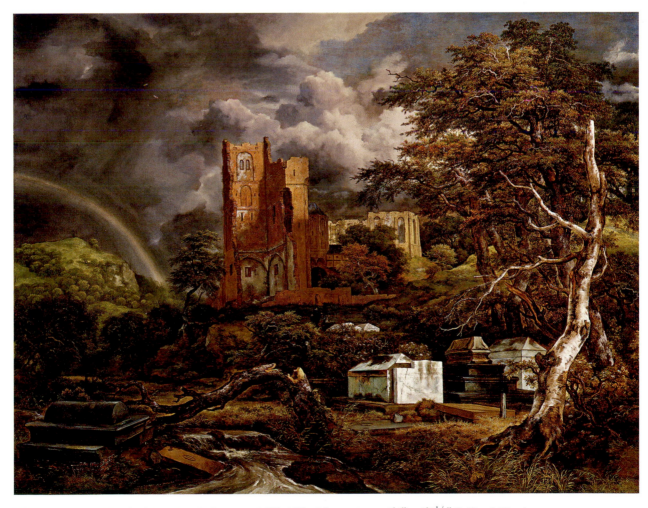

20.29. Jacob van Ruisdael. *The Jewish Cemetery.* 1655–1670. Oil on canvas, 4′6″ × 6′2¹⁄₂″ (1.42 × 1.89 m). The Detroit Institute of Arts, Detroit, MI. Gift of Julius H. Haass in memory of his brother, Dr. Ernest W. Haass

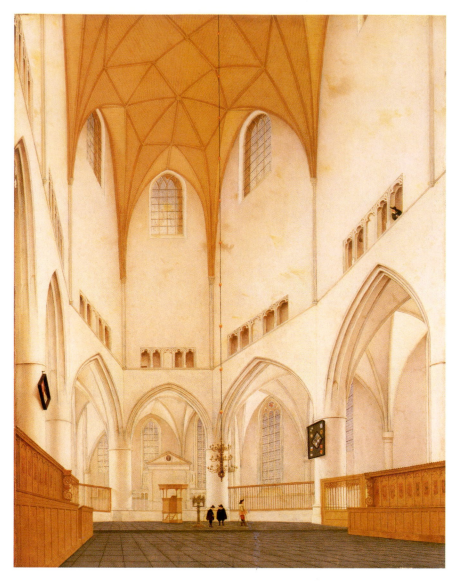

20.30. Pieter Saenredam. *Interior of the Choir of St. Bavo's Church at Haarlem.* 1660. Oil on panel, $27\frac{7}{8} \times 21\frac{5}{8}''$ (70.4 × 54.8 cm). Worcester Art Museum, Worcester, Massachusetts. Charlotte E. W. Buffington Fund.1951.29

seventeenth century—some often poor, from Germany and Eastern Europe, others often more prosperous, newly arrived from Brazil, where they sought refuge from the Inquisition in Spain. The cemetery, called *Bet Haim* (House of Life), belonged to the latter group, the Sephardic or Portuguese and Spanish Jews. Each of the tombs has been identified, and, though appearing ancient, they were all erected in the seventeenth century. Several drawings of this site by Ruisdael exist, as do prints by other artists. Jews in Amsterdam were exotic—the "other"— and this may account for the theme's popularity. Foreigners who came to Amsterdam visited and wrote about this community with curiosity and even awe.

In addition to this imaginary wild scene, Ruisdael adds other nonrealistic elements: The ruined building in the background has been identified as Egmond Abbey (Catholic), and it suggests a contrast (or perhaps a complementary relationship) between Jews and Catholics, as both are superseded in the Dutch Republic by the Reformed Church. Thus, the theme of death—the

cemetery, the tombs, the crumbling ruins of the abbey, and the dead trees—suggests the painting as a *vanitas*, a memorial to the brevity of life. The term, *vanitas*, comes from the Biblical book of Ecclesiastes and its phrase "vanity of vanities." It is a text on the passage of time and on mortality, just as this painting is also a visual reminder of the shortness of life. Yet the cemetery is all arced by a rainbow, a sign of God's promise and redemption. *The Jewish Cemetery* inspires that awe on which the Romantics, 150 years later, based their concept of the sublime.

Architectural Painting and Pieter Saenredam

In contrast to the dramatic mood and theatrical setting of *The Jewish Cemetery,* there are many examples, in paintings, prints, and drawings, of descriptive images of the interior of the Sephardic Synagogue and of many of the austere Reformed churches. The *Interior of the Choir of St. Bavo's Church at*

Haarlem (fig. **20.30**), painted by Pieter Saenredam (1597–1665), one of eleven that he painted, is meant to serve as more than a mere record. It is, in fact, an impossible view, suggesting a greater sense of vastness in the medieval structure than actually exists. Saenredam went to great lengths to construct his paintings. First, he made both freehand sketches and measured drawings in the church. His next step was to combine the two in additional drawings. Finally, he would paint a representation of the church that utilized the accurate details of his drawings but also included exaggerated elements for effect. This is the same church that is the focus of Ruisdael's *Bleaching Grounds Near Haarlem* (fig. 20.28). It is shown here stripped of all furnishings and whitewashed under the Protestants, and it has acquired a crystalline purity that invites spiritual contemplation through the painting's quiet intensity. (Both Saenredam and Frans Hals would be buried here.) The tiny figures in the interior provide scale and often narrative. Note the fellow at right looking out the triforium.

Still-life Painting: Willem Claesz. Heda

Dutch still lifes may show the remains of a meal—suggesting pleasure—of food and drink and luxury objects, such as crystal goblets, glasses of different sizes, and silver dishes, chosen for their contrasting shapes, colors, and textures. Flowers, fruits, and sea shells may be shown. All are part of the world of still life. And these are not too different from ingredients in a Flemish still life; many artists, such as Clara Peeters and Jan de Heem, traveled between both regions.

As seen here in his *Still Life* (fig. 20.31), the Haarlem artist, Willem Claesz. Heda (1594–1680) was fascinated by various surfaces and reflections—the rough edge of the lemon, the liquid, slimy quality of the oysters, the sparkling light on the glass, the multiple reflections of the window in the glass, the *prunts* (glass drops) on the *roemer* (wine glass), and the engraving on the silver. Heda is famous for these light effects, which are heightened by the tonal quality of the painting, which is largely monochromatic, much as in Jan van Goyen's landscape (fig. 20.27), also of mid-century. These are in marked contrast to the colorful Flemish works of Clara Peeters and Jan de Heem (fig. 20.11 and fig. 20.13). The table is set with white wine, lemon, oysters, and pepper in a cone—a bit of a fancy appetizer in this work—especially as oysters were known as aphrodisiacs. Yet the broken glass and overturned silver *tazza* suggest some upheaval on a narrative level. Whoever sat at this table was suddenly forced to leave the meal. The curtain that time has lowered on the scene, as it were, gives the objects a strange pathos. The unstable composition, with its signs of a hasty departure, suggests transience—a *vanitas*.

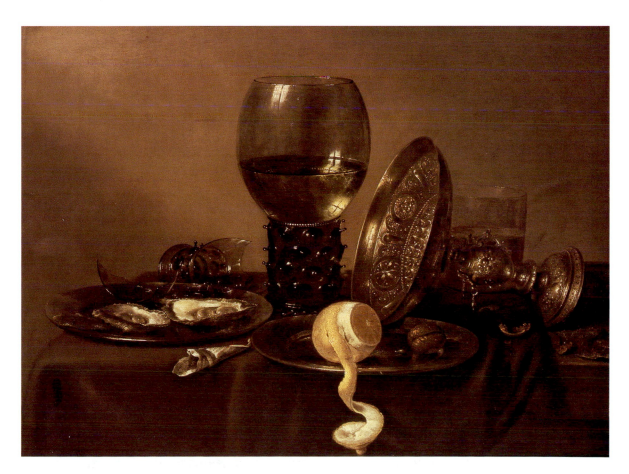

20.31. Willem Claesz. Heda. *Still Life*. 1634. Oil on panel, $16^7/_8 \times 22^7/_8''$ (43×57 cm). Museum Boijmans-van Beuningen, Rotterdam, The Netherlands

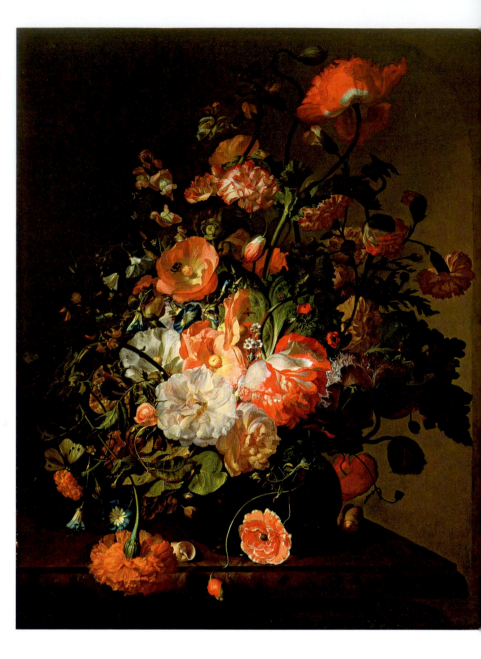

20.32. Rachel Ruysch. *Flower Still Life.* After 1700. Oil on canvas, $29^{3}/_{4} \times 23^{7}/_{8}''$ (75.5 × 60.7 cm). The Toledo Museum of Art, Toledo, Ohio. Purchased with Funds from the Libbey Endowment, Gift of Edward Drummond Libbey. 1956.57

Flower Painting and Rachel Ruysch

The independent floral still life seems to have begun in Flanders, but it developed in both Northern and Southern Netherlands. Rachel Ruysch (1664–1750) was one of the leading Dutch flower painters of the day, and was lauded as such in her lifetime. She had a long and prolific career and worked in Amsterdam, The Hague, and Düsseldorf, where she, with her husband Juriaen Pool II (1665–1745), a portraitist, became, as a team, court painters to the Elector Palatine until his death. One could even say she was born to be a flower painter, as her father was a professor of anatomy and botany. Ruysch knew every blossom, every butterfly, moth, and snail she put into a piece. We know from the inclusion of flowers in earlier paintings, such as the lilies in a vase in the *Mérode Altarpiece* (fig. 14.9), that flowers can have meaning beyond their beauty. The flowers in figure **20.32**, some with stems, wild and impossibly long, are arranged to create an extravaganza of color. Like the Heda *Still Life* (fig. 20.31) with broken glass, this still life has fallen, drooping flowers and suggests the *vanitas* theme.

Genre Painting: Jan Steen

GENRE PAINTING At the end of the seventeenth century, the same themes of genre painting are continued but then contain more narrative. Often there are interior scenes of homes and taverns. The human figures are often no longer half-length; they are shown full length, even when the paintings are small, creating a further sense of intimacy. The paintings of Jan Steen, Jan Vermeer and Gerard ter Borch, provide a range of subject matter from the comical to the deeply introspective, while suggesting a glimpse into the home, family, relationships, and even fashion of the seventeenth century. A scene of both comical circumstance and family intimacy can be seen in *The Feast of St. Nicholas* (fig. **20.33**) by Jan Steen, (1626–1679), St. Nicholas has just paid his pre-Christmas visit to the household, leaving toys, candy, and cake for the children. The little girl and boy are delighted with their presents. She holds a doll of St. John the Baptist and a bucket filled with sweets, while he plays with a golf club and ball. Everybody is jolly except their

brother, on the left, who has received only a birch rod (held by the maidservant) for caning naughty children. Soon his tears will turn to joy, however: His grandmother, in the background, beckons to the bed, where a toy is hidden.

Steen tells the story with relish, embroidering it with many delightful details. Of all the Dutch painters of daily life, he was the sharpest and the most good-humored observer. To supplement his earnings he kept an inn, which may explain his keen insight into human behavior. His sense of timing and his characterizations often remind us of Frans Hals (see figs. 20.16, 20.17, and 20.18), while his storytelling stems from the tradition of Pieter Bruegel the Elder (see fig. 18.38). Steen was also a gifted

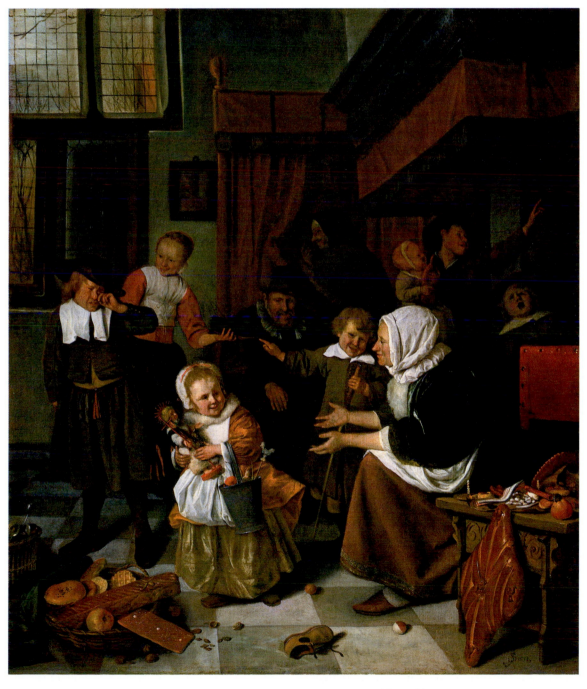

20.33. Jan Steen. *The Feast of St. Nicholas.* ca. 1665–1668. Oil on canvas, $32\frac{1}{4} \times 27\frac{3}{4}''$ (82×70.5 cm). Rijksmuseum, Amsterdam

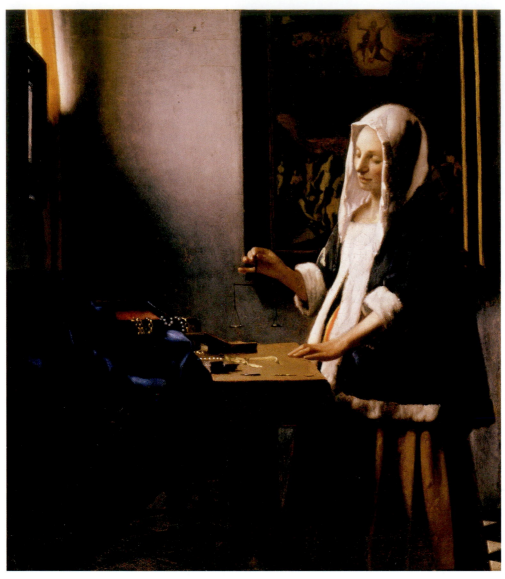

20.34. Jan Vermeer. *Woman Holding a Balance*. ca. 1664. Oil on canvas, $16^3/_4 \times 15''$ (42.5 × 38.1 cm). National Gallery of Art, Washington, DC. Widener Collection. (1942.9.97)

history painter, and although portions of his work are indeed humorous, they usually convey a serious message as well. *The Feast of Saint Nicholas* has such a content: The doll of St. John the Baptist is meant as a reminder of the importance of spiritual matters over worldly possessions, no matter how pleasurable.

Intimate Genre Painting and Jan Vermeer

In the genre scenes of the Delft artist Jan Vermeer (1632–1675), by contrast, there is no clear narrative. Single figures, usually women, are seemingly engaged in everyday tasks at private moments. They exist in a timeless "still life" world, as if becalmed by a spell. In *Woman Holding a Balance* (fig. **20.34**), a young woman, richly dressed in the at-home wear of the day, is contemplating a balance in her hand, with strings of pearls and gold coins spread out on the table before her. The painting gives a view into such a still-life world—with pearls and gold, paintings and fur all magically created to provide an eternal,

yet momentary, glance into a private world where, in fact, our view is not acknowledged. The painting in the background depicts Christ at the Last Judgment, when every soul is weighed. This may refer to the soul of her unborn child, and it parallels the woman's own activity, now contemplating the future of her unborn child. The pans of the balance were once thought to contain gold or pearls but scientific analysis of the painting indicates that they actually contain nothing, only beads of light. The painting is intensely private, quiet, yet also highly sensual, created with optical effects that make the surface shimmer.

Vermeer's use of light, frequently from a window at the left, with flecks of light on fabric, and reflections, mark his work. To achieve these effects that create a perfectly balanced painting, he seems to have used mechanics that are both old and new. Vermeer may have used a *camera obscura*, an experimental optical device (a forerunner of the photographic camera) that created

an image by means of a hole for light on the inside of a dark box. The hole acts as a primitive lens and a scene from outside the box can be seen, inverted, inside it. It is not suggested here that Vermeer copied such scenes, but he may have been inspired by them. Such scenes have a sparkling quality, often seen in parts of Vermeer's work (as seen here in the pearls and in the light on the balance). These sparkling areas are known as "discs of confusion." The *camera obscura* was well-known, and there is considerable evidence that it was used by Dutch artists. Further, Anthony van Leeuwenhoek, the inventor of the modern microscope, was a contemporary who lived in Delft and this suggests a local interest in practical optics.

This new way of looking is paired with an old way—one-point perspective view with a vanishing point. It has been shown that a hole (for a pin and string) was set in a number of Vermeer's paintings to create a one-point perspective system. The vanishing point in figure 20.34 is just to the left of the pinky finger that holds the balance. It sets the balance of all elements of the painting.

Vermeer's mastery of light's expressive qualities raises his concern for the reality of appearance to the level of poetry. He is concerned with all of light's visual and symbolic possibilities. *Woman Holding a Balance* is also testimony to the artist's faith: He was a Catholic (as was Jan Steen) living in Protestant Holland, where his religion was officially banned, although worship in private houses was tolerated.

A contemporary of Vermeer's remarked that he had seen "some examples of his [Vermeer's] art, the most extraordinary and most curious aspect of which consists in the perspective." Surely he was writing about *The Love Letter* (fig. **20.35**) or paintings like it, where the perspective system, through the use of the patterned tiled floor and doorway, is most striking. And indeed a vanishing point with pinhole is also observable in an x-ray. The subject of the painting itself is one of triple intimacy—between the woman and her lover (the sender of the letter), between the woman and her maid (who hands her employer this piece of private correspondence), and between us and this scene (as we peer, perhaps spy, into it).

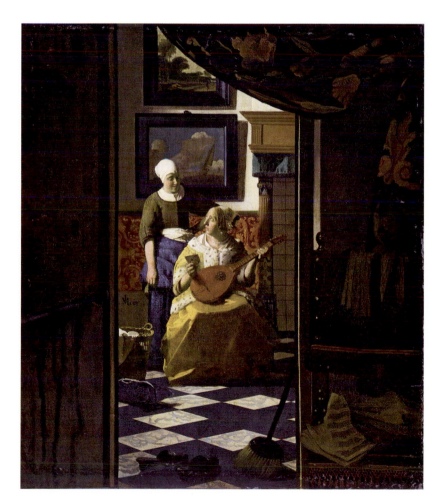

20.35. Jan Vermeer. *The Love Letter.* 1665–1668. Oil on canvas, 17¼ × 15¼″ (43.8 × 38.7 cm). Rijksmuseum, Amsterdam

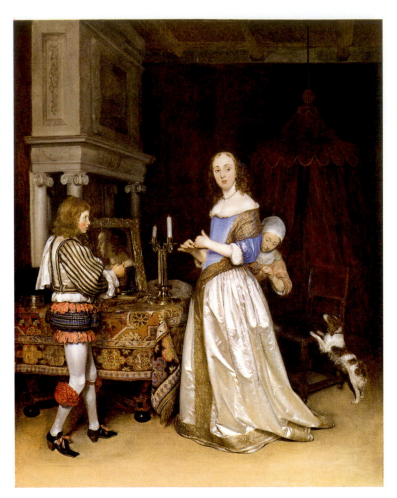

20.36. Gerard ter Borch. *Lady at Her Toilet*. ca. 1660.
Oil on canvas. 30 × 23¹/₂″ (76.2 × 59.7 cm.).
The Detroit Institute of Art, Detroit, MI. Founders Society
Purchase, Eleanor Clay Ford Fund, General Membership Fund,
Endowment Income Fund, and Special Activities Fund. 65.10

The Exquisite Genre Painting of Gerard ter Borch

Perhaps the most elegant—even exquisite—Dutch genre paintings were executed by Gerard ter Borch (1617–1681), who worked in the small city of Zwolle, but traveled widely both within Holland (he worked in both Haarlem and Amsterdam) and Europe. He came from a family of artists but little is known of his patrons or commissions. He painted both portraits and genre scenes; both types were often small (about the size of a notebook), but the figures were full-length and attired in the height of fashion. Such is the case in the *Lady at Her Toilet* (fig. **20.36**). She is, as are most of his women, dressed in satin, and Ter Borch was noted as an expert in recording this luxurious fabric. He did this by creating highly contrasting areas of light and dark, and by allowing the long satin skirts to reach the floor and buckle, creating even more shadows. This exact dress is also worn by another woman in a different painting, and these repeated patterns suggest that Ter Borch made drawings that he could use over again. The figures stand in a seemingly contemporary, but possibly imaginary, late seventeenth-century room, with a marble, four-column fireplace, and with canopied bed in the background. There is a Turkish-carpeted table and a page, magnificently dressed. (Pages or messengers similarly dressed also appear in paintings by other contemporary artists.) The simplicity of the room accentuates the high fashion of the woman, who appears more elegant than the equally wealthy subject of Vermeer's *The Love Letter* (fig. 20.35). Her maid adjusts her dress. The mirror set in a contemporary gilt frame reflects the profile of the woman; in reality, she could not be seen from that angle. The theme of "Venus at her Toilet" can be seen in the work of Titian, Vouet, and Boucher (figs. 17.30, 21.3, 22.5), but this is a nonmythological Venus, whose breathtaking beauty is reflected in all the trappings around her. The painting looks forward to the magnificence and opulence of the eighteenth century.

SUMMARY

In the seventeenth century, the Southern Netherlands (often know as Flanders) and the Northern Netherlands (eventually the Dutch Republic, often called Holland) were separated, even divided, by religion and government, and thus patronage in the two regions differed as well. Flanders, under Spanish rule was Catholic, and the Dutch Republic was predominately of the Reformed Church. Thus Catholic Church altarpieces, funded by major commissions, were executed in Flanders, whereas paintings of genre, still life, and landscape, while also painted in Flanders, were the dominant themes in Dutch art. Both Flanders and Holland saw the production of many portraits—with Civic Guard portraiture becoming a staple in Holland. Artists frequently traveled between the two regions.

FLANDERS

Peter Paul Rubens and his workshop dominated the art of Flanders. Rubens was the dominant force in Antwerp, and he created the Baroque style there. His style was disseminated by his workshop, both by individual artists

The theme of love letters was common in the seventeenth century. Here, the woman (in fig. **20.35**), dressed sumptuously in ermine and satin and bedecked in pearls, receives a letter (envelope) while sitting beneath a painting of the sea. Emblematic literature suggests that this refers to a lover far away and a letter sent by sea. The lute, an instrument filled with erotic meaning, traditionally signifies the harmony between lovers. The woman's yellow satin cape trimmed with ermine, as well as the pearl earrings and necklace, can also be seen in at least three other paintings by Vermeer. In the estate inventory after his death, a yellow satin jacket hemmed with white fur is listed and may have been a studio prop.

But all of these facts somehow do not get to the magical, hypnotic, truly original nature of his paintings. We do not know Vermeer's teachers or how he developed his unique style. No painter since Jan van Eyck *saw* as intensely as Vermeer. No other painter recorded his seeing in this exact yet somehow personal way.

and through collaborative projects. His paintings were grand, dynamic, and expressive. Upon his return from a time in Italy, he brought much of the force and dynamism of the Italian Baroque style to Northern Europe. The influence of Michelangelo, Caravaggio, and Titian can be seen in his works. The majority of his major commissions were altarpieces and portraits for the wealthy and ruling families of Italy and France, including the Marie de' Medici cycle. His workshop included artists who completed and collaborated on his works or who later worked independently, executing their own major commissions.

Anthony van Dyck, Rubens's assistant, was primarily a portrait and history painter. He also went to Italy, but later became the court painter to Charles I of England. His paintings are known for their elegance and for the impact of their color, which owed a debt to Titian.

Still-life painting in Flanders was executed in many forms; as a background for figure painting or as independent works. An example of collaborative work is the painting by Jan Brueghel and Rubens of the Five Senses. Independently executed still lifes, including both flower and food subjects, may be seen in the works of Clara Peeters. Game pieces were made by Frans Snyders, and elaborate (known as a *pronk*) still lifes were produced by Jan de Heem.

HOLLAND

Painting in the Dutch Republic was centered in several different cities: Utrecht, Haarlem, Amsterdam, and Delft. Ultrecht artists such as Hendrick Terbrugghen were frequently followers of Caravaggio. The Haarlem community of artists focused on portraits and genre painting—with the innovations in brushwork and in the representation of the individual. This can be seen in the individual, couple, and group portraits of Frans Hals. His work on Civic Guard portraiture was revolutionary. He, too, had many followers, although they were more independent than Rubens's followers. They included Judith Leyster, a genre, portrait, and still-life painter.

Rembrandt and his school dominated Amsterdam. Rembrandt produced many history paintings, portraits, and etchings. He is known for his depiction of the inner person and for revealing the pathos in a scene or moment. His works are famous for their poignancy.

THE MARKET: LANDSCAPE, STILL-LIFE, AND GENRE PAINTING

Landscape, still-life, and genre painting were the staple of the Dutch art market. Many of the landscapes were inspired by actual locales, and we can recognize these places in the works of Jan van Goyen and Jacob van Ruisdael, as well as in the architectural painting of Pieter Saenredam. Dutch still-life paintings paralleled those of Flanders in that they were simpler early in the seventeenth century and became more elaborate later—as in the flower still lifes of Rachel Ruysch. Vermeer's contribution to genre painting lies in the isolation of the single figure, suggesting a powerful intimacy. Other genre painters from the latter half of the century are Jan Steen and Gerard ter Borch.

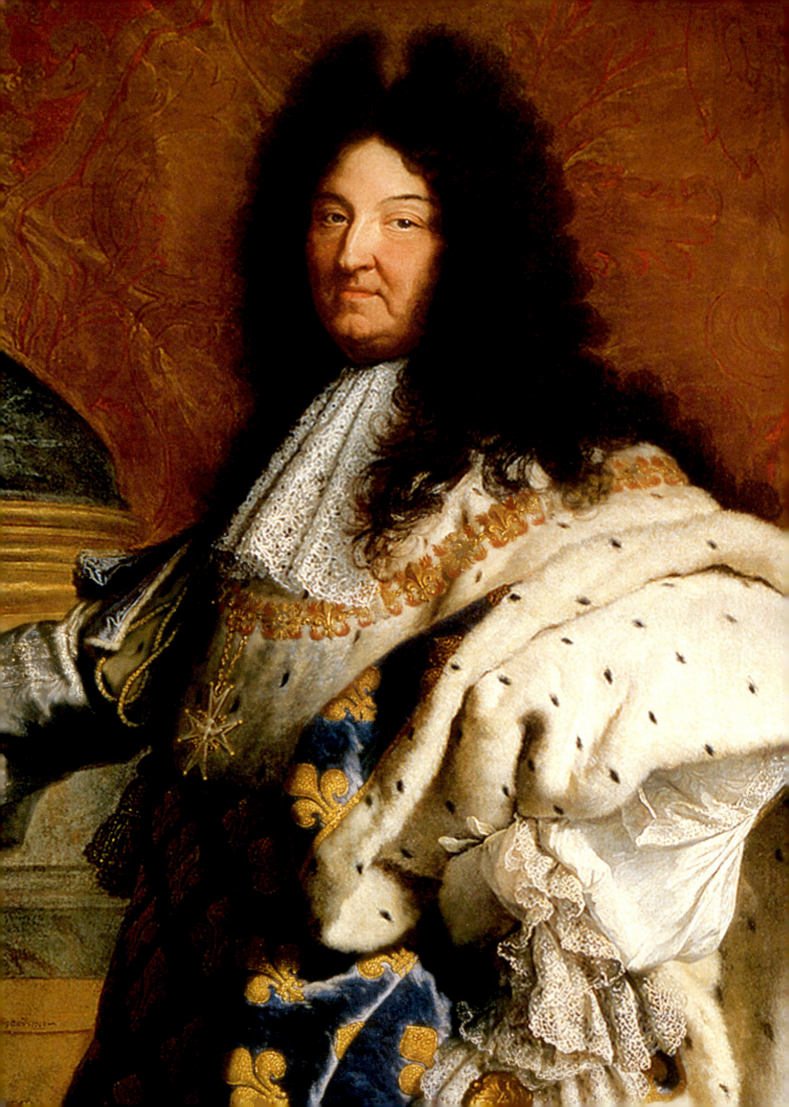

The Baroque in France and England

DURING THE COURSE OF THE TUMULTUOUS SEVENTEENTH CENTURY, the great monarchies of France and England—the former led by an absolute ruler, the latter governed by a king who shared power with the Parliament—underwent dramatic change. Devastated by the previous era's religious wars and dynastic struggles, both nations saw their

treasuries sorely drained, their populations severely reduced, and their societies bitterly divided. The theological controversies that had characterized the earlier Reformation and Counter-Reformation continued in this period, with Catholicism becoming the dominant religion in France and Protestantism in England. Each successive French and English monarch sought to strike a delicate balance between these competing forces while attempting to favor the religion of his choice. Such was true throughout Europe, where isolated skirmishes eventually coalesced into a conflict that encompassed nearly all nations—the Thirty Years' War (1618–1648).

England faced still more upheaval as its kings engaged in bitter battles with Parliament. The situation degenerated in 1642 into a civil war that led to the trial of King Charles I, who was convicted of treason and beheaded in 1649. With the abolishment of the monarchy, the Puritan Oliver Cromwell was named head of state and Lord Protector. Gradually his rule became a dictatorship with its own monarchial abuses, and upon his death in 1658 his government floundered. Two years later, in 1660, Parliament offered the throne to the son of the beheaded king, Charles II (1649–1685), thus ushering in the period known as the Restoration. Unfortunately, old religious rivalries and economic crises persisted, and the reign of Charles II's

successor, James II (r. 1685–1688), was soon in jeopardy. In the so-called Glorious Revolution of 1688, a relatively peaceful and bloodless event, members of the governing classes of Whigs and Tories proclaimed the Prince of Orange, Stadholder, ruler of the Dutch Republic, as king of England, who reigned as William III from 1689 to 1702. The Bill of Rights (1689) established Parliament's supremacy, thus creating a unique form of government that would gradually influence nations worldwide, notably the British colonies in North America.

Waging war was an expansive undertaking requiring an efficient government system to be successful, and sovereigns throughout Europe quickly realized the pressing need to consolidate the state's power and exert economic control. In France, which by midcentury had emerged as Europe's most powerful nation both militarily and culturally, this centralization was most successfully implemented by Louis XIV (1638–1715). Louis evoked the age-old divine right of kings—the idea that the monarch received his authority directly from God—in order to increase the state's power by gaining control over the nobility, amassing revenue through taxation, and curbing the power of local authorities. He relied on a form of royal government known as absolutism, which gave full power to the monarch. The absolute monarchy in France differed from England's constitutional monarchy, which divided power between the ruler and other institutions, Parliament being the most significant, although all European monarchies shared to some degree the

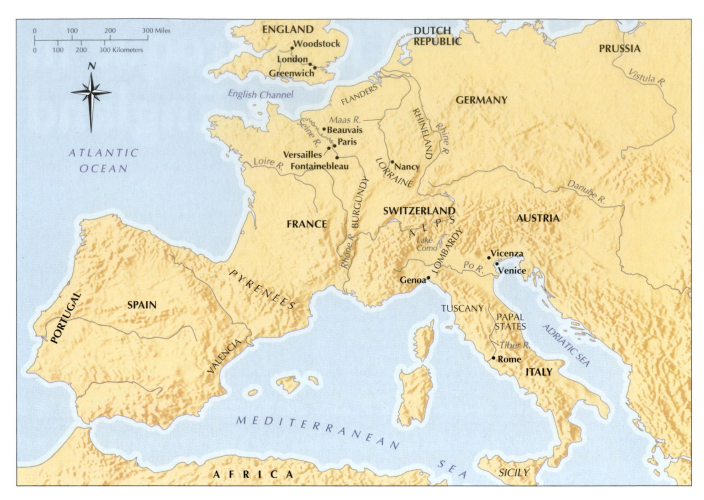

Map 21.1. Europe in the Seventeenth Century

notion of divine right. In his quest to assert the preeminence of France, Louis XIV embarked on a series of military campaigns from 1688 to 1713 against his rivals, Spain, The Dutch Republic, Germany, and England. Despite eventual defeat, France remained a world power upon Louis's death in 1715.

The wars and social turmoil took perhaps their harshest toll on peasants and commoners, who reeled from continually increasing taxes as well as from devastating natural disasters and the ensuing food shortages, famine, and rising prices. Rural and urban revolts broke out frequently, but such resistance was doomed, harshly suppressed by the state. Yet despite the abject poverty endured by some members of society, others enjoyed new wealth and prosperity. Both England and France reaped enormous profits from investments in their colonial empires, and established trading routes delivering a wider range of goods that enhanced the lifestyles of all Europeans. The development of mercantilism and a worldwide marketplace brought about the rise of a class of increasingly wealthy urban merchants seeking art to furnish and decorate their homes.

In the emerging capital cities of Paris and London (see map 21.1), the grandiose style of expanding civic projects, notably architecture, symbolized the wealth of each nation. By the late seventeenth century Paris was vying with Rome as Europe's art center. The French kings Henry IV (r. 1589–1610), Louis XIII (r. 1610–1643), and Louis XIV (r. 1643–1715)—aided by ambi-

tious and able ministers and advisers such as the Duc de Sully, cardinals Richelieu and Mazarin, and Jean-Baptiste Colbert—created the climate for this exciting turn of events. The kings and their officials recognized the power of art to convey the majesty and strength of the monarchy, and they set out on a massive program of patronage of all the arts and sciences—painting, sculpture, architecture, landscape design, decorative arts, theoretical and applied science, philosophy, and literature. Louis XIV especially manipulated art to serve as propaganda for his absolutist policies. He adopted the symbolic imagery of the sun as well as the Greek god Apollo and came to be called the Sun King. This symbolism provided an ancient lineage for Louis that would serve his principle as absolute ruler. The ideal of *gloire* (glory), seen in the portraits and architecture he commissioned, reflected his desire to give concrete form to the majesty of his rule, and thus of France.

During this period, the royal courts in England and France served as the greatest patron of the arts. Art historians most associate the style of classicism with the art of these two nations. Through its use of Classical vocabulary—from columns, capitals, and pediments in architecture to styles of dress in painting—classicism represents a response to the ancient world and suggests authority, order, and enduring tradition in its evocation of the imperial grandeur of Rome. Although the Mannerist style of the later school of Fontainebleau persisted in France

until about 1625 (see pages 625–628), classicism soon became the hallmark of seventeenth-century French art. It became the official court style of painting between 1660 and 1685, a period corresponding to the climactic phase of Louis XIV's reign. Classical principles also dominated architecture, with the new Louvre and Versailles representing the most visible accomplishments of Baroque classicism in France.

In England, too, classicism dominated art and architecture, notably the hospitals, churches, and country houses designed by Inigo Jones and Sir Christopher Wren. In the wake of the Great Fire of London in 1666, architecture thrived as massive reconstruction projects were undertaken to rebuild the city. Yet England's lasting artistic successes in the seventeenth century were in literature, with notable works by William Shakespeare, John Donne, and John Milton as well as the royal committee's translation of what would become known as the King James Bible.

FRANCE: THE STYLE OF LOUIS XIV

Because the Palace of Versailles and other vast building projects glorified the French king, we are tempted to think of French art in the age of Louis XIV as the expression of absolute rule. This perception holds true for the period 1660–1685, but by that time seventeenth-century French painting and sculpture had already attained its distinctive, Classical character. French historians are reluctant to call this style Baroque but refer to it instead as the *Style of Louis XIV*. They also use this term to describe art created prior to Louis XIV, particularly art produced in the court of his father, Louis XIII. In addition, scholars often describe the period's art and literature as "classic." In this context, the word has three meanings. It is a synonym for "highest achievement," which suggests that the Style of Louis XIV is the equivalent of the High Renaissance in Italy or the age of Perikles in ancient Greece. It also refers to the imitation of the forms and subject matter of Classical antiquity. Finally, it suggests qualities of balance and restraint shared by ancient art and the Renaissance. The last two meanings describe what could more accurately be called **classicism**. Because the Style of Louis XIV reflects Italian Baroque art, although in modified form, we may call it Baroque classicism.

Painting and Printmaking in France

The many foreign artists working in France drew inspiration from that country's styles and traditions, whereas French artists often traveled to Italy and The Netherlands to work. In the hopes of creating a nucleus of artists who would determine the Baroque in France, Louis XIII began officially recalling these artists to Paris. Among the summoned artists were painters Nicolas Poussin and Simon Vouet, who had been working in Rome, and the printmaker Jacques Callot, who returned from Florence to his home in northern France.

JACQUES CALLOT: A TRANSITIONAL FIGURE One of the most important early seventeenth-century artists was Jacques Callot (1592/93–1635), an etcher and engraver whose small-scale prints recording actual experiences inspired his compatriot Georges de La Tour (discussed below) and the young Rembrandt. Callot's exploitation of the medium's ability to produce stark tonal contrasts and intricate details reflects the tradition, dating from the fifteenth century, of using mass-produced prints to disseminate information. Yet his poignant representations of contemporary figures and events places him firmly in the art of his own time. Callot spent much of his early career at the court of Cosimo II de' Medici in Florence, where he produced prints inspired primarily by the theater and especially the *commedia dell'arte*. After returning to his native town of Nancy in 1621, he began to concentrate almost exclusively on the technique of etching and the subject of his work changed. He visited Breda in 1626, soon after the surrender of Dutch troops there (see fig. 19.36), and executed six plates showing a large panorama of the site.

Callot's insight into the personal and political geography of battle can best be seen in the series *The Great Miseries of War*, which represents a distillation of his experience of the Thirty Years' War. (Scholars once thought Callot executed the series in 1633 but now consider it to be from 1629–1632.) In the 18 etchings in the series, Callot reveals the misery, destruction, and poverty brought by the invading army. Several prints are devoted to the soldiers' crimes, whereas others, including *Hangman's Tree* (fig. **21.1**), focus on the punishments dealt to

21.1. Jacques Callot. *Hangman's Tree,* from *The Great Miseries of War.* 1633. Etching, $3\frac{1}{2} \times 9''$ (9 × 23 cm). The British Museum, London

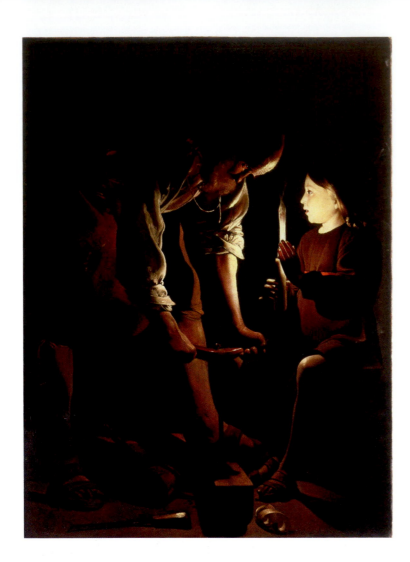

nized only in the nineteenth century. Although La Tour spent his career in Lorraine in northeast France (and, as such, suffered directly as a result of the Thirty Years' War), he was by no means a simple provincial artist. Besides being named a painter to King Louis XIII, he received important commissions from the governor of Lorraine. He began his career painting picturesque genre figures before turning to religious scenes that appealed to adherents of the Catholic faith, then the predominant religion in France. His use of light and his reliance on detailed naturalism derived largely from Caravaggio's Northern European followers (see page 711), whom he may have visited in the Dutch Republic.

La Tour's mature religious pictures effectively convey the complex mysteries of the Christian faith. With its carefully observed details and seemingly humble subject *Joseph the Carpenter* (fig. **21.2**) might initially be mistaken for a genre scene, but its devotional spirit soon overwhelms us. The two figures are set in profile, thus yielding little in their expressions. La Tour lends maximum significance to each gesture, each expression. The boy Jesus holds a candle, a favorite device of the artist, whose flame reinforces the devotional mood and imbues the scene with intimacy and tenderness. The painting has the power of Caravaggio's *Calling of St. Matthew* (see fig. 19.2), but the simplified forms, warm palette, and arrested movement are characteristic of La Tour's restrained and focused vision.

the French army for their excesses. The inscription at the bottom reads: "Finally these thieves, sordid and forlorn, hanging like unfortunate pieces of fruit from this tree, experience the justice of Heaven sooner or later." Despite the work's small size (it measures only a few inches), nearly 50 figures inhabit the scene. The awkward perspective emphasizes the tiny, elongated, Mannerist-style figures; in the figures on the right, however, Callot has shown a naturalism in costume and attitude that is characteristic of the new Baroque style. The bleak scene is as disturbing as Hieronymus Bosch's vision of hell in *The Garden of Earthly Delights* (fig. 14.24), and it may be even more so, for it is based on the artist's own experience of the horrors of war.

GEORGES DE LA TOUR AND THE INFLUENCE OF CARAVAGGIO Many French painters in the early seventeenth century were influenced by Caravaggio, although how they may have been exposed to the Italian artist's style remains unclear. Most were minor artists toiling in the provinces, but a few developed highly original styles. The finest of these was Georges de La Tour (1593–1652), whose importance was recog-

SIMON VOUET AND THE DECORATIVE STYLE Although Simon Vouet (1590–1649) became the leader of the French Caravaggesque painters in Rome, he painted in many styles throughout his career. At an early age he accompanied his artist father to England and Constantinople, but his most significant foreign travels were to Rome, where he lived from 1613 to 1627. In Rome he became an adherent of Caravaggio's style but was also later influenced by the Bolognese artist Annibale Carracci. Vouet was so well respected that he was elected President of the Academy of St. Luke in Rome. Officially recalled to France in 1627 by Louis XIII, he settled in Paris and became the leading painter of his day. Vouet quickly shed all traces of Caravaggio's manner and developed a colorful style, which won such acclaim that he was named First Painter to the king. It is from Vouet's studio that the official style in France emanated in the 1630s and 1640s. His paintings, influenced by Venetian artists, were known for their rich colors and use of light and thus provided the interiors of royal residences and a growing number of French aristocratic houses with a new vibrant decorative style.

21.3. Simon Vouet. *The Toilet of Venus.* ca. 1640. Oil on canvas, 65¼ × 45″ (165.7 × 114.3 cm). The Carnegie Museum of Art, Pittsburgh. Gift of Mrs. Horace Binney Hare

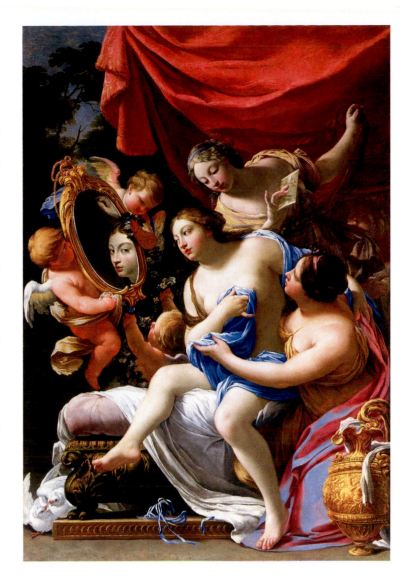

The Toilet of Venus (fig. **21.3**), possibly painted for one of the king's mistresses, is one of several on this theme that Vouet executed. It depicts a subject popular in Venice, notably executed by Titian and Veronese, and also treated by Rubens. The figure recalls Correggio's *Jupiter and Io* (fig. 17.24) but lacks that work's frank eroticism. Instead, Vouet has imbued his Venus with an elegant sensuousness that is uniquely French. The use of continuous swirling circles, near nudity, interest in fabric, and luminous colors only suggest the erotic, whose appeal would continue well into the eighteenth century and provide the basis for the Rococo style in painting. Vouet taught the next generation of artists, including those who worked on Louis XIV's palace at Versailles, the landscape designer and royal gardener André Le Nôtre, and Charles Le Brun, the royal painter who would later establish the French Royal Academy (from which he would exclude his teacher).

NICOLAS POUSSIN AND BAROQUE CLASSICISM

Despite Vouet's earlier influence on painting, after the 1640s classicism reigned supreme in France. The artist who contributed most to its rise was Nicolas Poussin (1594–1665), one of the most influential French painters of the century. Aside from an ill-fated two-year sojourn in Paris, however, Poussin spent his career in Rome. There he hosted and taught visiting French artists, absorbing the lessons of Raphael's and Carracci's classically ordered paintings and developing his own style of rational classicism. Patrons brought Poussin's paintings back to Paris, where they influenced the royal court. Indeed, when establishing the curriculum of the French Royal Academy in the 1660s, Jean-Baptiste Colbert, the king's chief adviser, and artist Charles Le Brun chose Poussin's Classical style to serve as a model for French artists. Yet the rivalry between Poussin and Vouet continued long afterward as the artists' differing traditions vied with each other through the next century, alternating in succession without either one gaining the upper hand for long.

POUSSIN AND HISTORY PAINTING: ANCIENT THEMES IN THE GRAND MANNER
Arriving in Rome via Venice in early 1624, Poussin studied perspective and anatomy and examined ancient sculpture, such as *The Laocoön, The Belvedere Torso,* and *The Apollo Belvedere,* the reliefs on ancient sarcophagi and vases, and the paintings of Raphael. His *The Death of Germanicus* (fig. **21.4**) reflects much of his studies. The work served as a model for artistic depictions of heroic deathbed scenes for the next two centuries and may in

fact be the first example of this subject in the history of art. A typical history painting, the work relates the powerful themes of death, loyalty, and revenge. The story comes from Tacitus and is set in 19 CE. Germanicus was a Roman general who had led campaigns against the Germanic tribes. At the urging of Tiberius, Germanicus' adoptive father, the ruler in Syria, poisoned the powerful general. Poussin depicts him on his deathbed, flanked on the left by his loyal soldiers swearing revenge and on the right by his mournful family. The promise to avenge is set at the center, commanding attention, as figures gesture their grief, loyalty, and suffering. Framed by the two groups, Germanicus becomes the focus of the composition, which is based on antique scenes of the death of Meleager (see fig. 7.62). The architecture sets the stage for the figures, which are arranged horizontally in a rectangular space, as in a Classical frieze. The curtain in the rear restricts the action to a shallow space, heightening the drama and creating a more intimate environment.

Nicolas Poussin (1594–1665)

From an undated manuscript

Poussin's ideas on art were central to the formation of the French Academy in 1648 and, because of the preeminence of that academy, therefore to the entire European academic movement of the seventeenth through the nineteenth centuries.

The magnificent manner consists of four things: subject, or topic, concept, structure and style. The first requirement, which is the basis for all the others, is that the subject or topic should be great, such as battles, heroic actions and divine matters. However, given the subject upon which the painter is engaged is great, he must first of all make every effort to avoid getting lost in minute detail, so as not to detract from the dignity of the story. He should describe the magnificent and great details with a bold brush and disregard anything that is vulgar and of little substance. Thus the painter should not only be skilled in formulating his subject matter, but wise enough to know it well and to choose something that lends itself naturally to embellishment and perfection. Those who choose vile topics take refuge in them on account of their own lack of ingenuity. Faintheartedness is therefore to be despised, as is baseness of subject matter for which any amount of artifice is useless. As for the concept, it is simply part of the spirit, which concentrates on things, like the concept realized by Homer and Phidias of Olympian Zeus who could make the Universe tremble with a nod of his head. The drawing of things should be such that it expresses the concept of the things themselves. The structure, or composition of the parts, should not be studiously researched, and not sought after or contrived with effort but should be as natural as possible. Style is a particular method of painting and drawing, carried out in an individual way, born of the singular talent at work in its application and in the use of ideas. This style, and the manner and taste emanate from nature and from the mind.

SOURCE: ALAIN MEROT, *NICOLAS POUSSIN*. TR. BY FABIA CLARIS (LONDON: THAMES AND HUDSON LTD., 1990)

This early work by Poussin, painted just a few years after he arrived in Rome, was probably created for Cardinal Francesco Barberini's secretary, Cassiano dal Pozzo (1588–1657), a major patron of the arts. Its composition, setting, and heroic historical subject (see *Primary Source*, above), are typical of Poussin's classicism.

THE ABDUCTION OF THE SABINE WOMEN Showing Poussin's allegiance to classicism, *The Abduction of the Sabine Women* (fig. 21.5) displays the severe discipline of his intellectual style, which developed in response to what he regarded as the excesses of the High Baroque (see page 671). The strongly modeled figures are "frozen in action," like statues. Many are,

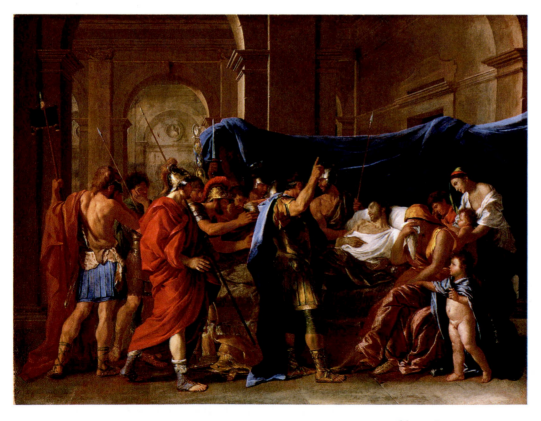

21.4. Nicolas Poussin. *The Death of Germanicus.* 1627–1628. Oil on canvas, 58¼ × 78″ (147.96 × 198.12 cm) Minneapolis Institute of Art, Minneapolis, Minnesota. The William Hood Dunwoody Fund. 58.28

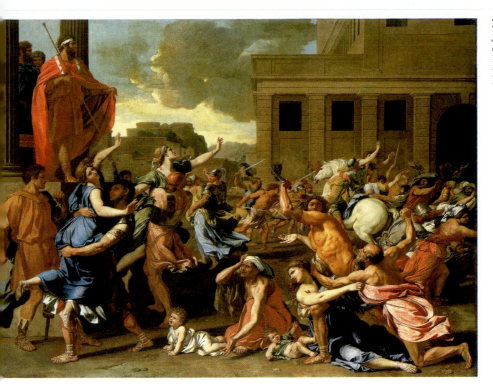

21.5. Nicolas Poussin. *The Abduction of the Sabine Women*. ca. 1633–1634. Oil on canvas, 5'7⅞" × 6'10⅝" (1.54 × 2.09 m). The Metropolitan Museum of Art, New York. Harris Brisbane Dick Fund, 1946

in fact, derived from Hellenistic sculpture, but the main group is directly inspired by Giovanni Bologna's *Rape of the Sabine Woman* (fig. 17.10). Poussin has placed them before reconstructions of Roman architecture that he believed to be archeologically correct. Emotion is abundantly displayed in the dramatic poses and expressions, but the lack of spontaneity causes it to fail to touch us. The scene has a theatrical air, and for good reason. Before beginning the painting, Poussin arranged wax figurines on a miniature stagelike setting until he was satisfied with the composition.

Poussin strikes us today as an artist who knew his own mind, an impression confirmed by the numerous letters in which he stated his views to friends and patrons. The highest aim of painting, he believed, is to represent noble and serious human actions. This is true even in *The Abduction of the Sabine Women,* whose subject many people admired as an act of patriotism ensuring the future of Rome. According to the accounts of Livy and Plutarch, the Sabines were young women abducted by the Romans to become their wives; the women later acted as peacemakers between the two opposing sides. Clearly the women do not go willingly as swords are drawn, babies are abandoned, and the elderly suffer. But Poussin's apparent detachment and lack of sympathy has caused the work to be labeled heroic. He appealed to the mind, that is, to the larger view of history, rather than to the senses. Poussin suppressed color and instead stressed form and composition. He believed that the viewer must be able to "read" the emotions of each figure as they related to the story. Such beliefs later proved influential to his student Charles Le Brun when establishing an approved court style for French painting.

These ideas were not new. We recall Horace's motto *Ut pictura poesis* ("As is painting, so is poetry"), and Leonardo's statement that the highest aim of painting is to depict "the intention of man's soul" (see page 560). Before Poussin, however, no artist had made the analogy between painting and literature so closely or put it into practice so single mindedly. His method accounts for the visual rhetoric in *The Abduction of the Sabine Women* that makes the picture seem so remote. The preliminary drawing (fig. **21.6**) for the theme (this drawing is in fact for a different version of the painting) suggests the artist's deliberate process. Using pen and ink and wash, Poussin worked out many of his compositions beforehand, as did Rubens. In this example, he placed figures in the foreground

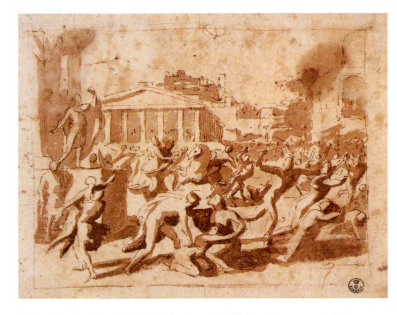

21.6. Nicolas Poussin. *The Abduction of the Sabine Women*. ca. 1630. Brush drawing, 6¼ × 8⅛" (16.1 × 20.7 cm). Arhivio del Gabinetto Disegni e Stampe, Galleria degli Uffizi, Florence

and ancient architecture as a stage set in the background. Such studies contrast sharply with the methods of Caravaggio and the Caravaggisti, who supported painting "from nature," that is, from living models and without the aid of preparatory drawings. Poussin regarded history painting as more intellectual and as derived from the imagination. Poussin, who would have seen these differences as dramatic and, perhaps, incomprehensible, reportedly told a contemporary that "Caravaggio had come into the world to destroy painting."

POUSSIN AND THE IDEAL LANDSCAPE The "ideal" landscape, serene and balanced, does not represent a particular locale but rather a generalized and often beautiful place. Because figures play only a minor role in such a setting, it is surprising that Poussin chose to explore this subject. The austere beauty and somber calm of the ideal landscape can be seen in his *Landscape with St. John on Patmos* (fig. **21.7**), which continues the Classical landscape tradition of Annibale Carracci. The ancient landscape strewn with architectural ruins suggests both the actual site and the concept of antiquity. Trees on either side balance the composition, and many of the ruins are set parallel to the picture plane. A reclining St. John, who at the end of his life lived on the island of Patmos, reportedly in somewhat abject circumstances, is shown in profile facing left. Poussin's pendant (paired) painting, *Landscape with St. Matthew*, shows that saint facing right, yet each work was created independently. Poussin executed both paintings in Rome for the secretary to Pope Urban VIII. The composition suggests the physical, rational arrangement of a spiritual world—a dichotomy truly suited and best explored by

Baroque classicism. Poussin's mythological landscapes show a similar construct of the physical, rational, and mythic.

CLAUDE LORRAIN AND THE IDYLLIC LANDSCAPE
While Poussin developed the heroic qualities of the ideal landscape, the great French landscapist Claude Lorrain (Claude Gellée, also called Claude; 1604/05?–1682) brought out its idyllic aspects. He, too, spent nearly his entire career in Rome, beginning as a pastry chef. From 1625 to 1627, however, he returned briefly to Nancy, where he was familiar with fellow resident Jacques Callot. He later copied Callot's etchings from *The Great Miseries of War* series (fig. 21.1). Claude's family in Nancy had been victims of the Thirty Years' War and so the series may have had particularly personal meaning for him. While in Rome Claude worked with several artists and was a pupil and assistant to Agostino Tassi (see fig. 19.10). Like many Northern Europeans, Claude thoroughly explored the surrounding countryside, the *campagna,* of Italy and his countless drawings made on site reveal his powers of observation. He is also the first artist known to have painted oil studies outdoors. Sketches, however, were only the raw material for his landscapes. To guard against forgeries, about 1635 Claude began making drawings of his paintings, which he kept as a record in a book known as *Liber Veritatis (The Book of Truth)*. (See *The Art Historian's Lens,* page 743.) It is from annotations on the verso of these drawings that we have learned the subjects of his paintings known as "pastorals," a literary genre that flourished in Venice in the sixteenth century in works by painters such as Giorgione and Titian (see figs. 16.30 and 16.31).

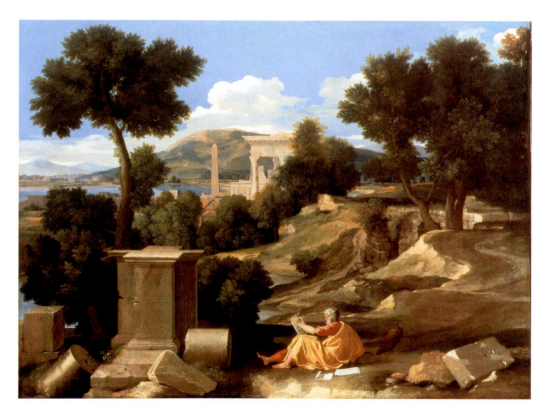

21.7. Nicolas Poussin. *Landscape with St. John on Patmos.* 1640. Oil on canvas, 39$\frac{1}{2}$ × 53$\frac{3}{4}$″ (100.3 × 136.4 cm.). Art Institute of Chicago. A. A. Munger Collection. (1930.500)

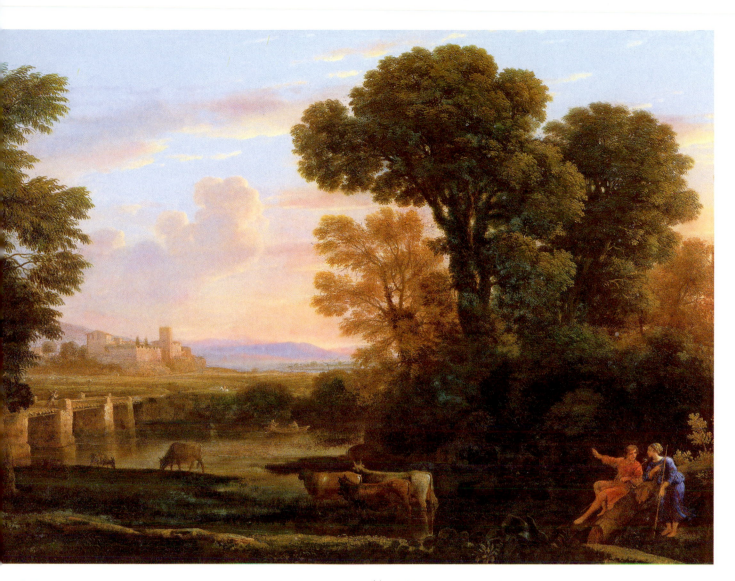

21.8. Claude Lorrain. *A Pastoral Landscape*. ca. 1648. Oil on copper, 15$\frac{1}{2}$ × 21″ (39.3 × 53.3 cm). Yale University Art Gallery, New Haven, Connecticut. Leonard C. Hanna, Jr., B. A. 1913, Fund. 1959.47

Claude's themes are often historical or pastoral, as in *A Pastoral Landscape* (fig. **21.8**). He does not aim for topographic accuracy in his paintings but evokes the poetic essence of a countryside filled with echoes of antiquity. Many of Claude's paintings are visual narratives of ancient texts, such as the epic tales and poetry of Virgil. Often, as in this painting, the compositions have the hazy, luminous atmosphere of early morning or late afternoon. One can refer to Claude's views as painting "into the light," that is, his sunlight (often sunsets) is at the center and at the horizon line of the painting so that the architecture and other elements appear almost as silhouettes. This example is painted on copper, a support seventeenth-century artists frequently employed for small paintings. The surfaces of these copper paintings are luminous. Here the space expands serenely rather than receding step-by-step as in works by Poussin. An air of nostalgia, of past experience enhanced by memory, imbues the scene. It is this nostalgic mood founded in ancient literature that forms its subject.

Claude succeeded in elevating the landscape genre, which traditionally had been accorded very low status. Prevailing artistic theory had ranked the rendering of common nature at the bottom of the hierarchy of painting genres (with landscape only just above still life). Claude, encouraged by sophisticated patrons, progressively moved away from showing the daily activity of life at the sea ports, and embellished his seascapes and landscapes with historical, biblical, and mythological subjects, thereby raising the status of the genre.

CHARLES LE BRUN AND THE ESTABLISHMENT OF THE ROYAL ACADEMY In art as in life, the French monarchy sought to maintain strict control, and thus the Royal Academy of Painting and Sculpture was founded in Paris in 1648. One of the 12 original founders was artist Charles Le Brun (1619–1690), who helped reorganize the academy in the 1660s into a formal institution. Although the academy came to be associated with the absolutism of Louis XIV's reign, at its

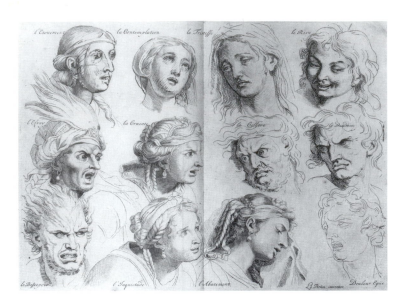

21.9. Henri Testelin after Charles Le Brun, *The Expressions*, 6th plate in *Henri Testelin's Sentiments de Plus Habiles Peintres*. Paris, 1696. Etching, 13$\frac{1}{16}$ × 17$\frac{3}{4}$" (33.1 × 45.1 cm). The Metropolitan Museum of Art, Rogers Fund, 1968. (68.513.6(6))

Much of this doctrine was derived from Poussin, with whom Le Brun had studied for several years in Rome. The academy also devised a method for assigning numerical grades to artists past and present in such categories as drawing, expression, and proportion. The ancients received the highest marks, followed by Raphael and his school, and then Poussin. Venetian artists, who "overemphasized" color, ranked low, while the Flemish and Dutch were placed lower still. Subjects were also classified: At the top was history (that is, narrative subjects, whether Classical, biblical, or mythological) and at the bottom was still life, with portraiture falling in between.

HYACINTHE RIGAUD AND THE SPLENDOR OF LOUIS XIV The monumental *Portrait of Louis XIV* (fig. **21.10**) by Hyacinthe Rigaud (1659–1743) conveys the power, drama, and splendor of the absolutist reign. The king is shown life-size and full-length, much like Van Dyck's portrait of Charles I (see fig. 20.8). The comparison is intentional, and the work follows the then formulaic nature of royal portraiture to espouse power and authority through the use of the insignias of rulership and the symbols of the opulence of the monarch's reign. Louis is

inception the king was only 10 years old, his mother Anne was regent, and Cardinal Mazarin effectively controlled the affairs of state. Yet the ideology of the academy and the throne would coincide with and strengthen each other in the ensuing years.

When Louis XIV assumed control of the government in 1661, Jean-Baptiste Colbert, his chief adviser, built the administrative apparatus to support the power of the absolute monarch. In this system, aimed at controlling the thoughts and actions of the nation, the task of the visual arts was to glorify the king. As in music and theater, which shared the same purpose, the official "royal style" was classicism. Centralized control over the visual arts was exerted by Colbert and Le Brun, who became supervisor of all the king's artistic projects. As chief dispenser of royal art patronage, Le Brun's power was so great that for all practical purposes he acted as dictator of the arts in France.

Upon becoming the academy's director in 1663, Le Brun established a rigid curriculum of instruction in practice and in theory, which he based on a system of rules. He lectured extensively at the academy; several lectures were devoted to examining the art of Poussin, venerating the works of Raphael, and studying physiognomy (facial expressions). Probably about 1668 he codified facial expressions in a series of annotated drawings published posthumously as engravings (fig. **21.9**). His lectures documented the movements of eyes, eyebrows, and mouths to show passions and emotions such as fear, anger, and surprise, corresponding to the *Passions of the Soul,* published in 1649 by Descartes. Le Brun's schemata were intended to be used as formulas by artists to establish narratives in their paintings that could be easily "read" by viewers.

21.10. Hyacinthe Rigaud. *Portrait of Louis XIV.* 1701. Oil on canvas, 9'2 × 6'3" (2.8 × 1.9 m). Musée du Louvre, Paris. Inv. 7492

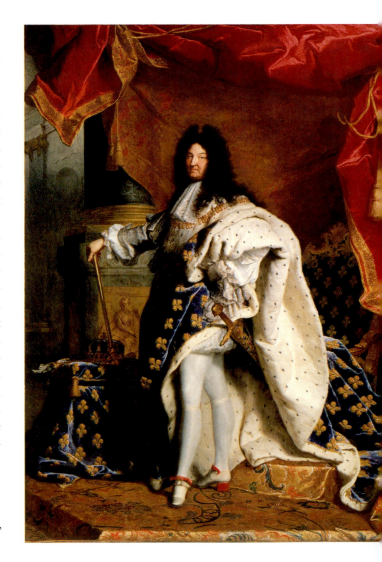

Forgeries and *The Book of Truth*

Art forgery—the deliberate copying or creation of a work of art without permission and with the intention to deceive—has long posed a serious threat to both artists and collectors. Art forgers have targeted jewelry, sculpture, painting, and prints, usually in the hopes of selling their fakes for personal gain.

Forgers may copy the works or style of artists from either the past or present. In ancient times, reports surfaced of forgeries made after the works of Myron and Praxiteles (see Chapter 5). We know, too, that Michelangelo made "antique" forgeries (see page 179) by burying sculpture to produce a patina imitating the effects of time and wear. To create the look of an older product, forgers may use authentic materials such as old paper, homemade paints, previously used canvases, and wood that has been peppered with buckshot to resemble aged wood infested with wormholes.

Not only are artists deprived of monetary compensation by a forgery, but their reputation can also be jeopardized by art of lesser quality passed off as theirs. Such was the case for Albrecht Dürer (see Chapter 18), who discovered upon his visit to Venice in 1506 that the well-known printmaker Marcantonio Raimondi (ca. 1480–ca. 1527) was selling engravings that he created in the manner of Dürer's woodcuts and bearing Dürer's monogram. Dürer sued, and although Raimondi could continue to produce the engravings, he could no longer include Dürer's signature on them.

Claude Lorrain experienced a similar problem, for which he developed a unique solution. We know from the writer Filippo Baldinucci (1625–1697) that Claude discovered that another artist, Sébastien Bourdon (1616–1671), was adept at imitating the light and tonal effects in Claude's paintings. In fact, Bourdon's skill in producing them was so proficient that after visiting Claude's studio, he painted a landscape and sold it as a work purportedly by Claude. Other artists also found it easy to imitate Claude's techniques and compositions.

To safeguard against any such dishonest practices, around 1635 Claude decided to compile the *Liber Veritatis* (*The Book of Truth*), an album of drawings that reproduce his paintings from that time on. On the verso, he annotated each drawing with the name of the patron, buyer, or place the work was sent; he sometimes included the date and a reference to the work's subject as well. Collectors could consult the book and verify whether a painting was included—and thus foil any potential forger.

By the time of his death, Claude had made drawings of 195 of his paintings. He did not record paintings made before 1635, and therefore an estimated 50 works are missing from the album. Claude was a prolific draughtsman—over 1,200 drawings by him are known, although the album records only drawings of his finished paintings (see Claude's draw-

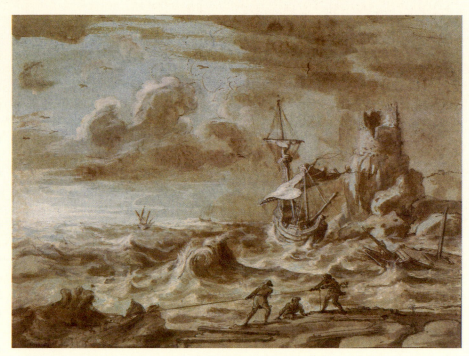

Claude Lorrain. *The Tempest*. ca. 1635. Pen and brown wash, heightened with white highlights on blue paper. $7^{11}/_{16} \times 10^{1}/_{4}''$ (195 × 260 cm). Courtesy of the Trustees of The British Museum, London

ing of *The Tempest*, above). *The Liber Veritatis*, now in the collection of The British Museum, consists of sheets measuring $7^{11}/_{16}$ by $10^{1}/_{4}$ inches (195 × 260 mm) that are organized in groups of four white sheets alternating with four blue ones. Scholars have speculated that Claude chose these paper colors to reflect the light effects in his paintings. This method also suggests that he probably did not execute the drawings in chronological order. To create them, he used pen and ink with brown and sometimes gray washes. He added highlights with white chalk and touches of gold. Such time-consuming details, especially evident in the book's later drawings, show that Claude began to use the album not just to reproduce paintings but to create elaborate, finished drawings that stand on their own as accomplished works of art.

Dealers and collectors today often rely on a comparable type of book called a *catalogue raisonné*. Compiled by an expert after years of meticulous research, this publication describes and illustrates all the known, verified, and some attributed (but nonauthenticated) works by a particular artist as well as pertinent information about each object's dimensions, condition, and provenance (history of ownership). But perhaps most important in the fight against forgeries is the wide range of available technologies—from carbon dating to infrared spectroscopy—to analyze and date a work's materials and stages of creation. Still, even with these advanced detection methods, not all experts agree about the authenticity of a work in question since these technologies can often only verify the time or place a work was produced and not the artist's hand. For that we still rely on connoisseurship and the experience and expertise of the art historian.

shown draped with his velvet coronation robes lined with ermine and trimmed with gold *fleurs-de-lis*. He appears self-assured, powerful, majestic—and also tall, an illusion created by the artist, for his subject measured only 5 feet 4 inches. The portrait proudly displays the king's shapely legs (emphasized by the high heels Louis himself designed to increase his height), for they were his pride as a dancer. Indeed, the king actively participated in the ballets of Jean Baptiste Lully (1632–1687) from the 1650s until his coronation. All the arts, from the visual arts to the performing arts, fell under royal control—a fact exemplified in Rigaud's painting, which expresses Louis's dominance and unequaled stature as the center of the French state.

French Classical Architecture

Because they were large, ostentatious, and public, building projects, even more than painting, transmitted the values of the royal court to a wide audience. In French architecture, the Classical style expressed the grandeur and authority of imperial Rome and confirmed the ideals of tradition, omnipotence, absolutism, strength, and permanence espoused by the monarchy. Mammoth scale and repetition of forms evoke these broad concepts, which were embodied in royal structures erected in the heart of Paris as well as outside the city, in the palace and gardens of Versailles.

In 1655, Louis XIV declared *"L'état, c'est moi"* ("I am the state"). This statement was not just political but represented an artistic and aesthetic intention as well. Louis's projects for his palace and court took on colossal proportions and represented not a single individual, or even a single monarch, but the entirety of France. He began by renovating the Louvre, a project begun by his father, but that had proven insufficient. Louis wanted to move his entire royal court to a more isolated location where he could control them more efficiently, and so he

began construction on the palace and gardens of Versailles, located a few miles outside Paris. These complex building projects all share a single style—that of Baroque Classicism.

FRANÇOIS MANSART The foundations of Baroque Classicism in architecture were laid by a group of designers of whom the best known was François Mansart (1598–1666). The classicism introduced by Lescot at the Louvre (see fig. 18.7) reached its height in the mid-1500s under Henry II and was continued by Salomon de Brosse (ca. 1571–1626) at Marie de' Medici's Luxembourg Palace. Mansart, who probably began his career under de Brosse in 1618, showed a precocious talent. Within five years he had established his reputation.

Although apparently Mansart never visited Italy, he was familiar with the new Italian style through other French architects who had imported and adapted Baroque aspects into their designs. His most important buildings are châteaux, and in this area the French Renaissance tradition outweighed any Italian influences. For that reason Mansart's earlier designs are also the most Classical. The Château de Maisons near Paris, built in the 1640s for the financier René du Longueil, shows Mansart's mature style. The exterior departs little from the precedents set by de Brosse, although it possesses a Classical logic and clarity that surpass any previous French design. The interior, however, breaks new ground. The vestibule leading to the grand staircase (fig. **21.11**) recalls Palladio, whose treatise Mansart knew and admired. Sculpture is used as an integral part of the architectural design, a characteristically French idea pioneered by De Brosse. The spread-winged eagles (from the owner's heraldry) soften the intersecting cornice line and bridge the space between the springing points of the vault ribs. These complex curves and the near disappearance of the planar wall below indicate that this structure, for all its classicism, fits squarely in the Baroque style.

21.11. François Mansart. Vestibule of the Château de Maisons. 1642–1650

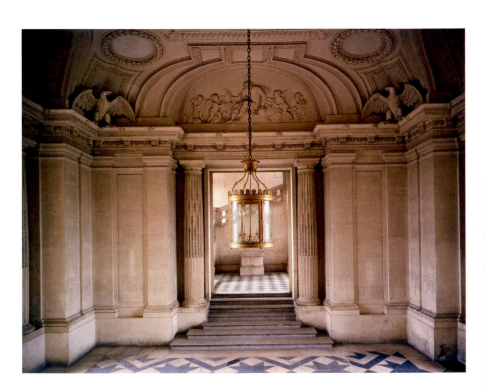

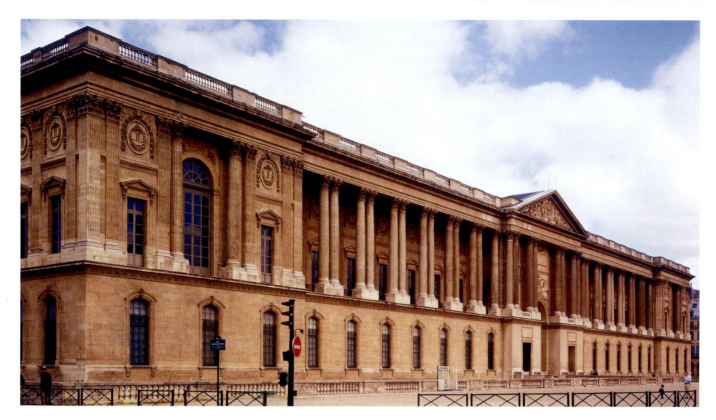

21.12. Louis Le Vau, Claude Perrault, and Charles Le Brun. East front of the Louvre, Paris. 1667–1670

THE LOUVRE Work on the palace had proceeded intermittently for more than a century, following Lescot's original design under Francis I; what remained was to close the square court on the east side with an impressive facade. Colbert was dissatisfied with the proposals of French architects including Mansart, who submitted designs not long before his death. Colbert then invited Bernini to Paris in the hope that the most famous artist of the Roman Baroque would do for the French king what he had done for the popes in Italy. Bernini spent several months in Paris in 1665 and submitted three designs, all on a scale that would have dwarfed the existing palace. After much argument and intrigue, Louis XIV rejected the plans and turned over the problem to a committee: Charles Le Brun, his court painter; Louis Le Vau (1612–1670), his court architect who had already done much work on the Louvre (including the Gallery of Apollo, the Queen's court, and the south facade); and Claude Perrault (1613–1688), an anatomist and student of ancient architecture but not a professional architect. All three men were responsible for the structure (fig. **21.12**), but Perrault is rightly credited with the major share. Certainly his supporters and detractors at the time thought so, and he was often called upon to defend his design.

Perrault based the center pavilion on a Roman temple front, and the wings look like the sides of the temple folded outward. The temple theme required a single order of free-standing columns, but the Louvre had three stories. Perrault solved this problem by treating the ground story as the podium of the temple and recessing the upper two stories behind the screen of a colonnade. Although the colonnade itself was controversial because of its use of paired columns, this treatment thereafter became a characteristic of French classicism in architecture.

The east front of the Louvre signaled the victory of French classicism over the Italian Baroque as the royal style. It further proclaimed France as the new Rome, both politically and culturally, by linking Louis XIV with the glory of the Caesars. The grand and elegant design in some ways suggests the mind of an archeologist, but one who also knew how to choose those features of Classical architecture that would be compatible with the older parts of the palace. This revitalization of the antique, both in its conception and its details, was Perrault's main contribution.

Perrault owed his position to his brother Charles Perrault (1628–1703), who, as Colbert's Master of Buildings under Louis XIV, had helped undermine Bernini during his stay at the French court. It is likely that Claude Perrault shared the views set forth some 20 years later in his brother's *Parallels Between the Ancients and Moderns* in which Charles claimed that "Homer and Virgil made countless mistakes which the moderns no longer make [because] the ancients did not have all our rules." The Louvre's east front presents not simply a Classical revival but a vigorous distillation of what Claude Perrault considered to be the eternal ideals of beauty, intended to surpass anything built by the Romans themselves. Indeed, Perrault had annotated Vitruvius and wrote his own treatise on the orders of columns.

THE PALACE OF VERSAILLES Louis XIV's largest enterprise was the Palace of Versailles (fig. 21.13), located eleven miles from the center of Paris. By forcing the aristocracy to live under royal scrutiny outside Paris, the king hoped to prevent a repeat of the civil rebellion known as the Fronde, which had occurred during his minority in 1648–1653.

The project was begun in 1669 by Le Vau, who designed the elevation of the Garden Front (fig. 21.14), but within a year he died. Under the leadership of Jules Hardouin-Mansart (1646–1708), a great-nephew and pupil of Mansart, the structure was greatly expanded to accommodate the ever-growing royal household. The Garden Front, intended by Le Vau to be the main view of the palace, was stretched to an enormous length but with no change in the architectural elements. As a result Le Vau's original facade design, a less severe variant of the Louvre's east front, looks repetitious and out of scale. The center block contains a single room measuring 240 feet long, the spectacular Galerie des Glaces, or Hall of Mirrors (fig. 21.15). At either end are the Salon de

la Guerre (Salon of War) and its counterpart, the Salon de la Paix (Salon of Peace). The sumptuous effect of the Galerie des Glaces recalls the Gallery of Francis I at Fontainebleau, but the use of full-length mirrors (composed of smaller mirrors) was unique, for such mirrors were rare and represented a great investment on the part of the monarchy. This art of large mirror-making was invented in Venice and brought to France by agents of Colbert. Such extravagant details were meant to reinforce the majesty of both Louis's reign and of France. The mirrors were placed to reflect the gardens outside, making the room appear larger by day. At night, the myriad reflections of candlelight illuminated the grand space. Whether day or night, the effect was impressive.

Baroque features, although not officially acknowledged by the architects, appeared inside the palace. This shift reflected the king's own taste. Louis XIV was interested less in architectural theory and monumental Classical exteriors than in the lavish interiors that would provide suitable settings for himself and his court. Thus the man to whom he listened most reliably

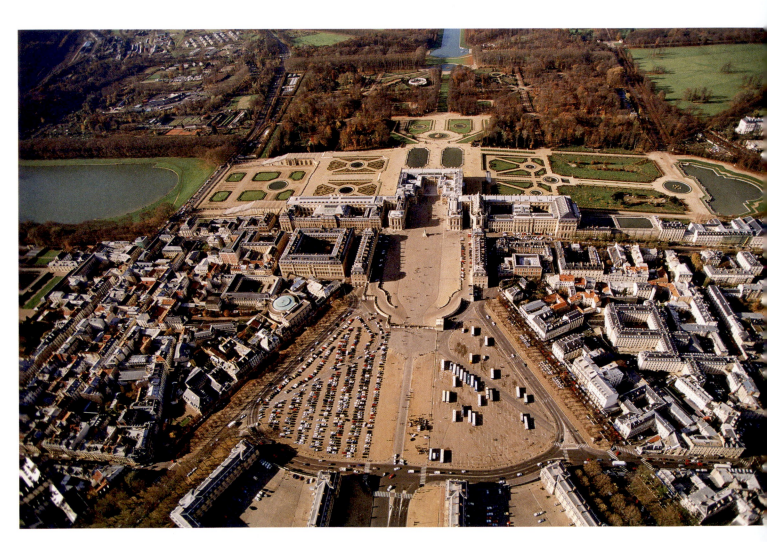

21.13. Aerial view of Versailles

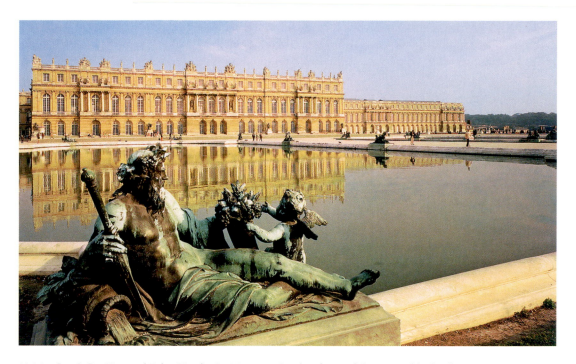

21.14. Louis Le Vau and Jules Hardouin-Mansart. Garden front of the center block of the Palace of Versailles. 1669–1685

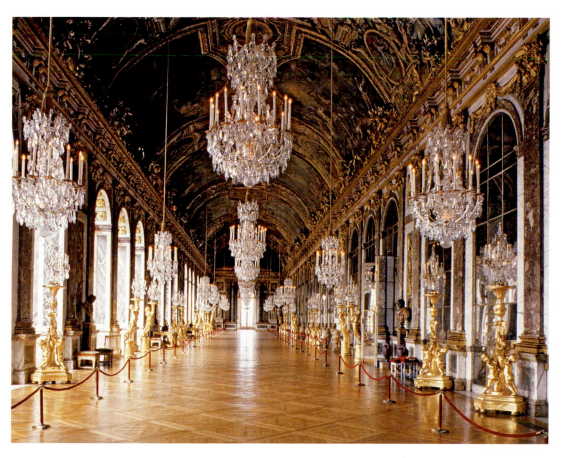

21.15. Hardouin-Mansart, Louis Le Vau, and Le Brun. Galerie des Glaces (Hall of Mirrors), Palace of Versailles. Begun 1678

was not an architect but the painter Le Brun, whose goal was to subordinate all the arts to the expression of the king's power. To achieve this aim, he drew freely on his memories of Rome, and the great decorative schemes of the Italian Baroque surely must have impressed him. Although a disciple of Poussin, Le Brun had studied first with Vouet and became a superb decorator. At Versailles, he employed architects, sculptors, painters, and decorators to produce ensembles of unprecedented splendor. The *Salon de la Guerre* (Salon of War, fig. **21.16**) is closer in many ways to the theatricality and the use of a variety of media of Bernini's Cornaro Chapel (fig. 19.31) than to the vestibule at Maisons. Although Le Brun's ensemble is less adventurous than Bernini's, he has given greater emphasis to surface decoration. As in many Italian Baroque interiors, the separate components are less impressive than the effect of the whole.

THE GARDENS OF VERSAILLES Apart from the magnificent interior, the most impressive aspect of Versailles is the park extending west of the Garden Front for several miles (see fig. 21.13). The vast park was designed by André Le Nôtre (1613–1700), who had become director of the gardens of Louis XIII in 1643 and whose family had served as royal gardeners for generations. The type of formal garden at Versailles had its beginnings in Renaissance Florence but had never been used on the scale achieved by Le Nôtre, who transformed an entire

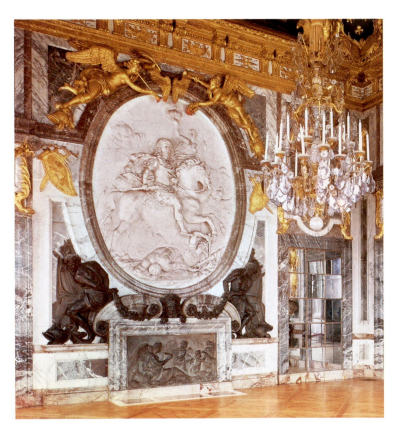

21.16. Hardouin-Mansart, Le Brun, and Coysevox. Salon de la Guerre (Salon of War), Palace of Versailles. Begun 1678

natural forest into a controlled park, a massive and expensive enterprise that reflected the grandeur of the king. In concept, the landscape is as significant as the palace—perhaps more so, for it suggests the king's dominion over Nature. The landscape design is so strictly correlated with the plan of the palace that it in effect continues the architectural space. Like the interiors, the formal gardens were meant to provide a suitable setting for the king's public appearances. They form a series of "outdoor rooms" for the splendid fêtes and spectacles that formed an integral part of Louis's court.

The spirit of absolutism is even more striking in the geometric regularity imposed upon an entire countryside than it is in the palace itself. Le Nôtre's plan called for the taming of Nature: Forests were thinned to create stately avenues, plants were shaped into manicured hedges, water was pumped into exuberant fountains and serene lakes. The formal gardens consist of a multitude of paths, terraces, basins, mazes, and parterres that create a unified geometric whole. Further from the palace, the plan becomes less formal and incorporates the site's densely wooded areas and open meadows. Throughout, carefully planned vistas result in unending visual surprises. An especially important aspect of the landscape design was the program of sculpture, much of which incorporated images of Apollo, the sun god, a favorite symbol of Louis XIV.

The elaborate and expansive gardens had its detractors as well. From these critics we are able to ascertain what life was like at Versailles. Duc de Saint-Simon, a member of the court but no admirer of Louis, recorded in his diary:

> Versailles ... the dullest of all places, without prospect, without wood, without water without soil; for the ground is all shifting sand or swamp, the air accordingly bad. ... You are introduced [in the gardens] to the freshness of the shade only by a vast torrid zone. ... The violence everywhere done to nature repels and wearies us despite ourselves. The abundance of water forced up and gathered together in all parts is rendered green thick and muddy; it disseminates humidity, unhealthy and evident; and an odor still more so. I might never finish upon the monstrous defects of a palace so immense.

> *Memoirs of Louis XIV and His Court and of the Regency by the Duke of Saint-Simon*. Vol. II. (New York: P. F. Collier and Son, 1910, p. 889)

THE STYLE OF JULES HARDOUIN-MANSART Constrained at Versailles by the design of Le Vau, Jules Hardouin-Mansart's own style can be better appreciated in the Church of the Invalides (fig. **21.17**), best known today for housing the tomb of Napoleon. Originally the structure formed part of a hospital that served as a hostel for the many disabled soldiers caused by Louis's continuous wars, gathering them off the streets of Paris where they might incite disorder. The complex consists of a series of dormitories, dining halls, infirmaries, and two chapels—a simple, unadorned one for the soldiers and an elaborate, domed space for the king, where he could be seen high above them during his visits. Hardouin-Mansart's design

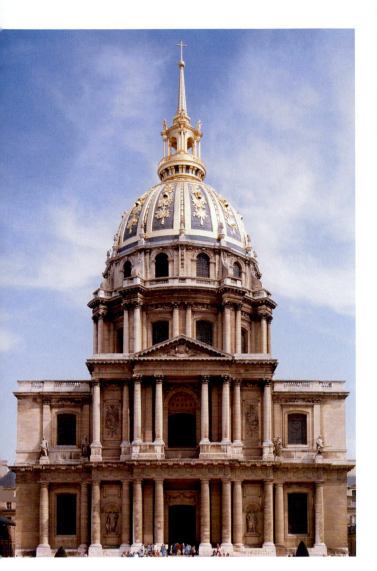

21.17. Jules Hardouin-Mansart. Church of the Invalides, Paris. 1677–1691

ART IN TIME

 1608—Samuel de Champlain, explorer of Canada, settles Quebec

1633–1634—Poussin's, *The Abduction of the Sabine Women*

 ca. 1642—La Tour, *Joseph the Carpenter*

 1643—Louis XIV crowned king of France

 1648—French Royal Academy of Painting and Sculpture founded

 1666—Moliere, *The Misanthrope*

1669–1685—Palace of Versailles built

reflects the influence of Michelangelo, but it consists of three shells instead of the usual two. The facade breaks forward repeatedly in the crescendo effect introduced by Maderno (see fig. 19.13), and the facade and dome are as closely linked as at Borromini's Sant'Agnese in Piazza Navona (see fig. 19.22). The dome itself is the most original, as well as the most Baroque, feature of Hardouin-Mansart's design. Tall and slender, it rises in one continuous curve from the base of the drum to the spire atop the lantern. On the first drum rests a second, short drum. Its windows provide light for the paintings on the dome's interior. The windows are hidden behind a "pseudo-shell" with a large opening at the top so that the painted visions of heavenly glory seem to be mysteriously illuminated and suspended in space. The bold theatrical lighting of the Invalides places it firmly within the Baroque style.

Sculpture: The Impact of Bernini

Sculpture evolved into an official royal style in much the same way as did architecture—through the influence of Rome and the impact of Bernini's visit to the royal court in 1665. While in Paris, Bernini carved a marble bust of Louis XIV. He was also commissioned to create an equestrian statue of the king, which he later executed in Rome and sent back to Paris, where it was reworked. It is now at Versailles.

ANTOINE COYSEVOX Bernini's influence can be seen in the work of Antoine Coysevox (1640–1720), the first of a long line of distinguished French portrait sculptors and one of the artists employed by Le Brun at Versailles. The large stucco relief of the victorious Louis XIV that Coysevox made for the Salon de la Guerre (see fig. 21.16) retains the pose of Bernini's equestrian statue, although with more restraint. In a vivacious terra-cotta portrait of Le Brun (fig. **21.19**), Coysevox shows the artist with slightly parted lips and head turned to the side. The drapery folded over itself below the shoulder line recalls the general outline of Bernini's bust of Louis XIV. Le Brun's face, however, shows a naturalism and subtle characterization that are Coysevox's own.

21.18. Plan of the Church of the Invalides

visually connected the sacrifice of the soldiers to their allegiance to the king and the absolute authority of monarchy.

In plan the Invalides consists of a Greek cross with four corner chapels (fig. **21.18**); it is based on Michelangelo's and Bramante's centralized plans for St. Peter's. The dome, too,

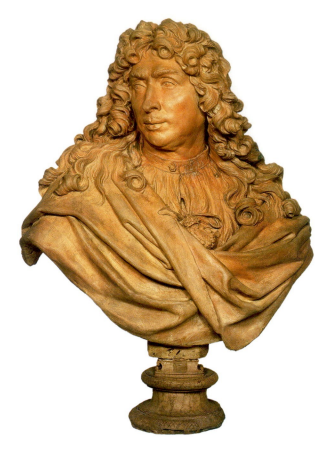

21.19. Antoine Coysevox. *Charles Le Brun*. 1676. Terra cotta, height 26″ (66 cm). The Wallace Collection, London. Reproduced by Permission of the Trustees

PIERRE-PAUL PUGET Of the seventeenth-century French sculptors, Pierre-Paul Puget (1620–1694) best represents the High Baroque style. Puget had no success at court until after Colbert's death, when Le Brun's power began to decline. His finest statue, *Milo of Crotona* (fig. **21.20**), benefits from a comparison with Bernini's *David* (see fig. 19.29). Although Puget's composition is more contained, he nevertheless successfully conveys the dramatic force of the hero attacked by a lion while his hand is trapped in a tree stump. The creature attacks from behind and digs its claws deeply into the thigh of Milo, who twists painfully and cries out in agony. The violent action imbues the statue with an intensity that also recalls the *Laocoön*. This reference to antiquity, one suspects, is what made the work acceptable to Louis XIV.

BAROQUE ARCHITECTURE IN ENGLAND

The English gained much but contributed little to the development of Baroque painting and sculpture. Foreign painters mainly from Italy, Flanders, and the Dutch Republic dominated the English royal court. During the reign of Charles I, the court painter Van Dyck executed both portraits and allegorical paintings. After his death many court artists continued his style of portraiture, initiating little in the visual arts until the Restoration of Charles II in 1660. After the Great Fire of

London in 1666, the rebuilding of the city gave priority to architecture, which thereafter represented the most important English artistic achievement.

Inigo Jones and the Impact of Palladio

The first significant English architect was Inigo Jones (1573–1652), architect to James I and Charles I as well as the era's leading English theatrical designer. Jones's style developed from the country house tradition of large private mansions in parklike settings, such as Longleat (see 18-30). Jones took two lengthy trips to Italy (and visited Venice) from 1597 to 1603 and during 1613–1614, with an interlude in Paris in 1609. Upon returning from his second trip to Italy, he was appointed Surveyor of the King's Works, a post he held until 1643. Jones was now an affirmed disciple of Antonio Palladio, whose Classical design principles he admired and whose treatises (along with those of Alberti) he owned and annotated. Before Jones, English architecture was a pastiche of medieval and Renaissance

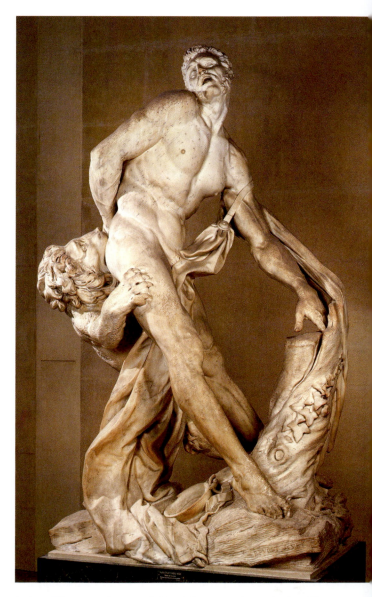

21.20. Pierre-Paul Puget. *Milo of Crotona*. 1671–1682. Marble. Height 8′10½″ (2.7 m). Musée du Louvre, Paris

forms. He is responsible for introducing Palladio's Renaissance Classicism to England, although the style took root only in the early decades of the eighteenth century, when a building boom resulted in the trend called the Palladian Revival.

The Banqueting House Jones built at Whitehall Palace in London (fig. **21.21**) conforms to the principles in Palladio's treatise, although it does not copy any specific Palladian project. Originally intended to be used for court ceremonies and performances called masques (a spectacle combining dance, theater, and music), evening entertainments were halted after 1635 because smoke from torchlights was damaging Rubens's *Apotheosis of James I*, painted in the recessed compartment of the ceiling. The Banqueting House is essentially a Vitruvian "basilica," a double-cube with an apse for the king's throne, which Jones has treated as a Palladian villa. It is more like a Renaissance palazzo than any building north of the Alps designed at that time. Jones uses an ordered, Classical vocabulary and the rules of proportion to compose a building in three parts. The Ionic and Composite orders of the pilasters add an understated elegance, and alternating segmental and triangular pediments over the first floor windows create a rhythmic effect. The sculpted garland below the roofline and the balustrade above decoratively enhance the overall structure. The building is perhaps starker than originally conceived; it once bore colored stones for each of the stories, but the facade was later resurfaced. Jones's spare style stood as a beacon of Classicist orthodoxy in England for 200 years.

Sir Christopher Wren

If not for the destruction caused by the Great Fire of London of 1666, Sir Christopher Wren (1632–1723), the most important English architect of the late seventeenth century, might have remained an amateur. Wren may be considered the Baroque counterpart of the Renaissance artist-scientist. An intellectual prodigy, he first studied anatomy and then physics, mathematics, and astronomy, and he was highly esteemed by Sir Isaac Newton for his understanding of geometry. Early in his career, Wren held the position of chair in the astronomy department at Gresham College, London, and then at Oxford University. His interest in architecture did not surface until he was about 30 years old. His technological knowledge may have affected the shape of his buildings; certainly, no previous architect went to such lengths to conceal a building's structural supports. Only an architect thoroughly grounded in geometry and mathematics could have achieved such results, and the technical proficiency of Wren's structures has continually confounded his critics.

After the catastrophic fire of 1666, Wren was named to the short-lived royal commission to reconstruct the city (see end of Part III, *Additional Primary Sources*). A few years later he

ART IN TIME

1603—Shakespeare, *Hamlet*

1619–1622—Inigo Jones, Banqueting House

1637—Descartes, *Discourse on Method*

1642–1649—English Civil War

1651—Thomas Hobbes, *Leviathan*

1666—The Great Fire of London

1675–1710—Sir Christopher Wren's St. Paul's Cathedral built in London

1687—Newton formulates the law of gravity

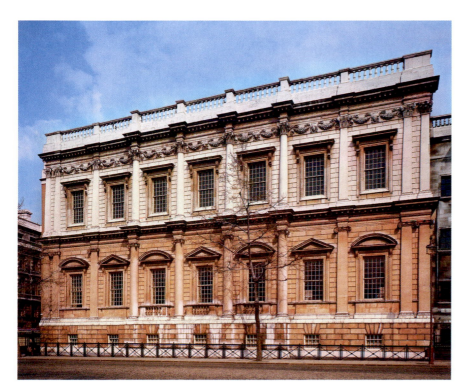

21.21. Inigo Jones. West Front of the Banqueting House, Whitehall Palace, London. 1619–1622

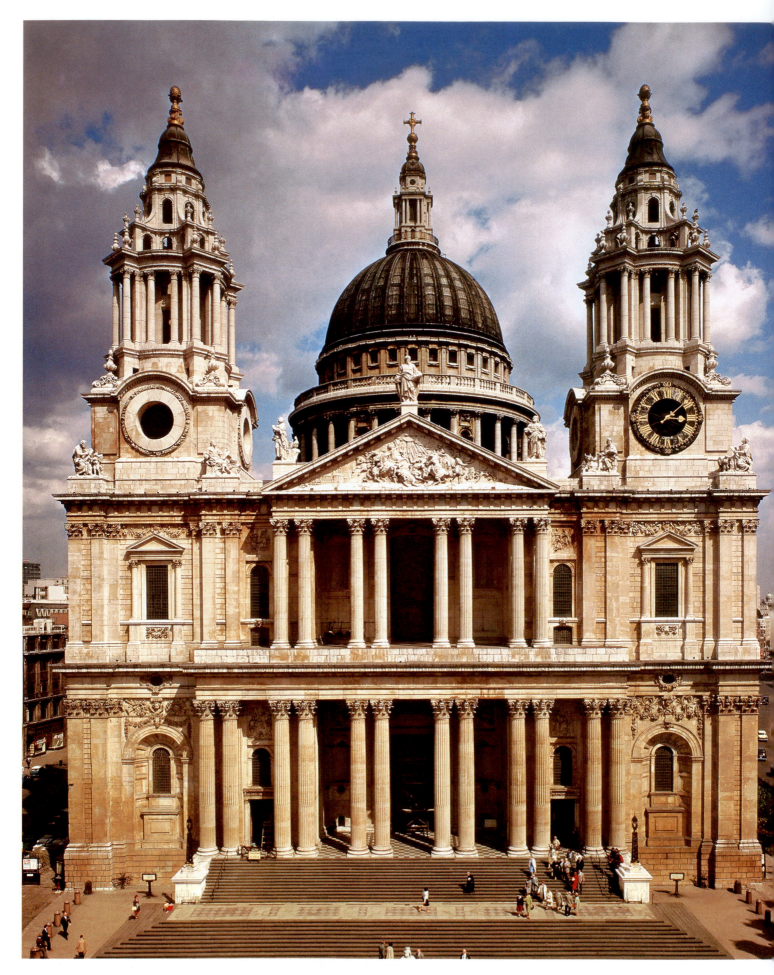

21.22. Sir Christopher Wren. Facade of St. Paul's Cathedral, London. 1675–1710

began his designs for the rebuilding of St. Paul's Cathedral (fig. **21.22**), one of many churches destroyed in the conflagration. Wren favored central-plan churches and originally conceived of St. Paul's in the shape of a Greek cross with a huge domed crossing, based on Michelangelo's plan of St. Peter's. This idea was evidently inspired by a previous design by Inigo Jones, who had been involved with the restoration of the original Gothic structure of St. Paul's earlier in the century. Wren's proposal was rejected by church authorities, however, who favored a conventional basilica as more suitable for a Protestant structure. In the end, the plan is that of a Latin cross (fig. **21.23**), the same followed for most Catholic churches including St. Peter's, an ironic outcome given that the building program could have provided an opportunity to create a new vocabulary for the Protestant Church of England.

On his only journey abroad in 1665–1666, Wren visited France and met with Bernini who was in Paris at the invitation of Louis XIV to design and complete the Louvre. The influence of this trip can be seen on the facade of St. Paul's, which bears a striking resemblance to Hardouin-Mansart's Church of the Invalides. The Invalides also inspired the three-part construction of the dome, which like St. Peter's has a diameter as wide as the nave and aisles combined. But St. Paul's dome rises high above the building and dominates the facade. The buttresses that support it are ingeniously hidden behind a screen wall, which further helps brace them. The classicism of Jones can also be seen in the dome, which looks like a much-enlarged version of Bramante's Tempietto (fig. 16.8). St. Paul's is an up-to-date Baroque design that reflects Wren's thorough knowledge of the Italian and French architecture of the day. Indeed, Wren believed that Paris provided "the best school of architecture in Europe," and he was equally affected by the Roman Baroque. The lantern and upper part of the bell towers

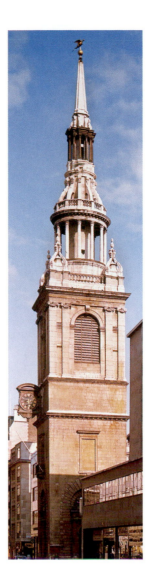

21.24. Sir Christopher Wren. Steeple of the Church of St. Mary-Le-Bow, 1680. London

suggest that he knew Borromini's Sant'Agnese in Piazza Navona, probably from drawings or engravings. The resulting structure reflects not only the complex evolution of the design but also later changes made by the commission overseeing construction, which dismissed Wren in 1718.

For Wren as for Newton (who was appointed a Commissioner of St. Paul's in 1697), mathematics and geometry were central to the new understanding of the universe and humanity's place in it. In Wren's *Five Tracts*, written toward the end of his life and presented by his son to the Royal Society in 1740, he stated that architecture must conform to "natural reason," which is the basis of eternal Beauty. In other words, architecture must use rational (that is, abstract) geometrical forms, such as the square and the circle, as well as proportion, perspective, and harmony—but it must not sacrifice variety. Such rationality and diversity are clearly evident in Wren's design for St. Paul's.

The Great Fire of London in 1666 provided Wren with the opportunity to rebuild and reframe the city and its skyline. Besides St. Paul's, he worked on 52 of the 87 damaged or destroyed churches, designing distinctive steeples for many of them. The steeple of the Church of St. Mary-Le-Bow (fig. **21.24**) provides us with his most famous example. (It should be noted that many of these churches, including this one, were damaged

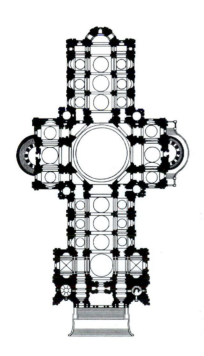

21.23. Plan of St. Paul's Cathedral

during the bombing of London in World War II and have been reconstructed.) The steeple is exceptionally tall (225 feet high) and even today soars over surrounding buildings. The height is achieved through an unusual stacking of components: a two-story base (with arched entrance), plain attic, bell housing with paired pilasters, and a colonnaded temple surmounted by buttresses that support a lantern and obelisklike pinnacle as seen in the Church of the Invalides. To indicate the church's dedication, Wren designed twelve "bows"—actually inverted brackets—at the base of the round temple. The result is an elaborate, multi-storied steeple, Gothic in its verticality yet based on Classical motifs. Nothing like it had yet been seen. Wren's innovation in this church, and in his variations for the churches built after the Great Fire, distinguished English Baroque church architecture.

John Vanbrugh and Nicholas Hawksmoor

The marriage of English, French, and Italian Baroque elements is still more evident in Blenheim Palace (fig. **21.25**), a grandiose structure designed by Sir John Vanbrugh (1664–1726), a gifted amateur, with the aid of Nicholas Hawksmoor (1661–1736), Wren's most talented pupil. Although Blenheim is considered to be Vanbrugh's greatest work, the building was in fact completed by Hawksmoor; yet the architecture is seamless. Blenheim skillfully combines the massing of an English castle with the breadth of a country house such as Longleat (see fig. 18.30), the rambling character of a French château such as Fontainebleau (see fig. 18.3), and a facade inspired by Sir Christopher Wren, Vanbrugh's rival. However, when Blenheim and its framing colonnade are compared with the piazza of St. Peter's (see fig. 19.14), Vanbrugh's design reveals itself to be even closer to Bernini. The main block uses a colossal Corinthian order to wed a temple portico with a Renaissance palace, while the wings rely on a low-slung Doric order. Such an eclectic approach, extreme even by the relaxed standards of the period, is maintained in the details. Vanbrugh, like Inigo Jones, had a strong interest in the theater and was a popular playwright. Blenheim's theatricality and massiveness make it a symbol of English power, a fitting, but more modest, counterpart to Versailles in both structure and grounds. Designed mainly for show and entertainment, it was presented by a grateful nation to the duke of Marlborough for his victories over French and German forces at the Battle of Blenheim in 1704, during the War of Spanish Succession.

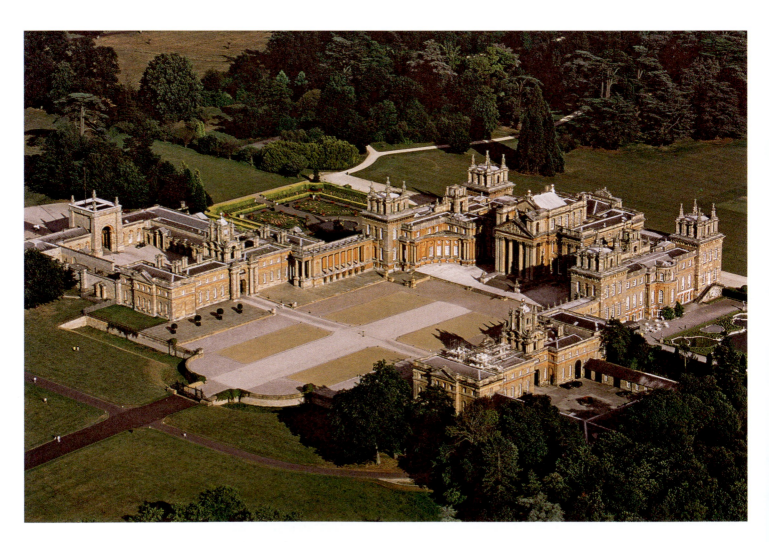

21.25. Sir John Vanbrugh and Nicholas Hawksmoor. Blenheim Palace, Woodstock, England. Begun 1705

SUMMARY

At the beginning of the seventeenth century, the great monarchies of France and England faced seemingly endless crises. With continued political, social, and religious turmoil plaguing both nations, each successive sovereign sought to consolidate power and centralize administration. From England's constitutional monarchy to France's absolutism, the royal state reigned supreme. Yet the societies they governed were in dramatic flux. Despite increased wealth among the bourgeoisie—coupled with an emerging mercantile system, growing trade routes, and profitable colonial empires—most people suffered overwhelming poverty. Weakened under the burden of ever-increasing taxes and disenfranchised from the political system, Europe's peasantry was realizing their inability to change the government except through violent uprising. At the same time, nobles were formulating their own complaints against the centralized authority, which was robbing them of power and privileges.

Set against this compelling backdrop, monarchs throughout Europe evoked the age-old divine right of kings. They used art to convey the power and prestige of the monarchy, and the royal courts of both France and England became the most important patrons of the arts. Grandiose Baroque art and architecture stood as symbols not only of their authority but also of the pride and glory of the nation as well. Classicism, with its references to the tradition and supremacy of ancient Greece and Rome, became the favored style of the court, arbiter of taste during this tumultuous period.

FRANCE: THE STYLE OF LOUIS XIV

Art produced during the reign of Louis XIII varied greatly, from the scathing documentary prints of Jacques Callot to the meditative religious themes of Georges de La Tour, to the colorful and decorative paintings of Simon Vouet.

By 1640 the calm classicism of Nicolas Poussin dominated French Baroque art. Working in Rome, Poussin advocated that artists explore the "great" themes of art as established by the French Academy: narratives, heroic battles, religious themes, and subjects from antiquity. In the 1660s his Classical style became the model for French artists trained at the French Academy, which had been founded in 1648. Like Poussin, Claude Lorrain also favored a rational classicism, which permeates his sophisticated, carefully rendered idyllic landscapes. Sculpture, meanwhile, shows the influence of Bernini, as seen in the sculpted portraits of Antoine Coysevox and the intense statues of Pierre-Paul Puget.

Native artists remaining on French soil likewise set the tone for French art. Employed by the royal courts, these artists worked specifically in the service of glorifying the king. From the symbolic portraits of Hyacinthe Rigaud to the ostentatious facade of the Louvre, much French art was spectacle meant to transmit the values of the monarchy to a wide audience. Perhaps the most grandiose architectural project of the 1600s was Versailles, both its palace and its gardens. The Classical style, repeated forms, and colossal size convey the power of Louis XIV and reflect his philosophy of absolute monarchy.

BAROQUE ARCHITECTURE IN ENGLAND

As in France, English Baroque art and architecture were dominated by classicism. Although English painting was primarily the realm of foreign painters from Italy, Flanders, and the Dutch Republic, architecture developed a distinctive national style. Inigo Jones, the first significant English architect, introduced Andrea Palladio's Renaissance Classicism to England, as seen in the Banqueting House at Whitehall Palace in London. In the latter half of the century, Christopher Wren became the country's preeminent architect. Distinguished by a technical proficiency lauded by his contemporaries, Wren created some of the era's most masterful structures, including the renovated St. Paul's Cathedral. The Great Fire of 1666 provided Wren with the opportunity to rebuild and reframe London and its skyline, and many of the city's redesigned churches bear the mark of his architectural genius.

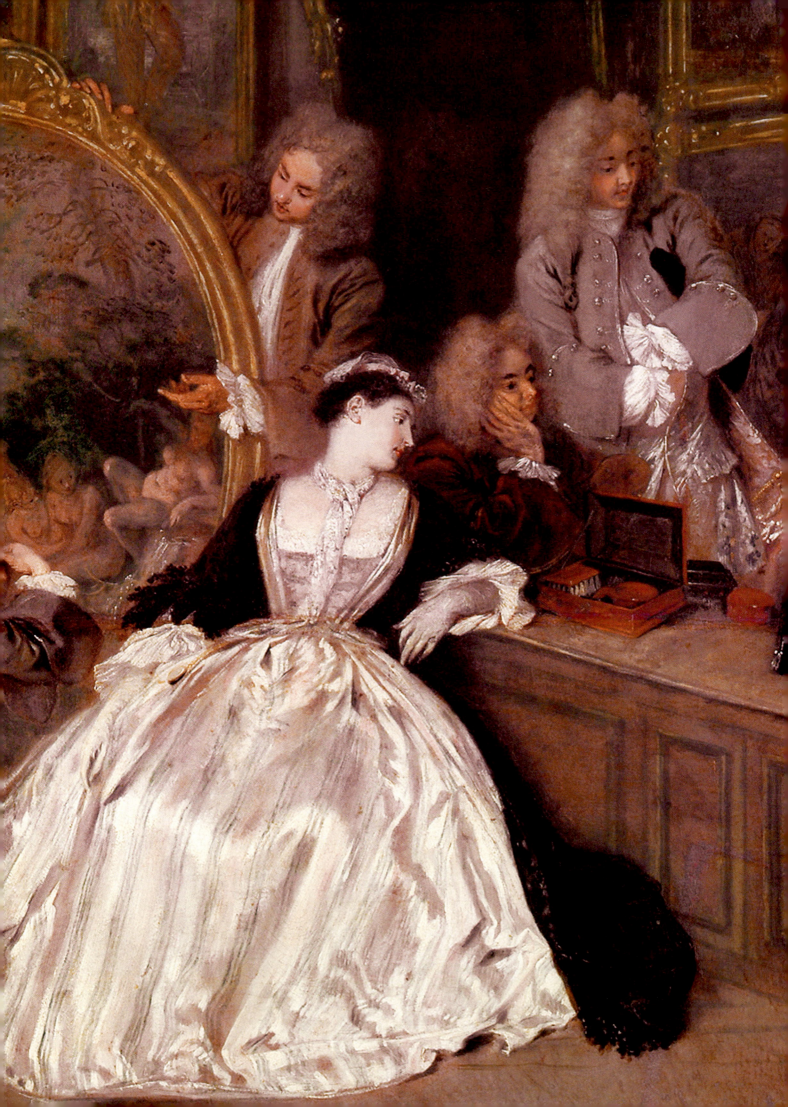

The Rococo

N FRANCE THE ROCOCO STYLE IS LINKED WITH LOUIS XV (1710–1774) BECAUSE it corresponds roughly to his lifetime. But the first signs of the Rococo style had appeared as much as 50 years earlier than Louis's birth, during the popularity of the late seventeenth-century Baroque style, and it extended through the excesses of the reign of Louis XVI (r. 1774–1792) and his wife, Marie Antoinette,

to the French Revolution of 1789. As noted by the philosopher François-Marie Arouet, better known by his pen name Voltaire (1694–1778), the eighteenth century lived indebted to the past. In art, Poussin and Rubens cast their long shadows over the period. The controversy between their followers, in turn, goes back much further to the debate between the supporters of Michelangelo and those of Titian over the merits of drawing versus color (see page 759). In this sense, the Rococo, like the Baroque, still belongs to the Renaissance world.

Despite similarities between the Baroque and Rococo, a fundamental difference exists between the two styles. In a word, it is fantasy. If the Baroque presents theater on a grand scale, the Rococo stage is smaller and more intimate. Its artifice evokes an enchanted realm that presents a diversion from real life. In some ways the Rococo in France manifests a shift in taste among aristocrats, who reasserted their power as patrons and began to favor stylized motifs from nature and a more domestic art—private rather than public—to decorate their new homes in Paris, called hôtels. The word Rococo fits well, for it implies both a natural quality and a sense of ornamentation well suited to the frivolity of court life. It was coined in the nineteenth century as a disparaging term, taken from the French word *rocaille*

(meaning "pebble") and *barocco* ("baroque"), to refer to what was then perceived as the excessive and ornate taste of the early eighteenth century. The word *Rococo*, then, refers to the playful, irregular pebbles, stones, and shells that decorated grottoes of Italian gardens and became the principal motifs of French interior designs.

Although sometimes viewed as the final phase of the Baroque, the Rococo asserted its own independent stylistic traits and represents a period of intense creative and intellectual activity. French artists continued to be trained in the tradition of the Royal Academy of Painting and Sculpture, which stressed working from live models, studying anatomy, and practicing perspective and proportion—lessons supplemented by lectures on the art of Raphael and Poussin. Yet artists also began exploring new subjects or treating old themes in new ways. The interest in the poetic genre of the pastoral, as practiced by Baroque artists including Claude, took on growing importance in the eighteenth century. Artists turned to pastorals and subjects of love and loss, romantic trysts, and poetic musings in response to demand from the art market and from patrons who were increasingly taken with the notion of "simple man" existing in an idealized nature. The appeal of these themes proved so strong that the French Academy established a new category called the *fête galante*, a type of painting introduced by Jean-Antoine Watteau. Some scholars today criticize the Rococo for its unabashed escapism and eroticism. Yet, to its

Detail of figure 22.4, Jean-Antoine Watteau, *Gersaint's Signboard*

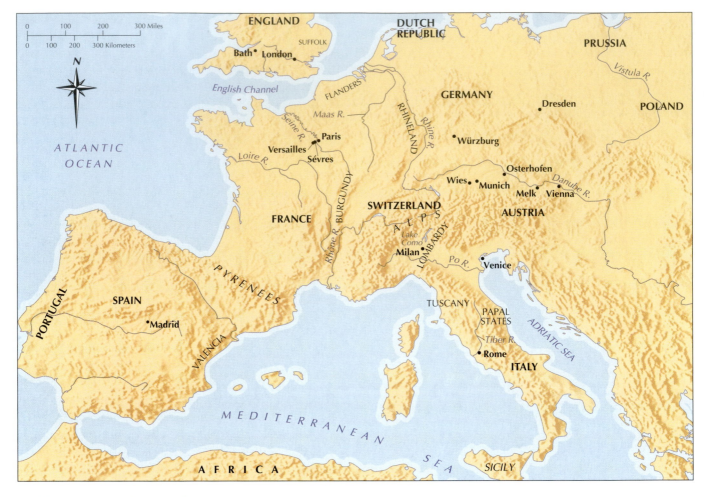

Map 22.1. Europe in the Rococo Period

credit, the style celebrated the tradition of love and broadened the range of human emotion depicted in art to include the family as a major theme.

Although most directly associated with France, the Rococo cast a wide geographical influence that affected the arts in England as well as most of western and central Europe (see map 22.1). English art, long dominated by foreign artists, saw the development of a distinct school of painting and the establishment of the Royal Academy of Arts in 1768, whose annual exhibitions attracted a fashionable London clientele and the best-known native artists. In western and central Europe, notably in Germany and Austria, the devastation of the Thirty Years' War (1618–1648) was followed in the eighteenth century by a period of rebuilding and the growth of pilgrimage churches, whose architecture and decoration reflected the Rococo style. Italian artists such as Tiepolo, with his assistants, painted ceiling frescos in central European churches and palaces in this new elaborate and elegant style and produced similar works for their native city of Venice as well. There, Canaletto painted *vedute,* or scenes of the city, which provided foreign visitors with souvenirs of their Venetian stay.

Also in the 1700s, European colonization of the New World continued. Armies battled to secure these distant lands, depleting their nations' treasuries yet succeeding in sending back to their homelands exotic objects, including feathers, jewels, and metals that collectors coveted and artists used in the creation of new art. In addition, European art often showed these foreign lands, albeit in imaginary or allegorical images, and gave concrete form to the wealth of the patrons. The period also saw the rise of aesthetics, a category of philosophy put forth by Immanuel Kant (1724–1804), stating that, among other things, humans have the capacity to judge beauty. In the performing arts, the Venetian composer Antonio Vivaldi (1678–1741) and the German composer Johann Sebastian Bach (1685–1750) produced extraordinary operas and choral music, and London became home to the establishment of legitimate theater, notably in Haymarket, Drury Lane, and Covent Garden.

FRANCE: THE RISE OF THE ROCOCO

After the death of Louis XIV in 1715, the nobility, formerly attached to the court at Versailles, were now freer from royal control. Louis XV, only 5 years old at his father's death, would not be crowned until 1723. This early period of the Rococo—between 1715 and 1723—is known as the Regency, so-called because France was governed by Louis's cousin Philip, duke of Orléans, acting as regent. With a nobleman in power, the aristocracy regained much power and authority, and they abandoned

the strict, demanding court life of Versailles. Rather than returning to their châteaux in the provinces, many chose to live in Paris, where they built elegant town houses called *hôtels*. Hôtels had been used as city residences by the landed aristocracy since about 1350, but during the seventeenth century they developed into social centers, a trend that continued in the eighteenth. The small, intimate rooms in the hôtels often served as the settings for informal intellectual and entertaining gatherings known as *salons*, which were hosted by powerful women (namely mesdames de Staël and de la Fayette, among others) and became enormously popular among the Parisian aristocracy. The rooms were decorated with paintings, porcelain, and small sculpture that created a lavish, light-hearted mood. Paintings, therefore, were just one part of the creation of the ambiance of refinement that permeated pre-Revolutionary France. These paintings, as well as interior designs, would influence the decor of western and central Europe throughout the century.

Painting: Poussinistes versus Rubénistes

Toward the end of the seventeenth century, a dispute arose among the members of the French Academy, who then formed two factions: the **Poussinistes** against the **Rubénistes**. Neither Poussin nor Rubens was still alive during this debate, which focused on the issue of drawing versus color. French artists were familiar with Poussin's paintings, which had been sent from Rome to Paris throughout his career, and they knew Rubens's work from the Marie de' Medici cycle in the Luxembourg Palace. The conservatives defended Poussin's view that drawing, which appealed to the mind, was superior to color, which appealed to the senses. The Rubénistes (many of whom were of Flemish descent) favored color, rather than drawing, as being truer to nature. They also pointed out that drawing, admittedly based on reason, appeals only to the expert few, whereas color appeals to everyone. This argument had important implications. It suggested that the layperson should be the judge of artistic values and this challenged the Renaissance notion that painting, as a liberal art, could be appreciated only by the educated mind. The colorists eventually won the day, due in part to the popularity of painter Jean-Antoine Watteau.

JEAN-ANTOINE WATTEAU The greatest of the Rubénistes was Jean-Antoine Watteau (1684–1721). Born in Valenciennes, which until a few years before his birth had still been part of the South Netherlands, Watteau showed an affinity for Rubens, the region's greatest artist. After moving to Paris in 1702 Watteau made many drawings styled after Rubens's French works, including the Marie de' Medici cycle (see fig. 20.5). Watteau was a significant contributor to the new Rococo style as well as to the new subjects associated with it. His painted visions of fantasy show idyllic images of aristocratic life, with elegant figures luxuriously dressed in shimmering pastel colors and set in dreamlike outdoor settings. He often seamlessly interweaves theater and real life in his works, incorporating well-known characters from the *commedia dell'arte* (a type of improvisational Italian theater) and creating stagelike settings that serve as backdrops for the actors. The carefully posed figures evoke forlorn love, regret, or nostalgia and imbue the scenes with an air of melancholy. Such works became increasingly sought after by collectors in France, and the popularity of this theme soon spread throughout Europe.

Because Watteau's fantasies had little historical or mythological basis, his paintings broke many academic rules and did not conform to any established category. To admit Watteau as a member and accept his romantic paintings, the French Academy created the new classification of painting called *fêtes galantes* (meaning "elegant fêtes" or "outdoor entertainments"). This category joined the hierarchy of genres that had been established in the seventeenth century by academy member André Félibien (1619–1695). The premier category was history painting, considered to be the highest form of art because it was thought to require the most imagination and was therefore the most difficult to execute. Next were portraits, landscapes, and then still life. Watteau's reception piece for the Academy, required when he became a member in 1712, was not delivered until 5 years later. The work, *A Pilgrimage to Cythera* (fig. 22.1), is an evocation of love and includes elements of Classical mythology. Cythera, which came to be viewed as an island of love, was one of the settings for the Greek myth of the birth of Aphrodite (Venus), who rose from the foam of the sea. The title suggests this traditional subject, but the painting was described in the French Academy records as a *fête galante*, perhaps the first use of this term.

It is unclear whether the couples are arriving at or leaving the island. What is certain is that Watteau has created a delightful yet slightly melancholic setting of love, where the couples may enjoy a melding of human passions and Nature in privacy and freedom. The action unfolds in the foreground from right to left like a continuous narrative, which suggests that the figures may be about to board the boat. Two lovers remain engaged in their amorous tryst; behind them, another couple rises to follow a third pair down the hill as the reluctant young woman casts a longing look back at the goddess's sacred grove. Young couples, accompanied by swarms of cupids, pay homage to Venus, whose garlanded sculpture appears on the far right. The delicate colors—pale greens, blues, pinks, and roses—suggest the gentle nature of the lovers' relationship. The subtle gradations of tone showed Watteau's debt to Rubens and helped establish the supremacy of the Rubénistes.

As a fashionable conversation piece, the scene recalls the elegant figures in the courtly scenes of the Limbourg brothers' illuminations and those in Rubens's *Garden of Love* (see fig. 20.6), but Watteau has altered the scale and added a touch of poignancy reminiscent of Giorgione and Titian. Watteau's figures are slim, graceful, and small in scale; they appear even more so when compared with most Baroque imagery. Yet the landscape does not overwhelm the scene but echos its idyllic and somewhat elegiac mood. Watteau produces a sense of nostalgia, with its implications of longing and unrealized passion, through not only the figures and their gentle touching and hesitancy but also the sympathetic parallel found in his landscape and the sculptures in it.

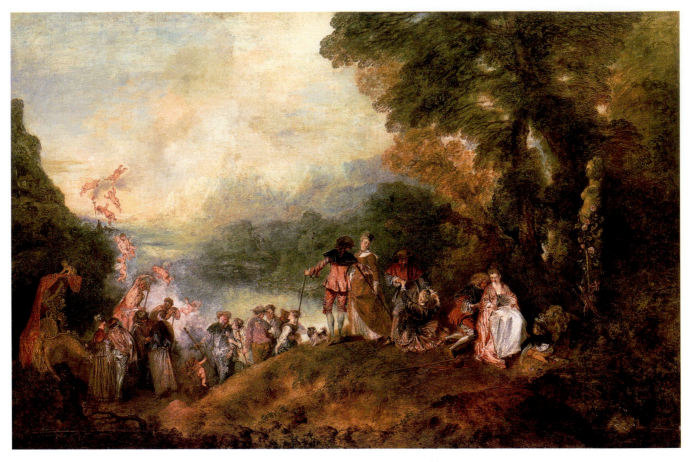

22.1. Jean-Antoine Watteau. *A Pilgrimage to Cythera*. 1717. Oil on canvas, 4′3″ × 6′4½″ (1.3 × 1.9 m). Musée du Louvre, Paris

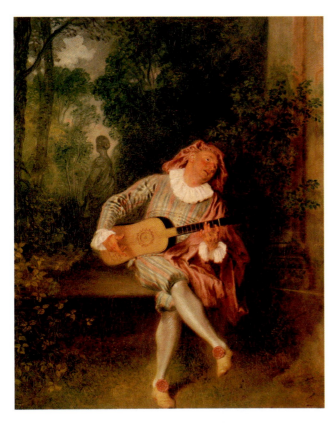

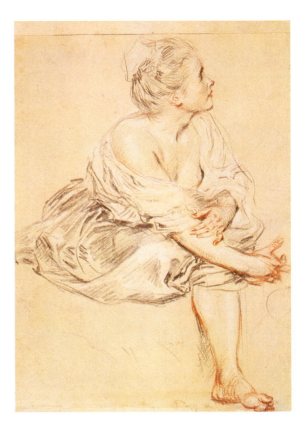

22.2. Jean-Antoine Watteau. *Mezzetin*. ca. 1718. Oil on canvas, 21¾ × 17″ (55.3 × 43.2 cm). The Metropolitan Museum of Art, New York. Munsey Fund, 1934 (34.138)

22.3. Jean-Antoine Watteau. *Seated Young Woman*. ca. 1716. *Trois crayon* drawing; red, black, and white chalks on cream paper, 10 × 6¾″ (25.5 × 17.1 cm). The Pierpont Morgan Library, New York

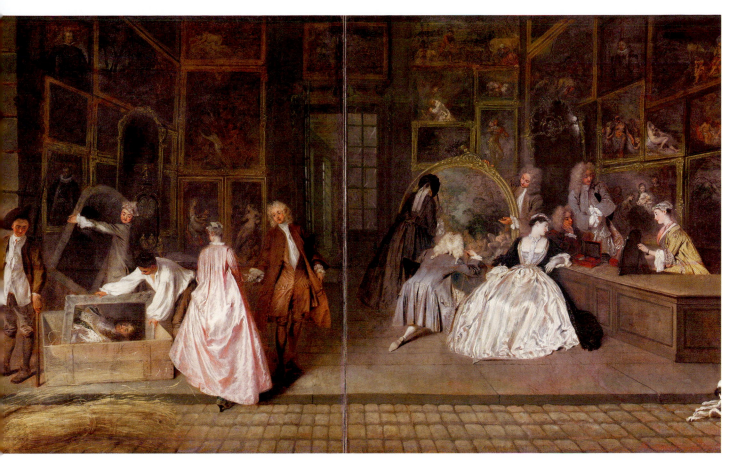

22.4. Jean-Antoine Watteau. *Gersaint's Signboard.* 1721. Oil on canvas, 5′5¼″ × 10′ (163 × 308 cm). (Later cut in two pieces and then rejoined.) Schloss Charlottenburg, Staatliche Schlösser und Gärten, Berlin

This nostalgic atmosphere is also evoked in Watteau's musician, *Mezzetin* (fig. **22.2**), a stock figure of the *commedia dell'arte*, whose name means "half-measure" and who played the role of an amorous suitor. He sings a pleading love song while playing his guitar in a parklike setting decorated with a statue of a woman in the background. Scholars presume that he is playing his music to her. It has been suggested that the painting, which was owned by Watteau's friend Jean de Jullienne (the author of a biography of the artist; see *Primary Source*, page 762), may have related to Jean's courtship of his wife. The wistful musician strains to look up to the right, out of the picture. Yet the fantastic, delicately striped costume of rose, pale blue, and white, paired with yellow shoes and rose beret and cape, transforms the scene from melancholic to magical. The small, single figure in pastel colors, set amid this pale verdant setting, is typical of the Rococo in spirit, figure type, and color of costume and setting.

Watteau's use of color planted him firmly in the Rubéniste camp. However, his innovations and creativity as a draftsman (which would have implied a Poussiniste status) combined both color and line (see *Materials and Techniques*, page 763). Although previous artists, including Rubens, may have drawn with red or black chalk heightened with white, Watteau excelled in the *trois crayons* technique. In *Seated Young Woman*

(fig. **22.3**), he uses the three chalks to best effect, so that the red color that defines her body—legs, hands, parts of her face (lips, tip of nose), nape, breast—suggests a vivacious quality when contrasted against the black and white of her clothing, eyebrows, and upswept hair. The colors enliven and add a spontaneity to this life drawing. In numerous sketches Watteau often worked out poses, movements, gestures, and expressions, many of which (although not this drawing) served as studies for figures in his paintings.

The same informality can be seen in one of Watteau's best-known works, *The Shopsign* or *Gersaint's Signboard* (fig. **22.4**). Created to advertise the wares of his friend and art dealer Edmé Gersaint, the sign does not in fact show Gersaint's gallery. Gersaint wrote about this commission and indicated that it was made at Watteau's suggestion to "stretch his fingers" after Watteau returned from a trip to London. Watteau had been physically ill (he would die soon after of tuberculosis), and the implication was that the artist used this work as part of a brief recovery. This account has since been disputed, but the work remains Watteau's last. The painting (originally arched at top) reportedly took only eight mornings to complete. It was meant to be exhibited outside but was shown for only 15 days (perhaps due to the weather or because it sold quickly). Gersaint reported that the painting attracted many

Jean de Jullienne (1686–1767)

A Summary of the Life of Antoine Watteau, 1684–1721

Jullienne, a dyer and later the Director of the Gobelin Tapestry, was a life-long friend of Watteau's and a collector of his works. At Watteau's death, he had all of the artist's drawings engraved and later did the same with the paintings, after buying many of them. His biography of the artist was published in 1726–1728, along with 350 engravings after Watteau's paintings and drawings, in two volumes as Figures de différents caractères. *Another two volumes followed.*

Watteau, inclined more and more to study, and excited by the beauties of the gallery of this palace [the Luxembourg Palace] painted by Rubens, often went to study the color and the composition of this great master. This in a short time gave him a taste much more natural and very different from that which he had acquired with Gillot. ...

Watteau was of medium height and weak constitution. He had a quick and penetrating mind and elevated sensibilities. He spoke little but well, and wrote likewise. He almost always meditated. A great admirer of nature and of all the masters who have copied her, assiduous work had made him a little melancholy. Cold and awkward in demeanor, which sometimes made him difficult to his friends and often to himself, he had no other fault than that of indifference and of a liking for change. It can be said that no painter ever had more fame than he during his life as well as after his death. His paintings which have risen to a very high price are today still eagerly sought after. They may be seen in Spain, in England, in Germany, in Prussia, in Italy, and in many places in France, especially in Paris. Also one must concede that there are no more agreeable pictures for small collections than his. They incorporate the correctness of drawing, truth of color and an inimitable delicacy of brushwork. He not only excelled in *gallant* and rustic compositions, but also in subjects of the army, of marches, and bivouacs of soldiers, whose simple and natural character makes this sort of pictures very precious. He even left a few historical pieces whose excellent taste shows well enough that he would have been equally successful in this genre if he had made it his principal objective.

Although Watteau's life was very short, the great number of his works could make one think that it was very long, whereas it only shows that he was very industrious. Indeed, even his hours of recreation and walking were never spent without his studying nature and drawing her in the situations in which she seemed to him most admirable.

The quantity of drawings produced by his study and which have been chose to be engraved and to form a separate work is a proof of this truth.

SOURCE: *A DOCUMENTARY HISTORY OF ART*, VOL II. ELIZABETH GILMORE HOLT ED. (PRINCETON, NJ: PRINCETON UNVERSITY PRESS, 1982)

artists as well as passersby who admired the natural, elegant poses of the figures—traits still admired today. The voluminous rose satin dress of the woman on the left, seen from the back, draws the eye; this figure is balanced by the languidly leaning woman on the right. Sophisticated and comfortable in the setting, the women are attended to by a solicitous staff as they admire paintings in the shop, arranged three to four high on the walls. Scholars do not believe these are copies of actual paintings but rather variants on Flemish and Venetian works, a theory that seems plausible when this work is compared with Jan Brueghel the Elder's *Allegory of Sight* and its real painting gallery (see fig. 20.10). The shop's stock also includes a variety of clocks and mirrors, which create an atmosphere of opulence and would remind the viewer of the world of the *ancien régime*. This association is supported by a portrait of Louis XIV based on Rigaud's (see fig. 21.10), seen on the left, which is being placed in a crate. Although on one level the presence of the king's image suggests the departure of the old (he had died only a few years before in 1715), it is actually a pun on the name of the shop, Au Grand Monarque. Watteau's extraordinary abilities as a painter are apparent as he transforms this commercial venture into a sensitive work of sophistication and tender beauty.

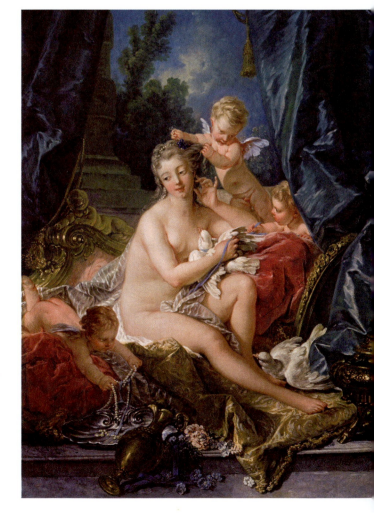

22.5. François Boucher. *The Toilet of Venus.* 1751. Oil on canvas, 43 × 33½″ (109.2 × 85.1 cm). The Metropolitan Museum of Art, New York. Bequest of William K. Vanderbilt. 1920. (20.155.9)

Pastel painting

Pastels are a form of colored chalks or powders that are mixed (or filtered) with glue, juice, gum arabic, or whey and then rolled into a cylindrical tube. They are made and sold today in much the same way as they were in the Rococo era. The fillers and water enable the pastels to be applied smoothly. Pastels can be soft or hard, but they must be dried out to be packaged as pastel crayons.

Leonardo had worked with pastels in the late fifteenth century (for his portrait of Isabella d'Este, 1499), but they gained popularity among artists in the sixteenth century. Yet artists used them only to execute preparatory drawings, not to create finished works. In the eighteenth century, however, artists realized the possibilities of the medium and began making pastel paintings as finished works. Pastels, as well as the popular **trois crayons** technique (see Watteau, fig. 22.3), had the advantage of suggesting both line and color at the same time. Since much debate arose in the late seventeenth and early eighteenth centuries about drawing (i.e., line) versus color, and since critics lauded artists such as Raphael who could combine both, the use of pastels may be considered a response to this issue. The lines could be smudged, built on each other, or hatched so that a single line could become an area of color and several together could create and an even more vibrant patch.

Artists chose pastels primarily to make portraits, applying flicks of color to suggest animation, emotion, or expression and thus make the sitter appear more vivid and lifelike. One of the greatest pastel portraitists is Rosalba Carriera (1675–1757), a Venetian artist known for revealing the psychological intensity of her sitters. Carriera was famous in her own time and had an international clientele of British, French, German, and Polish patrons. She was a member of the Academy of St. Luke of Rome in 1705, the Academy Clementina of Bologna in 1720, and the French Academy in 1721. Upon traveling to Paris in 1720–1721, she was hailed by both the French court and French artists including Hyacinthe

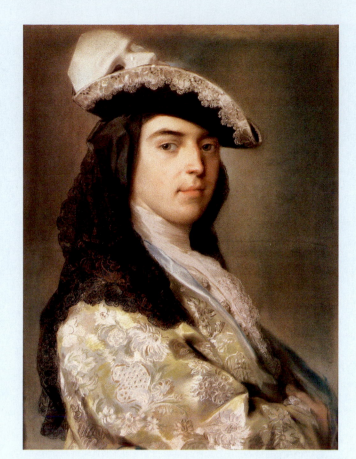

Rosalba Carriera. *Charles Sackville, Second Duke of Dorset.* ca. 1730. Pastel on paper, 25 × 19" (63.5 × 48.3 cm). Private Collection

Rigaud (see Chapter 21) and Watteau (see pages 759–762), who made several drawings of her. The intimacy and immediacy of her technique, combined with the indistinct, even hazy, quality of the image, suggest a tantalizingly allusive sensuality, as seen in this portrait of the second Duke of Dorset.

FRANÇOIS BOUCHER Following the untimely death of Watteau in 1721, François Boucher (1703–1770) rose to prominence in French painting. Boucher built his reputation on his imaginative compositions, pastoral landscapes, and scenes of bourgeois daily life. He served as court painter to Madame de Pompadour, Louis XV's mistress and frequent political advisor and a major patron of the arts. Boucher painted her portrait and other works for her, including *The Toilet of Venus* (fig. **22.5**) for her private retreat outside Paris. Although not a portrait of Madame de Pompadour, it is probably an allusion to her title role in the play *A Toilet of Venus*, performed at Versailles in 1750. Compared with Vouet's sensuous goddess (see fig. 21.3), Boucher's Venus has been transformed into an eternally youthful being. The pink tones of her skin are echoed in the pink chaise and the deep rose of fabric at her feet. Venus is engulfed by pale aquamarine drapery. The lush and erotic painting is typical of the Rococo in its figure type and sensual use of textures and colors—pastel pinks, roses, and blues. If Watteau elevated human love to the level of mythology, Boucher raised playful eroticism to the realm of the divine. He uncovered the fantasies that enrich people's lives. Indeed, Boucher's joyful visions of human dreams and desires were a mirror of the luxurious and exuberant lifestyles of his patrons in the French royalty and aristocracy, for whom his works held great appeal.

JEAN-HONORÉ FRAGONARD Transforming fantasy into reality in paint was the forte of Jean-Honoré Fragonard (1732–1806)—or at least that was the reputation of this star pupil of Boucher. Also a brilliant colorist, Fragonard won the distinguished Rome Prize in 1752 and spent five years in Rome, beginning in 1756. Upon his return to Paris, he worked mostly for private collectors. Fantasy, flirtation, and licentiousness—in short, the spirit of the Rococo—coalesce in his painting *The Swing* (fig. **22.6**). An anecdote provides an interpretation of the painting. According to the story, another artist, Gabriel-François Doyen, was approached by the Baron de Saint-Julien to paint his mistress "on a swing which a bishop is setting in motion. You will place me in a position in which I can see the legs of the lovely child and even more if you wish to enliven the picture." Doyen declined the commission but directed it to Fragonard.

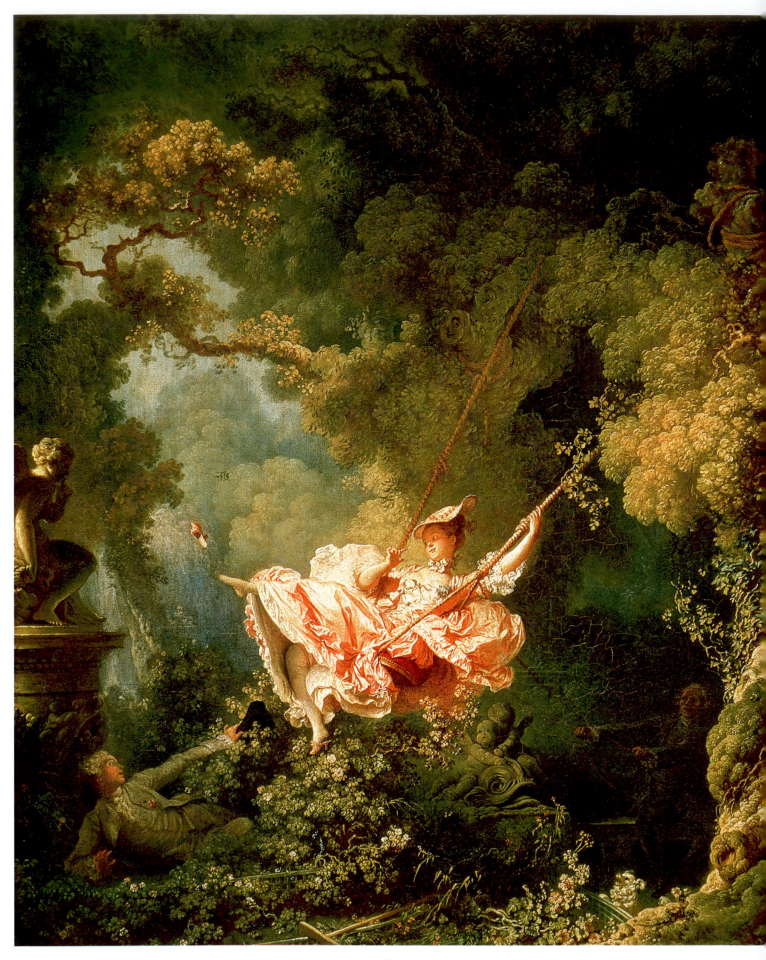

22.6. Jean-Honoré Fragonard, *The Swing*. 1767. Oil on Canvas, $32\frac{5}{8} \times 26''$ (82.9 × 66.0 cm). Wallace Collection, London

The painting, an example of an "intrigue," suggests a collusion in erotic fantasy between the artist and patron, with the clergy as their unwitting dupe. Like Boucher's *The Toilet of Venus*, this "boudoir painting" offers the thrill of sexual opportunity and voyeurism but here in a stagelike outdoor setting. The innocence of the public arena heightens the teasing quality of the motion of the swing toward the patron-viewer. The painted sculpture of a cupid to the left, holding a finger to his lips, suggests the conspiracy to the erotic escapade at which we as viewers are now participants. Fragonard used painted sculpture in many of his works to echo or reinforce their themes. Set in a lush arbor, this scene encapsulates the "place of love" secluded by trees that provides secrecy for this erotic encounter. The dense and overgrown landscape, lit by radiant sunlight, suggests the warmth of spring or summer and their overtones of sexuality and fertility. The glowing pastel colors create an otherworldly haze that enhances the sensuality of this fantasy spun by Fragonard.

Fragonard represented the epitome of the sensuality of the Rococo, and his works are marked by an extraordinary virtuosity in his use of color. His paintings range from erotic fantasies to intimate studies and pastoral landscapes, subjects that provided distraction for his wealthy patrons.

JEAN-SIMÉON CHARDIN Raised in a bourgeois household, Jean-Siméon Chardin (1699–1779) rose to become Treasurer of the French Academy as well as its Tapissier, responsible for installing the paintings at the Academy exhibitions. This role was especially notable because although Chardin was actively engaged in Academy life, his expertise was in still life, the area of painting considered the lowest in the Academy's hierarchy of subjects. Yet in his masterful hands, he raised this genre to an exalted and esteemed level. The interest in still-life paintings as well as in genre (which also became one of Chardin's specialties after colleagues encouraged him to paint figures as a way of raising his status) was inspired by the many Dutch and Flemish seventeenth-century paintings then in France. These artists settled in France in growing numbers after about 1550, maintaining close ties to their native region through the sale of Dutch paintings in French auction houses. They spurred a fascination with foreign painting, and indeed some of Chardin's own patrons were important collectors of seventeenth-century Dutch and Flemish art.

A keen observer of daily life, Chardin's genre paintings act as moral lessons not by conveying symbolic messages but by affirming the rightness of the existing social order and its values. To his patrons, members of the rising bourgeoisie in France, such genre scenes and domestic still lifes proclaimed the virtues of hard work, frugality, honesty, and devotion to family. Chardin's quiet household scenes struck a chord with his sophisticated patrons, and demand for them was so high that he often painted copies of his most popular subjects. His paintings were also reproduced as prints, making them affordable to those who lacked the means to buy an original work.

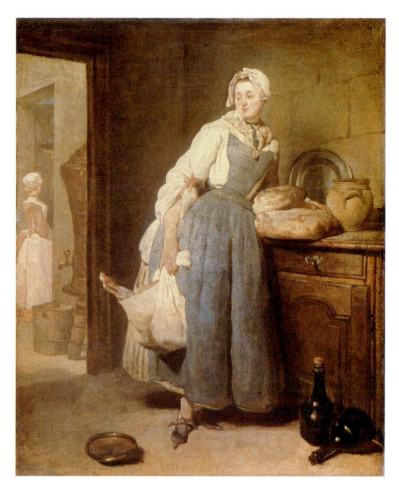

22.7. Jean-Siméon Chardin. *Back from the Market.* 1739. Oil on canvas, $18\frac{1}{2} \times 14\frac{3}{4}$″ (47 × 37.5 cm). Musée du Louvre, Paris

Back from the Market (fig. **22.7**) shows life in a Parisian bourgeois household. The beauty hidden in everyday life and a clear sense of spatial order beg comparison with the Dutch artist Jan Vermeer (see figs. 20.34 and 20.35). However, Chardin's technique differs significantly from that of any Dutch artist. As opposed to the exactitude seen in earlier Dutch still lifes, Chardin's brushwork is soft at the edges and suggests objects rather than defines them. Rather than painting every detail, Chardin seeks to reveal the inner nature of objects, summarizing forms and subtly altering their appearance and texture. Given his increasing fascination with the mere suggestion, the appeal of pastel painting is understandable, and Chardin often turned to this medium late in life, when his eyes were failing him. In this and other genre scenes, he reveals the complex beauty of even the most humble objects and endows them with timeless dignity.

Chardin's still lifes usually depict the same modest environment and, unlike Dutch still lifes, often focus on a few objects painstakingly rendered. *Kitchen Still Life* (fig. **22.8**) shows only the everyday items common to any kitchen: earthenware jugs, a casserole, a copper pot, a piece of raw meat, smoked herring, two eggs. But how important they seem, each so firmly placed in relation to the rest, each so worthy of the artist's—and a viewer's—attention. Despite his concern with formal problems,

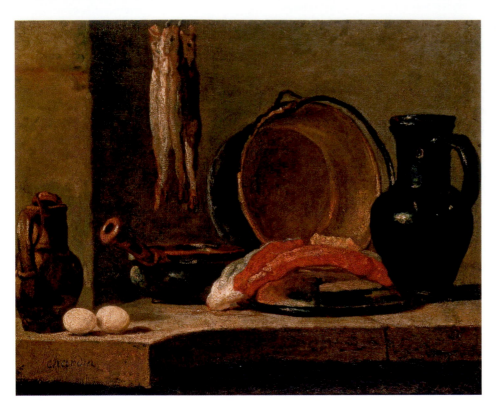

22.8. Jean-Siméon Chardin. *Kitchen Still Life.* ca. 1733. Oil on canvas, 12½ × 15⅜″ (32 × 39 cm). Ashmolean Museum, Oxford. Bequeathed by Mrs. W. F. R. Weldon

evident in the beautifully balanced composition, Chardin treats these objects with a respect close to reverence. Beyond their shapes, colors, and textures, they are to him symbols of the life and values of common people.

Blowing Bubbles (fig. **22.9**) is very much an outgrowth of Dutch genre painting and the vanitas symbols frequently seen in the still-life tradition. The bubble, intact only for a moment, symbolizes the brevity of life, which serves as one of the painting's underlying themes. However, Chardin has chosen a charming, endearing way to send his message to a viewer. He presents two children, an older boy, possibly instructing a younger one eagerly looking on, since play was a common theme in Chardin's work. He frequently depicted children or young adolescents at play or engaged in a card game. Unlike most Rococo painting, the figures in this work are lifesize rather than diminutive, and their size affects our understanding of the reality. The scale reinforces the possibility that we could encounter a similar scene in our own world.

ÉLISABETH-LOUISE VIGÉE-LEBRUN Portraits allow us to gain the clearest understanding of the French Rococo, for the transformation of the human image lies at the heart of the age. In portraits of the aristocracy, men were endowed with the illusion of substance as an attribute of their noble birth. But the finest Rococo portraits were those of elaborately garbed women, hardly a surprising fact in a society that idolized love and feminine beauty. Indeed, one of the finest, most accomplished, and most successful portrait painters of the Rococo was Élisabeth-Louise Vigée-Lebrun (1755–1842). As court painter to Marie Antoinette, and therefore responsible for glorifying

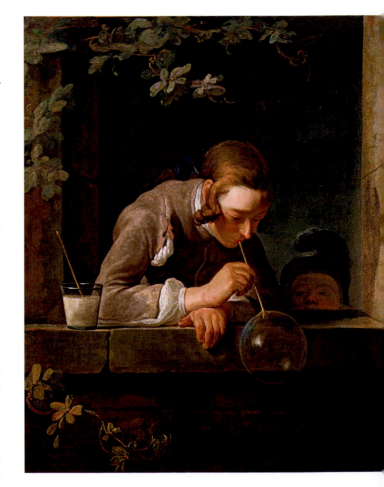

22.9. Jean-Simeon Chardin. *Blowing Bubbles.* ca. 1733. Oil on canvas, 36⅝ × 29⅜ (93 × 74.6 cm). The National Gallery of Art, Washington, DC. Gift of Mrs. John W. Simpson

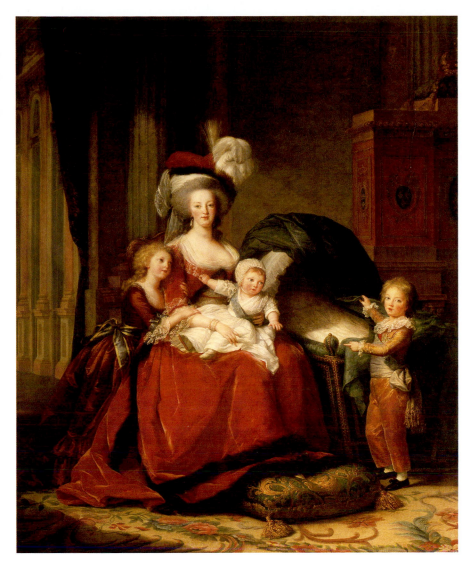

22.10. Élisabeth-Louise Vigée-LeBrun. *Marie Antoinette and Her Children*. 1787. Oil on canvas, 9'1½" × 7'5⅛" (2.75 × 2.15 m). Musée National du Château de Versailles, Versailles

the image of the monarch, Vigée-Lebrun held a dangerous position in the 1780s as the French Revolution approached. Yet she survived the war and serves as a bridge between the *ancien régime* of Louis XVI and the post-Revolutionary period.

Marie Antoinette and Her Children (fig. **22.10**) embodies the vision Vigée-Lebrun chose for the royal mother and the one the queen most attempted to incorporate into her life at Versailles. Surrounded by her children, Marie Antoinette is shown as a "normal," humble woman. At a time when a high infant mortality was the norm, the image of the empty cradle suggests the death of an infant, reinforcing the ordinariness of the royal family. The queen's eldest son, Louis Joseph (known as *le dauphin*; he would die of natural causes just two years later), is pointing to the empty cradle of Sophie. The second son, Louis Charles, sits on his mother's lap while her daughter, Marie Thérèse, stands at her side. This type of imagery, not just of a family scene but specifically of a mother with her children, was in vogue in both painting and in literature. Indeed, the concept

of motherhood as the epitome of a woman's life became fully developed at this time. A glimpse into the intimate life of the royal family, Vigée-Lebrun's portrait is intended to convey the ordinariness of what was likely the most extraordinary family in eighteenth-century France.

The French Rococo Interior

It is in the intimate spaces of early eighteenth-century interiors that the full elegance and charm of the Rococo are shown to full extent. This fact is manifest—yet disguised—in Vigée-Lebrun's portrait of Marie Antoinette, which is set in the midst of the magnificence of Versailles. But Versailles is not the only measure of the social world. The Parisian hôtels of the dispersed nobility soon developed into social centers. As state-sponsored building activity was declining, the field of "design for private living" took on new importance. Because these city sites were usually cramped and irregular, they offered few opportunities for impressive exteriors. Hence the layout and

ART IN TIME

1701–1714—War of the Spanish Succession

1715—Louis XIV dies

1718—New Orleans founded by the French

1723—Louis XV crowned king of France

1767—Fragonard's *The Swing*

more involved in interior decoration. Along with sculptors, who often created the architectural ornamentation, and painters, whose works were inserted over doors, architects helped to raise the decorative arts to the level of the fine arts, thus establishing a tradition that continues today. The decorative and fine arts were most clearly joined in furniture. French cabinetmakers known as *ébénistes* (after ebony, their preferred wood veneer) helped to bring about the revolution in interior décor by introducing new materials and techniques. Gilt, metals, and enamels were often applied to these to create the feathery ornamentation associated with the Rococo. Many of these artisans came originally from Holland, Flanders, Germany, and Italy.

décor of the rooms became the architects' main concern. The hôtels demanded an intimate style of interior decoration that gave full scope to individual fancy, uninhibited by the classicism seen at Versailles.

Crucial to the development of French décor was the importance assigned to interior designers. Their engravings established new standards of design that were expected to be followed by artisans, who thereby lost much of their independence. Designers also collaborated with architects, who became

The decorative arts played a unique role during the Rococo. Hôtel interiors were more than collections of objects. They were total environments assembled with extraordinary care by discerning collectors and the talented architects, sculptors, decorators, and dealers who catered to their exacting taste. A room, like an item of furniture, could involve the services of a wide variety of artisans: cabinetmakers, wood carvers, gold-

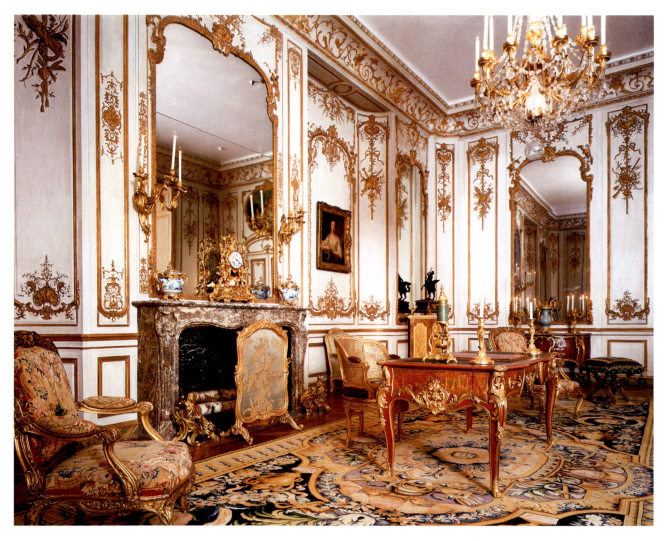

22.11. Nicolas Pineau. Varengeville Room in the Hôtel de Varengeville, 217 Boulevard St.-Germain, Paris. ca. 1735. (The chimney piece on the wall at left is not original to room.) Original paneling probably commissioned by Pineau. Carved, painted, and gilded oak, 18′3³⁄₄″ × 40′6¹⁄₂″ × 23′2¹⁄₂″ (5.58 × 12.35 × 7.07 m). Photographed about 1995. The Metropolitan Museum of Art, New York. Purchase, Mr. and Mrs. Charles Wrightsman Gift, 1963. (63.228.1)

and silversmiths, upholsterers, and porcelain makers. The varied artistic products of these artisans were set in rooms that were usually painted white and decorated with gilt molding and pastel-colored Rococo paintings set in walls and over doors, all enhanced by mirrors and light. The artists were dedicated to producing the ensemble, even though each craft was, by tradition, a separate specialty subject to strict regulations. Together they fueled the insatiable hunger for novelty that swept the aristocracy and haute bourgeoisie of Europe.

NICOLAS PINEAU Few of these Rococo rooms survive intact; the vast majority have been destroyed or greatly changed, or the objects and decorations have been dispersed. Even so, we can get a good idea of their appearance through the reconstruction of one such room (perhaps from the ground floor behind the garden elevation) from the Hôtel de Varengeville, Paris (fig. **22.11**), designed about 1735 by Nicolas Pineau (1684–1754) for the Duchesse de Villars. Pineau had spent 14 years in Russia as a collaborator with other French craftsmen on Peter the Great's new city of St. Petersburg. His room for the duchess incorporates many contemporary Rococo features. To create a sumptuous effect, the white walls are encrusted with gilded stucco ornamentation in arabesques, C-scallops, S-scrolls, fantastic birds, bat's wings, and acanthus foliage sprays. The elaborately carved furniture is embellished with gilt bronze. Everything swims in a sea of swirling patterns united by the most sophisticated sense of design and materials the world has ever known. No clear distinction exists between decoration and function in the richly designed fireplace and the opulent chandelier. The paintings, too, have been completely integrated into the decorative scheme, with paintings by Boucher set over two of the doors (these paintings even established a type of work, called overdoors).

Porcelain, and especially porcelain by Sèvres, the manufactory established by Louis XV and closely associated with the tastes of his mistress Madame de Pompadour, would have once been one of the prominent decorations within the interior, from the dinner and tea services to containers for playful bowls of potpourri (fig. **22.12**). In this example, the portholes of the shiplike vessel allow the sweet fragrance of the potpourri to escape. We see a similar example (although not of Sèvres) in the lower right corner of Boucher's *The Toilet of Venus* (fig. 22.5). These porcelain objects, even more popular later in Germany due to the popularity of wares produced by the Meissen pottery, transformed the colors of Rococo paintings and pastels—rose pinks, pale greens, turquoise blues—into three-dimensional art trimmed with gold.

CLODION AND FRENCH ROCOCO SCULPTURE Used to adorn interiors, French Rococo sculpture took many forms and was designed to be viewed at close range. A typical example is the miniature *Nymph and Satyr Carousing* (fig. **22.13**) by Claude Michel (1738–1814), known as Clodion, a successful sculptor of the Rococo period who later effectively adapted his style to the more austere Neoclassical manner. Clodion began his studies

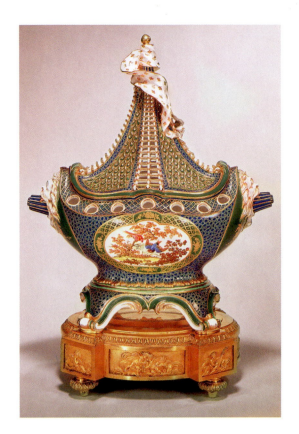

22.12. Potpourri container. ca. 1758. Sèvres Royal Porcelain Factory, France. Soft paste porcelain with polychrome and gold decoration, vase without base $14\frac{3}{4} \times 13\frac{3}{4} \times 6\frac{7}{8}$″ (37.5 × 34.6 × 17.5 cm). The Frick Collection, New York

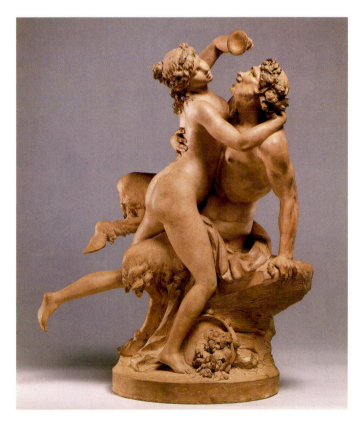

22.13. Claude Michel, known as Clodion. *Nymph and Satyr Carousing*. ca. 1780. Terra cotta, height $23\frac{1}{4}$″ (59 cm). The Metropolitan Museum of Art, New York. Bequest of Benjamin Altman, 1913. (14.40.687)

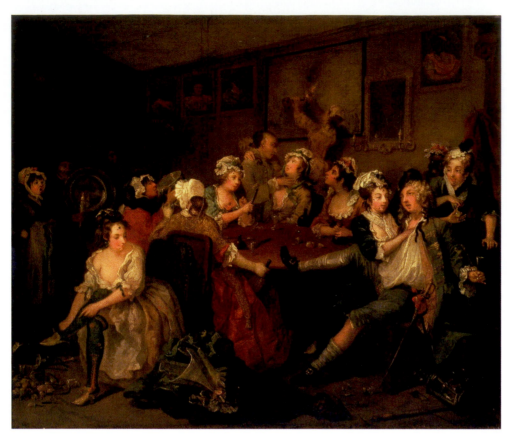

22.14. William Hogarth. *The Orgy*. Scene III of *The Rake's Progress*. ca. 1734. Oil on canvas,
24¹/₂ × 29¹/₂″ (62.2 × 74.9 cm). Sir John Soane's Museum, London. By Courtesy of the Trustees

at Versailles and won the prestigious Rome Prize. His greatest contribution to the Rococo was transforming the fantasies of Boucher and Fragonard into three-dimensional works of coquettish eroticism. The open and airy composition of this sculpture is related to a work by Bernini, but its reduced scale produces a more intimate and sensual effect. Although Clodion undertook several large sculptural cycles in marble, he reigned supreme in the intimate medium of terra cotta.

ENGLAND: PAINTING AND PRINTMAKING

The French Rococo exerted a major influence across the English Channel, where foreign artists—Holbein, Gentileschi, Rubens, Van Dyck—had flourished for generations in England, and the works of Dutch and Italian artists were widely collected. The Rococo helped to bring about the first school of English painting since the Middle Ages that had more than local importance. As we have seen with the works of Chardin and Rubens, among others, printmaking was used not just to create new compositions but to disseminate painted works, giving them a larger audience and broader appeal. This task proved most useful for landscapes and genre paintings, areas of great interest to, and increasingly collected by, the British public.

William Hogarth and the Narrative

William Hogarth (1697–1764) was the first major native English artist since Nicholas Hilliard (see fig. 18.28). Hogarth

began his career as an engraver and soon took up painting. Although he must have learned lessons about color and brushwork from Venetian and French examples, as well as from Van Dyck, his work is so original that it has no real precedent. He made his mark in the 1730s with a new kind of picture, which he described as "modern moral subjects … similar to representations on the stage." This new type of picture follows the vogue for sentimental comedies, such as the plays of Richard Steele, which attempted to teach moral lessons through satire. Hogarth's work is in the same vein as John Gay's *The Beggar's Opera* of 1728, a biting social and political parody that Hogarth illustrated in one of his paintings. He created these pictures, and the prints made from them for sale to the public, in series and repeated certain details in each scene to unify the sequence. Hogarth's morality paintings teach, by bad example, solid middle-class virtues and reflect the desire for a return to simpler times and values. They proved enormously popular among the newly prosperous middle class in England.

In *The Orgy* (figs. **22.14** and **22.15**), from *The Rake's Progress*, the artist shows a young wastrel who is overindulging in wine and women. (Later in the series, the rogue is arrested for debt, enters into a marriage of convenience, turns to gambling, goes to debtor's prison, and dies in an insane asylum.) The scene is set in a famous London brothel, The Rose Tavern. The girl adjusting her shoe in the foreground is preparing for a vulgar dance involving the silver plate and candle behind her; to the left a chamber pot spills its foul contents over a chicken dish; and in

the background a singer holds sheet music for a bawdy song of the day. The scene is full of witty visual clues, which the viewer would discover little by little, adding a comic element to the satire of social evils. Hogarth combines Watteau's sparkling color with Jan Steen's emphasis on the narrative (compare with figs. 22.1 and 20.33). His moral narratives are so entertaining that viewers enjoy his sermon without being overwhelmed by the stern message.

Thomas Gainsborough and the English Portrait

Portraiture remained the only constant source of income for English painters. Thomas Gainsborough (1727–1788), the country's greatest master of portraiture, began by painting landscapes but prospered greatly as the favorite portraitist of British high society. His early works, such as *Robert Andrews and His Wife* (fig. **22.16**), have a lyrical charm and light and airy sentimentality, qualities appreciated by his patrons and collectors but not always found in his later pictures. The outdoor setting, although clearly indebted to the French Rococo artists Boucher and Fragonard, was largely an invention of the English artist Francis Hayman (1708–1766), whom Gainsborough came to know as an art student in London. Gainsborough even painted the backgrounds in some of Hayman's works during the 1750s but soon surpassed him. Compared with Van Dyck's artifice in *Charles I Hunting* (see fig. 20.8) or Hals's larger and more exuberant figures in *Married Couple in a Garden, Portrait of Isaac Massa and Beatrix van der Laen* (fig. 20.17), Gainsborough's nonchalant country squire and his wife appear comfortably at home in their

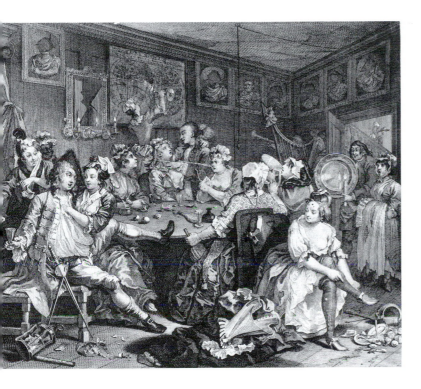

22.15. William Hogarth. *He Revels (The Orgy),* Scene III of *The Rake's Progress.* 1735. Engraving. The Metropolitan Museum of Art, New York. Harris Brisbane Dick Fund, 1932. (32.35(30))

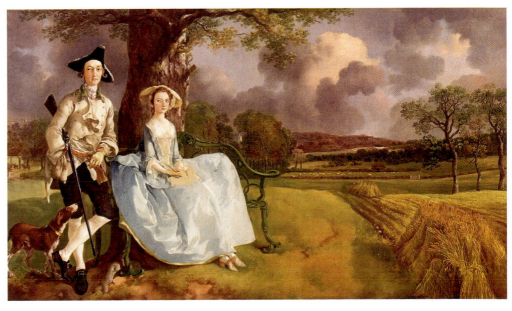

22.16. Thomas Gainsborough. *Robert Andrews and His Wife.* ca. 1748–1750. Oil on canvas, 27$\frac{1}{2}$ × 47″ (69.7 × 119.3 cm). The National Gallery, London. Reproduced by Courtesy of the Trustees

unpretentious setting. The landscape is derived from Ruisdael (see fig. 20.28) and his school, but it has a more open, sunlit, and hospitable air. The casual grace of these two figures recalls Watteau's style. The newlywed couple do not till the soil themselves. She is dressed in the fashionable attire of the day, while he is armed with a rifle to denote his status as a country squire. (Hunting was the privilege of wealthy landowners.) The painting nevertheless conveys the gentry's closeness to the land, from which the English derived much of their sense of identity. Out of this attachment to place, a feeling for nature developed that became the basis for English landscape painting, to which Gainsborough himself made an important early contribution.

Gainsborough spent most of his career working in the provinces, first in his native Suffolk, then in the resort town of Bath. Toward the end of his career he moved to London, where his work underwent a major change. The splendid portrait (fig. **22.17**) of the famous tragic actress Sarah Siddons (1755–1831) displays the virtues of the artist's late style: a cool elegance that translates Van Dyck's aristocratic poses into late eighteenth-century terms and a fluid, translucent technique reminiscent of Rubens's that renders the glamorous sitter, with her fashionable attire and coiffure, to ravishing effect. The portrait's unique qualities were summarized most ably by the French nineteenth-century critic Théophile Thoré-Burger (1807–1869) in 1857, more than 70 years after the portrait was painted:

> The great tragic actress, who interpreted the passions with such energy and such feeling, and who felt them so strongly herself, is better portrayed in this simple half length, in her day dress, than in allegorical portraits as the Tragic Muse or in character parts. This portrait is so original, so individual, as a poetic expression of character, as a deliberate selection of pose, as bold color and free handling, that it is a work of no other painter. It is useless to search for parallels, for there are none. Veronese a little—but no, it is a quite personal creation. This is genius.

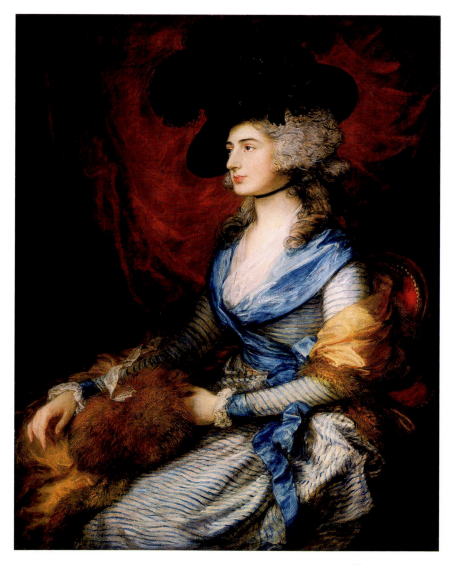

22.17. Thomas Gainsborough. *Mrs. Siddons.* 1785. Oil on canvas, $49\frac{1}{2} \times 39''$ (125.7 × 99.1 cm). The National Gallery, London. Reproduced by Courtesy of the Trustees

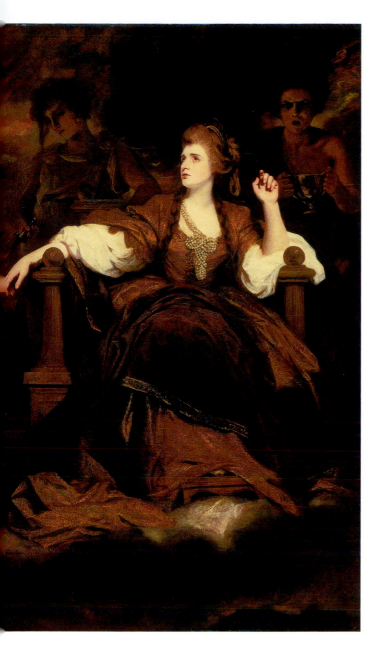

22.18. Sir Joshua Reynolds. *Mrs. Siddons as the Tragic Muse.* 1784. Oil on canvas, 7′9″ × 4′9½″ (2.36 × 1.46 m). Henry E. Huntington Library and Art Gallery, San Marino, California

Joshua Reynolds

As the French critic's pointed remarks suggest, Gainsborough painted Siddons to outdo his great rival on the London scene, Sir Joshua Reynolds (1723–1792), who had portrayed her as the embodiment of the Tragic Muse (fig. **22.18**). Siddons was one of the era's several well-known English actresses, and she made her fame playing tragic roles, of which the critic William Hazlitt wrote: "Power was seated on her brow, passion emanated from her breast as from a shrine. She was tragedy personified."

For his portrait Reynolds relied on expression and pose, derived from Michelangelo's Prophet Isaiah from the Sistine Chapel ceiling (fig. 16.17), to suggest the aura of the strength of Siddons's moral character. Reynolds, president of the British Royal Academy of Arts since its inception in 1768, championed the academic approach to art (copying the Old Masters), in

ART IN TIME

1707—Act of Union unites England and Scotland

1719—Daniel Defoe publishes *Robinson Crusoe*

1768—British Royal Academy of Arts founded in London

1785—Gainsborough's *Mrs. Siddons*

which he was well versed after having spent two years in Rome (see *Primary Source*, page 774). In his *Discourses* (annual lectures he presented to academy members), he set forth what he considered to be necessary rules and theories. His views were essentially those of Charles Le Brun, and like the French artist, Reynolds found it difficult to live up to his theories in practice. Although he preferred history painting in the grand style (as in the works of Poussin), most of his paintings are portraits that use allegory to ennoble them. We see this use here, for Reynolds has shown Siddons as the muse personified seated in her throne, and she is flanked by the allegorical figures of Pity and Terror.

Although his style owed a debt to the color and lighting of the Venetians, the Flemish Baroque artists, and even Rembrandt, Reynolds developed his own approach to the landscape that reflected a quintessential English attitude toward the land and its associations with personal liberty and prosperity. He was generous enough to praise Gainsborough, whom he eulogized as one who saw with the eye of a painter rather than a poet. For all their differences the two artists had more in common, artistically and philosophically, than they cared to admit. Reynolds and Gainsborough looked back to Van Dyck while drawing different lessons from his example. Both emphasized in varying degrees the visual appeal and technical skill of their paintings.

GERMANY AND AUSTRIA AND THE ROCOCO IN CENTRAL EUROPE

Rococo architecture was a refinement in miniature of the curvilinear, "elastic" Baroque of Borromini and Guarini. It was readily united with the architecture of Central Europe, where the Italian Baroque had firmly taken root. It is not surprising that the Italian style received such a warm response there. In Austria and southern Germany, ravaged by the Thirty Years' War, patronage for the arts was limited and the number of new buildings remained small until near the end of the seventeenth century. By the eighteenth century these countries, especially the Catholic parts, were beginning to rebuild. The Baroque was an imported style, practiced mainly by visiting Italian artists. Not until the 1690s did native architects come to the fore. There followed a period of intense activity that lasted more than 50 years and gave rise to some of the most imaginative creations in the history of architecture. These monuments were built to glorify princes and prelates who are generally remembered only as lavish patrons of the arts. Rococo architecture in Central

Sir Joshua Reynolds (1723–1792)

From "A Discourse, Delivered at the Opening of the Royal Academy, January 2, 1769"

The Royal Academy of London was founded in November 1768, based on the principles of the Academy of St. Luke in Rome and the French Academy, each founded more than a century earlier. The annual exhibition in London became the Royal Academy's prominent aspect, although teaching was, in theory, fundamental to all academies. Sir Joshua Reynolds, the academy's first president, explained its teaching principles in his first address.

The principal advantage of an Academy is, that ... it will be a repository for the great examples of the Art. These are the materials on which Genius is to work, and without which the strongest intellect may be fruitlessly or deviously employed. By studying these authentick models, that idea of excellence which is the result of the accumulated experience of past ages may be at once acquired, and the tardy and obstructed progress of our predecessors, may teach us a shorter and easier way. The Student receives, at one glance, the principles which many Artists have spent their whole lives in ascertaining. ... How many men of great natural abilities have been lost to this nation, for want of these advantages? ...

Raffaelle, it is true, had not the advantage of studying in an Academy; but all *Rome*, and the works of Michael Angelo in particular, were to him an Academy.

One advantage, I will venture to affirm, we shall have in our Academy, which no other nation can boast. We shall have nothing to unlearn. ...

But as these Institutions have so often failed in other nations ... I must take leave to offer a few hints, by which those errors may be rectified. ...

I would chiefly recommend, that an implicit obedience to the *Rules of Art*, as established by the practice of the great Masters, should be exacted from the *young* Students. That those models, which have passed through the approbation of ages, should be considered by them as perfect and infallible Guides; as subjects for their imitation, not their criticism.

I am confident, that this is the only efficacious method of making a progress in the Arts; and that he who sets out with doubting, will find life finished before he becomes master of the rudiments. For it may be laid down as a maxim, that he who begins by presuming on his own sense, has ended his studies as soon as he has commenced them. Every opportunity, therefore, should be taken to discountenance that false and vulgar opinion, that rules are the fetters of Genius.

SOURCE: *SEVEN DISCOURSES DELIVERED IN THE ROYAL ACADEMY, BY THE PRESIDENT.* (CHAMPSHIRE: SCHOLAR PRESS, 1971)

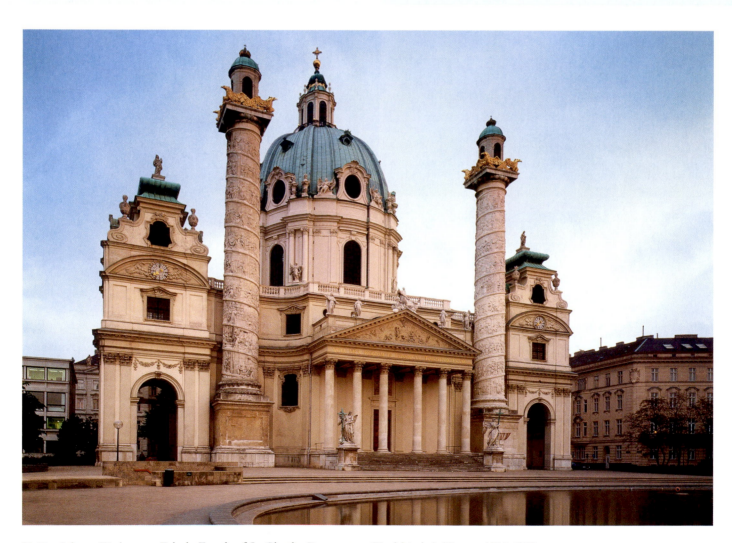

22.19. Johann Fischer von Erlach. Facade of St. Charles Borromaeus (Karlskirche), Vienna. 1716–1737

Europe is larger in scale and more exuberant than that in France. Moreover, painting and sculpture are more closely linked with their settings. Palaces and churches are decorated with ceiling frescoes and sculpture unsuited to domestic interiors, however lavish, although they reflect the same taste that produced the Rococo French hôtels.

Johann Fischer von Erlach

The Austrian Johann Fischer von Erlach (1656–1723), the first great architect of the Rococo in Central Europe, had studied in Rome and was closely linked to the Italian tradition. His work represents the decisive shift of the center of architecture from Italy to north of the Alps. His masterpiece, the church of St. Charles Borromaeus (Karlskirche) in Vienna (figs. **22.19** and **22.20**), was built in thanks for the ending of the plague of 1713, much like the church of Santa Maria della Salute in Venice of the previous century (see fig. 19.27). It was dedicated to the Counter-Reformation saint bearing the given name of the emperor, Charles VI, whose symbolism is apparent throughout. Fischer von Erlach uses several Italian and French architectural standards to new effect, combining the facade of Borromini's Sant'Agnese and the Pantheon portico (see figs. 19.22 and 7.39). He added a pair of huge columns, derived from the Column of Trajan (see fig. 7.28), and decorated with scenes from the life of the saint. The two columns symbolize the columns of Hercules—the straits of Gibraltar—a reference to Charles VI's claim to the throne of Spain. They also take the place of towers, which have become corner pavilions reminiscent of Lescot's Louvre court facade (see fig. 18.7). The church celebrates the emperor Charles VI as a Christian ruler and reminds us that the Turks, who repeatedly menaced Austria and Hungary, had been defeated at the siege of Vienna only in 1683, thanks mainly to the intervention of John III of Poland and that they remained a serious threat as late as 1718. Fischer von Erlach uses aspects of major works of the canon of Western architecture to create an entirely new work that brings with it all the grandeur and esteem of the old traditions.

ART IN TIME

1703—Saint Petersburg founded by Peter the Great. It serves as the Russian capital until 1918

1716–1737—Fischer von Erlach's Karlskirche built in Vienna

1740–1748—War of Austrian Succession

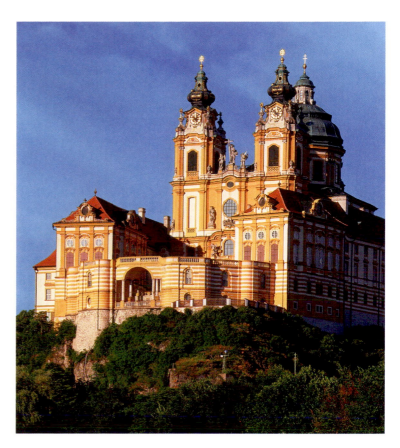

22.21. Jakob Prandtauer. Monastery Church, Melk, Austria. Begun 1702

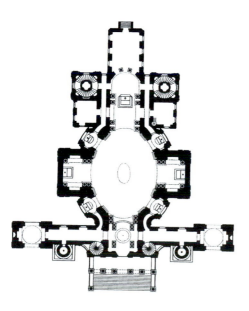

22.20. Plan of St. Charles Borromaeus

The extraordinary breadth of this ensemble is due to the site itself (fig. 22.19). It obscures the equally long main body of the church, which is a large oval with side chapels and a deep choir. With the inflexible elements of Roman imperial art embedded into the elastic curves of his church, Fischer von Erlach expresses, more boldly than any Italian architect of the time, the power of the Christian faith to transform the art of antiquity. Indeed, it was now Italy's turn to respond to the North.

Jakob Prandtauer

The Austrian architect Jakob Prandtauer (1660–1726) was a contemporary of Fischer von Erlach. Prandtauer, a mason, sculptor, and architect, began work in southern Germany and excelled in developing local traditions, which in Austria meant simple, refined exteriors integrated into the expansive landscape. Prandtauer's lifetime work, the Monastery of Melk (fig. **22.21**), owes

much of its monumental effect to its site on the crest of a cliff above the Danube, from which it rises like a vision of heavenly glory. The polychromed buildings form a tightly knit unit that centers on the church. The wings, housing the library and imperial hall, are joined at the west by curving arms, which meet at a high balcony that provides a dramatic view onto the world beyond the monastery. Although Prandtauer never went to Italy to study from original works, he read Italian architectural treatises, which formed a basis for his work.

Balthasar Neumann

The work of Balthasar Neumann (1687–1753), who designed buildings exuding lightness and elegance, is the culmination of the Rococo in Central Europe. Trained as a military engineer, he was named a surveyor for the Residenz (Episcopal Palace) in

Würzburg after his return from a visit to Milan in 1720. The basic plan was already established and although Neumann greatly modified it, he was required to consult the leading architects of Paris and Vienna in 1723. The final result is a skillful blend of the latest German, French, and Italian ideas. The breathtaking Kaisersaal (fig. 22.22) is a great oval hall decorated in the favorite color scheme of the mid-eighteenth century: white, gold, and pastel shades. The structural importance of the columns, pilasters, and architraves has been minimized in favor of their decorative role. Windows and vault segments are framed by continuous, ribbonlike moldings, and the white surfaces are covered with irregular ornamental designs. These lacy, curling motifs, the hallmark of the French style (see fig. 22.11), are happily combined with German Rococo architecture. (The basic design recalls an early interior by Fischer von Erlach.)

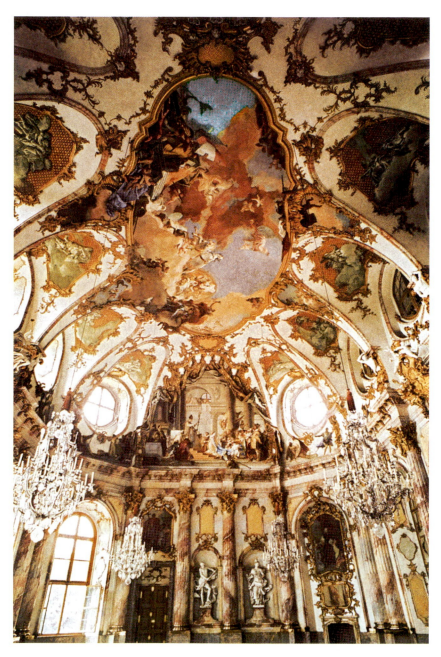

22.22. Balthasar Neumann. Kaisersaal Residenz, Würzburg, Germany. 1719–44. Frescoes by Giovanni Battista Tiepolo, 1751–1752

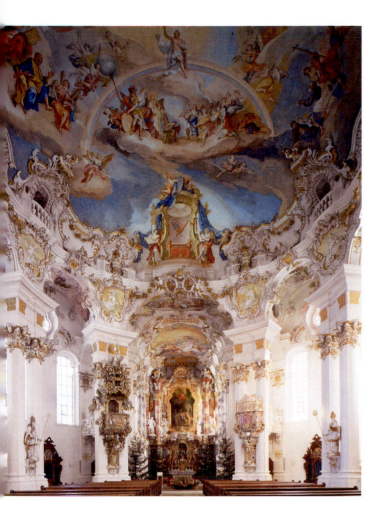

22.23. Dominikus Zimmermann. Interior of "Die Wies," Upper Bavaria, Germany. 1757

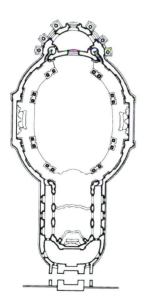

22.24. Plan of "Die Wies"

The abundant daylight, the play of curves and countercurves, and the weightless grace of the stucco sculpture give the Kaiser-saal an airy lightness far removed from the Roman Baroque. The vaults and walls seem thin and pliable, like membranes easily punctured by the expansive power of space.

Dominikus Zimmermann

Dominikus Zimmermann (1685–1766), a contemporary of Balthasar Neumann, created what may be the finest design of the mid-eighteenth century: the rural Bavarian pilgrimage church nicknamed "*Die Wies*" ("The Meadow"). The exterior is so plain that by comparison the interior seems overwhelming (figs. **22.23** and **22.24**). This interior richness reflects the fact that the architect and his brother, Johann Baptist Zimmermann (1680–1758), who was responsible for the frescoes, were initially trained as stucco workers. The interior design includes a combination of sculptural painted stucco decoration and painting. Like Fischer von Erlach's St. Charles Borromaeus, this church's basic shape is oval. Yet because the ceiling rests on paired, free-standing supports, the space is more fluid and complex, recalling a German Gothic Hallenkirche (hall church). Even the way the Rococo decor tends to break up the ceiling recalls the webbed vaults of the Gothic Heiligenkreuz in Schwäbisch-Gmünd (see fig. 12.52). Here Guarini's prophetic reevaluation of Gothic architecture has become reality.

ITALY

Just as the style of architecture invented in Italy achieved its climax north of the Alps, much Italian Rococo painting took place in other countries. The timidity of the Late Baroque style in Italy was transformed during the first decade of the eighteenth century by the rise of the Rococo in Venice, which had stagnated as an artistic backwater for one hundred years. The Italian Rococo is distinguished from the Baroque by a revived appreciation of Veronese's colorism and pageantry, but with an airy sensibility that is new. The Venetians, colorists skilled in Baroque illusionism, were active in every major center throughout Europe, especially in London, Dresden, and Madrid. They were not alone: Many artists from Rome and other parts of Italy also worked abroad.

Giovanni Battista Tiepolo and Illusionistic Ceiling Decoration

The last and most refined stage of Italian illusionistic ceiling decoration can be seen in the works of Giovanni Battista Tiepolo (1696–1770), who spent most of his life in Venice, where his works defined the Rococo style. Tiepolo spent two years in Germany, and in the last years of his life he worked for Charles III in Spain. His mastery of light and color, his grace and masterful touch, and his power of invention made him famous far beyond his home territory. When Tiepolo painted the Würzburg frescoes (figs. 22.22, **22.25**, and **22.26**), his powers were at their height. The tissuelike ceiling gives way so often to illusionistic openings, both painted and sculpted, that we no longer feel it to be a spatial boundary. Unlike Baroque ceilings (compare with figs. 19.11 and 19.12), these openings do not reveal avalanches of figures propelled by dramatic bursts of light. Rather, blue sky and sunlit clouds are dotted with an occasional winged creature soaring in the limitless expanse. Only along the edges of the ceiling do solid clusters of figures appear.

At one end, replacing a window, is *The Marriage of Frederick Barbarossa* (see figs. 22.22 and 22.26). As a public spectacle, it is as festive as *Feast in the House of Levi* by Veronese (see fig. 17.33). The artist has followed Veronese's example by putting the event, which took place in the twelfth century, in a contemporary setting. Its allegorical fantasy is "revealed" by the carved putti opening a gilt-stucco curtain onto the wedding ceremony in a display of theatrical illusionism worthy of Bernini. Unexpected in this festive procession is the element of classicism, which gives an air of noble restraint to the main figures, in keeping with the solemnity of the occasion.

Tiepolo later became the last in the long line of Italian artists who were invited to work at the Royal Palace in Madrid. There he encountered the German painter Anton Raphael Mengs, a champion of the Classical revival, whose presence signaled the end of the Rococo.

Canaletto

During the eighteenth century, landscape painting in Italy evolved into a new form in keeping with the character of the Rococo: These paintings were called **vedute** (meaning "view" paintings). The new form can be traced back to the seventeenth century, when many foreign artists, such as Claude Lorrain (see fig. 21.8), specialized in depicting the Roman countryside. After 1720, however, *vedute* took on a specifically urban identity, focusing more narrowly on buildings or cityscapes. The most famous of the vedutists was Canaletto (Giovanni Antonio Canal, 1697–1768) of Venice. His pictures found great favor with the British, particularly young men on the Grand Tour after their schooling, who brought them home as souvenirs. Canaletto later became one of several Venetian artists to spend long sojourns in London, where he created views of the city's new skyline dotted with the church towers of Wren

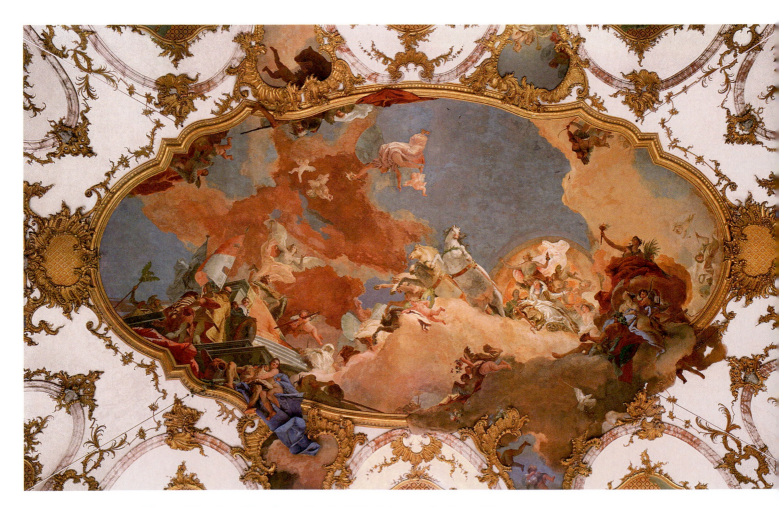

22.25. Giovanni Battista Tiepolo. Ceiling fresco (detail). 1751. Kaisersaal, Residenz, Würzburg

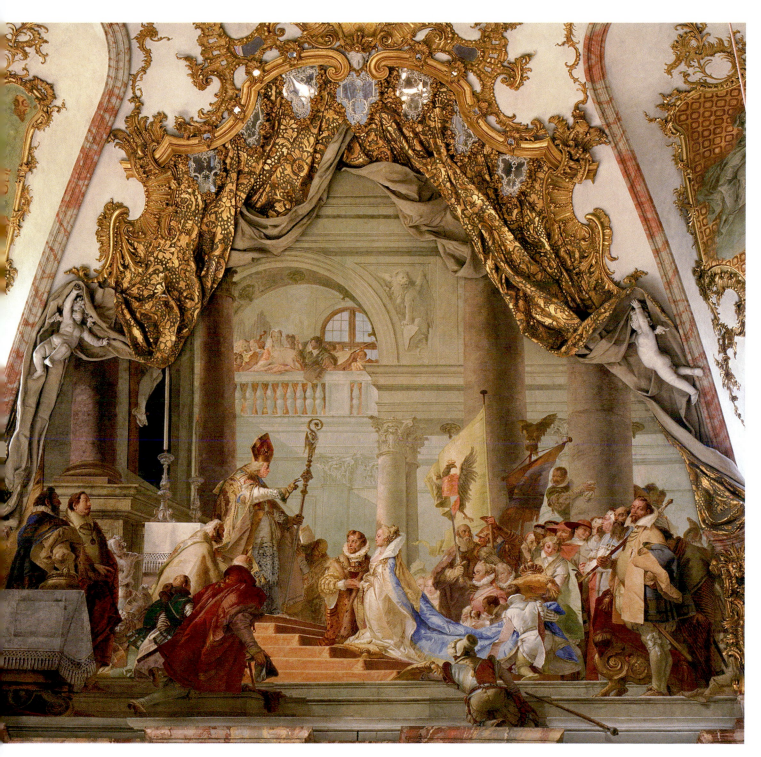

22.26. Giovanni Battista Tiepolo. *The Marriage of Frederick Barbarossa* (partial view). 1752. Fresco. Kaisersaal, Residenz, Würzburg

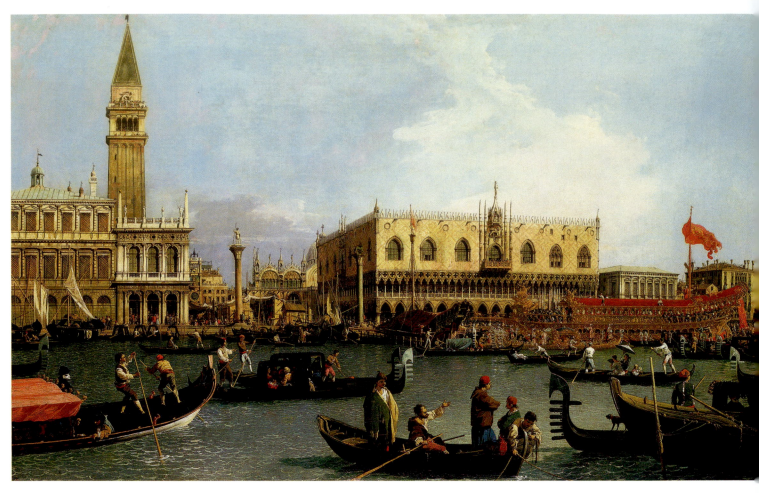

22.27. Canaletto. *The Bucintoro at the Molo.* ca. 1732. Oil on canvas, $30^{1}/_{4} \times 49^{1}/_{2}''$ (77×126 cm). The Royal Collection. © 2004 Her Majesty Queen Elizabeth II

(see pages 752–753). *The Bucintoro at the Molo* (fig. **22.27**) is one of a series of paintings of Venice commissioned by Joseph Smith, an English entrepreneur (later named British Consul to Venice) living there. Smith later issued the paintings as a suite of etchings to meet the demand for mementos of Venice from those who could not afford an original canvas by the artist. It shows a favorite subject: the Doge returning on his magnificent barge to the Piazza San Marco from the Lido (the city's island beach) on Ascension Day after celebrating the Marriage of the Sea. Canaletto has captured the pageantry of this great public celebration, which is presented as a brilliant theatrical display.

Canaletto's landscapes are, for the most part, topographically accurate. However, he was not above tampering with the truth. While he usually made only slight adjustments for the sake of the composition, he would sometimes treat scenes with considerable freedom or create composite views. He may have used a mechanical or optical device, perhaps a *camera obscura*, a forerunner of the photographic camera (see Vermeer, pages 728–729), to render some of his views. The liveliness and sparkle of his pictures, as well as his sure sense of composition, sprang in large part from his training as a scenographer. As in our example, Canaletto often included vignettes of daily life in Venice that lend a human interest to his scenes and make them fascinating cultural documents as well.

SUMMARY

France in the eighteenth century was defined by longstanding tradition. The monarchy continued its dominance, and the policies and practices of the *ancien régime* persisted through the reign of Louis XV and his influential mistress, Madame de Pompadour. French aristocracy regained its freedom and set about consolidating power during the long rule of Louis XV. Yet wealth was bestowed upon the privileged few, and the era was characterized by gaping disparities between rich and poor, aristocracy and peasantry.

The Rococo style emerged in the eighteenth century partially as a reaction to the large, dynamic, and dark or intensely colored works of the 1600s. Characterized by pastel colors, small scale, and delicately rendered figures and settings, Rococo art reflected the frivolity and extravagance enjoyed by the aristocracy. These wealthy classes indulged in the construction of elaborate hôtels (townhouses) in Paris and extensively patronized the arts to decorate their new homes. As the sites of salons and other gatherings of the intellectual and financial elites, hôtels boasted lavish interiors decorated in pastel color schemes and embellished with charming, intimate paintings and sculptures evoking the gaiety and lighthearted mood sought by aristocratic patrons. The charm and appeal of the Rococo style proved popular throughout Europe, and its lasting influence was felt in England and in central and western Europe as well.

FRANCE: THE RISE OF THE ROCOCO

To some extent, the rise of the Rococo in France parallels the ascending power of the aristocracy, its main patrons. Painter Jean-Antoine Watteau effectively captured the optimistic spirit of his clientele and elevated the Rococo to its esteemed status. He developed the painting type known as the *fête galante*, and his subtly gradated tones helped solidify the supremacy of the Rubénistes over the Poussinistes in the debate of color versus drawing. François Boucher and Jean-Honoré Fragonard continued this tradition in sensual, allegorical portraits and landscapes, while Élisabeth-Louise Vigée-Lebrun focused on portraying Marie Antoinette in the guise of an ordinary Frenchwoman, just as the queen wished. By contrast, the humble painting categories of still life and genre scenes were given renewed significance by Jean-Siméon Chardin, whose carefully observed scenes abound with quiet dignity as well as moral lessons, recalling Dutch and Flemish seventeenth-century traditions. Sculpture, too, embodied the Rococo propensity for intimacy and sensuality, seen especially in the work of Clodion. Yet it was in hôtel interiors that the Rococo style was displayed most elaborately, exerting an influence that swept Europe's aristocracy and *haute bourgeoisie*.

ENGLAND: PAINTING AND PRINTMAKING

English painters borrowed elements from the Rococo and formed a style uniquely their own. The British public was especially interested in collecting genre paintings and landscapes, and painters such as William Hogarth and Thomas Gainsborough responded to this ever-growing demand. Hogarth's satirical scenes of daily life—in fact thinly disguised moralizing narratives—often contained humorous details that added a sense of levity to the harsh social commentary embedded within them. Gainsborough concentrated on portraiture, often placing his figures in typically English landscapes with which his patrons and viewers identified. Joshua Reynolds also concerned himself with portraits, working in a refined, elegant style that soon became the height of fashion and was much sought after by his aristocratic English clientele.

GERMANY AND AUSTRIA AND THE ROCOCO IN CENTRAL EUROPE

The Rococo in Germany and Austria exhibited itself primarily in architecture. Architects developed a refined, scaled-down version of the curvilinear, "elastic" qualities of the Italian Baroque style already popular in Central Europe. The new Rococo style was preferred for the many churches, palaces, and other monuments erected after the Thirty Years' War. These structures are decorated with paintings and sculpture that are closely linked with their settings. In the church of St. Charles Borromaeus, architect Johann Fischer von Erlach incorporates aspects from the canon of Western architecture to produce an entirely new building type that projects the power of the Christian faith to transform the art of antiquity. The elaborate, elegant interiors of buildings such as Balthasar Neumann's Kaisersaal or Dominikus Zimmermann's "*Die Wies*" church embody the culmination of the Rococo in Central Europe.

ITALY

Many Italian artists worked abroad, and therefore much Italian Rococo painting was produced in other countries. Giovanni Battista Tiepolo, in particular, executed the illusionistic ceiling decorations of several German and Austrian churches and palaces. Venetian painter Canaletto painted *vedute*, or view paintings, of Venice which became particularly popular with young Englishmen who brought these works back to England as souvenirs of their Grand Tour.

Giovanni Boccaccio (1313–1375)

Decameron, from "The First Day"

The young people who tell the 100 stories of Boccaccio's Decameron *have fled Florence to escape the bubonic plague. At the beginning of the book, Boccaccio describes the horror of the disease and the immensity of the epidemic, as well as the social dissolution it produced.*

The years of the fruitful Incarnation of the Son of God had attained to the number of one thousand three hundred and forty-eight, when into the notable city of Florence, fair over every other of Italy, there came the death-dealing pestilence, through the operation of the heavenly bodies or of our own iniquitous doings, being sent down upon mankind for our correction by the just wrath of God. In men and women alike there appeared, at the beginning of the malady, certain swellings, either on the groin or under the armpits, whereof some waxed to the bigness of a common apple, others to the size of an egg, and these the vulgar named plague-boils. From these two parts the aforesaid death-bearing plague-boils proceeded, in brief space, to appear and come indifferently in every part of the body; wherefrom, after awhile, the fashion of the contagion began to change into black or livid blotches.

Well-nigh all died within the third day from the appearance of the aforesaid signs, this one sooner and that one later, and for the most part without fever or other complication. The mere touching of the clothes or of whatsoever other thing had been touched or used by the sick appeared of itself to communicate the malady to the toucher.

Well-nigh all tended to a very barbarous conclusion, namely, to shun and flee from the sick and all that pertained to them. Some there were who conceived that to live moderately and keep oneself from all excess was the best defense; they lived removed from every other, taking refuge and shutting themselves up in those houses where none were sick and where living was best. Others, inclining to the contrary opinion, maintained that to carouse and make merry and go about singing and frolicking and satisfy the appetite in everything possible and laugh and scoff at whatsoever befell was a very certain remedy for such an ill.

The common people (and also, in great part, the middle class) fell sick by the thousand daily and being altogether untended and unsuccored, died well-nigh all without recourse. Many breathed their last in the open street, by day and by night, while many others, though they died in their homes, made it known to the neighbors that they were dead rather by the stench of their rotting bodies than otherwise; and of these and others who died all about, the whole city was full. The consecrated ground not sufficing for the burial of the vast multitude of corpses there were made throughout the churchyards, vast trenches, in which those who came were laid by the hundred, being heaped up therein by layers, as goods are stowed aboard ship.

So great was the cruelty of heaven that, between March and the following July, it is believed for certain that upward of a hundred thousand human beings perished within the walls of the city of Florence. Alas, how many great palaces, how many goodly houses, how many noble mansions, once full of families, of lords and of ladies, remained empty even to the meanest servant! How many memorable families, how many ample heritages, how many famous fortunes were seen to remain without lawful heir! How many valiant men, how many fair ladies, how many sprightly youths, breakfasted in the morning with their kinsfolk, comrades and friends and that same night supped with their ancestors in the other world!

SOURCE: *GIOVANNI BOCCACCIO, DECAMERON.* TR. JOHN PAYNE, REV. CHARLES S. SINGLETON. (BERKLEY, CA: UNIVERSITY OF CALIFORNIA PRESS, 1984)

Petrarch (1304–1374)

Sonnet from the *Rime Sparse*, n. 77 (Translation by A. S. Kline)

The humanist Petrarch encountered the unattainable Laura in Avignon, and immortalized his love for her in many sonnets. This poem, number 77 from his Rime Sparse *(Scattered Rhymes), describes his reaction to a portrait of Laura painted by his friend, the Sienese painter Simone Martini. The portrait itself does not survive, but Petrarch's words make a comparison between the fourteenth-century painter and the famous Greek Sculptor, Polyclitus. Such learned references to the ancients in service of human emotion parallels the innovations of visual artists who explored the emotional content of religious narratives.*

Polyclitus gazing fixedly a thousand years
with the others who were famous in his art,
would not have seen the least part
of the beauty that has vanquished my heart.

But Simone must have been in Paradise
(from where this gentle lady came)
saw her there, and portrayed her in paint,
to give us proof here of such loveliness.

This work is truly one of those that might
be conceived in heaven, not among us here,
where we have bodies that conceal the soul.

Grace made it: he could work on it no further
when he'd descended to our heat and cold,
where his eyes had only mortal seeing.

SOURCE: *PETRARCH: THE CANZONIERE,* SONNET 77. TR. A.S. KLINE. HTTP://WWW.TONYKLINE.CO.UK)

Dante Alighieri (1265–1321)

The Divine Comedy: Purgatory, from Canto X

In the first circle of Purgatory are those guilty of the sin of pride. Dante meets a famous manuscript illuminator who has learned the vanity of pride and the fleeting nature of fame, illustrated by the rapidity with which Giotto eclipsed Cimabue.

"Oh!" I said, "*you* must be that Oderisi,
honor of Gubbio, honor of the art
which men in Paris call 'Illuminating.'"

"The pages Franco Bolognese paints,"
he said, "my brother, smile more radiantly;
his is the honor now—mine is far less.

Less courteous would I have been to him,
I must admit, while I was still alive
and my desire was only to excel.

For pride like that the price is paid up here;
I would not even be here, were it not
that, while I still could sin, I turned to God.

Oh, empty glory of all human power!
How soon the green fades from the topmost bough,
unless the following season shows no growth!

Once Cimabue thought to hold the field
as painter; Giotto now is all the rage,
dimming the lustre of the other's fame."

SOURCE: DANTE ALIGHIERI'S, *DIVINE COMEDY*. TR. MARK MUSA. (BLOOMINGTON, IN: INDIANA UNIVERSITY PRESS, 1986)

Karel Van Mander (1548–1606)

From *The Painter's Treatise*

Van Mander's biographies of distinguished Dutch and Flemish painters, published in 1604, are a counterpart to the lives of Italian artists by Giorgio Vasari, which first appeared in 1550. Van Mander, a painter himself, begins his biographies with Jan van Eyck because he was considered the inventor of oil painting and consequently the originator, with his brother Hubert, of the Netherlandish tradition of painting.

It is supposed that the art of painting with a glue and egg medium [tempera painting] was imported into the Netherlands from Italy, because, as we have noted in the biography of Giovanni of Cimabue, this method was first used in Florence, in 1250. . . .

According to the people of Bruges, Joannes [Jan] was a learned man, clever and inventive, who studied many subjects related to painting: He examined many kinds of pigment; he studied alchemy and distillation. At length, he worked out a method of varnishing his egg and glue paintings with oil, so that these shining and lustrous pictures exceedingly delighted all who saw them. . . .

Joannes had painted a panel on which he had spent much time. . . . He varnished the finished panel according to his new invention and placed it in the sunlight to dry. . . . The panel burst at the joints and fell apart. Joannes . . . took a resolve that the sun should not damage his work ever again.

Accordingly, . . . he set himself to discover or invent some kind of varnish which would dry within the house, away from the sunlight. He had already examined many oils and other similar materials supplied by nature, and had found that linseed oil and nut oil had the best drying ability of them all. . . .

Joannes found, after many experiments, that colors mixed with these oils could be handled easily, that they dried well, became hard,

and, once dry, could resist water. The oil made the color appear more alive, owing to a lustre of its own, without varnish. And what surprised and pleased him most was that paint made with oil could be applied more easily and mixed more thoroughly than paint made with egg and glue. . . .

Joannes . . . had created a new type of painting, to the amazement of the world. . . . This noble discovery, of painting with oil, was the only thing the art of painting still needed to achieve naturalistic rendition.

If the ancient Greeks, Apelles and Zeus [Zeuxis] had come to life again in this country and had seen this new method of painting, they would not have been any less surprised than if war-like Achilles [had] witnessed the thunder of cannon fire. . . .

The most striking work which the Van Eyck brothers did together is the altar-piece in the church of St John, in Ghent. . . .

The central panel of the altar-piece represents a scene from the Revelation of St John, in which the elders worship the Lamb. . . . In the upper part, Mary is represented; she is being crowned by the Father and the Son. . . .

Next to the figure of Mary are little angels singing from sheets of music. They are painted so exquisitely and so well that one can detect readily, from their facial expressions, who is singing the higher part, the high counter part, the tenor part, and the bass. . . .

Adam and Eve are represented. One may observe that Adam has a certain fear of breaking the command of the Lord, for he has a worried expression. . . .

The altar painting of the Van Eyck brothers was shown only to a few personages of high standing or to someone who would reward the keeper very well. Sometimes it was shown on important holidays, but then there was usually such a crowd that it was difficult to come near it. Then the chapel containing the altar-piece would be filled with all kinds of people—painters young and old, every kind of art lover, swarming like bees and flies around a basket of figs or raisins. . . .

Some Florentine merchants sent a splendid painting, made in Flanders, by Joannes to King Alphonso I of Naples. . . . A huge throng of artists came to see this marvelous painting, when it reached Italy. But although the Italians examined the picture very carefully, touching it, smelling at it, scenting the strong odor produced by the mixture of the colors with oil, and drawing all kinds of conclusions, the secret held until Antonello of Messina, in Sicily, went to Bruges to learn the process of oil-painting. Having mastered the technique, he introduced the art into Italy, as I have described in his biography. . . .

Joannes had once painted in oil two portraits in a single scene, a man and a woman, who give the right hand to each other, as if they had been united in wedlock by *Fides*. This little picture came through inheritance into the hands of a barber in Bruges. Mary, aunt of King Philip of Spain and widow of King Louis of Hungary, . . . happened to see this painting. The art loving princess was so pleased with this picture that she gave a certain office to the barber which brought him a yearly income of a hundred guilders.

SOURCE: KARE VAN MANDER, *DUTCH AND FLEMISH PAINTERS*. TR. CONSTANT VAN DE WALL. (MANCHESTER, NH: AYER CO. PUBLISHERS, 1978)

Giorgio Vasari (1511–1574)

From *The Lives of the Most Excellent Italian Architects, Painters, and Sculptors from Cimabue to Our Times*

Vasari was inspired to write The Lives *by his patron, Cardinal Alessandro Farnese. The book, first published in 1550 and expanded in 1568, was based on interviews conducted throughout Italy. Vasari personally knew many of the artists about whom he wrote, including Michelangelo, whom he idolized at the expense of others, most notably Raphael. Although art historians have spent entire careers disproving details of Vasari's narrative, they remain the starting point for the study of Italian Renaissance art.*

This marvellous and divinely inspired Leonardo ... would have been proficient at his early lessons if he had not been so volatile and unstable; for he was always setting himself to learn many things only to abandon them almost immediately. ... Clearly, it was because of his profound knowledge of painting that Leonardo started so many things without finishing them; for he was convinced that his hands, for all their skill, could never perfectly express the subtle and wonderful ideas of his imagination. ...

For Francesco del Giocondo, Leonardo undertook to execute the portrait of his wife, Mona Lisa. He worked on this painting for four years, and then left it still unfinished. ... If one wanted to see how faithfully art can imitate nature, one could readily perceive it from this head; for here Leonardo subtly reproduced every living detail. ... Leonardo also made use of this device: while he was painting Mona Lisa, who was a very beautiful woman, he employed singers and musicians or jesters to keep her full of merriment and so chase away the melancholy that painters usually give to portraits. As a result, in this painting of Leonardo's there was a smile so pleasing that it seemed divine rather than human; and those who saw it were amazed to find that it was as alive as the original.

... Raphael Sanzio of Urbino, an artist as talented as he was gracious, ... was endowed by nature with the goodness and modesty to be found in all those exceptional men whose gentle humanity is enhanced by an affable and pleasing manner, expressing itself in courteous behaviour at all times and towards all persons. ... Raphael [had] the finest qualities of mind accompanied by such grace, industry, looks, modesty, and excellence of character as would offset every defect, no matter how serious, and any vice, no matter how ugly. ...

At the time when Raphael determined to change and improve his style he had never studied the nude as intensely as it requires, for he had only copied it from life, employing the methods he had seen used by Perugino, although he gave his figures a grace that he understood instinctively. ... Nonetheless, Raphael realized that in this manner he could never rival the accomplishments of Michelangelo, and ... being unable to compete with Michelangelo in the branch of painting to which he had set his hand, resolved to emulate and perhaps surpass him in other respects. So he decided not to waste his time by imitating Michelangelo's style but to attain a catholic excellence in the other fields of painting. ...

When Michelangelo had finished the statue [of Pope Julius II, later destroyed], Bramante, the friend and relation of Raphael and therefore ill-disposed to Michelangelo, seeing the Pope's preference for

sculpture, schemed to divert his attention, and told the Pope that it would be a bad omen to get Michelangelo to go on with his tomb, as it would seem to be an invitation to death. He persuaded the Pope to get Michelangelo, on his return, to paint the vaulting of the Sistine Chapel. In this way Bramante and his other rivals hoped to confound him, for by taking him from sculpture, in which he was perfect, and putting him to colouring in fresco, in which he had had no experience, they thought he would produce less admirable work than Raphael. ... Thus, when Michelangelo returned to Rome, the Pope was disposed not to have the tomb finished for the time being, and asked him to paint the vaulting of the chapel. Michelangelo tried every means to avoid it, and recommended Raphael. ... At length, seeing that the Pope was resolute, [he] decided to do it. ... Michelangelo then made arrangements to do the whole work singlehanded. ... When he had finished half, the Pope ... daily became more convinced of Michelangelo's genius, and wished him to complete the work, judging that he would do the other half even better. Thus, singlehanded, he completed the work in twenty months, aided only by his mixer of colours. He sometimes complained that owing to the impatience of the Pope he had not been able to finish it as he would have desired, as the Pope was always asking him when he would be done. On one occasion Michelangelo replied that he would be finished when he had satisfied his own artistic sense. "And we require you to satisfy us in getting it done quickly," replied the Pope, adding that if it was not done soon he would have the scaffolding down. ... Michelangelo wanted to retouch some parts of the painting *a secco*, as the old masters had done on the scenes below ... in order to heighten the visual impact. The Pope, learning that this ornamentation was lacking ... wanted him to go ahead. However, he lacked the patience to rebuild the scaffolding, and so the ceiling stayed as it was. ...

Giovanni Bellini and other painters of [Venice], through not having studied antiquities, employed a hard, dry and laboured style, which Titian acquired. But in 1507 arose Giorgione, who began to give his works more tone and relief, with better style, though he imitated natural things as best he could, colouring them like life, without making drawings previously, believing this to be the true method of procedure. He did not perceive that for good composition it is necessary to try several various methods on sheets, for invention is quickened by showing these things to the eye, while it is also necessary to a thorough knowledge of the nude. ...

On seeing Giorgione's style Titian abandoned that of Bellini, although he had long practised it, and imitated Giorgione so well that in a short time his works were taken for Giorgione's. ... Titian's methods in these paintings differ widely from those he adopted in his youth. His first works are executed with a certain fineness and diligence, so that they may be examined closely, but these are done roughly in an impressionist manner, with bold strokes and blobs, to obtain the effect at a distance. This is why many in trying to imitate him have made clumsy pictures, for if people think that such work can be done without labour they are deceived, as it is necessary to retouch and recolour them incessantly, so that the labour is evident. The method is admirable and beautiful if done judiciously, making paintings appear alive and achieved without labour.

SOURCE: GIORGIO VASARI, *THE LIVES OF PAINTERS, SCULPTORS, AND ARCHITECTS*. EVERYMAN'S LIBRARY EDITION, ED. WILLIAM GAUNT (1963 EDITION, FIRST PUBLISHED 1927)

From the Canon and Decrees of the Council of Trent, 1563

The Catholic Church responded to the growth in Northern Europe of independent "Reformed" churches (inaugurated by Martin Luther's 1517 critique of the Church) by attempting to stop the Reformation and win back the territories and peoples lost to the Roman Church. These various measures of the sixteenth and early seventeenth centuries are collectively called the Catholic Reformation. One agency of this development was the Council of Trent, a series of three meetings of church leaders in 1545–1547, 1551–1552, and 1562–1563. The following is from one of the council's last edicts, dated December 3–4, 1563, a response to ongoing Protestant attacks against religious images.

The holy council commands all bishops and others who hold the office of teaching and have charge of the *cura animarum*, [care of souls] that in accordance with the usage of the Catholic and Apostolic Church, received from the primitive times of the Christian religion, and with the unanimous teaching of the holy Fathers and the decrees of sacred councils, they above all instruct the faithful diligently in matters relating to intercession and invocation of the saints, the veneration of relics, and the legitimate use of images. Moreover, that the images of Christ, of the Virgin Mother of God, and of the other saints are to be placed and retained especially in the churches, and that due honor and veneration is to be given them; not, however, that any divinity or virtue is believed to be in them by reason of which they are to be venerated, or that something is to be asked of them, or that trust is to be placed in images, as was done of old by the Gentiles who placed their hope in idols; but because the honor which is shown them is referred to the prototypes which they represent, so that by means of the images which we kiss and before which we uncover the head and prostrate ourselves, we adore Christ and venerate the saints whose likeness they bear. That is what was defined by the decrees of the councils, especially of the Second Council of Nicaea, against the opponents of images.

Moreover, let the bishops diligently teach that by means of the stories of the mysteries of our redemption portrayed in paintings and other representations the people are instructed and confirmed in the articles of faith, which ought to be borne in mind and constantly reflected upon; also that great profit is derived from all holy images, not only because the people are thereby reminded of the benefits and gifts bestowed on them by Christ, but also because through the saints the miracles of God and salutary examples are set before the eyes of the faithful, so that they may give God thanks for those things, may fashion their own life and conduct in imitation of the saints and be moved to adore and love God and cultivate piety. But if anyone should teach or maintain anything contrary to these decrees, let him be anathema.

If any abuses shall have found their way into these holy and salutary observances, the holy council desires earnestly that they be completely removed, so that no representation of false doctrines and such as might be the occasion of grave error to the uneducated be exhibited. Finally, such zeal and care should be exhibited by the bishops with regard to these things that nothing may appear that is disorderly or unbecoming and confusedly arranged, nothing that is profane, nothing disrespectful, since holiness becometh the house of God.

SOURCE: *CANONS AND DECREES OF THE COUNCIL OF TRENT.* TR. H.I. SHROEDER. (ROCKFORD, IL TAN BOOKS AND PUBLISHERS, 1978)

Martin Luther (1483–1546)

From *Against the Heavenly Prophets in the Matter of Images and Sacraments, 1525*

Luther inaugurated the Protestant Reformation movement in 1517 with a public critique of certain Church practices, including the sale of indulgences. His actions soon inspired a number of similar reformers in Northern Europe, some of whom were more extreme in their denunciations of the conventional artistic and musical trappings of the Church. The ideas of one of these, Andreas Bodenstein von Karlstadt, inspired this writing of 1525.

I approached the task of destroying images by first tearing them out of the heart through God's Word and making them worthless and despised. . . . For when they are no longer in the heart, they can do no harm when seen with the eyes. But Dr. Karlstadt, who pays no attention to matters of the heart, has reversed the order by removing them from sight and leaving them in the heart. . . .

I have allowed and not forbidden the outward removal of images, so long as this takes place without rioting and uproar and is done by the proper authorities. . . . And I say at the outset that according to the law of Moses no other images are forbidden than an image of God which one worships. A crucifix, on the other hand, or any other holy image is not forbidden. Heigh now! you breakers of images, I defy you to prove the opposite! . . .

Thus we read that Moses' Brazen Serpent remained (Num. 21:8) until Hezekiah destroyed it solely because it had been worshiped (II Kings 18:4). . . .

However, to speak evangelically of images, I say and declare that no one is obligated to break violently images even of God, but everything is free, and one does not sin if he does not break them with violence. . . .

Nor would I condemn those who have destroyed them, especially those who destroy divine and idolatrous images. But images for memorial and witness, such as crucifixes and images of saints, are to be tolerated. This is shown above to be the case even in the Mosaic law. And they are not only to be tolerated, but for the sake of the memorial and the witness they are praiseworthy and honorable, as the witness stones of Joshua (Josh. 24:26) and of Samuel (I Sam. 7:12).

SOURCE: *LUTHER'S WORKS,.* VOL. 40. TR. BERNHARD ERLING, ED. CONRAD BERGENDORFF. (MINNEAPOLIS, MN: AUGSBURG FORTRESS PUBLISHERS, 1958)

Giovanni Pietro Bellori (1613–1696)

From *Lives of the Modern Painters, Sculptors, and Architects: On Caravaggio*

Bellori's account was published in Rome in 1672, and it provides biographical information and criticism of seventeenth-century (mostly Italian) artists. His writing on Caravaggio's painting "from nature" is significant for understanding seventeenth-century views and for recognizing the sharp criticism of his work and his methods.

He [Caravaggio] recognized no other master than the model and did not select the best forms of nature but emulated art—astonishingly enough—without art . . .

Now he began to paint according to his own genius. He not only ignored the most excellent marbles of the ancients and the famous paintings of Raphael, but he despised them, and nature alone became the object of his brush. . . . Caravaggio . . . was making himself more and more notable for the color scheme which he was introducing, not soft and sparingly tinted as before, but reinforced throughout with bold shadows and a great deal of black to give relief to the forms. He went so far in this manner of working that he never brought his figures out into the daylight, but placed them in the dark brown atmosphere of a closed room, using a high light that descended vertically over the principal parts of the bodies while leaving the remainder in shadow in order to give force through a strong contrast of light and dark. The painters then in Rome were greatly impressed by his novelty and the younger ones especially gathered around him and praised him as the only true imitator of nature. Looking upon his works as miracles, they outdid each other in following his method . . . , undressing their models and placing their lights high; without paying attention to study and teachings, each found easily in the piazza or in the street his teacher or his model for copying nature. This facile manner attracted many, and only the old painters who were accustomed to the old ways were shocked at the new concern for nature, and they did not cease to decry Caravaggio and his manner. They spread it about that he did not know how to come out of the cellar and that, poor in invention and design, lacking in decorum and art, he painted all his figures in one light and on one plane without gradations. These accusations, however, did not retard the growth of his fame. . . .

He never introduced clear blue atmosphere into his pictures; on the contrary he always used black for the ground and depths and also for the flesh tones, limiting the force of the light to a few places. Moreover, he followed his model so slavishly that he did not take credit for even one brush stroke, but said it was the work of nature. He repudiated every other precept and considered it the highest achievement in art not to be bound to the rules of art. Because of these innovations he received so much acclaim that some artists of great talent and instructed in the best schools were impelled to follow him. With all this, many of the best elements of art were not in him; he possessed neither invention, nor decorum, nor design, nor any knowledge of the science of painting.

SOURCE: *ITALIAN & SPANISH ART, 1600–1750: SOURCES AND DOCUMENTS.* ED. R. ENGGASS AND J. BROWN. (EVANSTON, IL: NORTHERN UNIVERSITY PRESS, 1999)

Filippo Baldinucci (1625–1697)

From the *Life of Cavalier Gianlorenzo Bernini*

An artist, scholar, and consultant to the Medicis, Baldinucci published his laudatory biography of Bernini in 1682, shortly after the artist's death. Commissioned by Queen Christina of Sweden, it is still the main source of information on the artist.

The opinion is widespread that Bernini was the first to attempt to unite architecture with sculpture and painting in such a manner that together they make a beautiful whole. This he accomplished by removing all repugnant uniformity of poses, breaking up the poses sometimes without violating good rules, although he did not bind himself to the rules. His usual words on this subject were that those who do not sometimes go outside the rules never go beyond them. He thought, however, that those who were not skilled in both painting and sculpture should not put themselves to that test but should remain rooted in the good precepts of art. He knew from the beginning that his strong point was sculpture. . . .

Before Bernini's and our own day there was perhaps never anyone who manipulated marble with more facility and boldness. He gave his works a marvelous softness from which many great men who worked in Rome during his time learned. Although some censured the drapery of his figures as too complex and sharp, he felt this, on the contrary, to be a special indication of his skill. Through it he demonstrated that he had overcome the great difficulty of making the marble, so to say, flexible and of finding a way to combine painting and sculpture, something that had not been done by other artists.

It is not easy to describe the love Bernini brought to his work. He said that, when he began work, it was for him like entering a pleasure garden.

SOURCE: *ITALIAN & SPANISH ART, 1600–1750: SOURCES AND DOCUMENTS.* ED. R. ENGGASS AND J. BROWN. (EVANSTON, IL: NORTHERN UNIVERSITY PRESS, 1999)

Constantijn Huygens (1596–1687)

From his *Autobiography*

Contantijn Huygens (1596–1687), diplomat from The Netherlands to Venice and London, was secretary and advisor to the Stadhoulder Frederick Henry of Orange (r. 1625–1647), and then to William II of Orange (r. 1647–1650). He acted as intermediary for Rembrandt for his Passion Series, and was a promoter of Rembrandt's work. This selection from his Autobiography praises both Rembrandt the man and the emotional content of Rembrandt's work and compares him to a contemporary, Jan Lievens (1607–1674); he exhorts them both to keep a record of their works and to travel to Italy.

The first, who I described as an embroiderer's son, is called Jan Lievens; the other, whose cradle stood in a mill, Rembrandt. Both are still beardless and, going by their faces, more boys than men. I am neither able nor willing to judge each according to his works and application. As in the case of the aforementioned Rubens, I wish these two would draw up an inventory of their works and describe their paintings. Each could supply a modest explanation of his method, going on to indicate how and why (for the admiration and education of all future generations) they had designed, composed and worked out each painting.

I venture to suggest offhand that Rembrandt is superior to Lievens in his sure touch and liveliness of emotions. . . . Rembrandt . . .

devotes all his loving concentration to a small painting, achieving on that modest scale a result which one would seek in vain in the largest pieces of others. I cite as an example his painting of the repentant Judas returning to the high priest the silver coins which were the price for our innocent Lord. Compare this with all Italy, indeed, with all the wondrous beauties that have survived from the most ancient of days. The gesture of that one despairing Judas (not to mention all the other impressive figures in the painting), that one maddened Judas, screaming, begging for forgiveness, but devoid of hope, all traces of hope erased from his face; his gaze wild, his hair torn out by the roots, his hands clenched until they bleed; a blind impulse has brought him to his knees, his whole body writing in pitiful hideousness. All this I compare with all the beauty that has been produced throughout the ages . . . [to see] that a youth, a Dutchman, a beardless miller, could put so much into one human figure and depict it all. Even as I write these words I am struck with amazement. All honour to thee, Rembrandt! To transport Troy, indeed all Asia, to Italy is a lesser achievement than to heap the laurels of Greece and Italy on the Dutch, the achievement of a Dutchman who has never ventured outside the walls of his native city. . . . I do however censure one fault of these celebrated young men, from whom I can scarcely tear myself away in this account. I have already criticized Lievens for his self-confidence, which Rembrandt shares; hitherto, neither has found it necessary to spend a few months travelling through Italy. This is naturally a touch of folly in figures otherwise so brilliant. If only someone could drive it out of their young heads, he would truly contribute the sole element still needed to perfect their artistic powers. How I would welcome their acquaintance with Raphael and Michelangelo, the feasting of their eyes on the creations of such gigantic spirits! How quickly they would surpass them all, giving the Italians due cause to come to Holland. If only these men, born to raise art to the highest pinnacle, know themselves better!

SOURCE: ERNST VAN DE WETERING AND BERNHARD SCHNACKENBURG AND OTHERS. *THE MISTERY OF YOUNG REMBRANDT*. (WOLFRATSHAUSEN: EDITION MINERVA, 2001)

Sir Christopher Wren (1632–1723)

Report on Old St. Paul's after the Fire
(between September 5, 1666 and February 26, 1667)

Christopher Wren had already delivered a report on Old St. Paul's and its condition before the Great Fire of London, but his report now will justify the authorization by the king to rebuild this church. The Fire, which left a "pile of Pauls," also decimated the heart of London.

Advise to the Reverend the Deane & Chapter of St. Pauls concerning the ruines of that Cathedrall.

What time & weather had left intire in the old, & art in the new repaired parts of this great pile of Pauls, the late Calamity of fire hath soe weakened & defaced, that it now appears like some antique ruine of 2,000 years standing, & to repair it sufficiently will be like the mending of the Argo navis [the ship of the Argonauts], scarce any thing will at last be left of the old.

The first decayes of it were great, from severall causes first from the originall building it selfe, for it was not well shaped & designed for the firme bearing of its one vault how massie soever the walls seemed to be (as I formerly shewed in another paper) nor were the materialls good, for it seemed to have been built out of the stone of some other auncient ruines . . . A second reason of the decayes, which appeared before the last fire, was in probability the former fire which consumed the whole roofe in the raine of Queen Elizabeth. The fall of timber then upon the vault was certainly one maine cause of the crackes which appeared in the vault & of the spreading out of the walls above 10 inches in some places from their new perpendicular as it now appeares more manifestly. . .

. . .Having shewn in part the deplorable condition of our patient wee are to consult of the Cure if possibly art may effect it, & herein wee must imitate the Physician who when he finds a totall decay of Nature bends his skill to a palliation, to give respite for a better settlement of the estate of the patient. The Question is then where bes[t] to begin the kind of practice, that is to make a Quire for present use.

SOURCE: LYDIA M. SOO, *WREN'S "TRACTS" ON ARCHITECTURE AND OTHER WRITINGS*. (NEW YORK: CAMBRIDGE UNIVERSITY PRESS, 1997)

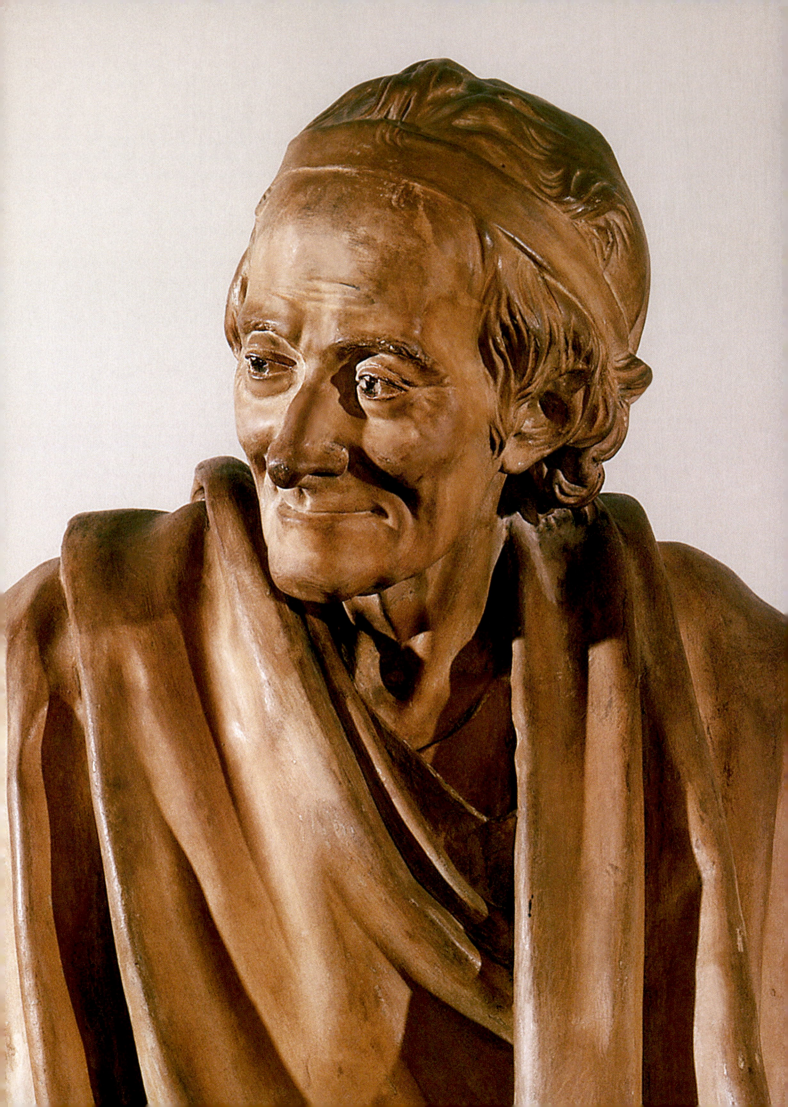

Art in the Age of the Enlightenment, 1750–1789

A most remarkable change in our ideas is taking place, one of such rapidity that it seems to promise a greater change still to come. It will be for the future to decide the aim, the nature and the limits of this revolution, the drawbacks and disadvantages of which posterity will be able to judge better than we can.

—Jean d'Alembert

WHEN THE FRENCH PHILOSOPHER AND SCIENTIST JEAN d'Alembert made this prophetic statement in 1759, the Western world was indeed embarking on a revolution, one that is still unfolding today. This revolution ushered in a radically new way of viewing the world, one that would lead to the social, scientific, economic, and political values that govern our present lives. Little did d'Alembert realize that he was witnessing the birth of the modern world.

This new world was heralded by twin revolutions: the Industrial Revolution, which began first in England in the middle of the eighteenth century and gradually spread worldwide in the nineteenth century, and the political revolutions of the United States and France in 1776 and 1789, respectively. Democracy, personal liberty, capitalism, socialism, industrialization, technological innovation, urbanization, and the "doctrine of progress," that is, a continuous upward march toward an improved life through science and knowledge, are just some of the many modern concepts that emerged from this period.

The force behind this transformation was the *Enlightenment*, a term that refers to the modern philosophy that emerged largely in England, France, Germany, and the United States in the eighteenth century (see map **23.1**). The foundation for this new thought lay in late seventeenth-century England with the philosopher John Locke (1632–1704) and the physicist and mathematician Isaac Newton (1642–1727), perhaps the two most influential thinkers of their age. Both stressed *empiricism* as the

basis for philosophy and science, and they advocated rational thought. For Newton, empiricism meant proceeding from data and observation—not superstition, mysticism, religion, hearsay, or whimsy—and applying this information in a logical fashion. For Locke, empiricism established experience as the only basis for formulating ideas. No longer could ideas be considered innate or ordained by God. Locke upset the applecart of original sin when he declared that all humans are born good and have a natural right to life, liberty, and property. He defined the function of government as the obligation to protect these natural rights; failure to do so granted citizens the license to remove their government, even if that required revolution.

What began as a trickle of influence evolved into a torrent as the basic premises behind the innovative ideas of Locke and Newton produced an explosion of treatises and theories throughout the eighteenth century. Leading this philosophical charge were the *philosophes*, as the French philosophers are commonly referred to. Among the best known are Voltaire (the assumed name of François-Marie Arouet, 1694–1778), Jean-Jacques Rousseau (1712–1778), and Denis Diderot (1713–1784), who along with d'Alembert, edited the 52-volume *Encyclopédie*, the world's first encyclopedia, which in its attempt to document the world and knowledge epitomizes Enlightenment empiricism.

Detail of figure 23.27, Jean-Antoine Houdon, *Voltaire Seated*

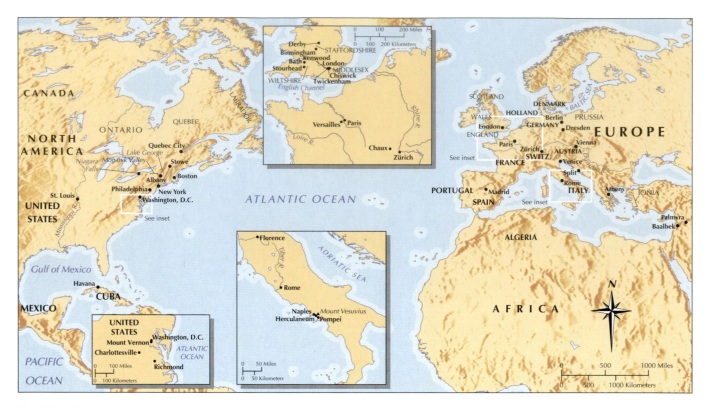

Map 23.1. Europe and America in the Age of Enlightenment

In addition to establishing basic human rights, logic, and a new moral order, Enlightenment thought also ushered in modern science. Electricity and oxygen were discovered, for example, and chemistry and natural science as we know it today were established. Science helped launch the Industrial Revolution. By midcentury the first mills were churning out yards of fabric at an unimaginable rate in the Midlands of England, and the notion of labor was redefined as the first factory workers, employed at subsistence wages, were tethered to clattering looms in enormous spaces filled with a deafening noise. Miners excavated coal and ore to produce iron, permitting construction of the first metal bridge. Perfection of the steam engine by Scottish engineer James Watt from 1765 to 1782 aided the mining and textile industries and enabled Robert Fulton, in 1807, to send a steamboat chugging up the Hudson River against the swift current and public incredulity, arriving in Albany from Manhattan in unimaginably quick time.

The second half of the eighteenth century was a period of transition as the world moved from the old to the modern. Art reflects this transformation, for it is often changing and complex, with several almost contradictory attitudes existing in a single work. The dominant style associated with the period is *Neoclassicism*, meaning the "New Classicism," which often illustrated what were considered the virtuous actions and deeds of the ancient Greeks and Romans. As we shall see, however, not all works labeled Neoclassical are set in historical antiquity; they may be contemporary genre scenes or contemporary major events that have the look or feel of Classical antiquity and that embrace similar moral values.

Neoclassicism embraced the logic and morality of the Enlightenment, which were perhaps best expressed by Voltaire. In his plays, poems, novels, and tracts, Voltaire used logic to attack what he called "persecuting and privileged orthodoxy," mainly meaning church and state, but any illogical institution or concept was fair game for his satire. He believed science could advance civilization and that logic presumed a government that benefited the people, not just the aristocracy. It is from Voltaire that we get the "doctrine of progress." The models for Voltaire's new civilization were the republics of ancient Greece and Rome, which in addition to being the first democracies provided the first rationalist philosophers. Neoclassicism took its vocabulary from ancient art, as well as from the classically inspired Renaissance and the great seventeenth-century French painter Nicolas Poussin (see pages 737–740).

Simultaneously, a second and seemingly antithetical thread appears in art: *Romanticism*. As we shall see in the next chapter, Romanticism comes of age about 1800, when the term itself is invented in order to describe the sweeping change in worldview then occurring. Instead of Neoclassicism's logic and its desire to control the forces of nature through science, Romanticism values emotion and intuition and believes in the supremacy of raw, unrestricted Nature. Jean-Jacques Rousseau is the principal proponent of this view, which he articulated in his *Discourse on the Arts and Sciences* (1750). Here he advocated a return to nature, arguing that humans are born good, not in sin, and that they use their innate sense or instincts to distinguish between good and bad, that is between what makes them happy and sad. Feeling determines their choices, not rational thought, which one uses to

explain choices, not to make them. Society, he believed, through its mores, values, and conventions, eventually imposes its own rationalized standards on humans, distracting them from their first true and natural instincts. Rousseau praised what he called the sincere "noble savage," steeped in nature, and he denounced contemporary civilization for its pretensions, artificiality, and, in general, those social restraints that prevent us from tapping into the power of our basic emotions.

The rational and the emotional survived side by side in art, and sometimes elements of each appeared within the same work, though usually not in equal proportions. Proponents of both attitudes aggressively rejected Rococo art (see Chapter 22), which they perceived as licentious, frivolous, even immoral, and which was generally associated with aristocracy and privilege, the twin evils condemned by the Enlightenment. While there was a call for a new art, one based on Classical values, no one was sure what it should look like. Not until the 1780s, with the paintings of Jacques-Louis David, did the Neoclassical style reach full flower. In the meantime, Neoclassicism would appear in many guises, sometimes even containing elements of Rococo elegance, a reminder that the Rococo still survived. Simultaneously, the Romantic fascination with strong emotions, with the irrational and unexplainable, and with the powerful forces of Nature was developing, which ironically would overshadow Neoclassicism by the 1790s, the decade following David's rise and the French Revolution of 1789. While England and France dominate art in the second half of the century and are the focus of our discussion, Neoclassicism, like the Enlightenment, was an international movement, well represented in Scandinavia, Austria, Germany, and Russia.

ROME TOWARD 1760: THE FONT OF NEOCLASSICISM

Rome was the center of the art world in the eighteenth century, and virtually anyone aspiring to become a painter, sculptor, or architect wanted to study there, experiencing the antiquities and the riches of the Renaissance and Baroque periods firsthand. The French Academy established a satellite school in Rome in 1666, and the English an unofficial school in the following century. There were several Roman academies open to foreigners, and the most famous artists residing in Rome—Pompeo Batoni, Anton Raphael Mengs, and Gavin Hamilton—all maintained academies in their studios. Artists also pooled together to form short-lived private schools.

Not just artists came to Rome, for no gentleman's education was complete without making a "Grand Tour" of Italy, including the North Country (Florence, Tuscany, Umbria, and Venice) and Naples, the jumping off point for Herculaneum and Pompeii, perfectly preserved Roman cities that were excavated beginning in 1738 and 1748, respectively. Rome, however, was the climax of the trip. Gentlemen, princes, and lords—anyone of means aspiring to culture—flocked to Rome from all over the Western world, including the American colonies. England led the list in sheer numbers, and in London there was even an archeological organization, the Society of Dilettanti, that many joined. The group sponsored excavations of the

Acropolis (1751), Palmyra (1753), Baalbek (1757), Split (Spalato, 1757), and Ionia (1764–1769), illustrations of which they published in lavish folio format, providing invaluable reference material of the largest size for artists seeking historical accuracy in their work. Rome itself was one large excavation site, with antiquities dealers furiously digging for artifacts and sculpture to sell to tourists. These tourists took back with them not only Roman art but a taste for the Classical, which surfaced in the designs of their country houses and gardens.

The archeological excavations, especially of Herculaneum and Pompeii, fueled an interest in antiquity and fired the imagination of artists. Equally responsible for creating a renewed preoccupation with antiquity were the writings of the German scholar Johann Winckelmann (1717–1768), librarian to the great antiquities collector Cardinal Albani, whose Villa Albani in Rome was one of the antiquities museums—along with the Villa Borghese and the Capitoline Hill—that every gentleman on the Grand Tour had to visit. In 1755, Winckelmann published *Reflections on the Imitation of Greek Art in Painting and Sculpture*, and in 1765, he produced his magnus opus, *History of Greek Art*. The latter was one of the most widely read books of its day, which accounts for its influence. In both publications, Winckelmann elevated Greek culture to a position of supremacy it never quite held in the Classical tradition: an era of perfection that was followed only by imitation and decline. But Winckelmann did not just see beauty in Greek art; he also saw moral qualities that paralleled Enlightenment thought: "the general and predominant mark of Greek masterpieces is *noble simplicity and calm grandeur*, both in gesture and in expression . . . The expression of all Greek statues reveals even in the midst of all passions a great and grave soul [italics added]." He concludes that "the only way for us to become great, and if possible, even inimitable, is through imitation of the ancients." In response to Winckelmann's influence, the rallying cry of Neoclassicism would be the creation of moral works embodying "noble simplicity and calm grandeur."

Artistic Foundations of Neoclassicism: Mengs, Batoni, Hamilton

Influenced by the revived interest in antiquity, three artists working in Rome began to lay the foundation for Neoclassicism: Mengs, Batoni, and Hamilton. Anton Raphael Mengs (1728–1779), a German who worked in Rome on and off from 1740 to 1765, gained notoriety when Cardinal Albani, at Winckelmann's urging, commissioned him to paint a ceiling fresco for the Villa Albani. Completed in 1761 and with Winckelmann assisting with the iconography, his *Parnassus* (fig. **23.1**) depicts the cardinal as Apollo and surrounded by the seven female muses, most of whom can be identified as the cardinal's friends. The composition is based on Raphael's Vatican fresco of the same title. Stylistically, Mengs drew on Raphael as well as ancient sources. His painting combines Raphael's **planarity** (objects and figures are parallel to the picture plane) and **linearity** (objects and figures have crisply drawn contours). The figures themselves are copied from Raphael and from the recently unearthed murals at Herculaneum and Pompeii. Apollo's pose recalls the *Apollo Belvedere*

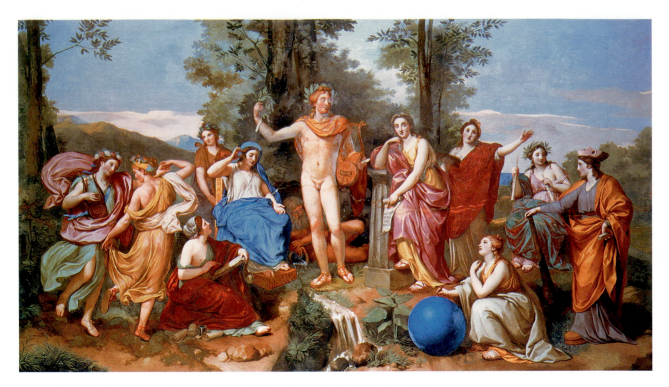

23.1. Anton Raphael Mengs. *Parnassus.* 1761. Ceiling fresco in the Villa Albani, Rome

(see fig. on page 156), a work in the Vatican collection and made famous by Winckelmann. For the sake of planarity, Mengs dispensed with the Baroque device of an illusionistic ceiling (see fig. 19.11), one that opens up to the sky. Instead he made his ceiling look like a wall painting by Raphael, simply hung on a ceiling. Instead of the lush Rococo brushwork then in style, Mengs daringly used tight brushmarks that dissolve into a smooth, hard surface. All of these elements—planarity and linearity, austere imperceptible brushwork, and Classical figures and themes—played a prominent role in the Neoclassical style.

Many of these same qualities are visible in *Thomas, First Lord Dundas* (fig. **23.2**) of 1764 by the history painter Pompeo Batoni (1708–1787). Batoni was best known for his portraiture, and the wealthiest Grand Tour gentlemen lined up to be painted by him, as did Dundas. As interesting as the dry paint handling, emphasis on line, and planarity (note how Dundas assumes an oddly twisted pose in order to run parallel to the picture plane) is the antique setting: Dundas stands with casts of the *Laocoön* and *Apollo Belvedere* (see pages 179 and 156), among others that Batoni kept in his studio as props. Batoni used this same setting for several portraits, simply changing the sitter's pose, which is often based on a famous Greek sculpture. Here, Batoni draws a parallel between the lapping dog and the sitter, suggesting Dundas has been drinking from the fountain of culture, nourished by his concentrated study of the ancients. The austere Doric column

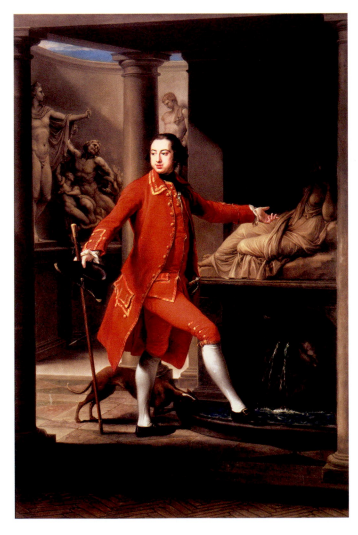

23.2. Pompeo Batoni. *Thomas, First Lord Dundas.* 1764. Oil on canvas, 9′7¾″ × 6′5½″ (298 × 197 cm). The Marquess of Zetland, Aske Hall, N. Yorkshire

behind him functions as a metaphor for the strong, noble character instilled in him by his Roman experience.

The Roman artist often credited with having the greatest impact in the development of Neoclassicism is the Scottish painter and antiquities dealer Gavin Hamilton (1723–1798). Toward 1761, he made an oil painting of the Homeric theme *Andromache Bewailing the Death of Hector*, which was reproduced in a widely circulated engraving of 1764 (fig. **23.3**). Everyone who went to Rome saw this picture in Hamilton's studio, since at the time he was one of the must-see painters. For those who did not get to see the work in Rome, it was available for viewing at a 1764 exhibition of the Society of Artists, a London organization providing an annual exhibition for members and considered the premier venue until the Royal Academy opened in 1768. This painting of mourning must have shocked eyes accustomed to Rococo gaiety, fantasy, and pleasure! Its moral is matrimonial devotion as opposed to matrimonial indiscretion, unwavering dedication rather than titillating deception, virtue not vice. Elements of the composition were inspired by reliefs on Roman sarcophagi and sepulchral buildings, but Hamilton's prime compositional source was Poussin's *Death of Germanicus* (see fig. 21.4), which was then in the Palazzo Barbarini in Rome. The two pictures share the receding barrel vault on the left and the same planar composition established by the lateral spread of the bed with canopy and recumbent body. Hamilton would paint other works on the themes of virtue and moral fortitude, and while he was not the first to reintroduce themes that had been of extreme importance to artists until the advent of the Rococo, his pictures seem to have been a catalyst. Increasingly in the 1760s and 1770s artists in all mediums turned to this kind of moralistic subject matter.

ROME TOWARD 1760: THE FONT OF ROMANTICISM

There was a second art current coming out of Rome in the 1750s, and this was an emphasis on evoking powerful emotions in a viewer, a quality that is called Romantic. The source of this current is Giovanni Battista Piranesi (1720–1778), a printmaker who by this time was renowned for his *vedute*, or views, of Rome, which gentlemen on the Grand Tour took home as souvenirs of their visit. In Venice, they would buy *vedute* by Canaletto and other artists (see pages 778–780). Wincklemann's glorification of the Greeks and belittling of Romans had infuriated Piranesi, and he set out to defend his Roman heritage, which he did by producing *Roman Antiquities*, a four-volume work completed in 1757 and illustrated with several

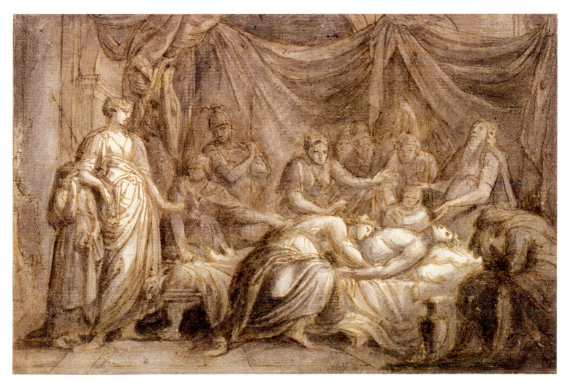

23.3. Gavin Hamilton. *Andromache Bewailing the Death of Hector*. 1764. Engraving by Domenico Cunego, after painting of ca. 1761. Yale Center for British Art. Paul Mellon Collection

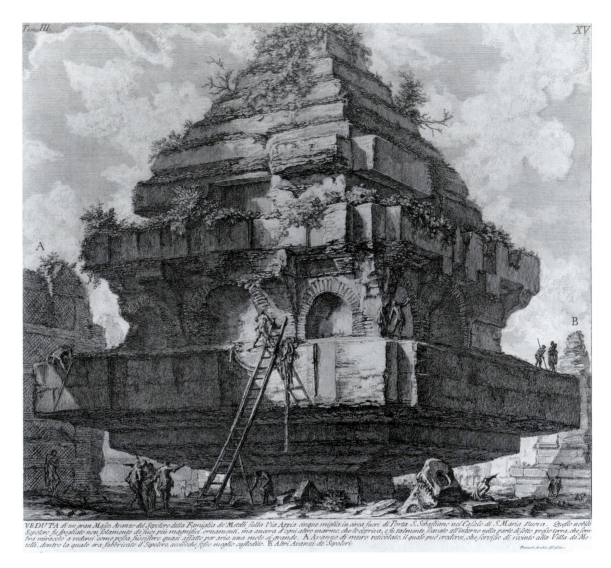

23.4. Giovanni Battista Piranesi. *Tomb of the Metalli*, Plate XV from *Antichità Romane III*. ca. 1756. Etching, $16\frac{3}{4} \times 18\frac{3}{8}$″ (425 × 46.5 cm). The Metropolitan Museum of Art, Rogers Fund, 1941, transferred from library. (41.71.3(15))

hundred etchings of Roman ruins. These etchings are hardly mere documentation of the sites. Often presenting the structures from a worm's-eye view (fig. **23.4**), Piranesi transformed them into colossal looming monuments that not only attested to the Herculean engineering feats of the ancient Romans but also the uncontested might and supremacy of Roman civilization. The frightening scale of the monuments dwarfs the wondrous tourists who walk among the dramatically lit ruins. These structures seem erected not by mere humans, but by a civilization of towering giants who mysteriously vanished. Time has taken a toll on their monuments, now crumbling and picturesquely covered by plants.

These images embody Piranesi's own sense of awe in the face of Roman civilization and constitute a melancholic meditation on the destructive ability of time to erode that once great empire. The prints are not intended to just inform; they are also meant to send shivers down a viewer's spine. In them we see the beginning of a sensitivity antithetical to the noble simplicity and calm grandeur of Neoclassicism.

Before the eighteenth century was out, the sense of awe that Piranesi was trying to evoke would be identified as being caused by what the period called the "*sublime*." The sublime is not a style, but a quality or attribute. Interestingly, the word became current in 1756, a year before Piranesi's publication, when the British statesman Edmund Burke (1729–1797) published a treatise titled *A Philosophical Inquiry into the Origin of Our Ideas of the Sublime and Beautiful*. Burke's study was directed more toward psychology than aesthetics, but its impact on the world of art was tremendous. He defined beauty as embodying such qualities as smoothness, delicacy, and grace, which produced feelings of joy, pleasure, and love. The *sublime*, however, was obscurity, darkness, power, vastness, and infinity, anything that generated feelings of fright, terror, being overwhelmed, and awe. The sublime produced "the strongest emotion which the mind is capable of feeling." As the century progressed more and more artists embraced the sublime, catering to viewers' demand to be awed or moved by paintings, sculpture, and architecture.

NEOCLASSICISM IN ENGLAND

It almost seems as though the British were predisposed to embracing Neoclassicism, not only because the birth of Enlightenment occurred in England but also because the nation already had an intense involvement with antiquity in literature, which dated to the opening decades of the eighteenth century. The Augustan or Classical Age of English poetry was in full bloom by then, with its leading authors, such as John Dryden, Alexander Pope, and Samuel Johnson, emulating the form and content of the writers active during the reign of the first Roman emperor, Augustus Caesar (63 BCE–14 CE), many of whom these same British poets translated. Britain at this time was enjoying unprecedented peace and prosperity, which, in part, was responsible for the identification with Augustus Caesar's reign, similarly marked by stability, economic prosperity, and the flourishing of culture. The liberal faction of the British aristocracy modeled itself on ancient Rome, relating the British parliamentary government that shared power with the king to the democracy of the Roman republic. As we shall see, by the 1720s, these liberals, who compared themselves with Roman senators, wanted country homes based on Roman prototypes.

Sculpture and Painting: Historicism, Morality, and Antiquity

The English were particularly receptive to the Neoclassical foundation established by Mengs, Batoni, and Hamilton. Hamilton's moralistic scenes set in antiquity especially had a major impact, and the list of artists inspired by them is extensive, starting with a handful in the 1760s and extending to dozens in the following decades. However, the taste for the Classical could also be just that, a taste for a style or look, with little consideration for a moralistic message. This was especially true in the decorative arts (see *Materials and Techniques*, page 796).

THOMAS BANKS Hamilton's impact was so great it extended beyond painting to sculpture, as seen in the work of Thomas Banks (1735–1805). Banks studied in Rome from 1772 to 1779, where he chiseled a marble relief of *The Death of Germanicus* (fig. **23.5**). Reflecting Enlightenment emphasis on logic, Banks authenticated his scene with archeologically correct architectural details and furniture (note the klismos chair, for instance), and aligned his Classical figures in a flat, shallow frieze composition. Heads are idealized and appear in Greek profile. The unusual stance of the soldier on the far right is a mourning pose that Banks copied from Roman reliefs. As in Hamilton's *Andromache Bewailing the Death of Hector*, the devoted women and children express intense sorrow for the dying general, while the dedicated soldiers, with raised oath swearing arms, vow to avenge his murder. Similar sweeping curves augment the intense emotion of both groups, although Hamilton's figures, especially Andromache, appear to imitate the explosive monumentality of Michelangelo's Sibyls and Prophets. As we shall see, Neoclassicism, in its climax in France the 1780s, will abandon curvilinear design and embrace a severe geometric grid that underscores the intense moralistic resolve of the figures.

ANGELICA KAUFFMANN Angelica Kauffmann (1741–1807) was among the most important artists for the development of Neoclassicism in England. She was born in Switzerland, studied in Rome in the 1760s, and moved to London in 1766. She befriended Joshua Reynolds and was a founding member of the Royal Academy in 1768, of which Reynolds was president. Prior to the twentieth century, she was one of only two women admitted into the academy, a statistic that on a negative note reflects male prejudice and on a positive one the high international esteem in which the 27-year-old Kauffmann was held. As a woman, she was denied access to studying the male nude, then considered critical to a history painter's success, and making her accomplishments all the more remarkable. Of the few eighteenth-century women artists to carve out a successful career in a man's world, Kaufmann was the only one who became a history painter. The others were either still-life painters, like the Parisian Anne Vallayer-Coster (1744–1818), or portraitists, like Marie-Louise-Elizabeth Vigée-Lebrun (see page 766), who was Queen Marie Antoinette's favorite artist, and Adélaïde Labille-Guiard (1749-1803). Male prejudice was so strong against the latter two French women, both of whom rank among the finest painters of their period, that they were accused of having employed men to make their works. Enlightenment philosophy, with its emphasis on equality, may have provided a theoretical premise for greater social, economic, and political freedom for women, but in reality women artists remained second-class citizens throughout the eighteenth century, only occasionally gaining access to the academies in London and Paris (the French Academy only allowed four women at a time). Furthermore, male artists continued to depict women stereotypically, as wives and mothers who in addition to being fertile and pretty are helpless, passive, grieving, and immobile, just as we saw in Banks's *The Death of Germanicus*.

Like so many of her contemporaries, Kauffmann raided Greek and Roman literature for her subjects. In 1769 at the first Royal Academy exhibition, she presented *Hector Taking*

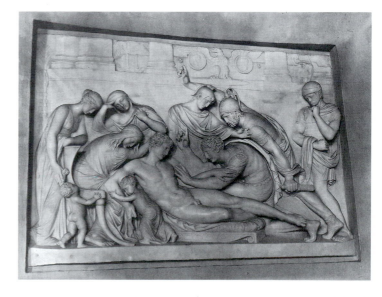

23.5. Thomas Banks. *The Death of Germanicus*. 1774. Marble. Height 30″ (76.2 cm). Holkham Hall, Norfolk, England. By Kind Permission of the Earl of Leicester and the Trustees of the Holkham Estate

Josiah Wedgwood and Neoclassical Jasperware

Reflecting the rising demand in Britain for all things Classical was jasperware porcelain, invented by Josiah Wedgwood and produced by the mid 1770s in his factory named Etruria in Staffordshire. Jasperware is a durable, unglazed porcelain decorated with classically inspired bas relief or cameo figures. Most jasperware is ornamented in white relief on a colored ground, especially blue and sage green. In 1775, Wedgwood hired the sculptor John Flaxman (1755–1826) to produce many of his designs, which were largely based on ancient Greek vases in the collection of William Hamilton. The Greek vases, not discovered until the middle of the century, were considered Etruscan, hence the name Etruria for Wedgwood's plant. Hamilton's collection, housed in Naples and sold to the newly founded British Museum in 1772, was published in enormous folio volumes in the 1760s and readily available for copying.

Reproduced here is a Flaxman vase depicting *Hercules in the Garden of the Hesperides*, designed in 1785, although not produced until later. Flaxman translated the two-dimensional drawing on a Hamilton vase into the shallow three-dimensionality appropriate for jasperware. He retained the strong contours, profiles, and basic configuration of the figures in Hamilton's vase, while subtly increasing the elegance of the original Greek design, largely by simplifying the drawing and making it more graceful.

Like most Wedgwood images, the scene is not one of action, resolve, or a decisive moment reflecting nobility of character. Instead, Flaxman shows Hercules in repose in the garden where his eleventh task required him to steal the golden apple belonging to Zeus, which was protected by

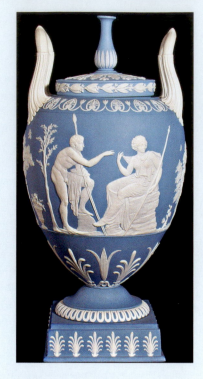

John Flaxman. *Hercules in the Garden of the Hesperides*. Designed 1785 and produced by Wedgwood ca. 1790. Jasperware, height 14″ (35.7 cm). The Potteries Museum and Art Gallery, Stoke-on-Trent

the hundred-headed hydra and the Hesperides, the daughters of Atlas. The image looks more like a Classical *fête galante* than a heroic act of Herculean courage and might. The prettiness of the color and delicacy of the design echo Rococo sensitivity and are a reminder that the taste for the Classical could also be just that, a taste for a style or look, with little consideration for a message, whether moralistic or erotic.

The rise of Wedgwood is due to the Industrial Revolution, for the company was based upon mass production. Wedgwood produced the same Flaxman design on different objects: vases, fireplace panels, plaques, medallions, and jardinières (large, ornamental flowerpot holders). With his partner Thomas Bentley, who was responsible for the firm's preoccupation with Classical art and for hiring Flaxman, Wedgwood opened a showroom in London to promote their wares and innovatively published a well-distributed catalog of their products. The two men were not only mass-producing art, they were also mass-marketing it, making high-quality work available to a broad public at a reasonable price. They also fulfilled a growing public infatuation for celebrities, for their medallions included portraits of famous people, in effect anticipating the role of photography some 75 years later and the mass media in the twentieth century. Flaxman designed profiles of such renowned figures as the writer Samuel Johnson and the sensation of London, the actress Sarah Siddons (see fig. 22.18).

The Industrial Revolution was increasing wealth and creating an upper middle class in England, and Wedgwood was meeting the needs of this new clientele—art was no longer just for royalty, the aristocracy, and the church. Demand was so great, Wedgwood installed his first steam engine at Etruria in the early 1780s to make his plant more efficient.

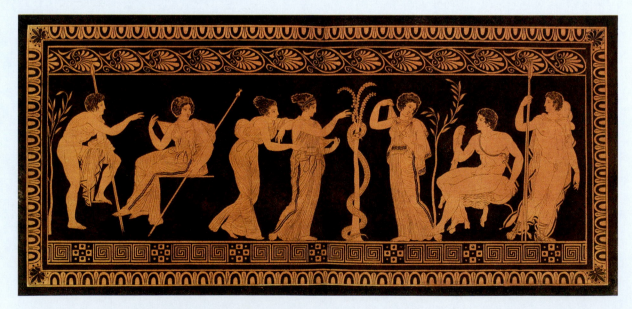

Hercules in the Garden of the Hesperides. Illustration in Pierre-François Hugues d'Hancarville, *Collection of Etruscan, Greek and Roman Antiquities from the Cabinet of the Honorable William Hamilton,* 1766–1767. Vol. II, Plate 127

Leave of Andromache, and three years later she showed *Andromache and Hecuba Weeping over the Ashes of Hector*, two pictures portraying unwavering marital fidelity, both as wife and widow. A classic example of Kauffmann's moralistic pictures is *Cornelia Presenting Her Children as Her Treasures (Mother of the Gracchi)* (fig. **23.6**) of about 1785. Here she champions child rearing and family over materialism. While portraying a woman as mother, she counters traditional male stereotyping by presenting her as proactive, deterministic, and controlling. In this second-century BCE story from Roman history, a visiting friend has just shown off her jewelry to Cornelia Gracchus. Instead of displaying her own gems, Cornelia proudly presents her children, two of whom, Tiberius and Gaius, would become great politicians. To prepare her sons for leadership, Cornelia acquired the finest tutors in the world, and it was said that she "weaned" them on conversation, not her breasts. She remained an ally and adviser to both, and in addition to her reputation for virtue and intelligence, she was one of the most powerful women in the history of the Roman Republic. Kauffmann, a woman artist struggling in a man's world, must have identified with the successful Cornelia, whose features resemble the artist's.

In *Cornelia Presenting Her Children*, Kauffmann has created an austere and monumental painting that reinforces the strength and nobility of the mother. Despite the Rococo grace

ART IN TIME

1725—Burlington and Kent begin constructing Chiswick House

ca. 1750—Industrial Revolution begins in England

1765–1782—James Watt perfects the steam engine

1767—John Wood the Younger designs the Royal Crescent in Bath

1768—Royal Academy founded in England

1775–1784—American Revolution

1776—Adam Smith publishes *The Wealth of Nations*

of the gestures and the elegant proportions of the figures, the picture is dominated by the bareness of the floor and walls and the stable composition anchored by a strong, solid triangle culminating in Cornelia. The Cornelia theme was not unique to Kauffmann, however, and was quite popular with artists. Not only did it illustrate virtue, but it reflected the new interest in the importance of the family unit that stemmed from the Enlightenment teachings of Jean-Jacques Rousseau, who advocated that parents nurture their children at home, rather than sending them off to wet nurses and nannies until they were adolescents.

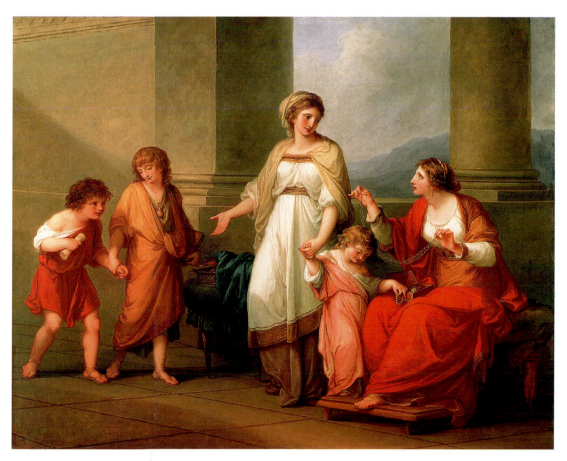

23.6. Angelica Kaufmann. *Cornelia Presenting Her Children as Her Treasures (Mother of the Gracchi)*. ca. 1785. Oil on canvas, 3′4″ × 4′2″ (101.6 × 127 cm). Virginia Museum of Fine Arts, Richmond. The Adolph D. and Wilkins C. Williams Fund. 75.22

The Birth of Contemporary History Painting

Enlightenment empiricism had a major impact on history painting in two ways. One was the strong emphasis on historicism—when portraying a scene set in the historical past, costume, setting, and props all had to be convincing and true to the period. The second impact affected the presentation of major contemporary events that the future would perceive as historically important. Until now, such moments were presented using allegory and symbols, not by portraying the actual scene, or figures were dressed in Classical garb in order to give them the sense of decorum and importance the event apparently required. But with the Enlightenment, paintings had to be logical and real and every bit as convincing to contemporaries as we expect period films to be today. This applied not only to the historical past but to contemporary events as well.

BENJAMIN WEST The artist perhaps most responsible for popularizing contemporary history painting is Benjamin West (1738–1820), one of the most successful British Neoclassical history painters. A Quaker born and raised just outside of Philadelphia, West went to Rome in 1760 where he studied with Mengs, befriended Gavin Hamilton, and immersed himself in antiquity and the classically influenced Renaissance masters, especially Raphael. By 1763 he had permanently settled in London, and within three years he was a success, in part because of his innovative Neoclassicism. He was a founding member of the Royal Academy in 1768, and he became its president in 1792 when Joshua Reynolds died. Throughout his life, he was a mentor for many American artists, and always remained proud of his New World heritage, even supporting the American Revolution.

Among the pictures that established West's reputation are his *Agrippina with the Ashes of Germanicus*, of 1768, a picture that falls into the moral category of the dedicated widow (see fig. 23.3), and *The Departure of Regulus from Rome* from 1769, which reflects the stoic self-sacrifice of a Roman general to save his country. Employing Enlightenment historicism, the pictures are set in convincingly real ancient Roman cities, with figures aligned in relief, parallel to the picture plane, against a backdrop of Classical buildings.

West shocked the London art world in 1770 when he announced he was working on a *contemporary* history painting, *The Death of General Wolfe* (fig. **23.7**), and placing the event in a realistic setting of 1759 Quebec during the French and Indian War. Wolfe won the Battle of Quebec, which became a turning

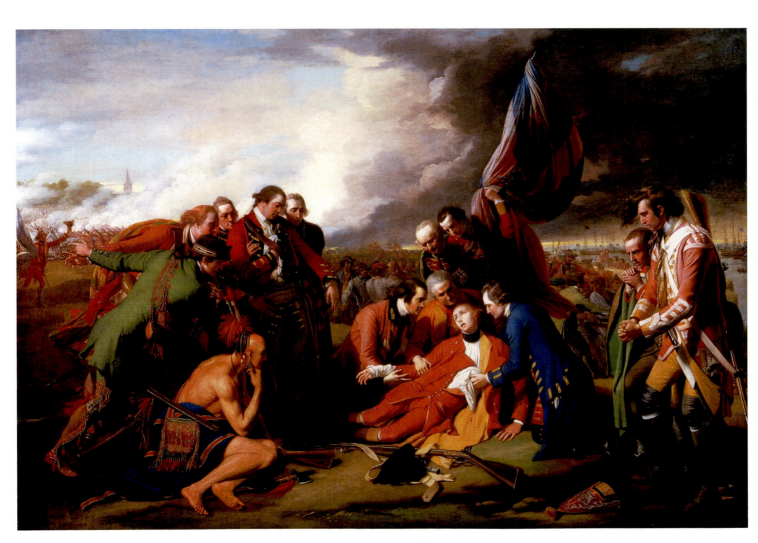

23.7. Benjamin West. *The Death of General Wolfe*. 1770. Oil on canvas, 59¹/₂ × 84″ (1.51 × 2.13 m). National Gallery of Canada, Ottawa. Gift of the Duke of Westminster

The Elusive Meaning of West's The Death of General Wolfe

The history of art is filled with mysteries, and among the most common unknowns for art made before 1900 are the authorship and date of a piece, the reason it was made, and its message. Art historians are often forced to rely on speculation, a tactic filled with risk but one that has the advantage of beginning an intellectual dialogue that may lead to firm answers. Benjamin West's *The Death of General Wolfe* raises probing questions and speculation. The most obvious question is, why did West depict this particular subject? The key to the answer may be the figure of William Johnson, who is in a green coat to the left. His name and a map with "Mohawk Valley" and "Ontario" on it are etched on his powder horn. These territories had been ceded to him as

superintendent of Indian affairs by the Native Americans. More important, he had been the hero at the battles of Lake George and Fort Niagara and therefore was a symbol of the important role that Americans played in winning the French and Indian War. Despite the picture's historicism, West's image is a fiction: Johnson had not been at Quebec, and the Indians aided the French, not the British. West made this picture on the threshold of the American Revolution (the Boston Massacre was in 1770), and his ahistorical inclusion of Johnson was designed to make the British aware of the their indebtedness to the colonists, represented here by Johnson, as faithful citizens who had supported England, and of the need to be more conciliatory in granting the concessions they felt they had earned. This interpretation accounts for many of the unusual components in the painting, although the fact that it is so logical is its only proof. Although conjecture, it provides a new way to think about the picture.

point in the war, making him a national hero. Upon hearing of West's plan, King George III declared he would never purchase a picture with his soldiers in modern uniforms, and Reynolds frowned on the picture's breach of decorum, which required an allegorical apotheosis scene. But when exhibited at the Royal Academy, the painting was immediately applauded by the public. The scene was so convincing the audience felt as though it were indeed witnessing its great national hero at the very moment he sacrificed his life for his country, in a far off land, an exotic touch that fascinated the public, which went to look at pictures the way we view movies today. (See *The Art Historian's Lens*, above.)

The painting was also successful because West aggrandized and classicized his figures and the event, in effect creating a modern classic. Contemporary viewers recognized they were in the presence of what amounted to a traditional Lamentation scene (for instance, see fig. 14.17), and that their hero was a modern-day Christ or martyr. The surrounding "apostles" express remorse and concern, but their powerful emotions, worthy of Poussin, are noble and controlled, in keeping with the Classical rule of decorum. Figures strike contrapposto poses, stand in profile, and have the sculptural quality of a shallow ancient relief or Raphael saint, apostle, or Greek philosopher (see fig. 16.25); they are simultaneously modern and Classical. The one unemotional figure is the Iroquois, Rousseau's noble savage, whom West presents with the grandeur and composure of an ancient river god. The Iroquois is withdrawn and able to contemplate the event without allowing emotions to cloud his understanding of the scene. West took the cue for his painting technique from Hamilton, Mengs, and Batoni, all of whom he knew firsthand in Rome, for he first drew and then colored in the figures, allowing crisp contours to ennoble them.

Architecture and Interiors: The Palladian Revival

In England a Classical revival began much earlier in architecture than it did in painting and sculpture, and its origins date to Colen

Campbell's three-volume treatise *Vitruvius Britannicus (British Vitruvius)* of 1715, 1717, and 1725. Campbell argued for a British architecture based on antiquity and Antonio Palladio's classically inspired villas, which not only evoked antiquity but projected a perfect harmony using geometry, mathematics, and logic (see pages 203–209). Campbell was building upon the 1712 treatise of the Enlightenment philosopher Anthony Ashley Cooper, third Earl of Shaftsbury, whose *Letter Concerning the Art, or Science of Design* called for an anti-Baroque national architecture based on well-informed taste, namely the work of the ancients and their descendants, again especially Palladio. Sounding much like Winckelmann did when discussing sculpture some 50 years later, Shaftsbury wrote that the proportions and geometry of ancient architecture reflected the nobility and beauty of the Greek and Roman soul, which have a powerful effect on the enlightened "man of taste." Architecture was beauty, not function.

Both Campbell and Shaftsbury reflect a British antagonism toward Roman Catholicism. In Britain, Baroque architecture was associated with two evils: papist Rome and French royalty. Shaftsbury, a patron and student of John Locke, was an advocate of individual freedom, and he equated ancient architecture with democracy. He was also a Whig, the liberal antimonarchy political party. (The Tories, the conservative promonarchy party, had backed the Roman Catholic Stuart king James II, who died in 1701.) In 1714, the Whig party came to power, ending 13 years of political turmoil. Its democratic members especially identified with Classical-revival architecture, for they saw themselves as the modern equivalent of Roman senators, who had country villas in addition to their city houses. Campbell, who was virtually unknown prior to the publication of *Vitruvius Britannicus*, could hardly fill single-handedly the demand from Whigs who wanted Palladian-style country homes. His three-volume treatise consisted of dozens of his own Palladio-inspired designs, which formed a pattern book for architects for the remainder of the century. Most British architects had a copy of Campbell's *Vitruvius Britannicus* as well as Vitruvius' *Ten Books of Architecture* and Palladio's *Four Books*.

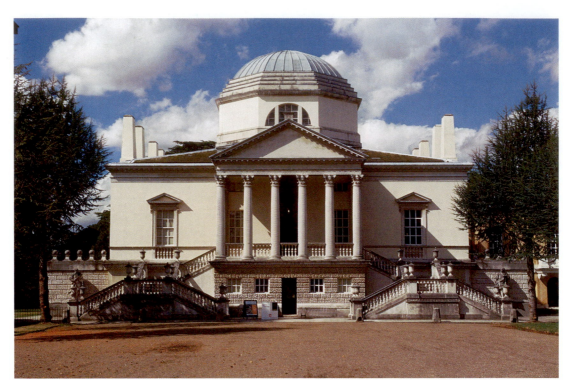

23.8. Lord Burlington and William Kent. Chiswick House, near London. Begun 1725

THE COUNTRY VILLA: CHISWICK HOUSE AND MONTICELLO
We can see the impact of *Vitruvius Britannicus* on Campbell's patron, Lord Burlington, who after a trip to Italy in 1719 became an amateur architect and eventually supplanted Campbell as the leading Palladian figure. In 1725 Burlington with the artist William Kent (1684–1748) designed Chiswick House (fig. **23.8**), located on Burlington's estate outside of London and one of the most famous Palladian-revival houses. This stately home is based on Palladio's *Villa Rotonda* (see fig. 17.37), which Lord Burlington had studied on his Grand Tour. The exterior staircase, however, could just as well have come from Campbell's 1715 design for the facade of Wanstead House, which appears in Volume I of *Vitruvius Britannicus*.

Chiswick House is remarkable for its simplicity and logic, making it easy to understand why Lord Burlington was such a success. The building is a cube. Its walls are plain and smooth, allowing for a distinct reading of their geometric shape and the form of the windows. The Greek temple portico protrudes from the wall, again creating a simple and clear form. Even the prominent domed octagonal rotunda is geometric, as are its tripartite semicircular clerestory windows, based on windows in Roman baths. Here we have reason and logic clearly stated, and put in the service of the ideals of morality, nobility, and republican government. Like Shaftsbury, Burlington believed architecture to be an autonomous art dealing in morality and aesthetics, not function.

The Palladian revival dominated English country architecture, and even jumped the Atlantic, where in the United States one of its finest examples is Monticello (fig. 23.9), the Charlottesville, Virginia house of Thomas Jefferson (1743–1826),

who was an amateur architect. Jefferson initially built Monticello from 1770 to 1782, and he lifted a plan from a midcentury publication by the English Palladian architect Robert Morris and a facade from Palladio's *Four Books*. The elegant elongated windows, however, are French, one of the many changes he made after serving as the ambassador to France in the 1780s. Despite compromises, the Palladian geometry and harmony are still evident.

URBAN PLANNING: BATH Perhaps the greatest example of the Classical revival in England is in Bath, a resort town that in Roman times had been a spa because of its hot springs. Local architects John Wood the Elder (ca. 1704–1754) and the Younger (1728–1782) played a major role in developing the sleepy town as it expanded to accommodate the flood of wealthy Londoners who as a result of the burgeoning economy at midcentury came to "take the waters." In the 1740s and 1750s, John Wood the Elder, influenced by the Classical revival, aspired to evoke ancient Rome and designed an imperial gymnasium, forum, and circus. Only the last was realized with success. Built in 1764, the circus consists of 33 attached houses surrounding a circle and divided by three streets. The facades are identical and continuous, and resemble the Colosseum turned outside inwards (see fig. 7.40). John Wood the Younger upstaged his father in 1767 when he designed the Royal Crescent (fig. **23.10**), a crescent-shaped space containing 30 houses. Wood the Younger used a colossal Palladian Ionic order mounted on a podium basement, giving the facade a magnificent unified grandeur. The Woods's urban planning of circuses was so innovative it would be replicated in Britain right through the nineteenth century.

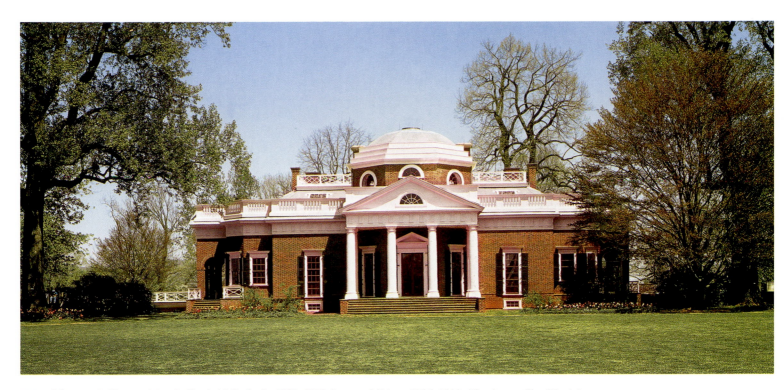

23.9. Thomas Jefferson. Monticello, initially built 1770–1782. Later additions 1796–1809. Charlottesville, Virginia

23.10. John Wood the Younger. Royal Crescent. 1767–ca. 1775. Bath, England

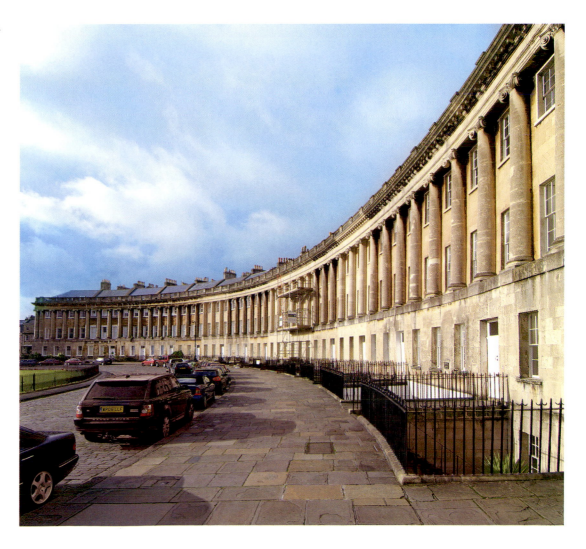

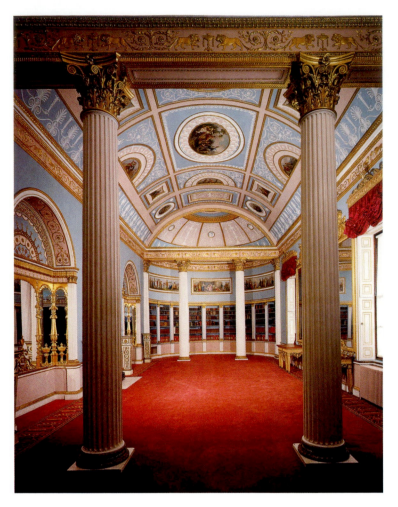

23.11. Robert Adam. The Library. 1767–1769. Kenwood, London

THE NEOCLASSICAL INTERIOR The English taste for the Classical extended to interior design and was largely due to one man, Robert Adam (1728–1792). Adam was a wealthy Scottish architect who made the Grand Tour from 1754 to 1758. He scrambled over the Roman ruins, assisting Piranesi in measuring and documenting the deteriorating structures and reconstructing them on paper. Upon returning to Great Britain, he began practicing in London and was soon the city's most fashionable architect. Although he designed several houses, his specialty was renovating interiors and designing additions, especially for country homes.

A fine example of his work is the library wing at Kenwood (fig. **23.11**), built in 1767–1769. The ceiling of the room is a Roman barrel vault, and at either end is an apse separated from the main room by Corinthian columns. This concept comes largely from Palladio. The decoration is based on Classical motifs, which Adam could copy from the many archeological books then being published. On the one hand, the library is quite Classical, not just because of the motifs, but also because it is symmetrical, geometric, and carefully balanced. On the other hand, it is filled with movement, largely because of the wealth of details and shapes that force the eye to jump from one design element to the next. Adam's palette is pastel in color and light in tone; light blues, white, and gold prevail. Curving circles,

delicate plant forms, and graceful fluted columns with ornate capitals set a festive, elegant, and refined tone closer to Rococo playfulness than to Neoclassical morality. For the decorative wall paintings, Adam often turned to the Italian Antonio Zucchi and occasionally to Angelica Kauffmann, whom Zucchi married in 1781. As we have seen, Kauffmann's Neoclassicism could strike the necessary balance between Classical and Rococo elements needed to support Adam's light brand of classicism.

EARLY ROMANTICISM IN ENGLAND

The architect Sir John Vanbrugh was not only one of the leading figures of the English Baroque (see page 754), he was also responsible for introducing Gothic design to domestic architecture when he built his own London mansion, Claremont, in 1708, silhouetting the roofline with massive medieval crenellations. This decision to depart from the Baroque or Classical may at first seem incongruous, but within Vanbrugh are the seeds of Romantic longing for emotional experience. Vanbrugh argued not to destroy old buildings but rather to conserve them because they inspire "more lively and pleasing Reflections on the Persons who have inhabited them; on the remarkable things which have been transacted in them, or the extraordinary occasions of erecting them." This longing for exotic experience, of being transported mentally to a distant past, gradually became a prevailing sentiment in British art, surfacing in painting, architecture, and landscape design. By the closing decades of the eighteenth century, exotic experience would not be sufficient; audiences would want to be awed or terrified, just as they do today when they go to see a horror film.

Architecture and Landscape Design: The Sublime and the Picturesque

We do not know what motivated Edmund Burke to write his 1756 treatise *A Philosophical Inquiry into the Origin of Our Ideas of the Sublime and Beautiful*, (see page 794), but he must have been prompted by the period's increasing desire to undergo powerful subjective experiences, an emphasis that existed alongside a strong belief in the primacy of logic and empiricism. We have already seen how Piranesi created a sense of awe and melancholy in his etchings of Roman monuments, which were popular throughout Europe and often labeled "Sublime" once the word became current. The British, however, were principally responsible for developing a taste for the sublime in the visual arts—for the experience of undergoing the most primal of emotions, those verging on terror—and it first appears in architecture and garden design.

Simultaneously, the English also developed two other concepts or principles, neither of which is a style. One is the **picturesque**. Initially the term was used in the guidebooks to the Lake District in the north of England to mean a scenic view that resembled a landscape painting. It gradually came to mean as well that something had variety and delightful irregularities that made it interesting to look at. In effect, like the term *sublime*, it became another alternative to *beauty*, which was manifest in the smooth, symmetrical, and harmonious qualities

that generated feelings of joy, pleasure, and love. The other major concept developed at the time was **associationism**, a term invented by twentieth-century historians to describe the eighteenth century's love of layering architecture and garden design with numerous associations, many exotic, that were often designed to elicit powerful emotional responses as well as to edify. Enlightenment research and publications vastly increased the knowledge of history and the world, and this knowledge was now poured into art. Winckelmann and Piranesi, for example, gave separate identities to Greek and Roman art, which previously had been combined under the banner of Classical art; now artists could make reference to the "noble simplicity and calm grandeur" of the Greeks or to the imperial might of the Romans. While architecture had always contained associations, now these associations became more extensive, precise, formal, and literary, and they were put in the service of eliciting strong emotional responses from viewers.

THE ENGLISH LANDSCAPE GARDEN Burlington and Kent landscaped the grounds surrounding the Palladian-revival Chiswick House to look natural, that is, unplanned and without human intervention. This was a radical departure from the style of the house itself and from the geometric gardens that were then in vogue, such as those at Versailles (see fig. 21.13). Winding paths, rolling lawn-covered hills, serpentine ponds, and irregular stands of trees greeted visitors making their way to the mansion. Picturesque asymmetry rather than orderly geometric symmetry prevailed. However, these natural-looking grounds were not intended to be a re-creation of untamed nature; rather, they were an idealized vision of the Classical past as if rendered in a landscape painting by Claude Lorrain (see fig. 21.8), who was extremely popular among British collectors. Aristocrats arriving in their carriages even had special yellow-tinted "Claude" glasses that gave the view the same warm twilight glow found in the French master's paintings. On the one hand, we can label the grounds as Neoclassical, since they are meant to evoke the

Classical past. But on the other hand, they are Romantic, for they are designed to transport viewers psychologically into a lost Arcadian world, an immersion accompanied by powerful emotions.

Kent was probably responsible for most of the landscaping at Chiswick, and he became renowned as a landscape designer, not as an architect. He is credited with establishing the English landscape garden, his finest perhaps being the one he developed at Stowe in the 1740s. There Kent sprinkled the grounds with carefully sited Classical temples and Gothic "ruins." Unfortunately, there is very little left of Kent's gardens. The best preserved picturesque landscape garden is by two followers of Kent and Burlington, the architect Henry Flitcroft (1697–1769) and the banker Henry Hoare II (1705–1785), whose grounds on his estate at Stourhead in Wiltshire they started developing in 1743 (fig. **23.12**). In the carefully orchestrated view reproduced here, we look across a charming bridge and artificial lake to see nestled in the distant trees a Pantheon-like structure that is a replica of the Temple of Apollo in Claude's *Coast View of Delos with Aeneas*, a picture based on Vergil's epic poem *The Aeneid*. The path around the lake is meant to be an allegorical reference to the journey of Aeneas through the underworld, for the lake itself represents Lake Avernus, the entrance to the underworld. A grotto by the lake contains statues of a nymph and river god. Thus, not only are there picturesque variety and picturesque views in the park at Stourhead, but there are also layers of historical and literary associations. Nor is the park limited to Greek and Roman motifs, for it includes rustic cottages, a Gothic spire, a Turkish tent, and Chinese bridges. And there are also the sham ruins that Kent popularized at Stowe "to raise the imagination to sublime enthusiasm, and to soften the heart to poetic melancholy," as contemporaries themselves described them.

In other words, the English garden did more than just evoke the nobility of the Classical past, in which case it would be described as Neoclassical. It catered as well to a Romantic

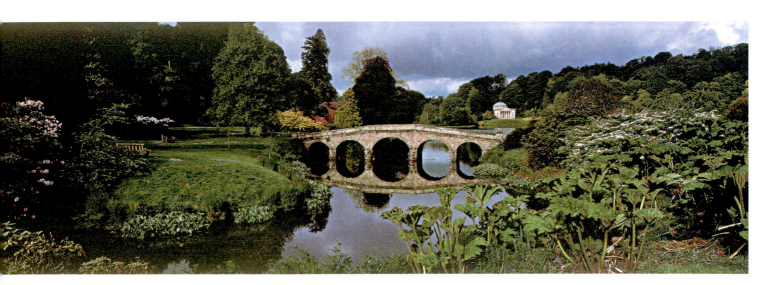

23.12. Henry Flitcroft and Henry Hoare II. The Park at Stourhead, Wiltshire, England, with a view toward a replica of the Pantheon. Designed 1743, executed 1744–1765, with later additions

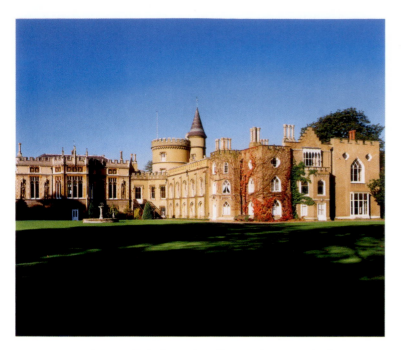

23.13. Horace Walpole, with William Robinson and others. Strawberry Hill, Twickenham, England, 1749–1777

sensibility developing at the time—a sensibility characterized by delight in the exotic as well as a desire to experience powerful emotions. It was, in fact, a Piranesian contemplation of the destructive power of time and mortality as seen in the ruins. Burke had put the word *sublime* into play, and, as we saw in the previous quote, the period was using it.

And lastly, in its variety, the English garden reflects a taste for the picturesque. The geometric regularity and comfort of beauty was now being replaced by picturesque variety, designed to delight and entertain the eye. The English would increasingly favor this new taste in their architecture and gardens as they entered the Romantic era. (See end of Part IV *Additional Primary Sources.*)

THE GOTHIC REVIVAL: STRAWBERRY HILL While the Woods were developing Bath to look like a Roman city and Palladian country houses were springing up all over England, a Gothic Revival was taking place as well. An interest in Gothic architecture—which was then perceived as a national architecture because it was believed to have originated in England—was sparked in part by the appearance of some of the first literature on the style, which until then was so unstudied that no one knew when the buildings were made or that they belonged to different periods, each with a different style. After midcentury, books began to identify the major buildings and their dates. But the style's appeal in large part lay in its sublime qualities. The cathedrals were cold, dark, and gloomy, and contained vast overwhelming spaces. Gothic ruins, which could be seen everywhere, evoked associations of death, melancholy, and even horror. In 1764, the Gothic novel emerged as a genre with the publication of Horace Walpole's *The Castle of Otranto: A Gothic Story,* set in a haunted castle.

The book started a medieval craze that peaked with Victor Hugo's 1831 *Notre-Dame de Paris,* in which the dark, foreboding cathedral is the home of the terrifying hunchbacked recluse Quasimodo.

Horace Walpole (1717–1797) also deserves credit for making the Gothic Revival fashionable when, with a group of friends, he redesigned Strawberry Hill (fig. 23.13), his country house in Twickenham, just outside of London. Started in 1749, the renovation took over 25 years to complete. The house is distinctly medieval; the walls are capped with crenellated battlements and pierced by tracery windows. For Walpole, Gothic meant picturesque, and consequently the L-shaped building is irregular, asymmetrical, and looks like a piling up of additions from different periods, which it actually is because the building was erected piecemeal over a long period, with each section designed by a different person. (The Neoclassical architect Robert Adam, for example, contributed the turret.) But there is nothing of the sublime on the exterior, which actually has a Rococo delicateness. The crenellations are petite, not massive, and the windows sit near the surface, making the walls look delicate and paper thin, not thick and fortresslike.

This Rococo effect also characterized the interior, as in the Picture Gallery (fig. 23.14). Walpole insisted on historical accuracy for his rooms and had architectural details copied from engravings of medieval buildings that were being researched at that time. The gallery ceiling, for example, is taken from the chapel of Henry VII at Westminster Abbey (compare with fig. 12.50). The walls may be richly brocaded, but they look dainty, as though covered with lace-paper doilies, while the thin, gilded fan vault is elegant and lighthearted. Walpole verbally expressed the playfulness with which he approached the past when he wrote about "the charming venerable Gothic" and "whimsical air of novelty" the style lent contemporary buildings. Walpole's Gothic

23.14. Picture Gallery at Strawberry Hill

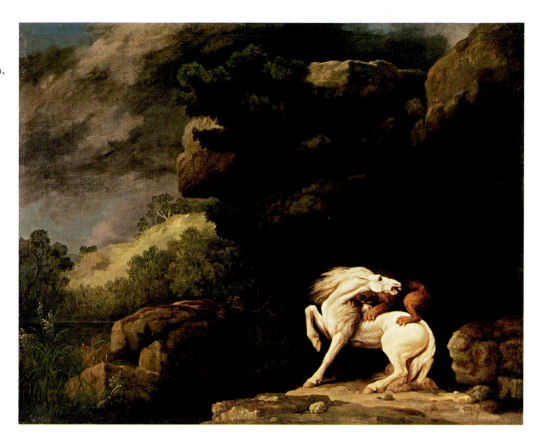

23.15. George Stubbs. *Lion Attacking a Horse*. 1770. Oil on canvas, $38 \times 49^{1}/_{2}$ " (96.5 × 125.7 cm). Yale University Art Gallery, New Haven, Connecticut. Gift of the Yale University Art Gallery Associates 1961.18.34

revival was in many respects as playful and decorative as Adam's Classical revival, a reminder that both represent a transition from the Rococo to the true Romantic revival.

Painting: The Coexistence of Reason and Emotion

Just as the Gothic revival thrived along side the Classical revival in England, Romantic painting coexisted with the Neoclassical. Romantic undercurrents even appeared in pictures that are essentially Classical, a paradox that underscores the limitations of labeling. Like a moth to a flame, the taste of the period was increasingly drawn to the awesome power of Nature, the experience of unfettered elemental emotions and instincts, and even the wonder of the irrational. In effect, the Enlightenment at moments could deny its very foundation of logic and empiricism and permit itself to be swept away by the emotional pull of the exotic, wondrous, terrifying, and unexplainable. The thirst for sublime experiences would prevail by the end of the century.

GEORGE STUBBS George Stubbs (1724–1806) is generally described as a Neoclassical painter, despite specializing in portraits of horses. At the same time, he made some of the earliest Romantic pictures, and is one of the first artists who directly responded to Burke's treatise on the sublime and the beautiful (1756). In the early 1760s, Stubbs began a series of approximately 21 paintings of a lion attacking either a horse or a stag, an example of which is the 1770 *Lion Attacking a Horse* (fig. **23.15**). Stubbs's motivation comes directly from Burke. He was challenged to portray a horrifying natural event that would evoke a sublime emotion in a viewer. Stubbs's protagonists are animals, who, unlike humans, are immersed in Nature and at one with

it, virtual personifications of unleashed natural forces. We identify with the horse, which is white, a symbol of goodness and purity. Its mouth, eye, mane, and legs are taut with fear and pain. Evil is represented by the lion's dark powerful legs, which seem almost nonchalant as they rip into the horse's back, pulling the skin to expose a skeletal rib cage. The lion's body disappears into the blackness of the landscape, identifying its evil force with a frightening darkness and elemental powers that surge from the earth. Ominous storm clouds announce the horse's fate as they threaten to cast the entire scene into dark shadow at the moment, we assume, the doomed horse expires. West, in *The Death of General Wolfe*, similarly harnessed the forces of nature to reinforce the emotional intensity and psychology of his figures.

JOSEPH WRIGHT Reason and emotion, Neoclassicism and Romanticism, the flip sides of the Enlightenment, coexisted in the work of Joseph Wright of Derby (1734–1797) as well, although he is primarily described as being in the Neoclassical camp. Wright spent much of his life in the Midlands, mostly in Derby, near Birmingham, the center of the Industrial Revolution, where he specialized in portraits. His clients included the wealthy new captains of industry. He is best known today, however, for his genre, history, and landscape paintings, which are often set at night so that he could indulge in his scientific love of painting complicated light effects.

An Experiment on a Bird in the Air-Pump (fig. **23.16**) of 1768 is one of a series of paintings made to promote a prestigious Derby scientific organization, the Lunar Society, to which Wright belonged, and it is a painting that despite being a genre scene would be called Neoclassical in style. The paint handling

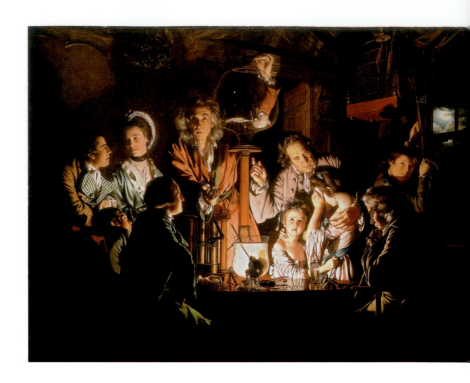

23.16. Joseph Wright. *An Experiment on a Bird in the Air-Pump.* 1768. Oil on canvas, 6 × 8′ (1.82 × 2.43 m). The National Gallery, London

is tight, the surface smooth, and there is emphasis on drawing. The subject is an Enlightenment theme, for it extols science. Its 6-foot scale is one generally reserved for history painting, and Wright has selected a theme that allows him to show off his ability to paint strong expressions, a prerequisite for any great history painter. Wright presents a demonstration of an air pump, a device used to create a vacuum and generally employed to experiment with gases. Here the vacuum is being used to illustrate the properties of oxygen; as air is removed from the upsidedown bowl, the bird will suffocate. The experiment was often done using an artificial bladder, which would collapse, like lungs, when the air was completely gone. Wright opted for a more dramatic presentation, using a live animal, although the lecturer's hand is poised above the vacuum ready to let in air before the bird expires. This threat of death allowed Wright to register a range of emotions in the room, the most sensational on the child who turns her head away in fear, while her sister looks on in wonderment. The father, using scientific logic, explains to the frightened girl that the bird will live, while the lecturer assuredly looks out at us knowing from experience how the experiment will play out. The light of reason will expel ritual and myth.

And yet, this scene has an aura of mystery, largely the result of the dim glow of the candle that plucks the figures out of the darkness and the eerie light of the moon, seen through the window. The candle and the moon can be interpreted as either metaphorical or symbolic: The former suggests the light of reason will expel the darkness of superstition, while the moon is a symbol of the Lunar Society, which met monthly on the Monday following a full moon. But a Romantic sense of mystery shrouds the scene as well and vies with the clarity of Enlightenment science and empiricism.

There is an even stronger dichotomy between Neoclassicism and Romanticism in Wright's *The Widow of an Indian Watching the Arms of Her Deceased Husband* (fig. **23.17**) of 1785. Here we return to the Neoclassical theme of the virtuous widow. But instead of Andromache or Agrippina, the heroine is an American Indian, who by tribal custom must sit continuously and unprotected for 30 days by her deceased husband's weapons. The mourning widow has the melancholic pose and beautiful profile we associate with Classical sculpture, and most likely Wright lifted her directly from an antique source, ennobling her and her virtue. Like Winckelmann's Greek sculptures, she is tranquil and composed, even stoical. But here the Neoclassicism stops and Romanticism begins. Not only is the American wilderness an exotic locale for a European audience, but it is also ravaged by the omnipotent forces of nature—an exploding volcano, an ominous storm, fierce lighting, and the pounding surf of whitecapped sea. The lone lightning-blasted tree is a chilling emblem of death and destruction, and the vortex framing the blazing sun, a motif that would become a favorite with Romantic artists in the next century, creates a deep all-powerful space suggesting the infinite. Here we are looking at a sublime landscape, one designed not only to elevate the widow's stoicism as it tests her endurance but also to reflect the turmoil of her emotional state.

And of course the Indian herself, an exotic "primitive" in eighteenth-century eyes, would have fascinated British viewers, the way that Chinese, Turkish, and Gothic motifs in English gardens did. More important, the Indian widow recalled for contemporary audiences Rousseau's "noble savage," a natural woman steeped in the virtues and purity of nature and uncorrupted by the artificiality of civilization.

JOHN HENRY FUSELI Plumbing the innermost recesses of the mind and the incomprehensible forces within nature was the special province of Swiss-born British painter John Henry Fuseli (1741–1825). Fuseli initially intended to be a theologian. In Zurich, he studied with the famous philosopher Johann Jakob Bodmer (1698–1783), who introduced him to the works of Shakespeare, Dante, Homer, and John Milton, and to the *Nibelungenlied*, a medieval Norse epic that Germans believed was the northern equivalent of Homer's *The Odyssey* and *The Iliad*. He also befriended Johann Kaspar Lavater, a poet and physiognomist, who was an antagonist of rationalism despite his scientific interest in how facial features reflect states of mind and personality. Lavater's interest in psychology heavily influenced Fuseli. As important, Lavater put Fuseli in direct contact with the German *Sturm und Drang* (Storm and Stress), a literary movement that thrived from the mid-1760s to the 1780s and included the poet Johann Wolfgang von Goethe (1749–1832). It is often considered the first Romantic movement. Heavily influenced by Rousseau, the group emphasized the purity and virtuousness of Nature and the primacy of emotion. Goethe's *The Sorrows of Young Werther* (1774), the most-read book of its day, tells the tale of a young man, Werther, who rejects society, falls in love with a woman who spurns him, and in depression kills himself, suicide, in effect, being an extreme form of withdrawal from civilization and the return to Nature. Here we have a new kind of hero, really an antihero, one who establishes personal moral codes and follows personal passions to attain freedom and fulfill individual needs. As we shall see, these values will become the foundation of Fuseli's art.

In 1764, Fuseli moved to London. Encouraged by Reynolds, he took up painting and in 1770 went to Rome, where he became the lead figure in a circle of British and Swedish artists

ART IN TIME

1743—Development of landscape garden begins at Stourhead

1749—Walpole begins remodeling Strawberry Hill

1757—Burke publishes *On the Sublime and Beautiful*

1762—Coronation of Catherine the Great

1770—Stubbs paints *Lion Attacking a Horse*

1781—Fuseli's *The Nightmare*

that included Thomas Banks (see page 795). Dismissing Winckelmann's adulation of the calm grandeur and noble simplicity of Greek sculpture, as well as the perfect harmony of the High Renaissance as represented by Raphael, he gravitated to Michelangelo's colossal, twisting, muscular figures on the Sistine Chapel ceiling and especially in the *Last Judgment* (see fig. 17.12). He was also inspired by the distorted anatomies of such Mannerists as Parmigianino (see fig. 17.27) and Rosso Fiorentino (see fig. 17.1).

His selection of subjects was as independent as his choice of style. Instead of noble, virtuous scenes from the Roman historians Livy and Plutarch, he selected psychologically and physically agonizing events from Homer, Shakespeare, Milton, Spencer, and Ossian (a fake ancient Gaelic epic poet invented by James Macpherson and foisted on the public in the 1760s), many with erotic overtones. The more horrific and tortured the scene, the better, and the artists surrounding Fuseli in Rome favored similar themes. By the 1780s, Fuseli's subject matter dominated British painting, with even Benjamin West painting lurid scenes from Shakespeare and the Bible.

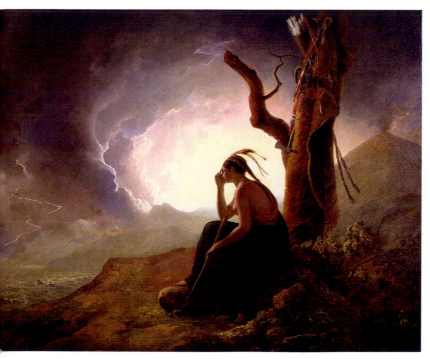

23.17. Joseph Wright. *The Widow of an Indian Chief Watching the Arms of Her Deceased Husband.* 1785. 40 × 50″ (101.6 × 127 cm.) Derby Museums and Art Gallery, England

Upon Fuseli's return to London in 1779, his themes and style were fixed, as we can see in *Thor Battering the Midgard Serpent* (fig. **23.18**) of 1790. The subject comes from the *Nibelungenlied*, an epic tale of the doom that results in the demise of the gods and the end of the cosmos and all morality. The wolf Skoll devours the sun and his brother Hatii eats the moon, plunging the world into darkness. Earthquakes shatter the world, releasing such monsters as Jormugand, the Midgard Serpent, who arises from the sea intent on poisoning the land and sky. Gods and giants fight fierce battles with the monsters, and here Thor, the god of thunder, is charged with slaying Jormugand, although ultimately he dies from the serpent's poison. The scene radiates sublime horror, from which the boatman shrinks and the ghost-white Wotan, king of the Gods, cowers. Neoclassical planarity, tight drawing, consistent lighting, and the smooth handling of paint are replaced by an explosion of light, a flurry of Baroque brushwork, and a dramatic composition. The bold elements of this composition include the tensely coiled serpent, the deep recession of both the boat and boatman, and the violent upward thrust of Thor, whose Michelangeloesque proportions seen from the low vantage point of the serpent itself endow him with a sense of Herculean strength. The image is all blood, water, rippling flesh, the heat of the serpent's breath, and the darkness of night, and because of the serpent's-eye perspective, a viewer is immersed in nature and put directly in the midst of the violent, frightening struggle.

While Thor epitomizes courage and sacrifice, Fuseli was often interested in portraying unconventional heroes who follow personal passion and exemplify individual freedom, especially in the face of societal pressure to conform and repress desires. How else to explain Fuseli's admiration for the Satan of Milton's epic poem *Paradise Lost*, whom he painted numerous times within the circle of Chaos, calling up his legions to launch a futile attack on the unfallen world of the Garden of Eden? Fuseli himself exemplified artistic freedom in his unique style and unconventional subjects, as well as in highly personal images, such as *The Nightmare* (fig. **23.19**) of 1781. The meaning of this work remains a puzzle. Clearly, sex permeates the picture, from the figure's erotic pose, to the mare's penetration of the "vaginal" parting of the curtain, and the sensual red of the fabric. But is the incubus (an evil spirit that has sexual intercourse with women while they sleep) on the woman's stomach her psychotic monster or Fuseli's repressed desires? A portrait of a woman on the back of the canvas suggests the exposed libido is Fuseli's, for although the figure is not identified, it may be of a Zurich woman who spurned the artist's offer of marriage in 1779 when he was passing through the city in route to London.

Regardless of the answer, this very personal painting is an extraordinary image, powerful, unique, and filled with sublime terror. It explores the erotic depths of the human mind and shrugs off expectations of what painting is supposed to be about. With Fuseli we have moved into the Romantic era, which begins to emerge throughout Europe toward 1800.

23.18. John Henry Fuseli. *Thor Battering the Midgard Serpent.* 1790. Oil on canvas, $51\frac{1}{2}'' \times 36\frac{1}{4}''$ (133 × 94.6 cm). © Royal Academy of Arts, London

NEOCLASSICISM IN FRANCE

As in England, the reaction against the Rococo in France first appeared in architecture, but it surfaced in the 1750s and 1760s, rather than the 1710s and 1720s. At first elegant and rational and largely based on seventeenth-century French Classical architecture, it moved into an austere, awe-inspiring, and even visionary stage by the late 1770s. This sublime phase of Neoclassicism had a profound impact on painting. Despite repeated appeals from numerous sources, including Enlightenment exponents and the government, painters were slow to meet the challenge to create a new moralistic art based on antiquity. It was not until the late 1770s that large numbers of painters took up the cause, and it was not until the 1780s, with the advent of Jacques-Louis David and his austere brand of Neoclassicism, that a new style emerged, one that thrived well into the nineteenth century.

Architecture: Rational Classicism

The first phase of French Neoclassical architecture was a reaction to the excesses of the Rococo, which had been about asymmetry, graceful movement, decorative flourishes, and curvilinear elegance. The new architecture was about rational design, and hence often called "Rational Classicism." All components of a

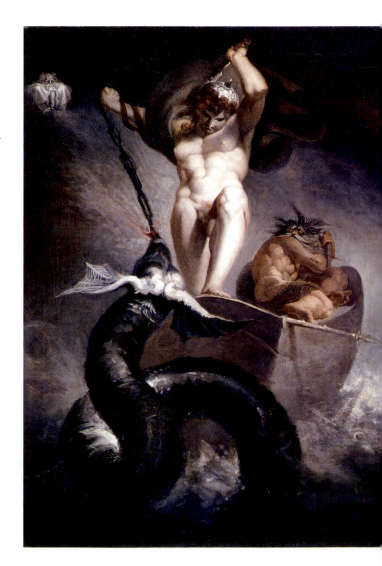

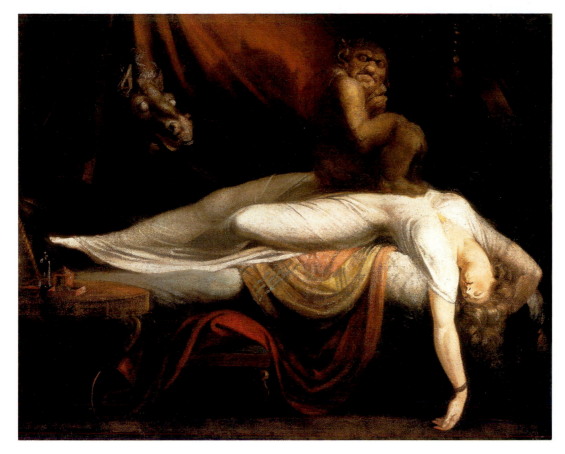

23.19. John Henry Fuseli. *The Nightmare*. 1781. Oil on canvas, $39^3/_4 \times 49^1/_2$ ″ (101 × 127 cm). The Detroit Institute of Arts. Gift of Mr. and Mrs. Bert Smokler and Mr. and Mrs. Lawrence A. Fleischmann

building had to be geometric, symmetrical, and logical in the sense that they were essential to the structure. While this rational phase of Neoclassical architecture was theoretically based on nature, it nonetheless took its lead from seventeenth-century French Classical architecture.

THEORETICAL BEGINNINGS AND THE FORCE OF MADAME DE POMPADOUR

Launching the attack on the Rococo was the architect Jacques-François Blondel (1705–1774), who in a speech at the opening of the Royal School of Architecture in 1747 condemned the ornate flamboyance of that style. Here, and in his later publications, he called for a return to the classicism of great seventeenth-century architects: Claude Perrault, Nicolas-François Mansart, and Louis Le Vau (see pages 744–749). Applying Enlightenment reason, Blondel demanded that buildings be logical, simple, functional, and symmetrical. They should be constructed with right angles, not curves, and there should be no superfluous ornament. Facades were to reflect interior layout and social use.

Blondel's rationalism was seconded by the influential writer Abbé Marc-Antoine Laugier (1713–1769), who in his *Essay on Architecture* (1753) and *Observations on Architecture* (1765) declared that function, not beauty, must determine the style of a building. Denouncing decorative ornament as well, his theory permitted only columns, architraves, pediments, and walls, all of which were essential and therefore natural. He condemned pilasters, niches, and any nonfunctional wall decora-

tion or shape. Architectural components had to be based on nature, as illustrated by the famous engraving on the frontispiece of his *Essay*: a primitive hut, in essence the first building, consisting of four crude tree trunks dug into the ground in a rectangular configuration, with a gable roof made of twigs. This structure was the primordial forerunner of the Greek post-and-lintel system and the pedimented facade. Laugier's aesthetics also accommodated Gothic architecture, for he viewed its soaring stone columns as logical and natural, like a forest of trees, and he loved its spaciousness and light. Buttressing was structural, thus allowed.

The theoretician who stripped rational architecture down to a bare-bones austerity that pointed to the future was Jean-François de Neufforge (1714–1791), who wrote *Basic Collection of Architecture* (1757–1768). Drawing on antiquity and Palladio but mostly on the British Palladians, his multi-volume treatise was filled with his own designs that reduced architecture to basic geometric forms: cubic houses, bare walls, severe unframed rectangular windows. Although he was otherwise virtually unknown, his treatise became a major source book for the period, one that many French architects owned and from which they lifted ideas.

A second major force for the Classical revival in architecture was Madame de Pompadour, the mistress of Louis XV, who is often identified with the Rococo style (see page 763). Her influence grew in 1746 when Louis XV brought her to Versailles. She immediately had her brother, the future Marquis de Marigny,

appointed director general of buildings. This gave him artistic control over France, since he oversaw all commissions for art and buildings, as well as the art academy. Madame de Pompadour sent him on the Grand Tour with the architect Jacques-Germain Soufflot from 1749 to 1751, providing the marquis with a Classical education that would prepare him to revolutionize French taste. Upon returning, he hired Soufflot to finish Perrault's Louvre (see fig. 21.12), which was literally a ruin and slated for demolition.

ANGE-JACQUES GABRIEL After the completion of the Louvre, the Marquis de Marigny instructed Ange-Jacques Gabriel (1698–1782), the newly appointed first architect to the king, to erect two enormous government buildings on the north side of what is today the Place de la Concorde, where they can still be seen: two huge identical facades framing the Rue Royale. Gabriel had never been to Rome, and for him classicism largely meant seventeenth-century French classicism.

His two buildings are so similar to Perrault's Louvre they almost do not need illustrating; the major differences are that the double columns of Perrault's facade are now single and the center pediment is pushed to either end, creating "bookends" to frame the colonnade.

In addition to a French Classical style, Gabriel also had a Palladian style, which reached its most exquisite pitch in the Petit Trianon, the charming garden house at Versailles that Madame de Pompadour commissioned in 1762. The building is the epitome of simplicity and understatement: It is a cube, with each side equally divided into five bays by Corinthian pilasters. Each bay contains a tall rectangular window with square panes on the main floor and a square window with square panes directly above on the top floor. The Corinthian pilasters support a simple flat entablature, capped in turn by a Classical balustrade. On the back garden facade (fig. 23.20), the pilasters are replaced by columns, which also support an entablature but again no pediment.

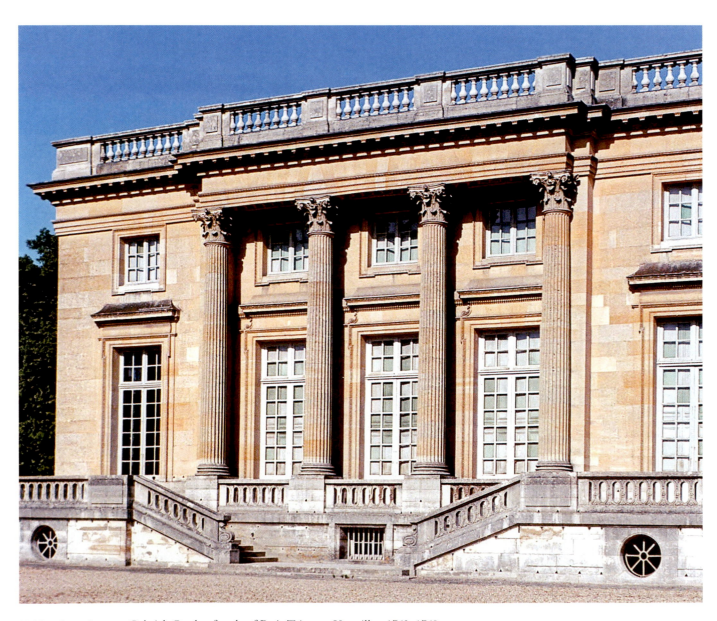

23.20. Ange-Jacques Gabriel. Garden facade of Petit Trianon, Versailles. 1762–1768

JACQUES-GERMAIN SOUFFLOT It was Soufflot (1713–1780), an ardent follower of Blondel, who designed the great rationalist building. Unfortunately, his masterpiece, the church of Sainte-Geneviève (fig. **23.21**) has been so altered, including its name and function, that its current appearance is quite misleading. Marigny assigned the project to Soufflot in 1755. Within two years, the architect completed his original design, which had a clearly stated geometry: an equilateral Greek cross with a six-column portico entrance. The wide square center crossing would have a hemispherical dome (modeled on the Pantheon in Rome) sitting on a drum supported by narrow piers consisting of four triangles, each formed by three columns. Perrault's Louvre was his model. The pedimented section of the Louvre's east facade inspired the portico, and the Louvre colonnade provided the idea for the rows of interior Corinthian columns supporting an entablature. The drum for the dome largely derives from the circular peristyle Perrault used for the dome at the Louvre Chapel. But Soufflot, following Laugier's vision of combining the clarity and grandeur of the Classical with the lightness and space of the Gothic, filled his spacious church with light. Using a daring system of hidden buttresses, he was able to remove the wall mass and open the building with enormous vertical windows.

Unfortunately the clergy and public attacked Soufflot's 1757 plan, and the church was heavily compromised. An apse was added and the transept extended, destroying the perfect symmetry of the first design. To adjust to these new proportions, Soufflot had to increase the size of the dome, with the result that it looks more like Christopher Wren's dome on St. Paul's Cathedral (see fig. 21.22). But the greatest abuses came with the French Revolution. In its ardor to erase religion and honor French heroes, the Directoire government of the new republic in 1793 declared the building a Pantheon to the nation's leaders. To convert the church into a lugubrious mausoleum, the windows were walled in and the interior ornamentation removed. Additional changes well into the nineteenth century destroyed Soufflot's vision.

The Sublime in Neoclassical Architecture: The Austere and the Visionary

French architecture started to move into a new, more austere phase in the 1770s, one less interested in following the rules of the ancients and more preoccupied with reducing architecture to elemental geometric forms that operate on a monumental scale and create a Piranesian sense of awe and power. Among the architects largely responsible for this were Marie-Joseph Peyre, Claude-Nicolas Ledoux, and Étienne-Louis Boullée.

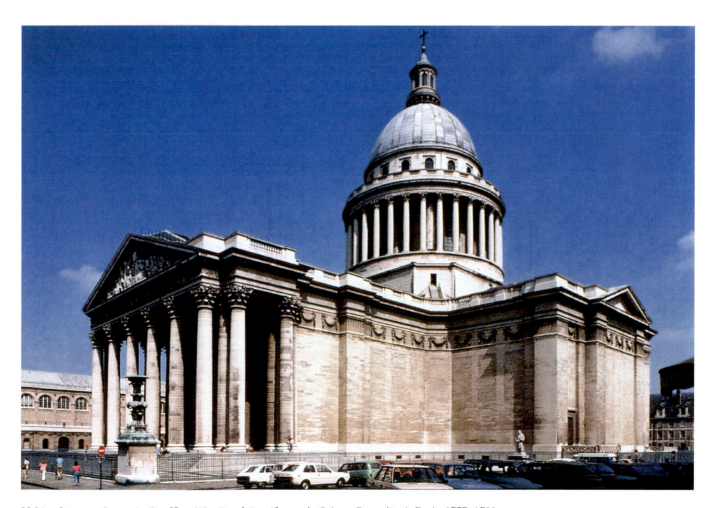

23.21. Jacques-Germain Soufflot. The Panthéon (formerly Sainte-Geneviève), Paris. 1757–1790

MARIE-JOSEPH PEYRE Marie-Joseph Peyre (1730–1785) was a student of Blondel's, and in 1751 he won the Prix de Rome. He met Piranesi and with his new mentor surveyed the baths of Diocletian and Caracalla (see figs. 7.71 and 7.66). This determined the course of his career, for he turned his back on the rules and propriety of Vitruvius and Palladio, and instead dreamed of making monumental, sublime architecture. In 1765, Peyre published *Architectural Works*, which included his plans for ideal buildings and the philosophy behind them. He emphasized the importance of scale and enormous cavernous spaces, especially advocating the use of vaults and domes that reflected the engineering prowess of the Romans. Modern architecture had to aspire to the sublime, to be awesome and grand, and he used the word *sublime* as defined by Burke. Decoration and detail were to be curtailed as the architect instead relied on the monumentality of the Romans to generate powerful emotional responses—shock, fear, awe, reverence, and passion.

Peyre's Théâtre Français (the present-day Théâtre de France, fig. **23.22**), designed from 1767 to 1770 with another likeminded architect, Charles de Wailly, reflects the severity and monumentality that he advocated in his treatise, although it falls a bit short of a sense of the sublime, largely due to the practical restrictions of the commission. Compared with the Classical elegance of Gabriel's Petit Trianon, for example, it seems austere. The building consists of a towering two-story, unpedimented portico. Instead of elegant Corinthian or Ionic columns, Peyre used the harsh, unfluted Tuscan Doric. The only "decoration" is the striations and rustication of the stone. There are no frames around the arched doors and windows, and these openings penetrate deep within the wall, making the wall seem formidable and weighty. Geometry prevails in the form of circles and rectangles, and in the strong horizontals of the entablatures. Peyre's theater is a forceful block of a building, imposing in scale, formidable in its massiveness, and rational in its geometry.

CLAUDE-NICOLAS LEDOUX Even more severe than Peyre's Théâtre Français were the buildings of Claude-Nicolas Ledoux (1736–1806), also a student of Blondel. Ledoux was heavily influenced by Peyre's *Architectural Works*, Piranesi's publications, and Neufforge's *Basic Collection of Architecture*. He had no need of going to Italy. By the mid-1760s he was a fashionable Parisian architect designing many of the most prestigious **hôtels**, as private homes were called, and by the 1770s, he was designing austere Palladian residences. In 1771, Ledoux became inspector of the Royal Salt Mine at Chaux in the Franche-Comté region of southeastern France, designing many of its buildings from 1774 to 1779. The entrance portico to the gatehouse of the salt mine was in the Tuscan Doric style, which meant columns had neither flutes nor base and instead sprang directly from a platform. The wall behind these primitive columns had an enormous primordial arch made of raw, uncut stone. The entrance to the director's house was a colossal hall with unorthodox columns interrupted at regular intervals by thick square blocks, identical to the columns on his Barrière de l'Étoile (Étoile Customs House) in Paris of the following decade (fig. **23.23**), which essentially has the same facade as the director's house, simply extended to all four sides.

At Chaux, Ledoux developed a utopian vision of architecture, one that provided for the needs of employees of every rank. He was heavily influenced by Rousseau's vision of a world without social barriers as well as by the social philosophy of the Enlightenment economic group called the Physiocrats, who advocated an economy operating like a well-oiled machine, which would give workers a respected and essential position. Ideally, he wanted to lay out Chaux in concentric circles, the most important functions symmetrically located in the

23.22. Marie-Joseph Peyre and Charles de Wailly. Facade of the Théâtre Français (Théâtre de l'Odéon), Paris ca. 1778–1782. Designed 1767–1770

23.23. Claude-Nicolas Ledoux. Barrière de l'Étoile (Étoile Customs House), Paris. 1785–1789. Bibliothèque Nationale, Paris. (Now destroyed)

center and the least farthest away. An essential component of the design had the concentric circles of buildings gradually dissolve into the surrounding countryside, thus becoming immersed in nature. Homes were often designed based on the dweller's job. The river authority's house, for example, was an enormous segment of pipe that the Chaux River would have literally run through if the house had actually been built (fig. **23.24**). Hoopmakers would reside in houses shaped like

23.24. Claude-Nicolas Ledoux. House of the River Authority, Ideal City of Chaux. ca. 1785. Bibliothèque National, Paris

wheels. Regardless of the owner's rank, each home had an austere stripped-down geometry that gave it a sense of importance and monumentality worthy of a noble civilization. While Ledoux's visionary architecture romantically conjured up the power and might of long-gone great civilizations, it simultaneously freed itself from the architectural vocabulary of the historical past as it radically reduced buildings to abstract forms, mutating Neoclassicism from a revival of the Classical past to a futuristic vision of purity and perfection.

As with most visionary architecture, Ledoux did not get to implement many of his ideas for Chaux, which were often quite impractical. It is ironic that the one sublime vision he got to effect was for the much-hated tax collectors, who represented an oppressive government, not a utopian one. From 1785 to 1789, Ledoux designed more than 50 tax gates or customs houses for the new 15-mile (24-kilometer) wall surrounding Paris. Each one was different, although like the Barrière de l'Étoile, reproduced here, they were all colossal, austere, and strictly geometric, based on cylinders, cubes, triangles, and circles. Classical proportions and harmony have given way to an exaggerated imposing scale designed to generate a sense of awe-inspiring power.

ÉTIENNE-LOUIS BOULLÉE Ledoux's contemporary Étienne-Louis Boullée (1728–1799) shared his quest to create a monumental architecture using a basically abstract vocabulary. Like Ledoux, he did not go to Italy and took his cue from Piranesi, Neufforge, and Peyre. After a modest career designing relatively severe Palladian hôtels, he retired in 1782 to teach at the Royal Academy of Architecture, which gave him considerable influence over the next generation of architects throughout Europe. He also designed and published visionary structures that were so impractical they could never be built, which he knew. They are important nonetheless because they reflect the growing taste for the sublime that was welling up in France by the 1780s and that could be expressed, if not in real buildings, then at least on paper.

One of Boullée's most famous visions is his design for a tomb for Isaac Newton (fig. **23.25**). Conceived as a 500-foot-high hollow sphere resting in three concentric circles, it was meant to suggest a planet tracking three orbits. The top quarter or so of the orb was perforated with small holes to allow in light, making the ceiling from inside look like a night sky filled with stars. Below lay Newton's cenotaph, dwarfed by the incomprehensible scale of the structure and lost in the low lighting. The dramatic shadows and dark clouds of Boullée's drawing augment the frightening monumentality of his structure and help transform the edifice into an awesome meditation on the power of universal forces and the insignificance of human existence. How ironic that Boullée should conceive of such a sublime building using a rational, geometric vocabulary—and have meant it to honor one of the most logical thinkers of all time.

Painting and Sculpture: Expressing Enlightenment Values

There was no parallel in French painting and sculpture to the swing toward classicism occurring in French architecture in the 1750s and 1760s. Until the 1780s, the Enlightenment emphasis on reason and morality was best presented not by history painting but by the lower stratum of genre painting.

JEAN-BAPTISTE GREUZE One artist alone created a vogue for genre painting, Jean-Baptiste Greuze (1725–1805), and from 1759 until the 1770s his scenes of everyday life were the sensation of the Paris Salons. Greuze emerged from a working-class background in the Lyon region and went to Paris in the mid-1750s to make his mark at the Royal Academy. A wealthy collector sponsored a trip to Italy for him from 1755 to 1759, but Greuze left Paris a genre and portrait painter and returned as one as well.

Nonetheless, he became the rage of Paris with *The Village Bride* (fig. **23.26**), his submission to the Salon of 1761, which shows a Protestant wedding the moment after a father has

23.25. Étienne-Louis Boullée.
Project for a Tomb to Isaac Newton. 1784.
Ink and wash drawing, $15\frac{1}{2} \times 25\frac{1}{2}$″
(39.4 × 64.8 cm). Bibliothèque Nationale, Paris

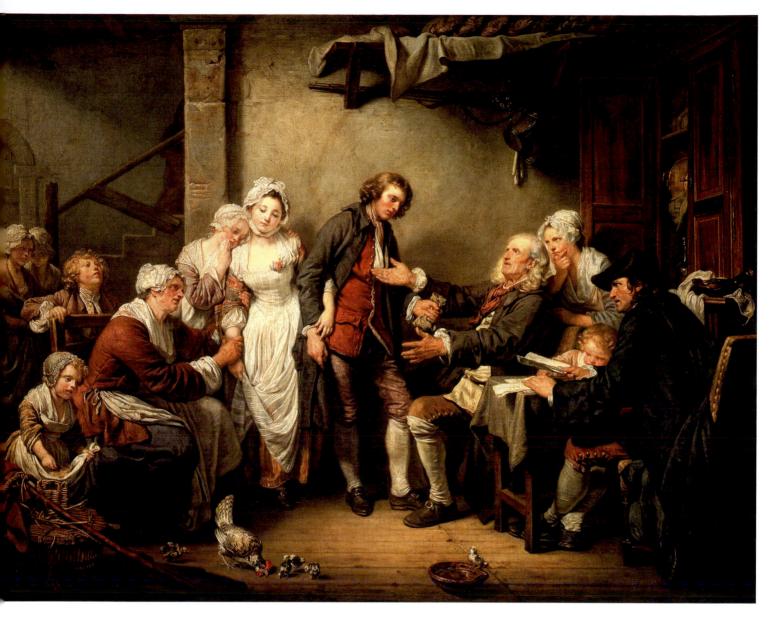

23.26. Jean-Baptiste Greuze. *The Village Bride*, or *The Marriage, The Moment When a Father Gives His Son-in-Law a Dowry*. 1761. Oil on canvas, 36 × 46½″ (91.4 × 118.1 cm). Musée du Louvre, Paris

handed his son-in-law a dowry, dutifully recorded by a notary, seated on the right. The scene seethes with virtue as the various members of this neat, modest, hardworking religious family express familial love, dedication, and respect. Here is the social gospel of Rousseau: The naïve poor, in contrast to the more cultivated, yet immoral aristocracy, are closer to nature and thus full of "natural" virtue and honest sentiment. Greuze draws a parallel between the family of humans and the family of the hen and her chicks, each with one member separated, thus reinforcing this point about the natural instinct of common folk. Critics and public alike raved about the authenticity of the gestures and emotions, comparing them favorably with those of the noble figures by Poussin (see fig. 21.5).

While Greuze was certainly attempting to match the intensity of emotion and gesture found in history painting, he was also inspired by contemporary theater, which accounts for the arrangement of the figures in a *tableau vivant* (a "living paint-

ing," when actors onstage freeze as in a painting to portray a pregnant moment) just when the father is declaiming his poignant speech about the sanctity of marriage.

Greuze was also heavily influenced by his friend Diderot, who championed him in his Salon reviews—often considered the first art criticism—that appeared anonymously in the *Correspondence littéraire*, a paper circulated privately throughout Europe and Russia (see *Primary Source*, page 816). In his painting Greuze perfectly captures Diderot's *drame bourgeois*, the new sentimental theatre this *philosophe* developed in the 1750s that focused on ordinary middle-class people. As important as the bourgeois settings and sentimentality supporting virtue is Diderot's Enlightenment emphasis on logic and naturalism in theater. The dialogue was to be in prose, not verse, and the actors were to be instructed to stay in character and play to each other, not to the audience, which would destroy the illusion of the event. In other words, he wanted the audience to

Denis Diderot (1713–1784)

From *Salon of 1763*, Greuze

Diderot's reviews of the biennial Salons, published in the outlawed newspaper Correspondence littéraire, *are generally considered the beginning of art criticism. The full title of the painting discussed below is* The Paralytic Succoured by His Children, *or* The Fruit of a Good Education, *which was subsequently acquired by Catherine II of Russia, with Diderot acting as intermediary. In a setting similar to* The Village Bride, *Greuze placed in the painting a paralyzed old man being affectionately attended by his large family.*

Now here is the man for my money, this Greuze fellow. Ignoring for the moment his smaller compositions . . . I come at once to his picture *Filial Piety*, which might better have been entitled the *Reward for Providing a Good Upbringing*.

To begin with, I like this genre: it is a painting with a moral. Come, now, you must agree! Don't you think the painter's brush has been employed long enough, and too long, in the portrayal of debauchery and vice? Ought we not to be glad to see it competing at last with dramatic poetry in moving us, instructing us, correcting us, and encouraging us to virtue? Courage, Greuze, my friend; you must go on painting pictures like this one!

forget they were in a theater and be transported to the world of his drama. Likewise, Greuze wanted his viewers to forget the gallery they were standing in as they became immersed in the scene he magically painted.

Largely derived from Dutch and Flemish genre painting and certainly playing to an audience that loved Chardin's illusionism (see page 765), *The Village Bride* is filled with realistic detail, including attention to texture. Even the figures are individualized, rather than portrayed as ideal types. They are so real that when Greuze used them again in later paintings, the public decided it was witnessing the continuation of the story of the same family. As we shall see, Greuze's realism and morality as well as his pregnant *tableau vivant* moment will figure prominently in French Neoclassicism when it emerges some 20 years later.

JEAN-ANTOINE HOUDON The French sculptor who perhaps best exemplifies Enlightenment empiricism is Jean-Antoine Houdon (1741–1828). Both Greuze and Houdon used realism in their works, but Houdon, unlike Greuze, incorporated realism into a facade of Classicism. Son of the concierge at the Royal Academy school and thus literally growing up in the academy, he had little education and ambition, but was extremely hardworking. The elegant, mythological frolics of Clodion (see fig. 22.13) and the complex allegories favored by many French sculptors were foreign to his sensitivity, which at moments were quite scientific. While a pensioner at the French Academy in Rome from 1765 to 1768, Houdon studied realistic Roman portrait busts, and in 1767 he executed in plaster a life-size flayed male torso revealing in detail every muscle of the body while it leans against a support in perfect contrapposto, like Praxiteles' *Hermes* (see fig. 5.61).

As would be expected of such an empirical mentality, Houdon specialized in portraits, and he became the portraitist to the Enlightenment, depicting virtually every major personality, including Diderot, Rousseau, Louis XVI, Catherine II of Russia, and Benjamin Franklin. Houdon's uncanny ability to capture both the look and personality of his sitter is apparent in *Voltaire*

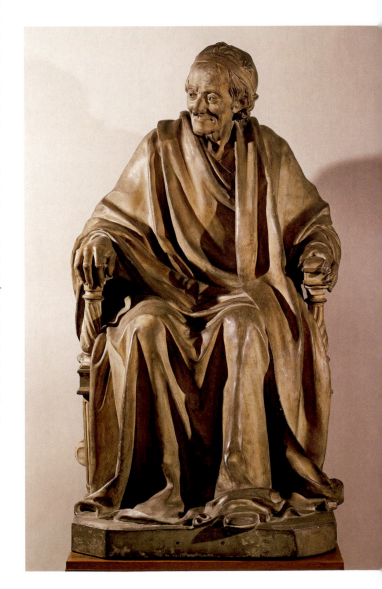

23.27. Jean-Antoine Houdon. *Voltaire Seated*. 1781. Terra-cotta model for marble original, height 47″ (119.3 cm). Institut et Musée Voltaire, Geneva, Switzerland

Seated (fig. **23.27**) here a terra cotta cast from the original plaster, which is lost. The sculptor classicizes his sitter by dressing him in a Roman toga and headband, and seating him in an antique-style chair. The sagging folds of skin on the neck, the sunken toothless mouth, the deep facial wrinkles, and the slumping shoulders mark Voltaire's age and frailty. But Houdon has brilliantly seized the *philosophe*'s sharp intellect and wit: The head is turning and the mouth smiling, and while one hand droops over the arm of the chair, the other grasps it firmly.

Having no American sculptors to turn to, the Virginia legislature chose Houdon in 1785 to sculpt a portrait of *George Washington* (fig. **23.28**). Houdon came to America that year, modeling Washington while staying at Mount Vernon. He presents Washington as a retired general, dressed in uniform, but with his sword removed and hanging from 13 Classical fasces rods, which represent the 13 original states. (A fasces was a symbol of authority carried by ancient Roman magistrates). He leans on a cane in front of a plow, representing his return from military duty to peace and agriculture. His contrapposto pose and noble air give him a Classical aura. Beneath the realistic details of contemporary empiricism we sense the stateliness and high moral purpose of a Classical Greek or Roman senator.

The Climax of Neoclassicism: The Paintings of Jacques-Louis David

The reign of genre painting in Enlightenment France was short, with Greuze's popularity peaking by 1765. The tide began to turn toward history painting in 1774 when Charles-Claude d'Angiviller was appointed director-general of buildings by Louis XVI. It became his personal mission to snuff out what he considered Rococo licentiousness and replace it with moralistic history painting. Beginning in 1777, he regularly commissioned "grand machines," as these enormous oils were called, based on the noble and virtuous deeds of the ancients as well as exemplary moments from French history, which included a number of pictures set in the Middle Ages and Renaissance. The resulting paintings are largely forgotten today, but the project triggered a quest, and even a heated competition, among artists to produce *the* great history painting. The fruit of d'Angiviller's program appeared in the mid-1780s with the emergence of Jacques-Louis David (1748–1825), whose images were so revolutionary they have virtually come to epitomize Neoclassicism, thus simplifying a very complex period and a very complicated term that encompasses much more than David's style

It took David almost two decades to find his artistic voice, his distinctive mature style. He began his studies at the academy school in 1766. He did not win the Rome Prize until 1774, and then studied in Rome from 1775 to 1781. His progress was painfully slow, and he only seemed to find himself in 1780 after copying a painting the year before of a Last Supper by Valentin de Bologne, a French follower of Carravaggio, in the Palazzo Barbarini. De Bologne's powerful naturalism and dramatic lighting, which carved out crisp sculptural figures and objects, triggered something within in him (see *Primary*

ART IN TIME

1734—Voltaire publishes *Philosophical Letters*

1751—Diderot and d'Alembert publish *Encyclopédie*

1774—Ledoux begins Royal Salt Mine at Chaux

1784—David's *Oath of the Horatii*

1789—French Revolution begins

Source, page 816), and in 1781 he submitted to the academy a painting of the Roman general Belisarius that incorporated this new aesthetic world he had just discovered. The work became his academic acceptance piece and garnered him a large following of students. It also won him his first major commission from d'Angiviller.

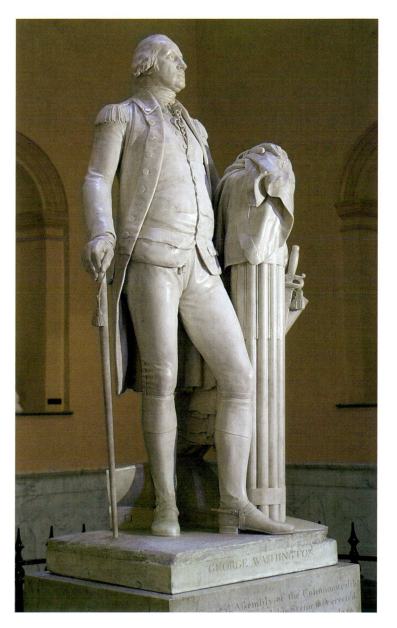

23.28. Jean-Antoine Houdon. *George Washington*. 1788–1792. Marble. Height 6′2″ (1.88 m). Collection of the Commonwealth of Virginia. State Capitol, Richmond, Virginia

ÉTIENNE-JEAN DELÉCLUZE (1781–1863)

From *Louis David, son école et son temps*

In the early 1820s, David related the following to his student Étienne-Jean Delécluze, who published it in his 1855 book on David. Here David describes the impact his 1779 discovery of Caravaggio and the Caravaggisti had on him. He ends his statement, however, by renouncing Caravaggio and embracing Raphael, an attitude that reflects a shift in style in his late work.

When I arrived in Italy, the most striking characteristic of the Italian pictures I saw was the vigor of the color and the shadows. It was the quality most radically opposed to the weakness of French painting; this new relationship between light and dark, this imposing vivacity of modeling, of which I had no idea, impressed me to such an extent that in the early days of my stay in Italy, I thought the whole secret of art consisted in reproducing, as had certain Italian colorists at the end of the sixteenth century, the bold uncompromising modeling that we see in nature . . . I could understand and appreciate nothing but the brutally executed but otherwise commendable pictures of Caravaggio, Ribera, and Valentin who was their pupil. There was something barbarous about my taste, my formation, even my intelligence; I had to get rid of this quality in order to arrive at the state of erudition, or purity, without which one can certainly admire the Stanze of Raphael, but vaguely, without understanding, and without the ability to profit from them.

SOURCE: ANITA BROOKNER, *JACQUES-LOUIS DAVID*. (NEW YORK: HARPER & ROW, 1980)

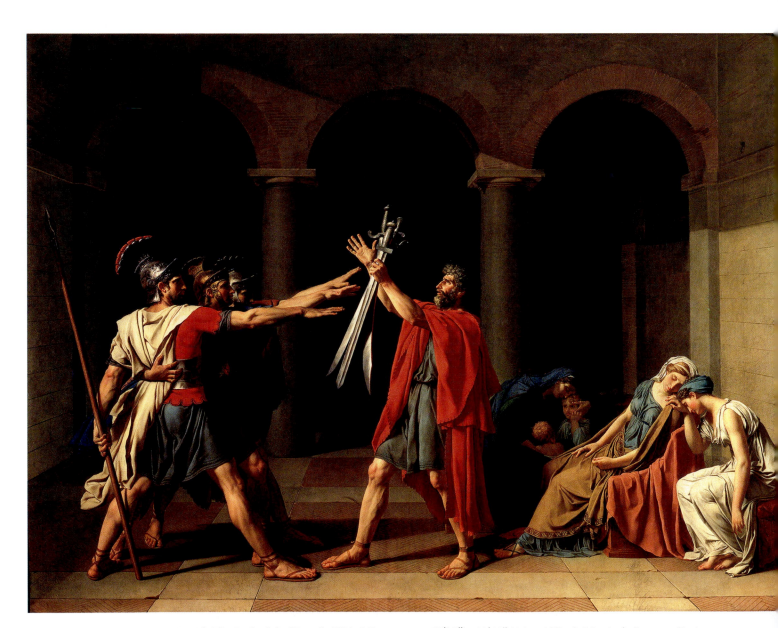

23.29. Jacques-Louis David. *The Oath of the Horatii*. 1784. Oil on canvas, 10′10″ × 13′11″ (3.3 × 4.25 m). Musée du Louvre, Paris

It took David three years to complete d'Angiviller's commission, *The Oath of the Horatii* (fig. **23.29**), and he finished it in Rome in 1783–1784. When David unveiled *The Oath* in his Rome studio, it instantly became an international sensation, with an endless procession of visitors filing through to see this revolutionary work. *The Oath* arrived in Paris from Rome a few days after the opening of 1784 Salon, its delayed grand entrance enhancing the public clamor.

The theme for the picture comes from a Roman seventh-century BCE story found in both Livy and Plutarch recounting how a border dispute between Rome and neighboring Alba was settled by a sword fight by three soldiers from each side. Representing Rome were the three Horatii brothers, and Alba the three Curiatii brothers. Complicating the story, a Horatii sister, Camilla, was engaged to a Curiatii brother, while one of the Horatii brothers was married to a Curiatii sister. Only Horatius of the Horatii brothers survived the violent fight, and David was instructed by d'Angiviller to paint the moment when Horatius returns home and slays his sister after she curses him for killing her fiancé. Instead, David painted a scene that does not appear in the literature: the Horatii, led by their father, taking an oath to fight to the death. The composition is quite simple and striking: David contrasts the virile stoic men, their bodies locked in rigorous determination, with the slack, curvilinear heap of the distressed women, Camilla and the Curiatii wife, who, either way, will lose a brother, husband, or fiancé.

David was undoubtedly inspired by the many oath-taking paintings that had appeared since Gavin Hamilton made an *Oath of Brutu*s in 1764. The dramatic, pregnant moment, which David made one of the hallmarks of Neoclassical history painting, allowed him to create a *tableau vivant* championing noble and virtuous action dedicated to the supreme but necessary sacrifice of putting state before family. The severity of the Horatii's dedication is reinforced by the severity of the composition. It can be seen in the austerity of the shallow space, and even in David's selection of stark, baseless Tuscan Doric columns, which Ledoux had made fashionable in France the decade before. It also appears in the relentless planarity that aligns figures and architecture parallel to the picture plane and in the harsh geometry of the floor, arches, and grouping of the warriors. It surfaces as well in the sharp linear contours of the figures, making them seem as solid and frozen as statues. In this planarity and linearity, David is more "Poussiniste" than his idol Poussin, from whom he borrows figures. Line and geometry, the vehicles of reason, now clearly prevail over the sensual color and brushwork of the Rococo.

But it is the Caravaggesque naturalism and intensity that make this image so powerful and distinguish it from Renaissance and Baroque classicism. Sharpening edges and heightening the drama of the painting is a harsh light that casts precise shadows, an effect derived from Caravaggio (see fig. 19.2), as is the attention to textures and such details as chinks in the floor marble. The picture is startlingly lifelike, with the setting and costumes carefully researched to recreate seventh-century BCE Rome.

While *The Oath* is generally perceived as the quintessential Neoclassical picture, one of several David made that came to define the style, it is filled with undercurrents of Romanticism. It is a horrific scene, one that frightened onlookers, sending chills up their spines. This is not *just* an image of moral resolve and logic, reflecting Cassius who declares in Voltaire's play *Death of Caesar* that "a true republican's only father and sons are virtue, the gods, law, and country." Under the frozen Neoclassical stillness of this scene lies the tension of the bloodbath soon to come. We see this tension in the father's brightly lit fingers, which echo the stridency of the swords. This enormous 13-foot painting is about the impending violence, from which the caregiver in the ominous background shadow tries to shield the children.

David was a rabid revolutionary once the French Revolution began in 1789. He became a powerful figure in the new republic when established in 1792. He was a member of the National Convention and was in charge of artistic affairs, in effect becoming the republic's minister of propaganda. He voted to execute the king, sent the revolutionary leader Georges-Jacques Danton to the guillotine, and successfully closed the academy. He was too busy signing arrest warrants to make much art.

Two major works from the early 1790s are portraits of assassinated revolutionaries and were conceived as pendants. Only one painting survives: *The Death of Marat* (fig. **23.30**), which was exhibited with its mate at the Louvre in May 1793, after which the government declared it would hang in perpetuity in the hall of the National Convention. The picture was propaganda. Marat was a deputy in the National Convention and the editor of a populist newspaper. He was a dedicated revolutionary and a defender of the people. But he was also a ruthless man, who was hated and feared. He was so despised that a counterrevolutionary from Caen, one Charlotte Corday, plunged a knife into his chest while he was writing on a portable desk across his bathtub, where he spent most of his time due to a lethal skin condition that grossly disfigured him.

David, who had visited Marat the day before, shows him expiring in the tub, still holding in one hand the quill with which he defended the French Republic, and in the other the fake petition Corday used to divert his attention before stabbing him. Like *The Oath*, David presented this scene with realism, attention to detail, sharp lighting, and planarity. But now he pushes the image much closer to the picture plane, almost to surface of the canvas, with Marat's writing crate and Corday's blood-stained knife dramatically thrust into the viewer's space and the figure of Marat just inches behind.

To contemporaries, this must have seemed like modern reportage. No matter that it was a propagandistic lie. Marat's bathroom was quite lavish, not the monastic Republican interior seen here, which is so frugal the sheets are patched and a crate is used as a writing surface. Marat was notoriously unattractive, but here he has the physique of a Greek god and a seraphic face. The pose of the slumped arm is unmistakably

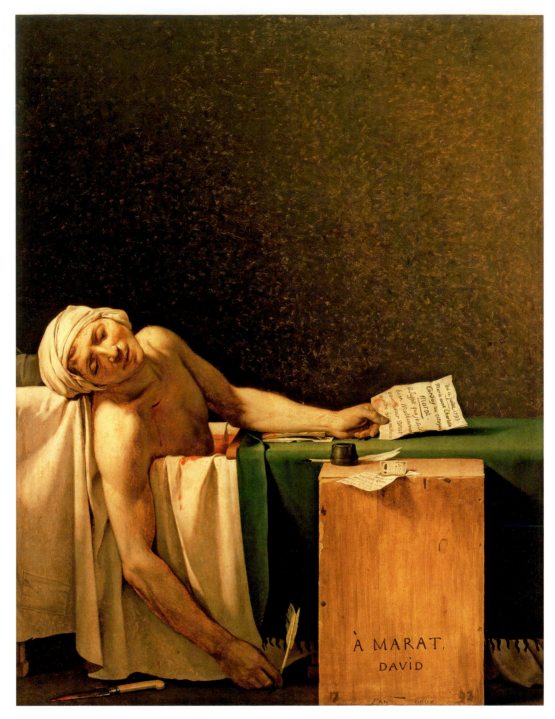

23.30. Jacques-Louis David. *The Death of Marat.* 1793. Oil on canvas, $65 \times 50\frac{1}{2}$ ″ (165.1 × 128.3 cm). Musées Royaux des Beaux-Arts de Belgique, Brussels

that of Christ in a Deposition, Lamentation, or Pietà (see fig. 16.12 and fig. 17.32), and derives from a Pietà by David's student Anne-Louis Girodet made the year before. The sheets recall Christ's shroud. The mundane writing crate is elevated to a time-worn tombstone. Like West in *The Death of General Wolfe* (see fig. 23.7), David appropriated religious iconography for secular glorification. David has also given the picture a personal twist, for on the crate, he has written "À Marat" ("To Marat") with his signature below. Although a commission, the painting was one that David, as a member of the government,

in a sense commissioned from himself, and one that he wanted to make. The dedication certainly makes the picture seem like a personal statement, almost a declaration that the powerful emotions expressed in it are particular to him as much as they are an expression of collective grief. The look of the painting has roots in a long Classical tradition going back to Poussin, Raphael, Caravaggio, and antiquity, but its personal intensity, as we shall see, is not far removed from that of the Romantic era, which is looming just around the corner and will be the subject of Chapter 24.

SUMMARY

In the last half of the eighteenth century, Western culture entered the modern era. People were continually adapting to shifting political values, changing socioeconomic conditions, and new scientific theories. Political rebellions occurred in America and France, gradually shifting power from a hereditary royalty and into the hands of citizens. Evolving philosophical outlooks spurred land reform, scientific discoveries, and technological advancements—and vice versa—resulting in the Industrial Revolution in England that eventually spread worldwide. Society was progressing, and a burgeoning moneyed middle class demanded new luxuries, including art. The roots of these changes can be traced to the Enlightenment, a new method of critical thinking that developed in the eighteenth century. Enlightenment thought brought about the establishment of basic human rights, a new moral order, and modern science. Rationalism ruled, with theories based on experience and observation. Living in the modern world today, we continue to feel the effects of these powerful upheavals.

Art reflected this complex era. Styles old and new mingled and evolved. Traces of the Rococo and Baroque remained as new trends emerged. The dominant style, Neoclassicism, emphasized logic and rationality and often featured moralistic themes borrowed from the ancient Greeks and Romans. Romanticism, a simultaneous thread in art, advocated emotion, imagination, and the supremacy of Nature.

ROME TOWARD 1760: THE FONT OF NEOCLASSICISM

Rome, home to treasures from antiquity and the Renaissance, held sway as the world's art center. The city attracted not only a flood of artists seeking inspiration but also the wealthy traveling on the "Grand Tour" of Italy. Fueled by recent archeological discoveries, notably those of Herculaneum and Pompeii, a renewed interest in antiquity gripped scholars and artists. In his influential writings, art critic Johann Winckelmann encouraged a new appreciation of Greek art by espousing its moral and aesthetic superiority. The austere brushwork of Anton Raphael Mengs, the strong linearity of Pompeo Batoni's portraits, and the dramatic solemnity of Gavin Hamilton's moralistic themes laid the foundations of the Neoclassical style.

ROME TOWARD 1760: THE FONT OF ROMANTICISM

Meanwhile, Romanticism emerged. Printmaker and publisher Giovanni Battista Piranesi celebrated ancient Roman civilization in dramatic *vedute* (views) of awe-inspiring monumental architecture that embodied the *sublime*, a quality associated with vastness, obscurity, power, and infinity that produced feelings of awe, fright, even terror. British statesman Edmund Burke defined the sublime in his treatise *A Philosophical Inquiry into the Origin of Our Ideas of the Sublime and Beautiful*. Piranesi and others increasingly embraced the sublime, reflecting a new audience demand for art that evoked intense emotion, even fright or horror, and that transported them emotionally.

NEOCLASSICISM IN ENGLAND

Antimonarchists and many intellectuals of England, steeped in the Enlightenment, identified with the ancient Romans and emulated that civilization's government, literature, and art. By extension, they invented Neoclassical art. Neoclassicism was only just gaining popularity, however, and several styles or influences often appeared simultaneously in the same work. Many English artists borrowed themes from Greek and Roman art and literature, although not always those with moralistic messages. Angelica Kauffmann's paintings reflect these dichotomies as she vacillated between erotic and virtuous themes, Rococo grace and Neoclassical austerity.

The tradition of contemporary history painting was born during this period as well. With Enlightenment emphasis on the logical, artists like Benjamin West and John Singleton Copley began conceiving convincing ways to show historic contemporary events through the depiction of accurate costumes and settings. West's *The Death of General Wolfe* and Copley's *Watson and the Shark* offer abundant truthful details mixed with Classical poses, calm dignity, and moral overtones—hallmarks of Neoclassical style.

The Classical revival in architecture appeared in England as early as 1715, with the publication of Colen Campbell's treatise *Vitruvius Britannicus,* and eventually spread to America. Campbell espoused the architecture of the ancients and their descendants, notably Antonio Palladio, and the demand for Palladian-inspired country villas exploded. The Classical revival extended to urban planning, as seen in the resort town of Bath, as well as to décor, embodied in the interiors designed by Robert Adam.

EARLY ROMANTICISM IN ENGLAND

In England, the desire of some people for logic and empiricism coexisted with an equally strong urge for emotion and subjective experiences. In architecture and landscape design, Neoclassical evocations of noble antiquity joined with Romanticism's delight in the exotic and the desire to elicit powerful emotions. The British taste for the sublime translated successfully into garden design, where it combined especially well with the interesting variety of the picturesque and the layered meanings of associationism, both concepts fully developed in England. The concurrent Gothic revival also reflected Romantic sensibilities, with its emphasis on the sublime emotions evoked by melancholic spaces. Painters also felt the dual pull of Neoclassicism and Romanticism. George Stubbs and Joseph Wright often fused both trends, whereas Heinrich Fuseli fully adopted sublime terror, carrying us dramatically into the Romantic era.

NEOCLASSICISM IN FRANCE

France experienced a similar reaction to the Enlightenment, and art began shifting from Rococo flamboyance toward Neoclassical rationalism. First seen in architecture, this Classical revival featured austere geometry and monumental scale, characteristic of structures by Marie-Joseph Peyre and Claude-Nicolas Ledoux. French painters and sculptors formulated their own response to the influential mainstream of thought. Jean-Baptiste Greuze's genre paintings, the sensation of the Paris Salons in the 1760s, embodied Enlightenment emphasis on logic and naturalism, while Jean-Antoine Houdon's sculpted portraits show realistic, classicized versions of the sitter. Yet the climax of French Neoclassicism is the moralizing history paintings of Jacques-Louis David, notably his *Oath of the Horatii*. Building on the *tableau vivant* made popular by Greuze, David creates a dramatic composition of noble beauty, but one where the undercurrents of horror reflect a taste for the Romantic as well.

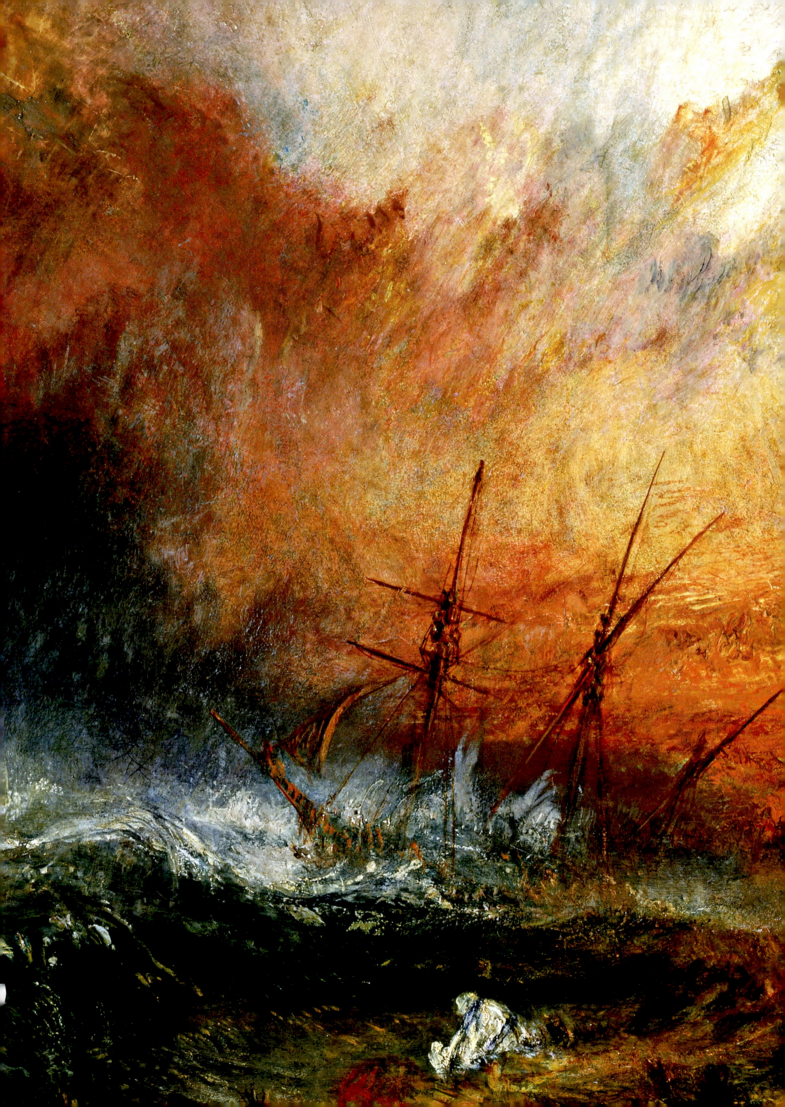

Art in the Age of Romanticism, 1789–1848

THERE IS NO PRECISE MOMENT WHEN NEOCLASSICISM DIED AND Romanticism was born. Just as Neoclassical and Romantic elements—the rational and the emotional—coexisted in the arts of the Enlightenment era (see Chapter 23) from 1750 to 1789 (and sometimes in the same work), Neoclassicism and Romanticism also thrived side by side from 1789 to

1848, the years bracketed by the French Revolution and the European workers' revolts. If rational Neoclassical components prevailed in the earlier period, then emotional, Romantic components did in the later one. No matter how Neoclassical in look or style, a work produced during this later period is still tinted with Romanticism. The word *Romanticism* did not appear until 1798, when the German writer and poet Friedrich von Schlegel (1772–1829) applied it to poetry. The term itself derived from the Gothic novels of such writers as Horace Walpole in England (see page 805), which projected an aura of gloom that became popular in the second half of the eighteenth century. By the end of that century, the Western world began to sense a fundamental transformation in consciousness occurring, a transformation that reached its peak in the first half of the nineteenth century.

This change in consciousness was an indirect result of the upheavals that accompanied the French Revolution, the Napoleonic wars, and the rise of industrialization and urbanization. The Enlightenment seemed to have failed; instead of social reform and progress, there was turmoil and dislocation. The French Revolution may have given rise to republican government, political enfranchisement, nationalism, and public institutions, including museums, but it also threw most of Europe into war by 1792 and resulted in the execution of some 17,000 people

Detail of Figure 24.9, Joseph Mallord William Turner, *The Slave Ship*

under Robespierre's Reign of Terror in 1793–1794. Fearful that Enlightenment reform spawned revolution, European governments cracked down on liberals, instituting a harsh reactionary conservatism. The rise of Napoleon Bonaparte from commander of the army under the Directory to leader of the coup d'état against that body and consul of a provisionary government and eventually to hereditary Emperor in 1804 quashed the French Republic and initiated the Napoleonic Wars, which at their peak saw France occupy most of Europe and lasted until 1815.

The military needs of war hastened the pace of the Industrial Revolution begun in England the previous century, and the return to peace with the defeat of Napoleon in 1815 hardly served as a brake. Waves of people fled the poverty of the countryside for the city to work in manufacturing. This new *proletariat* class, separated from the comforting predictability of the timeless rural world and needing to sell their labor, now experienced oppressive working conditions and subsistence wages, as well as poor housing facilities in cities not designed to accommodate such a dramatic increase in population. The period saw the birth of modern labor and worker-management conflict, which culminated in 1848 with the publication of Karl Marx and Friederick Engels's *Communist Manifesto* and a Europe-wide workers's revolution. The Industrial Revolution also gave rise to a powerful *bourgeoisie*, a wealthy middle class that controlled the means of production and demanded a greater voice in government.

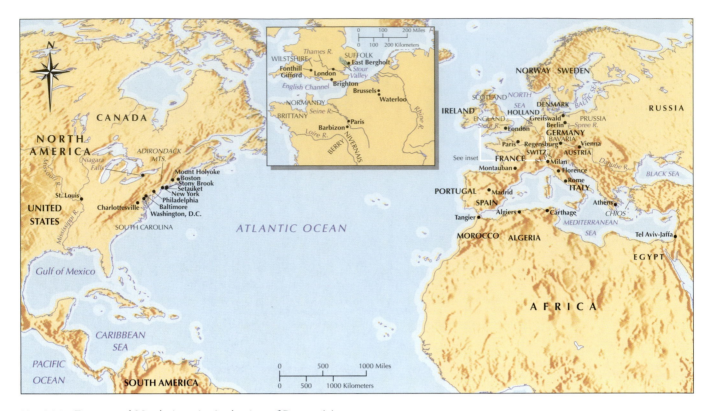

Map 24.1 Europe and North America in the Age of Romanticism

With this seemingly endless succession of crises, the West found a need to believe in something other than the Enlightenment values of logic and scientific empiricism. Thus arose a belief in the subjective emotion of the individual, promoted by Jean-Jacques Rousseau in France and the *Sturm und Drang* movement in Germany (see Chapter 23). What had been a strong undercurrent in the eighteenth century surfaced as the defining psychology of the West by the end of the century. Artists, writers, composers, and intellectuals now placed a premium on powerful emotion, intuition, and unrestrained creative genius. The era itself is often described as being dedicated to the "Cult of the Individual." For the intellectual and cultural elite, total liberation of imagination and creative freedom replaced rules, standards, and logic. As expressed by the French Romantic writer Victor Hugo, "All systems are false; only genius is true." From this perspective, the mind was the conduit of Nature, the only means of accessing elemental universal forces, and the goal of the artist was to tap into this reservoir of higher reality and express it. Sincerity and truthfulness were therefore now critical. Enlightenment morality was not applicable. Powerful emotions in response to violence, suffering, chaos, and ugliness replaced virtuous and noble actions and the perfection associated with ideal beauty. Romanticism produced a cult not only for exotic experiences but also for frightening, horrific, and extreme experiences as well. Uniqueness became a strong value in art; copying someone else's genius, originality, or individualism was the manufacture of something false. Consequently, Romanticism was not a style, but an attitude. It was a license to abandon logic and to follow one's genius wherever it led.

The worlds that Romanticism led to included the distant past—Egypt, Rome, Athens, the Middle Ages, and the Renaissance—as well as the present, where such cultures as Muslim or Native American, because of their "otherness," were considered exotic, primitive, and generally inferior but nonetheless fascinating. Rather than nobility and virtue, the values of the Enlightenment, the Romantic mind immersed itself in cruelty, suffering, and sexual oppression. Nature was among the favorite destinations of genius. It was the font of truth, and at one extreme, artists were enthralled by its awesome universal forces, and at the other, by its magical beauty. For artists who still believed in God in the wake of Enlightenment empiricism, nature was a manifestation of the divine. But for those who did not, or who at least questioned the existence of a supreme being, fear of the permanency of death permeated their art, a particularly modern psychology, not possible in the pre-Enlightenment Christian world.

Powerful emotions also arose from the nationalism consuming Europe, a nationalism that would result in the unification of various political entities into such nations as Germany and Italy in the second half of the century. (see map **24.1**) Instead of a begrudging allegiance to a king or an aristocracy, there was now a powerful bonding of individuals based on shared language and collective experience—yet another emotion with which artists identified and that they used as the foundation for their work. In part driven by nationalism, artists would abandon painting Italianate Classical arcadias and focus instead on the distinctive qualities of their own countryside.

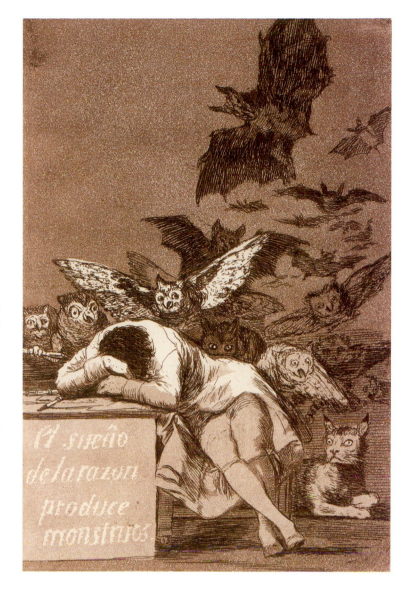

24.1. Francisco Goya. *The Sleep of Reason Produces Monsters*, from *Los Caprichos* (1st edition 1799, plate 43). ca. 1799. Etching, aquatint, drypoint and burrin, $8\frac{7}{8} \times 6''$ (21.5 × 15.2 cm). The Metropolitan Museum of Art, New York. Gift of M. Knoedler & Co., 1918.(18.64(43))

PAINTING

Of all the visual arts painting is most closely associated in our minds with Romanticism because, unlike sculpture and architecture, it allowed for a spontaneous outpouring of emotion. In fact, many art historians think of the study or sketch, whether painted or drawn, as the quintessential Romantic medium. While some of the most famous Romantic paintings are Baroque in their dramatic handling of paint and energetic compositions, Romantic paintings can just as readily be tightly painted and composed in accordance with Neoclassical planes, resulting in frozen images that project chilling emotions.

Spain: Francisco Goya

In the opening decades of the nineteenth century, Spanish art was dominated by Francisco Goya y Lucientes (1746–1828), an artist whose work in many ways encapsulates the new psychology and issues pervading Europe. Charles III (r. 1759–1788) appointed Goya royal painter in 1786, putting him directly in the tradition of Velázquez (see pages 689–693). For Goya, there was not necessarily a conflict between supporting the monarchy and advocating liberal reform. The king recognized the need to bring a stagnant Spain into the eighteenth century and permitted a degree of economic and social development, which gave hope to the progressive forces. Goya was a member of this progressive group. He was an Enlightened Spaniard who admired the French *philosophes*. His social circle, which included many of his aristocratic clients, was like-minded. But the French Revolution terrified heads of state throughout Europe and ushered in reactionary oppression, for now the Enlightenment was associated with revolution, not reform. Both church and state suppressed the liberal reformers. Spain went to war with France, forging an alliance with its old enemy England. On top of these reversals, Goya fell mysteriously ill in 1793, going deaf while barely surviving.

THE SLEEP OF REASON We can get some idea of Goya's reaction the period's crisis by looking at *The Sleep of Reason Produces Monsters* (fig. **24.1**), one of 80 etching-and-aquatint prints from the series *Los Caprichos* (*The Capriccios*), conceived by the artist in 1797 and published at his own expense at a financial loss. Here we see the artist asleep on the geometric block of reason, while behind him rises an ominous disarray of owls and bats, symbols of folly and ignorance, respectively. On the margin of a study for this image, Goya wrote, "The author's . . . intention is to banish harmful beliefs commonly held, and with this work of *caprichos* to perpetuate

the solid testimony of truth." This print introduces the second half of the series, which satirizes a range of sins, superstitions, and ignorance, and is populated with witches, monsters, and demons, in effect showing what the world is like when Enlightenment logic is suspended. But it is just as easy to interpret *The Sleep of Reason* as exposing a second, non-Enlightenment side to Goya's own personality—the emotional and illogical rather than the rational. The clue to this reading is the alert bobcat, a predatory night stalker anchored on the floor. Its feet echo Goya's crossed legs and arms, while its head with pointed ears links it to the owls and bats. Although traditionally a symbol of evil, the cat seems to be both Goya and the monsters behind him. Goya is announcing his right to abandon reason and use his imagination to express his deepest feelings, his innermost psychology—to release his demons and employ whatever stylistic tools and symbols he needs to do so.

ROYAL COMMISSIONS Goya continued to paint for church and state, which, in addition to portraits, is how he earned a living. In 1800, the king commissioned him to paint

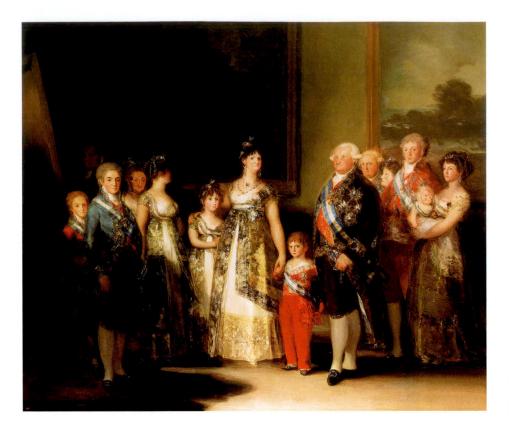

24.2. Francisco Goya. *The Family of Charles IV*. 1800. Oil on canvas, 9'2" × 11' (2.79 × 3.35 m). Museo del Prado, Madrid

The Family of Charles IV (fig. 24.2). This work is hardly a simple documentation of the royal family's likeness. And it certainly is not a grand machine designed to reaffirm the family's divine privilege and superiority, for the painting undermines this traditional premise by exposing their basic humanness, their ordinariness. The key to the picture is knowing that Goya meant it to be compared with Velázquez's *The Maids of Honor* (see fig. 19.38), a picture in the royal collection and

known to everyone at court. In each painting, the artist is present and the royal family appears before a shadowy backdrop of two large oils. In addition, Goya's Queen Maria Luisa (standing in the center) strikes the same pose as Velázquez's *infanta*. Missing in Goya's portrait, however, is the all-important mirror, which in the *Maids of Honor* reveals the royal parents, the keystone that holds the picture together compositionally and thematically because it not only explains the scene

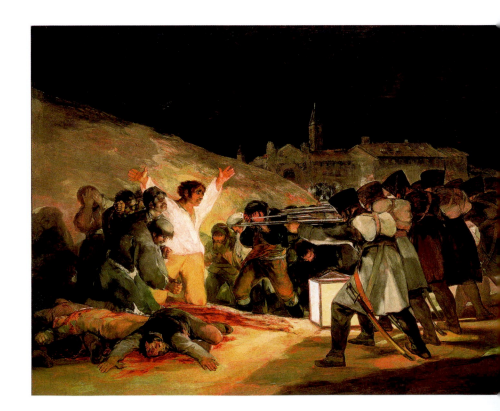

24.3. Francisco Goya. *The Third of May, 1808*. 1814. Oil on canvas, 8'9" × 13'4" (2.67 × 4.06 m). Museo del Prado, Madrid

but also establishes the hierarchical order of the figures. But where is the mirror in *Charles IV*? We must ask another question first, one that is always posed about Goya's picture: What is everyone gaping at so intently? The most likely answer is themselves. They are looking in a mirror—the unaccounted for mirror—and Goya shows himself painting their reflection as they see themselves.

Théophile Gautier, a nineteenth-century French critic, cleverly noted their discomfort when he described the royal couple as looking like "the corner baker and his wife after they have won the lottery." Goya reduces his sitters to human animals, uncomfortable with themselves. Their clothes may be royal, but the family members are as awkward in them as in their false aristocratic poses, which lack the assuredness we saw in royal portraits by Van Dyck and Rigaud (see figs. 20.8 and 21.10). The figures appear lonely, isolated, even afraid. Goya presents each one as an individual, plagued by the same doubts about the meaning of existence and the same sense of alienation that haunt all humans. This Romantic sense of awe when confronting the infinite is Goya's creation, superimposed onto the royal family. The Enlightenment and the French Revolution denied the presence of God, which meant the meaning of existence is unknowable and beyond comprehension. This shockingly modern psychology casts a dark shadow over the room. Surprisingly, Charles IV did not reject the portrait, although he did not like it either.

Goya covered the canvas with some of the most flamboyant brushwork in the history of art (difficult to see in reproduction), even outdoing Veláquez in its Baroque bravura. The dynamic paint handling animates the surface, sparkling and dazzling, especially as seen in the clothes, jewelry, and medals, obviously blinding the royal family to the truths lying beneath the surface.

An even more powerful mood of futility pervades Goya's *The Third of May, 1808* (fig. **24.3**), painted in 1814 and one of many paintings, drawings, and prints the artist made from 1810 to 1815 in response to the French occupation of Spain in 1808. The corruption of his administration forced Charles IV to abdicate in 1807. He was replaced by his son Ferdinand VII, who was deposed in 1808 when Napoleon's troops marched into Madrid and put the emperor's brother, Joseph Bonaparte, on the throne. Enlightened Spain was initially optimistic that the Enlightened French would reform their nation. But in Madrid a people's uprising spurred by nationalism resulted in vicious fighting and wholesale slaughter on both sides, within days fanning out across the entire country and then dragging on for six years. Goya's enormous, dramatic picture, painted after Napoleon had been deposed and Ferdinand reinstated, shows the mass execution of Spanish rebels that took place on May 3, 1808, on a hill outside Madrid.

How different from Neoclassical history painting that presented great and famous exemplars of nobleness, morality, and fortitude! Goya presents anonymous nobodies caught up in the powerful forces of history. Here we see the mechanical process of the slaughter. One rebel with raised arms, dressed in the yellow and white colors of the papacy, has the pose of Christ in the Garden of Gethsemane when he was surprised by Roman soldiers. His right hand has a wound suggesting the stigmata. But ironically Goya denies the rioters status as martyrs. They are consumed by the fear of death, not the ecstasy of sacrifice. No divine light materializes to resurrect them, and the church in the background of this imaginary scene remains dark. When the stable lantern—which in its geometry and light could be construed as an emblem of Enlightenment logic and progress—is extinguished, there will be only eternal night, symbolized by the inert foreground body, whose face is reduced to a gory mass of paint. The faceless executioners, also small cogs in the wheel of history, are indifferent to their victims' fear of death and frantic pleas for mercy.

Goya painted *The Third of May, 1808* at a time when he was desperate for work and wanted to gain royal favor with this picture, hence his scripting it so it could be read as being about the sacrifice of the Spanish to the agents of political tyranny. But the real themes of the image are the anonymity of death and the senseless brutality of war. Its power lies in its ability to instill in a viewer an intense sense of terror that makes one confront the inescapable knowledge of one's own mortality.

THE BLACK PAINTINGS Increasingly, in true Romantic fashion, Goya made pictures for himself, working out in paint his own emotions in a way that few had done before. Among his most famous pictures are the "Black Paintings," painted directly on the wall of his farmhouse just outside of Madrid, a clear sign they were personal works never to be sold. Image after image is dark, bleak, frightening, or horrifying, probably reflecting Goya's depression after recovering from an illness as well as his disappointment at the failures of the Enlightenment and the basic irrationality of civilization. We have no idea if Goya had titles for the pictures or what their subjects are, which means it is unlikely that the work generally described as *Saturn Devouring One of His Children* (fig. **24.4**) actually represents this scene from Classical mythology. We see none of the attributes usually associated with Saturn, and the child does not look like a child. In some respects, the painting does not need a title—it speaks for itself in its horror, irrationality, and madness. Contributing to the power and effectiveness of the image is the expressiveness of the brushwork; Goya virtually separates paint and color from what they represent in order to allow them a life all their own, one that reflects his own innermost emotions while supporting the theme. The intensity of paint application—the strident burst of red here and highlighted bright brown there—makes the picture explode with raw energy. Arms and legs are atrophied and contorted, virtually reduced to rubbery bone, as darkness seems to consume them. Here we witness the "Sleep of Reason" writ large.

England: Spiritual Intensity and the Bond with Nature

The road taken by Goya into a fantasy world that allowed his imagination and passions to go wild was most closely followed in England by William Blake. However, many English painters during the Romantic era followed the lead of such poets as William Wordsworth (1770–1850) and Percy Bysshe Shelley (1792–1822) and steeped themselves in Nature,

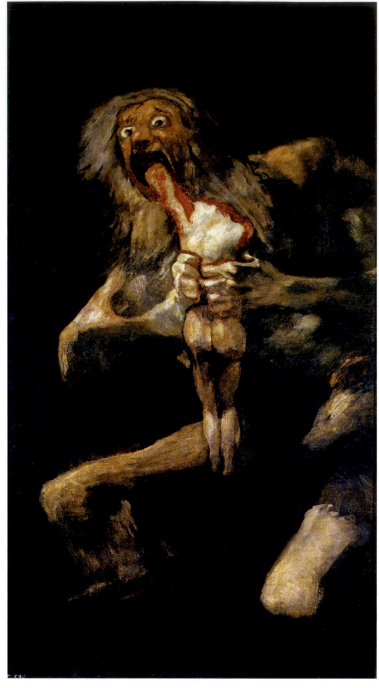

24.4. Franciso Goya. *Untitled* (*Saturn Devouring One of His Children*). ca. 1819–1823. Detached fresco mounted on canvas, 57$\frac{1}{8}$″ × 32$\frac{5}{8}$″ (145 × 82.9 cm). Museo del Prado, Madrid

emotionally swept away by its beauties and moods or awed by its sublime power and intimations of the infinite.

WILLIAM BLAKE Across the English Channel in London, the artist William Blake (1757–1827) was also retreating into a personal visual world as he responded to issues very similar to those affecting Goya. Blake was an ardent admirer of Jean-Jacques Rousseau and his theories about the inherent goodness of humans, who are born primitive savages, and then become corrupted by the restrictive artificialities of society. He detested European civilization for its rules and conventions, which he felt hindered personal freedom and also equality for women.

He loathed European materialism and the lack of spirituality, and condemned institutional religion for being as autocratic as government and society in general. His passion to find spiritual truths in a physical world led him to flirt with fringe religions in the 1780s. He began his career as an artisan engraver. He then enrolled in the Royal Academy in 1779 but left within a year, declaring its president, Joshua Reynolds, and the institution itself a microcosm of society, repressing imagination, creativity, and progress. In effect, he was largely self-taught. While never a recluse, Blake was quite insular, functioning on the edge of society. He did not show at the academy after the mid-1780s and received virtually no critical notice throughout his career.

Despite his intense dislike of the academy, Blake was a proponent of history painting, which he saw as a vehicle for reforming society. However, he shunned oil painting, which he associated with the artificial hierarchies of the academy, and instead turned to medieval manuscript illumination for inspiration, producing his own illustrated books designed to evoke the same kind of spirituality found in his model. Blake began his career as a poet, garnering an impressive reputation. In the late 1780s, he started publishing his own poems, which praised nature, freedom, youth, and imagination while denouncing the corruption of all components of civilization, a corruption stemming from an overreliance on reason. Toward 1793–1794, Blake spiraled into a deep depression, triggered by the violence and chaos of the French Revolution, England's declaration of war on France, and the repressive policies that British Prime Minister William Pitt instituted in response to the radical phase of the French Revolution. Like Goya, Blake was witnessing the failure of the Enlightenment.

At this point the images began to dominate the poetry in Blake's books. Simultaneously, his art reached maturity in twelve unusually large color prints made mostly in 1795, such as *The Lazar House* (fig. **24.5**). These works were never bound and presented in book form, so we do not know for sure the order in which they were meant to be seen or how Blake intended to use them. (See *Materials and Techniques*, page 827.) However, all of the prints relate to his vision of the early history of the world, in which humans, when born, are still attached to the infinite from which they have just come, and are morally good, free, and filled with imagination. As they age, they are ruled by reason, lose their freedom and morality, and become consumed by materialism, thus trapped in the finite. The subjects for this series are not all invented, some coming instead from Shakespeare, Milton, and the Bible, which, as we have discussed (see page 807), were favorite sources of the period for sublime imagery. Blake appropriated these themes because they could be integrated into his own philosophical system and thus support it. *Lazar House* comes from the eleventh book of Milton's *Paradise Lost*, where the angel Michael makes Adam look into the future and confront the consequences of his sin— mortality in its various forms, from the first death by violence (Abel murdered by his brother Cain) to death by disease in a lazar house, a hospice for the sick and dying. In Blake's representation of the lazar house, we see a fantastically bearded Death holding a scroll that probably represents law, the repres-

Blake's Printing Process

For the series of twelve prints that included *The Lazar House* (see fig. 24.5), William Blake invented a process that is similar to **monotype**, a printing technique that would become popular by the end of the nineteenth century but was rarely used earlier. Monotype involves painting an image on one surface and then pressing paper against this wet surface to attain a counterimage, which unlike the original has a mottled, softer looking surface. As the word *monotype* implies, generally only one impression is taken. However, a few impressions can be obtained before all of the original paint is consumed, with each image lighter than the previous.

Blake's process for the series that included *The Lazar House* was to first outline his image in black paint on a piece of millboard (a thick paperboard), often adding a small amount of modeling and details as well. He would pull roughly three paper impressions from the millboard, using low pressure so as not to extract too much paint at one time. This would produce a simple black design without color. To finish his image he would paint the millboard again but with colors, and then press it on top of the pulled impressions with the black design. He then touched up the works with watercolor. Blake is said to have used oil paint for his printing, but considering his distaste for the medium he most likely used an egg-based tempera.

sive instrument of reason, while the slumped jailer on the right, who appears in previous books by Blake, represents spiritual absence and evil.

Since the mid-1770s, Blake had been influenced by Michelangelo and the Mannerists as well as by medieval art, and the presence of all can be detected in this picture though transformed by Blake's own style. We see Michelangelo's overstated musculature (see fig. 16.21), as well as the curvilinear line of manuscript illumination (see fig. 10.9). The absence of an environmental setting and the emphasis on figures alone, as well as the selection of a sublime, horrifying situation derives from Fuseli (see figs. 23.18, 23.19), whom Blake greatly admired and periodically tried to befriend, without success.

The degree to which Blake mentally immersed himself in his fictitious worlds is remarkable. He claimed his visions were revealed to him by spirits: "I am under the direction of Messengers from heaven, Daily and Nightly." While we have to take this statement with a grain of salt, nonetheless, his art was not naturalistic (a faithful representation of reality), but a conceptual fantasy world for playing out his passionate moral beliefs, historical views, and vision of a utopian future. Objects are relatively flat, with space kept to a minimum, an artistic strategy that reinforces the ideal concepts behind his images.

JOHN CONSTABLE Landscape gradually became a major vehicle for the period's search for the truth. This is not surprising considering the importance of nature in Romantic ideology—the need to bond with Nature and to express its essence as personally experienced. John Constable (1776–1837) is one of two British artists who stand out in the period for their landscapes. Constable was born and raised in the village of East Bergholt, in the Stour Valley of Suffolk, and spent most of his life painting this rich farmland, which until then had been considered too ordinary and thus not suitable subject matter. Instead of working at the family's prosperous farm and mill, Constable, in 1799, was permitted to study at the Royal Academy School in London. He eventually realized that he was just

learning to replicate painting conventions, and returned to Bergholt to make "laborious studies from nature," drawings and oil sketches that he worked up into finished pictures in the studio but that retained the freshness and details of the original source. Constable even considered landscape scientific: "Painting is a science, and should be pursued as an inquiry into the laws of nature. Why, then, may not landscape painting be considered as a branch of natural philosophy, of which pictures are but experiments?" Constable was especially adept at capturing the ephemeral properties of Nature—clouds, light, and atmosphere. He made countless studies of just the sky, "the key note, standard scale, and chief organ of sentiment."

Constable's pictures are packed with the emotion that welled within him when experiencing the beauty of the Stour Valley—"Painting is but another word for feeling," he claimed.

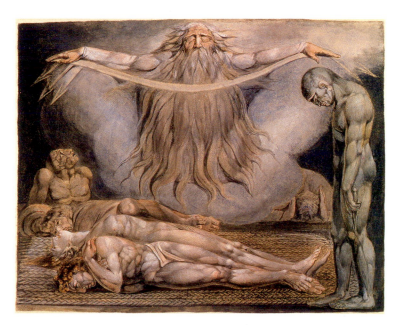

24.5. William Blake. *The Lazar House (The House of Death)*. 1795. Color print. 17 × 21″ (48.5 × 61 cm). This print illustrates lines from Book XI of Milton's poem , *Paradise Lost*. London, Tate Gallery

John Constable (1776–1837)

From a letter to John Fisher

Fisher, the archdeacon of Salisbury Cathedral, was a lifelong friend of the artist. This letter of October 23, 1821, reflects Constable's sensitivity to the beauties of the English landscape.

How much I wish I had been with you on your fishing excursion in the New Forest! What river can it be? But the sound of water escaping from mill-dams, etc., willows, old rotten planks, slimy posts, and brickwork, I love such things. Shakespeare could make everything poetical; he tells us of poor Tom's haunts among "sheep cotes and mills." As long as I do paint, I shall never cease to paint such places. They have always been my delight, and I should indeed have been delighted in seeing what you describe, and in your company, "in the company of a man to whom nature does not spread her volume in vain." Still I should paint my own places best; painting is with me but another word for feeling, and I associate "my careless boyhood" with all that lies on the banks of the Stour; those scenes made me a painter, and I am grateful; that is, I had often thought of pictures of them before I ever touched a pencil.

SOURCE: CHARLES ROBERT LESSLIE, *MEMOIRS OF THE LIFE OF JOHN CONSTABLE.* ED. J. MAYNE. (LONDON: PHAIDON PRESS, 1951)

(See *Primary Source*, above.) His pictures were both scientific and subjective, as in *The Haywain* (*Landscape: Noon*) (fig. **24.6**) of 1821, shown at the Royal Academy, where he had been exhibiting since 1811. We sense a blue sky pushing out darker clouds, and an atmosphere of moisture that makes everything glisten. Vibrant flecks of paint and color dissolve the material world and make the atmosphere sparkle. The sky is a symphony of subjectivity, presenting a range of emotion, as does the land as well. It can be dark and undulating, as in the dramatic, energized twisting of tree branches, or bright and placid, as in the horizontal spread of the distant hayfield. Constable fills his picture with detailed anecdote; besides the haywain, there is the dog, the boat, the harvesters in the distant field, and the puffs of smoke coming from the mill. This is no perfect world, representing ideal beauty or a Classical Arcadia. Rather it is a particular site presented in all of its heart-felt specificity.

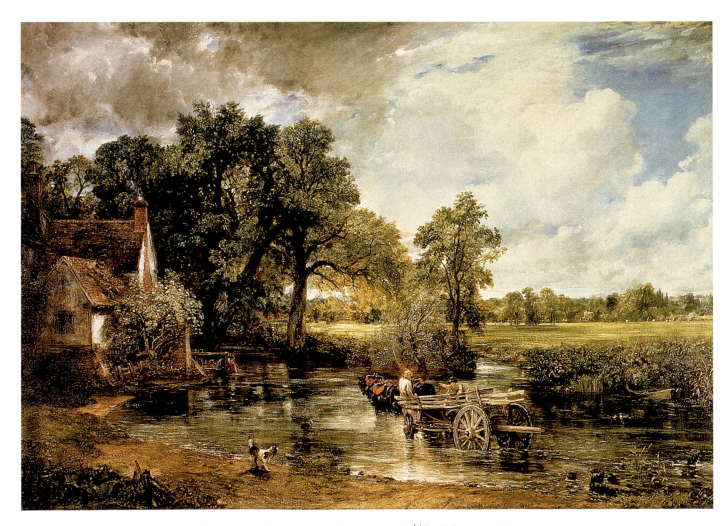

24.6. John Constable. *The Haywain* (*Landscape: Noon*). 1821. Oil on canvas, 51$\frac{1}{4}$" ×73" (1.3 × 1.85 m). The National Gallery, London. Reproduced by Courtesy of the Trustees

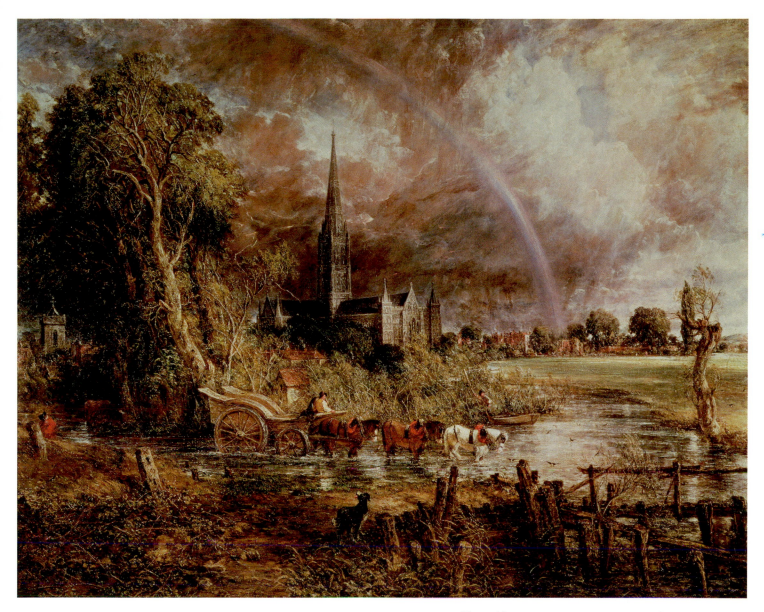

24.7. John Constable. *Salisbury Cathedral from the Meadows*. 1829–1834. Oil on canvas, $59\frac{3}{4} \times 74\frac{1}{4}$" (151.8 × 189.9 cm). Private Collection, on Loan to the National Gallery, London

The 6-foot canvas—an unusually large size for a genre painting and a controversial strategy for elevating landscape to a higher status as well as an attempt to gain attention—was based on numerous outdoor studies, mostly from 1814 to 1816, and developed into this large presentation format in the artist's London studio, where he worked in the winter. Typical of his Stour pictures, life in *The Haywain* moves slowly, with rural laborers routinely doing what they have done for millennia and in blissful harmony with Nature. This was a period of social and economic unrest in the British agricultural community, putting tremendous financial pressure on the Constable property, then run by the artist's brother. This labor crisis is absent from Constable's poetic picture, which instead focuses on personal attachment to the land and the life the artist knew as a boy.

Constable's landscapes grew darker and more turbulent during the course of the 1820s as family sicknesses and a lack of professional success sent him into periodic depression. Subjective poetry began to outweigh empirical observation. This mood reached a climax with *Salisbury Cathedral from the Meadows* (fig. **24.7**), begun in 1829, a year after his wife died. When the painting was exhibited at the academy in 1831 (it was reworked afterward), Constable attached several lines from *The Seasons,* James Thomson's Romantic poem celebrating the rural life, which reveal that the rainbow represents hope after the death of a young woman in the arms of her lover. The impassioned drama and how it is accomplished is evident, with trees, water, and sky reaching a feverish pitch, whipped up by bold, agitated brushwork—paint is even slathered on with a palette knife—and the harsh conflict of lights and darks. The huge ash tree on the left can be seen as a symbol of life, while the tomb on the farther left is death. Salisbury Cathedral, with its steeple reaching high into a clear spot in the sky, is the most stable element in the composition and an emblem for faith and resurrection. Constable added the rainbow last, inspired by the rainbow in a version of Jacob Ruisdael's *The Jewish Cemetery* (see fig. 20.29). But Constable's is not a Classical painting of dry allegorical symbols. It is a passionate display of deep-seated

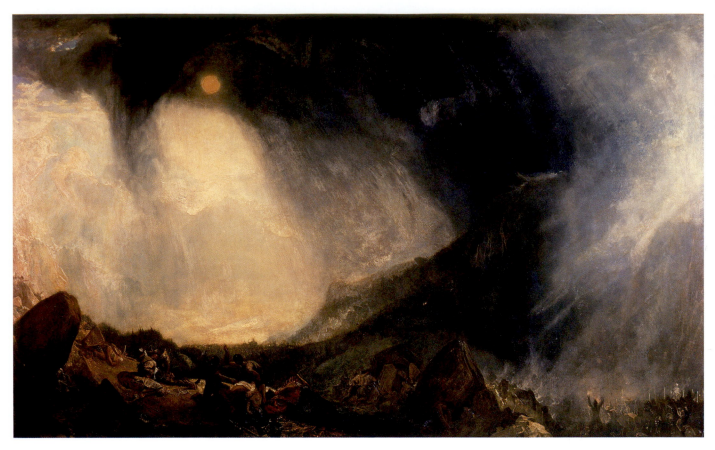

24.8. Joseph Mallord William Turner. *Snowstorm: Hannibal and His Army Crossing the Alps*. 1812. Oil on canvas, 57 × 93″ (144.8 × 236.2 cm). Tate Gallery, London

emotion that stems from extremely personal issues, far removed from the more literal world of the seventeenth-century Dutch painters (see fig. 20.28) or the Classical vision of Claude Lorrain (see fig. 21.8).

JOSEPH MALLORD WILLIAM TURNER The second major British landscape artist in this period is Joseph Mallord William Turner (1775–1851). In their basic operating premises Constable and Turner could not be further apart. Whereas Constable painted with scientific accuracy the land he intimately knew, Turner aspired to rival great history painting and consequently invested his views with a rich overlay of historical motifs, references to the Old Masters, and metaphorical themes. Constable was drifting into territory dominated by Turner when his landscapes became increasingly cataclysmic, symbolic, and metaphorical, in effect aspiring to a complexity generally associated with history painting. He was also touching on the sublime, as defined by Burke, when he portrayed powerful, uncontrollable natural forces. This is turf that Turner had staked out in the closing decade of the previous century.

Turner began his career in the early 1790s as a for-hire topographical watercolorist, and by 1799, at the unheard age of 24, he became an associate of the Royal Academy. While he made numerous landscape studies of specific rural scenes as Constable did of Stour, his drive to artistic greatness led him to take on the great landscape and marine painters of the past—Claude

Lorrain and Jacob Ruisdael—whose works his landscapes resemble in composition, subject, and atmosphere. The reason for this mimicry was to outdo them at their own game; his sun was brighter, atmosphere moister, haze hazier, and perspectival space deeper. Like Constable, his handling of the intangible properties of nature—wind, light, reflections, atmosphere—was magical.

Turner's quest for the grandiose and his rich imagination led him to embed spectacular mythological and historical moments in his landscapes, creating historical landscape on an epic, sublime scale. *Snowstorm: Hannibal and His Army Crossing the Alps* (fig. **24.8**) of 1812 is one of his best-known historical landscapes, a genre he had developed by the late 1790s. In this work the Carthaginian general Hannibal leads his troops across the French Alps in 218 BCE to launch a surprise attack on the Romans during the Punic Wars. A human sea of turmoil reigns in the valley below as Hannibal's troops plunder the alpine villages for desperately needed supplies. Above, the cataclysmic forces of nature—a wild snowstorm, turbulent wind, crashing storm clouds, and a blinding light from an ominous sun—threaten to engulf the insignificant figures below, too preoccupied with their immediate survival to notice. The great Hannibal is barely present, reduced to a speck on an elephant in the background.

During the Napoleonic Wars, Turner made several pictures about Carthage, with which, as a great maritime empire, the British identified. In *Snowstorm*, however, the reference is

probably to Napoleon's 1800 march across the Alps to invade Italy. However, it probably does not matter if the reference is to France or England, for the theme of the work is the folly of empire, and imperial expansion was a hotly debated issue in both France and England at the time. The picture is also about the folly of existence. When Turner exhibited *Snowstorm* at the Royal Academy, he accompanied it with several lines from his unfinished poem "The Fallacies of Hope," which moralized about the plundering and ultimate defeat of Hannibal's army. This picture, like his later Carthage paintings, including the 1817 *Decline of the Carthaginian Empire*, is not meant to glorify or condemn human activity. Instead it is designed to put human activity and civilization into a grander cosmic scheme, in which they appear insignificant compared to the relentless, uncontrollable power of sublime universal forces. Turner's goal is the Romantic notion of making a viewer feel Nature's unfathomable enormity, not to reproduce a landscape (although the painting is based on studies he made in the Alps). Consequently an atmospheric haze shrouds the insignificant figures and a dramatically receding vortex ends in a blaze of eternal light. With Turner, Edmund Burke's idea of the sublime reaches a terrifying pitch. But more horrifying than the sheer power of Nature are "the fallacies of hope," the Romantic notion that the infinity of the universe is unknown territory and that death could be permanent, a modern psychology we have already seen in Goya.

The direct experience of Nature becomes stronger in Turner's late work. Now the image begins to disappear, replaced by an atmospheric blur of paint and color that seems to sit on the surface of the canvas, making the viewer feel immersed in it. Today, Turner is best known for his late abstract style, which he developed toward 1838 and is seen in *The Slave Ship* or *Slavers Throwing Overboard the Dead and Dying—Typhoon Coming On* (fig. **24.9**) of 1840. These late works were condemned in Turner's own time. His contemporaries thought he had gone mad, for they found the works virtually unreadable, and certainly unintelligible. Furthermore, his epic stories were no longer coming from mythology or history but from seemingly minor contemporary events. His earlier work may have been atmospheric, but there was always enough drawing to suggest precise objects and legible spatial recession and relationships, as we see in *Snowstorm*. Later this readability evaporates in a haze of color and paint that represents the essence of mist, light, and atmosphere.

The Slave Ship shows the sick and dying human cargo thrown into the sea during a typhoon. Turner, like Constable, was inspired by James Thomson's *The Seasons*, where the poet describes how sharks follow a slave ship during a typhoon, "lured by the scent of steaming crowds, or rank disease, and death." Turner was also influenced by a recent newspaper account of a ship's captain who jettisoned slaves in order to collect insurance, which paid for cargo lost at sea but not for death

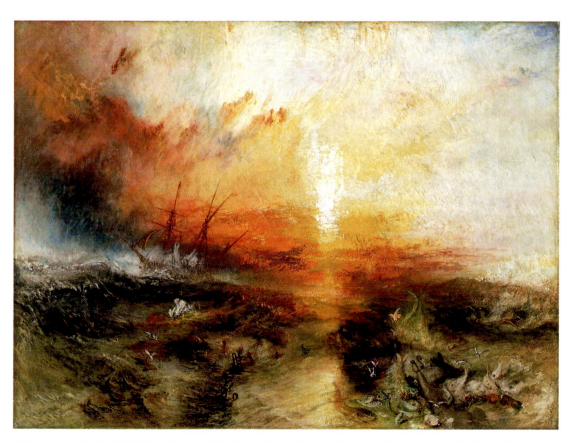

24.9. Joseph Mallord William Turner. *The Slave Ship* or *Slavers Throwing Overboard the Dead and Dying—Typhoon Coming On*. 1840. Oil on canvas, 35¹/₄ × 48″ (90.8 × 122.6 cm). Museum of Fine Arts, Boston. Henry Lillie Pierce Fund, Purchase. 99.22

from illness. Turner gives us a close-up of human suffering. Outstretched hands pleading for help, a leg about to disappear into the deep for a last time, the gruesome blackness of flailing chains and manacles, the frenzied predatory fish, and bloodstained water all dominate the immediate foreground. In the background is the slave ship, heading into the fury of the typhoon and its own struggle for survival, its distance and silence a metaphor for the callous indifference of the slavers. The searing brilliance of the sun bathes the sky in a blood-red aura, its seemingly infinite reach complementing the omnipotence of the raging sea.

This is a tragic, horrific scene, made a few years after Britain banned the slave trade. Turner certainly makes us feel the callous inhumanity of the slavers, encouraging us to despise them. And yet, the picture has a haunting thematic and moral ambiguity: Birds eat fish and human carcasses, fish feed on other fish and discarded slaves, and slavers fight for their lives in the face of a storm. The picture is as much about the struggle of daily life and the role of fate as it is about the immorality of the slavers, the only constant being the frightening power of Nature.

Germany: Friedrich's Pantheistic Landscape

Human destiny is treated with a chilling bleakness and unsettling silence in the sublime landscapes of the German artist Caspar David Friedrich (1774–1840). His mature pictures were so radical in their rejection of narrative history painting that they received little acclaim during his lifetime, although he had a small coterie of admirers who bought them. While Turner focuses on the insignificance of all life and endeavors in the face of the all-powerful cosmos, Friedrich's concern is the passage from the physical way station of earth to the spiritual being of eternity. His landscapes are virtually pantheistic, an especially German phenomenon, and he invests his detailed, realistic scenes with metaphysical properties that give them an aura of divine presence.

Friedrich was born into a prosperous bourgeois family of candle and soap manufacturers in the Baltic-coast harbor town of Greifswald, then part of Sweden. Here he found the austere landscape that served as the source material for his drawings, which formed the foundation of many of his paintings. He studied drawing at the Academy of Copenhagen from 1794 to 1797 and then continued his training in Dresden, where he would maintain a studio throughout his life. Until 1807, he worked exclusively in drawing, shunning historical themes and instead making topographical landscapes, including many of the Baltic region. His paintings would retain the hard linear draftsmanship he developed in these years.

Gradually, his landscape drawings became metaphorical, often presented in pairs with cyclical themes, such as the times of the day or the seasons. He continued this practice in his early paintings, which include *Monk by the Sea* (fig. **24.10**), which was paired with *Abbey in an Oak Forest* (fig. **24.11**), made in 1809–1810. The former, which would be hung on the left and read first, pits the small vertical figure of a standing monk against the vastness of an overwhelming explosive sky in a

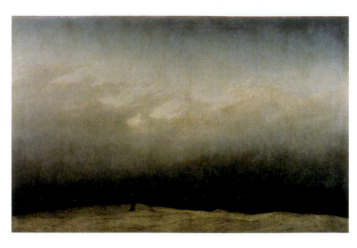

24.10. Caspar David Friedrich. *Monk by the Sea*. 1809–1810. Oil on canvas, 42$\frac{1}{2}$ × 67″ (1.08 × 1.70 m). Nationalgalerie, Staatliche Museen zu Berlin

landscape so barren and abstract that the beach, sea, and sky are virtually reduced to vague horizontal bands. Traditionally, art historians interpret the funeral depicted in *Abbey* as that of this monk, in part because the coffin-bearing Capuchins wear the same habit as that of the *Monk by the Sea*. If the first picture depicts life contemplating death, this second is an image of death, as suggested by a frozen snow-covered cemetery, a lugubrious funeral procession, distraught barren oak trees, the skeletal remains of a Gothic abbey, and a somber winter sky at twilight. The abbey and oaks, obviously equated, form a gate that the burial cortege will pass under. Religious hope is stated in the crucifixion mounted on the portal. The oval at the peak of the tracery window is echoed by the sliver of new moon in the sky, a symbol of resurrection. We sense a rite of passage, a direct connection, between abbey and sky. Just as the moon goes through a cycle as it is reborn, twilight yields to night followed by sunrise and day, and winter gives way to spring, summer, and fall; so also, it is suggested, death will be followed by an afterlife or rebirth. And yet, this is a very gloomy picture that leaves our fate after death in doubt, making us dread the unknown on the other side of the horizon.

Friedrich was influenced by the pantheism of the theologian and friend Gotthard Ludwig Kosegarten, who delivered his sermons on the shores of the Isle of Rügen in the Baltic, using the awesome and desolate coastal landscape as a metaphor for God. Kosegarten's pantheism was far from unique in Germany, and in large part it was a product of the *Sturm und Drang* movement of Goethe, Schiller, and Herder (see page 807).

Herder played a significant role in stimulating late eighteenth-century German nationalism, the political manifestation of Romanticism, which is also reflected in Friedrich's painting. In *Origin of Language* (1772) he argued that language was not divinely endowed but stemmed from the collective experience of a people, triggering a search to define this experience. Herder, for example, collected an anthology of German folk songs, while the Grimm brothers did the same for folktales. This delving into the distant primitive past in search of one's roots was distinctly Romantic, for it created a emotional bond among people that in intensity was quite different from

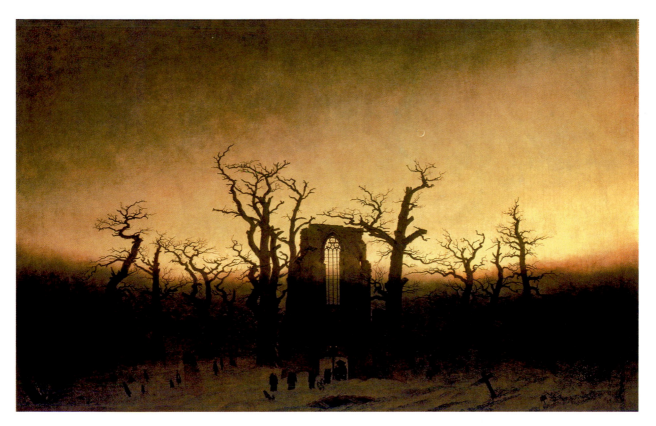

24.11. Caspar David Friedrich. *Abbey in an Oak Forest*. 1809–1810. Oil on canvas, 4 × 68¹/₂″ (111.8 × 174 cm). Nationalgalerie, Staatliche Museen zu Berlin

their former practical allegiance to the aristocracy. For his part, Goethe declared that Gothic architecture was native to Germany, and unlike Classical buildings, it was premised not on calculation but Romantic intuition, the cathedrals rising like the towering oak trees that made up the great northern forest.

It is not coincidental that Friedrich's most salient motifs in *Abbey* are the Gothic ruin and barren oak trees, motifs he knew his audience would immediately recognize as national emblems. The picture was made at a moment of national crisis. There was no Germany in 1810, only a loose confederation of some 300 German-speaking states and free cities called the Holy Roman Empire, nominally ruled by Austrian emperors of the Habsburg dynasty. The emotional surge toward unification was crushed when Napoleon's troops marched in. Friedrich's crumbling abbey and striped oaks are symbols of the demise of nationalism, while the winter chill, deadening silence, and gloomy light of a disappearing sun is a reflection of the national mood, and especially Friedrich's.

America: Landscape as Metaphor and the Popularity of Genre

Art had not been a priority in the struggling British colonies in America during the seventeenth and eighteenth centuries, and the only art market that existed was largely for portraiture. Sculpture was mostly limited to weathervanes and tombstones. This did not change dramatically in the Federalist period (1789–1801) and the opening decades of the nineteenth century, although the first academies and galleries were founded in the

first quarter of the century—the Pennsylvania Academy of Fine Arts (1802), the Boston Atheneum (1807), and New York's National Academy of Design (1825). By 1825 New York surpassed Philadelphia as the largest and wealthiest city in the nation—in large part due to the opening of the 383-mile Erie Canal that ran from Buffalo to the Hudson River at Albany, funneling the raw materials and produce of the hinterlands into New York City. New York simultaneously became the nation's art capital, and consequently our discussion of American art will center on New York well into the twentieth century.

In the 1820s, landscape began to acquire status and by the 1840s it had eclipsed portraiture as the most esteemed form of American art. A young nation with little history, the United States became preoccupied with a search for its own identity, one that would distinguish it from its Old World roots. Literary figures such as William Cullen Bryant (1794–1878) and Ralph Waldo Emerson (1803–1882)) identified the land itself as America's wealth and contrasted its unspoiled virginity to the densely populated, resource-impoverished lands of Europe. America was overflowing with natural resources, a veritable Garden of Eden. They also interpreted this pristine land as a manifestation of God, whose presence was to be seen in every blade of grass, ray of sun, and drop of water. To meditate on Nature was to commune with God. This belief stemmed not only from the metaphysics of such German philosophers as Herder and Immanuel Kant (1724–1804)—the same thought we saw expressed in Friedrich's paintings—but also from the American Transcendentalist movement, which surfaced in the 1830s and is perhaps best known today from such works as

Emerson's *Nature* (1836) and Henry David Thoreau's *Walden* (1852). In this famous quote from *Nature*, Emerson expresses the spiritual unification with Nature and the consequent role of the artist or writer to channel this unification into art:

> Standing on the bare ground—my head bathed by the blithe air, and uplifted into infinite space—all mean egotism vanishes. I become a transparent eyeball; I am nothing; I see all; the currents of the Universal Being circulate through me; I am part or parcel of God. . . .

Elsewhere, Emerson wrote: "The poet must be a rhapsodist—his inspiration a sort of bright casualty; his will in it only the surrender of will to the Universal Power." The American landscape became the emblem of the young nation.

THOMAS COLE AND THE HUDSON RIVER SCHOOL

America's first art movement, based on landscape and born in the 1820s, is called the Hudson River School, because the artists, most with studios in New York, were initially centered on the Hudson River Valley before fanning out through all of New England in the 1830s through 1850s. Spring through fall, the artists traveled through New York and New England making studies, generally drawings, of this unique land, which they then developed into large paintings in their New York studios during the winter. The lead figure in this group was Thomas Cole (1801–1848), who produced his first major landscapes after an 1825 summer sketching trip up the Hudson. Initially, his views were sublime, presenting a wild, primordial nature, often with storms pummeling the forests, dark clouds blacken-

ing the earth, and lightening-blasted trees. Despite depicting specific sites, his style relied on European landscape conventions and formulas, with little attention given to detail.

By the 1830s, however, Cole's paint handling became tighter and his pictures less formulaic and more specific, embracing a Romantic truth to Nature that we saw in Constable. This is apparent in *The Oxbow* (fig. **24.12**), made in 1836 for exhibition at the National Academy of Design. In this breathtaking view from atop Mount Holyoke in western Massachusetts, Cole presents the natural wonder of the American landscape. The foreground is sublime wilderness, with blasted and windswept trees and dark storm clouds dumping sheets of rain. Except for the representation of Cole next to his parasol looking up at us (and in effect declaring his preference for primordial Nature), there is no sign of humans in the foreground. Far below in the sunlit valley, separated by distance, height, and the sharp contour of the mountain ridge, are the Connecticut River and its plain. Closer inspection reveals not just a natural plain but also cultivated fields and settlements. But they are in such harmony with Nature they seem to blend in. Here is the "Garden of Eden," as Americans described their land, blessed by the divine light breaking through the clouds. Cole underscores God's presence in the land by roughly etching, under the guise of cleared forest, the name *Noah* into the distant hill; upside down, these same letters become Hebrew letters for *Shaddai*, meaning "the Almighty."

Cole's settlers respect Nature as well as its cycles and natural course, fitting right in. In the wilderness foreground, the dead trees and seedlings represent this life cycle, death, and

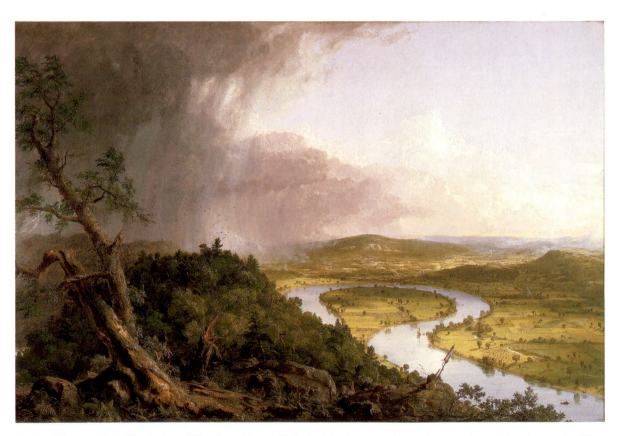

24.12. Thomas Cole. *The Oxbow (View from Mount Holyoke, Northampton, Massachusetts, after a Thunderstorm)*. 1836. Oil on canvas, $51\frac{1}{2} \times 76''$ (1.31 × 1.94 m). The Metropolitan Museum of Art, New York. Gift of Mrs. Russell Sage, 1908 (08.228)

resurrection. First and foremost, the picture is paean to the glory of the American land. Cole captures the immense scale of the American landscape and its many moods, from the wild sublimity of the foreground, to the pastoral tranquility of the valley, to the majestic vastness of the distant hills. In *The Oxbow*, we see the artist rhapsodizing in Romantic fashion as Emerson prescribed, bonding with Nature and God.

The Oxbow was also a political painting, which viewers at the 1836 exhibition would have recognized. While most Hudson River School painters depicted the glory of God as manifested in the American land, a handful, following Cole's lead, used landscape painting also to comment on the economic and social issues consuming the nation. An 1829–1832 trip to Europe gave Cole firsthand knowledge of Turner's paintings and reinforced Cole's interest in using landscape as a vehicle for themes of historical significance. In 1836, for example, Cole painted a five-picture series titled *The Course of Empire*, which traced the transformation of the same site from a primitive state, to an agrarian society, to a thriving empire, to a decadent empire, and lastly to a state of ruin. Just as Turner's landscapes were metaphors for social and political issues, so were Cole's. His audience would recognize in *The Course of Empire* a statement reflecting the heated debate about progress then consuming the country. On one side were those Americans arguing for a Jeffersonian agrarian America; on the other were the advocates of Jacksonian laissez-faire economics, which embraced unrestricted industrial, commercial, and financial development. Cole, who like the novelist James Fenimore Cooper (1789–1851) was an early environmentalist, found the rapid destruction of the wilderness and disrespect of

the land disheartening. His vision of healthy development stopped at Jeffersonian agrarian society, where Americans lived in harmony with the land. He equated Jacksonian politics with empire, which would result not only in the destruction of the land but also the eventual downfall of America. In *The Oxbow*, Cole proclaims his own personal preference for the wilderness, while championing the virtue of an agrarian civilization, one where Americans respect their covenant with God.

WILLIAM SIDNEY MOUNT AND GENRE PAINTING

Ever since the ratification of the U.S. Constitution, the North-South conflict over slavery plagued the nation as the most demanding and threatening issue. Not only does it appear in landscape painting but also in genre painting, which along with landscape became popular with the American public. In the hands of major artists, genre painting was rarely just a depiction of contemporary life. Like landscape, it was filled with references to the most pressing issues facing the nation. One of America's first outstanding genre painters was William Sidney Mount (1807–1868), who was raised in Stony Brook, on New York's Long Island, where he spent most of his life and found his subject matter. In 1826, at the age of 18, he enrolled in the National Academy of Design, where he barely spent a year. He became a portrait painter, although he also showed, without success, history paintings at the National Academy. Soon after 1831, he returned to the Stony Brook area for good, specializing in genre painting, depicting the world he knew best.

This world is seen in *The Power of Music* (fig. **24.13**) of 1847, which acknowledges the large African-American

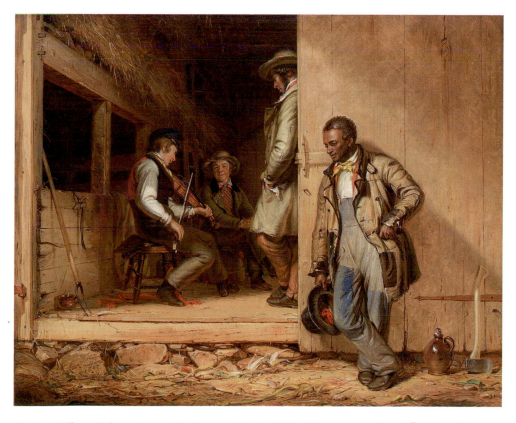

24.13. William Sidney Mount. *The Power of Music*. 1847. Oil on canvas, 17 × 21″ (43.2 × 53.3 cm). © The Cleveland Museum of Art 2002. Leonard C. Hanna, Jr., Fund. 1991.110

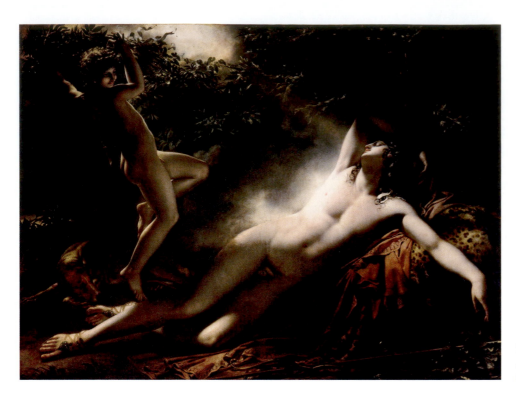

24.14. Anne-Louis Girodet. *The Sleep of Endymion*. 1791. Oil on canvas, $19^3/_8 \times 24^1/_2''$ (49 × 63 cm). Musée du Louvre, Paris

community in Setauket, where Mount lived. It is obvious that Mount did not reject the vocabulary of history painting when he abandoned the field for genre, as this picture of everyday life has Neoclassical planarity, geometry, and solidity, which are delicately balanced with realistic details, specificity, and American subject matter. The scientific perspective of the horse stalls and the geometry of their square openings recall the precise spatial structure and order of Renaissance painting (see fig. 16.25). His carefully drawn and modeled figures stand in Classical contrapposto poses. They seem to be individual people, and yet they have been subtly idealized. Mount was adamant about creating an American art, one that did not look to Europe; he even rejected offers from patrons to finance a Grand Tour of Europe so that his vision for an American art would remain pure. A Neoclassical vocabulary was for him not so much a means to aggrandize ordinary life as to transform the specific and unique into powerful symbols that reinforced his message. Old World art may underlie Mount's composition, but its importance is diminished by the picture's Americaness.

The Power of Music is a complex picture that juxtaposes the Jeffersonian bedrock of American democracy with the hypocrisy of racism that pervaded the nation. The black worker, who has just put down his ax and jug to listen to the fiddling, is physically and compositionally separated from the white world of the barn. Further suggesting racial prejudice, Mount draws a parallel between the black worker and the horses in the barn, for he has cropped square the barn door opening so that it is like the squares of the darkened stall openings; by using the same geometric shape for both the African American and the horses, Mount emphasizes their separation

from the white domain in the heart of the barn. Mount draws a parallel as well with the white worker, who is allowed inside the stable; they have identical poses, although facing in different directions, and each has put down a tool and jug while concentrating on the music. The invisible sounds link the two figures together, in effect functioning as a metaphor for the spiritual connectedness, emotional unity, and sameness of all humans, regardless of exterior appearances. In a sense, Setauket is left far behind in this picture that becomes an emblem of America, speaking to the harsh divisions separating the nation and appealing for universal compassion and understanding. The composition may be Neoclassical, but the emotional yearning for equality and democracy are Romantic.

France: Neoclassical Painting in the Romantic Era

Neoclassicism dominated French art in the late eighteenth and early nineteenth century. This was because of Jacques-Louis David's powerful impact on painting (see pages 817–820). In his lifetime, David had some 400 students, and after 1800 his most gifted followers from the 1790s began to rival him for public attention. Although David convinced the new Republican government to abolish the French Academy—which was eventually replaced and redefined—the biennial Louvre salon exhibitions were still held during the Directory (1794–1799) and the Napoleonic era (1799–1814) and remained critical for an artist's success.

ANNE-LOUIS GIRODET AND THE PRIMITIVES
Anne-Louis Girodet (1767–1824), one of David's most brilliant pupils, introduced a new Neoclassical type of painting in 1791 when he sent *The Sleep of Endymion* (fig. **24.14**) back to Paris

from Rome, where he was a pensioner at the French Academy, having won the Prix de Rome. The painting was shown at the Salon of 1793 to universal praise. As part of their requirements, Prix de Rome students were required to execute an oil painting of a nude. Girodet's figure conforms to the Neoclassical paradigm: It is a Classical nude with sharp contours and is carefully painted with tight brushwork. Rather than virile and virtuous, however, Girodet's nude is androgynous and sensuous. The choice of subject was also startling. Derived from Classical mythology, its theme was an indulgent hedonism at a time when everyone else was portraying noble sacrifice. Girodet presents the story of the moon goddess Selene (Diana), who fell desperately in love with the mortal shepherd Endymion, whom she put into an eternal sleep so she could visit him every night. Here we see one of these noctural visits, with Zephyr pulling back the branches of a tree so that Selene can seduce the sleeping shepherd. David's harsh, raking light gives way to a softer, more sensual illumination that gently caresses Endymion, creating a *chiaroscuro* that emphasizes the slow undulation of his soft, beautiful flesh. Moonbeams dramatically backlight the figures, etching strong, elegant curvilinear contours.

Despite the erotic content, this is hardly a titillatingly playful Rococo picture, for the work has a powerful mood of a primal sensuality, brought about in part by the mysterious moonlight. Combining Correggio's *chiaroscuro* and vaporous *sfumato* (see fig. 17.24) with the grace of Bronzino's contours (see fig. 17.8), both of whom Girodet studied firsthand in Rome, the artist created a painting that does not illustrate a story so much as it projects a state of mind characterized by powerful elemental urges, a quality that is distinctly Romantic.

By the late 1790s, a number of David's followers, who called themselves the Primitives, took their cue from Girodet's *Endymion*. Themes of sensuous love based on Classical myth, such as Cupid and Psyche and the death of Hyacinth in the arms of Apollo, became popular. Figures were backlit to highlight strong contours and create a sensuous undulating line. Reinforcing this taste for prominent outlines was the publication of John Flaxman's engraved illustrations of Homer's *The Iliad* and *The Odyssey*, made in Rome in 1792–1793 and based on Greek vase painting (see *Materials and Techniques*, page 796). Flaxman's startlingly severe engravings, in which he reduced figures and objects to a simple line with no shading or modeling, were popular throughout Europe and tremendously influenced the style and motifs of art during the Romantic era. While the Primitives in David's studio were heavily influenced by Flaxman and Girodet, they also admired the stripped-down clarity of Greek vase painting and the simple forms of fifteenth-century Italian painting, then considered "primitive" compared with the High Renaissance and hence the source of the group's name.

JEAN-AUGUSTE-DOMINIQUE INGRES The painter Jean-Auguste-Dominique Ingres (1780–1867) was briefly in the Primitive group, and a strong emphasis on contour and line became one of the hallmarks of his Neoclassical style. He entered David's studio in 1797 and won the Prix de Rome in 1801, although in part because of the Napoleonic wars he could not take advantage of his award until 1806. Before leaving for Italy, he received a commission from the French Legislative Assembly for a *Portrait of Napoleon on His Imperial Throne* (fig. **24.15**), which he showed at the Salon of 1806, where it was heavily criticized, even by Napoleon. Ingres's Neoclassical roots are evident in the harsh Davidian planarity, compressed space, and emphasis on line or contour, although Ingres's edge is sharper, more lively, almost seeming to have a life of its own, as, for example, in the white border of Napoleon's robe.

But here the comparison with David and the Primitives stops and Ingres's Romanticism begins, although it does not supercede the importance of his Neoclassicism and the fact that he would be recognized as the great standard-bearer of the style in the first half of the nineteenth century. Ingres fills every square inch of his portrait of Napoleon with opulence—gold, gems, ermine, marble, tapestries, rare objects. In one hand Napoleon holds the golden scepter of Charlemagne, in the other the ivory hand of justice of the French medieval kings, both certifying his royal legacy. The elaborate gilt throne looks as if it is from Imperial Rome. Its curved back forms a halo around the emperor's head, which contemporaries recognized as a reference to God the Father in the central panel of Jan and Hubert van Eyck's *Ghent Altarpiece* (see fig. 14.12), then installed in the Napoleon Museum in the Louvre and part of the immense

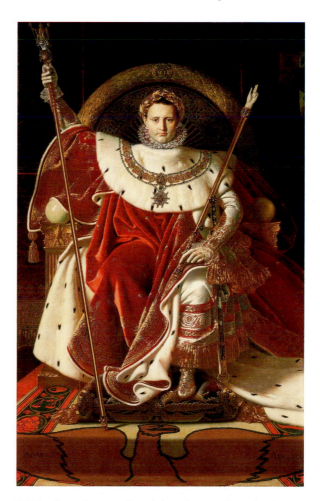

24.15. Jean-Auguste-Dominique Ingres. *Portrait of Napoleon on His Imperial Throne*. 1806. Oil on canvas, 8'9″ × 5'3″ (2.66 × 1.6 m). Musée de l'Armée, Palais des Invalides, Paris

booty of Napoleon's conquests. Ingres even has Napoleon strike the same pose as the Van Eycks's God, which when combined with the iconic frontal position suggests Napoleon is endowed with the same qualities, or at least is sanctioned by God. Ingres's deification of Napoleon is also strengthened by a resemblance to Zeus in a Flaxman line engraving.

Ingres's frozen larger-than-life image presents Napoleon as aloof and divine, but its wondrously exotic and Romantic content had to have fascinated, even awed, the audience at the Salon of 1806. While preferring tight brushwork and a hard icy surface to painterly gesture, Ingres was clearly a magnificent colorist. In *Napoleon*, his hues match the objects in opulence and have the same gemlike quality he found in the sparkling oils of the Van Eycks paintings. They have a similar level of realism in capturing various lush textures. Ingres was as concerned with harmonizing complex relationships of deeply saturated color as he was in balancing the intricate designs of his compositions.

In Italy, Ingres studied ancient art and fell in love with the classicism of Raphael. But as a Romantic, his interests were broad, even exotic, and led him to medieval, Byzantine, and Early Renaissance art. After his 4-year stipend expired, Ingres stayed on in Italy at his own expense for an additional 14 years, often impoverished and, like a Romantic artist, painting what he wanted. Periodically, he sent pictures back to Paris for exhibition, where they were generally met with derision. An example is *Grand Odalisque* (fig. **24.16**), commissioned in 1814 by Caroline Murat, Napoleon's sister and the Queen of Naples, and submitted to the Salon of 1819.

This picture is even more exotic than his portrait of Napoleon, for it represents a Turkish concubine and is one of the earliest painted examples of *Orientalism*—as the Western fascina-tion with the culture of the Muslim world of North Africa and the Near East was then called. (Byron's Romantic poem *The Corsair*, also featuring a harem slave, was published the same year the painting was commissioned.) This fascination was, in part, sparked by Napoleon's campaign in Egypt in 1798–1799 and the detailed description of the region and its culture and customs in the 24-volume government-sponsored publication *Description de l'Égypte*, which appeared from 1809 to 1822. Orientalism reflects European imperialism and its accompanying sense of superiority that viewed non-Christian Arab culture as not only different and exotic but also inferior—backward, immoral, violent, and barbaric. Here, the exotic subject gave Ingres license to paint a female nude who was not a Greek goddess, although she recalls numerous Renaissance and Baroque paintings of a reclining Venus and sculptures of Ariadne from antiquity. To make his figure more appealing to a Paris audience, Ingres gave his odalisque European features, even a Raphael face and coiffure. Although the figure is alluringly sensual, and the hashish pipe, incense burner, fan, and turban "authenticate" the exotic scene, the painting as a whole projects a soothing sense of cultivated beauty, refinement, and idealization that seems Classical.

Ingres focuses on the odalisque's flesh, delineated by a beautiful classical line, Ingres' trademark. Bathed in a caressing chiaroscuro, the body gently swells and recedes with delectable elegance. Its contours languidly undulate with sensuality, the sharply defined edges and tan color contrasting with the objects around it. The opulent color of the objects and the lush fabrics and peacock feathers enhance the sensual aura of the picture. Salon viewers noted the concubine's back had too many vertebrae and certainly her elbowless right arm is too long; but as far as Ingres was concerned, the sweeping curves of both were

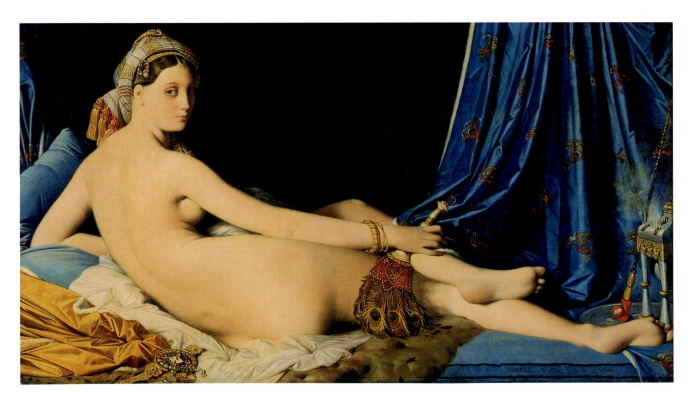

24.16. Jean-Auguste-Dominique Ingres. *Grand Odalisque*. 1814. Oil on canvas, $35\frac{7}{8} \times 63''$ (91 × 162 cm). Musée du Louvre, Paris. Inv. RF1158

essential components of the graceful composition, the line of the right arm even being continued into the folds of the drapery.

In 1821, Ingres received a commission to make an enormous painting of *The Vow of Louis XIII* for the cathedral in Montauban in his home town. Penniless, otherwise forgotten, and living in Florence, the painting turned Ingres's life around. Ingres showed the picture at the Salon of 1824 to rave reviews and was hailed as the great savior of the Classical tradition. With the final fall of Napoleon in 1815, David, who had been named painter to the emperor in 1801, was exiled to Brussels, and the careers of all of his students had stalled at the same time, displaced by a new generation of painterly Romantic artists. Almost by default, then, Ingres was crowned the protector of classicism, the champion of line over color, and the savior of the "wholesome traditions of great art" and ideal beauty over the unfettered emotionalism of the Romantics. In 1825, Ingres was elected to the French Academy he had disdained, and soon became its director. He was also awarded the Legion of Honor. His studio became the destination of choice for aspiring young history painters.

While Ingres defined himself as a history painter since it held the greatest prestige within the academy, his strength was portraiture, especially of women. His 1856 *Portrait of Madame Inès Moitessier* (fig. **24.17**) is a good example. The work was commissioned in 1844, and over the next 12 years the guardian of ideal beauty transformed the wife of a wealthy banker into an image of Classical perfection, an earthly goddess. He gave

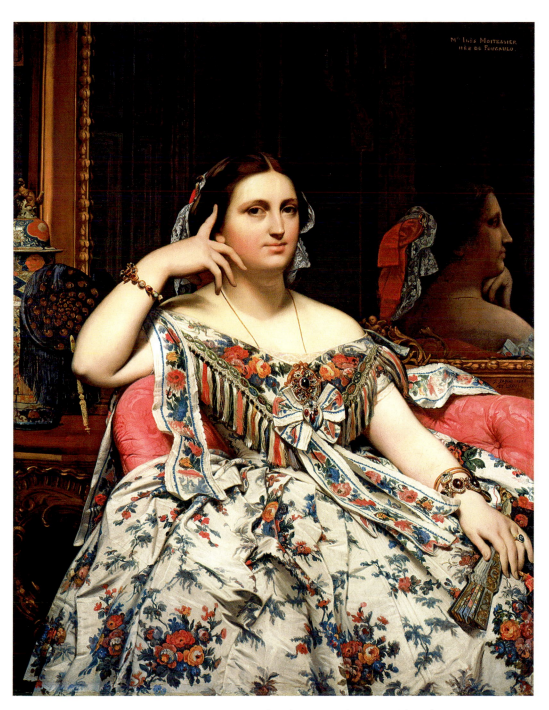

24.17. Jean-Auguste-Dominique Ingres. *Portrait of Madame Inès Moitessier*. 1856. Oil on canvas, 47$\frac{1}{4}$ × 36$\frac{1}{4}$" (120 × 92.1 cm). © The National Gallery, London

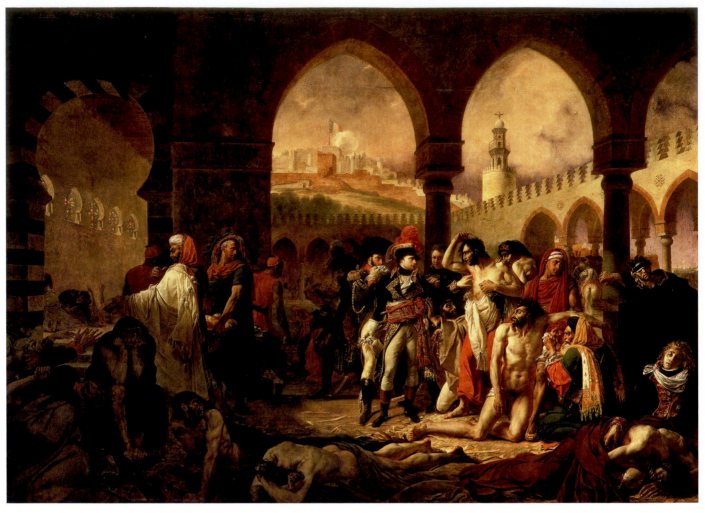

24.18. Antoine-Jean Gros. *Napoleon in the Pesthouse at Jaffa, 11 March 1799*. 1804. Oil on canvas, 17′5½″ × 23′7½″ (5.32 × 7.20 m). Musée du Louvre, Paris

her creamy smooth skin, beautiful curvilinear shoulders, arms, and hands, and a Raphaelesque face. He enriched her with an opulently rose-patterned gown, jewelry, and a peacock-feather fan, and placed her in front of a gilt-frame mirror. Contributing to her perfection also are the immaculately smooth paint surface (free of painterly brushwork), the precise drawing, and the harmonious blending of a complicated composition with a richly colored palette.

Moitessier's pose suggests various Classical prototypes, while her contemplative hand-to-head gesture derives from Roman murals at Herculaneum. The profile in the mirror, an obvious distortion, could not be more Greek. It also superimposes an eerie psychological veil on the work, reinforcing the introspection of her gesture and tinting the painting with a mysterious mood that converts the realistic materiality of Moitessier's physical surroundings into a spiritual embodiment of beauty. While the style is distinctly Neoclassical, this mysterious mood gives the picture Romantic overtones.

France: Painterly Romanticism and Romantic Landscape

While Ingres was taking Neoclassicism deep into the nineteenth century, Antoine-Jean Gros, a second student of David's,

opened up an alternative course, one that would abandon line, order, clear rational space, evenly diffused light, and Classical repose for bold brushstrokes, dazzling color, impetuous drama, confused space, irrational lighting, and extreme emotions. In his wake came Théodore Géricault and Eugène Delacroix, who brought painterly Romanticism to the fore in the 1820s, resulting in contemporaries applying to art the word *Romanticism*, previously reserved for literature and music. In the 1820s as well, landscape painting in France began to emerge from under the shadow cast by Neoclassicism. French Romantic landscape was never as apocalyptic as its British counterpart nor as pantheistic as in Germany and America. Instead it was more serene and poetic.

ANTOINE-JEAN GROS Gros (1771–1835) entered David's studio in 1785. During the turmoil of the French Revolution, David was able to secure a pass for Gros to go to Rome, although by the time Gros arrived the city was closed to the antipapist French. Through circumstance, he met Napoleon in Milan, traveled with his army, and impressed the general with his art. Napoleon charged Gros with painting his battles and glorifying his campaigns. Bonaparte, who was as brilliant at propaganda as he was at military strategy, carefully controlled

his public image and relied heavily on art to reinforce his political position. He made sure his commissions were shown at the Salons, where they would be seen by everyone and reported in the press.

The Napoleonic era was a catalyst for French Romanticism. The drama, glory, valor, and adventures of the Napoleonic Wars provided endless material for the artistic imagination. The North African campaigns took Europeans into the forbidden Arab world and introduced them to a wondrous exotic subject matter that they brought back to Europeans anxious for new experiences. Gros's first commission, *Napoleon in the Pesthouse at Jaffa, 11 March 1799* (fig. **24.18**), came in 1804 and was exhibited in that year's Salon to huge success. This 23-foot-wide picture was commissioned not only to promote the emperor's bravery and leadership but to reinforce his humanitarian image, which was propagandistically essential considering the enormous human loss tallied in many of his battles, especially in Jaffa, then in Palestine but today a section of Tel Aviv, Israel. During the campaign, the bubonic plague broke out among the French ranks. Legend has it that to calm his troops, Napoleon fearlessly entered the pesthouse and walked among the patients. Here we see the general, like Christ healing the sick, courageously touching the open sore of a victim, his presence virtually willing the dying to rise. The painting ignores the fact that Napoleon poisoned these same sick troops when he retreated from Jaffa.

While Gros's drawing and brushwork are relatively tight and Davidian, the picture has an overt turbulent drama, created by the dark shadows, bursts of light, splashes of bright red, the rapidly receding perspective of the arcades, and cloud-filled sky. Chaos prevails. Although Napoleon is placed in the center as a compositional anchor, he momentarily gets lost in the turmoil of the scene. Our eye goes to the circle of the dead, dying, and sick surrounding him, which includes the Michelangelesque figures in the foreground shadows and the "resurrected" nudes next to Bonaparte. The male nude is now neither heroic, as in David, nor lovely, as in Girodet, but helpless and horrifying. Napoleon's courageous act has to vie for a viewer's attention with the dark mood of psychological and physical suffering and the exoticism, to Western eyes, of the Arab attendants and Islamic architecture. (This picture helped launch the vogue for Oriental subjects that we saw in Ingres's *Grand Odalisque*; see fig. 24.16.) The monumental arches compositionally may pay homage to David's *Oath of the Horatii* (fig. 23.29), but instead of supporting a narrative of Neoclassical stoicism and clarity they contribute to a passionate Romantic exoticism and a foreboding of horrifying uncertainty.

THÉODORE GÉRICAULT Without the Napoleonic campaigns to feed his imagination, Gros's career soon waned. David's other outstanding students and followers, such as Girodet, were simultaneously eclipsed. The future was now represented by Théodore Géricault (1791–1824) and those who followed him. Géricault was independently wealthy and largely self-taught, frequenting the Napoleon Museum, where he copied the great colorists: Rubens, Van Dyck, and Titan. Gros,

however, was his role model, and Gros and Rubens were clearly the artistic sources for Géricault's submission to the Salon of 1812, *Charging Chasseur* (fig. **24.19**). The energetic brushwork, the sharp diagonal recession of the horse, the bold contrast of light and dark, the rippling contours on the horse's right legs, and the flashes of color could not be further from David or closer to Rubens. Completely gone is the Davidian planarity that structured the turmoil of Gros's pesthouse. Made during Napoleon's Russian campaign, the picture functions as an emblem of heroic valor. It is not meant to represent a specific event or person. Instead, the twisting *chasseur* (cavalryman) and rearing horse embody the psychological and physical forces that consume combatants in the heat of battle, and it is interesting how many compositional parallels there are between rider and horse, suggesting the sheer animalistic forces driving the cavalryman's heroism. This is a picture of raw emotion and physical tension, devoid of Neoclassical reason and the rules of beauty and morality. As the great Romantic writer Stendhal (pseudonym of Marie-Henri Beyle; 1783–1842) said in his review of the 1824 Salon, "The school of David can only paint bodies; it is decidedly inept at painting souls."

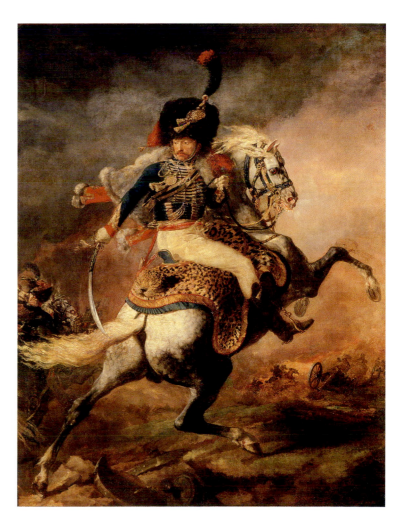

24.19. Théodore Géricault. *Charging Chasseur*. 1812. Oil on canvas, 11'5" × 8'9" (3.49 × 2.66 m). Musée du Louvre, Paris

But *Charging Chasseur* revealed Géricault's lack of formal training, namely his inability to draw, and continuing his independent study, he now worked from Classical models, copying High Renaissance painters at the Royal Museum, as the Louvre was called after the second fall of Napoleon in 1815 and with the establishment of Louis XVIII's Restoration monarchy. In 1816, he went to Italy, stopping in Florence to draw Michelangelo's Medici tombs (see fig. 17.3), before going to Rome to study the antiquities. Not long after his return to Paris in late 1817, he began thinking about the third and last painting he would exhibit at the Salons, *The Raft of the Medusa* (fig. **24.20**), painted between 1818 and 1819 after many studies. In 1816 the *Medusa,* a government vessel, foundered off the West African coast with approximately 400 people aboard. The captain commandeered the six lifeboats for government officials and officers, with the remaining 150 passengers consigned to a makeshift raft that was set adrift by the crew and at the mercy of the sea. When the passengers were finally rescued some two weeks later, only a handful had survived. The callous captain was incompetent, an aristocrat who had been politically appointed by the government of Louis XVIII, and the headline-making event was condemned in the press as a reflection of the corruption of Louis's administration.

Géricault decided to paint the moment when the survivors first sight a ship, not the more politically charged moment when the captain set the raft adrift. The painting is thus about the harrowing mental and physical experience of survival rather than an accusation of injustice. Géricault seems to have latched onto his subject after revisiting Gros's *Napoleon in the Pesthouse,* for the foreground is littered with Michelangelesque nudes. From the bodies of the dead and dying in the foreground, the composition recedes in a dramatic Baroque diagonal (see fig. 20.1), climaxing in the group supporting the frantically waving black man. As our eye follows this line of writhing, twisting bodies, we move from death to hope. But this is not a painting just about hope, for there are no heroes, no exemplary moral fortitude. Rather the theme is the human species against Nature, and Géricault's goal was to make a viewer feel the trials and tribulations of the castaways. The academic, classically proportioned monumental figures are a catalog of human misery, reflecting the death, cannibalism, fighting, insanity, sickness, exhaustion, hunger, and thirst that tormented the victims. The stark realism, obtained in part through tighter brushwork, heightens our visceral connection to the dramatically lit event; we too are on the crude raft, pitched about in the high sea, and aimlessly buffeted by the wind.

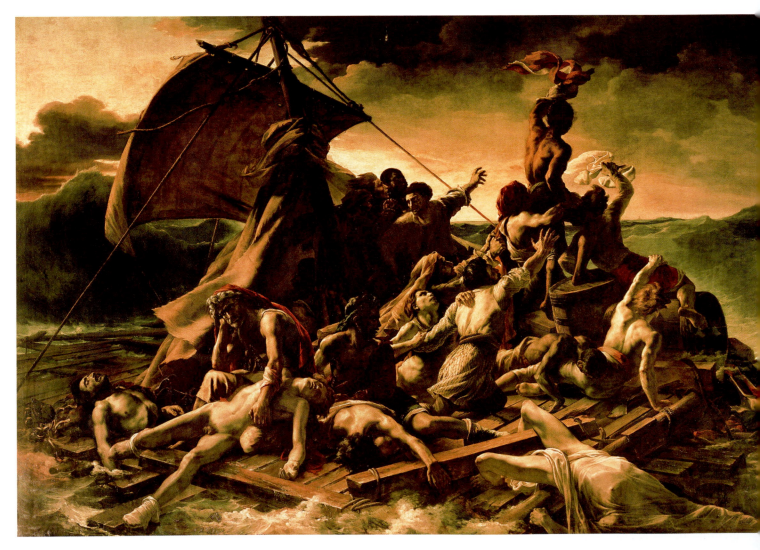

24.20. Théodore Géricault. *The Raft of the Medusa.* 1818–1819. Oil on canvas, 16′1″ × 23′6″ (4.9 × 7.16 cm). Musée du Louvre, Paris

Géricault would never exhibit again in a Salon and within six years would be dead at the age of 32. His later work, unlike *The Raft*, was not monumental; nor does it show off the artist's ability to draw and incorporate Classical models into an otherwise Baroque composition with a Romantic mood. Rather, it was largely painterly, a commitment reinforced by a trip to London in 1820 where he saw the work of Constable and Turner. His technique is apparent in a remarkable series of ten portraits of insane men and women made during the winter of 1822–1823, his last active months. Again, he was exploring the mind and human suffering, as seen in *Portrait of an Insane Man (Man Suffering from Delusions of Military Rank)* (fig. **24.21**). Using energetic brushwork that virtually signifies mental energy, he exposes the psychotic derangement plaguing his subject, including nervousness, fear, and a sternness that implies a delusion of importance. The presentation is sympathetic, but it does not undermine the powerful mood of alienation and irrationality that consumes the sitter. In contrast to the goddesslike perfection and poise of Ingres's *Mme. Inès Moitessier,* Géricault's insane man is an emblem of imperfection, embodying a range of human psychoses and foibles. It is a reflection of the Romantic antipathy to Enlightenment rationalism and Romantic interest in the psychological and physical suffering of the socially marginalized.

EUGÈNE DELACROIX In 1822 Eugène Delacroix (1798–1863) emerged as the standard bearer of painterly Romanticism, the position Géricault so dearly coveted. Delacroix was seven years younger than Géricault and came from a similar background—Parisian and wealthy. Like Géricault, he was essentially independent and self-taught, studying the great masterpieces at the Louvre, especially Rubens, Titian, and Veronese. His greatest excitement came when visiting the studios of Gros and Géricault. He befriended the latter in 1818 and posed for one of the figures in *The Raft of the Medusa*. His submission to the Salon of 1824, *Scenes from the Massacre at Chios* (fig. **24.22**), presents a compendium of misery and suffering in the foreground and was obviously inspired by the groupings of the dead and dying in Gros's *Pesthouse at Jaffa* and Gericault's *The Raft of the Medusa*. In 1820 the Greeks had revolted against the ruling Ottoman Empire, and the following year the Turks raided the Greek island of Chios, destroying villages and either massacring or enslaving virtually the entire populace of 20,000. Delacroix's painting was based upon this event and was, in part, made to show support for Greek independence as well as to express the Romantic passion for democracy and individual freedom.

Burning and slaying take place in a blur of smoke and confusion in the middle- and background of Delacroix's painting, while the foreground, which focuses on a group of Greeks gathered up for execution or enslavement, is remarkably devoid of violence. Instead, resignation, desperation at the impending loss of loved ones, and hopelessness reign, this pessimism symbolized by the foreboding silhouette of the armed Ottoman guard. Delacroix reinforces the turmoil of the violence in the background through the twisting and turning of the foreground figures and their undulating contours as well as by the chaotic piling up of bodies. The intense colors of the painting have dark-

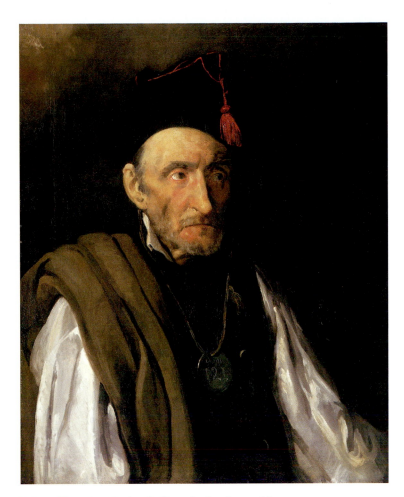

24.21. Théodore Géricault. *Portrait of an Insane Man (Man Suffering from Delusions of Military Rank)*. 1822–1823. Oil on canvas, $32\frac{1}{2} \times 26''$ (81 × 65 cm). Collection Oskar Reinhart "Am Römerholz," Winterthur, Switzerland. Inv. no.1924.7

ened considerably over time, especially the blues and reds, which originally created an optical snap that was reinforced by the bravura of the brushwork and sharp value contrasts. Clearly, Rubens is behind these qualities as well as the two asymmetrical compositional pyramids organizing the foreground group and the diagonal recession into deep space. (Delacroix, however, subverts the traditional device of putting a hero at the apex of the pyramids by instead placing villains, the Turkish guards, there.) Delacroix was also influenced by the color and brushwork of Constable, who had three landscapes, including *The Haywain* (see fig. 24.6), in the same Salon. Upon seeing them, Delacroix repainted the sky at the last minute, giving it a brilliant luminosity, and he worked vivid colors into the garments.

This "terrifying hymn in honor of doom and irremediable suffering," as the poet and critic Charles Baudelaire (1821–1867) described the painting, established Delacroix as the great Romantic painter. It was the first time the term *Romantic* was applied to a visual artist, making him the artistic equivalent of composer Hector Berlioz (1803–1929) and writer Victor Hugo (1802–1885). And certainly Delacroix shared their Romantic spirit. (See *Primary Source*, page 846.) The year 1824 therefore was a critical one. It was the year Géricault died, Constable was introduced in Paris, and Ingres returned from Italy, unaware that he would be anointed the guardian of the Classical tradition.

Eugène Delacroix (1798–1863)

From His *Journal*

Delacroix began his Journal in 1822 and maintained it irregularly until his death in 1863. He wrote it, he said "for myself alone" in the hope that it would "do me a lot of good." This excerpt is from an entry of May 14, 1824.

What torments my soul is its loneliness. The more it expands among friends and the daily habits or pleasure, the more, it seems to me, it flees me and retires into its fortress. The poet who lives in solitude, but who produces much, is the one who enjoys those treasures we bear in our bosom, but which forsake us when we give ourselves to others. When one yields completely to one's soul, it opens itself completely. . . .

Novelty is in the mind that creates, and not in nature, the thing painted.

SOURCE: *JOURNALS OF EUGÈNE DELACROIX*, TR. WALTER PACH. (NEW YORK: CROWN PUBLISHERS, A DIVISION OF RANDOM HOUSE INC. 1948)

In 1825 Delacroix went to England, like Géricault before him, reinforcing his appreciation of British landscape and literature, especially the plays of Shakespeare, the poetry of Lord Byron (George Gordon; 1788–1824), and the novels of Walter Scott (1771–1832). Delacroix would turn to their imagery, and to the imagery of Dante and Goethe, to fire his imagination and cultivate his moods. One product of his reading was the 1827 painting *Death of Sardanapalus* (fig. **24.23**), based on Byron's 1821 unrhymed poem *Sardanapalus*. Sardanapalus, the last Assyrian king, was overthrown by rebels because of his

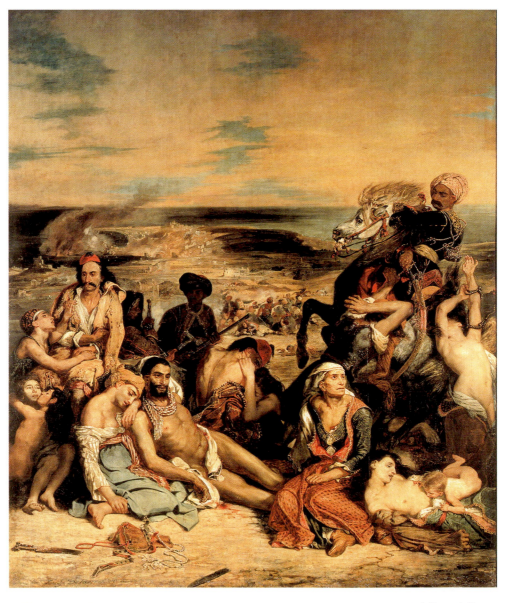

24.22. Eugène Delacroix. *Scenes from the Massacre at Chios.* 1824. Oil on canvas, 13′8″ × 11′7″ (4.17 × 3.54 m). Musée du Louvre, Paris

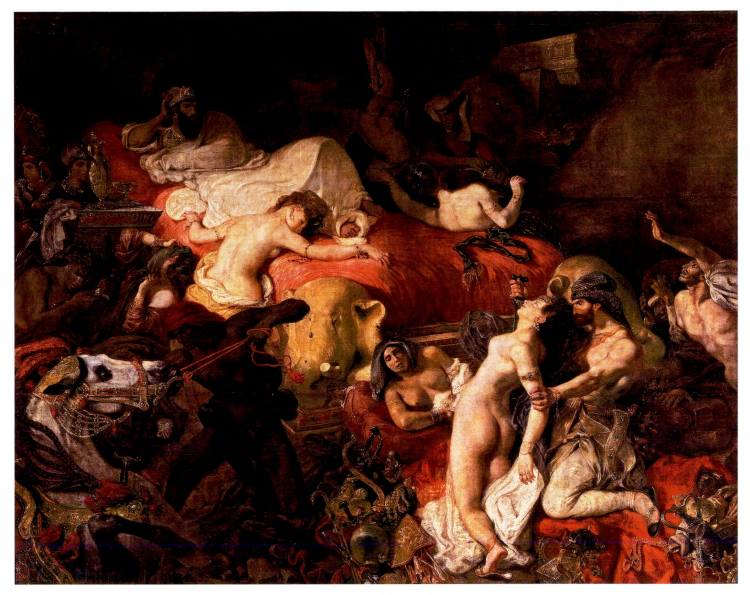

24.23. Eugène Delacroix. *Death of Sardanapalus*. 1827. Oil on canvas, 12′1½″ × 16′2⅞″ (3.69 × 4.94 m). Musée du Louvre, Paris

licentiousness and apathy. Rather than fight or flee, he committed suicide. Immersing himself in the king's mind as developed by Byron, Delacroix invented his death: He commands his eunuchs to bring to his bed, which is on a pyre, all of his prized possessions, including wives, pages, horse, and dog. The Rubenesque traits we identified in the foreground of the *Massacre at Chios* are intensified in this claustrophobic, chaotic composition. The only unifying element is the red bed, the perspective of which is so skewed it acts as a funnel, channeling all of the writhing energy and jumble of precious and exotic opulence to the anchor of the composition, the inert, indifferent king. He is the epitome of ennui. As in *Massacre at Chios*, Delacroix ignores Classical space and volume, allowing undulating contours, riotous color, and compositional pandemonium to project simultaneously the disparate moods of destruction, fear, violence, power, despair, sensuality, and indifference. With this

enormous canvas of wanton annihilation, Delacroix offended just about everybody at the Salon of 1827, for in it there was nothing left of David's Classical formula, and there was no redeeming moral, just fascinating horror. To modern eyes, the work is strongly misogynistic, reflecting male violence and the humiliation and domination of women.

Delacroix's style underwent a change in the 1830s after a trip to North Africa; his palette became brighter and his paint handling looser. In 1832–1833, Delacroix was asked to visually document the Duc de Mornay's diplomatic mission to Morocco, and he excitedly made hundreds of watercolors that provided him with wondrous Oriental themes for the rest of his life. In Morocco, Delacroix entered a world of exotic architecture, clothing, and landscape, of intense light, and of unimaginably bright colors in fabrics, tiles, and interior design that displayed a *horror vacuii* rivaling his own. Delacroix's palette became more colorful, as one

can see in *Women of Algiers* (fig. **24.24**), made in Paris in 1834 from studies. To enter the secluded world of a harem, Delacroix had to obtain special permission, and the mood of the painting captures the sultry, cloistered feeling of this sensual den. We can almost smell the aroma of incense, the fragrance of flowers, and the smoke from the hookah. Delacroix's hues are as sensual as the subject. Color is dappled, and contours are often not continuous or drawn but just materialize through the buildup of adjacent marks. A sea of paint and color covering the entire surface dissolves Neoclassical planarity and space. This technique began to free paint from what it was supposed to represent and established a platform for a new artistic style just over the horizon, Impressionism.

Romantic Landscape Painting

David's Neoclassicism was so dominant it even cast its shadow over French landscape painting in the opening decades of the nineteenth century, which was planar and stylized, largely modeled on Poussin and Claude Lorrain. The exhibition of Constable's landscapes at the pivotal Salon of 1824 opened up new possibilities, and a younger generation impressed by his powerful naturalism and Romantic moods made it the foundation of their work. By the following decades, they established landscape as a viable genre in France, one that could rival history painting in popularity and pave the way for the rise of Impressionism in the 1860s.

JEAN-BAPTISTE-CAMILLE COROT The first major nineteenth-century French landscape painter was Jean-Baptiste-Camille Corot (1796–1875), who was already committed to a vision of landscape that had Romanticism's fidelity to nature when Constable's *Haywain* was exhibited at the Salon of 1824. Uninfluenced by Constable, Corot's landscapes had Classical underpinnings. In 1822, he studied with a Parisian Classical landscape painter, Victor Bertin, who taught him the rudiments of drawing and, more important, emphasized making small **plein-air** ("open air") studies, called **pochades**, rapidly executed color studies in oil. In the studio, Bertin developed his sketches into large formulaic Salon-oriented canvases. Corot rarely did, at least not initially; his small *plein-air* sketches generally remained the final products until many years later, although he did not exhibit them either. In 1825, Corot went to Italy and produced his first major body of work, about 150 small paintings, most of famous sites. *View of Rome* (fig. **24.25**), an oil on paper, is a typical work. Made on the spot in an hour or so, it is a literal, objective presentation of "the truth of the moment," as Constable would say. We are convinced we are looking at the Castel Sant'Angelo and St. Peter's Basilica and real, not stylized clouds. We can feel the sun's intense heat bouncing off stone and see the clear late afternoon light crisply delineating the buildings and bridge. Without idealizing his landscape, Corot displays an instinct for Classical clarity and

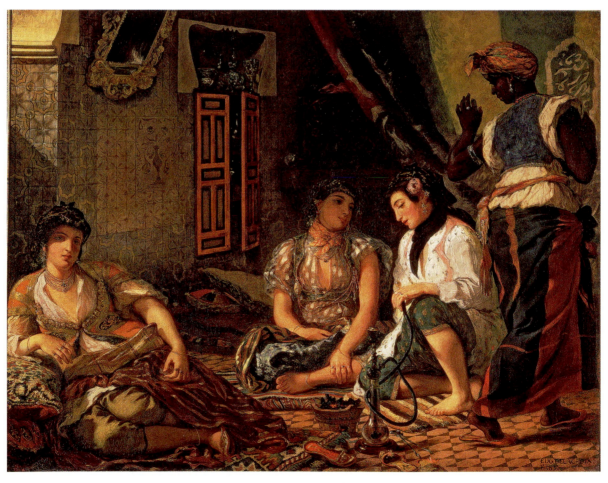

24.24. Eugène Delacroix. *Women of Algiers*. 1834. Oil on canvas, $70^7/_8 \times 90^1/_8$" (180×229 cm). Musée du Louvre, Paris

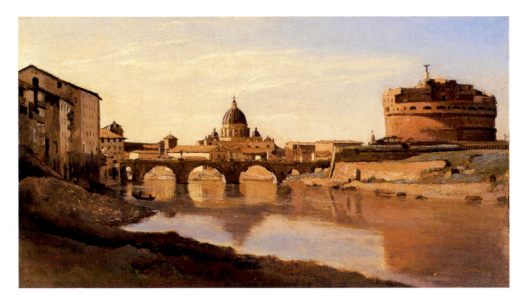

24.25. Jean-Baptiste-Camille Corot. *View of Rome: The Bridge and Castel Sant' Angelo with the Cupola of St. Peter's*. 1826–1827. Oil on paper mounted on canvas, $10^1/_2 \times 17''$ (22 × 38 cm). Fine Arts Museum of San Francisco. Museum Purchase, Archer M. Huntington Fund. 1932.2

stability that recalls Poussin and Claude. Strong verticals and horizontals anchor his composition to its surface of creamy brushwork, and his buildings, no matter how loosely painted and insignificant, have a monumental presence. Nature inspired Corot to create little poems of beautifully harmonized tones and colors and a seamless integration of painterly brushwork with a Classical grid.

After a second trip to Italy in 1834, Corot made a concerted effort to receive attention at the salons and added to his output

large historical landscapes, such as *Hagar in the Wilderness*, which gained him occasional sales and some interest. But it was not until the late 1840s, when he developed his third category of picture, the lyrical landscape, that he became popular, financially successful, and famous. Corot was no longer inspired directly by Nature, but by his memories of landscape and the romantic moods it provoked, as in his *Morning: Dance of the Nymphs* (fig. **24.26**) of 1850. These pictures are idealized arcadias, often set against a sunrise or sunset reminiscent of Claude Lorrain and

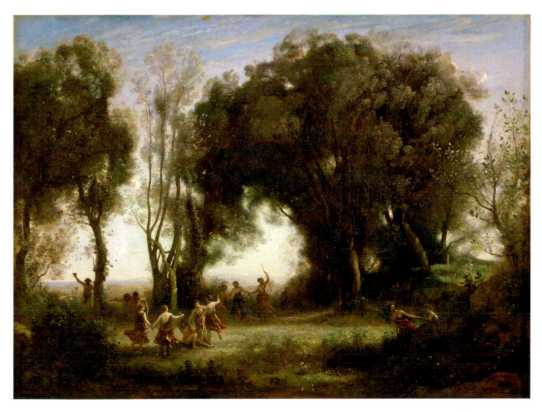

24.26. Jean-Baptiste-Camille Corot. *Morning: Dance of the Nymphs*. 1850. Oil on canvas, $38^5/_8 \times 51^5/_8''$ (97.1 × 130 cm). Musée d'Orsay, Paris.

painted with a silvery green and blue palette laid on with light feathery brushwork. Everything is soft and undulates in a pleasant curvilinear rhythm, with no monumental feature to impede this continuous visual ballet. Watteau's languid *fête-galantes* come to mind (see fig. 22.1), not Constable's turbulent *Haywain*.

THÉODORE ROUSSEAU AND THE BARBIZON SCHOOL Unlike Corot, a group of academically trained painters called the Barbizon School took their aesthetic lead directly from Constable, augmenting his direct impression of nature with a study of the great seventeenth-century Dutch landscapists, such as Ruisdael (see fig. 20.28), who were exhibited in the Louvre. The group emerged in the 1830s and got its name from the village of Barbizon, which bordered the Forest of Fontainebleau, where the artists painted and many settled. (Corot also often painted there.) The forest had been a royal hunting preserve, and as a result it offered Nature in a relatively unspoiled state, undisturbed by the Industrial Revolution smoldering just 40 miles away in Paris. The best-known Barbizon painter is Théodore Rousseau (1812–1867). He learned the rudiments of painting from two academically trained artists and by copying landscapes in the Louvre. In the early to mid-1830s, his work was occasionally accepted at the Salons, from which he was banished from 1837 to 1848, his view of Nature deemed too unseemly. He led a rather bohemian existence and permanently settled in Barbizon in 1848.

Under the Birches (fig. **24.27**) of 1842–1843 is a fine example of Rousseau's work, which is perhaps the most diverse of all of the Barbizon painters. Produced in the studio from studies made on a seven-month trip to the Berry region in central France, the painting, like that of Constable and Corot, avoids artificial compositional and stylized motifs and instead captures the essence of Nature. We readily sense this is a specific site; each tree seems individualized, for example, and each wisp of cloud unique. We can feel the onset of twilight and the cool damp atmosphere of autumn. While the blue-green sky and brownish-orange foliage offer a touch of color, Rousseau's palette is somber and earthy, evoking soil, decaying plant and animal matter, and the interior gloom of a thicket. Like Constable, Rousseau's brushwork is stippled, applied in small flecks that make the landscape pulse with energy, reinforced by the nervous outline of trees and bushes. We sense growth and the constant movement of nature. It is little wonder Rousseau was rejected at the salons. His dark, honest pictures with their turgid brushwork had to have been considered ugly and depressing by conservative taste.

SCULPTURE

Compared with painting, sculpture was a severely limiting medium for an artist at the opening of the nineteenth century. In its most monumental form, free-standing historical sculpture, it was

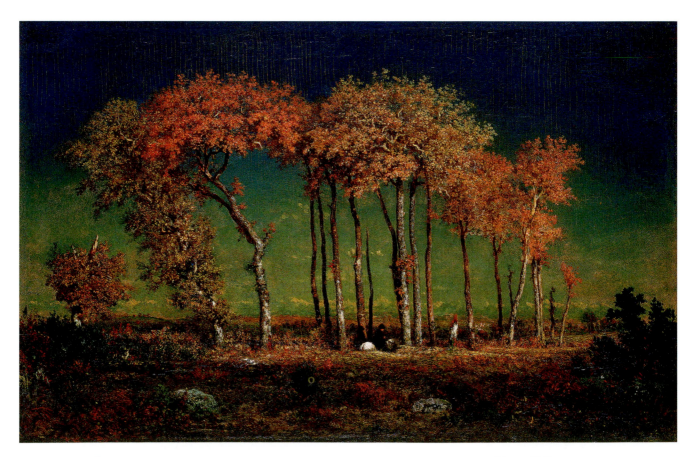

24.27. Pierre-Étienne-Théodore Rousseau. *Under the Birches*. 1842–1843. Oil on wood panel, $16^5/_8 \times 25^3/_8$ " (42.2 × 64.4 cm). Toledo Museum of Art, Ohio. Gift of Arthur J. Secor.

mostly limited to the human figure, and since the Renaissance the sculpted figure was largely based on antique models. Nineteenth-century sculptors throughout Europe would overwhelmingly follow the Classical paradigm of one or two figures that are based on Greek and Roman prototypes and embody some notion of virtue or beauty. Yet in France a dramatic change in the artistic climate toward 1830 allowed a small gap for experimentation. The rise of Delacroix and Romantic painting in the 1820s was followed by the new more liberal constitutional monarchy of Louis-Philippe (the July Monarchy), which emerged with the 1830 revolution and abdication of Charles X. The bourgeoisie had more of a presence in the new government and in society in general, ushering in an era of middle-class taste. These two forces gave a handful of artists the courage to create Romantic sculpture.

Neoclassical Sculpture in the Romantic Era: Antonio Canova

Cementing the dominance of the Neoclassical model in sculpture for 100 years beginning in the 1780s was the preeminence of Antonio Canova (1757–1822). Working in Rome, he became the most famous sculptor in the world, receiving commissions from all of Europe and America. He was the artist the majority of sculptors in both the Old and New World emulated and tried to equal.

Canova came from the area near Venice, where his talent was soon recognized, gaining him financial support to settle in Rome. By the mid-1780s, he was in tremendous demand. One of his commissions came in 1787 from a British tourist, who placed an order for a *Cupid and Psyche* (fig. 24.28). Canova first modeled the work in plaster, and then assistants roughed it out in marble. Canova then completed the work, which included

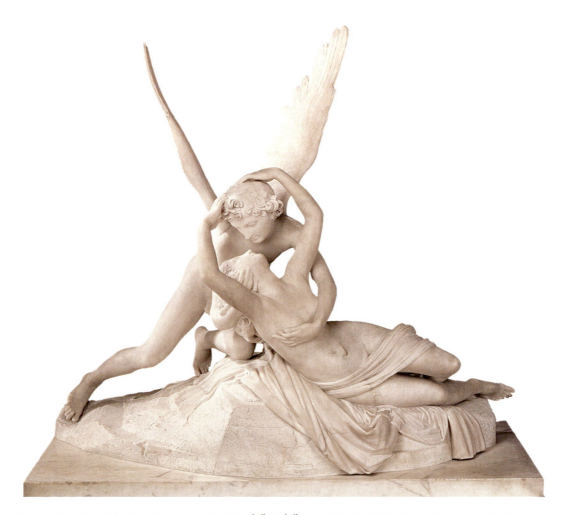

24.28. Antonio Canova. *Cupid and Psyche*. 1787–1793. Marble, 6′1″ × 6′8″ (1.55 × 1.73 m). Musée du Louvre, Paris. MR1777

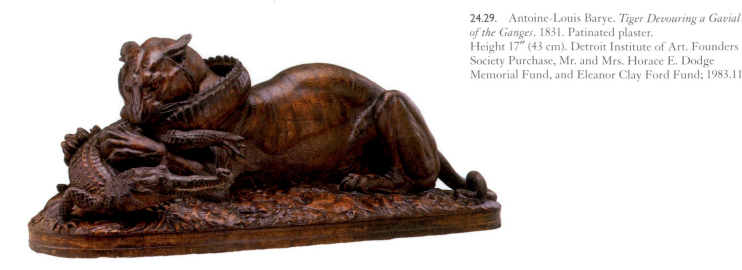

24.29. Antoine-Louis Barye. *Tiger Devouring a Gavial of the Ganges*. 1831. Patinated plaster. Height 17″ (43 cm). Detroit Institute of Art. Founders Society Purchase, Mr. and Mrs. Horace E. Dodge Memorial Fund, and Eleanor Clay Ford Fund; 1983.11

creating an impressive variety of surface textures, including the remarkable cold-perfect finish for flesh that was never equaled by his many imitators. Nor did anyone match his exquisite compositions of continuous elegant contours, which in *Cupid and Psyche* are visible in the curving pattern of the sensuous arms and legs, as well as in the flowing drapery and the oval mound gently elevating the figures.

Canova delivers more than beautiful idealized classical models, more than noble simplicity and calm grandeur—he presents an intense emotion that we associate with the Romantic era. Here he portrays the moment when Cupid, who has fallen in love with the human Psyche, gives her a kiss that awakens her from an eternal sleep cast by the jealous Venus. With this kiss, she is now immortal, like Cupid. Canova captures a tenderness and passion in both expression and gesture that was unthinkable before 1780, and this reflects the interest in states of mind that preoccupied the Fuseli circle in Rome in the 1770s and consumed British artists in the 1780s. Canova was a close of friend of Gavin Hamilton (see page 791), who in addition to introducing Canova to the antiquities of Rome undoubtedly brought to his attention the emotional intensity that his British colleagues were exploring in their art.

French Romantic Sculpture: Breaking from the Classical Model

It took both daring and considerable imagination for a sculptor to break away from the Classical model, which in its free-standing form focused on one or two classically inspired figures embodying the virtue of beauty, morality, nobility, or perfection. But a handful of artists, notably Antoine-Louis Barye and François Rude, explored new subjects, feelings, and compositions.

ANTOINE-LOUIS BARYE Antoine-Louis Barye (1796–1875) surprised his colleagues when he submitted a painted plaster of a tiger devouring a gavial, (a species of crocodile) to the Salon of 1831 (fig. **24.29**), winning a gold medal. There was no tradition for animal sculpture at the salons, and previously, in 1828, Barye had shown portrait busts. Barye, however, loved animals, and drew them at the zoo. He was also a friend of Delacroix, whose Romantic themes included animal hunts and fights, thus providing Barye with a thematic vehicle for his interest in animal anatomy. Like Stubbs's *Lion Attacking a Horse* (see fig. 23.15), the *Tiger Devouring a Gavial of the Ganges* is filled with Romantic terror, brute strength, and raw instinct unleashed without regard to morality, law, or concern for decorum. It is a fierce fight to the death in the wilds of Nature. Appealing to the Romantic imagination, Barye selected exotic animals, and often animals that traditionally do not prey on one another (tigers do not eat crocodiles). He also set his struggles in exotic locales, such as the Ganges. His composition is filled with movement and a variety of shapes and textures, reinforcing the chaotic struggle and animal energy. In the 1840s, Barye began mass-producing his animals in bronze in a variety of sizes, successfully marketing them to a worldwide middle-class audience and becoming quite famous.

FRANÇOIS RUDE Fame eluded François Rude (1784–1855), a sculptor who brought nationalistic fervor to his figurative work and is best remembered for his "*La Marseillaise*" (fig. **24.30**) on the Arc de Triomphe in Paris. Rude enrolled in the École des Beaux-Arts in 1809, studying sculpture, and as a Napoleon sympathizer fled to Brussels when Bonaparte was defeated in 1815. He returned to Paris in 1827, and with a nationalistic zeal we associate with the Romantic era, he began studying French sculptural history—first the French Renaissance tradition of the School of Fontainebleau and Giovanni Bologna (see page 595), and then delving deeper into the past to Claus Sluter (see page 471).

It was a perfect match, then, when in 1833 Rude received one of the four sculptural commissions on the Arc de Triomphe, since

the works were about patriotic fervor. The arch had been left unfinished when Napoleon was exiled in 1815, and Louis-Philippe and his minister of the interior saw the monument's completion as an opportunity to demonstrate that the new government supported national reconciliation. Hence the sculptural program consisted of four works by different artists, each surrounding the arch opening and offering something to every segment of the French political spectrum. Rude received the assignment based on the success of a rather Neoclassical-looking sculpture of a nude Neapolitan fisherboy playing with a turtle, which he had submitted to the Salon of 1833. The Salon submission hardly anticipated the chaotic explosion we see in *The Departure of the Volunteers of 1792*, the formal title for "*La Marseillaise*."

The scene honors the volunteers who rallied to defend the new French Republic from an Austro-Prussian threat in 1792. A winged allegorical figure representing both France and Liberty leads a collection of soldiers from different periods of the nation's past. Rather than a specific event, Rude evokes an eternal all-powerful nationalistic spirit that emanates from the people and arises when called upon. While the figures have a Classical anatomy, strike Classical poses, and are aligned parallel to the wall in shallow relief, the composition is frenetic, a whirligig of arms, legs, and twisted bodies that energize the outpouring of patriotism that is swept along by Liberty above. This claustrophobic jumble of figures brings to mind Delacroix's turbulent pile of victims and objects in *The Death of Sardanapalus* (see fig. 24.23). When unveiled in 1836, *The Departure* was unanimously hailed the best of the four works on the Arc de Triomphe and was nicknamed "*La Marseillaise*" because it so successfully embodied the national spirit. Rude himself attained no lasting fame from the project, and without commissions, which sculptors, unlike painters, rely on, he had no opportunity to develop further the innovative aesthetic implications of *The Departure*.

ROMANTIC REVIVALS IN ARCHITECTURE

The social and political turmoil that rocked Europe from 1789 to 1848 resulted in a search for stability and comfort, which in architecture came in the form of revival styles. Instead of developing new forms, architects resurrected the past, its familiarity providing solace and continuity in a world that otherwise seemed fractured, uncertain, and in constant flux. Intellectually justifying this appropriation of the past was the theory of evolution, developed by the German philosopher Georg Wilhelm Friedrich Hegel (1770–1831), who saw history, and thus reality, as a continuous, step-by-step unfolding of events reacting to one another in a dialectic. The present thus builds on the past, which it absorbs. Hegel's theory of evolution was the foundation for much nineteenth-century thinking and was the critical force behind Charles Darwin's theory of the evolution of the species (1859) and Karl Marx's dialectical materialism, which viewed history as a class struggle (1867). In architecture, Hegel's theory resulted in the

ART IN TIME

- 1787—Canova's *Cupid and Psyche*
- 1798—Edward Jenner develops smallpox vaccine
- 1792—New York Stock Exchange founded
- 1815—Final defeat of Napoleon at Waterloo, ending the Napoleonic Wars.

appropriation of every known architectural style, which were selected for their associations, picturesque qualities, or exoticism. Egyptian, Greek, Roman, Romanesque, Gothic, Renaissance, Baroque, Chinese, Turkish, Queen Anne, rustic thatched cottage—everything and anything could be found revived in nineteenth-century European architecture. It was not unusual for an architect to submit several proposals for a single project, each in a different style. Nor was it unusual to find several periods represented in a single building.

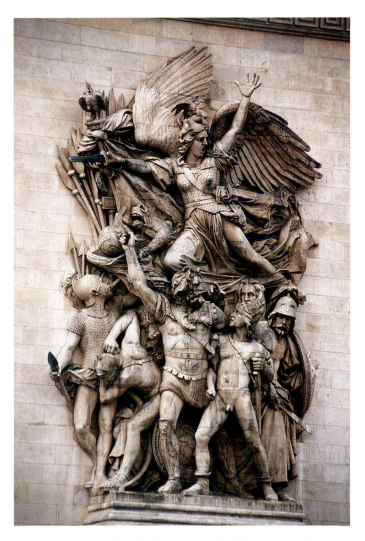

24.30. François Rude. *The Departure of the Volunteers of 1792* (*La Marseillaise*). 1833–1836. Stone, approx. 42 × 26′ (12.8 × 7.9 m). Arc de Triomphe, Paris

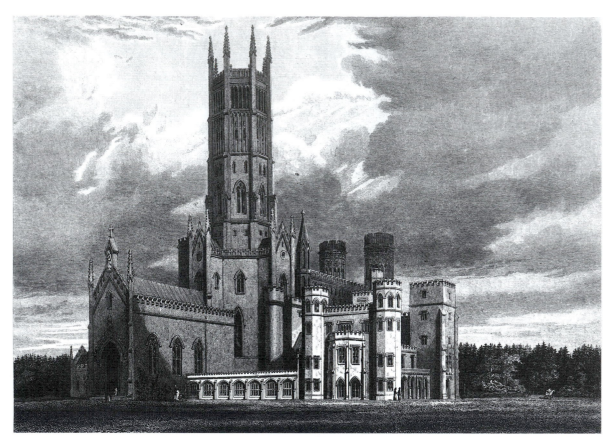

24.31. James Wyatt. Fonthill Abbey, Fonthill Gifford, Wiltshire, England. 1796–1813. (Engraving from J. Britton). Private Collection

England: The Sublime and the Picturesque

Although English architects experimented with every conceivable revival style in the first half of the nineteenth century, Gothic revival and Classical revival were the clear favorites. And in terms of numbers, Gothic revival buildings were probably only outnumbered by Classical revival. However, it is eclecticism that most characterizes British architecture in the Romantic era.

GOTHIC REVIVAL In England, sublime architecture peaked in the 1790s. In Gothic revival, it can be seen in James Wyatt's (1746–1813) Fonthill Abbey (fig. **24.31**), in Fonthill Gifford, Wiltshire, whose owner William Beckford wanted to upstage the playfulness of Strawberry Hill (see fig. 23.13) and build a medieval home that embodied the terror and gloom of Gothic romance novels. Rising an awesome 120 feet, the home not only looked like a Gothic cathedral, it was scaled like one. The interior was filled with medieval detail and endless dark, narrow corridors, which along with its immense soaring tower provided a sensation of Burke's "infinite sublime." The exterior was not only awesome in its bold massing, but also picturesque in its syncopated accretion of parts.

Most revival did not aspire to the sublime but satisfied their Romantic desires through historicism, exoticism, the pic-

turesque, and associational qualities (see page 804). The most famous Gothic revival building is the Houses of Parliament (fig. **24.32**) by Sir Charles Barry (1795–1860) and A. W. N. Pugin (1812–1852). It was commissioned in 1836 after the former building burned down, and the competition required the new Houses be designed in one of two "English" styles, Gothic or Elizabethan—91 of the 97 entries were Gothic. Barry was the head architect and best known for his work in Classical or Renaissance revival styles. Predictably, he laid out the building in a symmetrical, orderly fashion. He wisely hired Pugin, Britain's leading expert on the Gothic, to draw every Gothic detail on both the interior and exterior, which he designed with meticulous historical accuracy in the florid Perpendicular style (see page 422). The picturesque towers are believed to be Pugin's contribution as well. Instead of being sublime, Gothic revival now is largely picturesque and associational, the style having been specifically selected to conjure up a sense of nationalistic pride.

CLASSICAL REVIVAL The vast majority of nineteenth-century Classical revival buildings are quite straightforward imitations of ancient sources. Virtually entire cities, like Glasgow and Edinburgh, were built in the Neoclassical style. In Classical revival, the sublime is perhaps best represented by John Soane (1753–1837), especially in his Bank of England. In 1788, Soane

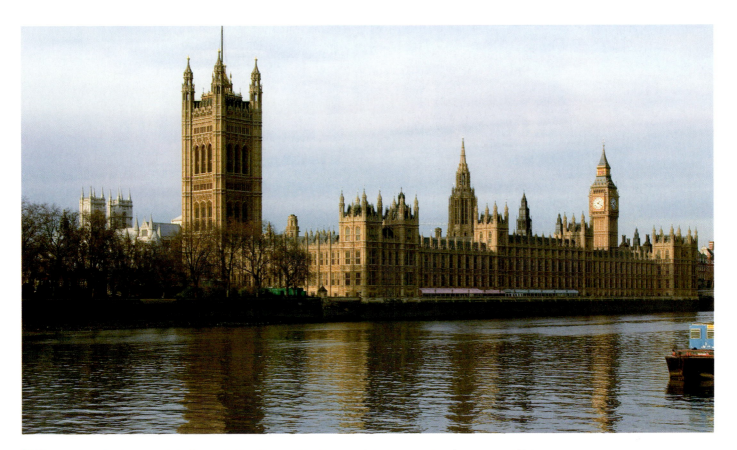

24.32. Sir Charles Barry and A. W. N. Welby Pugin. The Houses of Parliament, London. Begun 1836

was made the surveyor (chief architect) of the bank, a position he held almost until his death. During this time the bank expanded into a complex aggregate of dozens of enormous buildings, all of which Soane designed (most were destroyed in a 1927 fire). As seen in the Consols Office (fig. **24.33**), Soane's scale, inspired by Piranesi, was enormous, and his interior was austere, a reflection of the influence of Laugier (see page 809), whose treatises he owned in multiple copies. The interior of the Consols Office was meant to summon up the sublime grandeur of ancient Rome, for the enormous central space that expands into groin- and barrel-vaulted bays evokes the Baths of Diocletian (see fig. 7.71), an association reinforced by the segmented bathhouse-type windows, which for the sake of austerity and emphasis on geometric shape were left unframed.

ECLECTICISM John Nash (1752–1835) is one of the most eclectic architects of this period and in a sense epitomizes it. A contemporary of Soane (who was also quite eclectic), he moved from one style to the next with agility and lighting speed, often creating designs of extraordinary daring. Regardless of style, his hallmark was picturesque variety, with most of his buildings having an asymmetrical massing that made them look like a buildup of additions. One day he could design a hamlet with a thatched roof, the next an Italianate villa, followed by a mansion with medieval battlements.

24.33. Sir John Soane. Consols Office, Bank of England, London. 1797–1799. Destroyed in a 1927

24.34. John Nash. The Royal Pavilion, Brighton, England. 1815–1823

In 1815, Nash turned to the fashionable "Oriental" mode for the Prince Regent's Royal Pavilion at Brighton (fig. **24.34**). The building had already been partially erected in a Palladian style when he took over, so he was handicapped from the start. He quickly solved the problem, however, by throwing an iron armature over the Palladian facade to support cast-iron onion domes and minarets. Quoting Gothic, Chinese, Islamic, and Indian architecture, both inside and out, he created a rich fantasy world that played to the Romantic desire to be transported to exotic places and into the distant past.

America: An Ancient Style for a New Republic

Classical revival was ubiquitous in America, since the new republic modeled itself on the democracies of ancient Greece and Rome. The White House and nation's Capitol are Neoclassical, and most churches, banks, and government buildings were designed with a Graeco-Roman temple facade, although the Gothic was very popular as well for churches.

THOMAS JEFFERSON Thomas Jefferson, an amateur architect, designed his home Monticello (1770–1782) as a Palladian villa (see fig. 23.10), and he based his Virginia State Capitol (1785) on the Maison Carrée in Nîmes (see fig. 7.46). His best-known project in the Romantic era is the University of Virginia campus in Charlottesville (fig. **24.35**). Like Monticello and the Virginia State Capitol, the campus is based on antiquity in order to evoke the democratic heritage from Greece and Rome as well as the grandeur of these two great civilizations, which form the bedrock of Western art and culture. Designed from 1804 to 1817, the campus consists of two rows of five Palladian villas connected by a roofed colonnade, off of which are rooms for students. Each of the ten villas, which housed the professors and classrooms, was different, symbolizing individualism and aesthetically introducing picturesque variety. Each has a different

24.35. Thomas Jefferson. University of Virginia, Charlottesville. Designed 1804–1817, constructed 1817–1828

Classical association: One with a Doric order refers to the Baths of Diocletian in Rome, a second with an Ionic order to the Temple of Fortuna Virilis, also in Rome. At one end of the two rows and tying them together is a Pantheon-like Rotunda, the library, suggested by fellow architect Benjamin Latrobe and built 1823–1826. Lastly, the tree-lined lawn separating the two rows of villas imparts the complex with the naturalism of a picturesque English garden. Jefferson's genius in Charlottesville was to use Neoclassicism to create a metaphor for the new republic that expresses both the individualism and the unity that defined the new nation.

BENJAMIN LATROBE The most famous American architect during the Federal Period was Benjamin Latrobe (1764–1820), who emigrated from England in 1795. A friend of Jefferson's—which in part accounts for his winning the commission for the U.S. Capitol—he built the first Greek Revival building in the United States (1798) and later the first Gothic revival house. His most famous project is Baltimore Cathedral, designed in 1804–1808. The exterior is a Graeco-Roman temple facade with Ionic columns and is rather undistinguished. (Latrobe also submitted a Gothic proposal for the building.) The interior, however, is an impressive sequence of vaulted spaces, the centerpiece of which is a Pantheon-like dome springing from an arcade of segmental arches (fig. **24.36**). The arches and austere piers were inspired by Soane's 1792 Bank Stock Office at the Bank of England, while the elegant coffered vaulting recalls Robert Adam (see fig. 23.11). This eclecticism, the selection and use of elements from disparate sources in a single building, seems to work, however. The plain base serves as a foil for the decorative vault, and both are bound by a delicate simplicity.

France: Empire Style

The course of the Classical revival in France was set by Napoleon, who commissioned several Roman structures in Paris to reinforce his imperial image. What is today the Church of Mary Magdelene, in the Place de la Madeleine, was commissioned as a "Temple of Glory" to French soldiers and directly modeled on a Roman Corinthian temple, the Maison Carrée (see fig. 7.46). The Arc de Triomphe, of course, was meant to evoke Roman triumphal arches, while the 130-foot-high bronze Vendôme Column, initially called the Column of the Great Army, was modeled on the Column of Trajan (see fig. 7.28) and commemorated Napoleon's victory at Austerlitz in 1805. Little was actually built during Bonaparte's reign, and perhaps his greatest influence came from the interior design developed for his residences, a design that became known as Empire Style.

One of the finest examples is the state bedroom that the architects Charles Percier (1764–1838) and Pierre-François Fontaine (1762–1853) designed for Josephine Bonaparte at the Château de Malmaison outside of Paris (fig. **24.37**). The style is opulent, using exotic materials and a saturated palette similar to those we saw in Ingres's 1806 portrait of Napoleon (see fig. 24.15). The bed, decorated with swans and cornucopias, is Roman inspired, while the canopy resembles a military tent

and is crowned by an imperial eagle. The tripod washstand is based on the discoveries at Herculaneum and Pompeii, although the sphinxes supporting the bowl are Egyptian, and the decoration of the bowl itself is Greek, an eclecticism characteristic of the Romantic taste for picturesque variety and associational references. Despite the rich materials, the room does

24.36. Benjamin Latrobe. Interior of Baltimore Cathedral (Basilica of the Assumption), Baltimore, Maryland. Begun 1805

24.37. François-Honoré Jacob-Desmalter (after a design by Charles Percier and Pierre-François Fontaine). Bedroom of Empress Josephine Bonaparte. ca. 1810. Château de Malmaison, Rueil-Malmaison, France

not seem busy; rather, it appears serious and ponderous, the result of the deep hues, the weight of the objects (even the drapery seems monumental), and an underlying geometry.

Germany: Creating a New Athens

Although Prussian architects were as eclectic as their English, French, and American counterparts, they designed some of the finest Classical revival buildings. The most renowned architect is perhaps Karl Friedrich Schinkel, named state architect in 1815 by Friedrich Wilhelm III.

KARL FRIEDRICH SCHINKEL Like many architects of the day, Karl Friedrich Schinkel (1781–1841) worked in every imaginable style—Classical, Romanesque, Gothic, Renaissance, and *Rundbogen*, the German term for Italian vernacular construction. He began as a Neoclassicist, however, as can be seen in the Altes Museum in Berlin (fig. **24.38**), his second major commission. Designed in 1824, it was modeled on a Greek temple, in part with the intention of endowing the building with the aura of being a temple of aesthetic treasures, a place where one came not to worship the gods but to contemplate art. The entrance is on what looks like the side of a temple (the real sides—their edges seen at either end of the colonnaded facade—are plain stone walls with rectangular windows), a brilliant device to suggest a temple without actually copying

24.39. Leo van Klenze. Walhalla, near Regensburg, Germany. Designed 1821, built 1830–1842

one and avoiding the use of the pedimented facade so common in the Classical revival. The museum is raised on a high podium and accessed by a centralized staircase, which along with the colossal Grecian order gives the building a serene monumentality and strong sense of axis. The width of the staircase is echoed above by a second-floor attic, which encases a domed room for the display of sculpture. Schinkel is a master of perfect proportions and scale, and the symmetrical and logical interior echoes the exterior harmony.

Prussia emerged as a major political force at the Congress of Vienna, held after the fall of Napoleon in 1815, and the ambitious building program instituted by Friedrich Wilhelm III was designed to reinforce his imperial ambitions. Part of the charisma of the Altes Museum was to link Berlin with the glory and grandeur of ancient Athens.

24.38. Karl Friedrich Schinkel. Altes Museum, Berlin. 1824–1830.

LEO VON KLENZE Schinkel's strongest Prussian competitor was Leo von Klenze (1784–1864), state architect to Crown Prince Ludwig of Bavaria. Like Wilhelm III, Ludwig was heavily in favor of German nationalism, and toward 1820 he commissioned Klenze to design Walhalla (fig. **24.39**), a monument to notable Germans and named after the resting place of heroes in Teutonic mythology. The building, filled with portrait busts, was built from 1830 to 1842 in Regensburg overlooking the Danube River. Like so much Classical revival architecture, Walhalla is virtually a replica of a Greek Doric temple. It is sited on the top of a hill, an archeologically accurate feature that adds to its to Romantic flavor. But what distinguishes the building is its complex substructure of stairs—the cold, brutal geometry and intimidating sublimity of which brings to mind Ledoux (see fig. 23.23). Ascending the endless steps requires endurance and makes the visitor experience physically the tremendous feats accomplished by the luminaries honored in Walhalla, and the great heights they attained. Walhalla is a wonderful example of Romantic escapism into an association with the distant past, and its direct copying of historic buildings characterizes much of the architecture of the period.

SUMMARY

The political and social changes spawned by the Enlightenment continued unabated in the first half of the nineteenth century. Instability spread across Europe in the wake of urbanization, industrialization, the French Revolution, and the Napoleonic wars. The Industrial Revolution continued to reshape societies, resulting in unprecedented urbanization, capitalism, and the rise of the bourgeoisie and the proletariat. Migrants flooded cities in search of work, suffering dislocation, substandard housing, and oppressive working conditions. Intellectuals and the cultural community saw these crises as a failure of the Enlightenment. Spurning away from an emphasis on rationalism, logic, empiricism, and science, they now sought higher truths that could be founded on emotion, imagination, individual genius, and nature. This change in attitude gave rise to the Romantic era of the first half of the nineteenth century. Now artists steeped themselves in Nature, allowing themselves to be swept away by its higher truths. Or they escaped into exotic cultures, the distant past, or the world of their wild imaginations. Instead of morality and fixed values, artists plumbed the depths of the mind and extremes of physical experience.

PAINTING

In Spain, Francesco Goya represented this new Romantic spirit, creating portraits and contemporary history paintings imbued with a disturbing psychology that reflected modern doubt about the existence of life after death and portraying the inherent inhumanity of civilization. In England, William Blake also focused on the tyranny of civilization, lodging his distaste for society in visionary imagery presented in the format of medieval manuscripts designed to embrace a new spirituality. An especially popular subject for English Romantic painters was landscape, perceived by the Romantics as the locus of universal forces or the divine. Breaking with Classical formula that empha-

sized ideal beauty and Italianate arcadias, John Constable painted sites in the Stowe Valley, capturing the details of the view and reflecting his own powerful responses to Nature. In contrast, his contemporary, Joseph Mallord William Turner, is best known for sublime landscapes that project a sense of the infinite. In Germany, David Caspar Friedrich invested his landscapes with divine forces, paradoxically leaving the existence of resurrection in question. By the 1820s, Americans declared landscape the national emblem, perceiving the pristine wilderness of their country as a Garden of Eden that embodied God and that differentiated the New World from the Old World.

Neoclassicism survived in France, where Jean-Auguste-Dominque Ingres continued the Classical tradition of David. While Ingres championed drawing, planar composition, and ideal beauty, his themes were often Romantic, focusing on such exotic subjects as odalisques. Painterly, rather than Neoclassical, Romanticism prevailed, however, with strong brushwork and color as well as dynamic Baroque compositions creating energetic, even chaotic, images. The Napoleonic wars helped trigger the trend, which began with Antoine-Jean Gros, who, when portraying Bonaparte's military prowess, depicted the atrocities accompanying his campaigns. After the fall of Napoleon, Théodore Géricault further developed painterly Romanticism, as in his 1818 *Raft of the Medusa* that shows castaways suffering on an open sea. It is Eugène Delacroix who has come to epitomize painterly Romanticism. He emerged in the 1820s with exotic scenes set in Greece or inspired by literature and filled with fear, death, and suffering. It was in part Delacroix's rise that resulted in Ingres being crowned the defender of the Classical tradition of ideal beauty and good taste.

SCULPTURE

Neoclassicism dominated European and American sculpture during the Romantic period, in large part due to the powerful influence of an Italian, Antonio Canova. While Canova's figures look classically derived, they nonetheless project powerful emotions that are associated with Romanticism. Only a few sculptors tried to break away from the Classical mold to create Romantic sculpture. These include François Rude, whose energetic composition of *"La Marseillaise"* on the Arc de Triomphe in Paris captures the spirit of nationalism and Antoine-Louis Barye, who specialized in vicious fights, often between exotic animals.

ROMANTIC REVIVALS IN ARCHITECTURE

Revival styles dominated the architecture of the Romantic era, and well beyond. In an unstable world dominated by war and the changes brought on by the Industrial Revolution, the architectural styles of the past offered a note of familiarity and stability. They also appealed to the Romantic sensibility for the exotic. Greek and Gothic revivals were perhaps the most common, but they were followed closely by Egyptian, Renaissance, Cottage, Moorish, and Chinese, to mention but a few. In England, John Soane was among the best-known Classical-revival architects, and A. W. N. Pugin among the best known to work in the Gothic style. John Nash was the architect for the Royal Pavilion in Brighton. Thomas Jefferson, who designed the University of Virginia, and Benjamin Latrobe, responsible for the Baltimore Cathedral and the U. S. Capitol, were renowned Classical-revival architects. Rome inspired the small amount of construction in France during Napoleon's reign, which is best known for its interior decoration called Empire Style, largely based on the Roman Empire but with hints of Egyptian and Greek motifs. Among the best-known architects in Germany were Karl Friedrich Schinkel and Leo von Klenze. While they worked in many different rival styles, they are perhaps best known for their Classical work, Schinkel for the Altes Museum in Berlin and Klenze for the Walhalla near Regensburg, Germany.

The Age of Positivism: Realism, Impressionism, and the Pre-Raphaelites, 1848–1885

ROMANTICISM BEGAN TO DISSIPATE IN EUROPE AS AN INTELLECTUAL attitude and stylistic trend after 1848 and was gradually superceded by Realism. Increasingly, people came to rely on the physical, physiological, empirical, and scientific as a way to understand nature, society, and human behavior. Hard facts, not feelings, became the bricks and mortar of knowledge.

Positivism is the term often used to describe the new mentality of pragmatism and materialism that emerged in the 1840s. The word was coined by the French philosopher Auguste Comte (1798–1857), who in 1830 began to write a multivolume series called *Positive Philosophy*. Comte called for social progress to be based on observable fact and tested ideas—in other words, on science. This new scientific approach to studying society came to be called sociology.

Paralleling Comte's sociology was the appearance in the 1830s and 1840s of popular and widely distributed pamphlets called *physiologies*. These were short essays that analyzed in tremendous detail different niches of French society, not just professions and types, such as the Lawyer, the Nun, the Society Woman, but such specific categories as the Suburban Gardener and the Woman of Thirty. In a world undergoing tremendous flux due to rapid industrialization and urbanization, the *physiologies* were a means of understanding the dramatic transformations that were occurring.

In politics, this new tough pragmatism was called *Realpolitik*, a German word meaning the "politics of reality," a concept that Otto von Bismarck (1815–1898), first chancellor of the German Empire, deftly used to create a united Germany toward 1870.

Detail of Figure 25.17, Camille Pissaro, *Climbing Path L'Hermitage, Pontoise*

(See map 25.1.) In religion, Positivism brought about a renewal of eighteenth-century skepticism. Epitomizing Positivism is the rise of photography in the 1840s, which most people perceived not as an art form but as a tool for faithfully recording nature and documenting the rapidly changing world.

In the arts, Positivism resulted in Realism. Now, artists and writers did not idealize or fictionally dramatize life but instead presented it unembellished, unidealized, and by definition as fleeting. As early as 1846, the poet and critic Charles Baudelaire called for an art based on modern life, writing that "The pageant of fashionable life and the thousands of floating existences—criminals and kept women—which drift about in the underworld of a great city . . . all prove to us that we have only to open our eyes to recognize our heroism. . . ." By the 1850s, *réalisme* was the rallying cry of the new art and literature. The evangelist of realism was critic Jules-Antoine Castagnary (1831-1888), who in his 1857 Salon review wrote "There is no need to return to history, to take refuge in legends, to summon powers of imagination. Beauty is before the eyes, not in the brain; in the present not in the past; in truth, not in dreams."

Instead of valuing wild flights of imagination, the exotic, and the sublime, Realists planted both feet firmly on the ground and, generally without emotion, bluntly depicted modern life. This ranged from the grim existence of country peasants and the downtrodden urban poor to the leisure activities of

Map 25.1. Europe and North America in the Age of Positivism

the rapidly growing metropolitan middle class and nouveau riche. In landscape painting, this realism evolved into Impressionism. Often working in the environs of Paris as well as in the city itself, the Impressionist painters documented the transformation of the landscape from rural to suburban, recording the incursion into the countryside of factories and railroads. They observed, too, the influx of moneyed Parisians, who built fancy weekend villas in farm villages, raced sailboats in regattas on such waterways as the Seine and Oise rivers, and dined, danced, and swam at fashionable riverside establishments. Painting rapidly outdoors with bold brushstrokes and strong colors, the Impressionists empirically captured the world before their very eyes, the shimmering sketchiness of their finished paintings reflecting the impermanence of a constantly changing contemporary world.

While the Impressionists were committed to creating an empirical representational art—a realistic art—a by-product of their stylistic developments was the advent of Modernism. To the following generations, their bright color and broad brushwork, that is, the abstract qualities, seemed to challenge the representational components as the subject matter of the painting. In the twentieth century, critics and historians would label this shift in art towards abstraction as "Modernism." Impressionism also marked the appearance of the **avant-garde**: the notion that certain artists and ideas are strikingly new or radical for their time. This meant, in effect, that artists began making art that was only understood by a handful of people, namely other avant-garde artists and a few art experts, including collectors. The disconnect between the avant-garde

and the general public, including the working class, who felt comfortable attending the highly publicized academy exhibitions, is reflected in the rise of commercial art galleries as the principal venue for the display of new art and the corresponding decline in power of academic salons throughout the Western world. While Realism served as a springboard for the abstraction of Modernism, we must remember that first and foremost it was a movement preoccupied with the dramatic changes occurring in society, and that its birth coincides with the great European-wide Revolution of 1848.

REALISM IN FRANCE

The year 1848 was one of uprising in France. Republicans, liberals, and socialists (those advocating a classless society in which either a popular collective or the government controls the means of production) united in that year to demand an increased voice in government, and when King Louis-Philippe refused, armed conflict was imminent. The king abdicated. A provisional government was soon replaced by the Constituent Assembly. But the working class was still not represented, and already organized into labor camps instituted by the new government, it revolted, storming the parliament. War raged in the streets of Paris, and 10,000 people were killed or wounded. This proletarian rebellion produced shock waves of class revolution that radiated throughout Europe, resulting in similar uprisings in major cities. Even England was threatened, as the Chartists, a socialist group, agitated for workers' rights, going so far as to gather arms and conduct military drills. As one contemporary French writer

said, European society was "prey to a feeling of terror incomparable to anything since the invasion of Rome by the barbarians."

The forces of conservatism ultimately prevailed everywhere. In France, Louis Napoleon Bonaparte (1808–1873), the emperor's nephew, was overwhelmingly elected president of the Second Republic, largely on name recognition. By 1852, however, he dissolved the parliament and arranged to have himself "elected" emperor, becoming Napoleon III and establishing the Second Empire. France prospered under his reign, which ended in 1870 with the Franco-Prussian War.

The Industrial Revolution, which had not gained momentum in France until the 1840s, now increased dramatically, and new financial systems instituted by Louis Napoleon created unprecedented wealth. Dominated by financiers, industrialists, manufacturers, lawyers, and merchants, the bourgeoisie flourished, as did their desire for material possessions. Reflecting the new consumerism was the 1855 Paris International Exposition, or World's Fair, in which countries from all over the world displayed their products. The Parisian exposition was a competitive response to the first international trade fair presented in London in 1851, the Great Exhibition of the Works of Industry of All Nations. In Paris, the new wealth and increased time for leisure activities gave rise to grand restaurants, cafés, department stores, theaters, clubs, parks, and racetracks, where people, often from different social classes, congregated and shopped.

Paris itself received a makeover, taking on its glorious modern-day form when, beginning in 1853, Georges-Eugène Haussmann (1809–1891), Louis Napoleon's minister of the interior, initiated huge municipal improvements. Among them were the creation of magnificent wide avenues that cut through the medieval rabbit warren of the Old City and were flanked by chic modern apartments. The result was spectacular perspectives (and arteries that permitted the rapid deployment of troops in the event of more insurrections), punctuated by beautifully landscaped parks, gardens, and squares, and anchored by grand civic buildings, including an opera house and stately railway stations.

Realism in the 1840s and 1850s: Painting Contemporary Social Conditions

French Realism arose simultaneously with the Revolution of 1848. Especially in the hands of Gustave Courbet, the self-proclaimed banner carrier of this art movement, and Jean-François Millet, the painter of peasants, Realism was a highly political style. It championed laborers and common country folk, groups that challenged the authority and privilege of the Parisian aristocracy and bourgeoisie and that were in part responsible for the upheavals of 1848.

GUSTAVE COURBET Gustave Courbet (1819–1877) came from Ornans, a town at the foot of the Jura Mountains near the Swiss border, where his father, a former peasant, was a prosperous landowner and vintner. He went to Paris in 1839 to study painting, and by the late 1840s became a dominant figure

at the cafés on the Left Bank, a neighborhood made famous by Henri Murger's book *Scenes of Bohemian Life*. On the Left Bank, Courbet met the literary avant-garde, befriending Baudelaire, the socialist journalist Pierre-Joseph Proudhon (1809–1865), and the critic and writer Champfleury (the pen name of Jules-François-Félix Husson; 1821–1889). Largely under the influence of Proudhon, Courbet, already a Republican, became a socialist. Meanwhile, Champfleury swayed him toward Realism. Champfleury, who collected folk art and was interested in such nonelitist art forms as popular prints, children's art, and caricature, convinced Courbet to return to his rural roots and paint the simple world of Ornans.

In the fall of 1849, Courbet returned to Ornans, and there in his family's attic painted the 22-foot-wide *Burial at Ornans* (fig. 25.1), which was accepted at the Salon of 1850–1851. The picture was an affront to many viewers. It presented common provincial folk, portrayed in a coarse, heavy form, without a shred of elegance or idealization. The people of Ornans, many of whom can be identified, posed for Courbet, and the artist not only documented their clothes and bearing but their distinguishing facial features, which included bulbous noses, grotesquely wrinkled faces, and unkempt hair. The bleak overcast landscape is equally authentic, based on studies made at the Ornans cemetery. Courbet's realism extends to the democratic presentation of the figures. Despite bold brushwork and a *chiaroscuro* vaguely reminiscent of his favorite artists, Rembrandt and Velázquez, the picture has no Baroque drama and no compositional structure designed to emphasize one figure over another—the dog is as important as the priest or mayor. Nor does it use Classical formulas, as Benjamin West did in his pyramidal groupings in *The Death of General Wolfe* (see fig. 23.7). Instead, the image embraces the bold, simple compositions found in such popular art as broadsides, almanacs, and song sheets—the art of the people, not the academy.

The picture seems so matter-of-fact it is difficult to know what it is about. We see pallbearers and the coffin on the left, then a priest and assistants, followed by small-town patricians, and to the right, womenfolk. An open grave is in the foreground center. We do not even know whose funeral it is. Nor is it clear that this is a statement about the finality of death, although it is the strongest candidate for the theme. Clearly, the picture is a document of social ritual that accurately observes the distinctions of gender, profession, and class in Ornans. More important, it brazenly elevates provincial bourgeois events to a lofty status equal to historical events. In effect, it was an assault on the highly esteemed genre of history painting. As such, Courbet's work repulsed many Parisians. Equally unsavory was the political threat represented by the Ornans bourgeoisie, who under the Second Republic had considerable voting power, capable of swaying national elections. Furthermore, they were a sobering reminder to many Parisian bourgeoisie of their own provincial origins, which many tried to hide.

Courbet exhibited a second Ornans painting in the Salon of 1850–1851, *The Stone Breakers* (fig. 25.2). Here he presents on a

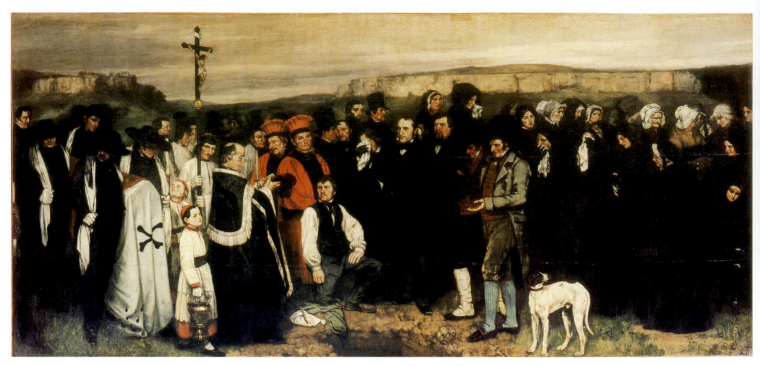

25.1. Gustave Courbet. *Burial at Ornans*. 1849–1850. Oil on canvas, 10'3$\frac{1}{2}$" × 21'9$\frac{1}{2}$" (3.13 × 6.64 m). Musée d' Orsay, Paris

confrontational, life-size scale two workers he met on the out-skirts of town who were pounding stones to make gravel for a road. Again, Courbet portrays the figures with complete veracity, their poverty and social class announced by their ragged clothes, by the coarseness of their labor, and by the dirt under their fingernails. He gives the workers the same detailed intensity as the stones, and the fact that their faces cannot be seen virtually transforms them into inanimate objects, like the rocks and tools. Once more, the composition lacks conventional structure, resulting in our eye jumping from one fact to another.

While the public both condemned and praised the picture for having a socialist message, both political sides admired the image's materiality. As in the *Burial*, Courbet used a broad application of paint, sometimes troweling it on with a palette knife, in effect transforming the artist into an artisan-laborer. This bold paint application reinforces the powerful physicali-ty of the figures and by its physical presence virtually stands in for the material objects. In both *Burial* and *Stone Breakers*, figures are in shallow space, pushed up to the surface of the canvas, and the landscape is so flat it seems like a backdrop that forces our eye to stay in the foreground. Courbet never admitted to having a socialist agenda in *Stone Breakers*, but this "complete expression of human misery," as the artist him-self described it, was about social injustice and was a product of the Revolution of 1848. Rather than presenting rural life as pastoral or comic, as had been traditional in art, Courbet depicts its harsh reality.

In 1855, Courbet had 11 paintings accepted for the Paris Universal Exposition, a trade fair designed to promote French commerce and industry. The fair's fine arts section replaced the Salon exhibition that year and featured such famous French masters as Ingres and Delacroix. To promote his career, Courbet created a sensation by doing what no living artist had ever done: He commissioned a Classically inspired building near the fair where he mounted his own one-person show, which included *Burial at Ornans*. He titled his exhibition *Du Realisme* (About Realism) and sold a pamphlet, a "Mani-festo of Realism." In it he made the following proclamation: "To be in a position to translate the customs, the ideas, the appearance of my epoch according to my own estimation: to be not only a painter, but a man as well, in short to create living art—this is my goal." At every turn, Courbet challenged aca-demic values. He replaced the hallowed Greek and Roman tra-dition with bold images of the contemporary world, images that contained no references, either iconographic or composi-tional, to the Classical tradition or history painting. He daring-ly troweled paint into the canvas, undermining the refinement of academic paint handling technique, whether the Neoclassi-cal hard smooth surface of Ingres or the painterly Venetian and Rubensian tradition found in Delacroix; and while not reject-ing the Salons, he refused to rely on them to promote his career and instead turned to commercial exhibition.

JEAN-FRANÇOIS MILLET We can see how matter-of-fact in presentation and unemotional Courbet's pictures are if we compare them with another Realist entry at the Salon of 1850–1851, *The Sower* (fig. **25.3**), by Jean-François Millet (1814–1875). Like Courbet, Millet had a rural upbringing. Born into a family of well-to-do farmers near Cherbourg in Normandy, he grew up steeped in the land and the timeless seasonal cycle of farm life. He was well educated and well read, and after choosing a career in painting and studying in both Cherbourg and Paris, he began by making portraits, using a

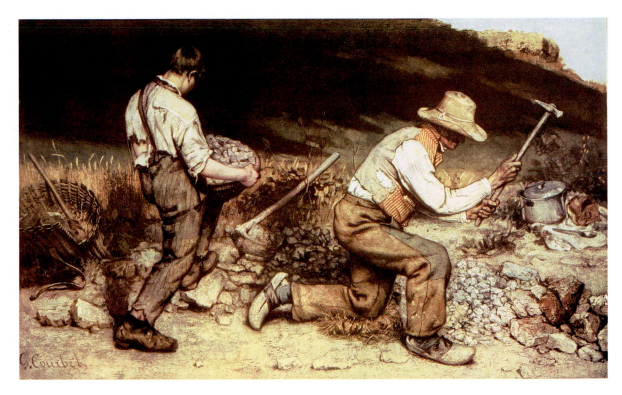

25.2. Gustave Courbet. *The Stone Breakers*. 1849. Oil on canvas, 5'3" × 8'6" (1.6 × 2.59 m). Formerly Gemäldegalerie, Dresden. (Believed to have been destroyed in World War II)

dark palette that reflected his love of seventeenth-century Spanish painting and Rembrandt. In the late 1840s, when back in Paris, he befriended several of the landscape painters of the Barbizon School (see page 850), and in 1848 he produced his first peasant picture, *Le Vanneur (The Grain Sifter)*. Pictures of peasant life would become his specialty for the remainder of his life. In 1848, after an outbreak of cholera in Paris, Millet settled permanently in Barbizon.

Coming on the heels of the Revolution of 1848, Millet's pictures dignifying the peasant were read politically. As seen in *The Sower*, Millet's workers, like Courbet's, are clearly poor and downtrodden: They wear tattered clothing and are consigned to a life of endless backbreaking work on the land. Shadowy and enormous, they were frightening to a Parisian audience that was reeling from the Revolution of 1848. More threatening yet, Millet ennobled them. The anonymous sower is monumental in size, a massive dynamic form consuming most of the picture frame. He is not so much an individual, as are Courbet's figures in *Burial at Ormans*, but rather a type—the noble farmworker, who is poorly paid for his dedicated labor. Using a dark *chiaroscuro* reminiscent of Rembrandt, Millet casts the laborer in murky shadow, making him blend in with the soil from which he seems to emerge. He is the embodiment of the earth, a reading enhanced by the gritty coarseness of Millet's paint. The dramatic sweep of the gesture and the undulating contours of the body align him with the eternal cyclical forces of nature itself. While a Realist in his peasant subject, Millet is clearly a Romantic in sensibility, his pictures aspiring to poetry and mood, not sheer fact.

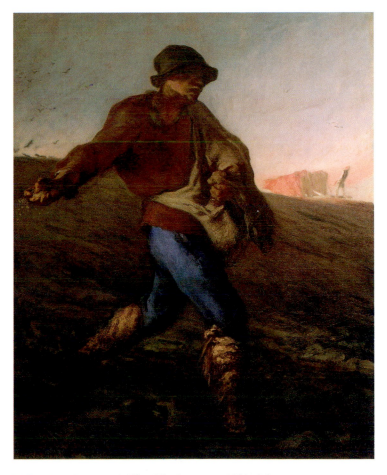

25.3. Jean-François Millet. *The Sower*. ca. 1850. Oil on canvas, 40 × 32½" (101.6 × 82.6 cm). Museum of Fine Arts, Boston. Gift of Quincy Adams Shaw through Quincy A. Shaw. Jr., and Mrs. Marion Shaw Haughton. 17.1485

HONORÉ DAUMIER Also appearing for the first time in the salons at this time was Honoré Daumier (1808–1879). Daumier was famous as a caricaturist but virtually unknown as a painter. His lithographs began appearing regularly in Paris newspapers about 1830. (See *Materials and Techniques*, page 911) The emergence of a sizeable and literate bourgeois public and the development of inexpensive paper and printing processes resulted in the modern-day newspaper, made all the more popular by being illustrated with lithographs and woodcuts. Daumier worked mostly for the socialist newspapers *La Caricature* and *Le Charivari*, both devoted to political and social satire. This was a perfect match, for Daumier was passionate about social causes, dedicating his life to exposing all evil, from the corrupt and repressive activities of the government to the avarice and vanity of the nouveau riche. His brilliant lithographs quickly and subtly documented the different professions, classes, and types emerging in a rapidly growing and changing Paris, in some respects paralleling the lengthy factual descriptions of the physiology pamphlets. His characterizations anticipated the observations of types found in the urban Realists and Impressionists of the 1860s and 1870s. We can see Daumier's sharp eye, caustic humor, and succinct draftsmanship in *It's Safe to Release This One!* (fig. **25.4**), made in 1834 after a workers' uprising in Paris that resulted in the deaths of numerous poor and innocent citizens. It presents a caricature of the overweight pear-shaped King Louis-Philippe, who, upon feeling no pulse in a chained emaciated worker, announces he is now free to go.

Daumier undoubtedly wanted to be considered a fine artist, and with this in mind he exhibited a handful of paintings at the Salons of 1849 and 1850–1851. He was ignored, however. For the rest of his life he painted privately, exhibiting only one more time, the year before he died, at a private gallery. His paintings were therefore essentially unknown. It appears Daumier taught himself to paint during the 1840s. In contrast to his

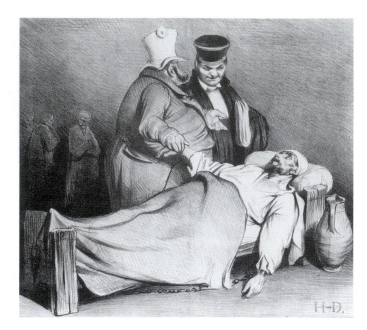

25.4. Honoré Daumier. *Its Safe to Release This One!* 1834. Lithograph

commercial work, his oils are pure compassion. He dispensed with humor and satire and, relying on his caricaturist's ability to concisely capture character and types, uncannily nailed down the psychology of contemporary urban life, as seen in *The Third-Class Carriage* (fig. **25.5**), made about 1863. Here he captures a peculiarly modern condition: "the lonely crowd," in which throngs of workers are jammed into a third-class railway car, consigned to hard benches rather than to the wide plush seats of first-class cars. A range of types, all anonymous, and part of the growing urban masses, endure their daily commute. The weary family in the foreground is the focus of the picture. They are simpler and poorer than the petit bourgeoisie behind them and seem to represent the uprooted rural poor

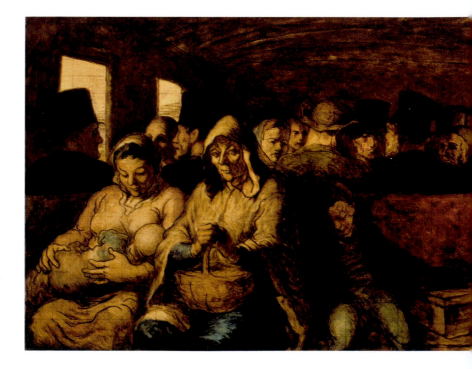

25.5. Honoré Daumier. *The Third-Class Carriage.* ca. 1863–1865. Oil on canvas,. 25¾ × 35½ ″ (65.4 × 90.2 cm). The Metropolitan Museum of Art, New York. Bequest of Mrs. H. O. Havemeyer, 1929. The H. O. Havemeyer Collection (29.100.129)

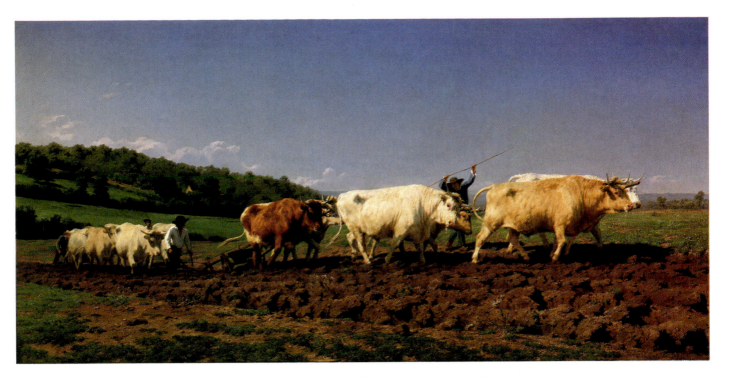

25.6. Rosa Bonheur. *Plowing in the Nivernais*. 1849, Oil on canvas, 5′9″ × 8′8″ (1.75 × 2.64 cm) Musée d' Orsay, Paris

who have come to Paris in search of opportunity, only to become victims of modern urbanism. Silent and tired, they are imprisoned in a turgid gloom, shut off from the wholesome bright light seen through the windows. But Daumier presents them with fortitude and dignity, for the two women have the monumental forms we saw in Millet's *Sower*. What appears to be a simple peasant family is transformed into the Mother and Child with St. Elizabeth. Like Millet, whom he admired, Daumier is alternately labeled a Realist and a Romantic, his paintings similarly combining Realist subject matter with the powerful compassion of a Romantic.

ROSA BONHEUR A fourth Realist exhibiting at the Salon of 1850–1851 was Rosa Bonheur, who garnered considerable attention. She studied with her father, a drawing instructor and socialist, who advocated full equality for women. From early on, Bonheur was determined to become a successful woman in a man's world. Instead of making small still lifes and watercolors traditionally associated with women, Bonheur became an animal painter and worked on a large scale, displaying the technical finesse of the finest academicians. Rather than the exotic animals of the Romantic world of Delacroix and Bayre, Bonheur painted farm animals, including cows, horses, and sheep. Influenced by the scientific empiricism of natural history, she carefully studied her subjects, accurately rendering them, often in minute detail. Bonheur began showing at the Salon of 1841, and during the course of the decade, her reputation grew. (See end of Part IV, *Additional Primary Sources*.)

In 1848, the new Second Republic, reflecting a Positivist compunction to document French regional agriculture, commissioned a large painting from Bonheur. At the Salon of 1850, she unveiled the 8-foot-wide result, *Plowing in the Nivernais:*

The Dressing of Vines (fig. **25.6**). The inspiration for this subject is believed to be *The Devil's Pool* (1846), a novel by George Sand (pen name of Amandine-Aurore-Lucile-Dupin, Baroness Dudevant [1804–1876]), who, as a successful woman author, was a role model for Bonheur. In the book's preface, Sand announced that the novel "brings back civilized man to the charms of primitive life." As industrialization was beginning to transform France dramatically, creating complex urban centers filled with such ills as overcrowding, poor housing, class conflict, and dislocated migrants, Sand advocated a return to nature, to a simple "primitive" world, a theme also found in Millet's paintings and one that would become popular with the cultural community in the closing decades of the century. Bonheur's interest in animals in part reflected her own interest in nature, and after 1860, she left Paris and permanently settled in the rural Forest of Fontainbleau, near Barbizon. There she lived with her companion, Nathalie Micas, and challenged societal conventions about women by wearing men's clothing, cropping her hair short, and smoking in public.

To create *Plowing in the Nivernais*, Bonheur spent weeks in the Nivernais, a rural area in central France, studying the unique qualities of the land, animals, farm tools, and regional dress, all of which salon goers recognized in her tightly-painted detailed picture and responded to favorably. Unlike Millet's *Sower*, her image is factual and unemotional, and in contrast to Courbet's Ornans paintings, it plays down the unseemly qualities of rural life. We may see the ponderous weight of the enormous Nivernais oxen, but we experience no stench of animals, no sweat of labor, and no smell of earth, although it is all represented. Like the physiologies, Bonheur documents, catalogues, and presents. The large size of the oxen and the processional alignment even lend a grandeur to the scene.

The Realist Assault on Academic Values and Bourgeois Taste

By presenting provincial bourgeoisie and peasants on a scale reserved for history painting, Courbet launched an assault on the values of the French Academy and bourgeois taste. In effect, he declared contemporary life, and especially contemporary social conditions, just as valid (if not more valid) a subject for painting as historical events, and his emergence signals the death knell of the hierarchy of the genres that can be traced back to the establishment of the academies. (Ironically, vanguard artists would return to history and religious painting in the closing decades of the century.) Courbet's rejection of academic values in order to depict the social conditions of the modern world was taken up by Édouard Manet (1832–1883) in the 1860s. Focusing on urban rather than rural life, he painted musical gatherings in the Bois de Boulogne, the new park on the western outskirts of Paris where the upper classes came to be seen, and he painted the fashionable throngs who congregated at Longchamp, the

new racetrack, also in the Bois. He painted chic masked balls held at the opera, courtesans with their clients, and the new leisure activities at the new cafes, dance halls, and restaurants. His pictures are often complex, loaded with references, and densely layered with multiple readings. They are so rich that he could comment on academic values while capturing the energy, psychology, and changes occurring in modern society. Such is the case with *Luncheon on the Grass* (fig. 25.10), which he submitted to the Salon of 1863. To understand this picture, it is first necessary to look at the academic values that prevailed in the 1860s and were used by the Salon jury.

OFFICIAL ART AND ITS EXEMPLARS While it is dangerous to characterize any one kind of art as being academic and taught at the Ecole des Beaux-Arts in the 1860s, most of the academicians still believed in the supremacy of history painting, the Greco-Roman paradigm, and the highly finished Neoclassical style of paint handling epitomized by Ingres. Among the more popular subjects was the female nude, and images of nudes plastered the walls of the salons. However, they were not ordinary nudes, for they were all Venuses, Dianas, bacchantes, or nymphs; that is they were noble beings with a Classical pedigree. Equally popular were nudes in genres scenes that took place in an exotic setting, such as a harem, or in a setting from the historical past, such as ancient Rome. Nonetheless, the pictures were esteemed since they continued the Classical tradition of beauty and perfection.

The most famous academic painter of the period was Adolphe-William Bouguereau (1824-1905), who became president of the Institute of France and the French Legion of Honor, and was the most famous French artist of his day. In addition to gypsies, peasant girls, and religious themes, he painted mythological scenes, such as *Nymphs and a Satyr* (fig. 25.7) of 1873. Here, nymphs playfully tug a satyr into the water in an image that is overtly erotic, as epitomized by the background nymph clutching the satyr's horn in unabashed ecstasy. Heightening the sensuality of flesh, gesture, and expression is Bouguereau's detailed naturalism, which reflects a Positivist penchant to record, not normally associated with the Classical tradition. Even Bouguereau's idealized women seem real and not godlike, not just because of their naturalistic flesh but also because they are voluptuous—they look more contemporary than Greek or Roman.

Despite upholding the Classical tradition into the twentieth century, Bouguereau is far from being just a standard bearer of a dying tradition. Besides his remarkable technical finesse, his pictures are distinguished by a powerful psychology—here of erotic abandonment—which will preoccupy artists later in century. His images are generally set against a backdrop of nature, reinforcing the expression of elemental desires and reflecting the period's desire to escape from the complex world of urbanization and industrialization and the longing to return to simpler times of Arcadian and rural retreats.

Sculpture remained tied to the Classical tradition and similarly often focused on the female nude. One of the outstanding

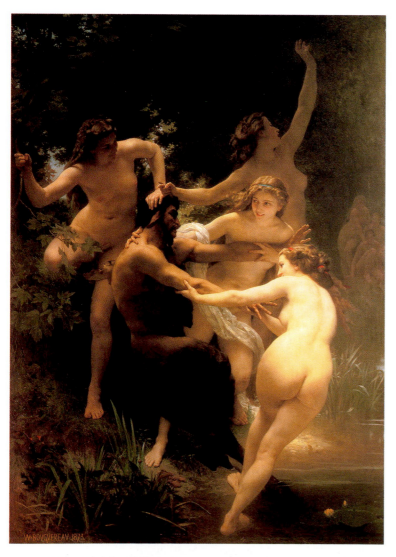

25.7. Adolphe-William Bouguereau. *Nymphs and a Satyr.* 1873. Oil on canvas, 9'3⅜" × 5'10⅞" (2.8 × 1.8 m). Sterling and Francine Clark Art Institute, Williamstown, MA

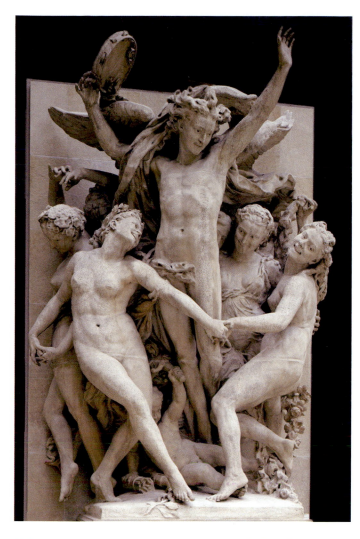

Carpeaux's naturalism and the egregiously erotic work was hailed as a great monument in the Classical tradition.

Because of its dynamic Baroque composition and excessiveness (too much flesh, too much mirth), *The Dance* was a perfect complement for its setting, the Opéra (fig. **25.9**), of Charles Garnier (1825–1898), built from 1861 to 1874 and sharing the same qualities. The Opéra has become an emblem of the opulence and extravagance of the Second Empire, reflecting the pretentious taste of the bourgeois audience that patronized Bouguereau and Carpeaux. The building was a lynchpin in Haussmann's design for Paris, the dramatic focal point for the Avenue de l'Opéra, as well as the hub for several other major arteries.

The Opéra marks the extension of nineteenth-century revival styles to the Baroque, rivaling the Classical and Gothic revivals that had prevailed before 1860. With the double-columned colonnade Garnier suggests Perrault's Louvre (see fig. 21.12), putting Louis Napolean in a line of descent from Louis XIV. The segmented arches springing from the columns at either end of the facade recall Lescot's Square Court of the Louvre (see fig. 18.4). The endless variety of colors and textures, the dazzling accretion of sculpture and decoration, and the extensive borrowing and recombining of architectural forms from the Renaissance and the Baroque—just the sheer density of *everything*—resulted in an opulent, ostentatious style that paralleled the materialistic conspicuous consumption of the period and appealed to *nouveau riche* tastes, although it was disdained by the old-moneyed aristocracy.

25.8. Jean-Baptiste Carpeaux. *The Dance*, 1867–1869. Plaster, $13\frac{3}{4} \times 9\frac{3}{4}''$ (420 × 298 cm). Musée de l'Opéra, Paris

sculptors from the period was Jean-Baptiste Carpeaux (1827–1875), and among his best known works is *The Dance* (fig. **25.8**), one of four marbles commissioned in 1867 for the public facade of the new Paris Opéra, each sculpture representing a component of opera. In the plaster model reproduced here—which is livelier and more precise than the finished marble—Dance is represented by an erect, winged allegorical male, who serves as an erotic maypole around which gleeful, well-proportioned bacchantes worshipfully prance. The satyr lurking under Dance's cape underscores the licentious intentions of their ritualistic play.

When *The Dance* was unveiled in 1869, critics panned the piece, declaring that the figures looked drunk, vulgar, and indecent. The naturalism certainly makes the dancers look undressed rather than nude; we see elbows, kneecaps, and roles of flesh on bodies that Canova (see fig. 24.28) would have presented perfectly smooth. While the figures may be Classically derived, they do not look quite Greek or Roman but rather Second Empire. Within a year, however, eyes adjusted to

25.9. Charles Garnier. The Opéra, Paris. 1861–1874

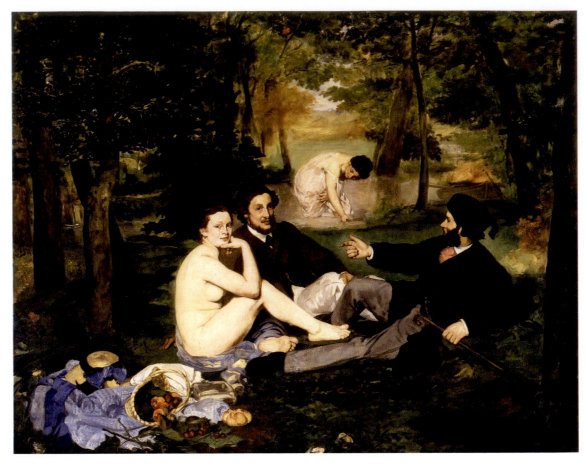

25.10. Édouard Manet. *The Luncheon on the Grass (Le Déjeuner sur l'Herbe)*. 1863. Oil on canvas, 7′ × 8′10″ (2.13 × 2.69 m). Musée du Louvre, Paris

ÉDOUARD MANET Manet's *The Luncheon on the Grass* (fig. **25.10**) was a condemnation of bourgeois values and academic taste as well as a statement about what art should be about—the modern world. Manet himself came from a Parisian bourgeois background, and he studied with a famous academician, Thomas Couture (1815–1879). His true masters were the painterly artists he copied at the Louvre—Hals, Titian, and the Spaniards Velázquez and Goya. He was a regular at the cafés, especially befriending Courbet, who was his role model, as well as Baudelaire, and the Realist novelist and art critic Émile Zola (1840–1902). Like many Realist writers and artists, Manet was a *flâneur*, a social type that surfaced as early as the 1830s, when the physiology pamphlets began appearing. Initially based on the British aristocrat and dandy, the *flâneur* was an impeccably dressed man with perfect manners who kept abreast of current events through newspapers and gossip. His day was spent inconspicuously strolling the streets of Paris and acutely observing the fleeting moments of modern life, which he then translated into a painted or written image. The *flâneur* was witty and gregarious and delighted in shocking the bourgeois. Manet's close friend Baudelaire ranks among the most famous *flâneurs* of the period.

Out of this background Manet produced the *Luncheon*, which shows two couples picnicking in the Bois de Boulogne. The painting was rejected by the 1863 Salon jurors. But that year the jurors rejected a record number of artists, causing such a popular outcry that Louis Napoleon declared there

would be a *Salon des refusés* (Salon of the Refused), an exhibition of the rejected artists to be held in conjunction with the official Salon of 1863. Many of the rejected artists preferred not to participate in what was perceived as an inferior exhibition; Manet, however, did.

The public showed up in record numbers to laugh at the rejects, and especially to view Manet's *Luncheon*, which was front-page news in all the papers. *Luncheon* created a scandal by presenting a contemporary scene of a naked woman in a park with two nattily dressed men. The public was outraged, for obviously the nude had to be a prostitute. It did not matter that critics acknowledged that the painting was inspired by the well-known *Fête Champêtre* (fig. 16.30) in the Louvre, which similarly presented a nude seated with two dressed men. One writer even correctly recognized that the seated group exactly replicates the poses of river gods in a circa 1520 print by Marcantonio Raimondi after Raphael's *The Judgment of Paris* (fig. 16.29). No mention was made, however, that the background woman in a shift is based on Watteau's *The Bather*, also in the Louvre; in fact, Manet originally used this title for his painting.

As far as the critics were concerned, referencing these august sources was not enough to overcome Manet's flagrant lack of decorum, a crime he brazenly committed on a roughly 7-by-9-foot scale, a scale generally reserved for history painting. So, why did Manet base his contemporary scene on historical sources? The answer may lie in the artificiality of his figures,

who fail to interact convincingly. As pointed out by one art historian, they look like École des Beaux-Arts students posing to recreate a famous painting. In effect, Manet is telling us the present cannot live in the past, which many academicians chose to do. As trumpeted by Baudelaire in 1846, Manet was declaring that artists must find their subject matter, their heroes, in the modern world. Furthermore, he was exposing the disguised eroticism that the tradition of the Classical nude had now stooped to. It is possible, as well, that Manet used historical sources as a device to put himself into the long tradition of great art. In effect, he is announcing that his Realism is not only the most valid direction for art to take, but also that it is as important and vital as the great art of the past.

What convinced the jurors and public that Manet was an incompetent sensationalist who deserved to be relegated to the *Salon des refusés* was his style. To their academically focused eye, he could neither model nor create convincing space. The picture looked like a preliminary sketch, not a finished picture. The figures are two-dimensional cutouts, flattened by their crisp, silhouetting contours and a flourish of broad brushstrokes that dispense with the halftones between dark and light needed to mold volume. A shadow indicating a fold on a pant's leg, for example, is rendered with one bold, black sweep of the brush. The woman wading in the background is too large for her recessed location and seems to float directly over the seated group. All of the objects—figures, trees, the colorful still life of clothes and basket—hover in space, failing to connect and assemble into a coherent spatial structure.

Manet has undermined the order of the illusionistic Renaissance window and replaced it with a new unifying logic—a sensual sea of brushwork composed of lush, oily, and thickly applied paint that dramatically covers the entire surface of his canvas. Our eyes delight in the lusciousness of his brushwork, the wonderful variety of his Velázquez- and Goya-inspired blacks, the range of greens in the grass, and the deft play of darks next to lights that makes our eyes jump from one light area to another and from one dark patch to the next. These abstract qualities—paint handling and value contrasts, for example—are the new structure of painting, not illusionistic space and modeling. With *Luncheon on the Grass*, Manet began what twentieth-century critics would consider the Modernist tradition, a tradition that emphasized the abstract qualities of art and that would continue for the next hundred years. Manet undoubtedly delighted in how the unfinished, sketchy look of his paintings irreverently countered the slick drawing and modeling of academic tradition and shocked bourgeois taste. Additionally, he used it to create a fleeting, momentary quality that reflected the quickly changing modern world, the world captured by the *flâneur's* perspicacious eye.

Surprisingly, Manet was accepted into the Salon of 1865, for his *Olympia* (fig. **25.11**), painted in 1863, is unequivocally a courtesan, a prostitute with a wealthy, upper-class clientele. This nude, based on Titian's *Venus of Urbino* (fig. 17.30), is the Second Empire gentleman's idea of a modern-day goddess, and everyone in Paris knew this, since Olympia was a common name adopted by powerful courtesans and kept women. With

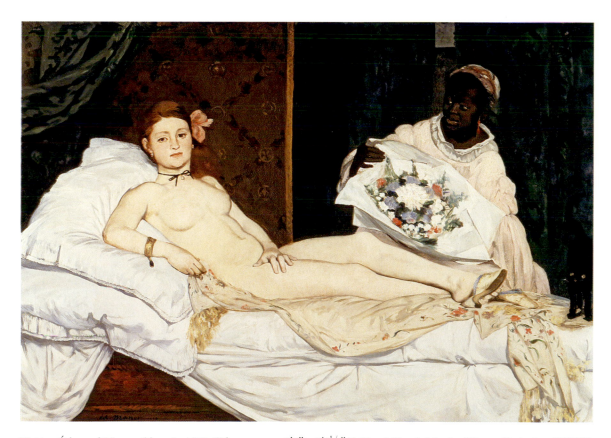

25.11. Édouard Manet. *Olympia*. 1863. Oil on canvas, 4'3" × 6'2¼" (1.31 × 1.91 m). Musée d'Orsay, Paris. Inv. RF2772

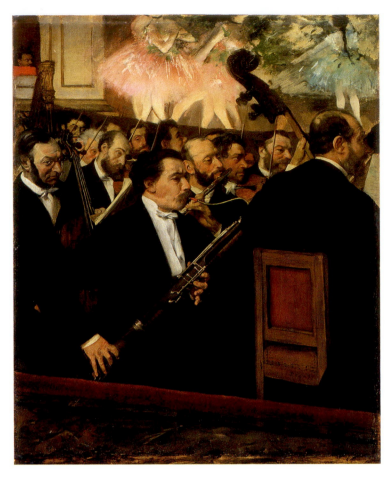

25.12. Edgar Degas. *The Orchestra of the Paris Opéra*. 1868–1869. Oil on canvas, 22$\frac{1}{4}$ × 18$\frac{3}{16}$ " (56.5 × 46.2 cm). Musée d' Orsay, Paris

its Classical ring, the name was also a sly attack on the allegorical veiling of erotic nudes that appeared in the Salons.

Manet's *Olympia* portrays a reality of contemporary Paris: Many wealthy men—the same ones who bought academic nudes for their eroticism, not for their smoke-screen Classicism—kept mistresses and visited prostitutes. Unlike Titian's Venus, Manet's Olympia is more real than idealized—she is somewhat angular, awkward, and harsh rather than voluptuously curvilinear. Furthermore, she is all business, returning our gaze with a daringly confident stare, a power stare that made men uncomfortable and fulfilled their worst fears of controlling, independent women. She engages the viewer in a way rarely seen in genre painting, and in a way that reflects Manet's interest in the new social mobility of Parisian society, the interaction of classes, and the importance of money and commodities in contemporary society.

EDGAR DEGAS AND JAPONISME Like Manet, Edgar Degas (1834–1917) came from a wealthy background, his father heading up the Paris branch of a family bank. And like Manet, he was something of a *flâneur*, although too much of a recluse to be considered a full-blown one. Initially he aspired to be a history painter. An admirer of Ingres, Degas studied with an Ingres follower and emphasized drawing and modeling in his early work. By 1865, Degas entered Manet's and Baudelaire's orbit at the Café Guerbois, and he turned to capturing

modern Paris. Degas developed a Manet-inspired painterly approach to his subject, as well as innovative compositional devices that give his images a spontaneous, transitory quality and put the viewer in the voyeuristic position of the unobserved *flâneur*. Now he painted the new Haussmann boulevards, the millinery shops, Longchamp racetrack, café concerts, the opera, bars, and cafés. His sharp eye captured types from all levels of society, from the bourgeoisie to performers, to the socially marginalized, to the working class.

A classic work from the 1860s is *The Orchestra of the Paris Opéra* (fig. **25.12**) of 1868–1869. The painting began as a portrait of the bassoonist, in the foreground, but was extended to include the other musicians, most of whom can be identified. Essentially the picture is a genre scene, in which we see not only the members of the orchestra but also the ballet dancers onstage. Yet the subject is not just the talented, toiling performers but the intensity, excitement, and fragmentation of contemporary life itself, which is presented in a matter-of-fact way. Degas has put us virtually in the pit, and we feel like unobserved voyeurs. Our view is not head-on but at an angle, which is unusual for a painting but certainly typical for a theatergoer. The cellist is arbitrarily cropped on the right, suggesting we are only looking at the left side of the orchestra, seeing only a fragment of a complete view. The same is true of the ballet dancers, whose heads and legs are chopped off.

Building on this energy are the planes of the wall, the stage, the front row of the orchestra, and the ballet dancers, all of which are slightly skewed, along with the angular thrust of instruments and the dancers' legs and arms. Space seems compressed, as far and near are dramatically juxtaposed, for example in the dark cello head and brightly colored tutus. The image seems to climb up the picture plane rather than recede in space. A precise line defines figures and objects, but a sporadic spray of dashing brushwork, best seen in the dancers' tutus, adds spontaneity and a fleeting quality, giving us a feeling of the moment.

Scholars often attribute Degas's innovative compositions to the influence of Japanese prints, which flooded the Parisian market in the late 1850s. In 1853, American Commodore Matthew Perry steamed into Tokyo Bay with four warships and forced Japan to open its doors to the West after two centuries of isolation. By the early 1860s the world was saturated with Japanese products. Fans, vases, kimonos, lacquer cabinets, folding screens, jewelry, and tea services were common items in most fashionable Western homes. The French were especially taken by Japanese culture, and their infatuation was called *Japonisme*, a term also used by the English and Americans. The most popular display at the 1867 Universal Exposition in Paris was the Japanese pavilion. Especially intriguing for artists were Japanese prints, works that first arrived in France as packing material for fragile objects but were nonetheless collected by the late 1850s by the artists in Manet's circle, who found them visually fascinating.

As can be seen in *Plum Estate, Kameido* (fig. **25.13**) by Andō Hiroshige (1797–1858), Japanese image making was quite foreign to a Western way of seeing. Forms are flat with sharp

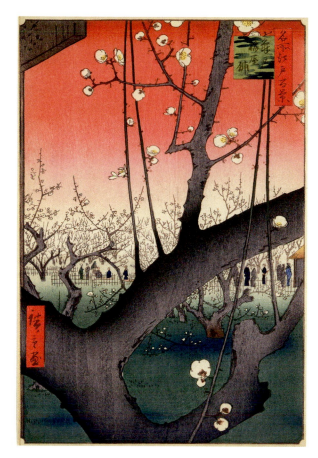

25.13. Andō Hiroshige, *Plum Estate, Kameido*, from the series *One Hundred Famous Views of Edo*. 1857. Woodblock print, 13³⁄₈ × 8⁵⁄₉ ″ (34 × 22.6 cm). Brooklyn Museum of Art, New York. Gift of Anna Ferris. 30.1478.30

contours, while space is compressed, the foreground pressed up against the viewer's nose, the background pulled right into the foreground space. There is no transition between near and far. Just the concept of situating a viewer in a tree from which to see the main activity miniaturized in the distance would have been radical to the eye of a Western artist. However, the flat contours, abrupt cropping, and spatial contraction of Japanese prints certainly influenced Degas and Manet, although in a far from obvious manner and never approaching direct copying.

Impressionism: A Different Form of Realism

The label *Impressionism* was coined by a hostile conservative critic in 1874 when reviewing the first exhibition of an artists' collaborative called the *Société anonyme des artistes* (Artists, Inc.). We now refer to that show as the first Impressionist exhibition (there would be eight altogether between 1874 and 1886). Like the general public, the writer found the paintings so sketchy that he felt they were just *impressions*, not finished paintings. Actually, the word *impression* had already been applied to the Realism of Manet and Degas to describe the sketchiness of their images. It appears in the title of an oil by Claude Monet of the harbor at Le Havre, which he exhibited in

the first Impressionist exhibition and called *Impression: Sunrise*, and Monet used the term on occasion when explaining his ideas on art to friends (see *Primary Source*, page 874).

Impressionism shares with the Realism of Manet and Degas a sketchy unfinished look, a feeling of the moment, and a desire to appear modern. It too presents its subjects matter-of-factly. Many scholars even apply the term Impressionism to the work of Manet and Degas, in part to distinguish their Realism from the earthy, rural Realism of Courbet and Millet and to indicate how Impressionism often shares with them a sense of the urbane and the modern. Like Manet and Degas, the Impressionists were interested in recording the transformations occurring in French society, especially the leisure activities of the nouveau riche. While they, too, painted city scenes and genre, they focused more on the evolution of the sleepy rural villages surrounding Paris into bustling suburbs containing factories, commercial wharves, and railroad trestles, on the one hand, and restaurants, regattas, and boating for Parisian weekenders on the other. Rather than the figure, the Impressionists focused more on landscape and cityscape, and instead of constructing their compositions in the studio using models, they worked empirically, outdoors, where they recorded the landscape and weather conditions that they witnessed at a fleeting moment in time. They painted not so much objects as the colored light that bounced off them. In effect, they painted what they saw, not what they knew.

CLAUDE MONET The leader in developing Impressionism was Claude Monet (1840–1926), who was born and raised in Le Havre in Normandy. He casually studied with an accomplished local landscape painter, Eugène Boudin (1824–1898), who painted outdoors, *en plein air*. But in order to get financial support from his grocer father, he was forced to study in Paris, and chose the academically-minded but liberal painter Charles Gleyre. In this studio he met Auguste Renoir, who along with the much older Camille Pissarro would form the core of the Impressionists. In the early 1860s, he was forced to serve in the army in Algeria, and like Delacroix before him, he experienced intense light and color that was foreign to the cloud-covered temperate Normandy coast. Throughout the 1860s, Monet and his friends painted the landscape surrounding Paris, meeting Corot and the Barbizon artists, who further encouraged their working *en plein air*. For Monet and his colleagues, however, these *plein-air* paintings were not small studies but large finished products. Painting rapidly in the landscape with bold brushwork, they sought to capture light (and the color it carried) as it bounced off of objects. Unlike Manet, who added oil to his store-bought paints to make them unctuous, Monet added none or very little, leaving them chalky and allowing color to supercede the plasticity of the paint. He did not varnish his finished oils, which would diminish their color. Monet's extensive use of primary and secondary colors, the principal hues on the traditional color wheel, was also influenced by recent scientific research about color that demonstrated that the intensity of complementary colors (e.g., blue and orange, red and green, and yellow and violet) is increased when they are placed next to one another. (See *Materials and Techniques*, page 876.)

Lila Cabot Perry (1848?–1933)

From "Reminiscences of Claude Monet from 1889 to 1909"

Perry was an American expatriate painter working in France in an Impressionist vein. Monet did not publicly theorize about art, and Perry's statement gives us one of the best insights into his ideas.

He never took any pupils, but he would have made a most inspiring master if he had been willing to teach. I remember his once saying to me:

"When you go out to paint, try to forget what objects you have before you—a tree, a house, a field, or whatever. Merely think, here is a little square of blue, here an oblong of pink, here a streak of yellow, and paint it just as it looks to you, the exact color and shape, until it gives your own naïve impression of the scene before you."

He held that the first real look at the motif was likely to be the truest and most unprejudiced one, and said that the first painting should cover as much of the canvas a possible, no matter how roughly, so as to determine at the outset the tonality of the whole. . . .

Monet's philosophy of painting was to paint what you really see, not what you think you ought to see; not the object isolated as in a test tube, but the object enveloped in sunlight and atmosphere, with the blue dome of Heaven reflected in the shadows.

SOURCE: *THE AMERICAN MAGAZINE OF ART*, MARCH 18, 1927

We can see the effectiveness of Monet's palette in *On the Bank of the Seine, Bennecourt* (fig. **25.14**), painted in 1868 in a small town upriver from Paris, one of the many Seine and Oise river locations that Parisians took the train to on summer weekends and where they built impressive villas. The artist works with glaring sun-drenched whites and bright blues and greens accented with touches of red and yellow. Objects in shadow, such as leaves and grass, retain color and do not go black. Browns are not muddy but a light-filled tan. Monet maintains the strength of his colors by keeping the imagery close to the picture plane, not allowing it to suggest depth. There is no *chiaroscuro* to model forms. The tree foliage is a two-dimensional silhouette, while the blue sky behind is equally flat. The reflection of the house on the water runs up and down the picture plane, reinforcing the two-dimensionality of the broad smears of light and dark blue in the river just below. The solid blue sky is virtually the same shade as the darker blue in the water, a correlation that momentarily pulls the sky to the foreground. The only motif that suggests depth is the rowboat running diagonally back in perspective. Also asserting the surface of the canvas is Monet's bold, variegated brushwork, which changes character from one object to the next and gives the picture a shimmering quality that suggests we are witnessing a fleeting moment in time.

Equally important, contemporaries realized the brushwork represented the unstable, rapidly changing qualities of modern

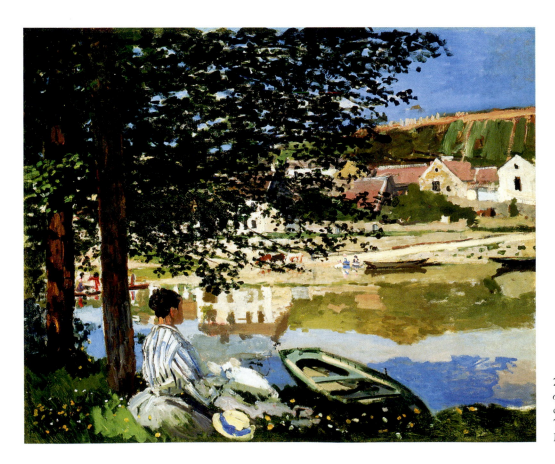

25.14. Claude Monet. *On the Bank of the Seine, Bennecourt*. 1868. Oil on canvas, 32 1/8 × 39 5/8 " (81.6 × 100.7 cm). The Art Institute of Chicago. Mr. and Mrs. Potter Palmer Collection

life. These pictures looked nothing like previous landscapes; they lacked the Classical look of Claude Lorrain, the Baroque conventions of the Dutch landscape painters and their earthy palette, and the emotional constructions of the Romantics. Their very look was considered modern as was their subject matter. We can safely assume that the fashionably dressed woman is not a local, but rather a Parisian who has been boating.

Monet also painted modern Paris from roughly the mid 1860s to the mid 1870s, picturing such new modern icons as the Gare St. Lazare train shed and the *Boulevard des Capucines* (fig. **25.15**), one of Haussmann's new wide avenues located near the Opéra and lined with fashionable apartment buildings and shops. In his street scene, Monet's flickering brushstrokes and contrasting lights and darks capture the pulse of the city street and sidewalk, while rendering such details as the white shirt and top hat of a well-to-do pedestrian and a bunch of pink balloons. The picture was made from the balcony of the studio of the photographer Nadar (see page 893), where the first Impressionist exhibition would be held. The high angular viewpoint, rare for painted cityscapes but not for photographic urban views, lends drama, energy, and scope to a picture meant to capture the transitory nature of the modern world.

AUGUSTE RENOIR After meeting and befriending Monet in Gleyre's studio, Auguste Renoir (1841-1919) also developed an Impressionist style of bright color, bold paint handling, and modern subjects. Often working beside Monet, Renoir painted landscapes. But he was attracted to the figurative tradition as well, and his career straddles the two genres.

Among his best known genre paintings is *Luncheon of the Boating Party* (fig. **25.16**) of 1881. The picture is set in the Restaurant Fournaise on an island in the Seine at Chatou,

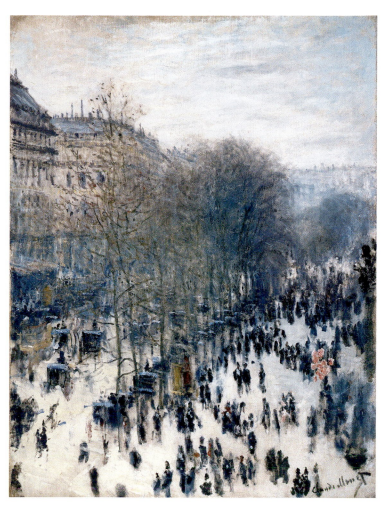

25.15. Claude Monet, *Boulevard des Capucines, Paris*. 1873–1874. Oil on canvas, 31¼ × 23¼″ (80.4 × 60.3 cm). The Nelson-Atkins Museum of Art, Kansas City, Missouri. Purchased: the Kenneth A. and Helen F. Spencer Foundation Acquisition Fund (F72–35)

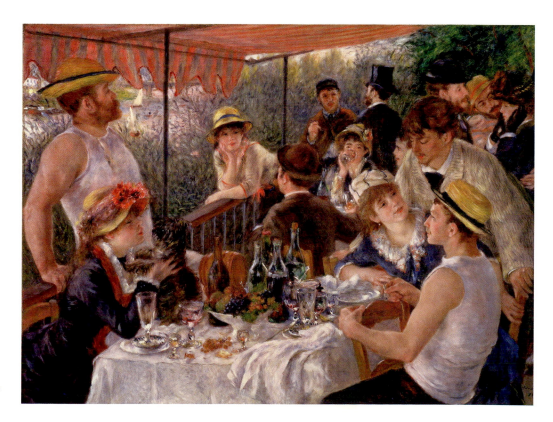

25.16. Auguste Renoir. *Luncheon of the Boating Party*. 1881. Oil on canvas, 51 × 68″ (130.2 × 175.6 cm). Acquired 1923. The Philips Collection, Washington, DC

Impressionist Color Theory

Impressionism was more than just the result of a Realist premise based on spontaneously and empirically capturing color and light on canvas. Scientific discoveries, technical developments, and mundane practicalities also went into the evolution of the style. One was the development of the theory of color by chemist Michel-Eugène Chevreul (1786–1889) that appeared in his 1839 book *The Principles of Harmony and Contrast of Colors*. Chevreul worked in the dyeing department of the tapestry workshop of Les Gobelins in Paris, and he noticed the intensity of a color was determined not just by the color itself but also by its relationship to a neighboring color. Primary colors (red, yellow, and blue) and secondary colors (green, orange, and violet), which were made by combining two primaries, became stronger when placed next to one another, a relationship he called **simultaneous contrast.** (Tertiary colors combine two secondaries.) Value contrast, placing a light hue next to a dark one, also affected the power of a color. The greatest intensity came from the juxtaposition of complements—red and green,

blue and orange, purple and yellow—colors opposite one another on the traditional color wheel. Place a pure green next to pure red and the red becomes redder and the green greener, the energy of each color escalating to the point that they seem to vibrate and pop.

Eugène Delacroix was probably the first artist influenced by Chevreul's theories, although he had intuitively developed similar ideas earlier (see page 845) and placed small marks of strong contrasting colors next to one another. However, the Impressionists were the first to work principally with primary and secondary color, though their palette was hardly restricted to just these hues. To maintain color intensity, the Impressionists began working on a primed surface that was light, instead of the traditional somber brown or brownish red ground. Camille Corot pioneered a lighter primed canvas when he started using silver, which helped harmonize his tight palette of greens, silver, and blue. It is unlikely that any of the Impressionists read Chevreul. But by the 1860s, his theories were common knowledge among many artists interested in color, and in 1867 they were repeated in Charles Blanc's *The Grammar of Painting and Engraving*, along with a discussion of Delacroix's use of simultaneous contrast.

The Traditional Color Wheel

a small village nine miles from Paris's Gare Saint Lazare. Chatou was especially popular with boaters, and restaurants like this catered to Parisians. In the background, on the river, we can just barely see sailboats, a rowboat, and a commercial barge. We also get a glimpse of a train bridge.

The restaurant party consists of urban types, with the exception of Alphonese Fournaise, the restaurant owner's son, who leans against the railing, his muscular biceps reflecting his time spent putting rental boats in the water. Renoir carefully observes his figures' attire, allowing us to identify each type. The top-hatted man, for example, appears to be more conservative and moneyed (the model was a collector) than the younger men (the models were Renoir's friends) wearing straw boating caps. Renoir even presents a range of boating caps, from a citified version worn by the seated figure on the lower right to a country version on the man on the upper right, to an old-fashioned mariner's cap popular some twenty years earlier, worn by the man to the left of the top-hatted gentleman. The colorful sundrenched scene of suburban leisure is pleasurable, relaxed, and sensuous, its sensuality enhanced by the lavish spread on the table and the glorious lush brushwork of the tablecloth. The picture has the momentary quality we associate with Realism, achieved in part by the flickering, feathery brushwork and the asymmetrical composition that runs off the

right side of the canvas, the picture cropped and fragmented as in Degas's *The Orchestra of Paris Opera*.

Luncheon of the Boating Party was made shortly before Renoir abandoned Impressionism. Renoir, like several of his colleagues, began to believe the critics' claim that the Realists could not draw and that their art lacked the timeless, monumental, and enduring qualities found in the great art of the past. In *Luncheon of the Boating Party*, Renoir began to model his figures and even give distinctive contours to his objects and figures. As we shall see, vanguard artists in the 1880s would return to many values we associate with Classical art.

CAMILLE PISSARRO (1830–1903) Pissarro was the elder statesman of the Impressionists. A decade older than the others, he came to Paris in 1855 from St. Thomas in the Caribbean, where he was born and raised. During the 1860s, he sought out Corot, who advised him, and he also studied the landscapes of Courbet and Charles Daubigny, a famous Barbizon-style artist, who worked outdoors and was especially known for painting on a boat. As much as Pissarro was committed to landscape, he was dedicated to developing a radical modern art, and by the late 1860s he arrived at a style that like Monet's was empirical, spontaneous, and used bright color. Unlike Manet, Monet, Degas, and Renoir, he never considered himself a Parisian, and

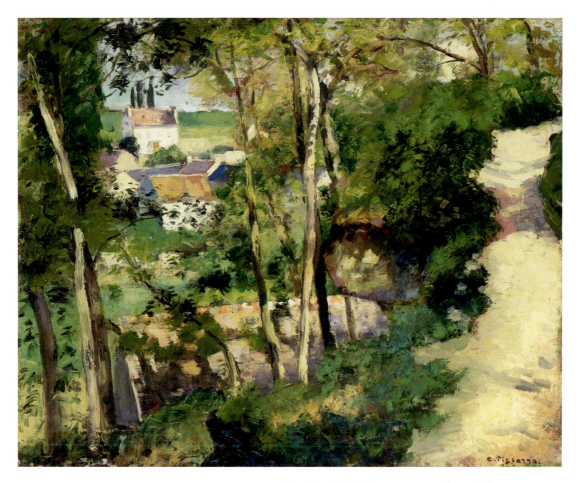

25.17. Camille Pissarro. *Climbing Path L'Hermitage, Pontoise*. 1875. Oil on canvas, $21\frac{1}{8} \times 25\frac{3}{4}$ " (54 × 65 cm). Brooklyn Museum of Art, New York. Purchased with Funds Given by Dikran K. Kelekian 22.60

instead lived in the surrounding countryside, which was becoming suburban. While he occasionally painted factories and trains, he was a social anarchist who was dedicated to the people. Peasants and farms, not city dwellers and suburban pleasures, were his preferred subject matter. When in Paris, he socialized with his fellow artists at the Café Guerbois, and not only mentored the younger artists but served as the arbitrator for Artists, Inc., of which he was a member, participating in all eight exhibitions.

Pissarro was a cautious, intellectual, and deliberate painter, who, like Monet in the 1860s, worked outdoors where he developed a colorful palette and bold paint handling that captured weather conditions and a sense of fleeting imagery. His compositions were often extremely complex, as seen in *Climbing Path at the Hermitage* (fig. **25.17**) of 1875, set in Pontoise, a suburb of Paris. Here he places a dense flat screen of trees in front of a deep view back to a village. This peek into the distance is contrasted by the path to the right, which seems to rise up the picture plane rather than recede. While the tree trunks, leaves, and rocks are painted with broad brushwork and bold sweeps of a palette knife that render them as flat, almost abstract objects, the distant houses are constructed in perspective, as dense three-dimensional cubic forms whose solidity contrasts with the flatness of the foreground. While

reflecting a Barbizon love of nature and rural life, Pissarro simultaneously emphasized the abstract qualities of picture making, playing flat off of solid, straight geometric line off of unstructured organic forms, or a deep view through flat trees off of a trail that rises up the picture plane. As we shall see Pissarro's complex, highly structured compositions would have an enormous impact on fellow Impressionist Paul Cézanne, who in turn influenced Pablo Picasso and Cubism.

MANET AND IMPRESSIONISM The landscape styles of Monet, Renoir, and Pissarro resembled one another the most from the late 1860s to the mid 1870s. However what is called the first Impressionist exhibition in 1874 was not designed to promote a particular style or artistic movement, although most of the 36 artists, could be described as painterly and often used bright color, many of them doing their work *en plein air*. Rather, the exhibition was meant to provide an alternative to the annual salons. Degas, who participated in most of the exhibitions and was one of the most vociferous in promoting them, repeatedly disclaimed being an Impressionist. His lack of emphasis on color and light certainly separates him from the core group. Manet never exhibited with the Impressionists, holding out for salon recognition and acceptance into the academy. By the early 1870s, however, he adopted Impressionist color, and in 1873 was

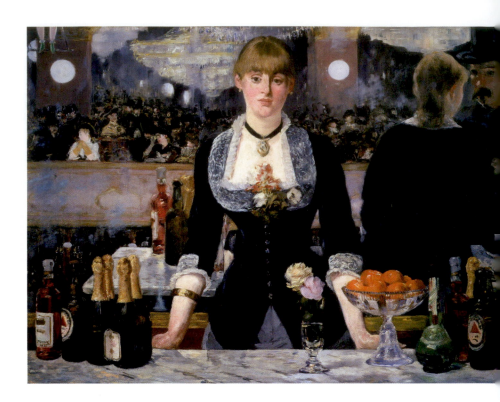

25.18. Édouard Manet. *A Bar at the Folies-Bergère.* 1881–1882. Oil on canvas, 37½ × 52″ (96 × 130 cm). The Samuel Courtauld Trust, Courtauld Institute of Art Gallery, London. P.1934.SC.234

painting outdoors next to Monet in Argenteuil, just outside of Paris, although his paint application remained unctuous and his colors were never quite as intense.

We can see this more colorful palette in his last great Realist masterpiece, *A Bar at the Folies-Bergère* (fig. **25.18**), of 1881–1882. Typical of Manet, the picture is rich in ideas and filled with references and hidden meanings, qualities generally not found in Realism or Impressionism. Most of the image occurs in a mirror, a flat surface, like a painting, that presents an illusion. Here, the illusion reflected behind the barmaid is that modern life is gay and festive. We see the densely packed sparkling interior of the dance hall that virtually symbolized Paris night life at the time. But the barmaid, who is real, not a reflection, looks out at us with a sad blank expression, suggesting alienation, the reality of contemporary urban life. She, too, appears in the mirror, although her image is distorted, as she leans slightly forward and appears active and engaged. The mirror reveals that she has been approached by a dapper top-hatted man, supposedly intent on buying the sensual drink and fruit at the bar. Some historians suggest he is propositioning the barmaid, citing evidence that some of the barmaids were also prostitutes and that they were as much an attraction of the Folies Bergère as the entertainment and conviviality. This theory would certainly account for the unexplainable distortion of the barmaid in the mirror, suggesting she has two identities or roles. Regardless of the interpretation, their quiet encounter, removed from the commotion in the mirror, reflects the reality of modern life—anonymous, arbitrary encounters and urban alienation. The picture also seems to comment on the materialism pervading modern life. The Folies Bergère was very expensive, catering to the well-to-do, and the remarkable still life on the bar captures the lavish richness of the music hall. But despite the illusion of gaiety

in the mirror, an emptiness and sadness fills the picture, evoking the inability of money to buy meaningful happiness. But Manet's pictures are often elaborate puzzles, which generally defy a secure reading and remain open to wide and controversial interpretation.

BERTHE MORISOT Berthe Morisot (1841-1895) was a key figure in the Impressionist circle. Born into a comfortable Paris family, she and her sister Edna took up painting seriously in the late 1850s. Women were not permitted to attend the École des Beaux-Arts, but the sisters studied independently with minor but supportive and knowledgeable artists. When they gravitated toward landscape in the early 1860s, they sought out Corot, who, struck by the quality of their work, met with them repeatedly, even giving them one of his paintings to study. Both Morisots had Corot-like landscapes accepted at the Salon of 1864, and Berthe had a figure painting accepted the following year. Edna married in 1869 and stopped painting, but Morisot continued to evolve as an artist.

As a woman, Morisot could not go to the Café Guerbois, but nonetheless she became an intimate of and even a favorite within the avant-garde circle, socializing with Manet, Degas, and other Realists at dinners and *salons*—weekly evening receptions at someone's home, such as the one that Manet's mother hosted. She especially developed a close friendship with Manet, posing for him in seven paintings. Morisot's brushwork became looser and her palette brighter. She made landscape and figure paintings, depicting the modern leisure activities of the city, suburbs, and the seashore. Her figures are generally women and children, the models most readily available to her. While her women are fashionably dressed, they are not pretty, frivolous, and mindless; rather they are meditative and thoughtful, sophisticated and in control of their image. They

are never presented as appendages to men (as in Renoir's *Luncheon of the Boating Party*). We sense Morisot defining a woman's world, one that is as valid and meaningful as a man's.

Morisot's pictures are virtually a catalogue of a well-to-do woman's activities: gathering flowers, taking tea, caregiving, reading, sewing, and vacationing in the suburbs and by the sea. But undoubtedly what impressed Morisot's vanguard colleagues was her brilliant technique and finesse: Her bold brushwork magically defined figures and objects while creating an abstract tapestry of paint across the surface of the canvas, a deft balancing act that even Manet had to admire. (The hanging committee for her memorial exhibition at the Durand-Ruel Gallery in 1894 consisted of Monet, Degas, and Renoir.) We can see her painterly brilliance in *Summer's Day (The Lake in the Bois de Boulogne)* (fig. **25.19**), a classic Realist/Impressionist theme of a leisure activity taking place at a trendy venue. Typical of Morisot, the fashionably dressed figures do not interact, but instead are deep in thought, or perhaps are even viewing, generally considered the attribute of a man, not a woman. While the palette is closer to Manet and Corot than to Monet, the scene is a summer day with light flickering off of objects. Morisot enhances the spontaneity created with her brush marks by using an asymmetrical, cropped composition, first developed by Degas.

MARY CASSATT Like Morisot, Mary Cassatt (1844-1926) approached Impressionism from a woman's perspective, her Realism even reflecting the social concerns developing within the women's movement of her time. Cassatt was an American, born into a wealthy family and raised in Pittsburgh. She trained at the Pennsylvania Academy of Art in Philadelphia, where her family moved, in part to support her career as an artist, a most unusual attitude for the time. In 1866 she went to Paris and first studied with an artist who offered classes for women, before being accepted as a student of the renowned academic Jean-Léon Gérôme. She also studied in Parma and Rome before returning to Paris in 1874, where she spent the remainder of her life. In Paris, she befriended Degas and abandoned her academic style for Realism. Invited by Degas, she participated in the fourth Impressionist exhibition in 1879. Now she displayed a bright palette, strong brushwork that hugged the surface, and the Realist compositional devices of asymmetry and cropping.

Like Degas and Manet, Cassatt was a figure painter, and her most famous themes from the late 1870s include women in loges at the opera, a subject treated by Renoir and Degas as well. She also painted women at home: reading, visiting, taking tea, sewing, or bathing an infant. Like Morisot, she presents the modern sophisticated woman in dress, manners, and leisure activities. In the 1880s, she abandoned her loge theme and focused increasingly on domestic scenes, especially of women and children.

Scholars often attribute Cassatt's subject matter to the restrictions she faced as a female: As a respectable woman, she could not go unattended to the same places as her male counterparts. But more at issue was her belief in the importance of women in society, even if this importance was largely restricted to the home. Her views coincided with developments then occurring with the women's movement. In 1878, the International Congress of Women's Rights was held in Paris, and at the top of its agenda was the need for better education for women that would mean free and compulsory education through secondary school, which France enacted as law in the 1880s. Education would not

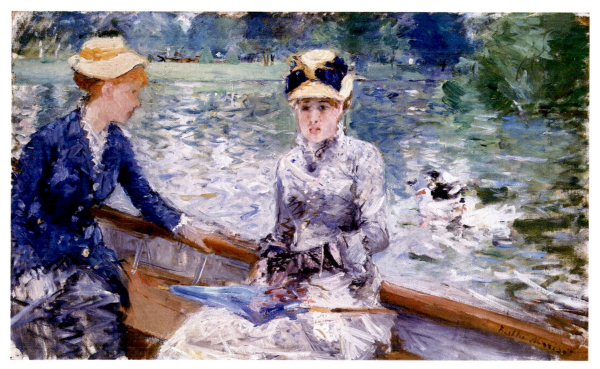

25.19. Berthe Morisot. *Summer's Day* ca. 1879. Oil on canvas, $17^{13}/_{16} \times 29^{5}/_{16}$ " (45.7 × 75.2 cm). The National Gallery, London. Lane Bequest, 1917

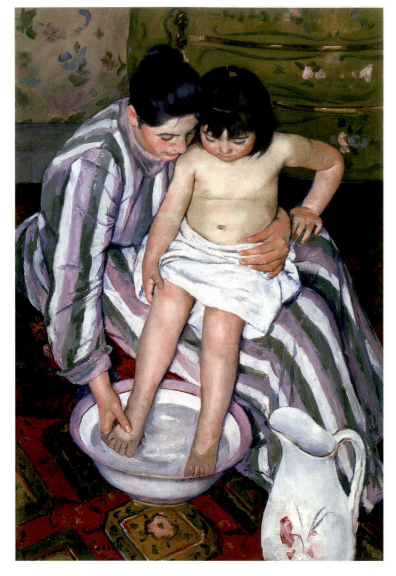

25.20. Mary Cassatt. *The Child's Bath*. 1891–1892. Oil on canvas, $39\frac{1}{2} \times 26''$ (100.3 × 66 cm). The Art Institute of Chicago. Robert S. Waller Collection

only allow women to become professionals but also to better manage the home and family. The Congress also focused on the important role that women played in nurturing children, advocating that mothers nurse and care for their offspring rather than hiring wet nurses. This position reflects the increased importance sociologists placed on the care of children in general in the 1870s, which in part stemmed from a concern about the high infant mortality rate in Europe, especially in France. The path to a healthier society and nation, many argued, began in the home and was in the hands of the mother who nurtured her children, both physically and emotionally, including attending to hygiene.

Cassatt's many domestic scenes of mothers tending their children, such as *The Child's Bath* (fig. **25.20**) of 1891–1892, came out of this context. The pitcher and basin may seem quaint and old-fashioned to us today (only America had widespread indoor plumbing at this point), but regular bathing was

a modern phenomenon for late nineteenth-century Paris, when people generally bathed only once a week. Not only is the picture about health, but also about intense emotional and physical involvement, as is reflected in the sensual yet tender manner with which the caregiver touches the child.

The picture contains all the ingredients we associate with Realism—the fashionable bourgeois décor, the bright colors, and the sense of spontaneity in the brushwork and skewed composition with its high viewpoint. The style of the picture reflects Cassatt's intense attraction to Japanese prints at this point in her career, an interest that is reflected in the overhead viewpoint as well as in the boldness of her forms and contours. Cassatt was also influenced by Renaissance art. Her palette has a chalky softness resembling tempera, and the strong line-defining contours have the same crispness found in *quattrocento* painting. Many of Cassatt's presentations of a mother and child resemble Renaissance depictions of a Madonna and Child, an allusion that sanctifies the important role of women in creating a better society. But it also reflects the direction that Realism took after 1880, as many of the artists, as we saw in Renoir's *The Luncheon of the Boating Party*, began to make a more monumental art that recalled the Classical art of the past.

MONET IN THE 1890s By the time the last Impressionist exhibition took place in 1886, any cohesiveness the core group had possessed was long gone, replaced by new concerns and styles. Manet's death in 1883 symbolically marks the death of a movement that began with Courbet in the 1840s. Monet, however, would live well into the twentieth century, and, while never abandoning the Realistic premise for his art and his commitment to Impressionism, he succeeded in making paintings that were among the most abstract of their day. At the same time they became increasingly dreamlike.

In the early 1890s, Monet began working in a series format, painting the same subject over and over. His motifs included wheatstacks, Rouen Cathedral, and a line of poplar trees. The stack paintings came first, and he painted 30 of them, beginning in 1890. His goal was to show the same subject at different times of the day and year, and under different weather conditions, believing life is not fixed but in continual flux. Working in a series format meant that the composition remained largely the same from one picture to the next. Again and again Monet painted a two-dimensional triangular wheatstack (occasionally he painted two) superimposed on top of a field in the foreground, with a line of trees, houses, and distant hills at the horizon, and with the sky above. With composition out of the way, Monet concentrated on color, his first love, which he changed from one painting to the next, theoretically to capture atmospheric and light conditions but also to have a free rein with color.

In *Wheatstack, Sun in the Mist* (fig. **25.21**) of 1891, Monet used basically two complementary colors, orange and blue, pitting them against each other to make the entire image vibrate. Monet's flickering brushwork, now long streaks of varying length and direction, increases the shimmering effect and give his wheatstacks a dreamy, haunting quality. Like the English landscapists Constable and Turner, Monet focused on

capturing atmospheric effects, although it can be argued because of his interest in color that he was not as dedicated to transforming paint into atmosphere. He heavily reworked the *Wheatstacks* in his studio, suggested that he was not solely dedicated to painting empirically. Critic Gustave Geffroy, in the introduction to the catalogue that accompanied the presentation of the *Wheatstacks* at the Durand-Ruel Gallery in Paris in 1891, strongly suggested the series is about experience and not seeing—that the paintings are about Monet's emotional reaction to the stacks and to Nature. Geffroy gave the images a poetic reading, describing the stacks in one painting as "glow[ing] like heaps of gems," and in another as "hearth fires."

ART IN TIME

1849—**Courbet's** *Burial at Ornans*

1852—Louis Napoleon, nephew of Napoleon I, proclaims himself Napoleon III, emperor of second Empire

1859—Charles Darwin publishes *The Origin of Species*, formulating the theory of evolution.

1863—**Manet's** *Olympia*

1885—Marxist party founded in Russia

1891—**Monet's** *Wheatstack, Sun in the Mist*

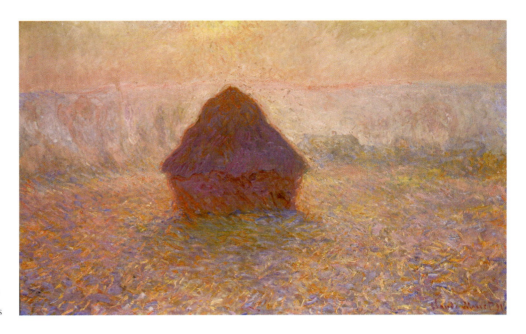

25.21. Claude Monet. *Wheatstack, Sun in the Mist*. 1891. Oil on canvas, $25\frac{5}{8} \times 39\frac{3}{8}$ " (65 cm × 1 m). Minneapolis Institute of Arts

Monet's *Wheatstack* paintings seem more imaginary than realistic. Despite his claims to the contrary, Monet had moved well beyond the empiricism of 1870s Impressionism to create poetic, visionary images that paralleled the dreamlike fantasy worlds then being created by the Symbolist avant-garde, whom we will meet in the next chapter.

BRITISH REALISM

Realism took a very different form across the English Channel, although the word itself was never applied to the art. There Positivism produced a detailed naturalism, an intense truth to nature, and an interest in social types. In England, the Industrial Revolution had an almost 100-year head start over France. Industrialization and urbanization accounted for the poverty and other social ills so familiar to us today from the serialized novels of Charles Dickens (1812–1870), which were set in a cruel, corrupt London suffocated by grime and soot. Materialism and greed were rampant. Cheap, ugly mass-produced objects replaced the highly refined handmade products that the aristocracy and upper class had once demanded. No longer was the worker a highly trained artisan with pride in his or her product but a human machine suffering the drudgery of dawn-to-dusk mindless labor to turn out an inferior product without personal identification.

It is precisely these conditions that gave rise to the most radical of socialist organizations, the Chartists, and gave new energy to Christian socialism, the biblically based belief in community service and in the renunciation of or sharing of personal wealth. It is these conditions that the German political philosopher Karl Marx (1818–1883) and socialist Friedrich Engels (1820–1895) addressed in their *Communist Manifesto*, published in 1848 in England, where they were then living and working.

It was artist, educator, writer, art critic, and environmentalist John Ruskin (1819–1900), however, who took the lead in attempting to arrest this decline into industrial hell. After Queen Victoria, he ranks as one of the greatest forces in the Victorian era, his impact extending well beyond Great Britain to mold American taste as well. His influence began in 1846, when he published the first of his four volumes of *Modern British Painters*, and continued from 1851 to 1853 with his *Seven Lamps of Architecture*.

Among Ruskin's most prominent beliefs was the need for contemporary society to aspire to a new spirituality and moral pride, which required adherence to truth and identification with the divinity of Nature. He advocated art education for all social classes, for the producer working class as well as the bourgeois consumer. He firmly believed art was a necessity, not a luxury, for it molded people's lives and moral values; great art

made great people. And by art, Ruskin meant not only painting, sculpture, and architecture but also the decorative arts, all of which had to be as handcrafted, beautiful, and sincere, as in the Middle Ages. Ruskin himself was influenced by the Ecclesiology Movement, which first appeared in England in the 1830s and was charged with reversing the increasing social and moral inertia, if not outright decline, of the Anglican church by, among other things, resurrecting church ritual, almost to the point of flirting with Catholicism.

Ruskin's emphasis on nature and religion marks the beginning of the nineteenth-century search for a simpler life, one that rejected the advances of urbanization and industrialization. As we've seen, Rosa Bonheur and George Sand were at virtually the same moment advocating a return to a "primitive" world—the countryside. For Ruskin, this purer primitive world could be found either in Nature or in the spirituality of medieval Christianity. By the end of the century, this escape from the modern world and a search for the primitive would be a dominant theme. The seeds for this quest, however, were planted at mid-century.

The Pre-Raphaelite Brotherhood

Ruskin championed the Pre-Raphaelite Brotherhood, a secret society started in September 1848 by three students enrolled in the Royal Academy School: William Holman Hunt, John Everett Millais, and Dante Gabriel Rossetti, who was the leader and spokesperson. The PRB, as they signed their paintings, denounced the art of the Royal Academy and most painting since the Italian Renaissance after the time of early Raphael. They found the work decadent in that it clouded truth and fact with a muddy *chiaroscuro* and placed a premium on such artificial formal qualities as elegant contours or pleasing compositional patterning. Like Ruskin, the PRB abhorred bourgeois materialism and taste. Their heroes were the fifteenth-century Italian and Netherlandish primitives, such as Jan van Eyck (see page 479), whose work they perceived as simpler, more direct, and hence sincere in its attempt to represent nature. They also considered this work more spiritual and moral because it was identified with the intensely religious Late Gothic period.

WILLIAM HOLMAN HUNT The most religious of the Pre-Raphaelite Brotherhood was William Holman Hunt (1827–1910), who came from a poor working-class family. His work is characterized by a combination of Victorian moral didacticism and intense naturalism. *The Awakening Conscience* (fig. 25.22) of 1853–1854 was inspired by a passage in Charles Dickens's *David Copperfield* when David's friend, the simple fisherman Peggoty, goes searching for his beloved Emily, who has run off with an amoral dandy. Hunt tells the tale of one of the thousands of poor women appearing in the Realist literature of the period who perceived prostitution as their only hope of improvement even though it would inevitably lead to ruin. While sitting on her lover's lap and singing a song, a kept woman becomes aware of the lyrics, thinks of her family, and suddenly abhors her sinful situation, from which she must then immediately escape. Hunt renders the room, cluttered with the

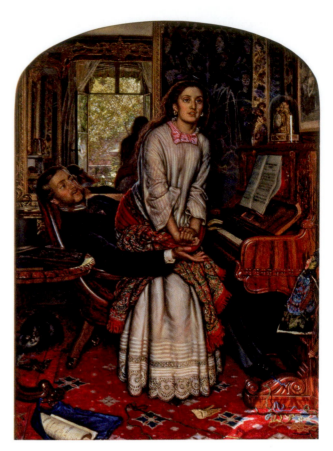

25.22. William Holman Hunt. *The Awakening Conscience.* 1853–1854. Oil on canvas, $29\frac{1}{2} \times 22''$ (76.2 × 55.9 cm). Tate Gallery, London

shiny, vulgar products of crass consumerism, with a microscopic attention to detail worthy of Jan van Eyck, whose *Arnolfini Portrait* (see fig. 14.16) entered the collection of the National Gallery in London in 1842. In his review of the academy exhibition, Ruskin described the objects in Hunt's painting as having a "terrible lustre" and a "fatal newness" that reflected "the moral evil of the age." As in the *Arnolfini Portrait*, every object seems to function symbolically. The cat chasing the bird under the table reflects the kept woman's predatory position, and the clock approaching high noon denotes that the time left for decisive action is quickly expiring. The background mirror reflects an open window—freedom—and through it the purity and beauty of sunlit nature beckons. Biblical warnings appear throughout the image, and on the bottom of the frame is a moralistic passage from Proverbs. The density of objects and figures in the painting eliminates the compositional patterning and pleasing aesthetic contours that the PRB disliked.

FORD MADOX BROWN An older painter who served as a professional mentor and father figure for the PRB was Ford Madox Brown (1821–1893), whose attention to meticulous detail and ethical issues in his complex images was inspirational. His *Work* (fig. 25.23), begun in 1852 but not finished until 1865 after the PRB had disbanded, is a veritable Christian Socialist sermon on how dignified work cures social ills. It is a visualization of a book by Scottish essayist and historian Thomas Carlyle (1795–1881) called *Past and Present* (1843), in

which the "reactionary socialist," as Carlyle was described by Marx, argues for great minds to conceive gratifying work for laborers. Carlyle viewed such physical toil as a "free-flowing channel, dug and torn by noble force . . . draining off the sour, festering water . . . making instead of a pestilent swamp, a green fruitful meadow."

Brown's scene, teeming with objects and details, takes place on Heath Street in Hampstead, a suburb of London, where laborers—called "navvies"—are vigorously but proudly engaged in laying water and sewer pipes. To the right they are observed by two gentlemen, the "sages" of labor: Thomas Carlyle, with the cane, and the Christian Socialist Frederick Denison Maurice. Behind the navvies are the idle rich, mounted on horseback. To the left is a wildflower vendor, who has no skills and knowledge and is therefore considered inherently lazy. In the foreground, a ten-year-old waif abandoned by her drunkard father—this we know from a pamphlet Brown wrote detailing

his picture—watches the workers while tending her siblings. Even the foreground dogs reflect the artist's scrupulous cataloguing of London's social types, with the orphan's mongrel and the navvies' bull pup apprehensively staring down the elegant bourgeois' whippet. Brown's immaculate brushwork records the bright light of the summer midday sun. Like Hunt's *Awakening Conscience*, a Biblical quotation appears on the frame: "In the sweat of thy face shalt thou eat bread" (Genesis 3:19), a reference to God's curse upon humankind for the Original Sin of eating the forbidden apple of the Tree of Knowledge.

JOHN EVERETT MILLAIS The PRB was initially best known for biblical and literary pictures. While the subjects were set in a spiritual past, the themes were selected for their parallels with contemporary London and served as moral lessons. This is clear in *Christ in the Carpenter's Shop* (fig. **25.24**), by John Everett Millais (1829–1896) and shown at the Royal Academy in 1850,

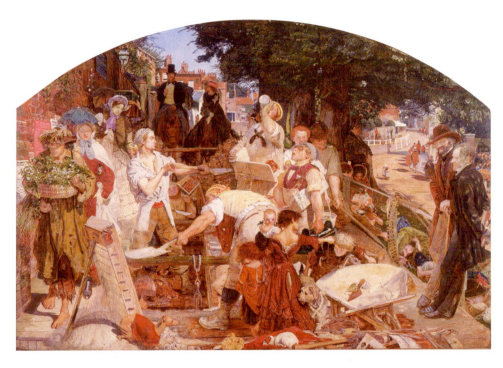

25.23. Ford Madox Brown, *Work*. 1852–1865. Oil on canvas, 54 × 78″ (137 × 197.3 cm). Manchester Art Gallery, Manchester, England

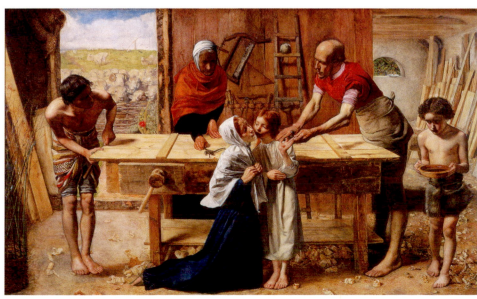

25.24. John Everett Millais. *Christ in the Carpenter's Shop (Christ in the House of His Parents)*. 1849–1850. Oil on canvas, 34 × 55″ (86.4 × 1.4 m). Tate Gallery, London

where it was poorly received. The painting shows Jesus as a young boy in his stepfather's shop being comforted by his parents over a wound to his hand. Virtually every object in the room is a disguised symbol prefiguring the future role of Jesus as the Savior. His cut palm anticipates the stigmata, his cousin John carries a bowl that prefigures the baptism, the flock beyond the door represents the congregation, and the tools on the wall, especially the ladder, announce the Crucifixion. Millais's attention to realistic detail was perhaps the most intense of any member of the PRB. To paint this picture, for example, he went to a carpenter's shop to make studies of wood shavings and the musculature of a woodworker. He painted the sheep from severed heads.

The picture is more than an uncanny recreation of a genre scene set during Jesus' boyhood. It is also an appreciation of quality workmanship and labor, its spirituality an attribute of hard-working artisans. Millais depicts dirt beneath Jesus' fingernails, just as Courbet did with his stone breakers, further identifying him with the working class.

WILLIAM MORRIS About 1856, two young painters attached themselves to the PRB: William Morris and Edward Burne-Jones. Morris (1834–1896) would dabble in architecture and become a renowned poet, but his true calling was implementing Ruskin's theories about replacing shoddy mass-produced products with beautifully designed handcrafted ones that, as in the Middle Ages, would reunite workers with their commodities. After collaborating in 1859 with architects, painters, and designers in the PRB and Ruskin's circle to design and furnish his own house, Morris in partnership with some of these same artists opened a design company in 1865, which eventually was called Morris & Co. It manufactured beautifully crafted fabrics, wallpaper, tapestries, carpets, tiles, furniture,

and stained glass, with Morris himself designing most of the wallpaper and fabrics, a talent that translated easily into the many book designs he also undertook and that had international influence as well.

The motifs and palette of Morris and his company were organic and Gothic, creating an aura of Nature and spirituality. This aesthetic is apparent in the dining room (fig. **25.25**) that Morris designed in 1867 for a new applied arts museum called the South Kensington Museum, known today as the Victoria & Albert Museum. The gold-ground panels, painted principally by Burne-Jones, represent the 12 months of the year. Morris's wallpaper, laboriously hand printed from woodblocks, is a flat abstract pattern based on an olive branch. The simple chest, also decorated by Burne-Jones, is by the architect Philip Webb, who also designed the ceiling and the frieze above the wallpaper. As important as the handcrafting were the principles of truth to materials and form following function that Ruskin had advocated. Prefabricated plaster moldings, brackets, and decoration were no longer allowed. Wallpaper could no longer mimic the lush fabric that before the 1840s covered the walls of upper-class homes. Inferior wood could no longer be painted to resemble the grain of expensive woodwork. Morris's impact on the applied arts was far-reaching, launching what is known as the Arts and Crafts Movement, which soon spread to the United States.

The Aesthetic Movement: Personal Psychology and Repressed Eroticism

While William Morris kept the moral and spiritual program of Ruskin alive with his Arts and Crafts Movement, the Pre-Raphaelite group dissolved by 1860. Millais, for example,

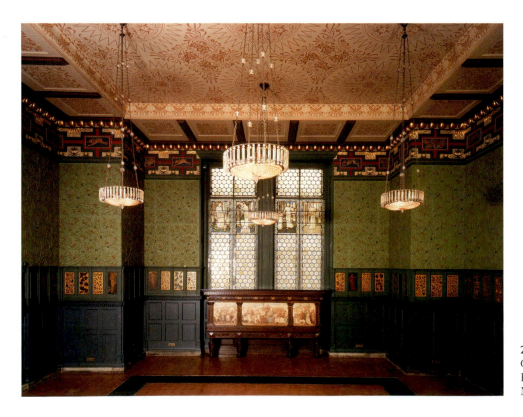

25.25. William Morris (Morris & Co.). Green Dining Room (William Morris Room). 1867. Victoria & Albert Museum, London

turned to anecdotal genre painting, and in 1863, ironically, became president of the Royal Academy. Rossetti, who had not been very productive in the 1850s, meanwhile gravitated toward a visionary art set in a medieval guise and expressing his own personal psychology, not social morality. Edward Burne-Jones followed Rossetti down this path toward a visionary art that eventually developed into what is known as the Aesthetic Movement. Running through the paintings of both Rossetti and Burne-Jones is an undercurrent of repressed sexuality, a reflection of the strict moral codes of Victorian England that did not allow for a display of sexual appeal or even the discussion of sex.

DANTE GABRIEL ROSSETTI Today Dante Gabriel Rossetti (1828–1882) is best known and most appreciated for his post-PRB work. As the initial leader and spokesperson for the PRB, his shift from its principles was significant. His *Beata Beatrix* (fig. 25.26), begun in 1864, is closer to this later phase of his production. It is a portrait of his wife and most frequent model, Elizabeth Siddal, who had committed suicide in 1862 by taking an overdose of laudanum, an addictive derivative of opium that was used for pain but often abused.

Rossetti depicts Siddal as Beatrice, the elusive, fictitious spiritual lover of his namesake the Italian poet Dante Alighieri in *La Vita Nuova* (ca. 1293), and the style is early Renaissance in its simplicity and linearity (compare fig. 15.17). The sundial in her hand records the hour of nine, when Siddal expired, while a haloed dove, reminiscent of the Holy Spirit, drops the poppy of death in her lap. In the background, Dante and Love walk the streets of Florence, missing each other in the fog, a prefiguration of Beatrice's death before they ever meet. Siddal is dressed in medieval garb, her famous flowing red hair looking very Late Gothic in style. Her head is encased in a "halo" of orange and yellow. She appears in a transitory state between life and death, her expression suggesting prayer, longing, resignation, and even sexuality, all a reflection of Rossetti's state of mind at the loss of his beloved and his own sexual frustration. Rippling contours add to the erotic tension. We are now far removed from the Realism and social concerns of the Brotherhood and witnessing the emergence of an art that expresses fantasy and deep psychological urges.

EDWARD BURNE-JONES Like Rossetti, Edward Burne-Jones (1833–1898) escaped the modern world to live in the medieval past, as can be seen in *Laus Veneris (Praise of Venus)* (fig. 25.27) of 1873–1878. The subject derives from the legend of Tannhäuser, concerning a knight torn between the carnal love of Venus and the pure love of his sweetheart, and which was famously used in an opera by the German composer Richard Wagner in 1845. Burne-Jones shows Venus being praised in song by maidens, whom the American novelist Henry James (1843–1916) in his review described as "pale, sickly, and wan, in the manner of all Mr. Burne-Jones's young people." The same could be said of Venus. Her languorously slumped body expresses longing and frustration, as well as sexual repression. She merges into a background tapestry

depicting a story from her life, while in the window to the left, appearing as surreal and artificial as the tapestry, voyeuristic knights peer in. There is a sexual tension between their open male space and the dense, enclosed world of the women. A strange linear patterning covers the work, and since everything in it has a single texture, the entire image becomes an elaborate tapestry.

In *Laus Veneris* the blunt morality and realism of the Pre-Raphaelites has given way to a strange, compelling dream world dominated not by action, resolve, or fact but a psychology

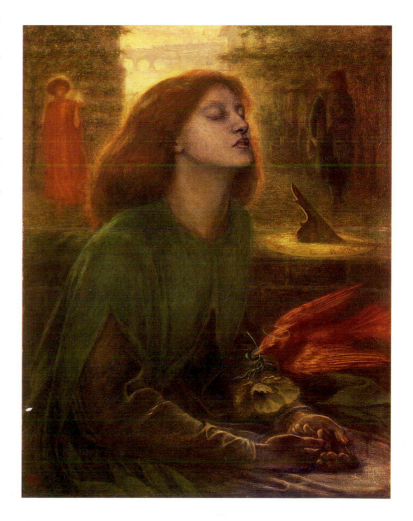

25.26. Dante Gabriel Rossetti. *Beata Beatrix*. ca. 1864–1870. Oil on canvas, 34 × 26″ (86.4 × 66 cm). Tate Gallery, London

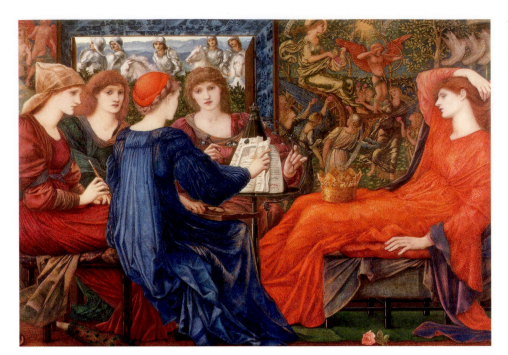

25.27. Edward Burne-Jones. *Laus Veneris.* 1873–1878. Oil on canvas, 48¾ × 73¼″ (1.23 × 1.86 m). Laing Art Gallery, Newcastle-upon-Tyne, England

of smoldering yet repressed eroticism. Burne-Jones showed this painting at the Grosvenor Gallery, which was a relatively new gallery dedicated to art that is now called the Aesthetic Movement. The English catalyst for this new attitude was the poet Algernon Charles Swinburne (1837–1909), who in turn was influenced in the 1850s by the French critic Théophile Gautier. Gautier was a leading advocate of "art for art's sake," a theory maintaining that art's function was first and foremost to be beautiful, to appeal to the senses and not project moral values or tell stories. Both Rossetti and Burne-Jones came under Swinburne's spell. But the most famous and notorious proponent of the Aesthetic Movement is the American painter James Abbott McNeill Whistler.

JAMES ABBOTT MCNEILL WHISTLER Raised in New England and Russia, James Abbott McNeill Whistler (1834–1903) studied painting with Charles Gleyre (1806–1874) in Paris, where he lived from 1855 to 1859. He met Monet in Gleyre's studio and befriended Courbet and made his mark as a Realist, painting scenes of contemporary life that captured the underbelly of the city. After moving to London in 1859 (he never returned to America), he continued to spend long periods in Paris, and traveled back and forth between the two cities into the 1860s, maintaining his Parisian connections and friendships and submitting to the salons. He knew Gautier through Courbet and Manet, and in London he befriended Swinburne.

By 1863, Whistler renounced French Realism to pursue Aestheticism, an example of which is his *Symphony in White No. I: The White Girl*, a title applied later and probably inspired by Gautier's poem "Symphony in White Major." Whistler submitted the picture to the 1863 *Salon des refusés*, where it hung not far from Manet's *Luncheon on the Grass*. Like Gautier's poem, which is a complex interfacing of different white visions, the painting orchestrates a range of whites, soft yellows, and reds in a full-length portrait of the artist's mistress Jo, who is dressed in white against a largely white ground. While Gautier and Swinburne conceptually influenced Whistler, visually the artist came under the spell of Japonisme, an influence that is more clearly stated in *Symphony in White No. II: The Little White Girl* (fig. **25.28**) of 1864. Here, Jo leans on the mantle of Whistler's London home, surrounded by a Japanese blue-and-white vase, fan, and a spray of cherry blossoms, often identified with Japan. At one level, the painting is a sensual display of abstract color, shapes, and composition. Using thin, delicate brushstrokes and almost transparent layers of paint, Whistler creates a symphony of whites, yellows, reds, pinks, and blues that gracefully dance across the picture plane. He plays the softness of his paint and such forms as Jo's dress against the rectangular linearity of the mantle, mirror, and reflected picture frames. The flowers entering the composition on the right are another delicate touch, a Japanese compositional device used earlier by Degas to create fragmentation and spontaneity but here to make the petals seem to float magically.

The painting was conceived as a tribute to Ingres, compositionally echoing his *Portrait of Madame Inès Moitessier* (see fig. 24.17) and acknowledging the great classicist's ability to create perfect beauty. But its psychology is similar to Rossetti's *Beata Beatrix* (fig. 25.26), for Whistler depicts a similarly dreamy, meditative, yet sensual mistress with long flowing hair. Jo's reflection floats ghostlike in the mirror, and this image inspired Swinburne to write a poem, which Whistler affixed to the back of the canvas: "Art thou the ghost, my sister / White sister there / Am I the ghost, who knows?"

In the following decade, Whistler became increasingly abstract, as in *Nocturne in Black and Gold: The Falling Rocket*

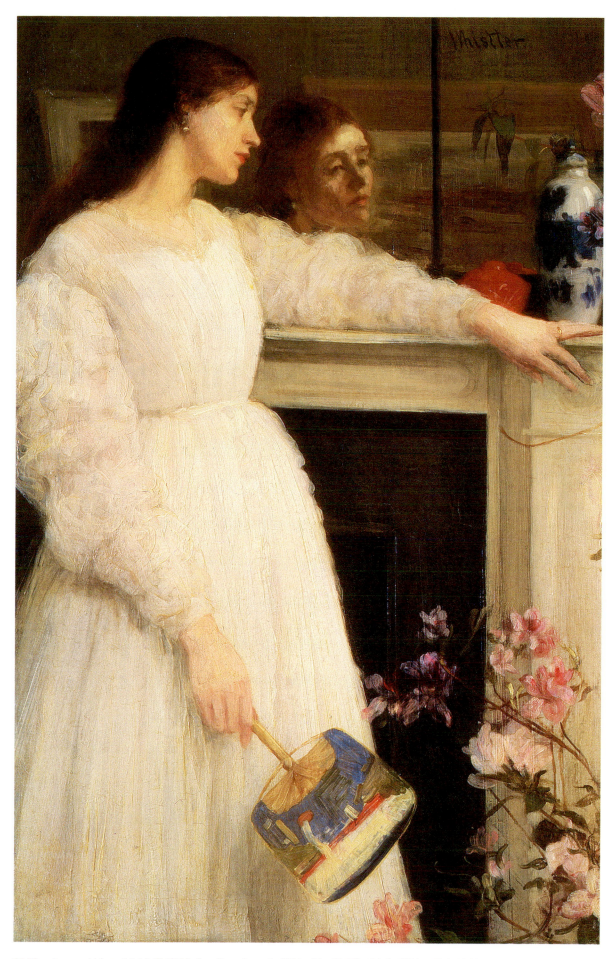

25.28. James Abbott McNeill Whistler. *Symphony in White No. II: The Little White Girl.* 1864.
Oil on canvas, 30$\frac{1}{8}$ × 20$\frac{1}{8}$ ″ (76.7 × 51.3 cm). The Tate Gallery, London

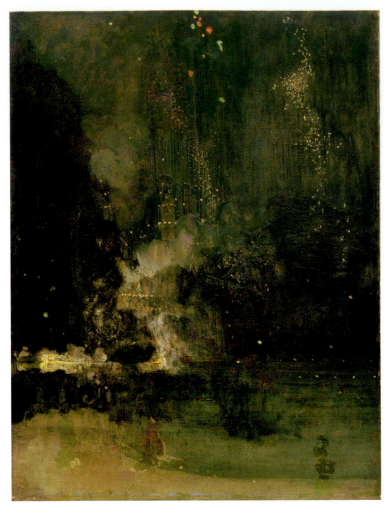

25.29. James Abbot McNeil Whistler. *Nocturne in Black and Gold: The Falling Rocket*. ca. 1875. Oil on panel, $23\frac{3}{4} \times 18\frac{3}{8}$" (60.2 × 46.8 cm). The Detroit Institute of Arts. Gift of Dexter M. Ferry, Jr.

(fig. **25.29**) of 1875. He exhibited the painting in 1877 at the Grosvenor Gallery with seven other ethereal, thinly painted blue-gray **nocturnes** (night scenes) of the Thames River, all meant to support his art-for-art's-sake position. *The Falling Rocket* is by far the most abstract, to the point that the aging Ruskin accused Whistler of "throwing a pot of paint in the public's face." Depicting fireworks at Cremorne Gardens, a popular nightspot in the Chelsea section of London, the theme allowed Whistler to be at once realistic and abstract, creating an image that was credible, even fulfilling the Realist quest to produce an image of modern life, but nonetheless concocted in the studio based on subjective dictates. As suggested by his titles, which included words such as *symphony, sonata*, and *nocturne*, Whistler considered painting visual music, declaring it, in essence, abstract. (See *Primary Source*, page 889.) (It is for the sake of this same analogy that Burne-Jones often portrayed music-making maidens.) Without *The Falling Rocket* in the title, we would be hard pressed to understand what the painting is about. We would be left savoring Whistler's abstract display of orange and yellow sprinkles lazily drifting down over a gray-blue-brown ground of gossamer-thin brushstrokes. As in *Symphony in White No. II*, Whistler's surface has a delicate

Japanese sensitivity, so refined that shapes and marks barely exist as one color bleeds through the haze of another. With his Grosvenor Gallery exhibition, Whistler moved art into a subjective, nonempirical realm based on a private vision and aesthetics. Unwittingly, he was presenting a preview of the art of the next two decades.

REALISM IN AMERICA

The ripple effect of the revolutions of 1848 did not reach America, although it did produce waves of new immigrants. A more defining benchmark for the United States is the Civil War, which had a devastating physical, psychological, and economic impact on the nation. The Garden of Eden was ravaged. After the war, that metaphor was replaced by the *Gilded Age*, a term coined by Mark Twain and his coauthor for an 1871 book of the same title describing the robber barons. These were the American speculators, manufacturers, industrialists, real estate investors, and railway, coal, and iron magnates who made vast fortunes, often exploiting workers. Their new wealth transformed them into an American aristocracy with aspirations to all things European, and the Europe-trained American painter John Singer Sargent (1856–1925) was their preferred portraitist. (See *The Art Historian's Lens*, page 890.) The robber barons and their families traveled to Europe, brought back European furniture and art, and built European-style villas and chateâux. The period is also defined by continued Western expansion, fulfilling what the nation saw as its God-given Manifest Destiny to overrun the North American continent. Survey teams mapped the new territories, and poorly paid workers completed the Transcontinental Railroad, connecting East and West, in 1869. By 1890, the government had subdued the Native American nations, either by containment in restricted territories or by violent annihilation.

Scientific Realism: Thomas Eakins

Thomas Eakins (1844–1916), a Philadelphian, was among the earliest and most powerful Realist painters in America. His scenes of the modern world included not only middle-class leisure activities and the popular sports and past-times of post–Civil War America but also surgery clinics portraying surgeons as modern heroes and highlighting new scientific techniques such as anesthesia and antiseptic surgery. Eakins even brought a scientific approach to his Realism, which made it quite different from the Realism of Manet and Degas that he witnessed in Paris from 1866 to 1869 while studying with a renowned academician.

Among Eakins's first works upon returning to Philadelphia was a series of sculling pictures, such as *Max Schmitt in a Single Scull* (also called *The Champion Single Sculls*) (fig. **25.30**), a painting that reflects the rising popularity of the sport and presents Max Schmitt, the winner of a championship race on the Schuylkill River in Philadelphia, as a hero of modern life. While the picture looks like a *plein-air* painting, we do not see a quickly recorded Impressionist moment but a painstakingly reconstructed event in time. Eakins's paintings are grounded in intense scientific inquiry designed to ensure the accuracy of his

James Abbott McNeill Whistler (1834–1903)

From *The Gentle Art of Making Enemies*

The Gentle Art of Making Enemies (1893) is Whistler's autobiography.

As music is the poetry of sound, so is painting the poetry of sight, and the subject matter has nothing to do with harmony of sound or of colour.

The great musicians knew this. Beethoven and the rest wrote music—simply music; symphony in this key, concerto or sonata in that. . . .

This is pure music as distinguished from airs—commonplace and vulgar in themselves, but interesting from their associations, as for instance, "Yankee Doodle. . . ."

Art should be independent of all clap-trap—should stand alone, and appeal to the artistic sense of eye or ear, without confounding this with emotions entirely foreign to it, as devotion, pity, love, patriotism, and the like. All these have no kind of concern with it, and that is why I insist on calling my works "arrangement" and "harmonies."

SOURCE: *THE GENTLE ART OF MAKING ENEMIES.* (NY: PUTNAM, 1925)

Realism. He made numerous perspective studies of the boats and oars, which result in the river receding with breathtaking mathematical precision, firmly locking the boats in place in space. He carefully studied light effects and anatomy, and as a teacher at the Pennsylvania Academy of Art, outraged his colleagues and suffered public scorn by having his students work from the nude model, rather than imitate plaster casts of Classical figures. His quest for realism drove him to record minute details, including a steamboat and landscape behind the distant bridges, details beyond the reach of normal vision (shortly later he would use photographs in addition to drawings as his preliminary studies). Eakins's Realism extends to modern psychology, for Schmitt's isolation in the broad expanse of the river seems a form of alienation, as does his expression of unfamiliarity as he twists to squint at *us*, not Eakins, who is in the scull behind Schmitt.

Iconic Image and Naturalist Landscape: Winslow Homer and Albert Bierstadt

Winslow Homer (1836–1910) was in Paris about the same time as Eakins. He was already disposed toward painting the modern world, for he began his career in 1857 as a magazine illustrator, recording the latest fashions and social activities and later covering the Civil War. He was in Paris in 1866–1867, where he saw the work of Courbet, Millet, and Manet, but he was too early to experience the full impact of Impressionism. Upon returning to New York, he made outdoor scenes of the middle class engaged in leisure activities of contemporary life, such as playing croquet, swimming at the newest shore resorts, and taking horseback tours in the White Mountains of New Hampshire, diversions now accessible by train.

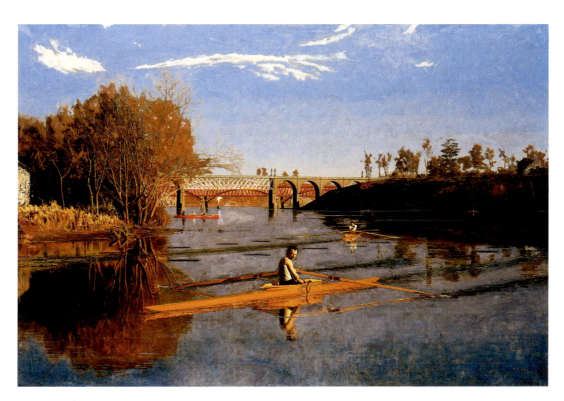

25.30. Thomas Eakins. *Max Schmitt in a Single Scull (The Champion Single Sculls)*. 1871. Oil on canvas, $32\frac{1}{4} \times 46\frac{1}{4}$″ (82 × 117.5 cm). The Metropolitan Museum of Art, New York. Alfred N. Punnett Endowment Fund and George D. Pratt Gift, 1934. (34.92)

An Artist's Reputation and Changes in Art Historical Methodology

A change in the methodology of art history can sometimes affect scholars' attitudes toward artists, sometimes resurrecting figures who had once been renowned but had gradually disappeared from the history books. A case in point is the American painter John Singer Sargent (1856–1925). In his day, he was one of the most famous and financially successful artists. He can even be considered the quintessential American artist, for he lived and worked in Europe and his art appeared to embrace the European values that so many nouveau riche Americans aspired to emulate.

Sargent was born and raised in Florence, studied at the École des Beaux-Arts in Paris, and by 1879 was winning medals at the salons. In part due to the encouragement of novelist Henry James, he moved permanently to London in 1886. He made his first professional trip to America in 1887, and immediately became the portraitist to high society, painting William Henry Vanderbilt of New York and Isabella Stewart Gardner of Boston, among others. By 1892, he was the most fashionable portraitist in London and perhaps on the Continent as well. Sargent's success was in part based on the luxuriousness of his imagery—expensive fabrics and furnishings—reinforced by his dramatic sensual brushwork.

Sargent was a proponent of the avant-garde. He befriended Claude Monet and acquired his paintings as well as Manet's. His own work reflects the painterly bravura of Manet, and like Manet he admired Velázquez. He also made numerous Impressionist landscapes and urban views, often in watercolor. Ironically, Sargent fell into oblivion because of the Modernism that evolved in the twentieth century. His consummate handling of paint may have had the abstract qualities that the Modernists admired, but his work was perceived as conservative. It failed to offer anything new. Worse yet, his avant-garde brushwork was carefully packaged in the old-fashioned formulas of society portraiture.

Sargent's reevaluation began in the 1950s, with a renewed appreciation of the paint handling in his Impressionist watercolors. In succeeding decades his reputation gradually inched its way up as Modernism was replaced by Post-Modernism and its broader values (see Chapter 30). Representational art became fashionable again, and art historians began to appreciate art for the way in which it reflected the spirit of its age. Sargent's portraiture was now perceived as the embodiment of Victorian and Edwardian society and of the later Gilded Age.

For example, gender studies, which began appearing in the 1970s, looked at his daring presentation of women, as can be seen in his 1897 portrayal of New York socialite Edith Stokes in *Mr. and Mrs. I. N. Phelps Stokes*. Instead of giving us a demure and feminine woman, Sargent presents a boldly aggressive Mrs. Stokes, who represents the "New Woman" who emerged in the 1890s (see page 903). In a period when the women's movement was fiercely advocating equal rights, many women were asserting their independence and challenging conventional gender roles. This New Woman was independent and rebelled against the conventional respectability of the Victorian era that sheltered women in domesticity. She went out in public; she was educated, and she was athletic, spirited,

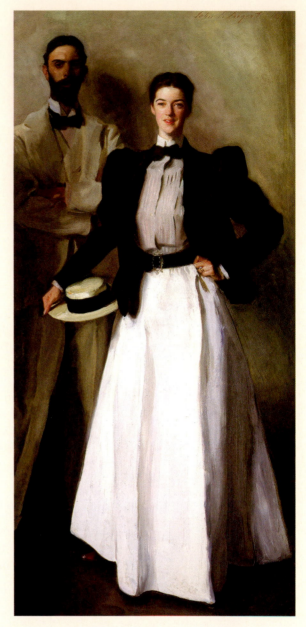

John Singer Sargent. *Mr. and Mrs. I.N. Phelps Stokes*, 1897. Oil on canvas, $84\frac{1}{4} \times 39\frac{3}{4}$″ (214 × 101 cm). Metropolitan Museum of Art, New York. Bequest of Edith Mintum Phelps Stokes (MRS. I. N.), 1938. (38.104)

and flaunted her sexual appeal. Not only did she wear comfortable clothes, she even wore men's attire, or a woman's shirtwaist based on a man's shirt. Instead of self-sacrifice, she sought self-fulfillment. Sargent presents Edith Stokes as just such a woman, even having her upstage her husband. For its time, this was a radical presentation of a woman and a reflection not only of the sitter's personality and identification with women's issues but also of Sargent's willingness to buck portrait conventions and societal expectations.

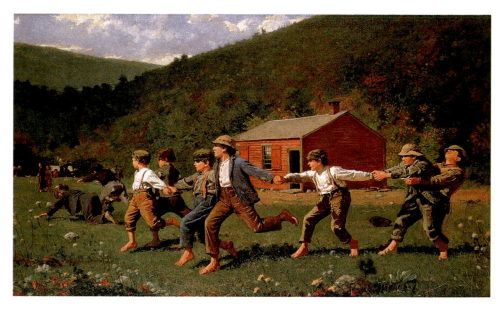

25.31. Winslow Homer.
Snap the Whip. 1872. Oil on canvas,
22$\frac{1}{4}$ × 36$\frac{1}{2}$″ (56.5 × 92.7 cm).
The Butler Institute of American
Art, Youngstown, Ohio

Rather than portraying a fleeting moment, however, Homer created iconic symbolic images of American life and issues, as had Millet of the French peasant. We can see this emblematic approach in his *Snap the Whip* (fig. **25.31**) of 1872. This visual record of a children's game, appears at first glance to be an Americanization of Impressionism, for the image is a sun-filled scene rendered with fairly strong color and flashy passages of brushwork. But Homer's color is not as intense as the Impressionists, nor his brushwork as loose. The picture is not about color and light and empirically capturing a specific scene and fleeting moment. This image is frozen. The figures are carefully outlined, modeled, and monumental, their solidity reinforced by the geometry of the one-room schoolhouse and the bold backdrop of the mountain, which parallels the direction of the boys' movement. The barefoot children in their plain country clothes, like the one-room school house behind them, are emblems of simplicity and wholesomeness, their youth projecting innocence and future hope for a recently reunified country. The game itself is symbolic of union, since the chain of boys is only as strong as its

weakest link. At a time when the nation was staggering under the weight of the disillusionment brought on by the Civil War and the turmoil of rampant industrialization, *Snap the Whip* embodied the country's lost innocence and was a nostalgic appeal for values that were quickly fading into memory.

The detailed naturalism and scientific documentation we associate with Positivism became increasingly present in American landscape painting by the 1850s, although in essence the work remained Romantic as it continued to emphasize the sublimity of the nation's wilderness. This urge to document in detail is especially apparent in the work of the artists-explorers, such as Albert Bierstadt (1830–1902), painters who traveled to the West as well as to South America and the Arctic to record awesome exotic locales.

Albert Bierstadt was a German raised in Massachusetts and trained at the Düsseldorf Academy. In 1859, he was attached to an army unit surveying an overland route through the Rockies and was one of the first Euro-Americans to witness the sublime beauty of these spectacular mountains. He painted *The Rocky Mountains, Lander's Peak* (fig. **25.32**) in his New York studio in

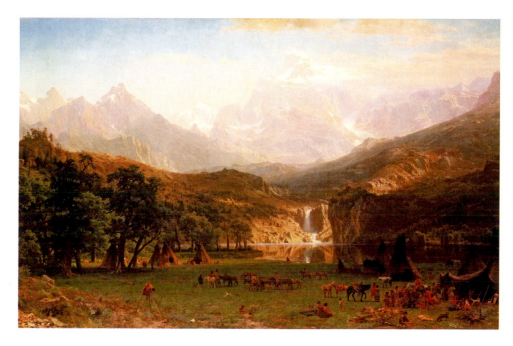

25.32. Albert Bierstadt. *The Rocky Mountains, Lander's Peak*. 1863. Oil on canvas 6'1$\frac{1}{4}$″ × 10'3$\frac{3}{4}$″ (1.86 × 3 m). Metropolitan Museum of Art, New York. Rogers Fund, 1907. (07.123)

1863 from sketches and photographs of that trip. The picture continues the sublime landscape tradition of the Hudson River School (see page 836), for Bierstadt captures the awesome scale of the Rocky Mountains, which dwarf an enormous waterfall. Divine light bounces off of a crystalline lake, and peaceful Native Americans harmoniously live with nature.

Made during some of the fiercest fighting of the Civil War, the huge painting when shown was viewed as an emblem of peace, for its subject was far removed from contested ground, reassuring Americans that the Garden of Eden was still intact somewhere. After the war, such pictures would play a major role in sparking western migration, and with the opening of the railroads they helped promote tourism.

PHOTOGRAPHY: A MECHANICAL MEDIUM FOR MASS-PRODUCED ART

In 1839 photography was commercially introduced almost simultaneously in both France and England. As a mechanical process that would eventually lend itself to mass-production and popular culture, it was a perfect fit with the Industrial Revolution and seems a natural consequence of it. It was also a perfect tool for the Positivist era, for initially it was largely perceived as a recording device for cataloguing, documenting, and supporting scientific inquiry. It had the appearance of being objective, paralleling the matter-of-fact presentation of much Realism and Impressionism.

The potential of photography had existed since antiquity in the form of the **camera obscura**, a box with a small hole in one end that allowed the entrance of light, projecting an upside-down image of an object outside to be cast on the inside wall of the opposite end of the box. An artist could then trace the projected image. We know that Vermeer and Canaletto, for example, occasionally used the camera obscura for their paintings. However, the problem that remained was how to *fix* the image mechanically, that is, how to give it permanence without the intervention of drawing.

First Innovations

In the early eighteenth century silver salts were discovered to be light sensitive, but it was not until 1826 that the French inventor Joseph-Nicéphore Niépce (1765–1833) made the first photographic image, a blurry view out of his window that required an eight-hour exposure time. He teamed up with artist Louis-Jacques-Mandé Daguerre (1787–1851), who after discovering the light-sensitive properties of silver iodide and the use of mercury fumes to fix a silver iodide-coated copper plate, unveiled the **daguerreotype** in 1838. The French government acquired the process and offered it free to the rest of the world, excepting England, with whom the French were in fierce economic competition. The invention represented both a nationalistic and imperialistic triumph, for it enabled the French nation to document not only the monuments of France but its colonies as well, especially Egypt. And it was also viewed as a very Republican medium since unlike painting and sculpture it was affordable, making portraits available to all social classes.

Meanwhile in England, William Henry Fox Talbot (1800–1877) announced in 1839 that he could fix an image on paper, rather than on metal or glass, and in 1841 he took out a patent for the new negative-positive photograph he called a **calotype**, a salted paper print. Unlike the daguerreotype, which resulted in a single image, the calotype generated endless positive paper prints from one paper negative.

Both the daguerreotype and calotype were displaced in the early 1850s with the simultaneous invention in France and Britain of the **wet-collodion process**. This technique used a very sensitive emulsion, collodion (gun-cotton dissolved in alcohol ether), that cut exposure time to under a second and produced a sharp, easily reproducible negative. However, the process was cumbersome, for it required the photographic glass plate to be prepared and processed when used. This meant keeping the plate chemically wet at all times and transporting a portable darkroom. At about the same time, Louis-Désiré Blanquart-Evrard (1802–1872) developed the **albumen print**, which used salted egg white on paper, creating a smooth, more refined surface that revealed greater detail with less graininess. For the next 30 to 40 years, photographers used wet-collodion plates for recording images and then printed them on albumen paper.

In 1846 Talbot published a photographically illustrated book, *The Pencil of Nature*, the title a reference to light, "nature's pencil," which "draws" on an emulsion-coated surface. (The word *photograph* is from the Greek words for light and drawing.) Here Talbot framed many of the basic issues that would surround photography well into the future. He not only saw the medium as a *recording* process capable of scientifically documenting the world but also as an *interpretative vehicle* that would allow for new ways of perceiving and understanding reality. Well into the twentieth century these insights did not prevent the general public from viewing photography primarily as a tool for recording truths and a symbol of mechanization and its accompanying social ills.

Recording the World

By the 1850s the most prevalent use of photography was for recording the world: people, sights, and objects. These pictures were generally viewed as fact, which is ironic since, as we shall see, photographers could manipulate images in various ways, including the selection of motif and the objects to be included or excluded in a photograph.

PORTRAITURE Americans especially took to photography, which the artist and inventor Samuel Morse (1791–1872) brought back from France just weeks after the French government made it available in 1839. Soon every American city had photography studios offering daguerreotype portraits, and this form of photograph remained popular in the United States long after it was superceded in Europe. Americans especially loved its wealth of details and simple factuality, which was reinforced by the blunt presentation of the sitter, posed against a plain background that did not detract from his or her physical presence. The daguerreotype could record the most minute details clearly, a quality that holds up even under a magnifying glass. (Do the same with an albumen print and you get a blur.)

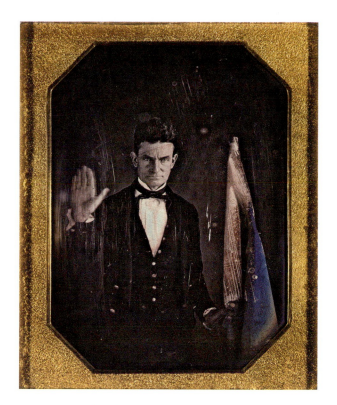

25.33. Augustus Washington. *John Brown*. ca. 1846–1847. Quarter-plate daguerreotype. 3⁹/₁₀ × 3¹/₄″ (10 × 8.2 cm). National Portrait Gallery, Smithsonian Institution, Washington, DC

In the daguerreotype portrait of the abolitionist John Brown (fig. 25.33) taken by Augustus Washington (1820–1875) about 1846–1847, we can count the hairs on Brown's head, trace the wrinkles on his face and hands, and even inspect the thread holding his buttons on! Unlike most of their European counterparts, American portraitists encouraged their clients to project a personality for their photographs. Undoubtedly the stern, determined, and almost confrontational pose in Brown's portrait was projected by the abolitionist himself, perhaps with some coaxing from Washington. The photographer captured Brown taking a vow and holding what historians believe to be a flag for the Subterranean Pass Way, the name he gave to an "underground railroad" he was planning for transporting runaway slaves north. Washington had the most successful studio in Hartford, Connecticut, but Brown undoubtedly went to him as a fellow abolitionist, which the portraitist, a free African American and political activist, most likely was. But convinced that blacks would never achieve equality during his lifetime, Washington sold his business and immigrated to the newly founded republic of Liberia, in Africa, before the Civil War.

In Europe, the largest portrait studio in the 1850s and 1860s belonged to Adolphe-Eugène Disdéri, whose business was headquartered in Paris but had branches in Madrid and London. His enormous staff churned out formulaic portraits using the same props and settings (e.g., a Greek column and a swag of drapery) designed to fulfill the social aspirations of his bourgeois patrons. In 1854 he increased the popularity of photographs when he invented the multi-image **carte-de-visite**, a visiting card left by a visitor and containing multiple small portraits of that person.

Among the most celebrated early portraitists of the era was the Parisian Gaspard-Félix Tournachon (1820–1910), known simply as Nadar. He began his career as a journalist and caricaturist and may have taken up photography as an aid in making the lithographic caricatures for his planned compendium of the 1,000 most prominent personalities of the day, which he called *Le Panthéon Nadar*. He began cashing in on the public infatuation with celebrities by mass-producing albumen prints of the famous, specializing in writers, actors, performers, and artists of bohemian Paris. His skill as a caricaturist proved invaluable in setting up his shots, enabling him to create incisive portraits that captured the essence of his sitter's mystique.

We can see this skill in Nadar's 1854–1855 portrait of the art critic Théophile Gautier (fig. 25.34), who although in repose has a forceful presence. A low camera angle makes the sitter loom large, a quality reinforced by the stomach protruding through the parted coat. The artistically out-of-focus right side of the figure, anathema to the reality-oriented American photographers, serves as foil to the sharp-focus bulk of Gautier's body. Nadar spotlights the writer's forehead and casts the eyes in shadow, suggesting acute mental power and a moody thoughtfulness. The disheveled bohemian outfit removes Gautier from the fantasy world that Disdéri captured in his bourgeois portraits.

VIEWS Along with portraits, views dominated photography, for they allowed people to travel the world without leaving their living room. Fulfilling the French government's vision of documenting its African conquests, Maxime Du Camp (1822–1894),

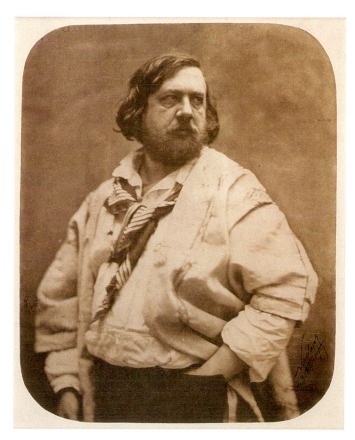

25.34. Nadar. *Théophile Gautier*. 1854–1855. Albumen salted paper print, mounted on Bristol board. Musée d'Orsay, Paris

ART IN TIME

1853—Commodore Perry of the United States opens up
 Japan to trade with West

1854—Nadar's *Théophile Gautier*

1861–1865—American Civil War

1876—Alexander Graham Bell patents the telephone

a Parisian journalist, photographed the French territories in Africa and the Middle East from 1848 to 1852, and in 1852 published 125 images in *Egypt, Nubia, Palestine and Syria*. More popular than such albums, which could be quite expensive, were **stereocards**, which by the 1860s were as prevalent as musical compact disks are today. Stereocards are side-by-side photographs of the same image taken by a camera with two lens, replicating human binocular vision. When put into a special viewer, the twin flat pictures appeared as a single three-dimensional image. To accommodate the tremendous demand for these images, distributing companies stocked as many as 300,000 different images at one time. The quality of the rapidly reproduced prints was generally low, a problem compounded by their 2-by-5-inch size, although much larger versions also existed.

A large contingent of American photographers, like their fellow painters, specialized in landscape, traveling West, often with survey teams, to record the sublime wilderness that symbolized the nation. One of the first and most famous of this group is Carleton Watkins (1829–1916), who beginning in 1861 made hundreds of glass stereographic views of Yosemite along with some 1,000 18 by 22-inch albumen prints. Despite his commercial marketing, Watkins thought of his work as art, not documentation. Originally from Oneonta, New York, he went west to San Francisco with the Gold Rush in 1851, eventually making daguerreotype portraits and photographically documenting land for surveys. Hearing about the sublime wonders of Yosemite, he took off in 1861 to photograph this awesome, primeval landscape. In order to capture the vast scale of the land, he felt it was necessary to make large prints, and consequently he developed a mammoth camera that used large glass plates. He then set off in a covered wagon with a ton of equipment, which included the wet-glass plates and a darkroom to process them immediately after they were exposed.

The results, as seen in *Yosemite Valley from the Best General View* (fig. **25.35**), made on a second trip to Yosemite in 1865–1866, were so breathtaking that when shown to President Lincoln they helped convince him to preserve Yosemite as a park. Watkins, like Bierstadt in his painting of Landers Peak, captures the sublime scale of the American wilderness, the mountain peaks dramatically dwarfing Yosemite Falls, one of the highest falls in America. Watkins produced a lush image by working up extremely rich textures in the developing process and a sense of drama by creating powerful value contrasts and a composition of forceful diagonals descending from both right and left. To keep the sky from going a monotonous white, Watkins used a second negative to add clouds. If we take into

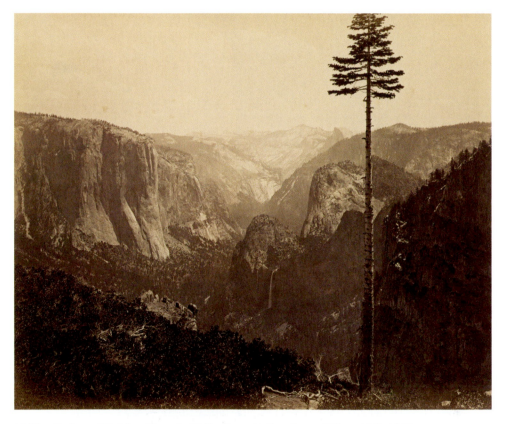

25.35. Carleton Watkins. *Yosemite Valley from the Best General View*. 1865–1866.
Albumen print, $16\frac{1}{8} \times 20\frac{1}{2}$″ (85 × 113 cm). The J. Paul Getty Museum, Los Angeles

consideration the degree of manipulation of the camera, including depth of focus and aperture time, the decisions that went into selecting and framing the composition, and the numerous tools used in the darkroom, we can understand why Watkins declared his photographs art, even exhibiting them in 1862 at the prestigious Goupil Gallery in New York.

DOCUMENTATION Photography was also put into the service of categorizing the social types so central to the Positivist mentality. One of the earliest examples of this use occurs in Henry Mayhew's *London Labour and London Poor* (1851–1862), a catalog of workers and street walkers illustrated by lithographs after now-lost daguerreotypes by Richard Beard, who opened the first portrait studio in London. Perhaps the best example of this use of photography is Adolphe Smith's *Street Life in London* (1878), initially issued monthly as illustrated brochures, much like the *physiologies* in France. Smith was the nom-de-plume for Adolphe Smith Headingley (1846–1924), a social activist, who teamed up with photographer John Thomson (1837–1921), who also wrote some of the lengthy text for each social type. As stated in their introduction, they viewed the photograph as an objective tool for validating their descriptions: "[We wish to bring] . . . to bear the precision of photography in illustration of our subject. The unquestionable accuracy of this testimony will enable us to present true types of the London Poor and shield us from the accusation of either underrating or exaggerating individual peculiarities of appearance."

While most of Thomson's images are quite objective and unbiased, some, like *The Crawlers* (fig. **25.36**), are powerful and compassionate, making the viewer sympathize with the plight of the poor. Here a homeless widow minds the child of a working mother. The photo appeared in a brochure called *The Crawlers*, a reference to the indigent street dwellers who occasionally got enough money to buy tea and then crawled to a pub for hot water.

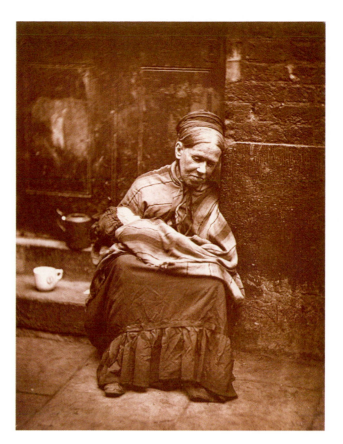

25.36. John Thomson. *The Crawlers*. 1877–1878. Woodburytype. Victoria & Albert Museum, London

Reporting the News: Photojournalism

Early photography also recorded famous events, and this was the forerunner of photojournalism. Among the most outstanding examples are images of the Civil War, such as *A Harvest of Death* (fig. **25.37**) by Timothy O'Sullivan (ca. 1840–1882), who like Watkins became one of the great photographers of the West. Before setting off to document the Civil War, O'Sullivan

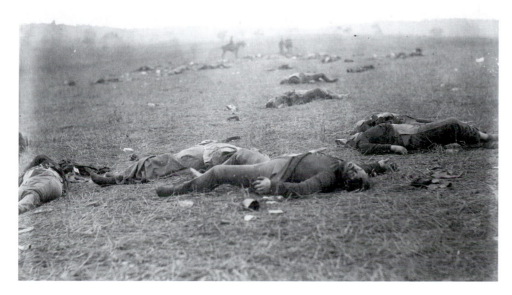

25.37. Timothy O'Sullivan. *A Harvest of Death, Gettysburg, Pennsylvania, July 1863*, from Alexander Gardner's *Gardner's Photographic Sketchbook of the War*. 1866. Albumen print (also available as stereocard), 7 × 8^{11}/$_{16}$ " (17.8 × 22 cm). Brady Civil War Collection. Library of Congress, Washington, DC

began his career as an apprentice to Mathew Brady (1823–1896), owner of the most famous photographic portrait gallery in America located in New York. (Abraham Lincoln sat for Brady over 30 times and credited Brady's flattering 1860 portrait for helping him win that November's presidential election.) In 1862–1863, O'Sullivan signed up with the photographic team of Alexander Gardner and contributed 44 images to the album *Gardner's Photographic Sketchbook of the War* (1866). Unlike the banal photographic images of wars, such as the 1854–1856 Crimean War, the Civil War photographs of O'Sullivan and his colleagues captured the horrific devastation of the American conflict, despite the fact that the exposure time required by their cameras did not permit action pictures.

In *A Harvest of Death*, we feel the power of the documentary reality of photography, which a painted image can never have. We see *real* people and *real* death—images of an actual event on a definite date, the Battle of Gettysburg on July 3, 1863—not a fictitious image. Although we know that the war photographers often moved objects and bodies for the sake of their image, we have no evidence that O'Sullivan did so here. In any case, he conveys the grim reality of war. The anonymous corpses are as lifeless as bales of hay waiting to be collected, their dark forms hauntingly contrasted with the void of the overcast sky. The cropped bodies at the right and left add to the brutality of the scene, so convincingly registered with the gaping mouth on the face of the dead soldier in the foreground. The living are pushed deep into the background, shrouded in the morning mist, as though life during this seemingly endless national conflict is itself dissolving into just the barest memory.

Photography as Art: Pictorialism and Combination Printing

Not all nineteenth-century photographers saw the new medium as primarily a tool to document reality. Some viewed it as high art and deliberately explored photography's aesthetic potential, confident it was as valid an art form as painting and sculpture. This attitude, which some critics found threatening (see *Primary Source*, page 898), was more prevalent in Europe than America in the first 50 years following the advent of photography. Many artists experimented with the camera. Degas, for example, used it independently of his painting, and Eakins used the photograph as he would a preliminary drawing, allowing it to establish his compositions, which ultimately do not look photographic. Many painters and sculptors had collections of photographs, especially of models. Arguments have been made that the look of photographs influenced artists, particularly Realists and Impressionists, but these claims remain controversial.

ENGLISH PICTORIALISM In London, a group headed by Oscar Gustave Rejlander (1813–1875), a former painter who has been called "the father of art photography," and Henry Peach Robinson (1830–1901), another former painter who at one time was perhaps the most famous photographer in the world, began making composite images designed to look like Old Master and esteemed contemporary painting. Rejlander used as many as 30 negatives to make his works, while Robinson used just a handful.

They both experimented with cut-and-paste assemblage. The results were heavy-handed images that were far from seamless and did not look lifelike. Contemporaries derogatorily referred to them as "patchwork quilts." Their style is called Pictorialism, because the staged images were meant to look like paintings. Despite the fame of its principal practitioners, Pictorialist combination printing did not develop into a major trend, although it has been revived periodically to the present day.

More successful were Pictorialists who had an aesthetic vision and manipulated the camera and printing process to meet their needs. Although far less known during her lifetime, Julia Margaret Cameron (1815–1879) is perhaps the most celebrated today of the British Pictorialists. Unlike Rejlander and Robinson, she did not use combination printing. Her trademark was an out-of-focus blurring of images to make them seem painterly, as seen in *Sister Spirits* (fig. **25.38**) of about 1865. Born in Calcutta and settling on the Isle of Wight in 1860 after the death of her husband, Cameron soon became an intimate of leading poets and scientists and a thorn in the side of the photography world when she challenged the supremacy of crisp, focused imagery. Like Rejlander and Robinson, she staged scenes using actors, costumes, and sets, and illustrated such literary sources as the Bible, Shakespeare, and the poet laureate Alfred, Lord Tennyson (1809–1892). Stylistically, her images recall artists as diverse as Rembrandt and Perugino.

Sister Spirits reflects the impact of the Aesthetic Movement, an example of which is seen in Rossetti's *Beata Beatrix* (see fig. 25.26). The scene in Cameron's photograph evokes a spiritual late medieval or early Renaissance past. The women look as though they stepped out of a Perugino painting and suggest

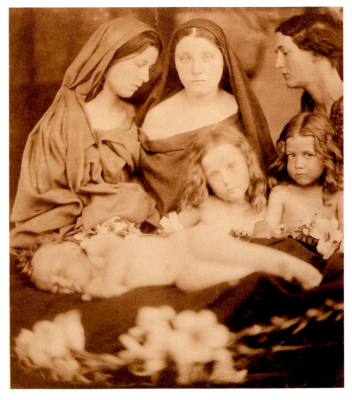

25.38. Julia Margaret Cameron. *Sister Spirits*. ca. 1865. Albumen print, $12^7/_{16} \times 10^1/_2$″ (31.6 × 26.6 cm). George Eastman House, Rochester, New York. Gift of Eastman Kodak Company

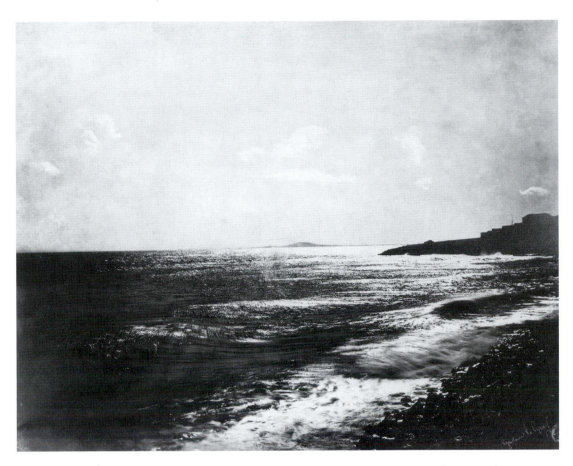

25.39. Gustave Le Gray. *Mediterranean Sea at Sète*. 1856–1859. Albumen silver print from two glass negatives. 12⅝ × 16½ ʺ (32.1 × 41.9 cm). The Metropolitan Museum of Art, Gilman Collection. Purchase, Robert Rosenkranze Gift, 2005. (2005.100.48)

such saints as Mary and Anne; the two children look like angels, and the sleeping child like the Christ Child. One can also view the picture as the three ages of woman, since the title suggests that the baby is most likely female. Cameron's blurred foreground is more than just a gimmick to give the image a painterly touch. It also carries psychological and symbolic meaning, for by dissolving the flowers and baby, leaving them unformed, Cameron makes the focused women consciously aware of the undetermined fate of the sleeping infant. Concern, pensiveness, and questioning are registered on the faces, and we sense a spiritual female bonding in this tight grouping of figures, who are closed off in the background as the image again goes fuzzy. While the image has sensual elements, it does not present women as objects meant for a male viewer, nor as appendages to a male world. Instead it reflects a powerful female vision as it embraces a female spirituality.

Cameron was generally criticized not only for her blurry images, which were attributed to incompetence, but also for just making photographs. As a female photographer in a sexist society, she found it difficult getting men to pose for her. She was criticized for exhibiting, which was a rare event for respectable Englishwomen in the Victorian era, and she was admonished for selling her photographs with a major London print dealer because it was deemed inappropriate for women to earn money. By redefining focus, Cameron challenged not only what was becoming the normative approach to photographic

vision but also a vocation that was specifically male. Ironically, by the end of the century, men adopted her vision.

COMBINATION PRINTING IN FRANCE In France, one of the most passionate champions of art photography was Gustave Le Gray (1820–1884). Initially a painter, he turned to photography and became one of the medium's technical innovators, being the first to use double printing, which he used to compensate for the bleaching out of the sky in his marine photographs. While he pioneered paper negatives and the wet-collodion process, both of which allowed for finer images and greater detail, his approach to the medium was often quite painterly, focusing on a dramatic contrast of dark and light. To accomplish this, he invented processes that produced extremely fine gradations of tone and one technique that allowed him to develop a print for up to two weeks after it was exposed, during which he could manipulate the image in the darkroom. He also touched up negatives with a brush to alter the tonality and remove objects.

These techniques can be seen in *Mediterranean Sea at Sète* (fig. **25.39**), of about 1856–1859, an especially lush albumen print made from two wet-collodion glass negatives, one for the sky, the other for the sea. Darkening large areas of the sky and sea, Le Gray transformed a simple, empty composition into a transcendental seascape where the drama of clouds, light, and sea seem to embody the elemental forces of nature.

PRIMARY SOURCE

Charles Baudelaire (1821–1867)

"The Modern Public and Photography," from Part 2 of *The Salon of 1859*

Baudelaire, now known primarily for his poetry, was an important art critic at midcentury and a powerful advocate for artists painting contemporary life.

I am convinced that the badly applied advances of photography, like all purely material progress for that matter, have greatly contributed to the impoverishment of French artistic genius. ... Poetry and progress are two ambitious men that hate each other, with an instinctive hatred, and when they meet along a pathway one or other must give way. If photography is allowed to deputize for art in some of art's activities, it will not be long before it has supplanted or corrupted art altogether, thanks to the stupidity of the masses, its natural ally. Photography must, therefore, return to its true duty, which is that of handmaid of the arts and sciences. ... Let photography quickly enrich the traveller's album, and restore to his eyes the precision his memory may lack; let it adorn the library of the naturalist, magnify microscopic insects, even strengthen, with a few facts, the hypotheses of the astronomer; let it, in short, be the secretary and record-keeper of whomsoever needs absolute material accuracy for professional reasons. ... But if once it be allowed to impinge on the sphere of the intangible and the imaginary, on anything that has value solely because man adds something to it from his soul, then woe betide us!

SOURCE: *ART IN PARIS, 1845–1862.* TR. JONATHAN MAYNES. (LONDON: PHAIDON PRESS, 1965)

Le Gray is believed to be the first photographer to appear in the graphic arts section of the Salon des Beaux-Arts, although we do not know for sure that he was included in the Salon of 1850–1851. He wrote, "the future of photography does not lie in the cheapness but in the quality of a picture. . . . it is my wish that photography, rather than falling into the domain of an industry or of commerce, might remain in that of an art."

ARCHITECTURE AND THE INDUSTRIAL REVOLUTION

Iron was another product of the Industrial Revolution, and its relationship to architecture was as nebulous as was that of photography to fine art. Initially, in the late eighteenth and early nineteenth centuries, iron was used for civil engineering, in such projects as bridges and factories. England, home of the Industrial Revolution, began mass-producing cast iron in 1767 and remained its greatest producer through the first half of the nineteenth century. It led the way in the architectural adaptation of iron, erecting in 1779 the first iron bridge, an arched structure spanning the narrow Severn River at Coalbrookdale. Soon, the metal was used for the columns in textile factories and by 1796–1797 for an entire internal structure. Revival styles continued to dominate architecture up to the closing decades of the nineteenth century, but the use of iron, while quite limited, freed buildings and civic structures from historicism because form (design) was now determined by the material and by engineering principles, thus setting the stage for the advent of modern architecture in Chicago in the 1880s. The pragmatism of iron construction and the blunt presentation of the medium's structural properties parallel the pragmatism and realism of the Age of Positivism.

Ferrovitreous Structures: Train Sheds and Exhibition Palaces

In the early nineteenth century, builders often used cast iron for the columns of Gothic revival churches, and in the 1830s, with the rise of railroads, they employed it for train sheds as well. The sheds had to span parallel tracks and platforms and be high enough to allow steam and smoke to dissipate. The first of these sheds, London's Euston Station (1835–1839), spanned 40 feet. The grandest was London's St. Pancras Station (1863–1876), the girded metal arches of which spanned 263 feet (fig. **25.40**) and when extended in depth formed the largest undivided space enclosed up to that time. The cast-iron skeleton supported a roof of glass. This combination of iron and glass is often called *ferrovitreous.* Each arch of St. Pancras Station is actually a double arch, one on top of the other, tied together with a **truss,** a reinforcing structure composed of two or more triangles sharing sides. Known since Roman times when it was used for wood construction and hence by all roof and bridge builders, the truss by 1860 was ubiquitous in metal construction spanning large spaces.

As spectacular an engineering feat as a train shed like St. Pancras was, it paled in comparison to the new railway bridges, which had to cross deep canyons and broad rivers. Train sheds were nothing more than small-scale bridge architecture, the arches girded together to whatever depth was needed. The regularized repetition of arches is itself symbolic of mass-production,

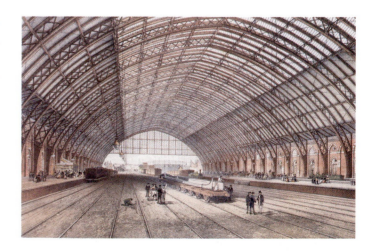

25.40. Lithograph of St. Pancras Station, London, 1863–1876. Science Museum, London

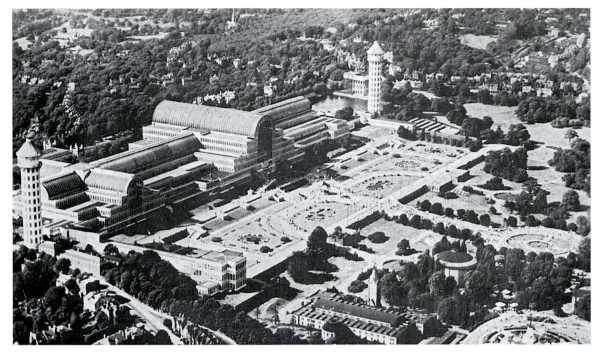

25.41. Sir Joseph Paxton. The Crystal Palace, London. 1851; reerected in Sydenham 1852; destroyed by fire 1936

reflecting the ability of industry to churn out an endless supply of the exact same product at a constant pace or rhythm.

Perhaps the most famous ferrovitreous building of the nineteenth century is the Crystal Palace (fig. **25.41**), built in London in 1851 to house the first great international trade fair, the Great Exhibition of the Works of Industry of All Nations. The fair was designed to showcase the product development, technological advances, agricultural improvements, and fine and applied arts of the new industrial nations, with Britain expecting to shine as the most advanced. The exposition was not just a trade fair but a celebration of Western industrialization. England's preeminent greenhouse architect, Sir Joseph Paxton (1801–1865), designed the building and with engineers erected what is essentially a giant greenhouse. While the ferrovitreous materials are the same as in Paxton's earlier greenhouses, the form is not, for it resembles an English cathedral, with a long, barrel-vaulted center nave, a lower barrel-vaulted transept, and stepped-down side aisles. (After the exposition closed, the building was dismantled and moved to nearby Sydenham, where another transept was added.) The building was a cathedral of industry, which had become the new religion. The familiar form and human scale of the building's small component parts such as panes of sheet glass, must have helped put people at ease within this looming, visionary, 1,851-foot-long structure.

Historic Eclecticism and Technology

The Crystal Palace had a strong technological look, perhaps because it was conceived as a temporary, nontraditional building designed to host an exposition dedicated to technology and industry. Generally, monumental, stately buildings, such as courts, theaters, and parliaments, were not built of iron. Instead they were executed in stone and were "representational," designed in a

revival style that established a lineage to the Classical, Gothic, or Renaissance past. We saw, for example, how Garnier incorporated elements of the Louvre into the Opéra in order to link Louis Napoleon to Louis XIV.

THE BROOKLYN BRIDGE The need to cloak technology in historic eclecticism is apparent in what is perhaps the greatest spanning structure of the nineteenth century, the Brooklyn Bridge (fig. **25.42**), designed by John Roebling (1806–1869) in 1867 and finished by his son Washington Roebling (1837–1926) in 1883. When announced, the bridge was considered a folly; when finished, a wonder of the world. Suspension bridges had existed on a much smaller scale, but no one imagined it possible to dig piers in such a deep waterway as New

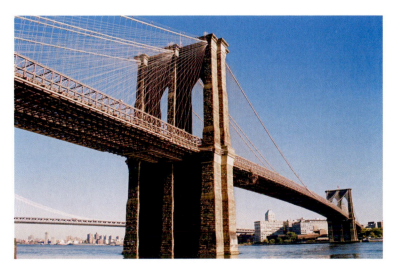

25.42. John and Washington Roebling. Brooklyn Bridge, New York. 1867–1883

York's East River, to have them rise 300 feet above the water, and then to span the vast distance from Brooklyn to Manhattan *while* supporting fives lanes for railroads, carriages, and pedestrians. To accomplish this feat, Roebling not only used vertical cables attached to the main drooping suspension cables but also wire cables running from the top of the piers to regular intervals on the bridge, creating triangular units that Roebling considered trusses.

Typical of the taste of the times, the two enormous piers are an eclectic combination of revival styles, with Gothic revival prevailing. In the original plan, however, the piers were Egyptian pylons, a motif retained in the final version only in the gorge moldings where the cables thread the top of the granite structure. As everyone at the time noted, the piers functioned like enormous Roman triumphal arches. The bridge was declared "America's Arch of Triumph," a reference not only to its awesome scale and achievements but also to America's technological superiority.

BIBLIOTHÈQUE SAINTE-GENEVIÈVE By the 1850s, New York excelled at the production of cast-iron facades, where five- and six-story buildings, generally used for light manufacturing, were entirely sheathed in skins of iron arches and columns resembling stone. The more monumental and nonindustrial the building, the less likely the overt use of iron. The most innovative use of iron in an important civic building is in Paris, where the Bibliothèque Sainte-Geneviève was designed in 1842 by Henri Labrouste (1801–1875). The exterior of the library (fig. **25.43**) evokes the Renaissance. Jacopo Sansovino's famous Library of San Marco (1536) in Venice inspired the arches springing from piers, while the building's proportions and such components as the closed lower and open upper stories recall the Medici Bank in Milan (ca. 1460), suggesting the structure is an intellectual treasury. Labrouste evokes Ptolemaic Egyptian temples by his inscription-covered, half-filled-in second-story openings, telling us the contents are sacred. The inscriptions are the names of great authors.

The exterior gives no hint of the radical technology displayed within. The main reading room (fig. **25.44**), located on the second floor, consists of two airy vaults, their columns and arches made of cast iron (the ceiling is mesh-reinforced plaster). Whereas the exterior mostly recalls the Classical Renaissance, the interior suggests the Gothic, specifically a Romanesque refectory. But to a Parisian, the metal arches would immediately bring to mind the new train sheds, suggesting not only modern life but also a sense of voyage, which indeed is the function of books.

Labrouste did not *need* to use iron in his library but he chose to do so for metaphorical and symbolic purposes. This symbolic use of iron even appears in the first-floor entrance, where a dense arrangement of fluted square Classical columns suggesting an Egyptian hypostyle hall supports metal arches resembling modern iron bridges, a reminder to the visitor that books are a bridge to the future.

Announcing the Future: The Eiffel Tower

The most famous iron structure from the period is the Eiffel Tower (fig. 25.45), erected by the French engineer Gustave Eiffel (1832–1923) in 1887–1889 as an entrance to the 1889 Paris International Exposition. To create his tower, Eiffel basically appropriated a trussed pylon from the many bridges he had already constructed. At 984 feet (300 meters) high, twice the height of any other structure then in the world, it dominated the city, and because its design was largely due to its structural integrity and not to a standard architectural style, it initially affronted the Parisians, who declared it an eyesore. The lacework tower was so thin it looked fragile and unstable, and Eiffel added arches at the base and organic decoration on the two platforms (removed in the 1930s) to make visitors more comfortable with his radical, visionary structure.

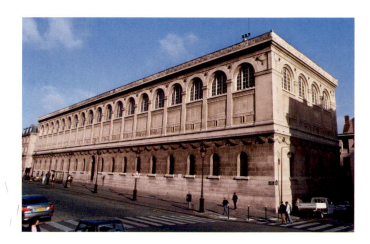

25.43. Henri Labrouste. Bibliothèque Sainte-Geneviève, Paris. Designed 1842, built 1842–1851

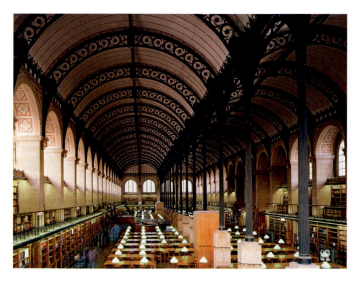

25.44. Main Reading Room, Bibliothèque Sainte-Geneviève

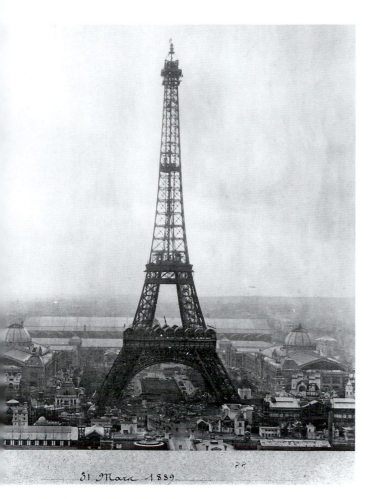

25.45. Gustave Eiffel. Eiffel Tower, Paris, 1887–1889

As with the Brooklyn Bridge, however, the public, grasping at the familiarity of the arches at the base, soon viewed the tower as a triumphal arch, one heralding the triumph of French technology and industry. It also saw the tower as a declaration of the triumph of the people: For a pittance, anyone could take the elevator to the upper platforms. Here common citizens could look down on the churches and palaces, the bastions of tradition and privilege, which the century's continuous march toward democracy had undermined. The Eiffel Tower became a tower of the people and a symbol of Paris, if not France as well. More important, it pointed to the architecture of the next century, one of Modernism that would shed historical references and instead allow style to reflect the nature and geometry of the new building materials.

SUMMARY

Widespread revolutions rocked many countries throughout Europe in 1848, a year that coincided with the rise of a philosophy of materialism and pragmatism that replaced Romantic imagination. Once again new governments—as well as new outlooks—were reshaping European societies. Europeans increasingly regarded science and tested facts as the foundation of knowledge.

Art in this so-called Age of Positivism became defined by Realism. Rather than idealizing life, artists candidly depicted the realities of the modern era, from the grim existence of the poor to the leisure activities of the well-to-do. In landscape painting this Realism evolved into Impressionism, which documented the transformation of rural France into Parisian suburbs.

REALISM IN FRANCE

With the rise of Louis Napoleon following the Revolution of 1848, French society was greatly transformed. Industrialization and the rise of the bourgeoisie were intensely accelerated and Paris was transformed into its modern-day form. Artists recorded the dramatic societal transformation of France. Gustave Courbet and Jean-François Millet championed the lifestyles and occupations of the laboring classes. Rosa Bonheur turned to the animal world, grounding her artwork in scientific observation of anatomy and movement. Beginning in the 1860s, such painters as Édouard Manet and Edgar Degas shifted Realism's focus to city life, whereas Impressionist artists like Claude Monet and Camille Pissarro relied on careful observation to record the hues of both natural and human-made objects.

BRITISH REALISM

In England, meanwhile, industrialization and urbanization engendered new wealth for some people but abject poverty for others. Many intellectuals decried the rise of crass materialism and amorality. In art, the era's Positivist mentality resulted in a detailed naturalism, truth to nature, and interest in social issues. The Pre-Raphaelite Brotherhood focused on the industrial and moral evils of contemporary London, using highly detailed, naturalistic style, sometimes set in the medieval spiritual past that served as a parable for modern society. A similar emphasis on spirituality and naturalism surfaced in the decorative arts as well, led by William Morris's design company that manufactured beautiful hand-crafted objects. In contrast to France, Realism died out early in England, supplanted in the 1860s by the Aesthetic Movement. Led by J. A. M. Whistler, artists embraced an art for art's sake aesthetic that also explored private visions and repressed eroticism.

REALISM IN AMERICA

The Civil War rather than the Revolution of 1848 had the greatest impact on the United States. Winslow Homer, for example, produced iconic and naturalist genre scenes incorporating symbolic imagery about the war. Meanwhile, Thomas Eakins applied a scientific Naturalism to his Realist presentations of contemporary America.

THE ADVENT OF PHOTOGRAPHY: A MEDIUM FOR MASS-PRODUCED ART

The perfect tool for the Positivist era, photography was used initially to record the world and support scientific inquiry. Portraits and places were favorite subjects. However, many photographers thought of their medium as art, not as a mechanical tool. Imitating painting, these photographers, called Pictorialists, staged their motifs and manipulated their images.

ARCHITECTURE AND THE INDUSTRIAL REVOLUTION

Iron helped free architecture from the eclecticism of revival styles. Used mainly for such non-stately buildings as train sheds, and often combined with glass, iron buildings were pragmatically skeletal, with form (that is, design) following function and having no historical references. The Eiffel Tower, built for the 1889 International Exposition in Paris, epitomizes this modern approach to building design.

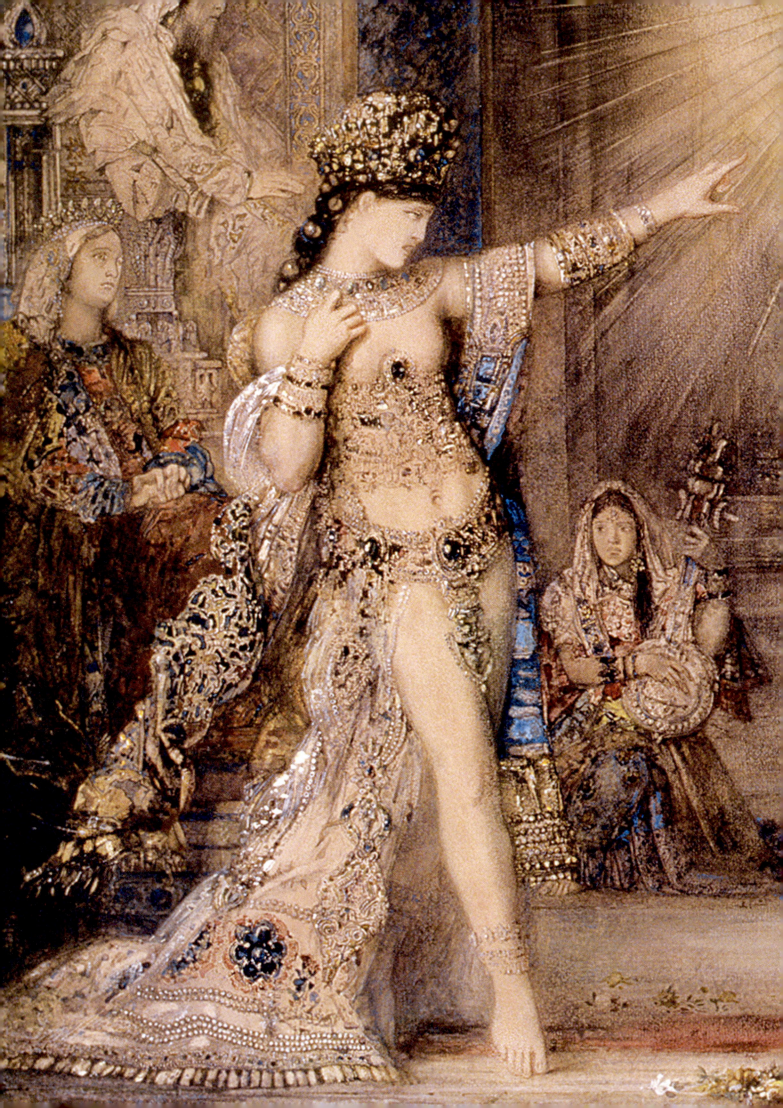

Progress and Its Discontents: Post-Impressionism, Symbolism, and Art Nouveau, 1880–1905

T HE CLOSING DECADES OF THE NINETEENTH CENTURY PRESENTED A cultural dichotomy. On one side were those who optimistically reveled in the wealth, luxury, and technological progress of the industrialized world. On the other were those who perceived these same qualities as signs of decadence, excess, and moral turpitude. The former experienced

exuberance and pride, the latter despair and anxiety. Depending on one's viewpoint, the period was either La Belle Époque, "the beautiful era," or Le Fin de Siècle, "the end of the century."

The end of the century, as well as the 14 years leading up to World War I, indeed constituted a period of unprecedented economic growth and prosperity, nurtured by virtually forty years of peace following the 1870 Franco-Prussian War. National consolidation was largely complete, with many countries functioning as republics. Germany and France joined England and Belgium as truly industrialized countries, with Germany producing twice as much steel as England by 1914. The United States was included as well in this exclusive group. Spurred by both capitalism and a heated nationalism was a dramatic increase in imperialism, which resulted in the carving up of Africa as well as parts of Asia and the Pacific islands into fiefdoms to be economically exploited. Now there was a true world market, with goods, services, capital, and people continually circulating across borders and around the globe.

The modern era, which began in the eighteenth century, now evolved into a new phase called *modernity*, often labeled the "New Industrial Revolution." The steam engine was refined and improved. Electricity, the telephone, the internal combustion engine, automobiles, submarines, airplanes, oil,

moving pictures, and machines increasingly defined modern life, whose pace quickened even as it became more comfortable and efficient. In 1901, Guglièlmo Marconi sent a wireless signal across the Atlantic, further shrinking the globe.

Cities epitomized modernity. Anonymous and impersonal, they were a magnet for people uprooted from the countryside as industrialization spread. These new city dwellers were less respectful of tradition than their rural counterparts and open to new ideas, which circulated rapidly with the dramatic increase in newspapers and literacy. Detached from traditional institutions, they identified with the state, reinforcing the fierce nationalism that also defines the period. With this confluence of people and ideas, cities became powerful centers for social reform, especially supporting socialism and Marxism. Newspapers, magazines, and books exposed the miserable living and working conditions of the poor, and became a persuasive force for change, especially when illustrated with photographs.

Another major force for molding this period was the emergence of the "New Woman," women bent on changing the restrictive laws and conventions of Victorian society. The women's movement launched in the second quarter of the nineteenth century in both Europe and America became a powerful force in the last quarter, as women organized and forcefully demanded political, economic, and educational and social equality. By the 1890s the term "New Woman" was coined, and the mass media, especially in America, developed a visual image

Detail of figure 26.16, Gustave Moreau, *The Apparition*

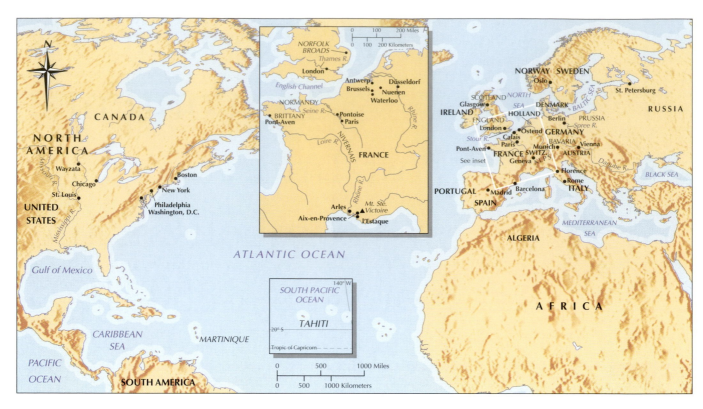

Map 26.1. Europe and North America 1904–1914

to describe her: She was tall, athletic, and independent and she rejected the restrictive conventions of the Victorian era, wearing comfortable masculine-inspired clothing and even flaunting her sexuality. This New Woman threatened most Victorian men who viewed her independence as a challenge to their power. They preferred women stay at home, uneducated and without financial independence. Male artists were no exception, and the castrating, dominating *femme fatale* became a popular theme, a visual expression of male fears. At the same time, an increasing number of women artists presented women from a female viewpoint, one that gave them social importance and dignity, as Mary Cassatt and Julia Margaret Cameron had done before (see Chapter 25). These artists broke with the male tradition of depicting women as sex objects, defined only by their dependence on men.

On the world stage, the late nineteenth century saw a dramatic increase in a sense of European superiority. Despite the sharp political divisions arising from nationalism, Europeans and such European-linked countries as the United States, Canada, Australia, and New Zealand shared a similar way of life and attitudes. They felt their world constituted the "civilized" world, and everything—and everyone—else was "backward." Enlightenment philosophy and science, Europeans believed, had reached a climax, creating the most sophisticated and elevated branch of humankind. As never before, Europeans became race conscious, with whites considering themselves superior. Charles Darwin's theory of evolution, set forth in the *Origin of Species* (1859) and *Descent of Man* (1871), was twisted to

reinforce this view of white supremacy. If life was a struggle that resulted in the "survival of the fittest" through "natural selection" of the "most favored races," then clearly, it seemed, advanced European civilization was the "most favored race."

Many cultural anthropologists, however, refused to label any society as better than any other, and found tribal societies to be just as complex as Western civilization. The mores and values of any culture, they argued, were appropriate to its environment and circumstances. Nonetheless, those Europeans who lamented industrialization and who were suspicious of unchecked progress perceived the newly colonized, exploited territories as unspoiled utopias, havens from the materialistic evils of modern civilization. Continuing the tradition launched by Jean-Jacques Rousseau in the eighteenth century, they viewed these so-called primitive societies as still steeped in Nature and thus virtuous and pure, as well as connected to universal spiritual forces.

A renewed search for the spiritual appeared in the closing decades of the century. Anthropologists demonstrated that the rituals, practices, and beliefs of Christianity were not unique at all, but had parallels in tribal cultures and Eastern religions. The strongest expression of this attitude appeared in Sir James Frazer's (1854–1941) multi-volume *The Golden Bough*, which even declared that magic and religion were separated by a very fine line. As growing numbers of people fled progress by embracing an intense spirituality, they were drawn to orthodox Western religions as well as to Eastern-inspired practices such as Theosophy and Rosicrucianism. Many were also drawn to animisim and the occult.

The late nineteenth century also marks the rise of psychology. The German physiologist Wilhelm Wundt (1832–1920) transformed psychology from a philosophy to a natural science by basing it on scientific method, which he detailed in his 1874 *Principles of Physiological Psychology*. From Russia, the research of Ivan Pavlov (1849–1936) sparked an intense interest in how human behavior is conditioned by experience and environment. And in Vienna, the neurologist Sigmund Freud began to formulate his theories of the unconscious, publishing his *Interpretation of Dreams* in 1900. This interest in the mind and the elemental forces driving human responses went well beyond science to permeate popular and high culture, and artists as diverse as Auguste Rodin and Edvard Munch increasingly focused on the unseen forces residing deep within the mind that produced such outward manifestations as sexual urges and anxiety.

In many respects progress was the watchword of the late nineteenth century, and the force to which artists responded. The vast majority rejected it, seeking a spiritual, utopian, or primitive alternative. The result was a range of styles or movements, chief among them Post-Impressionism, Symbolism, and Art Nouveau. Most of the artists built on the brilliant formal innovations of Manet and the Impressionists and created work that was more abstract than representational. Their art was also highly personal, not reflecting a group vision. Consequently many artists, like Vincent Van Gogh and Paul Cézanne, cultivated their own distinctive form of mark-making. Often their work was visionary, depicting fantasies and dreamworlds, and often it was spiritual, as it sought relief from the crass, empty materialism of modernity and a more meaningful explanation for existence. Many artists found their subject matter in the sanctuary of the Classical, medieval, and biblical past, which the Realists had so fiercely rejected. Even modern architecture indulged in fantasy and spirituality. Art Nouveau, for example, succeeded in freeing architecture from the dominance of the eclecticism of revival styles by creating buildings that eerily resembled strange but marvelous organic forms. At the same time, the great Chicago architects of the 1880s and 1890s developed the first glass and steel skyscrapers and, in the case of Frank Lloyd Wright, complex houses made up of a relentless modern geometry of horizontals and verticals. Still, they invested their modern buildings and houses with a powerful spirituality that tied them as much to cosmic forces as they did to the constant march of progress. While Realism and Impressionism had sought to capture the essence of the modern world, Post-Impressionism, Symbolism, and Art Nouveau largely struggled to escape it and provide an antidote.

POST-IMPRESSIONISM

The early twentieth-century British art critic Roger Fry coined the term Post-Impressionism to describe the avant-garde art that followed Impressionism, work that became a springboard that took art in new directions. Each of the Post-Impressionist artists—Paul Cézanne, Georges Seurat, Vincent Van Gogh, and Paul Gauguin—developed a unique style. Still there are artistic conditions that unify the period from 1880 to 1904. The Post-Impressionists rejected the empiricist premises of Realism and Impressionism in order to create art that was more monumental, universal, and even visionary. Post-Impressionists also rejected a collective way of seeing, which we saw in Impressionism; instead, each artist developed a personal aesthetic. Like the Impressionists, however, many Post-Impressionists continued to mine Japanese art for aesthetic ideas. They also maintained the anti-bourgeois, anti-academic attitude of the Impressionists, similarly turning to artists' cooperatives and private galleries to promote their art.

Paul Cézanne: Toward Abstraction

Actually, Cézanne (1839–1906) is the same generation as the Impressionists, developing his Post-Impressionism in tandem with the rise of the style. Born into a wealthy but socially isolated family in Aix-en-Provence in southern France, he rejected law and went to Paris to study art in 1861. He enrolled at a drawing academy, but was essentially self-taught, copying paintings in the Louvre by Delacroix and Courbet, among others. From 1864 to 1869, Cézanne submitted rather crude, dark, intensely worked paintings depicting mysterious, morbid, and anonymous orgies, rapes, and murders to the Salon. These works were rejected, as the anti-bourgeois, anti-academic Cézanne knew they would be. In part, they were meant to shock. Using a palette knife and the dark pigments of Courbet, he was also inspired by the Romantic imagery of Delacroix as well as the thematic brazenness of Manet. He even painted several *Modern Olympias*, one of which he showed at the first Impressionist exhibition in 1874. (He would participate in the first three shows.)

In 1872, Cézanne left Paris for Pontoise and then nearby Auvers at the suggestion of Pissarro (see fig. 25.17), who was already living there. The older artist became his mentor, and they bonded in their desire to make an art that stylistically looked modern. He began painting landscapes, occasionally at Pissarro's side. With this steadying influence, Cézanne's emotionalism dissipated, his palette lightened, even becoming colorful, and his compositions took on a powerful structural integrity, which had been suggested in his earlier work but now blossomed. As he would state later in life, he wanted "to make of Impressionism something solid, like the art in the museums." We can see how he achieved this goal in a work from the next decade, *Mont Sainte-Victoire* (fig. **26.1**), painted in Provence around 1885 to 1887. Typical of Impressionism, this canvas presents a light-filled landscape painted with broad brushstrokes and fairly bright color. The picture seems to shimmer at first, then it freezes. Cézanne has locked his image into a subtle network of shapes that echo one another. The curves and bends of the foreground tree branches can be found in the distant mountain and foothills. The diagonal lines on the edges of the green pastures reverberate in the houses, mountain slopes, and the directionality of the clusters of parallel dashlike brushstrokes,

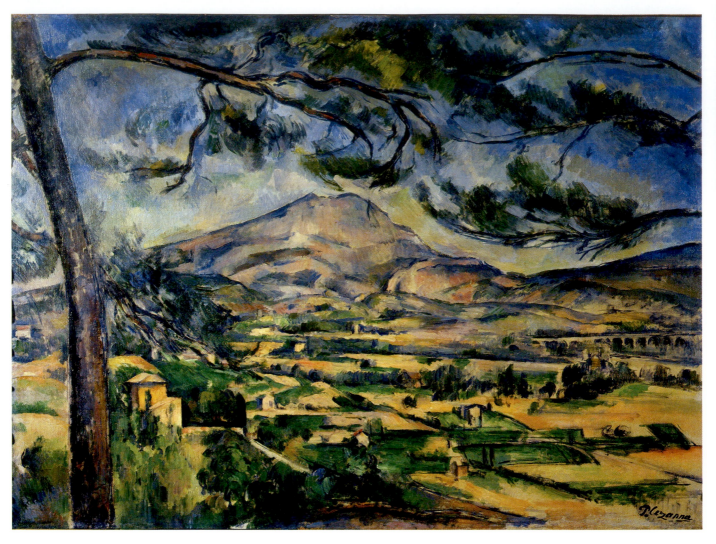

26.1. Paul Cézanne. *Mont Sainte-Victoire*. ca. 1885–1887. Oil on canvas, $25\frac{1}{2} \times 32''$ (64.8 × 92.3 cm). The Samuel Courtauld Trust, Courtauld Institute of Art Gallery, London. P. 1934. SC. 55

perhaps best seen in the green pine needles. Just as the building to the right of the tree has a solid cubic presence, combinations of contiguous flat green pastures and ochre fields cause blocklike forms to emerge from the earth, before they dissolve once again in thin planes of color. A fair number of vertical stresses, often quite minute, are tucked into the landscape and play off strong horizontals to suggest an underlying grid.

Many aspects of the picture can be read in two diametrically opposed ways. There is an Impressionistic flicker, but a structurally frozen image. The picture is a deep panoramic view, and yet it is also flat and compressed, for the distant sky sits on the same plane as the foreground tree branches. This conflation is in part due to the tapestry of aligned, off-white brushstrokes that seem simultaneously to encase the pine needles and be woven into the sky. Every brushstroke sits on the surface of the canvas as a flat mark asserting the surface; and yet the strokes overlap one another, causing a sense of space or depth to exist between them. Even line has a dual function, for it can be read as shadow, as on the top of the mountain, making depth happen, or it can be seen as flat contour line. There is a conflict between figuration and abstraction, for while the pic-

ture obviously depicts a real world, we are never allowed to forget that we are looking at flat paint, lines, and patches of color applied to a flat canvas. We can sense the enormous amount of time that went in to resolving all of these conflicts and achieving a balance of two- and three-dimensional space. Most pictures took Cézanne years to paint as he meticulously pondered every mark. (See *Primary Source*, page 907.)

In addition to landscape, Cézanne made portraits of acquaintances (never commissions, since his father provided him with a modest income), still lifes, and figure paintings, especially bathers in a landscape, and in every genre we can see the same conflicts and suppression of tension. In his 1879–1883 *Still Life with Apples in a Bowl* (fig. **26.2**), we can immediately sense a Chardinesque monumentality (see fig. 22.8). There is a balancing of apples in the compote with those on the dish, and a balancing of the folds of the white cloth with the wallpaper's leaf motif. Everything is framed by the forceful horizontal edges of the table. Each apple has a powerful physical presence as it is built up out of slablike brushstrokes, its form also carefully delineated with a distinct line. The folds of the cloth are equally plastic, their illusionistic tactility reinforced by the concrete

PAUL CÉZANNE (1839–1906)

From a letter to Emile Bernard

Bernard had worked with Gauguin to formulate the style of the Pont-Aven school. He began a correspondence with Cézanne after meeting him at Aix-en-Provence in the spring of 1904, when this letter was written.

May I repeat what I told you here: treat nature by the cylinder, the sphere, the cone, everything in proper perspective so that each side of an object or a plane is directed towards a central point.

Lines parallel to the horizon give breadth, that is a section of nature or, if you prefer, of the spectacle that the Pater Omnipotens Aeterne Deus spreads out before our eyes. Lines perpendicular to this horizon give depth. But nature for us men is more depth than surface, whence the need of introducing into our light vibrations, represented by reds and yellows, a sufficient amount of blue to give the impression of air.

SOURCE: *PAUL CÉZANNE: LETTERS.* ED. JOHN REWALD, TR. MARGUERITE KAY. (LONDON: BRUNO CASSIRER, 1946)

presence of parallel bricks of paint. But the picture also has a nervous energy and ethereal flatness: The compote refuses to recede in space because its back lip tips forward. The same is true of the dish. Its edges disappear behind the apples and we have difficulty imagining their connection to each other in space. The tabletop is also spatially disorienting, for it tilts forward and up the canvas rather than moving back into space. The chunks of brushstrokes are obviously flat marks, and they cover the surface with a nervous energy. This energy is epitomized by the strange interior life that the folds of the cloth seem to have. Meanwhile, the wallpaper's leaf pattern momentarily does a reversal as it escapes its two-dimensional assignment to take on a three-dimensional life, one as concrete as that of the apples or folds of cloth. Cézanne has abandoned faithfully observed reality to create his own pictorial world, one that adheres to a private aesthetic order and acknowledges with every move that art is inherently abstract—painting is first and foremost about putting paint on canvas to create an arrangement of line and color.

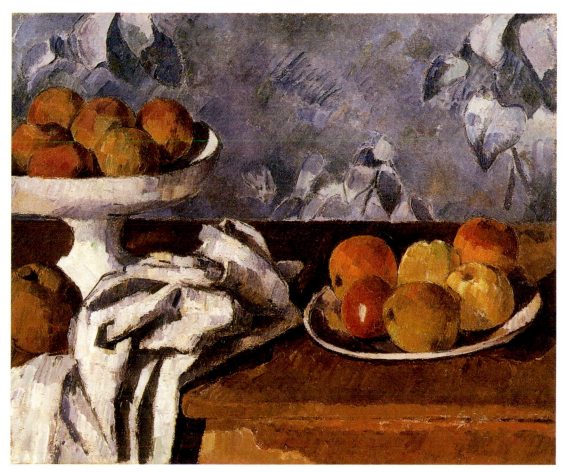

26.2. Paul Cézanne. *Still Life with Apples in a Bowl.* 1879–1883. Oil on canvas, $17\frac{1}{8} \times 21\frac{1}{4}''$ (43.5×54 cm). Ny Carlsberg Glyptotek, Copenhagen, Denmark

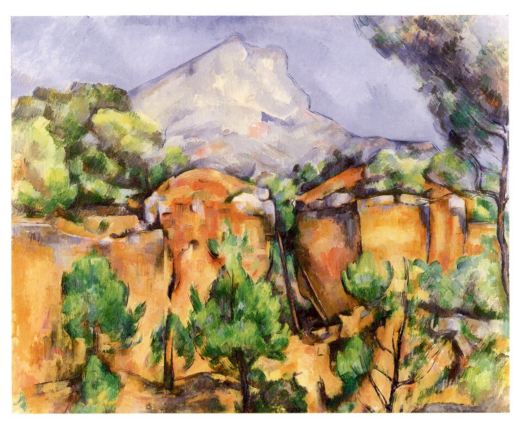

26.3. Paul Cézanne. *Mont Sainte-Victoire Seen from Bibemus Quarry*. ca. 1897–1900. Oil on canvas, 25 1/2 × 31 1/2″ (65.1 × 80 cm). The Baltimore Museum of Art. The Cone Collection, Formed by Dr. Claribel Cone and Miss Ette Cone of Baltimore, Maryland. (BMA 1950.196)

Cézanne's art became increasing abstract in the last ten years of his life, as can be seen in *Mont Sainte-Victoire Seen from Bibemus Quarry* (fig. **26.3**), painted from 1897–1900. Mont Sainte-Victoire was a favorite motif, almost an obsession, as it appeared in over 60 late paintings and watercolors. The deep vista we saw in the earlier view of the mountain (see fig. 26.1) has now been replaced with a more compressed version. The overlapping of representational objects is one of the few devices suggesting depth. Otherwise, the image is an intense network of carefully constructed brushstrokes, lines, and color that begs to be read as an intricate spaceless tapestry. The foreground trees bleed into the quarry rock, or on the upper right into the sky. The sky in turn melds into mountain, from which it is distinguished only by its defining line of the summit. No matter how flat and airless, the image, as with any Impressionist picture, paradoxically is also filled with light, space, and movement. Looking at this hermetic picture we cannot help but feel how the tension and energy of his early romantic pictures were suppressed and channeled into a struggle to create images that balanced his direct observation of nature with his desire to abstract nature's forms. Here is the work of the painter most responsible for freeing the medium from a representational role and giving artists license to invent images that instead adhered to painting's own inherent laws. The Paris gallery Durand-Ruel began exhibiting Cézanne in the late 1890s, and the public exposure had a powerful influence on artists, especially Pablo Picasso and Henri Matisse.

Georges Seurat: Seeking Social and Pictorial Harmony

Like Cézanne, Georges Seurat (1859–1891) wanted to make Impressionism more like the great art of the past. He studied briefly in 1878 at the École des Beaux-Arts with a follower of Ingres, and after a year of compulsory military service in Brittany returned to Paris, where he spent the rest of his short life. He set up a studio, and in 1884 he unveiled his new style with a large picture called *A Bathing Place, Asnières*, which depicts a group of workers swimming in the Seine in a working-class suburb of Paris, not far from where Seurat grew up. The picture, refused at the Salon, was shown in 1884 at the first exhibition of the Independent Artists, a new artists' cooperative whose shows were unjuried like those of the Impressionists' Artist's, Inc. Seurat next participated in what would be the last Impressionist exhibition, in 1886, submitting *A Sunday Afternoon on the Island of La Grande Jatte* (fig. **26.4**). The dates of the two shows are significant, for they mark the end of the Impressionist era and the rise of Post-Impressionism.

La Grande Jatte's roots in the realism of Manet and in Monet's impressionistic canvases are obvious, since it is a scene of the middle class taking its Sunday leisure on a sunny, color-filled afternoon. The painting, presents a compendium of types that contemporaries would have easily recognized, such as the courtesan, shown walking a monkey, and the boatman, who is the sleeveless man smoking a pipe in the left corner. (Seurat's

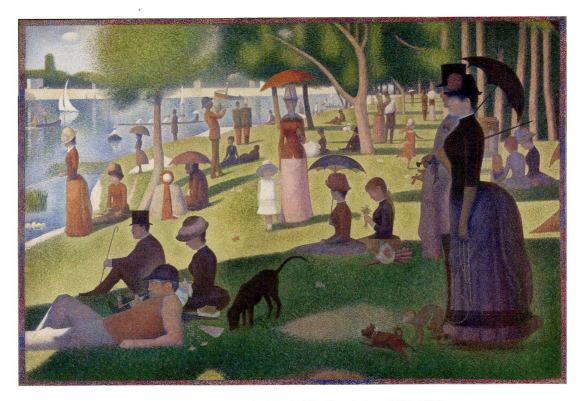

26.4. Georges Seurat. *A Sunday Afternoon on the Island of La Grande Jatte*. 1884–1886. Oil on canvas, 6′10″ × 10 1⁄4″ (2.08 × 3.08 m). The Art Institute of Chicago. Helen Birch Bartlett Memorial Collection. 1926.224

cataloging of types extends to the dogs in the foreground and boats on the Seine.) Seurat renders his figures as icons, for each is silhouetted in profile, frontally, or three-quarter view, following the prescription of the famous Roman architect Vitruvius for the arrangement of sculptural figures on temples. Seurat declared that he wanted "to make the moderns file past like figures on Phidias' Pan-Athenaic Frieze on the Parthenon, in their essential form. . . ." And this was no idle claim. The 6 by 10-foot canvas was meant to function on the scale of great history painting and be seen in the tradition of Poussin and David. Like a history

painter, Seurat made detailed studies for every component of his work, even making a painting of the landscape alone, before the insertion of the figures and looking like a stage set.

INFLUENCE OF PUVIS DE CHAVANNES Critics noted that Seurat's *La Grand Jatte* recalls the Classical murals of Pierre Puvis de Chavannes (1824–1898), whose work was so ubiquitous his fame was widespread by the 1880s. His paintings, such as *The Sacred Grove* (fig. **26.5**), are set in an idyllic mythical or biblical past where life is serene, bountiful, and

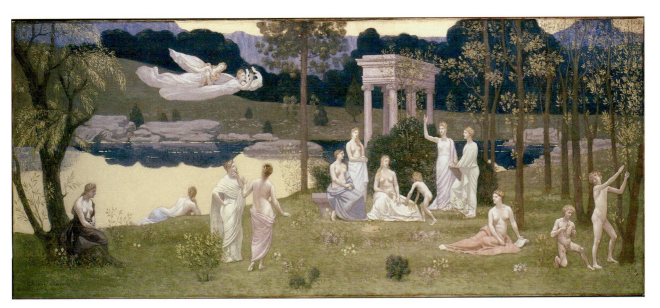

26.5. Puvis de Chavannes. *The Sacred Grove*. 1884. Oil on canvas, 3 1⁄2″ × 7 1⁄2″ (93 × 231 cm). The Art Institute of Chicago. Potter Palmer Collection. 1922.445

carefree. In Puvis's world there is little movement, and certainly no exertion. Without appearing geometric, everything is orderly, either vertical or horizontal, with a soothing planarity bringing everything into harmonious alignment. The decorative flatness evokes ancient murals as well as primitive Italian trecento and quattrocento frescos. There is a minimum of detail, endowing the picture with a tranquil and unencumbered look. His figures tend to be silhouetted in profile or frontal, and often have an archaic angularity and simplicity that adds to the aura of primitive purity and innocence. Puvis, who emerged from the academic ranks in the early 1860s, provided a startling Classical alternative to Bouguereau (see page 868), although his classicizing dreamy images often appealed to the same conservative audience. By the 1880s, they would attract the avant-garde as well, which saw in their visionary world and abstract simplicity the same sanctuary from the modern world that they too were trying to attain.

SEURAT AND NEO-IMPRESSIONISM As much as Seurat was influenced by Puvis, his agenda could not be more different, for instead of escaping into a distant past his goal was to create a utopian present, a poetic vision of middle- and working-class tranquility and leisure. His religion was not just Classicism, but also science. Familiar with the color theory of the American physicist Ogden Rood, he believed that colors were more intense when mixed optically by the eye rather than on the palette. Consequently, he would build up his paint surface, first laying down a thin layer of a partially mixed local color, over which came a layer of short strokes of related hues, and finally a top layer of equally sized dots of primary and binary color. As explained in an 1886 article by Seurat's art critic friend Félix Fénéon, this top layer of ". . . colors, isolated on the canvas, recombine on the retina: we have, therefore, not a mixture of material colors (pigments), but a mixture of differently colored rays of light." It does not matter that Seurat misinterpreted Rood and that the claim is not true. Seurat believed his colors were more luminous than the Impressionists, and certainly his technique, which he called "Chromoluminarism" and scholars later labeled "Pointillism" or "Divisionism," created a uniform, if vibrant, surface that was a systematized Impressionism. Like the figures, the regularized dot surface of Seurat's pictures seems mechanical, as though the subjective hand-eye reaction of the Impressionist has been replaced by a machine capable of recording color and light with uniform dots of paint.

In his review of the Impressionist show, Fénéon labeled Seurat's style Neo-Impressionism, the "New Impressionism," and before the decade was out, it had an army of practitioners who were attracted to its scientific approach, monumentality,

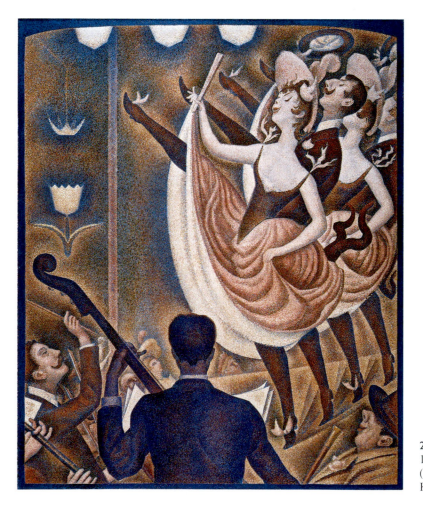

26.6. Georges Seurat. *Le Chahut*. 1889–1890. Oil on canvas, $66\frac{1}{2} \times 54\frac{3}{4}''$ (169 × 139 cm). Rijksmuseum Kröller-Müller, Otterlo, The Netherlands

LITHOGRAPHY

Grease rejects water. Starting with that principle, Aloys Senefelder, an inspector of maps at the royal printing office in Munich, invented the process of lithography shortly before 1800. Essentially, an artist draws on stone with greasy crayon or ink, called *tusche*. The stone is then dampened with water, which is absorbed into the porous stone, except for where there is *tusche* drawing. The printmaker next applies printer's ink, which adheres only where there are *tusche* marks. The stone is then put through a press, and the image is printed in reverse on paper. The process requires such technical proficiency that artists usually work with skilled lithographers who do the technical work and "pull" the prints, that is, they run the paper through the press. A later variation of the process allowed artists to draw with *tusche* on paper, which was then transferred onto the stone. Artists immediately embraced lithography, and it became one of the most popular print mediums of the nineteenth and twentieth centuries.

Unlike engraving plates (see *Materials and Techniques* in Chapters 14 and 20), which wear down with repeated printing and require frequent strengthening of the lines, lithography needs no maintenance, and a seem-ingly unlimited number of prints could be produced from a single stone. Toward 1830, paper was becoming less expensive and literacy was growing, a combination that increased the medium's appeal to newspaper and magazine publishers, whose print runs were rising. Of the many newspaper illustrators who worked in lithography, Honoré Daumier became the most celebrated (see fig. 25.4).

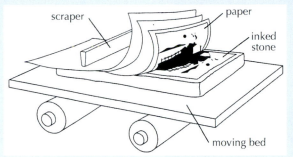

With the development of larger printing presses and the ability to print in several colors, lithography became the preferred medium for posters, which in the closing decades of the nineteenth century began to feature images in addition to words. Advertisers now wanted pictures of their products and strong colors so that their poster would stand out on a building wall that was filled with advertisements. Artists responded. Large colored lithographic posters began to plaster the sides of buildings, commercial wagons, and omnibuses, reflecting the consumerism overtaking Europe. The art world quickly recognized the artistic merit of many such posters, and in 1889 a poster exhibition was mounted for the International Exposition at the Palace of Liberal Arts. Collectors began buying posters, galleries began selling them, and artists made them with collectors in mind. Today, Henri de Toulouse-Lautrec is among the most acclaimed of the artists who made colored lithographic posters (see fig. 26.7).

and modern look. Many worked well into the twentieth century. As distinctive as the technique is, it would be a mistake to emphasize it at the expense of the meaning of art. Seurat was a socialist sympathizer and was dedicated to creating a utopia of middle- and working-class tranquility and leisure. His socialist vision of a harmonious, perfect world and belief in science as the force to make this happen characterize his method.

Seurat's experimental approach led him to the theories of Charles Henry as outlined in the treatise, *A Scientific Aesthetic* (1885). Henry claimed that colors, as well as line, carried specific emotional meaning (e.g., yellow or a line rising from a horizontal connotes happiness, while blue or a descending line evokes sadness). Seurat put this theory into practice in the major paintings of his last five years, genre paintings of popular urban entertainment, such as circuses and cabarets. In the joyous and festive *Le Chahut* (fig. **26.6**) of 1889–1890, we cannot miss the dominant yellow hue and upward thrusting lines. The scene represents the finale of a cancan-like dance at a nightclub near Seurat's studio, a scene so based on reality that the performers can be identified, although they, like the audience to either side of the runway, function as a catalogue of types as well. Seurat uses a Degas-like skewered, cropped, and conflated composition, which he then freezes, transforming figures and even furniture, such as the gas lamps, into powerful icons. His passionate belief in science, technology, and machines as the tools to attain progress and equality will be shared by later generations of artists.

Henri de Toulouse-Lautrec: An Art for the Demi-Monde

Paradoxically, Seurat, like the other Post-Impressionist artists, constituted a new avant-garde that would lead art down a path that made it esoteric and thus incomprehensible for mass audiences. The artist who succeeded in capturing the urban exuberance at the close of the nineteenth century and had a major impact on the public was Henri de Toulouse-Lautrec (1864–1901). His pictures of the Cirque Fernando were exhibited at the circus, and his work of dance halls, cabarets, and nightclubs were shown at those same venues (of course he also exhibited with the new artists' cooperatives). His widest impact, however, was made through his large colorful lithographic posters for these popular spectacles, which were plastered over all of Paris. His images of urban nightlife became the public's perception as well, and his work continues to form our image of the period. (See *Materials and Techniques*, above.)

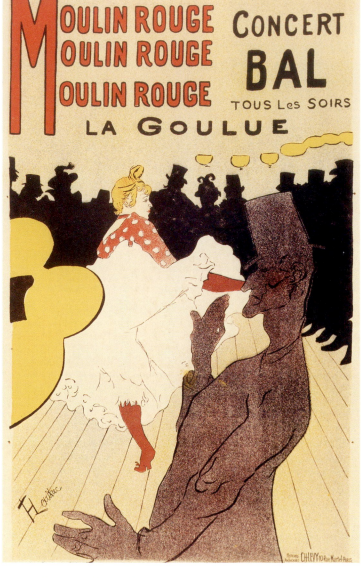

26.7. Henri de Toulouse-Lautrec. *La Goulue*. 1891. Colored lithographic poster, 6′3″ × 3′10″ (1.90 × 1.16 m). Private Collection

typeface, which along with undulating version of the word Moulin Rouge and the syncopation of the three colored inks, produce a rhythm corresponding to the music.

Along with Japanese art, Degas was Toulouse-Lautrec's idol and his artistic starting point. If the decorative patterning of Japanese prints can be sensed in *La Goulue*, then it is Degas who comes to the fore in the slightly later oil *At the Moulin Rouge* (fig. **26.8**). But Toulouse-Lautrec's ability to dramatically satirize and caricature separates him from his mentor, who was more subtle in his caricaturing. The woman in the foreground, whose face is so garishly lit by a gas lamp that it takes on the character of mask, sets the tone for the painting. In this joyless room, we sense the folly of the social strutting and pretense that took place every evening under the guise of gaiety. Toulouse-Lautrec, who died of alcoholism, certainly knew this dissolute world as well as anyone, which he proclaims here by picturing himself in the background, the third of the four aligned top-hatted men. Here is depicted the decadent fin de siècle world from which artists like Van Gogh and Gauguin will try to escape.

Vincent van Gogh: Expression through Color and Symbol

Before becoming a painter, the Dutch artist Vincent van Gogh (1853–1890) had tried his hand at preaching, teaching, and art dealing. Drawn to these vocations by his desire for a life both spiritually fulfilling and socially useful, Van Gogh determined that art alone could provide access to the ideal world he sought. After receiving rudimentary art training, he spent the years 1883 through 1885 painting at the family's vicarage (his father was a pastor) in the village of Nuenen in Holland, where he was deeply affected by the dignity, spirituality, and stolid sturdiness of the impoverished peasants. His major work from this period, *The Potato Eaters* (fig. **26.9**), reflects his compassion and respect for the underclasses, as described in one of the 650 pages of letters he wrote to Theo, his brother: "I have tried to emphasize that these people eating their potatoes in the lamplight, have dug the earth with those very hands they put in the dish, and so it speaks of manual labor, and how they have honestly earned their food. I have wanted to give an impression of a way of life quite different from us civilized human beings." Here we see Van Gogh's admiration and respect for a simple life based on direct contact with nature as well as his suspicion of bourgeois values and urban modernity. His artistic role models include Millet, whose powerful and sympathetic depictions of peasants are echoed in Van Gogh's, and his countryman Rembrandt, whose tenebrism shrouds this humble, almost ritualistic supper in a reverential cloak. What especially distinguishes this image is Van Gogh's technical naïvete, which gives the picture a raw, crude energy that simultaneously endows the peasants with a surging elemental vitality and reflects the artist's own uncontainable enthusiasm and passion for his subject. Gnarled fingers and hands, prominent twisted physiognomies, rippling folds of clothing, ceiling beams that recede with eruptive force, a clock and a picture of the Crucifixion that seem to jump off rather than hang on the wall—everything explodes within the picture, despite the tranquility of

Toulouse-Lautrec was a master of caricature, as can be seen in *La Goulue* (fig. **26.7**), which depicts the popular Moulin Rouge dancer surrounded by an audience. With minimum marks and working with flat planes of color and line, he captures the dancer's physical exertion as well as her psychological isolation and detachment. The repetition of silhouetted feet on the right elicits the collective spirit of the dance; the Seurat-like outlines of hats indicates different personalities and types. La Goulue herself is poignantly contrasted with the performer Valentin le désossé ("Valentin the Boneless"), known for his ideosyncratic dancing. Unlike Seurat, who creates a three-dimensional monumental world, Toulouse-Lautrec's vision is paper thin and satirical. Even the writing reinforces the spirit of overindulgence and consumerism, with "Moulin Rouge" prominently repeated three times. While wording within a poster's image was not new, it generally was restricted to the top and bottom and never fully integrated into the picture as we see here. Nor did it have the same shifts in scale and

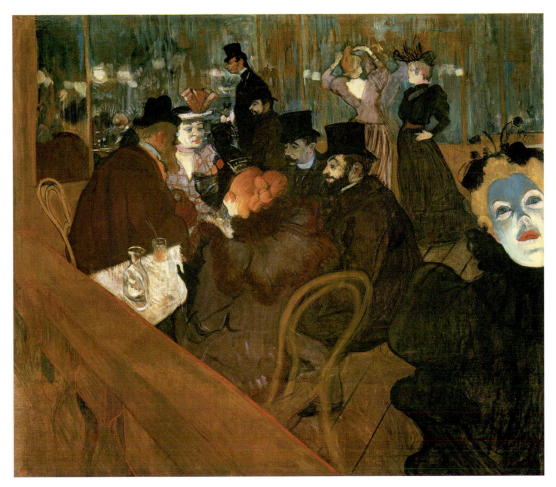

26.8. Henri de Toulouse-Lautrec. *At the Moulin Rouge*. 1893–1895. Oil on canvas, $58^3/_8 \times 55^1/_2''$ (123 × 144 cm). The Art Institute of Chicago. Helen Birch Bartlett Memorial Collection

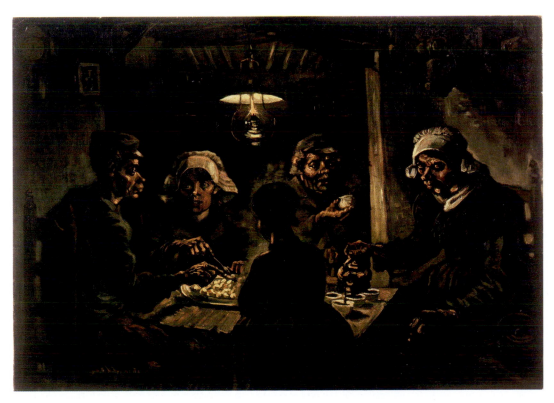

26.9. Vincent van Gogh. *The Potato Eaters*. 1885. Oil on canvas, $32^1/_4 \times 45''$ (82 × 114.3 cm). Vincent van Gogh Foundation/Van Gogh Museum, Amsterdam

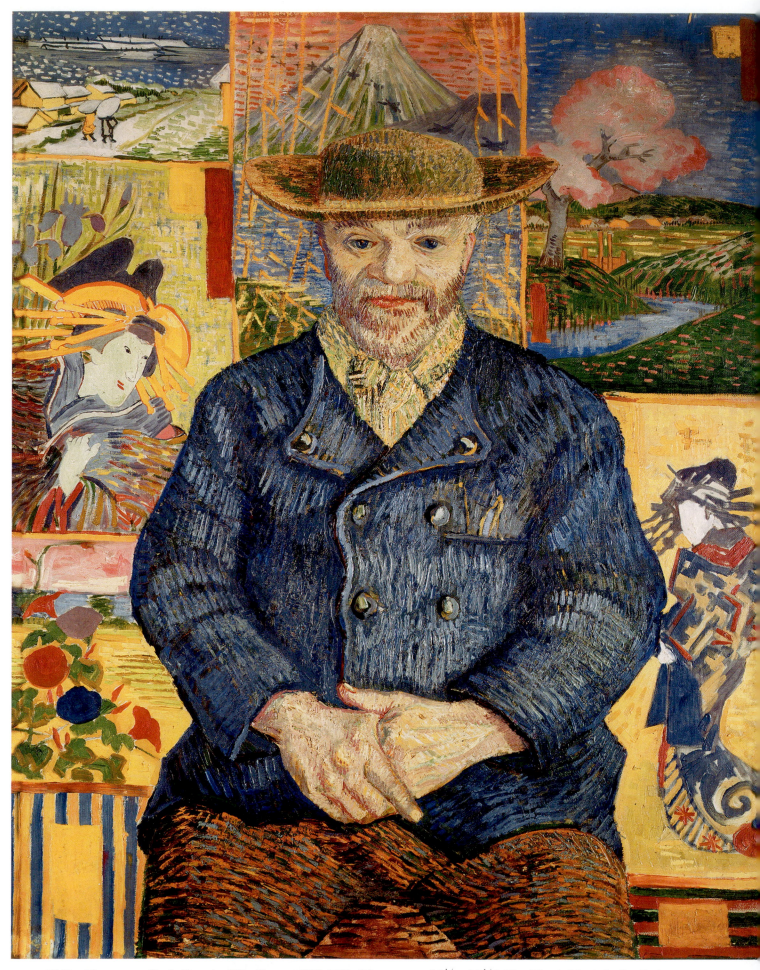

26.10. Vincent van Gogh. *Portrait of Père Tanguy*. 1887–1888. Oil on canvas, 36 ¼ × 29 ½" (92 × 75 cm). Musée Rodin, Paris

this event of work-weary laborers taking their frugal evening meal. Van Gogh's thick excited marks, which convey his overbearing enthusiasm and compassion, reinforce the powerful physical presence of his peasants.

Van Gogh briefly enrolled at the Academy of Fine Arts in Antwerp, where he studied Rubens's paintings and collected Japanese prints. Unhappy in Belgium, Van Gogh went to Paris to be with his brother, who handled the contemporary painting department at an art gallery. Here, from 1886 to 1888, he experienced Impressionism and Neo-Impressionism firsthand, consuming their lessons with the same fervor he applied to everything else. In the *Portrait of Père Tanguy* (fig. **26.10**), a paint supplier and outspoken socialist, he joyously embraced a palette of vivid primary and binary colors. While retaining his passionate brushwork, he now employs it in a more systemized fashion. It courses through Tanguy, investing him with a spiritual verve and making him radiate a peaceful harmony. Van Gogh even presents his friend in the pose of a Buddha with folded hands. Behind him is a wall of Japanese prints, which Van Gogh admired not only for obvious aesthetic reasons but also because they represented a blissful utopian world. He started hounding fellow painters in Paris to join him in starting an artist's commune in the sun-drenched south of France, a "Studio of the South" that he envisioned as a Occidental Japan.

Only Paul Gauguin bought into this dream, although he only lasted two months. Alone in Arles, Van Gogh thrived in the Provençal landscape, fiercely generating from 1888 to 1889 his strongest body of work, including *Night Café* and *Starry Night*. His intense uncontrollable emotions took over and his painting became increasingly expressionistic, using color to convey emotion rather than to document reality and employing a personal symbolic vocabulary. In *Night Café* (fig. **26.11**) he registered his repulsion at an Arles den of iniquity, claiming he wanted "to express the terrible passions of humanity by means of red and green." This symbolic use of complementary color visually creates a harsh acidic atmosphere, made all the more sour by the jarring range of off-greens that appears on the billiard table, tabletops, bar, ceiling, and even the waiter's hair. The morbid blood red of the walls bleeds into the strident floor boards, whose fiery yellow seems to connote hell, not happiness, an aura reinforced by the rays emanating from the gas ceiling lamps.

ART IN TIME

1880s—European nations colonize Africa

ca. 1885–1887—**Paul Cézanne's *Mont Sainte-Victoire***

1888–1889—**Vincent van Gogh's *Night Café***

1891—Paul Gauguin's first visit to Tahiti

1899—Claude Debussy composes *Nocturnes*

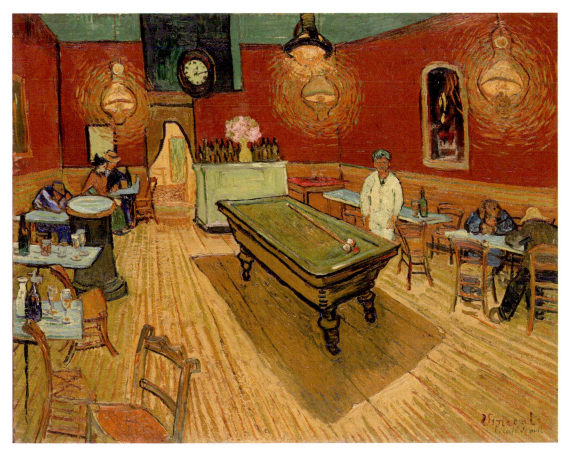

26.11. Vincent van Gogh. *Night Café*. 1888. Oil on canvas, 8 ½ × 36 ¼″ (72.4 × 92.1 cm). Yale University Art Gallery, New Haven. Bequest of Stephen Carlton Clark, B.A. 1903.1961.18.34

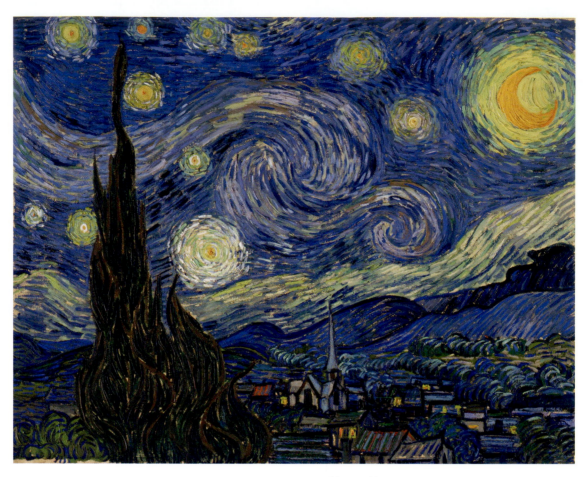

26.12. Vincent van Gogh. *Starry Night*, 1889. Oil on canvas, 28 ³/₄ × 36 ¹/₄″ (73 × 93 cm). Museum of Modern Art, New York. Acquired through the Lillie P. Bliss Bequest (472.1941)

The personality that prevailed in the majority of Van Gogh's pictures, however, belongs to the secular evangelist who celebrated all life and longed for universal harmony. This can be seen in *Starry Night* (fig. **26.12**). Here we see snugly ensconced in a valley the inviting hearth-lit homes of plain rural folk. The yellow glow from their rectangular windows unites them with yellow round stars in the universe above, their contrasting shapes a yin and yang of elemental harmony. An upwardly spiraling cypress tree filled with life dominates the foreground. It parallels the church steeple, and both penetrate the fiery, star-filled sky, linking earth with the transcendental. The sky is alight with a spectacular cosmic fireworks—halos of stars and joyous tumbling clouds echo the undulation of the mountains and trees below. Harnessing his expressionistic vocabulary, Van Gogh painted the primitive world and utopia he dreamed of: the peaceful tranquility of simple, unpretentious people, nurtured by nature and in harmony with universal forces. Yet, despite Van Gogh's frenetic output and his humanitarian yearnings, he was a deeply troubled and depressed man. He gradually began to doubt his ability to paint and committed suicide within a year of painting *Starry Night*.

Paul Gauguin: The Flight from Modernity

Paul Gauguin (1848–1903), the fourth of the major Post-Impressionists, shared Van Gogh's distaste for advanced civilization and likewise yearned for a utopian alternative. His abandonment of society, however, was perhaps the most radical of any artist of his time. A stockbroker, he was attracted to art, collected the Impressionists, and by the early 1870s, had taken up painting himself. He lost his job in 1882 and began to paint full time. He studied with his friend Pissarro, who introduced him to the work of Cézanne, and participated in the last four Impressionist exhibitions between 1881 and 1886. In 1886, he abandoned Paris to begin a nomadic search for a more meaningful existence, which he believed existed in a simpler society steeped in nature. He first went to the village of Pont-Aven, a remote, rural community in Brittany. Here locals wore a distinctive regional costume and displayed an intense, charismatic piety.

After briefly leaving Brittany for the Caribbean Island of Martinique in 1887, Gauguin returned to Pont-Aven in 1888, where he painted with a colleague Émile Bernard. Together they developed a style they called Synthetism, a reference to their synthetic production of images based on imagination and emotion as opposed to a mimetic, empirical replication of reality. In their search to produce an authentic, direct art, as free of civilized influences as possible, they turned to a variety of vernacular and primitive sources, including crude popular illustrations (especially religious) and folk, children's, and medieval art. They were also attracted to such archaic styles as the fourteenth-century Italian primitives and both Egyptian

PAUL GAUGUIN (1848–1903)

From a letter to J. F. Willumsen

The Danish painter J. F. Willumsen was a member of Gauguin's circle in Brittany. Gauguin wrote this letter in the autumn of 1890, before his departure for the South Seas.

As for me, my mind is made up. I am going soon to Tahiti, a small island in Oceania, where the material necessities of life can be had without money. I want to forget all the misfortunes of the past, I want to be free to paint without any glory whatsoever in the eyes of the others and I want to die there and to be forgotten there. . . . A terrible epoch is brewing in Europe for the coming generation: the kingdom of gold. Everything is putrefied, even men, even the arts. There, at least, under an eternally summer sky, on a marvellously fertile soil, the Tahitian has only to lift his hands to gather his food; and in addition he never works. When in Europe men and women survive only after unceasing labor during which they struggle in convulsions of cold and hunger, a prey to misery, the Tahitians, on the contrary, happy inhabitants of the unknown paradise of Oceania, know only sweetness of life. To live, for them, is to sing and to love. . . . Once my material life is well organized, I can there devote myself to great works of art, freed from all artistic jealousies and with no need whatsoever of lowly trade.

SOURCE: *THE GENESIS OF MODERNISM.* ED. SVEN LOEVGREN. (NEW YORK: HACKER ART BOOKS, 1983)

and Mesopotamian art. Especially appealing were medieval stained-glass windows, because of their spiritual function and saturated colors, and cloisonné enamels, which similarly use curvilinear lead dividers to separate areas of flat color.

The impact of medieval glass and cloisonné is apparent in Gauguin's *The Vision after the Sermon* (fig. **26.13**), where an undulating blue line encases everything. Gauguin presents a group of Breton women just after they have heard a sermon about Jacob wrestling with the angel. The artist attributes to the women a blind, naïve piety that allows them to see spirituality in such mundane objects as a cow, whose shape resembles the two struggling biblical figures the priest had just described. In a bold composition that conceptually comes from Japanese prints (see fig. 25.13), Gauguin places the cow and the wrestlers to either side of a tree, sharply contrasted on an intense mystical field of red. The objects of the women's vision clearly exist in an otherworldly sphere, where they appear to float magically. Everything seems possessed in Gauguin's picture, invested with an unseen religiosity. The string ties on two of the caps are animated like snakes, while the silhouettes of the hats on the two

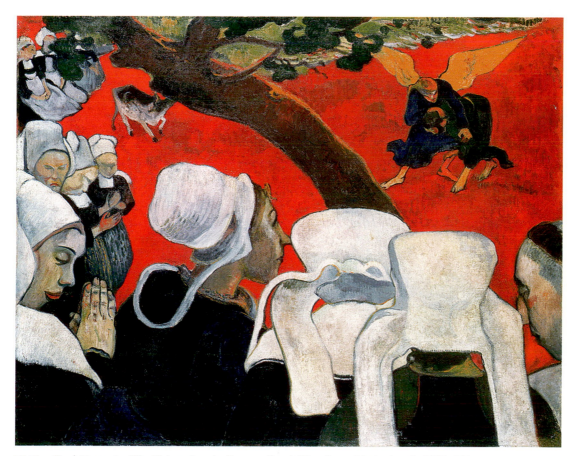

26.13. Paul Gauguin. *The Vision after the Sermon (Jacob Wrestling with the Angel).* 1888. Oil on canvas, 28 3/4 × 36 1/2″ (73 × 92.7 cm). The National Galleries of Scotland, Edinburgh

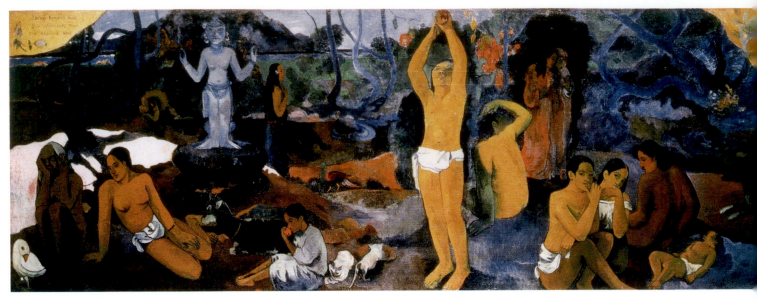

26.14. Paul Gauguin. *Where Do We Come From? What Are We? Where Are We Going?* 1897. Oil on canvas, 4′5³/₄″ × 12′3¹/₂″ (1.39 × 3.74 m). Photograph © Museum of Fine Arts, Boston. Arthur Gordon Tompkins Residuary Collection. 36.270

women seen from the back on the right seem to take on a life all their own. Flat, curvilinear forms, and even forms within forms, can be found throughout the image, levitating, just as the cow and the wrestlers do.

Despite its provincial charm and remove from Paris, Brittany for Gauguin was geographically far too close to modern civilization and its decadent materialism. In 1891, he left for the French colony of Tahiti in the South Pacific, convinced that on this remote island he would find Jean-Jacques Rousseau's "noble savage," an elemental, innocent human, "a primitive" steeped in nature and in harmony with the universe. In Tahiti he also felt he would be able "to go back . . . as far back as the *dada* from my childhood, the good old wooden horse." (*Dada* is French for rocking horse.) He expected to live in a tropical Garden of Eden, uncovering the most basic truths about human existence. And a Garden of Eden is what he depicts in *Where Do We Come From? What Are We? Where Are We Going* (fig. **26.14**) from 1897. Fruit hangs from the trees for the picking, while a statue of a god oversees the welfare of the islanders, bestowing blessings and an intense spirituality on every aspect of daily life, while pointing to heaven and the afterlife. The tropical landscape is dense, lush, and sensuous, an abstract tapestry of deeply saturated, flat curvilinear forms in which everything seems to gently float. Life is languorous and untroubled, and time has stopped. When the picture was shown in Paris, critics, not surprisingly, compared it with Puvis's Classical worlds of milk and honey. (See *Primary Source*, page 917.)

As the title suggests, the painting represents the three stages of life we have already seen in Renaissance art; birth is pictured on the right, youth in the center, and old age at the far left. The center figure is obviously a Tahitian Eve. The statue of the deity is a compilation of the Tahitian goddess Hina, a Javanese Buddha, and an Easter Island megalith. Torsos are twisted so that they resemble Egyptian figures, and the bright gold upper corners with title and signature recall Byzantine and early Renaissance icons. The old woman on the left is derived from a Peruvian mummy Gauguin saw at a Paris ethnological museum. Pervading the image is the spirituality and look of medieval stained glass, as well as the bold forms and colors of Japanese prints. The entire painting is a remarkable synthesis of cultures, religions, and periods, testifying to Gauguin's desire to portray the elemental mythic forces underlying all humanity.

Gauguin believed the renewal of Western art and Western civilization as a whole must come from outside its traditions. He advised other artists to shun Graeco-Roman forms and to turn instead to Persia, the Far East, and ancient Egypt for inspiration. This idea itself was not new. It stems from the Romantic myth of the noble savage and the ideas of the Enlightenment more than a century earlier, and its ultimate source is the age-old belief in an earthly paradise where people once lived, and might one day live again, in a state of nature and innocence. No artist before Gauguin had gone as far to put this doctrine of "primitivism"—as it was called—into practice. His pilgrimage to the South Pacific had more than a purely private meaning: It symbolized the end of the 400 years of expansion that had brought most of the globe under Western domination. Colonialism, once so cheerfully—and ruthlessly—pursued by the empire builders, was, for many, becoming a symbol of Western civilization's corruption.

SYMBOLISM

Although Gauguin devised the label Synthetism to describe his art, he was soon heralded as a Symbolist. Symbolism was a literary movement announced in a manifesto issued by poet Jean Moréas (1856–1910) in the newspaper *Figaro littéraire* in 1886. The poet Baudelaire, author of the *Flowers of Evil* (1857),

was considered a forebear of the movement, and the poets Stephen Mallarmé and Paul Verlaine ranked among its salient representatives. Another poet, Gustave Kahn, succinctly encapsulated the movement's essence when he wrote shortly after Moréas that the writer's goal was to "objectify the subjective ... instead of subjectifying the objective," meaning the everyday, contemporary world was rejected, replaced by one of dreams that abstractly expressed sensations, moods, and deep-seated fears and desires. The label was soon extended to art, and Gauguin's name always topped anyone's list of important Symbolists. Van Gogh, with his expressionist fantasies, was considered a Symbolist as well. In 1891, art critic Georges-Albert Aurier defined Symbolism with five adjectives: "ideal, symbolist, synthetist, subjective, and decorative." Gauguin himself felt compelled to use Symbolist terminology to describe his painting *Where Do We Come From?* when it was exhibited at the Ambroise Vollard Gallery in Paris in 1898. Writing from Tahiti, he stressed the picture was "musical," declaring it communicates via the abstract qualities of line, color, and form, and not through anecdote. At this time, the operas of Richard Wagner were the rage in Paris, as they were throughout Europe and America, and they inspired Symbolist writers and painters alike to use abstract means to project powerful emotional yearnings and the most elemental psychology.

The Nabis

Gauguin's impact was tremendous, and by the 1890s, flat curvilinear organic patterning was ubiquitous. For example, it is the basis for Toulouse-Lautrec's posters (see fig. 26.7), and it is apparent in many of his oils, such as *At the Moulin Rouge* (see fig. 26.8). Gauguin was also the formative influence on the Nabis, a secret organization founded in 1888 by young Parisian artists, including Edouard Vuillard and Pierre Bonnard, who were stunned by the novelty and spirituality of Gauguin's Pont-Aven paintings. *Nabis* is Hebrew for "prophet," and as the name suggests, the members immersed themselves in religion, which was perhaps an easier way to flee modernity than voluntary exile in Tahiti.

Their spiritual interests were extremely broad and included the occult and the supernatural, concerns sweeping Europe and America at the same time as people sought relief from the blunt materialism of modernity. Besides Near and Far Eastern religions, many of the Nabis were taken in by the craze for Theosophy and Rosicrucianism. While theosophical mysticism dates to Plato, nineteenth-century theosophy originated with the Theosophical Society, founded in New York in 1875 by the Russian emigré, occultist, medium, and mystic, Madame Helena Blavatsky. The Theosophical Society basically claimed all religions were essentially the same and sought to reveal the mystical connectedness of all things. Like Gauguin, whose *Where Do We Come From?* attempted to give pictorial form to a synthesis of diverse spiritual and cultural influences, the Nabis sought to convey theosophical mysticism through their art. But instead of seeking transcendent imagery in far-off places, Vuillard and Bonnard turned to scenes of domestic life, leisure activities, and views of their native French landscape.

Although the Nabis fizzled out in the 1890s, Edouard Vuillard (1868–1940) and Pierre Bonnard developed into prominent artists. Abandoning the group's religious thrust, they retained its emphasis on emotion expressed through abstraction, which Denis, in a famous quote, summed up when he wrote "A picture—before being a warhorse, a female nude, or some anecdote—is essentially a flat surface covered with colors in a particular order." Reality dissolving into an abstraction of emotion can be seen Vuillard's small intimate oil of 1893, *The Suitor* (fig. 26.15). Here we see the artist's favorite theme, interiors, which are magical, not mundane. He presents his dressmaker mother, his sister, and her husband, a respected painter and member of the Nabis. The real world disappears into a poetry of paint. Lush, dappled brushwork and a subdued but colorful, rich palette create a tranquil, sensuous mood. Tables, chairs, figures, and bolts of fabric are two-dimensional ghosts floating in an enchanting sea of paint, color, and form that embody the sweet intimacy and languid pace of bourgeois domesticity.

Other Symbolist Visions in France

Two artists predating Symbolism were embraced by the movement: Gustave Moreau and Odilon Redon. Moreau emerged in the 1860s, and Redon the following decade. Both gained in notoriety when they were featured in Joris-Karl Huysman's Symbolist novel *À Rebours* (*Against Nature*) of 1884. Huysman's protagonist is a jaded eccentric who retreats into a strange dream world that is filled with such surreal items as a live turtle with a jewel-encrusted shell and artworks by Moreau and Redon.

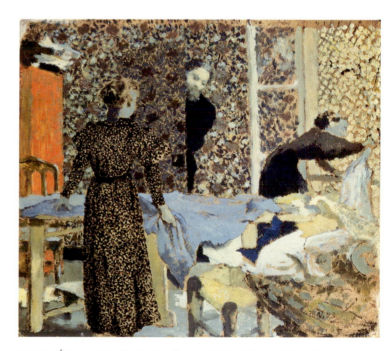

26.15. Édouard Vuillard. *The Suitor*. 1893. Oil on millborad panel, 12$\frac{1}{2}$ × 14″ (31.8 × 35.6 cm). Smith College Museum of Art, Northampton, Massachusetts. Purchased, Drayton Hillyer Fund, 1938. SC. 1938:15. © Artists Rights Society (ARS), New York/ADAGP, Paris

GUSTAVE MOREAU The imagery of Gustave Moreau (1826–1898) combined exotic Romantic motifs with an unsettling, mysterious psychology set in a supernatural world. In his large watercolor *The Apparition* (fig. **26.16**) of about 1876, Salomé is presented with the head of St. John the Baptist, as she requested. But instead of appearing on a plate, as is traditional, the head, gushing blood and encased in bright halo, magically levitates. We see a bold stare-down between good and evil and between the sexes, since it was Salomé's physical lusting that resulted in John's beheading—if she could not have him in life, then she would in death. The setting and costumes are vaguely Near Eastern, and the vast hall dazzles with imperial opulence. Flowers, clothing, columns, and walls are created with minute, gem-like brushstrokes that are reminiscent of Delacroix and make everything sparkle. (Even the palette is Delacroix's, although the Classical structure is Ingres's.) In Moreau's hands the story of Salomé is not simply illustrated, but becomes a a macabre hallucination of sex and death, presented through a dazzling haze of jewel-like marks and a strange, smoldering light.

ODILON REDON Even more visionary and dreamlike, perhaps, are the intense images of another artist claimed by the Symbolists, Odilon Redon (1840–1916). His drawings and prints deliver crepuscular fantasies enveloped in a velvety blurring of black charcoal or lithographic crayon. He drew inspiration from the prints of Goya (see fig. 24.1), and probably saw the Black Paintings (see fig. 24.4) when they were exhibited at the Paris international exposition in 1878. Redon's style can be seen in the print reproduced here from an 1882 series dedicated to Edgar Allan Poe (fig. **26.17**). Translated into French by Baudelaire and Mallarmé, Poe's terrifying psychological tales were popular in France. Redon was inspired by Poe's Romantic mood, but his lithographs do not illustrate Poe. They are "visual poems" in their own right, evoking the macabre, hallucinatory world of Poe's imagination. If Goya created very pointed horrific nightmares, Redon envisions nebulous poetic dreams. Things float, glide, and hover, and edges are soft, grainy, and indistinct. Everything in Redon's world is in doubt and in some kind of strange evolutionary flux. Here a balloon quietly morphs into a hairy eye and parts

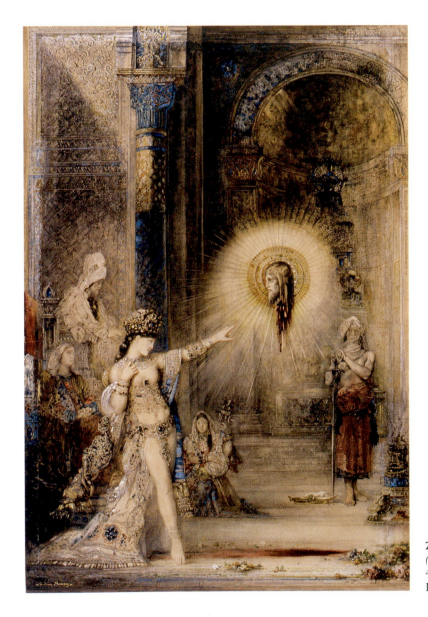

26.16. Gustave Moreau. *The Apparition (Dance of Salomé)*. ca. 1876. Watercolor, $41\frac{3}{4} \times 28\frac{3}{8}$ ″ (106 × 72 cm). Musée du Louvre, Paris. RF 2130

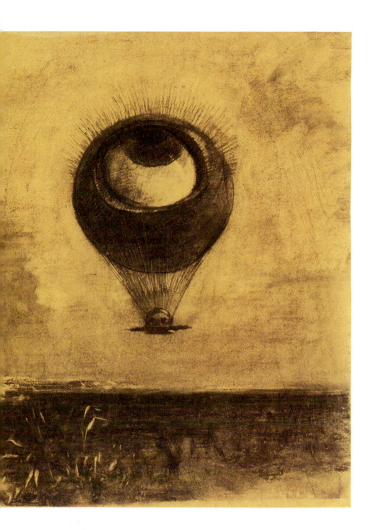

the sky as it rises up to heaven carrying a mysterious cargo, while a primordial plant with pyrotechnic fronds glows against the forbidding dark sea. Connotations of resurrection, transcendence, a rite of passage, life, death, eternity, and the unknown are embedded in *The Eye*, but the image's narrative meaning remains shrouded in mystery. Instead, what prevails is a troubling psychology and a feeling of frightening uncertainty.

HENRI ROUSSEAU A Symbolist preoccupation with portraying fundamental human urges and the psychology of sexual desire can be seen in the French primitive painter Henri Rousseau (1844–1910). A retired customs officer who started painting later in life, Rousseau took as his ideal the hard-edged academic style of the followers of Ingres (see fig. 24.16). In his 1910 painting *The Dream* (fig. **26 .18**), he presents a nude woman mysteriously lying on a sofa in a cardboard stage-set fantasy of a luxuriant jungle. Wide-eyed animals stare voyeuristically at her. We assume they are male: The phallic orange snake points directly at her and the musician holds a flute, a conventional symbol of masculine sexual desire. The primordial pull of the jungle with its voluptuous iridescent flowers and fruit is reinforced by the cosmic glow of a full moon presiding in the sky.

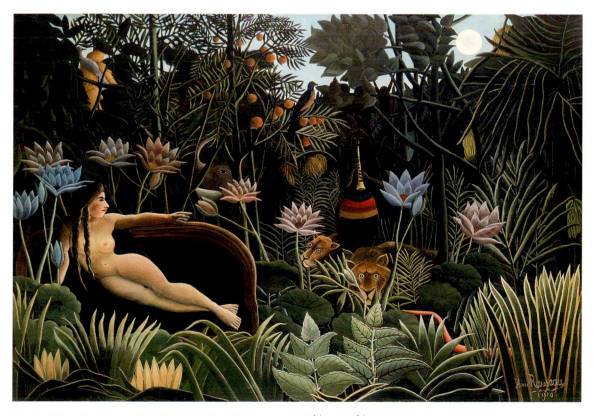

26.18. Henri Rousseau. *The Dream*. 1910. Oil on canvas, $6'8^{1}/_{2}'' \times 9'9^{1}/_{2}''$ (2.05 × 2.96 cm). The Museum of Modern Art, New York. Gift of Nelson A. Rockefeller. © Estate of Henri Rousseau

Rousseau received no official recognition during his lifetime, but in 1905 he was discovered by Pablo Picasso and his circle, who found in his naive paintings the creative honesty and authenticity they felt academic art lacked.

Symbolism Beyond France

Strange dreamlike imagery was not unique to Paris. By the late 1880s, a Symbolist otherwordly aesthetic of fantasy, escapism, and psychology could be found throughout the Western world, including America.

MAX KLINGER In Berlin, Symbolism was perhaps best represented by Max Klinger (1857–1920), a painter and sculptor. In 1881 he made a series of ten etchings called *The Glove*, which is every bit as suggestive, inexplicable, and psychological as Redon's response to Edgar A. Poe. His work is perhaps more illustrational and conventional with a stronger narrative, but it is equally bizarre and hallucinatory. Each print in the series shows a futile attempt to retrieve a lost glove. In *The Abduction* (fig. **26.19**), a glove is being carried off by a prehistoric bird located just beyond the reach of outstretched arms that have crashed through glass window panes. Below is a bush of brutally cropped flowers. As in Redon's *The Eye*, it is a disturbing psychology, not a rational story, that prevails. The anthropomorphic glove is presented as a fetish, a must-have object of desire or need, and we sense sex, longing, abandonment, and passion lurking beneath the surface of the visual world in Klinger's strange juxtaposition of objects.

JAMES ENSOR AND LES VINGT In Belgium, Symbolism surfaced in the extraordinarily crude and visually aggressive paintings of James Ensor (1860–1949), who like Gauguin was repulsed by modernity and led a reclusive life above his parents' souvenir shop at the seaside resort of Ostend. In 1877, he enrolled in the Brussels Academy of Fine Arts, lasting three years even though he described it as "that establishment for the near blind" and declaring, "All the rules, all the canons of art vomit death like their bronze brethren." He joined with socialists and anarchists and in 1883 helped found in Brussels the

counterpart of the Parisian Independent Artists association. Called *Les Vingt* (The Twenty), it offered unjuried exhibitions for a wide range of avant-garde Belgium artists, from Impressionists to Neo-Impressionists to Symbolists. But when the group started showing Whistler, Seurat, and Redon and became international, Ensor, a Belgian nationalist, permanently retreated to Ostend, where he immersed himself in his own world, one of disgust at the pretenses, artificiality, corruption, and lack of values of modern civilization. Turning his back on the cold refinement of academic art, he embraced popular culture, declaring "Long live naïve and ignorant painting!" His nationalism and loathing of insincere refinement led him to admire the grotesque depictions of Breugel and Bosch. The carnivals they favored still lived on in Ostend in annual festivals, for which the Ensor souvenir shop sold masks.

Ensor's mature style can be seen in his enormous 14-foot wide *Christ's Entry into Brussels in 1889* (fig. **26.20**), painted in 1888 and representing a second coming of Christ. Beneath a banner declaring "Long Live Socialism" and swallowed up in the crowd and pushed into the background is a diminutive Christ on a donkey. The crowd wears masks, which reveal as opposed to hide the greed, corruption, and immorality that resides behind the false face of contemporary society. Not only does he appropriate the masks from his parents' shop to give his image a primitive grotesqueness, but he paints everything with a crudeness and distortion we associate with popular art forms—caricature, graffiti, and naive and children's art. A garish red intensified by its complement green hypes the stridency of this repulsive, claustrophobic image. Here we see the philosophical antithesis of Seurat's genteel *La Grande Jatte*, which was shown at a *Les Vingt* exhibition the year before and seen by Ensor. The similar scale of *Christ's Entry* suggests Ensor's chaotic vision of ubiquitous evil is a sarcastic response to Seurat's Pollyanna rendition of modernity.

EDVARD MUNCH Much Symbolist painting was influenced by Gauguin's mysterious sinuous patterning and abstracting as well as by a quest to explore visually the most elemental psychological forces underlying modern civilization. Perhaps no

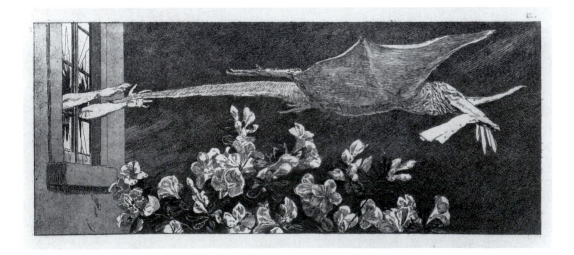

26.19. Max Klinger. *The Abduction* (from *A Glove*). 1881. Etching, printed in black, $3\frac{1}{2} \times 9\frac{1}{2}$" (8.9 × 22 cm). Kupferstichkabinett, Staatliche Museen zu Berlin. Inv: 426-92

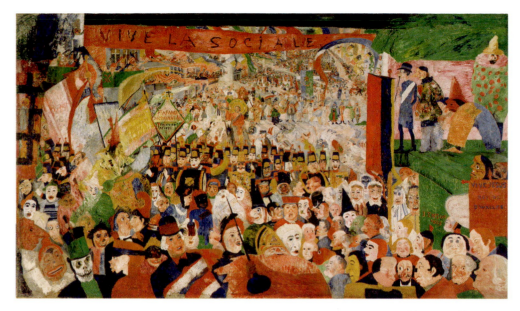

26.20. James Ensor. *Christ's Entry into Brussels in 1889*. 1888. Oil on canvas, 8'6½" × 14'1½" (2.6 × 4.3 m). Collection of the J. Paul Getty Museum, Los Angeles. 87. PA. 96. © Artists Rights Society (ARS), New York/SABAM, Brussels

one did this better than the Norwegian painter Edvard Munch (1863–1944), whose style matured in the early 1890s after he spent time in Paris, where he experienced firsthand Gauguin's Pont-Aven paintings and the intense brushwork and color of Van Gogh's Arles pictures. Munch's themes were similar to those of his Scandinavian friends, the playwrights Henrik Ibsen and August Strindberg, whose investigations of sexuality and inquiries into the meaning of existence plumbed the deepest recesses of the mind to tap into primordial forces.

Munch crafts an image of horrifying anxiety in *The Scream* (fig. **26.21**), painted in 1893 after he had moved to Berlin. Clasping hands to a skull-like head, a grotesquely compressed writhing figure gives voice to a base fear that appears funneled into it from the oozing hysterical landscape behind. The violent perspective of the uptilted walkway and the Van Gogh brushwork elevates the hysteria to a frightening feverish pitch. The scene was perhaps in part prompted by the 1883 eruption of the Indonesian volcano Krakatoa, which was so violent it generated the loudest sound heard by any human (the sound waves traveled 1,500 miles) and spewed forth ashes that circled the globe, immersing Europe in frightening blood-red or blue sunsets for some six months. After witnessing such an apocalyptic display of color in Christiania (now Oslo), Munch, already in a melancholic mood, wrote in his diary ". . . I sensed a great, infinite scream pass through nature."

AUBREY BEARDSLEY While a morbid, fear-of-the-infinite psychology appears in much of Munch's work, perhaps his most prevalent subject is the uncontrollable yearnings of the libido, along with the sexual conflict it produces, especially as expressed by the femme fatale theme. This is a topic that preoccupied contemporary artists and writers, one of the most

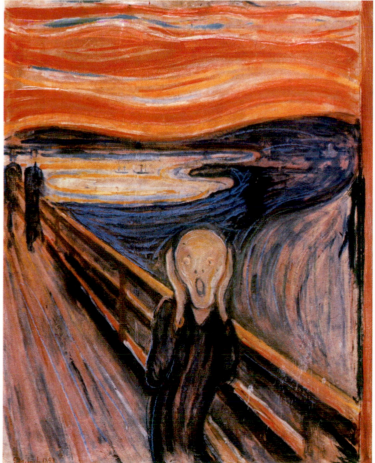

26.21. Edvard Munch. *The Scream*. 1893. Tempera and casein on cardboard, 36 × 29" (91.4 × 73.7 cm). Munch Museet, Oslo, Norway. (Stolen in May, 2003.) © The Munch Museum/ The Munch-Ellingsen Group/Artists Rights Society (ARS), New York

famous works of which is Oscar Wilde's French play *Salomé*, which launched a vogue for Salomé images. One example (fig. **26.22**) is by British illustrator Aubrey Beardsley (1872–1898), which was commissioned for the play's publication in 1894. Salomé possessively holds John's severed head, which although dead still projects disdain. His snakelike hair and her octopus coif transform each into an irrational Medusa driven by a base hatred. John's blood drips into a black pool of phallic plants that, like an insidious vine, slither around Salomé. Their nightmarish confrontation takes place in an abstract world of curvilinear elegance, one so precious that the line virtually disappears at times as it twists in a sultry rhythm. As we shall shortly see, this plantlike, tendril quality is characteristic of Art Nouveau (see page 929), an architectural and decorative arts style that emerged in the 1890s.

GUSTAVE KLIMT A fascination with organic patterns and the psychological meanings they might convey also pervades the work of Gustave Klimt (1862–1918), whose career unfolded primarily in Vienna. Beginning in 1902, Klimt made a series of paintings centering on "the kiss," the best known version dating from 1907 to 1909 (fig. **26.23**). Although

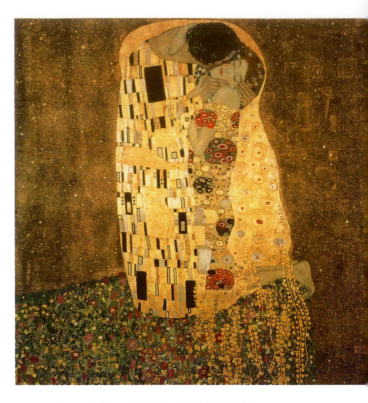

26.23. Gustav Klimt. *The Kiss*. 1907–1908. Oil on canvas, $70\,^7/_8 \times 70\,^7/_8$" (180 × 180 cm). Österreichische Nationalbibliothek, Vienna

reflecting Klimt's own personal life (the woman is his lover), the theme is Symbolist inspired and relates directly to an 1897 painting by Munch of the same title. (In turn, both pictures were inspired by Rodin's *The Kiss*.) Munch's image presents a couple in a similarly unified form, but they are a simple dark mass, with the lovers' faces frighteningly merging as if consuming one another. Klimt's version of the theme with its rich surface patterning shows a faceless lustful male losing his identity as he is lured by passion and consumed by an enticing but indifferent femme fatale, who appears about to pull him over the edge into the abyss below. The femme fatale—a sexually alluring yet dangerous woman—became commonplace in avant-garde as well as popular art, in part due to the rise of the New Woman. (See *The Art Historian's Lens*, page 926.)

Formally inspired by the divine shimmer of Byzantine mosaics, which he studied firsthand in Ravenna, Klimt cloaks his figures in richly patterned gold-leafed robes and encases them in a halo of bright light. In his intricate designs and shifting surfaces, Klimt hints at the instability inherent in individual subjectivity and social relations. Set on a mountain carpet of wild flowers and floating high above a celestial neverland, the painting simultaneously suggests the beauty and the spiritual pull of passion as well as its fleeting nature and painful consequences.

The Kiss has a strong decorative component, most evident in the exotic robes the lovers are wearing. In 1897 Klimt was one of 22 founders and the first president of Vienna Secession, an avant-garde artists' organization. It was part of a loosely allied international secession movement that started in Munich in 1892 and spread to Berlin that same year. Not only did the Vienna Secession provide an alternative to the conservative

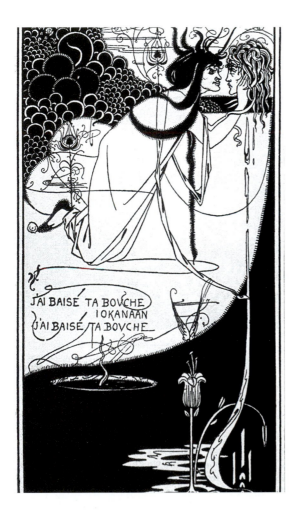

26.22. Aubrey Beardsley. *Salomé*. 1892. Pen drawing, 11 × 6″ (27.8 × 15.2 cm). Aubrey Beardsley Collection. Manuscripts Division, Department of Rare Books and Special Collections, Princeton University Library, New Jersey. Special Collections, Princeton University Library, New Jersey

academy, but its objectives included showcasing the applied arts and breaking down the hierarchy of the arts that placed painting and sculpture at the pinnacle and the decorative arts in the artisanal lower ranks.

Symbolist Currents in American Art

In the 1880s, a smaller number of American artists also began to make more ethereal, otherworldly pictures. Their imagery was more poetic and music-inspired, in many respects reflecting Whistler's aestheticism. Some Americans, like George Inness and Henry O. Tanner, however, are never labeled Symbolists. Inness is considered a late Hudson River painter working in a Romantic vein, while Tanner tends to be associated with the Realism of Thomas Eakins, reflecting his training in Philadelphia. Nonetheless, their art has the dreamlike, visionary, and spiritual qualities found in Symbolist art, and if not Symbolists per se, their art is highly influenced by the movement, to the point of sharing its spirit if not its abstract look.

GEORGE INNESS The Hudson River School painter, George Inness (1825–1894), who in his youth studied in France where he was influenced by the Barbizon artists, began in the mid 1880s to dissolve his landscapes in a mystical haze, with trees and figures dematerializing before our very eyes, as seen in *The Trout Brook* (fig. **26.24**). "What is art anyway? Nothing but temperament, expression of your feelings," declared Inness. The mystical and spiritual theories of Emanuel Swedenborg, which made a deep and lasting impression on Inness, became a major force in his intellectual life. These theories included the idea that a sacred omnipotent force coursed through all things and harmoniously unified them. Inness sought to make his

paintings convey the profound spiritual meaning he felt in landscape. In other words, his pictures were about experience and not seeing, about mood, not observation, much like Monet's *Wheatstack* (see fig. 25.21). In the *Trout Brook*, we sense a divine presence in the soft light, and in the Corot-like green tones mystically unifying the objects.

ALBERT PINKHAM RYDER Far more than Inness, Albert Pinkham Ryder (1847–1917), a somewhat reclusive artist working in New York, abandoned empirical observation to abstractly express his emotions. It was literature that inspired him, in particular works by Chaucer and Poe. He was influenced by the Bible, and, as with so many artists on both sides of the Atlantic, by Wagner's operas. In 1881, Ryder painted *Siegfried and the Rhine Maidens* (fig. **26.25**), beginning at midnight after

26.24. George Inness. *The Trout Brook.* 1891. Oil on canvas, 30¼ × 45¼″ (76.8 × 104.9 cm). The Newark Museum, New Jersey. 65.36

26.25. Albert Pinkham Ryder. *Siegfried and the Rhine Maidens.* 1888–1891. Oil on canvas, 19⅞ × 20½″ (50.5 × 52.1 cm). National Gallery of Art, Washington, DC. Andrew W. Mellon Collection

Feminist Art History

It is tempting to view Gustav Klimt's *The Kiss* as just another example of Fin de Siècle decadence and indulgence, and a preoccupation with the psychology of sexual urges. But we can begin to read the image in other ways if we ask how this picture and others of its kind from this period present women, recognizing that it was made by a male and reflects male attitudes toward women. Now we can place the picture within the context of the late nineteenth-century feminist movement and the emergence of the New Woman, both of which threatened male dominance. Interestingly, this new approach to interpreting images like *The Kiss* is itself a product of another feminist movement that began late in the twentieth century.

Feminism emerged from the social radicalism of the 1960s, and its effects on the practice of art history were felt almost immediately. Feminist art historians began to reconstruct the careers and examine the work of women artists including Berthe Morisot, Mary Cassatt, Paula Modersohn-Becker, and Käthe Kollwitz. These studies demonstrated that women artists, far from being peripheral oddities, contributed importantly to the nineteenth-century avant-garde. In her groundbreaking essay of 1971, "Why Have There Been No Great Women Artists?", Linda Nochlin examined Western notions of genius and artistic success and concluded that social and economic factors prevented women from achieving the same status as their male counterparts. These factors, not inherent ability, were responsible for the relative paucity of "great women artists." Nochlin's essay spurred the historical study of artists' training, exhibition practices, and the effects of the art market on artists' careers. Other scholars, including Griselda Pollock and Rozsika Parker even went further, examining art historical language with its gender-based terms such as *Old Master* and *masterpiece*.

Nochlin's essay also sparked an interest in studying artistic genres, such as the female nude and scenes of everyday, modern life. Feminist scholars revealed the unspoken commercial and ideological interests vested in these scenes. In particular, feminist art historians brought to light previously ignored connections between depictions of women and late nineteenth-century attitudes toward gender roles and female sexuality. Quite often in the art of this period, images of women conform to simplistic (yet socially powerful) stereotypes of good or bad women. Mothers, virginal heroines, and martyrs represent the good women; prostitutes, adulteresses, and the myriad femmes fatales, such as vampires and incubuses, represent the bad.

The second wave of feminist art history, which would continue throughout the 1980s, was launched as early as 1973 when British film critic Laura Mulvey used psychoanalytic methods to introduce the concept of the controlling power of the male viewer's gaze. Studying Impressionist and Post-Impressionist imagery in terms of who gets to look and who is watched, feminist art historians exposed the operation of power, visual pleasure, and social control. "Men look at women, women watch themselves being looked at," the critic John Berger wrote in *Ways of Seeing* (1972). For Berger, Western art reflects the unequal status of men and women in society. Griselda Pollock analyzed the "Spaces of Femininity" in Impressionist paintings, and examined the ways in which some respectable bourgeois women artists like Cassatt and Morisot depicted a very different experience of modern life from that of their male peers. Alternately, the working-class Montmartre model turned artist Suzanne Valadon, who grew up in the studios of Impressionists such as Degas, went on to paint revolutionary nudes from the position of someone who knew what it meant to pose for the artist's gaze.

In the 1990s, a third generation of feminist art historians broadened the scope of feminist art history to include gender studies, queer theory, the politics of globalization and post-colonial studies. Nineteenth-century art remains fertile ground, however, for such interdisciplinary study, and new feminist investigations of this period continue to shape the discipline of art history.

attending a performance of *Götterdämmerung* in New York, and obsessively painting nonstop for 48 hours. He reworked the painting until 1891, when it was exhibited at the Society of American Artists. Here we see again a variant of the femme fatale theme, as a sexual struggle is embedded in the legend of the alluring Rhine maidens who foretell Siegfried's doom for refusing to return to them an all-powerful ring. Echoing the power of Wagner's music, which embodies mythic Nordic forces, the broadly painted fantastical landscape erupts with seething trees and sky and is possessed by the supernatural illumination of a full moon. We sense uncontrollable power, reflecting uncontainable emotions, channeled through every brushstroke and distorted form.

HENRY O. TANNER The African-American artist Henry O. Tanner (1859–1937) fell under the spell of Symbolism in Paris. Tanner studied in the 1880s under the liberal and supportive Thomas Eakins in Philadelphia, becoming a Realist. With little hope of achieving artistic parity in racist America, he went to Paris in 1892, where he permanently settled. There, his work began to show the influence of Symbolism as he experimented

26.26. Henry Ossawa Tanner. *Angels Appearing before the Shepherds*. ca. 1910. Oil on canvas, 25³/₄ × 31⁷/₈" (65.3 × 81.1 cm). Smithsonian American Art Museum. Gift of Mr. and Mrs. Norman Robins

with abstraction and pursued new themes, even producing several Salomé paintings. Tanner was the son of a preacher, and his work is dominated by religious imagery, such as *Angels Appearing before the Shepherds* (fig. **26.26**). The composition is ingenious, for Tanner positions us in the sky with the angels. From this vantage we see the Holy Land: a breathtaking abstraction of lines and marks that nonetheless unmistakably contains hills, terraces, walls, and a city. We can even make out the shepherd's fire, the only note of color in what is otherwise a blue symphony. This spiritual blue pervades earth, sky, and angels, linking them together. Although the paint handling is rich and lush, everything in the image seems ethereal and ephemeral, the material world as transitory and weightless as the transparent angels.

The Sculpture of Rodin

The Symbolist desire to penetrate and portray the innermost essence of being had a parallel in the sculpture of Auguste Rodin (1840–1917). The most influential sculptor of the late nineteenth century, who single-handedly laid the foundation for twentieth-century sculpture, Rodin's career started slowly.

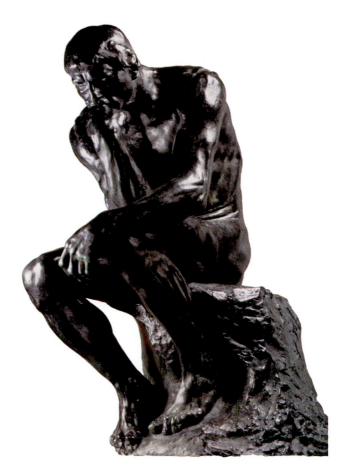

26.28. Auguste Rodin. *The Thinker*. 1879–1887. Bronze, height 27$\frac{1}{2}$″ (69.8 cm). Musée Rodin, Paris

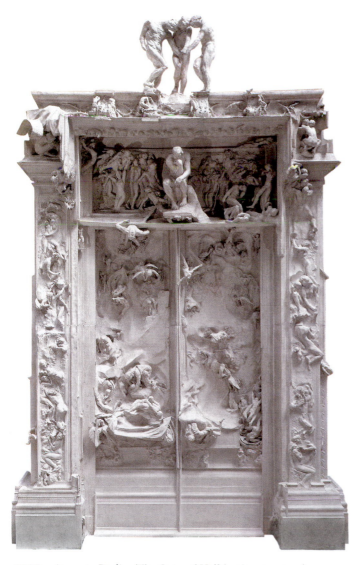

26.27. Auguste Rodin. *The Gates of Hell* (entire structure). 1880–1900. Plaster, height 217 × 157 × 37″ (552 × 400 × 94 cm). Musée d'Orsay, Paris

He was rejected at the École des Beaux-Arts, forcing him to attend the Petit École, which specialized in the decorative arts. His big break came in 1880, when he won a prestigious commission to design the bronze doors for a new decorative arts museum. Although the project eventually fell through, Rodin continued to work on it right up to his death. Called *The Gates of Hell* (fig. **26.27**), the 17-foot high doors were inspired by Baudelaire's *Flowers of Evil* and Dante's *Inferno* from the *Divine Comedy*, and at one point the thinker sitting in the tympanum contemplating the chaotic ghoulish scene below was to be Dante. Ultimately, the doors became a metaphor for the futility of life, the inability to satisfactorily fulfill our deepest uncontrollable passions, which is the fate of the sinners in Dante's second circle of hell, the circle that preoccupied Rodin the most. It is the world after the Fall, of eternal suffering, and Adam and Eve are included among the tortured souls below. Despite Rodin's devotion to the project, the Gates were never cast during his lifetime.

Rodin made independent sculptures from details of the *Gates*, including *The Thinker* (fig. **26.28**) and *The Three Shades,* the group mounted at the very peak of the *Gates*, which shows the same figure merely turned in three positions. While his figures are based on familiar models —*The Thinker*, for example, recalls the work of Michelangelo, his favorite artist—they have

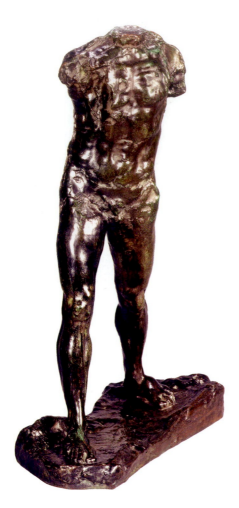

26.29. Auguste Rodin. *The Walking Man*. Model 1878–1900, cast ca. 1903. Bronze, height 33¼″ (84.45 cm). National Gallery of Art, Washington, DC. Gift of Mrs. John W. Simpson

thinker's psychological load, while his elongated arm is draped limply over his knee, suggesting inertia and indecision.

Equally expressive is Rodin's use of fragments, works that are just a hand or a torso, for example. The part not only represents the whole, embodying its essence, but it serves to strip away the unessential and focus on specifics. In *The Walking Man* (fig. **26.29**), which he began in 1877–1878 as a preliminary study for a St. John, we see another example of this distortion. The anatomy was again inspired by Michelangelo, while the partial body evokes damaged Classical statues. By not including a head, Rodin removed the distraction of the face and any associations it may embody including identity and psychology, allowing Rodin instead to stress movement, specifically forward motion. Rodin eventually recognized it as a self-sustaining work, casting it in bronze before 1888, when it was exhibited at the Georges Petit Gallery in Paris.

Rodin's emphasis on psychology can be seen in the *Burghers of Calais* (fig. **26.30**), a monument commissioned by the city fathers to commemorate six citizens who agreed to sacrifice themselves during the 1347 English siege of Calais, a major event in the Hundred Years' War. In exchange for the execution of the six burghers, the English agreed to lift the siege and spare the town and its citizens. Rodin depicts the volunteers in crude burlap sacks and snakelike ropes trudging to their imprisonment and death. (Ultimately, they were freed.) Instead of courageous heroes, he presents six men confronting death and displaying, among their emotions, fear, resignation, and anguish. They are not a united group but a chaotic mass, each alone with his thoughts. Massive hands and feet, slumped bodies, and awkward gestures make the figures human. Rodin wanted the monument to sit on the ground in a plaza outside of the town hall, so it would appear that the figures were walking from the building, thus allowing viewers to share the space of the burghers and experience their trauma. The ignoble, blunt monument embarrassed the town council, however, which hid it at a desolate site, mounted on a high pedestal.

Clearly, Rodin's preoccupation with expressing elemental fears and passions relates him to the Symbolist quest to plumb the depths of the mind. His thematic interests were stated as early as 1864, and in some ways it is possible to view him as a late Romantic. What marks him as a Symbolist, though, is his interest in the psychic toll exacted on the individual by civilization. Whether he is exploring the crushing effects of war or the emotional costs of creative effort, Rodin emphasizes the psychological consequences of modern life. His ability to convey intense psychological states through forms at once both familiar and abstract confirms his kinship with Symbolism. While the Romantics called for action—as in, for example, the case of the War of Greek Independence (1821–1832)—the Symbolists embraced a contemplative, inward-turning relationship to the world. The Franco-Prussian War (1870–1871) and the horror of the 1871 Commune offered a grim lesson in direct action and political engagement. It was the hidden, inner struggle that Rodin, the Symbolists, and the nascent science of psychology now sought to understand and render visible. And this inner struggle would preoccupy European artists until 1914.

an unfamiliar, organic quality. Rodin preferred to mold, not carve, working mostly in plaster or terra cotta, which artisans would then cast in bronze. We see where Rodin's hand has worked the malleable plaster with his fingers, for his surfaces ripple and undulate. His medium, instead of being smoothed out, remains intentionally rough and uneven, unlike Canova, for example, whose marble aspires to a graceful smoothness (see fig. 24.28). With Rodin, we are made to feel privy to the creation of the figure, as if watching God making Adam out of clay. This primal quality is reinforced by his figures' nudity, which is less a Classical reference than a device to present an elemental figure, a figure who has been stripped down to the very core of its humanity to expose primordial fears and passions.

For the sake of expression, Rodin does not hesitate to distort his figures, shattering Classical notions of the idealized form and beauty. Look, for example, at *The Shades* atop the doors of *The Gates*. Their Michelangelesque musculature has been yanked and twisted, endowing these specters with a form that is at once familiar and unfamiliar. These uncanny messengers have arisen from tombs and now cast their message of eternal gloom on the teeming humanity below. We can even see this distortion to a lesser degree in *The Thinker*. Here, massive hands and feet project a ponderous weight that underscores the

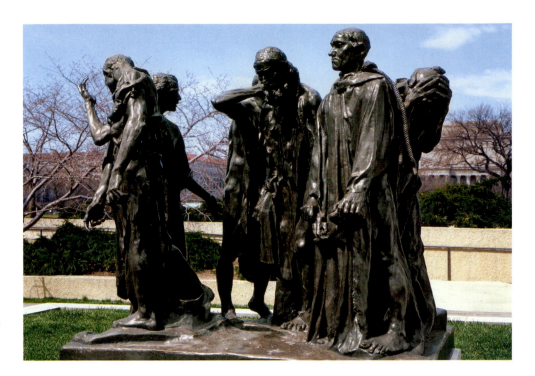

26.30. Auguste Rodin. *Burghers of Calais.* 1884–1889. Bronze, 6′10¹⁄₂ × 7′11″ × 6′6″ (2.1 × 2.4 × 2 m). Hirshhorn Museum and Sculpture Garden, Smithsonian Institution, Washington, DC. Gift of Joseph H. Hirshhorn, 1966. 66.4340

ART NOUVEAU AND THE SEARCH FOR MODERN DESIGN

In 1895, a German entrepreneur, Siegfried Bing, opened a decorative arts shop called *La Maison de l'Art Nouveau* (The House of New Art) in Paris. He had made a fortune importing Japanese art and furnishings, and now sought to promote the Japanese principle of total design: Every detail of an interior space would be integrated into a single style. Aiming to eliminate any distinction between the fine and decorative arts, he hired famous architects, artists, and designers to develop every detail of entire rooms for his shop, as well as to design individual products, including furniture, vases, tiles, and stained-glass windows. This new style was called *Art Nouveau*, after Bing's shop. Elsewhere in Europe it took on different names, such as *Jugendstil* (Youth Style) in Germany and the Secession Style in Vienna. Though varying somewhat from one country to the next, the style is usually characterized by organic forms and arabesques.

Art Nouveau can be seen as a response to William Morris's Arts and Crafts Movement, and certainly the emphasis on handcrafted, finely designed products reflects this. The design products of Louis Comfort Tiffany (1848–1933) were another important influence on Art Nouveau, especially his stained-glass windows (fig. **26.31**) and glass lampshades with their organic motifs. Tiffany's New York store was actually the inspiration for Bing's *La Maison de l'Art Nouveau*. Important differences exist between the Arts and Crafts Movement and Art Nouveau. For instance, many Art Nouveau artists embraced mass-production and new, industrial materials. Also, it is important to note that Art Nouveau designs, though clearly organic, are often purely abstract rather than based on identifiable botanical specimens, as is the case in Morris's designs.

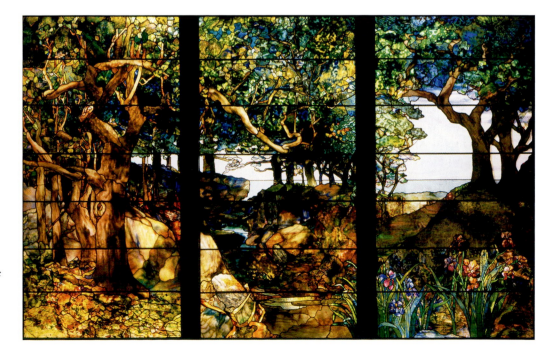

26.31. Louis Comfort Tiffany. *A Wooded Landscape.* ca.1905. Glass, copper-foil, and lead, Museum of Fine Arts, Houston, Museum Purchase with funds provided by the Brown Foundation Accessions Endowment Fund. 96.765. A, B, C

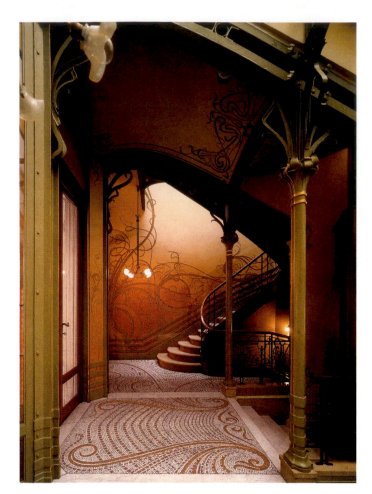

26.32. Victor Horta. Interior Stairwell of the Tassel House, Brussels. 1892–1893. © SOFAM, Brussels

whiplash tendrils on the walls, ceiling, and mosaic floor. The supporting role of the column has been made as slender as possible. In a play on the Corinthian capital, it sprouts ribbonlike tendrils that dissolve into arches. The linear patterns extend to the floor and wall, a device that further integrates the space visually. Sunlight filters through the glass ceiling, heightening the organic quality of the stairwell. The curvilinear patterning derives from a variety of sources, including Japanese prints and Gauguin's cloisonnism. (See fig. 26.13.) Everything has an organic fluidity, a springlike sense of growth and life, which has the effect of destroying the conventional boxlike quality of interior space.

HECTOR GUIMARD Art Nouveau next migrated to Paris, where its most famous practitioner was the architect Hector Guimard (1867–1942), who is especially renowned for designing the entrances to the Paris Métro, or subway, which opened in 1900 (fig. **26.33**). Like Horta, he worked with wrought and cast iron, patinated a soft, earthy green, but his sensitivity, while still organic, is quite different. If Horta suggests dynamic whiplash tendrils, Guimard evokes a lethargic prehistoric world, part plantlike, suggesting stalks and tendrils, and part zoomorphic, evoking praying mantises and dinosaurs. Even the lettering of *Métropolitain* morphs into strange organic characters, irregular, primitive, and scary. How appropriate for an architecture marking entrances to a new underworld. And how revealing that the style for a high-tech, machine world should be an escapist fantasy that is emphatically organic. Aside from his very public designs for the Métro, Guimard's

The Public and Private Spaces of Art Nouveau

Compared with dark, ponderous Victorian interiors, the buoyant naturalism of Art Nouveau was a breath of fresh air, exuding youth, liberation, and modernity. It shared with Symbolism the element of fantasy, in this case a biomorphic fantasy, which can especially be seen in architecture. Art Nouveau designers concerned themselves equally with exterior finish and interior space. The typically complex, animated facades endow Art Nouveau buildings with a sculptural quality that engages a viewer as he or she approaches. This energetic dialogue continues in the interior, for Art Nouveau spaces pulse with a sense of movement: Interior decoration and furnishings give the impression of having germinated and grown *in situ*. This effect is often enhanced by the admission of sunlight through glass ceilings or skylights, lending the space the fecundity of a greenhouse where everything seems to have grown spontaneously.

VICTOR HORTA The style began in Brussels with Belgian architect Victor Horta (1861–1947). Born in Ghent, Horta studied drawing, textiles, and architecture there at the Academie des Beaux-Arts, and worked in Paris before returning to Belgium to start his own practice. In 1892, Horta designed the Tassel House in Brussels. The centerpiece of the design is the ironwork of the stairwell (fig. **26.32**), the malleable wrought-iron columns and railings that were easily shaped into vines that evolve into

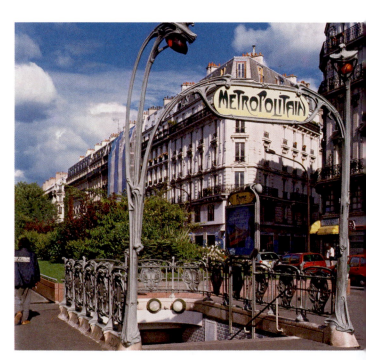

26.33. Hector Guimard. Métro Station, Paris. 1900

practice was largely limited to private houses and apartment buildings for the *haute bourgeoisie*. He remained faithful to Art Nouveau even after it passed from fashion, around 1910.

ANTONI GAUDÍ By far the most bizarre creations sprung from the wild imagination of Antoni Gaudí (1853–1926). Gaudí worked in Barcelona, the next and last major stop for the short-lived Art Nouveau, and his style reflects the fervent nationalism of the period, drawing heavily upon Mediterranean architectural traditions. His remarkable Casa Milà

ART IN TIME

- 1889—Eiffel Tower completed
- **1892–1893—Victor Horta's Tassel House**
- 1895—Siegfried Bing opens La Maison de l' Art Nouveau in Paris
- 1898—Spanish-American War
- 1900—Paris Métro opens
- **1905–1910—Antoni Gaudí's Casa Milà Apartments**

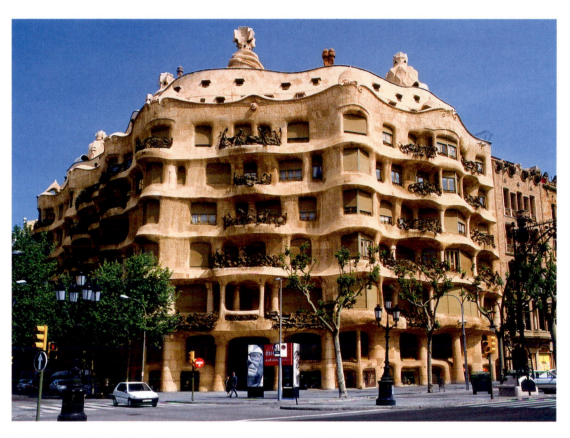

26.34. Antoni Gaudí. Casa Milà Apartments, Barcelona. 1905–1910

(figs. **26.34** and **26.35**), a large apartment house, expresses one person's fanatical devotion to the ideal of "natural" form, one quite different from Horta's plantlike designs. The building conjures up the Spanish Baroque, the Plateresque (indigenous Renaissance architecture suggesting elaborate silver plate), and the Moorish mosques of southern Spain. Believing there are no straight lines in nature, Gaudí created an undulating facade and irregularly shaped interior spaces, in effect destroying the architectural box. With its huge stone blocks, the exterior evokes austere seaside cliffs while the wrought-iron balconies resemble seaweed and the scalloped cornice mimics ocean waves. To twenty-first century eyes, the chimneys may recall soft ice cream cones, but in 1905, they would have evoked, among other things, sand castles. These references to the seashore elicit Barcelona's distinctive geographic, cultural, and economic relationship to the Mediterranean. As the capital of Catalonia, Barcelona held a special significance for Gaudí, who supported Catalan nationalism.

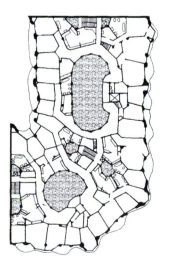

26.35. Antoni Gaudí. Plan of typical floor, Casa Milà

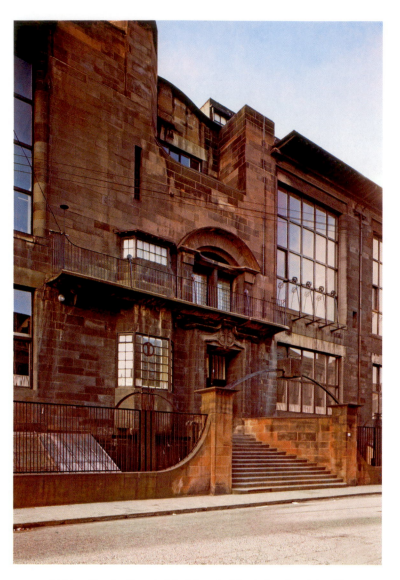

CHARLES RENNIE MACKINTOSH Just as Gaudí's buildings evoke the landscape and culture of Catalonia, the work of the Glasgow architect Charles Rennie Mackintosh (1868–1928) speaks to a decidedly northern, Scottish sensibility. Mackintosh's designs are often labeled Art Nouveau, and he certainly began in this camp, especially adhering to Arts and Crafts values, and retaining organic qualities in his work throughout his career. As can be seen in his most famous project, the Glasgow School of Art (fig. **26.36**) built from 1897 to 1909, his work is infinitely more mainstream than Gaudí's, Guimard's, or Horta's. The facade is largely rectangular. Its austere windows, which hint at the Queen Anne revival style, dominate the building, making it look very geometric. The grid of the windows is reinforced by the horizontal overhang above the entrance. The entrance section evokes a Scottish baronial tower, within which is set an arched Baroque aedicula, or altar, with a Queen Anne oriel, or picture window, in a niche above. In other words, the building is an abstract presentation of revival styles, but those styles are so reduced to a geometric essence that they almost disappear. The only suggestion of the curvilinear Art Nouveau is in the eccentric, organic ironwork, including the railings and fences, the entrance arch with lantern, and the strange plantlike brackets used by window cleaners.

Mackintosh's interiors, for which he is most noted, retain more of a balance between the geometric and organic, as seen in his 1904 Salon de Luxe at the Willow Tea Room in Glasgow (fig. **26.37**). The door and walls have a frail linear patterning suggesting willow branches, and the backs of the chairs gracefully buckle and taper, while their leg brackets curve. A severe grid of verticals and horizontals, however, symbolized by the nine squares on the backs of the chairs, sharply organizes the room, which nonetheless is quite elegant and refined. Regardless of labeling, Macintosh's design is certainly "new" and also total, encompassing every detail in the room, down to the door handle, all of which are beautifully handcrafted. While not the botanical

26.36. Charles Rennie Mackintosh. North facade of the Glasgow School of Art, Glasgow, Scotland. 1897–1909

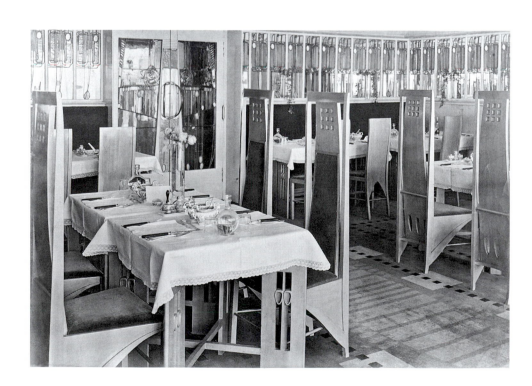

26.37. Charles Rennie Mackintosh. Salon de Luxe, Willow Tearoom, Sauchiehall Street, Glasgow. 1904

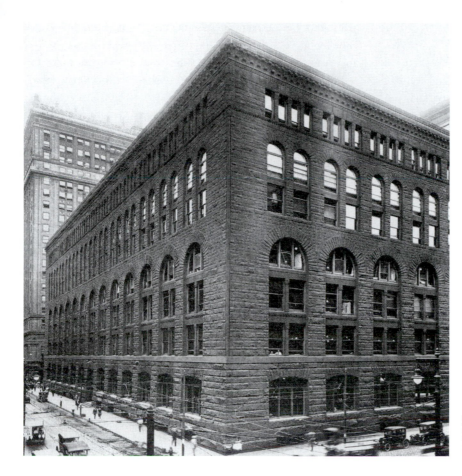

26.38. Henry Hobson Richardson. Marshall Field Wholesale Store, Chicago. 1885–1887. Demolished 1931

and zoological fantasies of Horta and Guimard, Macintosh's vision equally dispatches the historical past and certainly charts strange territory, making tearoom guests feel as though they have passed through a magic door into a marvelous wonderland.

AMERICAN ARCHITECTURE: THE CHICAGO SCHOOL

Little did anyone know in 1871 that Chicago's devastating Great Fire would launch modern architecture and make American architects for the first time the most advanced in the world. Once the flames of the fire were extinguished, the issue at hand was not just one of rebuilding. Chicago had been growing rapidly, putting a premium on real estate, and now there was a need to maximize land use by building vertically. This was made possible by the invention of the safety elevator, perfected in New York in the 1850s and 1860s by Elisha Otis. Ambitious construction was delayed for ten years, however, due to the national financial collapse of 1873, which lasted through the decade. When rebuilding finally proceeded in the 1880s, it was dominated by young designers who were largely trained as engineers with virtually no architectural background. This meant they were not hampered by strong preconceived notions of what buildings should look like and were open to allowing their structures to reflect the new technologies and materials they employed. They abandoned the historicism of revival architecture and designed abstract structures as they allowed form to follow function. The buildings they erected were technically so complicated and the work load so great that

the major architects paired off into complementary teams: Burnham and Root, Holabird and Roche, and Adler and Sullivan. Of this group, only Louis Sullivan had attended architectural school, one year at MIT and a half year at the École des Beaux-Arts in Paris.

Henry Hobson Richardson: Laying the Foundation for Modernist Architecture

Designed by Boston architect Henry Hobson Richardson (1838–1886), the Marshall Field Wholesale Store (fig. 26.38) provided an intellectual challenge to the new generation of Chicago architects. Born in New Orleans and educated at Harvard, Richardson rose to international fame for his Romanesque revival style, which became so renowned that the style was eventually named after him. Made of stone, his buildings were massive, bold, and highly textured. They were also quite simplified, emphasizing volumetric forms. With the Marshall Field Wholesale Store, a seven-story building that took up an entire Chicago block, Richardson's style evolved to its most refined form, one that moved beyond the Victorian Romanesque revival. The internal structure contains some cast iron columns, pointing to the new age of skyscraper construction, though this is disguised by walls of red granite and red sandstone. And these walls are free-standing, not a veneer attached to the steel. The building looks as though it were made of stone, not metal, and it feels massive because it takes up the entire city block, asserting its physical presence. The scale and texture of the blocks as well as the dark hollows of the deeply recessed windows add to the sculptural quality of this vital building.

The arches, especially when used by Richardson, recall the Romanesque, although the three arched tiers evoke a quattrocento Florentine palazzo as well (see fig. 15.32). The three-tier layering of the building also calls to mind Beaux-Arts architecture (see fig. 25.9), a reference to the rigorous architectural program of the Paris École des Beaux-Arts that established strict design principles. These rules included a stylobate-column-entablature configuration, that is, a base, rise, and crown format. In the Marshall Field building, the stylobate, or platform, is represented by the basement level, with the next two tiers representing the columnated level and the entablature. Despite parallels to past architecture, the building is innovative because it is remarkably abstract: There are no columns, piers, capitals, or entablatures per se. Instead the uniform stone, despite its rustication, is like a skin covering the building, and there is just enough stone to keep the building from becoming skeletal and reflecting the grid structure of the interior framework.

Louis Sullivan and Early Skyscrapers

Richardson did not consider himself a Modernist, and he wasn't. But the abstraction of the Marshall Field building helped spawn Modernist architecture. As important as Richardson were technical developments. As the Chicago fire clearly demonstrated,

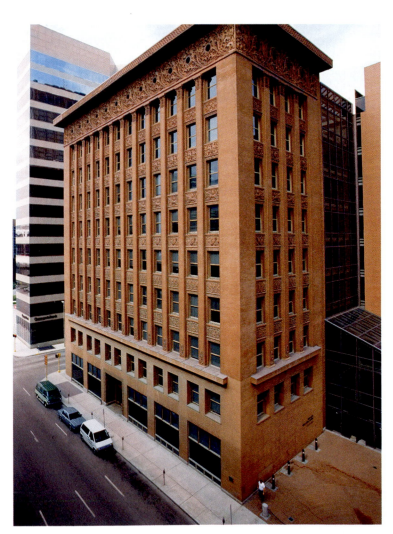

26.39. Louis Sullivan. Wainwright Building, St. Louis, Missouri. 1890–1891. Destroyed

iron is not fire resistant; intense heat makes it soften, bend, and, if hot enough, melt. To avoid towering infernos, it was necessary to fireproof the metal, enveloping iron, and shortly thereafter steel (which was only developed as we know it today in the early twentieth century) with terra-cotta tiles and later in a coating of concrete (modern concrete, called Portland cement, was invented in England in 1825). The insulation also prevented corrosion.

An equally important technological development was the invention of the *curtain wall*. Unlike a self-supporting wall, the type Richardson used for the Marshall Field Wholesale Store, a curtain wall hangs from the lip of a horizontal I-beam. Without this innovation, the base of the wall for a tall building would have had to be extremely thick (6 to 10 feet for a 15-story building) in order to support the weight of the wall above, severely limiting the number of floors. Furthermore, curtain walls allowed for entire walls to be made of glass. The first extensive use of the curtain wall was in Chicago for the 1884–1885 Home Insurance Building, built by William Jenney, the elder statesman of the Chicago architects.

The architect generally credited with playing the main role in developing the aesthetic implications of the steel skeleton into powerful architecture is Louis Sullivan (1856–1924). In 1880 Sullivan joined the Chicago firm of Dankmar Adler, which in 1883 became Adler and Sullivan (Adler left the firm in 1891). Adler was the engineer, planner, and project manager who kept building construction moving forward, while Sullivan was the idealistic visionary who provided the design concepts.

Sullivan's early masterpiece is the Wainwright Building (fig. **26.39**), erected in St. Louis in 1890–1891 (most of his major buildings, however, are in Chicago). Using the curtain wall, Sullivan designed a building that reflects the grid structure of the steel skeleton, although for aesthetic purposes he has doubled the number of external piers, with only every other one having a structural beam behind it. The major problem for the early architects of skyscrapers was how to design a building that rose so many floors, while maintaining a visually interesting exterior that did not rely on outmoded revival styles. Sullivan's solution was ingenious. Like Richardson's Marshall Field Wholesale Store, the end piers are widened, dramatically framing the building, and the *spandrels* (the decorated horizontals panels between piers) are recessed, both elements giving the building a monumental sculptural quality and the sense of the building evolving from a solid block. The seven-story colossal piers and the enormous one-story cornice add to this grandeur. Again, we see the Beaux-Arts stylobate-column-entablature configuration of the Marshall Field building, which feels even more Classical in the Wainwright Building because of the grid and absence of Romanesque arches.

While the building's exterior presents a compilation of abstract, geometric forms, largely reflecting the substructure, Sullivan did not hesitate to design terra-cotta panels for the cornice and spandrels that feature a pattern based on an antique rinceau motif (an ornamental vine, leaf, or floral design). Sullivan intended these biomorphic decorations to symbolize his belief that architecture should utilize new technologies to promote social harmony and progress and to be part of a natural

organic evolution of the world. Like the painter George Inness, Sullivan believed in Swedenborg's ideas of correspondence—that universal forces run through and unite all things, each of which is otherwise unique and an individual. The decoration allowed Sullivan to distinguish the various parts of the building, giving each a separate identity (e.g., the upper story, the spandrels), and yet at the same time, all of these distinctive parts are tightly woven together into a unified whole, as suggested by the powerful grid of piers and spandrels. The flowering plant life energizes the building, reflects the vitality of the human element within, and relates both to the universal current flowing through all things. Although he was down-to-earth, practical, and functional—it was Sullivan who issued the famous dictum that "form ever follows function"—Sullivan was also a visionary Symbolist. (See end of Part IV, *Additional Primary Sources*.)

Sullivan's style became considerably lighter, airier, and abstract by 1900, anticipating the floating, geometric, glass boxes of the twentieth century modernist architecture. This style can be seen in the Schlesinger and Meyer Store in Chicago (fig. **26.40**), which originally was a commission for the three-

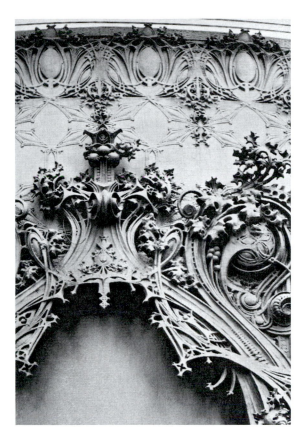

26.41. Louis Sullivan. Cast-iron ornament, Schlesinger and Meyer Store

bay, nine-story section on the left but evolved into the twelve-story structure we see today. The thin vertical piers actually reflect the skeleton behind, and the mechanomorphic facade echoes the structural grid behind it. The wall has virtually disappeared, giving way to glass. Instead of the enormous monumental one-story cornice we saw on the Wainwright Building, Sullivan's top floor "entablature" is actually a hollow recessed balcony, capped by a sliver of a cornice, which instead of being a weighty lid seems to be a floating piece of cardboard. There is still a two-story Beaux-Arts "base," but it seems recessed (although it is not) because of the horizontal molding above, making the nine-floors of horizontal windows seem to float. The first floor dissolves in a wild flurry of Art Nouveau plant forms that cover cast-iron panels (fig. **26.41**), in effect unifying the building with cosmic forces. With the Schlesinger and Meyer Store, the aesthetic for the Modernist skyscraper had perhaps reached its finest expression to date.

Frank Lloyd Wright and the Prairie House

After studying engineering at the University of Wisconsin, Frank Lloyd Wright (1867–1959) worked for Sullivan from 1888 until 1893. His sensitivity and strengths, however, could not have been more different. While Sullivan specialized in commercial buildings, Wright's forte was domestic architecture, although his public buildings are brilliant. Sullivan's innovations were largely in facades, whereas Wright's was in space, including interior

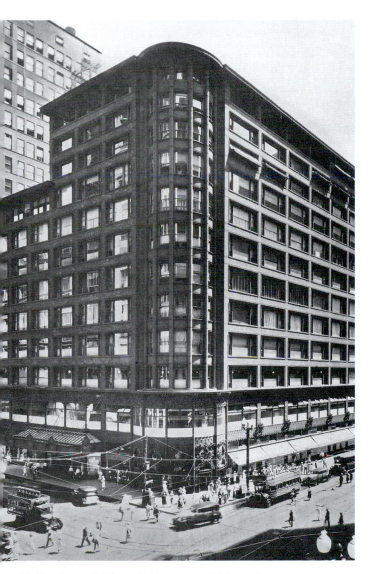

26.40. Louis Sullivan. Schlesinger and Meyer Store (now Carson, Pirie & Scott Department Store), Chicago. 1899–1901, 1903–1904

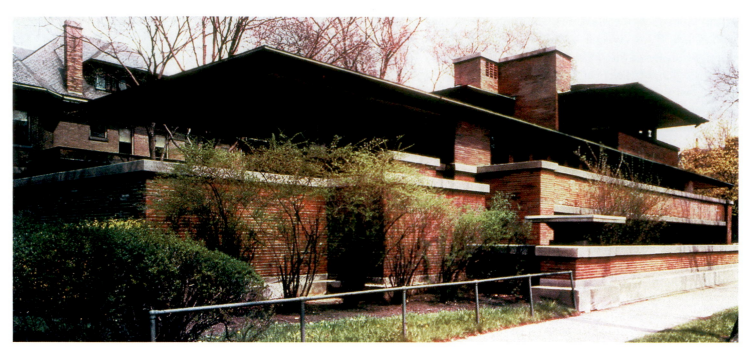

26.42. Frank Lloyd Wright. Robie House. Chicago. 1908–1910. © Frank Lloyd Wright Foundation, Scottsdale, Arizona/Artists Rights Society (ARS), New York

space and its relationship to the exterior. Wright's architecture, like Sullivan's, is based on nature, and his reputation was established with what are known as his Prairie Houses, so-called because their strong horizontal sweep echoes the planarity of the Midwest landscape where the homes were built.

The crowning achievement of Wright's Prairie Houses, which he began designing in the early 1890s, is the Robie House (fig. **26.42**), designed in Chicago in 1908. The building was so shockingly modern it would take architects a good 10 to 20 years to understand it and develop its implications. As can be readily seen from the exterior, the house is an abstract play of not only horizontals and verticals, but also of open spaces and enclosed volumes. The dramatic cantilevered roofs (which are not flat as suggested by our reproduction, but slightly slopping) define one space, while the floor of the terrace, or the balcony below, charts another. The interior spaces not only flow into the exterior, but into one another, for rooms, especially communal rooms, generally do not have doors and four walls (fig. **26.43**).

Wright always claimed his extraordinary ability to envision complex space and design came from playing with the Froebel Blocks that his mother bought for him at the 1876 World's Fair in Philadelphia. Developed by Friedrich Froebel as part of his

campaign to institute kindergarten throughout the country, the blocks were the first children's blocks, and part of a program that progressed to working with sticks, clay, folding paper, and weaving various materials. The Froebel "gifts," as each stage was called, not only taught Wright to think in terms of abstract form, but also organic growth. Froebel was influenced by crystallography and consequently emphasized pattern making, not construction, with the pattern spreading out uniformly from a center row (the child was required to use all of the blocks). When complete, the child was encouraged to attach symbolic content to the shapes, relating the patterns to the living world of plants and cosmos (suns and stars, for example). Equally important for Wright's development was a visit to the Japanese temple at the 1893 Chicago World's Fair. Here he saw the dramatic projection of eaves, and severely geometrically shaped rooms that had sliding doors, which allowed one room to flow into another. Everything in a Japanese building was as tightly interlocked as a Froebel project.

As abstract and geometric as the Robie House is, the home resonates with nature and the organic. Even from our reproduction, the house, made of a horizontal brick made to Wright's specifications (the face is $1\frac{1}{2}$ by 5 inches), appears per-

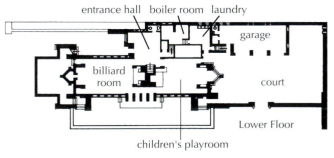

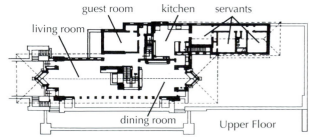

26.43. Plan of Robie House

fectly integrated into the land, its lateral spread paralleling the surrounding plains. Wright thought of his architecture as organic, evolving much as a crystal develops or a tree grows. The Robie House, like many of his homes, radiates from a large masonry fireplace, which Wright saw as a domestic altar to the "gods of shelter." The rest of the house develops organically from this fulcrum, with one room naturally flowing into another and into the exterior, which in turn is integrated into the surrounding land. This sense of growth can be readily seen from the exterior, where the lateral spread of roofs, terraces, and balconies seems to be in constant movement. The picturesque variety of overhangs and recesses creates a play of light and shadow that we do not normally associate with architecture, but rather with nature.

Wright's interior design also embraces this organic note. Reproduced here is the living room from the Francis W. Little House (fig. 26.44), perhaps his finest extant early interior. Influenced by William Morris's Arts and Crafts Movement as well as the principles, if not the look, of Art Nouveau, Wright, when possible, designed every detail of his interiors, with everything handmade and of the highest quality. Like his architecture, his furniture and designs are geometric, continuing the spatial interplay of his building. But the geometric designs that appear on the leaded stained-glass windows and ceiling grillwork are actually abstractions of plant and landscape motifs, and the palette of the room features somber, warm, earth colors. As much as we may want to see early Wright as an abstract, machine-age thinker conceptually play-

ing with spaces and completely breaking with tradition, his theories and sensitivity are very much of the 1890s—he still has one foot planted in the Symbolist nineteenth century that advocated a retreat from modernity into the arms of nature and its rejuvenating spiritual forces.

PHOTOGRAPHY

The primary preoccupation of photographers at the end of the century was the ongoing debate of whether photography was art. Complicating their cause was the dramatic increase in nonart photography. The invention of the half-tone printing process was one reason for this upsurge, for it resulted in photographs being directly printed in newspapers, magazines,

ART IN TIME

1883—Brooklyn Bridge completed

1884—Mark Twain publishes *The Adventures of Huckleberry Finn*

1885–1887—Henry Hobson Richardson's Marshall Field Warehouse

ca. 1887—High-speed elevator perfected

1890–1891—Louis Sullivan's Wainwright Building

1901—United States Steel Corporation formed

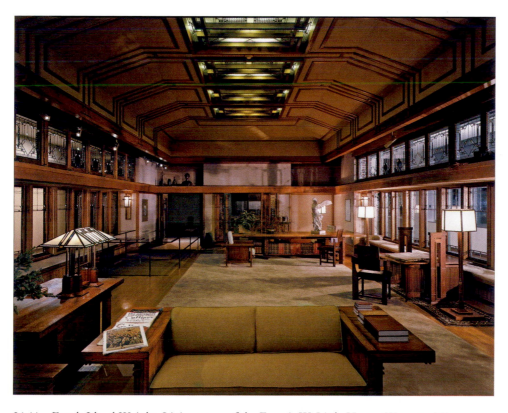

26.44. Frank Lloyd Wright. Living room of the Francis W. Little House, Wayzata, Minnesota, designed 1912–1914, as installed at The Metropolitan Museum of Art, New York. Purchase Bequest of Emily Crane Chadbourne, 1972. 1972.60.1 © Frank Lloyd Wright Foundation, Scottsdale, Arizona/Artists Rights Society (ARS), New York

and books using either lithographic or relief printing. It also brought about the rise of the picture postcard, which during the height of its popularity in 1907–1908 resulted in some 667 million postcards, most with pictures, being sent through the U.S. Mail. Another reason for the proliferation of photographs was the invention of dry plates, which replaced the awkward and impractical wet-plate process. Now photographers could work faster and go anywhere. The process reduced exposure time to one-fiftieth of a second, and hand-held cameras with shutters were invented. Tripods were no longer necessary, and cameras could now record movement. In 1888, the Eastman Dry Plate Company of Rochester, New York, introduced the Kodak camera. It came loaded with a

paper roll containing 100 frames, which once exposed, were sent back to the company in the camera for developing and printing. The company's advertisement declared "You press the button—We do the rest." Also appearing about this time was the single-lens reflex camera, which had a mirror that allowed the photographer to see the image in a viewer. Suddenly, everyone was taking pictures, and the word "snapshot" came into common parlance. Toward 1890, there were 161 photographic societies worldwide and 60 photographic journals. The medium became so popular that newspapers had an amateur photography column.

Pictorialist Photography and the Photo Secession

To counter the image of photography as a ubiquitous, mindless, popular tool best suited for documenting the visual world, organizations sprang up dedicated to promoting the medium as high art. The first was the Wien Kamera Klub (Vienna Camera Club), founded in 1891, soon followed by the Linked Ring in London and The Photo-Club de Paris (1894). The Berlin, Munich, and Vienna secessions, dedicated to breaking down any hierarchical ranking of the arts, showed art photography. In 1902, Alfred Stieglitz quit the conservative Camera Club of New York to form the Photo Secession, taking its name from the European secession groups. All of

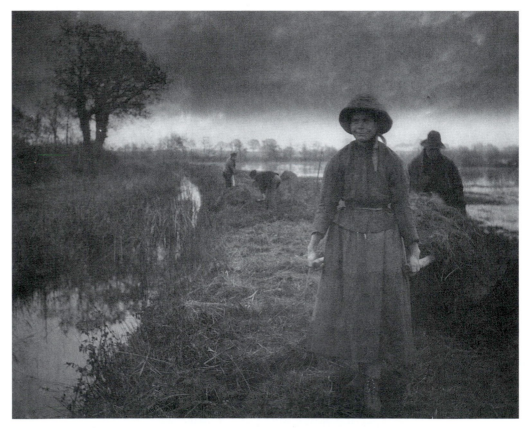

26.45. Peter Henry Emerson. *Poling the Marsh Hay*. 1886. Platinum print. Gernsheim Collection. Harry Ransom Humanities Research Center, University of Texas, Austin

these photography organizations had international membership, often with the same members, and mounted exhibitions and published magazines. And they all promoted a Pictorialist aesthetic, placing a premium on a painterly look, countering the sharp focus that characterized postcard, stereoscope, newspaper, and magazine images and the single fixed focus of the Kodak camera. Photographs by art photographers were taken out of focus, like those of Julia Margaret Cameron, whose work experienced a resurgence of interest. Pictorialist photographs were often highly textured, with gum brushed onto the printing paper before exposure or due to the use of a rough, pebbly paper.

PETER HENRY EMERSON The British photographer Peter Henry Emerson (1856–1936) became a role model for Pictorialist photography, although ironically his own aim was to combine art and science by applying a scientific approach to the creation of the image. His pictures were meant to look scientific, not artistic. Emerson was a medical doctor, who abandoned the profession for photography in 1885. He was influenced by the German scientist Hermann von Helmholtz's theory of vision, which maintains that the eye at any one time can only focus on one area with everything else becoming hazy. Wanting to make a realistic photography based on scientific principle, Emerson set out to produce images that replicated Helmholtz's optical premise. In *Poling the Marsh Hay* (fig. **26.45**), the foreground woman is most focused while the rest of the image is mildly blurred or indistinct. The picture appeared in Emerson's book *Life and Landscape on the Norfolk Broads* (1888), a folio of 40 mounted platinum prints, a photographic process that yielded an extraordinarily fine range of soft gray tones. Emerson was fascinated by the rural world of Southeast England, where time seemed to stand still and hay was harvested by hand, not with the new steam-driven tractors. In this nostalgic image, we are presented with a Romantic view of an idyllic life of humans immersed in nature. Ironically, Emerson's scientific goal to realistically replicate the world as the eye sees it resulted in a poetic timeless vision, a soft-focused dream world of indistinct lush grays and of mysteriously floating darks and lights, such as a ghostly silhouetted tree and the light mystically shimmering on the canal and marshes.

GERTRUDE KÄSEBIER The international Pictorialists took their lead from Emerson and Cameron, among others, and similarly created painterly, dreamlike images. New Yorker Gertrude Käsebier (1852–1934) was one of the more prominent figures in the group, becoming a member of the Linked Ring in 1900, less than five years after taking up photography, and one of the founding members of Stieglitz's Photo Secession in 1902. Fleeing a wretched marriage, she enrolled in art classes at Pratt Institute in 1889, and soon took up the camera with the intention of making art, although she supported herself through studio portraiture. In *Blessed Art Thou Among Women* (fig. **26.46**), an 1899 platinum print on Japanese tissue, we see Käsebier displaying all of the hallmarks of Pictorialism: a soft, grainy image, slightly off focus, and with a spectacular range of lush grays that only a platinum print can pro-

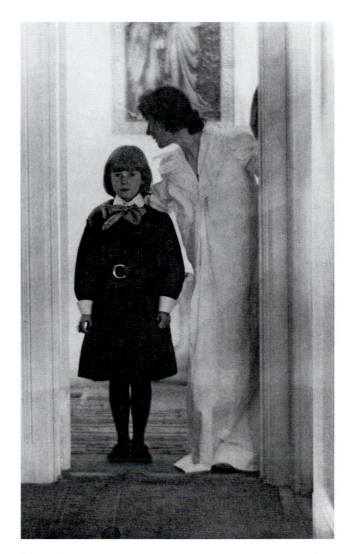

26.46. Gertrude Käsebier. *Blessed Art Thou Among Women*. 1899. Platinum print on Japanese tissue, $9^{1}/_{2} \times 5^{1}/_{16}$" (24.2 × 14.8 cm). Princeton University Art Museum. The Clarence H. White Collection; Collection assembled and organized by Professor Clarence H. White and given in memory of Lewis F. White, Dr. Maynard P. White, Sr., and Professor Clarence H. White, Jr., the sons of Clarence H. White, Sr. and Jane Felix White

vide, made all the more delicate by being printed on a gossamer-like Japanese tissue. The mother wears a white Pre-Raphaelite robe and conspicuously stands before an image of the Annunciation on the back wall. The daughter, who is about to cross the threshold to go out into the world, is encased in a mandorla-like divine light created by the brilliant white that surrounds her, especially defined by the small gap between her and her mother. The scene has a spiritual quality, set within a sanctum dedicated to maternal protection and nurturing. In a modern urban society becoming increasingly fast, fragmented, and materialistic, Käsebier creates a tranquil domestic sanctuary based on, as the title suggests, the nurturing care of a mother. Käsebier's image shares with Mary Cassatt's *The Child's Bath* (see fig. 25.20) the same late nineteenth-century feminist belief in the important role that women play in the development of children, and with Cameron's *Sister Spirits* (see fig. 25.38) a female bonding or spiritual sisterhood designed to protect the rights and future of their gender.

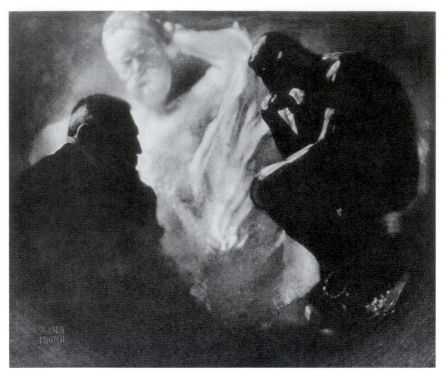

26.47. Edward Steichen. *Rodin with His Sculptures "Victor Hugo" and "The Thinker."* 1902. Gum print, $14\frac{1}{4} \times 12\frac{3}{4}$" (36.3 × 32.4 cm). Courtesy George Eastman House. © Joanna T. Steichen.

EDWARD STEICHEN Along with Käsebier and Stieglitz, Edward Steichen (1879–1973) helped to found the Photo Secession. Steichen's early contributions to this movement were painterly and moody, his landscapes having the same tonalist and mystical qualities as Inness's (see fig. 26.24). His early style can be seen in his 1902 portrait *Rodin with His Sculptures "Victor Hugo" and "The Thinker"* (fig. **26.47**), a gum print. Using the painterly effect of the gum combined with the fuzziness of the focus, he created an image that looks more handcrafted than mechanically reproduced, demonstrating that the photographer made aesthetic decisions that profoundly affected the meaning of the image. Picturing together the brooding silhouettes of Rodin and *The Thinker,* Steichen uses them to frame a brightly lit, phantomlike *Victor Hugo.* Clearly, Steichen identifies Rodin with *The Thinker.* One of the readings of the famous sculpture is that it is meant to represent Rodin and the daunting creative process and mental struggle behind the development of a work of art. This interpretation certainly accounts for this image, as suggested by the light striking Rodin's "brain" and the emergence of Victor Hugo as an apparition, a figment of Rodin's imagination. While in some respects Rodin is portrayed here as a Romantic genius, we also sense a Symbolist psychology at work—ideas do not gush from his imagination and emotions, but instead they are the result of a prolonged search into the dark recesses of the mind.

ALFRED STIEGLIZ Several of the Pictorialists in the Stieglitz circle photographed New York City, although paradoxically their images have a Romantic atmospheric quality more appropriate to landscape than urban concrete and steel. By 1900, New York, not Chicago, was the city of skyscrapers, and as America attained global technological and financial superiority, New York and its "cathedrals of capitalism" became an emblem of this superiority. Even though Stieglitz

(1864–1946) abhorred modernity and lamented the city's "mad, useless Materiality," he repeatedly photographed Gotham from the early 1890s up to 1910, as seen in *The City of Ambition* (fig. **26.48**) of 1910. Typical of Pictorialist images of New York, his pictures allow meteorological effects, such as snow, mist, steam, and fog, to upstage the buildings. In *The City of Ambition,* Stieglitz uses the Pictorialists' characteristic soft focus. The metropolis looms large, but buildings are indistinct and in shadow, softened by puffs of smoke and the clouds behind. Light shimmering on the water gets as much attention as the skyline, and we are very much aware of the glow of the sun setting behind the buildings. Stieglitz capitalizes on this light to orchestrate a beautiful symphony of gray rectangular forms harmonizing with rich darks and bright whites. He captures the awesome scale of the city, this "monster" as he described it, and he suggests, by immersing it in an atmospheric veil, that it seems to harness the awesome forces of nature.

Documentary Photography

Among the most powerful documentary photographs made in the closing decades of the nineteenth century were those chronicling the horrific working and living conditions of the modern city. Some of the best known work was made in New York, a crowded, fast-growing metropolis teeming with indigent immigrants and migrants readily victimized by unscrupulous landlords and employers. These masses were unsupported by social services and unprotected by the government. Conditions were especially appalling in the immigrant slums on the Lower East Side and the violent, lawless bars and brothels of Five Points, a district largely centering on the Bowery. Unlike the Pictorialists, whose techniques and subjects often softened the realism of their images, documentary photographers embraced the medium's capacity to secure direct, seemingly truthful records. Some

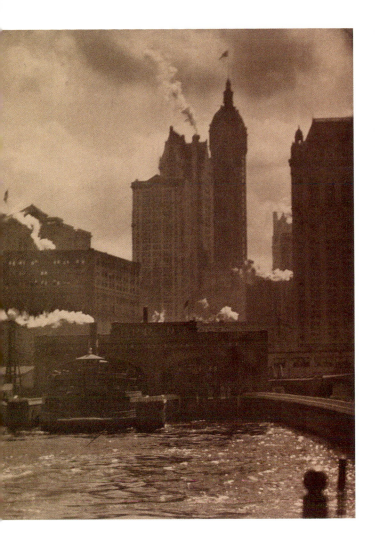

26.48. Alfred Stieglitz. *The City of Ambition*. 1910. Photogravure on Japanese tissue mounted on paperboard, $13^{3}/_{8} \times 10^{1}/_{4}$″ (34 × 26 cm). The Metropolitan Museum of Art, Alfred Stieglitz Collection. 1949. (49.55.15)

documentary photographers felt that their work attained the status of art due to its apparent ability to convey "truth"; others pursued documentary photography for commercial or even political ends. Jacob Riis numbered among the latter.

JACOB RIIS Emigrating from Denmark in 1870, Jacob Riis (1849–1914) became a police reporter in the roughest neighborhoods of New York City, and was so appalled by the degradation and squalor that he began photographing it in order to generate support for social reform. He made lantern slides of his images to illustrate his lectures, and published others in newspapers and magazines. Although Riis did not consider himself an artist, his works are undeniably striking. In order to create authentic, unposed, spontaneous images, he used a "flash," a magnesium flash powder (the predecessor of the flashbulb), which allowed him to enter tenements, flop houses, and bars at night and instantaneously take a picture, temporarily blinding his shocked subjects but capturing a candid image, as seen in *Five Cents a Spot* (fig. 26.49). Here he has burst into an overcrowded sleeping den on Bayard Street, creating an image that documents the greedy abuse of the homeless and leaves no doubt to the unsanitary conditions that made such squalid, illegal quarters a breeding ground for disease. Riis published his photographs in a groundbreaking book, *How the Other Half Lives* (1890), which

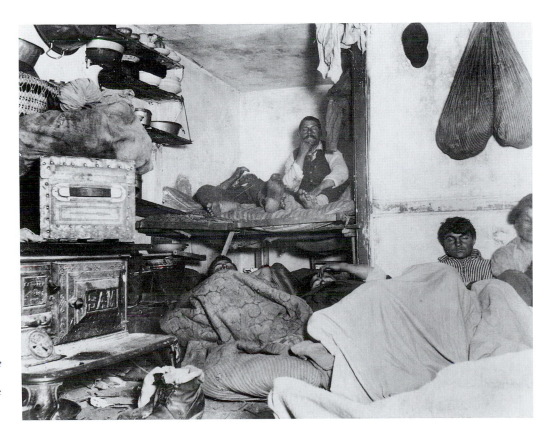

26.49. Jacob Riis. *Five Cents a Spot, Unauthorized Lodgings in a Bayard Street Tenement*. ca. 1889. Gelatin silver print, 8 × 10″ (20.3 × 25.4 cm). Museum of the City of New York, Jacobs Riis Collection #155

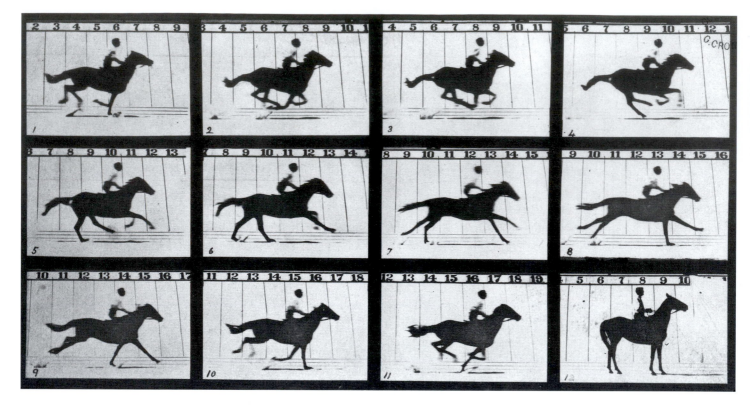

26.50. Eadweard Muybridge. *Untitled* (Sequence photographs of the trot and gallop), from *La Nature*, December 1878. Gravures. George Eastman House, Rochester, New York

in part resulted in the bulldozing of the shanties in the Bayard Street neighborhood and the transformation of the site into a park. An army of social photographers emerged around and after the turn of the century, among the best known Lewis Hine and Jessie Tarbox Beals.

Motion Photography and Moving Pictures

In 1878, Eadweard Muybridge (1830–1904), who had made some of the most remarkable photographs of Yosemite the decade before, was hired by Leland Stanford, a business tycoon, politician, and founder Stanford University, to use photography to resolve one of the great questions plaguing horse trainers and artists for centuries: Do all four legs of a horse leave the ground when it is running? Setting up 12 cameras on a raceway and creating a calibrated backdrop, he made a series of sequential photographs (fig. 26.50) that once and for all answered the question: Yes. Artists ever since have used these images to draw a horse in motion, including Degas in 1879. Muybridge became a celebrity, and was invited to the University of Pennsylvania in Philadelphia to make studies in locomotion, producing in the

26.51 (a and b). Étienne-Jules Marey. *Man in Black Suit with White Stripes Down Arms* and *Legs, Walking in Front of a Black Wall*. ca. 1884. Chronophotograph. Institut Marey, Beaune, France

1880s some 100,000 images of nudes and animals. He published 781 plates in *Animal Locomotion* (1887). These motion studies convey a peculiarly modern sense of dynamics, reflecting, especially in their regularly repeated serial imagery, the new tempo of life in the machine age.

The French physiologist Étienne-Jules Marey (1830–1904) saw Muybridge's horse-in-motion photographs reproduced in the magazine *La Nature*, and became obsessed with studying motion as well. He used a single camera, the lens open, placed behind a rotating disk with regularly placed slots. When a slot appeared, an image was recorded, so that a moving object would appear in a different position each time. Since he was interested in the mechanics of locomotion and not the figure itself, he clothed his models in black body suits with a white stripe running along the length of the side. The models were then photographed in action against a black wall. Thus, only the white line of movement is visible in his photographs (fig. **26.51**). Though Marey saw no artistic merit in these studies, the results offer fascinating abstractions. And they would influence artists who were interested in rendering the movement of an object through space.

SUMMARY

Although the visual art produced in Europe and the United States from 1880 to 1914 does not cohere around a single style, it can be understood collectively as a response to the development of modernity. The ambivalence displayed toward urban life, new technologies, imperialism, and capitalism reflects the contradictions that define modernity. The Positivist embrace of scientific inquiry and technological advances points to a widespread optimism, but the idealist attempt to find authenticity in life through spirituality or through "primitive" cultures shows that modern life was not welcomed by everyone.

POST-IMPRESSIONISM

United by their responsiveness to the stylistic innovations of Impressionism and their desire to make a distinctly modern art, the Post-Impressionists worked with a variety of styles, subjects, and techniques as they turned away from the Realist premises of Impressionism to create utopias and private or primitive worlds. Georges Seurat was the only one of the four major Post-Impressionists to continue to present images of modernity. Using scientific theories about optics and the psychology of color and line, he sought to present modern life in a controlled, idealistic way. Finding little solace in science or civilization, Paul Cézanne, Vincent van Gogh, and Paul Gauguin sought aesthetic (and often spiritual) authenticity by working outside the rush of Paris. Gauguin, in particular, attempted to adopt both the artistic habits and themes of cultures he believed to be more primitive than that of Paris, Europe, or America in order to produce artworks that conveyed honesty rather than artificiality, which he associated with modernity. Of course, not all Post-Impressionists left Paris to find the "truth." Henri de Toulouse-Lautrec instead turned an unblinking, sarcastic eye to the cafés, dance halls, and brothels of Paris.

SYMBOLISM

The search for escape from modern pressures and a desire for authentic experiences led the Symbolists in a very different direction. Rather than seeking inspiration in distant lands, the Symbolists turned instead to their own imaginations, seeing the mind as the only true vehicle for aesthetic transformation. Wild fantasies and strange imaginings characterize the work of many Symbolists. Mysterious narratives, as conveyed in Max Klinger's series *The Glove*, give many Symbolist works a dreamlike quality, where objects take on the function of personal talismans or fetishes, precisely the sort of visual fragments Freud was exploring in his contemporaneous work on dreams and the unconscious. Indeed, it almost seems as though a tortured unconscious is pouring forth from the agonized figure in Edvard Munch's *The Scream*.

ART NOUVEAU AND THE SEARCH FOR MODERN DESIGN

Art Nouveau was considered a modern style, the first to turn its back on revival styles and eclecticism and forge a new, fresh look in architecture and design. It especially relied on biomorphic motifs, which resulted in an organic style that broke down the box of conventional architecture and suggested growth and evolution, as can be seen in Victor Horta's Tassel House and Antoni Gaudí's Casa Milà. In addition to creating a fresh, new look that rejected the styles of the past, Art Nouveau was important for advocating tearing down the division between the fine and decorative, or applied arts, and the creation of total environments. These environments share with Symbolism a dreamlike fantasy quality.

AMERICAN ARCHITECTURE: THE CHICAGO SCHOOL

Many scholars date the rise of modern architecture to the skyscrapers that went up in Chicago in the 1880s and 1890s. Known as the Chicago School, the architects, who included Louis Sullivan, used new building materials and techniques to design what were considered tall buildings for their time. As important, they allowed form to follow function, making their designs reflect the metal grid skeleton of the building rather than incorporate historical styles. Frank Lloyd Wright also worked in Chicago, but is best known for his Prairie Houses. While the Chicago skyscrapers were remarkable for their exteriors, Wright also developed innovative interiors, with one space flowing into another, and then out to the exterior of the building and the surrounding land. Despite developing a modern architecture, Sullivan and Wright invested their structures with universal, spiritual qualities designed to make modernity more meaningful.

PHOTOGRAPHY

The late nineteenth century saw the development of the Kodak camera, which made picture taking ubiquitous and further challenged the notion that photography could be art. Art photographers increasingly turned to a style called Pictorialism, where photographs were made to look like fine art, such as paintings or drawings. Countering the crisp, sharp images of documentary photography, Pictorialists, such as Gertrude Käsebier and Edward Steichen, worked in soft-focus, even blurry styles that imitated painterly brushwork or dark chiaroscuro. Another aspect to the period's photography was a fascination with portraying movement, which resulted in sequence photography and ultimately moving pictures.

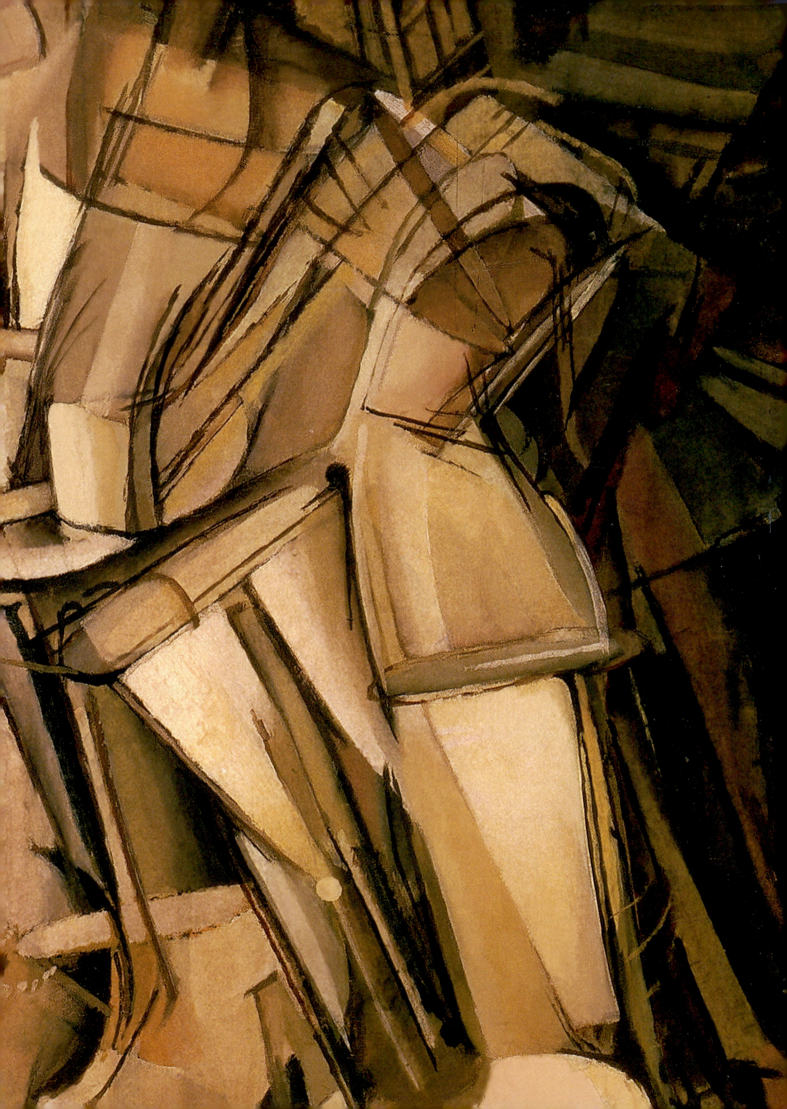

Toward Abstraction: The Modernist Revolution, 1904–1914

T IS TEMPTING TO VIEW THE FIRST YEARS OF THE TWENTIETH CENTURY AS A time of wholesale modernization, when traditional ideas and values joined the horse and buggy as outmoded and irrelevant. In reality, the situation was much more complex. Astonishing scientific discoveries and new modes of living did transform irrevocably the day-to-day existence of most inhabitants of the industrialized West. Yet, at the same time, traditional social values and habits of thought continued uninterrupted. A defining characteristic of early twentieth-century culture was the ability to reconcile the competing impulses of tradition and innovation. By knitting together the new and revolutionary with the familiar and enduring, a new social fabric was created.

In the political arena, imperialism continued to stoke nationalist ambitions and economic growth. This combination gave the West tremendous military and industrial strength but was also the root of its greatest weaknesses. Fervent nationalism led many toward a narrow patriotism, or chauvinism, that sharpened political, racial, economic, and religious differences. Of course, many rejected such ideas and instead embraced an Enlightenment-generated liberalism that exalted the individual over the state. But the intensifying nationalism and its accompanying imperialism won out, culminating in 1914 with the start of World War I, with most of Europe against Germany, Bulgaria, Austro-Hungary, and Turkey (see map 27.1). This conflict was so cataclysmic that it transformed utterly Western cultural assumptions and aspirations.

Scientific endeavors reveal clearly the interplay between tradition and innovation. By the turn of the twentieth century, scientists recognized that Newtonian physics could only partially explain the nature of atoms. Physicists sought to understand where Newtonian principles succeeded in predicting the structure and behavior of atoms and where they failed. One major breakthrough came via the experiments of Max Planck (1858–1947), who proved in 1900 that energy was not distinguishable from matter. He also showed that energy was emitted and absorbed in bundles called quanta, disproving the idea that energy existed in a stable, uniform state. Energy and, hence, matter were in constant flux. This concept was especially pertinent to the discovery of radioactivity in 1902 by Ernest Rutherford (1871–1937). In 1913, the atom itself was further redefined when Niels Bohr (1885–1962) declared that it consisted of protons and neutrons. But the greatest amendment to classical physics was proposed by Albert Einstein (1879–1955). Einstein's revolutionary proposals appeared in a series of papers published in 1905 and 1916, and they included his theory of relativity, which claimed that time, space, and motion were not fixed but all relative, especially in relation to the observer's own position. The Newtonian world order, based on notions of energy and matter that remained stable, was now supplanted by a more complex and contingent notion of the universe.

Similar ideas emerged in accounts of human behavior by philosophers and psychologists. Henri Bergson (1859–1941), a French philosopher, was so influential in the first years of the twentieth century that he was well known even to the general public. Bergson postulated that we experience life not as a series

Detail of figure 27.30, Marcel Duchamp, *Nude Descending a Staircase, No. 2*

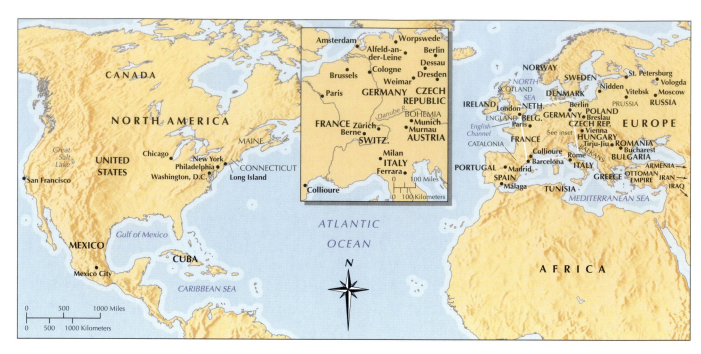

Map 27.1.　Europe and North America 1904–1914

of continuous rational moments, but as intuited random memories and perceptions that we then piece together to form ideas. The world, therefore, was complex and fractured, or as expressed by the Harvard philosopher and psychologist William James (1842-1910), whose theories independently paralleled Bergson's, a "booming buzzing confusion." Only intuition transcended this chaos. The mind, according to Bergson, was pure energy, an *élan vital* ("vital force") that penetrated the essence of all things. While Bergson was philosophically redefining consciousness, Austrian neurologist and founder of psychoanalysis Sigmund Freud (1856–1939) continued to refine his ideas of the unconscious through observations made during clinical practice, an approach that he felt gave his conclusions a scientific basis. Despite taking a different approach, Freud likewise developed a model of human consciousness as fragmented and conflicted.

Artists pursued similar lines of inquiry, testing traditional approaches to art making against new ideas. And, as did the philosophers and scientists discussed above, they used diverse measures to gauge their success. Some artists, like Pablo Picasso and Georges Braque, emulated scientists, treating their studios like laboratories where each creative breakthrough served as a steppingstone to the next, as they sought to develop a new model of visual perception. Others, such as the Italian Futurists, embraced modernity and used the radical stylistic developments of Picasso and Braque to capture the technological wonders and new psychology of the modern world. Others, however, like the German Expressionists, sought an antidote for the cold, impersonal tenor and crass materialism of modernity and tried to invest contemporary life with spirituality. Continuing Gauguin's quest to find a spiritual peace in a primitive world that was in tune with nature, many artists turned to the direct, more abstract vocabulary of tribal art as well as children's, folk, and medieval art. Many of these artists were heavily influenced by Theosophy (see page 919) and believed in the mystical interpenetration of all

things, which they sought to capture in their art and architecture. For artists attempting to visualize the spiritual, the essence of which is abstract, the new stripped down vocabulary of art was the perfect vehicle.

FAUVISM

The rise of Fauvism, the first major style to emerge in the twentieth century, is part of a colorist tradition that can be traced back through Van Gogh, Gauguin, Monet, and Delacroix to Titian and the Venetians. The Fauves, however, took the free, expressive use of color to new heights. Van Gogh and Gauguin had the greatest impact on the Fauves, as is readily apparent in the work of Henri Matisse (1869–1954) and André Derain (1880–1954). Matisse was well aware of the aesthetic traditions with which he was wrestling. Trained in the studio of Gustave Moreau (see fig. 26.16), Matisse had received an exacting academic education under the auspices of the École des Beaux-Arts. He understood the extent of his participation in and departure from tradition when, in 1905, he presented his latest pictures at the *Salon d'Automne,* or Autumn Salon, an important venue for vanguard artists. As exhibitions of avant-garde art proliferated in Paris at the turn of the century, the Salon d'Automne enjoyed a special status as a juried show where critics anticipated seeing the best of the new work. Few critics or other viewers for that matter were prepared for what they saw there in 1905.

By that year, Matisse had not only moved beyond his academic training with Moreau, but had passed through an Impressionist phase in the 1890s, then a Cézannesque period, and finally a Neo-Impressionist stage. Strongly influenced by the Post-Impressionists' use of color for formal and expressive ends, Matisse pushed even further the independence of color. His experiments proved too radical for some. Art critic Louis Vauxcelles was so shocked by the "orgy of pure colors" he encountered

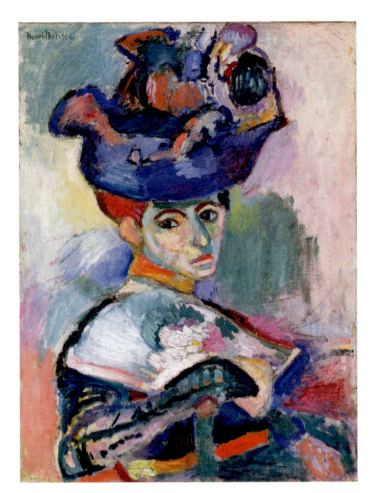

27.1. Henri Matisse. *The Woman with the Hat*. 1905. Oil on canvas, 31¾ × 23½″ (80.6 × 59.7 cm). San Francisco Museum of Modern Art. Bequest of Elise S. Haas. 91.161. © Succession H. Matisse, Paris/Artists Rights Society (ARS), New York

in the work of Matisse, Derain, and their colleagues at the Salon d'Automne that he declared the pictures *fauves*, or wild beasts.

A classic example of the Fauve work exhibited in 1905 is *The Woman with the Hat* (fig. **27.1**). While the subject evokes a tradition of coloristic, virtuoso portraiture that stretches back to Élisabeth-Louise Vigée-LeBrun, Peter Paul Rubens, and Titian (see figs. 22.10, 20.4, and 16.34, respectively), Matisse's use of color presents something totally new. Matisse constructed the portrait using primary and secondary colors that look as if he had squeezed them directly from the tube. As in the works of Cézanne, pigments both suggest and deny perspective space. The background splashes of greens, yellows, reds, and blues appear to reside on the same plane as the head and body in the foreground, locking all together as in one continuous flat mosaic. Matisse has dispensed with Cézanne's structure and monumentality, and instead achieves compositional coherence by balancing intense, complementary hues applied with brash, seemingly spontaneous brushwork.

Traditionally, art historians have placed the work of the Fauves in the category of Expressionism, but this is problematic, since the term generally applies to work displaying an outpouring of emotion—a tortured, anguished, or a pained state of mind. Despite the riot of color and chaos of brushstrokes, *The Woman with the Hat* is not about the sitter's or the artist's psychology. The figure is nothing more than an armature for an exercise in design and the release of color from a naturalistic or documentary function. The same is true of Matisse's landscapes and still lifes from this period as well.

André Derain, likewise, understood painting as an intellectual rather than emotional medium. His *Mountains at Collioure* (fig. **27.2**), a subject located in the south of France, where he was

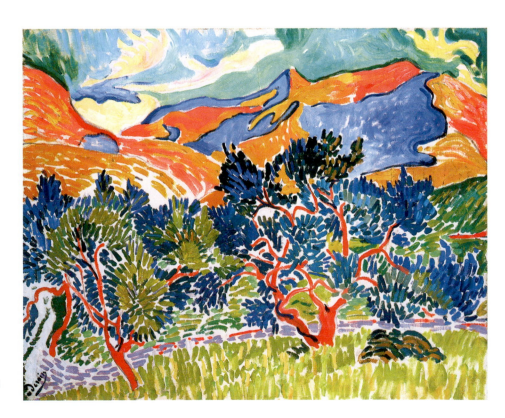

27.2. André Derain. *Mountains at Collioure*. 1905. Oil on canvas, 32 × 39½″ (81.5 × 100 cm). National Gallery of Art, Washington, DC. John Hay Whitney Collection. © Artists Rights Society (ARS), New York/ADAGP, Paris

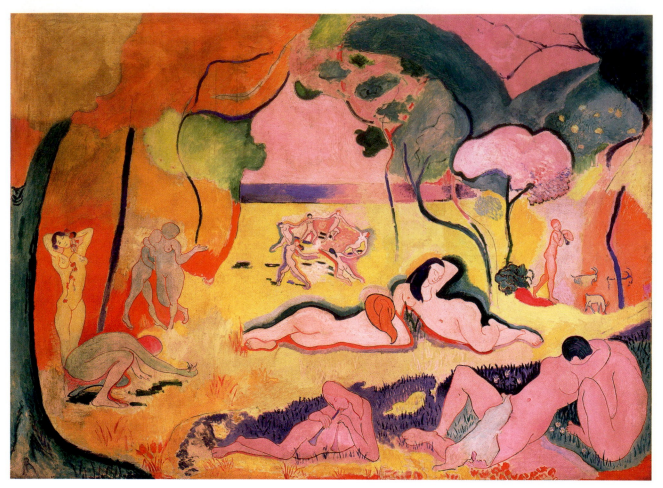

27.3. Henri Matisse. *Le Bonheur de Vivre (The Joy of Life)*. 1905–1906. Oil on canvas, 5′8″ × 7′9 ¾″ (1.74 × 2.38 m). The Barnes Foundation, Merion, Pennsylvania. © Succession H. Matisse, Paris/Artists Rights Society (ARS), New York

painting with Matisse in 1905, may seethe with Van Gogh's energetic brushwork and Gauguin's arabesques, but Derain did not intend it to embody those artists' spirituality or primitivism. Like the figure for Matisse, the landscape is just a vehicle for Derain's complex play of joyous color and surface design. Derain's overriding interest is in the *formal*—meaning abstract—qualities of image-making, with special emphasis on bright color in a nonrepresentational role.

The Fauves were never an organized group. The term was applied by critics to artists, many of whom had been friends since 1900, who used bright color and happened to show together at the Salon d'Automne of 1905, where the similarity of their work was recognized. By 1908, Fauvism had disintegrated. For Matisse, Fauvism was just one more stage toward making art that was, as he put it, "something like a good armchair in which to rest from physical fatigue." In other words, Matisse sought to use color in an abstract way that was beautiful, peaceful, serene, and sensuous.

We can see Matisse beginning to move out of Fauvism in his 1905–1906 painting *Le Bonheur de Vivre (The Joy of Life)* (fig. **27.3**). This work shows the influence not only of Derain's curvilinear patterning but also of firsthand experience with Gauguin's paintings. In fact, Gauguin's estate was being stored near Collioure, and Matisse visited the collection twice. The color remains intense and nonrealistic, but now it is contained in

graceful arabesques. Matisse's most innovative move here is to dispense with logical space and scale while increasing the abstraction. No matter how abstract and flat Derain's and Matisse's Fauvist pictures of just a year earlier are, they still project a rational progression of space. Now, in Matisse's work, that space is gone, as two enormous reclining nudes in the middle ground are as large if not larger than the pipe player and kissing couple in the foreground. Figures dissolve into one another and so do trees into sky and hills, so that it is nearly impossible to tell which sits in front of which. Reality gives way to a joyous abstract orchestration of colored lines and planes, which takes its hedonistic cue from the Classical idyll of dance, passion, and music making of Puvis de Chavannes (see fig. 26.5). We sense we are witnessing a primitive rite or bacchanal that takes place in a prehistoric time, when humans were still harmoniously integrated with nature. The pipes, garlands, shepherd, and sense of Graeco-Roman nudity evoke an archaic Classical world, the same world conjured by French painters like Poussin and Claude, (see figs. 21.7 and 21.8).

Because of the intensity of its color, *The Joy of Life* is generally labeled a Fauvist picture. By 1907, however, Matisse's palette, while still colorful, was subdued, becoming sensuous and serene rather than joyfully riotous. We can see this new sensitivity in his 1911 *The Red Studio* (fig. **27.4**). While the subject is again a conventional one—in this case, the artist's

studio—in Matisse's hands, the theme takes on new import. On the one hand, reassuringly familiar objects appear, such as pencils, a collection of studio props arranged as a still life, and even several of Matisse's own canvases. On the other hand, *The Red Studio* offers a viewer a completely novel visual experience through the manipulation of color and line to radically redefine pictorial space.

As the title indicates, the painting's keynote is the color red, which is like a flat window shade pulled through the entire canvas. Basically unvarying in tone, it momentarily becomes floor, wall, and tablecloth because of the white-line drawing, before popping back to the surface as a flat red shade. Even the white lines that delineate the table, high-backed chair, and wall, for example, and suggest recession and thus space, reinforce the two-dimensionality of the image, for they are not painted lines. Rather, they are slivers of canvas that Matisse has allowed to show through. The red itself is highly evocative. It is enticing, lush, sensuous, soothing, and comforting, telling us with extraordinary efficiency and immediacy that this studio is warm, cheerful, and relaxing. The paintings on the wall seem to float on this red field, asserting themselves as objects of pride and accomplishment. Matisse similarly highlights his box of pencils, plate, flowers, and chair, personal objects that must have been special to him. Only by dispensing with conventional space and volume, meaning realism, could Matisse push these objects to the fore and make them so prominent. The flat red field also allowed Matisse to create a wonderful syncopated rhythm with the paintings and other objects, producing a vitality that suggests artistic creativity, which complements the peacefulness of the room.

CUBISM

The second major style to emerge in the new century was Cubism, largely under the leadership of Pablo Picasso and Georges Braque. As much an analysis of artistic traditions and possibilities as an approach to making art, Cubism sparked new ways of thinking about the appearance and even the purpose of art. The journey to Cubism was a long one, however, starting only after both artists had fully absorbed the lessons offered by Post-Impressionism and Fauvism. Picasso was the first to press further the limits of abstraction observed by Cézanne, Derain, and Matisse.

Reflecting and Shattering Tradition: Les Demoiselles d'Avignon

Pablo Picasso (1881–1973) was born in the Spanish town of Malaga, on the Mediterranean coast, where he began his artwork under the direction of his father, who was a painter. At age 15 he moved to Barcelona and continued his training at the

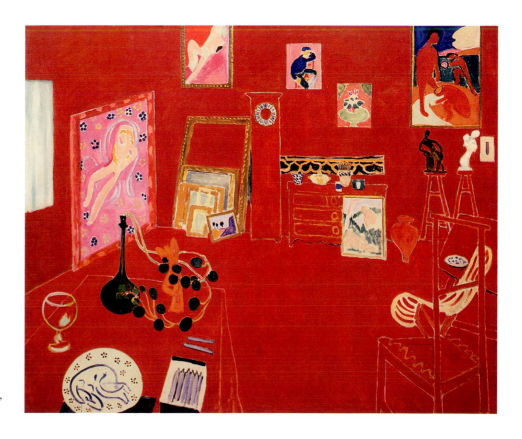

27.4. Henri Matisse. *The Red Studio*. 1911. Oil on canvas, 5'11¼" × 7'2¼" (1.81 × 2.19 m). The Museum of Modern Art, New York. Mrs. Simon Guggenheim Fund. © Succession H. Matisse, Paris/Artists Rights Society (ARS), New York

Escuela de Bellas Artes. He was soon a major figure in Barcelona's art community, working primarily in a Symbolist style. After roughly four years of shuttling back and forth between Barcelona and Paris and leading a desperate, abject existence, he settled permanently in Paris, moving into a run-down building nicknamed the "*bateau-lavoir*" ("laundry boat") in bohemian Montmartre, the hill overlooking the city. The neighborhood was a center for the impoverished cultural avant-garde, and Picasso quickly became part of the group's inner circle, which also included writers Max Jacob (1876–1944) and Guillaume Apollinaire (1880–1918). In 1907 Picasso shocked even his closest companions when he unveiled in his studio *Les Demoiselles d'Avignon (The Young Ladies of Avignon)* (fig. **27.5**). The painting's style departed sharply from Picasso's previous work. To his contemporaries, this large, frightening picture seemed to come out of nowhere.

Of course, the painting did not emerge from an aesthetic vacuum. Among Picasso's sources were the great French history paintings of the seventeenth and eighteenth centuries. The canvas he chose for the work is uncharacteristically large, consistent with the dimensions of a painting destined for the traditional salon. Another influence was the work of Matisse, with whom Picasso maintained a friendly rivalry until the older artist's death in 1954. In the case of *Les Demoiselles*, he was responding to the spatial ambiguity of Matisse's *The Joy of Life*, which Picasso felt compelled to upstage. These sources were not immediately apparent to visitors to Picasso's studio, and *Les Demoiselles* initially outraged Matisse and everyone else. But once understood, it provided inspiration for untold artists.

The title of the painting refers to the "red-light" district in Barcelona. Early studies show a sailor in a brothel, seated before a table with a plate of fruit and surrounded by prostitutes.

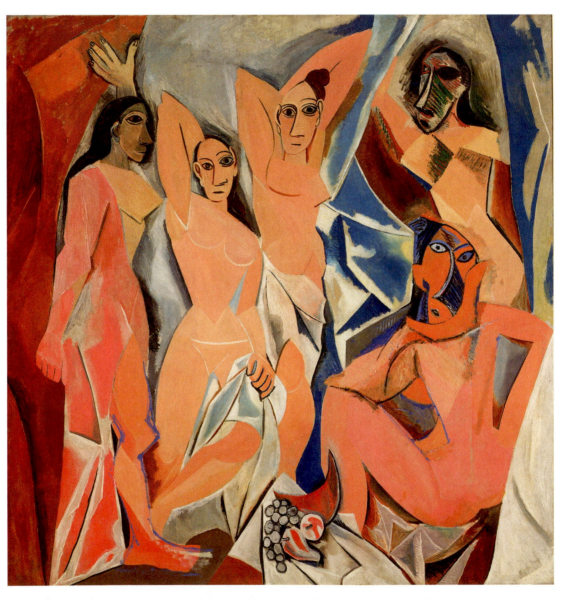

27.5. Pablo Picasso. *Les Demoiselles d'Avignon (The Young Ladies of Avignon)*. 1907. Oil on canvas, 8′ × 7′8″ (2.44 × 2.34 m). The Museum of Modern Art, New York. Acquired through the Lillie P. Bliss Bequest. © Estate of Pablo Picasso/Artists Rights Society (ARS), New York

The Myth of the Primitive

Over the past two decades, art historians have studied critically the practice by Western artists of borrowing themes and forms from non-Western art. Known as **primitivism**, this practice raises complex issues. Modern artists were attracted to non-Western artworks for aesthetic as well as ideological reasons. Aesthetically, the avant-garde saw these works as a means to escape the influence of Western artistic traditions, especially the Graeco-Roman tradition. Because non-Western artworks offered alternative ways of conceiving form and space, artists eagerly studied, collected, and emulated them. Ideologically, this fascination with non-Western cultures is an offshoot of Jean-Jacques Rousseau's eighteenth-century concept of the "noble savage": a belief that nonindustrialized, non-Western indigenous peoples were less civilized, more "natural" and in touch with nature than urban Western Europeans and that they could express their emotions, sexuality, and religious beliefs more directly. Many Western artists deliberately adopted a Westernized style of primitivism in emulation of these cultures in order to energize their artwork and find alternatives to centuries' old standards of beauty, standards that seemed to many to be exhausted or irrelevant.

Among the European Modernists who pursued primitivism were Pablo Picasso and Ernst Ludwig Kirchner, both of whom collected and drew inspiration from African and Oceanic art. Before European artists came in contact with African or Oceanic art, however, they turned to peasant culture for a view of "primitive" life. The progression of this notion from the domestic to the exotic is exemplified by Paul Gauguin, who sought out primitive inspiration first in the peasant culture of the French province of Brittany, as in *The Vision after the Sermon* (see fig. 26.13), before going farther afield to Tahiti, as in *Where Do We Come From? What Are We? Where Are We Going?* (see fig. 26.14).

Agrarian and subsistence-based cultures were not the only sources for primitivism. For example, Matisse's development of flat decorative patterns, as in *The Red Studio* (see fig. 27.4), was inspired by his travels in Islamic North Africa, a region with an advanced trade economy and urban centers. Thus, we use the term *primitivism* to describe borrowings from diverse cultures that had little in common except their place in the Western imagination. Some artists even turned to works by children or the insane in their quest for primitive sources. The willingness of these avant-garde artists to equate non-Western artworks with works by children or the insane as equally "primitive" points to a widely held perception of non-Western cultures as untutored, immature, and irrational, ignoring the research of anthropologists who found so-called primitive cultures as complex and sophisticated as Western civilization.

Generally speaking, when European artists looked at non-Western art, they did not care to understand it in the same way that they appreciated art of their own cultures. Because many of the masks and other carvings that arrived in Europe in the early twentieth century were essentially the spoils of colonialism, much information about them had been lost. Western artists approached these objects without knowing the artists' names, the cultures that produced them, the ways in which they were carved, and the cultural contexts in which they were originally used and viewed.

By the mid-twentieth century, when many anticolonialist movements were well underway it was clear that the West's attitude toward non-Western art and cultures was extremely problematic. The field of postcolonial studies came into being with the publication of Edward Said's book *Orientalism* (1978). Said argued that Western, especially imperialist, societies defined themselves in opposition to the cultures they dominated. Focusing on colonialist literature, Said showed that non-Western societies were characterized as uncivilized, chaotic, and violent and were seen in contrast to the advanced, rational, and benevolent societies of the West. Said's observations applied equally to visual representations of colonized cultures. For the past two decades, art historians have researched the political as well as aesthetic significance of primitivism.

The sailor is now gone, but the theme remains, for we, the viewers, are seated in place of the sailor at the table in front of the fruit, an age-old symbol of lust. Coming through the brothel curtains and staring directly at us are five of the most savage, confrontational nudes ever painted. Thematically, then, the picture began as a typical Symbolist painting about male lust and castrating women. From its inception, then, the *Les Demoiselles* represented a continuation of the femme fatale theme prevalent in late nineteenth century art and literature. The painting also speaks to Picasso's personal ambivalence toward women and his intense fear of venereal disease.

Instead of relying on conventional forms of pictorial narrative to tell his tale, Picasso allowed the abstract qualities of the medium to speak for him. The formal qualities are threatening and violent. The space is incoherent and jarring, virtually unreadable. The entire image is composed of what looks like enormous shards of glass that overlap in no comprehensible way. Instead of receding, they hover on the surface of the picture plane, jostling each other. Sometimes the facets are shaded, as in the diamond-shaped breast of the harlot parting the curtain on the right, but Picasso has reversed the shading, in effect, detaching the breast from the body. Even more incomprehensible is the seated figure below her, who has her back to us yet simultaneously faces us. The table with fruit is tilted at such a raking angle it would shock even Cézanne, who provided the most immediate model for this spatial distortion (see fig. 26.2) and was the subject of a major retrospective in Paris in 1907. The menacingly pointed melon sets the shrill tone for the picture and through its unsubtle phallic erection announces the sexual theme.

The use of conflicting styles within a single picture is another disturbing quality. The three nudes to the left with their almond-shaped eyes and severe facial features were inspired by ancient Iberian sculptures, which Picasso collected. But the frightening faces on the right are entirely different. At this point in the creation of the painting, or so the story goes, Picasso's Fauve friends took him to the Trocadéro Museum of ethnographic art, where he saw African masks, providing the source for the ski-jump noses, facial scarifications, and lopsided eyes. The story seems logical enough. We know Matisse and Derain were already collecting African art, and that Picasso and Matisse had known one another since 1905. Direct

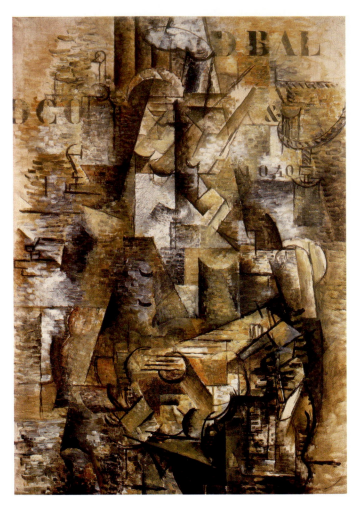

27.6. Georges Braque. *The Portuguese*. 1911. Oil on canvas, $45\frac{7}{8} \times 32\frac{1}{8}$″ (116 × 81.6 cm). Kunstmuseum, Basel. Gift of Raoul LaRoche, 1952. © Artists Rights Society (ARS), New York/ADAGP, Paris

sources for Picasso's borrowings can be found in African sculpture, and the abstraction and "barbarism" of the masks must have appealed to the artist's sensibility. (See *The Art Historian's Lens*, page 951.)

Picasso adamantly denied the influence at this time of *art nègre*, as African art was then called, although he would soon collect it himself. And, sure enough, in the early 1990s, art historians discovered that his source was most likely his own imagination. Doodlings that predate his exposure to African art appear in his sketchbooks. The striations, for example, were notational marks for shadow. The head of the crouching demoiselle was actually the result of the witty transformation of a female torso into a face (visual double-entendres occur frequently in Picasso's art). But given Picasso's friendship with the Fauves, it is hard to imagine that he had not heard about and visited the Trocadéro Museum before he finished the painting.

Regardless of his sources, what cannot be denied is Picasso's willingness to look anywhere for inspiration, from the lowly source of his own caricaturing to African masks (then considered artifacts and not art), to Classical Greek sculpture, reflected here by the tradition of the monumental nude, which Matisse had presented so differently in the *The Joy of*

Life. But most important about *Les Demoiselles* is the new freedom it announced for painting, for now line, plane, color, mass, and void were freed from their representational role to take on a life all their own. The picture laid the foundation for Analytic Cubism.

Analytic Cubism: Picasso and Braque

It may seem incredible that *Les Demoiselles* owes anything to the methodical, highly structured paintings of Cézanne, but Picasso had carefully studied Cezanne's late work and found in his abstract treatment of volume and space the basic units from which to derive the faceted shapes of what became Analytic Cubism. Picasso did not arrive at this style on his own, however, and even seemed creatively stalled after *Les Demoiselles*. To help him move beyond this point, the emotional Spaniard needed an interlocutor, a steadying force, someone with whom he could discuss his ideas and experiment. This intellectual partner was the French artist Georges Braque (1882–1963), who conveniently lived around the corner from him in Montmartre. From 1908 to 1910 the two fed off each other, their styles developing from a representational picture of fractured forms and space like *Les Demoiselles* to a shimmering evanescent mirage of abstract lines and brushwork like Braque's *The Portuguese* (fig. **27.6**) of 1911. Picasso and Braque were so intertwined that their styles began to merge by 1910.

The Portuguese is a classic example of the Analytic Cubism that had emerged in 1910. Gone is the emotional terror and chaos of *Les Demoiselles*. Braque arranged a grid of lines following the shape of the canvas and an orderly geometric pattern of diagonal lines and curves, all recalling Cézanne's vision of a tightly structured world. Despite being abstract, however, these shapes also represent signs. The circle at the lower center is the sound hole of a guitar, and the horizontal lines are the strings, although Braque used the same sign to indicate fingers, a confounding or visual punning of objects that is characteristic of Cubism. The stenciled letters and numbers are borrowed from a poster that probably read "Grand Bal" and listed the price of admission (10 francs, 40 centimes). The lines and shadows suggest arms, shoulders, and the frontal pose of a figure tapering toward the head. Behind the figure hangs a poster and, in the upper right, we see the harbor from a window. By providing these subtle visual clues, Braque prompts the viewer to recognize that the painting shows a guitar player in a Marseilles bar. Once again, we find a conventional subject—a genre scene—presented with a radical new artistic language. The atmosphere and light that floods the picture and falls on individual facets seems real or naturalistic but fails to create coherent space and volume. Ultimately everything is in a state of flux without absolutes, including a single interpretation of reality. The only reality is the pictorial world of line and paint. In a 1909 review of Braque's earlier work, Louis Vauxcelles, who had named Fauvism, labeled the paintings *Cubism*, influenced by Matisse's description of earlier Cubist works as appearing to be made of little cubes. The word was then applied to the analytic experiments of Braque and Picasso.

Synthetic Cubism: The Power of Collage

To focus on structure and line, Picasso and Braque painted monochrome images, thus removing the problem of color from their Analytic Cubism. This situation changed in 1912, however, when they began working in collage, pasting flat objects, generally paper, onto the canvas. Picasso made the earliest known example in May 1912, when he glued onto the surface of a painting a sheet of imitation chair caning, a product not unlike contact paper. (These oilcloth sheets with a chair-caning pattern printed on them were normally pasted on wood as an inexpensive way to repair a broken seat.) This device allowed him to complicate notions of the real and the illusionistic, for the chair caning was simultaneously real—a piece of real imitation chair caning—and illusionistic, a picture of chair caning.

Picasso and Braque realized immediately the broader implication of this daring move. The pasted image now literally sat on top of the canvas, a statement Matisse had made a year earlier in *The Red Studio* when he revealed the canvas to emphasize how paint sat atop its surface. Once and for all, the Renaissance conception of the picture plane as a window into an illusionistic world was shattered. Instead of a window, the picture surface became a tray on which art was served. Art occurred in front of, not behind, the canvas, a fact Edouard Manet had implied some 50 years earlier (see page 870).

Collage changed completely the way in which Braque and Picasso made their images. Instead of breaking down or abstracting an object into essential forms, the artists now synthetically constructed it by building it up or arranging it out of cut pieces of paper, hence the name Synthetic Cubism. Constructing the image out of large, flat shapes meant that they could introduce into Cubism a variety of textures and colors, as seen in Picasso's *Guitar, Sheet Music, and Wine Glass* (fig. **27.7**) of 1912. Because music is abstract, like their art, it became a favorite theme for the Cubists, who wished to establish parallels between the two art forms. Picasso built his composition on a background of real wallpaper that, like the imitation chair caning used earlier, serves as a visual pun on illusion and reality.

Picasso puns with solid forms and intangible space as well. The guitar sound hole, an element that should be negative space but appears as a solid circle of paper, contrasts with the wine-glass in the Analytic Cubist drawing, which should be three dimensional and solid but instead consists of lines on a flat piece of off-white paper that has more physical presence than the drawn glass. Picasso even tells us he is punning, for he has cropped the newspaper collage at the bottom to read LE JOU, a shortening of *Le Journal*, or "newspaper," which in French sounds like the verb *jouer*, meaning "to play" or the noun *jouet*, meaning "toy." The headline for the article is "*La Bataille s'est engagé*," which translates as "The Battle Has Started," and refers to the violent war then raging in the Balkans, with Greece, Serbia, Bulgaria, and Montenegro fighting for independence against the Ottoman Empire (see map. 27.1). Picasso uses the announcement to signal the friendly rivalry between himself and Braque. Possibly, he is subtly contrasting the sensual pleasure of his still life and comfortable bourgeois living with the horrendous suffering of the Balkan conflict, in effect commenting on French or middle-class indifference to the tragedy occurring to the east.

The logical peak of Cubism occurred when Picasso extended Synthetic Cubism to sculpture and created the first **construction**, a three-dimensional assemblage of materials. Although his earliest construction was made in 1912 (and evidence suggests Braque had made some even earlier), Picasso did not produce a large number of these sculptures until 1914–1915; most were musical instruments, such as *Violin*

ART IN TIME

1905—Albert Einstein formulates his Theory of Relativity
1907—Pablo Picasso's *Les Demoiselles d'Avignon*
1911—Georges Braque's *The Portuguese*
1913—Igor Stravinsky's ballet *The Rite of Spring*
1914—James Joyce publishes *Ulysses*

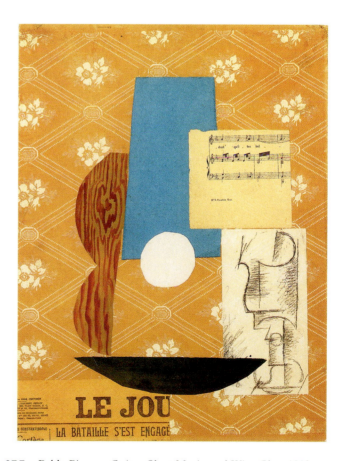

27.7. Pablo Picasso. *Guitar, Sheet Music, and Wine Glass*. 1912. Charcoal, gouache, and pasted paper, $24^5/_8 \times 18^1/_2$" (62.5 × 47 cm). The McNay Art Institute, San Antonio, Texas. Bequest of Marion Koogler McNay. © Estate of Pablo Picasso/Artists Rights Society (ARS), New York

(fig. **27.8**) of 1915. Instead of pasting paper to canvas, he assembled flat or slightly bent sheets of painted metal into a low relief. Just as he had for painting, he now redefined sculpture. Instead of being carved, chiseled, or molded, his sculpture was assembled, and, unlike most sculpture since the Renaissance, it was painted. He used paint perhaps with a bit of irony, since the cross hatching used to represent shading in painting is unnecessary for a sculpture, the three-dimensional form not requiring illusionistic shadow. Again Picasso creates puns about the medium. Without knowing the title, a viewer could not know for certain that this work represents a violin. That is not the issue, however, for Picasso is more concerned with creating a visual equivalent to music—here a staccato rhythm of shape, color, and texture—that transforms the individual metal pieces into playful musical notes that we can almost hear.

The outbreak of war in 1914 disrupted daily life, bringing an end to the brilliant visual game between Picasso and Braque. By then, the two artists had completely transformed painting and sculpture, undermining some 700 years of tradition by destroying notions about what art forms could be. Conventional systems for representing perspectival space were demolished and now line and color conveyed formal or expressive content instead of serving to duplicate observed reality.

Braque and Picasso sparked a revolution in our perception of reality as radical as those of Freud and Einstein. Music and literature were undergoing similar transformations. For example, Russian composer Igor Stravinsky (1882–1971) changed the face of music with his primitive, rhythmic ballet score *The Rite of Spring*, first performed in 1913 in Paris, where it caused a riot because people perceived it as cacophonous. Irish author James Joyce (1882–1941) similarly dismantled and restructured the novel in *Ulysses*, begun in 1914, in which he disrupted the continuity of the narrative by giving the reader multiple views of the character's personality and psychology.

Especially close to the Cubists, however, was the writer Gertrude Stein (1874–1946), who with her brother Leo amassed an astonishing collection of works by Picasso and Matisse, which they displayed in their Paris apartment. Stein is famous for such passages as "Rose is a rose is a rose is a rose" or "Out of kindness comes redness and out of rudeness comes rapid same question, out of an eye comes research, out of selection comes painful cattle." Inspired by Cézanne, her novels and poems have a stream-of-consciousness and fractured abstract quality meant to evoke "the excitingness of pure being." Like Cubism, Stein's rhythmic "word-paintings" deny any absolutes.

THE IMPACT OF FAUVISM AND CUBISM

Matisse's and Picasso's liberation of color and line from illusionistic roles marked important steps in the development of modern art. As innovative as their achievements were, their interests and sensitivity during these years were limited. Their works were rational, intellectual, and pleasurable, and they focused on such traditional subjects as still life, portraiture, and the figure. Yet they provided a new artistic vocabulary for

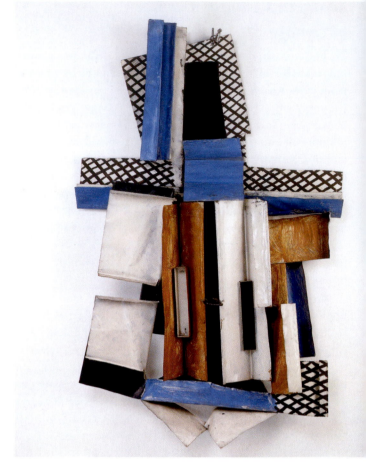

27.8. Pablo Picasso. *Violin*. 1915. Construction of painted metal, $37\frac{1}{2} \times 25\frac{5}{8} \times 7\frac{1}{2}$ " (94.5 × 65 × 19 cm). Musée Picasso, Paris. © Estate of Pablo Picasso/Artists Rights Society (ARS), New York

artists with very different interests and concerns, artists who used this new language to project powerful emotions, spirituality, and the intensity of modernity.

German Expressionism

The long tradition of Expressionism in German art extends back to the grotesque physical and psychological tensions of such Renaissance artists as Matthias Grünewald (see fig. 18.13) and Albrecht Dürer (see fig. 18.17). German Expressionism surfaced as a cohesive movement, however, toward 1905, and although it encompassed a range of issues and styles, it can be characterized as tortured, anguished, brutally primitive, or passionately spiritual, reflecting elemental cosmic forces.

A precursor of the first German Expressionist movement is Paula Modersohn-Becker (1876–1907), whose career was cut short by her early death at the age of 31. Her artistic activity was limited to two mature years, during which she produced remarkable pictures that promised a brilliant future. In 1898, she settled in in the commune of Worpswede, a haven for artists and intellectuals seeking escape from modern urban life, just outside Bremen in north Germany. There, she befriended two major Symbolist writers, the poet Rainer Maria Rilke (1875–1926) and the novelist Carl Hauptmann (1862–1946),

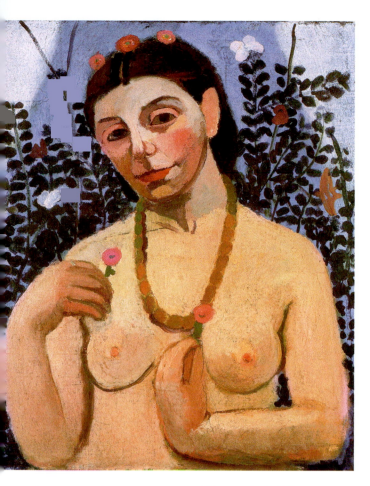

27.9. Paula Modersohn-Becker. *Self-Portrait*. 1906. Oil on canvas, 24 × 19¾″ (61 × 50.2 cm). Öffentliche Kunstsammlung Basel, Kunstmuseum, Basel, Switzerland. © Paula Modersohn-Becker

both of whom urged her to seek the spiritual in her art and to reject the naturalistic. Modersohn-Becker visited Paris regularly, and in 1905–1906 she was especially influenced by exhibitions of works by Gauguin and Cézanne.

The emergence of her individual style is represented by her 1906 *Self-Portrait* (fig. **27.9**). In this revolutionary self-portrait, the artist presents herself nude. With this gesture, Modersohn-Becker reclaims the nude female form for women, endowing it with creative vitality and agency, challenging the tradition of the passive nude Venuses and bathers popular since the Renaissance. The artist presents herself as an emblem of fertility, an earth goddess. Showing herself frontally, like an icon, she reduces her contours to a Gauguin-like curvilinear simplicity. Her awkward yet charming pose suggests the primitive, recalling especially Gauguin's Tahitian women (see fig. 26.14); her amber necklace even resembles a lei. She poignantly displays two small flowers, symbols of fertility, which she has colored and shaped similarly to her nipples. Also symbolic of fecundity is the garden in which she depicts herself. A celestial blue halo deifies her and reinforces her elemental presence. What is revealing about the image is Modersohn-Becker's German primitivism, which differs so radically from that of Gauguin. There is a cultivated crudeness throughout the picture,

reflected in the pasty application of paint, particularly in the masklike face and neck, and the awkward gestures, especially of her left hand. It appears as well in the ungainly flat ear and coarse fingers of the right hand. Despite the beautiful colorful palette, we sense a raw, primal energy and an earthiness, characteristics of much German Expressionism.

DIE BRÜCKE (THE BRIDGE) Scholars generally assert that German Expressionism began with *Die Brücke* (The Bridge), a group conceived in 1903 when four Dresden architecture students, including Ernst Ludwig Kirchner (1880–1938) and Erich Heckel (1883–1970), decided to form an art alliance "to clear a path for the new German art." In 1905, the group officially formed and went public with no artistic program other than to oppose "older well-established powers" and create a "bridge" to the future. Like so many progressive Germans, their vision was formed by the philosopher Friedrich Nietzsche (1844–1900). In his most famous book, *Thus Spoke Zarathustra* (1883–1885), Nietzsche called for the rise of an *Übermensch*, or "superhuman," a youthful noble of superior intellect, courage, fortitude, creativity, and beauty who would dominate the inferior masses huddling safely in the conventional, restrictive past. This strong-willed *Übermensch* would be the "bridge" that would lead the world into a glorious future of new ideas.

The initial problem confronting these largely self-taught artists, who shared a communal studio in a former butcher shop, was to find subject matter and a way to express it. Initially they focused on the unsettling psychology of modern Germany and turned to intense color to express it. Kirchner, the leader of *Die Brücke*, was the first to mature artistically, about 1907, as seen in his *Street, Dresden* (fig. **27.10**) of 1908. The group's love of Van Gogh and their recent discovery of Matisse are reflected in the intense Fauvist color liberated from a representational role. As important is the impact of Edvard Munch (see fig. 26.21), who

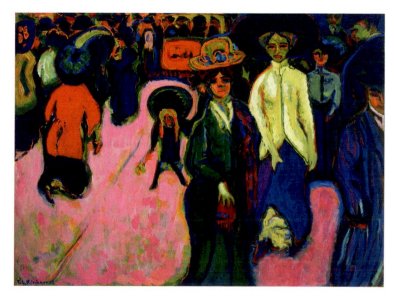

27.10. Ernst Ludwig Kirchner. *Street, Dresden*. 1908 (dated 1907 on painting). Oil on canvas, 4′11¼″ × 6′6⅞″ (1.51 × 2 m). The Museum of Modern Art, New York. © by Ingebourg and Dr. Wolfgang Henze-Ketter, Wichtrach/Bern

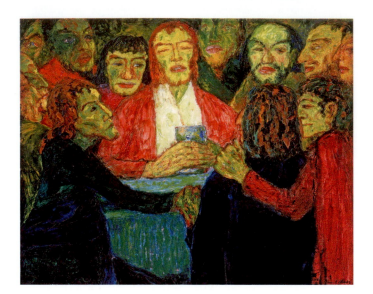

27.11. Emil Nolde. *The Last Supper*. 1909. Oil on canvas, 32½ × 41¾" (86 × 107 cm). Kopenhagen Statens Museum for Kunst Wvz Urban 316. © Nolde-Stittung Seebull

exhibited throughout Germany and often resided in Berlin after 1892. The disturbing psychological undertones and arabesque patterning are decidedly Munch-like, and Kirchner's crowded street evokes a claustrophobic anxiety worthy of Munch. Like most Munch images, this one focuses on sexual confrontation. Wraithlike women stare out. One, dressed in yellow, lifts her dress to reveal her petticoat. Searing pinks, yellows, and oranges contrast with electrifying blues and greens, creating a disturbing dissonance and sexual excitement. This picture could never be mistaken for one by Matisse.

In 1906, the Berlin artist Emil Nolde (1867–1956) had a one-person show at the Galerie Arnold in Dresden. The *Brücke* artists were so captivated by Nolde's powerful use of color that they invited him to join the group. Older than the other members, he lasted only a year, for his brooding nature and highly personal style were not really compatible with the group's communal mission. Still, his preoccupation with intense emotion and color conformed to the direction in which the group was heading, in part due to his influence. In 1909, after recovering from a serious illness, he made a series of religious pictures, including *The Last Supper* (fig. 27.11). Nolde claimed that in this picture he "followed an irresistible desire to represent profound spirituality, religion, and tenderness." This painting, created in a flurry over several days, is about emotion, his own as well as that of Jesus and the apostles. Nolde crowds the figures and presses them to the surface of the picture plane, making their passions ours. A somber yet spiritual red dominates, contrasted by its complement green and laced with yellows and blues, making the surface appear to burn with emotion. He used bold slabs of paint to crudely construct faces and bodies, an effect difficult to see in reproductions. A brutal angularity occasionally appears in chins and noses, and color patterns have jagged edges, as in the hair of the foreground figures.

At first the faces look like masks and are almost grotesque. These are not Ensor masks (see fig. 26.20), however; nor are they masks at all. The distortions and strident gestures, both figural and painterly, underscore the powerful scene. The rawness of the figures enhances the direct emotional force. It also makes the protagonists appear more human and earthy, para-

doxically more real despite their sketchiness. By this point in his career, Nolde regularly visited the Völkerkundemuseum in Berlin, drawn to the spirituality and emotionalism of the tribal artifacts displayed there. Here we can sense his adoption of the abstraction and directness of these works in an effort to create similar powerful psychological effects.

The ranks of *Die Brücke* gradually expanded to eight or nine artists, but by 1909, they began moving one by one to Berlin. There they found a more sophisticated art scene, dominated by Herwarth Walden's avant-garde art publication *Der Sturm*, begun in 1910, a concept he expanded into a gallery by 1911. By that year, all the *Brücke* artists had relocated, although the group did not disband until 1913. Heavily influenced by Cubism, their style began to change as well. Most abandoned the undulating contours of Munch and the *Jungendstil* (German Art Nouveau) and embraced a fractured planarity and geometric linearity.

This new style that emerged toward 1910 can be seen in Erich Heckel's *A Crystal Day* (fig. 27.12) of 1915. Although *Die Brücke* artists retained the linear look of Cubism, they generally used it to create psychological tension rather than a complicated pictorial space. In this work, Heckel uses Cubist line and fracturing of space to portray abstract, universal ideals. While Kirchner portrayed the psychologically debilitating and moralistically bankrupt side of modernity, Heckel presented the antidote, a Rousseauian elemental, almost primitive, unification with nature and its universal forces. In *A Crystal Day*, Heckel captures cosmic forces through the energy of his colorful lines that, especially in sky and lake, look like a painterly abstract Cubist composition. Similar asymmetrical jagged shapes are echoed throughout, locked in a tight mosaic. Even the angular figure, reduced to a simplified form and vaguely reminiscent of the African sculpture the group so admired, is closely woven into the linearity of the land. Heckel gives us the feeling of a common life force surging through all of nature, binding everything together.

In their quest to create a nationalistic art, *Die Brücke* artists revived the printmaking technique of woodcut, favored by German artists during the early Renaissance. (See *Materials and Techniques*, page 958.) Adding to the medium's attraction was its rawness—one can sense the grain of the wood, which gives not only a stridency but also an earthly, organic feeling to the images. These qualities can be readily seen in Kirchner's *Peter Schlemihl: Tribulations of Love* (fig. 27.13) of 1915, one of a series Kirchner created to illustrate the prose tale *Peter Schlemihl's Wondrous History* (1814) by Adelbert von Chamisso (1781–1838), which tells the tale of a man who sells his shadow (soul) for a pot of gold. This colored woodcut shows the use of the ambiguous space of Cubism to project the invisible inner workings of the mind and to juxtapose that with the representational world. Here we see a man next to a manifestation of his psychosexual conflict. Spatial dislocation, a splintering sharpness to the edges, a chaotic composition, and the touches of emotion-evoking color (a passionate violent red and a chilling

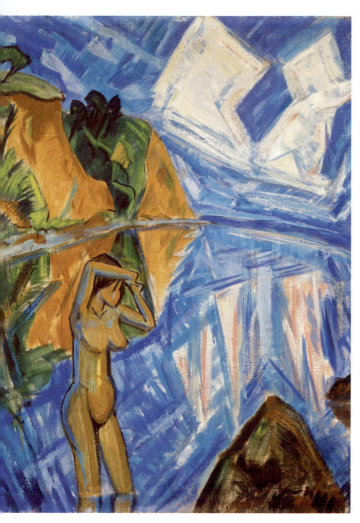

27.12. Erich Heckel. *A Crystal Day*. 1913. Oil on canvas, 47¼ × 37¾ ″ (120 × 96 cm). Pinakothekder Moderne, Munich. Loan from Collection of Max Kruss, Berlin. © Artists Rights Society (ARS), New York/ADAGP, Paris

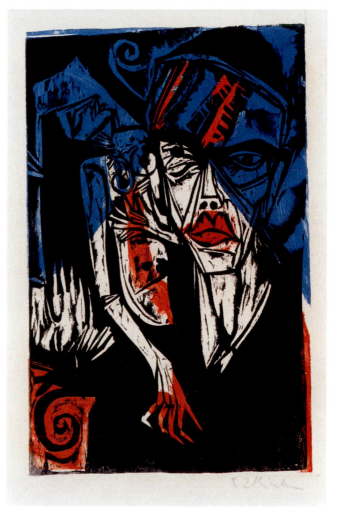

27.13. Ernst Ludwig Kirchner. *Peter Schlemihl: Tribulations of Love*. 1915. Color woodcut from two blocks on wove paper, 13⅛ × 8¼ ″ (33.6 × 21.7 cm). National Gallery of Art and Brücke Museum. Collection of Karl and Emy Schmidt-Rottluff. © by Ingebourg and Dr. Wolfgang Henze-Ketter, Wichtrach/Bern

melancholy blue)—all abstract qualities—create an unsettling and distressing image. Kirchner, like Heckel, displays a Brücke reliance on African sculpture, seen especially in the sharp angularity and faceting of the man's face, although this time he uses it to impart a brutal harshness.

DER BLAUE REITER (THE BLUE RIDER) The second major German Expressionist group, *Der Blaue Reiter* (The Blue Rider), developed in Munich, in southern Germany. It lasted but four months, from December 1910 to March 1911. Like their *Brücke* counterparts, the artists associated with *Der Blaue Reiter* drew on art forms from Western art history as well as non-Western and folk art traditions to create images that reveal their skepticism toward modern, industrial life. The group focused on visually expressing a spirituality they believed resided beneath the surface of the visual world.

The key figure in *Der Blaue Reiter* was the Russian artist Vasily Kandinsky (1866–1944). He left Moscow in 1896 to study art in Munich and brought with him Russian influences, namely the spirituality of native religious icons and the robust, emotional

colors of folk art. His interest in folk culture was rekindled when, in 1908, he moved with painter Gabriele Münter (1877–1962) to Murnau, just south of Munich in the Bavarian Alps. There he immersed himself in folk culture and was deeply affected by the powerful colors and the directness of the decorations and paintings on glass, a medium that he and Münter adopted. The couple also lived in the Schwabing neighborhood of Munich, a bohemian enclave of cafés and liberalism. The area was a breeding ground for explorations of spirituality and the occult, where Theosophy was daily conversation. A mystical philosophy that attracted numerous adherents in the early twentieth century, Theosophy promoted spiritual attainment through meditation and esoteric teachings. Kandinsky owned the book *Theosophie* by German philosopher Rudolf Steiner (1861–1925) and attended his Theosophy lectures in Berlin in 1908. Inspired in part by Steiner's ideas, Kandinsky in 1910 wrote *Concerning the Spiritual in Art*, published the next year and read worldwide. He proclaimed the need to paint one's connectedness with the universe and to use an abstract vocabulary, one that functioned much like music, to portray the abstract qualities of spirituality.

The Woodcut in German Expressionism

Some of the best-known European artists in the fifteenth and sixteenth centuries practiced the printmaking medium of the woodcut, but by the early nineteenth century this method was eclipsed by commercial print technologies, such as wood engraving and lithography. These technologies produced images of great detail that could be executed rapidly and mass-produced. In the late nineteenth century, however, European painters and sculptors returned to the woodcut as an artistic medium precisely because it produced a crude, unsophisticated look in contrast to the slick techniques of modern image reproduction.

Japanese woodblock prints were the elaborate product of a series of designers, block cutters, and printers, and Europeans in the mid-nineteenth century avidly collected them. In the 1890s Edvard Munch and Paul Gauguin reinvented a very different form of the woodblock print, or woodcut, as did such German Expressionists as Ernst Ludwig Kirchner (see fig. 27.13) and, somewhat later, Käthe Kollwitz in the early 1900s. Their simplified, handmade process contributed to the planar effect of flat, simplified shapes, which can evoke strong emotional tensions. Unlike the division of labor characteristic of the production of Japanese prints and those of Northern Renaissance artists such as Albrecht Dürer, these modern artists designed, cut, and printed the woodcuts themselves. They could thus exploit unforeseeable expressive qualities in the wood grain that became evident only during the carving process. Munch developed an influential technique in which he cut the block into jigsaw pieces that were inked individually, reassembled, and printed, resulting in a multicolor print produced in one pull through the press. The Kirchner woodcut seen in figure 27.13 was printed from two blocks.

Although many prints by these artists appear spontaneous or perhaps haphazard, they are in fact the result of deliberate forethought: The block had to be cut in such a way that the wood remaining in relief, when rolled with ink, produced the sought-after image. There was no room for error, for the artist had not only to plan the positive and negative spaces but also to reverse his intended picture because, when printed, the impression created is a mirror image of the original woodblock design.

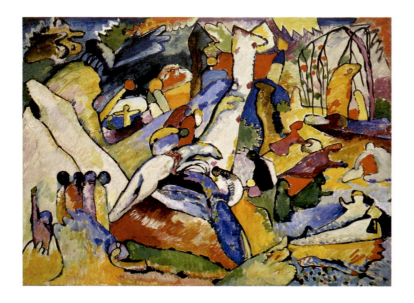

27.14. Vasily Kandinsky. *Sketch for "Composition II."* 1910. Oil on canvas, $38^1/_2 \times 51^5/_8$" (97.5 × 131 cm). Solomon R. Guggenheim Museum, New York. 45.961. © Artists Rights Society (ARS), New York/ADAGP, Paris

Despite his rhetoric about abstraction, Kandinsky was reluctant to let go of representational imagery, fearing audiences would not understand his paintings. This hesitancy is visible in *Sketch for "Composition II"* (fig. **27.14**) of 1910. Despite appearing abstract, the work is filled with recognizable forms—figures, mountains, waves, trees, flowers, the sun, and even Russian onion-domed cathedrals, now reduced to balls on sticks that resemble the foreground figures. Featured in the center foreground are two horses, one white, one blue, with riders. The horse and rider motif is common in Kandinsky's oeuvre, often interpreted as a reference to the artist himself and his idol St. George, the biblical dragon slayer, and their parallel quest to bring a new spirituality into the world. Kandinsky's palette has the festive coloration of folk art, although it still retains from his Murnau pictures of the year before a residue of the deep saturation of medieval stained-glass windows, evoked especially by the dark outlines suggestive of lead dividers. The bowed heads of the processional figures on the left add a reverent, even religious, note, while the mirthful reclining of animated forms on the right suggest a classical idyll, reminiscent of Matisse's *The Joy of Life*. His goal was to portray not just his emotions, feelings, or states of mind but also this cosmic power as he felt it within himself.

Kandinsky made a total of ten "Compositions," and by 1911 they had become entirely abstract, as seen in *Sketch I for "Composition VII"* (fig. **27.15**). Painted in 1913, this was one of numerous preliminary studies for a large final version that retains some of the same compositional elements but has an entirely different palette. Drawing a parallel with music, Kandinsky titled many of his works "composition," "improvisation," and "concert." (See *Primary Source*, page 960.) Kandinsky was especially influenced by Wagner in his conjuring of universal forces and a sense of musical abstraction. These qualities differ greatly from the lyrical, refined imagery of James Abbott McNeill Whistler, who similarly aspired to create visual music (see fig. 25.29). Horses, riders, figures, buildings, and specific landscape motifs are gone, yielding to an abstract play of color and painted line and form. The image may appear apocalyptic and chaotic, but these dynamic qualities are meant to capture the relentlessness of universal forces, not to portend a catastrophic future.

Franz Marc (1880–1916), who met Kandinsky in 1910 or 1911, shared many of the same objectives, especially the search to portray spirituality. Both artists discussed how animals instinctively bonded with nature and thus with the cosmos. (This belief underscores Kandinsky's repeated use of the horse and rider motif, which dates to 1903.) Marc claimed that "animals with their virginal sense of life awakened all that was good in me." This statement conveys a feeling shared by all the artists of *Der Blaue Reiter*: the belief that Western, industrialized

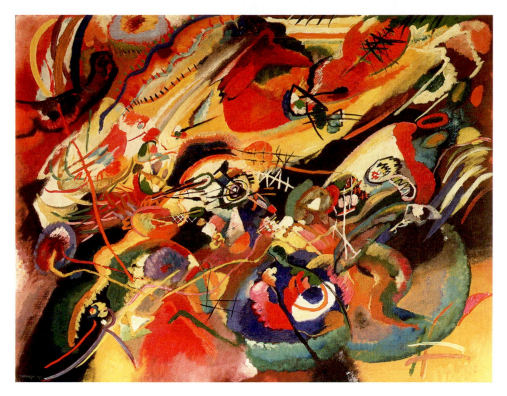

27.15. Vasily Kandinsky. *Sketch I for "Composition VII."* 1913. Oil on canvas, $30\frac{3}{4} \times 39\frac{3}{8}$″ (78 × 100 cm). Private Collection. © Artists Rights Society (ARS), New York/ADAGP, Paris

society was spiritually bankrupt. By 1911, Marc was interweaving animals, often horses, into tightly composed landscapes, and by early 1912, he was using Cubism to effect this instinctual interlocking of animal, natural, and primordial forces, as seen in *Animal Destinies* (fig. **27.16**) of 1913.

In this work Marc has transformed Cubist facets into dynamic rays of light that seem to have passed through an unseen mystical crystal. The horses, foxes, and deer dissolve into these spiritual lightning bolts, becoming one with them and a universal life force. A sense of a cataclysmic finale

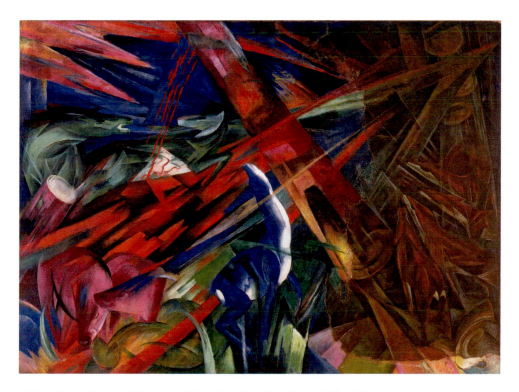

27.16. Franz Marc. 1913. *Animal Destinies (The Trees Showed Their Rings, The Animals Their Arteries)*. 1913. Oil on canvas, $6'4\frac{1}{2}$″ × $8'7$″ (1.94 × 2.62 m). Öffentliche Kunstsammlung Basel, Kunstmuseum, Basel, Switzerland. 1739

Vasily Kandinsky (1866–1944)

From *Concerning the Spiritual in Art*

Kandinsky hoped to inaugurate a new spiritual era for modern human beings through his art. These remarks first appeared in 1912.

If you let your eye stray over a palette of colors, you experience two things. In the first place you receive *a purely physical effect,* namely the eye itself is enchanted by the beauty and other qualities of color. You experience satisfaction and delight, like a gourmet savoring a delicacy. Or the eye is stimulated as the tongue is titillated by a spicy dish. But then it grows calm and cool like a finger after touching ice. These are physical sensations, limited in duration. They are superficial, too, and leave no lasting impression behind if the soul remains closed.

And so we come to the second result of looking at colors: their psychological effect. They produce a correspondent spiritual vibration, and it is only as a step towards this spiritual vibration that the physical impression is of importance....

Generally speaking, color directly influences the soul. Color is the keyboard, the eyes are the hammers, the soul is the piano with many strings. The artist is the hand that plays, touching one key or another purposively, to cause vibrations in the soul.

It is evident therefore that color harmony must rest ultimately on purposive playing upon the human soul.

SOURCE: *CONCERNING THE SPIRITUAL IN ART* BY VASILY KANDINSKY. TR. FRANCIS GOLFFING, MICHAEL HARRISON, FERDINAND OSTERTAG. (NY: WITTENBORN, SCHULTZ, 1947)

pervades the image, suggesting death, or the end of the life cycle, at which point living matter fulfills its destiny by being absorbed back into the cosmos. On the reverse of the canvas, Marc wrote, "And all being is flaming suffering," suggesting the inevitability of a spiritual redemption and the innate ability of animals to accept this course. Marc's colors are the deep saturated hues of stained-glass windows, this reference to mystical illumination reinforced by the illusionistic light streaming through the image.

By 1912, *Der Blaue Reiter* had dissolved. The group had two shows. The first was in the Galerie Thannhauser in Munich in December 1911. It then toured Germany to harsh reviews, closing at Der Sturm Galerie in Berlin. Clearly, the German viewing public was not ready to embrace the group's striking and abstracted images of nature, despite the works' evocation of traditional art forms such as stained-glass windows and religious icons. The second exhibition featured works on paper and was mounted at a Munich bookstore. Perhaps more important than their exhibitions was *Der Blaue Reiter Almanac (The Blue Rider Yearbook)*, which included members' work along with reproductions of examples of Egyptian, Gothic, Asian, tribal, and folk art. Even works by children found a place in the *Yearbook*. Further enhancing the publication's eclecticism was an article on the spirituality of music by the great tonalist composer and Theosophist Arnold Schönberg (1874–1951), who was also a painter and member of *Der Blaue Rieter*. The *Yearbook* was in effect a catalog of art that was simple, direct, and spiritual—art that Kandinsky and Marc believed tapped into the cosmos and shared their own goals.

PAUL KLEE The artist whose long career touched on many of the elements expressed in the *The Blue Rider Yearbook* is the Swiss painter Paul Klee (1879–1940). Officially, Klee was only minimally involved with *Der Blaue Reiter*. He had come to Munich in 1898 to study painting and had settled there in 1906. On friendly terms with Kandinsky and other members of *Der Blaue Reiter*, Klee's understanding of Expressionism and other modern art movements came through his travels around Europe, though no voyage had a more decisive effect than a two-week trip to Tunisia. As had been the case with Delacroix and Monet the century before, the bright light and color of North Africa overwhelmed Klee. Soon after arriving he wrote in his diary, "Color has taken hold of me.... That is the meaning of this happy hour: Color and I are one. I'm a painter." But equally important for his development was his connection to *Der Blaue Reiter*, for his art was the most comprehensive amalgam of all the sources listed in the *Yearbook*, especially children's art, tribal art, and music.

Klee's new Tunisia-inspired palette appears in *The Niesen* (fig. **27.17**) of 1915. Combined within the grid of Cubism is an abstract use of color reminiscent of Matisse and Kandinsky. The image echoes the directness and naiveté of children's and folk art as well as the luminescent, saturated colors of stained-glass windows, the white of the paper flickering through the transparent watercolor to create a glowing illumination. We instantly sense the spirituality that is the foundation of this picture and almost feel as though we can retrace Klee's steps in its creation. The triangular mountain, the Niesen, dominates the image, its rock-hard geometry providing a sense of permanence and eternity while reflecting the theosophical belief in the spirituality of the triangle, which represents, among other

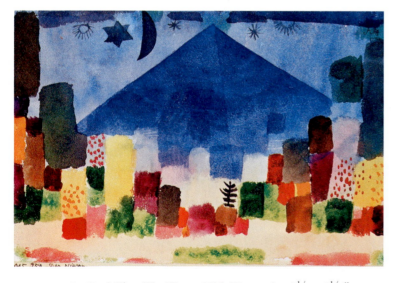

27.17. Paul Klee. *The Niesen.* 1915. Watercolor, $7\frac{1}{8} \times 9\frac{1}{2}''$ (17.7×26 cm) watercolor and pencil on paper. Hermann and Marguerite Rupf-Stiftung. © Artists Rights Society (ARS), New York/VG Bild-Kunst, Bonn

things, the mystical correspondence of the universe. The night sky is filled with religious symbols, such as the Jewish Star of David and the Islamic crescent moon, which mingle with primitive hieroglyphic suns. The branches of the sole tree, suggesting life and all living things, rhythmically corresponds to the rays emanating from the stars and suns above and is further linked to them by the Niesen, the shape of which powerfully connects earthly elements with cosmic ones.

Using an abstract vocabulary of color and shape, into which are inserted a handful of representational signs, Klee has stripped away everything unessential. He reveals in a poetic, understated way his innermost feelings about the nature of life and the universe. Or as he himself said, "Art does not render the visible; rather it makes visible." Adding to the charm and intimacy of Klee's art is its small scale and childlike "draftsmanship," which he used for both paintings and works on paper.

Austrian Expressionism

Another major center for German Expressionism was Vienna. Home of Sigmund Freud, it was an especially repressive city, socially and culturally dominated by a conservative bourgeoisie and a decadent aristocracy resistant to change. Not surprisingly, Viennese artists generated some of the era's most neurotic and disturbing visual imagery.

OSKAR KOKOSCHKA Perhaps the most prominent Viennese artist is Oskar Kokoschka (1886–1980), who entered the Vienna School of Arts and Crafts in 1905 and specialized in portraiture. In 1908 he exhibited with Gustav Klimt (see fig. 26.23) and other avant-garde artists at the *Vienna Kunstschau*, an exhibition for avant-garde art, where his violent portraits, inspired by Van Gogh, generated so much controversy he was expelled from art school. Kokoschka called his expressionistic portraits "black portraits," and the sitters appeared to be so troubled that he became known as "the Freud of painting" who "paints the dirt of one's soul." Kokoschka described his process similarly: "From their face, from the combination of expressions and movement, I tried to guess the true nature of a person, recreating with my own pictorial language, what would survive in the memory."

We can get a sense of how expressionistic these portraits looked from the figures in *The Bride of the Wind* (fig. **27.18**), Kokoschka's 1914 self-portrait with his lover Alma Mahler, the notoriously beautiful and sophisticated widow of the famous Austrian composer Gustav Mahler (1860–1911). By 1914, their passionate relationship was threatened, and it ended the following year. *The Bride of the Wind* visually encapsulates the artist's distress. Originally, Kokoschka intended to disguise this personal dilemma as *Tristan and Isolde*, based on Wagner's opera of tragic lovers. The final title comes from Georg Trakl (1887–1914), a depressed Viennese bohemian poet who produced morbid and nightmarish work. Kokoschka expresses his anxiety through coarse, violent brushstrokes and a seething, swirling composition. Oblivious to this turmoil, Mahler is shown peacefully sleeping, while Kokoschka restlessly worries, his body transformed into a flayed corpse, his hands grotesquely

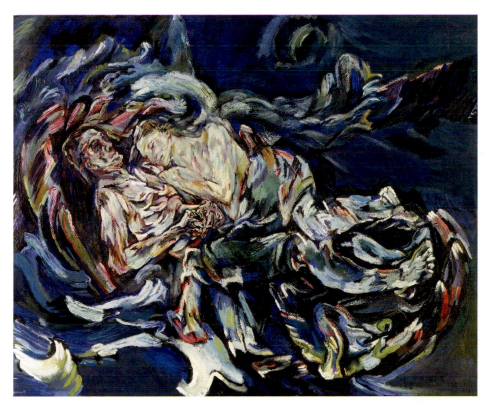

27.18. Oskar Kokoschka. *The Bride of the Wind.* 1914. Oil on canvas, 5′11¼″ × 7′2⅝″ (1.81 × 2.20 m). Öffentliche Kunstsammlung Basel, Kunstmuseum, Basel, Switzerland. © Artists Rights Society (ARS), New York/ProLitteris, Zurich

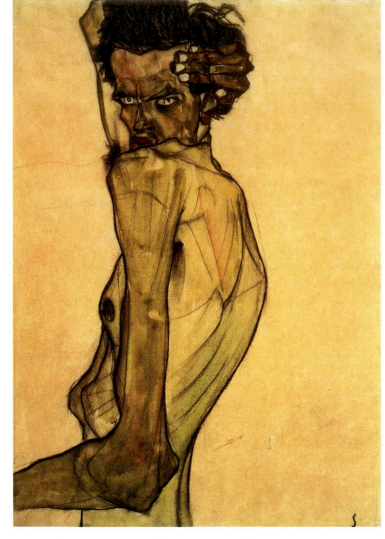

27.19. Egon Schiele. *Self-Portrait with Twisted Arm*. 1910. Watercolor and charcoal on paper, $17\frac{3}{4} \times 12\frac{1}{2}$″ (45 × 31.75 cm). Private Collection, New York

gnarled. The couple is cradled in a monstrous shell-like berth adrift in a landscape that is bleak, uncontrollable, and subject to cosmic forces, as suggested by the gravitational pull of a distant moon. This lunar force seems to represent a Freudian sexual drive, for the moon is recessed in a vaginalike tube and framed by phallic peaks. The bizarre environment seems liquid and insubstantial, the entire image transformed into a threatening quagmire of paint.

EGON SCHIELE Egon Schiele (1890–1918), another major Viennese painter, likewise defied bourgeois mores. He watched his father's painful death from syphilis, which probably accounts in part for his preoccupation with sickness and mortality. He then feuded bitterly with his conservative middle-class uncle in order to become an artist. He attended the Vienna Academy of Fine Art, and Gustav Klimt soon took him under his wing. At Klimt's invitation, Schiele exhibited at the same 1908 and 1909 *Vienna Kunstschau* exhibitions as Kokoschka.

He soon dropped out of art school and with friends established yet another secessionist organization, the *Neukunstgruppe* (New Art Group). Inspired by Klimt's defiance toward bourgeois conservatism, he led a bohemian life, and in 1911 fled Vienna with his mistress to live in nearby small villages.

Schiele's art is dominated by images of nudes—of himself, prostitutes, and lovers—and although he worked in oil, many of his finest works are on paper, such as *Self-Portrait with Twisted Arm* (fig. **27.19**) of 1910. The nude had dominated Western art since antiquity, but Schiele's presentation of the unclothed body departs from the tradition of the heroic male nude introduced in Classical antiquity and revived in the Renaissance. Here instead is an outright affront in its frank presentation of the body and its sickly and grotesque distortions of the figure. Schiele made the drawing most likely just after his uncle cut him off financially, and it seems to represent the conflict between conformist bourgeois guardian and independent bohemian painter. Schiele is defiant, not only in his demonic glare and bold, contorted gestures but also in his willingness to present himself as disfigured and ghoulish. However, we also sense an element of self-scrutiny. The 20-year-old artist reveals ribs, underarm hair, and nipple. We sense the body's skeleton, its physicality, and despite the confrontational stare, its vulnerability. Schiele's evocative handling of the medium, the velvety quality of the charcoal and splashes of watercolor, reinforce the sensuality of the flesh exposed to deterioration, one of the work's dominant themes. Just as his career was taking off in 1918, Schiele fell victim to the pandemic influenza that killed 20 million people worldwide, including his pregnant wife who died three days before him.

Cubism in Paris after Picasso and Braque

In France, Cubism was thoroughly entrenched by 1911–1912, expanding well beyond Picasso and Braque. A handful of individual painters had closely followed Picasso's and Braque's developments in 1909–1910, and in late 1910 they began exhibiting together at the large Paris salons and at a private gallery, calling themselves the *Section d'Or* (Golden Section). Original members Robert Delaunay, Albert Gleizes, Jean Metzinger, and Henri Le Fauconnier were soon joined by Fernand Léger, Roger de La Fresnaye, Marcel Duchamp, and his brother Raymond Duchamp-Villon. In 1912, Gleizes and Metzinger published *Du Cubisme (Cubism)*, the first book on the subject.

ROBERT DELAUNAY Of this group, Robert Delaunay (1885–1941) was among the most influential. Unlike concurrent Analytic Cubist works by Braque and Picasso, Delaunay's 1910 Cubist paintings of the Eiffel Tower, an icon of modern technology, incorporated color. They also differed in their subject: the movement and energy of modernity and the constant flux of the contemporary world.

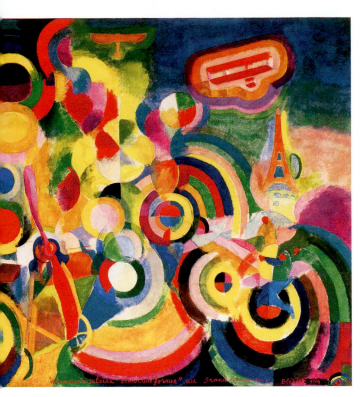

27.20. Robert Delaunay. *Homage to Blériot*. 1914. Tempera on canvas, 8'2¹⁄₂" × 8'3" (2.5 × 2.51 m). Öffentliche Kunstsammlung Basel, Kunstmuseum, Basel, Switzerland. Emanuel Hoffman Foundation. © Robert Delaunay

Delaunay's preoccupation with the dynamism of the modern world is evident in his 1914 *Homage to Blériot* (fig. **27.20**), honoring the French aviator Louis Blériot (1872–1936), inventor of the modern single-wing airplane and the first to fly across the English Channel. Delaunay integrates emblems of the modern world—airplanes, propellers, and the Eiffel Tower—into a kaleidoscope of floating balls and rotating disks suggesting whirling propellers and blazing suns. He creates movement not only through the ambiguity of Cubist space but also through the use of what Delaunay called "simultaneous contrasts," the placement of flat planes of primary and secondary colors next to one another, not only creating movement but also light and space, none of which is illusionist.

Two years before, Delaunay had exhibited total abstractions called *Simultaneous Disks* or *Simultaneous Contrasts*, paintings consisting entirely of the multihued circles seen in *Homage to Blériot*. While Delaunay's color theory was derived from that of the nineteenth-century color theorist Michel-Eugène Chevreul (see page 876), his move into total abstraction was prompted by his contact with Marc and Kandinsky. (Delaunay had been included in the first *Blaue Reiter* exhibition.) Some of these abstract paintings contain overlapping circles, suggesting a relationship among spheres in space, a reading reinforced by the subtitle *Sun and Moon*. These works might be taken as evidence that Delaunay, like his German colleagues, was attempting to evoke a spiritual and cosmic world. If so, Delaunay did not pursue this theme for long.

FRANTIŠEK KUPKA In his 1913 review of the Salon des Indépendents, Apollinaire labeled Delaunay's abstract work *Orphism,* a reference to the mythological lyre player Orpheus and evocative of the parallel between abstract art and music. Apollinaire named Frantisek Kupka (1871–1957) an Orphist as well. Kupka's abstract art evolved out of his mysticism. A practicing medium, he was deeply steeped in Theosophy and the occult. His development of **nonobjective painting**, that is, paintings having no representational components, began perhaps as early as 1910, and was based on his passionate urge to capture unseen metaphysical forces, which he believed could be represented by color and geometric form. Kupka was from Bohemia (in the present-day Czech Republic), had trained in Vienna, and in 1896 moved to Paris. He was fascinated by the movement captured in the chronophotography of Muybridge and Marey (see pages 942–943). Kupka likewise sought to convey motion in order to represent cosmic energy, as in *Disks of Newton (Study for Fugue in Two Colors)* (fig. **27.21**) of 1911–1912, which predates Delaunay's Disks series and was made independent of Kandinsky's abstraction. Like Kandinsky, Kupka draws upon the abstract power of music, as the subtitle suggests.

In this prismatic spiral of transparent colored rectangles, Kupka evokes a divine light, and his saturated palette recalls medieval stained glass. (Kupka also made a series of abstractions called *Cathedrals.*) Predominant is a gentle flow of cosmic forces, which the artist felt coursing within himself and strove to express visually.

Italian Futurism: Activism and Art

In January 1909, Filippo Tommaso Marinetti (1876–1944), a free-verse poet based in Milan, launched the Futurist movement when he published his *Manifesto of Futurism*, a pamphlet sent to thousands of artists and poets. On February 20, it appeared on the front page of the Parisian newspaper *Le Figaro*. Marinetti called for a rebirth of Italy, a country he saw as mired in the dusty, anachronistic Classical past. He advocated an uncompromising acceptance of modernity in all its manifestations, including electricity, automobiles, and machines, writing that "all subjects previously used must be swept aside in order to express our whirling life of steel, of pride, of fever and of speed" (see end of Part IV, *Additional Primary Sources*).

For Marinetti, Futurism was a continual process, a permanent revolution. As soon as one change is effected, a new one must begin. Artists were no longer the manufacturers of a high-end product for a wealthy clientele, but rather they were vital forces operating within the community and influencing such daily concerns as fashions, games, toys, graphics, interior design, sports, food, and behavior. Marinetti toured Italy, enrolling artists, musicians, playwrights, architects, and designers into his movement. He arranged Futurist soirées, where from a stage he expounded upon his theories, often provoking, if not insulting, the audience in his attempt to incite them to action or even violence, which Marinetti perceived as socially

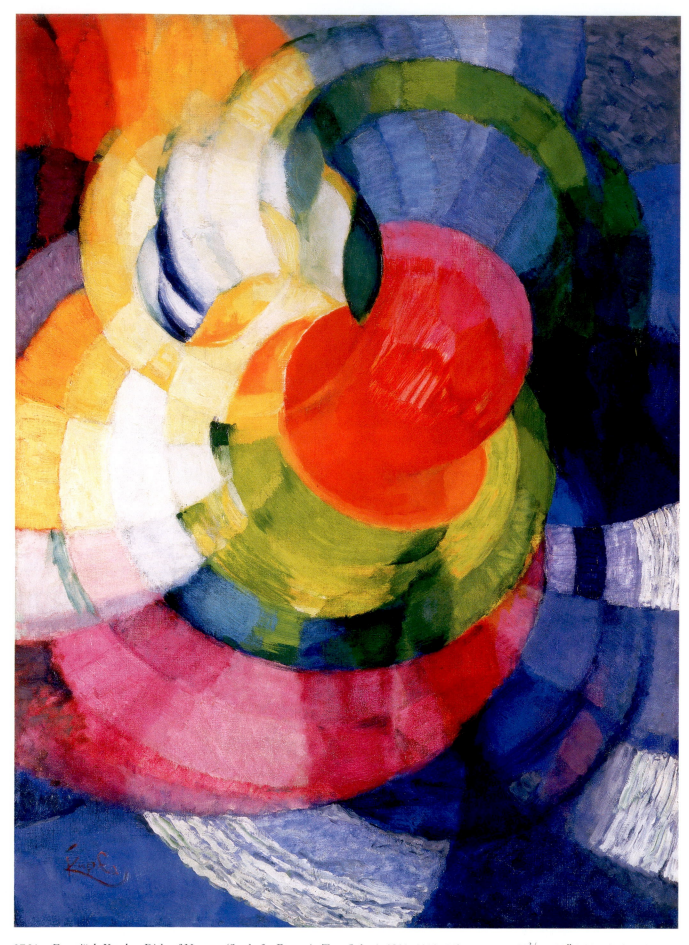

27.21. František Kupka. *Disks of Newton (Study for Fugue in Two Colors)*. 1911–1912. Oil on canvas, $39\frac{3}{8} \times 29''$ (100×73.7 cm). Philadelphia Museum of Art. The Louise and Walter Arensberg Collection, 1950–134-122. © Artists Rights Society (ARS), New York/ADAGP, Paris

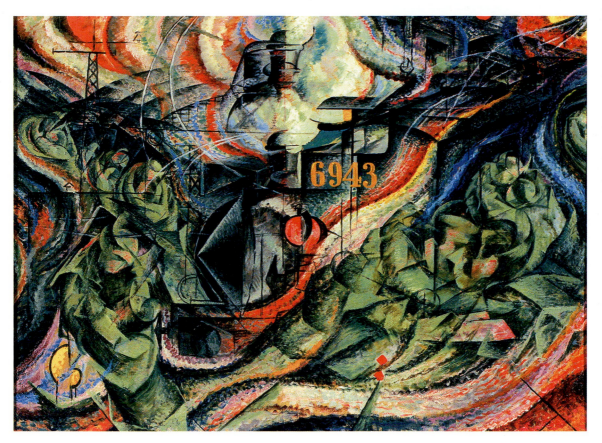

27.22. Umberto Boccioni. *States of Mind I: Farewells*. 1911 (second version). Oil on canvas, $28 \times 37^7/_8''$ (70.7 × 96 cm). Museum of Modern Art, New York. Gift of Nelson A. Rockefeller. © Estate of Umberto Boccioni

cleansing and productive. Marinetti was intent on generating constant activism, which he saw as the conduit for a cultural *Risorgimento*, or rebirth, of Italy.

After a 1909 lecture in Milan presented to the avant-garde art group *Famiglia Artistica* (Artistic Family), Marinetti enlisted a handful of its members, including Umberto Boccioni (1882–1916), to become Futurists. In 1909, these artists were mostly Neo-Impressionists who transformed the color and energy of Divisionism to portray contemporary dynamism. Their manifesto claimed that "Motion and light destroy the materiality of bodies" and that their concern would be the visualization of movement and energy. For their visual vocabulary, they rejected anything redolent of Classical Italian culture and instead turned to science: the motion studies of Marey and Muybridge, Ernst Mach's graphic representations of shock waves, and Wilhelm Konrad Röentgen's x-rays, which proved the dematerialization of all things. Much like Seurat, they wanted to create a new artistic language based on science, but without prescribing any one style. Their goal was to capture the intensity of movement—physical, psychological, and universal. In effect, they wanted to visualize Bergson's *élan vital*.

Initially following Marinetti's lead, the Futurists were activists. By the end of 1911, however, they had become disenchanted with Marinetti's politics and instead chose to concentrate on art. More important, they turned from Neo-Impressionism to Cubism in their search for aesthetic direction.

Their interest in Cubism, however, departed from the concerns of Braque and Picasso because the Futurists wanted to convey motion, dynamic energy, and social progress. After visiting Paris and seeing Cubist works in 1911, Boccioni painted *States of Mind I: Farewells* (fig. **27.22**). Embedded in a fractured world of Cubist facets is an eruption of steam, sound, moving objects, and psychic energy. The white curving lines over the locomotive reflect Mach's lines of thrust, whereas the repetition of the vaguely rendered green-tinted embracing couple is inspired by Muybridge's motion sequences. Boccioni is championing not just modern technology, as represented by the train, electric railroad signals, and trussed steel towers, but the perpetual movement of all objects and energy. In a May 1911 lecture in Rome, he proclaimed that painting had to capture the energy in all matter, energy in perpetual motion that dissolves the object while fusing it with surrounding space, an effect he called "plastic dynamism."

In *States of Mind I: Farewells*, we sense not only the dematerialization of the train and figures through time and movement, in part created by Boccioni's application of Divisionism, but also the simultaneous presence of space as something plastic and as vital as form. Swirling throughout the chaotic image is also an emotional energy—a sense of painful separation and disappearance—which the title reveals as a theme of the work. This "plastic dynamism," or the fusing of object and space, is evident in Boccioni's sculpture *Unique Forms of Continuity in*

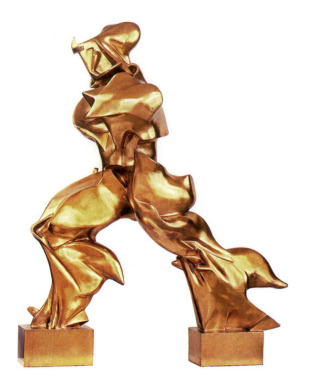

27.23. Umberto Boccioni. *Unique Forms of Continuity in Space*. 1913 (cast 1931). Bronze, $43\frac{7}{8} \times 34\frac{7}{8} \times 15\frac{3}{4}$″ (111.4 × 88.6 × 40 cm). The Museum of Modern Art, New York. Acquired through the Lillie P. Bliss Bequest. © Estate of Umberto Boccioni

Space (fig. **27.23**) of 1913. The pointed forms trailing off legs and torso capture the direction of the energy, as if the displaced space were itself worn like a mantle.

The leading Futurist architect was the Milanese Antonio Sant'Elia (1888–1916), who joined the movement in 1914, issuing the *Manifesto of Futurist Architecture*. Sant'Elia asserted that new buildings could no longer look like those of the past, but must be based on a "definitive Futurist aesthetic of giant locomotives, spiral tunnels, ironclads, torpedo boats, Antoinette monoplanes, and racing cars." He regarded Futurist architecture, like these conveyances, as impermanent, continually replaced to keep pace with industrial developments. The proposed tower reproduced here in *The New City* (fig. **27.24**) is a study of movement and flux. Sant'Elia located the elevators on the building's exterior, as flying buttresses would be. The building is dramatically stepped-back, a feature that creates dynamic movement, and is surmounted by electric telegraph towers. The building straddles a major transportation artery and looks more like a futuristic factory than a comfortable dwelling. Sant'Elia's vision leaves no room for parks, plazas, or other places for rest and reflection. Instead, he encases structures in endless walkways, highways, train tracks, elevators, and runways. His efficient machinelike world is one of constant movement.

Cubo-Futurism and Suprematism in Russia

Of the major European countries in the 1910s, Russia was the least industrialized. Nevertheless, it became an important center for avant-garde art. Most of the population were serfs ruled

by an indifferent czar and dominated by the Orthodox Church. Despite a rush to modernize, Russia in some respects remained trapped in the Middle Ages. In a culture dominated by folk-art and icon-painting traditions, how did radical art emerge? Part of the explanation may lie in the country's desperate need for reform. When in 1917 the October (or Bolshevik) Revolution, led by Vladimir Ilyich Lenin (1870–1924) and marking the first officially Communist-led revolution of the twentieth century, finally brought about improvements, change was far more radical than it had been in eighteenth-century America or France. The transformation in Russia was so revolutionary that it even embraced equality for women, who had proved integral to developing the radical art of the preceding years.

THE RUSSIAN AVANT-GARDE In Moscow, Sergey Shchukin and Ivan Morozov, two of the greatest collectors of contemporary art, made available to Russian artists their extraordinary holdings of works by Matisse and Picasso. In response to these works and to growing ties with the Western European avant-garde, Russian artists began to explore Cubism and other approaches to abstraction. In 1910, a group of Russian artists

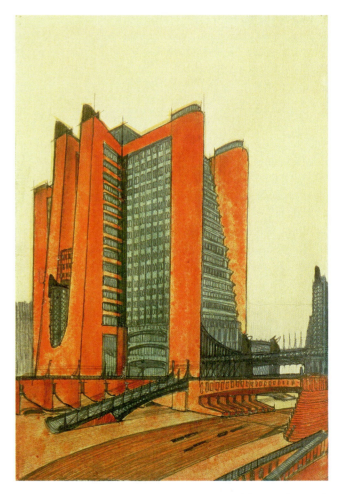

27.24. Antonio Sant'Elia. *The New City* (Building with outside elevators, arcade, covered passageway, on three street levels—tramway track, street for automobiles, metal footbridge—lighthouse and wireless telegraph). 1914. Ink and black pencil on yellow paper, $20\frac{5}{8} \times 20\frac{1}{4}$″ (52.5 × 51.5 cm). Private Collection

formed an avant-garde art association called the Jack of Diamonds to support exhibitions of experimental work. Two years later, a splinter group, The Donkey's Tail, emerged. The latter especially was modeled on the Futurists. These groups embraced the modern, emphasizing the machine and industry, both critical to bringing Russia into the twentieth century.

One of the outstanding painters in this avant-garde circle was Lyubov Popova (1889–1924), who studied in Paris in 1912 and in Italy in 1914, experiencing firsthand the latest developments in Cubism and Futurism. These influences are reflected in *The Traveler* (fig. **27.25**) of 1915. In this depiction of a woman wearing a yellow necklace and holding a green umbrella, Popova combines the fracturing of Cubism with the energy and movement of Futurism.

KAZIMIR MALEVICH By 1913 many of the Russian artists were calling themselves *Cubo-Futurists*, a term coined by Kazimir Malevich (1878–1935) that reflects the dual origins of the style. Malevich had exhibited with both the Jack of Diamonds and The Donkey's Tail. In 1913 he designed Cubo-Futurist costumes and sets for what was hyped as the "First Futurist Opera" and titled *Victory over the Sun*. Presented in St. Petersburg, this radical "opera" embraced the principle of *zaum*, a term invented by progressive Russian poets. Essentially, *zaum* was a language based on invented words and syntax, the meaning of which was supposedly implicit in the basic sounds and patterns of speech. The poets' intention was to return to the nonrational and primitive base of language that, unencumbered by conventional meaning, expressed the essence of human experience. In *Victory over the Sun*, performers read from nonnarrative texts often consisting of invented words while accompanied by the clatter of an out-of-tune piano. Malevich's geometric costumes and sets were equally abstract. A stack of triangles ran up and down the legs of one costume, while one backdrop was a square divided in half to form two triangles, one white, the other black.

It took Malevich two years to realize the implications of *zaum* for his art. In 1915, after working in a Cubo-Futurist style similar to Popova's, Malevich presented 39 nonobjective geometric paintings in a St. Petersburg exhibition entitled *0, 10 (Zero–Ten): The Last Futurist Exhibition* (fig. **27.26**). The best-known work in the show is *Black Square*, seen in the installation photograph hanging in the manner of a Russian icon across the corner of a room. In the 1920s Suprematist treatise *The Non-Objective World*, Malevich explained that Suprematism is the supremacy of feeling. (See *Primary Source*, page 969.) This feeling is not just personal or emotional but revelatory, for the abstract essence of the world is translated into painting using an entirely new abstract language, stripped of any vestiges of realism. Like his fellow Russian Kandinsky, Malevich was a mystic, searching for cosmic unity, even a utopian world, as would supporters of the Bolshevik Revolution of 1917. *Black Square* embodies both the legacy of simple, otherworldly Russian icons and the mysticism of folk art.

Malevich's abstract language included different geometric shapes and colors. In *Suprematist Composition: Airplane Flying*

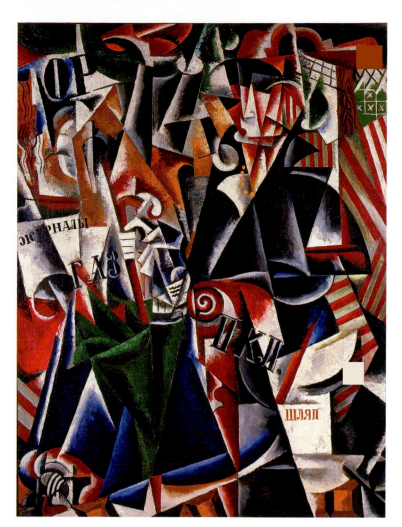

27.25. Lyubov Popova. *The Traveler*. 1915. Oil on canvas, 56 × 41½″ (142.2 × 105.4 cm). Norton Simon Art Foundation, Pasadena, California. © Liubov Popova

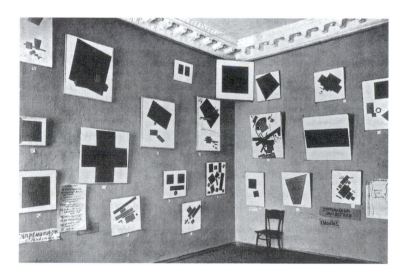

27.26. Kazimir Malevich. Installation photograph of the artist's paintings in *0, 10 (Zero–Ten): The Last Futurist Exhibition*. St. Petersburg, December 1915

infatuation with technology, the image itself relates to the experience of air travel and the new relationship to the universe brought about by this mode of transportation.

Unfortunately, reproductions of Malevich's paintings almost never show their organic quality. The shapes in *Airplane Flying* may appear to be hard edged and geometric, but in person one can see that their boundaries waver ever so slightly. Malevich's paintings contain the same human presence evident in the work of Kandinsky. Like Kandinsky, Malevich powerfully projects a serene mystical connection with the universe, which he accomplishes through the use of the white ground extending beyond the canvas into infinity.

Cubism and Fantasy: Marc Chagall and Giorgio de Chirico

Malevich stripped down Cubist geometry so that Cubist structure itself disappeared. Fellow Russian Marc Chagall (1887–1985), however, embraced Cubist structure in many of his works. With its ability to juxtapose and integrate the most disparate objects, Cubism was a perfect tool for creating dreamlike, fantasy worlds. Chagall grew up in the Jewish quarter of Vitebsk, and his paintings evoke simpler times, values, and rituals. In 1910, Chagall moved to Paris, where he immediately converted to Cubism, as seen in *I and the Village* (fig. 27.28). But this dream image is hardly a Cubist intellectual dissection of form. Using the saturated colors of a stained-glass window and the simple shapes of Russian folk art, Chagall conjures up the most elemental issues of life itself. Man and animal are equated in almost mirrorlike symmetry, and the translucent, ephemeral quality of their heads makes the scene appear ethereal and mystical. The circular composition symbolizes the cycle of life, with birth as the blooming bush and death as the farmer carrying a scythe. Chagall adamantly denied any links to storytelling or fairytales in his paintings. Instead his dreamscapes are a Cubist kaleidoscope of objects and incidents he considered to be of elemental significance.

Arriving in Paris at virtually the same moment as Chagall was the Italian artist Giorgio de Chirico (1888–1978). While studying in Munich from 1905–1909, de Chirico was heavily influenced by German Romantic and Symbolist artists and the philosophy of Friedrich Nietzsche, who described life as a "foreboding that underneath this reality in which we live and have our being, another and altogether different reality lies concealed." Like Kandinsky, Marc, and Klee, de Chirico was steeped in the theosophical debates swirling around Munich. Upon arriving in Paris, de Chirico abandoned his painterly style for crisply drawn scenes with multiple vanishing points. His reliance on diagonal line and disjointed space vaguely echoes Cubism, which surely must have influenced his sudden and dramatic change in style. He set many of his scenes in an empty town square resembling a stage, such as in *Mystery and Melancholy of a Street* (fig. 27.29), made in Ferrara in 1914 after he returned permanently to Italy.

Unlike his Futurist compatriots, de Chirico idolized rather than rejected the Classical past, although he subverted its

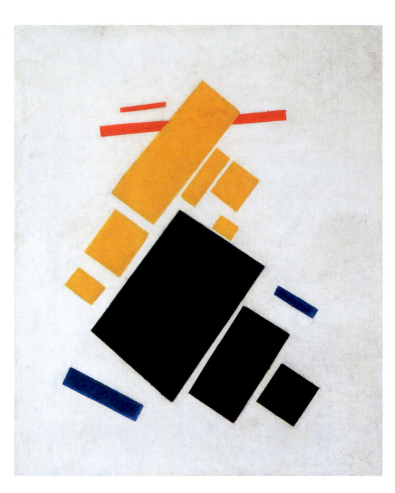

27.27. Kazimir Malevich. *Suprematist Composition: Airplane Flying.* 1915 (dated 1914). Oil on canvas, $22^7/_8 \times 19''$ (58 × 48.3 cm). Museum of Modern Art, New York. Purchase. Acquisition confirmed in 1999 by agreement with the Estate of Kazimir Malevich and made possible with the funds from the Mrs. John Hay Whitney Bequest (by exchange). (248.1935)

(fig. **27.27**), also painted in 1915, he used red, yellow, and blue shapes in addition to black to create a sensation of movement and floating. Color, size, and shape produce a unique rhythm against the white ground. From one composition to the next, Malevich altered the rhythm by changing these characteristics. Although the title includes the word *airplane* and suggests an

Kazimir Malevich (1878–1935)

From *The Non-Objective World*

Kazimir Malevich published "The Non-Objective World" in 1919 in the catalogue for the 10th State Exhibition in Moscow. Here he emphasizes how non-objective art represents feeling, not objects, as it strips away all of the accumulations of civilization to get at the essence of existence, much as so-called primitive artists do.

Under Suprematism I understand the supremacy of pure feeling in creating art . . .

Hence, to the Suprematist, the appropriate means of representation is always the one which gives fullest possible expression to feeling as such and which ignores the familiar appearance of objects. . . .

Even I was gripped by a kind of timidity bordering on fear when it came to leaving "the world of will and idea," in which I had lived and worked and in the reality of which I had believed.

But a blissful sense of liberating nonobjectivity drew me forth into the 'desert,' where nothing is real except feeling . . . and so feeling became the substance of my life.

This was no "empty square" [referring to the Black Square] which I had exhibited but rather the feeling of nonobjectivity. . . .

The black square on the white field was the first form in which nonobjective feeling came to be expressed. The square = feeling, the white field = the void beyond this feeling. . . .

The Suprematist square and the forms proceeding out of it can be likened to the primitive marks (symbols) of aboriginal man which represented, in their combinations, *not ornament but a feeling of rhythm*.

Suprematism did not bring into being a new world of feeling, but, rather, an altogether new and direct form of representation of the world of feeling.

SOURCE: KAZIMIR MALEVICH, *THE NON-OBJECTIVE WORLD*. TR. HOWARD DEARSTYNE. (CHICAGO: THEOBALD, 1959).

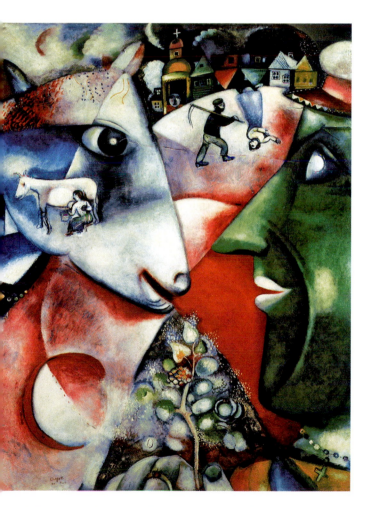

27.28. Marc Chagall. *I and the Village*. 1911. Oil on canvas, 6′ 3 5/8″ × 4′ 11 1/2″ (1.92 × 1.51 m). The Museum of Modern Art, New York. Mrs. Simon Guggenheim Fund. © Artists Rights Society (ARS), New York/ADAGP, Paris

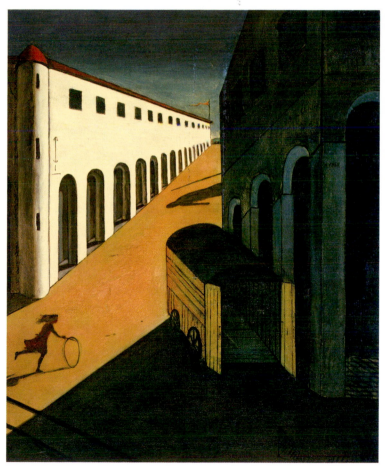

27.29. Giorgio de Chirico. *Mystery and Melancholy of a Street*. 1914. Oil on canvas, 34 1/4 × 28 1/2″ (87 × 72.4 cm). Private collection. © Artists Rights Society (ARS), New York/SIAE, Rome

MARCEL DUCHAMP AND THE DILEMMA OF MODERN ART

The tension between tradition and innovation erupts forcefully in the work of Marcel Duchamp (1887–1968). Like most artists studied in this chapter, Duchamp received academic training, even as its influence waned. He understood the traditional representational role of the fine arts; but he also understood the avant-garde's challenge to this tradition, a challenge asserting that the quest to represent an ideal can be distinct from the depiction of observed reality. What Duchamp recognized by the second decade of the twentieth century was that this struggle between tradition and innovation had called into question the very definition of art, a question that had been simmering beneath the surface of works by Matisse, Picasso, and Kandinsky, among others. Duchamp insisted that the very nature of art not only be made clearly visible, but that it also become a fundamental theme of art itself. In this way, Duchamp introduced the notion that art must be self-critical, calling into question its own status as a work of art.

Working in Paris in the 1910s, Duchamp quickly digested Impressionism and Post-Impressionism. Toward 1911, he took on Cubism, as seen in *Nude Descending a Staircase, No 2* (fig. **27.30**), which he attempted to exhibit at the 1912 Salon des Indépendents. The hanging jury, which included some of his friends and even his two brothers, Raymond Duchamp-Villon and Jacques Villon, found the painting neither serious nor Cubist enough, so Duchamp withdrew it. The work began as an illustration for a poem that described a figure ascending a stairway to the stars. Ever the iconoclast, Duchamp portrayed a nude figure, mechanical looking and grandly descending a staircase, as he described, "More majestic you know, the way it's done in music halls." Like Kupka, whose studio was next door, Duchamp was fascinated by Marey's chronophotographs, which inspired the sequential movement of his "nude." Because one needs to know the title to understand that the figure is unclothed, Duchamp underscores the way in which words become an integral part of an artwork, going so far as to paint the title on the front of the work. With this gesture, Duchamp makes an important move in his exploration of the essence of art. A title, which defines a work, circumscribes its meaning, and also recalls it to the mind of a viewer long after the work has been seen, fulfilling a role as important as the artwork itself. Here, then, Duchamp makes plain the inseparability not only of artwork and title, but of visual and linguistic experience.

Duchamp's machinelike figure was not unique for 1912. By then the theme was becoming commonplace in Cubist art, reflecting the era's worship of technology as a symbol of modernity and science's ability to improve the world. For example, Duchamp's older brother, Raymond Duchamp-Villon (1876–1918), was a Cubist sculptor who on occasion rendered living forms as machines, as in *The Great Horse* (fig. **27.31**). Initial drawings show a realistic horse, but the final sculpture is an abstract monument to horsepower: The body has become a tapering cylinder with the tension of a coiled spring, and the legs look like thrusting pistons. Cubist facets and geometry have

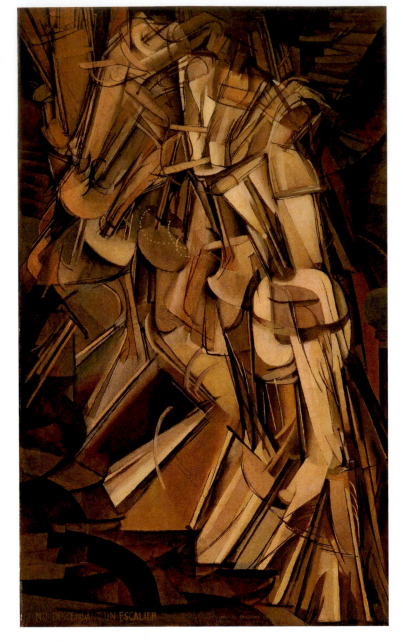

27.30. Marcel Duchamp. *Nude Descending a Staircase, No. 2.* 1912. Oil on canvas, 4′10″ × 2′11″ (147 × 90 cm). Philadelphia Museum of Art. Louise and Walter Arensberg Collection. 1950–134-59. © Artists Rights Society (ARS), New York/ADAGP, Paris/Succession Marcel Duchamp

austere authority by evoking a Romantic melancholy, using ominous shadows, intense light, and skewed perspective to create an unsettling eeriness. In *Mystery and Melancholy of a Street,* railroad tracks, darkened windows and arches, the empty moving van, and the girl with the hoop seem to be symbols, but de Chirico provides no clues about their meaning, insisting none existed. Instead, the painting offers a dreamscape that can be interpreted uniquely by each viewer, just as individuals respond differently to the symbolic narratives of their dreams. De Chirico called his works metaphysical paintings, and his psychologically disturbing poetic reveries would serve as a springboard for representational Surrealism in the next decade.

been ordered into an animal of twisting dynamism. Duchamp-Villon's horse, like most other mechanomorphic figures from the period, underscores the import role of industry in fashioning the modern age. In contrast, Marcel Duchamp's mechanical nude is humorous, sarcastic, and iconoclastic.

The following year Marcel Duchamp's humorous inquiry into the nature of art culminated in a revolution as monumental as Picasso's *Les Demoiselles d'Avignon*. Duchamp placed a bicycle wheel upside down on a stool (fig. **27.32**) and declared it art. He later labeled his sculpture an "assisted Readymade," because he had combined two found mass-produced objects—a witty challenge to the notion that art involved only technical skill and craft. That the stool vaguely suggests a pedestal and the wheel a head underscores its clever engagement with artistic tradition, evoking the countless sculpted portrait busts that line museum galleries.

By providing no clues to the artwork's meaning and leaving it to the viewer to determine its content, Duchamp further tested the boundaries of art. Duchamp was adamant that his Readymades had no aesthetic value. The act of combining stool and wheel, placing each in a new context, was more important to him than the resulting object. The new context changes the meaning of the objects, demonstrating that context is fundamental to the meaning of art. Duchamp's claims notwithstanding, his Readymades may be seen as beautiful: They exhibit many qualities traditionally associated with beauty, such as balance, symmetry, and novelty. The artist also seems to want to call our attention to the often overlooked comeliness of com-

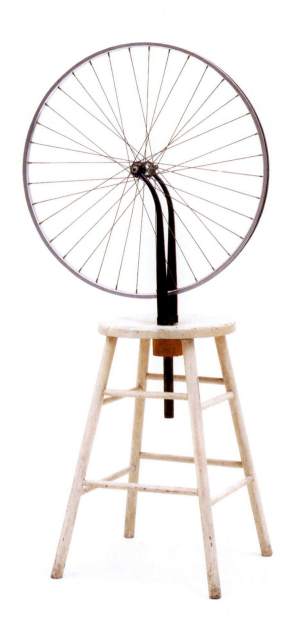

27.32. Marcel Duchamp, *Bicycle Wheel*. 1913/1951. (Third version, after lost original of 1913.) Assemblage: metal wheel mounted on painted wood stool, $50\frac{1}{2} \times 25\frac{1}{2} \times 16\frac{5}{8}$" (128.3 × 64.8 × 42.2 cm). The Museum of Modern Art, New York. © Artists Rights Society (ARS), New York/ADAGP, Paris/Succession Marcel Duchamp

mon objects. Duchamp made three assisted readymades prior to World War I; none were exhibited. Only during the war years was his revolution fully unleashed on the art world, as we shall see in the next chapter.

MODERNIST SCULPTURE: CONSTANTIN BRANCUSI AND ARISTIDE MAILLOL

Like Picasso's constructions and Duchamp's assisted readymades, the sculptures of Constantin Brancusi (1876–1957) were among the most innovative artworks being produced before the war. Indeed, Brancusi's work is so minimal-looking

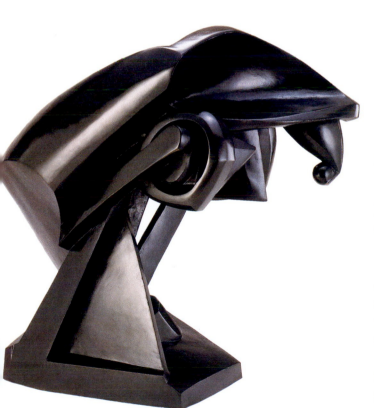

27.31. Raymond Duchamp-Villon. *The Great Horse*. 1914. Bronze, height $39\frac{1}{4}$" (99.7 cm). The Art Institute of Chicago. Gift of Miss Margaret Fisher in Memory of Her Parents, Mr. and Mrs. Walter L. Fisher. © Estate of Raymond Duchamp-Villon

and abstract it has come to symbolize modern sculpture itself. Ironically, Brancusi's background could not have been more removed from the modern world. The son of Romanian peasants, he grew up herding sheep in the remote village of Tîrju-Jiu in the Carpathian Mountains. The region had a long tradition of ornate folk carving, in which Brancusi excelled. After studying art in Bucharest and passing through Munich in 1903, he settled in Paris and became an assistant to Auguste Rodin. Declaring that "Nothing can grow under big trees," he struck out on his own.

Besides Rodin, the other influential forward-looking sculptor working in Paris who could have exerted influence on Brancusi was Aristide Maillol (1861-1944). Maillol had begun making sculpture only in the late 1890s, and in the opening years of the new century and working in the Greco-Roman tradition, he developed a style of simple, geometric, monumental forms, as seen in *Seated Woman* (fig. **27.33**) of about 1901. Maillol usually presented the female nude, his favorite subject, as voluminous and massive, reducing the figure to a severe geometry that gives it an archaic, almost primitive, quality. In this sculpture, the repeated triangular forms provide structure and "freeze" the pose. Maillol later titled this work *La Méditerranée*, in acknowledgment of the antique tradition in which he wanted it to be viewed.

Escaping the far-reaching shadow of Rodin and the growing presence of Maillol, two artists with strong ties to nineteenth-century art, Brancusi steered a radical course that aesthetically if not thematically broke with sculptural tradition and laid a foundation for much twentieth-century sculpture. Brancusi's mature

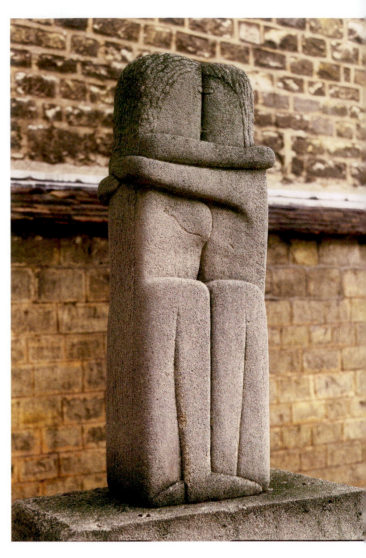

27.34. Constantin Brancusi. *The Kiss*. 1909. Stone, height 35$\frac{1}{4}$″ (89.5 cm). Tomb of T. Rachevaskaia, Montparnasse Cemetery, Paris. © Artists Rights Society (ARS), New York/ADAGP, Paris

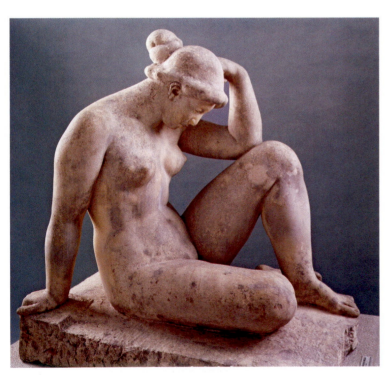

27.33. Aristide Maillol. *Seated Woman (La Méditerranée)*. ca. 1901. Stone, height 41″ (104.1 cm). Collection Oskar Reinhart, Winterthur, Switzerland. Inv. no. 1931.9. © Artists Rights Society (ARS), New York/ADAGP, Paris

style began to evolve with *The Kiss* of 1907, here represented by the 1909 version (fig. **27.34**). As we have seen, this Symbolist subject had also appeared in works by Rodin, Munch, and Klimt (see fig. 26.23). Brancusi's treatment of the theme is unique. The two nude figures are clenched together as one, forming a primordial block with minimal details etched in low relief. Rather than psychological conflict or Symbolist passion, Brancusi presents a tribute to the highest ideals, the universal need to create life. The stone's geometric severity recalls prehistoric monuments such as Stonehenge or austere Egyptian sculpture. Through its simplicity, *The Kiss* has shed the clutter of visual reality to pursue invisible essential truths, the very core of existence and a life force. As Brancusi explained, "Simplicity is not an end in art, but one arrives at simplicity in spite of oneself in approaching the real sense of things."

In the early 1910s, Brancusi began to simplify his works further. In *The Newborn* (fig. 27.35), he reduced his subject to an ovoid suggesting an egg. The form also resembles a head, with the concave depression as the mouth releasing its first

27.35. Constantin Brancusi. *The Newborn*. 1915. Marble, $5^3/_4 \times 8^1/_4 \times 5^7/_8$" (14.6 × 20.9 × 14.9 cm). Philadelphia Museum of Art. Louise and Walter Arensberg Collection. 1950–134-10. © Artists Rights Society (ARS), New York/ADAGP, Paris

ART IN TIME

1909—Brancusi's *The Kiss*
1912–1913—Balkan Wars
1914—World War I begins

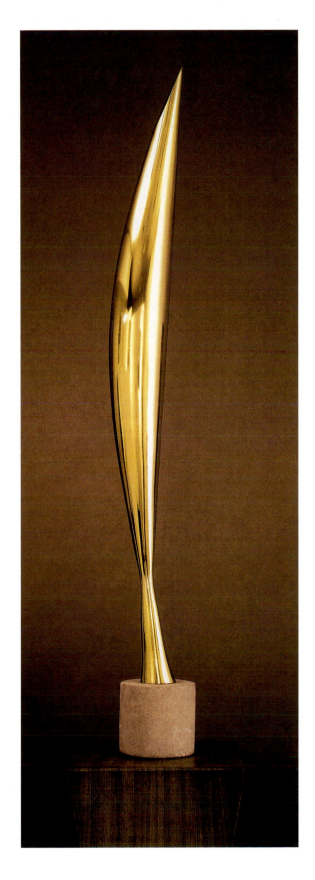

cry and the narrow triangle as the nose. Yet the whole is so abstract that we are left with a sense of the elemental power of the marble, which seems to harbor the hidden mysteries of life. The work has the appeal of Cycladic sculpture and the types of simplified, geometric African masks that Brancusi knew well.

The relationship between medium and subject is important in Brancusi's work and must always be taken into consideration. The visual effect and psychic associations of a particular medium—sometimes traditional like marble or wood, sometimes industrial-looking as in highly polished brass—influence the meaning conveyed by the sculpture. Likewise, Brancusi's sensitivity to the display of his works reveals his understanding that a viewer's physical as well as emotional relationship to a sculpture affects its meaning. For instance, Brancusi insisted that *The Newborn* be exhibited on a low pedestal, forcing the viewer to lean over the piece in order to scrutinize it. In this way, Brancusi placed his viewers in the position of an adult looking down at a cradled infant, evoking physically feelings of awe and sympathy.

Brancusi repeated a few motifs throughout his long career, exploring slight variations in different materials. As early as 1910, he had introduced the motif of the bird. Titled *Maiastra*, it was based on Romanian legends about a magical golden bird whose song held miraculous powers. By the 1920s, Brancusi showed the bird soaring, as in *Bird in Space* (fig. **27.36**).

27.36. Constantin Brancusi. *Bird in Space*. 1928 (unique cast). Bronze, $54 \times 8^1/_2 \times 6^1/_2$" (137.2 × 21.6 × 16.5 cm). The Museum of Modern Art, New York. Given Anonymously. © Artists Rights Society (ARS), New York/ADAGP, Paris

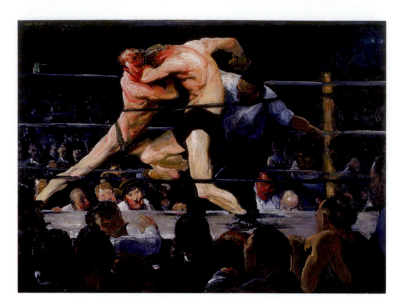

27.37. George Bellows. *Stag at Sharkey's*. 1909. Oil on canvas, $36\frac{1}{4} \times 48\frac{1}{4}''$ (92.1 × 122.6 cm). The Cleveland Museum of Art. Hinman B. Hurlbut Collection

The elegantly streamlined form balances on a short, tapering column, and the pinched section suggests the juncture of legs and body. In constrast to *The Newborn*, which is placed on a low base, *Bird in Space* is often mounted on a high geometric pedestal, soaring above the viewer. In some 20 versions made between the 1920s and 1940s, Brancusi explored the essence of flight. Inspired by a folktale of a spiritual bird, Brancusi's avian sculptures are meant to embody elemental forces.

AMERICAN ART

Eager to establish a decidedly American artistic sensibility, many artists working in the United States in the first years of the twentieth century self-consciously resisted emulating European models. These artists avoided both the conventional Classicism of European academic painting and the challenging experiments of the avant-garde. Instead, they sought to distinguish themselves from their European counterparts by pursuing typically American subjects, often depicted in deliberately antiacademic, graphic, or naive styles. Yet some American artists found in European avant-garde art a new, exciting artistic vocabulary that allowed them to express their reation to modernity.

The Ashcan School

American art opened the century with a movement unique to the United States, the Ashcan School, which centered on the gritty urban realism of New York City. Originally, the members of the group were newspaper illustrators in Philadelphia, but Robert Henri (1865–1929) convinced them to become painters. Henri had studied painting at the Pennsylvania Academy of the Fine Arts with a pupil of the realist Thomas Eakins (see pages 888–889). Gradually the group moved to New York and by 1905 they were painting the energy of the city's streets, parks, and places of entertainment, capturing the rapidly changing social mores and styles. These artists found beauty in

the commonplace and the ordinary. They recorded especially the changing demographics resulting from the waves of immigrants from eastern and southern Europe and the migrations of African Americans from the South. In addition, they documented the new working-class woman and the mixing of the classes in the city's public spaces.

To capture this modern urban energy, Ashcan School artists used a Manet-like brushstroke and emphasis on the surface of the picture plane, which lent their paintings a sense of spontaneity and directness that we saw in nineteenth-century Realism (see chapter 25). This effect is clear in *Stag at Sharkey's* (fig. 27.37), a 1909 painting by George Bellows (1882–1925), the youngest of the group and not an original member. Bellows presents one of the city's favorite entertainment spots, Tom Sharkey's Athletic Club, a bar located across from Bellow's studio. The artist places a viewer in the scene by using a viewpoint located in the seats, causing the lunging fighters to hover over us like monumental gladiators. We sense the boxers' sweat, strain, and rippling muscles and the audience's enthusiasm and involvement. Inspired indirectly by Manet, a flicker of darks and lights as well as an intense creamy brushwork animate the surface of the painting. These, along with the rhythmic undulation of curved heads and the flailing arms and legs of the fighters, cause the image to pulsate with a powerful dynamism that captures the raw, crude tenor of the city.

The Armory Show: Modernism Comes to America

Modernism did not come to America until the second decade of the twentieth century. It first appeared in New York at "291," the progressive art gallery owned by Alfred Stieglitz (see page 940). Beginning in 1909, Stieglitz started featuring such seminal modernists as Picasso, Matisse, Henri Rousseau, Rodin, and Brancusi as well as African art and children's art. The momentous Modernist event in New York was the 1913 International Exhibition of Modern Art, known as the Armory Show after the 26th Street armory where it was held. Exhibited were over 400 European works, mostly French, from Delacroix through Courbet, Monet, Gauguin, Van Gogh, and Cézanne to Picasso, Brancusi, and Matisse. Three times as many American artists were represented, but by comparison their work looked provincial and was largely ignored.

Ruthless newspaper reviews lambasted the radical contemporary French art, and the public came out in droves—75,000 people attended the four-week show. They came especially to ridicule Duchamp's *Nude Descending a Staircase,* which one reviewer claimed looked like an "explosion in a shingle factory." The exhibition's slogan was "The New Spirit," and its symbol was the pine tree flag of Revolutionary Massachusetts. The American organizers intentionally set out to create their own revolution to jolt conventional bourgeois taste and bring about an awareness and appreciation for contemporary art. Despite the public's derision, the show spawned several modern art galleries and collectors adventurous enough to dedicate themselves to supporting radical art.

America's First Modernists: Arthur Dove and Marsden Hartley

American artists digested European Modernism almost as quickly as it was made, but those in Europe, especially in Paris, absorbed most rapidly the new movements of Fauvism and Cubism. In 1908 a young Arthur Dove (1880–1946) was in Paris, where he saw work by Matisse and the Fauves. When he returned to New York, he met Stieglitz and began showing at "291."

While remaining involved in the New York City art world throughout his life, Dove lived in rural areas in New York State and Connecticut, even spending several years on a houseboat anchored off Long Island. His art focused on nature, not modernity, and capturing universal forces. By 1910 he was painting complete abstractions, two years before Kandinsky. In *Plant Forms* (fig. **27.38**), from a series of pastels titled *The Ten Commandments*, Dove has supplied all the components of nature without painting it illusionistically.

As with Cubism, the composition of *Plant Forms* is made up of abstract components, although they overlap in a logical, consistent fashion to suggest continuous recession in space. The work has light and atmosphere as well as an organic quality, largely due to the elliptical, oval, and round forms and the biomorphic shapes suggestive of plants and trees. We associate the colors green, ochre, and brown with earth and vegetation, and white and yellow with light. The curved white and yellow forms evoke suns, moons, and hills, and although the frondlike shapes recall plants and trees, they are also symbols of an unidentifiable burst of energy. We feel the powerful surge of

ART IN TIME

1901–1909—Theodore Roosevelt is U.S. president

1905—Alfred Stieglitz opens his gallery "291"

1908—Model T Ford developed

1909—George Bellows's *Stag at Sharkey's*

1913—Armory Show in New York City

1914—Panama Canal opens

nature and an elemental life force, and because each form suggests many different objects, Dove is able to convey the universal interconnectedness of all things. The picture is cosmic in its scope yet provides an intimate view of nature. Dove's preoccupation with portraying potent natural forces will become a major theme in American art and, as we shall see, one of the major issues for artists in Stieglitz's circle.

Stieglitz's stable of artists also included Marsden Hartley (1877–1943), a Maine native who was making Pointillist paintings of the New England woods when the two met in 1909. In 1912 Hartley set off for Paris, where he became infatuated with the tribal art on view at the Trocadéro Museum, declaring, with an air of Western supremacy, that one "can no longer remain the same in the presence of these mighty children who get so close to the universal idea in their mud-baking." He stated that art had to be "created out of spiritual necessity" and, finding French art superficial and lacking soul, he went to Berlin in 1913. There he read the writings of the great German mystics, such as Jakob Boehme (1575–1624). He then developed a unique form of

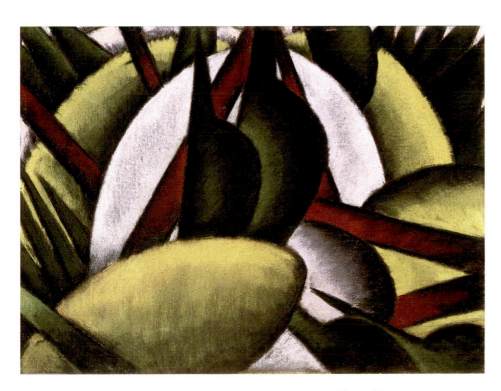

27.38. Arthur Dove. *Plant Forms.* ca. 1912. Pastel on canvas, $17\frac{1}{4} \times 23\frac{7}{8}$″ (43.8 × 60.6 cm). Whitney Museum of American Art, New York. Collection of the Whitney Museum of American Art. Purchase. Purchase with Funds from Mr. and Mrs. Roy R. Neuberger 51.20

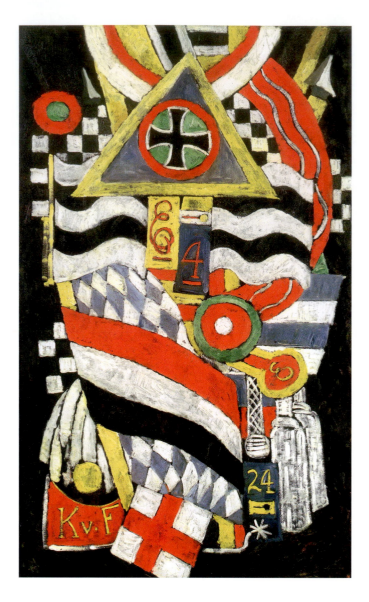

27.39. Marsden Hartley. *Portrait of a German Officer*. 1914. Oil on canvas, $68\frac{1}{4} \times 41\frac{3}{8}$ " (173.4 × 105.1 cm). The Metropolitan Museum of Art, New York. The Alfred Stieglitz Collection, 1949. (49.70.42) © Marsden Hartley

EARLY MODERN ARCHITECTURE IN EUROPE

In Chapter 26, we saw the emergence of two distinct approaches to modern architecture, one in the United States and another in Europe. American artists like Louis Sullivan and Frank Lloyd Wright challenged historicism and conventional revivalism, when they eliminated the distinction between the form of a building and its proposed function. In Europe, we also saw a rejection of revival styles when Art Nouveau defined modern architecture as an organic style of growth and movement. Throughout the twentieth century, modern architecture followed these opposite poles set by the Chicago School and Art Nouveau—the rational, geometric and functional versus the personal, referential, and expressive.

Austrian and German Modernist Architecture

Austria and Germany shaped modern architecture in the opening decades of the century. Charles Rennie Mackintosh, discussed in the previous chapter (see page 932), became the rage in Europe in the 1890s and was particularly idolized in Vienna at the turn of the century by young architects searching for an alternative to Art Nouveau.

JOSEF HOFFMANN The Austrian architect Josef Hoffmann (1870–1956) was especially taken by Mackintosh. In 1903 Hoffmann established the Wiener Werkstätte (Vienna Workshop), a Viennese version of the Arts and Crafts Movement that in the early twentieth century produced some of the greatest applied arts. Hoffmann, in both architecture and design, took his cue from Mackintosh's geometry, becoming so obsessed with the cube that he earned the nickname Quadrat-Hoffmann (*quadrat* is German for "square"). In 1903 he designed the Purkersdorf Sanitarium, an austere building lacking ornamentation or detailing, the expanses of white wall punctuated only by windows.

Hoffmann's masterpiece is the Palais Stoclet (fig. **27.40**), a private residence built in Brussels in 1905 for a Belgium banker who had lived in Vienna. The dominance of squares and rectangles is obvious and extends to the white marble veneer, which is composed of square tiles, and the windows. Hoffmann also introduces the delicacy and refinement, if not the biomorphism, of Art Nouveau, apparent in the bands of gilt bronze outlining the borders of the palace, in the elegant scale of the rooftop railing, and in the tall, vertical staircase window. The bronze bands and joints of the marble veneer give the building a delicate linear surface. In keeping with the Arts and Crafts and Art Nouveau aesthetics, Hoffmann designed every element of the Palais Stoclet, from the gardens, to the furniture, to the cutlery. A sense of harmonious integration pervades the whole, generating a Zen-like serenity and reflecting the Wiener Werkstätte's emulation of the Arts and Crafts Movement's admiration for Japanese art and culture (see Chapter 26).

Synthetic Cubism, which he combined with Fauvist and German Expressionist color to produce paintings filled with spiritual content, as can be seen in *Portrait of a German Officer* (fig. **27.39**), completed in 1914 and later bought by Stieglitz.

This large painting is one in a series dedicated to the memory of Karl von Freyburg, Hartley's lover, who was among the first soldiers killed in World War I. Shown in the painting are such German military paraphernalia as iron crosses, insignia, helmets, boots, service stripes, badges, flags, spurs, and tassels. In a sense, this abstraction is a still life that in spirit recalls Victorian keepsake boxes made for the deceased and containing photographs, clothing, hair, and memorabilia—all pressed under glass. The painting is dominated by a triangle and is filled with circles and diamonds that recall Kandinsky's theosophical belief in the spirituality of geometry. In its jumble of color, form, and composition, *Portrait of a German Officer* expresses a cosmic force similar to Kandinsky's *Compositions* (see figs. 27.14 and 27.15) from this same period, and at times its abstraction seems to suggest landscape almost as readily as it does still life. Soon after returning to the United States, Hartley returned to making landscapes, using an expressionist style that revealed the elemental, spiritual power of nature.

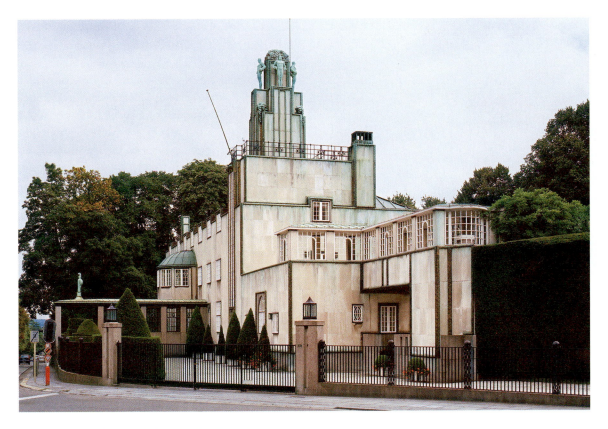

27.40. Josef Hoffmann. Palais Stoclet, Brussels. 1905–1911

ADOLF LOOS A second major Viennese architect was Adolf Loos (1870–1933). After graduating from the Dresden College of Technology, Loos traveled to Chicago to attend the 1893 Columbian Exposition and stayed three years, digesting the functionalism of the Midwest architects and especially coming under the spell of Louis Sullivan. Upon returning to Vienna, he designed interiors and wrote for a liberal magazine, in which he railed against the extravagant ornamentation of Art Nouveau. In 1908, he published his functionalist theories in a book titled *Ornament and Crime*. He declared that except for tombs and monuments, buildings should be functional. "Modern man, the man with modern nerves, does not need ornamentation; it disgusts him," he wrote. He even drew a parallel between ornament and scatological graffiti. Furthermore, as a socialist, he found decoration and historicism particularly offensive because of their associations with the wealthy as well as with the oppression of the artisan.

Loos put his theories into practice in the Steiner House (fig. 27.41) of 1910. He based the U-shaped garden facade on the much larger Purkersdorf Sanitarium, designed by Hoffmann, although Loos's design is much more severe and has greater emphasis on mass. Loos reduces the cornice to a thin, almost undetectable strip. The design of the windows, especially the horizontal ones, appears more functional than aesthetic. In 1923 Loos migrated to Paris, where, as we shall see, High Modernist architects embraced his antiornamentalism, and viewed his Steiner House as an important model.

HERMANN MUTHESIUS AND PETER BEHRENS In Germany, government and industry nurtured Modernist architecture. In 1896, government officials sent architect Hermann Muthesius to London, then the world leader in quality mass production, to study British industry and design. Upon returning in 1904, Muthesius was appointed to the Prussian Trade Commission and given the task of restructuring education in the applied

27.41. Adolf Loos. Steiner House, garden facade, Vienna. 1910.
© Artists Rights Society (ARS), New York/VBK, Vienna

27.42. Peter Behrens. A.E.G. Turbinenfabrik (Turbine Factory), Berlin. 1909–1910. © Artists Rights Society (ARS), New York/ VG Bild-Kunst, Bonn

arts. To dominate world markets, he advocated mass production of functional objects executed in a well-designed machine style. In 1907, he was instrumental in establishing the Deutsche Werkbund, an association of architects, designers, writers, and industrialists whose goal was "selecting the best representatives of art, industry, crafts, and trades, of combining all efforts toward high quality in industrial work." In architecture he called for a new monumental style based on Schinkel's Classicism (see page 858), but reflecting modern industrial values.

One of Muthesius's appointments to the Werkbund was architect Peter Behrens (1868–1940), who had been head of an applied arts school in Düsseldorf. Also in 1907, Behrens was named design consultant to A.E.G., the German General Electric Company; he was responsible for the design of their buildings,

products and marketing materials. Between the Werkbund and A.E.G., Behrens had a mandate to implement the German belief in industrialization as manifest destiny, and he was charged with finding a visual expression for the brute reality of industrial power. He accomplished this goal in his finest A.E.G. building, the 1909 Berlin Turbinenfabrik (Turbine Factory) (fig. 27.42).

This temple to industry is a veritable symbol of industrial might. The enormous main space is constructed of a row of hinged steel arches (their shape echoed in the roofline on the facade) such as those used for nineteenth-century ferrovitreous train stations and exhibition halls (see figs. 25.40 and 25.41). Instead of a greenhouse encased in historical facade, however, Behrens produces an abstract monumental structure that evokes a noble Classical temple and Egyptian entrance gateway. The corners are massive rusticated Egyptian pylons that support an enormous gable, whereas the windows on the side walls are recessed so that the lower portion of the steel arches is exposed, making the row of arches resemble a colonnade. Yet Behrens declares the building's modernity not only in its austere vocabulary but also in the enormous window on the end—an unmistakably Modernist transparent curtain wall that seems to hang from the "pediment."

Although Behrens aggrandized industry in the monumental Turbinenfabrik, he did not produce the machine style that Muthesius was advocating—the *Typisierung*, a type or a basic unit, the equivalent of a mass-produced modular building that could be used by all architects. This machine style would be developed by the three architects in Behrens's office: Walter Gropius, Ludwig Mies van der Rohe, and Le Corbusier.

WALTER GROPIUS Of the architects in Behrens's office in 1910, Walter Gropius (1883–1969) was the most advanced. With associate Adolf Meyer, he was commissioned in 1911 to design the Fagus Factory (fig. 27.43), a shoe plant in Alfeld-an-der-Leine. Well versed in the achievements of Hoffmann, Loos,

27.43. Walter Gropius and Adolf Meyer. Fagus Factory, Alfeld-an-der-Leine, Germany. 1911–1913. © Artists Rights Society (ARS), New York/VB Bild-Kunst, Bonn

and Behrens, Gropius nonetheless reached back to the Chicago School and utilized their steel-grid skeleton, sheathed in a ferrovitreous curtain wall. The factory's glass facade appears to be magically suspended from the brick-faced entablature above. It even turns corners unobstructed. The building feels light and transparent, the window mullions thin and elegant. Horizontal opaque panels, the exact size and shape of the glass, indicate each of the three floors and continue the modular composition of the windows. The only nod to the past is the Classical Beaux-Arts entrance and the thin pseudo-piers faced in brick that support the entablature. Otherwise, with the Fagus Factory, Gropius created the machine style Muthesius was seeking: An unadorned building that adheres to a grid skeleton. This building type was so efficient and reproducible it would serve as the prototype for the glass-box structures that would dominate world architecture for the rest of the century.

German Expressionist Architecture

Not all German architects embraced technology, the machine age, and Muthesius's concept of the *Typisierung*. Others instead designed expressive spiritual structures meant to counter the cold impersonal impact of modernity.

HENRI VAN DE VELDE Another Werkbund architect was Henri van de Velde (1863–1957), a native of Belgium, where he was initially a successful Neo-Impressionist painter and then an Art Nouveau architect and designer. In 1901 he became consultant to the craft industries in the Grand Duchy of Saxe-Weimer. Van de Velde was a strong advocate of Nietzsche's theory of the *Übermensch* and believed in the importance of designing powerful, expressive architecture. He was also heavily influenced by the Munich psychologist Theodor Lipps and his theory of *Einfühlung*, meaning "empathy," the mystical projection of the ego onto the art object. This background led him to examine Wilhelm Worringer's 1908 book *Abstraktion und Einfühlung (Abstraction and Empathy)*, which advocated attaining transcendence through abstraction as well as championing an aesthetic of emphatic expression of vital psychic states.

On a 1903 trip to Greece and the Middle East, Van de Velde became entranced by the powerful simplicity and purity of Mycenaean and Assyrian buildings, which he translated into modern terms in the theater (fig. **27.44**) he built for the 1914 Werkbund Exhibition in Cologne. This structure was designed to counter Mathesius's *Typisierung*, as best represented by Gropius's model factory at the 1914 fair. Despite its massive abstraction, Van de Velde's structure seems like a living organic body rather than a cold, rigid box. Each space within the building is readable from the exterior and has its own identity. Because of the curves, the building seems to swell and breathe. However, this is no longer the springtime effervescence of Art Nouveau; rather it is a reflection of a need to invest architecture with a spirituality and life force and to enhance these qualities by echoing the powerful monumentality and purity of the forms of ancient Near Eastern civilizations.

ART IN TIME

1908—Adolf Loos publishes *Ornament and Crime*

1908—Wilhelm Worringer publishes *Abstraction and Empathy*

1909–1910—Peter Behrens's A.E.G. Turbine Factory

1911–1913—Walter Gropius and Adolf Meyer's Fagus Factory

27.44. Henri van de Velde, Werkbund Theater, Cologne. 1913–1914. Demolished 1920

BRUNO TAUT (1880–1928) A more overt spiritual contribution at the 1914 Werkbund Exhibition was Bruno Taut's Glass Pavilion (fig. **27.45**), built for the glass industry and reflecting his belief in the mystical properties of crystal. The guru of glass was poet Paul Scheerbart, whose 1914 essay *Glasarchitektur*, published in *Der Sturm*, had a tremendous impact on artists and architects. (See end of Part IV, *Additional Primary Sources*.) The entablature of Taut's Glass

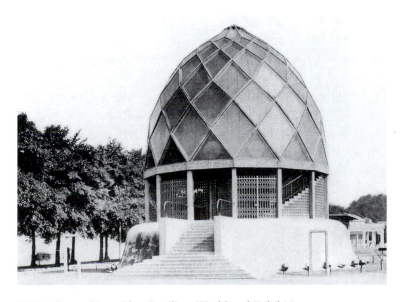

27.45. Bruno Taut. Glass Pavilion, Werkbund Exhibition, Cologne. 1914

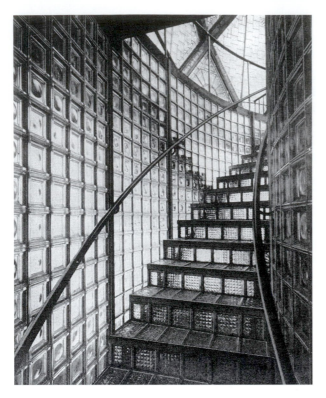

27.46. Bruno Taut. Staircase for Glass Pavilion, Cologne. 1914

Pavilion is even etched with Scheerbart's aphorisms about the power of glass.

Scheerbart claimed that only a glass architecture that opened all rooms to light could raise German culture to a new spiritual level. Consequently, Taut used glass brick for the walls and floors (fig. 27.46). The bulbous dome, which resembles a giant crystal, is made of two layers of glass; the outer one reflective, the inner a myriad of colored-glass pieces resembling medieval stained glass. Taut also considered his cupola to be Gothic, its facets evoking the *élan vital* of the ribbing of the Flamboyant style. The ceiling of the main space had a central oculus that emitted a shower of colored spiritual light.

MAX BERG. The year before, the mystically inspired architect Max Berg (1870–1947) used a similar ocular motif for his Jahrhunderthalle (Centennial Hall) (fig. **27.47**) in Breslau, erected to celebrate the one-hundreth anniversary of Germany's liberation from Napoleon's rule. Berg's Expressionism is quite Romantic, for the enormous building, made possible by ferroconcrete (steel-reinforced concrete), conjures the sublime grandeur of Piranesi's fantasies of Rome (see fig. 23.4) and Boullée's visionary monuments (see fig. 23.25). (See *Materials and Techniques*, page 1013.) Massive elliptical arches resemble an ancient Roman aqueduct or bridge bent into a circle and springing from the floor. The ribbing of the ceiling recalls the Pantheon, but solid and void have been reversed since the coffered section is now windows, creating an aura of celestial light that makes the dome seem to float. The Pantheon's ocular opening is now closed. At the time, critics likened this dark disk to the iris of an eye, and the entire levitating dome to a giant eyeball connected to the universe. As expressed by one contemporary writer, "the cosmos opened to reveal the courses of the stars and the empyrean."

In 1925 Berg abandoned architecture to dedicate his life to Christian mysticism. But in 1912, when *Die Brücke* and *Der Blaue Reiter* were committed to leading Germany into a world of higher spirituality through painting, prints, and drawings, Berg sought to achieve the same in ferroconcrete and glass.

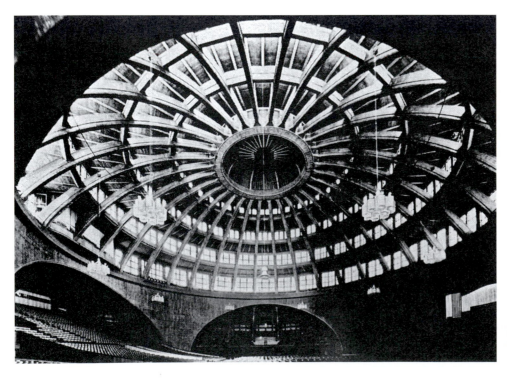

27.47. Max Berg. Interior of the Centennial Hall, Breslau, Germany. 1912–1913

SUMMARY

The social and cultural conditions of the early twentieth century were a crucible for the continuing development of modern art in the West. Scientific breakthroughs revised centuries' old beliefs about the fundamental nature of matter and energy, leading some artists to reconsider the basic principles of composition. For many in the avant-garde, it was as if a veil had been lifted, revealing new relationships between form and space, and new functions for line and color. Philosophic and psychoanalytic conceptions of human consciousness likewise encouraged many avant-garde artists to pursue new representations of self, some even finding the essence of humanity in pure abstraction.

FAUVISM

When seen at the Salon d'Automne of 1905, works by Matisse and Derain struck viewers as so shocking and unconventional that the artists were labeled *fauves*, wild beasts. With no apparent relationship to natural appearances, Fauvist color served strictly formal ends. Similarly, conventional systems of perspective, such as one-point perspective or objects getting smaller as they receded, were abandoned. Space was now treated as fluid, subjective, and subordinate to theme. Yet the themes adopted by the Fauves were far from radical: idyllic pastoral views, portraits, still lifes. These were the genres pursued by Claude and Poussin—a connection lost on the critics in 1905 but well understood by Matisse and his colleagues.

CUBISM

Like the Fauves, Picasso and Braque were conscious of artistic tradition when they embarked on their Cubist experiments. Indeed, Picasso had deliberately engaged French academicism when he painted his radical *Les Demoiselles d'Avignon* in 1907 on a canvas consistent in size with history paintings destined for the official Salon. Cubism, however, would have been impossible to conceive without the aesthetic model developed by Cézanne. Cézanne's solidly structured meditations on nature pointed the way to Cubist approaches to form and line, while Picasso's and Braque's speculations on the nature of a space-time continuum freed them from the convention that held that pictures could represent only a single viewpoint.

THE IMPACT OF FAUVISM AND CUBISM

The emotional restraint of Fauvism and Cubism gives way in Expressionism and some aspects of Orphism. Tapping into elemental, often difficult emotions, the German and Austrian Expressionists sought a visual language that could convey the raw intensity of their feelings. Paula Modersohn-Becker led the way with her reformulation of the female nude, stripping away its hackneyed conventions and its anonymous, faceless eroticism in favor of a strong, monumental, and personal vision. Viennese Expressionist Egon Schiele did the same for the male nude, which he transformed into a conduit for personal emotion rather than a collective ideal. Orphists, like Robert Delaunay, found a different path. Seeking to depict a mystical encounter with the universe, the Orphists illuminated their vaguely Cubist constructions with Fauvist color to evoke an infinite space that pulses with vitality. Also intrigued by Cubist reconfigurations of space were painters like Marc Chagall and Giorgio de Chirico, who sought to represent fantastical landscapes of dream, myth, and memory. Cubism provided a means to leave behind the conventional logic of Renaissance perspective for a new, disorienting conception of space that enhanced the mysteriousness of their images.

Other artists and groups used Fauvism and Cubism as springboards to different, sometimes more doctrinaire directions. Futurism exemplifies this latter response. Believing Italy's Classical legacy to be a barrier to national progress, the Futurists embraced what they believed to be the hallmarks of modernity: industrialization, speed, factories, and even mechanized warfare. They deployed Fauvist color and the Cubist conception of the relation between form and space to convey movement and dynamic energy.

MARCEL DUCHAMP AND THE DILEMMA OF MODERN ART

Marcel Duchamp took art in a new direction when he invented the assisted readymade, such as *Bicycle Wheel*. Placing a bicycle wheel on a stool challenged numerous notions about art: that art is about craft, style, beauty, illusion or representation, and was invested with fixed meaning. Art was now a vehicle for ideas.

MODERNIST SCULPTURE: CONSTANTIN BRANCUSI AND ARISTIDE MAILLOL

Constantin Brancusi simultaneously released art from the powerful hold of the Classical paradigm as well as Rodin's influence when he reduced sculpture to a minimal essence of abstract form that captured elemental truths about life and experience. Aristide Maillol before him had reduced his figures to simple monumental shapes, but they retained the look of Classical sculpture and evoked a sense of Mediterranean perfection, beauty, and idealism, reflecting an escape from modernity, as in Matisse's *The Joy of Life*.

AMERICAN ART

American Art opened the twentieth century with a style unique to the nation: the Ashcan School. Harking back to the Realism of Manet, a group of Philadelphia illustrators who moved from Philadelphia to New York recorded the dramatic social changes occurring in Manhattan, including the mass immigration from Europe and migration of African Americans from the rural South, as well as the emergence of the independent New Woman. Alfred Stieglitz's gallery "291," and the 1913 Armory Show sought to introduce Modernism to America and succeeded in generating a handful of galleries and collectors dedicated to supporting modern art. The most advanced art was made by those American artists who went to Europe, including Arthur Dove, who made abstract paintings as early as 1910, and Marsden Hartley, who made a series of expressionistic Synthetic Cubist paintings in Berlin toward 1915. Both artists anticipated a search for the spiritual that would preoccupy many American artists in between the wars.

EARLY MODERN ARCHITECTURE IN EUROPE

Modern European architecture first appeared in Vienna and in Germany. It followed one of two paths: It was mechanomorphic, following the form-follows-function concept of the Chicago School, or it was personal, expressionistic, and fantastic, following the model established by Art Nouveau. The former path was taken by Adolf Loos in Vienna, who rejected the notion of ornamentation in favor of simple forms, and Walter Gropius, who developed an architectural design that viewed a building as a steel grid skeleton clad in a thin skin of glass. The expressionist course was advocated by a group of German architects, especially Bruno Taut, who made buildings out of glass, allowing mystical light to permeate the interior, or Max Berg, whose monumental Roman-looking ferroconcrete auditorium had a ceiling that seemed to levitate and allow spiritual forces to enter.

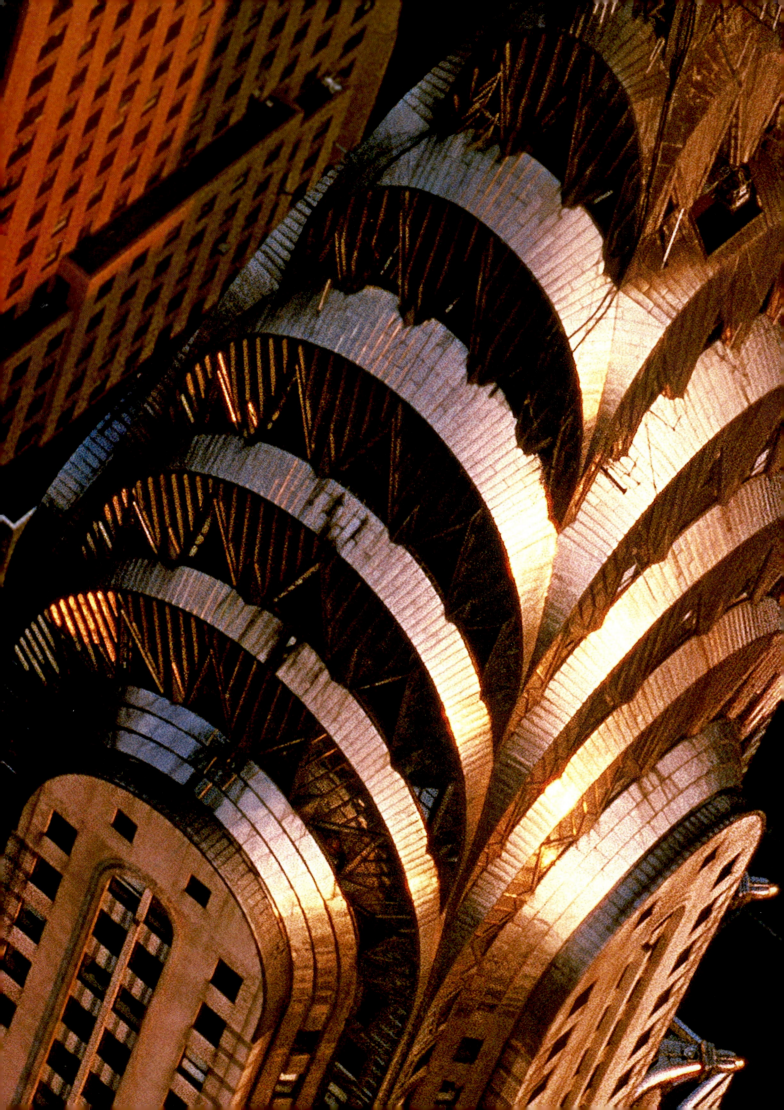

Art Between the Wars

PHYSICALLY AND PSYCHOLOGICALLY, WORLD WAR I DEVASTATED WESTERN civilization. The destruction and loss of life were staggering, with hundreds of thousands of soldiers dying in single battles. The logic, science, and technology that many thought would bring a better world had gone horribly awry. Instead of a better world, the advancements of the nineteenth century had

produced such high-tech weapons as machine guns, long-range artillery, tanks, submarines, fighter planes, and mustard gas.

To many, the very concept of nationalism now seemed destructive, and the rise of the first Communist government in Russia in 1917 offered the hope of salvation. Around the world, branches of the Communist Party sprang up, with the goal of creating a nationless world united by the proletariat, the working class that provides the labor force for the capitalist system. Others maintained that a new world order could not be attained without first destroying the old; they advocated anarchy, which remained a constant threat in the postwar decades. Despite this drive to create a nationless and classless world, by the 1930s, it was fascism that took hold of European politics. Fascism, a totalitarian political system that exalts the nation over the individual and demands allegiance to a single leader, held a special appeal in nations defeated in World War I. Germany, in particular, had been humiliated by the terms of the Treaty of Versailles, and had suffered extreme inflation and then economic collapse. Germans gradually became enthralled by Adolf Hitler (1889–1945) and the Nazis, who skillfully used economic crises and anti-Semitism to consolidate their power. In Italy and Japan, as well, fascists, under the command of charismatic leaders took control. Armed with new technological tools of

destruction, these nations would plunge the world into another great war by 1939.

While fascism, communism, anarchy, and democracy jockeyed for dominance in Europe, America enjoyed unprecedented prosperity in the 1920s. Historians have called the economic and cultural exuberance of the postwar years the Roaring Twenties; it was a time of jazz, speakeasies, radio, and film. The 1920s also saw the rise of the city as the emblem of the nation. Technology and machines were king in America, where the world's largest skyscrapers could be erected in a year. This economic exhilaration came to a screeching halt with the stock market crash of October 1929, which sent the entire world into a downward economic spiral known as the Great Depression, which lasted throughout the 1930s. A reactionary backlash then occurred in both Europe and America: fascism in the former, and a conservative regionalism and isolationism in the latter. Nonetheless, the 1930s marked the advent in America of liberal social and economic programs, instituted by Franklin Delano Roosevelt's administration (1932–1944). Believing that economic markets were inherently unstable, Roosevelt advocated The New Deal, which created millions of government sponsored jobs, including many for artists.

Perhaps the strongest defining influence for artists between the wars was the Great War itself and the technology, science, and Enlightenment rationalism that allowed it to be so devastating. The war directly produced Dada, a movement

Detail of figure 28.47, William van Alen, Chrysler Building

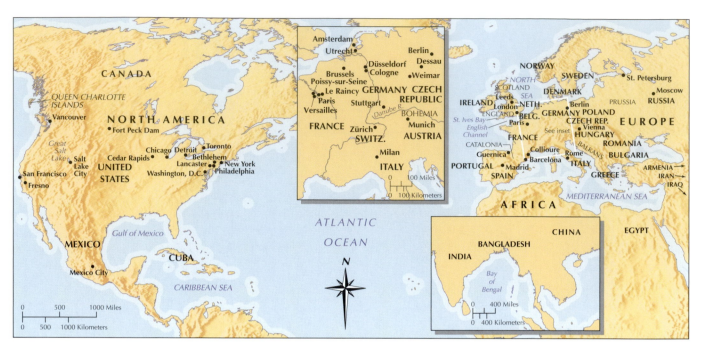

Map 28.1. Europe and North America (with Asia insert)

that created a nonsensical nihilistic art that attacked bourgeois values and conventions, including a faith in technology. The Dadaists aimed to wipe the philosophical slate clean, leading the way to a new world order. Other artists embraced the modernity of the Machine Age (as this interwar period is sometimes called), seeing it as a means to create classless utopias; still others rejected it, seeking higher truths or a meaningful spirituality in an increasingly materialistic, soulless world. Both groups often turned to abstraction to implement their vision. Those supporting technology embraced the geometry and mechanical look of the Machine Age, while those who rejected it sought higher truths using an organic or biomorphic vocabulary.

A second major force for the period was Sigmund Freud, whose theories about the unconscious and dreams were a formative influence on Surrealism, a prevailing movement in the 1920s and 1930s. Like many abstract artists, the Surrealists sought to reveal invisible realities, not spiritual realities, but nonetheless elemental universal forces that drove all humans. These unseen realities were deeply embedded in the mind and symbolically revealed in dreams. Freud maintained that the conventions of civilization had repressed the elemental needs and desires that all people shared, and that this suppressed, invisible world of desires and sexual energy was fundamental to human behavior, the driving force within all humans. Freud acknowledged that civilized societies required the repression and channeling of those desires, but asserted that individuals paid a price in the form of neuroses and discontent. For Surrealist artists, as well as writers and intellectuals, Freud's theory of the unconscious confirmed the existence of realities unseen by the eye or perceived by the conscious mind, and they served as the springboard for the development of Surrealist imagery and style.

Politics also strongly shaped the art of the period. Many if not most avant-garde artists were socialists and Communists, or at least sympathizers, and their utopian dreams and aesthetic visions stem in part from these political ideologies. The narrative, representational murals of the great Mexican artists directly champion Communism, especially when paired with science, as the vehicle for creating a classless utopian society. With the rise to power of Hitler and his National Socialist Party, many avant-garde artists turned their attention to making anti-fascist imagery and exposing the insane thinking and sadistic brutality of the new German government.

This period also saw a growing interest in racial and ethnic identity, which was expressed in Mexican art and African American art. The Mexican muralists were preoccupied with national identity, which they associated with the indigenous population, not Euro-Mexicans, while African Americans sought to uncover their heritage and culture. Just as Mary Cassatt, Berthe Morisot, and Margaret Julia Cameron sought to present women from a female viewpoint as opposed to that of a male, obtaining very different results, the Mexicans and African Americans did the same for African and native cultures. These artists presented a very different image of and attitude toward non-European cultures.

DADA

The Great War halted much art making, as many artists were enlisted in their country's military service. Some of the finest were killed, such as Expressionists Marc and Macke, and Futurists Boccioni and Sant'Elia. But the conflict also produced one art movement: Dada. Its name was chosen at random, the story goes, when two German poets, Richard Huelsenbeck and Hugo Ball, plunged a knife into a French-German dictionary and its

point landed on *dada*, the French word for "hobbyhorse." The word's association with childishness as well as the random violence of the poets' act of word choice fit the postwar spirit of the movement perfectly. As the birth story of Dada suggests, the foundations of the movement lay in chance occurrences and the absurd. Logic and reason, the Dada artists concluded, had led only to war. For them the nonsensical and the absurd became tools to jolt their audience out of their bourgeois complacence and conventional thinking. The movement was profoundly committed to challenging the status quo in politics as well as in culture. Dada began in 1916 in neutral Zurich, where a large number of writers and artists had sought refuge from the war and dedicated themselves, as Ball declared, "to remind the world that there are independent men, beyond war and nationalism, who live for other ideals." The Dada spirit spread across the West and to parts of Eastern Europe and would become a reference point for artists throughout the twentieth century.

Zurich Dada: Jean (Hans) Arp

In Zurich, the poet Hugh Ball founded the Cabaret Voltaire in 1916 as a performance center where writers and artists could protest the absurdity and wastefulness of the Great War. (The name of Voltaire referred to the great Enlightenment *philosophe* whose ideas epitomized the logic that the Dadaists were attacking; see page 790.) Ball was soon joined by the Romanian poet Tristan Tzara, who became Dada's most vociferous proponent. The artists and writers at the Cabaret Voltaire attacked the rational thinking that, in their view, produced the depraved civilization responsible for the war. Their target was all established values—political, moral, and aesthetic—and their goal was to level the old bourgeois order through "nonsense" and anarchy. In the end, they hoped to produce a *tabula rasa*, a clean slate, that would provide a new, fresh foundation for an understanding of the world.

The Cabaret Voltaire group, which included the Alsatian painter and poet Jean (Hans) Arp, mounted boisterous performances. Wearing fanciful costumes, including primitive cardboard masks, they recited abstract phonetic poems of nonwords and nonverses. ("Zimzum urallal zumzum urallal zumzum zanzibar zumazall zam" went one line in Hugo Ball's *O Gadji Beri Bimba*.) The readings were virtually drowned out by an accompanying "music," a cacophony of sounds, often the arhythmic beating of a drum. The performers' chaos whipped the audiences into frenzies of catcalls, whistles, and shouts. Some evenings, Tzara harangued the audience with rambling, virtually incomprehensible Dada manifestos. And, just as chance had named the Dada movement, it was used to create works themselves. Dada poems were "written" by pulling words out of a hat. Sometimes one poem was read simultaneously in different languages, or different verses of the same poem were read simultaneously in one language. The resulting chance weaving of words together in a new way created a fresh unpredictable poetic fabric, both in sound and meaning. Some performances included *dances nègres* and *chantes nègres*, as African dance and music were called, reflecting the group's interest in so-called primitive cultures, cultures supposedly free of the evils of advanced civilization.

Furthermore, the Dada artists believed that the directness and simplicity of African cultures put those cultures in touch with the primal essence of nature itself. Perhaps the most far-reaching influence of Dada performances was that they tore down the boundaries that had separated the various arts as visual artists, musicians, poets, actors, and writers worked together. Furthermore, the Dadaists destroyed any hierarchy of medium and genre. The Zurich Dadaists exhibited a broad range of avant-garde art, such as paintings by de Chirico and Klee—as long as the art undermined bourgeois taste and standards. Most of the art presented at the Cabaret Voltaire and its successor, the Galerie Dada, was abstract. Among the strongest visual artists in the group was Jean (Hans) Arp (1886–1966), whose abstract collages hung on the walls of the Cabaret Voltaire on opening night. Arp made his collages by dropping pieces of torn rectangular paper on the floor; where they fell determined the composition. Although he claimed that chance alone arranged the papers, Arp probably manipulated them.

Arp believed that chance itself replicated nature. For him, life, despite the best-laid plans, was pure chance. Arp had been in Munich with Kandinsky (see pages 957–958), and there he adopted a mystical view of the world that envisioned a life force running through all things, binding them together in no particular order. Like Kandinsky, Arp sought to capture abstract universal forces. This spiritual outlook can be seen in the low relief sculptures he began making at about this time, such as *The Entombment of the Birds and Butterflies (Head of Tzara)* (fig. **28.1**).

28.1. Jean (Hans) Arp. *The Entombment of the Birds and Butterflies (Head of Tzara)*. 1916–1917. Painted wooden relief, $15\frac{3}{4} \times 12\frac{3}{4}$" ($40 \times 32.5$ cm). Kunsthaus, Zurich. © Artists Rights Society (ARS), New York/VG Bild-Kunst, Bonn

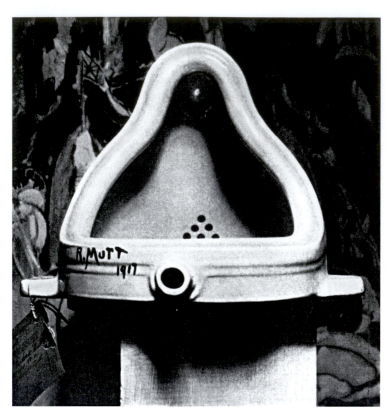

28.2. Marcel Duchamp. *Fountain.* 1917. Photograph by Alfred Stieglitz, from *The Blind Man.* May 1917. Philadelphia Museum of Art, Louise and Walter Arensberg Collection. © Artists Rights Society (ARS), New York/ADAGP, Paris/ Succession Marcel Duchamp

The different shapes were determined by doodling on paper. He then had a carpenter cut the shapes out of wood, which Arp painted and assembled into abstract compositions evoking plant and animal forms as well as clouds, cosmic gases, and celestial bodies. The title came last, and, as it suggests, the image can be also seen as a mask, suggesting an elemental connection between humans and nature.

Cabaret Voltaire closed by the summer of 1916 and was replaced by a succession of other venues. Meanwhile, Tzara's magazine, *Dada*, spread the word of the movement worldwide. By the end of the war in late 1918, Zurich had been abandoned by many of the major artists, and by early 1919, Zurich Dada drew to a close. Only after the war was over did Tzara hear that there was a New York Dada movement happening simultaneously, if not in name, at least in spirit.

New York Dada: Marcel Duchamp

New York Dada was centered on Marcel Duchamp and Francis Picabia, both of whom fled Paris and the war in 1915. Picabia was notorious for his satirical portraits in which the subject is represented by a machine. In one, the photographer Alfred Stieglitz (see page 940) was portrayed as a camera, which takes on human qualities embodying Stieglitz's personality. The New York artists had no Café Voltaire, no manifestos, and no performances, although they did hold a weekly salon at the home of the wealthy writer Walter Arensberg and his wife, Louise. From 1915 to 1916 they published their avant-

garde art and ideas in a magazine entitled *291*, which was sponsored by Alfred Stieglitz, who as well as being a photographer was one of the first dealers of avant-garde art in America. The word Dada was never used at the time to describe their art; it was only applied in retrospect because their spirit was similar to that found in Zurich.

Perhaps the highlight of New York Dada is Duchamp's *Fountain* (fig. 28.2). Duchamp submitted this sculpture to the 1917 exhibition of the Society of Independent Artists, an organization begun several decades earlier to provide exhibition opportunities for artists who did not conform to the conservative standards of New York's National Academy of Design, which had been the primary exhibition venue. Duchamp labeled his *Fountain* an "assisted Readymade." He took the term from American readymade clothing, and applied it to his sculptures that simply re-presented a found object, such as a snow shovel, which Duchamp entitled *In Advance of a Broken Arm*. Objects that he "assisted," by joining them with other objects, as in *Bicycle Wheel* (see fig. 27.32), or by signing, as in *Fountain*, he called an "assisted Readymade." As we saw in Chapter 27, Duchamp began working with found objects when he made his *Bicycle Wheel* in 1913, although he did not exhibit his Readymades and coin the term until he was in New York. *Fountain* was, in fact, a urinal manufactured by J. L. Mott Iron Works in New York. Duchamp selected it, purchased it, turned it ninety degrees, set it on a pedestal, and crudely signed it with the fictitious name of "R. Mutt"—a reference not only to the manufacturer but also to the character Mutt in the popular Mutt and Jeff comic strip. The work was submitted to the Society's exhibition under Mutt's name, not Duchamp's. According to the Society's rules, anyone paying the $6 admission fee would have his or her work accepted. But Duchamp knew the hanging committee would not allow *Fountain* to go on view, and when it was removed at the opening, his friends formed a rowdy procession that drew attention to its rejection.

Duchamp continued the hoax of R. Mutt's authorship of the work when he wrote an article about the piece in a small newspaper he published, *The Blind Man*, which only made it through two issues but was circulated in the art world. The article was illustrated by a Stieglitz photograph of it placed before a painting by Marsden Hartley (see fig. 27.39), thus asserting that the proper context for the *Fountain* was the art world. The article defended Mutt's right to create a Readymade: "Whether Mr. Mutt with his own hands made the fountain or not has no importance. He chose. He took an ordinary article of life, placed it so that its useful significance disappeared under a new title and point of view . . . [creating] a new thought for that object."

Like all of Duchamp's works, *Fountain* is rich in ideas, and it stands as one of the seminal works of twentieth-century art, although the original has disappeared. The sculpture is all about idea. A viewer of *Fountain* must ask, what is the work of art? Is it the urinal, the provocation of submitting it to the exhibition, the flamboyant parade when it was removed from the show, or the article about it in *The Blind Man*? Obviously, it is all of these things. Even the title is essential to the work, since it is an essential part of the sculpture, and it allows Duchamp to make it clear

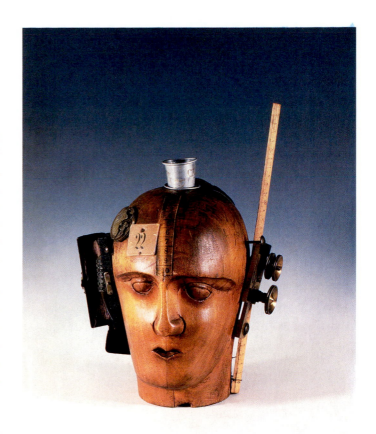

28.3. Raoul Hausmann. *Mechanical Head (Spirit of the Age).* ca. 1920. Assemblage. h. 12³⁄₄″ (32.5 cm). Musée National d'Art Moderne, Centre Georges Pompidou, Paris. © Artists Rights Society (ARS), New York/ADAGP, Paris

that he is attacking one of the more revered of all art forms, the fountain, which is the centerpiece for most European towns and city squares and is, in some respects, a symbol for the tradition of fine art. The satirical title also reinforces the humor of the piece, an ingredient found in much of Duchamp's work. Duchamp is telling us art can be humorous; it can defy conventional notions of beauty, and while intellectually engaging us in a most serious manner, it can also make us smile or laugh. Duchamp challenges the notion of what is art and the importance of technique or craft, as well as the artist's signature. He also asks how a work of art takes on meaning. Here, Duchamp emphasizes the relationship between context and meaning: By taking a urinal out of its normal context he has changed its meaning. (For a more extensive discussion of Duchamp, see pages 970–971.) He even allows a viewer to assign meaning to the work, underscoring how this is a reality for all art. Ironically, unlike all art that preceded his, his Readymades have no aesthetic value and theoretically no intended meaning. They are merely a device to launch ideas.

Because *Fountain* is industrially manufactured and can be easily replaced if broken or lost, Duchamp also questions the significance attached to the uniqueness of a work of art. As we shall see, in the second half of the twentieth century, Duchamp will become the dominant figure in art as artists worldwide make what will be called Conceptual Art. For those artists, an idea or conceptual premise is the most important component of their work, often the most important.

In contrast to Zurich Dada, New York Dada was very quiet. In Manhattan, the group was removed from the war, and it did not have a political agenda. Its focus was largely on defining art, following Duchamp's lead. More important, New York Dada was lighthearted and witty, as in Picabia's humanoid machines and Duchamp's *Fountain*. It attacked bourgeois artistic values through punning, teasing, irony, pranks, and intellectual games of the highest order. Dada art with a more acute sense of social mission was produced in war-torn Germany.

Berlin Dada

With the end of the war, the Dada poet Richard Huelsenbeck (1892–1974) left Zurich for Berlin. There he found a moribund city, which like all of Germany was without food, money, medicine, or a future. Germans, especially the working class, loathed the military-industrial machine, which they felt had betrayed their interests by leading them into war. With the surrender, conditions worsened as Germany was punished by harsh and, some thought, unrealistic reparation demands. Inflation was rampant, and the value of the German mark plunged. Open class conflict in 1919 resulted in Communist-led worker uprisings in Berlin and Munich that were brutally repressed by right-wing armed units. The Weimar Republic government, which had replaced the kaiser and represented Germany's first experience with democracy, failed to revive the

economy; its refusal in 1923 to make war reparations only resulted in further humiliation. The French military occupied the Ruhr Valley and seized the German assets in that coal-mining region.

For many, hope lay in the East, in Russia, where the Bolshevik Revolution established the prospect for a nationless world governed by the proletariat. The artists and writers in Berlin Dada looked to international worker solidarity as Germany's salvation. Here was a situation where Dada anarchy and nihilism could be put to practical use. Almost without exception, the Berlin Dada contingent made political art and were political activists, with some members, such as George Grosz and John Heartfield, joining the Communist Party.

In Berlin, the poet Huelsenbeck employed the usual Dada devices. He created an organization, Club Dada, and published manifestos calling for the overthrow of the bourgeois establishment and the creation of an egalitarian society. The principal members of the group included Raoul Hausmann, Hannah Höch, George Grosz, and John Heartfield. In 1920 they organized the first Dada International Fair, which featured worldwide Dada art. In the center of the fair, hanging from the ceiling, was an army-uniformed dummy with the head of a pig and wearing a sign saying "Hanged by the Revolution." The work, a collaboration by Hausmann and Grosz, epitomized Dada's abhorrence of the establishment.

RAOUL HAUSMANN Hausmann (1886–1971) quickly became the leader of Berlin Dada, and was perhaps the most visually inventive, as can be seen in his 1920 assemblage *Mechanical Head (Spirit of the Age)* (fig. **28.3**). He used found

objects, which at the time were so foreign to the art world they were considered junk: a mannequin's head, a collapsible cup, a wallet, labels, nails, and rulers. But now we see a new approach to making sculpture: The found objects are assembled together, and for the purpose of making a statement condemning materialism and the loss of individuality and personal identity.

Hausmann, however, is best known for his use of language and collage. Like Hugo Ball in Zurich, he wrote and performed phonetic poems made according to the laws of chance. His interest in words, letters, and sound led him to innovative experiments with typography, in which he used different typefaces and sizes for individual letters cut from magazines and newspapers, the shifts in scale indicating how the letter should be emphasized when sounded. These words were incorporated into ingenious collages made from material cut from different printed sources and rearranged in new contexts, as seen in *ABCD* (fig. **28.4**). Collage, of course, was not new but previously it had been used in a refined manner, particularly by the Cubists, who had transformed the found materials taken from popular culture into beautiful art (see fig. 28.12). With Hausmann, however, col-

lage retained the look and feeling of popular culture, especially the advertising look seen in the mass media. The Berlin Dadaists did not call their works collages, which suggests fine art. Instead, they labeled them "photomontages," which evoked machine-made, mass-produced images. Their photomontages looked like antiart, and their powerfully abrupt compositions embodied the group's political stridency.

HANNAH HÖCH Some of the most elaborate and powerful Dada collages from the period were created by Hannah Höch (1889–1978), who was also Hausmann's companion. Her Dada collages mimic manipulated portraits made for the Germany military photographs. Individuals or entire battalions hired photographers to create fictitious portraits by photographing the patron or patrons, then cutting out their heads and pasting them onto pre-existing pictures of, for example, mounted militia. (See *Primary Source*, page 991.) *Cut with the Kitchen Knife Dada through the Last Weimar Beer Belly Cultural Epoch of Germany* (fig. **28.5**) speaks volumes about the agenda of Berlin Dada. Using a chaotic, cramped composition of crowds, words, machinery, and lettering of different sizes and styles, Höch captures the hectic social, political, and economic intensity of the Weimar Republic. Her photomontage represents the reality captured by photographers for the popular press. To Höch and her Dada colleagues, the camera was another machine, related to the technological advances that had led to the war. With her "kitchen knife," she rearranged the imagery to create a handmade photograph, thus forcing the machine to be subject to the human rather than vice versa. The result is a spinning, gearlike composition with a portrait of the radical antiwar female artist Käthe Kollwitz at the center. German masses and the new leaders of their government, the Weimar Republic, are pushed to the sides and villainously labeled as the "anti-Dada," meaning against Dada and leftist politics.

KÄTHE KOLLWITZ Though not a Dada artist, Käthe Kollwitz (1867–1945), the artist spotlighted by Höch in *Cut with the Kitchen Knife*, provided an important precedent for the political and expressive nature of Berlin Dada. A generation older than Höch, she was denied admission to the Berlin Academy because she was a woman. She studied at a woman's art school, and after marrying a doctor, settled in a working-class neighborhood in Berlin. There, her husband treated the poor, who became the subject of her art. She shunned painting as an elitist medium of the academy and the bourgeois, and instead made drawings and prints, which could be mass produced and circulated to wide audiences. For the Berlin Dada artists, who were committed to clear political messages, Kollwitz was an inspiration. Although for

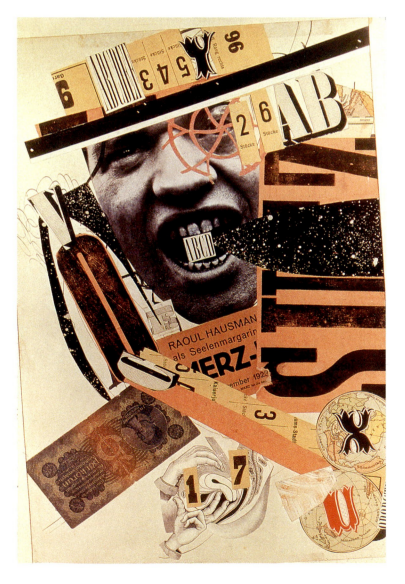

28.4. Raoul Hausmann. *ABCD*. 1923–24. Photomontage, 16 × 11¼″ (40.7 × 28.5 cm). Musée National d'Art Moderne, Centre Georges Pompidou, Paris. © Artists Rights Society (ARS), New York/ADAGP, Paris

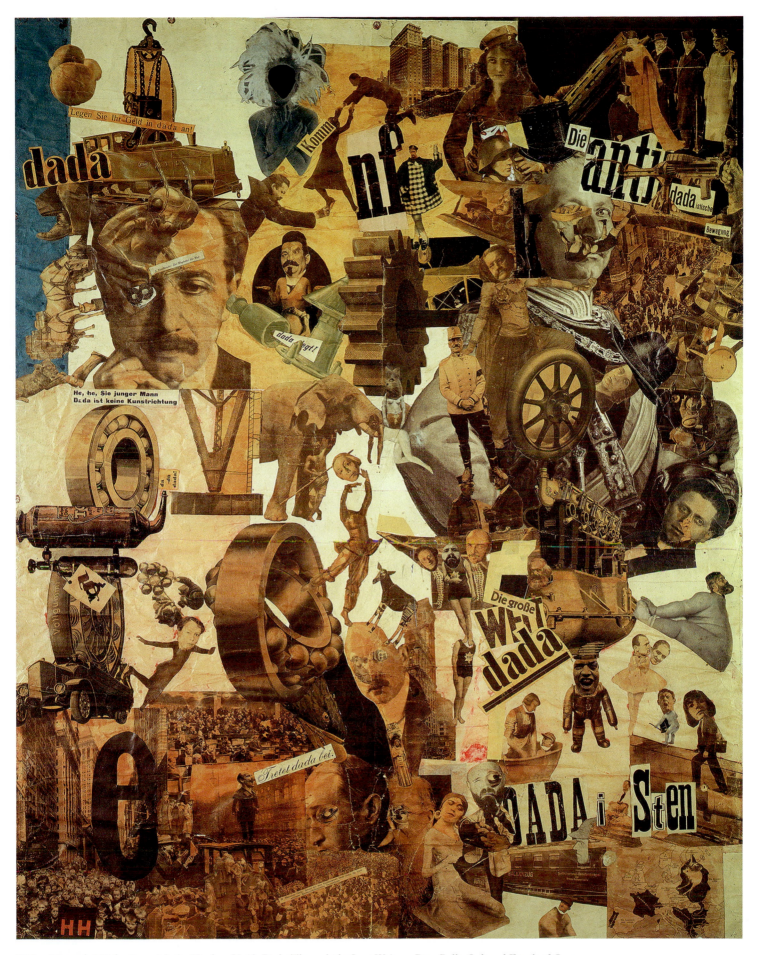

28.5. Hannah Höch. *Cut with the Kitchen Knife Dada Through the Last Weimar Beer Belly Cultural Epoch of Germany.*
ca. 1919. Collage, 44⁷⁄₈ × 35³⁄₈″ (114 × 90.2 cm). Staatliche Museen, Berlin. © Artists Rights Society (ARS), New York/
VG Bild-Kunst, Bonn

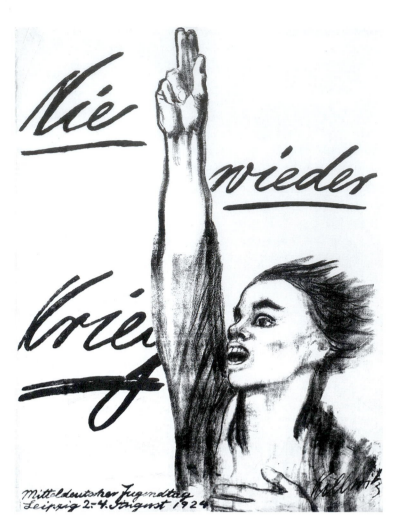

28.6. Käthe Kollwitz. *Never Again War!* 1924. Lithograph, 37 × 27¹/₂″ (94 × 70 cm). Courtesy Galerie St. Étienne, New York. © Artists Rights Society (ARS), New York/VG Bild-Kunst, Bonn

Upon convalescing and returning to Berlin, he was stylistically inspired by the expressive Cubism of the Futurists and worked in this style at the same time as he produced photomontages. A fine example of his Cubist style is *Germany, A Winter's Tale* (fig. **28.7**) of 1918. Here, the city of Berlin forms the kaleidoscopic and chaotic background for several large figures, which are superimposed on it as in a collage. They include the marionette-like "good citizen" at his table and the sinister forces that molded him: a hypocritical clergyman, a brutal general, and an evil schoolmaster. This, Grosz tells us, is the decadent world of the bourgeoisie that he, like many German intellectuals, hoped would be overthrown by Communism. In 1920, he, along with Kollwitz and other artists, joined the International Workers Aid.

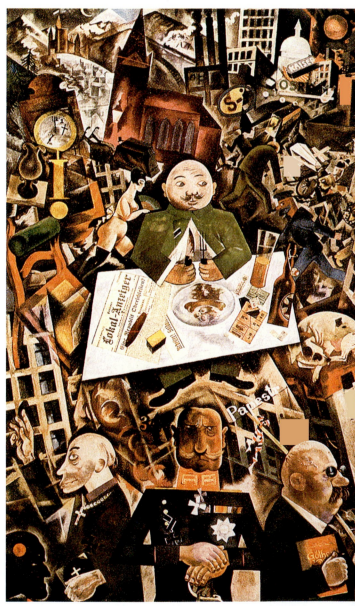

the 1920s, her representational style was somewhat conservative, her message was influential, for she had created a large body of powerful Expressionist work that conveyed her sympathies with the working class, women, and victims of war. In addition, her imagery contains far more women than does that of her male counterparts and reflects her socialist vision of women playing an equal role in the ideal Germany of the future. Typical of her Expressionistic style of strident marks, strong value contrast, and powerful emotions is *Never Again War!* (fig. **28.6**), a lithograph published in 1924.

GEORGE GROSZ An early maker of Dada photomontages, George Grosz (1893–1959), provides a clear example of the Expressionist element in Berlin Dada and its direct connection with Kollwitz. Grosz, who had been seriously wounded twice in the war and had a mental breakdown, was especially bitter about the disastrous course charted by the German leaders.

28.7. George Grosz. *Germany, A Winter's Tale*. 1918. Formerly Collection Garvens, Hannover, Germany. Whereabouts unknown. Art © The Estate of George Grosz/Licensed by VAGA, New York

Hannah Höch (1889–1978)

From an interview with Édouard Roditi

In an interview with art historian Édouard Roditi, the German Dada artist Hannah Höch talks about the inspiration for Dada photocollage.

Actually, we borrowed the idea from a trick of the official photographers of the Prussian army regiments. They used to have elaborate oleolithographed mounts, representing a group of uniformed men with a barracks or a landscape in the background, but with the faces cut out; in these mounts, the photographers then inserted photographic portraits of the faces of their customers, generally coloring them later by hand. But the aesthetic purpose, if any, of this very primitive kind of photomontage was to idealize reality, whereas the Dada photomonteur set out to give to something entirely unreal all the appearances of something real that had actually been photographed. . . .

Our whole purpose was to integrate objects from the world of machines and industry in the world of art. Our typographical collages or montages also set out to achieve similar effects by imposing, on something which could only be produced by hand, the appearances of something that had been entirely composed by a machine; in an imaginative composition, we used to bring together elements borrowed from books, newspapers, posters, or leaflets, in an arrangement that no machine could yet compose.

SOURCE: ÉDOUARD RODITI, *DIALOGUES: CONVERSATIONS WITH EUROPEAN ARTISTS.* (BEDFORD ARTS PUBLISHERS, 1990)

Cologne Dada

In the city of Cologne, Dada initially took its lead from Berlin, but it was never as political. Dada artists here were intrigued by Freud's theory of the unconscious and favored figures that combined mechanical and human forms (sometimes called mechanomorphic art), reminiscent of the work of Duchamp and Picabia. The key Cologne Dada artists were Max Ernst (1891–1976) and Johannes Baargeld (a pseudonym meaning "money bags"), both of whom appropriated the Berlin artists' collage technique. Ernst and Baargeld were iconoclasts, not social evangelists, who delighted in submitting their witty low-end irreverent collages to the staid Cologne Kunstverein Exhibition in 1919, creating a scandal. When prohibited from showing there the following year, Ernst mounted a solo exhibition at a nearby brewery, forcing visitors to walk past the lavatory to get to the "gallery," where the central work was a sculpture that visitors were instructed to destroy with an axe he provided.

Typical of Ernst's work from this very productive period is *1 Copper Plate 1 Zinc Plate 1 Rubber Cloth 2 Calipers 1 Drainpipe Telescope 1 Piping Man* (fig. **28.8**), a gouache, ink, and pencil drawing on an illustration from a 1914 book about chemistry equipment. With a line here and a dab of paint there, Ernst transformed the picture of laboratory utensils into bizarre robotic figures set in a stark symbol-filled landscape. Perhaps we should say dreamscape, for the glazed-over stares and skewed de Chirico-like perspective, which culminates in a mystifying square, give this little collage an elemental power that suggests some otherworldly sphere—one of the imagination. Ernst was influenced by others who had made dream imagery, but he was also familiar with de Chirico's metaphysical paintings, to which he was introduced by his friend Jean Arp. The dreamlike quality of Ernst's image endows his figures with heavy psychological overtones. Not surprisingly, Ernst was fascinated by Sigmund Freud's theories about the unconscious and the importance of dreams.

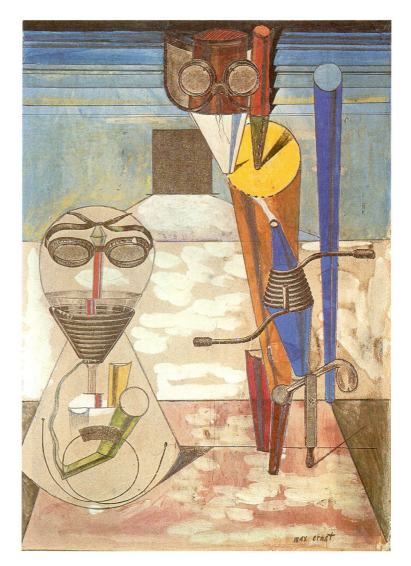

28.8. Max Ernst. *1 Copper Plate 1 Zinc Plate 1 Rubber Cloth 2 Calipers 1 Drainpipe Telescope 1 Piping Man*. 1920. Collage, 12 × 9″ (30.5 × 22.9 cm). Estate of Hans Arp. © Estate of Max Ernst

Through Arp, Ernst was put in contact with two leaders of the Paris Dada movement, poets André Breton and Paul Éluard, both of whom had also come under Freud's spell, entranced by the idea that the unconscious contained realities that had been suppressed by civilization. In 1921 they arranged for Ernst to show his Dada collages at a small avant-garde exhibition in Paris, where they made such a sensation he was hailed as the "Einstein of painting." The following year, Ernst emigrated to Paris. In 1924 Breton issued their Surrealist Manifesto, anointing Ernst's 1921 show as the first Surrealist exhibition.

Paris Dada: Man Ray

The transition from Dada to Surrealism was well on its way by 1922, and it occurred in Paris. Dada had established a foothold in the French capital with the return of Duchamp at the end of 1918 and with the arrival of Picabia from Barcelona in 1919. As in Zurich, the thrust behind Paris Dada came from the literary contingent. Inspired by Tzara's *Dada* magazine, three young poets—Louis Aragon, André Breton, and Phillipe Soupault—founded a journal called *Littérature*. It was so avant-garde that there was hardly anything in it that the literary establishment would consider literature. In addition to phonetic poems by Tzara, it included Breton and Soupault's collaborative poem *Les Champs magnétique (Magnetic Fields)* of 1920, which was written in a stream-of-consciousness style that was derived from working sessions lasting up to ten hours.

One of the artists who moved in and out of the Paris Dada circle was the independent American Man Ray (1890–1976). He had befriended Duchamp in New York, participated in New York *Dada*, and followed Duchamp to Paris in 1921. Best known as a photographer, Man Ray was extraordinarily inventive and worked in many media, some like airbrush painting being quite innovative. Most important, Man Ray was the first artist to consistently use photography within a Dada context, often using the same conceptual premises favoring idea over technique that are found in Duchamp's work, and thus freeing the medium from the merely representational restrictions placed on it by fine art photographers. Man Ray helped establish photography, at least within Dada and Surrealist circles, as a medium that was viewed on a par with painting and sculpture.

In 1922, Man Ray had a major impact on the development of photography, as well as on Dada and abstract art, when he popularized the *photogram*—a one-of-a-kind cameraless photograph made by putting objects directly on photographic paper and then exposing both the object and paper to light (fig. **28.9**). Solid objects block light from striking the white paper, so they appear white in the image, while the spaces between and around objects become black, since there is nothing to prevent the light from exposing the paper. Tzara dubbed Man Ray's print a "rayograph," and that year, using cover prints (photographic copies of the original print) made by Man Ray, Tzara published a limited edition book, entitled *Champs délicieux,* (Delicious Fields), containing twelve rayographs.

Our reproduction is one of these untitled works, which reveals the silhouettes of a brush and comb, a sewing pin, a coil of paper, and a strip of fabric, among the identifiable items. The image, like much of Man Ray's work, helps demonstrate the close relationship between the random and defiant art of Dada and the evocative, often sensual, art of Surrealism. The objects appear ghostlike and mysterious and in a strange environment where darks and lights have been reversed and where a haunting overall darkness prevails. Shapes and lines move in and out of dark shadows, sometimes vibrating, as with the brush and comb silhouette, other times crisply stated, as in the center oval. Because Man Ray exposed the paper with a light bulb that he moved several times during the process, he created multiple light sources, which caused the edges of some objects to shimmer and allowed other forms to recede back in space instead of just existing as flat silhouettes. His pictures, as with the Surrealistic art that would follow, have a magical blend of

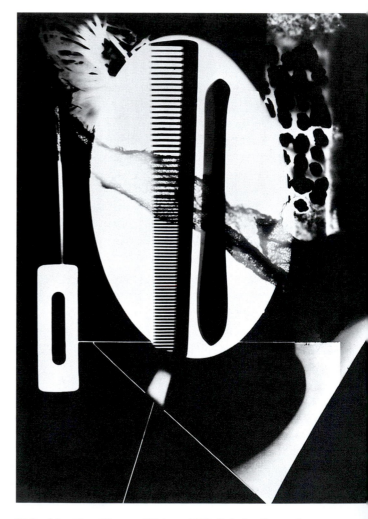

28.9. Man Ray. *Champs délicieux*. 1922. Gelatin silver print. © Man Ray Trust

the real and nonreal. We feel the presence of a real comb and sewing pin, and yet they seem to exist in a dream world. Just as unexplainable is the relationship of these objects and shapes to one another.

Man Ray also used a chance process to make films, which have the same dreamlike quality of his rayographs. At Tzara's invitation, Man Ray participated in what turned out to be the final major Dada event in Paris, La Soirée de la Coeur de la Barbe (The Bearded Heart Soirée) in 1923. Using sand, nails, and pins sprinkled randomly on unexposed cinematic film, he created a short abstract movie titled *The Return to Reason* (to view the film, visit www.prenhall.com/janson), an ironic title because the hallucinatory flickering of white objects floating in dark blackness created a sense of chaos that was far from rational. Instead, it represented a new way to view the world, one that was Surrealistic, although the term had yet to be coined or the movement recognized. The film not only introduced the medium to the Parisian fine art world, but it also helped spawn a flurry of experimental films by other artists. Shortly after Man Ray's movie was screened that evening, a riot broke out when Breton, Éluard, and Soupault, all uninvited, stormed the stage screaming that Dada was dead. Though Dada continued to provide the intellectual foundation for challenging art throughout the century, the spirit of the moment was clearly shifting away from chance and nonsense to the psychological investigations of Surrealism.

SURREALISM

Surrealism had existed in spirit, if not in name, well before 1924, but the movement was formally launched by Breton that year with his Surrealist Manifesto. Surrealism, Breton wrote, is "pure psychic automatism, by which it is intended to express, either verbally, or in writing, or in any other way, the true functioning of thought. Thought expressed in the absence of any control exerted by reason, and outside all moral and aesthetic considerations." Banished was the Neoclassical god of reason, the sureness of logic, and the need to portray an observable reality. Also gone was Dada nihilism, replaced by an intensive exploration of the unconscious. Surrealists argued that we see only a surface reality. More important was uncovering the reality that, as Freud maintained, resided in the deep-seated secrets and desires of the unconscious mind. For Freud, the basic human desires, particularly sexual, that define our individual identities are repressed by the conventions of civilization but are revealed in dreams. Random dream images, are, for Freud, charged with meaning and provide the "royal road to the unconscious." They contain symbols of our desires and anxieties. Using his own and his patients' dreams as "raw material," Freud decoded dream images into what he believed to be their true meaning, claiming sexual desires or concerns were often disguised as ordinary objects. A vase, for example, is a symbol of female sexuality, the vagina, while a tall building or a mountain suggests phallic maleness.

ART IN TIME

- 1917—Marcel Duchamp's *Fountain*
- 1919—Weimar Republic in Germany
- ca. 1919—Hannah Höch's *Cut with the Kitchen Knife*
- 1920—Dada International Fair
- 1922—James Joyce publishes *Ulysses*
- 1923—Sigmund Freud publishes *The Ego and the Id*

Breton's manifesto proposed several ways to tap into the unconscious. He encouraged the use of dreamlike images, the juxtaposition of unrelated objects, and stream-of-consciousness writing. He called for "... the future resolution of these two states, dream and reality, which are seemingly so contradictory, into a kind of absolute reality, a surreality." He emphasized the concept of creating "the marvelous," images, either verbal or visual, that are mysterious, chance, and poetic, and jolt the audience into a new, unknown plane of reality, a surreality.

Surrealism was first a literary style. Breton traced its roots to several sources, including Comte de Lautréamont's 1869 novel *Chants de Maldoror*, which included wondrous passages of surreal images, the most famous perhaps being "... as beautiful as a chance encounter of a sewing machine and an umbrella on an operating table." Breton's literary circle delighted in such "chance encounters" of words, even devising a game in which each participant provided words for a sentence, not knowing what had already been written. One game produced "The exquisite corpse will drink the new wine," and Exquisite Corpse became the game's name. Surrealist visual artists played Exquisite Corpse as well. Folding a piece of paper, each artist drew on his or her segment without seeing what the others had done. The result was a provocative image of unrelated objects or a strange form. But visual art had little place in Breton's manifesto, and artists were only mentioned as a footnote, appearing in a single sentence. Among those listed were Ernst, Man Ray, de Chirico, and Picasso.

Picasso and Surrealism

Perhaps the most surprising name on Breton's list is Picasso's. The Dada artists found little of interest in the analytic logical thinking of the Cubists. But Breton saw Picasso's Cubism as the first step toward loosening the grip of reality on the artistic imagination. Also, beginning in the mid 1920s, Picasso's work paralleled that of the Surrealists. They shared many symbols and myths, including the female praying mantis, which eats it male partner upon mating, and the suffering, tortured male minotaur. But Picasso was very independent, and though he provided artwork for Surrealist publications and participated in some Surrealist shows, he did not consider himself a Surrealist.

Picasso's interest in dreamlike imagery filled with sexual and psychological content can be seen in his 1921 *Three Musicians* (fig. **28.10**). The picture is a traditional *comedia dell'arte*, or Italian comedy, subject. (This was improvisational theater dealing with jilted love and played by stock characters.) We instantly sense that this is no longer just a witty Synthetic Cubist painting of ingenious interlocking flat colored planes, although the painting suggests humor through its bright hues and playful patterning. Ultimately it is the black that prevails, as well as the frightening masks of the musicians. The jarring, even abrasive, rhythm of the composition has more in common with the brutal 1907 *Les Demoiselles d'Avignon* than with the refined *Guitar, Sheet Music, and Wine Glass* of 1912 (see figs. 27.5 and 27.7). And what is the dog doing lurking under the table, his head demonically silhouetted against the barren corner of the room, his body sliced up by the legs of the table and intertwined with the musician's legs? These are not just jovial music-making men, but pathetic lusting lovers, in keeping with the *commedia dell'arte* theme. The wood-

wind player on the left resembles Henri Rousseau's snake charmer in his lustful painting *The Dream* (see fig. 26.18), which Picasso knew as intimately as he did the artist himself. Picasso has transformed this scene of music making into a ritualistic event, as further suggested by the masks, which are more mysterious than comic. The painting even has spiritual overtones, implied by the monk-like, and therefore celibate, vocalist on the right. The dark silhouetted head of the dog suggests deep-seated animalistic urges, which drives the music-making, while the austere boxlike room becomes a claustrophobic container—a room of the mind. Picasso has created a psychologically loaded dream world, one that Breton found compelling.

With the advent of Surrealism in 1924, the primal forces smoldering beneath the surface in *Three Musicians* burst into the foreground, as seen in *Three Dancers* (fig. **28.11**), made in 1925, less than a year after Breton published his manifesto. These are not the Three Graces, but rather disquieting nudes engaged in a strange performance. The figure in the center—the most con-

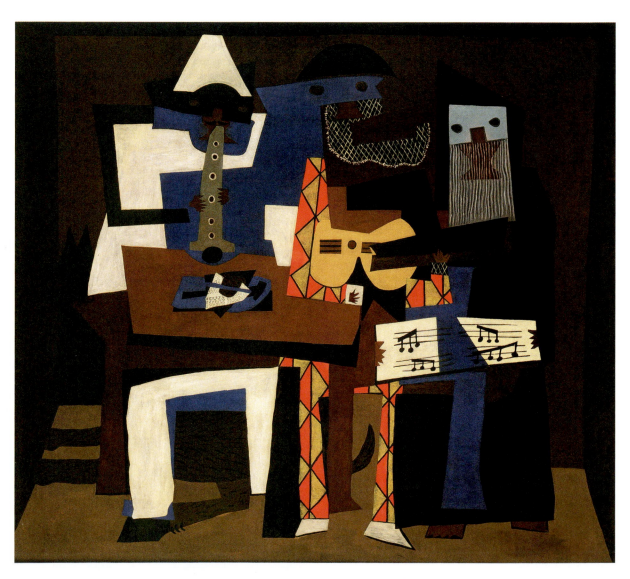

28.10. Pablo Picasso. *Three Musicians*. Summer 1921. Oil on canvas, 6′7″ × 7′3³⁄₄″ (2 × 2.23 m). The Museum of Modern Art, New York, Mrs. Simon Guggenheim Fund. © Estate of Pablo Picasso/Artists Rights Society (ARS), New York

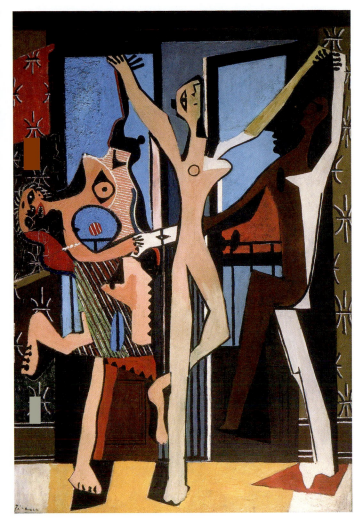

WELDED SCULPTURE Picasso also turned to sculpture to express his urge to portray the unseen deep-seated psychological passions that drive physical urges, and it led him to revolutionize sculpture for a second time. By late 1928, he was welding metal, which he experimented with for the next five years, starting a trend that by the 1940s established welded steel as a major sculptural process rivaling cast bronze and chiseled stone. Picasso began working in the medium when he decided to make sculpture based on the linear drawing of the figures in his current paintings, figures that were in effect skeletal stick figures. The resulting three-dimensional sculpture was made up of metal rods that represented the painted lines, and it looked like a line drawing in space.

Gradually, Picasso turned from metal rods to working with metal in a variety of shapes and sizes, including the use of found objects, as seen in *Head of a Woman* (fig. **28.12**) from 1929-1930, which was made from colanders and scraps of metal. Picasso is still drawing in space, as seen in the hair, face, skull, and body—if this is indeed what these abstract shapes are. He has pared his figure down to a bare-bones essence, peeling away the superficial layers of physicality to reveal the psychological core of the woman that lies beneath. The sculpture's overall resemblance to African masks, and the use of tribal hieroglyphic notations for different parts of the body, such as the stick legs, reinforces its elemental quality.

28.11. Pablo Picasso. *Three Dancers*. 1925. Oil on canvas, $7'1\frac{1}{2}'' \times 4'8\frac{1}{4}''$ (2.15 × 1.4 m). The Tate Gallery, London. © Estate of Pablo Picasso/Artists Rights Society (ARS), New York

ventionally rendered—appears at one moment to be completing a pirouette, at the next moment to be crucified. The contorted figure to the left has been reduced to an assemblage of abstruse hieroglyphic forms, which never quite coalesce into a single meaning. Her head is shaped like a quarter moon, and it has been placed against a backdrop of a night sky filled with stars as represented by the abstracted *fleur-de-lis* of the wallpaper. At every turn, familiar forms are made to dissolve into disorienting shapes and colors. What seems to be a dance rehearsal in a light-filled studio at one moment turns into a midnight bacchanal at the next. What remains consistent, however, is the pivotal role of the female body whether as a symbol of erotic athleticism or of spiritual suffering. Just as Freud attributed to the female body the power to incite desire as well as dread in men, Picasso, like the Surrealists, places the female form at the service of the male viewer's contradictory libidinal impulses. Here, the Symbolist theme of the femme fatale is once again revisited through radically different formal means.

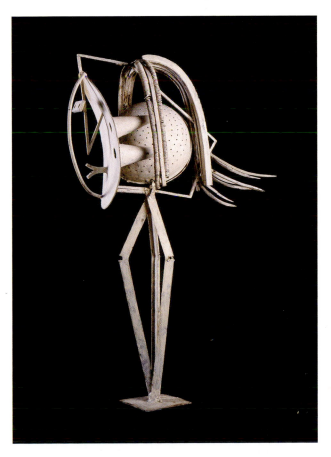

28.12. Pablo Picasso. *Head of a Woman*. 1929–1930. Painted iron, sheet metal, springs, and colanders, $39\frac{3}{8} \times 14\frac{1}{2} \times 23\frac{1}{4}''$ (100 × 37 × 59 cm). Musée Picasso, Paris. © Estate of Pablo Picasso/Artists Rights Society (ARS), New York

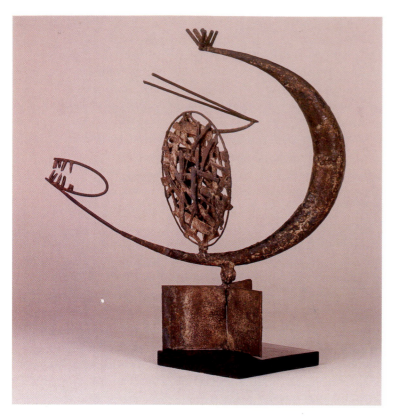

28.13. Julio González. *Head*. ca. 1935. Wrought iron, 17³/₄ × 15¹/₄″ (45.1 × 38.7 cm). The Museum of Modern Art. Purchase (266.1937). © Artists Rights Society (ARS), New York/ADAGP, Paris

Picasso hired fellow Spaniard Julio González (1876-1942), who had learned welding in a Renault automobile factory, to do his welding. By the 1930s, González was making his own work, such as *Head* (fig. 28.13) of ca. 1935, which would garner him a reputation as the world's foremost practitioner of welded sculpture. González specialized in figures and heads, which like Picasso's *Head of a Woman*, project primitive, psychological, and hallucinatory qualities. Here the sculptor reduces the figure to a pernicious clamplike mouth, stalklike eyes, spiky hair, and frazzled face, all attached to a moonlike crescent not only suggesting a skull but also the cosmos, a parallel we saw Jean Arp make as well in *The Entombment of the Birds and Butterflies* (see fig. 28.1)

Surrealism in Paris

In 1925, Breton, like everyone, had doubts about the possibility that there could even be Surrealist painting or sculpture. Many argued that the visual arts, unlike writing, did not allow for a stream of consciousness since artists always had the work in front of them and, while creating, could see where they have been and think about where they are at that moment. The imagery could seem surreal, but the method was not. Initially, many of the visual artists Breton championed relied on automatic drawing and chance to produce their images. In late 1925, Breton organized the first Surrealist exhibition, which featured Ernst, Picasso, André Masson, and Joan Miró, but also included de Chirico, Klee, Man Ray, and Arp.

ANDRÉ MASSON The use of automatic drawing had been initiated by André Masson (1896–1987) the year before, in 1924. In this process, Masson first made a series of lines while in a trancelike state, and he then used them to spur the imagination to further develop the image. In 1926, Masson began prompting his unconscious by randomly putting glue on his canvases and then sprinkling sand over the surface, the sand adhering where there was glue. In *Battle of Fishes* (fig. 28.14), the result was the creation of a mysterious environment inhabited by primitive organic forms, suggesting both the origin of life and the powerful universal urges that drive it.

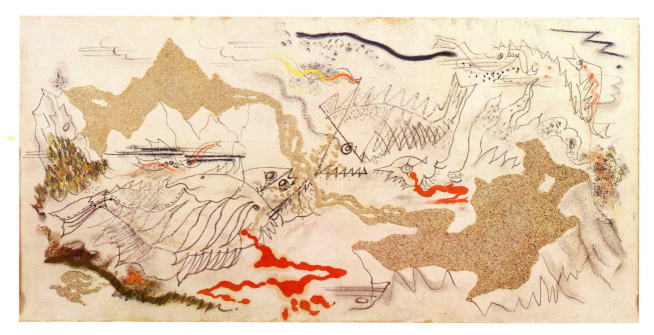

28.14. André Masson. *Battle of Fishes*. 1926. Sand, gesso, oil, pencil, and charcoal on canvas, 14¹/₄ × 28³/₄″ (36.2 × 73 cm). The Museum of Modern Art, Purchase (260.1937). © Artists Rights Society (ARS), New York/ADAGP, Paris

MAX ERNST Not to be outdone by Masson, Ernst in 1925 developed frottage. *Frottage* consisted of rubbing graphite over paper placed on an object, like floor boards, chair caning, and pressed flowers, and then discerning an image in the irregular pattern of wood grain or botanical geometry. The image often turned out to be a primeval forest filled with birds, animals, and bizarre creatures, having a mythic force similar to Masson's imagery. Among other techniques he devised to spur the imagination, Ernst in the 1930s, started working with *decalcomania*, a process that uses pressure to transfer diluted oil paint to canvas from some other surface, creating a highly suggestive irregular texture, which Ernst then developed into an illusionistic picture, as in *La Toilette de la mariée (Attirement of the Bride)* (fig. **28.15**) of 1940. Here he used this technique to create hair and a robe. Its bizarre texture contrasts with the illusionistic style used in the rest of the image. The phallic spear, monstrous bird and bride, four-breasted potbellied monster on the floor, and picture-within-in-a-picture on the wall make this real scene unreal, and charges it with a disconcerting psychology of violence and sex.

JOAN MIRÓ A Catalan from Barcelona, Joan Miró (1893–1983) came to Paris in 1920 and took a studio next to Masson's. Soon after, through a hole in their adjoining wall, Masson whispered to Miró to go see Breton, not Picasso—because "he was the future." Within a short time Miró abandoned Cubism and began painting from his imagination. (Actually, he claimed he was working from hallucinations brought on by starvation— "I was living on a few dry figs a day.") He adopted Masson's wiry line and the childlike drawing and atmospheric quality of Klee (see fig. 27.17). Miró's pictures became abstractions of biomorphic and geometric forms set against a minimal color field that suggested a landscape or watery environment. Miró's paintings became increasingly abstract, as seen in *Composition* (fig. **28.16**),

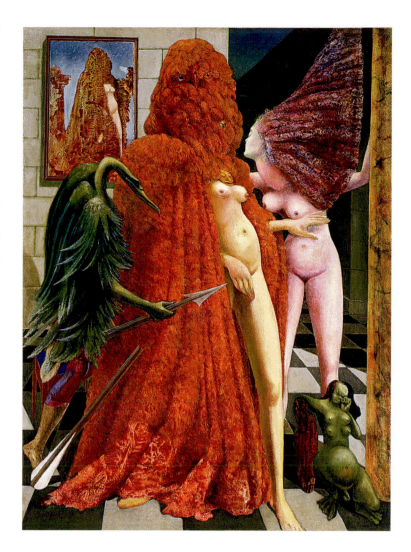

28.15. Max Ernst. *La Toilette de la mariée (Attirement of the Bride)*. 1940. Oil on canvas, 51 × 37⅞″ (129.5 × 96.2 cm). Peggy Guggenheim Collection, Venice, 1976. 76.2553.78. © Estate of Max Ernst

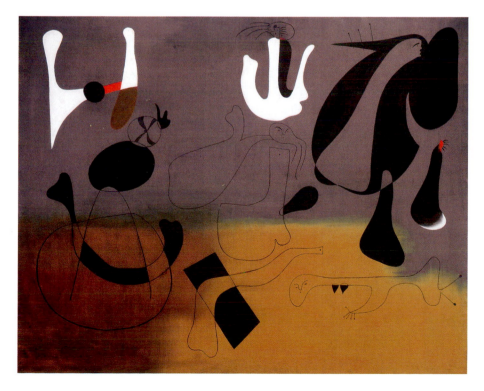

28.16. Joan Miró. *Composition*. 1933. Oil on canvas, 51¼ × 63½″ (130.2 × 161.3 cm). Wadsworth Atheneum, Hartford, Connecticut. Ella Gallup Sumner and Mary Catlin Sumner Collection Fund. © Succession Miró/Artists Rights Society (ARS), New York/ADAGP, Paris

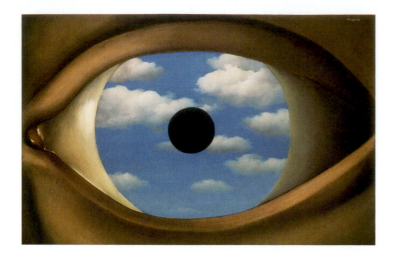

28.17. René Magritte. *The False Mirror*.
1928. Oil on canvas, 21¼ × 31⅛" (54 × 81 cm).
The Museum of Modern Art, New York. © Herscovici,
Brussels/Artists Rights Society (ARS), New York

a 1933 oil. The work was one in a series based on collages on cardboard made from images cut out of catalogues with the idea that the shape and even details of the objects would fire his imagination. The setting of *Composition* is a hazy atmospheric environment of washes, suggesting the same kind of primeval landscape we saw in Masson. This eerie world is populated by strange curvilinear floating forms that suggest prehistoric and microscopic creatures, as well as spirits, ghosts, or souls. We can even find a story in places, such as two figures playing with or fighting over a ball in the upper left corner. Or are they? Regardless, they suggest play or fighting, as other features in the painting express sex, struggle, and fear. Miró uses a minimal vocabulary, which includes color as well as form, to create a mythic image evoking primal conditions.

Representational Surrealism: Magritte and Dali

Initially, Breton's strongest support was for an abstract Surrealism that was based on chance, spontaneity, and trance. Over the next decade, however, artists with all kinds of styles would move in and out of the movement, most abandoning it, in part because of the group's strong socialist and Communist stance, but also because of Breton himself, who was rather controlling and functioned as though he were the Pope of Surrealism, capriciously anointing or not anointing artists as Surrealists for the flimsiest of reasons.

RENÉ MAGRITTE By the late 1920s, more and more artists worked in a representational or quasi-representational style. One was René Magritte (1898–1967), who was from Brussels. There, he was a member of the Surrealist circle, a group of artists and intellectuals who were also very involved with communism. Magritte spent 1927 to 1930 in Paris, but Breton never officially recognized him as a Surrealist. He returned to Belgium, where he spent the remainder of his life, not achieving fame until late in his career. His *The False Mirror* (fig. **28.17**), painted in 1928, reads like a manifesto of Surrealism, proclaiming the superior reality of the unconscious mind. We see an uncanny close-up of an eye, which reflects a distant sky. The iris, however, is transformed

into an eerie eclipsed sun, behind which, Magritte suggests, lies the unconscious that perceives the reality of things. The eye absorbs only the visual, not the real, world.

SALVADOR DALI Arriving in Paris a few years after Magritte was another major representational Surrealist, Salvador Dali (1904–1989), who came from Madrid, where he had already developed a meticulously detailed realist style heavily based on the psychological complexes that Freud described in his writings. He made a grand entrance into the world of Parisian Surrealism with his 17-minute film *An Andalusian Dog* (to view the film visit www.prenhall.com/janson), which he made with fellow Spaniard, the filmmaker Luis Buñuel (1900–1983). The nonsequential movie opens with Buñuel on a balcony with a woman, and as a cloud mysteriously passes behind them the camera goes to a close-up of an eye, the woman's, which is dramatically sliced by a straight razor. This opening scene has been interpreted as a reference to the Oedipus complex and fear of castration, which is symbolized by a fear of blindness, two major themes in Freud's writings about male psychological development. The entire film lends itself to similar Freudian analysis. To produce their surrealist effects, Dali and Buñuel rely on montage, juxtaposing unrelated objects to create dream sequences that constantly put objects into new contexts designed to generate the "marvelous" and to jolt the unconscious. In one famous sequence, for example, the film's protagonist drags across a room two priests and two grand pianos, each containing a putrefying dead donkey. In another scene, an army of ants crawls over a hand.

Dali made his paintings using a process he called "paranoiac-critical"—"[a] spontaneous method of irrational knowledge based upon the interpretative-critical association of delirious phenomena." He created in a frenzy, a self-induced paranoid state where he would begin a painting with a single object in mind. Then, he would respond to that object and so on, developing a mysterious image reflecting an irrational process that released the unconscious. *The Persistence of Memory* (fig. **28.18**) began with the strange amorphous head with an elongated trailing neck lying on the ground. Looking at a plate of soft Camembert cheese at dinner, he was then inspired to paint the soft pocket watches. While allowing no certain reading, the picture evokes a host of associations, most obvious the crippling passage of time that leads to inevitable deterioration and death, although the title suggests we are looking backward to the past, not forward to the future. Dali has created a provocative image of mysterious objects that can be read as metaphors for the deepest desires, fears, and anxieties, especially sexual, of the mind, and that can unleash multiple interpretations from a viewer's own unconscious.

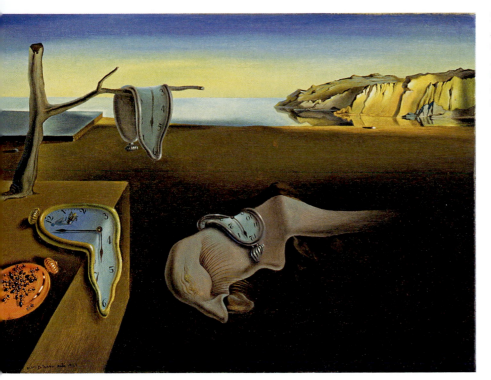

28.18. Salvador Dali. *The Persistence of Memory*. 1931. Oil on canvas, $9\frac{1}{2} \times 13''$ (24.1 × 33 cm). The Museum of Modern Art, New York. Given Anonymously. (162.1934). © Salvador Dali, Gala-Salvador Dali Foundation/Artists Rights Society (ARS), New York

Surrealism and Photography

Photographers were discovering that film and photography, which could both manipulate reality and create dreamlike sequences, were perfect vehicles for Surrealism. Many major photographers, though not in Breton's circle, were deeply affected by Surrealism, including Eugène Atget and Henri Cartier-Bresson.

EUGÈNE ATGET In photography (and painting and sculpture as well), Surrealism did not always have to be consciously produced; it could just happen, confirming the Surrealist belief in the marvelous residing behind the appearance of things. Eugène Atget (1857–1927) was a photographer who just hap-

pened to make Surrealism happen when he had an entirely different agenda. He was a self-taught commercial photographer, who began specializing in images of Paris and its environs about 1897. His self-proclaimed mission was to document old Paris, which was quickly disappearing with twentieth-century modernization. With blind dedication to his project, he produced some ten thousand images, despite the lack of a market for them and living in abject poverty.

Atget generally shot his photographs when no one was present, giving the images a desolate quality. The craftsmanship in his prints was high, and he was able to obtain lush textures and a remarkable range of tones and play of light and shadow. The result, as we can see in *Pool, Versailles* (fig. **28.19**) is images that

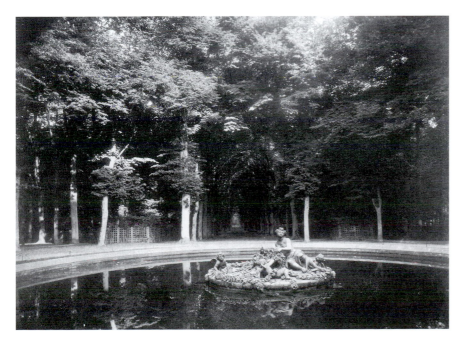

28.19. Eugène Atget. *Pool, Versailles*. 1924. Albumen-silver print, $7 \times 9\frac{3}{4}''$ (17.8 × 23.9 cm). The Museum of Modern Art, New York. Abbott-Levy Collection. Partial Gift of Shirley C. Burden

are dreamlike and magical. Time has stopped, and in the hushed stillness, the fountain's figures seem to come to life. The plunging dark tunnel of the trees in the center, the flickering V-pattern of light in the leaves above, and the dramatic curve of the pool subtly animate this frozen image. A strange, unexplainable dialogue exists among the statue, wire fence, brightly lit tree trunks, and the alley. Atget's powerful images, which seem to burrow deep into a distant timeless past, went largely unnoticed until the 1920s when Man Ray, among others, became entranced by their otherworldliness and praised their surreal quality. Breton published several in *La Révolution surréaliste*.

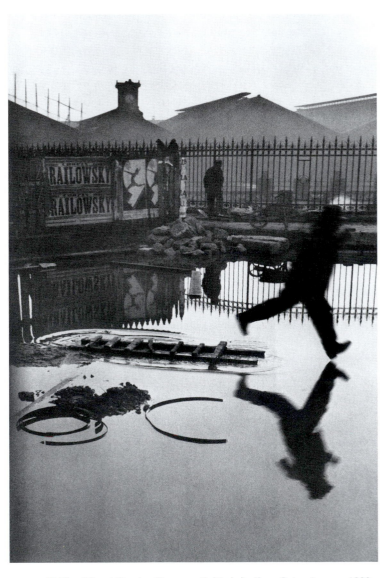

28.20. Henri Cartier-Bresson. *Behind the Gare Saint-Lazare*. 1932. Gelatin silver print. © Henri Cartier-Bresson/Magnum Photos

HENRI CARTIER-BRESSON Surrealism had an enormous impact on many of the major photographers of the period, although most were not members of Breton's circle. In this group is the Frenchman Henri Cartier-Bresson (1908–2004), who made some of the most extraordinary images of the twentieth century. Cartier-Bresson is the master of what he termed "the decisive moment": the instant recognition and visual organization of an event at the most intense moment of action and emotion. Using the new hand-held 35-mm Leica camera, he accomplished this vision, as can be seen in his *Behind the Gare Saint-Lazare* (fig. **28.20**) of 1932. Cartier-Bresson made photograph after photograph that miraculously captured the same supernatural magic we see in this fleeting image of a silhouetted man unexplainably suspended in midair. A master of strong value contrasts, Cartier-Bresson was able to make strange hieroglyphic shapes materialize out of the water. Like Atget, he established a powerful eerie dialogue among the shapes and objects, such as the clock, ladder, and reflections, throughout the composition.

The Surrealist Object

When Joan Miró began work on his *Composition*, he started with an image that, like a dream, took him on a journey of psychological exploration and formal invention. Surrealists created objects that would initiate such journeys for viewers as well as for themselves. In fact some of the most succinct Surrealist artworks were fetishistic objects, mysterious poetic things that were found and created, and had no narrative, but jolted the unconscious and spawned infinite associations, mostly sexual and often violent. As early as 1921, Man Ray had already made one of the first Surrealist objects, *The Gift* (fig. **28.21**), a gift for the composer Eric Satie. The work is nothing more than tacks glued onto the flat side of a clothing iron. It is a shocking dislocation of both a household item and hardware that creates something unidentifiable, without logic or narrative, but filled with innuendoes of violence, pain, and sex.

Probably the most famous Surrealist object was made by Meret Oppenheim (1913–1985). Oppenheim, the daughter of a Jungian psychologist, went to Paris as an 18-year-old in 1932. For a period she was Man Ray's model and assistant. Inspired by an off-hand comment she made when lunching with Picasso in 1936, she covered a teacup, saucer, and spoon with gazelle fur and called it *Object* (fig. **28.22**), although Breton, when he included it in a Surrealist exhibition, retitled it *Luncheon in Fur*, punning on Manet's sexually fraught *Luncheon on the Grass* (see pages 870–871). Oppenheim presents us with eroticism offered and eroticism denied, for individually, fur and beverage are sensual, but juxtaposed as they are, they are disconcerting, if not outright repulsive. The fur anthropomorphizes the porcelain and spoon, and suggests pubic hair. The work is designed to trigger the unconscious, to evoke infinite associations that deal with the repressed realities of eroticism, sensuality, desire, and anxiety. Using minimal means, Oppenheim created the "marvelous" that takes a viewer into the realm of the surreal.

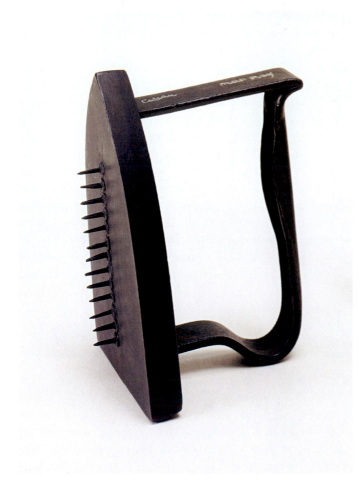

ART IN TIME

1915—Franz Kafka publishes *The Metamorphosis*

1919—Treaty of Versailles

1924—Eugene Atget's *Pool, Versailles*

1924—André Breton publishes his first Surrealist manifesto

1936—Meret Oppenheim's *Object*

ORGANIC SCULPTURE

The abstract Surrealism of Miró and Arp inspired many artists to search for universal truths beneath the surface of things. As did the Romantic landscape painters of the previous century, they focused on nature, trying to pry loose the unseen pulse of the cosmos that coursed through the natural world. To reveal these higher truths and realities, a number of artists, including Jean Arp and Alexander Calder in Paris and Henry Moore and Barbara Hepworth in England, turned to working with abstract organic forms. Often, they showed in Surrealist exhibitions and were occasionally labeled Surrealists, especially since their work dealt with hidden realities. But despite many parallels, their interests were quite different from Breton's as they evolved in the 1930s. Breton was more concerned with the psychology of anxiety, desire, and sex; the artists working with abstract organic forms were interested in the powerful forces of the universe.

28.21. Man Ray. *The Gift*. 1921 (1958 replica). Painted flatiron with row of 13 tacks with heads glued to the bottom, $6\frac{1}{8} \times 3\frac{5}{8} \times 4\frac{1}{2}''$ (15.5 × 9.2 × 11.43 cm). Museum of Modern Art, New York. James Thrall Soby Fund (249.1966). © Man Ray Trust

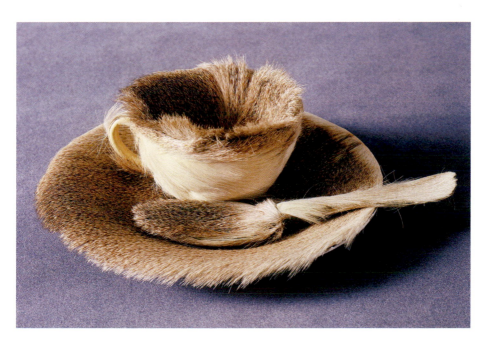

28.22. Meret Oppenheim. *Object (Luncheon in Fur)*. 1936. Fur-covered teacup, saucer, and spoon; diameter of cup $4\frac{3}{4}''$ (12.1 cm); diameter of saucer $9\frac{3}{8}''$ (23.8 cm); length of spoon 8″ (20.3 cm). The Museum of Modern Art, New York. © Artists Rights Society (ARS), New York/ProLitteris, Zurich

28.23. Jean (Hans) Arp. *Human Concretion*. 1935. Original plaster, $19\frac{1}{2} \times 18\frac{3}{4} \times 15\frac{1}{2}''$ (49.5 × 47.6 × 64.7 cm). The Museum of Modern Art, New York, Gift of the Advisory Committee. © Artists Rights Society (ARS), New York/VG Bild-Kunst, Bonn

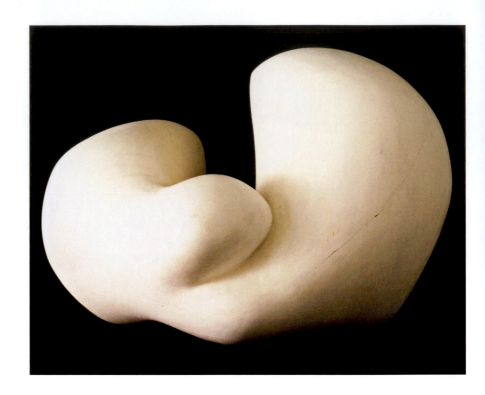

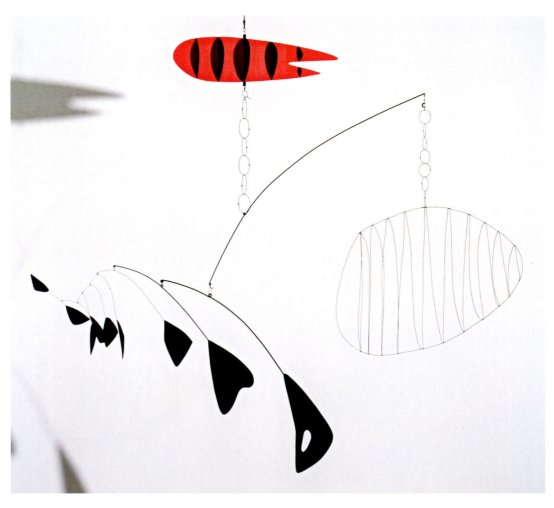

28.24. Alexander Calder. *Lobster Trap and Fish Tail*. 1939. Painted steel wire and sheet aluminum, approx. 8'6" × 9'6" (2.59 × 2.89 m). The Museum of Modern Art, New York, Commissioned by the Advisory Committee for the Stairwell of the Museum. © Estate of Alexander Calder/Artists Rights Society (ARS), New York

Jean Arp and Alexander Calder in Paris

In the early 1930s Jean Arp left the Surrealists and joined an international Paris-based group, called Abstraction-Création, which was dedicated to abstraction. He convinced his friend Alexander Calder (1898–1976) to become a member as well. Now Jean Arp turned away from making curious objects based on chance operations and began molding a series of forms called human concretions (fig. **28.23**) that he conceived as metaphors for growth and life. Their organic quality and simplicity reminds us of Brancusi, but where Brancusi sought to strip everything away to project the essence of a subject, Arp wanted to create living organisms that seem to grow, even breathe, as they expand and contract, in effect, replicating the essence of life. Arp had his plasters executed in bronze and marble by artisans, but regardless of the medium, they have a smooth unblemished quality that lends them an aura of purity and perfection.

Born in Philadelphia, Calder went to Paris in 1926, where he befriended Miró and the abstract Dutch painter Piet Mondrian. In the early 1930s he started making mobiles, a name that Duchamp gave his kinetic sculpture. Each mobile was constructed of painted sheet metal attached to metal wires that were hinged together and perfectly balanced. With the slightest gust of air, the mobile seems to glide, tilting and turning in space. Some of his mobiles make a chiming sound as round gonglike elements periodically swing around to strike a piece of flat metal. The mobiles vary in size from tabletop models to others with a 30-foot span that hang from a ceiling.

Taking his lead from Miró and Arp, Calder generally used organic shapes, as seen in *Lobster Trap and Fish Tail* (fig. **28.24**) from 1939. The forms suggest marine life, but generally they are abstract, and like Miró's paintings, simultaneously suggest the microscopic and macroscopic. The black forms in *Lobster Trap* can be seen as a school of fish, but viewed together they can suggest something skeletal, even primeval. Calder was inspired to develop kinetic sculpture to suggest growth and cosmic energy. He kept his colors basic, generally using primary and secondary colors, as well as black and white. All colors stem from these, so Calder's palette symbolized the basic building blocks of life, a notion Calder got from Mondrian, whose Paris studio he visited in 1930 (see page 1007).

Henry Moore and Barbara Hepworth in England

The organic abstract style favored by Miró and Arp jumped the English Channel in the 1930s, surfacing in the work of Henry Moore (1898–1986) and Barbara Hepworth. Moore studied at the Royal College of Art in London from 1921 to 1925, and in the following five years, from extensive museum visits in England and on the Continent, and through art publications, he digested the contemporary art of Brancusi, Arp, Miró, and Picasso. He was also influenced by the period's intense interest in non-Western art, including the Pre-Columbian art of Mexico.

By the early 1930s, Moore's mature style emerged, represented here by *Recumbent Figure* (fig. **28.25**), made in 1938. The work is reminiscent of a Classical reclining river goddess, although based more directly on Pre-Columbian figures. Moore is more interested in projecting the elemental and universal than in Classical antiquity as he explores the associations between the forms of nature and the shapes of the figure. We see a woman, but the stone retains its identity as stone, looking like a rock that has been eroded by the elements for millions of years. Moore ingeniously suggests that figure and rock are one and the same, even making the female form harmonize with the striations of the stone. The universal forces present in the rock are transferred to the figure, which becomes an earth goddess or fertility figure. The undulation of her abstract body virtually transforms her into a landscape. Adding to the mystical aura is Moore's

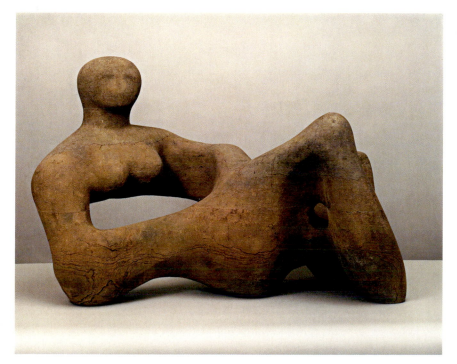

28.25. Henry Moore. *Recumbent Figure*. 1938. Green Horton stone, length approx. 54″ (137.2 cm). The Tate Gallery, London.

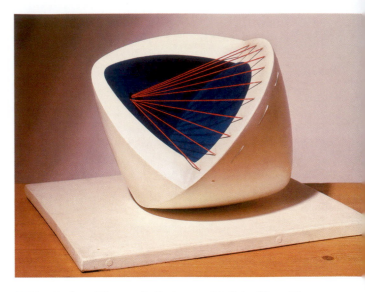

28.26. Barbara Hepworth. *Sculpture with Color (Deep Blue and Red)*. 1940–1942. Wood, painted white and blue, with red strings, on a wooden base, 11 × 10″ (27.9 × 26 cm). Private Collection. © Bowness, Hepworth Estate

brilliant interplay between solid and void, each having the same weight in the composition and evoking the womblike mystery of caves or tidal pools embedded in seashore rocks.

Moore felt comfortable showing works similar to *Recumbent Figure* at the International Surrealist Exhibition held in London in 1936; he may have seen an affinity with the Surrealists in his attempts to express a higher reality lying beneath the surface of things. But Moore felt equally comfortable exhibiting in shows of abstract art, and his sculpture poses a classic case of the problematic nature of labeling art.

Barbara Hepworth (1903–1975) identified entirely with abstraction, and was a member of Abstraction-Création. She traveled to Paris in 1933 and visited the studios of Arp and Brancusi, and she met Picasso. She was in Paris again in 1935 and met Mondrian. Like Moore, who was with her for a time at the Leeds School of Art and was a lifelong friend, she was interested in investing her abstract forms with a sense of the unseen forces of nature. She began working in abstraction in the early 1930s, and within a few years her sculpture became geometric. Instead of seeming hard-edge and mechanical, they are organic and mysterious, a quality that became even stronger after she moved to a cottage overlooking St. Ives Bay in Cornwall on the southwest tip of England when war broke out in 1939. Her sculpture was a personal response to nature. (See *Primary Source*, page 1006.) In *Sculpture with Color (Deep Blue and Red)* (fig. **28.26**), the egglike form, vaguely reminiscent of Brancusi's heads and newborns, is an elemental shape, suggesting fertility and birth. The carved wood is finely polished and covered with an immaculate sheen of white paint producing a surface that, like the shape of the work, evokes purity. In addition, the bright white of the shell heightens the mystery of the dark cavity, which harbors a sky or water of deep blue. The stretched red strings have the intensity of the sun's rays and perpetual energy of life forces. Hepworth herself said, "the strings were the tension I felt between myself and the sea, the wind or the hills."

CREATING UTOPIAS

While Dada and Surrealism constituted a major force for the period between the wars, they were not the only movements. Many twentieth-century artists remained committed to exploring abstract art. Surrealists and abstract artists often shared similar social goals: Both groups championed individual freedom, and both wished to undermine bourgeois values, to eradicate nationalism, to destroy capitalism, and to create a classless society

(see end of Part IV, *Additional Primary Sources*.) Many Dadaists and Surrealists were socialists who also participated in Communist Party activities. Simarly, many abstract artists were socialists and Communists, but they viewed abstract art itself as a vehicle for creating a utopian society.

Two major centers of geometric abstraction emerged simultaneously: Constructivism, which appeared with the Russian Revolution in 1917, and de Stijl (The Style), which appeared in Amsterdam. A third center was the Bauhaus in Germany, an art school founded in 1919 that succeeded as a significant force in the following decade and was often influenced by Constructivist refugees from Russia and de Stijl artists.

Russian Constructivism: Productivism and Utilitarianism

The most direct connection between abstract art and radical politics came in the revolutionary society that developed in Russia. There, before and after the October Revolution of 1917, artists committed themselves to developing new art forms that they hoped would bring about a new utopian society. Building on the innovations of Malevich's Suprematism (see pages 967–968), several movements followed, each attempting to put art at the service of the new revolutionary society.

VLADIMIR TATLIN As Malevich was developing his Suprematist painting in Moscow (see pages 967–968), a fellow Russian, Vladimir Tatlin (1885–1953), was working in Berlin and Paris. In 1914, Tatlin visited Picasso's Paris studio and saw his constructions (see pages 953–954). Upon returning to Russia, he then made his own constructed reliefs (fig. 28.27), which he called "counter-reliefs," for which he used cardboard, wood, and metal covered with a variety of materials, including glazes, glass, and plaster. Similar to Russian icons and Malevich's *Black Square*

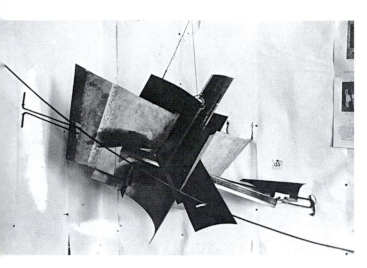

28.27. Vladimir Tatlin. *Corner Counter-Relief.* 1915. Mixed media, 31¹/₂ × 59 × 29¹/₂" (80 × 150 × 75 cm). Presumed destroyed. Art © Estate of Vladimir Tatlin/RAO Moscow/Licensed by VAGA, New York

units, housing conferences and meetings, were to revolve, making a complete revolution once a year, month, and day, respectively. The industrial materials of steel and glass and the dynamic, kinetic nature of the work symbolized the new machine age and the dynamism of the Bolshevik Revolution. The tower was to function as a propaganda center for the Communist Third International, an organization devoted to world revolution, and its rotating, ascending spiral symbolized the aspirations of communism.

Following Tatlin's dictum of "Art into Life," many artists, at least temporarily if not completely, gave up making conventional art in order to design functional objects that would help create the great classless utopia. Both Aleksandr Rodchenko (1891–1956) and his wife Varvara Fedorovna Stepanova (1894–1958) fall into this category. In the early 1920s, Rodchenko stopped making Suprematist paintings and Constructivist assemblages to focus on graphic design, as seen here in an untitled poster promoting literacy (fig. **28.29**). We are far removed from the organic and human Art Nouveau posters of Toulouse-Lautrec (see fig. 26.7), for example. Instead, a bold mechanical geometry prevails, with a

(see fig. 27.26), some of the counter-reliefs spanned corners, in effect, using the space of the room to create a small environment. Unlike Picasso's constructions, which were generally musical instruments, Tatlin's were nonobjective, that is, they were totally abstract like Malevich's paintings, and not meant to evoke real objects. Following Tatlin's lead, other Russian sculptors began making abstract sculpture from geometric forms, a movement that in 1922 was formally called Constructivism.

With the Bolshevik Revolution in 1917, Tatlin's attitude toward his art changed. He embraced communism and focused his effort on supporting the party's goal of creating a utopian society. He worked for the Soviet Education Commissariat and turned his attention to architecture and engineering. A major component of his teachings was his passionate belief in the utility of modern machinery, the democratic quality of mass-produced objects, and the efficiency of industrial materials. Technological modernity was the future and the new religion, and industrial efficiency and materials had to be incorporated into art, design, and architecture, where they would produce a new, better, classless world. In other words, the social revolution had to be complemented with an aesthetic revolution. According to Tatlin's theory called Constructivist Productivism, everything—from appliances to clothing, from living space to theater—now had to be machinelike and streamlined. Form must follow function and objects were to be stripped of all ornamentation, which was associated with bourgeois values and aristocratic ostentation.

Tatlin's one famous work is his *Project for "Monument to the Third International"* (fig. **28.28**), begun in 1919 and exhibited in Petrograd (St. Petersburg) and Moscow in December 1920. The project was supposed to be 1,300 feet high, which would have made it the tallest structure in the world at that time. It was to have a metal spiral frame tilted at an angle and encompassing a glass cube, cylinder, and cone. These steel and glass

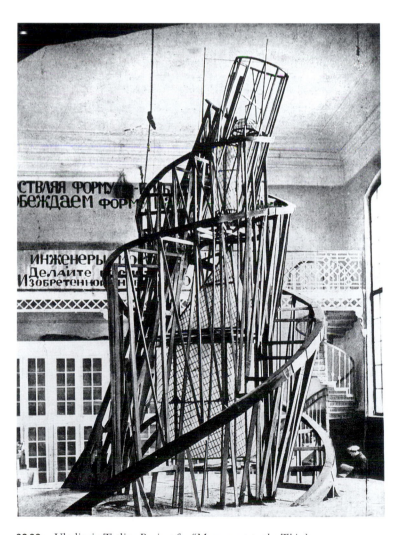

28.28. Vladimir Tatlin. *Project for "Monument to the Third International."* 1919–1920. Wood, iron, and glass, height 20′ (6.10 m). Destroyed; contemporary photograph. Art © Estate of Vladimir Tatlin/RAO Moscow/Licensed by VAGA, New York

Barbara Hepworth (1903–1975)

"On Sculpture" (1937)

In a 1937 book of artists' statements, British abstract sculptor Barbara Hepworth made the following statement about how her work reflects universal truths and an individual's relationship to nature.

The whole life force is in the vision which includes all phantasy, all intuitive imagination, and all conscious selection from experience. Ideas are born through a perfect balance of our conscious and unconscious life and they are realized through this same fusion and equilibrium. The choice of one idea from several, and the capacity to relate the whole of our past experience to the present idea is our conscious mind: our sensitivity to the unfolding of the idea in substance, in relation to the very act of breathing, is our unconscious intuition. . . .

Contemporary constructive work does not lose by not having particular human interest, drama, fear or religious emotion. It moves us profoundly because it represents the whole of artists's experience and vision, his whole sensibility to enduring ideas, his whole desire for a realization of these ideas in life and a complete rejection of the transitory and local forces of destruction. It is an absolute belief in man, in landscape and in the universal relationship of constructive ideas. The abstract forms of his work are now unconscious and intuitive—his individual manner of expression. His conscious life is bent on discovering a solution to human difficulties by solving his own thought permanently, and in relation to his medium. . . . [Abstraction] is no escapism, no ivory tower, no isolated pleasure in proportion and space—it is an unconscious manner of expressing our belief in a possible life. The language of colour and form is universal and not one for a special class (though this may have been in the past)—it is a thought which gives the same life, the same expansion, the same universal freedom to everyone.

SOURCE: *CIRCLE—INTERNATIONAL SURVEY OF CONSTRUCTIVE ART.* J. L. MARTIN, B. NICHOLSON, AND N. GABO, EDS. (LONDON: FABER AND FABER, 1937)

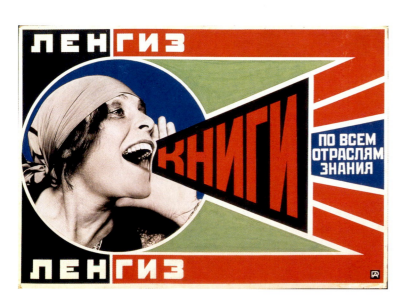

28.29. Alexander Rodchenko. *Advertisement: "Books!"* 1925. Rodchenko Archive, Moscow, Russia. Art © Estate of Alexander Rodchenko/Licensed by VAGA, New York/RAO, Moscow

nearly spaceless image pressed to the surface. Even the letters are austere and geometric. Bold color creates an energy that is reinforced by the design, where the word *Books*, for example, is shaped like a megaphone that emits the phrase "In All Spheres of Knowledge." At the time, Stepanova was the designer for a Moscow textile factory. In the sportswear reproduced here (fig. **28.30**), we again see bright colors and a simple yet energetic machinelike geometry. There is no ornamentation or reference to

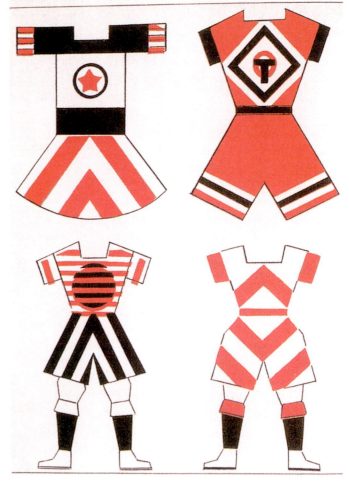

28.30. Varvara Fedorvna Stepanova. *Design for Sportswear.* 1923. Gouache and ink on paper, $11^{7}/_{8} \times 8^{1}/_{2}''$ (30.2 × 21.7 cm). Collection Alexander Lavrentiev. Art © Varvara Stepanova/Licensed by VAGA, New York/RAO, Moscow

the past, nothing that could be associated with any class, time period, ethnic type, or region. Confronted with the problem of creating a new society, the Constructivist designers invented a new graphic language, one that was distinctly modern, utilitarian, and classless.

De Stijl and Universal Order

In 1917 in Amsterdam, Piet Mondrian (1872–1944) founded a movement called de Stijl (The Style) with painter Theo van Doesburg (1883–1931), architect Gerrit Rietveld (1888–1964), and several other artists and architects. Though not backed by a revolutionary government, as were the Russian artists, their goal was every bit as radical and utopian, for de Stijl artists sought to create, through abstraction, total environments that were so perfect they embodied a universal harmony. Unlike their Russian counterparts, their mission was literally spiritual. Driven by Mondrian's and Van Doesburg's intense commitment to Theosophy, De Stijl, as did the Communists, sought a universal order that would make nationalism obsolete. They called their style the International Style, applying it most often to a new architecture of glass and steel that was modern, pure, and universal, with no national identification.

PIET MONDRIAN In the magazine *De Stijl*, the group's publication, the artist Piet Mondrian (1872–1944) published his theory of art in a series of articles. (See *Primary Source*, page 1008.) His philosophy was based on Theosophy, which he was interested in before his move to Paris in 1910. After returning to neutral Amsterdam during the Great War, he was further influenced by the ideas of the mystical lay philosopher and his close acquaintance M. H. J. Schoenmaekers and especially Schoenmaekers's book *New Image of the World*, the only book other than his own publications in his library. Schoenmaekers argued that there was an underlying mathematical structure to the universe that constituted true reality. He believed that an artist could access and present this structure through the rational manipulations of geometric forms. Mondrian developed an art based on such geometry and using Schoenmaekers's term, he called it *Neo-Plasticism*, meaning "new plasticism." By "plastic" in painting, he meant that the world of the painting had a plastic, or three-dimensional, reality of its own that corresponded to the harmonious plastic reality of the universe. In other words, he sought to replicate in his art the unseen underlying structure of the universe.

Beginning in 1917 Mondrian struggled to achieve this using total geometric abstraction, and only succeeded in his efforts upon returning to Paris in 1920. Once establishing his style, he pretty much retained it for the rest of his life, as seen in *Composition with Red, Blue, and Yellow* (fig. **28.31**) of 1930. His paintings, which are always asymmetrical, are remarkable for their perfect harmony. Mondrian very precisely gives every element in his painting equal weight. Each line and rectangle in

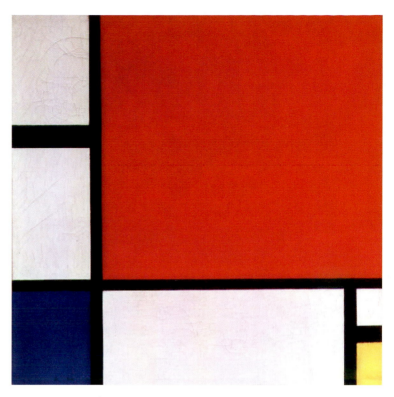

28.31. Piet Mondrian. *Composition with Red, Blue, and Yellow.* 1930. Oil on canvas, 20 × 20″ (50.8 × 50.8 cm). Private Collection. Courtesy of the Mondrian Estate/Holtzman Trust/MBI NY

this square canvas is assigned its own identity. Every line exists in its own right, not as a means of defining the color rectangles. (The thickness of the lines often varies in his paintings, a function of individual identity.) Each component in the painting sits on the same plane on the surface—there is no foreground or background, no one object sitting on top of another. Despite this perfectly interlocking surface, the painting has a feeling of tremendous space, even of infinity, largely due to the rectangles expanding off the edge of the canvas. Space and mass have merged into a harmonious whole of what Mondrian called "dynamic equilibrium," where everything is energized yet balanced. Mondrian has attempted to capture the complexity of the universe—the individuality of its infinite components and the harmony that holds everything together.

Mondrian did endless variations of these motifs. Even the color did not change, since these elementary hues, from which all colors are derived, are symbolic of the building blocks of the cosmos. But in principle, painting was not the end product of Mondrian's aesthetic program. He considered it just a stop-gap measure until perfect abstract environments of architecture, furniture, and objects embodying all of these same principles could be achieved. Until then the world needed his painting.

GERRIT RIETVELD Mondrian's de Stijl colleagues sought to implement his theories in architecture and interior design. In 1917, Gerrit Rietveld (1888–1964), a furniture maker who became a self-taught architect, designed the "Red-Blue" chair

Piet Mondrian (1872–1944)

From "Natural Reality and Abstract Reality" (1919)

This is an excerpt from an essay originally published in the magazine De Stijl in 1919. Here Mondrian explains how Neo-Plastic painting, using an abstract vocabulary, captures universal harmony.

The cultivated man of today is gradually turning away from natural things, and his life is becoming more and more abstract.

Natural (external) things become more and more automatic, and we observe that our vital attention fastens more and more on internal things. The life of the truly modern man is neither purely materialistic nor purely emotional. It manifests itself rather as a more autonomous life of the human mind becoming conscious of itself.

Natural man—although a unity of body, mind and soul—exhibits a changed consciousness: every expression of his life has today a different aspect, that is, an aspect more positively abstract.

It is the same with art. Art will become the product of another duality in man: the product of a cultivated externality and of an inwardness deepened and more conscious. As a pure representation of the human mind, art will express itself in an aesthetically purified, that is to say, abstract form.

The truly modern artist is aware of abstraction in an emotion of beauty; he is conscious of the fact that the emotion of beauty is cosmic, universal. This conscious recognition has for its corollary an abstract plasticism, for man adheres only to what is universal.

The new plastic idea cannot, therefore, take the form of a natural or concrete representation, although the latter does always indicate the universal to a degree, or at least conceals it within. This new plastic idea will ignore the particulars of appearance, that is to say, natural form and color. On the contrary, it should find its expression in the abstraction of form and color, that is to say, in the straight line and the clearly defined primary color. . . .

We find that in nature all relations are dominated by a single primordial relation, which is defined by the opposition of two extremes. Abstract plasticism represents this primordial relation in a precise manner by means of the two positions which form the right angle. This positional relation is the most balanced of all, since it expresses in a perfect harmony the relation between two extremes, and contains all other relations.

If we conceive these two extremes as manifestations of interiority and exteriority, we will find that in the new plasticism the tie uniting mind and life is not broken; thus, far from considering it a negation of truly living life we shall see a reconciliation of the matter-mind dualism.

SOURCE: *DE STIJL*, VOL. I, 1919.

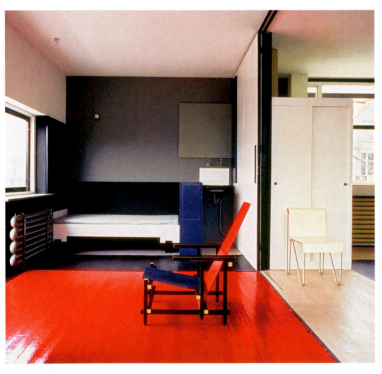

28.32. Gerrit Rietveld. Interior, Schröder House, with "Red-Blue" chair. Utrecht, Holland. 1924. © Artists Rights Society (ARS), New York/Beeldrecht, Amsterdam

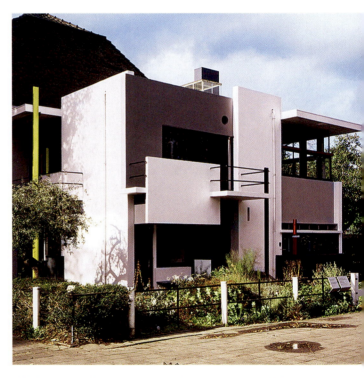

28.33. Gerrit Rietveld. Schröder House, Utrecht, Holland. 1924. © Artists Rights Society (ARS), New York/Beeldrecht, Amsterdam

(fig. **28.32**), representing the first attempt to apply Neo-Plasticism to the decorative arts. One of the more uncomfortable chairs ever made, its emphasis was on spiritual aesthetics, employing flat planes and primary colors to implement Mon-

drian's dynamic equilibrium. Once the de Stijl members discovered and understood Frank Lloyd Wright (see page 000), whose works were published and available in Europe in 1911, they were able to apply architectural solutions to the theoretical

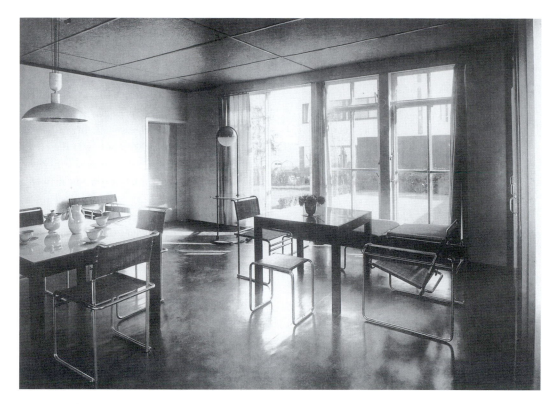

28.34. Walter Gropius. Two houses for the Werkbund housing development Am Weissenhof, Stuttgart, with furniture by Marcel Breuer. 1927. © Artists Rights Society (ARS), New York/ VG Bild-Kunst, Bonn

ideas of Neo-Plasticism. They recognized that Wright had destroyed "the box," and declared "the new architecture will be anticubic." Combining the color and floating planes of Mondrian and the fluid spaces of Wright, Rietveld produced the definitive de Stijl building in 1924, the Schröder House in Utrecht (fig. **28.33**), which was built onto the end of existing row houses. On the facade, we can find Mondrian's "floating" rectangles and lines. Even the Wright-like cantilevered roof appears to float. The interior (fig. 28.32) is designed along the same principles, with wall-to-ceiling sliding panels allowing for a restructuring of the interior space. Both inside and out, the Schröder House is ethereal, buoyant, and harmonious, embodying dynamic equilibrium.

The Bauhaus: Creating the "New Man"

As we have seen, most Dadaists, Surrealists, and Abstract artists were socialists or Communists who believed the Bolshevik Revolution in Russia would save the world from bourgeois material-ism and decadence and would establish a worldwide utopian society. Left-wing artists flocked to Berlin in 1922 to see the first Russian Art Exhibition, which presented the Constructivists for the first time in the West. Twice more that year, the avant-garde held conferences in Germany, attempting to commit to a social program that would put art at the service of restructuring society. All of these attempts came to naught. Instead, it was the Bauhaus, an art and design school, that gradually emerged as the strongest center for advocating social progress through art.

The Bauhaus was founded in Weimar, Germany, in 1919 by Walter Gropius. In many respects, the Bauhaus School was the embodiment of Muthesius's German Werkbund (see page 978), since the goal of the workshops was to design modern high-quality production-line products (see page 978). Its guiding principle, however, was more utopian and less commercial, for the Bauhaus (meaning House of Building) was dedicated to the creation of utilitarian design for "the new man" through the marriage of art and technology. The school was formed by the merger of two Weimar arts and crafts schools, and designed to combine the fine and applied arts, giving each equal weight, as had the earlier Secessionist movements. The artists were called artisan/craftspeople, and their mission was to create an abstract environment of the most progressive moder-nity. Their design ethic was based on "the living environment of machines and vehicles." Only "primary forms and colors" could be used, all in the service of creating "standard types for all practical commodities of everyday use as a social necessity." Like de Stijl, this was a philosophy oriented toward environ-ments, not just painting and sculpture, and the Bauhaus is often more associated with the work that came out of the textile, metal, and ceramic workshops, such as Marcel Breuer's 1927 aluminum tubular chairs and Anni Albers's abstract tex-tiles, than the paintings of Klee, Kandinsky, and Josef Albers, who also taught at the school.

MARCEL BREUER We can see the Bauhaus machine aes-thetic at work in the living room of a Gropius house built in 1927 for a Werkbund housing development in Stuttgart (fig. 28.34). The furniture and lighting were designed by Marcel Breuer (1902–1981), a former Bauhaus student who became a

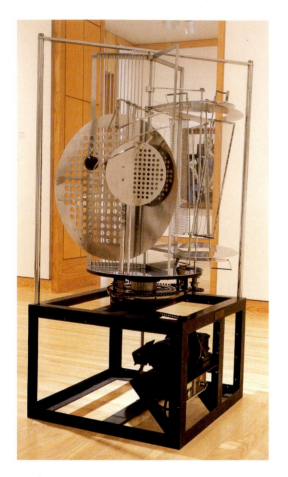

28.35. László Moholy-Nagy. *Light-Space Modulator*. 1922–1930. Kinetic sculpture of steel, plastic, wood and other materials with electric motor, $59\frac{1}{2} \times 27\frac{1}{2} \times 27\frac{1}{2}''$ (151.1 × 69.9 × 69.9 cm). Busch-Reisinger Museum, Harvard University Art Museums, Cambridge, Massachusetts. © Artists Rights Society, New York/ VG Bild-Kunst, Bonn

faculty member in 1925, heading the furniture workshop. All of Breuer's objects are geometric, made of modern materials, and easily mass produced. On the far right is perhaps his most famous product, the "Wassily" armchair, made of polished, nickel-plated tubular steel and cotton fabric. In its planarity, Breuer was clearly influenced by the Rietvelt "Red-Blue" chair (which Van Doesburg had introduced to the Bauhaus in 1921 when he taught there and when Breuer was a student). But now heavy wood has been replaced by a strong but light metal tube that is geometrically structured in an airy, open pattern. The feeling that results echoes the transparency and weightlessness of Suprematist painting and Constructivist sculpture, qualities that can even be seen in Tatlin's *Project for "Monument to the Third International"* (see fig. 28.28). Breuer described a practical side to his design when in the product catalogue he wrote that the chair "provides a light, fully self-sprung sitting opportunity, which has the comfort of the upholstered armchair, but with the difference that it is much lighter, handier, more hygienic."

LÁZLÓ MOHOLY-NAGY Perhaps the strongest advocate of Constructivism at the Bauhaus, and perhaps the most influential figure, was the Hungarian Lázló Moholy-Nagy (1895–1946). Gropius hired Moholy-Nagy in 1923 as head of the metal workshop, but gradually he became the school's primary theoretician, concerned particularly with light and movement. As early as 1922, he began designing Constructivist sculptures that generated light, as seen in *Light-Space Modulator* (fig. 28.35). This machinelike construction of planes of plastic, steel, and wood was propelled in a circle by a motor and projected an everchanging light spectacle onto its surroundings. It was used as a prop in a

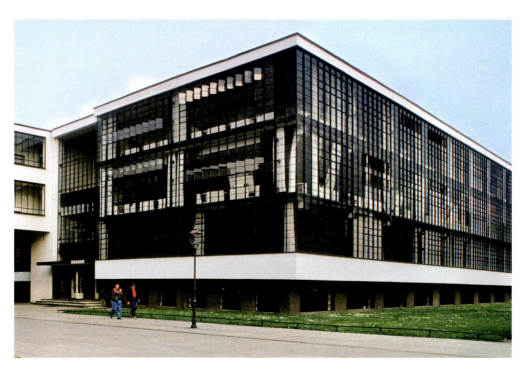

28.36. Walter Gropius. Shop Block, The Bauhaus, Dessau, Germany. 1925–1926. © Artists Rights Society (ARS), New York/VG Bild-Kunst, Bonn

1930 ballet at the Bauhaus, but Moholy-Nagy also viewed it as a tool to study light and space, hoping to uncover new applications for environmental or stage lighting.

WALTER GROPIUS Many art historians consider the crowning aesthetic achievement of the Bauhaus to be the building itself (fig. 28.36), designed by Gropius in 1925 when the school moved from Weimar to Dessau. The building consists of three L-shaped wings coming off a central hub: The Shop Block, a workshop wing, is shown in figure 28.36; a second wing had classrooms; and a third wing held an auditorium/theater, dining hall, and dormitory with studios. The complex is dominated by a clearly articulated geometry. The workshop wing looks like an empty glass box, the glass curtain wall on two sides continuing around corners and flush with the stuccoed parapet above and socle below. (A *socle* is the projecting molding that underlies a wall, pedestal, column, or superstructure of any kind.) Instead of mass, we feel a weightless volume as defined by the metal and glass wall. And because the building projects over a setback half-basement, it seems to float.

Perhaps more than anything designed by De Stijl, Gropius's Bauhaus came to epitomize High Modernist architecture—the architecture that evolved out of early Modernism (see pages 933–937) in the period between the two wars. With High Modernism, buildings became more severely geometric and so light they seemed to float. Their unadorned geometric shapes represented volume, not mass. Their walls were thin membranes of a taut veneer that encased the building, and, as with the Bauhaus Workshop, often this veneer was a curtain of glass, although horizontal strips of windows were generally favored by High Modernist architects. But High Modernism was more than just a style; it was a social movement predicated on utopian socialist philosophy and a rationalist belief in progress. Life could be improved, the theory went, by creating a machine-age environment. Ultimately, the movement was reduced to a style in 1932 when Philip Johnson and historian Henry-Russell Hitchcock organized an exhibition entitled "The International Style" at the newly opened Museum of Modern Art in New York. Their concern was with the look of the architecture, not its social premises. The exhibition brought the style to the attention of Americans, and resulted in the label "International Style" being used to describe High Modernist architecture.

LUDWIG MIES VAN DER ROHE In 1930, architect Ludwig Mies van der Rohe (1886–1969) became the last director of the Bauhaus, which closed in 1933. In the 1920s, Mies had been at the center of the Berlin avant-garde. A student of Behrens, he became a leading Modernist, and in 1927 organized the experimental Weissenhof Estate exhibition in Stuttgart, where leading architects were invited to build inexpensive but quality housing for workers. At this point he was converted to High Modernism, or the International Style, and was heavily influenced by the floating planes of de Stijl and the complex spaces of Wright. His motto, however, was "Less is more," and his architecture is characterized by a severe geometry and simplicity. Nonetheless, his buildings never seem austere; they invariably have elegant proportions and a sense of refinement that makes them seem rich and lush. When budget allowed, he augmented this refinement by using luxurious materials, such as expensive marble and travertine, bronze, and tinted glass.

We can see these qualities in his German Pavilion (fig. 28.37), designed for the 1929 Barcelona Exposition and dismantled after the fair closed. There is nothing overtly innovative here; the overlapping horizontal and vertical planes and the interlocking open-form space had been used in the work of Wright and the de Stijl architects. Mies's innovation is subtle and it resides in its simplicity of style. Geometry is everywhere. The pavilion sits on an enormous rectangular platform of travertine, and is partially enclosed by rectangular walls of travertine or Tinian marble. At either end, the platform is not covered and there is a rectangular pool lined with black glass and placed asymmetrically. The cantilevered flat roof is supported by a grid of eight slender piers, between which are five partition walls, two in onyx, and the three others made of different kinds of glass —clear, frosted, and

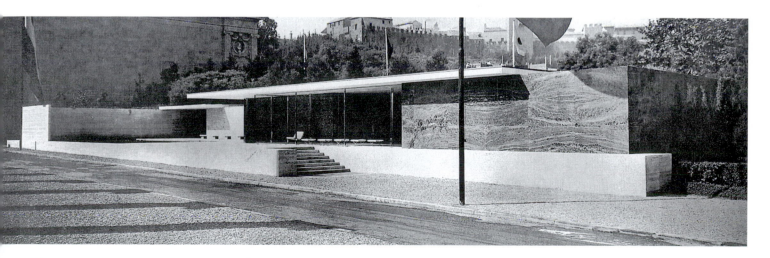

28.37. Ludwig Mies van der Rohe. German Pavilion, International Exposition, Barcelona. 1929. Guggenheim.
© Artists Rights Society (ARS), New York/VG Bild-Kunst, Bonn

green—and encased in chrome mullions (fig. **28.38**). Using a minimal vocabulary, Mies created a sumptuous, elegant feast for the eye. Even the chair he designed for the pavilion, known as the Barcelona Chair and seen in figure 28.38, is simultaneously simple and posh, and (unlike the Rietveld Red-Blue Chair) exceptionally comfortable.

The Machine Aesthetic

The machine aesthetic and the utopian dream that accompanied it also made its way to Paris, where it found a rather different voice in the architecture of Charles-Édouard Jeanneret, called Le Corbusier (1886–1965). While developing his radical architectural theories, Le Corbusier was also a painter, working under his given name Jeanneret. He created a style of painting that he called Purism, which reflected his belief in the supremacy of a machine aesthetic that embodied a Classical

spirit. Purism influenced the French Cubist Fernand Léger, who was already well disposed toward glorifying the efficiency and purity of modern technology. Unlike Moscow, Amsterdam, and Dessau, Paris had no art schools or major artistic movements pushing for a utopian vision. Instead, the cause there was undertaken by individuals.

LE CORBUSIER'S IDEAL HOME Le Corbusier was Swiss, and led a rather peripatetic life prior to settling in Paris in the 1910s. In 1907, in Lyon, France, he met architect Tony Garnier, who had developed an ideal industrial city, *Cité industrielle*, which influenced Le Corbusier to think in terms of socialist utopian architecture and the creation of an easily reproducible architectural type that provided superior housing for everyone. The following year in Paris, he worked part-time for Auguste Perret, the architect responsible for popularizing ferroconcrete—steel-reinforced concrete—as an architectural medium. Most important, however, he demonstrated, as Max Berg had in his Breslau *Jahrhunderthalle* in 1912–1913 (see fig. 27.47) the practicality of ferroconcrete: It is inexpensive, adaptable, easy to use, and very strong, combining the tensile strength of steel with the compressive resistance of concrete. (See *Materials and Techniques*, page 1013.) It is the medium Le Corbusier would adopt for most of his buildings. The last major influence on Le Corbusier was his experience in 1910 working in Peter Behrens's office in Berlin, where his

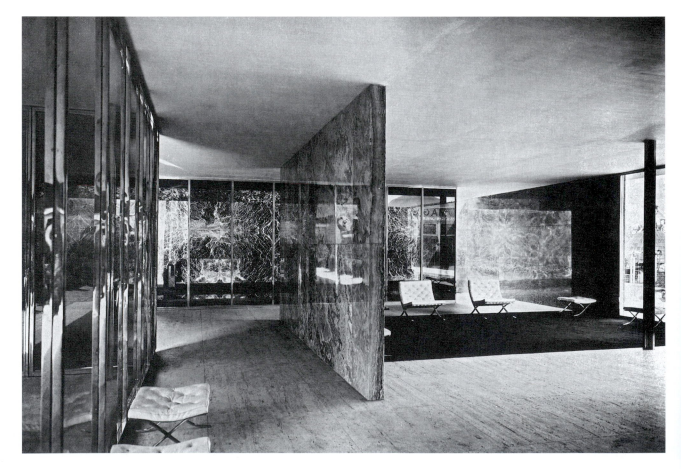

28.38. Ludwig Mies van der Rohe. Interior of the German Pavilion, with Barcelona Chairs. Guggenheim. © Artists Rights Society (ARS), New York/VG Bild-Kunst, Bonn

Reinforced Concrete

Reinforced concrete became one of the most popular building materials in the twentieth century. Concrete is a cement mixture of sand, limestone, and water, that contains small stones or other (generally solid) small objects. While its history dates to 5600 BCE in the former Balkans, the Romans were the first to use it extensively, starting in the second century BCE (see pages 181–182). Romans builders used concrete for bridges, docks, pavements, and aqueducts, but it was also used for homes and major civic buildings, such as the Pantheon (see fig. 7.39).

Concrete virtually disappeared from architecture after the fall of Rome. Its continuous revival began in 1824, when an English mason, Joseph Aspdin, patented an improved cement. Because it resembled a natural stone found on the Isle of Portland, the new material was called Portland cement. To make his cement, Aspdin heated clay and limestone to especially high temperatures, a process still used today. While concrete is fire-resistant and can stand extremely high compression, or evenly applied weight, it does not have much tensile strength. That is, it does not hold up under unevenly applied stresses. To solve the problem, engineers reinforced the concrete by embedding iron rods within it. Steel rods replaced iron rods in the late nineteenth century. (A form of steel first appeared in

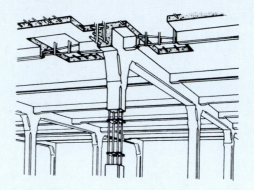

François Hennebique. System for reinforced concrete. 1892. (after Curtis)

Hennebique designed a ferroconcrete post-and-slab construction where each floor/ceiling was an integral part of the structure, not a separate element lying on top of a supporting frame (see figure). Hennebrique's engineering was applied largely to industrial buildings and simply imitated traditional post-and-lintel styles.

Credit for introducing ferroconcrete to "high" architecture generally goes to the French architect Auguste Perret, who designed apartment buildings and parking garages using steel reinforced concrete in the opening decades of the twentieth century. One of his most famous buildings is the Raincy Church, outside Paris, built in 1922 (see figure), which conceptually uses the Rationalism we saw in Soufllot's St. Geneviève (see fig. 23.21) while aspiring to implement the lightness and airiness of a Gothic cathedral. Max Berg's Jahrhunderthalle (see fig. 27.47) in Breslau, built in 1912–1913, also played a major role in popularizing ferroconcrete. Ultimately, it became the principal medium for Le Corbusier (see pages 1112, 1114) and a favorite for Frank Lloyd Wright (see page 1070).

In addition to its strength, ferroconcrete is attractive because it is inexpensive. The concrete component is readily available. The steel, the most expensive and rare component,

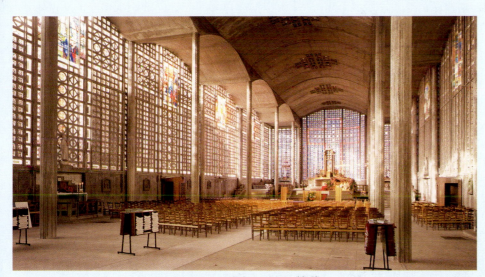

Auguste Perret. Notre Dame, Le Raincy, France. 1923–1924

the second half of the nineteenth century, although modern steel was not invented until toward the end of the century.) Iron and concrete were a perfect match, since the materials complemented each other. Concrete protected the iron, which otherwise melted and corroded easily, while iron provided the tensile strength concrete lacked.

Almost simultaneously in England and France, inventors began to patent ferroconcrete, as steel-reinforced concrete is called. A British plasterer patented concrete floors and roofs made with iron bars and wire rope, while a French gardener took out a patent on steel reinforced concrete planters, eventually designing guardrails and posts and beams as well. But it was not until the 1890s that the French engineer François

makes up only 1 to 6 percent of the structure. By 1904, ferroconcrete was being used in skyscrapers; the first use was for the Ingalls Building in Cincinnati, which was 16 stories and rose to 210 feet. By 1962, it was being used in modern high-rises, including the 60-story twin towers of Marina City in Chicago. From 1998 to 2003, the largest building in the world was the ferroconcrete Petronas Towers in Kuala Lampur, Malaysia, designed by Cesar Pelli, who is based in Hartford, Connecticut. Rising 88 stories and 1,483 feet, the building would have been prohibitively expensive without ferroconcrete, since Malaysia does not manufacture steel. Like much of the world, however, Malaysia readily produces high-quality concrete.

Le Corbusier (1886–1965)

From *Towards a New Architecture* (1923)

First published in 1923, Towards a New Architecture *codified ideas that were being widely discussed among architects, and, it became the first manifesto of the International Style. The following excerpts are from the opening argument.*

The Architect, by his arrangement of forms, realizes an order which is a pure creation of his spirit; by forms and shapes he affects our senses to an acute degree and provokes plastic emotions; by the relationships which he creates he wakes profound echoes in us, he gives us the measure of an order which we feel to be in accordance with that of our world, he determines the various movements of our heart and of our understanding; it is then that we experience the sense of beauty.

Primary forms are beautiful forms because they can be clearly appreciated.

The great problems of modern construction must have a geometrical solution. . . .

The house is a machine for living in.

Standards are a matter of logic, analysis, and minute study. . . .

Man looks at the creation of architecture with his eyes, which are 5 feet 6 inches from the ground.

Industry, overwhelming us like a flood which rolls on towards its destined ends, has furnished us with new tools adapted to this new epoch, animated by the new spirit.

The problem of the house is a problem of the epoch.

If we eliminate from our hearts and minds all dead concepts in regard to the house, and look at the question from a critical and objective point of view, we shall arrive at the "House-Machine," the mass-production house, healthy (and morally so, too) and beautiful. . . .

SOURCE: LE CORBUSIER, *TOWARDS A NEW ARCHITECTURE*. NEW YORK: DOVER, 1986

colleagues included Walter Gropius and Mies van der Rohe. Here, he worked firsthand with German avant-garde architects who would be responsible for developing the International Style, and even then he was talking about creating a machine-based, easily reproduced architecture (see page 978).

In 1922, Le Corbusier opened an architectural firm with his cousin Pierre Jeanneret, and over the course of the next two decades, he designed a series of houses that allowed him to develop and implement his theories of the ideal house, one that could serve as a prototype for all homes. (See *Primary Source*, above.) He called his first type, developed in 1914, the Dom-Ino, because the house consisted of concrete floors with ceilings that sat on concrete columns arranged in a grid pattern that resembled the dots on a domino. (Dom-Ino also referred to the industrial patent for the game, a pun on his plan to design a standardized house that could be "patented.") By 1923 he developed the principles for his ideal home, which he published in an article entitled "Five Points of a New Architecture." His five points were the following: (1) no ground floor, with the house raised on columns called *pilotis*; (2) a flat roof, which would be used as a garden terrace; (3) an open floor plan, with partitions slotted between supports; (4) free composition of the exterior curtain walls; and (5) preferably ribbon (horizontal) windows. The raised house allowed for privacy and light and made the outdoors accessible by putting a garden on the roof. Much later, Le Corbusier remarked that "a house is a machine for living in," which suggested—wrongly—to many critics that he advocated a brutal functionalism that was not concerned with beauty and comfort. In fact, Le Corbusier wanted to create a Classical purity based on geometry and a machine-age look. "Architecture is the masterly, correct, and magnificent play of masses brought together in light," he wrote. "Cubes, cones, cylinders, and pyramids are the primary forms which light reveals to advantage." Within this aesthetic, however, his emphasis was on the human being and "living." Machine-

age values and technology were meant to serve humans: His houses would have a machine-age look and efficiency, using the latest technology. And they would be filled with light.

The 1928 Villa Savoye (fig. **28.39**) in Poissy-sur-Seine, outside Paris, is Le Corbusier's best-known house, and here we can see most of the elements called for in his "Five Points": the *pilotis*, the raised living space, the ribbon windows, and the flat-roof terrace, which is protected behind the enormous cylindrical windscreens that look like ocean-liner smokestacks. The main floor, the second, has an open-space plan using partition walls, and it faces into a court (fig. **28.40**), from which a ramp leads up to the roof. Everywhere we look we see a beautiful classicizing geometry, the building blocks of Le Corbusier's design aesthetic. The building is a perfect square box precisely defined by its taut skin of concrete; the *pilotis* are cylinders, and the windbreakers are enormous arcs. (Obscured by the shadow in figure 28.39 is another geometric curve on the ground floor, which encloses the garage and servants' quarters.) Like the Bauhaus and Schröder House, the house appears light, virtually floating on its *pilotis*.

But as abstract and futuristic as the house may seem, it resonates with the past. We can especially feel the classic, white-box Mediterranean house, oriented around a central court, (enclosed on two sides) that sits on a hill overlooking the sea. Le Corbusier described his villa as a "jardin suspendu," a hanging garden reflecting the mythical gardens of Babylon. The house recalls Palladio in the perfection of the square, and the colonnade of *pilotis* echoes the Doric temple. The ramps (there is a circular staircase as well) linking the floors have reminded scholars of the great entrance ramps of Mycenae. In one of the great statements of International Style architecture and High Modernism, Le Corbusier has given us the Modernist, machine-age update of the great Greek temple perched on a hill, overlooking nature, and permeated with light and air.

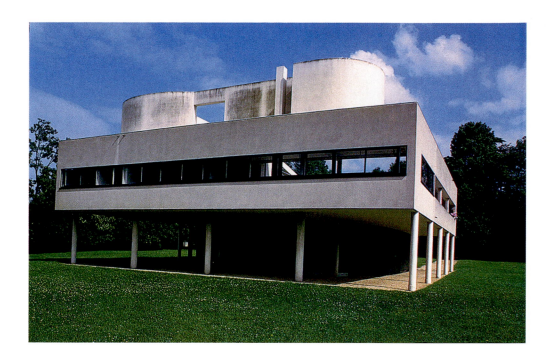

PURISM AND FERNAND LÉGER In 1917, Le Corbusier met the painter Amédée Ozenfant (1886–1966), and together they developed a theory called Purism, which in essence was a Neo-Platonic concept that reduced all artistic expression to an abstract Classical purity that reflected a machine aesthetic. Clean line, pure forms, and mathematical clarity were highly valued. In 1918, they published an essay entitled "After Cubism" that railed against the distortions of the Cubist style, and in 1920 they published an essay, "Purism," which gave a label to their theory. Le Corbusier was a painter as well. Working and writing under his given name Charles-Édouard Jeanneret, and like his colleague,

Ozenfant, he made mostly still lifes, which used the multiple perspectives of Cubism but reduced objects to geometric mechanomorphic forms that run parallel to the picture plane.

The Cubist Fernand Léger (1881–1955) became an adherent of Purism, although he never defined himself as a Purist. He was certainly predisposed to their ideas, for in the early 1910s, he had made mechanical-looking Cubist figures, and was an outspoken socialist and champion of modernity and technological advancement. In the early 1920s, however, his style reflected the machinelike geometry and Classicism advocated by Jeanneret (Le Corbusier) and Ozenfant, as can

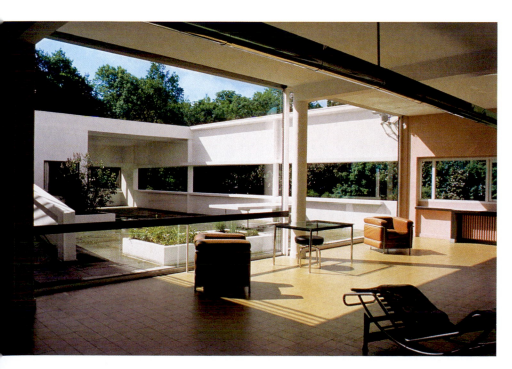

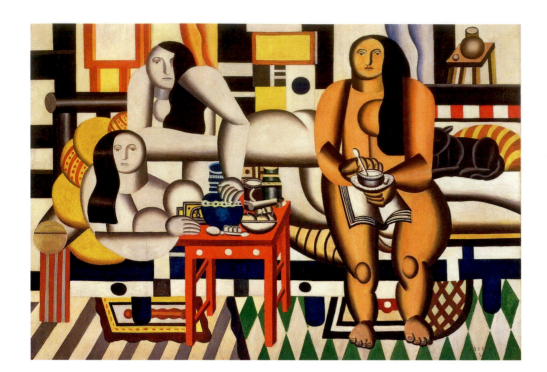

28.41. Fernand Léger. *Three Women (Le Grand Déjeuner)*. 1921. Oil on canvas, 6'1/4" × 8'3" (1.8 × 2.5 m). The Museum of Modern Art, New York. © Artists Rights Society (ARS), New York/ADAGP, Paris

be seen in *Three Women (Le Grand Déjeuner)* (fig. **28.41**) of 1921. His almost identical-looking nudes are constructed of circles and cylinders; their parts, such as their hair and faces, are so similar they could be interchangeable. Virtually all of the objects look machine made, and, as with the figures, they are reduced to cubes, cones, cylinders, and pyramids. Organic and man-made elements are virtually indistinguishable, and both types are ordered in a tight grid of horizontal and verti-cals and run parallel to the picture plane. Color is also kept to essentials—the primary and binaries—the building blocks of the color spectrum. Léger has taken the Classical theme of the monumental nude (although here we seem to be in a brothel) and updated it by placing it in a contemporary world of technological harmony and perfection, in effect telling us, as Seurat had 30 years earlier, that the new Classicism and world order are based on the machine and science.

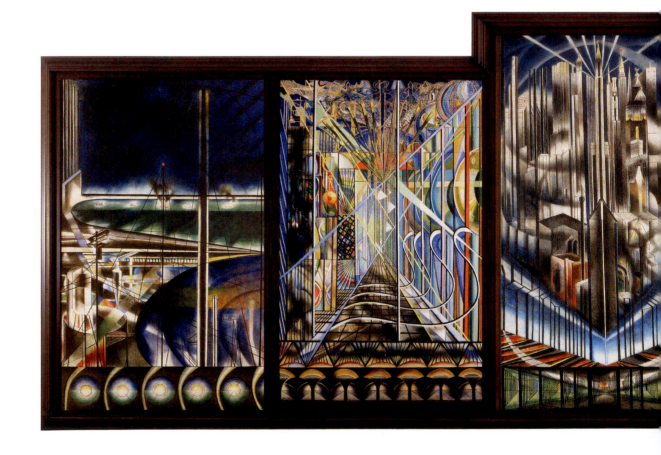

ART IN AMERICA: MODERNITY, SPIRITUALITY, AND REGIONALISM

Perhaps more than Europe, the United States could embrace the machine as the emblem of progress, for after World War I, America was the undisputed technological world leader. In contrast to the European avant-garde that sought a classless, nationless world, Americans were preoccupied with national identity. American artists, however, generally did not have a utopian vision. Instead they viewed skyscrapers, factories, and machines as symbols of the nation's technological superiority. But not everyone embraced modernity. As the economy boomed in the postwar years, culminating in the dizzying exuberance of the Roaring Twenties, many artists rejected materialism and looked for the spiritual. While some artists turned to nature in search of universal truths, others sought strength in old-fashioned American values that could be found in the American heartland, especially in the lifestyle of its hearty, hard-working, God-fearing farmers.

Still others responded to the poverty and social discontent that coexisted with the boom years. The period was marked by the oppression of labor, violent labor strikes, and anarchist threats. Racism escalated in the South, led by the dramatic growth of the Ku Klux Klan and increased lynchings of black men. The Twentieth Amendment granted women the right to vote in 1920, but it had no impact on granting social and economic parity, as women continued to be restricted to "women's jobs" and were paid less. The Great Depression exacerbated these injustices, resulting in the rise in the 1930s of a representational art called Social Realism.

The City and Industry

Arriving in New York harbor for the first time in 1915, Marcel Duchamp marveled at the towering skyscrapers and pronounced them the epitome of modernity. He saw in America the future of art. The skyscraper and modern industry did indeed become the emblems of America, replacing landscape, which had dominated painting in the previous century. Skyscrapers and modern industry represented America's technological and financial superiority, for the United States entered the century as the wealthiest and most modern country in the world. World War I fueled the economy, ushering in an era of unprecedented consumerism and materialism. Known as the Roaring Twenties and the Jazz Age, the 1920s were dominated by the culture of the city, for by 1920 more people lived in cities than in the countryside.

The symbol of the nation was New York, and its defining feature the skyscraper. Beginning in the late 1910s, these "cathedrals of capitalism" became the favorite subject for painters and photographers—and for sculptors and designers—who presented the icon in all its technological splendor. Skyscrapers were shown soaring toward the heavens without a hint of the streets or humanity below. Bridges, factories, dams, refineries—anything that demonstrated America's advanced modernity—were transformed into monuments as grand as the pyramids of Egypt and as sacred as the Gothic cathedrals of France.

JOSEPH STELLA Perhaps the greatest single visual icon of the city was made by the Italian immigrant Joseph Stella (1877–1946). Entitled *New York Interpreted (The Voice of the City)* (fig. **28.42**) and completed in 1922, it is an 8-foot high,

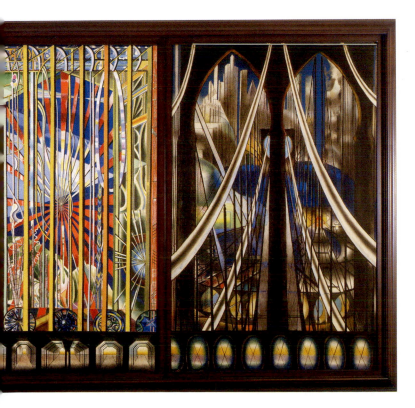

28.42. Joseph Stella. *The Voice of the City, New York Interpreted.* 1920–1922. Oil and tempera on canvas, five panels, 8'3¾" × 22'6" (2.53 × 6.86 m). The Newark Museum, Newark. 37.288 a–e. © Joseph Stella

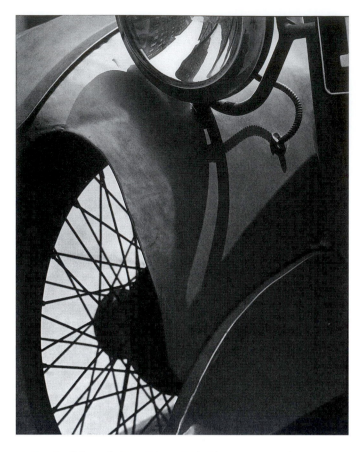

28.43. Paul Strand. *Wire Wheel*. 1917. Platinum print from enlarged negative, 13 × 10¼″ (33.1 × 26.1 cm). George Eastman House. © Estate of Paul Strand

States of Mind (see fig. 27.22). Their dizzying kaleidoscope of color powerfully captures the intense visual experience of Times Square at night. But in the skyscraper and Brooklyn Bridge panels, Stella is not only representational, he is iconic, centering his motifs and transforming them into emblems of modernity. His palette is deeply saturated and color is often encased in heavy black-line drawing, in effect, transforming his image into a "stained-glass window." He reinforces the religious motif by adding a predella at the bottom (see page 516), which itemizes the different tunnels and utility tubes running beneath the city. Technology and modernity are now declared the new religion.

PAUL STRAND Photography, it turns out, was especially well suited for capturing the triumphs of the machine age. However, the first photographs of modern New York, such as Alfred Stieglitz's *The City of Ambition* (see fig. 26.48), romanticized the metropolis by immersing it in a soft pictorial haze. A breakthrough occurred when the young Paul Strand (1890–1976) from 1915 to 1917 made a large body of work of sharply focused, high-contrast photographs. Stieglitz immediately recognized their importance and showed a selection of them at "291." *Wire Wheel* (fig. **28.43**) is from this period. Its abstracted subject is a Model A Ford, an icon of the machine age since it marked the advent of the assembly line. The picture rejects the "painterliness" of turn-of-the-century pictorial photography. In its place is a new compositional style based on the Cubism that Strand saw displayed at Stieglitz's "291." By taking

five-panel work that features in the center panel an abstraction of the city's towers, with the famous Flat Iron building in the foreground, surrounded by both actual and fictitious buildings. The panels flanking the center panel represent the "Great White Way" (Broadway), which has been reduced to an abstraction of color and light. The far left panel presents the harbor on the Hudson River on the west side of lower Manhattan, while the right panel shows the Brooklyn Bridge on the east side. Every image features the technological wonders of Manhattan. We see communication towers, air venting systems, and elevated trains in the harbor picture. The Great White Way panels present the dazzling illumination of Times Square at night, which at the time had no equivalent anywhere else in the world. In effect, these two panels are an homage to electricity and the energy of the city. And even 35 years after opening, the Brooklyn Bridge still remained one of the world's great feats of engineering.

Stella came to America in 1896, but returned to Italy to study in 1910, where he met the Futurists (see Chapter 27). Through the Stieglitz gallery and his friendship with Duchamp and Man Ray, among others, he kept in touch with European trends, with Cubism becoming his primary artistic language in the 1910s. The Great White Way panels especially reflect the tenets of Futurism, for here we see the sound waves and Mach-like indications of motion that we saw in Boccioni's

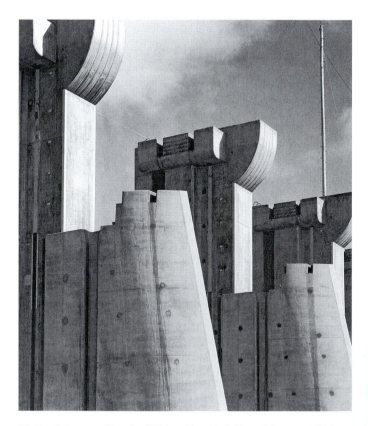

28.44. Margaret Bourke-White. *Fort Peck Dam, Montana*. 1936. Time-Life, Inc.

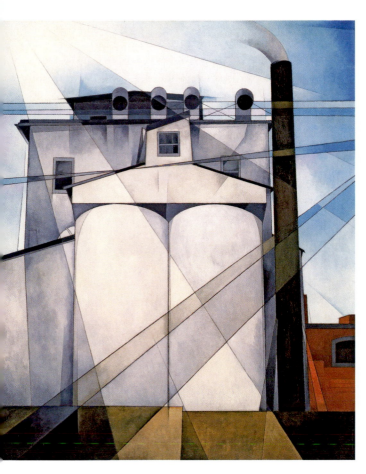

28.45. Charles Demuth. *My Egypt*. 1927. Oil and graphite on composition board, 2′ 11¾″ × 2′6″ (91 × 76 cm). Whitney Museum of American Art, New York. Purchase, with Funds from Gertrude Vanderbilt Whitney. 31.172

a close-up of the car, Strand created a skewed perspective and tight cropping, resulting in a difficult-to-read image with a flattened and complicated space.

In 1920, Strand collaborated with painter/photographer Charles Sheeler (1883–1965) to make a film intended to capture the energy and grandeur of New York. Entitled *Manahatta (New York the Magnificent)* (to view the film visit www.prenhall.com/janson), it opens with commuters arriving by ferry in lower Manhattan, spilling off the boat in teeming masses, and swarming through the financial district on their way to work. At the end of the film, the crowds get back on the boat at sunset. Rapid editing, vertiginous shots taken from the top of skyscrapers, raking angles, and sharp value contrasts are among the formalist devices that give this movie a sense of surging energy and constant movement designed to capture the rapid pace of modernity and the powerful current of the urban experience. Interspersed throughout the film are fragments of Walt Whitman's 1860/1881 poem *Manhatta* which proclaims New York's greatness and might.

MARGARET BOURKE-WHITE Strand's hard-edged aesthetic transformed photography, not only in America, but eventually throughout the world. His style was especially appropriate for technological and industrial images, reinforcing the machine-made precision of the subject. Photojournalist Margaret Bourke-White especially embraced this new aesthetic and was drawn to technological imagery, as seen in *Fort Peck Dam, Montana* (fig. **28.44**), the cover image for the very first issue of *Life*, published on November 23, 1936. The photograph's power lies in its severe austerity, which reinforces the mammoth scale of the dam, dwarfing the antlike workers below. Each of the dam's pylons is identical, looking as though they were pressed out of an enormous machine mold, and because the photograph of the dam is cropped on either side, these gigantic assembly-line towers seem endless as well. But they take on the grandeur of ancient Assyrian or Egyptian monuments, and again we find an artist declaring modern technology to be the new Classicism.

CHARLES DEMUTH In his 1927 painting *My Egypt* (fig. **28.45**), depicting contemporary grain elevators near his native Lancaster, Pennsylvania, Charles Demuth (1883–1935) similarly transformed American modernity into a Classical icon. Demuth had studied in Paris from 1912 to 1914, absorbing European modernism, and by the 1920s he was traveling in the most sophisticated artistic circles and showing with Alfred Stieglitz. His work is quite varied in style, even in a given period, and here we see him working with the American counterpart of Purism in a style called Precisionism. In the 1920s, a group of American artists, including Demuth, developed a look that had the hard-edged geometric quality of Cubism but was far more representational. It came to be called Precisionism not only because of its precise geometry and drawing, but also because it seemed to capture the precision of mechanization and industry, which was often its subject matter. Brushwork was meticulous, and at one point these artists, who rarely showed together and did not think of themselves as a group, were called Immaculates. At first glance, *My Egypt* seems quite Cubist. But the physical integrity of the grain elevators is barely compromised, and what seems like Cubist fracturing are mysterious, almost mystical, beams of light that only slightly distort the objects but quite successfully invest the building with a brute power, if not a mystical transcendence. The title *My Egypt* suggests that such agricultural architecture as grain elevators, were America's pyramids. The smokestack endows the grain elevators with an industrial might, and the geometry of the ventilation ducts and massive cylinders of the storage tanks virtually transform the building into an efficient machine.

STUART DAVIS Among the American artists who captured the essence of the modern experience using abstraction was Stuart Davis (1892–1964). The 1913 Armory Show in New York (see page 974) converted Davis into a dedicated Modernist, and by the 1920s his work was becoming increasingly abstract. Just as Mondrian tried to find an abstract equivalent for invisible life forces, Davis wanted to create the plastic equivalent for experiencing modern life—flying in an airplane, looking down from a towering skyscraper, listening to jazz music, or riding in a speeding car, motorcycle, or train. He wanted to capture the experience of the "new lights, speeds, and spaces which are uniquely real in our time." To do this he used a Synthetic Cubist vocabulary, and by the 1930s his palette had become bright, limited to primary, secondary, and tertiary colors, and his forms

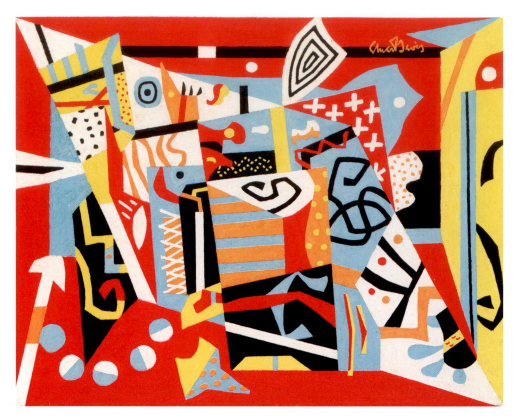

28.46. Stuart Davis. *Hot Still-Scape for Six Colors—Seventh Avenue Style*. 1940.
Oil on canvas, 36 × 45″ (91.4 × 113.9 cm). Photograph © Museum of Fine Arts, Boston. Gift of
the William H. Lane Foundation and the M. and M. Karolik Collection, by Exchange, 1983.120.
Art © Estate of Stuart Davis/Licensed by VAGA, New York

quite jaunty and their juxtaposition raucous, as seen in *Hot Still-Scape for Six Colors—Seventh Avenue Style* (fig. **28.46**) as of 1990. After describing how his colors were used like musical instruments to create a composition (Davis loved jazz and swing), he went on to describe his picture, painted in his Seventh Avenue studio: "The subject matter . . . is well within the experience of any modern city dweller. Fruit and flowers; kitchen utensils; fall skies; horizons; taxi cabs; radio; art exhibitions and reproductions; fast travel; Americana; movies; electric signs; dynamics of city sights and sounds; these and a thousand more are common experience and they are the basic subject matter which my picture celebrates." Embedded within this playful jumble of color and shapes and overlapping planes are smokestacks, seascapes, and brick walls, all reduced to funky hieroglyphic notations, which in their cartoony character seem to tap into American popular culture. In an almost undefinable way, Davis's sensitivity captures the pulse of America—its gaudy advertising, its love of the new, its jazz, its mobility, its rootlessness.

Art Deco and The International Style

While the skyscraper became the national emblem of America's modernity, the buildings themselves were aesthetically conservative compared with European architectural developments, especially the International Style. Their distinguishing characteristic was their height. By 1900, New York once again became the home of the skyscraper, taking the lead from Chicago. Buildings became progressively taller, with Cass Gilbert's 792-foot Woolworth Building dominating the cityscape in 1913.

Aesthetically the new towers were very nineteenth-century, reflecting a variety of historical styles, often the Gothic. The wealth of the Roaring Twenties produced furious building campaigns, as architects competed to design the world's tallest building. Almost simultaneously, the 77-story Chrysler Building and 102-story Empire State Building went up in 1930.

The Chrysler Building (fig. **28.47**) was designed by little known architect William van Alen (1883–1954), and is often considered the finest Art Deco skyscraper. Art Deco is a decorative arts style that emerged in 1925 at the Exhibition of Decorative and Industrial Art held in Paris. Like the Bauhaus school, Art Deco concepts aimed to close the gap between quality design and mass production. It was an outgrowth of Art Nouveau, but it replaced the organic forms with a machine-age geometric and streamlined look. Unlike the Bauhaus, Art Deco had no utopian goal; it was largely bourgeois, indulging in fantasy and lavishness. It was about decorative veneer, not idealistic substance. Within the geometry and streamlining of the machine aesthetic, it absorbed a wide range of historical references, from Cubist fracturing to the zigzag patterning of Native American and Pre-Columbian design. Deco designers loved lush colors, opulent materials, and shiny surfaces. Inspired by the geometry of machines, it generally drew together a variety of angular forms, often in jagged, staccato rhythms and set them off against organic motifs that recall Art Nouveau or Jugendstil. We can see these qualities in the Chrysler Building. The geometry is streamlined in the tapering tower with its steadily receding arches. The flamelike triangular windows create a staccato rhythm, and

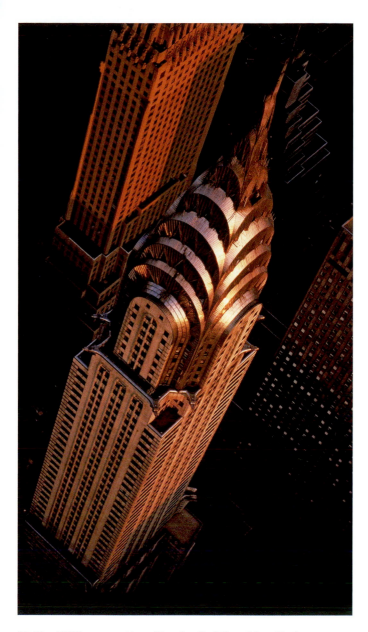

28.47. William van Alen. Chrysler Building, New York, 1928–1930

the entire crown is sheathed in glistening stainless steel. Gargoyles duplicating the hood ornament for the 1929 Chrysler decorate the corners.

The International Style came to America about this same time, appearing in Raymond M. Hood's 1931 McGraw-Hill Building in New York and in the 1929–1932 Philadelphia Savings Fund Society Building (fig. **28.48**) by George Howe (1886–1955) and William E. Lescaze (1896–1969). That Howe and Lescaze got to design a modern building is itself quite remarkable, since there was nothing else like it in America when it was planned. The building already presented an enormous financial risk, as potential renters were becoming scarce as the Great Depression deepened. Their building has many of the characteristics of High Modernism, but its floating, cantilevered blocks with glass curtain walls were compromised when the client insisted the piers get pushed to the outer perimeter of the building, creating strong vertical accents and interfering with the horizontal windows. While the building seems more massive than its light, floating European counterparts (see fig. 28.36), the Philadelphia Savings Fund Society Building reflects its functionalism, as each of the Constructivist-like blocks that we can see on the exterior was designed to accommodate a different purpose.

Seeking the Spiritual

In the 1910s, much of the American creative community turned its attention to producing an American art. Writers, musicians, artists, and poets all felt that American culture was derived from Europe; now they would seek to discover what was unique about the American experience and try to express it in an indigenous way. For some artists, like Stella in *New York Interpreted (The Voice of the City)* and Demuth in *My Egypt*, the answer lay in American modernity. Others looked to nature, going back to the pantheistic Romanticism of the Hudson River School and its successors. Stieglitz became preoccupied with this issue of an American art, deciding in the 1920s to represent only American artists and naming his last gallery, which he opened in 1928, An American Place. Stieglitz himself became increasingly intolerant of modernity, not buying a radio or a car until quite late in life, and like so many at the time shunning materialism to seek a spirituality in modern America. Stieglitz, who had published sections of Kandinsky's *Concerning the Spiritual in Art* in *Camera Work* (see page 960), became preoccupied with visually capturing an equivalent of his emotions when confronting sublime nature.

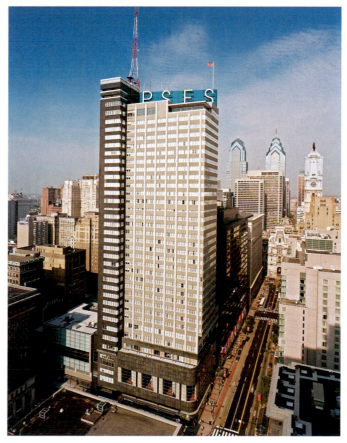

28.48. George Howe and William E. Lescaze. Philadelphia Savings Fund Society Building, Philadelphia. 1929–1932

The artists that Stieglitz showed from the early 1920s until his death in 1946 were generally, but not always, preoccupied with finding a higher meaning in life within a materialistic modern world, often focusing on nature. One was Georgia O'Keeffe (1887–1986), with whom Stieglitz became romantically involved in 1918 and later married.

GEORGIA O'KEEFFE When Stieglitz first showed her work in 1916, Georgia O'Keeffe was making small abstract minimalist watercolors that evoked sublime landscape. Toward

28.50. Edward Weston. *Pepper*. 1930. Gelatin silver print. Center for Creative Photography, Tucson, Arizona

1920, her presentation of nature evolved into close-ups of flowers, as seen in *Black Iris III* (fig. **28.49**) of 1926, where the image is so magnified it virtually becomes abstract. We do not have to look far to find the pictorial source for O'Keeffe: Paul Strand. O'Keeffe fell in love with the young, handsome Strand in 1917 and was smitten as well by the power of his photography, especially the use of the close-up image. This compositional device, she wrote, forced a viewer to see flowers with the same intensity that she did. But by abstracting the close-up, O'Keeffe accomplished much more: The forms of the flowers morph into the parts of a woman's body, and the iris is redolent of female sexuality. The petals ethereally dissolve into their surroundings, seeming to become one with the rest of nature.

Partly because of Stieglitz's marketing, critics described O'Keeffe's flowers as overtly erotic and sexual, which the new loose morality of the Roaring Twenties could accommodate. This interpretation outraged O'Keeffe, who denied that her pictures were about sexuality per se. And they are not. As with the banned sexually explicit novels of her friend the English author D. H. Lawrence, her paintings were not about lust but the uncontainable surging force of nature, which includes the urge to procreate. Sexuality was portrayed as being natural, beautiful, and as essential as a flower blossoming, disseminating pollen, and reproducing. And if her wonderful organic flower, which seems to be growing before our very eyes, begins

28.49. Georgia O'Keeffe. *Black Iris III*. 1926. Oil on canvas, $36 \times 29\frac{7}{8}$″ (91.4 × 75.9 cm). The Metropolitan Museum of Art, New York. The Alfred Stieglitz Collection, 1949.
© The Georgia O'Keeffe Foundation/Artists Rights Society (ARS), New York

to take on the look of other objects, such as clouds, smoke, buttocks, and flesh, it only increases the sense of universal equivalence that she believed ran through all things. In this microcosm of an iris, O'Keeffe presents a macrocosm so large it encompasses the entire universe.

EDWARD WESTON Due to both Strand and O'Keeffe, the close-up became a popular device with both painters and photographers in the 1920s, and in the hands of some artists it had the same spiritual dimensions found in O'Keeffe's paintings. *Pepper* (fig. **28.50**) by the Californian Edward Weston (1886–1958) falls into this category, as the rippling gnarled vegetable is transformed through lighting and cropping to resemble, in some places, a curled up figure (the back facing the upper right corner, buttocks to the lower right) and in other places breasts, arms, and so on.

ALFRED STIEGLITZ In 1922, challenged by O'Keeffe's spiritual magnifications of flowers and landscapes, Stieglitz began a series of photographs of the night sky, which he called *Equivalents*. A 1926 example is reproduced here (fig. **28.51**). The title, in part, is a reference to nature embodying a spirituality that Stieglitz himself could feel, which in turn transcend-

ed through him and into the photograph, thus becoming the spiritual equivalent of nature. The images are abstract, paralleling the abstraction of emotion and spirituality. And, of course, it is no accident that Stieglitz selected the sky to represent the mystical, since it is a traditional symbol of infinity and transcendence. Part of the impact of these prints is their scale: They are $4\frac{5}{8} \times 3\frac{5}{8}$ inches. Their diminutive format allows for an intense richness of darks, and since the entire series is set at night with moonlight filtering through clouds, the prints are predominantly dark. The magic of these images is their density: We feel as though the entire universe has been concentrated into mere square inches.

Regionalism and National Identity

While the New York avant-garde sought a national identity and spirituality using either images of modernity or compact abstract styles, a group of Midwest artists, headed by Grant Wood, Thomas Hart Benton, and John Stewart Curry, turned to "old-fashioned" representational art and regional imagery. Although trained in modern art centers (Benton and Wood studied in Europe as well as in New York and Chicago), they generally preferred to work in the Midwest, where they came from and with which they identified.

28.51. Alfred Stieglitz. *Equivalents.* 1926. Gelatin silver print, $4\frac{3}{4} \times 3\frac{3}{4}''$ (11.6 × 9.2 cm). National Gallery of Art, Washington, D.C. Alfred Stieglitz Collection

The most famous image produced by this group is *American Gothic* (fig. **28.52**) by Grant Wood (1891–1942) of Cedar Rapids, Iowa. The picture was shown at the Art Institute of Chicago in 1930, where it caused a stir and brought Wood to national attention. It was intended as a window into the Midwest world in which the artist grew up and lived. A fictitious father and spinster daughter are presented as the God-fearing descendants of stalwart pioneers who first worked the soil. They are dressed in old-fashioned clothes and stand firmly against the march of progress. The style of their house, from which the title of the painting is taken, is called Carpenter Gothic, a nineteenth-century style evoking both the humble modesty and old-fashioned ways of the residents as well as their religious intensity, which parallels the fervor of the medieval period when Gothic cathedrals were built.

Wood further emphasizes his characters' faith by developing numerous crosses within the facade, and by putting a church steeple in the distant background. We know they are orderly and clean, as suggested by the crisp drawing and severe horizontal and vertical composition. This propriety also stems from the primness of the woman's conservative dress and hair and the suggestions that she carefully tends to the house, as she does to the plants on the front porch. The figures' harsh frontality, the man's firm grasp on his pitchfork, and his overalls suggest that they are hardworking and strong. There is no

hint of modernity, and the simplicity and the austerity of the setting suggests they are frugal. Nonetheless, many critics viewed Wood as ridiculing his sitters and their lifestyle, and indeed it does contain humor, such as the woman warily looking off to the side as if to make sure nothing untoward is occurring. But regardless of the interpretation, no one seemed to deny that the picture seemed to capture something fundamentally American, and especially Midwestern.

The Harlem Renaissance

In the 1910s and 1920s, hundreds of thousands of African Americans fled the racism and poverty of the rural South for the cities of the industrial North, where they hoped to find jobs and justice and equality. In the North, the new migrants often discovered they had exchanged rural poverty for urban slums, and the racism encoded in Southern Jim Crow laws for prejudice, segregated neighborhoods, and second-class citizenship in the North. Nonetheless, the confluence of blacks in New York's Harlem and Chicago's South Side resulted in a cultural flourishing devoted to self-discovery and to establishing a black identity, something white America had methodically denied African Americans. The movement was then called the New Negro Movement, although today it is generally known as the Harlem Renaissance, after its primary center, often described as its "capital."

28.52. Grant Wood. *American Gothic*. 1930. Oil on board, 29⅞ × 24⅜″ (74.3 × 62.4 cm). The Art Institute of Chicago. Friends of American Art Collection. Art © Grant Wood/Licensed by VAGA, New York

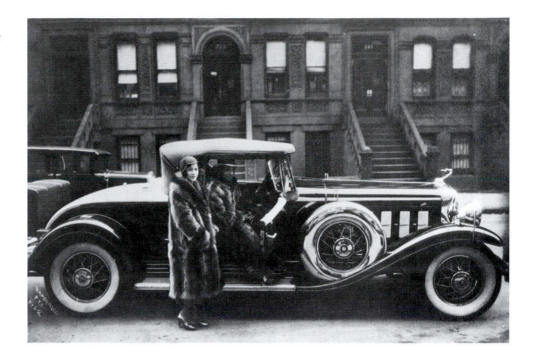

28.53. James Van Der Zee. *Couple Wearing Raccoon Coats with a Cadillac, Taken on West 127th Street, Harlem, New York.* 1932. Gelatin silver print

Leading this movement in literature, music, theater, and art was the Howard University philosopher Alain Locke (1886–1954), who called for a distinctive style that evoked a black sensibility and perspective. He advocated recapturing the African past and its art, which white avant-garde artists had already done, although presenting it from their own narrow perspective and reflecting their own needs and interests. Locke encouraged representations of African Americans and their lives as well as a portrayal of the distinctive physical qualities of the race, just as African masks often stressed black physiognomy. In effect, he was advocating artists and writers declare "black is beautiful." In his promotion of a black aesthetic, he encouraged artists to depict a distinct African-American culture, one that departed from the Euro-American tradition and reflected the enormous contributions Americans of African descent had made to American life and identity.

Prior to the Harlem Renaissance, African American fine artists made art that was inspired by the art that their Euro-American counterparts were producing, with the intention of "fitting in," conforming, and appealing to market values, which were determined by white artists. They made the same landscapes, still lifes, and genre scenes, all devoid of black content. (In the crafts and folk art, such as quilts, metalwork, and furniture, and in music as well, African Americans were often influenced by African traditions.) With the Harlem Renaissance, artists began making African Americans the subject of their art. Although most major African American artists worked within the Modernist tradition, they also offered an alternative to this tradition by making racial identity a prominent theme in their work. In effect, they made the subject of race and the power of its presentation as important as formal innovation.

JAMES VAN DER ZEE The self-taught Harlem photographer James Van Der Zee (1886–1983) was a studio photographer, who carefully crafted his portraits to create images that presented sitters according to their own desires; sometime in haute couture, at other times in the uniforms of Marcus Garvey's African Nationalist Militia. Van Der Zee was known for his use of multiple exposures, a method he used to present deceased relatives rising toward heaven, or to look into the future of a young couple's life and depict healthy children yet to be born. One of his most famous images is *Couple Wearing Raccoon Coats with a Cadillac* (fig. **28.53**) of 1932, made during the depths of the Great Depression. Despite the deprivation of the period, we still sense the optimism and energy of the Harlem Renaissance, which continued into the 1930s, creating an environment in which the New Negro could thrive and prosper.

JACOB LAWRENCE The most famous painter to emerge from the Harlem Renaissance was Jacob Lawrence (1917–2000), who received his training as a teenager in the 1930s at the federally-sponsored Harlem Art Workshop and Harlem Community Art Center. Lawrence regularly went to midtown to take in all the art the city had to offer, from a Primitive Art show at the Museum of Modern Art, to Mexican textiles, to all of the latest European styles. In the late 1930s, he began making large narrative series dedicated to black leaders, including Harriet Tubman, Toussaint L'Ouverture, and Frederick Douglass. The images were small and modest, made of poster paint on cardboard or posterboard.

Lawrence is best known for his *Migration Series*, begun in 1940. In 60 images, Lawrence presented the reasons for blacks migrating North and their experiences in both North and

South. While the series is anecdotal, the images did much of the talking through their abstraction, as seen in number 58 in the series *In the North the Negro Had Better Educational Facilities* (fig. **28.54**). Three girls write numbers on a blackboard, but we do not see their faces, which would make them individuals. Instead, we see numbers and arms rising higher, suggesting elevation through education, and we see a clean slate for a clean start. The girls' brightly colored dresses affirm life and happiness, while the jagged and pointed edges in their hair and skirts impart an energy and a quality of striving. Lawrence generally shows a collective black spirit, not an individual or an individual expression. He is interested in a human spirit that relentlessly and energetically moves forward building a better future. His sparse and beautifully colored pictures embody a remarkable psychology, which is often reinforced by the Modernist space of his pictures. Here a flat field pushes the figures to the surface, prominently displaying them.

MEXICAN ART: SEEKING A NATIONAL IDENTITY

The Mexican revolution, which began in 1910 with the overthrow of the dictatorship of General Porfirio Diaz and ended in 1921 with the formation of the reformist government of Alvaro Obregón, triggered a wave of nationalism within the cultural community, one that focused on indigenous traditions while rejecting European influences. A government building campaign resulted in a large number of impressive mural commissions, which in turn gave rise to a school of muralists headed by Diego Rivera, David Siquieros, and Jose Clemente Orozco. Either socialists or Communists, the muralists proclaimed murals as the true art of the people. The Mexican muralists gained international renown and were especially popular in the United States, where they received enormous commissions, ironically from major capitalists, like the Rockefeller family.

Diego Rivera

Diego Rivera (1886–1957) is perhaps the best known of the three major muralists. He lived in Europe, primarily in Paris, from 1907 to 1921, and was an accomplished Cubist. By the late 1910s, Rivera was consumed by the idea of creating a nationalistic revolutionary art through mural painting, and he traveled to Italy to study Renaissance murals. Upon returning to Mexico, he jettisoned his elite esoteric Cubism for the straight-forward representational art of the quattrocento, giving it a monumentality that also echoed the strong simple forms of Aztec and Mayan art. Furthermore, he shunned easel painting, declaring it a bourgeois capitalistic art form, a commodity for the rich. He viewed his fresco murals as a public art, an art for the masses. He also felt his art should be about the indigenous people, not the Euro-Mexicans and their European customs. Consequently, many of his mural commissions are about national identity and the uniqueness of Mexican customs and tradition.

Rivera was a Communist, and his politics, especially his championing of the common folk and labor, appear in his

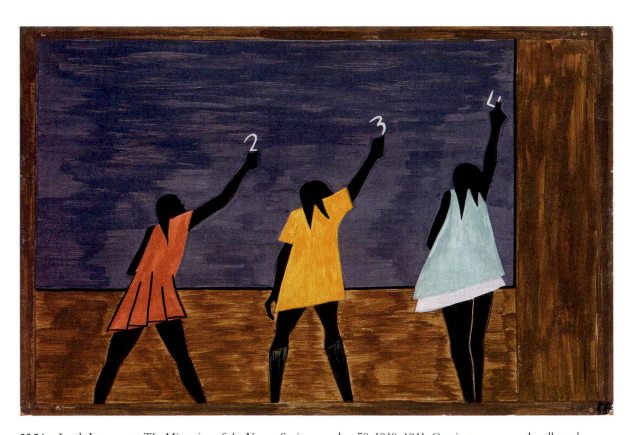

28.54. Jacob Lawrence. *The Migration of the Negro,* Series, number 58. 1940–1941. Casein tempera on hardboard, 12 × 18″ (30.5 × 45.7 cm). Museum of Modern Art, New York. Gift of Mrs. David M. Levy.
© The Jacob and Gwendolyn Lawrence Foundation, Seattle/Artist Rights Society (ARS), New York

murals. From 1930 to 1934, he received numerous commissions in the United States, and his representational art had a tremendous impact on American mural painting, which was proliferating due to support from Franklin Roosevelts's New Deal administration that provided artists work. One major project was the lobby of the RCA building in Rockefeller Center. Entitled *Man at the Crossroads Looking with Hope and High Vision to a New and Better Future*, it included a portrait of the Communist leader Lenin, which outraged the Rockefellers, who had commissioned the mural. The Rockefellers paid Rivera but then destroyed the mural. Rivera remade it as *Man, Controller of the Universe* (fig. **28.55**) at the Museo del Palacio de Bellas Artes in Mexico City in 1934. The painting praises science and Communism, which, for Rivera, were the twin tools of progress. In the center of the composition we see Man, positioned under a telescope and with a microscope to his right (our left), indicating that humankind will control the future through science. Two crisscrossing ellipses of light seem to emanate from Man, one depicting a microscopic world, the other the cosmos. Below him is the Earth, and the superior agricultural products generated by scientific discovery. To Man's left (our right), we see sandwiched between the healthy microorganisms and a harmonious cosmos, Lenin holding hands with workers of different races. Beyond is a scene of healthy unified labor. To Man's right (our left), are the evils of capitalism. Between the ellipses showing diseased organisms and a clashing cosmos is a decadent bar scene depicting the well-heeled bourgeoisie, which includes

ART IN TIME

1933—Pablo Neruda publishes *Residence on Earth and Other Poems*
1934—Diego Rivera's *Man, Controller of the Universe*
1939—Frida Kahlo's *The Two Fridas*

John D. Rockefeller, Jr. Beyond are frightening soldiers and discontented, protesting laborers.

Frida Kahlo and Manuel Álvarez Bravo

A more remarkable, if less influential, artist from this period was Rivera's wife, Frida Kahlo (1907–1954). She was almost killed in a traffic accident when she was 18, and when recuperating, she started painting, cultivating a folk style that reflected her strong interest in the power of naive Colonial pictures and such folk imagery as ex-votos (a Catholic folk image depicting a cure for a miraculous event in someone's life, designed to give thanks to Jesus). Kahlo's imagery was personal, focusing on her state of mind, generally her tumultuous relationship with her philandering husband Rivera or her lifelong excruciating suffering from her injuries. She made easel pictures, often quite small, which while focusing on herself, nonetheless deliberately placed her in a Mexican context. She often presented herself in traditional Mexican clothing and jewelry, and with attributes associated with folk beliefs and superstition.

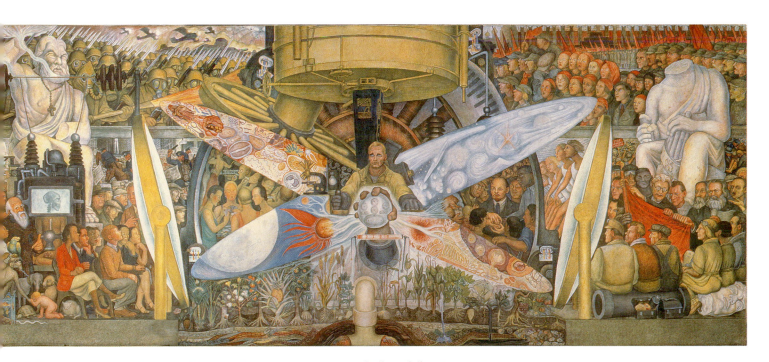

28.55. Diego Rivera. *Man, Controller of the Universe.* 1934. Fresco, 15'11" × 37'6" (4.85 × 11.45 m). Museo del Palacio de Bellas Artes, Mexico City

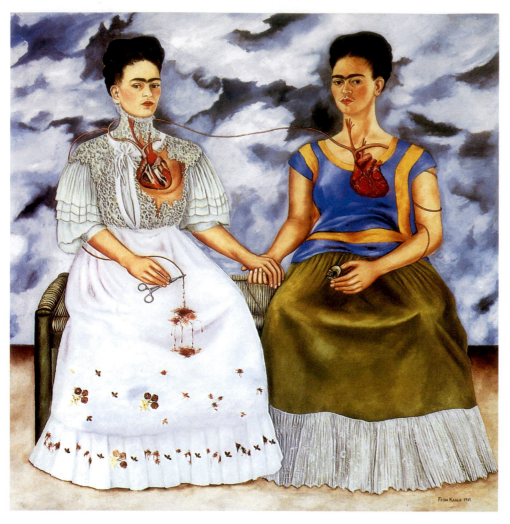

28.56. Frida Kahlo. *The Two Fridas.* 1939. Oil on canvas, 5′ 8½ ″ × 5′ 8½ ″ (1.74 × 1.74 m). Museo de Arte Moderno, Instituto Nacional de Bellas Artes, Mexico City

We can see this focus on her own identity and psychology in her 1939 painting *The Two Fridas* (fig. **28.56**), made when she and Rivera were divorcing. On the left is the European Frida in Victorian dress, reflecting her father's Hungarian Jewish ancestry, and on the right the Mexican Frida in peasant costume, reflecting her mother's Indian and Creole background but, more important, the Frida that Rivera wanted her to be. The Mexican Frida holds a miniature portrait of Rivera as a boy, the source of the blood coursing through her and into the European Frida, who is trying to cap the flow that ties the two sides of her personality together and links her to her husband. The exposed heart, dripping blood, and the miniature have the surreal drama found in the Mexican ex-votos that Kahlo so admired, while the crisp contours of the figures and the bench, for example, echo their plain direct folk art style. Contrasted with these simple unarticulated passages are meticulously detailed motifs, such as the hearts and lace, which changes the texture of the image, making it all the more bizarre. André Breton was in Mexico in 1938 and declared Kahlo a Surrealist, a label she objected to, declaring she was not painting dreams but rather the reality of her life. Her pictures were not meant to churn the unconscious, but rather to reflect her own pain and suffering.

Breton also added photographer Manuel Álvarez Bravo (1902–2002) to his roster of Surrealists. Bravo, who was self-taught, was in the muralist circle in Mexico City and equally preoccupied with creating a Mexican art. Like Cartier-Bresson's images, Bravo's have a similar uncanny quality, sometimes due to an unusual juxtaposition of objects, sometimes simply because of a strange silence and mysterious shadows. In some respects, his Surrealism was the result of his quest to capture the magical essence of folk myths and superstitions, as seen in *La Buena Fama Durmiendo (Good Reputation Sleeping)* (fig. **28.57**). Here Bravo posed his model on the roof of the national arts school where he was teaching, having her lie on a Mexican blanket and binding her wrists, ankles, and feet as well as her pelvis and upper legs in bandages. He allows her pubic hair to show, and surrounds her with thorny cactus pears. Breton wanted to use this image for the cover of a 1940 international Surrealist exhibition he was organizing for Mexico City, and because of the

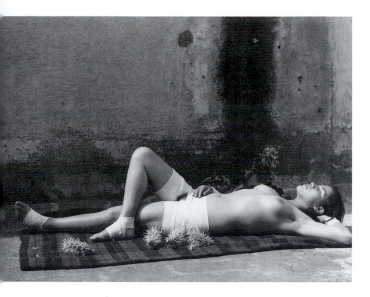

28.57. Manuel Álvarez Bravo. *La Buena Fama Durmiendo*
(Good Reputation Sleeping). 1938–1939. Gelatin silver print.
Museum of Photographic Arts, San Diego, California

ART IN TIME

1922—Benito Mussolini comes to power in Italy
1930—Edward Hopper's *Early Sunday Morning*
1933—Adolf Hitler establishes Nazi dictatorship in Germany
1936—Spanish Civil War
1936—Francisco Franco becomes dictator of Spain
1937—Pablo Picasso's *Guernica*
1941—Japan bombs Pearl Harbor

jarring relationship of prickly pears to the model, the exposed
crotch, the strange tightly-wound bandages, and the violent
stains on the wall, it is not difficult to understand why. But
Bravo's motivation was not just about evoking the pain,
suffering, violence, and desire associated with sex; he also want-
ed to encompass the intensity of local legends that go back for
centuries. In Mexican folklore, for example, the thorny pears are
supposed to ward off danger during sleep. The bandages were
inspired by watching dancers bind their feet, which reminded
Bravo of Pre-Columbian sculptural reliefs of dancers, which
were related to the earth goddess Coatlicue, who was conceived
without sexual intercourse. The image is a wonderful exercise in
doctrinaire Surrealism, but at the same time it is steeped in the
myth and magic of Mexican tradition, in effect drawing upon
indigenous cultures in the way that Surrealists prescribed.

THE EVE OF WORLD WAR II

In October 1929, the New York stock market crashed, unleash-
ing the Great Depression that fanned out around the globe.
The depravation it inflicted lasted an excruciating 16 years. In
Europe and Asia, fascists rose to power—Mussolini in Italy,
Hitler in Germany, Franco in Spain, and Hirohito in Japan.
Communist Russia became totalitarian with the emergence of
Stalin in the late 1920s. In 1931 Japan invaded continental Asia.

For European artists, the rise of Hitler was the defining
influence. To those bent on establishing a democratic classless
world, his policies were insane. He was aggressively militaris-

tic, believing great nations are based on a powerful, ruthless
military. He declared Aryans, Germans of Scandinavian and
Teutonic descent, to be a master race, superior to all others, and
claimed Germany's economic and political decline resulted
from its ethnic and linguistic diversity. He especially faulted
Jews and Communists for undermining German superiority,
and by the late 1930s, Jews, Slavs, Gypsies, gays, the mentally
and physically impaired, as well as Communists and political
dissenters, were imprisoned, sent to work camps, or executed.
The utopian dream of Dada, Surrealism, de Stijl, Construc-
tivism, and the Bauhaus proved to be just that, a dream. Hitler
closed the Bauhaus in 1933, and in 1937, the Nazis staged a
Degenerate Art Exhibition in Munich, denigrating German
avant-garde artists in full public view. In America, social real-
ism and representational regional art gained at the expense of
avant-garde art. While regionalists painted stoic or dynamic
scenes of American fortitude and drive, others focused on the
plight of the urban poor.

America: The Failure of Modernity

The avant-garde continued to work in abstraction through the
1930s, but in an era dominated by the terrible social ills of the
Great Depression, it became increasingly difficult for artists
not to be socially concerned. Many in the avant-garde got
involved by becoming socialists or Communists and by sup-
porting the labor movement, even forming their own unionlike
organizations. But for many artists, political activity was not
enough. Now, more and more artists worked in a style called
Social Realism, a representational format that focused on such
pervasive problems as poverty, labor oppression, suffering
migrant workers, alienation resulting from increased urban-
ization and industrialization, and racism, especially as seen in
the Ku Klux Klan lynchings.

EDWARD HOPPER One of the most powerful representa-
tional painters of the period was Edward Hopper (1882–1967),
who was based in New York. His pictures are saturated with
the alienation associated with life in the big city, and more gen-
erally with modern America. A classic Hopper is *Early Sunday*

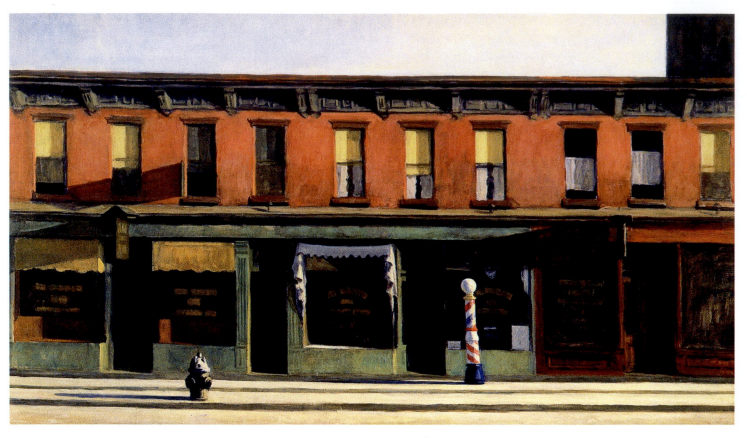

28.58. Edward Hopper. *Early Sunday Morning*. 1930. Oil on canvas, 35 × 60″ (88.9 × 152.4 cm). Whitney Museum of American Art. Purchase with funds from Gertrude Vanderbilt Whitney. (31.426)

Morning (fig. **28.58**) of 1930. The image is frightening in its uncanny quiet and emptiness, qualities reinforced by the severe frozen geometry of the composition. The second-floor windows suggest a different story for each apartment, but none is forthcoming as their inhabitants remain secreted behind curtains and shades. A strange relationship exists among the fire hydrant, the barber shop pole, and the void of the square awning-framed window between them. The harsh morning light has a theatrical intensity. Hopper's only love outside of art was film and theater, and his paintings have a cinematic and staged quality that intimates that something is about to happen. His pictures are shrouded in mystery, and because their settings are distinctly American, the dreary psychology he portrays becomes distinctly American as well.

WALKER EVANS The largest art patron during the Great Depression was the United States government, which put tens of thousands of unemployed artists to work through the Works Project Administration and Federal Art Project, important components of Franklin Delano Roosevelt's New Deal. What was so remarkable about these programs was their lack of racial, ethnic, or gender discrimination, which resulted in financial support for women and minorities. One especially powerful project was designed to document the suffering and poverty of both rural and urban Americans. The Farm Security Administration (FSA) hired about 20 photographers to record the desperate conditions of the poor. These images were then distributed to the media.

One of the first photographers hired in 1935 was Walker Evans (1903–1975), who was fired two years later because he was stubbornly difficult and did not make images that dramatically portrayed how wretched the conditions were in America. Instead, his subtle photographs focus on the nation's psychology,

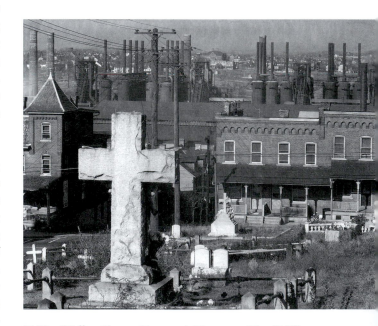

28.59. Walker Evans. *Graveyard, Houses, and Steel Mill, Bethlehem, Pennsylvania*. 1935. Film negative 8 × 10″. © Walker Evans Archive, The Metropolitan Museum of Art. 1944. (1944.258.753)

showing its gloom and alienation, much as Hopper's paintings did. This can be readily seen in the Bethlehem, Pennsylvania, image reproduced here (fig. **28.59**). We see a town without people, where the cemetery, workers' row houses, and treeless industrial landscape of smokestacks and telephone poles convey the meaningless, rote, empty life cycle of the American worker. In addition to creating a tragic mood, Evans's genius lies in the brilliant formal play of his detailed compositions that subtly pit light against dark and vertical against horizontal.

DOROTHEA LANGE One of the most famous images from the FSA project is Dorothea Lange's *Migrant Mother, California* (fig. **28.60**). Using the sharp-focus photography that had become commonplace by the 1930s, Lange created a powerful image that in its details captures the sitter's destitution, and in its complex composition of hands, arms, and turned heads, the family's emotional distress. Because of this photograph and an accompanying news story, the government rushed food to California, and eventually opened relief camps for migrant workers. The immediate impact of this poignant photograph testifies to the overpowering credibility that the medium of photography projects.

Europe: The Rise of Fascism

If America had to contend with economic deprivation in the 1930s, the situation was even worse in Europe, where the dark cloud of fascism added to the gloom of the worldwide financial collapse. In rapid succession, Italy, Germany, and Spain became fascist dictatorships, depriving citizens of their civil liberties and threatening the peace and security of surrounding nations. The Enlightenment logic that had ushered in some 200 years of progress seemed to be crumbling, replaced by a world that had lost its senses, as a large portion of the European population gave up their freedom and followed Mussolini, Hitler, and Franco down an authoritarian and murderous path that ended in World War II.

MAX BECKMANN AND GERMAN EXPRESSIONISM
German Expressionism continued throughout the 1920s and 1930s, taking on forms quite different from Die Brücke and Der Blaue Reiter but nonetheless retaining a sense of violence, suffering, and the grotesque that can be traced back to the Renaissance. Although we looked at George Grosz within the context of Berlin Dada, he generally is viewed as an Expressionist, which considering the clear political nature and narrative character of a work like *Germany, A Winter's Tale* (see fig. 28.7) is perhaps a more accurate label. Another Expressionist active since the 1910s was Max Beckmann (1884–1950), whose art tended to be more universal than Grosz's, focusing on the folly and despair of existence. Beckmann's pessimistic view of human nature stems from his experience in World War I, which caused him to become an Expressionist in order to "reproach God for his errors." In the early 1930s, he began working in his final style, seen in *Departure* (fig. 28.61), which is one of nine enormous triptyches (inspired by the triptyches of Hieronymus Bosch) that the

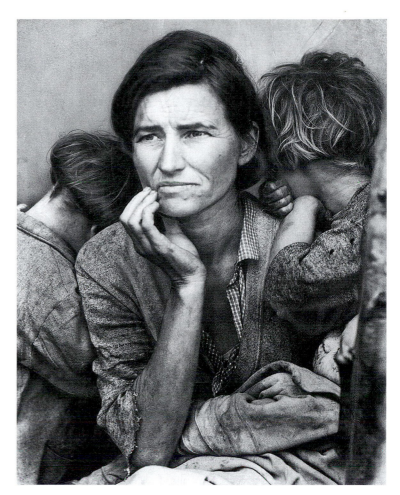

28.60. Dorothea Lange. *Migrant Mother, California*. 1936. Gelatin silver print, Library of Congress, Washington, D.C.

artist made in the last 20 years of his life. The complex symbolism in the flanking panels represents life itself, seen as an endless misery filled with all kinds of physical and spiritual pain. The bright-colored center panel represents "the King and Queen hav(ing) freed themselves of the torture of life. . . ." Beckmann assigned specific meaning to each action and figure: The woman trying to make her way in the dark with the aid of a lamp is carrying the corpse of her memories, evil deeds, and failure, from which no one can ever be free so long as life beats its drum. But Beckmann believed that viewers did not need a key to his iconography; any interpretation would inevitably be similar to his, at least in spirit, if not in the details.

The triptych's rich allegory and symbolism reflects Beckmann's early study of the Old Masters and his deep appreciation for the grim and disturbing imagery of Grünewald and Bosch. But a narrative of mythic proportions, which only starts appearing in Beckmann's art in the 1930s, seems to reflect the artist's familiarity with Parisian Surrealism. The Frankfurt-based Beckmann was a regular visitor to Paris, and it appears he returned with more than just a semblance of Picasso's palette, for he seems to have also brought home the Surrealist emphasis on myth. His hell-on-earth nightmare of bizarre and sadistic events relies on disjointed puzzling motifs that parallel the device he saw in the dream imagery of the Surrealists.

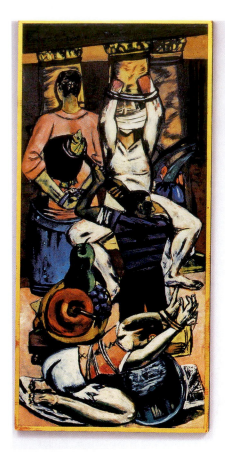
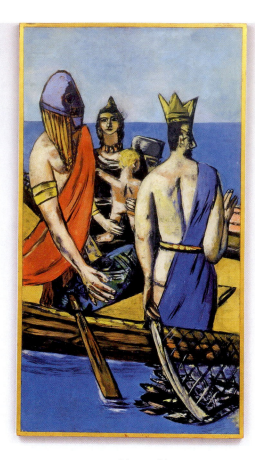
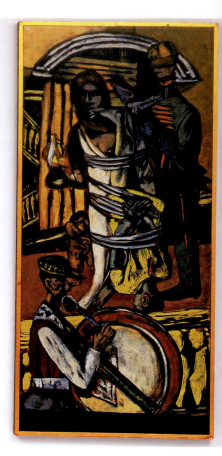

28.61. Max Beckmann. *Departure*. 1932–1933. Oil on canvas, 21'2¼ × 3'9⅜ (6.45 × 3.45 m). The Museum of Modern Art, New York. Given Anonymously by Exchange. © Artists Rights Society (ARS), New York/VG Bild-Kunst, Bonn

Shortly after Beckmann began *Departure*, life itself became surreal in Germany, for Hitler became chancellor in 1933. Now the Nazis turned from bullying and threats to overt violence toward their perceived enemies and inferiors, anyone they viewed as at odds with the "Aryan" ideals of the Third Reich. German avant-garde art was deemed depraved and therefore ridiculed. The artists were forbidden from buying art supplies. Eventually their work was confiscated from museums and either destroyed or sold in Switzerland to raise money. In 1937, the Nazis removed some 650 pieces of German modern art from museums and presented it in an exhibition entitled *Degenerate Art*, which opened in Munich and then toured Germany for three years. Beckmann was represented in this humiliating exhibition, an event that contributed to Ernst Ludwig Kirschner's suicide. But by 1937, Beckmann was in the United States, a path taken by numerous artists, including Moholy-Nagy, who established a new Bauhaus in Chicago, today part of the Illinois Institute of Technology.

JOHN HEARTFIELD John Heartfield, the Berlin Dadist who along with Grosz, Hausmann, and Höch, played a seminal role in the development of photomontage, in the early 1920s, now took aim at the Nazis, creating some of his best work. *As in the Middle Ages, So in the Third Reich* (fig. **28.62**) is

a wonderful example of his montage technique, which consisted of collaging disparate images together and then photographing them. In this poster he juxtaposes a Nazi victim crucified on a swastika with a Gothic image of the figure of humanity punished for its sins on the wheel of divine judgment. Heartfield was not interested in the original meaning of the Gothic motif; he used it to imply that the Nazis had ruthlessly transported the nation back to the dark barbaric past of the Middle Ages.

PABLO PICASSO In 1936 civil war broke out in Spain when conservatives loyal to the king and under the leadership of Franco (the Nationalists) tried to overthrow the popularly elected leftist, republican government (the Republicans or Loyalists). In some ways, it was a rehearsal for World War II. Hitler and Mussolini provided military and political support for the Nationalists, which included monarchists, fascists, and Catholics. The Loyalists consisted of Communists, socialists, and Catalan and Basque separatists, as well as the International Brigade, made up of volunteers from all over the world. On April 26, 1937, Hitler's Nazi pilots used saturation bombing to attack the undefended Basque town of Guernica, killing thousands of civilians. Picasso, like most of the free world, was outraged, and responded by painting *Guernica* (fig. **28.63**), an

enormous black, white, and gray mural that he exhibited as a protest at the Spanish Republican Pavilion of the 1937 Paris International Exposition. He pulled every artistic device out of his Cubist and Surrealist arsenal to create a nightmarish scene of pain, suffering, grief, and death. We see no airplanes and no bombs, and the electric light bulb is the only sign of the modernity that made the bombing possible.

The symbolism of the scene resists exact interpretation, despite several traditional elements: The mother and her dead child are descendents of the Pietà, the woman with the lamp who vaguely recalls the Statue of Liberty suggests enlightenment, and the dead fighter clutching a broken sword is a familiar emblem of heroic resistance. We also sense the contrast between the menacing human-faced bull, which we know Picasso intended to represent the forces of brutality and darkness, and the dying horse, which stands for the people.

Picasso insisted, however, that the mural was not a political statement about fascism, and it is interesting that many of the figures were used quite differently in Picasso's earlier work. The horse and bull are motifs from the bullfight, which Picasso had been using since the early 1930s as a metaphor for sexual conflict. The huge vulva-shaped tear on the side of the horse is certainly not a coincidence. Nor is the same sexual orifice on the inside of the sword-holding arm broken off of a Classical statue of a solider. Nor is it coincidence that the flames on the back of the supplicating woman on the right remind us of the saw-tooth groin of the sexually aggressive dancer in *Three Dancers* (see fig. 28.11), or that the quarter moon silhouetted against a rooster's head just beyond her flailing breast reminds us of the same dancer's moon-shaped head. And is it coincidence that this

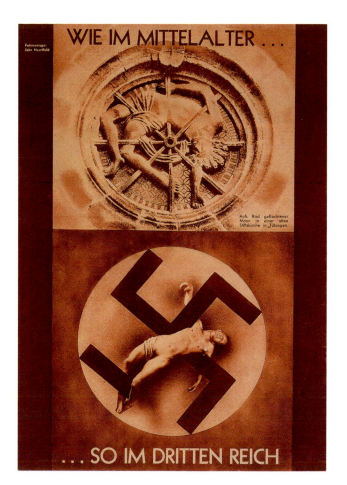

28.62. John Heartfield. *As in the Middle Ages, So in the Third Reich*. 1934. Poster, photomontage. Akademie der Künste, John Heartfield Archiv, Berlin. © Artists Rights Society (ARS), New York/VG Bild-Kunst, Bonn

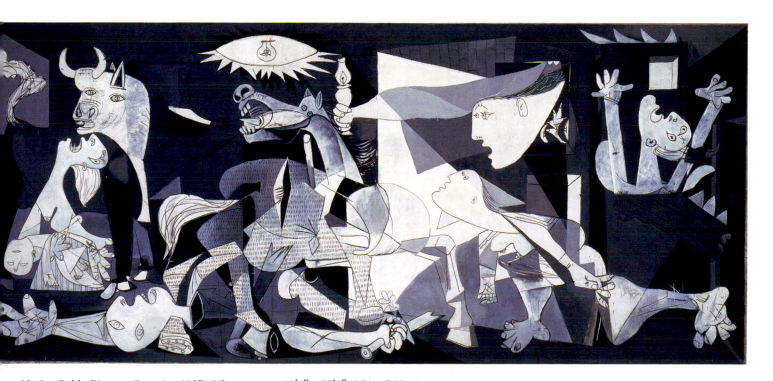

28.63. Pablo Picasso. *Guernica*. 1937. Oil on canvas, 11′6″ × 25′8″ (3.51 × 7.82 m). Museo Nacional Centro de Arte Reina Sofia, Madrid. On Permanent Loan from the Museo del Prado, Madrid. © Estate of Pablo Picasso/Artists Rights Society (ARS), New York

figure, who resembles a Mary Magdalene at the cross, also brings to mind Goya's supplicating rebel in *The Third of May, 1808* (see fig. 24.3). If it were not for the title, there is not much to indicate this is not another of Picasso's images about the tormenting psychology of sexual conflict that we saw as far back as *Les Demoiselles d'Avignon* (see fig. 27.5) of 1907. As with the *Three Musicians* (see fig. 28.10), the scene is even set in a box-shaped room, again suggesting the room of the mind.

But the title cannot be ignored—nor the smashed statue of a soldier, the suffering women and children, the political use of the painting at the International Exposition, and the fact that it was made in response to the destruction of Guernica. When Picasso denied that this was an antifascist picture, he may very well have meant in part that this monumental mural was more than just mundane propaganda against Franco and his ilk. Like Beckmann's *Departure*, we cannot help but feel that this horrifying image is meant to portray the psychology of a world in perpetual conflict and misery—albeit using sexual imagery to convey this message, but this is what Picasso knew best. In *Guernica*, however, Picasso, unlike Beckmann, does not provide a boat to take us away to safety.

SUMMARY

Physically and psychologically, World War I devastated Western civilization and, in Europe, it was the defining force on the art made between the two world wars. Artists now sought to undermine the nationalism and bourgeois values, particularly capitalism, that brought about the war, and many of these artists became ardent socialists and Communists, advocating a classless, nationless world dominated by the proletariat. World War I directly produced one art movement, Dada, which was dedicated to undermining bourgeois values and Enlightenment rationalism. In Russia, Germany, Holland, and France, many artists turned to geometric abstraction to create utopian societies. Some artists relied on the abstraction of a machine aesthetic in order to visualize this new classless society. Other artists, however, used an organic abstract art to uncover universal forces that lay beneath the appearance of things. Still others, heavily influenced by the psychology of Sigmund Freud, sought to express higher realities embedded deep within the unconscious.

In contrast to Europe, America entered a period of unprecedented prosperity following World War I, which climaxed with the Roaring Twenties. America was now the undisputed technological and financial leader of world. Politically stable, it had no interest in creating a nationless, classless society. To the contrary, America was quite nationalistic. The nation's emblems were skyscrapers and industry. Some artists embraced the symbols of technology, but others were discouraged by the crass materialism of modernity, and instead sought the spiritual in their work, often using nature as their motif.

DADA

Dada was the one style directly produced by World War I. Originating in Zurich during the war, it was based on chance and nonsense and designed to undermine the bourgeois logic that—its creators believed—had produced the conflict destroying Europe. Dada was also meant to produce a clean slate for building a new and better society. After the war, Dada spread to Berlin, where it was highly expressionistic and political and relied heavily on photomontage. In Cologne, Dada, led by Max Ernst, was more dreamlike and psychological, and in Paris, it was witty and analytic, taking its cue from Marcel Duchamp, Francis Picabia, and Man Ray, key figures in wartime New York Dada.

SURREALISM

Dada evolved into Surrealism, a style officially declared in Paris in 1924 by the poet André Breton. Largely based on the theories of Sigmund Freud, Surrealism was dedicated to revealing the higher realities that lay deep within the unconscious, especially repressed sexual urges. Initially, Surrealists relied on the Dada technique of chance, creating a provocative abstract art. André Masson used automatic drawing to tap into the unconscious, while Max Ernst used such devices as frottage, grattage, and decalcomania. Surrealists, especially Salvator Dali and René Magritte, also worked in a representational dream-like style, often juxtaposing unrelated objects in bizarre contexts to provoke the imagination.

ORGANIC SCULPTURE

Surrealism inspired many artists to search for universal truths lying beneath the surface of things. Looking to the natural world, Jean Arp and Alexander Calder in Paris and Henry Moore and Barbara Hepworth in England, began working with organic forms that resembled plants, animals, and microscopic organisms and elicited timeless universal forces that coursed through all things.

CREATING UTOPIAS

The war challenged artists to create a classless, nationless world. In Russia, the first communist nation, artists, led by Vladimir Tatlin, developed an abstract, geometric, machine aesthetic. In sculpture, this style was called Constructivism; conceptually it was based on Pablo Picasso's sculptural constructions. In design, it was called Productivism, and applied to books, posters, and clothing, for example. In Germany, the cause of Productivism was embraced by a new art school, the Bauhaus. Headed by Walter Gropius, the most famous product of the school was the building itself. Designed by Gropius, the Bauhaus was the climax of High Modernist architecture, an abstract, mechanomorphic style based on utopian ideals. In Paris, utopian High Modernist architecture was purveyed by Le Corbusier, and in Amsterdam, it was championed by a movement called de Stijl. De Stijl, however, was also deeply spiritual, for it was heavily influenced by Theosophy. In painting, de Stijl was represented by Piet Mondrian.

ART IN AMERICA: MODERNITY, SPIRITUALITY, AND REGIONALISM

America was the world's technological and financial leader. Cities, particularly New York, and industry now became the subjects favored by artists, as seen in the paintings of Joseph Stella and Charles Demuth and the photographs of Paul Strand and Margaret Bourke-White. Unlike the European avant-garde that was bent on creating a nationless world, American artists were preoccupied with national identity. But many artists, including Georgia O'Keeffe and Alfred Stieglitz, sought relief from the cold, impersonal technology of the Machine Age and crass consumerism, and instead created a spiritual art. Other artists, like Grant Wood, favored a return to pre-twentieth-century values, and painted representational images of the rural Midwest. The interwar period also saw the rise of African American art, which focused on racial identity, providing an alternative to Modernism.

MEXICAN ART: SEEKING A NATIONAL IDENTITY

The Mexican Revolution brought about a wave of nationalism that rejected European precedents and emphasized indigenous traditions, techniques, and subjects. Mexican art was dominated by mural painters, led by Diego Rivera, who viewed the mural as an art of the people. But nationalism figured into easel painting and photography as well, as seen in the highly personal images of Frida Kahlo and the mysterious photographs of Manuel Álvarez Bravo.

THE EVE OF WORLD WAR II

The Great Depression that began in 1929 and the rise of fascism in Italy, Germany, and Spain in the 1930s cast a dark shadow over the Western world. Many artists reflected this psychological change, as seen in the mythic triptychs of German Expressionist Max Beckmann, the pointed political satires of John Heartfeld, and Pablo Picasso's enormous canvas, Guernica, which captures the atrocities of the Spanish Civil War. The grim psychology of modern America was portrayed in the disturbing urban scenes of Edward Hopper. But the devastating toll of the Depression was perhaps best captured by photographers, especially Walker Evans and Dorothea Lange, who were hired by Franklin Delano Roosevelt's New Deal administration to record the poverty and misery sweeping across the nation.

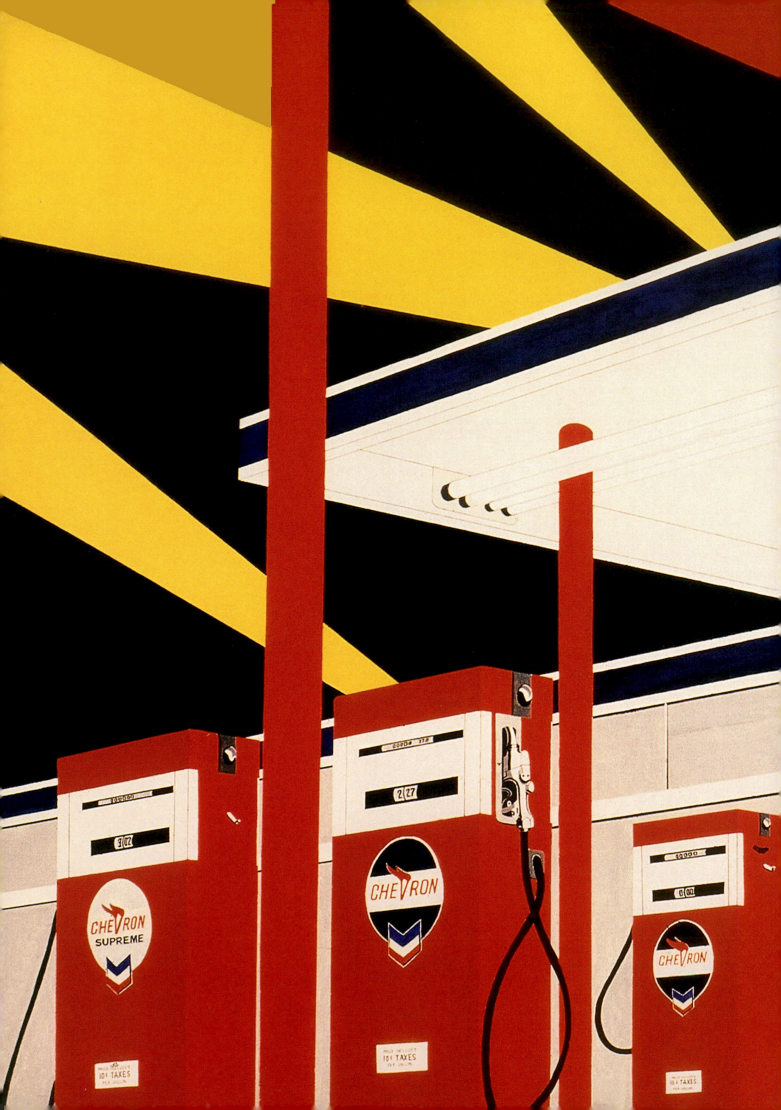

Postwar to Postmodern, 1945–1980

SCHOLARS TRADITIONALLY VIEW WORLD WAR II (1939–1945) AS A TURNING point for the art world, the time when its focus shifted from Paris to New York. In fact, the 1950s, not the 1940s, were the watershed for the second half of the century. Now Duchamp's preoccupation with how art functions became a driving force as the decade progressed. Likewise, many artists became

obsessed with the concept, rooted in the early Cubism of Picasso and Braque, that art and image making were a form of language, and they dedicated their work to revealing the structure of this visual language and the complex ways it could be used to present ideas and opinions, even to deceive and manipulate.

Artists also realized that art need not be limited to the traditional mediums, such as oil on canvas or cast bronze or chiseled marble. It did not have to hang on a wall or sit on a pedestal. Artists could use anything to make art, and by the late 1950s and 1960s, they did. They made art with televisions, film, junk, earth, fluorescent lights, steel tiles, acrylics, entire environments, postcards, and words. Performance Art, earthworks, Conceptual Art, Mail Art, happenings, and Video Art are just a handful of the movements and materials that sprang up from the mid-1950s through the 1970s.

In part, this burst of new mediums reflects the expansive spirit of the period, especially in America. World War II ended 16 years of financial depression and deprivation in America, and by the 1950s, the United States had become a nation of consumers. Returning soldiers, eager to resume their lives, married and had children in record numbers, creating the baby-boom generation. They moved from cities to new cookie-cutter tract houses in the

suburbs. And, as never before, Americans shopped—for cars, televisions, labor-saving household appliances, boats, and movie cameras. Americans were fascinated by everything technological, symbolized by the Cold War space race.

The new postwar American lifestyle, however, was not equally available to all. Magazines, newspapers, and television depicted a distinct hierarchy within American democracy, with white males heading up a patriarchal society that viewed women and people of color as second-class citizens. Beatniks, Zen Buddhists, underground improvisational jazz musicians, bikers, and urban gangs of juvenile delinquents established alternative lifestyles in the late 1940s and 1950s.

But it was the civil rights movement that first seriously challenged the status quo in the second half of the 1950s, gaining tremendous momentum in the following decade. Spurred also by the Vietnam Conflict (1964–1973), which generated persistent anti-war protests, the mid 1960s began a period of social upheaval that produced the feminist movement, Gay Pride, Black Power, Gray Power, and environmental groups such as Greenpeace. It was an age of liberation aimed at shattering the status quo and questioning the validity of any claim to superiority or fixed truth. And in the forefront was art. But before this artistic revolution could occur, the center of the art world had to move from Paris to New York. This "coup," often referred to as the "Triumph of New York Painting," coincided with the rise of Abstract Expressionism in the late 1940s.

Detail of figure 29.18, Ed Ruscha, *Standard Station, Amarillo, Texas*

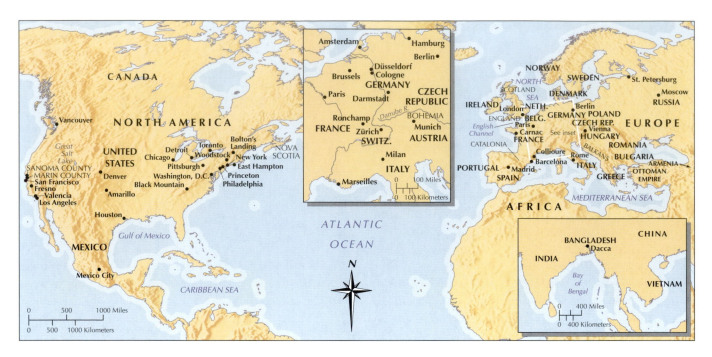

Map 29.1. Europe and North America (with Asia insert)

EXISTENTIALISM IN NEW YORK: ABSTRACT EXPRESSIONISM

Abstract Expressionism evolved out of Surrealism, which traced its roots to the Dada movement of the 1910s (see page 984). Like the Surrealists, the Abstract Expressionists were preoccupied with a quest to uncover universal truths. In this sense, their heritage goes back to Kandinsky and Malevich as well (see pages 957 and 967). In many respects, Abstract Expressionism is the culmination of the concerns of the artists of the first half of the twentieth century. But the Abstract Expressionists were also driven by a deep-seated belief in *Existentialism,* a philosophy that came to the fore with the devastation caused by World War II. The war shattered not only faith in science and logic, but even the very concept of progress, the belief in the possibility of creating a better world. A belief in absolute truths had been abandoned.

Existentialism maintained that there were no absolute truths—no ultimate knowledge, explanations, or answers—and that life was a continuous series of subjective experiences from which each individual learned and then correspondingly responded in a personal way. Essential to this learning process was facing the direst aspects of human existence—fear of death, the absurdity of life, and alienation from individuals, society, and nature—and taking responsibility for acts of free will without any certain knowledge of what is right or wrong, good or bad. The Abstract Expressionists, like so many intellectuals after the war, embraced this subjective view of the world. Their art was a personal confrontation with the moment, reflecting upon their physical, psychological, and social being.

The Bridge from Surrealism to Abstract Expressionism: Arshile Gorky

Surrealism dominated New York art in the early 1940s. In late 1936, the seven-year-old Museum of Modern Art mounted the blockbuster exhibition *Fantastic Art, Dada, and Surrealism*, an eye-opener for many New York artists. Many artists not converted by the exhibition were swayed by the dramatic influx of European artists who fled the Continent shortly before and during World War II. André Breton, Marcel Duchamp, André Masson, and Max Ernst were just a few of the many artists and intellectuals who sought the safety of Manhattan and were a powerful presence in the art world. Peggy Guggenheim, a flamboyant American mining heiress who had been living in Europe, returned to New York and opened a gallery, Art of This Century, which featured Surrealism. Surrealism was *everywhere,* and many New York artists took to it enthusiastically.

Just as Dada developed into Surrealism, New York Surrealism seamlessly evolved into Abstract Expressionism. The transformation occurred when all of the symbols and suggestions of myths and primordial conditions disappeared, and images dissolved into a complete abstraction containing no obvious references to the visible world. We can see the beginning of this process in the paintings of Arshile Gorky (1904–1948), an Armenian immigrant, whose family fled Armenia to escape the genocide of the ruling Turks of the Ottoman Empire. (See map 29.1) Gorky's mother died of starvation in his arms in a Russian refugee camp. By the 1930s, Gorky was in New York, where, over the next decade, his

Cubist style began to evolve toward complete abstraction. At his wife's farm in Connecticut, he would dash off minimal abstract line drawings inspired by nature. In the studio, he would then develop these linear patterns into paintings, similar to his 1944 surrealistically titled *The Liver Is the Cock's Comb* (fig. **29.1**).

Here we see wiry black-line drawing and washes of predominantly red, blue, yellow, and black play off of one another, giving a sense of how the composition developed as a series of psychological reactions of one mark and color triggering the next, and so on until completion. While the painting has echoes of Miró's biomorphic shapes (see fig. 28.16), Masson's automatic drawing (see fig. 28.14), and Kandinsky's color and cosmic chaos (see figs. 27.14 and 27.15), it is more abstract and flatter. We cannot safely read much into the image other than a feeling of a landscape filled with some kind of organic animation, much of which seems hostile or in conflict. In fact, many scholars have suggested that Gorky's abstractions refer to the Turkish slaughter of Armenians, but again, the picture is too abstract to substantiate such speculation. What stands out as a prominent theme in the picture is the art process itself, our sense of how the image was made.

Abstract Expressionism: Action Painting

Three years later, in 1947, Jackson Pollock made the physical act of energetically applied paint—the gesture— the undisputed focus of painting. This is not to say that his abstract **gesture paintings** are just about the art process, because that process is now a metaphor for the human condition, which previously had been represented through hieroglyphs and biomorphic forms. Almost simultaneously, a second artist emerged, Willem de Kooning, who similarly employed bold gestural abstraction to express his innermost feelings.

JACKSON POLLOCK Through the 1930s, Jackson Pollock (1912–1956) was a marginal figure in the art world who worked odd jobs, including being a custodian at what is today called the Solomon R. Guggenheim Museum. In the early 1940s, just when he started Jungian psychoanalysis, he became a hardcore Surrealist, making crude but powerful paintings filled with slapdash hieroglyphs, totems, and references to primitive myth, whipped about in a swirling sea of paint. His big break came in 1943 when Peggy Guggenheim exhibited his work at her gallery, Art of This Century, and gave him a stipend to paint.

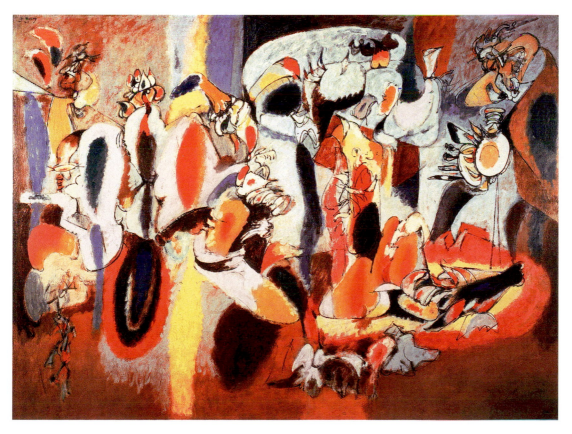

29.1. Arshile Gorky. *The Liver Is the Cock's Comb*. 1944. Oil on canvas, 6'¹⁄₄″ × 8'2″ (1.86 × 2.49 m). Albright-Knox Art Gallery, Buffalo, New York. Gift of Seymour H. Knox, 1956. © Artists Rights Society (ARS), New York

Jackson Pollock (1912–1956)

From "My Painting"

In 1947, when these remarks were recorded, Pollock rejected the usual easel format by placing his unstretched canvases directly on the floor. Using ordinary paint, he claimed he was not just throwing paint but delineating some real thing in the air above the canvas.

My painting does not come from the easel. I hardly ever stretch my canvas before painting. I prefer to tack the unstretched canvas to the hard wall or the floor. I need the resistance of a hard surface. On the floor I am more at ease. I feel nearer, more a part of the painting, since this way I can walk around it, work from the four sides and literally be in the painting. This is akin to the method of the Indian sand painters of the West.

I continue to get further away from the usual painter's tools such as easel, palette, brushes, etc. I prefer sticks, trowels, knives and dripping fluid paint or a heavy impasto with sand, broken glass and other foreign matter added.

When I am *in* my painting, I'm not aware of what I'm doing. It is only after a sort of "get acquainted" period that I see what I have been about. I have no fears about making changes, destroying the image, etc., because the painting has a life of its own. I try to let it come through. It is only when I lose contact with the painting that the result is a mess. Otherwise there is pure harmony, an easy give and take, and the painting comes out well.

The source of my painting is the unconscious. I approach painting the same way I approach drawing. That is direct—with no preliminary studies. The drawings I do are relative to my painting but not for it.

SOURCE: *POSSIBILITIES*, I WINTER 1947/48, P. 79. REPRINTED IN *JACKSON POLLOCK* BY FRANCIS V. O'CONOR. (NY: MUSEUM OF MODERN ART, 1967)

In his final show with Guggenheim, in 1947, he unveiled his first gesture or **action paintings**, the latter term coined in the 1950s by art critic Harold Rosenberg (1906-1978) and represented here by *Autumn Rhythm: Number 30* (fig. **29.2**) of 1950, an 8 × 17-foot wall of house paint that was applied by dripping, hurling, and splattering when the unstretched canvas was on the floor. Pollock had worked on it from all four sides, and he claimed that its source was his unconscious. (See *Primary Source*, above) Despite the apparent looseness of his style, Pollock exerted great control of his medium by changing the viscosity of the paint, the size of the brush or stick he used to apply the paint, and the speed, size, and direction of his own movements, and he rejected many paintings when the paint did not fall as anticipated. The energy of the painting is overwhelming, and from its

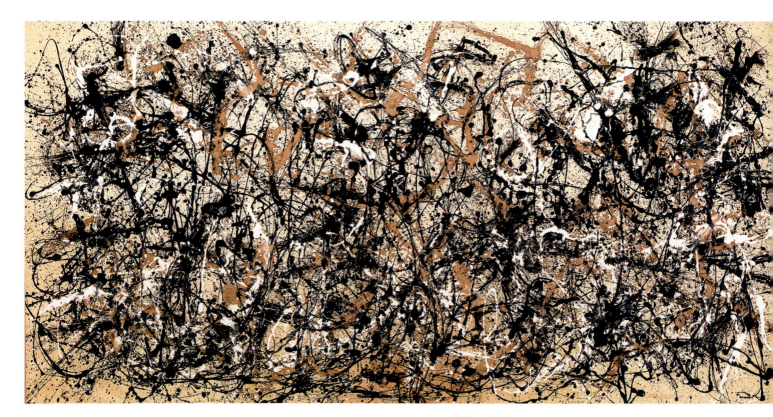

29.2. Jackson Pollock. *Autumn Rhythm: Number 30*. 1950. Enamel on canvas, 8'8" × 17'3" (2.64 × 5.26 m). The Metropolitan Museum of Art, New York, George A. Hearn Fund, 1957 (57.92). © Pollock-Krasner Foundation/Artists Rights Society (ARS), New York

position on a wall the work looms above us like a frozen wave about to crash. Our eye jumps from one stress to another—from a white blob, to a black splash, to a Masson-like automatic line (see fig. 28.14), and so on. There is no focus upon which the eye can rest. Because of these even stresses throughout the image, Pollock's compositions are often described as **allover paintings**.

Pollock constructed his picture as he went along, as did Gorky, with each new move playing off of the previous one, and emotional intuition dictating the next gesture. The resulting image is not just a record of the physical self, but also of the psychological being. Because the artist must face the challenge of the bare canvas and the risk-taking responsibility of making each mark, painting becomes a metaphor for the challenges of the human condition and the risks inherent in taking responsibility for one's actions, particularly in an Existentialist world. World War II dashed the blind belief in the superiority of science, progress, and utopian societies. The one thing that could be trusted and believed in was the self, and *that* became the sole subject of Abstract Expressionist painting.

WILLEM DE KOONING Pollock's style was too personal to spawn significant followers. The gesture painter who launched an entire generation of painters was Willem de Kooning (1904–1997), a Dutch immigrant, who quietly struggled at his art for decades in New York's Greenwich Village. Encouraged by his friend and mentor Arshile Gorky, de Kooning made Picasso-inspired Cubist-Surrealist paintings in the 1940s, mostly of women. He finally obtained a one-person show in 1948, at the Egan Gallery, when he was 44. The radical works he presented appeared to be total abstractions of dramatically painted curving lines and shapes that entirely covered the canvas with the same evenness as in Pollock's allover paintings.

Despite the spontaneity implied by the bravura paint handling, the pictures were laboriously crafted, often using methods similar to those of the Surrealists. For example, de Kooning fired his imagination by pinning line drawings on his canvas, not only at the beginning but throughout the process. Charcoal lines drawn on dried paint to both provoke and experiment with composition sometimes remained in the final picture. He jump-started other paintings by inscribing large letters across the canvas. Like Gorky and Pollock, he constructed the paintings through a continuous process of gestural reactions based on intuition and emotion, with the resulting marks reflecting his presence, feeling, and uncontrollable urges.

De Kooning shocked the art world with his second exhibition, held at the Sidney Janis Gallery in 1953. He did the unthinkable for an Abstract Expressionist: He made representational paintings, depicting women, as seen in *Woman I* (fig. 29.3), a work he struggled with from 1950 to 1952. It now became clear that the curvilinear patterning of the earlier abstractions was as sexual as everyone had suspected it was, or as the critic Tom Hess put it, the works were "covert celebrations of orgiastic sexuality." De Kooning reportedly painted and completely repainted *Woman I* hundreds of times on the same canvas, and he made numerous other paintings of women

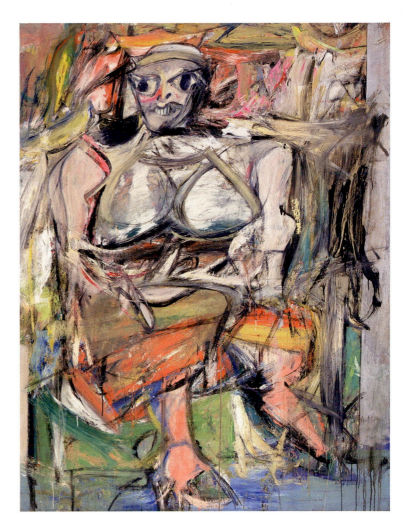

29.3. Willem de Kooning. *Woman I.* 1950–1952. Oil on canvas, 75⅞ × 58″ (1.93 × 1.47 m). The Museum of Modern Art, New York. Purchase. © The Willem de Kooning Foundation

in the summer of 1952 when he was located in East Hampton on Long Island, New York. The other paintings in the Women Series show a compendium of female types, not just the hostile-looking creature of the final painting. The process of making the picture was almost as important as the final product, as though it were a ritualistic catharsis of sorts. The final figure in *Woman I* is by far the most violent and threatening of the series, with the others that followed having a neutral appearance and embodying a broad range of attributes.

Woman I was meant to be as unfixed in meaning, or as open to interpretation, as the other women in the series. De Kooning was surprised that viewers did not see the humor in his threatening, wide-eyed, snarling figure, which was based as much on contemporary advertisements of models smoking Camel cigarettes as on primitive fertility goddesses, such as the Paleolithic *Woman of Willendorf* (see fig. 1.16), both of which the artist cited as sources. In the Women series, as in all of his paintings, de Kooning played out his own ambivalent emotions, which, because they constantly changed, allowed him to keep repainting his figure.

Abstract Expressionism: Color-Field Painting

Abstract Expressionism had a flip side. If one side was gestural painting, then the other was **color-field painting**. Instead of bombastic brushstrokes and the overt drama of paint, these painters used large meditative planes of color to express the innermost primal qualities that linked them to universal forces. The objective of the color-field painters, like that of their gestural counterparts, was to project the sublime human condition as they themselves felt it. The principal color-field painters all started out by making myth-inspired abstract Surrealist paintings in the 1940s and were close friends until 1952.

MARK ROTHKO Mark Rothko (1903–1970) ranks among the best known color-field painters. His paintings from this period drew heavily from Greek tragedy, such as Aeschylus' Agamemnon Trilogy, and from Christ's Passion cycle and death—scenes with a harrowing psychology where the lone individual faces ultimate truths about existence, death, and spirituality. But all suggestion of figuration disappeared in 1947. In 1949, Rothko arrived at his mature style, from which he did not deviate for the remainder of his life.

Beginning in 1949, Rothko's paintings consisted of flat planes of color stacked directly on top of one another, as in the 10-foot-high 1953 work *No. 61 (Rust and Blue)* (fig. **29.4**). There is no longer any storytelling, nor any hieroglyphics or symbols, not even in the title. The artist has painted what he himself has confronted, the inevitable void of our common future and our sense of mystical oneness with unseen cosmic forces, a theme reminiscent of Caspar David Friedrich's in *Abbey in an Oak Forest* (see fig. 24.11). Rothko's subject, he explained, was "tragedy, ecstasy, doom, and so on." His ethereal planes are so thin, color glimmers through from behind and below, creating a shimmering spiritual light. Their edges are ragged, and like clouds dissipating in the sky, they seem precariously fragile. Although the painting is not about process, we feel Rothko's hand building up the planes with individual marks, giving the work a poignant organic quality. Space is paradoxically claustrophobic and infinite. On the one hand, the planes literally crowd the picture to the edges and hover at the very front of the picture plane, while on the other hand, the pervasive blue ground seems to continue forever, uncontained by the edge of the canvas and suggesting infinity. Enormous shifts in scale give a sense of the sublime. Note, for instance, the tiny, thin wisp of soft white on the bottom of the middle plane, which seems so insignificant in comparison to the enormous planes and the vast size of the canvas.

Regardless of the palette, whether bright yellows and oranges or the more moody blues and browns in *No. 61*, the colors in a Rothko painting have a smoldering resonance that makes the image seem to glow from within and evoke a spiritual aura. Rothko wanted viewers to stand close to his enormous iconic images, which would tower over them, and where they would be immersed in this mystical void of the unknown future, as if standing on the precipice of infinity and death. After making a series of predominantly dark paintings, Rothko committed suicide in 1970.

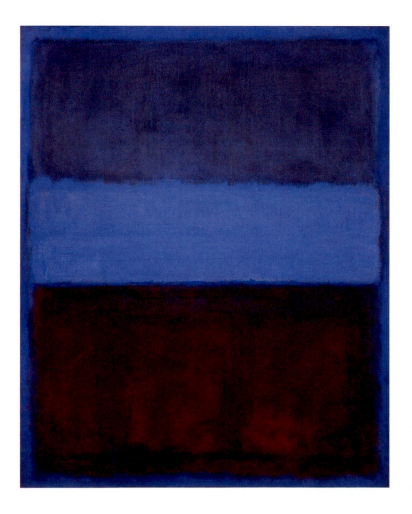

29.4. Mark Rothko. *No. 61 (Rust and Blue)* (also known as *Brown, Blue, Brown on Blue*). 1953. Oil on canvas, 115¾ × 91¼″ (2.94 × 2.32 m). The Museum of Contemporary Art, Los Angeles. The Panza Collection. © 1998 Kate Rothko Prizel and Christopher Rothko

BARNETT NEWMAN Almost simultaneously with Rothko, Barnett Newman (1905–1970), another major figure in the color-field school, began working in enormous flat planes of color. In his 1950–1951, *Vir Heroicus Sublimis* (fig. **29.5**), Latin for "Man, Heroic and Sublime," an intense red covers the 18-foot-wide canvas and is periodically divided by five different colored vertical lines, which the artist called *zips*. The monochrome expanse of red has a sense of infinity as it extends off the four sides of the canvas. The fragile, vibrating zips are surrogate figures, reduced to a bare-bones abstraction. While they animate the surface, forcing our eye to jump from one to the next, they also seem consumed by the cosmic field they divide, qualities one can sense when standing in front of the picture but not in reproductions. Also not apparent in reproduction is Newman's brushwork, which is rich and organic and deeply layered, revealing multiple levels of paint and different shades of red. Like Rothko, Newman places viewers in a sublime space and makes them feel both the vitality and loneliness of existence.

New York Sculpture: David Smith and Louise Nevelson

Like the Abstract Expressionist painters, the avant-garde sculptors of the postwar period were originally Surrealists, and most were similarly steeped in Existential philosophy. Some, like David Smith, developed their compositions as they worked on their sculptures, which were largely abstract.

Others, like Louise Nevelson, retained the hieroglyphic signs of Surrealism but now began working on an enormous scale, in part spurred by the scale of Abstract Expressionist painting.

Along with Alexander Calder, David Smith (1906–1965) was perhaps the most important American sculptor at midcentury. He began as a painter, but upon seeing illustrations of welded steel sculpture by Picasso and González (see pages 995–996), he adopted the blowtorch as his tool and metal as his medium, which he used through his career. He was friendly with the Abstract Expressionist painters, and even after moving to a farm in Bolton's Landing in upstate New York in 1940, he periodically came to the city for long periods and socialized with them in Greenwich Village.

Smith was steeped in the Existential philosophy of his circle, and, like his colleagues, he dedicated his work to expressing his physical and psychological being. His career follows a path similar to Rothko's, moving from Surrealist sculptures that were basically drawings of organic forms in space, suggestive of Miró, to totally abstract iconic forms. Beginning in the mid-1940s, Smith constructed his sculptures from large reserves of metal that he always had on hand, working not so much from preliminary sketches and preconceived notions of a finished product but, like de Kooning and Pollock, by a continuous chain of reactions to each gesture, which in his case would be a welded material. Despite his working method, which allowed him to work and think in the round, he generally conceived his sculptures like paintings, to be seen almost two-dimensionally from a single viewpoint.

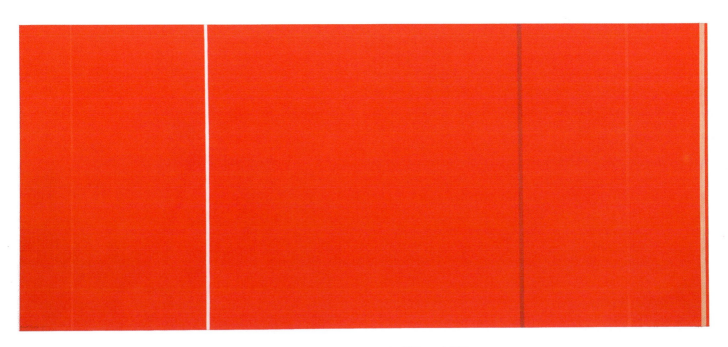

29.5. Barnett Newman. *Vir Heroicus Sublimis*. 1950–1951. Oil on canvas, 7'11³⁄₈" × 17'9¹⁄₄" (2.42 × 5.41 m). The Museum of Modern Art, New York. Gift of Mr. and Mrs. Ben Heller. (240.1969). © Barnett Newman Foundation/Artists Rights Society (ARS), New York

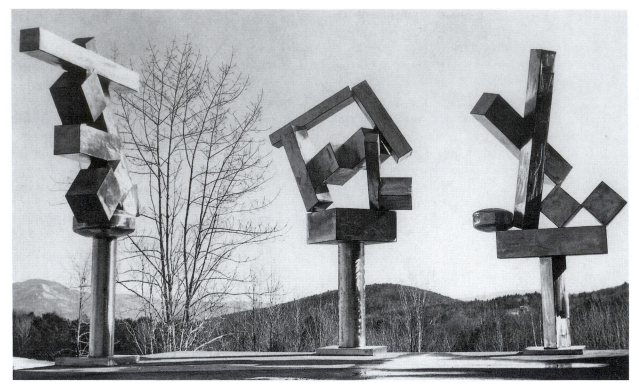

29.6. David Smith. *Cubi* series as installed at Bolton's Landing, New York. Stainless steel. Left: *Cubi XVIII*. 1964. Height 9'8" (2.95 m). Museum of Fine Arts, Boston. Center: *Cubi XVII*. 1963. Height 9' (2.74 m). Dallas Museum of Art. Right: *Cubi XIX*. 1964. Height 9'5" (2.87 m). The Tate Gallery, London. Art © Estate of David Smith/Licensed by VAGA, New York

An example of Smith's late, totally iconic style is the *Cubi* series (fig. **29.6**), begun in 1961 and consisting of 18 works. Because of its severe geometry, the *Cubi* series is unusual for Smith. He did not have equipment to cut stainless steel, and consequently was forced to order it from the manufacturer in precut rectangular shapes, which he assembled into boxes of different sizes that he welded together based on intuition and personal emotion. Despite their relentless geometry, these enormous sculptures are hardly mechanical and unemotional. They are both anthropomorphic and totemic, evoking giant figures and ritualistic structures. They have the sublime presence of a prehistoric monument and embrace a powerful spirituality. It is as though the elemental forms, placed on a tabletop altar, are the very building blocks of the universe itself, their sense of movement and solidity reflecting the essence of life, their precarious arrangement the inevitable impermanence of all things. Smith finished by burnishing the steel, giving it a textured finish. And because we can feel his touch here, the work takes on a surprising organic quality.

Smith's work became dramatically larger in the 1950s, influenced, in part, by the scale of Abstract Expressionist painting.

Another Surrealist sculptor followed suit: Louise Nevelson (1900–1988), who emerged in the 1940s. By the 1950s, she was working with fragments of black-painted wood assembled in mysterious black boxes, and by the end of the decade, she began making enormous walls of these boxes.

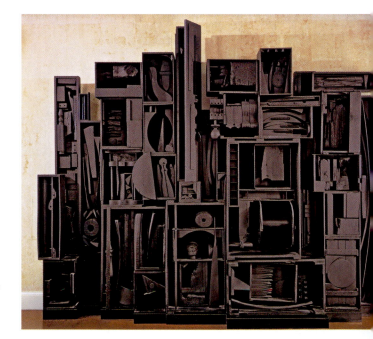

29.7. Louise Nevelson. *Sky Cathedral—Moon Garden Plus One.* 1957–1960. Painted wood, black, 9'1" × 10'2" × 1'7" (2.78 × 3.1 × 0.5 m). Collection of Milly and Arne Glimcher, New York. Courtesy PaceWilderstein, New York. © Estate of Louise Nevelson/Artists Rights Society (ARS), New York

One of these is *Sky Cathedral—Moon Garden Plus One* (fig. 29.7), produced from 1957 to 1960. In it, fragments of furniture and architecture become provocative Surrealist objects in a poetic dreamlike setting. We sense we are looking at the flotsam and jetsam of civilization, the fragments of people's lives, of people long gone. But as the title suggests, Nevelson's forms also evoke landscape and the cosmos, the round shapes suggesting the planets and moons, the splintered wood the mountains, and the accumulation of boards the rock formations. As reproduced here, Nevelson wanted her black works (others are all gold or white) illuminated by a blue light, which would suggest twilight, the moment of transformation, when things begin to look different and to change into something else, swallowed up by unseen mystical forces.

EXISTENTIALISM IN EUROPE: FIGURAL EXPRESSIONISM

Abstract Expressionism was identified with the United States, which began exporting the work to Europe in exhibitions organized by the federal government in the 1950s. These shows, ostensibly for the sake of good international public relations, strutted the country's artistic superiority and virility, and complemented its military, financial, and technological dominance. While Europeans developed a counterpart to Abstract Expressionism, perhaps the most interesting Existential painting was figurative. Two especially powerful artists were Jean Dubuffet and Francis Bacon. Both were loners, with no group or movement affiliations, and artistically kept to themselves, independently developing their own responses to the existential loneliness of human existence.

Jean Dubuffet

As a young man, the Frenchman Jean Dubuffet (1901–1985) was an unlikely candidate for artistic fame. Until the early 1940s his commitment to, and even his belief in, art was intermittent, and he often worked in a family wine business. Many of his attitudes paralleled Dada: He was antiart and antibourgeois. What interested him most was finding a way to see beyond the blinders of civilization, with its limited concepts of beauty and reality. As had Kandinsky, Malevich, and Mondrian, Dubuffet sought to reveal higher truths, namely the interconnectedness of all things in the universe.

Critical to Dubuffet's development was his discovery in the early 1940s of the art of the untrained and insane, which he called **Art brut** and which he collected. He felt artists untouched by conventional training were uninhibited by the superego and expressed primal urges and desires that were directly connected to universal forces. Graffiti, children's art—anything equally uninhibited and spontaneously produced—fell into this same category. Dubuffet adopted these direct untutored styles in his own art because he believed they represented a universal language that anyone could understand and appreciate.

The second major ingredient in Dubuffet's worldview is the concept that all things are equally consecrated because everything is composed of the same matter and energy. We can see this

ART IN TIME

1949—George Orwell publishes *1984*

1950—Jackson Pollock's *Autumn Rhythm: Number 30*

1957–1960—Louise Nevelson's *Sky Cathedral—Moon Garden Plus One*

virtually illustrated in *Le Métafisyx* (fig. 29.8), painted in 1950 in his *Art brut* style. Here he literally etches his woman into a deep bed of paint, which is crude and rough, suggesting earth, ancient plaster walls, and stone. Not only is this comic-repulsive, soil-encrusted woman identified with mineral matter, she is also timeless, for she resembles an archeological find excavated from a remote prehistoric site. The frenetic graffiti-like style is so abstract, we can read the figure in endless ways and even see the scratchy wiry lines as representing an unseen energy that courses through all things. There is even the suggestion of the body dissolving back into elemental matter. *Le Métafisyx* is part of a series called *Corps de Dames*, which in its crude drawing and grating texture was meant to shock, challenging the art world's conventional notions of beauty and art.

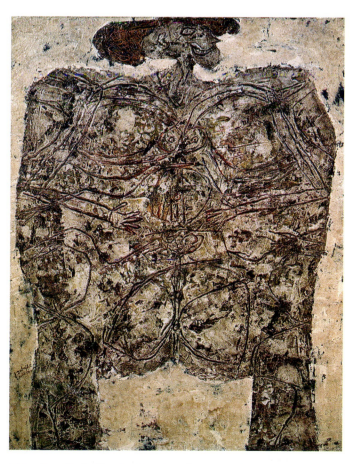

29.8. Jean Dubuffet. *Le Métafisyx*, from the *Corps de Dames* series. 1950. Oil on canvas, $45^{3}/_{4} \times 35^{1}/_{4}$″ (116.2 × 89.5 cm). Musée Art Moderne, Centre Georges Pompidou, Paris. © Artists Rights Society (ARS), New York/ADAGP, Paris

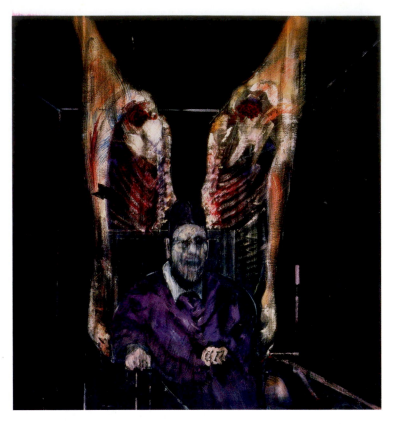

29.9. Francis Bacon. *Head Surrounded by Sides of Beef.* 1954. Oil on canvas, 50¼ × 48″ (129 × 122 cm). The Art Institute of Chicago. Harriott A. Fox Fund. © The Estate of Francis Bacon/Artists Rights Society (ARS), New York/DACS, London

Francis Bacon

Across the English Channel, Francis Bacon (1909–1992), a second loner, was stirring up the art world by expressing his own Existential angst. One look at his *Head Surrounded by Sides of Beef* (fig. 29.9) of 1954 and we realize we are in the presence of one of the more frightening images of the twentieth century. Bacon emerged as a force on the London art scene right after World War II, and it is tempting to view his horrific pictures as a statement about the senseless savagery he had just witnessed. But Bacon's themes were already in place well before the war, and presumably they stem largely from his own horrible circumstances, which included abuse as a child and an adult life dominated by the classic vices of alcohol, gambling, and promiscuous sex.

We cannot be sure that these experiences account for Bacon's work, for unlike Dubuffet and the Abstract Expressionists, for example, Bacon did not pontificate about art, issue manifestos, or declare that painting had to fill social voids. Like his Existential contemporaries he painted from the gut, claiming that when he started a picture he had no idea where he would end up. His first painting based on Velázquez's *Pope Innocent X* (there are 45 versions), which is the source for the central figure in *Head Surrounded by Sides of Beef,* supposedly began as a garden scene. Our painting not only refers to the Velázquez portrait, but also to a contemporary photograph of Pope Pius XII (whose bespectacled head we see), a Rembrandt painting of a flayed ox, and a still photograph of a nurse screaming in the 1925 classic silent film *Battleship Potemkin* by

Sergei Eisenstein (1898–1948). In most of Bacon's paintings based on Pope Innocent X, the focal point is the primal scream of the sitter, the wide dark pit of the opened mouth. In our figure, however, this motif is not nearly as prominent, as it is balanced by the crucified slab of beef that frames the sitter. Add the black void, the claustrophobic compression of the glass cage, and the gritty quality of sections of the paint surface, and we have a house of horror, obviously the chamber of the artist's grim psyche. A viewer cannot get back from the scene, which seems thrown in one's face by the bold brushwork that prominently sits on the surface of the canvas, pulling the image along with it and toward us. Bacon said of his paintings, "You can't be more horrific than life itself."

REJECTING ABSTRACT EXPRESSIONISM AMERICAN ART OF THE 1950S AND 1960S

By the mid-1950s other styles were already beginning to overshadow Abstract Expressionism. The 1950s planted the seeds of a cultural revolution, producing a thirst for freedom of expression that required the invention of radically new art forms. Combines, environments, happenings, Minimal Art, and Conceptual Art took art into uncharted territory, breaking down the barriers that had narrowly restricted art to certain standard mediums.

Re-Presenting Life and Dissecting Painting

No one person or event triggered the dramatic change that occurred in art in the 1950s, but artist Robert Rauschenberg and composer John Cage certainly played major roles. Rauschenberg probably spoke for many when he explained why he rejected Abstract Expressionism: "It was all about suffering and self-expression and the State of Things. I just wasn't interested in that, and I certainly did not have any interest in trying to improve the world through painting." Jasper Johns, Rauschenberg's close friend at the time, similarly rejected Abstract Expressionism. While both artists made paintings that had the gestural mark-making of the Abstract Expressionists, these works were an intellectual, impersonal analysis of art rather than an explosion of feelings and primal urges.

ROBERT RAUSCHENBERG AND JOHN CAGE Robert Rauschenberg (b. 1925) was a Texan from a working-class family who ended up in New York studying painting by 1947. A critical component of his development was attending the avant-garde Black Mountain College in North Carolina in the fall of 1948, and again in 1951 and 1952. The painting department at the small liberal arts school was headed by Josef Albers (1888–1976), who, with his wife Anni (1889–1994), had taught at the Bauhaus, in Germany. Rauschenberg did not care for Albers as a teacher, but the institution encouraged experimentation, which turned Rauschenberg away from pure painting, toward an analysis of the very concept of art. At Black Mountain in 1951, he made a series of White Paintings, which he

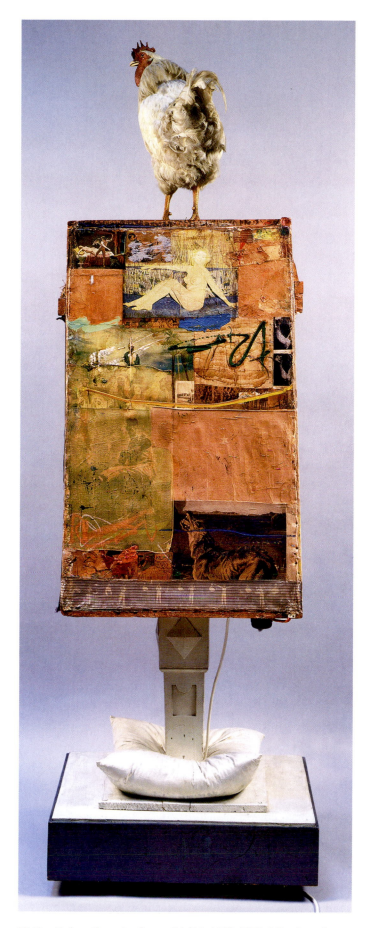

29.10. Robert Rauschenberg. *Odalisk*. 1955–1958. Mixed media, 6'9" × 2'1" × 2'1" (205.7 × 63.5 × 63.5 cm). Museum Ludwig, Cologne. Art © Robert Rauschenberg /Licensed by VAGA, New York

ART IN TIME

1945–1949—Jean-Paul Sartre publishes his trilogy *Les Chemins de la liberté (The Roads to Freedom)*

1950s—Theater of the absurd emerges

1954—Francis Bacon's *Head Surrounded by Sides of Beef*

1961—Berlin Wall erected

exhibited at the Stable Gallery in New York in 1953. These were large canvases painted a solid white, with no evidence of brushwork. Viewers wondered what they were supposed to see. Themselves for one thing. Their shadows were cast on the canvases, which also caught reflected colored light and accumulated dust and dirt. These canvases captured real life, which was presented without comment or meaning. Viewers could read anything into them that they wanted. Like Duchamp, Rauschenberg was making conceptual art, determined by chance, and aimed at capturing the world without attaching any firm meaning in that process. In their objective neutrality, these extraordinary paintings were the antithesis of the intensely personal Abstract Expressionism, which ruled the day.

One of the people who thoroughly understood the White Paintings was John Cage (1912–1992), an avant-garde composer who was garnering a reputation for his works for altered piano (a piano with objects placed under the strings to change their sound). In response to the White Paintings, Cage wrote *4'33"*, a piano piece first performed in Woodstock, New York, in 1952. The work was "played" by a pianist who sat down and simply opened the keyboard and did nothing else for 4 minutes and 33 seconds. During this time the audience listened to the sounds of the real world: the shuffling, coughing, and whispering of the audience and the falling rain and chirping birds coming in through an open window. The last sound was the keyboard case being shut, signaling the end of the piece.

These and many other conceptual works from this period were designed to remove the artist from the work of art as well as ask such questions as: What is art? How does it function? Rauschenberg picked up where Duchamp had left off, although his art was never meant to shock or destroy. His attitude and approach are always positive. He is a presenter, not a nihilist. He is a collector of life, which he gathers up and energetically presents for us to think about and interpret for ourselves. Furthermore, he was not interested in painting life, but *re-presenting* it. "I don't want a picture to look like something it isn't. I want it to look like something it is. And I think a picture is more like the real world when it's made out of the real world."

In 1955 Rauschenberg incorporated the real world into his art when he began making **combines**, innovative works that combined painting, sculpture, collage, and found objects, as in his *Odalisk* (fig. **29.10**) of 1955–1958. This four-sided "lamp"—there is an electric light inside—is crowded with collaged

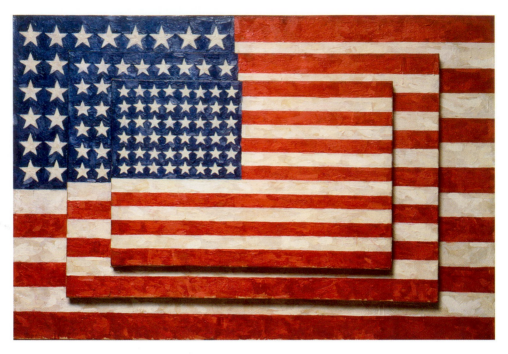

29.11. Jasper Johns. *Three Flags.* 1958. Encaustic on canvas, $30^7/_8 \times 45^1/_2 \times 5''$ (78.4 × 115.6 × 12.7 cm). Whitney Museum of American Art, New York. Art © Jasper Johns/Licensed by VAGA, New York

material culled from contemporary magazines and newspapers as well as detritus from the street and from thrift shops. Even the title is part of this busy collage, for it has to be considered when we try to construct a narrative for the work. But is there a narrative in this poetic collage of disparate material? Obviously, *Odalisk* has a subject, for it is filled with sexual innuendo: the phallic pole jammed into the pillow on the bottom, the cock mounted above the nude pinup while the dog howls at her from below, the comic strip of a woman in bed being surprised by a man (on a side of the sculpture not pictured here). Even the title, which is a pun on *odalisque* (see fig. 24.16) and *obelisk*, can be interpreted sexually. But the artist places no value on material, suggests no interpretation, makes no grand statement. The work just is. It is our materials, our time, our life. Rauschenberg re-presents it with extraordinary formal powers and with a poetry of paint and collage. In its energy and fragmentation, the work powerfully captures the spirit of the constantly changing world and the fractured way we experience it.

JASPER JOHNS In 1954 Rauschenberg met Jasper Johns (b. 1930) and moved into a loft in the same run-down building in lower Manhattan. While Johns incorporated objects into his paintings before Rauschenberg made his combines, he is primarily a painter, and his works are literally about painting. This can be seen in *Three Flags,* a work of 1958 (fig. **29.11**). Because of the Americana theme, many writers talk about this painting as Pop Art, a style that in New York emerges in the early 1960s and derives its imagery from popular culture. American pride surged in the postwar period as the United States emerged as the most powerful and wealthiest nation in the world. More than ever before, images of the flag were everywhere and an integral part of vernacular culture. *Three Flags*, however, is not

about popular culture, for it is part of series in which the artist repeatedly painted flat objects, such as numbers, targets, and maps, with the intention of eliminating the need to paint illusionistic depth. Here he has painted a flat object (a flag) on a flat surface (the canvas), so we are not tempted to read, for example, a white star as sitting on top of a blue field because we know it does not. Furthermore, Johns does not place the flag in any context that allows us to read specific meaning or emotion into it. The flag is a sign to which Johns has attached no specific meaning or emotion. In other words, Johns has created a non-illusionistic, impersonal image. What we are left to look at is *how* the picture was made. Johns's very beautiful and methodical application of wax-based encaustic paint reminds us that a painting consists of paint on canvas. And, of course, painting can be about color, here red, white, and blue. Lest we forget a painting is a three-dimensional object, Johns has stacked three flag paintings one atop another. We see their sides and hence their depth. Lastly, Johns reminds us that painting can produce an image. However, he does not give us an illusionistic image; we would never mistake Johns's flag for an illusion of a real flag. By doing so, Johns tells us an image is a sign, that painting is an abstract language, just like verbal language. Just as a word is a sign, standing for something else and not the real thing, so too is painting; it signifies something else, just as numbers and maps are signs for something else.

While the intellectual gymnastics in Johns's paintings are complex and rigorous, the works themselves are objective, devoid of any emotion. Like Rauschenberg, Johns paved a way for artists to break away from the subjectivity and vocabulary of Abstract Expressionism. His powerful assertion of the properties of painting and its inherent flatness would inspire numerous artists in the following decade.

Environments and Performance Art

Rauschenberg's combines played a major role in setting off a chain reaction that caused an explosion of art making that entirely redefined art. Art was no longer just painting, sculpture, and work on paper; now it took on the form of limitless mediums and moved out of galleries and museums into the real world, sometimes interacting with daily life, other times taking place in locations so removed, few people ever got to see it. Art was often no longer an object; rather it could be temporary and ephemeral, something that could not be bought and sold.

ALLAN KAPROW In 1956, months after Pollock's death in a car crash, Allan Kaprow (b. 1927), a painter teaching at Rutgers University, published an article in *Art News* entitled "The Legacy of Jackson Pollock." He described how Pollock's action paintings, often because of their scale and the fact that some contained real objects, had started to become environmental. The next step, he claimed, was to make environmental art: "Pollock as I see him, left us at the point where we must become preoccupied with and even dazzled by the space and objects of our everyday life, either our bodies, clothes, rooms, or, if need be, the vastness of Forty-second Street." Kaprow knew Rauschenberg's work (he was awed by the White Paintings), and this pronouncement about incorporating everyday life into art sounds like a description of the Texan's combines.

In 1958 Kaprow began to make what he called **environments**, constructed installations that a viewer can enter. His most famous environment, *Yard* (fig. **29.12**), came in 1961. Filled mostly with used tires, the work had the allover look and energy of a Pollock painting, but visitors to the town house garden where it was installed were expected to walk through it, experiencing it physically, including the smells. Like Rauschenberg in his combines, Kaprow attached no firm meaning to his works, although the discarded synthetic materials suggest a modern industrial urban environment, as well as a sense of waste, even death.

To learn how to add sound to his environments, Kaprow sat in on John Cage's music composition course at the New School for Social Research, a class filled with artists—not musicians—almost all of whom went on to become famous. Music was made by chance and generally without traditional instruments. A typical exercise would be to compose a piece with radios and use a method governed by chance, such as the I-Ching (an ancient Chinese system of divination based on random number-generation procedures), to determine when and by whom each radio would be turned on and off and the length of the piece.

The class inspired Kaprow to add the live human figure to his environments, which initially were made of a variety of collaged non-art materials that ran from floor to ceiling, vaguely resembling a Rauschenberg combine. He unveiled the result to the New York art world in 1959 at the Reuben Gallery as *18 Happenings in 6 Parts*. Kaprow divided his collaged environment into three rooms, in which seated spectators watched, listened, and smelled as performers carried out such tasks as painting (Rauschenberg and Johns participated),

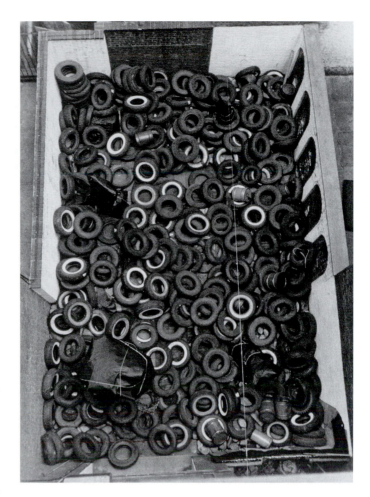

29.12. Allan Kaprow. *Yard*. 1961. Environment of used tires, tar paper, and barrels, as installed at the Martha Jackson Gallery, New York. Life size. Destroyed. Photo © Robert McElroy/ Licensed by VAGA, New York

playing records, squeezing orange juice, and speaking fragments of sentences, all determined by chance. In a sense the work was like a Rauschenberg combine that took place in time and space and with human activity. Because of the title of Kaprow's innovative work, a **happening** became the term for this new visual art form in which many of the major artists of the day, including Rauschenberg, started working. While many artists accepted this term, others used different labels, all of which can be grouped under the umbrella term **Performance Art**, which is distinguished from theater in that it takes place in an art context.

ROBERT WHITMAN *18 Happenings* unleashed a flurry of Happenings, or Performance Art, which lasted through the mid 1960s. Soon-to-be-famous artists like Claes Oldenburg, Jim Dine, and Red Grooms along with Rauschenberg created works. The artist who has dedicated his life to the genre, which he prefers to call Theater Pieces, is Robert Whitman (b. 1935), a student of Kaprow's at Rutgers and also another auditor in Cage's music class. In 1960, he presented *American Moon* at the Reuben Gallery, which had a magical poetic beauty of materials (largely paper, cardboard, and plastic), human activity, and pacing. All of these elements would characterize his work, defying interpretation while evoking a broad range of responses.

(To view the performance and a documentary film on this and other theater pieces, visit www.prenhall.com/janson). If Kaprow's performance pieces were prosaic, mundane, and very down to earth, Whitman's were abstract and dreamlike, garnering him a reputation with historians as the master of the medium and one of its most innovative practitioners. An especially radical feature of *American Moon* was Whitman's use of film projection, which he used in many of his performances, as seen in *Prune Flat* (fig. **29.13**) of 1965. Whitman's use of film, made before the advent of video, anticipated the video art and installations of later decades.

GEORGE BRECHT In John Cage's class with Kaprow in 1958, there was another auditor, George Brecht (b. 1926), who for a class assignment wrote a composition for automobiles entitled *Motor Vehicle Sunset Event*. For this work, participants drew cards with instructions and at sundown in a parking lot they honked horns, rolled down windows, slammed trunks shut, and opened hoods. Brecht began typing up this and other so-called **Events**, as he called these compositions, on white cards and mailing them to acquaintances, thus inventing Mail Art.

By 1960, Brecht's events had become quite Minimal. *Three Aqueous Events*, printed on a roughly 2 × 3-inch card, consisted of the title and under it three bulleted words: *water, ice,* and *steam*. People receiving the card in the mail could respond any way they wanted—they could even frame the card. Allan Kaprow, for

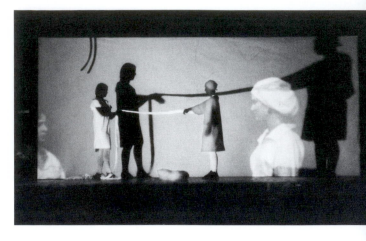

29.13. Robert Whitman, *Prune Flat*. 1965. As performed in 1976. Photo © Babette Mangolte. Courtesy of Dia Art Foundation

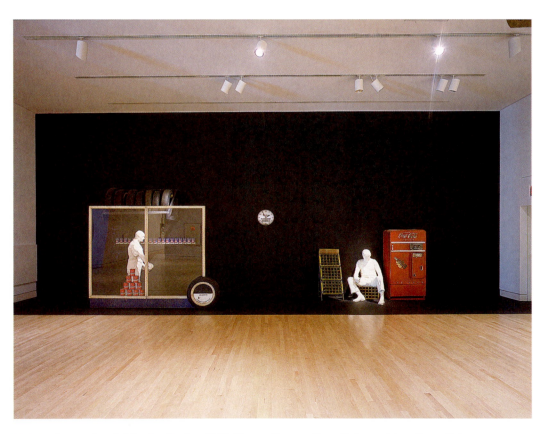

29.14. George Segal. *The Gas Station*. 1963. Plaster figures, Coca-Cola machine, Coca-Cola bottles, wooden Coca-Cola crates, metal stand, rubber tires, tire rack, oil cans, electric clock, concrete blocks, windows of wood and plate glass, 8′6″ × 24′ × 4′ (2.59 × 7.32 × 1.22 m). National Gallery of Canada, Ottawa. Art © George and Helen Segal Foundation/Licensed by VAGA, New York

example, thought of making iced tea. What is the work of art in *Three Aqueous Events*? The idea? The card itself? The execution of the piece? And who is actually the artist in this work that allows the recipient to be the creator? Brecht was posing the classic Duchampian questions while simultaneously integrating art into daily life and taking it off the aesthetic and intellectual pedestal reserved for high art. By 1962, Brecht's example help spawn a New York–based international art movement called Fluxus (Latin for "a flowing"), similarly dedicated to making a conceptual art that violated the conventional distinctions between art and life, artist and nonartist, museum and street, and which included performance art as a major component.

GEORGE SEGAL Living down the road from Kaprow in rural New Jersey was George Segal (1924–2000), who responded to his friend's environments and happenings by creating representational, not abstract, environments out of real objects and populated by plaster figures, as in *The Gas Station* (fig. **29.14**) of 1963. Now the performers are frozen, reduced to ghost-white mannequins. To create them, Segal used real people, making castings of them by using medical plaster bandages. Like Rauschenberg and Kaprow, he was breaking down the barrier between art and life. But his art is far from neutral; it is emotional and makes a statement. Segal's work condemns the alienation he perceived in contemporary life. This alienation can be seen in his figures, which are left white, as though drained of life. Generally they are lethargic, exhausted, and alone, and seem trapped by a harsh geometry of the horizontals and verticals of their setting.

The works even contain symbols used in more traditional art. *Gas Station*, for example, is dominated by a Bulova clock, a *memento mori* ("reminder of death") motif, which floats in a 10-foot expanse of darkness. Its shape mysteriously resonates with the tire on the floor. The vending machine, tires, cans of high-performance oil, and the gas station itself suggest modernity, technology, and fast, efficient living. Missing from this materiality, however, is something meaningful—human interaction and spirituality. Segal retains the Existential angst of his Abstract Expressionist background by questioning the meaning of modern existence. Although he often used contemporary branded objects, such as Coke bottles, to give his environments the look of reality and modernity, Segal never celebrated the products of consumer culture, nor questioned how mass-media imagery, including advertising, manipulates its audience. His sculpture is closer in spirit and style to the paintings of Edward Hopper (see fig. 28.58) than to Pop Art, with which he has been mistakenly associated.

Pop Art: Consumer Culture as Subject

Pop Art is a style that emerged in New York in the early 1960s, although it had appeared in a very different guise in England a decade earlier. The style got its name because it derives its imagery from popular or vernacular culture. Like Rauschenberg and Kaprow, Pop artists re-presented the artifacts of the world they lived in, namely the imagery of the mass media, although they did it using conventional painting rather than new mediums. Unlike Johns and Segal, both of whom occasionally used

popular imagery, Pop artists focused on the products of popular culture by taking what art historians often describe as a *low* art form, that is commercial art, and incorporating it into one that is considered *high*, meaning fine art. By doing so, however, they subversively revealed the manipulative impact of the mass media. Among the best known Pop artists are the Americans Roy Lichtenstein, Andy Warhol, and Ed Ruscha, as well as the British collagist and painter Richard Hamilton.

ROY LICHTENSTEIN Another close friend of Kaprow's, Roy Lichtenstein (1923–1997), arrived at Rutgers University to teach in 1960. When he arrived he was an Abstract Expressionist painter. Within a year, however, he was making what would be considered Pop paintings, in part influenced by Kaprow's dictum to make art that did not look like art. (See *Primary Source*, page 1053.)

The contemporary life that Lichtenstein scavenged and represented was not the urban streets, as was the case with Kaprow, Rauschenberg, and Segal, but the crude black-and-white advertisements in telephone books and newspapers and the prosaic drawings in comic books. These he cropped and adjusted into visually riveting images, like *Drowning Girl* (fig. **29.15**). Traditionally, Lichtenstein is appreciated for seeing the beauty of "low art" and elevating it to "high art," in effect celebrating popular culture, and in particular American culture. When first shown, his paintings were so radical they were thought hideous and were not even considered art by many.

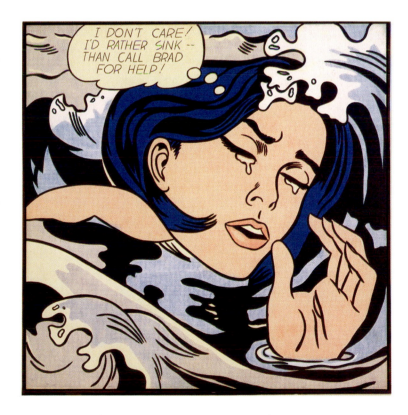

29.15. Roy Lichtenstein. *Drowning Girl*. 1963. Oil on canvas, 5′7⅝″ × 5′6¾″ (1.72 × 1.69 m). The Museum of Modern Art, New York. Philip Johnson Fund and Gift of Mr. and Mrs. Bagley Wright. © Roy Lichtenstein, New York

deeply embedded in the media. But the paintings themselves appear objective and unemotional, giving little suggestion of a polemical agenda or a sense of the artist's presence, whether his hand (brushwork) or emotions.

After all, they looked like images from comic books. Furthermore, art, and particularly Modernist art, was supposed to move art forward, investigating new aspects of abstraction. High art was not supposed to look like low art, and it was not supposed to be representational.

Lichtenstein's work does more than just blur the distinctions between fine art and mass culture. Like Johns, whose *Flag* paintings had a profound impact on him, Lichtenstein was interested in the language of art, particularly with issues of perception. He does not just imitate the comic strip, he also plays with that genre's technique of making an image out of *benday dots*, the small dots that when massed together create color and shading in printed material. He was intrigued by how an illusion of three-dimensional volume could be made using flat dots and flat black lines. When viewed from close up, Lichtenstein's large images dissolve into a flat abstract pattern, virtually becoming Abstract Expressionist compositions.

The images that Lichtenstein selected for his paintings from 1961 to 1964 fall into a distinct pattern: Men are portrayed as strong, virile soldiers and fighter pilots, whereas women are shown as emotionally distraught, dependent on men, and happily slaving around the house doing domestic work. With deadpan brilliance, Lichtenstein made his paintings a mirror of contemporary society, revealing the stereotyping

ANDY WARHOL Andy Warhol (1928–1987) was making art based on comic books at exactly the same time as Lichtenstein, and when the dealer Leo Castelli decided to represent Lichtenstein and not him, he turned to other kinds of popular imagery, namely product design and newspaper photographs. His most famous work is *Campbell's Soup Cans* (fig. **29.16**), and he produced 32 Campbell's Soup Can images for his first exhibition, in 1962, at the Ferus Gallery in Los Angeles, which had a burgeoning art scene. Campbell offered 32 soup varieties at the time, hence 32 paintings, which Warhol made by the **silkscreen** process. By using this process, he simply printed a photographic image onto canvas, as he did for the Ferus show, or onto paper, as he did to make prints.

Warhol installed the works as monotonously as possible, evenly spacing them and placing them on a shelf, as soup cans would be in a supermarket. Just as the soup came off a mass-production assembly line, Warhol mass-produced his paintings in his studio that he called "the Factory." Assistants made the works to his specifications, and he only touched them when signing the backs. With a Duchampian gesture, Warhol tells us that paintings are commodities, that people are buying a name product—that is, a Warhol—and that art is about idea, not necessarily about technique or craftsmanship. But he also comments on the camouflaging function of product design, on how it tells us nothing about the mass-produced product it promotes and how the packaging lures us into buying it. Warhol's message is that Campbell's soup is everywhere, having penetrated to the farthest reaches of the country, and that mass-production uniformity and consumerism dominate American society. In effect, these soup cans are a portrait of modern America. As with Lichtenstein, Warhol neither praises nor condemns.

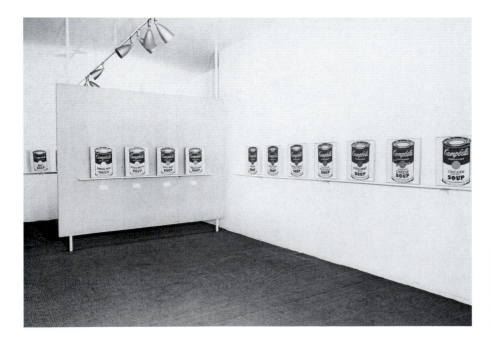

29.16. Andy Warhol. Installation view of *Campbell's Soup Cans*, installation at Ferus Gallery, 1962. Founding Collection, The Andy Warhol Museum, Pittsburgh. © Andy Warhol Foundation for the Visual Arts/Artists Rights Society (ARS), New York

Roy Lichtenstein (1923–1997)

From an interview with Joan Marter

In this 1996 interview with the art historian Joan Marter, Roy Lichtenstein talks about the enormous impact Allan Kaprow's Environments and New York Happenings had on the development of his Pop Art.

JOAN MARTER: In one of your interviews, you say that "although I feel that what I am doing almost has nothing to do with Environments, there is a kernel of thought in Happenings that is interesting to me." Can you comment?

ROY LICHTENSTEIN: Well, there's more than a kernel of thought in Happenings that is interesting to me. . . . Many of them tended to have American objects rather than School of Paris objects. I'm thinking of the tires, and the kind of advertising sort of things in [Claes] Oldenburg's and [Jim] Dine's Happenings. They were like an American street, maybe from Pollock in a certain way. The Environments are like expanded Pollocks; they are allover in the same kind of sense. If I look at Pollock now, I think they're really beautiful; I don't get all of the gutsy stuff—the cigarette butts and house paint, and everything

they're made out of. They had a big influence on Happenings. Because the Environment would envelop you the way that we thought that Pollock's paintings enveloped you—they were big and seemed to have no end. They were allover, all of that. Some of that, I think, went into Environments, which were kind of a background for Happenings. . . . But the thing that probably had the most influence on me was the American rather than the French objects

JM: Do you remember anything specifically [about Allan Kaprow's work] that interested you?

RL: The tires he did [*Yard* at the Martha Jackson Gallery, 1961; see fig. 29.12]. Also other things with strips of paper and things written on them [*Words*, at the Smolin Gallery, 1962]. I think the thing I most got from him was this kind of statement about it doesn't have to look like art, or how much of what you do is there only because it looks like art. You always thought artists should be original, whatever it was. I was doing Abstract Expressionism very late, 1961, and much of that was because it looked like art to me. . . . I was amazed at how much he [Kaprow] actually liked [my *Look Mickey* and the other first Pop paintings]. Most people hated it at first.

SOURCE: *OFF LIMITS: RUTGERS UNIVERSITY AND THE AVANT-GARDE, 1957–1963*. ED. JOAN MARTER. (NJ: RUTGERS UNIVERSITY PRESS, 1999)

Warhol was from Pittsburgh, and in the 1950s in New York he established himself as a successful illustrator of women's shoes, learning firsthand the deceiving and manipulative role of advertising and product packaging. He was also fascinated by the impact of the mass media on public opinion, and in 1961 he began silkscreening onto canvas newspaper photographs he found in a dumpster. His imagery includes car crashes, electric chairs, and pictures of celebrities, such as Elvis Presley, Elizabeth Taylor, and Marilyn Monroe. His style, as in *Gold Marilyn Monroe* (fig. 29.17), replicates the cheap, impersonal presentation of newspapers and magazines. Here, he reproduces the sloppy, gritty look and feel of 1960s color newspaper reproduction, where the colors often did not align properly with the image. The Marilyn we see is the impersonal celebrity of the media, supposedly glamorous with her lush red lipstick and bright blond hair but made pathetically tacky because of the garish color and grimy black ink. Her personality is impenetrable, reduced to a public smile. The painting was prompted, in part, by the actress's recent suicide, which implied that there was another Marilyn, one that was not part of the public persona created to glorify her for a celebrity-hungry public. Monroe's image was about product packaging, much as the jazzy

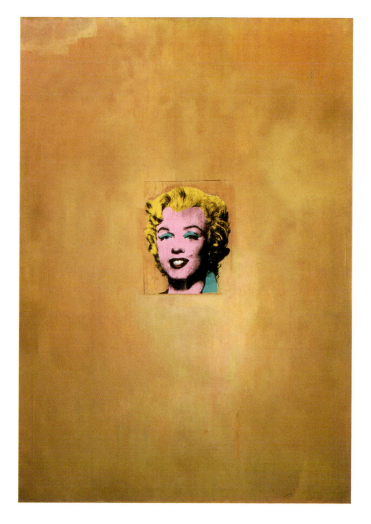

29.17. Andy Warhol. *Gold Marilyn Monroe.* 1962. Synthetic polymer paint, silkscreen, and oil on canvas, 6'11" × 4'7" (2.12 × 1.39 m). The Museum of Modern Art, New York. Gift of Philip Johnson. © Andy Warhol Foundation for the Visual Arts/Artists Rights Society, ARS, New York

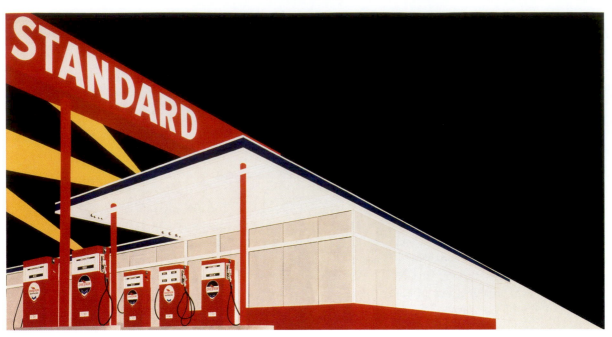

29.18. Ed Ruscha. *Standard Station, Amarillo, Texas*. 1963. Oil on canvas, 5′5″ × 10′ (1.65 × 3 m). Hood Museum of Art, Dartmouth College, Hanover, NH. Gift of James J. Meeker, Class of 1958 in memory of Lee English. P.976.281. © Edward Rusha

packaging of Campbell's soup is designed to sell a product without telling us anything about the product itself. Warhol floats Marilyn's face in a sea of gold paint, imitating Christian icons and thus deifying her. In a rare emotional note, Warhol dwarfs her head in the celestial gold, alluding to the tragedy behind this portrait that so trenchantly comments on the enormous gulf between public image and private reality.

EDWARD RUSCHA Simultaneously and independently, Los Angeles artists were also developing Pop art. The best known is Edward Ruscha (b. 1937). Ruscha had been a graphic designer, specializing in book design, and many of his paintings from the early 1960s have the hard-edge look of mechanical drawing. As can be seen in *Standard Station, Amarillo, Texas* (fig. **29.18**), Ruscha is interested in the semiotics or visual language of product packaging. Here he dramatizes the sleek, modern International Style look of a Standard Oil gas station by accentuating and simplifying its geometry and organizing the roof and sign on an energized diagonal that sweeps across the image from one corner to its opposite. Beacon lights celebrate the station, as though its mere existence were a celebrity event. But of course, much of the image is just facade. In the case of the station, this is literal, since the building disappears as it recedes. Ruscha also exposes the "facade" of art, since the representational image of the building becomes abstract; it fades into an artificial construction of flat planes and colors. Like Warhol and Lichtenstein, Ruscha's image looks impersonal and mechanical. It feels synthetic and artificial, embodying the very values that George Segal was lamenting in *The Gas Station* (fig. 29.14).

BRITISH POP While Pop Art emerged in America in the early 1960s, it had already appeared in London in the mid-1950s. Protesting the conservatism of the Institute of Contemporary

Arts, a handful of artists formed the Independent Group, dedicated to bringing contemporary life into contemporary art. The war had left Britain commercially weak and with few creature comforts. Thus the British were more than ready to appreciate the celebrity promotion and advertisements for appliances, cars,

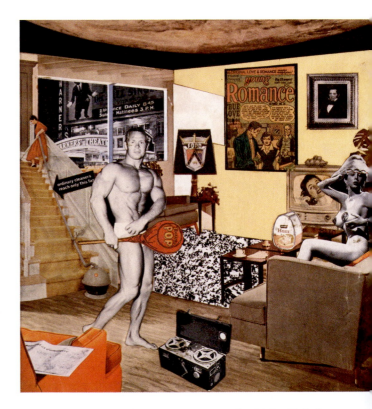

29.19. Richard Hamilton. *Just What Is It That Makes Today's Homes So Different, So Appealing?* 1956. Collage on paper, 10¼ × 9¾″ (26 × 24.8 cm). Kunsthalle Tübingen. Sammlung Zundel, Germany. © Artists Rights Society (ARS), New York/DACS, London

and homes that they found in the American magazines that flooded London. Well before their American counterparts, the British were fascinated by the technology they saw taking over American society. The Independent Group, led by artists Richard Hamilton (b. 1922) and Eduardo Paolozzi (1924–2005) and critic Lawrence Alloway (1926–1990), embraced American mass culture and celebrated it in their art.

Using the collage technique developed by the Berlin Dadaists (see page 988), Richard Hamilton cut images from comic books and body-building and pinup magazines, as seen in his *Just What Is It That Makes Today's Homes So Different, So Appealing?* (fig. **29.19**) of 1956. Sprinkled around the room depicted in this collage on paper is a tape recorder, television, and space-age vacuum cleaner. A Ford logo decorates a lampshade, while a can of ham sits on a coffee table as though it were a sculpture. The weight lifter carries a lollipop inscribed with the word *pop*, a term coined by Alloway, announcing this is a Pop image. In comparison to Pop in the United States, British Pop of the 1950s held a more celebratory view of mass culture.

FORMALIST ABSTRACTION OF THE 1950s AND 1960s

The most influential art critic in the 1940s and well into the 1960s was Clement Greenberg, who wrote art reviews for *The Nation* and *The Partisan Review*. He began by championing Pollock's formalism, but as the 1940s progressed he increasingly promoted an art that was totally abstract and dealt with just those qualities inherent to the medium, that is color, texture, shape of field, and composition. This work, which emphasized the formalist or abstract qualities of the medium, could make no

reference beyond itself. Greenberg's theories had an enormous impact on the way painters, sculptors, and critics thought about art. His criticism helped lay a foundation for the Post-Painterly painting and Minimalist Art of the 1950s and 1960s.

Formalist Painting

Formalist painting emerged in the heyday of Abstract Expressionism, the early 1950s, and in large part was a reaction to it. Just as Rauschenberg, Johns, Kaprow, and the Pop artists rejected the subjective components of Pollock and de Kooning, the formalist painters sought to make unemotional art. They replaced bold, gestural brushwork with smooth surfaces that gave no hint of the artist's hand or feelings. Instead of the push-pull Cubist space of de Kooning's style of Abstract Expressionism, they powerfully asserted the flatness of the canvas, virtually eliminating any sense of space. Led by Greenberg, they were attracted to the formalist implications of Abstract Expressionism, not its emotional content. They also embraced the style's enormous scale. Among the formalist abstraction styles of the period are Post-Painterly Abstraction, Hard-Edge Abstraction, and Minimalism.

HELEN FRANKENTHALER Greenberg championed Helen Frankenthaler (b. 1928) as one of the new formalists. Frankenthaler was inspired by Jackson Pollock, who, toward 1950, in an attempt to expand his art beyond drip paintings, began working on unprimed canvases, using just black paint and allowing it to seep into the fabric, creating a smooth surface. Frankenthaler built on the implications of this technique. In a breakthrough work of 1952, *Mountains and Sea* (fig. **29.20**), Frankenthaler developed **stain painting**. She had just returned

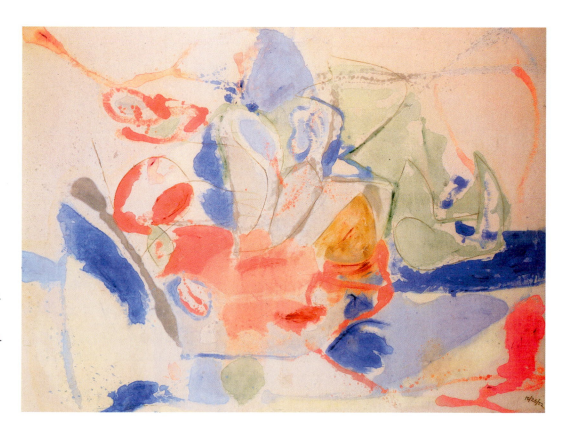

29.20. Helen Frankenthaler. *Mountains and Sea.* 1952. Oil and charcoal on canvas, 7'2¾" × 9'8¼" (2.2 × 2.95 m). Collection of the artist on extended loan to the National Gallery of Art, Washington, DC. © Helen Frankenthaler

from Nova Scotia, and using charcoal on unprimed canvas, she quickly laid in a composition suggesting landscape. Working like Pollock, she put her canvas on the floor. She then poured thin oil paint on it, tilting it to allow the paint to run, drawing and painting by changing the angled tilt of the canvas rather than using a brush. The thin oil bled into the canvas, becoming one with it and having the translucency of watercolor. Greenberg admired the picture's flatness and the fact that the paint was not tactile, a three-dimensional quality that he felt would result in the illusion of space. He declared you could not sense the artist's hand, and thus her presence, and praised the picture's non-referential "decorativeness" as opposed to its "expressionistic" qualities. While Pollock first used unprimed canvas, it was Frankenthaler's example of thin translucent oils that spawned in the 1950s and 1960s legions of stain painters, of which the best known are the Washington Color School painters. Unlike Frankenthaler, however, her followers' work was entirely abstract and contained no references.

Greenberg's personal infatuation with Frankenthaler apparently blinded him to the Abstract Expressionist side of her work. Like her many followers, she is now often labeled a Post-Painterly Abstractionist, a term that refers to the smooth nongestural nature of this kind of abstraction, but in the 1950s and 1960s she was generally considered a second-generation Abstract Expressionist. As the title implies, *Mountains and Sea* reflects her experience of the Nova Scotia landscape. The energy of the curving explosive composition seems to embody the sublime force of nature, while the soft translucent colors and white unprimed canvas evoke the brilliant glare of sunlight. Although essentially abstract, the picture is filled with references, which is generally true of her work up to the present day.

ELLSWORTH KELLY Ellsworth Kelly (b. 1923) developed a distinctly American brand of abstract painting in Paris from 1948 to 1954. During those years, he began to reduce painting to a bare-bones simplicity, which some critics called Hard-Edge Abstraction. To free his mind from earlier art, he based his abstractions on shapes he saw in the world around him, especially negative spaces, such as the opening under a bridge, a shadow, or a window. His paintings use just a handful of geometric shapes in solid primary and secondary colors that explore how forms move through space, colors interact, and "figure" relates to "ground," that is, how image relates to background. Kelly generally locks his figure and ground so tightly into a single unit they seem to coexist on the same spatial plane.

In *Red Blue Green* (fig. **29.21**), a 1963 work, Kelly plays a red rectangle and a blue curved shape off of a green ground. The left side of the painting appears fixed, whereas the right has movement. When standing in front of this enormous work, which is more than 11 feet wide, a viewer can feel at one moment the green ground consuming the blue and the next moment the blue plunging down into the green. In other words, the figure-ground relationship is reversed. But never to be forgotten is the sheer intensity of the color, especially as presented on such a large scale. Kelly's genius is his simple gesture: He stripped everything else away, including any sense of himself, to make a painting that is about color—in this case red, blue, and green—and movement.

FRANK STELLA Just as Kelly was returning from Europe, a young Frank Stella (b. 1936) began his studies at Princeton University, opting for an art education at a university rather than an art school, which became commonplace after the war.

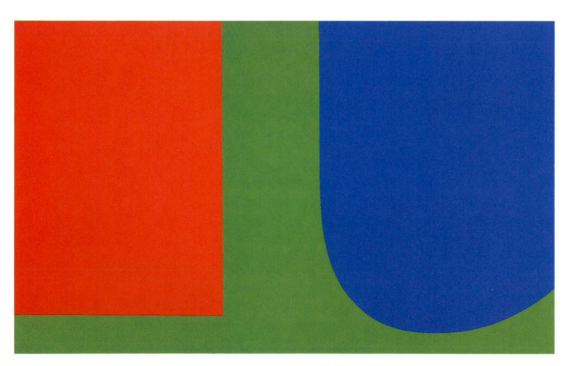

29.21. Ellsworth Kelly. *Red Blue Green*. 1963. Oil on canvas, 7′8″ × 11′4″ (2.34 × 3.45 m). Museum of Contemporary Art, San Diego, La Jolla, CA. Gift of Jack and Carolyn Farris. © Ellsworth Kelly 1963

Frank Stella (b. 1936)

Pratt Institute Lecture

In 1959 Stella gave a lecture to students at New York's Pratt Institute in which he discussed his paintings then being shown at the Museum of Modern Art's Sixteen Americans *exhibition. He specifically addressed what he saw as one of the most pressing formalist issues facing painters at the time: how to make a composition that was not about the relationship of its parts.*

There were two problems which had to be faced. One was spatial and the other methodological. In the first case, I had to do something about relational painting, i.e., the balancing of the various parts with and against each other. The obvious answer was symmetry—make it the same all over. The question still remained, though, of how to do this in depth. A symmetrical image or configuration placed on an open ground is not balanced out in the illusionistic space. The solution I arrived at—and there are probably quite a few, although I know of only one other, color density—forces illusionistic space out of the painting at a constant rate by using a regulated pattern. The remaining problem was simply to find a method of paint application which followed and complemented the design solution. This was done by using the house painter's technique and tools.

SOURCE: PRATT INSTITUTE LECTURE, 1959

Within a year of graduating he was in New York and the talk of the town because of his "black paintings," included in a 1959 Museum of Modern Art exhibition called *Sixteen Americans*. These were total abstractions consisting of black parallel bands created by allowing white pinstripe lines of canvas to show through. He soon began working in color, as in *Empress of India* (fig. **29.22**) of 1965, and on an enormous scale, here over 18 feet across. Inspired by the inherent flatness of Johns's *Flag* paintings (fig. 29.11), Stella made entirely flat works as well.

There is no figure-ground relationship in *Empress of India*, and no push-pull of Cubist and Abstract Expressionist space. In fact, there is no hierarchy to the composition, which is determined by the V-shape of each of the four canvases that have been butted together. Stella said of his work, "What you see is what you see." In other words, the painting has nothing that you do not see—no hidden meanings, symbols, or references. Despite giving his work suggestive titles such as *Empress of India*, Stella wanted his canvases viewed simply as objects with an independent life of their own, free from associations. (See *Primary Source*, above.)

Fellow artists and critics evaluated this kind of abstract art on its ability to invent new formalist devices (for example, Stella's ability to create perfectly flat, spaceless painting or the innovative shapes of his canvases). However, the power of such work lies in the sheer force of its scale and dramatic sense of movement as the V's change direction to create new lines of movement. Because Stella used a stripped-down artistic vocabulary and often determined his compositions using a geometric premise, critics often describe his paintings from this period as Minimal Art.

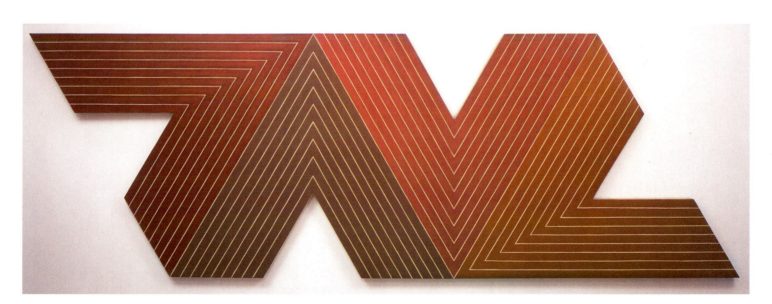

29.22. Frank Stella. *Empress of India*. 1965. Metallic powder in polymer emulsion on canvas, 6'5" × 18'8" (1.96 × 5.69 cm). The Museum of Modern Art, New York. Gift of S. I. Newhouse, Jr. © Artists Rights Society Frank Stella/(ARS), New York

Formalist Sculpture

A group of sculptors emerged in the early 1960s who generally composed their work using a mathematical or conceptual premise, paralleling in sculpture what Stella was doing in painting. The reliance upon geometry in this new work emphasized conceptual rather than emotional content and favored the means and materials of mass production. Their sculpture come to be known as *Minimal art*. Artists often avoided making the objects themselves, preferring to send specifications to an artisan, or more likely a factory, for production. Like Pop paintings, Minimal sculpture lacks the evidence of the artist's touch that traditionally served as the sign of personal emotion and expression as well as proof of the artist's technical accomplishment. There is no sign of the artist at all. Furthermore, the artists used unconventional nonart materials to make art—Plexiglas, fluorescent tubes, galvanized steel, magnesium tiles—continuing the exploration of new materials that characterized so much of the art making of the late 1950s and 1960s. Similarly, one of their concerns was to make art that did not look like art. Like Stella, they wanted their art to be perceived as independent objects, having no reference to things beyond themselves.

DONALD JUDD The characteristics of Minimalism are apparent in *Untitled*, a 1969 sculpture of copper boxes (fig. **29.23**) by Donald Judd (1928–1994). The sculptor determined the shape and spacing of the boxes by mathematical premise (each box is 9 × 40 × 31 inches, with 9 inches between boxes), not by intuition or artistic sensitivity, as David Smith, for example, operated (see fig. 29.6). Like Stella's paintings, Judd's work was constructed by serial repetition of elements so there is no hierarchy of composition and no evocation of emotion. A viewer can take in and readily understand his composition at a glance. The sculpture is a real object, a "specific object" as Judd called it to distinguish Minimalism from traditional art, and critics admired it for its precision, consistency, color, texture, and scale.

In addition to possessing the properties of a well-made "real thing," Judd's boxes occupy space like ordinary things as well. They are not presented on a base, and there is no glass case to protect them. We encounter Judd's work as we might a table or chair. By relinquishing the props that announce an object to be a work of art, Minimalism heightens our awareness of the spaces in which we view art. In other words, the space around the object becomes an integral part of the work and of the art experience.

DAN FLAVIN The Minimalist whose work was perhaps most severely limited to mathematical formula is the light sculptor Dan Flavin (1933–1996), renowned for his use of

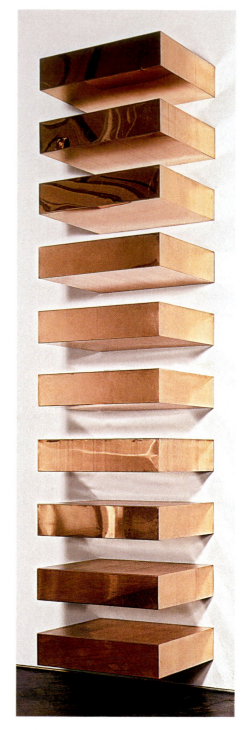

29.23. Donald Judd. *Untitled*. 1969. Copper, ten units, 9 × 40 × 31″ (22.8 × 101.6 × 78.7 cm) each, with 9″ (22.8 cm) intervals; 170 × 40 × 31″ (432 × 101.6 × 106.7) overall. Solomon R. Guggenheim Museum, New York. Panza Collection. 91.37.13. Art © Judd Foundation/Licensed by VAGA, New York

common fluorescent tubes, which he used to sculpt with colored and white light. Flavin's tubes were store-bought and came in 2-, 4-, 6-, and 8-foot lengths.

Although difficult to tell from reproductions, Flavin's deceivingly simple works are spectacularly beautiful, even when they use just white light, as in *the nominal three (to William of Ockham)* (fig. **29.24**). The magical quality of the light as it radiates through the surrounding space is mesmerizing, even

calming, often projecting a Classical serenity. For some viewers, it even embodies spirituality. The work, however, is strictly formalist and is determined by geometric premises, here a progression from one to two to three lights. No references are intended, despite the suggestion of the title, which Flavin attached upon finishing the work.

Flavin's sculpture could be extremely simple, consisting of a single tube of white or colored light, sometimes placed vertically on the floor, other times coming off a corner at a 45-degree angle. With Minimalism, art reached "Ground Zero." Reduced to bare essentials, it *seemed* to have no place left to go.

THE PLURALIST 1970S: POST-MINIMALISM

The cold objectivity of Minimalism and formalist abstraction dominated contemporary art in the mid-1960s, overshadowing styles that focused on subjectivity and the human figure. Even Pop Art seemed unemotional and machine-made. But as the 1960s progressed, so did an interest in an art based on emotion, the human being, and referential and representational subject matter. In the midst of the Vietnam Conflict and the civil rights–led social revolution that challenged the status quo, artists began to view formalist abstraction as an escapist indulgence. With Minimalism, the Modernist avant-garde completely lost touch with society, retreating into a hermetic world of its own. By the mid-1960s, artists could no longer remain removed from their emotions and the hotly contested social and political issues of the day. By the late 1960s, American artists began to put the human component back into art, and many addressed the issues tearing the nation apart. The responses were diverse, with artists using what seems like an endless array of mediums to deal with an endless array of issues. Now, many artists made art that was temporary or conceptual and could not be collected, in effect, dematerializing the art object.

While often driven by aesthetic premises, these artists nonetheless reflected the antimaterialistic stance of the 1960s social revolution. Led by women, African Americans, and Latinos, minority groups, generally ignored by the white-male-dominated art establishment, protested their exclusion from the art world. They picketed museums, denouncing the prejudices of those organizations, and made art that dealt with issues that museum curators and directors did not consider mainstream or valid aesthetic concerns—issues such as gender, ethnic and racial identity, and sexual orientation. Disenfranchised artists, like the Impressionists 100 years earlier, began opening their own galleries to provide an alternative to museums. Because the pluralism of the 1970s came on the heels of Minimalism, and in many respects is a response to its hermetic aesthetics, the art from this decade is often called Post-Minimalism.

Post-Minimal Sculpture: Geometry and Emotion

Some of the first Post-Minimal sculptors retained the geometry of Minimalism, but they were hardly creating insular, discreet objects. To the contrary, their geometric forms were loaded with powerful emotional issues.

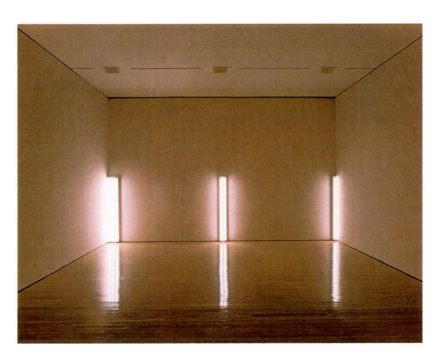

29.24. Dan Flavin. *the nominal three (to William of Ockham)*. 1963. Fluorescent light fixtures with daylight lamps, each 6′ (1.83 m). Solomon R. Guggenheim Museum, New York. Panza Collection. 91.3698. © Estate of Dan Flavin/Artists Rights Society (ARS), New York

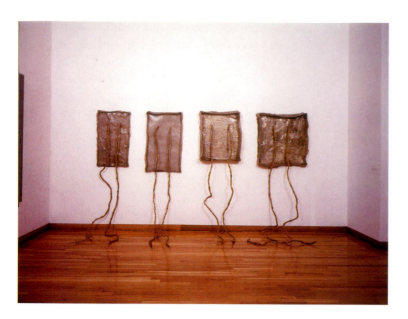

29.25. Eva Hesse. *Untitled.* 1970. Fiberglass over wire mesh, latex over cloth and wire (four units), 7'6⅞" × 12'3⅝" × 3'6½" (2.31 × 3.75 × 1.08 m), overall. Des Moines Art Center, Des Moines, IA. Purchased with Funds from the Coffin Fine Arts Trust, Nathan Emory Coffin, Collection of the Des Moines Art Center, 1988 (1988.b.a-d). © Estate of Eva Hesse

RICHARD SERRA Emerging at the same time was sculptor Richard Serra (b.1939), who befriended Hesse. He explored the properties of sculpture in a series of works that included making **process art,** in which the creative act itself was the art, such as throwing molten lead at the spot where floor and wall meet, a kind of Jackson Pollock action sculpture that resulted in a violent, energetic splattering on wall and floor. It also resulted in **site-specific art,** since it could not be removed from the site of its creation without substantially altering the work.

By the late 1960s, Serra was making objects—now extremely heavy geometric lead forms—and invoking such themes as gravity, fear, and life and death. In *Corner Prop* (fig. **29.26**), an enormous lead cube weighing thousands of pounds is precariously propped up against the wall with a lead rod, with *nothing* securing either element. The piece, like much of Serra's sculpture, communicates an unmistakable threat of violent collapse and an aura of danger that can be terrifying. In an even more frightening piece, Serra placed an enormous rectangular lead plate on the floor and another directly above, at a right angle, but attached to the ceiling. The viewer was expected to walk on the one plate, thereby going under the other. Serra's sculptures may look like Minimal Art, but they are loaded with narrative and emotion.

EVA HESSE One of the outstanding Post-Minimalists in the 1960s was Eva Hesse (1936–1970). Her accomplishment is astonishing when one considers that her career was cut short when she died of a brain tumor at age 34. Born in Hamburg, Germany, she was raised in New York after her Jewish parents fled Nazi persecution. Hesse worked with a variety of unusual materials, such as acrylic paint on paper-mâché over balloons. Her works were abstract and had a basis in geometry. Because her sculptures reveal the dripping, pooling, flowing, stretching, and drying by which they took shape, they suggest organic forms and processes, and growth and sexuality. In 1968 she began using fiberglass, which became her trademark material and was perhaps responsible for her brain cancer.

A classic work is *Untitled* (fig. **29.25**), which has as its starting point the geometric form of Minimalism. The four rectangular units of which it is composed imply boxes or framed paintings because of their curled edges. Contradicting their geometry is the uneven rippling surfaces and sides, which transform the fiberglass into an organic substance, especially recalling skin. The strange ropelike latex appendages eccentrically flopping from either side of center suggest arms or legs, although they ultimately are nothing more than abstract elements, like the rectangular units. The work is full of contradictions: It is simultaneously funny and morbid, geometric and organic, erotic and repulsive, abstract and referential. (See end of Part IV *Additional Primary Sources.*) Perhaps the most powerful quality in Hesse's sculptures is the sense of frailty, wear, decay, and aging—best expressed in *Untitled* by the wobbly "legs."

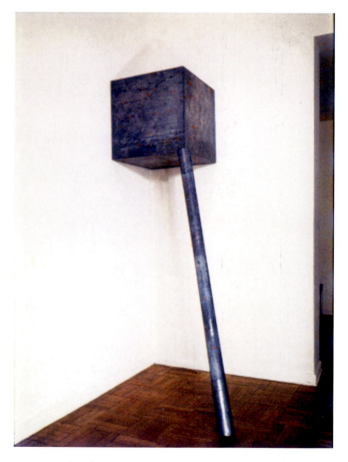

29.26. Richard Serra. *Corner Prop.* 1969. Lead antimony, box 25 × 25 × 25" (63.5 × 63.5 × 63.5 cm), pole 6'8" (2.03 m). © Richard Serra/Artists Rights Society (ARS), New York

Earthworks and Site-Specific Art

By the late 1960s, the Post-Minimal aesthetic operated on an enormous scale, not only far beyond the confines of the gallery but far away from the art world, and in many instances in uninhabited remote areas. Several artists began sculpting with earth, snow, volcanoes, lightning, and deep-sea sites, their work often temporary and existing today only in photographs and drawings. Often the work had a strong geometric component, reflecting the influence of Minimal Art and Hard-Edge Abstraction. But in contrast, this sculpture generally was filled with references, including environmental, ontological (concerned with the nature of being), and political issues, as we will see in the work of Robert Smithson and the team of Christo and Jeanne-Claude.

ROBERT SMITHSON One of the most famous **earthworks,** works of art created by manipulating the natural environment, is *Spiral Jetty* (fig. **29.27**), made by Robert Smithson in 1970. Smithson, who was a friend of Serra's, became a prominent figure in the New York art world in the mid to late 1960s because of his articles on art, which often took an environmental approach to discussing land and nature. He also became known for his **nonsite sculptures,** which were "landscapes" consisting of rocks and stones from specific sites (often in neighboring New Jersey) that Smithson put into geometrically shaped bins or mirrored boxes on a gallery floor. A map or aerial photograph showed the actual site of the "landscape." Instead of painting a landscape, Smithson was re-presenting the real thing in the form of what looks like a Minimal sculpture. What a viewer was witnessing was the *entropy*, or steady degradation, of the land as it was removed from one site and taken to another.

Like Hesse's sculpture, Smithson's Minimalist-looking sculpture is full of references and issues, which is apparent in *Spiral Jetty*. The work is 1,500 feet long, 15 feet wide, and involved moving 6,650 tons of mud, black basalt, and salt crystal, the last lining the jetty on either side. It is located at Rozel Point, a remote area of Utah's Great Salt Lake that looks like an industrial wasteland because of the rusting, discarded mining equipment littering the site. Just as time consumes civilization, and all things for that matter, so too will the jetty eventually disappear as it erodes into the lake. The spiral form, as it wraps around itself, going nowhere, and trapping microorganisms that turn the water red, seems like the relic of a prehistoric civilization. Rather than just a minimal geometric shape to be admired for its own sake, *Spiral Jetty* is a powerful sculpture that utilizes time as a major component to speak about the entropy of all things.

CHRISTO AND JEANNE-CLAUDE Christo (Christo Javacheff; b. 1935) is a Bulgarian-born American artist. He met his French-born American wife and collaborator Jeanne-Claude (Jeanne-Claude de Guillebon, b. 1935) in Paris in 1958. In Paris, Christo was interested in creating a social dialogue and provoking his audience to think about its immediate world. In one work Christo and Jeanne-Claude dammed up a Paris street with a neat Minimalist-looking stack of barrels, preventing passage. He was best known for wrapping unidentified objects in fabric, stimulating viewer curiosity about the object as well as the reason for the gesture. In 1964, the couple moved to New York. Working with Jeanne-Claude, Christo's goal was to operate on an environmental or architectural scale, which they first did a small scale in 1961 in

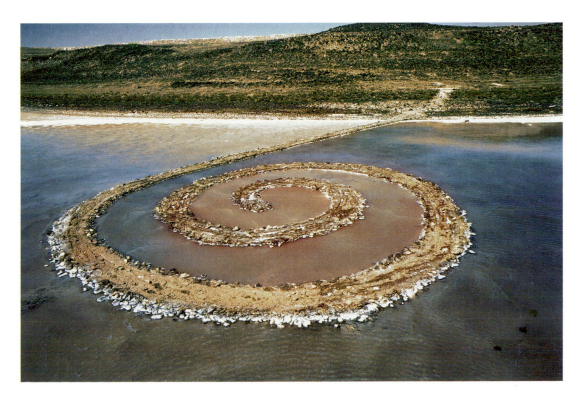

29.27. Robert Smithson. *Spiral Jetty*. 1970. Total length 1,500′ (457.2 m); width of jetty 15′ (4.57 m). Great Salt Lake, Utah. Art © Estate of Robert Smithson/Licensed by VAGA, New York

Studying the Absent Object

By the 1970s, art historians and critics were talking about the "dematerialization of the art object" in contemporary art. By this, they meant that art was no longer exclusively an object. Art was also something that could *not* be bought and sold, something so temporary that it could be seen only for a brief time, making it difficult for scholars and critics to study, analyze, and write about it. Artists were now making temporary sculpture out of crumpled paper, bread placed on the mouth of a volcano, or patterns made in the snow. Many of the artists making temporary art photographed their work. The photographs became works of art in themselves and allowed scholars to study the artist's output.

A handful of artists worked almost entirely in temporary mediums and left no record in photographs, films, or drawings. Not surprisingly, their careers along with their contributions and accomplishments are today underrecognized, if not virtually lost to art historians. Perhaps the most vulnerable artists were the performance artists who emerged toward 1960 (see page 1049). Yvonne Rainer and Robert Whitman, for example, had a wide following and strongly influenced art in the 1960s, but today they are largely forgotten. Their work was performed, sometimes once, sometimes for several weeks, and then it disappeared. During the 1960s, Robert Whitman, especially, had tremendous visibility. His integration of film projection into his Performance Pieces (see fig. 29.13) was startlingly innovative, anticipating the video installations that would become popular in the 1980s (see pages 1100–1101 [Bill Viola]). Like his performances, Whitman's installations disappeared when they were dismantled and put into storage, where they cannot be seen, unlike conventional paintings or sculptures. Today, his Theater Pieces are occasionally performed, and one work *Prune Flat* was acquired by a museum, the Dia Center for the Arts in New York, which owns the "score," the detailed drawings for costumes, and instructions for performance.

Cologne (*Dockside Packages*) and on a large scale in 1969 when they wrapped a one million-square-foot section of a rocky coast in Australia. Since then they have wrapped enormous buildings, a bridge, and surrounded eleven islands with floating fabric, creating site-specific sculptures.

Reproduced here is *Running Fence* (fig. **29.28**), proposed in 1972 and executed in 1976. On the one hand, the work looks like Minimal art, since it consists of pre-determined mathematical units that extend to fill an allocated space, here the 24½-mile hilly terrain in California's Sonoma and Marin counties, with one terminus literally ending in the ocean. Each segment is 18 feet high and consists of cloth attached to steel poles. But this work is not only about the object itself, which was removed by the artists after being displayed for two weeks. Rather, it includes the entire process of implementing the concept: from the endless negotiations

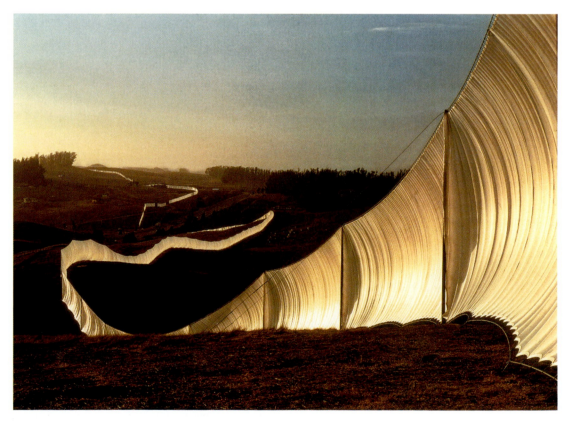

29.28. Christo and Jeanne-Claude. *Running Fence*, Sonoma and Marin County, California. 1972–1976. Fabric, 18′ × 24½ miles (5.5 m × 39.4 km). © Christo and Jeanne-Claude

with government officials, landowners (mostly ranchers), the acquiring and supervising of an enormous workforce, manufacturing of the work, and removal of it. It took four years to produce, the largest stumbling block being the tremendous community resistance. But the dialogue resulted in a raised consciousness about the land. It forced people to look at the land, and to think about it, recognizing how it was emotionally and aesthetically valued. The use of *fence* in the title specifically raised issues about how the land was to be used, and for whom.

Once installed, *Running Fence* transformed the landscape. The fence itself was like a fleet of ships sailing across hill and dale. Probably hundreds of thousands of people came to experience it. In a documentary of the project, one rancher, who had fought the installation, described how he and his son slept next to the fence one night—listening to it ripple in the wind, watching the stars—in effect, undergoing a transformative experience. And then it was gone. Nothing was left, except memories of experiences, pieces of the cloth (which were given to the landowners), and hundreds of drawings that Christo had made to finance the $3.2 million project, which Christo and Jeanne-Claude paid for themselves.

Conceptual Art: Art as Idea

Although the Frenchman Marcel Duchamp had made ideas the focus of art beginning in the 1910s (see page 970) and American George Brecht had begun to create conceptual art in the 1950s (see pages 1050–1051), the term Conceptual Art did not become commonplace until the 1960s, when a large number of artists started producing art that emphasized ideas rather than the aesthetics of style. Of course, ideas appear in all art, but the ideas are closely tied to the formal qualities of art and cannot exist without them. In Conceptual Art, the art generally exists solely as an idea, with no visual manifestation other than words. Or the idea or information can appear as a graph, chart, map, or documentary photograph. In addition to works that are entirely conceptual, we can also talk about art that is basically visual and aesthetic but has a conceptual component as well. For example, Smithson's *Spiral Jetty* has such an element for we *know* that the work is going to very slowly disappear, which is something that was not visible when it was made in 1970. But with the Conceptual artists, idea, concept, or information will be the consuming quality of the work.

JOSEPH KOSUTH By the late 1960s, more and more artists were making art based on ideas, and in 1970, the Museum of Modern Art in New York mounted an exhibition entitled *Information*, dedicated to Conceptual Art and taking as its thesis that art provides information and ideas, not aesthetics. The show's cocurator was artist Joseph Kosuth (b. 1945). Characteristic of Kosuth's own work is *One and Three Chairs* (fig. **29.29**) of 1965, in which he combined a large gelatin-silver print of a folding chair with the real chair and a photograph of a dictionary definition of a chair. By using words instead of just an image, Kosuth tells us how cerebral and nonaesthetic his intentions are.

ART IN TIME

1970—Women's movement gains ground in the United States
1970—Eva Hesse's *Untitled*
1971—Four students killed at Kent State University, protesting the Vietnam War
1976—Christo and Jeanne-Claude's *Running Fence*
1977—*Star Wars* debuts

The work appears to be a textbook study in *semiotics*—the science of signs—a popular topic in universities and in a small segment of the art community at the time. In the language of semiotics, the real chair is the "signified," the photograph is the "signifier," signifying that particular chair, and the dictionary definition is the idealized nonspecific chair. By arranging three versions of a chair in this particular way, Kosuth has determined their context, which leads a viewer to consider issues of language and meaning, rather than such typical art issues as beauty and expression. Reading the definition, we tend to think of the real chair next to it. If it were not present, we would probably think of some other chair from our own experience. If we look only at the photograph of a chair, we may even think the subject of the photograph is not necessarily the chair but the absence of a person sitting in the chair. The title is an important part of the work, for it too provides context, suggesting we can view the chairs as the same chair (one chair) or as three different chairs with very different stories. In other

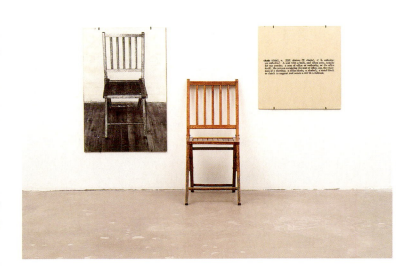

29.29. Joseph Kosuth. *One and Three Chairs.* 1965. Wooden folding chair, photographic copy of chair, and photographic enlargement of dictionary definition of chair; chair, $32^3/_8 \times 14^7/_8 \times 20^7/_8''$ (82.2 × 37.8 × 53 cm); photo panel, $36 \times 24^1/_8''$ (91.5 × 61 cm); text panel, $24 \times 24^1/_8''$ (61. × 62.2 cm). The Museum of Modern Art, New York. Larry Aldrich Foundation Fund. © Joseph Kosuth/Artists Rights Society (ARS), New York

words, this work is about ideas as much as it is about the aesthetics of the visual presentation, which is as unemotional and straightforward as Minimalism. Ultimately, the task of establishing meaning is the viewer's.

One and Three Chairs also reflects a new approach to photography that appeared in the mid-1960s: The medium was no longer the sacred preserve of professional photographers, who worked on a modest scale, carefully took their own photographs, and often slaved over their prints. Now photographs were used by Installation, Earthwork, Performance, and Conceptual artists, who in their primary medium often worked on a large scale. They now made photographs based on their work that functioned at a similar scale, even rivaling painting. Generally, they did not take their own pictures, and few if any did their own printing. Most shocking to traditional photographers, they often integrated photography into other mediums, as Kosuth did in *One and Three Chairs*, thus violating the time-honored integrity of the medium.

JOSEPH BEUYS Joseph Beuys (1921–1986) was a German Conceptual artist who produced work so complex and rich in ideas it is nearly impossible to pin down exactly what his art is. His objects, diagrams, photographs, and performances interrelate so tightly that no one piece can comfortably stand on its own. He was based in Düsseldorf, a city that by the 1970s was home to many of the world's leading artists, its art scene perhaps second only to New York's. Beuys played a major role in developing this artistic climate. His impact included spurring German artists to confront their Nazi past, to rediscover the German Romantic tradition, and to invest their art with spirituality, much like the German Expressionists had done in the early twentieth century.

Two key factors in Beuys's development were his experiences in World War II as a fighter pilot in Hitler's *Luftwaffe* and the 1963 arrival in Düsseldorf of the Fluxus artists (see page 1051). Beuys propagated a myth that his plane was shot down in 1943 in a snowstorm over Crimea, and that nomadic Tartars saved him from freezing to death by covering him in animal fat and layers of felt, materials that became a foundation for much of his sculptural work. Whatever Beuys's war experience actually was, it was clearly traumatic, for after attending the Düsseldorf Art Academy in the late 1940s, he disappeared into the German countryside to work as a farmhand and purge himself of his guilt and anxiety.

In 1961 Beuys was teaching at the Düsseldorf Art Academy, and two years later he was introduced to Fluxus, joining them for a segment of their European tour. In 1965 he performed *How to Explain Pictures to a Dead Hare* (fig. **29.30**). For three hours he moved his lips as if silently lecturing the dead hare cradled in his arm about the pictures surrounding him on the walls. Attached to his left sole was felt, and to his right, steel, the one representing "spiritual warmth," the other "hard reason." Honey and gold paint covered Beuys's head, transforming him into a shaman, a high priest who uses magic to cure ills.

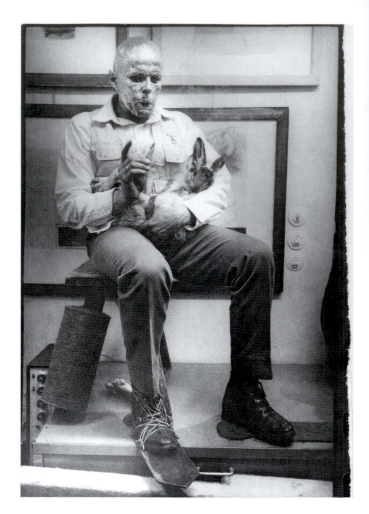

29.30. Joseph Beuys. *How to Explain Pictures to a Dead Hare*. 1965. Performed at Galerie Schmela, Düsseldorf, Germany. © Artists Rights Society (ARS), New York/VG Bild-Kunst, Bonn

The honey represented a life force. This mysterious ritualistic performance was about the meaninglessness of conventional picture making—art that had to be explained—and about the need to replace it with a more spiritual and natural form of communication, an art the meaning of which could be felt or intuited by a viewer rather than understood intellectually. The performance was designed to create a magical art that would cause people to invest their own lives with spirituality. Anyone who watched the performance found it riveting and unforgettable, even if they did not understand it. His objects, too, such as a worn wooden chair with a pile of fat on its seat, affected people similarly.

Television Art: Nam June Paik

Another artist who participated in Fluxus activities in Düsseldorf in the early 1960s was the Korean-born musician, Performance artist, and sculptor Nam June Paik (b. 1932). Paik's background was in music, but shortly after studying composition with John Cage in Darmstadt, Germany, in 1958, he became a radical Performance artist, exploring unconventional mediums. Living in Düsseldorf in 1963 and performing in the Fluxus program, he began making art using television monitors. He called television the "electronic superhighway"

and declared it the medium of the future, dedicating his life to working with it. The following year he moved to New York, and with the launch of the first affordable video camera by Sony, he often used video as well.

Paik's work in the 1970s became increasingly grand and complex. Typical of the more elaborate structure of the later work is a piece from 1995, *Electronic Superhighway: Continental U.S.* (fig. **29.31**). Fed by numerous computer-controlled video channels, this installation consists of dozens of monitors inserted in a neon map of the 48 continental states. The rapidly changing images generally relate to the respective states, except for New York, which was fed from a live camera in the New York Holly Solomon Gallery, where the work was shown and from where our reproduction originates.

In the *Electronic Superhighway*, Paik reaffirms the prevalence of television in American society, presenting it with the fast-paced continuous stream of information characteristic of broadcast television. The work celebrates American vernacular culture, both in its use of neon and television as mediums and in the Americana presented on the videos. Television is America, Paik tells us. It is, in effect, real life, because most Americans experience the world through their television screens. Paik is not condemning the medium, which would be antithetical to the objective position of a Fluxus artist, but simply revealing its power to define contemporary life.

ART WITH A SOCIAL AGENDA

Most of the postwar artists discussed thus far did not have a social agenda. Even some who did, such as Lichtenstein and Warhol, subversively buried their message so that it was not readily visible, especially to the groups they criticized. While an atmosphere of counterculture dominated the vanguard art world paralleling the social revolution occurring not only in America but also worldwide by the late 1960s, few artists made political art. By the 1970s the trickle of artists making work that dealt with social issues began to swell into a torrent. So great was its influence that we think of social issues playing a major role in avant-garde art for the last 35 years. An art with a social agenda became a key component of 1970s Post-Minimalism.

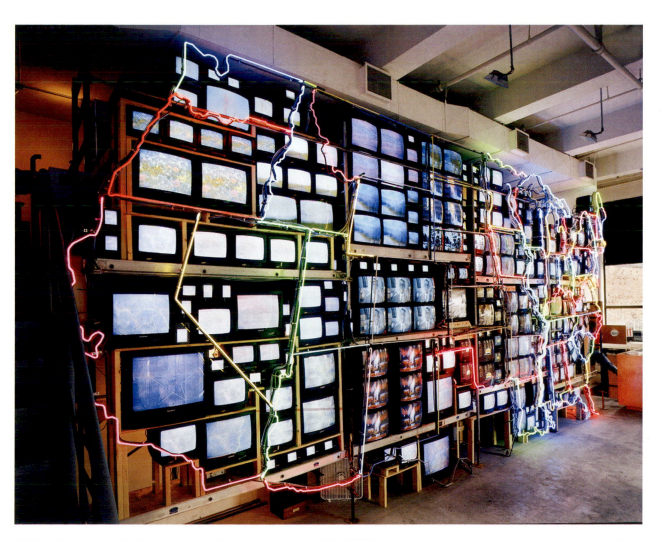

29.31. Nam June Paik. *Electronic Superhighway: Continental U.S.* 1995. Installation: Forty-seven-channel closed-circuit video installation with 313 monitors, laser disk images with sound, steel structure and neon, 15 × 32 × 4′ (4.57 × 9.75 × 1.2 m). Courtesy of the Artist and Holly Solomon Gallery, New York. © Nam June Paik.

Street Photography

Not everyone was caught up in the economic boom and technological euphoria of the 1950s. Some observers, including many outstanding photographers, perceived serious problems within American society. In part inspired by the powerful photographs of Walker Evans, they trained their cameras on the injustices smoldering beneath the placid surface of society and made what is often called **street photography**. They were free to do so because photography was not handcuffed by the Modernist aesthetics of painting and sculpture that demanded an increasingly abstract nonreferential art.

Perhaps the best known of the postwar street photographers is Robert Frank (b.1924), who emigrated from Switzerland in the 1940s. In 1955, Frank crisscrossed the nation, taking candid, unposed photographs in banal public settings, which he then published as a photoessay in a book called *The Americans* (1958). American publishers found his view of America so grim that Frank had to go to France to find someone to produce the book. An American edition came out in 1959 with an introduction by Jack Kerouac (1922–1969), author of the classic Beatnik novel *On the Road* (1957).

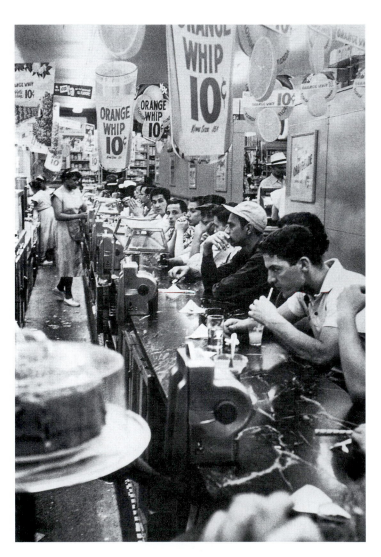

29.32. Robert Frank. *Drug Store, Detroit*. 1955. Gelatin-silver print, 11 × 14″ (27.9 × 35.5 cm). Courtesy of the Pace MacGill Gallery, New York. © Robert Frank, from *The Americans*

Like his friend George Segal, Frank used his work to reflect his concerns about the alienation and lack of spirituality in twentieth-century America. *Drug Store, Detroit* (fig. **29.32**) is characteristic of his national portrait of emptiness, alienation, and despair. Under a barrage of bold advertising (reminding us of Andy Warhol's *Campbell's Soup Cans*), some 15 men order, among other items, artificial orange whips, each patron seemingly unaware of the others. On the other side of the counter dutifully serving the white males (undoubtedly working for a minimum wage) are African-American women. Just as the cake is trapped in the airless foreground case, the waitresses seem trapped behind the counter in the drudgery of their menial jobs. The glare of bare fluorescent bulbs bouncing off of linoleum, Formica, and plastic is a reminder of the period's deadening aesthetic of efficiency and modernity, while the monotonous lineup of jukeboxes on the counter opposite the patrons declares the "sell, sell, sell" mentality of American business.

Unlike Evans, Lange, and Bourke-White (see pages 1018, 1030–1031), Frank avoids refinement in his photographs. His prints are blurry and gritty, and grimy blacks violently contrast with whites. Their harsh crudeness projects an undercurrent of unease and disquiet. We sense the speed with which Frank operated in the informal settings he encountered, wielding his 35mm single-lens reflex camera as spontaneously as his instinct dictated. It should come as no surprise that the downtown Detroit where this photograph was taken was largely destroyed during the race riots of the late 1960s. (For a discussion of a second documentary photographer from their period, see page XXIX on Lee Friedlander.)

African-American Art: Ethnic Identity

Other American artists soon joined the street photographers and began doing what had been unthinkable in the art world of the 1960s: turning their backs on both Minimalism and abstraction in general and instead making art about the nation's problems and issues, particularly those concerning race, ethnic background, gender, and sexual orientation. Because of the civil rights movement, African-American artists were challenged to make art about their heritage. At the university and in art school, they were trained like everyone else to make abstract art. But their communities pressured them to do the exact opposite: Make narrative art and take up the black cause. To balance both claims was a challenge.

ROMARE BEARDEN In New York in 1963, a number of African-American artists formed a loose group called Spiral, dedicated to supporting the civil rights movement. They met in the studio of Romare Bearden (1911–1988), a New York University–educated mathematician and philosopher who in the 1940s increasingly became a committed artist. Influenced by Martin Luther King, Jr.'s 1963 March on Washington, DC, Bearden suggested a collaborative project for Spiral that involved the members all contributing to a large photo collage about black identity. When no one turned up, Bearden undertook the project by himself, cutting up newspapers and magazines to make collages, for which he became famous.

Romare Bearden (1911–1988)

From a 1984 interview with Joseph Jacobs

Romare Bearden talks about why collage was so important for him and its relationship to jazz.

One of the attractions of collage for me is it allows me to work quickly, which is a very twentieth-century attitude. The development of the machine, and now of the computer, killed man's capacity for patience. It is too nervous a century for people to paint the way Jan van Eyck painted, for example. Many modern super-realist paintings, which may look as detailed as a Van Eyck, are made from photographs or slides which get projected onto the canvas and are then painted. Collage is the cutting out rather than the painting of things, and it allows a more direct way to get something down. Just cut it out and put it down.

No, the physicality of the medium did not attract me to collage. Also, I don't think of my use of collage as an extension of Abstract Expressionism. Rather I would like to think of it within the context of Cubism. My quarrel with Abstract Expressionism, if any, is that sometimes the space is naturalistic. If you place in one area of the canvas a large field of blue, and then in another area you put an orange, you have painted sunlight, which is naturalistic space and light. I prefer to bring things forward, not just for the sake of making Cubism, but to make flat painting and not fool the eye with depth and perspective. And that is achieved by having the collage sit on the surface. . . .

Yes, you can draw parallels between my work and jazz. As you just said, there is a spirit that is there before a work is begun and develops with the work that is similar to the kind of improvisation that one gets in jazz. . . . [Jazz] has a rhythmic component, and it also has interval. When you listen to the piano of Earl Hines, what really counts is the silences between the notes struck. . . . The same importance of interval can be seen in confetti thrown at a wedding; the confetti dazzles the eye, but it is the spaces between the pieces that really causes things to happen.

SOURCE: FROM *SINCE THE HARLEM RENAISSANCE: 50 YEARS OF AFRO-AMERICAN ART.* (ORGANIZED BY THE CENTER GALLERY OF BUCKNELL UNIVERSITY, 1985.)

The composition of Beardon's collages is based on Cubism, as seen in *The Prevalence of Ritual: Baptism* (fig. **29.33**), created in 1964, but the subject matter is distinctly African-American. Bearden grew up in Charlotte, North Carolina, before moving to New York City's Harlem, and the fractured image shows a baptism, reflecting the importance of religion in black culture. The faces not only express the African physiognomy but in some instances also suggest African masks. This work has the effect of tracing American culture back to its African roots and reinforcing the continuous importance of ritual and

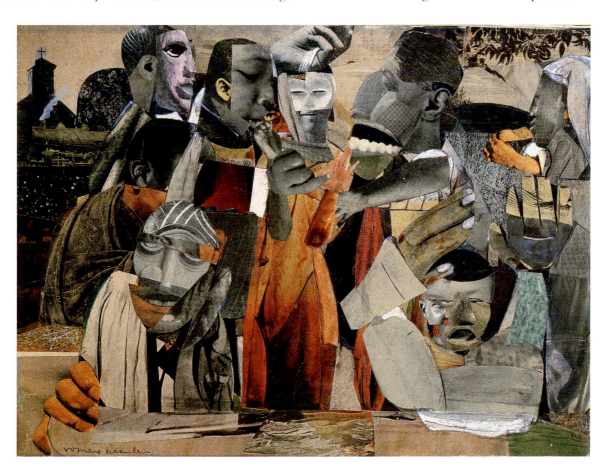

29.33. Romare Bearden. *The Prevalence of Ritual: Baptism.* 1964. Collage of photochemical reproduction, synthetic polymer, and pencil on paperboard, $9\frac{1}{8} \times 12''$ (23.2 × 30.5 cm). Hirshhorn Museum and Sculpture Garden, Smithsonian Institution, Washington, DC. Gift of Joseph H. Hirshhorn, 1966. Art © Romare Bearden Foundation/Licensed by VAGA, New York

community. The collage composition has a wild syncopation and even a sense of improvisation that seems to relate to the black jazz musicians of the period, such as Charlie Parker or John Coltrane. (See *Primary Source*, page 1067.) The power of Bearden's work lies in the artist's ability to pack so much information and energy into a single image that it overflows with the vitality and essence of the African-American experience, an energy we saw as well in the small temperas of Jacob Lawrence (see fig. 28.54).

MELVIN EDWARDS At virtually the same moment, Melvin Edwards (b. 1937) took an entirely different approach to reflecting his racial background. Raised in Houston, Texas, and studying welded-steel sculpture at the University of Southern California in Los Angeles, Edwards was outraged at the lynchings of blacks in the South, which were increasing as the Ku Klux Klan responded to the civil rights movement. In 1963 he began to make a series of relief sculptures entitled *Lynch Fragments* (see fig. **29.34**), incorporating chains and spikes and brutal metal fragments, all of which had a brown tonality when oiled to prevent rusting.

While there is no set reading of these works—which Edwards continues to make today as a New York resident—they evoke oppression, bondage, violence, and anger, as well as skin color. They also appear to refer to African masks (which the artist denies is intended) and ritual, and in their bold frontality

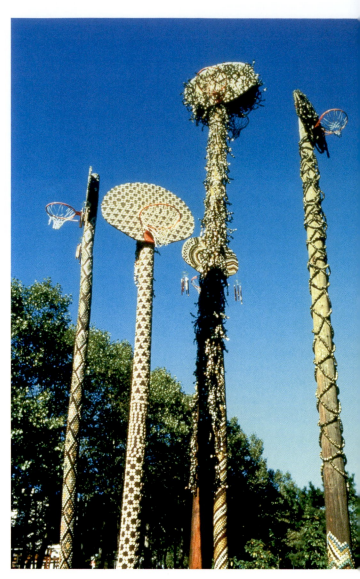

29.35. David Hammons. *Higher Goals*. 1982. Wood poles, basketball hoops, bottle caps, and other objects. Height 40′ (12.19 m). Shown installed in Brooklyn, New York, 1986. Photograph by Dawoud Bey. © David Hammons

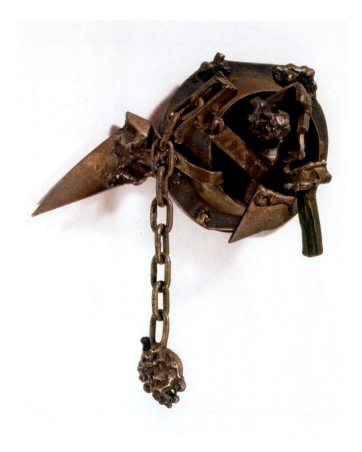

29.34. Melvin Edwards. *Lynch Fragment: Some Bright Morning*. 1963. Welded steel, 1′2¼″ × 9¼″ × 5″ (36.2 × 23.5 × 12.7 cm). Collection of the artist. © Melvin Edwards

they display a sense of confrontation and dignity. These basically abstract works are so open to interpretation, we can view them as autobiographical as well. A horseshoe that appears in many of the Lynch Fragments is the artist's reminiscence of visits to his uncle's ranch outside of Houston. Edwards's political and expressive art stands in stark contrast to the Minimalist Art being produced at the same time.

DAVID HAMMONS Emerging in the late 1960s, David Hammons (b. 1943) is a quirky Conceptual artist who creates work that exists within African-American communities as well as in museums and art galleries. We can see his Duchamp-like humor in a later work, *Higher Goals* (fig. **29.35**) of 1982, originally installed in his Harlem neighborhood and here photographed at a Brooklyn site. The provocation for the work was a group of neighborhood teenagers playing basketball when they should have been attending school. They told the artist that the road to success lay in sports, not education.

Higher Goals consists of 40-foot-high basketball hoops decorated with wind chimes, which look like spirit catchers, and bottle caps arranged in colorful geometric patterns suggesting African motifs and designs. As the title states, the work is about setting realistic higher goals, such as getting an education, as opposed to unrealistic goals, such as becoming a professional basketball player. Its brightly decorated objects have a ritualistic even totemic quality, and they raise the issue of what is to be revered and where ancestral spirit is to be placed.

While clearly humorous, Hammons's works are thought-provoking, but they communicate at a "cool" level with the neighborhood and in the neighborhood. Simultaneously, they satisfy the highest demands of the art world, although this is a very secondary consideration for this socially engaged artist.

Feminist Art: Judy Chicago and Gender Identity

Betty Friedan's 1963 book *The Feminine Mystique* signaled the start of the feminist movement. Almost simultaneously a number of women artists began making work that dealt with women's issues. Nancy Spero (b. 1926) made simple but power-

ful expressionistic drawings depicting violence toward women, while Mimi Smith (b. 1942) made what is now recognized as the first American clothing art, objects like a Minimalist *Girdle* (1966), constructed of rubber bathmats that capture the discomfort of women's clothing.

The most famous work coming out of the women's movement is *The Dinner Party* (fig. **29.36**), orchestrated by Judy Chicago (b. 1939) and made by over 400 women between 1974 and 1979. By the late 1960s, Chicago was a dedicated feminist, who in

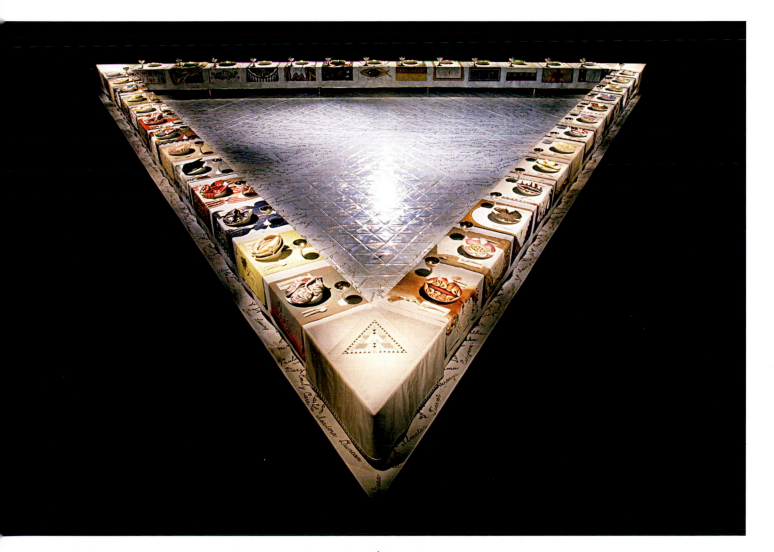

29.36. Judy Chicago. *The Dinner Party*. 1979. Mixed media, 3 × 48 × 42′ (0.9 × 17.6 × 12.8 m). Brooklyn Museum of Art, New York. © Judy Chicago/Artists Rights Society (ARS), New York

the early 1970s established a Feminist Art Program, the first of its kind, at California State University at Fresno. Shortly thereafter, with artist Miriam Schapiro (b. 1923), she started a second similar program at the California Institute of the Arts in Valencia. The thrust of these courses was to encourage women to make art and deal with gender issues, which the art world, including university and art school faculties, said she could not do because the work did not conform to the aesthetic norms of Modernist formalism that signified serious art. The Feminist Art Program was designed to provide support for women artists and to redefine aesthetic values in contemporary art.

The Dinner Party reflects Chicago's shift from a maker of abstract Minimalist objects and paintings to works on feminist themes in alternative mediums and installations. It pays homage to the many women who Chicago felt were ignored, underrated, or omitted from the history books. Chicago laboriously researched these lost figures. She then designed a triangular table with 39 place settings, 13 to a side, each honoring a significant woman, ranging from ancient goddesses to such twentieth-century icons as Georgia O'Keeffe. In addition, 919 other women's names are inscribed on the white floor tiles lying in the triangular intersection of the tables. Each place setting included a hand-painted ceramic plate that pictured a vagina executed in a period style. American poet Emily Dickinson's reproductive organ, for example, is surrounded by lace, and French queen Eleanor of Aquitaine's is encased in a *fleur-de-lis*. Under each place setting is an embroidered runner, often elaborate and again in period style.

Instead of using bulldozers, chain saws, hoists, and welding equipment as men did for their environments, Chicago intentionally turned to mediums associated with women—painted china, ceramics, and embroidery—and created an elegant, beautiful work that subtly operates on an epic scale, spanning millennia. Also present is a sense of community and ritual, for we feel as though Chicago has appropriated and transformed the Christian male theme of the Last Supper into a spiritual communion of women.

LATE MODERNIST ARCHITECTURE

Modernist architecture thrived after World War II, especially in America, which previously preferred traditionalist architecture (skyscrapers, for example, in a Gothic style) as discussed in the previous chapter (see pages 1020–1021). But now Modernist architecture was only a look or style. It no longer had the utopian vision and revolutionary zeal to improve the world that we saw in the High Modernism of de Stijl and the Bauhaus (see pages 1007–1012), and in the art and design of Constructivist Productivism (see pages 1004–1005). However, some of the most influential buildings of the period continued to be built by the great Early and High Modernist architects: Wright, Mies van der Rohe, and Le Corbusier. While Mies continued the International Style aesthetic of light, floating geometric buildings with taut, thin glass walls, Frank Lloyd Wright and Le Corbusier, joined by the emerging Philadelphia architect Louis Kahn, developed a sculptural architecture that emphasized mass and the physical presence of a building, and they were not afraid to be referential.

Continuing the International Style: Ludwig Mies van der Rohe

Postwar Late Modernism resulted in glass boxes sprouting up in urban centers and dotting the beltways that circled American cities, especially beginning in the 1960s and 1970s. The glass box became the required image for corporate headquarters, such as I. M. Pei and Henry N. Cobb's John Hancock Center in Boston (1977) and Skidmore, Owens, and Merrill's Sears Tower in Chicago (1974). If one were to choose a single building to epitomize the Late Modernist skyscraper it would have to be Mies van der Rohe's Seagram Building (fig. **29.37**) in New York, built from 1954 to 1958, with interiors by Philip Johnson (1906–2005). This building was imitated worldwide, but rarely did the imitations begin to approach the perfection that Mies achieved with his aesthetic of "Less is more."

We can see these minimal gestures in the Seagram Building. Mies began by removing the building from its urban environment. He placed his 38-story tower on a plaza elevated above street level. The plaza is simple but sumptuous; it is made of pink granite, has two shallow pools placed symetrically on either side of the building, and is surrounded by a low serpentine marble wall. The weightless tinted glass-and-bronze tower sits on a colonnade of *pilotis* that leaves the first floor open, and every detail, including the paving stones, is carefully proportioned to create a sense of perfection and elegance. With the rise of Hitler in Germany, Mies had joined Moholy-Nagy at the new Bauhaus in Chicago, and in the Seagram Building we can see the influence of the nineteenth-century Chicago School in the emphasis on the skeletal grid of the building. To acknowledge the functionalism of the grid, Mies used thin I-beams for the mullions between windows. They provide the vertical accent that the proportions of the horizontal spandrels so perfectly counterbalance with their thin ridges on top and bottom. Inside and out, lavish, beautifully harmonized materials embellish the building's exquisite proportions.

Sculptural Architecture: Referential Mass

Mies's architecture was essentially nonreferential, just like Minimalist sculpture. However, his contemporaries Frank Lloyd Wright and Le Corbusier took Late Modernist architecture in a different direction. Their buildings contain references and are organic, if not outright expressionistic. Made of poured concrete, they are massive monumental buildings that have a powerful sculptural presence.

FRANK LLOYD WRIGHT Going up simultaneously with the Seagram Building was Frank Lloyd Wright's Solomon R. Guggenheim Museum (fig. **29.38**), some 50 blocks north in Manhattan. The building could not be more different, for instead of a non-referential mechanomorphic grid, the museum, although geometric, is organic, and dominated by curves. Made of poured concrete, it is also weighty, massive, and sculptural. The spiral structure is based on a snail's shell and basically encases one large room (fig. **29.39**). Wright's objective was to get away from the static rectangular art gallery and create an

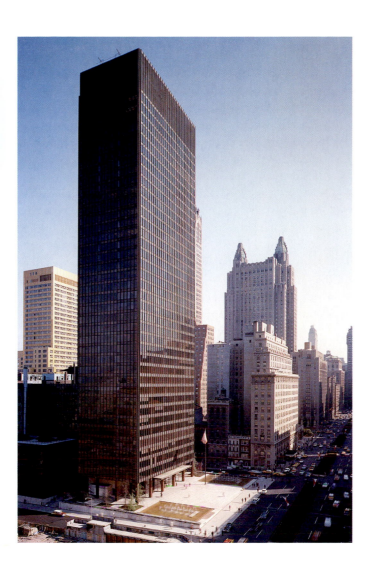

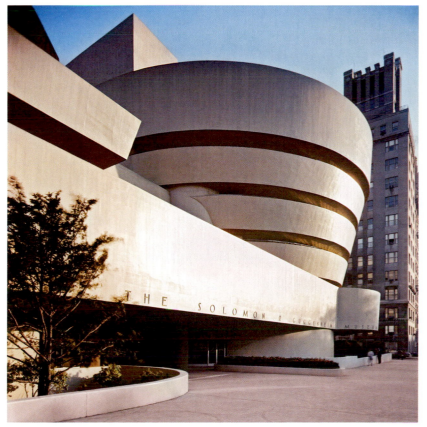

29.37. Ludwig Mies van der Rohe and Philip Johnson. Seagram Building, New York. 1954–1958. © Artists Rights Society (ARS), New York/VG Bild-Kunst, Bonn

29.38. Frank Lloyd Wright. The Solomon R. Guggenheim Museum, New York. 1956–1959. © The Solomon R. Guggenheim Foundation, New York. © Frank Lloyd Wright Foundation, Scottsdale, Arizona/Artists Rights Society (ARS), New York

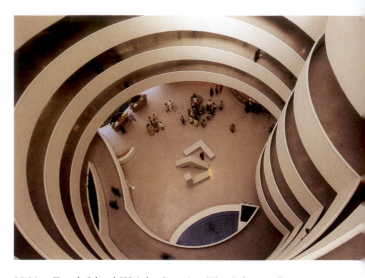

29.39. Frank Lloyd Wright. Interior. The Solomon R. Guggenheim Museum, New York. 1956–1959. Robert Mates © The Solomon R. Guggenheim Foundation, New York. © Frank Lloyd Wright Foundation, Scottsdale, Arizona/ Artists Rights Society (ARS), New York

entirely new viewing experience. He wanted visitors to take the elevator to the top of his huge "vase" and then saunter down the spiraling ramp, pulled by the gravity of the 3 percent grade. Because the ramp is narrow, visitors cannot get too far away from the art, thereby, developing an intimate relationship with it. Because of the spiral they can look back to where they have been and forward to where they are going.

This sense of movement, or continuous flow, and of a structure that swells and contracts is a feature of the building's rhythmic play of convex and concave curves, as seen in our reproduction. The width of the ramp gradually changes as well, another form of expansion and contraction. To enhance the sense

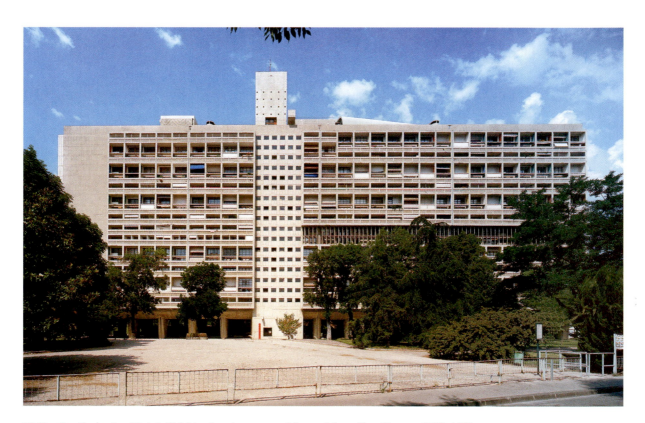

29.40. Le Corbusier. Unité d'Habitation Apartment House, Marseilles, France. 1947–1952. © Artists Rights Society (ARS), New York/ADAGP, Paris/FLC

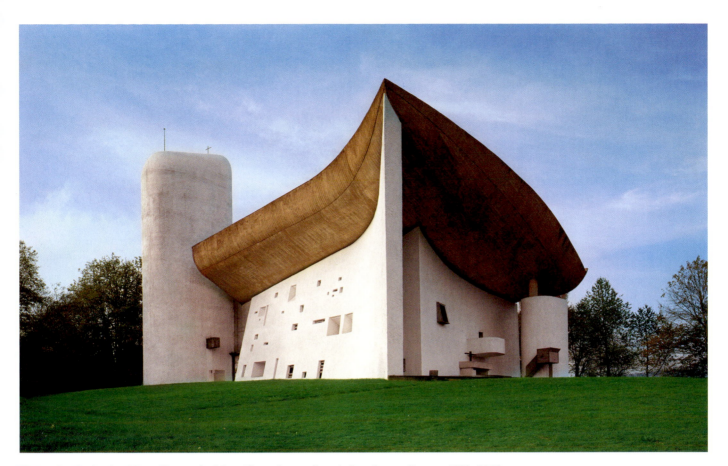

29.41. Le Corbusier. Nôtre-Dame-du-Haut (from the southeast), Ronchamp, France. 1950–1955.
© Artists Rights Society (ARS), New York/ADAGP, Paris/FLC

of the organic, Wright added light and water to his building, opening the ceiling up with an enormous skylight and placing a pool directly below on the floor. Visitors to the Guggenheim experience a sense of journey and adventure, and because everyone is gathered under one roof, of community as well.

LE CORBUSIER Like Wright, Le Corbusier also became quite sculptural in his late architecture. Unité d'Habitation (fig. **29.40**), a 1947 housing project in Marseilles, allowed him to develop his concept for ideal mass housing. The architect conceived the building as a self-contained communal environment. It is a ferroconcrete grid into which he literally inserted prefabricated apartments (there are 23 configurations), like "bottles into a wine rack." Two floors have interior shops, restaurants, and even a hotel, and the roof has athletic facilities and a child-care center. Aesthetically, however, we are far from the Villa Savoye (see fig. 28.39). Instead of a floating volume and thin walls, we now see bold mass and the rugged texture of concrete, and it is not hard to understand why this late expressionistic style is sometimes called Brutalism, a style of architecture that uses aggressive-looking chunky forms and either rough surfaces of raw concrete or the harsh unfinished look of metal, giving the building a functional industrial appearance. The *pilotis* that leave the ground floor open are transformed

into organic muscular legs, which Le Corbusier likened to a curvaceous woman's thighs. Each apartment has a deep balcony, which aesthetically adds to the sculptural effect and functionally provides shade to the floor below since the walls are solid glass. (These balconies, called *brises soleil*, would become standard on buildings in tropical climates.)

Le Corbusier's sculptural masterpiece is Nôtre-Dame-du-Haut (fig. **29.41**), a chapel in Ronchamp, France, built from 1950 to 1955. While the interior space is basically simple, an oblong nave, the exterior erupts with diagonals and curves. The concrete-covered masonry walls are thick and massive, and the poured concrete roof (which is hollow) is ponderous, even if it also seems to float. Visitors enter front and back through enormous fissures in the wall, giving them a sense of slipping through a cleft in a rock formation. The pointed facade reminds us of a ship's prow, while the roof recalls the bottom of a boat, allusions to such vessels of salvation as Noah's ark and the church as St. Peter's fishing boat. But these shapes also suggest a nun's cowl, praying hands, and a church spire. The vertical tower-like forms to the right and left resemble the nearby prehistoric dolmens of Carnac (see fig. 1.24). A sense of the primordial continues in the cavelike interior, where the ceiling precipitously drops from 32 feet over the altar to 16 feet in the center of the room. Faint streams of colored light pierce the stained-glass

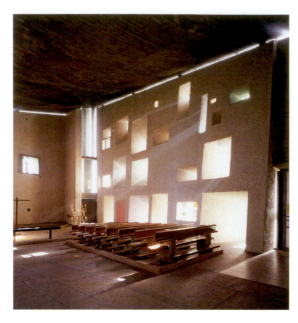

29.42. Le Corbusier. Interior of Nôtre-Dame-du-Haut. © Artists Rights Society (ARS), New York/ADAGP, Paris/FLC

windows set in the thick walls (fig. **29.42**), gently illuminating the space and giving it a mystical aura. Regardless of religion, anyone visiting Nôtre-Dame-du-Haut is likely to be transported to the realm of the mysterious and magical.

LOUIS KAHN Louis Kahn (1901–1974) is a difficult artist to place and is alternatively labeled an Expressionist, a Brutalist, and a Proto-Postmodernist. He was in his fifties when he finally found his architectural voice, largely due to a year spent at the American Academy in Rome in 1950–1951. Here he awakened to the importance and power of the ancient monuments of the Mediterranean, from the pyramids of Egypt to the baths

and aqueducts of Rome to the Athenian Akropolis. Their bold, sculptural forms and pure geometry evoked a timeless serenity and Classical grandeur and became the building blocks of his Modernist aesthetic. In the late 1950s Kahn discovered the Expressionist, Brutalist style of late Le Corbusier, of whom Kahn said, "He was my teacher, although he didn't know it." He rejected the International Style's emphasis on light volume defined by a taut membrane as he instead designed massive, weighty structures that evoked ancient civilizations that seemed capable of defying the ravages of time.

We can see these qualities in his 1962 ferroconcrete National Assembly Building in Dacca, Bangladesh (fig. **29.43**). The assembly chamber is in the center, surrounded by concentric circles of meeting rooms, press offices, and a mosque, each building separated by unroofed walkways, creating a veritable light-filled city. Monumental triangles, rectangles, and circles puncture the massive walls of each ring of rooms, allowing light to filter in and virtually structure the space. The entire complex looks like a fortress, the outer wall projecting the sublime presence of antiquity, although functionally it is a Le Corbusier *brise soleil* designed to keep out the harsh sun of the Indian subcontinent. As we shall see in the next chapter, Kahn's referential architecture would inspire the next generation of architects.

SUMMARY

The focus of the art world shifted from Paris to New York during and after World War II. But the watershed for the remainder of the century occurred in the 1950s, when art was totally redefined. In the United States, the civil rights movement of the 1950s and 1960s challenged the status quo, and the Vietnam Conflict of the 1960s began a period of social upheaval. Artists similarly

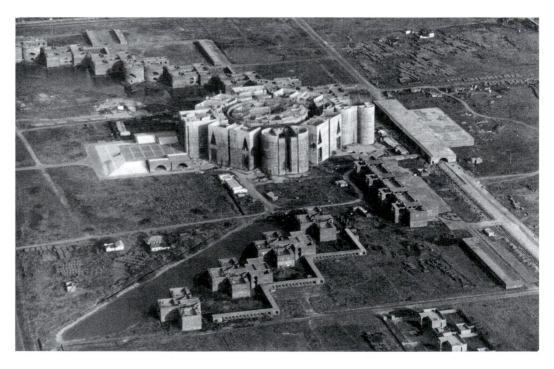

29.43. Louis Kahn. National Assembly Building. Dacca, Bangladesh. 1962

challenged the status quo, accepting nothing at face value. They questioned how art functions, and they broke down the barriers that largely restricted art to painting and sculpture. They now began using every material imaginable, including words, earth, and junk, and created countless new art forms, including Enviroments, Earth Art, Performance art, mail art, and conceptual art.

EXISTENTIALISM IN NEW YORK: ABSTRACT EXPRESSIONISM

Abstract Expressionism, the first important postwar style, surfaced in New York in the late 1940s. The Surrealist work of Arshile Gorky represents a bridge to Abstract Expressionism, which developed in the gestural paintings of Jackson Pollock and Willem de Kooning. Pollock emphasized the forceful application of paint onto canvas, making the physical act both the focus of painting and a metaphor for the human condition. De Kooning similarly employed bold expressive abstraction in representational paintings, mostly of women.

A flip side of Abstract Expressionism was color-field painting, in which large planes of color express primal qualities linked to universal forces. The objective of such Color-Field painters as Mark Rothko and Barnett Newman, like that of their Abstract Expressionist counterparts, was to project the sublime human condition as they felt it.

Avant-garde sculptors of the postwar period were similarly steeped in Existential philosophy. Some, like David Smith, developed their abstract compositions as they worked. Others, like Louise Nevelson, retained the hieroglyphic signs of Surrealism but began working on an enormous scale.

EXISTENTIALISM IN EUROPE: FIGURAL EXPRESSIONISM

Many European artists resisted the dominance of American culture and the preeminence of Abstract Expressionism. Some developed their own solutions to the problem of making art that expressed the existential loneliness of human existence. These artists rejected complete abstraction in favor of a return to the human figure, which allowed them to make statements about the place of the individual within the cosmos. Believing that untrained artists were more directly connected to universal forces, French painter Jean Dubuffet explored *Art brut*. By contrast, English artist Francis Bacon looked within, drawing upon personal demons from his own life to create paintings of disturbing psychological intensity.

REJECTING ABSTRACT EXPRESSIONISM: AMERICAN ART OF THE 1950s AND 1960s

Beginning in the 1950s radically new art forms burst onto the scene, eventually overshadowing Abstract Expressionism. Robert Rauschenberg's combines, which joined painting, sculpture, and found objects in a single work, and Jasper Johns's unemotional paintings of objects from vernacular culture re-presented common artifacts of everyday life. Likewise, Allan Kaprow's Happenings, George Segal's Environments, and George Brecht's is Conceptual Art thrust art into uncharted territory. Pop Art emerged in the 1950s in England and in the 1960s in the United States with artists Richard Hamilton, Roy Lichtenstein, Andy Warhol, and Edward Ruscha incorporating into their work commercial imagery from sources such as comic books, advertising, and product packaging. These artists blurred the distinction between fine art and popular art and highlighted the subtle yet pervasive impact of the mass media on culture.

FORMALIST ABSTRACTION OF THE 1950s AND 1960s

In the 1940s influential art critic Clement Greenberg developed a formalist approach that advocated an understanding and appreciation of art solely on a work's formal qualities (line, shape, composition, and so on) rather than its relationship to an art-historical tradition or its place of creation. During the next two decades, formalist painters sought to create completely abstract art that was devoid of emotion. They replaced bold, gestural brushwork with smooth surfaces that gave no hint of the artist's hand or feelings. From the Post-Painterly stain paintings of Helen Frankenthaler to the hard-edge abstractions of Ellsworth Kelly and Frank Stella, the emphasis on flatness virtually eliminated any sense of three-dimensional space. Formalist abstraction in sculpture took the form of Minimalism, with works that similarly lack emotional content or evidence of the artist's touch. Sculptors Donald Judd and Dan Flavin chose nontraditional materials, including Plexiglas, fluorescent tubes, and galvanized steel, continuing the exploration of new media that characterized much art of the late 1950s and 1960s.

THE PLURALIST 1970s: POST-MINIMALISM

Faced with the social turmoil resulting from the postwar decades, artists found they could no longer remain removed from the era's debates and concerns. By the late 1960s, many began putting the human component back into art, addressing political, social, and environmental problems. Their responses were diverse, as were the mediums they chose. Because the pluralism of the 1970s came on the heels of Minimalism, the art of this decade is often called Post-Minimalism. Sculptors Eva Hesse and Richard Serra retained the geometry of Minimalism but loaded it with powerful emotional content. Others made art that was not only temporary but also far removed from traditional gallery or museum settings—in effect, dematerializing the art object. The earthworks of Robert Smithson and the site-specific art of Christo and Jeanne-Claude transformed landscapes and imbued them with new meaning and personal references. Another trend was Conceptual Art, whose beginnings can be traced back to Marcel Duchamp in the early twentieth century. Art that is entirely conceptual exists solely as an idea, whereas some works may be basically visual and aesthetic but have a conceptual component as well. Leading Conceptual artists were Joseph Kosuth and Joseph Beuys.

ART WITH A SOCIAL AGENDA

Art with a social agenda became a key component of 1970s Post-Minimalism. The 1960s social revolution had been led by groups generally ignored by the white-male-dominated establishment. Soon many disenfranchised artists likewise protested their exclusion from the conventional art world. They began producing works that museum curators and directors did not consider commercially viable or aesthetically valid. These artists delved into problems inherent in gender, ethnicity, racial identity, and sexual orientation. Anticipating this movement were the street photographers, like Robert Frank, who trained their cameras on the injustices smoldering beneath the placid surface of American society. African-American artists such as Romare Bearden, Melvin Edwards, and David Hammons made art about black identity, and the feminist movement produced artists like Judy Chicago who dealt with gender identity.

LATE MODERNIST ARCHITECTURE

Modernist architecture thrived after World War II, especially in America, but as a look or a style rather than a reflection of the utopian vision found in the International Style and Constructivist Productivism. Ludwig Mies van der Rohe continued the International Style aesthetic of light, seemingly weightless geometric buildings encased in thin glass walls. Moving in a different direction were Frank Lloyd Wright and Le Corbusier. These architects, along with Louis Kann, chose to instill their structures with historic references, and they developed a sculptural architecture that emphasized mass and the physical presence of a building.

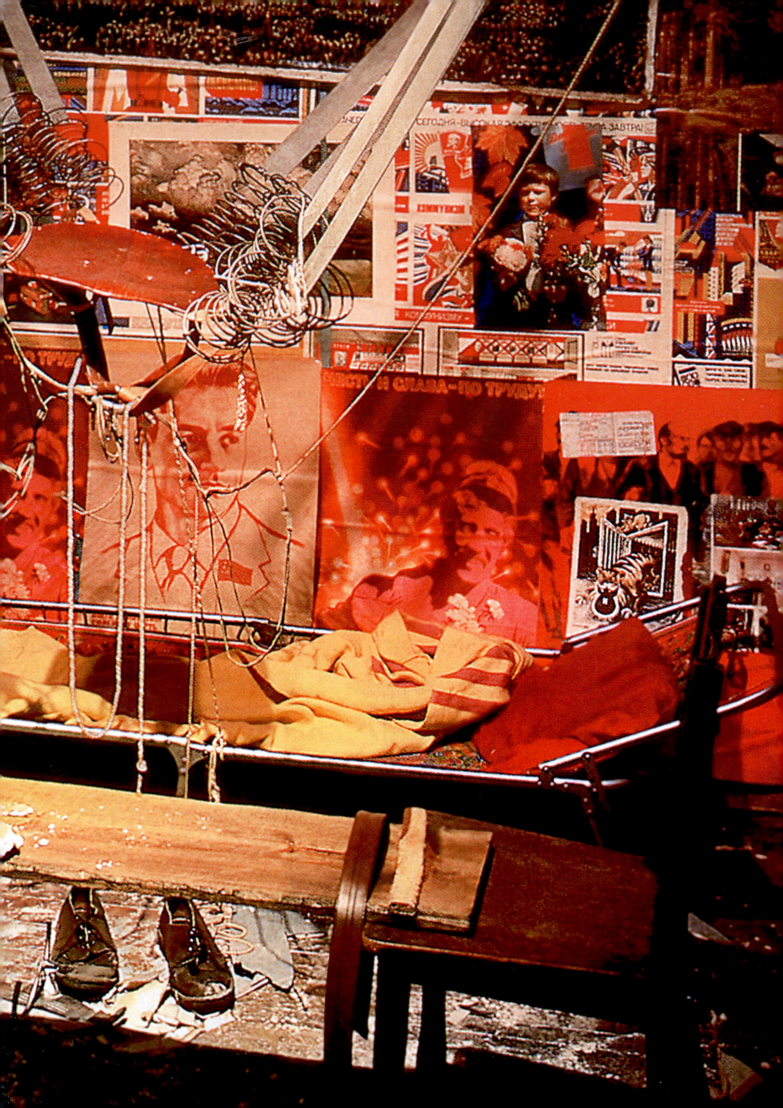

The Postmodern Era: Art Since 1980

THE ART THAT CAME TO THE ART WORLD'S ATTENTION TOWARD 1980 IS generally known as *Postmodern* art. The term was coined in the mid-1960s by European literary critics in the circle of the French philosopher Jacques Derrida (1930–2004) and first applied to literature. (Derrida's theories are also called Deconstructionism or Post-Structuralism.)

At the heart of European Postmodernism is the premise that all literature and art is an elaborate construction of signs, and that the meaning of these signs is determined by their context. A Raphael altarpiece, for example, meant one thing to a sixteenth-century Catholic viewing it in a church (its original context), but it conveys a different message today when it is presented as a fine art object in a prestigious museum. Context can change as viewers bring their personal experiences to the work. Postmodernists claimed there can be no fixed meaning, and thus no fixed truths. By the late 1970s, artists and critics had digested this theory and applied it to art. Postmodern theory now became the driving force behind much art making and criticism.

Of course, these ideas did not just form in the late 1970s. Marcel Duchamp had made similar statements in the 1910s, as did Conceptual artists, such as George Brecht and Joseph Kosuth, in the 1960s. Robert Rauschenberg, Andy Warhol, and Roy Lichtenstein in the 1950s and 1960s had all been interested in similar issues. While the immediate seeds of Postmodernism in the visual arts date from this period, a self-consciousness about entering a new era only occurred in the art world in the late 1970s. In large part, this new awareness stemmed from the critical writing in the new art magazine *October*, which reflected Derrida's ideas. (See end of Part IV *Additional Primary Sources*). Now a large number of artists and critics asked more overtly and persistently: How do signs acquire meaning? What is the message? Who originates it? What—and whose—purpose does it serve? Who is the audience and what does this tell us about the message? Who controls the media—and for whom? More and more artists, such as the American Cindy Sherman and the German Sigmar Polke, began using familiar images in new contexts, revealing—or *deconstructing*—their deeper social, political, economic, and aesthetic meanings. The preferred mediums for many of these artists were those of the mass media, namely photography, electronic signs, billboards, and video.

While this Postmodernist attitude signified a major thrust in art toward 1980, it has been only one of numerous issues that have preoccupied the art world in the last 25 years. The period is characterized by pluralism, in effect, continuing the pluralism associated with 1970s Post-Minimalism. Now, however, it had a philosophical foundation in Postmodern theory. By denying any one system, reading, interpretation, or truth, Postmodern theory destroyed the credibility of the authoritarian hierarchies of styles, media, issues, and themes, and it opened the door for everything and everyone. It also had an enormous impact on art history, as art historians began to question the validity of the traditional story of art, generally told from a narrow viewpoint that has emphasized the evolution of style. Now scholars approached art from countless angles, using issues of gender, sexual orientation, ethnicity, race, economics, and

Detail of figure 30.29, Ilya Kabakov, *The Man Who Flew into Space from His Apartment*

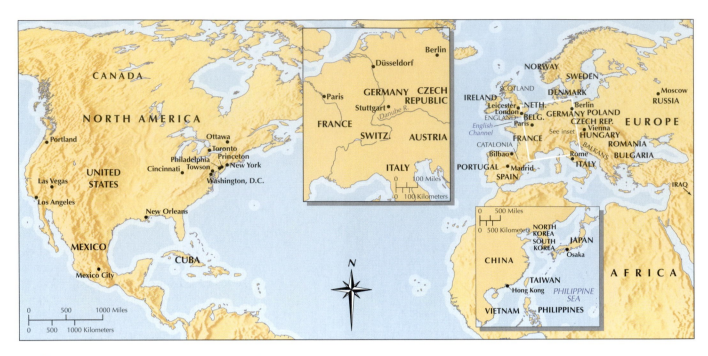

Map 30.1. Europe and North America (with Asia insert)

politics to demonstrate the many layers of meaning and ideas embedded in a work of art. In part, this trend had begun in the late 1960s, a result of the social revolution that accompanied the civil rights movement and the Vietnam War and challenged the validity of the status quo.

In effect, Postmodernism marked the end of the Modernist era. Modernism viewed modern art as a linear progression of one style building upon the last, continuously advancing art toward the "new." The search for the new had been a mandate of Modernism that had lasted into the 1950s and 1960s, as we saw in the art of Frank Stella and Donald Judd (see pages 1056 and 1058). The tearing down of all art barriers in those decades and the proliferation of styles and media in the pluralistic 1970s meant, in a sense, that there was nothing new to be done. By the 1980s, artists had license *not* to be new. Not only did they appropriate art in every imaginable style and media from the history of civilization and combine it as they saw fit, many of the leading artists, such as Felix Gonzalez-Torres, Jeff Koons, Kiki Smith, and Damien Hirst, did not even concern themselves with cultivating a distinguishable style as they jumped from one medium to the next, relying on a theme rather than a look to tie their work together. For them, message was more important than having a readily identifiable, single style, a quality that had been one of the hallmarks of Modernism. Artists also challenged the premium that Modernism placed on individuality and authorship; some began working in groups, such as Guerilla Girls, Group Material, and Collaborative Projects (Colab).

The Postmodern era also redefined the nature of the art world itself. The art establishment widened to embrace artists of all ethnicities and races, accepting all kinds of media, styles, and issues without placing a value on one over another. In this new multicultural environment, artists who had been marginalized in the 1970s became mainstream. Furthemore, artists from all over the world, not just America and Europe, molded contemporary art. A benchmark exhibition for presenting this new

world view was *Magiciens de la Terre*, presented at the National Museum of Modern Art (Pompidou Center) in Paris and featuring artists from all the continents, especially emphasizing those working out of the mainstream rather than those adhering to European and American trends.

The acceptance of artists worldwide mirrors the global restructuring of the last 25 years. Political and economic realignments resulted as first the U.S.S.R. and then China abandoned a strict adherence to Communism, experimented with capitalism, and opened up to foreign trade and investment. In the 1990s, Europe formed the European Union, and the United States, Mexico, and Canada signed the North American Free Trade Agreement. Barriers were falling everywhere, with people crossing borders more readily than ever before. Another important force behind the creation of a world art is the long-term impact of the American civil rights movement and the independence movements, especially in African and Asia, of the post-colonial 1950s and 1960s. These movements asserted their cultural traditions as viable and valuable alternatives to mainstream culture, which in the last 25 years have increasingly been woven into the fabric of a world culture. But perhaps the communications field more than anything else was responsible for the creation of the "Global Village." Television, cellular phones, satellites, computers, and the Internet have linked the world. The Post-Industrial era is also the Information Age. Today, the world's leading artists come from countries as varied as Lebanon, Iran, Israel, Cambodia, Thailand, Korea, Japan, China, South Africa, Mali, Russia, Colombia, Brazil, Cuba, and Iceland.

In this world of complex media and changing interpretations, scholars do not always agree on the meaning of Postmodernism. While the term initially was applied specifically to the European philosophy that emerged in the 1960s, today scholars and historians use the term quite loosely, to encompass all of the art made since 1980. In effect, they use it to mean art made after Modernism. We will use it in the same way.

ARCHITECTURE

Postmodernism appeared in architecture in the 1960s and was accompanied by a manifesto of sorts. In his book *Complexity and Contradiction,* the architect Robert Venturi called for a new architecture, one that rejected the cold, abstract Modernist International Style. The new architecture would be referential, that is, buildings would recall earlier architectural styles, or contain motifs that referred to the past and present. Furthermore, architects would be free to design buildings without following a set of the rules or principles. They were free, too, to be entertaining, and witty. Venturi's message was gradually absorbed by the architectural community. By the 1980s, an architecture that the architectural community labeled "Postmodern" emerged. The term was used specifically to describe work that made references to earlier periods and styles.

Since fundamental to European Postmodernism is the concept that no one authoritative style or set of principles can prevail, architecture since the 1980s reflects a broad range of issues and interests going well beyond just designing referential buildings. Among them is a revised Modernism, one strain of which we can call *Hi-Tech* because of its highly technological appearance. Another strain is *Deconstructivism*, a concept relating to Derrida's theories of Deconstruction and embracing the notion that architecture should not have a fixed structure or logic, thus being wide open to interpretation.

Postmodern Architecture: A Referential Style

Modernist architecture, best characterized by the International Style, was rule-bound and abstract. Some architectural critics — as well as the general public—found it cold and impersonal. With Postmodernist architecture, buildings, as in the nineteenth century, once again contain references to earlier architectural styles.

Sometimes they project a sense of place, imparting an aura of uniqueness that makes them special to those using them. While Postmodern architecture did not come to the fore until about 1980, a handful of architects had been advocating and practicing a new architecture by the 1960s, among them Robert Venturi and Charles Moore.

ROBERT VENTURI Robert Venturi (b. 1925) upset the architectural establishment by attacking Modernist architecture in *Complexity and Contradiction*. He challenged Mies van der Rohe's dictum "Less is more" with "Less is a bore" and argued that architecture could be whatever the architect wanted it to be. He asserted that art and the architectural past, as well as life itself, are filled with complexity and contradiction, and buildings should be too. Instead of being pure, simple, and conventional, buildings should be complicated, rich, and filled with references to the past and to the present as well. Buildings should contain meanings, even if these are contradictory, as in Mannerist architecture. And structures could be fun and humorous as well as serious. Venturi's idol was Louis Kahn who was also based in Philadelphia, and whose Modernist buildings such as the National Assembly Building (see fig. 29.43) in Dacca, Bangladesh, are filled with overt historical references. Venturi admired Kahn's daring use of symbolism and historical layering. Venturi outraged the architectural world again in 1972, when he published *Learning from Las Vegas* with his wife, the architect Denise Scott Brown. The couple declared Los Angeles and Las Vegas to be the modern-day equivalents of ancient Rome and Renaissance Florence, and they proposed that the strip malls, neon signs, and highways of these American cities reflected contemporary needs and a new architectural language, one that should be embraced by architects.

Venturi practiced what he preached. In 1962, he designed a house for his mother in Chestnut Hill, Philadelphia (fig. **30.1**).

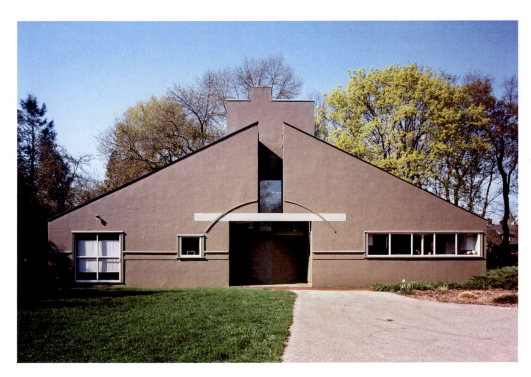

30.1. Robert Venturi. Vanna Venturi House, Chestnut Hill, Philadelphia. 1962. Venturi, Scott Brown and Associates, Inc.

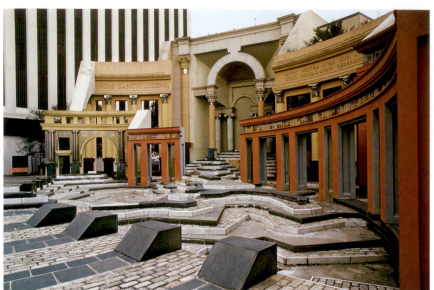

The structure resembles a Modernist abstraction of flat planes, strict geometry, clean lines, and a play of forms and spaces, notably in the enormous cleft in the center of the facade. But the house is also referential, for it is a parody of a conventional American home, complete with a slanted gable (the roof is much lower), a front porch, and behind that a large rectangular block that looks like a chimney. (It's a false chimney; the real chimney is dwarfed in front of it.) Venturi then complicates the house with endless architectural references—the cleft, for example, derives from Kahn's medieval-city buildings with slotted parapets and lintels embedded in the wall. The "lintel" that seems to support the two halves of the facade and the interrupted "segmental arch," floating over and framing the entrance, recall an Egyptian pylon. Venturi has imbued the over-scaled house with humor, irony, and allusions, transforming the traditional American home into a rich architectural statement.

CHARLES MOORE As important as Venturi for the development of Postmodern architecture was his contemporary, the Californian Charles Moore (1925–1993), who also idolized Kahn. Moore recognized that a sense of place was rapidly disappearing in America as strip malls and freeways were homogenizing the landscape. For him, excavating the past to design the present was one way to give a meaningful and distinct identity to modern America. Unlike Venturi, however, he obviously, rather than subtly, quoted the past, preferring especially the ancient Mediterranean world, which he used for his first Postmodern project, his own home, designed in 1962.

Moore's reliance on Classical antiquity is evident in his 1975 commission to design a plaza for the New Orleans Italian community, which needed a space in which to hold its annual festivals. The Piazza d'Italia (fig. **30.2**) consists of a series of concentric circles inlaid on the plaza. On one side

they are enclosed by layers of post and lintel screens incorporating all the Classical orders. These screens become increasing complex as they radiate out and on one side ascend stepped tiers, their increased elevation a metaphor for the Alps. Fountains and pools named for Italy's rivers gush from the steps. A map of Italy is inlaid on the paving stones, the Alps located on the stepped tiers and Sicily in the center of the plaza, thus emphasizing the heritage of most of the Italian residents of New Orleans. Triumphal arches and Classical pergolas lead to the plaza, helping to isolate it from surrounding streets and office towers. The post and lintel screens are painted in colors reminiscent of those used in Pompeian frescoes. Water gushes down columns adorned with stainless steel Ionic volutes and neon necks, which add a blaze of iridescent color at night. Moore simultaneously evokes Rome's Trevi Fountain, a glitzy 1960s American diner, and fragments of Roman colonnades, combining them in a fantastical modern vision that creates a powerful sense of place.

SITE At the other extreme, the Postmodern architect could abandon all pretenses to historicism and instead rely on anecdote, surprise, shock, wit, and ambiguity. We can see all of these qualities in the Best Products stores created by SITE (Sculpture in the Environment), a design team founded in 1970 by Alison Sky, Michelle Stone, and James Wines. Typical of the team's wit and cleverness is the 1976–1978 Tilt Showroom (fig. **30.3**) in Towson, Maryland. The building's facade seems to be precariously rising (or lowering) as though operated by an enormous garage-door opener gone awry. The effect is nothing less than surreal. This kind of anecdote or storytelling is duplicated in the Best Products Houston store, whose facade crumbles into a ruin, and in their Richmond, Virginia, showroom, where the bricks peel off like wallpaper. SITE describes these projects as "de-architecture" since the buildings appear to be self-

30.3. SITE (Sculpture in the Environment). Tilt Showroom of Best Products, Inc. Towson, MD. 1976–1978 (destroyed)

destructing. But in the world of strip malls and the monotonous repetition of identical buildings, the architects faced the challenge of designing a store that would stand out amid the cluttered urban sprawl. Clearly, SITE learned a lesson from the American highway culture that Venturi admired and described in *Learning from Las Vegas*, in which he suggested a vernacular language of signs and buildings shaped to attract consumers.

PHILIP JOHNSON By the late 1970s Postmodern architecture was appearing everywhere. Even a stalwart of Modernism, Philip Johnson (1906–2005), one of the curators for the 1931 Museum of Modern Art's International Style exhibition and coarchitect for Mies's Seagram Building, could not resist the enormous attractions of Postmodernism, and he became one of its most powerful proponents. However, when in 1978 he unveiled plans for his New York AT&T Building (fig. **30.4**), which he designed with his partner John Burgee, everyone thought he had gone mad. The skyscraper is an example on a grand scale of roadside *architecture parlante*, "speaking architecture," which can be seen in an ice cream stand shaped like an ice cream cone. Johnson's AT&T building is shaped like an enormous eighteenth-century American Chippendale highboy cabinet. (Some observers noted that it resembles a pay phone, with the coin slot at the top and the coin return at the bottom.) Above is the characteristic Chippendale scrollwork, and below, the highboy legs, which support the 28 "drawers," or stories, of offices. The base also recalls Brunelleschi's Pazzi Chapel (see fig. 15.11), which similarly has coffering and an oculus over an arch (this cannot be seen in our reproduction). Despite the building's humor and irony, this grand emblem of Americana has a severe monumentality, especially as experienced within the massive base at street level, which is completely within the Classical tradition, evoking a grand, if austere, Renaissance space.

30.4. Philip Johnson and John Burgee. Model for the AT&T Building (now the Sony Building), New York. 1978–1983

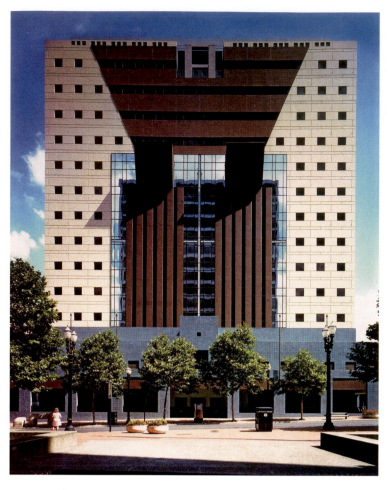

30.5. Michael Graves. Public Services Building, Portland, OR. 1980–1982

every design on the building's surface begs to be seen in several ways: flat and sculptural, representational and abstract, historical and modern. The form of the building is a Palladian cube sitting atop a platform, with the square or near-square motif echoed in the outline of the facade and in additional squares within (for example, the enormous mirror-glass window, which encases a square defined by the maroon vertical piers). The individual windows are each 4-foot square. The wall can be read as a flat mural, a thin Modernist membrane stretched over the metal skeleton; but suddenly it becomes three-dimensional and sculptural, an effect heightened by the maroon-colored vertical shafts in front of the large mirror window. These mullionlike shafts become the fluting of pilasters, topped with bracket capitals, which support an enormous keystone above. Yet, if you read the keystone with the beige-colored wall, it becomes part of a flat arch framing the mirror window. The facade can even be described as anthropomorphic, for the pilasters and keystone can be read as a huge face, the capitals as eyes, and the pilasters as legs. The building has a whimsical sense of play, but it is also serious, recalling such great historical models as Palladio, Mannerism, and one of Graves's favorite predecessors, John Soane, who is reflected here in the sublime pilasters (see fig. 24.33). The enormous curtain wall window, massive corner piers, and prominent "pediment" bring to mind Behren's Turbinenfabrik (see fig. 27.42), not coincidentally one of the great Early Modernist buildings made just before Modernism would abandon all overt reference to the historical past.

MICHAEL GRAVES Johnson played a major role in securing the 1980 commission for the Public Services Building (fig. **30.5**) in Portland, Oregon for the Princeton, New Jersey architect Michael Graves (b. 1934). The building is much more complex and difficult to interpret than Johnson's AT&T Building. Furthermore, it is filled with paradox, as

JAMES STIRLING As subtle, complex, and difficult as Graves is the London architect James Stirling (1926–1992), as can be seen in his Neue Staatsgalerie in Stuttgart (fig. **30.6**). This museum and theater complex is located on the side of a steep hill, with a highway at its base and a city street above. Like Kahn's National Assembly Building, Stirling's bold massing of simple forms and switchback ramps evoke ancient civilizations. Egypt especially comes to mind because of the large pylonlike forms

30.6. James Stirling. Neue Staatsgalerie, Stuttgart. 1977–1983

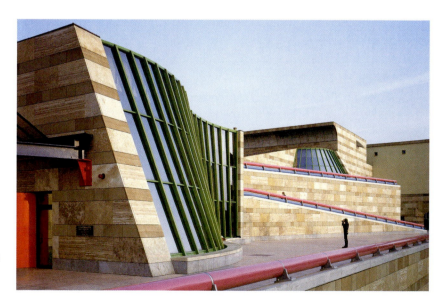

and clefts that allow for narrow passageways. The pattern of alternating sandstone and travertine suggests medieval Italian structures, while the enormous wavelike window of the museum reverberates with memories of Paxton's Crystal Palace and the great curtain-wall window in Behren's Turbinenfabrik. The curving window also suggests a grand piano, reminding us of its function as a theater. The pink and blue tubular railing and the blue I-beam support for the "pedimented" museum entrance are Hi-Tech and industrial. The same can be said for the skeletal taxi stand, whose ferrovitreous construction is also reminiscent of Paxton, while its form recalls a Greek temple. As in the work of Venturi and Graves, all these familiar sources are seamlessly melded into a unified vision that brings the past into the present. The result is a building that is distinctly modern yet imparts a Kahn-like monumentality and aura of importance.

New Modernisms: High-Tech Architecture

Late 1970s and 1980s Postmodernism, with its historicism and symbolism, was important for launching new architectural freedoms. Released from the narrow constraints of pure Modernism, architects were free to explore a new range of possibilities that went well beyond the eclectic historical references of Postmodernism. Facilitating and even encouraging artistic license was the economic boom of the 1980s and 1990s, when unprecedented amounts of private and corporate money poured into building projects, dramatically energizing architecture and architectural vision. Just as New York real estate developers in the 1920s had competed to create the tallest building, so clients worldwide now strove to erect the most spectacular, exciting structure, one with international cachet. At every level, the public was no longer settling for undistinguished generic Modernist buildings. Even the American strip malls of the 1990s became Charles Moore Mediterranean minicities (Victorian, Queen Anne, Tudor, and Romanesque are popular styles as well), with many of those built in earlier decades in a Modernist style getting Postmodern face-lifts.

Major Postmodern architecture in the vein of Venturi and Moore faded in the 1990s, superseded by an exhilarating diversity that expanded architecture to a true Postmodernism. Many architects now revisited Modernism, reinvigorating it with the new artistic license that had emerged during the late 1970s. An extreme version of this New Modernism is Hi-Tech, a style whose buildings resemble powerful industrial machines. Like Postmodern architecture, the most immediate roots of Hi-Tech design can be found in a few rare examples in the 1950s and 1960s, such as James Stirling's 1959–1963 Engineering School in Leicester, England (fig. **30.7**). The building looks more like a factory then a school. Its vents and maintenance hoist are boldly exposed. The building's massing and angularity exude a fierce energy, which is characteristic of Brutalism (see page 1073). Perhaps the most famous prototype for Hi-Tech Modernism is the 1971 Pompidou Center (fig. **30.8**) in Paris, There, architects Richard Rogers (b. 1933) and Renzo Piano (b. 1937) exposed the building's utilities—instead of being buried within

the interior, they are displayed on scaffolding around the perimeter of what is otherwise a classical Modernist glass box. Elevators, escalators, and plumbing, electrical, and ventilation ducts are all prominently displayed as exterior "ornament." Besides challenging architectural aesthetics, this device has the advantage of completely opening up the interior space, allowing for any necessary configuration.

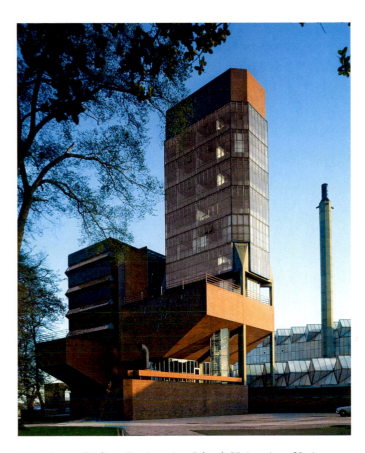

30.7. James Stirling. Engineering School, University of Leicester, England. 1959–1963

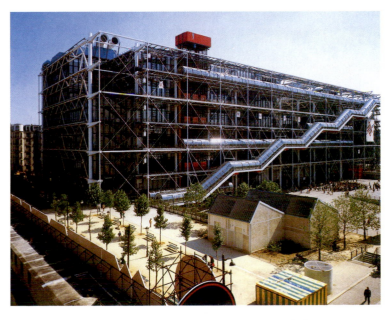

30.8. Richard Rogers and Renzo Piano. Centre National d'Art et Culture Georges Pompidou, Paris. 1971–1977

shafts at either end of the building, allowing the interior to be virtually free of obstructions (fig. **30.10**). Foster transformed the ground floor into a piazza, opening it up to the surrounding streets and leaving it unlevel since the streets themselves are at different elevations. The piazza has an enormous curved ceiling, penetrated by escalators that ascend to a spectacular atrium (extending 10 stories and 170 feet high and seen in our reproduction), off of which are balconies of work space. On the south side of the building, computer-driven mirrors (called "sun scoops") track the sun and reflect light onto a second set of mirrors that in turn direct light down into the piazza, which becomes filled with spectacular natural light strong enough to cast shadows. Inside and out, machines, mechanics, a megastructure of truss work, rooftop maintenance hoists, and sleek service shafts define the building, giving it an appearance of industrial strength, efficiency, and functionalism.

RENZO PIANO If Foster's HKSB building dazzles and even shocks with the complexity and scale of its Hi-Tech look, the Kansai Airport (figs. **30.11** and **30.12**), designed by Renzo Piano, is breathtaking in its simplicity. Built between 1988 and 1994, the airport terminal measures 1.7 kilometers (1.06 miles), making it the world's longest building. It was constructed on an artificial island five kilometers off the coast of Osaka and is accessible by train, car, and hydrofoil. Airports generally are sites of confusion, and designing one at this scale presented an enormous challenge. Piano's solution is masterful. The

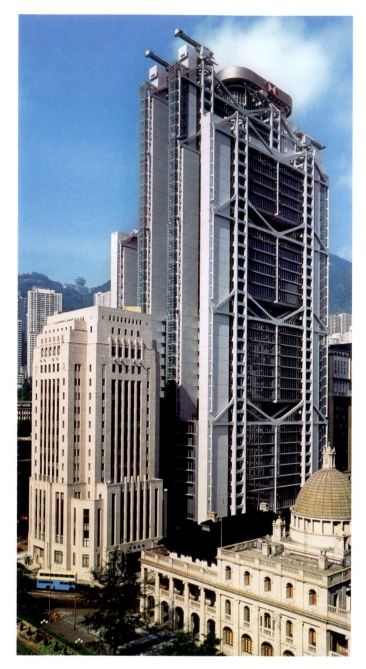

30.9. Norman Foster. Hong Kong and Shanghai Bank, Hong Kong, China. 1979–1986

NORMAN FOSTER By the late 1970s, Hi-Tech Modernism came to the fore, its arrival announced in part by the eye-popping Hong Kong and Shanghai Bank (HKSB) (fig. **30.9**), designed in 1979 by Norman Foster (b. 1935) at a cost of $1 billion. Here was a skyscraper that did not look like a skyscraper. Gone is the grid of the typical office tower, replaced by a complex structural apparatus that looks like a machine. The building is composed of four units, each consisting of four colossal piers that are pushed to either end of the rectangular building. Mammoth truss-work supports are cantilevered from these piers, and the floors then hang from these cantilevers in five stacked groups of six to nine floors each, groups that Foster called "villages." Elevators stop only on the communal floor of each village, and escalators then connect the remaining floors. All the services, including elevators, are placed in sleek

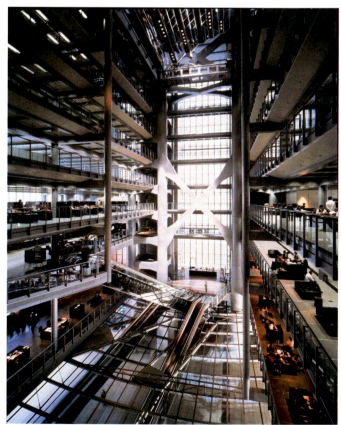

30.10. Norman Foster. Interior of the Hong Kong and Shanghai Bank

30.11. Renzo Piano. Aerial view, Kansai International Airport, Japan. 1988–1994. Courtesy, Renzo Piano Building Workshop, architects-N. Okabe, senior partner in charge in association with Nikken Sekkeí Ltd., Aeroports de Paris, Japan Airport Consultants, Inc.

30.12. Renzo Piano. View of roof, Kansai International Airport. 1988–1994. Courtesy, Renzo Piano Building Workshop, architects-N. Okabe, senior partner in charge in association with Nikken Sekkeí Ltd., Aeroports de Paris, Japan Airport Consultants, Inc.

building is in the shape of a long airplane wing, with the entrance located at what looks like an airplane's elevation flap and forming the base of the T-shaped ground plan. The interior retains this wing shape, making travelers feel as though they have boarded an airplane. As in a Beaux-Arts building, visitors immediately know where to enter and where to go. Domestic flights are located closest to the entrance; international flights are at the ends. Layers of ferrovitreous walls allow travelers to see where they are at any time, and computerized shuttles whisk them to their destinations. This building is so rational and clear that signs are unnecessary. Clad in a shiny space-age-looking metal, the aerodynamically sleek structure immediately engenders confidence in the technology and efficiency of air travel.

Deconstructivism: Countering Modernist Authority

In 1988 the Museum of Modern Art mounted an exhibition titled *Deconstructivism*. The show included seven architects whose work displayed a Constructivist geometry and planarity that created an architecture of "disruption, dislocation, deviation, and distortion," as Mark Wigley, who co-curated the exhibition with Philip Johnson, wrote in the accompanying catalogue. Originally the show, proposed by architect Peter Eisenman, was to have been called "Violated Perfection," which would have spared everyone from struggling to determine what Deconstructivism actually is. The term caught on, however, with none of its advocates agreeing on a definition or

even who is a Deconstructivist. The show's curators derived the term from Derrida's theory of Deconstruction. Esssentially, Derrida's theory posits that there are no firm meanings to any written text; outside of the text there are infinite forces that continually restructure its meaning and provide endless readings and interpretations. Similarly, Deconstructivist architecture had no fixed meaning. Wigley and Eisenman linked architectural Deconstructivism with Russian Constructivism. This connection is based on style and not theory, since Constructivism was about establishing a new order and a utopian perfection, whereas Deconstructivism focused on denying any fixed structure or logic.

Ironically, most of the architects in the show had no or little interest in Derrida, and if they did, it was through indirect associations rather than a reading of his abstruse writing. That said, a major trend emerged in the 1980s that challenged the idea that architecture had to adhere to any single concept or ideal. These architects rebelled against the notion that architecture had to aspire to some kind of perfection, order, or logic.

COOP HIMMELBLAU Early advocates of this movement are Wolf Prix (b. 1942) and Helmut Swiczinsky (b. 1944), whose Viennese firm Coop Himmelblau was included in the 1988 *Deconstructivism* exhibition. Their aesthetic is prominently displayed in the rooftop conference room (fig. **30.13**) they designed in 1983 for a law firm in Vienna. No explanation or logic can be applied to this architectural phenomenon, in which the roof seems to explode, creating a sense of catastrophe wholly at odds with the staid conservatism usually associated with the legal

30.13. Coop Himmelblau. Rooftop Office, Vienna. 1983–1988

profession. Even the materials are jarring, conflicting violently with the nineteenth-century apartment building below. The planarity of the forms may suggest Constructivist sculpture, but the design lacks the clarity, structure, and logic of the Russian movement. The project is devoid of historicism and architectural references. Replacing order and logic is a sense of slashing, thrusting, tilting, fragmentation, and skewing. Yet these attributes are not about destruction, demolition, dismantling, or disaster. Rather, the architects aspired to disrupt preconceived notions of architecture.

ZAHA HADID Zaha Hadid (b. 1950) is the one artist who is on everyone's list of Deconstructivist architects, although she has little interest in Derrida and claims her work is not based in theory, but instead is intuitive. Born in Iraq and trained and based in London, she was heavily influenced by the energized geometric forms of Suprematism (see pages 956–968). Hadid's projects generally show her concern for creating easily perceived fluid spaces that encourage people to come into and move about her structures.

In the Lois and Richard Rosenthal Center for Contemporary Art in Cincinnati (fig. **30.14**), which opened in 2003, broad shifting Suprematistlike planes and Constructivistlike boxes move up and down and in and out on the museum's facade. Hadid describes the facade as an "Urban Carpet," and in fact, the sidewalk curves slowly upward into the building, encouraging people to enter. The ground floor is a landscaped lobby, serving as an enclosed park, further encouraging visitation. It is dominated by a dramatic series of lobby ramps that run the length of the entire space. The ramps lead to a mezzanine that opens onto galleries. The galleries and their shapes are visible from the street, further enticing the public to enter the museum. Because the museum does not have a permanent collection and only mounts temporary exhibits, Hadid designed a wide range of spaces to accommodate all kinds of art objects. The galleries appear to be suspended in space, floating on a variety of levels. This sense of energized fluidity, not only within the museum but also in the relationship of the street and sidewalk with the building, is one of the hallmarks of Hadid's work.

FRANK GEHRY Frank Gehry (b. 1929) was also one of the seven architects included in the 1988 *Deconstructivism* show, but he views himself as an independent, refusing to be associated with any style or group. Nevertheless, his projects share with Coop Himmelblau's rooftop office a sense of disorder, fragmentation, and energy, as seen in his most famous project, the Guggenheim Museum, Bilbao (fig. **30.15**). Its unique forms and vocabulary make it impossible to establish any specific meaning or architectural references. People have described the building's forms as a boat, a fish, and a blossoming flower (Gehry's own description), but ultimately the structure is an exploration of the abstract sculptural play of enormous volumes, and it shows clearly the architect's pure delight in architectural freedom.

The building's curvilinear masses are contrary to orthodox Deconstructivism, which emphasizes flat planes and angularity.

Gehry designed their complex forms using computer technology, an integral tool in the fabrication of the building as well. (See *Materials and Techniques*, page 1088.) The museum even feels High-Tech, for covering the steel skeleton is a thin skin made up of thousands of tiny titanium shingles. These shimmer in the light, changing color—silver, blue, gold—as the time of day or the weather changes. The interior is equally spectacular. A handful of conventional, rectilinear rooms containing modern art contrast with large, irregularly shaped galleries that accommodate contemporary works. One such space is the so-called boat gallery, a long corridor created by two massive convex walls. Perhaps the most sensational area is the vast entrance atrium. Crisscrossed by catwalks and lined with elevator cages, the atrium contains spiraling ribbons of piers and opens up to a sea of windows and skylights.

The Guggenheim, Bilbao is an example of the architectural diversity that had emerged by the end of the twentieth century, when all rules about design were suspended. As important, it reflects how architecture has moved beyond just being about designing buildings. Architects have, once again, begun to create prominent symbols for a city. From its conception, the museum was intended to be more than just a museum; it was meant to change the image of this Spanish industrial port, giving it cultural cache and transforming it into a tourist destination. That is precisely what happened: Gehry designed one of the greatest buildings of the twentieth century, a satellite of Frank Lloyd Wright's sensational 1950s Solomon R. Guggenheim Museum in New York (see figs. 29.38 and 29.39), which it rivals in audacity and individuality.

30.14. Zaha Hadid. Lois and Richard Rosenthal Center for Contemporary Art, Cincinnati. 2003

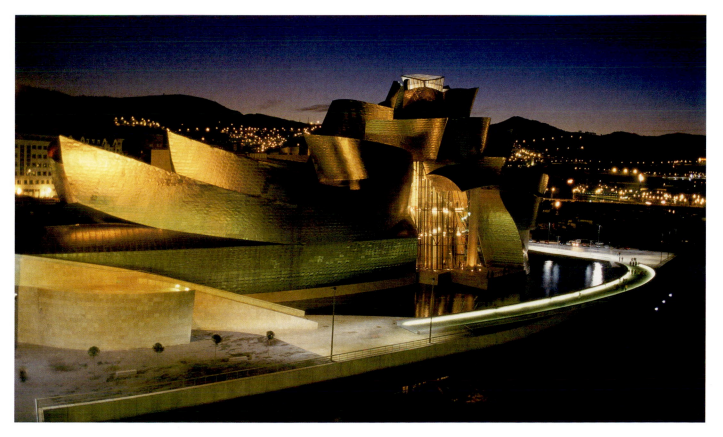

30.15. Frank Gehry. Guggenheim Museum, Bilbao, Spain. 1992–1997

Computer Aided Design in Architecture

In the early 1990s, architects began using CAD (computer-aided design) to create their buildings. In the "paperless studio," plans were developed using computer programs without the use of traditional architectural drawings or models in wood and cardboard. This approach to design was initially quite controversial, since it forsook the age-old intuitive process of creating by putting hand to paper or modeling with wood or cardboard.

Frank Gehry used a CAD program to produce the extremely complicated forms of the Guggenheim, Bilbao, and without this advanced technology, the structure and its titanium veneer probably would have been difficult to achieve, or at least the building would have been prohibitively expensive. The CAD program that Gehry, with his associate Him Glymph, selected is called CATIA, originally developed by Dessault Systems of France to digitally design and precisely produce extremely complicated products, such as airplane wings and fuselages for the French aerospace industry.

Perhaps more important for Gehry and Glymph than facilitating the design, CATIA made the fabrication possible. Without CATIA, Gehry would have had to hand his plans over to artisans and workers, who then would have been challenged to precisely translate them into three-dimensional forms, a daunting if not impossible task. (Frank Lloyd Wright had tremendous difficulty finding a contractor willing to build his highly irregular, organic Solomon R. Guggenheim Museum in New York.) Instead, Gehry and Glymph sent computer files to fabricators, who fed

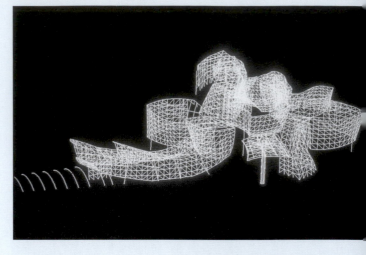

Computer generated diagram of the Guggenheim Museum, Bilbao, Spain

the digitized information into computer-robotic equipment that then manufactured the forms. Every detailed component of the building could be produced this way, from each unique oddly shaped window to each irregular titanium slate. CATIA also kept costs down. It no longer mattered that large segments of the building were uniquely sized and shaped and therefore could not be cost-effectively mass-produced. The computer program could manufacture each unique product with virtually the same expediency and cost as those of a Modernist building that has thousands of uniform windows and I-beams.

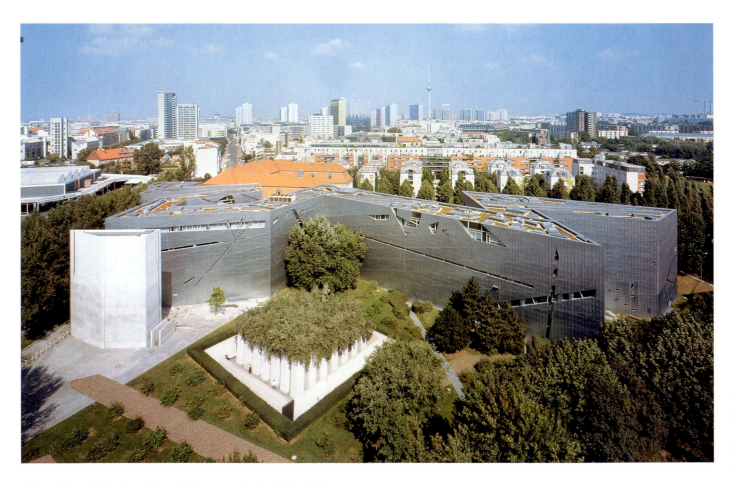

30.16. Daniel Libeskind. Jewish Museum, Berlin. 1989–1998

Architecture, Experience, and Memory: Daniel Libeskind

The Jewish Museum in Berlin (fig. **30.16**), designed by David Libeskind (b. 1946), reflects how varied and complicated architecture has become, as well as how it is now often used to raise public awareness of historical and social issues, even becoming central to a city's identity. Built in Berlin from 1989 to 1998, the building reminds us of the Deconstructivist style as defined by Eisenman in 1988: Its surface is piercing, fractured, zigzagging, slashing, and disorienting. But, although it is composed of

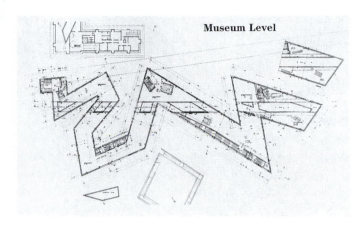

Museum Level

30.17. Daniel Libeskind. Plan of the Jewish Museum, Berlin

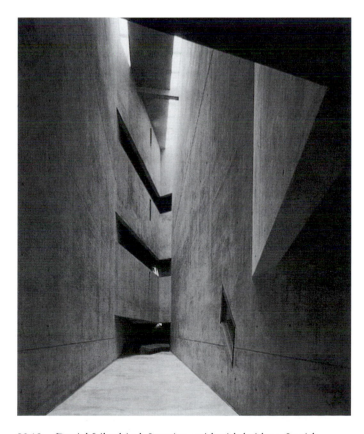

30.18. Daniel Libeskind. Interior, void with bridges, Jewish Museum, Berlin. 1989–1998

jagged, shifting planes, similar to those in the work of Hadid and Coop Himmelblau, Libeskind's building is imbued with metaphor and meaning. The zinc-covered High-Tech exterior is brutal and angry as well as fortresslike and insular. The plan of the building (fig. **30.17**) is organized around two lines. One is the continuous, tortuous zigzag that continues to "infinity." The other is a fragmented straight line that defines a concrete hollow space 13 feet wide and 90 feet high, (fig. **30.18**) that appears and disappears through six of the zigzagging segments. Some of these voids are completely sealed; others can be seen from bridges or windows, although they cannot be entered. The zigzagging line imparts a sense of meandering journey, appropriate for a museum of Jewish history and cultural objects, whereas the austere voids symbolize tombs for victims of the Holocaust as well as evoke the persistent presence and continuity of Judaism. Libeskind has described the plan as a broken Star of David. It also resembles a thunderbolt, perceived by many as an instrument of divine wrath. The shape recalls as well the Nazi SS, Hitler's special police corps whose uniforms bore a thunderbolt. This aggressively dynamic, and even violent, building—punctuated by zones of silence, meditation, and mourning—is loaded with meaning and emotion, qualities completely foreign to the Deconstructivist works of Coop Himmelblau and Hadid (see figs. 30.13 and 30.14). Even Libeskind's role as architect is meaningful. Now a United States citizen, he was born in Poland to survivors of the Holocaust. As architect Frank Gehry said of Libeskind, "You feel his anger about the Holocaust in this building."

POST-MINIMALISM AND PLURALISM: LIMITLESS POSSIBILITIES

Beginning in the late 1960s, the Post-Minimalists had rejected the austerity of Minimalism (see pages 1055–1058) and once again returned the human figure, the artist's hand, subjectivity, and references back into art. The reaction to Minimalism was accompanied by the rise of a broad range of issues, styles, and media in the 1970s. During the 1980s this pluralism began to gain widespread acceptance as it moved from marginalized art to the mainstream. At the same time, Derrida's Postmodern

theory provided a philosophical basis for pluralism, as it argued against all authoritative aesthetics and philosophical positions. The Modernist notion that one and only one style was correct and could move art forward at any given moment was dead. Indeed, if a single word could encapsulate the art made since the 1980s, it would be "diverse." The art market, too, has become truly global, with artists from every continent developing individual styles that express a wide range of subjects in almost limitless media. Art has become so complex that it has become difficult to comfortably place an artist in a single category or hang a label on her or him.

Among the many developments of the last 25 years are a revival of interest in painting, the popularity of installation art, and the ascendance of photography and video as leading media. Among the more popular themes are racial, ethnic, and gender identity, a preoccupation with the body and death, and a Postmodern analysis, or Deconstruction, of how images and art take on meaning. But if there is anything that unites this period, it is the belief that Modernism and its authoritarian posturing is dead, and that the possibilities of what art can be and be about are limitless.

The Return of Painting

Painting was back by 1980. Not that it had disappeared, but in the late 1960s and 1970s it had been overshadowed by Conceptual, Video, Performance, and Earth art. The Derrida-influenced art critics of the late 1970s associating painting with Modernism were talking about "the death of painting," even though a stream of shows featuring the medium opened in London, New York, Germany, and Italy in the late 1970s and 1980s. In the introduction to his book about painting's revival, critic Achille Bonito Oliva wrote in 1982, "The dematerialization of the work and the impersonality of execution which characterized the art of the seventies, along strictly Duchampian lines, are being overcome by the reestablishment of manual skill through a pleasure of execution which brings the tradition of painting back into art." Another staunch advocate of painting, Christos Joachimides, lauded the medium because now "Subjectivity, the visionary, myth, suffering and grace have all been rehabilitated." The demand for painting was fueled by an explosion of personal and corporate wealth in the 1980s in America, Western Europe, and Japan. As the recession of the 1970s ended, demand grew for art that could be bought and hung on a collector's wall or in a corporate lobby.

The new type of painting that emerged came to be known as Neo-Expressionism, an appropriate label for works that are both painterly and expressionistic. Neo-Expressionism appeared first in Germany and Italy in the 1970s and then migrated to New York. In Germany, painters self-consciously recalled the Northern Romanticism and Expressionism so deeply ingrained in that nation's culture. Joseph Beuys, through his mystical performances, was the catalyst for this resurrection of the German past. Among the themes he and other artists began to explore was the legacy of Hitler's Third Reich.

ANSELM KIEFER Among Beuys's students at the Düsseldorf Art Academy was Anselm Kiefer (b. 1945). Kiefer created images of mythical themes and epic scope that evoke centuries of German history. Kiefer's enormous painting *To the Unknown Painter* (fig. **30.19**) explodes with the energy of flailed paint and the dramatic perspective of crop furrows rushing toward an eerie monumental tomb. Cold, bleak, and lifeless, the neutral-colored image seems to exude an atmosphere of death. Or does it? Crops lying fallow in the winter will be reborn in the spring; the cycle of life continues. Kiefer's expressive use of paint and dramatic composition can be interpreted as a metaphor for the constant movement and force of nature. Inspired by Beuys's use of symbolic objects, Kiefer often incorporated real materials into his paintings, imbuing them with a similar ritualistic magic. In this work, he embedded straw into the paint, and viewers could smell its scent for years. Nature is not just illustrated in this work, it is physically present. Yet unlike crops in a field that continually rejuvenate, the straw in this painting will eventually disintegrate.

How does the tomb fit into this image? As the title suggests, the mausoleum is for painters. We deduce they are German because the tomb is not painted but rendered in a large woodcut, a medium associated with German art since being widely used by Northern European artists during the Renaissance as well as by the Expressionists in the early twentieth century (see page 958). The bunkerlike shape suggests a shelter, and the isolated but well-anchored monument seems to be surrounded by the swirling forces of nature, representing not only the German mythical past but also the Romantic spirit that has driven German artists for centuries. We know from other works by Kiefer that these destructive forces are meant to symbolize Hitler's perversion of the German Romantic tradition, which he manipulated to serve his racist agenda. During the Third Reich, all avant-garde artists, even those who supported the Nazi party, were suppressed.

In a painting about national identity, Kiefer's Expressionistic style and use of Romantic themes proclaim his place within the Northern European Romantic tradition. He assures us that this tradition is once again in safe hands. With its wealth of symbols, metaphors, and overlapping and interlocking interpretations, the resulting image is varied and complex, reflecting the epic scale Kiefer covers and the mythical themes he evokes.

JEAN-MICHEL BASQUIAT Of the many American Neo-Expressionists to emerge in the 1980s, among the most exciting was Jean-Michel Basquiat (1960–1988). Born in New York to a middle-class family, Basquiat's father was Haitian and his mother was of Puerto Rican descent. He dropped out of school at age 17, first writing poetry and then becoming a street artist using the tag name SAMO ("same old"). By studying art books, he became knowledgeable about art history and began painting. By the time he was 22, he had achieved international stardom. He died of a drug overdose at age 27.

In *Horn Players* (fig. **30.20**) of 1983, Basquiat combines both poetry and graffiti. More important, he draws upon the lessons of the pluralistic 1970s by brilliantly incorporating the era's strategies of using texts, making process art, working with narratives, and dealing with social politics, here racial identity.

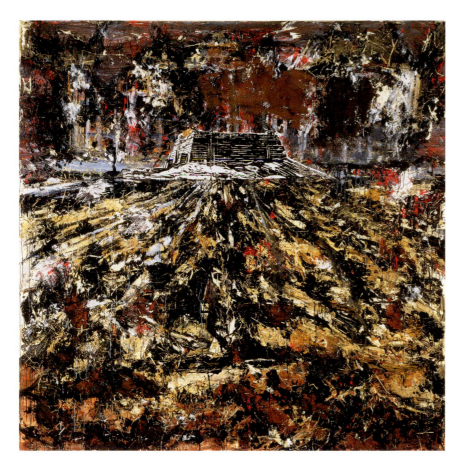

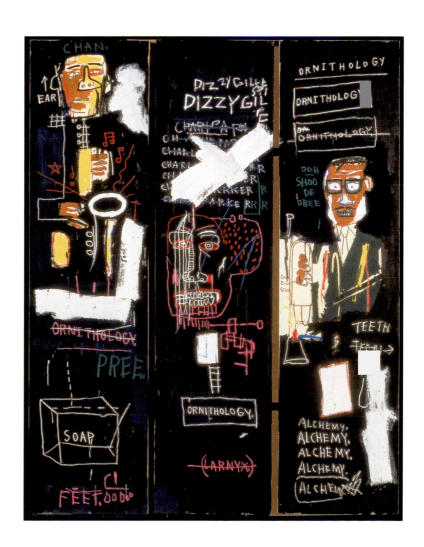

Basquiat also owes a debt to Abstract Expressionism, seen in his dynamic handling of paint, and to Pop Art, visible in his cartoonlike imagery and popular-culture references.

Basquiat was prolific, working quickly and with the stream-of-consciousness intensity sensed here. We can feel him painting, writing, crossing out. He draws us into the canvas by forcing us to read and piece it together. He makes us experience the sounds coming out of the saxophone, think about the repetition of words and the rhythms they make, and analyze his masterful use of color—a brilliant pink and blue here, yellow and green there. Because they are so powerfully presented, we cannot dismiss Basquiat's use of the words, such as *alchemy* (a reference to the alchemy of jazz), *ornithology* (a nod to jazz musician Charlie Parker, nicknamed "Bird"), and *ear* (an allusion to musical instinct). His works evoke the raw energy of the 1950s; the Beat poetry, improvisational jazz, and Abstract Expressionism. But 1980s hip-hop also comes to mind. Basquiat creates a powerful, sensuous experience as he shares his passionate feelings about the black musicians Dizzy Gillespie and Charlie Parker with whom he clearly identifies. Much of his work features African-American musicians, singers, and athletes, and is a reflection of the importance artists were now giving to racial, ethnic, and gender identity.

ELIZABETH MURRAY In 1978 the Whitney Museum of American Art in New York mounted an exhibition of American artists entitled *New Image Painting*. The show not only claimed that painting was alive and well, it heralded the arrival of a new kind of painting, one that had representational objects embedded within seemingly abstract paintings. At the time, Elizabeth Murray (b. 1940) was producing totally abstract works and was not included in the show. But within a few years, she began adding representational components to her abstraction. Because of their associations, these recognizable elements served as a metaphor for a psychological state. Murray's evolution to referential abstraction can be seen in *More Than You Know* (fig. **30.21**) of 1983. At a glance, the painting appears to consist of entirely abstract shapes. But we soon realize that the sweeping organic curve playing off a blue-gray Constructivist rectangle is the back of a spindle-back chair. We then recognize the mostly gray rectangle as a painting hanging on a yellow wall. Finally, the green anthropomorphic shape evolves into a table with collapsed legs. On the table lie a white form resembling a piece of paper and a disturbing biomorphic shape that recalls the skull in Munch's *The Scream* (see fig. 26.21). Tension dominates the image, symbolized by the collapsed table as well as the strident colors, the unfinished-looking paint handling, and the violent tilt of the floor. Even the shape of the painting is frenzied. Murray combines ten canvases, overlapping them and producing a ragged profile that transforms the painting into a wildly spinning pinwheel. Nothing seems to be anchored in this composition as objects shift like detritus adrift in a stormy sea. In her three-dimensional, heaving paintings Murray continually focuses on the psychological tension of daily life, the edgy reality that lies beneath the facade of domestic harmony.

Sculpture

The Post-Minimal aesthetic in sculpture, which combined the geometry of Minimalism with references and emotion that we saw in the work of Eva Hesse and Richard Serra (see page 1060), continued unabated into the 1980s and 1990s. It could appear in such diverse forms as beautifully crafted mysterious objects, as in the work of Martin Puryear, or readily understood public monuments, as the Vietnam Memorial by Maya Lin.

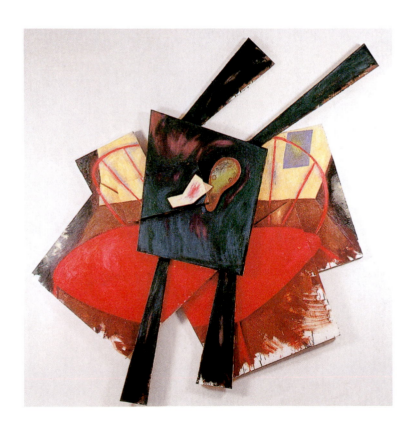

30.21. Elizabeth Murray. *More Than You Know*. 1983. Oil on ten canvases, 9'3" × 9' × 8" (2.82 × 2.74 × 20.3 m). The Edward R. Broida Collection. Courtesy Pacewildenstein Gallery, New York. © Elizabeth Murray

MARTIN PURYEAR One of the many outstanding sculptors who made objects rather than installations is Martin Puryear (b. 1941). Puryear fulfills in sculpture "the reestablishment of manual skill through a pleasure of execution," as the critic Oliva had said about painting. After serving in the Peace Corps in the West African nation of Sierra Leone, studying print-making and woodworking in Sweden, and visiting Japan, Puryear settled in Brooklyn in 1973, where he soon emerged as a leading sculptor of his generation.

One of the first things we notice is the craftsmanship of his 1985 wood and steel sculpture *The Spell* (fig. **30.22**). We marvel at the beauty of the curved shapes, the elegant tapering of the cone, the playful variety of its rectangular openings, and the sensuous texture of the flat, striated wood strips that make up the "webbing" of what looks like a basket. The allusion to basket making suggests crafts and craftsmanship, which in turn implies a human presence—we sense the hand that carefully constructed this object, unlike Minimal Art, which seemed mass-produced and machine-made. We also sense Puryear's background not only in Africa, where he would have seen magnificently crafted utilitarian and ceremonial wooden objects, but also in Sweden, where he trained in woodworking, and in Japan, a culture with a long tradition of crafting wood into functional and decorative objects. It would be a mistake, however, to interpret Puryear's references to African art as an acknowledgment of his African-American background. His sculpture is not about ethnic identity and politics but instead reflects his broader experiences in diverse cultures well versed in using wood as an artistic medium.

The Spell defies interpretation. Resembling a trap lying on the floor, the sculpture appears to be utilitarian but is not. Despite its title suggestive of mystery and sorcery, there is nothing ritualistic about the work. Rather, we sense the essence of

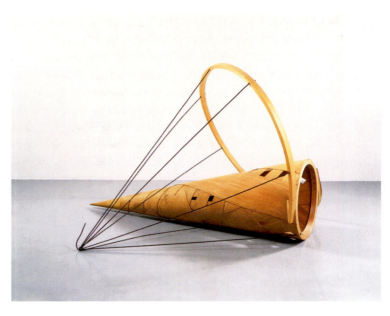

30.22. Martin Puryear. *The Spell*. 1985. Pine, cedar, and steel, 4′8″ × 7′ × 5′5″ (1.42 × 2.13 × 1.65 m). Collection of the artist. Courtesy of the McKee Gallery, New York. © Martin Puryear

the wood itself, and therefore the sculpture evokes nature. Yet it is the human component—the craftsmanship—that prevails. Like Eva Hesse (but working in a radically different style), Puryear transforms the austerity of Minimalist geometry into an enigmatic yet warm organic object loaded with powerful human allusions.

MAYA LIN One of the great Post-Minimal sculptures of the 1980s is the *Vietnam Veterans Memorial* (fig. **30.23**) by Maya Lin (b. 1959). Lin received the commission while still a student in

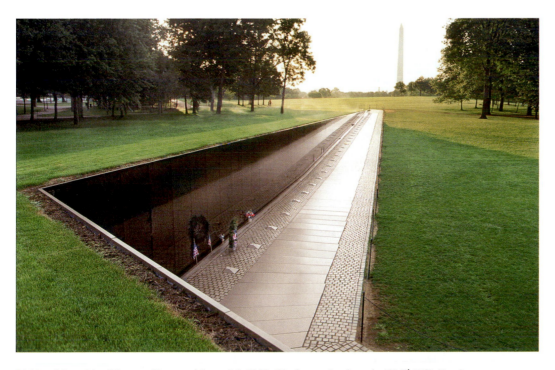

30.23. Maya Lin. *Vietnam Veterans Memorial*. 1982. Black granite, length 493.5′ (150.42 m). The Mall, Washington, DC

the architecture program at Yale University. A daunting project because of the strong emotions and opinions surrounding the Vietnam War, Lin's solution proved beautiful in its simplicity, ingenious in its neutrality, and sublime in its emotional impact. Lin presents the names of the dead and missing in action in a chronological list from 1959 to 1975. The names are etched into slabs of black granite that carve out a V-shaped gash in the earth. Viewers start reading from the left, representing the year 1959, where the first killed are listed and the granite rises out of the ground. The name-laden stone gradually rises along its 247-foot (75.2-meter) length as more and more Americans die. The names keep coming, and the viewer soon becomes emotionally overwhelmed by their number.

At its 10-foot peak, the granite turns at a 130 degree angle and then descends along another 247-foot length, with fewer soldiers listed as the 1973 withdrawal from Vietnam approaches. At the end, as the granite again disappears into the ground, many viewers are left with an feeling of existential nothingness. Adding to this sense of loss is the impact of the granite's polished surface, which acts like a mirror casting reflections of the living onto the names of the dead. This memorial is a sharp departure from traditional representational monuments to heroism, like Rude's *La Marseillaise* (see fig. 24.30), which glorified nationalistic spirit and dedication. In a sense, the granite wall acts as an enormous tombstone. While the monument takes the form of Minimal sculpture, it has been transformed through references into a brilliant Postmodern monument of powerful emotions.

Deconstructing Art: Context as Meaning

By 1980 many artists were making art that analyzed how images functioned. We have seen Warhol and Lichtenstein doing this in the 1960s, by appropriating mass-media images to comment on how they influence public perception. Warhol focused on the camouflaging of products to make them alluring, while Lichtenstein revealed social stereotyping. (See pages 1051–1054.) Now, influenced by Derrida's ideas about Deconstruction, even more artists were exploring how images function and how context affects meaning. They were also influenced by a second French Postmodern or Post-Structuralist philosopher, Jean Baudrillard (b. 1929), and especially by his theory of simulacrum. Baudrillard wrote that contemporary American culture was based on a notion of hyperreality—that Americans, especially through the mass media, including films and television, had constructed an artificial, perfect, timeless world that was more "real" than reality itself. In effect, the copy had replaced authenticity, and looking at images and experiencing the world through images had become a simulacrum, or visual substitute, for real experience. Artists now began representing this simulacrum, appropriating images from the mass media, and analyzing how context affects meaning.

In effect, their art was about deconstructing images as used in the social environment. Often they appropriated images and designs. They then recontexualized and layered this imagery with the intention of exposing, or deconstructing the social,

aesthetic, political, and economic systems that the original images presented. The final effect was to demystify, even undermine, the authority of the original image. By putting images into new contexts, artists revealed how they were initially used to promote the view of one group, often at the expense of another.

THE PAINTINGS OF SIGMAR POLKE During the 1960s and 1970s, the art world was focused so heavily on New York that other art centers, especially those in Europe, were all but ignored. Particularly in Germany, artists in the city of Düsseldorf were producing some of the most important work of the period, yet only Joseph Beuys was well known internationally. It was not until the mid-1980s that the New York art world discovered Sigmar Polke (b. 1941), Gerhard Richter, and the photography team of Bernhard and Hilla Becher. Along with Anselm Kiefer and a handful of other Düsseldorf artists, they conquered the New York, London, and Paris art scenes in the closing decades of the twentieth century.

The paintings of Polke and his then good friend Richter were such eye-openers because they powerfully reflected Derrida's theory of Postmodern Deconstruction. Here were German artists in the 1960s making art that dealt with how images take on meaning: In fact, the Düsseldorf artists had developed their form of Postmodernism independent of Derrida, and they had produced the newly popular paintings in the mid-1960s, well before Derrida's ideas became widely known to artists. They were heavily influenced by Robert Rauschenberg and Pop Art, especially the works of Roy Lichtenstein and Andy Warhol, which they knew from magazines. They were also well versed in Dada (the first postwar Dada exhibition took place in Düsseldorf in 1958) and Fluxus, which came to town—literally—in 1963 (see page 1051). The last ingredient in the mix was the spirituality of Beuys, who taught at the art academy where they were students.

Armed with this background, Polke made paintings that combined appropriated images, patterns, and designs from various sources, as seen in *Alice in Wonderland* (fig. 30.24) of 1971. On top of fabrics with designs of soccer players or polka dots, Polke, like Warhol, mechanically reproduced images taken from other media, a process often referred to as appropriating. In this painting, the white image of a basketball player came from a magazine. Alice and the caterpillar with his hookah is an illustration lifted directly from *Alice in Wonderland*. Hard to see in our reproduction are the 1950s-style outlined heads of a man and woman, hand-stamped repeatedly in yellow and red. Polke borrowed all this imagery from popular culture and re-presented it in this enormous painting, which is not on canvas but on store-bought printed fabric. Viewed separately and in a different context, each of these images would be interpreted differently from the way they are when experienced together in this work. In other words, their relationship here creates a context that influences and changes their meaning. Polke avoids assigning a fixed meaning; instead he allows us to weave any story we like from this kaleidoscope of motifs.

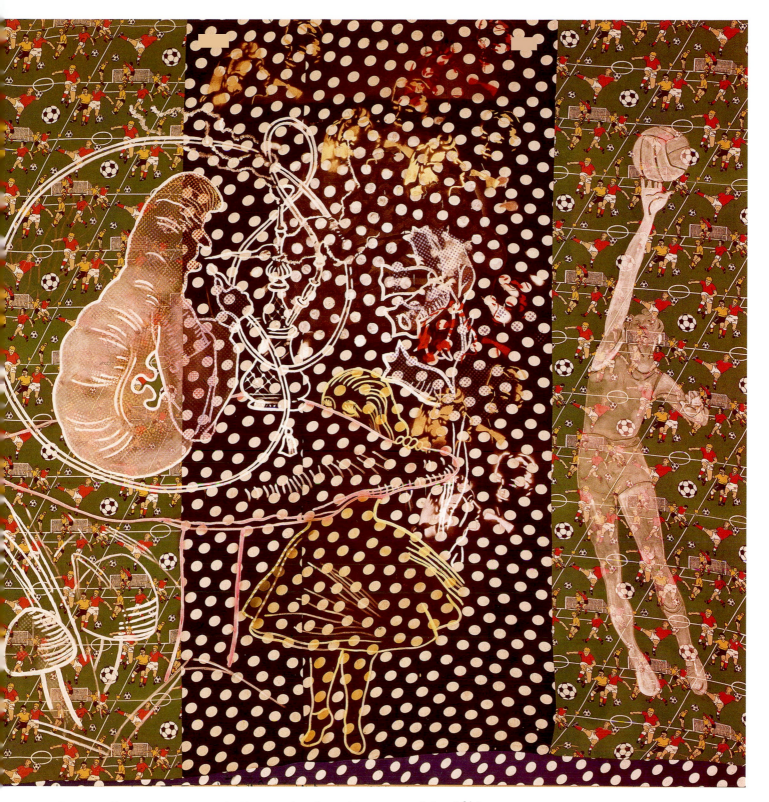

30.24. Sigmar Polke. *Alice in Wonderland.* 1971. Mixed media on fabric strips, 10'6" × 8'6¾" (3.2 × 1.6 m). Private collection, Cologne. © Sigmar Polke

Polke is concerned with how the popular imagery we confront daily structures our world. He explores how what we see becomes what we know and, by extension, what we believe in. He examines how images structure our thinking, feelings, and attitudes. In *Alice in Wonderland*, he fashions a Pollyanna vision of childhood—the naive innocence that believes in perfect romance, wholesome sports, and charming fairy tales—all propagated by the mass media and interior design. But unlike the works of the American Pop artists, Polke's paintings have an emotional content. The ghost-white silhouettes hovering over the fabric and the stamped 1950s heads immersed in the patterns of dots and soccer players create an ethereal feeling and even a romantic quality. A sense of absence and loss, of the fleeting nature of life and things, lend a startling spiritual quality to Polke's paintings.

PHOTOGRAPHY AND LED SIGNS The art community's excitement over painting lasted through the 1980s, but the same period also saw the rise of photography, video, and installation art as principal art forms. The first to challenge the painters were the Postmodern photographers Cindy Sherman,

Laurie Simmons, Louise Lawler, Barbara Kruger, and Richard Prince. Although initially unsuccessful commercially, by the time the decade was over the photographers had dethroned the painters. Their art now seemed more relevant than painting, for it presented the world, as Baudrillard pointed out, as we actually experience much of it—through the lens of a camera, rather than through firsthand experience. Like many artists today, these Postmodern photographers were heavily influenced by the theories of Derrida and Baudrillard. As was the case with Joseph Kosuth and the many other vanguard artists who started using the camera in the 1960s and 1970s (see pages 1063–1064), most are not interested in the mechanics of taking and processing pictures. Some of them do not handle the camera, and almost none do their own printing. What interests these artists is revealing how the context of an image determines its meaning, and how the mass media subversively structures content to manipulate viewers.

Barbara Kruger (b. 1945) boldly states this position in *You Are a Captive Audience* (fig. **30.25**), a 4-foot-tall print, also available as a 10-foot image. Kruger appropriated a photograph of a tooth extraction and superimposed her title over it. (She often

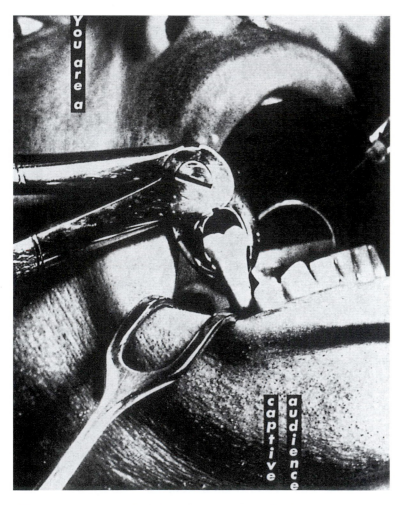

30.25. Barbara Kruger. *You Are a Captive Audience*. 1983. Gelatin silver print, 48 × 37³/₄″ (122 × 96 cm). Courtesy Mary Boone Gallery, NY. © Barbara Kruger

30.26. Cindy Sherman. *Untitled Film Still #15*. 1978. Gelatin silver print, 10 × 8″ (25.4 × 20.3 cm). Courtesy of the artist and Metro Pictures, New York. © Cindy Sherman

uses a red background under the white words, the red suggesting Russian propaganda.) Although painful to look at, this unsettling image sets up an "us versus them" opposition. We are the captive audience excruciatingly manipulated by the mass media, which Kruger knew all too well from her background in graphic design. Through her combination of stark imagery and concise text, Kruger conveys that advertising reflects an agenda established by someone who may or may not have our best interests in mind. The boldness of the close-up captures the strong influence wielded by advertising and emphasizes how promotion and marketing invade our private lives and personal space.

While Kruger reveals the raw power of the media, Cindy Sherman (b. 1954) is more interested in its subtle nuances and a viewer's participation in determing meaning. Beginning in 1977, Sherman began a series called Film Stills, in which she photographed herself in situations that resemble a still from a B-grade movie. For each, she created a set and a female character that she played herself, wearing different clothes, wigs, and accoutrements so that she is unrecognizable as the same person from one still to the next. That she is always the actress is conceptually important, for her metamorphosis represents the transformation women undergo subliminally as they conform to societal stereotypes reinforced, if not actually determined, by

the mass media. In *Untitled Film Still # 15,* Sherman plays the "sexy babe" who seems to be anxiously awaiting the arrival of a date or lover (fig. **30.26**). But is this really what is happening? Sherman leaves the viewer guessing. She may suggest a narrative, but she never provides enough information to securely determine one. In effect, the story viewers imagine tells more about their own backgrounds, experiences, and attitudes than it does about the picture itself, which remains ambiguous. Her "babe" could very well be dressed for a costume party instead of a date, and her look of concern could be for something occurring on the street below. Innumerable stories can be spun from this image, taking into account such details as her cross pendant or the old-fashioned spindle-back chair and brick wall, which seem to conflict with her youth and the contemporary lifestyle her clothing suggests. Remove any one of these motifs, and the story would change. Through what seems a simple strategy, Sherman brilliantly reveals the complex ways in which images become invested with meaning. (See *Primary Source,* page 1099.)

Like Kruger and Sherman, Jenny Holzer (b. 1950) works in the very media she wants to expose. For Holzer, the target is the advertising slogan that passes as truth. In 1977 she began writing what she calls "truisms," which she printed on posters, flyers, T-shirts, and hats. Eventually, she moved on to electronic signs, even using the big electronic board in New York's Times Square in 1982. In the mid-1980s, she began working with LED (light-emitting diode) boards, a medium for which she is most famous. Holzer's truisms were home-spun aphorisms, one-liners that express a broad range of attitudes and biases, such as "Murder has its sexual side," "Raise boys and girls the same way," "Any surplus is immoral," and "Morality is for little people." In effect, she presents either side of the "us versus them" conflict exposed by Kruger, but the impact is the same. Her works provoke an awareness that one person is trying to impose a position on another. Holzer created the installation of truisms reproduced here (fig. **30.27**) for the Guggenheim Museum in 1989. LED boards run up the side of Frank Lloyd Wright's spiral ramp, while below, arranged in a ritualistic circle, are benches with truisms etched on their seats. Wherever visitors turn, they are being manipulated, harangued, preached to, and controlled. But what is the truth, who is talking, and for whom?

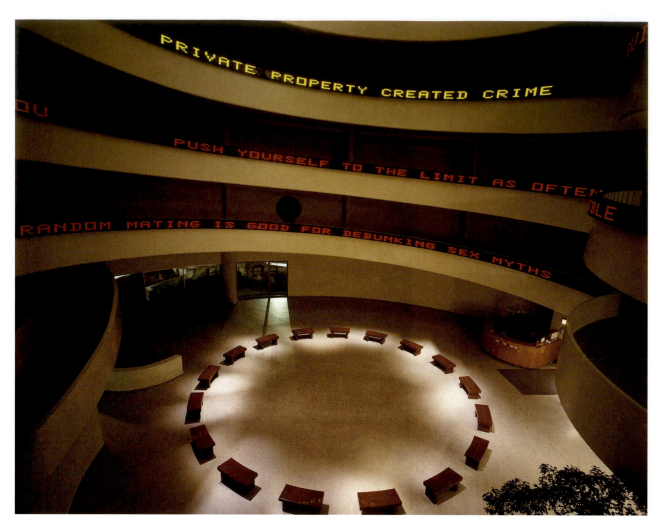

30.27. Jenny Holzer. *Untitled* (Selections from *Truisms, Inflammatory Essays, The Living Series, The Survival Series, Under a Rock, Laments,* and *Child Text*). 1989. Extended helical tricolor LED electronic display signboard, 16″ × 162′ × 6″ (40.6 × 4937.8 × 15.2 cm). Site-specific dimensions. Solomon R. Guggenheim Museum, New York. Partial gift of the artist, 1989. 89.3626. © Jenny Holzer/Artists Rights Society (ARS), New York

SCULPTURE Working in another medium entirely, Jeff Koons explored the relationship of fine art sculpture to mass culture and the distinctions between the two. Koon's work is rich in conceptual issues. The variety of his ideas drives the diverse styles and media in which he works. Koons continuously pushes the limits of sculpture, creating objects that range from two basketballs suspended in a water-filled fish tank to a cast-bronze aqualung, and from a rabbit-shaped chrome balloon to a 43-foot-tall puppy made of flowers.

Entirely different is the ceramic sculpture *Michael Jackson and Bubbles* (fig. **30.28**) of 1988. Like a Warhol print, the sculpture was factory produced, made to Jeff Koons's (b. 1955) specifications in a limited edition by craftsmen in Italy. The image was not drawn or designed by the artist but rather chosen by him, in Duchampian fashion, from a publicity photograph of the singer with his pet chimpanzee. Its ornateness recalls seventeenth-century Italian Baroque sculpture (see Chapter 19) and eighteenth-century French porcelain, while the tawdry gold paint and rouged lips, along with the pop-culture imagery, give the work a crass look associated with mass-produced gift-shop figurines. Koons realized that by presenting his subject life-size, like a Classical sculpture of a Greek god, he was placing a mass-media image in the context of fine art, and giving it new meaning. He transformed it from a kitsch souvenir into a compelling statement about what constitutes art, exploring the differences between fine art and "low" art. And because souvenirs are commodities, Koons reminds us that art, too, is merchandise. Again, with a hint of Warhol, Koons captures and parodies the glitz of celebrity promotion. But the tawdriness of the image and the porcelain medium give the sculpture a poignant sense of fragility and impermanence, suggesting the temporary nature of life and fame. Koons rolls the influences of Duchamp, Warhol, and Derrida into one package and updates it for the consumption-oriented 1980s.

The Power of Installation and Video Art

Installation art had existed since the late 1950s (when the work was called environments), but its popularity surged dramatically in the 1980s, when it became a featured medium, just as photography had. Its rise helped push Jenny Holzer from producing flyers and posters to making large-scale environmental LED displays. As we saw in Kiefer's incorporation of actual materials into his canvases, a thirst for the real figures prominently in much art since 1980.

Cindy Sherman (b. 1954)

From an interview

In these excerpts from a 1988 interview with Jeanne Siegel, Sherman discusses her photographic role-playing.

CINDY SHERMAN: I still wanted to make a filmic sort of image, but I wanted to work alone. I realized that I could make a picture of a character reacting to something outside the frame so that the viewer would assume another person.

Actually, the moment that I realized how to solve this problem was when Robert [Longo] and I visited David Salle, who had been working for some sleazy detective magazine. Bored as I was, waiting for Robert and David to get their "art talk" over with, I noticed all these 8 by 10 glossies from the magazine which triggered something in me. (I was never one to discuss issues—after all, at that time I was "the girl-friend.")

JEANNE SIEGEL: In the "Untitled Film Stills," what was the influence of real film stars? It seems that you had a facination with European stars. You mentioned Jeanne Moreau, Brigitte Bardot, and Sophia Loren in some of your statements. Why were you attracted to them?

CS: I guess because they weren't glamorized like American starlets. When I think of American actresses from the same period, I think of bleached blonde, bejeweled, and furred sex bombs. But, when I think of Jeanne Moreau and Sophia Loren, I think of more vulnerable, lower-class types of characters, more identifiable as working-class women.

At that time I was trying to emulate a lot of different types of characters. I didn't want to stick to just one. I'd seen a lot of the movies that these women had been in but it wasn't so much that I was inspired by the women as by the films themselves and the feelings in the films.

JS: And what is the relationship between your "Untitled Film Stills" and the real film stills?

CS: In real publicity film stills from the 40s and 50s something usually sexy/cute is portrayed to get people to go see the movie. Or the woman could be shown screaming in terror to publicize a horror film.

My favorite film images (where obviously my work took its inspiration) didn't have that. They're closer to my own work for that reason, because both are about a sort of brooding character caught between the potential violence and sex. However, I've realized it is a mistake to make that kind of literal connection because my work loses in the comparison. I think my characters are not quite taken in by their roles so that they couldn't really exist in any of their so-called "films," which, next to a real still, looks unconvincing. They are too aware of the irony of their role and perhaps that's why many have puzzled expressions. My "stills" were about the fakeness of role-playing as well as contempt for the domineering "male" audience who would mistakenly read the images as sexy. . . .

JS: Another critical issue attached to the work was the notion that the stereotypical view was exclusively determined by the "male" gaze. Did you see it only in this light or did it include the woman seeing herself as well?

CS: Because I'm a woman I automatically assume other women would have an immediate identification with the roles. And I hoped men would feel empathy for the characters as well as shedding light on their role-playing. What I didn't anticipate was that some people would assume that I was playing up to the male gaze. I can understand the criticism of feminists who therefore assumed I was reinforcing the stereotype of woman as victim or as sex object.

SOURCE: FROM AN INTERVIEW WITH JEANNE SIEGEL FROM *ARTWORDS*. 2 ED. JEANNE SIEGEL (NY: DA CAPO PRESS, 1990). COPYRIGHT © 1988 BY JEANNE SIEGEL. REPRINTED BY PERMISSION OF JEANNE SIEGEL.

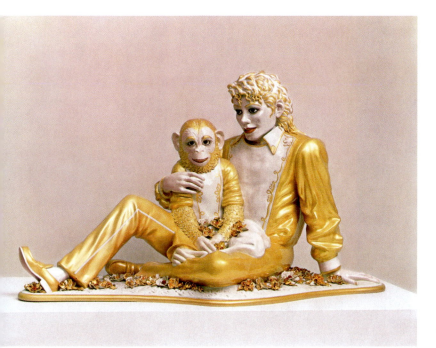

30.28. Jeff Koons. *Michael Jackson and Bubbles.*
1988. Porcelain. $42 \times 70\frac{1}{2} \times 32\frac{1}{2}''$
($107 \times 179 \times 83$ cm). Courtesy Sonnabend Gallery, New York. © Jeff Koons

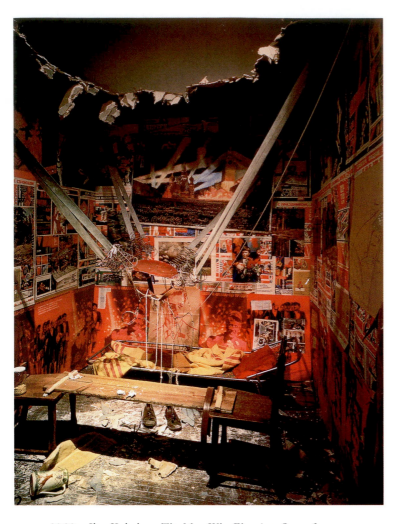

30.29. Ilya Kabakov. *The Man Who Flew into Space from His Apartment*, from *Ten Characters*, 1981–1988. Mixed-media installation, life-size. © Artists Rights Society (ARS), New York/VG Bild-Kunst, Bonn

ILYA KABAKOV Of the legions of installation artists who emerged in the 1980s, one of the most engaging is the Russian Ilya Kabakov (b. 1933), who emigrated from Moscow to New York in 1988. In Russia from 1981 to 1988, he made a series of rooms he called *Ten Characters* that replicated the types of seedy communal apartments assigned to people by the Russian state under the Communist regime. Each was inhabited by an imaginary person with an "unusual idea, one all-absorbing passion belonging to him alone." One spectacular cubicle was *The Man Who Flew into Space from His Apartment* (fig. **30.29**). We see the room after its occupant has achieved his dream of flying into space, hurled through the ceiling from a catapult suspended by springs and alluding to the space race between the U.S. and Russia. Like the other rooms, this one is accompanied by a grim story, worthy of the Russian novelist Fëdor Dostoevski. The text, the collapsed ceiling, limp sling, and clutter becomes a tableau of life in Communist Russia, where claustrophobic squalor has brought about a hopeless delusional state, and flights of fantasy are the only escape from the drudgery of daily life. The ruin we are witnessing in *The Man Who Flew into Space* is not just the devastation of one man's life, but rather the shattered dream of the utopia in which Tatlin, the Constructivists,

the Dadaists, and the Communist world in general had so firmly believed. Kabakov's installation is presented as a relic of an actual event, and like any relic, it possesses a powerful aura, almost impossible to achieve in conventional painting and sculpture. (See *Primary Source,* page 1101.)

BILL VIOLA An especially popular form of installation is video or film installation, which had its roots in Robert Whitman's film installations of the early 1960s (See page 1049). Among its best-known practitioners is Bill Viola (b. 1951). Viola was also one of the first to specialize in video. He started working with the medium in the 1970s after graduating from Syracuse University and by the early 1980s was incorporating it into installations or environments containing real objects.

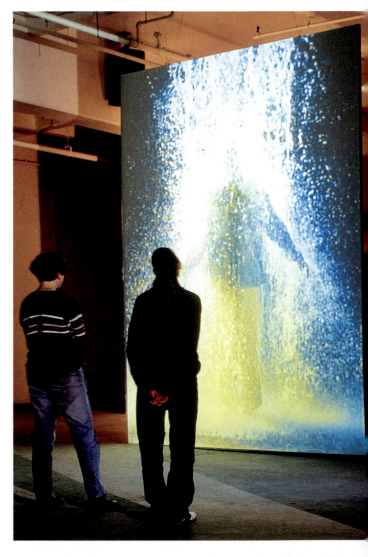

30.30. Bill Viola. *The Crossing*. 1996. Video/sound installation with two channels of color video projected onto 6-foot-high screens, $10\frac{1}{2}$ minutes. View of one screen at 1997 installation at Grand Central Market, Los Angeles. Courtesy of the Artist. © Bill Viola

Ilya Kabakov (b. 1933)

On installations

Kabakov discusses his installations entitled Ten Rooms, *which deal with life in Soviet Russia. He especially emphasizes the importance of the space in his installations, claiming the rooms have a spirit that establishes the mood and meaning of the work.*

How does this "spirit of the place" seize you? In the first place, the rooms are always deconstructive, asymmetrical to the point of absurdity or, on the contrary, insanely symmetrical. In the second place, they look dull, oppressing, semidark, but this is not so because the windows are small or weak lamps are on. The main thing is the light both during the day and at night is arranged so excruciatingly, so awkwardly that it creates a peculiar discomfort distinctive to that place alone. The third important feature of our rooms' effect is their wretched, ridiculous preparation from the planning stage to the realization: everything is crooked, unfinished, full of stains, cracks; even in the most durable materials, there is something temporary, strange, made haphazardly, just to "pass."

What is especially depressing is the fact that everything is old, but at the same time it isn't clear when it was made, it doesn't have all the noble "patina of time," the marks of "wonderful days of old"; it is old in the sense of being decrepit and useless. All of this despite the fact that it might have been made and painted only yesterday, already appears outdated, marked for disposal. There is an impression of dust and dirt in every place and in everything—on the walls, at the ceiling, on the floor, in the corners. But the sensation is even stronger that these rooms, including private apartments, do not belong to anyone, that they are no-one's and that, in essence, no-one cares in the least about them. No-one loves them, people live in them temporarily and will leave not remembering them at all, like a train station, an underground crosswalk or a toilet at the bus station....

Sociality, being completely interlinked, was the natural means of survival, the very same traditional Russian "commune" which later also entered Soviet reality, in which you as a voluntary or subordinated participant were forever drowned, dissolved. But on the other hand, the commune saved you, supported you, didn't let you disappear or perish in loneliness, in despair, in a state of material or moral neglect. Every second of your life, you belonged to some kind of community.... The atmosphere of the surrounding space was, in essence, its "spirit." ... And you caught this spirit immediately, all you had to do was to enter this or that space.

SOURCE: ILYA KABAKOV, *THE TEXT AS THE BASIS OF VISUAL EXPRESSION*. ED. ZDENEK FELIX. (COLOGNE: OKTAGON, 2000)

Although Viola's work does not always have a clear sequential narrative, it always has a theme, usually an unsettling, intense questioning of the meaning of existence.

One of Viola's best known—and simplest—works is *The Crossing* (fig. **30.30**). In two simultaneous, approximately ten-minute projections, shown side by side, or on either side of a single screen, a plainly dressed man approaches from the distance, passing through an empty, darkened space and stopping when his body, now nearly 12-feet tall, fills the screen. In one projection, water begins to drip on him, eventually becoming a deluge that washes him away. In the other, a small fire erupts at his feet, increasingly swelling into a bonfire that ultimately consumes him. The projections end with water hauntingly dripping in one, and a fire mysteriously smoldering in the other. Both videos are accompanied by a deafening soundtrack of pouring water and crackling fire, which intensifies the force of the imagery and heightens its visceral impact. Viola's elemental symbols of fire and water seem to have destroyed the figure. Or perhaps the two forces have brought about a transformative process, as the body dissolves into a spiritual state, crossing into a higher reality and becoming one with the unseen universal forces. We do not know. The video relentlessly instills a sense of the physical and sensory and then suddenly leaves us in an existential void. In an era when technology and science are extending life and providing hope for cures for deadly diseases, artists such as Bill Viola were returning to the early twentieth-century quest for the spiritual. Others, as we shall now see, bypassed the spiritual and instead were preoccupied only with death.

Many Styles, One Artist: Felix Gonzalez-Torres

By rejecting traditional hierarchies in media, style, and content, Postmodern artists gained the freedom to work in a variety of media and styles. Cultivating an easily recognizable "look" or identity was not important. Felix Gonzalez-Torres (1957–1996) is a classic example of this attitude, also found in the work of Jeff Koons, Kiki Smith, Damien Hirst, and Cai Guo-Qiang, discussed later in this chapter. Covering a wide range of media and social issues, Gonzalez-Torres is best known for his work focusing on the psychological impact of AIDS and the attitudes toward this epidemic. Gonzalez-Torres, who was born in Cuba and came to America in the 1981 Mariel boat lift, can best be described as a Conceptual artist working in a Minimalist mode. He presents an idea as simply as possible. Despite his spare vocabulary the emotional impact is significant, and the content and implications are far-reaching.

Gonzalez-Torres's media stretches from jigsaw puzzles and mirrors to strings of electric lights and live male go-go dancers. For *Untitled (Portrait of Ross in L.A.)* of 1991, he chose candy. The work is a Minimalist pyramid of multicolored candies piled into the corner of a gallery. The candies weigh 175 pounds, the weight of his partner Ross Laycock, who died of an AIDS-related illness. Visitors are instructed, usually by a guard, to take a piece of the candy. The diminishing of the pile paralleled the deterioration of Ross's health. By encouraging museum viewers' participation, Gonzalez-Torres hoped to raise public awareness of the many issues

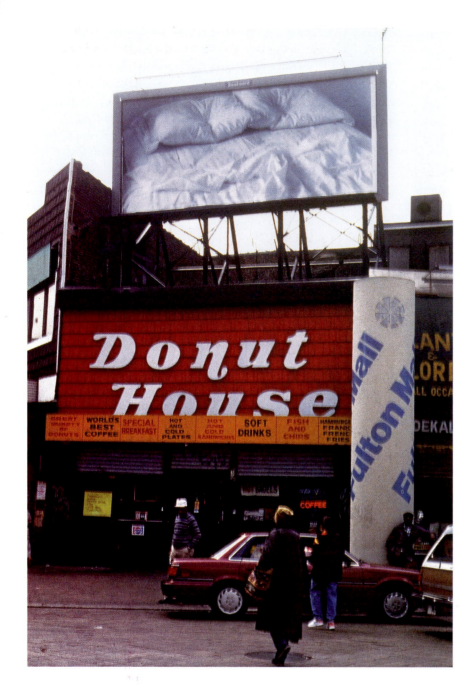

30.31. Felix Gonzalez-Torres. *Untitled.* 1991. Billboard, overall dimensions vary with installation. The Felix Gonzalez-Torres Foundation. Courtesy of Andrea Rosen Gallery, New York and Museum of Modern Art, New York. © The Felix Gonzalez-Torres Foundation

related to AIDS, including the lack of public funding to fight the disease and the emotional toll it takes on the victim and loved ones alike.

Like many artists in the 1980s, Gonzalez-Torres took his art out of an art context and into the public domain. In 1991, in conjunction with an exhibition at the Museum of Modern Art in New York, he had a chilling, blue-toned photograph of an empty, unmade bed installed on 24 billboards around the city (fig. **30.31**). Unlike traditional advertising billboards, this one was enigmatic and forced people to question who made it and why. Most viewers never even knew it was art. The quintessential Postmodern picture, it was highly suggestive and subject to broad interpretation. Despite having a political agenda, Gonzalez-Torres was not a sloganeer. But even devoid of text, the simple image of an unmade bed spoke volumes. It conjured thoughts of intimacy, relationships, and love as well as loss and absence and, ultimately, death. The artist intended the image to evoke the realization of the thousands of gay men who had died from AIDS, and also the heterosexual people and the children who became victims as well. The meaning behind the work centered on suffering and loss, and Gonzalez-Torres hoped it would raise public awareness of the disease. Gonzalez-Torres died of AIDS in 1996, at the age of 38.

Preoccupation with the Body

Gonzalez-Torres reflects the powerful impact that the AIDS crisis had on artists during the Postmodern era, and their concern with drawing public attention to this disease that pervaded all segments of American society and that was tragically being ignored by the administration of Ronald Reagan. His powerful foray into this theme encouraged many other artists to follow suit. His work also reflects a new preoccupation with the body and human frailty, an awareness brought about by the death and suffering of AIDS victims.

KIKI SMITH One artist to explore the vulnerability of the body and the brevity of life was New Yorker Kiki Smith (b. 1954). In the 1980s, she created a work consisting of eight identical jars of blood, and another presenting silver-coated water-cooler bottles etched with the names of such bodily fluids as tears, milk, saliva, vomit, semen, urine, and sweat that a viewer is led to believe is in the jars. Because these works contain repeated elements, they resemble Minimal Art. Yet the conceptual component—the thoughts we have when confronting the blood, for example—packs a powerful visceral response and the emotional punch of Baroque art or German Expressionism. By reducing the human being to bodily fluids, ones that carry viruses and are subject to attack, Smith denies individuality and uniqueness. She reveals an elemental essence linking all humans that courses through the body and out of it.

Toward 1990, Smith began constructing entire figures, usually using such impermanent materials as paper, papier-mâché, and wax, which served as a metaphor for the fragility of the body and the transience of life. In the 1990 untitled work reproduced here (fig. **30.32**), Smith cleverly revives the classical tradition of the nude figure. However, we are viewing neither Greek gods and goddesses nor heroic athletes and soldiers. Rather, Smith portrays flesh-and-blood mortals. The woman oozes milk from her breast and the man semen from his penis, attributes of nourishment, procreation, and life. But death dominates the work, seen in the form of the limp figures slumped on their poles and the jarring discoloration of the skin. Smith presents the entire life cycle, but it is the sadness of deterioration and our ultimate fate of death that prevails.

DAMIEN HIRST One of the most powerful statements about death, decay, and impermanence comes from the British artist Damien Hirst (b. 1965). Hirst, who has a flamboyant personality and is often accused of being a publicity hound, is head of a group of London artists who came to the fore in 1988, when Hirst organized a student exhibition, entitled *Freeze* in a London warehouse. The group created a public sensation and a critical storm due to their outrageous subject matter, highlighted by Hirst's dead shark floating in a tank of formaldehyde. Hirst went on to make beautiful, ethereal paintings

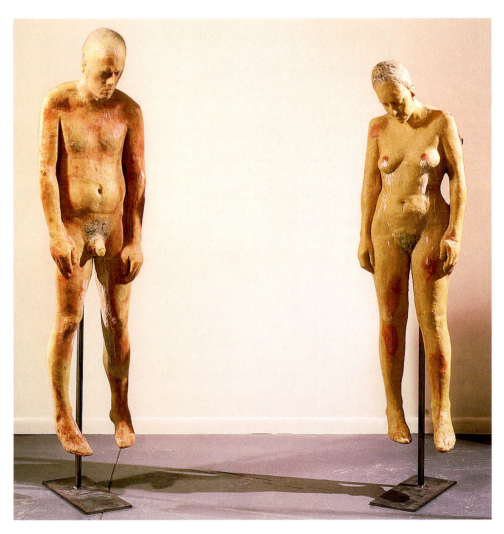

30.32. Kiki Smith. *Untitled.* 1990. Beeswax and micro-crystalline wax figures on metal stands, female figure installed height 6′4¹⁵⁄₁₆″. Collection Whitney Museum of American Art, New York. Purchase, with funds from the Painting and Sculpture committee. 91.13 (a–d). © Kiki Smith

ART IN TIME

1981—Sandra Day O'Connor appointed Supreme Court justice

1982—Maya Lin's Vietnam Veterans Memorial

1983—Barbara Kruger's *You Are a Captive Audience*

1991—World Wide Web launched

1991—Soviet Union collapses

1991—European Union formed

2003—Cai Guo-Qiang's *Light Cycle*

incorporating dead butterflies and Minimalist abstractions using dead flies stuck to an enormous canvas. In *Mother and Child Divided* (fig. **30.33**) of 1993, a cow and calf, each divided in two, float in four tanks of formaldehyde. Using a Minimalist seriality, Hirst placed the bisected cows into identical tanks, thus creating a feeling of scientific objectivity. Even the nearly identical halves of each cow are multiples. The Minimalist tanks function as frames, the cow and calf as "realist pictures." The beauty and repulsiveness of this daring presentation is fascinating. As with Kabakov's installations, however, we are confronted with real objects, and hence the power they embody.

We are literally confronting death, as well as a vain attempt to prolong the physical existence of the animals. An especially powerful aspect of this work is the separation of mother from calf, a poignant reminder of the life that once was and the emotional attachment of mother and child. While many critics condemn Hirst's work as sensational and self-promotional, the animals he displays in formaldehyde tanks are powerful and unforgettable metaphors about life and death, and a testament to the success of his art.

A World Art: Cai Guo-Qiang

The closing decades of the twentieth century have marked the rise of a world art, although this phenomenon has its roots in the 1950s. With the Internet and satellite communications, artists in even the most remote areas no longer operate in isolation. More artists than ever have access to what is being produced in New York, London, Paris, Düsseldorf, and Tokyo. Jet travel circulates artists from Korea to Cairo, from Johannesburg, to São Paulo from Basel to Kassel, for exhibitions and art fairs. (See *The Art Historian's Lens,* page 1105*).* The entire world is artistically bound together, transforming it into one large art gallery and making it nearly impossible to talk about art in one hemisphere without talking about developments occurring everywhere else. Now,

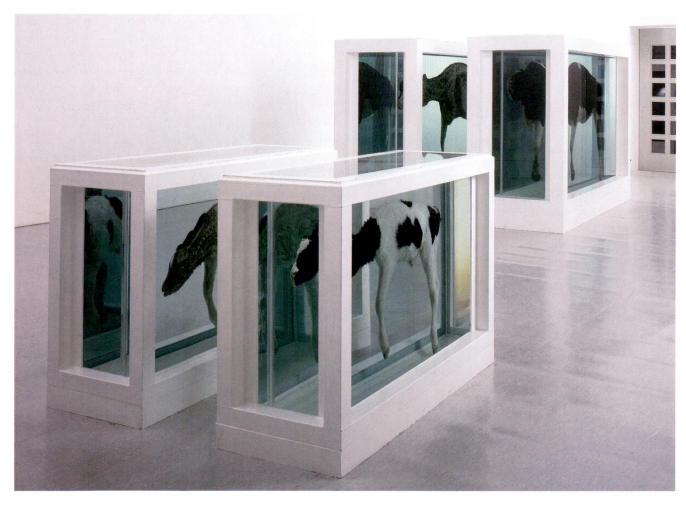

30.33. Damien Hirst. *Mother and Child Divided*. 1993. Steel, GRP composites, glass, silicone, cow, calf, and formaldehyde solution, two tanks at $74\frac{7}{8} \times 126\frac{7}{8} \times 43''$ (190 × 322 × 109 cm). And two tanks at $40\frac{1}{8} \times 66\frac{1}{2} \times 24\frac{5}{8}''$ (102.5 × 169 × 62.5 cm). Astrup Fearnley Museet for Moderne Kunst. © Damien Hirst

The Changing Art Market

The world of contemporary art is as complex and varied as the art itself. Museums, commercial galleries, private dealers, auction houses, art fairs, international exhibitions, collectors from all strata of society, critics, curators, art historians, books, and a vast mass media that includes the Internet are some of the pieces that form the kaleidoscopic art market of the twenty-first century.

How different this conglomerate of influences is from the late medieval and early Renaissance world that was largely defined by artists' guilds, the apprentice system, and a patronage system dominated by aristocrats and the church. The rise of academies in the sixteenth and seventeenth centuries, especially, the French Royal Academy in 1648, marked a shift of power to the academy system and its accompanying exhibitions (called salons in Paris) that showcased members and students. Historians published the first books on artists during this period. The eighteenth century witnessed the rise of prominent art auctions in Paris and London, the opening of the first public art museums in those cities, and the beginning of what many consider to be the first art criticism (see pages 815–816). In the nineteenth century, the French salon changed from a members' exhibition into an open show that was juried and that presented hundreds of artists and thousands of works. Artists from all over Europe and the Americas aspired to exhibit at the Paris salon, which, although dominated by the French, in effect became the first international showcase and an important venue for attracting patrons and commercial success. By the end of the nineteenth century, art dealers, who had virtually always been around, became a major force in the art world, especially in Paris.

Today, one of the strongest influences on an artist's career is representation by a prestigious dealer with a reputation for selecting "important" artists. Also significant is exhibiting and being collected by major museums, such as the Museum of Modern Art in New York, the Museum of Contemporary Art in Los Angeles, the Tate Gallery in London, the Ludwig Museum in Cologne, and the National Museum of Modern Art in Paris. These are just a few of the many museums known for presenting prestigious exhibitions and collecting contemporary art.

Artists also aspire to be included in the big international exhibitions, the twentieth-century equivalent of the nineteenth-century French salons,

International Art Fair. Art/Basel/Miami Beach/1–4/Dec/05

although the artists are generally invited by curators and do not submit work to a jury. One of the oldest international exhibitions is the Venice Biennale, established in 1903 and located in a park in Venice. Today, the show occurs once every two years and takes place in permanent pavilions owned by the various countries which present their own artists. Such international shows were often conceived to promote the host cities and to encourage their economic development. For example, Andrew Carnegie founded the Carnegie Museum of Art in Pittsburgh in 1895, and the following year he established what is now known as the Carnegie International in order to draw international attention to Pittsburgh. Both the Venice Biennale and the Carnegie International, however, only gained their current prestige after World War II, when they were joined by other major international shows, such as the Documenta in Kassel, Germany, which is held every four years, and the São Paulo Biennale in Brazil. In the last few decades many other international biennials have joined the art scene, including those in Istanbul, Havana, Cairo, and Johannesburg. A major venue for American artists has been New York's Whitney Museum of American Art, which was founded in 1930 and has always held an annual or biennial exhibition.

Despite the excitement generated by fairs and galleries, however, contemporary art has largely lived in the shadow of Old Masters and Impressionism, and, as the twentieth century progressed, early European Modernism. It was not until the 1970s that contemporary art became fashionable. Triggering the stampede to buy work by living artists was the sensationally successful auction of the Pop Art collection of Robert and Ethel Scull at Sotheby's in New York in 1973. Such major auction houses as Sotheby's and Christie's, both dating to eighteenth-century London, had long sold contemporary art, but in small quantities and with little fanfare. But after the Scull auction, countless collectors rushed into the contemporary arena, and in the last 25 years, auctions of contemporary art have shared the limelight with sales of Impressionism and European Modernism. This collecting fever spurred the appearance of numerous international art fairs, including Art Basel in Basel, Switzerland; Art Basel Miami in Miami Beach; the Frieze Art Fair in London; the Armory Show in New York; and the Foire Internationale d'Art Contemporain or FIAC (International Fair of Contemporary Art) in Paris. Every year these high-end art fairs are flooded with tens of thousands of collectors and visitors scouting for new work and new artists.

30.34. Cai Guo-Qiang. *Light Cycle: Explosion Project for Central Park*. 2003.
Tiger tails, titanium solutes fitted with computer chips, shells with descending stars.
© Cai Guo-Qiang

artists worldwide use the same art language, deal with similar issues, and avidly follow each other's work. Tremendous differences exist, but a thirst to learn about other cultures and values makes art forms from around the world even more acceptable, if not exciting and fashionable. Differences are embraced and admired rather than rejected as inferior.

It seems only fitting to end this book with Cai Guo-Qiang (b. 1957), a Chinese artist living in New York since 1995. Among the most visible artists today, Cai brings to this new global art a Chinese background and perspective, which enriches the world's visual language. Like Gonzalez-Torres and Koons, Cai is primarily a conceptual artist working in a broad range of media. His oeuvre is dominated by installation art and the use of explosions, namely fireworks, which have become his signature style. Explosives, including fireworks, are a Chinese invention, and through his use of this medium, Cai highlights his cultural identity. Yet his choice of explosives is motivated by other aesthetic and conceptual concerns. As the artist explains: "Explosions make you feel something intense at the very core of your being because, while you can arrange explosives as you please, you cannot control the explosion itself.

And this fills you with a great deal of freedom." Cai "draws" with the explosives, sometimes evoking Chinese calligraphy. And like the work of the Abstract Expressionists, his drawing contains sublime references or represents an attempt to tap into universal forces. He even discusses the yin and yang of the explosions, the way in which the work, in a split second, presents both creation and destruction.

In 2003 Cai was commissioned by New York City and the Central Park Conservancy to create an explosion piece in Central Park. Titled *Light Cycle: Explosion Project for Central Park* (fig. **30.34**), the work lasted four minutes and was divided into three parts: "Signal towers" (pillars of light), "The Light Cycle" (a series of haloes), and "White Night" (small-shell explosions of brilliant white light). The degree to which Cai controls the explosions is remarkable. He draws and paints with the medium. Through his work, Cai seeks to to capture a spiritual essence. He has said that his work is for extraterrestrials, and he has subtitled many of his explosions "Project for Extraterrestrials." Just as the art world has become global, so Cai, perhaps with a little wink, is looking beyond Earth, seeking to create art for the universe.

SUMMARY

Art historians have labeled the period since 1980 as Postmodern. The term comes from the European Deconstruction or Post-Structural philosophy of the 1960s, and is generally used to described how many intellectuals, recognizing that context determines meaning and context constantly changes, have come to believe that there are no absolute meanings or truths. The result is that pluralism has characterized Postmodern art, in contrast to the Modernist position that believed that one and only one style at any given moment best moved art forward. Postmodernism also undermines Modernism's emphasis on style, uniqueness, and authorship, with artists now working in multiple styles and even in groups. A Postmodern attitude also brought about a world art, an interest and acceptance of all art as engaging and important. The communication revolution that has shrunk the world into a Global village has also contributed to the emergence of a world art.

ARCHITECTURE

In architecture the break with Modernism had occurred in the 1960s and was promoted by architect Robert Venturi. Venturi advocated that buildings incorporate not only traditional references to architecture's past but also contemporary imagery, elements, or materials, resulting in an eclectic mix of old and new that many architects readily embraced. They left behind the simplicity of Modernism's stark "glass box" and created complex, sometimes ambiguous, structures that were often witty and fun. By the 1980s, Postmodern buildings appeared in cities worldwide, from the paradoxical and anthropomorphic facade of Michael Graves's Public Services Building in Oregon to James Stirling's complex and evocative Neue Staatsgalerie in Germany. Some architects, such as Norman Foster in his Hong Kong and Shanghai Bank returned to Modernism, reinvigorating it through the use of an industrial style known as Hi-Tech. Others, such as the firm of Coop Himmelblau or Zaha Hadid, chose a Deconstructivist idiom to disrupt viewers' preconceived notions of architecture. The diversity of Postmodernism can be seen in the purpose of buildings as well, such as the Guggenheim, Bilbao, which Frank Gehry designed to serve as a symbol of the city, and Daniel Libeskind's Jewish Museum, meant to raise public awareness of the Holocaust and Jewish history.

POST-MINIMALISM AND PLURALISM: LIMITLESS POSSIBILITIES

The pluralism of the 1970s became widespread in the 1990s as artists explored a broad range of subjects, styles, and media. Painting made a comeback in the 1980s, strengthened by the emergence of Neo-Expressionism in works by Anselm Kiefer and Jean-Michel Basquiat as well as in the abstractions of Elizabeth Murray. The Post-Minimal aesthetic continued in sculpture in the 1980s and 1990s, notably in Martin Puryear's organic, sensual, and finely crafted objects and the powerful and moving Vietnam War memorial by Maya Lin. Artists in varied media also created works exploring how the function and meaning of images changes in different contexts. In photography, video, and installation art, artists analyzed popular symbols, imagery, and even the medium itself to expose issues related to class, gender, sexuality, and race, to name just a few.

Sir William Chambers (1723–1796)

From *Designs of Chinese Buildings, Furniture, Dresses, Machines, and Utensils*

Sir William Chambers was a British architect and founding member of the Royal Academy who as a young man spent nine years in Asia as an employee of the Swedish East India Company and became an expert on Chinese architecture. In 1755, after studying architecture in Rome and Paris, attending Jacques François Blondel's famous lectures, he became a respected London architect. The following passage from his book on Chinese architecture and artifacts (1757) reflects the importance of the concept of the picturesque in midcentury England, as well as the inferior status accorded exotic cultures that were perceived as fascinating, sensually exciting, but clearly remaining "other."

For generally speaking, Chinese architecture does not suit European purposes; yet in extensive parks and gardens, where a great variety of scenes are required, or in immense palaces, containing a numerous series of apartments, I do not see the impropriety of finishing some of the inferior ones in the Chinese taste. Variety is always delightful; and novelty, attended with nothing inconsistent or disagreeable, sometimes takes the place of beauty. History informs us that Hadrian, who was himself an architect, at a time when the Grecian architecture was in the highest esteem among the Romans, erected in his Villa, at Tivoli, certain buildings after the manner of the Egyptians and of other nations.

SOURCE: ELIZABETH GILMORE HOLT, *A DOCUMENTARY HISTORY OF ART*, VOL. II. (GARDEN CITY, NY: DOUBLEDAY ANCHOR BOOKS, 1958)

Jean-Auguste-Dominique Ingres (1780–1867)

From "The Doctrine of Ingres"

Maurice Denis, a late nineteenth-century painter, compiled these aphorisms from Ingres's notebooks and from the reminiscences of his students.

Art should only depict beauty. ... And no matter what your genius, if you paint to the last stroke not according to nature, but your model, you will always be its slave; your manner of painting will smack of servitude. The proof of the contrary is seen in Raphael. He tamed the model to such a point and possessed it so thoroughly in his memory, that instead of the model giving him orders, one would say that the model obeyed him....

To form yourself in beauty, ... walk with your head raised to the sky instead of keeping it toward the earth like pigs searching in the mud....

The figures of antiquity are only beautiful because they resemble the beauty of nature.... And nature will always be beautiful when it resembles the beauties of antiquity....

I will write on the door of my studio: School of drawing, and I will make painters.

Drawing is the probity of art....

Drawing is everything; it is all of art. The material processes of painting are very easy and may be learned in eight days....

There is neither correct nor incorrect drawing; there is only beautiful or ugly drawing. That is all! ...

In front of Rubens, put on blinders like those a horse wears.

SOURCE: FROM *THE CLASSICISTS TO THE IMPRESSIONISTS: ART AND ARCHITECTURE IN THE 19TH CENTURY*, ED. ELIZABETH GILMORE HOLT (NEW HAVEN: YALE UNIVERSITY PRESS, 1977)

Rosa Bonheur (1822–1899)

From *Reminiscences of Rosa Bonheur*

Bonheur's father Raymond was a landscape painter and a disciple of the utopian socialist Henri de Saint-Simon, who considered the artist the priest of his "new Christianity" and thought the messiah of the future would be, as Bonheur states here, a woman. These reminiscences were published in 1910.

I have never counseled my sisters of the palette to wear men's clothes in the ordinary circumstances of life.

If, however, you see me dressed as I am, it is not in the least in order to make me into an original, but simply to facilitate my work. Consider that, at a certain period in my life, I spent whole days at the slaughterhouse.... I also had the passion for horses. Now where better to study these animals than in the fairs ...? I was forced to recognize that the clothing of my sex was a constant bother. That is why I decided to solicit the authorization to wear men's clothing from the prefect of police.

But the suit I wear is my work attire, and nothing else. The epithets of imbeciles have never bothered me....

Two years ago (October 8, 1896) on the occasion of the reception of the Russian royalty in Paris, the minister of the fine arts had the desire to introduce to them the leading figures of French art.... I wore my beautiful suit of black velvet and my little feathered bonnet....

From the moment I arrived at the Louvre, I would have given I do not know what to have had on my head my gray felt hat. I was the only woman, in the middle of a crowd of men.... All the eyes turned toward me; I didn't know where to hide myself. This was a harsh test, and that day I really missed my masculine attire, I can assure you....

In spite of my metamorphosis of costume, there is no daughter of Eve who appreciates more than I the nuances; my brusque and almost savage nature never prevented my heart from always remaining perfectly feminine....

Why wouldn't I be proud of being a woman? My father, that enthusiastic apostle of humanity, repeated to me many times that

woman's mission was to uplift the human race, that she was the messiah of future centuries. I owe to his doctrines the great and proud ambition that I conceived for the sex to which I take glory in belonging, and whose independence I will uphold until my last day. Moreover, I am persuaded that the future belongs to us.

SOURCE: *VOICES OF WOMEN ARTISTS*, ED. WENDY SLAKIN (ENGLEWOOD CLIFFS, NJ: PRENTICE HALL, 1993)

Louis Sullivan (1856–1924)

From "The Tall Office Building Artistically Considered"

Sullivan had already completed several skyscrapers, including the Wainwright Building (see fig. 26.39) and the Guaranty Building, when he recorded these ideas in an essay of 1896.

The architects of this land and generation are now brought face to face with something new under the sun—namely, . . . a demand for the erection of tall office buildings. . . .

Offices are necessary for the transaction of business; the invention and perfection of the high-speed elevators make vertical travel, that was once tedious and painful, now easy and comfortable; development of steel manufacture has shown the way to safe, rigid, economical constructions rising to a great height; continued growth of population in the great cities, consequent congestion of centers and rise in values of ground, stimulate an increase in number of stories. . . . Thus has come about that form of lofty construction called the "modern office building. . . ."

Problem: How shall we impart to this sterile pile, . . . this stark, staring exclamation of eternal strife, the graciousness of those higher forms of sensibility and culture that rest on the lower and fiercer passions? . . .

What is the chief characteristic of the tall office building? . . . It is lofty. This loftiness is to the artist-nature its thrilling aspect. . . . It must be every inch a proud and soaring thing, rising in sheer exultation that from bottom to top it is a unit without a single dissenting line. . . .

SOURCE: *LIPPINCOTT'S MAGAZINE*, MARCH 1896

Paul Scheerbart (1863–1914)

From *Glasarchitektur*, published in *Der Sturm*, 1914.

Scheerbart was a German Expressionist writer and architect who formulated and conceptualized a theory of glass in his 1913 treatise Glasarchitektur. He was a prophet of both the aesthetic and technological merits of glass in architecture.

In order to raise our culture to a higher level, we are forced . . . to change our architecture. And this will be possible only if we free the rooms in which we live of their enclosed character. This, however, we can only do by introducing a glass architecture, which admits the light of the sun, of the moon, and of the stars into the rooms, not only through a few windows, but through as many walls as feasible, these to consist entirely of glass—of colored glass.

SOURCE: KENNETH FRAMTON, *MODERN ARCHITECTURE: A CRITICAL HISTORY*. (NY: OXFORD UNIVERSITY PRESS, 1980)

Filippo Tommaso Marinetti (1876–1944)

From "The Foundation and Manifesto of Futurism"

After Marinetti's example of 1908, the manifesto became a popular device for innovative twentieth-century artists to publicize their views.

1. We intend to glorify the love of danger, the custom of energy, the strength of daring. . . .

3. Literature having up to now glorified thoughtful immobility, ecstasy, and slumber, we wish to exalt the aggressive movement, the feverish insomnia, running, the perilous leap, the cuff, and the blow.

4. We declare that the splendor of the world has been enriched with a new form of beauty, the beauty of speed. A race-automobile adorned with great pipes like serpents with explosive breath . . . a race-automobile which seems to rush over exploding powder is more beautiful than the *Victory of Samothrace*. . . .

7. There is no more beauty except in struggle. No masterpiece without the stamp of aggressiveness. Poetry should be a violent assault against unknown forces to summon them to lie down at the feet of man. . . .

9. We will glorify war—the only true hygiene of the world—militarism, patriotism, the destructive gesture of the anarchist, the beautiful Ideas which kill, and the scorn of woman.

10. We will destroy museums, libraries, and fight against moralism, feminism, and all utilitarian cowardice. . . .

It is in Italy that we hurl this overthrowing and inflammatory declaration, with which today we found Futurism, for we will free Italy from her numberless museums which cover her with countless cemeteries. . . .

To admire an old picture is to pour our sentiment into a funeral urn instead of hurling it forth in violent gushes of action and productiveness. . . .

The oldest among us are thirty; we have thus at least ten years in which to accomplish our task. When we are forty, let others—younger and more daring men—throw us into the wastepaper basket like useless manuscripts!

SOURCE: *THEORIES OF MODERN ART: A SOURCEBOOK BY ARTISTS AND CRITICS*, ED. HERSHEL B. CHIPP WITH CONTRIBUTIONS BY PETER SELZ AND JOSHUA C. TAYLOR. (BERKELEY, CA: UNIVERSITY OF CALIFORNIA PRESS, 1968)

André Breton (1896–1966) and Leon Trotsky (1879–1940)

"Manifesto: Towards a Free Revolutionary Art" (1938)

André Breton, the leader of Surrealist movement, and Leon Trotsky, a Russian Communist leader (who had fled Joseph Stalin's purges and was living in Mexico), wrote the following statement denouncing totalitarian regimes, especially in Germany and Russia, and calling for artists to make a revolutionary art, one that changes the worldview. The manifesto was published in the leftist New York magazine, The Partisan Review. *Originally, for political reasons, the Mexican muralist Diego Rivera appeared as co-author instead of Trotsky.*

In the contemporary world we must recognize the ever more widespread destruction of those conditions under which intellectual creation is possible. From this follows of necessity an increasingly manifest degradation not only of the work of art but also of the specifically "artistic" personality. The regime of Hitler, now that it has rid Germany of all those artists whose work expressed the slightest sympathy for liberty, however superficial, has reduced those who still consent to take up pen or brush to the status of domestic servants of the regime, whose task it is to glorify it on order, according to the worst possible aesthetic conventions. If reports may be believed, it is the same in the Soviet Union, where Thermidorean reaction is now reaching its climax.

It goes without saying that we do not identify ourselves with the currently fashionable catchword: "Neither fascism nor communism!" a shibboleth which suits the temperament of the Philistine, conservative and frightened, clinging to the tattered remnants of the "democratic" past. True art, which is not content to play variations on ready-made models but rather insists on expressing the inner needs of man and of mankind in its time—true art is unable *not* to be revolutionary, *not* to aspire to a complete and radical reconstruction of society. This it must do, were it only to deliver intellectual creation from the chains which bind it, and to allow all mankind to raise itself to those heights which only isolated geniuses have achieved in the past.

SOURCE: *THE PARITISAN REVIEW,* 1938, VOL. IV #1, FALL 1938, PP. 49–53, TR. DWIGHT MACDONALD

Eva Hesse (1936–1970)

From an interview with Cindy Nemser

Hesse made the following statement in an interview with art critic Cindy Nemser just before her death from cancer in 1970.

Art and work and art and life are very connected and my whole life has been absurd. There isn't a thing in my life that has happened that hasn't been extreme—personal health, family, economic situations. My art, my school, my personal friends were the best things I ever had. And now back to extreme sickness—all extreme—all absurd. Now art being the most important thing for me, other than existing and staying alive, became connected to this, now closer meshed than ever, and absurdity is the key word. . . . It has to do with contradictions and oppositions. In the forms I use in my work the contradictions are there. I was always aware that I should take order versus chaos, stringy versus mass, huge versus small, and I would try to find the most absurd opposites or extreme opposites. . . . I was always aware of the absurdity and also their formal contradictions, and it was always more interesting than making something average, normal, right size, right proportion.

SOURCE: *ART TALK: CONVERSATIONS WITH 12 WOMEN ARTISTS* (NY: CHARLES SCRIBNER'S SONS, 1975)

Rosalind Krauss (b. 1940)

From "The Originality of the Avant-Garde"

Krauss was one of the founders of the critical art magazine October *in 1976. This passage is take from an article originally published in the magazine in October 1981.*

I will focus on the example of Sherrie Levine, because it seems most radically to question the concept of origin and with it the notion of originality.

Levine's medium is the pirated print, as in the series of photographs she made by taking images of Edward Weston of his young son Neil and simply rephotographing them, in violation of Weston's copyright. But as has been pointed out about Weston's "originals," these

are already taken from models provided by others; they are given in that long series of Greek kouroi by which the nude male torso has long ago been processed and multiplied within our culture. Levine's act of theft, which takes place, so to speak, in front of the surface of Weston's print, opens the print from behind to the series of models from which it, in turn, has stolen, of which it is itself the reproduction. . . .

Now, in so far as Levine's work explicity deconstructs the modernist notion of origin, her effort cannot be seen as an *extension* of modernism. It is, like the discourse of the copy, postmodernist. Which means that it cannot be seen as avant-garde either.

Because of the critical attack it launches on the tradition that precedes it, we might want to see the move made in Levine's work as yet another step in the forward march of the avant-garde. But this would be mistaken. In deconstructing the sister notions of origin and originality, postmodernism establishes a schism between itself and the conceptual domain of the avant-garde, looking back at it from across a gulf that in turn establishes a historical divide. The historical period that the avant-garde shared with modernism is over. That seems an obvious fact. What makes it more than a journalistic one is a conception of the discourse that has brought it to a close. This is a complex of cultural practices, among them a demythologizing criticism and a truly postmodernist art, both of them acting now to void the basic propositions of modernism, to liquidate them by exposing their fictitious condition. It is thus from a strange new perspective that we look back on the modernist origin and watch it splintering into endless replication.

SOURCE: *OCTOBER MAGAZINE*, 1981 (CAMBRIDGE: MIT PRESS, 1981)

Glossary

ABACUS. A slab of stone at the top of a Classical capital just beneath the architrave.

ABBEY. (1) A religious community headed by an abbot or abbess. (2) The buildings that house the community. An abbey church often has an especially large choir to provide space for the monks or nuns.

ACADEMY. A place of study, the word coming from the Greek name of a garden near Athens where Plato and, later, Platonic philosophers held philosophical discussions from the 5th century BCE to the 6th century CE. The first academy of fine arts was the Academy of Drawing, founded 1563 in Florence by Giorgio Vasari. Later academies were the Royal Academy of Painting and Sculpture in Paris, founded 1648, and the Royal Academy of Arts in London, founded 1768. Their purpose was to foster the arts by teaching, by exhibitions, by discussion, and occasionally by financial aid.

ACANTHUS. (1) A Mediterranean plant having spiny or toothed leaves. (2) An architectural ornament resembling the leaves of this plant, used on moldings, friezes, and Corinthian capitals.

ACROTERION (pl. **ACROTERIA**). Decorative ornaments placed at the apex and the corners of a pediment.

ACRYLIC. A plastic binder medium for pigments that is soluble in water. Developed about 1960.

ACTION PAINTING. In Abstract art, the spontaneous and uninhibited application of paint, as practiced by the avant-garde from the 1930s through the 1950s.

AERIAL PERSPECTIVE. See *perspective*.

AISLE. The passageway or corridor of a church that runs parallel to the length of the building. It often flanks the nave of the church but is sometimes set off from it by rows of piers or columns.

ALBUMEN PRINT. A process in photography that uses the proteins found in eggs to produce a photographic plate.

ALLA PRIMA. A painting technique in which pigments are laid on in one application with little or no underpainting.

ALTAR. A mound or structure on which sacrifices or offerings are made in the worship of a deity. In a Catholic church, a tablelike structure used in celebrating the Mass.

ALTARPIECE. A painted or carved work of art placed behind and above the altar of a Christian church. It may be a single panel or a *triptych* or a *polytych*, both having hinged wings painted on both sides. Also called a reredos or retablo.

ALTERNATE SYSTEM. A system developed in Romanesque church architecture to provide adequate support for a *groin-vaulted nave* having *bays* twice as long as the side-aisle bays. The *piers* of the nave *arcade* alternate in size; the heavier *compound piers* support the main nave vaults where the *thrust* is concentrated, and smaller, usually cylindrical, piers support the side-aisle vaults.

AMAZON. One of a tribe of female warriors said in Greek legend to dwell near the Black Sea.

AMBULATORY. A covered walkway. (1) In a basilican church, the semicircular passage around the apse. (2) In a central-plan church, the ring-shaped aisle around the central space. (3) In a cloister, the covered colonnaded or arcaded walk around the open courtyard.

AMPHITHEATER. A double theater. A building, usually oval in plan, consisting of tiers of seats and access corridors around the central theater area.

AMPHORA (pl. **AMPHORAE**). A large Greek storage vase with an oval body usually tapering toward the base. Two handles extend from just below the lip to the shoulder.

ANDACHTSBILD. German for "devotional image." A picture or sculpture with imagery intended for private devotion. It was first developed in Northern Europe.

ANIMAL STYLE. A style that appears to have originated in ancient Iran and is characterized by stylized or abstracted images of animals.

ANNULAR. From the Latin word for "ring." Signifies a ring-shaped form, especially an annular barrel vault.

ANTA (pl. **ANTAE**). The front end of a wall of a Greek temple, thickened to produce a pilasterlike member. Temples having columns between the antae are said to be "*in antis*."

APOCALYPSE. The Book of Revelation, the last book of the New Testament. In it, St. John the Evangelist describes his visions, experienced on the island of Patmos, of Heaven, the future of humankind, and the Last Judgment.

APOSTLE. One of the twelve disciples chosen by Jesus to accompany him in his lifetime and to spread the gospel after his death. The traditional list includes Andrew, Bartholomew, James the Greater (son of Zebedee), James the Lesser (son of Alphaeus), John, Judas Iscariot, Matthew, Peter, Philip, Simon the Canaanite, Thaddaeus (or Jude), and Thomas. In art, however, the same twelve are not always represented, since "apostle" was sometimes applied to other early Christians, such as St. Paul.

APSE. A semicircular or polygonal niche terminating one or both ends of the nave in a Roman basilica. In a Christian church, it is usually placed at the east end of the nave beyond the transept or choir. It is also sometimes used at the end of transept arms.

APSIDIOLE. A small apse or chapel connected to the main apse of a church.

AQUATINT. A print processed like an etching, except that the ground or certain areas are covered with a solution of asphalt, resin, or salts that, when heated, produces a granular surface on the plate and rich gray tones in the final print. Etched lines are usually added to the plate after the aquatint ground is laid.

AQUEDUCT. Latin for "duct of water." (1) An artificial channel or conduit for transporting water from a distant source. (2) The overground structure that carries the conduit across valleys, rivers, etc.

ARCADE. A series of arches supported by piers or columns. When attached to a wall, these form a blind arcade.

ARCH. A curved structure used to span an opening. Masonry arches are generally built of wedge-shaped blocks, called *voussoirs*, set with their narrow sides toward the opening so that they lock together. The topmost *voussoir* is called the *keystone*. Arches may take different shapes, such as the pointed Gothic arch or the rounded Classical arch.

ARCHBISHOP. The chief bishop of an ecclesiastic district.

ARCHITECTURAL ORDER. An architectural system based on the column and its entablature, in which the form of the elements themselves (capital, shaft, base, etc.) and their relationship to each other are specifically defined. The five Classical orders are the Doric, Ionic, Corinthian, Tuscan, and Composite.

ARCHITRAVE. The lowermost member of a classical entablature, such as a series of stone blocks that rest directly on the columns.

ARCHIVOLT. A molded band framing an arch, or a series of such bands framing a tympanum, often decorated with sculpture.

ARCUATION. The use of arches or a series of arches in building.

ARIANISM. Early Christian belief, initiated by Arius, a 4th-century CE priest in Alexandria. It was later condemned as heresy and suppressed, and it is now largely obscure.

ARRICCIO. A coating of rough plaster over a stone or cement wall that is used as a smooth base or ground (support) in fresco painting.

ART BRUT. Meaning "raw art" in French, *art brut* is the direct and highly emotional art of children and the mentally ill that served as an inspiration for some artistic movements in Modern art.

ASHLAR MASONRY. Carefully finished stone that is set in fine joints to create an even surface.

ATRIUM. (1) The central court or open entrance court of a Roman house. (2) An open court, sometimes colonnaded or arcaded, in front of a church.

ATTIC. A low upper story placed above the main cornice or entablature of a building and often decorated with windows and pilasters.

AUTOCHROME. A color photograph invented by Louis Lumière in 1903 using a glass plate covered with grains of starch dyed in three colors to act as filters and then a silver bromide emulsion.

AUTOMATIC DRAWING. A technique of drawing in Modern art whereby the artist tries to minimize his or her conscious and intellectual control over the lines or patterns drawn, relying instead on subconscious impulses to direct the drawing.

AVANT-GARDE. Meaning "advance force" in French, the artists of the avant-garde in 19th- and 20th-century Europe led the way in innovation in both subject matter and technique, rebelling against the established conventions of the art world.

BACCHANT (fem. **BACCHANTE**). A priest or priestess of the wine god, Bacchus (in Greek mythology, Dionysus), or one of his ecstatic female followers, who were sometimes called maenads.

BALDACCHINO. A canopy usually built over an altar. The most important one is Bernini's construction for St. Peter's in Rome.

BALUSTRADE. (1) A railing supported by short pillars called balusters. (2) Occasionally applied to any low parapet.

BANQUET PIECE. A variant of the still life, the banquet piece depicts an after-meal scene. It focuses more on tableware than food and typically incorporates a vanitas theme.

BAPTISTRY. A building or a part of a church in which the sacrament of baptism is administered. It is

often octagonal in design, and it contains a baptismal *font*, or a receptacle of stone or metal that holds the Holy Water for the rite.

BARREL VAULT. A vault formed by a continuous semicircular arch so that it is shaped like a half-cylinder.

BAR TRACERY. A style of tracery in which glass is held in place by relatively thin membranes.

BAS-DE-PAGE. Literally "bottom of the page." An illustration or decoration that is placed below a block of text in an illuminated manuscript.

BASE. (1) The lowermost portion of a column or pier, beneath the shaft. (2) The lowest element of a wall, dome, or building or occasionally of a statue or painting.

BASILICA. (1) In ancient Roman architecture, a large, oblong building used as a public meeting place and hall of justice. It generally includes a nave, side aisles, and one or more apses. (2) In Christian architecture, a longitudinal church derived from the Roman basilica and having a nave, an apse, two or four side aisles or side chapels, and sometimes a narthex. (3) Any one of the seven original churches of Rome or other churches accorded the same religious privileges.

BATTLEMENT. A parapet consisting of alternating solid parts and open spaces designed originally for defense and later used for decoration. See *crenelated.*

BAY. A subdivision of the interior space of a building. Usually a series of bays is formed by consecutive architectural supports.

BELVEDERE. A structure made for the purpose of viewing the surroundings, either above the roof of a building or freestanding in a garden or other natural setting.

BENEDICTINE ORDER. Founded at Monte Cassino in 529 CE by St. Benedict of Nursia (ca. 480–ca. 553). Less austere than other early orders, it spread throughout much of western Europe and England in the next two centuries.

BIBLE MORALISÉE. A type of illustrated Bible in which each page typically contains four pairs of illustrations representing biblical events and their related lessons.

BISHOP. The spiritual overseer of a number of churches or a diocese. His throne, or cathedra, placed in the principal church of the diocese, designates it as a cathedral.

BLACK-FIGURED. A style of ancient Greek pottery decoration characterized by black figures against a red background. The black-figured style preceded the red-figured style.

BLIND ARCADE. An arcade with no openings. The arches and supports are attached decoratively to the surface of a wall.

BLOCK BOOKS. Books, often religious, of the 15th century containing woodcut prints in which picture and text were usually cut into the same block.

BODEGÓNES. Although in modern Spanish *bodegón* means "still life," in 17th-century Spain, *bodegónes* referred to genre paintings that included food and drink, as in the work of Velázques.

BOOK COVER. The stiff outer covers protecting the bound pages of a book. In the medieval period, they were frequently covered with precious metal and elaborately embellished with jewels, embossed decoration, etc.

BOOK OF HOURS. A private prayer book containing the devotions for the seven canonical hours of the Roman Catholic church (matins, vespers, etc.), liturgies for local saints, and sometimes a calendar. They were often elaborately illuminated for persons of high rank, whose names are attached to certain extant examples.

BRACKET. A stone, wooden, or metal support projecting from a wall and having a flat top to bear the weight of a statue, cornice, beam, etc. The lower part may take the form of a scroll; it is then called a scroll bracket.

BROKEN PEDIMENT. See *pediment.*

BRONZE AGE. The earliest period in which bronze was used for tools and weapons. In the Middle East, the Bronze Age succeeded the Neolithic period in ca. 3500 BCE and preceded the Iron Age, which commenced ca. 1900 BCE.

BRUSH DRAWING. See *drawing.*

BUON FRESCO. See *fresco.*

BURIN. A pointed metal tool with a wedged-shaped tip used for engraving.

BUTTRESS. A projecting support built against an external wall, usually to counteract the lateral thrust of a vault or arch within. In Gothic church architecture, a *flying buttress* is an arched bridge above the aisle roof that extends from the upper nave wall, where the lateral thrust of the main vault is greatest, down to a solid pier.

BYZANTIUM. City on the Sea of Marmara, founded by the ancient Greeks and renamed Constantinople in 330 CE. Today called Istanbul.

CAESAR. The surname of the Roman dictator, Caius Julius Caesar, subsequently used as the title of an emperor; hence, the German Kaiser and the Russian czar (tsar).

CALLIGRAPHY. From the Greek word for "beautiful writing." (1) Decorative or formal handwriting executed with a quill or reed pen or with a brush. (2) A design derived from or resembling letters and used to form a pattern.

CALOTYPE. Invented in the 1830s, calotype was the first photographic process to use negatives and positive prints on paper.

CALVARY. The hill outside Jerusalem where Jesus was crucified, also known as *Golgotha*. The name *Calvary* is taken from the Latin word *calvaris*, meaning skull; the word *Golgotha* is the Greek transliteration of the word for "skull" in Aramaic. The hill was thought to be the spot where Adam was buried and was thus traditionally known as "the place of the skull." See *Golgotha*.

CAMEO. A low relief carving made on agate, seashell, or other multilayered material in which the subject, often in profile view, is rendered in one color while the background appears in another, darker color.

CAMERA OBSCURA. Latin for "dark room." A darkened enclosure or box with a small opening or lens on one wall through which light enters to form an inverted image on the opposite wall. The principle had long been known but was not used as an aid in picture making until the 16th century.

CAMES. Strips of lead in stained-glass windows that hold the pieces of glass together.

CAMPAGNA. Italian word for "countryside." When capitalized, it usually refers to the countryside near Rome.

CAMPANILE. From the Italian word *campana*, meaning "bell." A bell tower that is either round or square and is sometimes free-standing.

CAMPOSANTO. Italian word for "holy field." A cemetery near a church, often enclosed.

CANON. A law, rule, or standard.

CANOPY. In architecture, an ornamental, rooflike projection or cover above a statue or sacred object.

CAPITAL. The uppermost member of a column or pillar supporting the architrave.

CARDINAL. In the Roman Catholic church, a member of the Sacred college, the ecclesiastical body that elects the pope and constitutes his advisory council.

CARMELITE ORDER. Originally a 12th-century hermitage claimed to descend from a community of hermits established by the prophet Elijah on Mt. Carmel, Palestine. In the early 13th century it spread to Europe and England, where it was reformed by St. Simon Stock and became one of the three great mendicant orders.

CARTHUSIAN ORDER. An order founded at Chartreuse, France, by Saint Bruno in 1084; known for its very stringent rules. See *Chartreuse.*

CARTOON. From the Italian word *cartone*, meaning "large paper." (1) A full-scale drawing for a picture or design intended to be transferred to a wall, panel, tapestry, etc. (2) A drawing or print, usually humorous or satirical, calling attention to some action or person of popular interest.

CARVING. (1) The cutting of a figure or design out of a solid material such as stone or wood, as contrasted to the additive technique of modeling. (2) A work executed in this technique.

CARYATID. A sculptured female figure used in place of a column as an architectural support. A similar male figure is an *atlas* (pl. *atlantes*).

CASEMATE. A chamber or compartment within a fortified wall, usually used for the storage of artillery and munitions.

CASSONE (pl. *CASSONI*). An Italian dowry chest often highly decorated with carvings, paintings, inlaid designs, and gilt embellishments.

CASTING. A method of duplicating a work of sculpture by pouring a hardening substance such as plaster or molten metal into a mold.

CAST IRON. A hard, brittle iron produced commercially in blast furnaces by pouring it into molds where it cools and hardens. Extensively used as a building material in the early 19th century, it was superseded by steel and ferroconcrete.

CATACOMBS. The underground burial places of the early Christians, consisting of passages with niches for tombs and small chapels for commemorative services.

CATALOGUE RAISONNÉ. A complete list of an artist's works of art, with a comprehensive chronology and a discussion of the artist's style.

CATHEDRA. The throne of a bishop, the principal priest of a diocese. See *cathedral.*

CATHEDRAL. The church of a bishop; his administrative headquarters. The location of his *cathedra* or throne.

CELLA. (1) The principal enclosed room of a temple used to house an image. Also called the *naos.* (2) The entire body of a temple as distinct from its external parts.

CENTERING. A wooden framework built to support an arch, vault, or dome during its construction.

CENTRAL-PLAN CHURCH. (1) A church having four arms of equal length. The crossing is often covered with a dome. Also called a Greek-cross church. (2) A church having a circular or polygonal plan.

CHAMPLEVÉ. An enameling method in which hollows are etched into a metal surface and filled with enamel.

CHANCEL. The area of a church around the altar, sometimes set off by a screen. It is used by the clergy and the choir.

CHAPEL. (1) A private or subordinate place of worship. (2) A place of worship that is part of a church but separately dedicated.

CHARTREUSE. French word for a Carthusian monastery (in Italian, Certosa). The Carthusian Order was founded by St. Bruno (ca. 1030–1101) at Chartreuse near Grenoble in 1084. It is an eremitic order, the life of the monks being one of silence, prayer, and austerity.

CHASING. (1) A technique of ornamenting a metal surface by the use of various tools. (2) The procedure used to finish a raw bronze cast.

CHÂTEAU (pl. **CHÂTEAUS** or **CHÂTEAUX**). French word for "castle," now used to designate a large country house as well.

CHEVET. In Gothic architecture, the term for the developed and unified east end of a church, including choir, apse, ambulatory, and radiating chapels.

CHEVRON. A V-shaped decorative element that, when used repeatedly, gives a horizontal, zigzag appearance.

CHIAROSCURO. Italian word for "light and dark." In painting, a method of modeling form primarily by the use of light and shade.

CHOIR. In church architecture, a square or rectangular area between the apse and the nave or transept. It is reserved for the clergy and the singing choir and is usually marked off by steps, a railing, or a choir screen. Also called the *chancel*.

CHOIR SCREEN. A screen, frequently ornamented with sculpture and sometimes called a *rood screen*, separating the choir of a church from the nave or transept. In Orthodox Christian churches it is decorated with icons and thus called an *iconostasis*.

CHRISTOLOGICAL CYCLE. A series of illustrations depicting the life of Jesus Christ.

CIRE-PERDU PROCESS. The lost-wax process of casting. A method in which an original is modeled in wax or coated with wax, then covered with clay. When the wax is melted out, the resulting mold is filled with molten metal (often bronze) or liquid plaster.

CISTERCIAN ORDER. Founded at Cîteaux in France in 1098 by Robert of Molesme with the objective of reforming the Benedictine Order and reasserting its original ideals of a life of severe simplicity.

CITY-STATE. An autonomous political unit comprising a city and the surrounding countryside.

CLASSICISM. Art or architecture that harkens back to and relies upon the style and canons of the art and architecture of ancient Greece or Rome, which emphasize certain standards of balance, order, and beauty.

CLERESTORY. A row of windows in the upper part of a wall that rises above an adjoining roof. Its purpose is to provide direct lighting, as in a basilica or church.

CLOISONNÉ. An enameling method in which the hollows created by wires joined to a metal plate are filled with enamel to create a design.

CLOISTER. (1) A place of religious seclusion such as a monastery or nunnery. (2) An open court attached to a church or monastery and surrounded by an ambulatory. Used for study, meditation, and exercise.

CLUNIAC ORDER. Founded at Cluny, France, by Berno of Baume in 909. It had a leading role in the religious reform movement in the Middle Ages and had close connections to Ottonian rulers and to the papacy.

CODEX (pl. **CODICES**). A manuscript in book form made possible by the use of parchment instead of papyrus. During the 1st to 4th centuries CE, it gradually replaced the *rotulus*, or "scroll," previously used for written documents.

COFFER. (1) A small chest or casket. (2) A recessed, geometrically shaped panel in a ceiling. A ceiling decorated with these panels is said to be coffered.

COLLAGE. A composition made with cut and pasted scraps of materials, sometimes with lines or forms added by the artist.

COLONNADE. A series of regularly spaced columns supporting a lintel or entablature.

COLONNETTE. A small, often decorative, column that is connected to a wall or pier.

COLOPHON. (1) The production information given at the end of a book. (2) The printed emblem of a book's publisher.

COLOR-FIELD PAINTING. A technique of Abstract painting in which thinned paints are spread onto an unprimed canvas and allowed to soak in with minimal control by the artist.

COLOSSAL ORDER. Columns, piers, or pilasters in the shape of the Greek or Roman orders but that extend through two or more stories rather than following the Classical proportions.

COLUMN. An approximately cylindrical, upright architectural support, usually consisting of a long, relatively slender shaft, a base, and a capital. When imbedded in a wall, it is called an engaged column. Columns decorated with wraparound reliefs were used occasionally as freestanding commemorative monuments.

COMPOSITE IMAGE. An image formed by combining different images or different views of the subject.

COMPOUND PIER. A pier with attached pilasters or shafts.

CONCRETE. A mixture of sand or gravel with mortar and rubble invented in the ancient Near East and further developed by the Romans. Largely ignored during the Middle Ages, it was revived by Bramante in the early 16th century for St. Peter's.

CONTÉ CRAYON. A crayon made of graphite and clay used for drawing. Produces rich, velvety tones.

CONTINUOUS NARRATION. Portrayal of the same figure or character at different stages in a story that is depicted in a single artistic space.

CONTRAPPOSTO. Italian word for "set against." A composition developed by the Greeks to represent movement in a figure. The parts of the body are placed asymmetrically in opposition to each other around a central axis, and careful attention is paid to the distribution of weight.

CORBEL. (1) A bracket that projects from a wall to aid in supporting weight. (2) The projection of one course, or horizontal row, of a building material beyond the course below it.

CORBEL VAULT. A vault formed by progressively projecting courses of stone or brick, which eventually meet to form the highest point of the vault.

CORINTHIAN STYLE. An ornate Classical style of architecture, characterized in part by columns combining a fluted shaft with a capital made up of carved acanthus leaves and scrolls (*volutes*).

CORNICE. (1) The projecting, framing members of a classical pediment, including the horizontal one beneath and the two sloping or "raking" ones above. (2) Any projecting, horizontal element surmounting a wall or other structure or dividing it horizontally for decorative purposes.

COUNTER-REFORMATION. The movement of self-renewal and reform within the Roman Catholic church following the Protestant Reformation of the early 16th century and attempting to combat its influence. Also known as the Catholic Reform. Its principles were formulated and adopted at the Council of Trent, 1545–1563.

COURT STYLE. See *Rayonnant*.

CRENELATED. Especially in medieval Europe, the up-and-down notched walls (*battlements*) of fortified buildings and castles; the *crenels* served as openings for the use of weapons and the higher *merlons* as defensive shields.

CROMLECH. From the Welsh for "concave stone." A circle of large upright stones probably used as the setting for ritual ceremonies in prehistoric Britain.

CROSSHATCHING. In drawing and etching, parallel lines drawn across other parallel lines at various angles to represent differences in values and degrees of shading. See also *hatching*.

CROSSING. The area in a church where the transept crosses the nave, frequently emphasized by a dome or crossing tower.

CROSS SECTION. (1) In architecture, a drawing that shows a theoretical slice through a building along an imagined plane in order to reveal the design of the structure. (2) An imagined slice through any object along an imagined plane in order to reveal its structure.

CRYPT. A space, usually vaulted, in a church that sometimes causes the floor of the choir to be raised above that of the nave; often used as a place for tombs and small chapels.

CUNEIFORM. The wedge-shaped characters made in clay by the ancient Mesopotamians as a writing system.

CURTAIN WALL. A wall of a modern building that does not support the building; the building is supported by an underlying steel structure rather than by the wall itself, which serves the purpose of a facade.

CYCLOPEAN. An adjective describing masonry with large, unhewn stones, thought by the Greeks to have been built by the Cyclopes, a legendary race of one-eyed giants.

DAGUERREOTYPE. Originally, a photograph on a silver-plated sheet of copper, which had been treated with fumes of iodine to form silver iodide on its surface and then after exposure developed by fumes of mercury. The process, invented by L. J. M. Daguerre and made public in 1839, was modified and accelerated as daguerreotypes gained popularity.

DECALCOMANIA. A technique developed by the artist Max Ernst that uses pressure to transfer paint to a canvas from some other surface.

DEËSIS. From the Greek word for "entreaty." The representation of Christ enthroned between the Virgin Mary and St. John the Baptist, frequent in Byzantine mosaics and depictions of the Last Judgment. It refers to the roles of the Virgin Mary and St. John the Baptist as intercessors for humankind.

DENTIL. A small, rectangular, tooth-like block in a series, used to decorate a classical entablature.

DIKKA. An elevated, flat-topped platform in a mosque used by the muezzin or cantor.

DIORITE. An igneous rock, extremely hard and usually black or dark gray in color.

DIPTYCH. (1) Originally a hinged, two-leaved tablet used for writing. (2) A pair of ivory carvings or panel paintings, usually hinged together.

DIPYLON VASE. A Greek funerary vase with holes in the bottom through which libations were poured to the dead. Named for the cemetery near Athens where the vases were found.

DISGUISED SYMBOLISM. "Hidden" meaning in the details of a painting that carry a symbolic message.

DOLMEN. A structure formed by two or more large, upright stones capped by a horizontal slab. Thought to be a prehistoric tomb.

DOME. A true dome is a vaulted roof of circular, polygonal, or elliptical plan, formed with hemispherical or ovoidal curvature. May be supported by a circular wall or drum and by pendentives or related constructions. Domical coverings of many other sorts have been devised.

DOME VAULT. The arched sections of a dome that, joined together, form the rounded shape of a dome. See *dome, vault,* and *arch*.

DOMINICAN ORDER. Founded as a mendicant order by St. Dominic in Toulouse in 1220.

DOMUS. Latin word for "house." A detached, one-family Roman house with rooms frequently grouped around two open courts. The first court, called the *atrium*, was used for entertaining and conducting business. The second court, usually with a garden and surrounded by a *peristyle* or colonnade, was for the private use of the family.

DONOR. The patron or client at whose order a work of art was executed; the donor may be depicted in the work.

DORIC STYLE. A simple style of Classical architecture, characterized in part by smooth or fluted column shafts and plain, cushionlike capitals, and a frieze of *metopes* and *triglyphs*.

DRAWING. (1) A work in pencil, pen and ink, charcoal, etc., often on paper. (2) A similar work in ink or wash, etc., made with a brush and often called a brush drawing. (3) A work combining these or other techniques. A drawing may be large or small, a quick sketch or an elaborate work. Among its various forms are a record of something seen, a study for another work, an illustration associated with a text, and a technical aid.

DRESSED STONE. A masonry technique in which exposed stones are finished, or dressed, to produce a surface that is smooth and formal.

DRÔLERIES. French word for "jests." Used to describe the lively animals and small figures in the margins of late medieval manuscripts and in wood carvings on furniture.

DRUM. (1) A section of the shaft of a column. (2) A circular-shaped wall supporting a dome.

DRYPOINT. A type of *intaglio* printmaking in which a sharp metal needle is use to carve lines and a design into a (usually) copper plate. The act of drawing pushes up a burr of metal filings, and so, when the plate is inked, ink will be retained by the burr to create a soft and deep tone that will be unique to each print. The burr can only last for a few printings. Both the print and the process are called drypoint.

EARTHWORKS. Usually very large scale, outdoor artwork that is produced by altering the natural environment.

ECHINUS. In the Doric or Tuscan Order, the round, cushionlike element between the top of the shaft and the abacus.

ELEVATION. (1) An architectural drawing presenting a building as if projected on a vertical plane parallel to one of its sides. (2) Term used in describing the vertical plane of a building.

EMBLEM BOOK. A reference book for painters of Christian subjects that provides examples of objects and events associated with saints and other religious figures.

EMBOSSING. A metalworking technique in which a relief design is raised by hammering into the back side of a metal sheet.

EMPIRICISM. The philosophical and scientific idea that knowledge should be attained through observation and the accumulation of evidence through repeatable experiments.

ENAMEL. (1) Colored glassy substances, either opaque or translucent, applied in powder form to a metal surface and fused to it by firing. Two main techniques developed: champlevé (from the French for "raised field"), in which the areas to be treated are dug out of the metal surface; and cloisonné (from the French for "partitioned"), in which compartments or cloisons to be filled are made on the surface with thin metal strips. (2) A work executed in either technique.

ENCAUSTIC. A technique of painting with pigments dissolved in hot wax.

ENGAGED COLUMN. A column that is joined to a wall, usually appearing as a half-rounded vertical shape.

ENGRAVING. (1) A means of embellishing metal surfaces or gemstones by incising a design on the surface. (2) A print made by cutting a design into a metal plate (usually copper) with a pointed steel tool known as a burin. The burr raised on either side of the incised line is removed. Ink is then rubbed into the V-shaped grooves and wiped off the surface. The plate, covered with a damp sheet of paper, is run through a heavy press. The image on the paper is the reverse of that on the plate. When a fine steel needle is used instead of a burin and the burr is retained, a drypoint engraving results, characterized by a softer line. These techniques are called, respectively, engraving and drypoint.

ENTABLATURE. (1) In a classical order, the entire structure above the columns; this usually includes architrave, frieze, and cornice. (2) The same structure in any building of a classical style.

ENTASIS. A swelling of the shaft of a column.

ENVIRONMENT. In art, environment refers to the Earth itself as a stage for Environmental art, works that can be enormously large yet very minimal and abstract. These works can be permanent or transitory. The term Earth art is also used to describe these artworks.

ETCHING. (1) A print made by coating a copperplate with an acid-resistant resin and drawing through this ground, exposing the metal with a sharp instrument called a *stylus*. The plate is bathed in acid, which eats into the lines; it is then heated to remove the resin and finally inked and printed on paper. (2) The technique itself is also called etching.

EUCHARIST. (1) The sacrament of Holy Communion, the celebration in commemoration of the Last Supper. (2) The consecrated bread and wine used in the ceremony.

EVANGELISTS. Matthew, Mark, Luke, and John, traditionally thought to be the authors of the Gospels, the first four books of the New Testament, which recount the life and death of Christ. They are usually shown with their symbols, which are probably derived from the four beasts surrounding the throne of the Lamb in the Book of Revelation or from those in the vision of Ezekial: a winged man or angel for Matthew, a winged lion for Mark, a winged ox for Luke, and an eagle for John. These symbols may also represent the evangelists.

FACADE. The principle face or the front of a building.

FAIENCE. (1) A glass paste fired to a shiny opaque finish, used in Egypt and the Aegean. (2) A type of earthenware that is covered with a colorful opaque glaze and is often decorated with elaborate designs.

FATHERS OF THE CHURCH. Early teachers and defenders of the Christian faith. Those most frequently represented are the four Latin fathers: St. Jerome, St. Ambrose, and St. Augustine, all of the 4th century, and St. Gregory of the 6th.

FERROCONCRETE. See *reinforced concrete*.

FERROVITREOUS. In 19th-century architecture, the combining of iron (and later steel) with glass in the construction of large buildings (e.g., railway stations, exhibition halls, etc.).

FIBULA. A clasp, buckle, or brooch, often ornamented.

FILIGREE. Delicate decorative work made of intertwining wires.

FINIAL. A relatively small, decorative element terminating in a gable, pinnacle, or the like.

FLAMBOYANT GOTHIC. A style of Late Gothic architecture in which the bar tracery supporting the strained glass windows is formed into elaborate pointed, often flamelike, shapes.

FLUTING. In architecture, the ornamental grooves channeled vertically into the shaft of a column or *pilaster*. They may meet in a sharp edge, as in the Doric style, or be separated by a narrow strip or fillet, as in the Ionic, Corinthian, and composite styles.

FLYING BUTTRESS. An arch or series of arches on the exterior of a building, connecting the building to detached pier buttresses so that the thrust from the roof vaults is offset.

FOLIO. A leaf of a manuscript or a book, identified so that the front and the back have the same number, the front being labeled *recto* and the back *verso*.

FONT. (1) In printing, a complete set of type in which the letters and numbers follow a consistent design and style. (2) The stone or metal container that holds the Holy Water in a baptistry.

FORESHORTENING. A method of reducing or distorting the parts of a represented object that are not parallel to the picture plane in order to convey the impression of three dimensions as perceived by the human eye.

FORMALISM. The emphasis in art on form; i.e, on line, shape, color, composition, etc. rather than on subject matter. Hence, art from any era may be judged on the basis of its formal elements alone.

FORUM (pl. **FORA**). In an ancient Roman city, the main public square, which was a public gathering place and the center of judicial and business activity.

FOUR-IWAN MOSQUE. A mosque with a rectangular interior courtyard designed with a large vaulted chamber or recess open to the courtyard on each side.

FRANCISCAN ORDER. Founded as a mendicant order by St. Francis of Assisi (Giovanni de Bernardone, ca. 1181–1226). The order's monks aimed to imitate the life of Christ in its poverty and humility, to preach, and to minister to the spiritual needs of the poor.

FRESCO. Italian word for "fresh." Fresco is the technique of painting on plaster with pigments ground in water so that the paint is absorbed by the plaster and becomes part of the wall itself. *Buon fresco* is the technique of painting on wet plaster; *fresco secco* is the technique of painting on dry plaster.

FRIEZE. (1) A continuous band of painted or sculptured decoration. (2) In a Classical building, the part of the entablature between the architrave and the cornice. A Doric frieze consists of alternating triglyphs and metopes, the latter often sculptured. An Ionic frieze is usually decorated with continuous relief sculpture.

FRONTALITY. Representation of a subject in a full frontal view.

FROTTAGE. The technique of rubbing a drawing medium, such as a crayon, over paper that is placed over a textured surface in order to transfer the underlying pattern to the paper.

GABLE. (1) The triangular area framed by the cornice or eaves of a building and the sloping sides of a pitched roof. In Classical architecture, it is called a *pediment*. (2) A decorative element of similar shape, such as the triangular structures above the portals of a Gothic church and sometimes at the top of a Gothic picture frame.

GALLERY. A second story placed over the side aisles of a church and below the clerestory. In a church with a four-part elevation, it is placed below the triforium and above the nave arcade.

GENIUS. A winged semi-nude figure, often purely decorative but frequently personifying an abstract concept or representing the guardian spirit of a person or place.

GENRE. The French word for "kind" or "sort." In art, a genre scene is a work of art, usually a painting, depicting a scene from everyday, ordinary life.

GEOMETRIC ARABESQUE. Complex patterns and designs usually composed of polygonal geometric forms, rather than organic flowing shapes; often used as ornamentation in Islamic art.

GESSO. A smooth mixture of ground chalk or plaster and glue used as the basis for tempera painting and for oil painting on panel.

GESTURE PAINTING. A technique in painting and drawing where the actual physical movement of the artist is reflected in the brush stroke or line as it is seen in the artwork. The artist Jackson Pollock is particularly associated with this technique.

GIGANTOMACHY. From Greek mythology, the battle of the gods and the giants.

GILDING. (1) A coat of gold or of a gold-colored substance that is applied mechanically or chemically to surfaces of a painting, sculpture, or architectural decoration. (2) The process of applying this material.

GIORNATA. Because fresco painting dries quickly, artists apply only as much wet plaster on the wall as can be painted in one day. That amount of work is called the *giornata*, from the Italian word *giorno*, meaning "day." So, *giornata* means "one day's work."

GISANT. In a tomb sculpture, a recumbent effigy or representation of the deceased. At times, the gisant may be represented in a state of decay.

GLAZE. (1) A thin layer of translucent oil color applied to a painted surface or to parts of it in order to modify the tone. (2) A glassy coating applied to a piece of ceramic work before firing in the kiln as a protective seal and often as decoration.

GLAZED BRICK. Brick that is baked in a kiln after being painted.

GLORIOLE (or **GLORY**). The circle of radiant light around the heads or figures of God, Christ, the Virgin Mary, or a saint. When it surrounds the head only, it is called a *halo* or *nimbus*; when it surrounds the entire figure with a large oval, it is called a *mandorla* (the Italian word for "almond"). It indicates divinity or holiness, though originally it was placed around the heads of kings and gods as a mark of distinction.

GOLD LEAF. (1) Gold beaten into very thin sheets or "leaves" and applied to illuminated manuscripts and panel paintings, to sculpture, or to the back of the glass tesserae used in mosaics. (2) *Silver leaf* is also used, though ultimately it tarnishes. Sometimes called gold foil, silver foil.

GOLGOTHA. From the word in Aramaic meaning "skull," Golgotha is the hill outside Jerusalem where the Crucifixtion of Jesus Christ took place; it is also known as Calvary. See *Calvary*.

GORGON. In Greek mythology, one of three hideous female monsters with large heads and snakes for hair. Their glance turned men to stone. Medusa, the most famous of the Gorgons, was killed by Perseus only with help from the gods.

GOSPEL. (1) The first four books of the New Testament. They tell the story of Christ's life and death and are ascribed to the evangelists Matthew, Mark, Luke, and John. (2) A copy of these, usually called a Gospel Book, often richly illuminated.

GRANULATION. A technique of decoration in which metal granules, or tiny metal balls, are fused to a metal surface.

GRATTAGE. A technique in painting whereby an image is produced by scraping off paint from a canvas that has been placed over a textured surface.

GREEK CROSS. A cross with four arms of equal length arranged at right angles.

GREEK-CROSS CHURCH. A church designed using the shape of an equal-armed Greek cross; it has a central room with four equally sized rooms extending outward from the main room.

GRISAILLE. A monochrome drawing or painting in which only values of black, gray, and white are used.

GRISAILLE GLASS. White glass painted with gray designs.

GROIN VAULT. A vault formed by the intersection of two barrel vaults at right angles to each other. A groin is the ridge resulting from the intersection of two vaults.

GROUND-LINE. The line, actual or implied, on which figures stand.

GROUND PLAN. An architectural drawing presenting a building as if cut horizontally at the floor level. Also called a *plan*.

GUTTAE. In a Doric entablature, small peglike projections above the frieze; possibly derived from pegs originally used in wooden construction.

HALL CHURCH. See *hallenkirche*.

HALLENKIRCHE. German word for "hall church." A church in which the nave and the side aisles are of the same height. The type was developed in Romanesque architecture and occurs especially frequently in German Gothic churches.

HALO. In painting, the circle or partial circle of light depicted surrounding the head of a saint, angel, or diety to indicate a holy or sacred nature; most common in medieval paintings but also seen in more modern artwork. Also called a *nimbus*.

HAPPENING. A type of art that involves visual images, audience participation, and improvised performance, usually in a public setting and under the loose direction of an artist.

HATAIJI STYLE. Meaning literally "of Cathay" or "Chinese"; used in Ottoman Turkish art to describe an artistic pattern consisting of stylized lotus blossoms, other flowers, and sinuous leaves on curving stems.

HATCHING. A series of parallel lines used as shading in prints and drawings. When two sets of crossing parallel lines are used, it is called *crosshatching*.

HERALDIC COMPOSITION. A design that is symmetrical around a central axis.

HIERATIC SCALE. An artistic technique in which the importance of figures is indicated by size, so that the most important figure is depicted as the largest.

HIEROGLYPH. A symbol, often based on a figure, animal, or object, standing for a word, syllable, or sound. These symbols form the early Egyptian writing system, and are found on ancient Egyptian monuments as well as in Egyptian written records.

HIGH RELIEF. See *relief*.

HÔTEL. French word for "hotel" but used also to designate an elegant town house.

HOUSE CHURCH. A place for private worship within a house; the first Christian churches were located in private homes that were modified for religious ceremonies.

HUMANISM. A philosophy emphasizing the worth of the individual, the rational abilities of humankind, and the human potential for good. During the Italian Renaissance, humanism was part of a movement that encouraged study of the classical cultures of Greece and Rome; often it came into conflict with the doctrines of the Catholic church.

HYPOSTYLE. A hall whose roof is supported by columns.

ICON. From the Greek word for "image." A panel painting of one or more sacred personages, such as Christ, the Virgin, or a saint, particularly venerated in the Orthodox Christian church.

ICONOCLASM. The doctrine of the Christian church in the 8th and 9th centuries that forbade the worship or production of religious images. This doctrine led to the destruction of many works of art. The iconoclastic controversy over the validity of this doctrine led to a division of the church. Protestant churches of the 16th and 17th centuries also practiced iconoclasm.

ICONOGRAPHY. (1) The depicting of images in art in order to convey certain meanings. (2) The study of the meaning of images depicted in art, whether they be inanimate objects, events, or personages. (3) The content or subject matter of a work of art.

ILLUSIONISM. In artistic terms, the technique of manipulating pictorial or other means in order to cause the eye to perceive a particular reality. May be used in architecture and sculpture, as well as in painting.

IMPASTO. From the Italian word meaning "to make into a paste"; it describes paint, usually oil paint, applied very thickly.

IN ANTIS. An architectural term that indicates the position of the columns on a Greek or Roman building when those columns are set between the junction of two walls.

INCISION. A cut made into a hard material with a sharp instrument.

INLAID NIELLO. See *niello*.

INSULA (pl. **INSULA**). Latin word for "island." (1) An ancient Roman city block. (2) A Roman "apartment house": a concrete and brick building or chain of buildings around a central court, up to five stories high. The ground floor had shops, and above were living quarters.

INTAGLIO. A printing technique in which the design is formed from ink-filled lines cut into a surface. Engraving, etching, and drypoint are examples of intaglio.

INTONACO. The layer of smooth plaster on which paint is applied in fresco painting.

IONIC STYLE. A style of Classical Greek architecture that is characterized in part by columns that have fluted shafts, capitals with volutes (scrolls), and a base; a continuous frieze is also characteristic.

IWAN. A vaulted chamber in a mosque or other Islamic structure, open on one side and usually opening onto an interior courtyard.

JAMBS. The vertical sides of an opening. In Romanesque and Gothic churches, the jambs of doors and windows are often cut on a slant outward, or "splayed," thus providing a broader surface for sculptural decoration.

JAPONISME. In 19th-century French and American art, a style of painting and drawing that reflected the influence of the Japanese artworks, particularly prints, that were then reaching the West.

JESUIT ORDER. The "Society of Jesus" was founded in 1534 by Ignatius of Loyola (1491–1556) and was especially devoted to the service of the pope. The order was a powerful influence in the struggle of the Catholic Counter-Reformation with the Protestant Reformation and was also very important for its missionary work, disseminating Christianity in the Far East and the New World. The mother church in Rome, Il Gesù, conforms in design to the preaching aims of the new order.

KEEP. (1) The innermost and strongest structure or central tower of a medieval castle, sometimes used as living quarters, as well as for defense. Also called a donjon. (2) A fortified medieval castle.

KEYSTONE. The highest central stone or voussoir in an arch; it is the final stone to be put in place, and its weight holds the arch together.

KITSCH. A German word for "trash," in English *kitsch* has come to describe a sensibility that is vulgar and sentimental, in contrast to the refinement of "high" art or fine art.

KORE (pl. **KORAI**). Greek word for "maiden." An Archaic Greek statue of a standing, draped female.

KOUROS (pl. **KOUROI**). Greek word for "male youth." An Archaic Greek statue of a standing, nude youth.

KRATER. A Greek vessel, of assorted shapes, in which wine and water are mixed. A *calyx krater* is a bell-shaped vessel with handles near the base; a *volute krater* is a vessel with handles shaped like scrolls.

KUFIC. One of the first general forms of Arabic script to be developed, distinguished by its angularity; distinctive variants occur in various parts of the Islamic worlds.

KUNSTKAMMEN (German, pl. **KUNSTKAMMERN**; in Dutch, **KUNSTKAMER**). Literally this is a room of art. Developed in the 16th century, it is a forerunner of the museum—a display of paintings and objects of natural history (shells, bones, etc.) that formed an encyclopedic collection.

KYLIX. In Greek and Roman antiquity, a shallow drinking cup with two horizontal handles, often set on a stem terminating in a foot.

LABORS OF THE MONTHS. The various occupations suitable to the months of the year. Scenes or figures illustrating these were frequently represented in illuminated manuscripts. Sometimes scenes of the labors of the months were combined with signs of the zodiac.

LAMASSU. An ancient Near Eastern guardian of a palace; often shown in sculpture as a human-headed bull or lion with wings.

LANCET. A tall, pointed window common in Gothic architecture.

LANDSCAPE. A drawing or painting in which an outdoor scene of nature is the primary subject.

LANTERN. A relatively small structure crowning a dome, roof, or tower, frequently open to admit light to an enclosed area below.

LAPITH. A member of a mythical Greek tribe that defeated the Centaurs in a battle, scenes from which are frequently represented in vase painting and sculpture.

LATIN CROSS. A cross in which three arms are of equal length and one arm is longer.

LAY BROTHER. One who has joined a monastic order but has not taken monastic vows and therefore belongs still to the people or laity, as distinguished from the clergy or religious.

LEKYTHOS (pl. **LEKYTHOI**). A Greek oil jug with an ellipsoidal body, a narrow neck, a flanged mouth, a curved handle extending from below the lip to the shoulder, and a narrow base terminating in a foot. It was used chiefly for ointments and funerary offerings.

LIBERAL ARTS. Traditionally thought to go back to Plato, they comprised the intellectual disciplines considered suitable or necessary to a complete education and included grammar, rhetoric, logic, arithmetic, music, geometry, and astronomy. During the Middle Ages and the Renaissance, they were often represented allegorically in paintings, engravings, and sculpture.

LINTEL. In architecture, a horizontal beam of any material that is held up by two vertical supports.

LITHOGRAPH. A print made by drawing a design with an oily crayon or other greasy substance on a porous stone or, later, a metal plate; the design is then fixed, the entire surface is moistened, and the printing ink that is applied adheres only to the oily lines of the drawing. The design can then be transferred easily in a press to a piece of paper. The technique was invented ca. 1796 by Aloys Senefelder and quickly became popular. It is also widely used commercially, since many impressions can be taken from a single plate.

LOGGIA. A covered gallery or arcade open to the air on at least one side. It may stand alone or be part of a building.

LONGITUDINAL SECTION. A cross section of a building or other object that shows the lengthwise structure. See *cross section*.

LOUVERS. A series of overlapping boards or slats that can be opened to admit air but are slanted so as to exclude sun and rain.

LOW RELIEF. See *relief*.

LUNETTE. (1) A semicircular or pointed wall area, as under a vault, or above a door or window. When it is above the portal of a medieval church, it is called a *tympanum*. (2) A painting, relief sculpture, or window of the same shape.

MADRASA. An Islamic religious college.

MAESTÀ. Italian word for "majesty," applied in the 14th and 15th centuries to representations of the Madonna and Child enthroned and surrounded by her celestial court of saints and angels.

MAGICO-RELIGIOUS. In art, subject matter that deals with the supernatural and often has the purpose of invoking those powers to achieve human ends, e.g., prehistoric cave paintings used to ensure a successful hunt.

MAGUS (pl. **MAGI**). (1) A member of the priestly caste of ancient Media and Persia. (2) In Christian literature, one of the three Wise Men or Kings who came from the East bearing gifts to the newborn Jesus.

MANDORLA. A representation of light surrounding the body of a holy figure.

MANIERA. In painting, the "Greek style" of the 13th century that demonstrated both Italian and Byzantine influences.

MANUSCRIPT ILLUMINATION. Decoration of handwritten documents, scrolls, or books with drawings or paintings. Illuminated manuscripts were often produced during the Middle Ages.

MAQSURA. A screened enclosure, reserved for the ruler, often located before the *mihrab* in certain important royal Islamic mosques.

MARTYRIUM (pl. **MARTYRIA**). A church, chapel, or shrine built over the grave of a Christian martyr or at the site of an important miracle.

MASTABA. An ancient Egyptian tomb, rectangular in shape, with sloping sides and a flat roof. It covered a chapel for offerings and a shaft to the burial chamber.

MATRIX. (1) A mold or die used for shaping a ceramic object before casting. (2) In printmaking, any surface on which an image is incised, carved, or applied and from which a print may be pulled.

MAUSOLEUM. (1) The huge tomb erected at Halikarnassos in Asia Minor in the 4th century BCE by King Mausolos and his wife Artemisia. (2) A generic term for any large funerary monument.

MEANDER. A decorative motif of intricate, rectilinear character applied to architecture and sculpture.

MEDIUM (pl. **MEDIUMS**). (1) The material or technique in which an artist works. (2) The vehicle in which pigments are carried in paint, pastel, etc.

MEGALITH. From the Greek *mega*, meaning "big," and *lithos*, meaning "stone." A huge stone such as those used in cromlechs and dolmens.

MEGARON (pl. **MEGARONS** or **MEGARA**). From the Greek word for "large." The central audience hall in a Minoan or Mycenaean palace or home.

MENHIR. A megalithic upright slab of stone, sometimes placed in rows by prehistoric peoples.

MESOLITHIC. Transitional period of the Stone Age between the Paleolithic and the Neolithic.

METOPE. The element of a Doric frieze between two consecutive triglyphs, sometimes left plain but often decorated with paint or relief sculpture.

MIHRAB. A niche, often highly decorated, usually found in the center of the *qibla* wall of a mosque, indicating the direction of prayer toward Mecca.

MINARET. A tower on or near a mosque, varying extensively in form throughout the Islamic world, from which the faithful are called to prayer five times a day.

MINBAR. A type of staircase pulpit, found in more important mosques to the right of the mihrab, from which the Sabbath sermon is given on Fridays after the noonday prayer.

MINIATURE. (1) A single illustration in an illuminated manuscript. (2) A very small painting, especially a portrait on ivory, glass, or metal.

MINOTAUR. In Greek mythology, a monster having the head of a bull and the body of a man who lived in the Labyrinth of the palace of Knossos on Crete.

MODEL. (1) The preliminary form of a sculpture, often finished in itself but preceding the final casting or carving. (2) Preliminary or reconstructed form of a building made to scale. (3) A person who poses for an artist.

MODELING. (1) In sculpture, the building up of a figure or design in a soft substance such as clay or wax. (2) In painting and drawing, producing a three-dimensional effect by changes in color, the use of light and shade, etc.

MODULE. (1) A segment of a pattern. (2) A basic unit, such as the measure of an architectural member. Multiples of the basic unit are used to determine proportionate construction of other parts of a building.

MOLDING. In architecture, any of various long, narrow, ornamental bands having a distinctive profile that project from the surface of the structure and give variety to the surface by means of their patterned contrasts of light and shade.

MONASTIC ORDER. A religious society whose members live together under an established set of rules.

MONOTYPE. A unique print made from a copper plate or other type of plate from which no other copies of the artwork are made.

MOSAIC. Decorative work for walls, vaults, ceilings, or floors composed of small pieces of colored materials, called *tesserae*, set in plaster or concrete. Romans, whose work was mostly for floors, used shaped pieces of colored stone. Early Christians used pieces of glass with brilliant hues, including gold, and slightly irregular surfaces, producing an entirely different glittering effect.

MOSQUE. A building used as a center for community prayers in Islamic worship; it often serves other functions including religious education and public assembly.

MOTIF. A visual theme, a motif may appear numerous times in a single work of art.

MOZARAB. Term used for the Spanish Christian culture of the Middle Ages that developed while Muslims were the dominant culture and political power on the Iberian peninsula.

MUQARNAS. A distinctive type of Islamic decoration consisting of multiple nichelike forms usually arranged in superimposed rows, often used in zones of architectural transition.

MURAL. From the Latin word for wall, *murus*. A large painting or decoration either executed directly on a wall (fresco) or done separately and affixed to it.

MUSES. In Greek mythology, the nine goddesses who presided over various arts and sciences. They are led by Apollo as god of music and poetry and usually include Calliope, muse of epic poetry; Clio, muse of history; Erato, muse of love poetry; Euterpe, muse of music; Melpomene, muse of tragedy; Polyhymnia, muse of sacred music; Terpsichore, muse of dancing; Thalia, muse of comedy; and Urania, muse of astronomy.

MUTULES. A feature of Doric architecture, mutules are flat rectangular blocks found just under the cornice.

NAOS. See *cella*.

NARTHEX. The transverse entrance hall of a church, sometimes enclosed but often open on one side to a preceding atrium.

NATURALISM. A style of art that aims to depict the natural world as it appears.

NAVE. (1) The central aisle of a Roman basilica, as distinguished from the side aisles. (2) The same section of a Christian basilican church extending from the entrance to the apse or transept.

NECROPOLIS. Greek for "city of the dead." A burial ground or cemetery.

NEOLITHIC. The New Stone Age, thought to have begun ca. 9000–8000 BCE. The first society to live in settled communities, to domesticate animals, and to cultivate crops, it saw the beginning of many new skills, such as spinning, weaving, and building.

NEW STONE AGE. See *neolithic*.

NIELLO. Dark metal alloys applied to the engraved lines in a precious metal plate (usually made of gold or silver) to create a design.

NIKE. The ancient Greek goddess of victory, often identified with Athena and by the Romans with Victoria. She is usually represented as a winged woman with windblown draperies.

NIMBUS. See *halo*.

NOCTURNE. A painting that depicts a nighttime scene, often emphasizing the effects of artificial light.

NONOBJECTIVE PAINTING. In Abstract art, the style of painting that does not strive to represent objects, including people, as they would appear in everyday life or in the natural world.

OBELISK. A tall, tapering, four-sided stone shaft with a pyramidal top. First constructed as *megaliths* in ancient Egypt, certain examples have since been exported to other countries.

OCULUS. The Latin word for "eye." (1) A circular opening at the top of a dome used to admit light. (2) A round window.

ODALISQUE. Turkish word for "harem slave girl" or "concubine."

OIL PAINTING. (1) A painting executed with pigments mixed with oil, first applied to a panel prepared with a coat of gesso (as also in tempera painting), and later to a stretched canvas primed with a coat of white paint and glue. The latter method has predominated since the late 15th century. Oil painting also may be executed on paper, parchment, copper, etc. (2) The technique of executing such a painting.

OIL SKETCH. A work in oil painting of an informal character, sometimes preparatory to a finished work.

OLD STONE AGE. See *paleolithic.*

OPTICAL IMAGES. An image created from what the eye sees, rather than from memory.

ORANT. A standing figure with arms upraised in a gesture of prayer.

ORCHESTRA. (1) In an ancient Greek theater, the round space in front of the stage and below the tiers of seats, reserved for the chorus. (2) In a Roman theater, a similar space reserved for important guests.

ORTHODOX. From the Greek word for "right in opinion." The Eastern Orthodox church, which broke with the Western Catholic church during the 5th century CE and transferred its allegiance from the pope in Rome to the Byzantine emperor in Constantinople and his appointed patriarch. Sometimes called the Byzantine church.

ORTHOGONAL. In a perspective construction, an imagined line in a painting that runs perpendicular to the picture plane and recedes to a vanishing point.

ORTHOSTATS. Upright slabs of stone constituting or lining the lowest courses of a wall, often in order to protect a vulnerable material such as mud-brick.

PALAZZO (pl. **PALAZZI**). Italian word for "palace" (in French, palais). Refers either to large official buildings or to important private town houses.

PALEOLITHIC. The Old Stone Age, usually divided into Lower, Middle, and Upper (which began about 35,000 BCE). A society of nomadic hunters who used stone implements, later developing ones of bone and flint. Some lived in caves, which they decorated during the latter stages of the age, at which time they also produced small carvings in bone, horn, and stone.

PALETTE. (1) A thin, usually oval or oblong board with a thumbhole at one end, used by painters to hold and mix their colors. (2) The range of colors used by a particular painter. (3) In Egyptian art, a slate slab, usually decorated with sculpture in low relief. The small ones with a recessed circular area on one side are thought to have been used for eye makeup. The larger ones were commemorative objects.

PANEL. (1) A wooden surface used for painting, usually in tempera, and prepared beforehand with a layer of gesso. Large altarpieces require the joining together of two or more boards. (2) Recently, panels of Masonite or other composite materials have come into use.

PANTHEON. From *pan*, Greek for "all," and *theos*, Greek for "god." A Hellenistic Greek or Roman temple dedicated to all of the gods; in later years, often housing tombs or memorials for the illustrious dead of a nation.

PANTOCRATOR. A representation of Christ as ruler of the universe that appears frequently in the dome or apse mosaics of Byzantine churches.

PAPYRUS. (1) A tall aquatic plant that grows abundantly in the Near East, Egypt, and Abyssinia. (2) A paperlike material made by laying together thin strips of the pith of this plant and then soaking, pressing, and drying the whole. The resultant sheets were used as writing material by the ancient Egyptians, Greeks, and Romans. (3) An ancient document or scroll written on this material.

PARCHMENT. From Pergamon, the name of a Greek city in Asia Minor where parchment was invented in the 2nd century BCE. (1) A paperlike material made from bleached animal hides used extensively in the Middle Ages for manuscripts. Vellum is a superior type of parchment made from calfskin. (2) A document or miniature on this material.

PASSION. (1) In ecclesiastic terms, the events of Jesus' last week on earth. (2) The representation of these events in pictorial, literary, theatrical, or musical form.

PASTEL. (1) A soft, subdued shade of color. (2) A drawing stick made from pigments ground with chalk and mixed with gum water. (3) A drawing executed with these sticks.

PEDESTAL. An architectural support for a statue, vase, column, etc.

PEDIMENT. (1) In Classical architecture, a low gable, typically triangular, framed by a horizontal cornice below and two raking cornices above; frequently filled with sculpture. (2) A similar architectural member used over a door, window, or niche. When pieces of the cornice are either turned at an angle or interrupted, it is called a *broken pediment*.

PELIKE. A Greek storage jar with two handles, a wide mouth, little or no neck, and resting on a foot.

PENDENTIVE. One of the concave triangles that achieves the transition from a square or polygonal opening to the round base of a dome or the supporting drum.

PERFORMANCE ART. A type of art in which performance by actors or artists, often interacting with the audience in an improvisational manner, is the primary aim over a certain time period. These artworks are transitory, perhaps with only a photographic record of some of the events.

PERIPTERAL. An adjective describing a building surrounded by a single row of columns or colonnade.

PERISTYLE. (1) In a Roman house or *domus*, an open garden court surrounded by a colonnade. (2) A colonnade around a building or court.

PERPENDICULAR STYLE. The third style of English Gothic architecture, in which the bar tracery uses predominantly vertical lines. The fan vault is also used extensively in this style.

PERSPECTIVE. A system for representing spatial relationships and three-dimensional objects on a flat two-dimensional surface so as to produce an effect similar to that perceived by the human eye. In *atmospheric* or *aerial* perspective, this is accomplished by a gradual decrease in the intensity of color and value and in the contrast of light and dark as objects are depicted as farther and farther away in the picture. In color artwork, as objects recede into the distance, all colors tend toward a light bluish-gray tone. In *scientific* or *linear* perspective, developed in Italy in the 15th century, a mathematical system is used based on orthogonals receding to vanishing points on the horizon. Transversals intersect the orthogonals at right angles at distances derived mathematically. Since this presupposes an absolutely stationary viewer and imposes rigid restrictions on the artist, it is seldom applied with complete consistency. Although traditionally ascribed to Brunelleschi, the first theoretical text on perspective was Leon Battista Alberti's *On Painting* (1435).

PHILOSOPHES. Philosophers and intellectuals of the Enlightenment, whose writings had an important influence upon the art of that time.

PHOTOGRAM. A shadowlike photograph made without a camera by placing objects on light-sensitive paper and exposing them to a light source.

PHOTOGRAPH. The relatively permanent or "fixed" form of an image made by light that passes through the lens of a camera and acts upon light-sensitive substances. Often called a print.

PHOTOMONTAGE. A photograph in which prints in whole or in part are combined to form a new image. A technique much practiced by the Dada group in the 1920s.

PIAZZA (pl. **PIAZZE**). Italian word for "public square" (in French, place; in German, platz).

PICTURE PLANE. The flat surface on which a picture is painted.

PICTURESQUE. Visually interesting or pleasing, as if resembling a picture.

PIER. An upright architectural support, usually rectangular and sometimes with capital and base. When columns, pilasters, or shafts are attached to it, as in many Romanesque and Gothic churches, it is called a compound pier.

PIETÀ. Italian word for both "pity" and "piety." A representation of the Virgin grieving over the dead Christ. When used in a scene recording a specific moment after the Crucifixion, it is usually called a Lamentation.

PIETRA SERENA. A limestone, gray in color, used in the Tuscany region of Italy.

PILASTER. A flat, vertical element projecting from a wall surface and normally having a base, shaft, and capital. It has generally a decorative rather than a structural purpose.

PILGRIMAGE CHOIR. The unit in a Romanesque church composed of the apse, ambulatory, and radiating chapels.

PILGRIMAGE PLAN. The general design used in Christian churches that were stops on the pilgrimage routes throughout medieval Europe, characterized by having side aisles that allowed pilgrims to ambulate around the church. See *pilgrimage choir*.

PILLAR. A general term for a vertical architectural support that includes columns, piers, and pilasters.

PILOTIS. Pillars that are constructed from *reinforced concrete* (*ferroconcrete*).

PINNACLE. A small, decorative structure capping a tower, pier, buttress, or other architectural member. It is used especially in Gothic buildings.

PLAN. See *ground plan*.

PLATE TRACERY. A style of tracery in which pierced openings in an otherwise solid wall of stonework are filled with glass.

PLEIN-AIR. Sketching outdoors, often using paints, in order to capture the immediate effects of light on landscape and other subjects. Much encouraged by the Impressionists, their *plein-air* sketches were often taken back to the studio to produce finished paintings, but many *plein-air* sketches are considered masterworks.

PODIUM. (1) The tall base upon which rests an Etruscan or Roman temple. (2) The ground floor of a building made to resemble such a base.

POLYTYCH. An altarpiece or devotional work of art made of several panels joined together, often hinged.

PORCH. General term for an exterior appendage to a building that forms a covered approach to a doorway.

PORTA. Latin word for "door" or "gate."

PORTAL. A door or gate, usually a monumental one with elaborate sculptural decoration.

PORTICO. A columned porch supporting a roof or an entablature and pediment, often approached by a

number of steps. It provides a covered entrance to a building and a connection with the space surrounding it.

POST AND LINTEL. A basic system of construction in which two or more uprights, the posts, support a horizontal member, the lintel. The lintel may be the topmost element or support a wall or roof.

POUNCING. A technique for transferring a drawing from a cartoon to a wall or other surface by pricking holes along the principal lines of the drawing and forcing fine charcoal powder through them onto the surface of the wall, thus reproducing the design on the wall.

POUSSINISTES. Those artists of the French Academy at the end of the17th century and the beginning of the 18th century who favored "drawing," which they believed appealed to the mind rather than the senses. The term derived from admiration for the French artist Nicolas Poussin. See *Rubénistes*.

PREDELLA. The base of an altarpiece, often decorated with small scenes that are related in subject to that of the main panel or panels.

PREFIGURATION. The representation of Old Testament figures and stories as forerunners and foreshadowers of those in the New Testament.

PRIMITIVISM. The appropriation of non-Western (e.g., African, tribal, Polynesian) art styles, forms, and techniques by Modern era artists as part of innovative and avant-garde artistic movements; other sources were also used, including the work of children and the mentally ill.

PRINT. A picture or design reproduced, usually on paper and often in numerous copies, from a prepared wood block, metal plate, stone slab, or photograph.

PRONAOS. In a Greek or Roman temple, an open vestibule in front of the *cella*.

PRONK. A word meaning ostentatious or sumptuous; it is used to refer to a still life of luxurious objects.

PROPYLAEUM (pl. **PROPYLAEA**). (1) The often elaborate entrance to a temple or other enclosure. (2) The monumental entry gate at the western end of the Acropolis in Athens.

PROVENANCE. The place of origin of a work of art and related information.

PSALTER. (1) The book of Psalms in the Old Testament, thought to have been written in part by David, king of ancient Israel. (2) A copy of the Psalms, sometimes arranged for liturgical or devotional use and often richly illuminated.

PULPIT. A raised platform in a church from which the clergy delivers a sermon or conducts the service. Its railing or enclosing wall may be elaborately decorated.

PUTTO (pl. **PUTTI**). A nude, male child, usually winged, often represented in classical and Renaissance art. Also called a cupid or amoretto when he carries a bow and arrow and personifies Love.

PYLON. Greek word for "gateway." (1) The monumental entrance building to an Egyptian temple or forecourt consisting either of a massive wall with sloping sides pierced by a doorway or of two such walls flanking a central gateway. (2) A tall structure at either side of a gate, bridge, or avenue marking an approach or entrance.

QIBLA. The direction toward Mecca, which Muslims face during prayer. The qibla wall in a mosque identifies this direction.

QUADRANT VAULT. A half-barrel vault designed so that instead of being semicircular in cross-section, the arch is one-quarter of a circle.

QUADRA RIPORTATE. Painted scenes depicted in panels on the curved ceiling of a vault.

QUATREFOIL. An ornamental element composed of four lobes radiating from a common center.

RADIATING CHAPELS. Term for chapels arranged around the ambulatory (and sometimes the transept) of a medieval church.

RAYONNANT. The style of Gothic architecture, described as "radiant," developed at the Parisian court of Louis IX in the mid-13th century. Also referred to as *court style*.

READYMADE. An ordinary object that, when an artist gives it a new context and title, is transformed into an art object. Readymades were important features of the Dada and Surrealism movements of the early 20th century.

RED-FIGURED. A style of ancient Greek ceramic decoration characterized by red figures against a black background. This style of decoration developed toward the end of the 6th century BCE and replaced the earlier *black-figured* style.

REFECTORY. (1) A room for refreshment. (2) The dining hall of a masonry, college, or other large institution.

REFORMATION. The religious movement in the early 16th century that had for its object the reform of the Catholic church and led to the establishment of Protestant churches.

REGISTER. A horizontal band containing decoration, such as a relief sculpture or a fresco painting. When multiple horizontal layers are used, registers are useful in distinguishing between different visual planes and different time periods in visual narration.

REINFORCED CONCRETE. Concrete that has been made stronger, particularly in terms of tensile strength, by the imbedding of steel rods or steel mesh. Introduced in France ca. 1900. Many large modern buildings are only feasible through the use of reinforced concrete.

RELIEF. (1) The projection of a figure or part of a design from the background or plane on which it is carved or modeled. Sculpture done in this manner is described as "high relief" or "low relief" depending on the height of the projection. When it is very shallow, it is called *schiacciato*, the Italian word for "flattened out." (2) The apparent projection of forms represented in a painting or drawing. (3) A category of printmaking in which lines raised from the surface are inked and printed.

RELIQUARY. A container used for storing or displaying relics.

RESPOND. (1) A half-pier, pilaster, or similar element projecting from a wall to support a lintel or an arch whose other side is supported by a free-standing column or pier, as at the end of an arcade. (2) One of several pilasters on a wall behind a colonnade that echoes or "responds to" the columns but is largely decorative. (3) One of the slender shafts of a compound pier in a medieval church that seems to carry the weight of the vault.

RHYTON. An ancient drinking or pouring vessel made from pottery, metal, or stone, and sometimes designed in a human or animal form.

RIB. A slender, projecting, archlike member that supports a vault either transversely or at the groins, thus dividing the surface into sections. In Late Gothic architecture, its purpose is often primarily ornamental.

RIBBED VAULT. A style of vault in which projecting surface arches, known as ribs, are raised along the intersections of segments of the vault. Ribs may provide architectural support as well as decoration to the vault's surface.

ROMANESQUE. (1) The style of medieval architecture from the 11th to the 13th centuries that was based upon the Roman model and that used the Roman rounded arch, thick walls for structural support, and relatively small windows. (2) Any culture or its artifacts that are "Roman-like."

ROOD SCREEN. A partition in a church on which a crucifix (rood) is mounted and that separates the public nave area from the choir. See also *choir screen*.

ROSE WINDOW. A large, circular window with stained glass and stone tracery, frequently used on facades and at the ends of transepts in Gothic churches.

ROSTRUM (pl. **ROSTRA**). (1) A beaklike projection from the prow of an ancient warship used for ramming the enemy. (2) In the Roman forum, the raised platform decorated with the beaks of captured ships from which speeches were delivered. (3) A platform, stage, or the like used for public speaking.

ROTULUS (pl. **ROTULI**). The Latin word for scroll, a rolled written text.

RUBBING. A reproduction of a relief surface made by covering it with paper and rubbing with pencil, chalk, etc. Also called frottage.

RUBÉNISTES. Those artists of the French Academy at the end of the 17th century and the beginning of the 18th century who favored "color" in painting because it appealed to the senses and was thought to be true to nature. The term derived from admiration for the work of the Flemish artist Peter Paul Rubens. See *Poussinistes*.

RUSTICATION. A masonry technique of laying rough-faced stones with sharply indented joints.

SACRA CONVERSAZIONE. Italian for "holy conversation." A composition of the Madonna and Child with saints in which the figures all occupy the same spatial setting and appear to be conversing or communing with one another.

SACRISTY. A room near the main altar of a church, or a small building attached to a church, where the vessels and vestments required for the service are kept. Also called a *vestry*.

SALON. (1) A large, elegant drawing or reception room in a palace or a private house. (2) Official government-sponsored exhibition of paintings and sculpture by living artists held at the Louvre in Paris, first biennially, then annually. (3) Any large public exhibition patterned after the Paris Salon.

SANCTUARY. (1) A sacred or holy place or building. (2) An especially holy place within a building, such as the cella of a temple or the part of a church around the altar.

SARCOPHAGUS (pl. **SARCOPHAGI**). A large coffin, generally of stone, and often decorated with sculpture or inscriptions. The term is derived from two Greek words meaning "flesh" and "eating."

SATYR. One of a class of woodland gods thought to be the lascivious companions of Dionysos, the Greek god of wine (or of Bacchus, his Roman counterpart). They are represented as having the legs and tail of a goat, the body of a man, and a head with horns and pointed ears. A youthful satyr is also called a faun.

SAZ. Meaning literally "enchanted forest," this term describes the sinuous leaves and twining stems that are a major component of the *hatayi* style under the Ottoman Turks.

SCHIACCIATO. Italian for "flattened out." Describes low relief sculpture used by Donatello and some of his contemporaries.

SCIENTIFIC PERSPECTIVE. See *perspective*.

SCRIPTORIUM (pl. **SCRIPTORIA**). A workroom in a monastery reserved for copying and illustrating manuscripts.

SCROLL. (1) An architectural ornament with the form of a partially unrolled spiral, as on the capitals of the Ionic and Corinthian orders. (2) A form of written text.

SCUOLA. Italian word for school. In Renaissance Venice it designated a fraternal organization or confraternity dedicated to good works, usually under ecclesiastic auspices.

SECCO (or **A SECCO**). See *fresco secco* under *fresco*.

SECTION. An architectural drawing presenting a building as if cut across the vertical plane at right angles to the horizontal plane. A *cross section* is a cut along the

transverse axis. A *longitudinal section* is a cut along the longitudinal axis.

SELECTIVE WIPING. The planned removal of certain areas of ink during the etching process to produce changes in value on the finished print.

SEXPARTITE VAULT. See *vault*.

SFUMATO. Italian word meaning "smoky." Used to describe very delicate gradations of light and shade in the modeling of figures. It is applied especially to the work of Leonardo da Vinci.

SGRAFFITO **ORNAMENT.** A decorative technique in which a design is made by scratching away the surface layer of a material to produce a form in contrasting colors.

SHAFT. In architecture, the part of a column between the base and the capital.

SIBYLS. In Greek and Roman mythology, any of numerous women who were thought to possess powers of divination and prophecy. They appear on Christian representations, notably in Michelangelo's Sistine ceiling, because they were believed to have foretold the coming of Christ.

SIDE AISLE. A passageway running parallel to the nave of a Roman basilica or Christian church, separated from it by an arcade or colonnade. There may be one on either side of the nave or two, an inner and outer.

SILENI. A class of minor woodland gods in the entourage of the wine god, Dionysos (or Bacchus). Like Silenus, the wine god's tutor and drinking companion, they are thick-lipped and snub-nosed and fond of wine. Similar to satyrs, they are basically human in form except for having horses' tails and ears.

SILKSCREEN PRINTING. A technique of printing in which paint or ink is pressed through a stencil and specially prepared cloth to produce a previously designed image. Also called serigraphy.

SILVER LEAF. See *gold leaf*.

SILVERPOINT. A drawing instrument (stylus) of the 14th and 15th centuries made from silver; it produced a fine line and maintained a sharp point.

SILVER SALTS. Compounds of silver—bromide, chloride, and iodide—that are sensitive to light and are used in the preparation of photographic materials. This sensitivity was first observed by Johann Heinrich Schulze in 1725.

SINOPIA (pl. *SINOPIE*). Italian word taken from "Sinope," the ancient city in Asia Minor that was famous for its brick-red pigment. In fresco paintings, a full-sized, preliminary sketch done in this color on the first rough coat of plaster or *arriccio*.

SITE-SPECIFIC ART. Art that is produced in only one location, a location that is an integral part of the work and essential to its production and meaning.

SKETCH. A drawing, painting, or other artwork usually done quickly, as an aid to understanding and developing artistic skills; sometimes a sketch may lead to a more finished work of art.

SOCLE. A portion of the foundation of a building that projects outward as a base for a column or some other device.

SPANDREL. The area between the exterior curves of two adjoining arches or, in the case of a single arch, the area around its outside curve from its springing to its keystone.

SPHINX. (1) In ancient Egypt, a creature having the head of a man, animal, or bird and the body of a lion; frequently sculpted in monumental form. (2) In Greek mythology, a creature usually represented as having the head and breasts of a woman, the body of a lion, and the wings of an eagle. It appears in classical, Renaissance, and Neoclassical art.

SPIRE. A tall tower that rises high above a roof. Spires are commonly associated with church architecture and are frequently found on Gothic structures.

SPOLIA. Latin for "hide stripped from an animal." Term used for (1) spoils of war and (2) fragments of architecture or sculpture reused in a secondary context.

SPRINGING. The part of an arch in contact with its base.

SQUINCHES. Arches set diagonally at the corners of a square or rectangle to establish a transition to the round shape of the dome above.

STANZA (pl. **STANZE**). Italian word for "room."

STEEL. Iron modified chemically to have qualities of great hardness, elasticity, and strength.

STELE. From the Greek word for "standing block." An upright stone slab or pillar, sometimes with a carved design or inscription.

STEREOBATE. The substructure of a Classical building, especially a Greek temple.

STEREOSCOPE. An optical instrument that enables the user to combine two photographs taken from points of view corresponding to those of the two eyes. The combined single image has the depth and solidity of ordinary binocular vision. First demonstrated by Sir Charles Wheatstone in 1838.

STILL LIFE. A term used to describe paintings (and sometimes sculpture) that depict familiar objects such as household items and food.

STILTS. Term for pillars or posts supporting a superstructure; in 20th-century architecture, these are usually of ferroconcrete. Stilted, as in stilted arches, refers to tall supports beneath an architectural member.

STOA. In Greek architecture, a covered colonnade, sometimes detached and of considerable length, used as a meeting place or promenade.

STOIC. A member of a school of philosophy founded by Zeno about 300 BCE and named after the stoa in Athens where he taught. Its main thesis is that man should be free of all passions.

STRUCTURAL STEEL. Steel used as an architectural building material either invisibly or exposed.

STUCCO. (1) A concrete or cement used to coat the walls of a building. (2) A kind of plaster used for architectural decorations, such as cornices and moldings, or for sculptured reliefs.

STUDY. A preparatory sketch, drawing, painting, or other artwork that is used by an artist to explore artistic possibilities and solve problems before a more finished work is attempted. Often studies come to be regarded as finished works of art.

STYLOBATE. A platform or masonry floor above the stereobate forming the foundation for the columns of a Greek temple.

STYLUS. From the Latin word "stilus", the writing instrument of the Romans. (1) A pointed instrument used in ancient times for writing on tablets of a soft material such as clay. (2) The needlelike instrument used in drypoint or etching.

SUBLIME. In 19th-century art, the ideal and goal that art should inspire awe in a viewer and engender feelings of high religious, moral, ethical, and intellectual purpose.

SUNKEN RELIEF. Relief sculpture in which the figures or designs are modeled beneath the surface of the stone, within a sharp outline.

SUPERIMPOSED ORDERS. Two or more rows of columns, piers, or pilasters placed above each other on the wall of a building.

SYMPOSIUM. In ancient Greece, a gathering, sometimes of intellectuals and philosophers to discuss ideas, often in an informal social setting, such as at a dinner party.

TABERNACLE. (1) A place or house of worship. (2) A canopied niche or recess built for an image. (3) The portable shrine used by the ancient Jews to house the Ark of the Covenant.

TABLEAU VIVANT. A scene, usually derived from myth, the Bible, or literary sources, that is depicted by people standing motionless in costumes on a stage set.

TABLINUM. The Latin word meaning "writing tablet" or "written record." In a Roman house, a room at the far end of the atrium, or between the atrium and the second courtyard, used for keeping family records.

TEMPERA PAINTING. (1) A painting made with pigments mixed with egg yolk and water. In the 14th and 15th centuries, it was applied to panels that had been prepared with a coating of gesso; the application of gold leaf and of *underpainting* in green or brown preceded the actual tempera painting. (2) The technique of executing such a painting.

TENEBRISM. The intense contrast of light and dark in painting.

TERRA COTTA. Italian word for "baked earth." (1) Earthenware, naturally reddish-brown but often glazed in various colors and fired. Used for pottery, sculpture, or as a building material or decoration. (2) An object made of this material. (3) Color of the natural material.

TESSERA (pl. **TESSERAE**). A small piece of colored stone, marble, glass, or gold-backed glass used in a mosaic.

THEATER. In ancient Greece, an outdoor place for dramatic performances, usually semicircular in plan and provided with tiers of seats, the orchestra, and a support for scenery.

THEATINE ORDER. Founded in Rome in the 16th century by members of the recently dissolved Oratory of Divine Love. Its aim was to reform the Catholic church, and its members pledged to cultivate their spiritual lives and to perform charitable works.

THERMAE. A public bathing establishment of the ancient Romans that consisted of various types of baths and social gymnastic facilities.

THOLOS. A building with a circular plan, often with a sacred nature.

THRUST. The lateral pressure exerted by an arch, vault, or dome that must be counteracted at its point of greatest concentration either by the thickness of the wall or by some form of buttress.

TONDO. A circular painting or relief sculpture.

TRACERY. (1) Ornamental stonework in Gothic windows. In the earlier or plate tracery, the windows appear to have been cut through the solid stone. In bar tracery, the glass predominates, the slender pieces of stone having been added within the windows. (2) Similar ornamentation using various materials and applied to walls, shrines, façades, etc.

TRANSEPT. A cross arm in a basilican church placed at right angles to the nave and usually separating it from the choir or apse.

TRANSVERSALS. In a perspective construction, transversals are the lines parallel to the picture plane (horizontally) that denote distances. They intersect orthogonals to make a grid that guides the arrangement of elements to suggest space.

TREE OF KNOWLEDGE. The tree in the Garden of Eden from which Adam and Eve ate the forbidden fruit that destroyed their innocence.

TREE OF LIFE. A tree in the Garden of Eden whose fruit was reputed to give everlasting life; in medieval art it was frequently used as a symbol of Christ.

TRIBUNE. A platform or walkway in a church constructed overlooking the *aisle* and above the *nave*.

TRIFORIUM. The section of a nave wall above the arcade and below the clerestory. It frequently consists of a blind arcade with three openings in each bay. When the gallery is also present, a four-story elevation results, the triforium being between the gallery and clerestory. It may also occur in the transept and the choir walls.

TRIGLYPH. The element of a Doric frieze separating two consecutive metopes and divided by grooves into three sections.

TRIPTYCH. An altarpiece or devotional picture, either carved or painted, with one central panel and two hinged wings.

TRIUMPHAL ARCH. (1) A monumental arch, sometimes a combination of three arches, erected by a Roman emperor in commemoration of his military exploits and usually decorated with scenes of these deeds in relief sculpture. (2) The great transverse arch at the eastern end of a church that frames altar and apse and separates them from the main body of the church. It is frequently decorated with mosaics or mural paintings.

TROIS CRAYONS. The use of three colors, usually red, black, and white, in a drawing; a technique popular in the 17th and 18th centuries.

TROMPE L'OEIL. Meaning "trick of the eye" in French, it is a work of art designed to deceive a viewer into believing that the work of art is reality, an actual three-dimensional object or scene in space.

TROPHY. (1) In ancient Rome, arms or other spoils taken from a defeated enemy and publicly displayed on a tree, pillar, etc. (2) A representation of these objects, and others symbolic of victory, as a commemoration or decoration.

TRUMEAU. A central post supporting the lintel of a large doorway, as in a Romanesque or Gothic portal, where it is frequently decorated with sculpture.

TRUSS. A triangular wooden or metal support for a roof that may be left exposed in the interior or be covered by a ceiling.

TURRET. (1) A small tower that is part of a larger structure. (2) A small tower at a corner of a building, often beginning some distance from the ground.

TUSCHE. An inklike liquid containing crayon that is used to produce solid black (or solid color) areas in prints.

TYMPANUM. (1) In Classical architecture, a recessed, usually triangular area often decorated with sculpture. Also called a pediment. (2) In medieval architecture, an arched area between an arch and the lintel of a door or window, frequently carved with relief sculpture.

TYPOLOGY. The matching or pairing of pre-Christian figures, persons, and symbols with their Christian counterparts.

UNDERPAINTING. See *tempera painting.*

VANISHING POINT. The point at which the orthogonals meet and disappear in a composition done with scientific perspective.

VANITAS. The term derives from the book of Ecclesiastes I:2 ("Vanities of vanities, …") that refers to the passing of time and the notion of life's brevity and the inevitability of death. The vanitas theme found expression especially in the Northern European art of the 17th century.

VAULT. An arched roof or ceiling usually made of stone, brick, or concrete. Several distinct varieties have been developed; all need buttressing at the point where the lateral thrust is concentrated. (1) A barrel vault is a semicircular structure made up of successive arches. It may be straight or annular in plan. (2) A groin vault is the result of the intersection of two barrel vaults of equal size that produces a bay of four compartments with sharp edges, or groins, where the two meet. (3) A ribbed groin vault is one in which ribs are added to the groins for structural strength and for decoration. When the diagonal ribs are constructed as half-circles, the resulting form is a domical ribbed vault. (4) A sexpartite vault is a ribbed groin vault in which each bay is divided into six compartments by the addition of a transverse rib across the center. (5) The normal Gothic vault is quadripartite with all the arches pointed to some degree. (6) A fan vault is an elaboration of a ribbed groin vault, with elements of tracery using cone-like forms. It was developed by the English in the 15th century and was employed for decorative purposes.

VEDUTA (pl. **VEDUTE**). A view painting, generally a city landscape.

VELLUM. See *Parchment.*

VERISTIC. From the Latin *verus,* meaning "true." Describes a hyperrealistic style of portraiture that emphasizes individual characteristics.

VESTRY. A chamber in a church where the vestments (clerical garbs) and sacramental vessels are maintained. Also called a *sacristy.*

VICES. Often represented allegorically in conjunction with the seven virtues, they include Pride, Envy, Avarice, Wrath, Gluttony, Lust, and Sloth, though others such as Injustice and Folly are sometimes substituted.

VILLA. Originally a large country house but in modern usage a lso a detached house or suburban residence.

VIRTUES. The three theological virtues, Faith, Hope, and Charity, and the four cardinal ones, Prudence, Justice, Fortitude, and Temperance, were frequently represented allegorically, particularly in medieval manuscripts and sculpture.

VOLUTE. A spiraling architectural element found notably on Ionic and Composite capitals but also used decoratively on building façades and interiors.

VOTIVE. A devotional image used in the veneration or worship of a deity or saint.

VOUSSOIR. A wedge-shaped piece of stone used in arch construction.

WASH. A thin layer of translucent color or ink used in watercolor painting and brush drawing, and occasionally in oil painting.

WATERCOLOR PAINTING. Painting, usually on paper, in pigments suspended in water.

WEBS. Masonry construction of brick, concrete, stone, etc. that is used to fill in the spaces between groin vault ribs.

WESTWORK. From the German word *Westwerk.* In Carolingian, Ottonian, and German Romanesque architecture, a monumental western front of a church, treated as a tower or combination of towers and containing an entrance and vestibule below and a chapel and galleries above. Later examples often added a transept and a crossing tower.

WING. The side panel of an altarpiece that is frequently decorated on both sides and is also hinged, so that it may be shown either open or closed.

WOODCUT. A print made by carving out a design on a wooden block cut along the grain, applying ink to the raised surfaces that remain, and printing from those.

WROUGHT IRON. A comparatively pure form of iron that is easily forged and does not harden quickly, so that it can be shaped or hammered by hand, in contrast to molded cast iron.

WUNDERKAMMER (pl. **WUNDERKAMMERN**). Literally a "room of wonders." This forerunner of the museum developed in the 16th century. Such rooms displayed wonders of the world, often from exotic, far off places. The objects displayed included fossils, shells, coral, animals (bones, skins, etc.), and gems in an effort to form an encyclopedic collection. See *kunstkammen.*

ZIGGURAT. From the Assyrian word *zigquratu,* meaning "mountaintop" or "height." In ancient Assyria and Babylonia, a pyramidal mound or tower built of mud-brick forming the base for a temple. It was often either stepped or had a broad ascent winding around it, which gave it the appearance of being stepped.

ZODIAC. An imaginary belt circling the heavens, including the paths of the sun, moon, and major planets and containing twelve constellations and thus twelve divisions called signs, which have been associated with the months. The signs are Aries, the ram; Taurus, the bull; Gemini, the twins; Cancer, the crab; Leo, the lion; Virgo, the virgin; Libra, the balance; Scorpio, the scorpion; Sagittarius, the archer; Capricorn, the goat; Aquarius, the waterbearer; and Pisces, the fish. They are frequently represented around the portals of Romanesque and Gothic churches in conjunction with the Labors of the Months.

Books for Further Reading

This list is intended to be as practical as possible. It is therefore limited to books of general interest that were printed over the past 20 years or have been generally available recently. However, certain indispensable volumes that have yet to be superseded are retained. This restriction means omitting numerous classics long out of print, as well as much specialized material of interest to the serious student. The reader is thus referred to the many specialized bibliographies noted below.

REFERENCE RESOURCES IN ART HISTORY

1. BIBLIOGRAPHIES AND RESEARCH GUIDES

Arntzen, E., and R. Rainwater. *Guide to the Literature of Art History*. Chicago: American Library, 1980.

Barnet, S. *A Short Guide to Writing About Art*. 8th ed. New York: Longman, 2005.

Ehresmann, D. *Architecture: A Bibliographical Guide to Basic Reference Works, Histories, and Handbooks*. Littleton, CO: Libraries Unlimited, 1984.

———. *Fine Arts: A Bibliographical Guide to Basic Reference Works, Histories, and Handbooks*. 3d ed. Littleton, CO: Libraries Unlimited, 1990.

Freitag, W. *Art Books: A Basic Bibliography of Monographs on Artists*. 2d ed. New York: Garland, 1997.

Goldman, B. *Reading and Writing in the Arts: A Handbook*. Detroit, MI: Wayne State Press, 1972.

Kleinbauer, W., and T. Slavens. *Research Guide to the History of Western Art*. Chicago: American Library, 1982.

Marmor, M., and A. Ross, eds. *Guide to the Literature of Art History 2*. Chicago: American Library, 2005.

Sayre, H. M. *Writing About Art*. New ed. Upper Saddle River, NJ: Pearson Prentice Hall, 2000.

2. DICTIONARIES AND ENCYCLOPEDIAS

Aghion, I. *Gods and Heroes of Classical Antiquity*. Flammarion Iconographic Guides. New York: Flammarion, 1996.

Boström, A., ed. *Encyclopedia of Sculpture*. 3 vols. New York: Fitzroy Dearborn, 2004.

Brigstocke, H., ed. *The Oxford Companion to Western Art*. New York: Oxford University Press, 2001.

Burden, E. *Illustrated Dictionary of Architecture*. New York: McGraw-Hill, 2002.

Carr-Gomm, S. *The Hutchinson Dictionary of Symbols in Art*. Oxford: Helicon, 1995.

Chilvers, I., et al., eds. *The Oxford Dictionary of Art*. 3d ed. New York: Oxford University Press, 2004.

Congdon, K. G. *Artists from Latin American Cultures: A Biographical Dictionary*. Westport, CT: Greenwood Press, 2002.

Cumming, R. *Art: A Field Guide*. New York: Alfred A. Knopf, 2001.

Curl, J. *A Dictionary of Architecture*. New York: Oxford University Press, 1999.

The Dictionary of Art. 34 vols. New York: Grove's Dictionaries, 1996.

Duchet-Suchaux, G., and M. Pastoureau. *The Bible and the Saints*. Flammarion Iconographic Guides. New York: Flammarion, 1994.

Encyclopedia of World Art. 14 vols., with index and supplements. New York: McGraw-Hill, 1959–1968.

Fleming, J., and H. Honour. *The Penguin Dictionary of Architecture and Landscape Architecture*. 5th ed. New York: Penguin, 1998.

———. *The Penguin Dictionary of Decorative Arts*. New ed. London: Viking, 1989.

Gascoigne, B. *How to Identify Prints: A Complete Guide to Manual and Mechanical Processes from Woodcut to Inkjet*. New York: Thames & Hudson, 2004.

Hall, J. *Dictionary of Subjects and Symbols in Art*. Rev. ed. London: J. Murray, 1996.

———. *Illustrated Dictionary of Symbols in Eastern and Western Art*. New York: HarperCollins, 1995.

International Dictionary of Architects and Architecture. 2 vols. Detroit, MI: St. James Press, 1993.

Langmuir, E. *Yale Dictionary of Art and Artists*. New Haven: Yale University Press, 2000.

Lever, J., and J. Harris. *Illustrated Dictionary of Architecture, 800–1914*. 2d ed. Boston: Faber & Faber, 1993.

Lucie-Smith, E. *The Thames & Hudson Dictionary of Art Terms*. New York: Thames & Hudson, 2004.

Mayer, R. *The Artist's Handbook of Materials and Techniques*. 5th ed. New York: Viking, 1991.

———. *The HarperCollins Dictionary of Art Terms & Techniques*. 2d ed. New York: HarperCollins, 1991.

Murray, P., and L. Murray. *A Dictionary of Art and Artists*. 7th ed. New York: Penguin, 1998.

———. *A Dictionary of Christian Art*. New York: Oxford University Press, 2004, © 1996.

Nelson, R. S., and R. Shiff, eds. *Critical Terms for Art History*. Chicago: University of Chicago Press, 2003.

Pierce, J. S. *From Abacus to Zeus: A Handbook of Art History*. 7th ed. Englewood Cliffs, NJ: Pearson Prentice Hall, 2004.

Reid, J. D., ed. *The Oxford Guide to Classical Mythology in the Arts 1300–1990*. 2 vols. New York: Oxford University Press, 1993.

Shoemaker, C., ed. *Encyclopedia of Gardens: History and Design*. Chicago: Fitzroy Dearborn, 2001.

Steer, J. *Atlas of Western Art History: Artists, Sites, and Movements from Ancient Greece to the Modern Age*. New York: Facts on File, 1994.

West, S., ed. *The Bulfinch Guide to Art History*. Boston: Little, Brown, 1996.

———. *Portraiture*. Oxford History of Art. New York: Oxford University Press, 2004.

3. INDEXES, PRINTED AND ELECTRONIC

ARTbibliographies Modern. 1969 to present. A semiannual publication indexing and annotating more than 300 art periodicals, as well as books, exhibition catalogues, and dissertations. Data since 1974 also available electronically.

Art Index. 1929 to present. A standard quarterly index to more than 200 art periodicals. Also available electronically.

Avery Index to Architectural Periodicals. 1934 to present. 15 vols., with supplementary vols. Boston: G. K. Hall, 1973. Also available electronically.

BHA: Bibliography of the History of Art. 1991 to present. The merger of two standard indexes: *RILA* (*Répertoire International de la Littérature de l'Art/International Repertory of the Literature of Art*, vol. 1. 1975) and *Répertoire d'Art et d'Archéologie* (vol. 1. 1910). Data since 1973 also available electronically.

Index Islamicus. 1665 to present. Multiple publishers. Data since 1994 also available electronically.

The Perseus Project: An Evolving Digital Library on Ancient Greece and Rome. Medford, MA: Tufts University, Classics Department, 1994.

4. WORLDWIDE WEBSITES

Visit the following websites for reproductions and information regarding artists, periods, movements, and many more subjects. The art history departments and libraries of many universities and colleges also maintain websites where you can get reading lists and links to other websites, such as those of museums, libraries, and periodicals.

http://www.aah.org.uk/welcome.html Association of Art Historians

http://www.amico.org Art Museum Image Consortium

http://www.archaeological.org Archaeological Institute of America

http://archnet.asu.edu/archnet Virtual Library for Archaeology

http://www.artchive.com

http://www.art-design.umich.edu/mother/ Mother of all Art History links pages, maintained by the Department of the History of Art at the University of Michigan

http://www.arthistory.net Art History Network

http://artlibrary.vassar.edu/ifla-idal International Directory of Art Libraries

http://www.bbk.ac.uk/lib/hasubject.html Collection of resources maintained by the History of Art Department of Birkbeck College, University of London

http://classics.mit.edu The Internet Classics Archive

http://www.collegeart.org College Art Association

http://www.constable.net

http://www.cr.nps.gov/habshaer Historic American Buildings Survey

http://www.getty.edu Including museum, five institutes, and library

http://www.harmsen.net/ahrc/ Art History Research Centre

http://icom.museum/ International Council of Museums

http://www.icomos.org International Council on Monuments and Sites

http://www.ilpi.com/artsource

http://www.siris.si.edu Smithsonian Institution Research Information System

http://whc.unesco.org/ World Heritage Center

5. GENERAL SOURCES ON ART HISTORY, METHOD, AND THEORY

Andrews, M. *Landscape and Western Art*. Oxford History of Art. New York: Oxford University Press, 1999.

Barasch, M. *Modern Theories of Art: Vol. 1, From Winckelmann to Baudelaire. Vol. 2, From Impressionism to Kandinsky*. New York: 1990–1998.

———. *Theories of Art: From Plato to Winckelmann*. New York: Routledge, 2000.

Battistini, M. *Symbols and Allegories in Art*. Los Angeles: J. Paul Getty Museum, 2005.

Baxandall, M. *Patterns of Intention: On the Historical Explanation of Pictures*. New Haven: Yale University Press, 1985.

Bois, Y.-A. *Painting as Model*. Cambridge, MA: MIT Press, 1993.

Broude, N., and M. Garrard. *The Expanding Discourse: Feminism and Art History*. New York: Harper & Row, 1992.

———., eds. *Feminism and Art History: Questioning the Litany*. New York: Harper & Row, 1982.

Bryson, N., ed. *Vision and Painting: The Logic of the Gaze*. New Haven: Yale University Press, 1983.

———., et al., eds. *Visual Theory: Painting and Interpretation*. New York: Cambridge University Press, 1991.

Chadwick, W. *Women, Art, and Society*. 3d ed. New York: Thames & Hudson, 2002.

D'Alleva, A. *Methods & Theories of Art History*. London: Laurence King, 2005.

Freedberg, D. *The Power of Images: Studies in the History and Theory of Response*. Chicago: University of Chicago Press, 1989.

Gage, J. *Color and Culture: Practice and Meaning from Antiquity to Abstraction*. Berkeley: University of California Press, 1999.

Garland Library of the History of Art. New York: Garland, 1976. Collections of essays on specific periods.

Goldwater, R., and M. Treves, eds. *Artists on Art, from the Fourteenth to the Twentieth Century*. 3d ed. New York: Pantheon, 1974.

Gombrich, E. H. *Art and Illusion*. 6th ed. New York: Phaidon, 2002.

Harris, A. S., and L. Nochlin. *Women Artists, 1550–1950*. New York: Random House, 1999.

Holly, M. A. *Panofsky and the Foundations of Art History*. Ithaca, NY: Cornell University Press, 1984.

Holt, E. G., ed. *A Documentary History of Art: Vol. 1, The Middle Ages and the Renaissance. Vol. 2, Michelangelo and the Mannerists. The Baroque and the Eighteenth Century. Vol. 3, From the Classicists to the Impressionists*. 2d ed. Princeton, NJ: Princeton University Press, 1981. Anthologies of primary sources on specific periods.

Johnson, P. *Art: A New History*. New York: HarperCollins, 2003.

Kemal, S., and I. Gaskell. *The Language of Art History*. Cambridge Studies in Philosophy and the Arts. New York: Cambridge University Press, 1991.

Kemp, M., ed. *The Oxford History of Western Art*. New York: Oxford University Press, 2000.

Kleinbauer, W. E. *Modern Perspectives in Western Art History: An Anthology of Twentieth-Century Writings on the Visual Arts*. Reprint of 1971 ed. Toronto: University of Toronto Press, 1989.

Kostof, S. A. *History of Architecture: Settings and Rituals*. 2d ed. New York: Oxford University Press, 1995.

Kruft, H. W. *A History of Architectural Theory from Vitruvius to the Present*. Princeton, NJ: Princeton Architectural Press, 1994.

Kultermann, U. *The History of Art History*. New York: Abaris Books, 1993.

Langer, C. *Feminist Art Criticism: An Annotated Bibliography*. Boston: G. K. Hall, 1995.

Laver, J. *Costume and Fashion: A Concise History*. 4th ed. The World of Art. London: Thames & Hudson, 2002.

Lavin, I., ed. *Meaning in the Visual Arts: Views from the Outside: A Centennial Commemoration of Erwin Panofsky (1892–1968)*. Princeton, NJ: Institute for Advanced Study, 1995.

Minor, V. H. *Art History's History*. Upper Saddle River, NJ: Pearson Prentice Hall, 2001.

Nochlin, L. *Women, Art, and Power, and Other Essays*. New York: HarperCollins, 1989.

Pächt, O. *The Practice of Art History: Reflections on Method*. London: Harvey Miller, 1999.

Panofsky, E. *Meaning in the Visual Arts*. Reprint of 1955 ed. Chicago: University of Chicago Press, 1982.

Penny, N. *The Materials of Sculpture*. New Haven: Yale University Press, 1993.

Pevsner, N. *A History of Building Types*. Princeton, NJ: Princeton University Press, 1976.

Podro, M. *The Critical Historians of Art*. New Haven: Yale University Press, 1982.

Pollock, G. *Differencing the Canon: Feminist Desire and the Writing of Art's Histories*. New York: Routledge, 1999.

———. *Vision and Difference: Femininity, Feminism, and the Histories of Art*. New York: Routledge, 1988.

Prettejohn, E. *Beauty and Art 1750–2000*. New York: Oxford University Press, 2005.

Preziosi, D., ed. *The Art of Art History: A Critical Anthology*. New York: Oxford University Press, 1998.

Rees, A. L., and F. Borzello. *The New Art History*. Atlantic Highlands, NJ: Humanities Press International, 1986.

Roth, L. *Understanding Architecture: Its Elements, History, and Meaning*. New York: Harper & Row, 1993.

Sedlmayr, H. *Framing Formalism: Riegl's Work*. Amsterdam: G+B Arts International, © 2001.

Smith, P., and C. Wilde, eds. *A Companion to Art Theory*. Oxford: Blackwell, 2002.

Sources and Documents in the History of Art Series. General ed. H. W. Janson. Englewood Cliffs, NJ: Prentice Hall. Anthologies of primary sources on specific periods.

Sutton, I. *Western Architecture*. New York: Thames & Hudson, 1999.

Tagg, J. *Grounds of Dispute: Art History, Cultural Politics, and the Discursive Field*. Minneapolis: University of Minnesota Press, 1992.

Trachtenberg, M., and I. Hyman. *Architecture: From Prehistory to Post-Modernism*. 2d ed. New York: Harry N. Abrams, 2002.

Watkin, D. *The Rise of Architectural History*. Chicago: University of Chicago Press, 1980.

Wolff, J. *The Social Production of Art*. 2d ed. New York: New York University Press, 1993.

Wölfflin, H. *Principles of Art History: The Problem of the Development of Style in Later Art*. Various eds. New York: Dover.

Wollheim, R. *Art and Its Objects*. 2d ed. New York: Cambridge University Press, 1992.

PART ONE: THE ANCIENT WORLD

GENERAL REFERENCES

Baines, J., ed. *Civilizations of the Ancient Near East*. 4 vols. New York: Scribner, 1995.

Boardman, J., ed. *The Oxford History of Classical Art*. New York: Oxford University Press, 2001.

De Grummond, N., ed. *An Encyclopedia of the History of Classical Archaeology*. Westport, CT: Greenwood, 1996.

Fine, S. *Art and Judaism in the Greco-Roman World: Toward a New Jewish Archaeology*. New York: Cambridge University Press, 2005.

Holliday, P. J. *Narrative and Event in Ancient Art*. New York: Cambridge University Press, 1993.

Redford, D. B., ed. *The Oxford Encyclopedia of Ancient Egypt*. 3 vols. New York: Oxford University Press, 2001.

Stillwell, R. *The Princeton Encyclopedia of Classical Sites*. Princeton, NJ: Princeton University Press, 1976.

Tadgell, C. *Origins: Egypt, West Asia and the Aegean*. New York: Whitney Library of Design, 1998.

Van Keuren, F. *Guide to Research in Classical Art and Mythology*. Chicago: American Library Association, 1991.

Wharton, A. J. *Refiguring the Post-Classical City: Dura Europos, Jerash, Jerusalem, and Ravenna*. New York: Cambridge University Press, 1995.

Winckelmann, J. J. *Essays on the Philosophy and History of Art*. 3 vols. Bristol, England: Thoemmes, 2001.

Wolf, W. *The Origins of Western Art: Egypt, Mesopotamia, the Aegean*. New York: Universe Books, 1989.

Yegül, F. K. *Baths and Bathing in Classical Antiquity*. Architectural History Foundation. Cambridge, MA: MIT Press, 1992.

CHAPTER 1. PREHISTORIC ART

Bahn, P. G. *The Cambridge Illustrated History of Prehistoric Art*. New York: Cambridge University Press, 1988.

Chauvet, J.-M., É. B. Deschamps, and C. Hilaire. *Dawn of Art: The Chauvet Cave*. New York: Harry N. Abrams, 1995.

Clottes, J. *Chauvet Cave*. Salt Lake City: University of Utah Press, 2003.

———. *The Shamans of Prehistory: Trance and Magic in the Painted Caves*. New York: Harry N. Abrams, 1998.

Cunliffe, B., ed. *The Oxford Illustrated Prehistory of Europe*. New York: Oxford University Press, 1994.

Fitton, J. L. *Cycladic Art*. London: British Museum Press, 1999.

Fowler, P. *Images of Prehistory*. New York: Cambridge University Press, 1990.

Leroi-Gourhan, A. *The Dawn of European Art: An Introduction to Paleolithic Cave Painting*. New York: Cambridge University Press, 1982.

Ruspoli, M. *The Cave of Lascaux: The Final Photographs*. New York: Harry N. Abrams, 1987.

Sandars, N. *Prehistoric Art in Europe*. 2d ed. New Haven: Yale University Press, 1992.

Saura Ramos, P. A. *The Cave of Altamira*. New York: Harry N. Abrams, 1999.

Twohig, E. S. *The Megalithic Art of Western Europe*. New York: Oxford University Press, 1981.

White, R. *Prehistoric Art: The Symbolic Journey of Mankind*. New York: Harry N. Abrams, 2003.

CHAPTER 2. ANCIENT NEAR EASTERN ART

Amiet, P. *Art of the Ancient Near East*. New York: Harry N. Abrams, 1980.

Aruz, J., ed. *Art of the First Cities: The Third Millennium B.C. from the Mediterranean to the Indus*. Exh. cat. New York: Metropolitan Museum of Art; Yale University Press, 2003.

Collon, D. *Ancient Near Eastern Art*. Berkeley: University of California Press, 1995.

———. *First Impressions: Cylinder Seals in the Ancient Near East*. Chicago: University of Chicago Press, 1987.

Crawford, H. *The Architecture of Iraq in the Third Millennium B.C.* Copenhagen: Akademisk Forlag, 1977.

Curtis, J., and N. Tallis. *Forgotten Empire: The World of Ancient Persia*. Exh. cat. London: British Museum, 2005.

Frankfort, H. *The Art and Architecture of the Ancient Orient*. 5th ed. Pelican History of Art. New Haven: Yale University Press, 1997.

Goldman, B. *The Ancient Arts of Western and Central Asia: A Guide to the Literature*. Ames: Iowa State University Press, 1991.

Harper, P. O., ed. *The Royal City of Susa: Ancient Near Eastern Treasures in the Louvre*. New York: Metropolitan Museum of Art; Dist. by Harry N. Abrams, 1992.

Leick, G. *A Dictionary of Ancient Near Eastern Architecture*. New York: Routledge, 1988.

Lloyd, S. *The Archaeology of Mesopotamia: From the Old Stone Age to the Persian Conquest*. Rev. ed. New York: Thames & Hudson, 1984.

Moscati, S. *The Phoenicians*. New York: Abbeville Press, 1988.

Oates, J. *Babylon*. Rev. ed. London: Thames & Hudson, 1986.

Reade, J. *Mesopotamia*. 2d ed. London: Published for the Trustees of the British Museum by the British Museum Press, 2000.

Zettler, R., and L. Horne, eds. *Treasures from the Royal Tombs of Ur*. Exh. cat. Philadelphia: University of Pennsylvania, Museum of Archaeology and Anthropology, 1998.

CHAPTER 3. EGYPTIAN ART

Aldred, C. *The Development of Ancient Egyptian Art, from 3200 to 1315 B.C.* 3 vols. in 1. London: Academy Editions, 1972.

———. *Egyptian Art*. London: Thames & Hudson, 1985.

Arnold, D., and C. Ziegler. *Building in Egypt: Pharaonic Stone Masonry*. New York: Oxford University Press, 1991.

———. *Egyptian Art in the Age of the Pyramids*. New York: Harry N. Abrams, 1999.

Bothmer, B. V. *Egyptian Art: Selected Writings of Bernard V. Bothmer*. New York: Oxford University Press, 2004.

Davis, W. *The Canonical Tradition in Ancient Egyptian Art*. New York: Cambridge University Press, 1989.

Edwards, I. E. S. *The Pyramids of Egypt*. Rev. ed. Harmondsworth, England: Penguin, 1991.

Egyptian Art in the Age of the Pyramids. New York: Metropolitan Museum of Art; Dist. by Harry N. Abrams, 1999.

Grimal, N. *A History of Ancient Egypt*. London: Blackwell, 1992.

Mahdy, C., ed. *The World of the Pharaohs: A Complete Guide to Ancient Egypt*. London: Thames & Hudson, 1990.

Malek, J. *Egypt: 4000 Years of Art*. London: Phaidon, 2003.

———. *Egyptian Art. Art & Ideas*. London: Phaidon, 1999.

Mendelssohn, K. *The Riddle of the Pyramids*. New York: Thames & Hudson, 1986.

Parry, D. *Engineering the Pyramids*. Stroud, England: Sutton, 2004.

Robins, G. *The Art of Ancient Egypt*. Cambridge, MA: Harvard University Press, 1997.

Schaefer, H. *Principles of Egyptian Art*. Oxford: Clarendon Press, 1986.

Schulz, R., and M. Seidel. *Egypt: The World of the Pharaohs*. Cologne: Könemann, 1998.

Smith, W., and W. Simpson. *The Art and Architecture of Ancient Egypt*. Rev. ed. Pelican History of Art. New Haven: Yale University Press, 1999.

Tiradritti, F. *Ancient Egypt: Art, Architecture and History*. London: British Museum Press, 2002.

Walker, S. and P. Higgs, eds. *Cleopatra of Egypt: From History to Myth*. Exh. cat. Princeton, NJ: Princeton University Press, 2001.

Wilkinson, R. *Reading Egyptian Art: A Hieroglyphic Guide to Ancient Egyptian Painting and Sculpture*. New York: Thames & Hudson, 1992.

CHAPTER 4. AEGEAN ART

Akurgal, E. *The Aegean, Birthplace of Western Civilization: History of East Greek Art and Culture, 1050–333 B.C.* Izmir, Turkey: Metropolitan Municipality of Izmir, 2000.

Barber, R. *The Cyclades in the Bronze Age*. Iowa City: University of Iowa Press, 1987.

Dickinson, O. T. P. K. *The Aegean Bronze Age*. New York: Cambridge University Press, 1994.

Elytis, O. *The Aegean: The Epicenter of Greek Civilization*. Athens: Melissa, 1997.

German, S. C. *Performance, Power and the Art of the Aegean Bronze Age*. Oxford: Archaeopress, 2005.

Getz-Preziosi, P. *Sculptors of the Cyclades*. Ann Arbor: University of Michigan Press, 1987.

Graham, J. *The Palaces of Crete*. Rev. ed. Princeton, NJ: Princeton University Press, 1987.

Hampe, R., and E. Simon. *The Birth of Greek Art from the Mycenean to the Archaic Period*. New York: Oxford University Press, 1981.

Higgins, R. *Minoan and Mycenaean Art*. Rev. ed. The World of Art. New York: Oxford University Press, 1981.

Hood, S. *The Arts in Prehistoric Greece*. Pelican History of Art. New Haven: Yale University Press, 1992.

———. *The Minoans: The Story of Bronze Age Crete*. New York: Praeger, 1981.

Hurwit, J. *The Art and Culture of Early Greece, 1100–480 B.C.* Ithaca, NY: Cornell University Press, 1985.

McDonald, W. *Progress into the Past: The Rediscovery of Mycenaean Civilization*. 2d ed. Bloomington: Indiana University Press, 1990.

Preziosi, D., and L. Hitchcock. *Aegean Art and Architecture*. New York: Oxford University Press, 1999.

Renfrew, C. *The Cycladic Spirit: Masterpieces from the Nicholas P. Goulandris Collection*. London: Thames & Hudson, 1991.

Vermeule, E. *Greece in the Bronze Age*. Chicago: University of Chicago Press, 1972.

CHAPTER 5. GREEK ART

Beard, M. *The Parthenon*. Cambridge, MA: Harvard University Press, 2003.

Beazley, J. D. *Athenian Red Figure Vases: The Archaic Period: A Handbook*. The World of Art. New York: Thames & Hudson, 1991.
———. *Athenian Red Figure Vases: The Classical Period: A Handbook*. The World of Art. New York: Thames & Hudson, 1989.
———. *The Development of Attic Black-Figure*. Rev. ed. Berkeley: University of California Press, 1986.
———. *Greek Vases: Lectures*. Oxford and New York: Clarendon Press and Oxford University Press, 1989.
Boardman, J. *The Archaeology of Nostalgia: How the Greeks Recreated Their Mythical Past*. London: Thames & Hudson, 2002.
———. *Athenian Black Figure Vases: A Handbook*. Corrected ed. The World of Art. New York: Thames & Hudson, 1991.
———. *Early Greek Vase Painting: 11th–6th Centuries B.C.: A Handbook*. The World of Art. New York: Thames & Hudson, 1998.
———. *Greek Art*. 4th ed., rev. and expanded. The World of Art. New York: Thames & Hudson, 1996.
———. *Greek Sculpture: The Archaic Period: A Handbook*. Corrected ed. The World of Art. New York: Thames & Hudson, 1991.
———. *Greek Sculpture: The Classical Period: A Handbook*. Corrected ed. New York: Thames & Hudson, 1991.
———. *The History of Greek Vases: Potters, Painters, and Pictures*. New York: Thames & Hudson, 2001.
Burn, L. *Hellenistic Art: From Alexander the Great to Augustus*. London: The British Museum, 2004.
Carpenter, T. H. *Art and Myth in Ancient Greece: A Handbook*. The World of Art. New York: Thames & Hudson, 1991.
Carratelli, G. P., ed. *The Greek World: Art and Civilization in Magna Graecia and Sicily*. Exh. cat. New York: Rizzoli, 1996.
Fullerton, M. D. *Greek Art*. New York: Cambridge University Press, 2000.
Hampe, R., and E. Simon. *The Birth of Greek Art*. Oxford: Oxford University Press, 1981.
Haynes, D. E. L. *The Technique of Greek Bronze Statuary*. Mainz am Rhein: P. von Zabern, 1992.
Himmelmann, N. *Reading Greek Art: Essays*. Princeton, NJ: Princeton University Press, 1998.
Hurwit, J. M. *The Acropolis in the Age of Pericles*. New York: Cambridge University Press, 2004.
———. *The Art & Culture of Early Greece, 1100–480 B.C.* Ithaca, NY: Cornell University Press, 1985.
Lawrence, A. *Greek Architecture*. Rev. 5th ed. Pelican History of Art. New Haven: Yale University Press, 1996.
Osborne, R. *Archaic and Classical Greek Art*. New York: Oxford University Press, 1998.
Papaioannou, K. *The Art of Greece*. New York: Harry N. Abrams, 1989.
Pedley, J. *Greek Art and Archaeology*. 2d ed. New York: Harry N. Abrams, 1997.
Pollitt, J. *The Ancient View of Greek Art: Criticism, History, and Terminology*. New Haven: Yale University Press, 1974.
———. *Art in the Hellenistic Age*. New York: Cambridge University Press, 1986.
———., ed. *Art of Ancient Greece: Sources and Documents*. New York: Cambridge University Press, 1990.
Potts, A. *Flesh and the Ideal: Winckelmann and the Origins of Art History*. New Haven: Yale University Press, 1994.
Rhodes, R. *Architecture and Meaning on the Athenian Acropolis*. New York: Cambridge University Press, 1995.
Richter, G. M. A. *A Handbook of Greek Art*. 9th ed. New York: Da Capo, 1987.
———. *Portraits of the Greeks*. Ed. R. Smith. New York: Oxford University Press, 1984.
Ridgway, B. S. *Hellenistic Sculpture: Vol. 1, The Styles of ca. 331–200 B.C.* Bristol, England: Bristol Classical Press, 1990.
Robertson, M. *The Art of Vase Painting in Classical Athens*. New York: Cambridge University Press, 1992.
Rolley, C. *Greek Bronzes*. New York: Philip Wilson for Sotheby's Publications; Dist. by Harper & Row, 1986.
Schefold, K. *Gods and Heroes in Late Archaic Greek Art*. New York: Cambridge University Press, 1992.
Smith, R. *Hellenistic Sculpture*. The World of Art. New York: Thames & Hudson, 1991.
Spivey, N. *Greek Art*. London: Phaidon, 1997.
Stafford, E. *Life, Myth, and Art in Ancient Greece*. Los Angeles: J. Paul Getty Museum, 2004.
Stansbury-O'Donnell, M. *Pictorial Narrative in Ancient Greek Art*. New York: Cambridge University Press, 1999.
Stewart, A. F. *Greek Sculpture: An Exploration*. New Haven: Yale University Press, 1990.
Whitley, J. *The Archaeology of Ancient Greece*. Cambridge: Cambridge University Press, 2001.

CHAPTER 6. ETRUSCAN ART

Boethius, A. *Etruscan and Early Roman Architecture*. 2d ed. Pelican History of Art. New Haven: Yale University Press, 1992.
Bonfante, L., ed. *Etruscan Life and Afterlife: A Handbook of Etruscan Studies*. Detroit, MI: Wayne State University, 1986.
Borrelli, F. *The Etruscans: Art, Architecture, and History*. Los Angeles: J. Paul Getty Museum, 2004.
Brendel, O. *Etruscan Art*. Pelican History of Art. New Haven: Yale University Press, 1995.
Hall, J. F., ed. *Etruscan Italy: Etruscan Influences on the Civilizations of Italy from Antiquity to the Modern Era*. Provo, UT: Museum of Art, Brigham Young University, 1996.
Haynes, Sybille. *Etruscan Civilization: A Cultural History*. Los Angeles: J. Paul Getty Museum, 2000.
Richardson, E. *The Etruscans: Their Art and Civilization*. Reprint of 1964 ed., with corrections. Chicago: University of Chicago Press, 1976.
Spivey, N. *Etruscan Art*. The World of Art. New York: Thames & Hudson, 1997.
Sprenger, M., G. Bartoloni, and M. Hirmer. *The Etruscans: Their History, Art, and Architecture*. New York: Harry N. Abrams, 1983.
Steingräber, S., ed. *Etruscan Painting: Catalogue Raisonné of Etruscan Wall Paintings*. New York: Johnson Reprint, 1986.
Torelli, M., ed. *The Etruscans*. Exh. cat. Milan: Bompiani, 2000.

CHAPTER 7. ROMAN ART

Allan, T. *Life, Myth and Art in Ancient Rome*. Los Angeles: J. Paul Getty Museum, 2005.
Andreae, B. *The Art of Rome*. New York: Harry N. Abrams, 1977.
Beard, M., and J. Henderson. *Classical Art: From Greece to Rome*. New York: Oxford University Press, 2001.
Bowe, P. *Gardens of the Roman World*. Los Angeles: J. Paul Getty Museum, 2004.
Brilliant, R. *Commentaries on Roman Art: Selected Studies*. London: Pindar Press, 1994.
———. *My Laocoon: Alternative Claims in the Interpretation of Artworks*. University of California Press, 2000.
Claridge, A. *Rome: An Oxford Archaeological Guide*. New York: Oxford University Press, 1998.
D'Ambra, E. *Roman Art*. New York: Cambridge University Press, 1998.
———., comp. *Roman Art in Context: An Anthology*. Englewood Cliffs, NJ: Prentice Hall, 1993.
Davies, P. *Death and the Emperor: Roman Imperial Funerary Monuments from Augustus to Marcus Aurelius*. Austin: University of Texas Press, 2004.
Dunbabin, K. M. D. *Mosaics of the Greek and Roman World*. New York: Cambridge University Press, 1999.
Elsner, J. *Imperial Rome and Christian Triumph: The Art of the Roman Empire, A.D. 100–450*. New York: Oxford University Press, 1998.
Gazda, E. K. *Roman Art in the Private Sphere: New Perspectives on the Architecture and Decor of the Domus, Villa, and Insula*. Ann Arbor: University of Michigan Press, 1991.
Jenkyns, R., ed. *The Legacy of Rome: A New Appraisal*. New York: Oxford University Press, 1992.
Kleiner, D. *Roman Sculpture*. New Haven: Yale University Press, 1992.
———., and S. B. Matheson, eds. *I, Claudia: Women in Ancient Rome*. New Haven: Yale University Art Gallery, 1996.
Ling, R. *Ancient Mosaics*. London: British Museum Press, 1998.
———. *Roman Painting*. New York: Cambridge University Press, 1991.
Nash, E. *Pictorial Dictionary of Ancient Rome*. 2 vols. Reprint of 1968 2d ed. New York: Hacker, 1981.
Pollitt, J. J. *The Art of Rome, c. 753 B.C.–A.D. 337: Sources and Documents*. New York: Cambridge University Press, 1983.
Ramage, N., and A. Ramage. *The Cambridge Illustrated History of Roman Art*. Cambridge: Cambridge University Press, 1991.
———. *Roman Art: Romulus to Constantine*. 4th ed. Upper Saddle River, NJ: Pearson Prentice Hall, 2005.
Richardson, L. *A New Topographical Dictionary of Ancient Rome*. Baltimore, MD: Johns Hopkins University Press, 1992.
Rockwell, P. *The Art of Stoneworking: A Reference Guide*. Cambridge: Cambridge University Press, 1993.
Strong, D. E. *Roman Art*. 2d ed. Pelican History of Art. New Haven: Yale University Press, 1992.
Vitruvius. *The Ten Books on Architecture*. Trans. I. Rowland. Cambridge: Cambridge University Press, 1999.

Ward-Perkins, J. B. *Roman Imperial Architecture*. Reprint of 1981 ed. Pelican History of Art. New York: Penguin, 1992.
Zanker, P. *The Power of Images in the Age of Augustus*. Ann Arbor: University of Michigan Press, 1988.

PART TWO: THE MIDDLE AGES

GENERAL REFERENCES

Alexander, J. J. G. *Medieval Illuminators and Their Methods of Work*. New Haven: Yale University Press, 1992.
———., ed. *A Survey of Manuscripts Illuminated in the British Isles*. 6 vols. London: Harvey Miller, 1975–1996.
Avril, F., and J. J. G. Alexander, eds. *A Survey of Manuscripts Illuminated in France*. London: Harvey Miller, 1996.
Bartlett, R., ed. *Medieval Panorama*. Los Angeles: J. Paul Getty Museum, 2001.
Cahn, W. *Studies in Medieval Art and Interpretation*. London: Pindar Press, 2000.
Calkins, R. G. *Medieval Architecture in Western Europe: From A.D. 300 to 1500*. New York: Oxford University Press, 1998.
Cassidy, B., ed. *Iconography at the Crossroads*. Princeton, NJ: Princeton University Press, 1993.
De Hamel, C. *The British Library Guide to Manuscript Illumination: History and Techniques*. Toronto: University of Toronto Press, 2001.
———. *A History of Illuminated Manuscripts*. Rev. and enl. 2d ed. London: Phaidon Press, 1994.
Duby, G. *Art and Society in the Middle Ages*. Polity Press; Malden, MA: Blackwell Publishers, 2000.
Hamburger, J. *Nuns as Artists: The Visual Culture of a Medieval Convent*. Berkeley: University of California Press, 1997.
Katzenellenbogen, A. *Allegories of the Virtues and Vices in Medieval Art*. Reprint of 1939 ed. Toronto: University of Toronto Press, 1989.
Kazhdan, A. P. *The Oxford Dictionary of Byzantium*. 3 vols. New York: Oxford University Press, 1991.
Kessler, H. L. *Seeing Medieval Art*. Peterborough, Ont. and Orchard Park, NY: Broadview Press, 2004.
Pächt, O. *Book Illumination in the Middle Ages: An Introduction*. London: Harvey Miller, 1986.
Pelikan, J. *Mary Through the Centuries: Her Place in the History of Culture*. New Haven: Yale University Press, 1996.
Ross, L. *Artists of the Middle Ages*. Westport, CT: Greenwood Press, 2003.
———. *Medieval Art: A Topical Dictionary*. Westport, CT: Greenwood Press, 1996.
Schütz, B. *Great Cathedrals*. New York: Harry N. Abrams, 2002.
Sears, E., and T. K. Thomas, eds. *Reading Medieval Images: The Art Historian and the Object*. Ann Arbor: University of Michigan Press, 2002.
Sekules, V. *Medieval Art*. New York: Oxford University Press, 2001.
Snyder, J. *Medieval Art: Painting, Sculpture, Architecture, 4th–14th Century*. New York: Harry N. Abrams, 1989.
Stokstad, M. *Medieval Art*. Boulder, CO: Westview Press, 2004.
Tasker, E. *Encyclopedia of Medieval Church Art*. London: Batsford, 1993.
Watson, R. *Illuminated Manuscripts and Their Makers: An Account Based on the Collection of the Victoria and Albert Museum*. London and New York: V & A Publications; Dist. by Harry N. Abrams, 2003.
Wieck, R. S. *Painted Prayers: The Book of Hours in Medieval and Renaissance Art*. New York: George Braziller in association with the Pierpont Morgan Library, 1997.
Wixom, W. D. *Mirror of the Medieval World*. Exh. cat. New York: Metropolitan Museum of Art; Dist. by Harry N. Abrams, 1999.

CHAPTER 8. EARLY CHRISTIAN AND BYZANTINE ART

Beckwith, J. *Studies in Byzantine and Medieval Western Art*. London: Pindar Press, 1989.
Bowersock, G. W., ed. *Late Antiquity: A Guide to the Postclassical World*. Cambridge, MA: Belknap Press of Harvard University Press, 1999.
Demus, O. *Studies in Byzantium, Venice and the West*. 2 vols. London: Pindar Press, 1998.
Drury, J. *Painting the Word: Christian Pictures and Their Meanings*. New Haven and London: Yale University Press in association with National Gallery Publications, 1999.
Durand, J. *Byzantine Art*. Paris: Terrail, 1999.

Evans, H. C., ed. *Byzantium: Faith and Power, 1261–1557.* Exh. cat. New York and New Haven: Metropolitan Museum of Art; Yale University Press, 2004.

Galavaris, G. *Colours, Symbols, Worship: The Mission of the Byzantine Artist.* London: Pindar, 2005.

Grabar, A. *Christian Iconography: A Study of Its Origins.* Princeton, NJ: Princeton University Press, 1968.

Henderson, G. *Vision and Image in Early Christian England.* New York: Cambridge University Press, 1999.

Kalavrezou, I. *Byzantine Women and Their World.* Exh. cat. Cambridge, MA and New Haven: Harvard University Art Museums; Yale University Press, © 2003.

Kleinbauer, W. *Early Christian and Byzantine Architecture: An Annotated Bibliography and Historiography.* Boston: G. K. Hall, 1993.

Krautheimer, R., and S. Curcic. *Early Christian and Byzantine Architecture.* 4th ed. Pelican History of Art. New Haven: Yale University Press, 1992.

Lowden, J. *Early Christian and Byzantine Art.* London: Phaidon, 1997.

Maguire, H. *Art and Eloquence in Byzantium.* Princeton, NJ: Princeton University Press, 1981.

Mango, C. *The Art of the Byzantine Empire, 312–1453: Sources and Documents.* Reprint of 1972 ed. Toronto: University of Toronto Press, 1986.

Mark, R., and A. S. Çakmak, eds. *Hagia Sophia from the Age of Justinian to the Present.* New York: Cambridge University Press, 1992.

Matthews, T. *Byzantium from Antiquity to the Renaissance.* New York: Harry N. Abrams, 1998.

———. *The Clash of Gods: A Reinterpretation of Early Christian Art.* Princeton, NJ: Princeton University Press, 1993.

Milburn, R. *Early Christian Art and Architecture.* Berkeley: University of California Press, 1988.

Rodley, L. *Byzantine Art and Architecture: An Introduction.* New York: Cambridge University Press, 1994.

Simson, O. G. von. *Sacred Fortress: Byzantine Art and Statecraft in Ravenna.* Reprint of 1948 ed. Princeton, NJ: Princeton University Press, 1987.

Webster, L., and M. Brown, eds. *The Transformation of the Roman World A.D. 400–900.* Berkeley: University of California Press, 1997.

Weitzmann, K. *Late Antique and Early Christian Book Illumination.* New York: Braziller, 1977.

CHAPTER 9. ISLAMIC ART

Asher, C. E. B. *Architecture of Mughal India.* New Cambridge History of India, Cambridge, England. New York: Cambridge University Press, 1992.

Atil, E. *The Age of Sultan Süleyman the Magnificent.* Exh. cat. Washington, DC: National Gallery of Art; New York: Harry N. Abrams, 1987.

———. *Renaissance of Islam: Art of the Mamluks.* Exh. cat. Washington, DC: Smithsonian Institution Press, 1981.

Behrens-Abouseif, D. *Beauty in Arabic Culture.* Princeton, NJ: Markus Wiener, 1998.

Bierman, I., ed. *The Experience of Islamic Art on the Margins of Islam.* Reading, England: Ithaca Press, 2005.

Blair, S., and J. Bloom. *The Art and Architecture of Islam 1250–1800.* Pelican History of Art. New Haven: Yale University Press, 1994.

Brookes, J. *Gardens of Paradise: The History and Design of the Great Islamic Gardens.* New York: New Amsterdam, 1987.

Burckhardt, T. *Art of Islam: Language and Meaning.* London: World of Islam Festival, 1976.

Creswell, K. A. C. *A Bibliography of the Architecture, Arts, and Crafts of Islam.* Cairo: American University in Cairo Press, 1984.

Denny, W. B. *The Classical Tradition in Anatolian Carpets.* Washington, DC: Textile Museum, 2002.

Dodds, J. D., ed. *al-Andalus: The Art of Islamic Spain.* Exh. cat. New York: Metropolitan Museum of Art; Dist. by Harry N. Abrams, 1992.

Erdmann, K. *Oriental Carpets: An Essay on Their History.* Fishguard, Wales: Crosby Press, 1976, © 1960.

Ettinghausen, R., O. Grabar, and M. Jenkins-Madina. *Islamic Art and Architecture, 650–1250.* 2d ed. Pelican History of Art. New Haven: Yale University Press, 2001.

Frishman, M., and H. Khan. *The Mosque: History, Architectural Development and Regional Diversity.* London: Thames & Hudson, 2002, © 1994.

Goodwin, G. *A History of Ottoman Architecture.* New York: Thames & Hudson, 2003, © 1971.

Grabar, O. *The Formation of Islamic Art.* Rev. and enl. ed. New Haven: Yale University Press, 1987.

Hillenbrand, R. *Islamic Architecture: Form, Function, and Meaning.* New York: Columbia University Press, 1994.

Komaroff, L., and S. Carboni, eds. *The Legacy of Genghis Khan: Courtly Art and Culture in Western Asia, 1256–1353.* Exh. cat. New York: Metropolitan Museum of Art; New Haven: Yale University Press, 2002.

Lentz, T., and G. Lowry. *Timur and the Princely Vision: Persian Art and Culture in the Fifteenth Century.* Exh. cat. Los Angeles: Los Angeles County Museum of Art; Washington, DC: Arthur M. Sackler Gallery; Smithsonian Institution Press, 1989.

Lings, M. *The Quranic Art of Calligraphy and Illumination.* 1st American ed. New York: Interlink Books, 1987, © 1976.

Necipoğlu, G. *The Age of Sinan: Architectural Culture in the Ottoman Empire.* Princeton, NJ: Princeton University Press, 2005.

———. *The Topkapı Scroll: Geometry and Ornament in Islamic Architecture.* Topkapı Palace Museum Library MS H. 1956. Santa Monica, CA: Getty Center for the History of Art and the Humanities, 1995.

Pope, A. U. *Persian Architecture: The Triumph of Form and Color.* New York: Braziller, 1965.

Robinson, F. *Atlas of the Islamic World Since 1500.* New York: Facts on File, 1982.

Ruggles, D. F. *Gardens, Landscape, and Vision in the Palaces of Islamic Spain.* University Park: Pennsylvania State University Press, 2000.

———., ed. *Women, Patronage, and Self-Representation in Islamic Societies.* Albany: State University of New York Press, 2000.

Tabbaa, Y. *The Transformation of Islamic Art During the Sunni Revival.* Seattle: University of Washington Press, 2001.

Thompson, J., ed. *Hunt for Paradise: Court Arts of Safavid Iran, 1501–1576.* Milan: Skira; New York: Dist. in North America and Latin America by Rizzoli, 2003.

———. *Oriental Carpets from the Tents, Cottages, and Workshops of Asia.* New York: Dutton, 1988.

Vernoit, S., ed. *Discovering Islamic Art: Scholars, Collectors and Collections, 1850–1950.* London and New York: I. B. Tauris; Dist. by St. Martin's Press, 2000.

Welch, S. C. *Imperial Mughal Painting.* New York: Braziller, 1978.

———. *A King's Book of Kings: The Shah-nameh of Shah Tahmasp.* New York: Metropolitan Museum of Art; Dist. by New York Graphic Society, 1972.

CHAPTER 10. EARLY MEDIEVAL ART

Backhouse, J. *The Golden Age of Anglo-Saxon Art, 966–1066.* Bloomington: Indiana University Press, 1984.

———. *The Lindisfarne Gospels: A Masterpiece of Book Painting.* London: British Library, 1995.

Barral i Altet, X. *The Early Middle Ages: From Late Antiquity to A.D. 1000.* Taschen's World Architecture. Köln and New York: Taschen, © 1997.

Conant, K. *Carolingian and Romanesque Architecture, 800–1200.* 4th ed. Pelican History of Art. New Haven: Yale University Press, 1992.

Davis-Weyer, C. *Early Medieval Art, 300–1150: Sources and Documents.* Reprint of 1971 ed. Toronto: University of Toronto Press, 1986.

Diebold, W. J. *Word and Image: An Introduction to Early Medieval Art.* Boulder, CO: Westview Press, 2000.

Dodwell, C. R. *Anglo-Saxon Art: A New Perspective.* Ithaca, NY: Cornell University Press, 1982.

———. *The Pictorial Arts of the West, 800–1200.* New ed. Pelican History of Art. New Haven: Yale University Press, 1993.

Graham-Campbell, J. *The Viking-age Gold and Silver of Scotland, A.D. 850–1100.* Exh. cat. Edinburgh: National Museums of Scotland, 1995.

Harbison, P. *The Golden Age of Irish Art: The Medieval Achievement, 600–1200.* New York: Thames & Hudson, 1999.

Henderson, G. *The Art of the Picts: Sculpture and Metalwork in Early Medieval Scotland.* New York: Thames & Hudson, 2004.

Kitzinger, E. *Early Medieval Art, with Illustrations from the British Museum.* Rev. ed. Bloomington: Indiana University Press, 1983.

Lasko, P. *Ars Sacra, 800–1200.* 2nd ed. Pelican History of Art. New Haven: Yale University Press, 1994.

Mayr-Harting, M. *Ottonian Book Illumination: An Historical Study.* 2 vols. London: Harvey Miller, 1991–1993.

Megaw, M. R. *Celtic Art: From Its Beginnings to the Book of Kells.* New York: Thames & Hudson, 2001.

Mosacati, S., ed. *The Celts.* Exh. cat. New York: Rizzoli, 1999.

Nees, L. *Early Medieval Art.* Oxford History of Art. New York: Oxford University Press, 2002.

Ohlgren, T. H., comp. *Insular and Anglo-Saxon Illuminated Manuscripts: An Iconographic Catalogue, c. A.D. 625 to 1100.* New York: Garland, 1986.

Rickert, M. *Painting in Britain: The Middle Ages.* 2d ed. Pelican History of Art. Harmondsworth, England: Penguin, 1965.

Stalley, R. A. *Early Medieval Architecture.* Oxford History of Art. New York: Oxford University Press, 1999.

Stone, L. *Sculpture in Britain: The Middle Ages.* 2d ed. Pelican History of Art. Harmondsworth, England: Penguin, 1972.

Webster, L., and J. Backhouse, eds. *The Making of England: Anglo-Saxon Art and Culture, A.D. 600–900.* Exh. cat. London: Published for the Trustees of the British Museum and the British Library Board by British Museum Press, 1991.

CHAPTER 11. ROMANESQUE ART

Bizzarro, T. *Romanesque Architectural Criticism: A Prehistory.* New York: Cambridge University Press, 1992.

Boase, T. S. R. *English Art, 1100–1216.* Oxford History of English Art. Oxford: Clarendon Press, 1953.

Cahn, W. *Romanesque Bible Illumination.* Ithaca, NY: Cornell University Press, 1982.

Davies, M. *Romanesque Architecture: A Bibliography.* Boston: G. K. Hall, 1993.

Focillon, H. *The Art of the West in the Middle Ages.* Ed. J. Bony. 2 vols. Reprint of 1963 ed. Ithaca, NY: Cornell University Press, 1980.

Hearn, M. F. *Romanesque Sculpture: The Revival of Monumental Stone Sculpture.* Ithaca, NY: Cornell University Press, 1981.

Mâle, E. *Religious Art in France, the Twelfth Century: A Study of the Origins of Medieval Iconography.* Bollingen series, 90:1. Princeton, NJ: Princeton University Press, 1978.

Minne-Sève, V. *Romanesque and Gothic France: Architecture and Sculpture.* New York: Harry N. Abrams, 2000.

Nichols, S. *Romanesque Signs: Early Medieval Narrative and Iconography.* New Haven: Yale University Press, 1983.

O'Keeffe, T. *Romanesque Ireland: Architecture and Ideology in the Twelfth Century.* Dublin and Portland, OR: Four Courts, 2003.

Petzold, A. *Romanesque Art.* Perspectives. New York: Harry N. Abrams, 1995.

Platt, C. *The Architecture of Medieval Britain: A Social History.* New Haven: Yale University Press, 1990.

Sauerländer, W. *Romanesque Art: Problems and Monuments.* 2 vols. London: Pindar, 2004.

Schapiro, M. *Romanesque Art.* New York: Braziller, 1977.

Stoddard, W. *Art and Architecture in Medieval France.* New York: Harper & Row, 1972, © 1966.

Stones, A., and J. Krochalis. *The Pilgrim's Guide to Santiago de Compostela: A Critical Edition.* 2 vols. London: Harvey Miller, 1998.

Toman, R. *Romanesque Architecture, Sculpture, Painting.* Cologne: Könemann, 1997.

Zarnecki, G. *Further Studies in Romanesque Sculpture.* London: Pindar, 1992.

CHAPTER 12. GOTHIC ART

Barnes, C. F. *Villard de Honnecourt, the Artist and His Drawings: A Critical Bibliography.* Boston: G. K. Hall, 1982.

Belting, H. *The Image and Its Public: Form and Function of Early Paintings of the Passion.* New Rochelle, NY: Caratzas, 1990.

Blum, P. *Early Gothic Saint-Denis: Restorations and Survivals.* Berkeley: University of California Press, 1992.

Bony, J. *French Gothic Architecture of the Twelfth and Thirteenth Centuries.* Berkeley: University of California Press, 1983.

Camille, M. *Gothic Art: Glorious Visions.* Perspectives. New York: Harry N. Abrams, 1997.

———. *The Gothic Idol: Ideology and Image Making in Medieval Art.* New York: Cambridge University Press, 1989.

———. *Sumptuous Arts at the Royal Abbeys of Reims and Braine.* Princeton, NJ: Princeton University Press, 1990.

Cennini, C. *The Craftsman's Handbook (Il Libro dell'Arte).* New York: Dover, 1954.

Coldstream, N. *Medieval Architecture.* Oxford History of Art. New York: Oxford University Press, 2002.

Erlande-Brandenburg, A. *Gothic Art.* New York: Harry N. Abrams, 1989.

Frankl, P. *Gothic Architecture.* Rev. by P. Crossley. Pelican History of Art. New Haven, CT: Yale University Press, 2001.

Frisch, T. G. *Gothic Art, 1140–c. 1450: Sources and Documents.* Reprint of 1971 ed. Toronto: University of Toronto Press, 1987.

Grodecki, L. *Gothic Architecture.* New York: Electa/Rizzoli, 1985.

————. *Gothic Stained Glass, 1200–1300*. Ithaca, NY: Cornell University Press, 1985.

Hamburger, J. F. *The Visual and the Visionary: Art and Female Spirituality in Late Medieval Germany*. Zone Books. Cambridge, MA: MIT Press, 1998.

Jantzen, H. *High Gothic: The Classic Cathedrals of Chartres, Reims, Amiens*. Reprint of 1962 ed. Princeton, NJ: Princeton University Press, 1984.

Kemp, W. *The Narratives of Gothic Stained Glass*. New York: Cambridge University Press, 1997.

Limentani Virdis, C. *Great Altarpieces: Gothic and Renaissance*. New York: Vendome Press; Dist. by Rizzoli, 2002.

Mâle, E. *Religious Art in France, the Thirteenth Century: A Study of Medieval Iconography and Its Sources*. Ed. H. Bober. Princeton, NJ: Princeton University Press, 1984.

Marks, R., and P. Williamson, eds. *Gothic: Art for England 1400–1547*. Exh. cat. London and New York: Victoria & Albert Museum; Dist. by Harry N. Abrams, 2003.

Murray, S. *Beauvais Cathedral: Architecture of Transcendence*. Princeton, NJ: Princeton University Press, 1989.

Panofsky, E., ed. and trans. *Abbot Suger on the Abbey Church of Saint-Denis and Its Art Treasures*. 2d ed. Princeton, NJ: Princeton University Press, 1979.

————. *Gothic Architecture and Scholasticism*. Reprint of 1951 ed. New York: New American Library, 1985.

Parnet, P., ed. *Images in Ivory: Precious Objects of the Gothic Age*. Exh. cat. Detroit, MI: Detroit Institute of Arts, © 1997.

Sandler, L. *Gothic Manuscripts, 1285–1385*. Survey of Manuscripts Illuminated in the British Isles. London: Harvey Miller, 1986.

Scott, R. A. *The Gothic Enterprise: A Guide to Understanding the Medieval Cathedral*. Berkeley: University of California Press, 2003.

Simson, O. von. *The Gothic Cathedral: Origins of Gothic Architecture and the Medieval Concept of Order*. 3d ed. Princeton, NJ: Princeton University Press, 1988.

Toman, R., ed. *The Art of Gothic: Architecture, Sculpture, Painting*. Cologne: Könemann, 1999.

Williamson, P. *Gothic Sculpture, 1140–1300*. New Haven: Yale University Press, 1995.

Wilson, C. *The Gothic Cathedral*. New York: Thames & Hudson, 1990.

PART THREE: THE RENAISSANCE THROUGH THE ROCOCO

GENERAL REFERENCES AND SOURCES

Campbell, L. *Renaissance Portraits: European Portrait-Painting in the 14th, 15th, and 16th Centuries*. New Haven: Yale University Press, 1990.

Chastel, A., et al. *The Renaissance: Essays in Interpretation*. London: Methuen, 1982.

Cloulas, I. *Treasures of the French Renaissance*. New York: Harry N. Abrams, 1998.

Cole, A. *Art of the Italian Renaissance Courts: Virtue and Magnificence*. London: Weidenfeld & Nicolson, 1995.

Gascoigne, B. *How to Identify Prints: A Complete Guide to Manual and Mechanical Processes from Woodcut to Inkjet*. New York: Thames & Hudson, 2004.

Grendler, P. F., ed. *Encyclopedia of the Renaissance*. 6 vols. New York: Scribner's, published in association with the Renaissance Society of America, 1999.

Gruber, A., ed. *The History of Decorative Arts: Vol. 1, The Renaissance and Mannerism in Europe. Vol. 2, Classicism and the Baroque in Europe*. New York: Abbeville Press, 1994.

Harbison, C. *The Mirror of the Artist: Northern Renaissance Art in its Historical Context*. New York: Harry N. Abrams, 1995.

Harris, A. S. *Seventeenth-Century Art and Architecture*. Upper Saddle River, NJ: Pearson Prentice Hall, 2005.

Hartt, F., and D. Wilkins. *History of Italian Renaissance Art*. 6th ed. Upper Saddle River, NJ: Pearson Prentice Hall, 2007.

Hopkins, A. *Italian Architecture: from Michelangelo to Borromini*. World of Art. New York: Thames & Hudson, 2002.

Hults, L. *The Print in the Western World*. Madison: University of Wisconsin Press, 1996.

Impey, O., and A. MacGregor, eds. *The Origins of Museums: The Cabinet of Curiosities in Sixteenth- and Seventeenth-Century Europe*. New York: Clarendon Press, 1985.

Ivins, W. M., Jr. *How Prints Look: Photographs with a Commentary*. Boston: Beacon Press, 1987.

Landau, D., and P. Parshall. *The Renaissance Print*. New Haven: Yale University Press, 1994.

Lincoln, E. *The Invention of the Italian Renaissance Printmaker*. New Haven: Yale University Press, 2000.

Martin, J. R. *Baroque*. Harmondsworth, England: Penguin, 1989.

Millon, H. A., ed. *The Triumph of the Baroque: Architecture in Europe, 1600–1750*. New York: Rizzoli, 1999.

Minor, V. H. *Baroque & Rococo: Art & Culture*. New York: Harry N. Abrams, 1999.

Norberg-Schultz, C. *Late Baroque and Rococo Architecture*. New York: Harry N. Abrams, 1983.

Olson, R. J. M. *Italian Renaissance Sculpture*. The World of Art. New York: Thames & Hudson, 1992.

Paoletti, J., and G. Radke. *Art in Renaissance Italy*. 3d ed. Upper Saddle River, NJ: Pearson Prentice Hall, 2006.

Payne, A. *Antiquity and Its Interpreters*. New York: Cambridge University Press, 2000.

Pope-Hennessy, J. *An Introduction to Italian Sculpture: Vol. 1, Italian Gothic Sculpture. Vol. 2, Italian Renaissance Sculpture. Vol. 3, Italian High Renaissance and Baroque Sculpture*. 4th ed. London: Phaidon Press, 1996.

Smith, J. C. *The Northern Renaissance*. Art & Ideas. London: Phaidon, 2004.

Snyder, J. *Northern Renaissance Art: Painting, Sculpture, the Graphic Arts, from 1350–1575*. 2d ed. New York: Harry N. Abrams, 2005.

Tomlinson, J. *From El Greco to Goya: Painting in Spain 1561–1828*. Perspectives. New York: Harry N. Abrams, 1997.

Turner, J. *Encyclopedia of Italian Renaissance & Mannerist Art*. 2 vols. New York: Grove's Dictionaries, 2000.

Vasari, G. *The Lives of the Artists*. Trans. with an introduction and notes by J. C. Bondanella and P. Bondanella. New York: Oxford University Press, 1998.

Welch, E. *Art in Renaissance Italy, 1350–1500*. New ed. Oxford: Oxford University Press, 2000.

Wiebenson, D., ed. *Architectural Theory and Practice from Alberti to Ledoux*. 2d ed. Chicago: University of Chicago Press, 1983.

Wittkower, R. *Architectural Principles in the Age of Humanism*. 5th ed. New York: St. Martin's Press, 1998.

CHAPTER 13. ART IN THIRTEENTH- AND FOURTEENTH-CENTURY ITALY

Bellosi, L. *Duccio, the Maestà*. New York: Thames & Hudson, 1999.

Bomford, D. *Art in the Making: Italian Painting Before 1400*. Exh. cat. London: National Gallery of Art, 1989.

Cole, B. *Studies in the History of Italian Art, 1250–1550*. London: Pindar, 1996.

Derbes, A. *The Cambridge Companion to Giotto*. New York: Cambridge University Press, 2004.

Kemp, M. *Behind the Picture: Art and Evidence in the Italian Renaissance*. New Haven: Yale University Press, 1997.

Maginnis, H. B. J. *The World of the Early Sienese Painter*. With a translation of the Sienese Breve dell'Arte dei pittori by Gabriele Erasmi. University Park: Pennsylvania State University Press, 2001.

Meiss, M. *Painting in Florence and Siena after the Black Death: The Arts, Religion, and Society in the Mid-Fourteenth Century*. Princeton, NJ: Princeton University Press, 1978, © 1951.

Norman, D., ed. *Siena, Florence, and Padua: Art, Society, and Religion 1280–1400*. New Haven: Yale University Press in association with the Open University, 1995.

Schmidt, V., ed. *Italian Panel Painting of the Duecento and Trecento*. Washington, DC: National Gallery of Art; New Haven: Dist. by Yale University Press, 2002.

Stubblebine, J. H. *Assisi and the Rise of Vernacular Art*. New York: Harper & Row, 1985.

————. *Dugento Painting: An Annotated Bibliography*. Boston: G. K. Hall, 1983.

White, J. *Art and Architecture in Italy, 1250–1400*. 3d ed. Pelican History of Art. New Haven: Yale University Press, 1993.

CHAPTER 14. ARTISTIC INNOVATIONS IN FIFTEENTH-CENTURY NORTHERN EUROPE

Ainsworth, M. W., and K. Christiansen. *From Van Eyck to Bruegel: Early Netherlandish Painting in the Metropolitan Museum of Art*. New York: Metropolitan Museum of Art, 1998.

Blum, S. *Early Netherlandish Triptychs: A Study in Patronage*. Berkeley: University of California Press, 1969.

Chapuis, J., ed. *Tilman Riemenschneider, Master Sculptor of the Late Middle Ages*. Washington, DC: National Gallery of Art; New York: Metropolitan Museum of Art; New Haven: Dist. by Yale University Press, 1999.

Cuttler, C. *Northern Painting from Pucelle to Bruegel*. Fort Worth: Holt, Rinehart & Winston, 1991, © 1972.

De Vos, D. *Rogier van der Weyden: The Complete Works*. New York: Harry N. Abrams, 1999.

Dhanens, E. *Hubert and Jan van Eyck*. New York: Alpine Fine Arts Collection, 1980.

Dixon, L. *Bosch*. Art & Ideas. London: Phaidon, 2003.

Friedländer, M. *Early Netherlandish Painting*. 14 vols. New York: Praeger, 1967–1973.

Koldeweij, J., ed. *Hieronymus Bosch: New Insights into His Life and Work*. Rotterdam: Museum Boijmans Van Beuningen: NAi; Ghent: Ludion, 2001.

Mâle, E. *Religious Art in France, the Late Middle Ages: A Study of Medieval Iconography and Its Sources*. Princeton, NJ: Princeton University Press, 1986.

Muller, T. *Sculpture in the Netherlands, Germany, France, and Spain, 1400–1500*. Pelican History of Art. Harmondsworth, England: Penguin, 1966.

Nuttall, P. *From Flanders to Florence: The Impact of Netherlandish Painting, 1400–1500*. New Haven: Yale University Press, 2004.

Pächt, O. *Van Eyck and the Founders of Early Netherlandish Painting*. London: Harvey Miller, 1994.

Panofsky, E. *Early Netherlandish Painting*. 2 vols. New York: Harper & Row, 1971. Orig. published Cambridge, MA: Harvard University Press, 1958.

Williamson, P. *Netherlandish Sculpture 1450–1550*. London: V & A; New York: Dist. by Harry N. Abrams, 2002.

CHAPTER 15. THE EARLY RENAISSANCE IN ITALY

Ahl, D. C. *The Cambridge Companion to Masaccio*. New York: Cambridge University Press, 2002.

Aikema, B. *Renaissance Venice and the North: Crosscurrents in the Time of Bellini, Dürer and Titian*. Exh. cat. Milan: Bompiani, 2000.

Alberti, L. B. *On Painting*. Trans. C. Grayson, introduction and notes M. Kemp. New York: Penguin, 1991.

————. *On the Art of Building, in Ten Books*. Trans. J. Rykwert, et al. Cambridge, MA: MIT Press, 1991.

Ames-Lewis, F. *Drawing in Early Renaissance Italy*. 2d ed. New Haven: Yale University Press, 2000.

Baxandall, M. *Painting and Experience in Fifteenth-Century Italy: A Primer in the Social History of Pictorial Style*. 2d ed. New York: Oxford University Press, 1988.

Blunt, A. *Artistic Theory in Italy, 1450–1600*. Reprint of 1940 ed. New York: Oxford University Press, 1983.

Bober, P., and R. Rubinstein. *Renaissance Artists and Antique Sculpture: A Handbook of Sources*. New York: Oxford University Press, 1986.

Borsook, E. *The Mural Painters of Tuscany: From Cimabue to Andrea del Sarto*. 2d ed. New York: Oxford University Press, 1980.

Cole, B. *The Renaissance Artist at Work: From Pisano to Titian*. New York: Harper & Row, © 1983.

Fejfer, J. *The Rediscovery of Antiquity: The Role of the Artist*. Copenhagen: Museum Tusculanum Press, University of Copenhagen, 2003.

Gilbert, C. E. *Italian Art, 1400–1500: Sources and Documents*. Englewood Cliffs, NJ: Prentice Hall, 1980.

Goldthwaite, R. *Wealth and the Demand for Art in Italy, 1300–1600*. Baltimore, MD: Johns Hopkins University Press, 1993.

Gombrich, E. H. *Norm and Form: Studies in the Art of the Renaissance*. 4th ed. London: Phaidon, 1985.

————. *Symbolic Images: Studies in the Art of the Renaissance*. 3d ed. London: Phaidon, 1972.

Heydenreich, L., and W. Lotz. *Architecture in Italy, 1400–1500*. Rev. ed. Pelican History of Art. New Haven: Yale University Press, 1996.

Humfreys, P., and M. Kemp, eds. *The Altarpiece in the Renaissance*. New York: Cambridge University Press, 1990.

————., ed. *The Cambridge Companion to Giovanni Bellini*. New York: Cambridge University Press, 2004.

Huse, N., and W. Wolters. *The Art of Renaissance Venice: Architecture, Sculpture, and Painting, 1460–1590*. Chicago: University of Chicago Press, 1990.

Janson, H. W. *The Sculpture of Donatello*. 2 vols. Princeton, NJ: Princeton University Press, 1979.

Joannides, P. *Masaccio and Masolino: A Complete Catalogue*. New York: Harry N. Abrams, 1993.

Kempers, B. *Painting, Power, and Patronage: The Rise of the Professional Artist in the Italian Renaissance*. New York: Penguin, 1992.

Kent, D. V. *Cosimo de' Medici and the Florentine Renaissance: The Patron's Oeuvre*. New Haven: Yale University Press, © 2000.

Krautheimer, R., and T. Krautheimer-Hess. *Lorenzo Ghiberti*. Princeton, NJ: Princeton University Press, 1982.

Lavin, M. A. *Piero della Francesca*. Art & Ideas. New York: Phaidon, 2002.

Murray, P. *The Architecture of the Italian Renaissance*. New rev. ed. The World of Art. New York: Random House, 1997.

Pächt, O. *Venetian Painting in the 15th Century: Jacopo, Gentile and Giovanni Bellini and Andrea Mantegna*. London: Harvey Miller, 2003.

Panofsky, E. *Perspective as Symbolic Form*. New York: Zone Books, 1997.

———. *Renaissance and Renascences in Western Art*. Trans. C. S. Wood. New York: Humanities Press, 1970.

Pope-Hennessy, J. *Donatello*. New York: Abbeville Press, 1993.

———. *Italian Renaissance Sculpture*. 3d ed. New York: Oxford University Press, 1986.

Randolph, A. *Engaging Symbols: Gender, Politics, and Public Art in Fifteenth-Century Florence*. New Haven: Yale University Press, 2002.

Rosenberg, C. *The Este Monuments and Urban Development in Renaissance Ferrara*. New York: Cambridge University Press, 1997.

Saalman, H. *Filippo Brunelleschi: The Buildings*. University Park: Pennsylvania State University Press, 1993.

Seymour, C. *Sculpture in Italy, 1400–1500*. Pelican History of Art. Harmondsworth, England: Penguin, 1966.

Turner, A. R. *Renaissance Florence*. Perspectives. New York: Harry N. Abrams, 1997.

Wackernagel, M. *The World of the Florentine Renaissance Artist: Projects and Patrons, Workshop and Art Market*. Princeton, NJ: Princeton University Press, 1981.

Wood, J. M., ed. *The Cambridge Companion to Piero della Francesca*. New York: Cambridge University Press, 2002.

CHAPTER 16. THE HIGH RENAISSANCE IN ITALY, 1495–1520

Ackerman, J., *The Architecture of Michelangelo*. 2d ed. Chicago: University of Chicago Press, 1986.

Beck, J. H. *Three Worlds of Michelangelo*. New York: W. W. Norton, 1999.

Boase, T. S. R. *Giorgio Vasari: The Man and the Book*. Princeton, NJ: Princeton University Press, 1979.

Brown, P. F. *Art and Life in Renaissance Venice*. Perspectives. New York: Harry N. Abrams, 1997.

———. *Venice and Antiquity: The Venetian Sense of the Past*. New Haven: Yale University Press, 1997.

Chapman, H. *Raphael: From Urbino to Rome*. London: National Gallery; New Haven: Dist. by Yale University Press, 2004.

Clark, K. *Leonardo da Vinci*. Rev. and introduced by M. Kemp. New York: Penguin, 1993, © 1988.

Cole, A. *Virtue and Magnificence: Art of the Italian Renaissance Courts*. Perspectives. New York: Harry N. Abrams, 1995.

De Tolnay, C. *Michelangelo*. 5 vols. Some vols. rev. Princeton, NJ: Princeton University Press, 1969–1971.

Freedberg, S. *Painting in Italy, 1500–1600*. 3d ed. Pelican History of Art. New Haven: Yale University Press, 1993.

———. *Painting of the High Renaissance in Rome and Florence*. 2 vols. New rev. ed. New York: Hacker Art Books, 1985.

Goffen, R. *Renaissance Rivals: Michelangelo, Leonardo, Raphael, Titian*. New Heaven: Yale University Press, 2002.

Hall, M. B. *The Cambridge Companion to Raphael*. New York: Cambridge University Press, 2005.

Hersey, G. L. *High Renaissance Art in St. Peter's and the Vatican: An Interpretive Guide*. Chicago: University of Chicago Press, 1993.

Hibbard, H. *Michelangelo*. 2d ed. Boulder, CO: Westview Press, 1998, © 1974.

Kemp, M. *Leonardo*. New York: Oxford University Press, 2004.

———, ed. *Leonardo on Painting: An Anthology of Writings*. New Haven: Yale University Press, 1989.

Nicholl, C. *Leonardo da Vinci: Flights of the Mind*. New York: Viking Penguin, 2004.

Panofsky, E. *Studies in Iconology: Humanist Themes in the Art of the Renaissance*. New York: Harper & Row, 1972.

Partridge, L. *The Art of Renaissance Rome*. Perspectives. New York: Harry N. Abrams, 1996.

Rowland, I. *The Culture of the High Renaissance: Ancients and Moderns in Sixteenth Century Rome*. Cambridge: 1998.

Rubin, P. L. *Giorgio Vasari: Art and History*. New Haven: Yale University Press, 1995.

Steinberg, L. *Leonardo's Incessant Last Supper*. New York: Zone Books, 2001.

Wallace, W. *Michelangelo: The Complete Sculpture, Painting, Architecture*. Southport, CT: Hugh Lauter Levin, 1998.

Wölfflin, H. *Classic Art: An Introduction to the High Renaissance*. 5th ed. London: Phaidon, 1994.

CHAPTER 17. THE LATE RENAISSANCE AND MANNERISM

Ackerman, J. *Palladio*. Reprint of the 2d ed. Harmondsworth, England: Penguin, 1991, © 1966.

Barkan, L. *Unearthing the Past: Archaeology and Aesthetics in the Making of Renaissance Culture*. New Haven: Yale University Press, 1999.

Beltramini, G., and A. Padoan. *Andrea Palladio: The Complete Illustrated Works*. New York: Universe; Dist. by St. Martin's Press, 2001.

Ekserdjian, D. *Correggio*. New Heaven: Yale University Press, 1997.

Friedlaender, W. *Mannerism and Anti-Mannerism in Italian Painting*. Reprint of 1957 ed. Interpretations in Art. New York: Columbia University Press, 1990.

Goffen, R. *Titian's Women*. New Haven: Yale University Press, 1997.

Klein, R., and H. Zerner. *Italian Art, 1500–1600: Sources and Documents*. Reprint of 1966 ed. Evanston, IL: Northwestern University Press, 1989.

Kliemann, J., and M. Rohlmann. *Italian Frescoes: High Renaissance and Mannerism, 1510–1600*. New York: Abbeville Press, 2004.

Murphy, C. *Lavinia Fontana: A Painter and Her Patrons in Sixteenth-Century Bologna*. New Haven: Yale University Press, 2003.

Partridge, L. *Michelangelo—The Last Judgment: A Glorious Restoration*. New York: Harry N. Abrams, 1997.

Rearick, W. R. *The Art of Paolo Veronese, 1528–1588*. Cambridge: Cambridge University Press, 1988.

Rosand, D. *Painting in Sixteenth-Century Venice: Titian, Veronese, Tintoretto*. New York: Cambridge University Press, 1997.

Shearman, J. K. G. *Mannerism*. London: Penguin Books, 1990, © 1967.

Smyth, C. H. *Mannerism and Maniera*. 2d ed. Bibliotheca artibus et historiae. Vienna: IRSA, 1992.

Tavernor, R. *Palladio and Palladianism*. The World of Art. New York: Thames & Hudson, 1991.

Valcanover, F., and T. Pignatti. *Tintoretto*. New York: Harry N. Abrams, 1984.

Wundram, M. *Palladio: The Complete Buildings*. Köln and London: Taschen, 2004.

CHAPTER 18. EUROPEAN ART OF THE SIXTEENTH CENTURY: RENAISSANCE AND REFORMATION

Bartrum, G. *Albrecht Dürer and His Legacy: The Graphic Work of a Renaissance Artist*. Princeton, NJ: Princeton University Press, 2002.

Baxandall, M. *The Limewood Sculptors of Renaissance Germany*. New Haven: Yale University Press, 1980.

Eichberger, D., ed. *Durer and His Culture*. New York: Cambridge University Press, 1998.

Harbison, C. *The Mirror of the Artist: Northern Renaissance Art in Its Historical Context*. Perspectives. New York: Harry N. Abrams, 1995.

Hayum, A. *The Isenheim Altarpiece: God's Medicine and the Painter's Vision*. Princeton, NJ: Princeton University Press, 1989.

Hitchcock, H.-R. *German Renaissance Architecture*. Princeton, NJ: Princeton University Press, 1981.

Hulse, C. *Elizabeth I: Ruler and Legend*. Urbana: Published for the Newberry Library by the University of Illinois Press, 2003.

Hutchison, J. C. *Albrecht Dürer: A Biography*. Princeton, NJ: Princeton University Press, 1990.

Jopek, N. *German Sculpture, 1430–1540: A Catalogue of the Collection in the Victoria and Albert Museum*. London: V & A, 2002.

Kavaler, E. M. *Pieter Bruegel: Parables of Order and Enterprise*. New York: Cambridge University Press, 1999.

Koerner, J. *The Moment of Self-Portraiture in German Renaissance Art*. Chicago: University of Chicago Press, 1993.

———. *The Reformation of the Image*. Chicago: University of Chicago Press, 2004.

Mann, R. *El Greco and His Patrons: Three Major Projects*. New York: Cambridge University Press, 1986.

Melion, W. *Shaping the Netherlandish Canon: Karel van Mander's Schilder-Boeck*. Chicago: University of Chicago Press, 1991.

Moxey, K. *Peasants, Warriors, and Wives: Popular Imagery in the Reformation*. Chicago: University of Chicago Press, 1989.

Osten, G. von der, and H. Vey. *Painting and Sculpture in Germany and the Netherlands, 1500–1600*. Pelican History of Art. Harmondsworth, England: Penguin, 1969.

Panofsky, E. *The Life and Art of Albrecht Dürer*. 4th ed. Princeton, NJ: Princeton University Press, 1971.

Smith, J. C. *Nuremberg: A Renaissance City, 1500–1618*. Austin: Published for the Archer M. Huntington Art Gallery by the University of Texas Press, 1983.

Stechow, W. *Northern Renaissance Art, 1400–1600: Sources and Documents*. Evanston, IL: Northwestern University Press, 1989, © 1966.

Van Mander, K. *Lives of the Illustrious Netherlandish and German Painters*. Ed. H. Miedema. 6 vols. Doornspijk, Netherlands: Davaco, 1993–1999.

Wood, C. *Albrecht Altdorfer and the Origins of Landscape*. Chicago: University of Chicago Press, 1993.

Zerner, H. *Renaissance Art in France: The Invention of Classicism*. Paris: Flammarion; London: Thames & Hudson, 2003.

CHAPTER 19. THE BAROQUE IN ITALY AND SPAIN

Avery, C. *Bernini: Genius of the Baroque*. London: Thames & Hudson, 1997.

Bissell, R. W. *Masters of Italian Baroque Painting: The Detroit Institute of Arts*. Detroit, MI: Detroit Institute of Arts in association with D. Giles Ltd., London, 2005.

Blunt, A. *Borromini*. Cambridge, MA: Harvard University Press, 1979.

———. *Roman Baroque*. London: Pallas Athene Arts, 2001.

Brown, B. L., ed. *The Genius of Rome, 1592–1623*. Exh. cat. London: Royal Academy of Arts; New York: Dist. in the United States and Canada by Harry N. Abrams, 2001.

Brown, J. *Francisco de Zurbaran*. New York: Harry N. Abrams, 1991.

———. *Painting in Spain, 1500–1700*. Pelican History of Art. New Haven: Yale University Press, 1998.

———. *Velázquez: The Technique of Genius*. New Haven: Yale University Press, 1998.

Dempsey, C. *Annibale Carracci and the Beginnings of Baroque Style*. 2d ed. Fiesole, Italy: Cadmo, 2000.

Enggass, R., and J. Brown. *Italy and Spain, 1600–1750: Sources and Documents*. Reprint of 1970 ed. Evanston, IL: Northwestern University Press, 1992.

Freedberg, S. *Circa 1600: A Revolution of Style in Italian Painting*. Cambridge, MA: Harvard University Press, 1983.

Garrard, M. D. *Artemisia Gentileschi: The Image of the Female Hero in Italian Baroque Art*. Princeton, NJ: Princeton University Press, 1989.

Haskell, F. *Patrons and Painters: A Study in the Relations Between Italian Art and Society in the Age of the Baroque*. Rev. and enl. 2d ed. New Haven: Yale University Press, 1980.

Kubler, G., and M. Soria. *Art and Architecture in Spain and Portugal and Their American Dominions, 1500–1800*. Pelican History of Art. Harmondsworth, England: Penguin, 1959.

Marder, T. A. *Bernini and the Art of Architecture*. New York: Abbeville Press, 1998.

Montagu, J. *Roman Baroque Sculpture: The Industry of Art*. New Haven: Yale University Press, 1989.

Nicolson, B. *Caravaggism in Europe*. Ed. L. Vertova. 3 vols. 2d ed., rev. and enl. Turin, Italy: Allemandi, 1989.

Posner, D. *Annibale Carracci*. 2 vols. London: Phaidon, 1971.

Smith, G. *Architectural Diplomacy: Rome and Paris in the Late Baroque*. Cambridge, MA: MIT Press, 1993.

Spear, R. E. *From Caravaggio to Artemisia: Essays on Painting in Seventeenth-Century Italy and France*. London: Pindar Press, 2002.

Spike, J. T. *Caravaggio*. Includes CD-ROM of all the known paintings of Caravaggio, including attributed and lost works. New York: Abbeville Press, © 2001.

Varriano, J. *Italian Baroque and Rococo Architecture*. New York: Oxford University Press, 1986.

Wittkower, R. *Art and Architecture in Italy, 1600–1750*. 4th ed. Pelican History of Art. New Haven: Yale University Press, 2000.

———. *Bernini: The Sculptor of the Roman Baroque*. 4th ed. London: Phaidon, 1997.

CHAPTER 20. THE BAROQUE IN FLANDERS AND HOLLAND

Alpers, S. *The Art of Describing: Dutch Art in the Seventeenth Century*. Chicago: University of Chicago Press, 1983.

———. *The Making of Rubens*. New Haven: Yale University Press, 1995.

Chapman, H. P. *Rembrandt's Self-Portraits: A Study in Seventeenth-Century Identity*. Princeton, NJ: Princeton University Press, 1990.

Fleischer, R., ed. *Rembrandt, Rubens, and the Art of Their Time: Recent Perspectives*. University Park: Pennsylvania State University, 1997.

Franits, W. E. *Dutch Seventeenth-Century Genre Painting: Its Stylistic and Thematic Evolution*. New Haven: Yale University Press, 2004.

Grijzenhout, F., ed. *The Golden Age of Dutch Painting in Historical Perspective*. New York: Cambridge University Press, 1999.

Hofrichter, F. F. *Haarlem: The Seventeenth Century*. Exh. cat. New Brunswick, NJ: Zimmerli Art Museum, 1982.

Kiers, J. and E. Runia, eds. *The Glory of the Golden Age: Dutch Art of the 17th Century*. 2 vols. Exh. cat. Rijksmuseum, Amsterdam: Waanders: 2000.

Logan, A. S. *Peter Paul Rubens: The Drawings*. Exh. cat. New York: Metropolitan Museum of Art; New Haven: Yale University Press, 2004.

Rosenberg, J. *Rembrandt: Life and Work*. Rev. ed. Ithaca, NY: Cornell University Press, 1980.

————., S. Slive, and E. ter Kuile. *Dutch Art and Architecture, 1600–1800*. 3d ed. New Haven: Yale University Press, 1997.

Salvesen, S., ed. *Rembrandt: The Master and His Workshop*. 2 vols. Exh. cat. New Haven: Yale University Press, 1991.

Schama, S. *The Embarrassment of Riches: An Interpretation of Dutch Culture in the Golden Age*. New York: Alfred A. Knopf, 1987.

Schwartz, G. *Rembrandt: His Life, His Paintings*. New York: Viking, 1985.

Slive, S. *Dutch Painting, 1600–1800*. Pelican History of Art. New Haven: Yale University Press, 1995.

————. *Frans Hals*. San Francisco: A. Wofsky Fine Arts, 1989.

————. *Frans Hals*. Exh. cat. Munich: Prestel-Verlag, 1989.

————. *Jacob van Ruisdael: A Complete Catalogue of His Paintings, Drawings, and Etchings*. New Haven: Yale University Press, 2001.

————. *Jacob van Ruisdael: Master of Landscape*. London: Royal Academy of Arts, 2005.

Stechow, W. *Dutch Landscape Painting of the Seventeenth Century*. Reprint of 1966 2d ed. Ithaca, NY: Cornell University Press, 1980.

Sutton, P. *The Age of Rubens*. Exh. cat. Boston: Museum of Fine Arts, 1993.

Vlieghe, H. *Flemish Art and Architecture, 1585–1700*. Pelican History of Art. New Haven: Yale University Press, © 1998.

Walford, F. *Jacob van Ruisdael and the Perception of Landscape*. New Haven: Yale University Press, 1992.

Westermann, M. *Art and Home: Dutch Interiors in the Age of Rembrandt*. Exh. cat. Zwolle: Waanders, 2001.

————. *Rembrandt*. Art & Ideas. London: Phaidon, 2000.

————. *A Worldly Art: The Dutch Republic 1585–1718*. Perspectives. New York: Harry N. Abrams, 1996.

Wheelock, A. K., ed. *Johannes Vermeer*. Exh. cat. New Haven: Yale University Press, 1995.

————, et al. *Anthony van Dyck*. Exh. cat. New York: Harry N. Abrams, 1990.

White, C. *Peter Paul Rubens*. New Haven: Yale University Press, 1987.

CHAPTER 21. THE BAROQUE IN FRANCE AND ENGLAND

Blunt, A. *Art and Architecture in France, 1500–1700*. 5th ed. Pelican History of Art. New Haven: Yale University Press, 1999.

————. *Nicolas Poussin*. London: Pallas Athene, 1995, © 1967.

Brusatin, M., et al. *The Baroque in Central Europe: Places, Architecture, and Art*. Venice: Marsilio, 1992.

Donovan, F. *Rubens and England*. New Haven: Published for The Paul Mellon Centre for Studies in British Art by Yale University Press, 2004.

Downes, K. *The Architecture of Wren*. Rev. ed. Reading, England: Redhedge, 1988.

Garreau, M. *Charles Le Brun: First Painter to King Louis XIV*. New York: Harry N. Abrams, 1992.

Kitson, M. *Studies on Claude and Poussin*. London: Pindar, 2000.

Lagerlöf, M. R. *Ideal Landscape: Annibale Carracci, Nicolas Poussin, and Claude Lorrain*. New Haven: Yale University Press, 1990.

Liechtenstein, J. *The Eloquence of Color: Rhetoric and Painting in the French Classical Age*. Berkeley: University of California Press, 1993.

Mérot, A. *French Painting in the Seventeenth Century*. New Haven: Yale University Press, 1995.

————. *Nicolas Poussin*. New York: Abbeville Press, 1990.

Röthlisberger, M. *Claude Lorrain: The Paintings*. 2 vols. New Haven: Yale University Press, 1961.

Summerson, J. *Architecture in Britain, 1530–1830*. Rev. 9th ed. Pelican History of Art. New Haven: Yale University Press, 1993.

Tinniswood, A. *His Invention So Fertile: A Life of Christopher Wren*. New York: Oxford University Press, 2001.

Verdi, R. *Nicolas Poussin 1594–1665*. London: Zwemmer in association with the Royal Academy of Arts, 1995.

Vlnas, V., ed. *The Glory of the Baroque in Bohemia: Essays on Art, Culture and Society in the 17th and 18th Centuries*. Prague: National Gallery, 2001.

Waterhouse, E. K. *The Dictionary of Sixteenth and Seventeenth Century British Painters*. Woodbridge, Suffolk, England: Antique Collectors' Club, 1988.

————. *Painting in Britain, 1530–1790*. 5th ed. Pelican History of Art. New Haven: Yale University Press, 1993.

Whinney, M. D. *Wren*. World of Art. New York: Thames & Hudson, 1998.

CHAPTER 22. THE ROCOCO

Bailey, C. B. *The Age of Watteau, Chardin, and Fragonard: Masterpieces of French Genre Painting*. New Haven: Yale University Press in association with the National Gallery of Canada, 2003.

Baillio, J. *Louise-Elisabeth Vigée-Lebrun 1755–1842*. Exh. cat. Fort Worth, TX: Kimbell Art Museum, 1982.

Brunel, G. *Boucher*. New York: Vendome, 1986.

————. *Painting in Eighteenth-Century France*. Ithaca, NY: Cornell University Press, 1981.

Cormack, M. *The Paintings of Thomas Gainsborough*. New York: Cambridge University Press, 1991.

Cuzin, J. P. *Jean-Honoré Fragonard: Life and Work: Complete Catalogue of the Oil Paintings*. New York: Harry N. Abrams, 1988.

François Boucher, 1703–1770. Exh. cat. New York: Metropolitan Museum of Art, © 1986.

Gaunt, W. *The Great Century of British Painting: Hogarth to Turner*. 2d ed. London: Phaidon, 1978.

Kalnein, W. von. *Architecture in France in the Eighteenth Century*. Pelican History of Art. New Haven: Yale University Press, 1995.

Levey, M. *Giambattista Tiepolo: His Life and Art*. New Haven: Yale University Press, 1986.

————. *Painting and Sculpture in France, 1700–1789*. New ed. Pelican History of Art. New Haven: Yale University Press, 1993.

————. *Painting in Eighteenth-Century Venice*. 3d ed. Pelican History of Art. New Haven: Yale University Press, 1993.

————. *Rococo to Revolution: Major Trends in Eighteenth-Century Painting*. Reprint of 1966 ed. The World of Art. New York: Thames & Hudson, 1985.

Links, J. G. *Canaletto*. Completely rev., updated, and enl. ed. London: Phaidon, 1994.

Mannings, D. *Sir Joshua Reynolds: A Complete Catalogue of His Paintings*. New Haven: Yale University Press, 2000.

Paulson, R. *Hogarth*. 3 vols. New Brunswick: Rutgers University Press, 1991–1993.

Penny, N., ed. *Reynolds*. Exh. cat. New York: Harry N. Abrams, 1986.

Pointon, M. *Hanging the Head: Portraiture and Social Formation in Eighteenth-Century England*. New Haven: Yale University Press, 1993.

Posner, D. *Antoine Watteau*. Ithaca, NY: Cornell University Press, 1984.

Rococo to Romanticism: Art and Architecture, 1700–1850. Garland Library of the History of Art. New York: Garland, 1976.

Rosenberg, P. *Chardin*. Exh. cat. London: Royal Academy of Art; New York: Metropolitan Museum of Art, 2000.

————. *From Drawing to Painting: Poussin, Watteau, Fragonard, David & Ingres*. Princeton, NJ: Princeton University Press, 2000.

Scott, K. *The Rococo Interior: Decoration and Social Spaces in Early Eighteenth-Century Paris*. New Haven: Yale University Press, 1995.

Sheriff, M. D. *The Exceptional Woman: Elisabeth Vigée-Lebrun and the Cultural Politics of Art*. Chicago: University of Chicago Press, 1996.

Wintermute, A. *Watteau and His World: French Drawing from 1700 to 1750*. Exh. cat. London: Merrell Holberton; New York: American Federation of Arts, 1999.

PART FOUR: THE MODERN WORLD

GENERAL REFERENCES

Arnason, H. H. *History of Modern Art: Painting, Sculpture, Architecture, Photography*. 5th ed. Upper Saddle River, NJ: Pearson Prentice Hall, 2004.

Atkins, R. *Artspoke: A Guide to Modern Ideas, Movements, and Buzzwords, 1848–1944*. New York: Abbeville Press, 1993.

Baigell, M. *A Concise History of American Painting and Sculpture*. Rev. ed. New York: Icon Editions, 1996.

Banham, R. *Theory and Design in the First Machine Age*. 2d ed. Cambridge, MA: MIT Press, 1980, © 1960.

Bearden, R., and H. Henderson. *A History of African-American Artists from 1792 to the Present*. New York: Pantheon, 1993.

Bergdoll, B. *European Architecture 1750–1890*. Oxford History of Art. Oxford: Oxford University Press, 2000.

Bjelajac, D. *American Art: A Cultural History*. Upper Saddle River, NJ: Pearson Prentice Hall, 2005.

Boime, A. *A Social History of Modern Art. Vol. 1, Art in the Age of Revolution, 1750–1800. Vol. 2, Art in the Age of Bonapartism, 1800–1815. Vol. 3, Art in the Age of Counterrevolution, 1815–1848*. Chicago: University of Chicago Press, 1987–2004.

Bown, M. C. *A Dictionary of Twentieth Century Russian and Soviet Painters 1900–1980s*. London: Izomar, 1998.

Campany, D., ed. *Art and Photography*. Themes and Movements. London: Phaidon, 2003.

Castelman, R. *Prints of the Twentieth Century: A History*. Rev. ed. London: Thames & Hudson, 1988.

Chiarmonte, P. *Women Artists in the United States: A Selective Bibliography and Resource Guide to the Fine and Decorative Arts, 1750–1986*. Boston: G. K. Hall, 1990.

Chilvers, I. *A Dictionary of Twentieth-Century Art*. New York: Oxford University Press, 1998.

Chipp, H., ed. *Theories of Modern Art: A Source Book by Artists and Critics*. Berkeley: University of California Press, 1968.

Colquhoun, A. *Modern Architecture*. New York: Oxford University Press, 2002.

Crary, J. *Techniques of the Observer: On Vision and Modernity in the Nineteenth Century*. Cambridge, MA: MIT Press, 1990.

Craven, W. *American Art: History and Culture*. New York: Harry N. Abrams, 1994.

Crook, J. *The Dilemma of Style: Architectural Ideas from the Picturesque to the Post Modern*. Chicago: University of Chicago Press, 1987.

Crow, T. *Modern Art in the Common Culture*. New Haven: Yale University Press, 1996.

Cummings, P. *Dictionary of Contemporary American Artists*. New York: St. Martin's Press, 1988.

Documents of Modern Art. 14 vols. New York: Wittenborn, 1944–1961. Anthologies of primary source material. Selected titles listed individually, below.

The Documents of Twentieth-Century Art. Boston: G. K. Hall, Anthologies of primary source material. Selected titles listed individually, below.

Doss, E. *Twentieth-Century American Art*. Oxford History of Art. New York: Oxford University Press, 2002.

Drucker, J. *The Century of Artists' Books*. New York: Granary Books, 2004.

Eisenman, S. *Nineteenth Century Art: A Critical History*. New York: Thames & Hudson, 2002.

Eitner, L. *An Outline of Nineteenth-Century European Painting: From David Through Cézanne*. 2 vols. New York: Harper & Row, 1986.

Elderfield, J., ed. *Modern Painting and Sculpture: 1880 to the Present at the Museum of Modern Art*. New York: Museum of Modern Art; Dist. by D.A.P./Distributed Art Publishers, 2004.

Evans, M. M., ed. *Contemporary Photographers*. 3d ed. New York: St. James Press, 1995.

Farrington, L. E. *Creating Their Own Image: The History of African-American Women Artists*. New York: Oxford University Press, 2005.

Frampton, K. *Modern Architecture: A Critical History*. 3d ed. New York: Thames & Hudson, 1992.

Frascina, F. and J. Harris, eds. *Art in Modern Culture: An Anthology of Critical Texts*. New York: Harper & Row, 1992.

Gaiger, J., ed. *Art of the Twentieth Century: A Reader*. New Haven: Yale University Press in association with the Open University, 2003.

————. *Frameworks for Modern Art*. New Haven: Yale University Press in association with the Open University, 2003.

Goldberg, R. *Performance Art: From Futurism to the Present*. Rev. and exp. ed. The World of Art. New York: Thames & Hudson, 2001.

Goldwater, R. *Primitivism in Modern Art*. Enl. ed. Cambridge: Harvard University Press, 1986.

Gray, J. *Action Art: A Bibliography of Artists' Performance from Futurism to Fluxus and Beyond*. Westport, CT: Greenwood Press, 1993.

Harrison, C., and P. Wood, eds. *Art in Theory, 1815–1900: An Anthology of Changing Ideas.* Malden, MA: Blackwell, 1998.

———. *Art in Theory, 1900–2000: An Anthology of Changing Ideas.* New ed. Malden, MA: Blackwell, 2003.

Heller, N. *Women Artists: An Illustrated History.* New York: Abbeville Press, 2003.

Hertz, R., ed. *Theories of Contemporary Art.* 2d ed. Englewood Cliffs, NJ: Prentice Hall, 1993.

———., and N. Klein, eds. *Twentieth-Century Art Theory: Urbanism, Politics, and Mass Culture.* Englewood Cliffs, NJ: Prentice Hall, 1990.

Hitchcock, H. R. *Architecture: Nineteenth and Twentieth Centuries.* 4th rev. ed. Pelican History of Art. New Haven: Yale University Press, 1987, © 1977.

Hughes, R. *American Visions: The Epic History of Art in America.* New York: Alfred A. Knopf, 1997.

Hunter, S., and J. Jacobus. *Modern Art: Painting, Sculpture, Architecture.* 3d rev. ed. New York: Harry N. Abrams, 2000.

Igoe, L. *250 Years of Afro-American Art: An Annotated Bibliography.* New York: Bowker, 1981.

Joachimides, C., et al. *American Art in the Twentieth Century: Painting and Sculpture, 1913–1933.* Exh. cat. Munich: Prestel, 1993.

Johnson, W. *Nineteenth-Century Photography: An Annotated Bibliography, 1839–1879.* Boston: G. K. Hall, 1990.

Kostelanetz, R. *A Dictionary of the Avant-Gardes.* New York: Routledge, 2001.

Lewis, S. *African American Art and Artists.* Berkeley: University of California Press, 1990.

Marien, M. *Photography: A Cultural History.* Upper Saddle River, NJ: Pearson Prentice Hall, 2002.

McCoubrey, J. *American Art, 1700–1960: Sources and Documents.* Englewood Cliffs, NJ: Prentice Hall, 1965.

Meikle, J. L. *Design in the USA.* Oxford History of Art. New York: Oxford University Press, 2005.

Modern Arts Criticism. 4 vols. Detroit, MI: Gale Research, 1991–1994.

Newhall, B. *The History of Photography from 1830 to the Present.* Rev. and enl. 5th ed. New York: Museum of Modern Art; Dist. by Bulfinch Press/Little, Brown, 1999.

Nochlin, L. *The Politics of Vision: Essays on Nineteenth-Century Art and Society.* New York: Harper & Row, 1989.

Osborne, H., ed. *Oxford Companion to Twentieth-Century Art.* Reprint. New York: Oxford University Press, 1990.

Patton, S. F. *African-American Art.* Oxford History of Art. New York: Oxford University Press, 1998.

Piland, S. *Women Artists: An Historical, Contemporary, and Feminist Bibliography.* Metuchen, NJ: Scarecrow Press, 1994.

Powell, R. J. *Black Art and Culture in the 20th Century.* New York: Thames & Hudson, 1997.

Robinson, Hilary. *Feminism-Art-Theory: An Anthology, 1968–2000.* Oxford and Malden, MA: Blackwell, 2001.

Rose, B. *American Art Since 1900.* Rev. ed. New York: Praeger, 1975.

———. *American Painting: The Twentieth Century.* New updated ed. New York: Rizzoli, 1986.

Rosenblum, N. *A World History of Photography.* 3rd ed. New York: Abbeville Press, 1997.

Rosenblum, R., and H. W. Janson. *19th Century Art.* Rev. and updated ed. Upper Saddle River, NJ: Pearson Prentice Hall, 2005.

Schapiro, M. *Modern Art: Nineteenth and Twentieth Centuries.* New York: Braziller, 1982.

Scharf, A. *Art and Photography.* Reprint. Harmondsworth, England: Penguin, 1995.

Sennott, S., ed. *Encyclopedia of 20th Century Architecture.* 3 vols. New York: Fitzroy Dearborn, 2004.

Stiles, K., and P. Selz. *Theories and Documents of Contemporary Art.* Berkeley: University of California Press, 1996.

Tafuri, M. *Modern Architecture.* 2 vols. New York: Rizzoli, 1986.

Taylor, J. *The Fine Arts in America.* Chicago: University of Chicago Press, 1979.

———., ed. *Nineteenth-Century Theories of Art.* California Studies in the History of Art. Berkeley: University of California Press, 1987.

Tomlinson, J. *Readings in Nineteenth-Century Art.* Upper Saddle River, NJ: Prentice Hall, 1995.

Upton, D. *Architecture in the United States.* New York: Oxford University Press, 1998.

Varnedoe, K., and A. Gopnik, eds. *Modern Art and Popular Culture: Readings in High and Low.* New York: Harry N. Abrams, 1990.

Waldman, D. *Collage, Assemblage, and the Found Object.* New York: Harry N. Abrams, 1992.

Weaver, M. *The Art of Photography, 1839–1989.* Exh. cat. New Haven: Yale University Press, 1989.

Wilmerding, J. *American Views: Essays on American Art.* Princeton, NJ: Princeton University Press, 1991.

Witzling, M., ed. *Voicing Our Visions: Writings by Women Artists.* New York: Universe, 1991.

CHAPTER 23. ART IN THE AGE OF THE ENLIGHTENMENT, 1750–1789

Bryson, N. *Tradition and Desire: From David to Delacroix.* Cambridge: Cambridge University Press, 1984.

———. *Word and Image: French Painting in the Ancient Régime.* Cambridge: Cambridge University Press, 1981.

Crow, T. *Painters and Public Life in Eighteenth-Century Paris.* New Haven: Yale University Press, 1985.

Eitner, L. E. A. *Neoclassicism and Romanticism, 1750–1850: Sources and Documents.* Reprint of 1970 ed. New York: Harper & Row, 1989.

Fried, M. *Absorption and Theatricality: Painting and Beholder in the Age of Diderot.* Chicago: University of Chicago Press, 1980.

Friedlaender, W. *David to Delacroix.* Reprint of 1952 ed. New York: Schocken Books, 1968.

Goncourt, E. de, and J. de Goncourt. *French Eighteenth-Century Painters.* Reprint of 1948 ed. Ithaca, NY: Cornell University Press, 1981.

Honour, H. *Neoclassicism.* Reprint of 1968 ed. London: Penguin, 1991.

Irwin, D. G. *Neoclassicism.* Art & Ideas. London: Phaidon, 1997.

Licht, F. *Canova.* New York: Abbeville Press, 1983.

Miles, E. G., ed. *The Portrait in Eighteenth-Century America.* Newark: University of Delaware Press, 1993.

Ottani Cavina, A. *Geometries of Silence: Three Approaches to Neoclassical Art.* New York: Columbia University Press, 2004.

Picon, A. *French Architects and Engineers in the Age of Enlightenment.* Cambridge: Cambridge University Press, 1992.

Rebora, C., et al. *John Singleton Copley in America.* Exh. cat. New York: The Metropolitan Museum of Art, 1995.

Rosenblum, R. *Jean-Auguste-Dominique Ingres.* New York: Harry N. Abrams, 1990.

Rosenthal, M., ed. *Prospects for the Nation: Recent Essays in British Landscape, 1750–1880.* Studies in British Art. New Haven: Yale University Press, © 1997.

Saisselin, R. G. *The Enlightenment Against the Baroque: Economics and Aesthetics in the Eighteenth Century.* Berkeley: University of California Press, 1992.

Solkin, D. *Painting for Money: The Visual Arts and the Public Sphere in Eighteenth-Century England.* New Haven: Yale University Press, 1993.

Vidler, A. *The Writing of the Walls: Architectural Theory in the Late Enlightenment.* Princeton, NJ: Princeton Architectural Press, 1987.

Watkin, D., and T. Mellinghoff. *German Architecture and the Classical Ideal.* Cambridge: MIT Press, 1987.

CHAPTER 24. ART IN THE AGE OF ROMANTICISM, 1789–1848

Boime, A. *The Academy and French Painting in the Nineteenth Century.* New ed. New Haven: Yale University Press, 1986.

Brown, D. B. *Romanticism.* Art & Ideas. New York: Phaidon, 2001.

Chu, P. *Nineteenth-Century European Art.* Upper Saddle River, NJ: Pearson Prentice Hall, 2002.

Eitner, L. E. A. *Géricault: His Life and Work.* Ithaca, NY: Cornell University Press, 1982.

Hartley, K. *The Romantic Spirit in German Art, 1790–1990.* Exh. cat. London: South Bank Centre, © 1994.

Herrmann, L. *Nineteenth Century British Painting.* London: Giles de la Mare, 2000.

Honour, H. *Romanticism.* New York: Harper & Row, 1979.

Johnson, E. *The Paintings of Eugène Delacroix: A Critical Catalogue, 1816–1863.* 6 vols. Oxford: Clarendon Press, 1981–1989.

———. *The Paintings of Eugène Delacroix: A Critical Catalogue.* 4th supp. and reprint of 3d supp. New York: Oxford University Press, 2002.

Joll, E. The *Oxford Companion to J. M. W. Turner.* Oxford: Oxford University Press, 2001.

Koerner, J. *Caspar David Friedrich and the Subject of Landscape.* New Haven: Yale University Press, 1990.

Licht, F. *Goya: The Origins of the Modern Temper in Art.* New York: Harper & Row, 1983.

Middleton, R. *Architecture of the Nineteenth Century.* Milan: Electa, © 2003.

Noon, P. J. *Crossing the Channel: British and French Painting in the Age of Romanticism.* Exh. cat. London: Tate, 2003.

Novak, B. *Nature and Culture: American Landscape and Painting, 1825–1875.* Rev. ed. New York: Oxford University Press, 1995.

Novotny, F. *Painting and Sculpture in Europe, 1780–1880.* 3d ed. Pelican History of Art. New Haven: Yale University Press, 1992.

Pérez Sánchez, A., and E. A. Sayre. *Goya and the Spirit of Enlightenment.* Exh. cat. Boston: Bulfinch Press, 1989.

Roseblum, R. *Transformations in Late Eighteenth Century Art.* Princeton, NJ: Princeton University Press, 1967.

Tomlinson, J. *Goya in the Twilight of Enlightenment.* New Haven: Yale University Press, 1992.

Vaughn, W. *Romanticism and Art.* World of Art. London: Thames & Hudson, © 1994.

CHAPTER 25. THE AGE OF POSITIVISM: REALISM, IMPRESSIONISM, AND THE PRE-RAPHAELITES, 1848–1885

Adriani, G. *Renoir.* Cologne: Dumont; Dist. by Yale University Press, 1999.

Broude, N. *Impressionism: A Feminist Reading.* New York: Rizzoli, 1991.

Cachin, F., et al. *Cézanne.* Exh. cat. New York: Harry N. Abrams, 1995.

Cikovsky, N., and F. Kelly. *Winslow Homer.* Exh. cat. New Haven: Yale University Press, 1995.

Clark, T. J. *The Absolute Bourgeois: Artists and Politics in France, 1848–1851.* Berkeley: University of California Press, 1999, © 1973.

———. *The Painting of Modern Life: Paris in the Art of Manet and His Followers.* Rev. ed. Princeton, NJ: Princeton University Press, 1999.

Denvir, B. *The Chronicle of Impressionism: A Timeline History of Impressionist Art.* London: Thames & Hudson, 2000, © 1993.

———. *The Thames & Hudson Encyclopaedia of Impressionism.* New York: Thames & Hudson, 1990.

Elsen, A. *Origins of Modern Sculpture.* New York: Braziller, 1974.

Fried, M. *Courbet's Realism.* Chicago: University of Chicago Press, 1990.

———. *Manet's Modernism, or, The Face of Painting in the 1860s.* Chicago: University of Chicago Press, 1996.

Goodrich, L. *Thomas Eakins.* 2 vols. Exh. cat. Cambridge, MA: Harvard University Press, 1982.

Gray, C. *The Russian Experiment in Art, 1863–1922.* Rev. ed. The World of Art. New York: Thames & Hudson, 1986.

Hamilton, G. H. *Manet and His Critics.* Reprint of 1954 ed. New Haven, CT: Yale University Press, 1986.

Hares-Stryker, C., ed. *An Anthology of Pre-Raphaelite Writings.* New York: New York University Press, 1997.

Herbert, R. *Impressionism: Art, Leisure, and Parisian Society.* New Haven: Yale University Press, 1988.

Higonnet, A. *Berthe Morisot.* New York: Harper & Row, 1990.

House, J. *Impressionism: Paint and Politics.* New Haven: Yale University Press, 2004.

———. *Monet: Nature into Art.* New Haven: Yale University Press, 1986.

Jenkyns, R. *Dignity and Decadence: Victorian Art and the Classical Inheritance.* Cambridge, MA: Harvard University Press, 1991.

Kendall, R., and G. Pollock, eds. *Dealing with Degas: Representations of Women and the Politics of Vision.* New York: Universe, 1992.

———. *Degas: Beyond Impressionism.* Exh. cat. London: National Gallery; Chicago: Art Institute of Chicago; New Haven: Dist. by Yale University Press, 1996.

Krell, A. *Manet and the Painters of Contemporary Life.* The World of Art. New York: Thames & Hudson, 1996.

Lipton, E. *Looking into Degas.* Berkeley: University of California Press, 1986.

Mainardi, P. *Art and Politics of the Second Empire: The Universal Expositions of 1855 and 1867.* New Haven: Yale University Press, 1987.

———. *The End of the Salon: Art and the State in the Early Third Republic.* Cambridge: Cambridge University Press, 1993.

Miller, D., ed. *American Iconology: New Approaches to Nineteenth-Century Art and Literature.* New Haven: Yale University Press, 1993.

Needham, G. *Nineteenth-Century Realist Art.* New York: Harper & Row, 1988.

Nochlin, L., ed. *Impressionism and Post-Impressionism, 1874–1904: Sources and Documents.* Englewood Cliffs, NJ: Prentice Hall, 1976.

———. *Realism and Tradition in Art, 1848–1900: Sources and Documents.* Englewood Cliffs, NJ: Prentice Hall, 1966.

Novak, B. *American Painting of the Nineteenth Century: Realism and the American Experience*. 2d ed. New York: Harper & Row, 1979.

———. *Nature and Culture: American Landscape and Painting, 1825–1875*. New York: Oxford University Press, 1995.

Pollock, G. *Mary Cassatt: Painter of Modern Women*. New York: Thames & Hudson, 1998.

Prettejohn, E. *The Art of the Pre-Raphaelites*. Princeton, NJ: Princeton University Press, 2000.

Reff, T. *Manet and Modern Paris*. Exh. cat. Washington, DC: National Gallery of Art, 1982.

Rewald, J. *Studies in Impressionism*. New York: Harry N. Abrams, 1986, © 1985.

Rubin, J. H. *Impressionism*. Art & Ideas. London: Phaidon, 1999.

Spate, V. *Claude Monet: Life and Work*. New York: Rizzoli, 1992.

Tucker, P. H. *Claude Monet: Life and Art*. New Haven: Yale University Press, 1995.

———. *The Impressionists at Argenteuil*. Washington, DC: National Gallery of Art; Hartford, CT: Wadsworth Atheneum Museum of Art, 2000.

———. *Monet in the '90s: The Series Paintings*. Exh. cat. New Haven: Yale University Press, 1989.

Walther, I., ed. *Impressionist Art, 1860–1920*. 2 vols. Cologne: Taschen, 1996.

Weisberg, G. *Beyond Impressionism: The Naturalist Impulse*. New York: Harry N. Abrams, 1992.

Werner, M. *Pre-Raphaelite Painting and Nineteenth-Century Realism*. New York: Cambridge University Press, 2005.

CHAPTER 26. PROGRESS AND ITS DISCONTENTS: POST-IMPRESSIONISM, SYMBOLISM, AND ART NOUVEAU, 1880–1905

Brettell, R., et al. *The Art of Paul Gauguin*. Exh. cat. Boston: Little, Brown, 1988.

Broude, N. *Georges Seurat*. New York: Rizzoli, 1992.

Denvir, B. *Post-Impressionism*. The World of Art. New York: Thames & Hudson, 1992.

Dorra, H., ed. *Symbolist Art Theories: A Critical Anthology*. Berkeley: University of California Press, 1994.

Gibson, M. *The Symbolists*. New York: Harry N. Abrams, 1988.

Hamilton, G. H. *Painting and Sculpture in Europe, 1880–1940*. 6th ed. Pelican History of Art. New Haven: Yale University Press, 1993.

Herbert, R. L. *Georges Seurat, 1859–1891*. New York: Metropolitan Museum of Art; Dist. by Harry N. Abrams, 1991.

Hulsker, J. *The New Complete Van Gogh: Paintings, Drawings, Sketches: Revised and Enlarged Edition of the Catalogue Raisonné of the Works of Vincent van Gogh*. Amsterdam: J. M. Meulenhoff, 1996.

Mosby, D. *Henry Ossawa Tanner*. Exh. cat. New York: Rizzoli, 1991.

Schapiro, M. *Paul Cézanne*. New York: Harry N. Abrams, 1988.

———. *Vincent Van Gogh*. New York: Harry N. Abrams, 2000, © 1983.

Shiff, R. *Cézanne and the End of Impressionism: A Study of the Theory, Technique, and Critical Evaluation of Modern Art*. Chicago: University of Chicago Press, 1984.

Silverman, D. *Art Nouveau in Fin-de-Siècle France*. Berkeley: University of California Press, 1989.

Théberge, P. *Lost Paradise, Symbolist Europe*. Exh. cat. Montreal: Montreal Museum of Fine Arts, 1995.

Troy, N. J. *Modernism and the Decorative Arts in France: Art Nouveau to Le Corbusier*. New Haven: Yale University Press, 1991.

Varnedoe, K. *Vienna 1900: Art, Architecture, and Design*. Exh. cat. New York: Museum of Modern Art, 1986.

CHAPTER 27. TOWARD ABSTRACTION: THE MODERNIST REVOLUTION, 1904–1914

Bach, F., T. Bach, and A. Temkin. *Constantin Brancusi*. Exh. cat. Cambridge: MIT Press, 1995.

Behr, S. *Expressionism*. Movements in Modern Art. Cambridge: Cambridge University Press, 1999.

Bowlt, J. E., ed. *Russian Art of the Avant-Garde: Theory and Criticism, 1902–1934*. New York: Thames & Hudson, 1988.

Brown, M. *The Story of the Armory Show*. 2d ed. New York: Abbeville Press, 1988.

Duchamp, M. *Marcel Duchamp, Notes*. The Documents of Twentieth-Century Art. Boston: G. K. Hall, 1983.

Edwards, S. *Art of the Avant-Gardes*. New Haven: Yale University Press in association with the Open University, 2004.

Elderfield, J. *Henri Matisse: A Retrospective*. Exh. cat. New York: Museum of Modern Art; Dist. by Harry N. Abrams, 1992.

Golding, J. *Cubism: A History and an Analysis, 1907–1914*. 3d ed. Cambridge, MA: Harvard University Press, 1988.

Goldwater, R. *Primitivism in Modern Art*. Enl. ed. Cambridge, MA: Belknap Press, 1986.

Gordon, D. *Expressionism: Art and Idea*. New Haven: Yale University Press, 1987.

Green, C. *Cubism and Its Enemies*. New Haven: Yale University Press, 1987.

Heiting, M., ed. *August Sander, 1876–1964*. Köln and New York: Taschen, 1999.

Herbert, J. *Fauve Painting: The Making of Cultural Politics*. New Haven: Yale University Press, 1992.

Hoffman, K., ed. *Collage: Critical Views*. Ann Arbor, MI: UMI Research Press, 1989.

Kallir, J. *Egon Schiele: The Complete Works*. Exp. ed. New York: Harry N. Abrams, 1998.

Krauss, R. *The Originality of the Avant-Garde and Other Modernist Myths*. Cambridge: MIT Press, 1986.

Kuspit, D. *The Cult of the Avant-Garde Artist*. New York: Cambridge University Press, 1993.

Rosenblum, R. *Cubism and Twentieth-Century Art*. New York: Harry N. Abrams, 2001.

Rubin, W. S. *Picasso and Braque: Pioneering Cubism*. Exh. cat. New York: Museum of Modern Art, 1989.

Szarkowski, J., and M. Hambourg. *The Work of Atget*. 4 vols. New York: Museum of Modern Art, 1981–1985.

Taylor, B. *Collage: The Making of Modern Art*. London: Thames & Hudson, 2004.

Washton, R.-C., ed. *German Expressionism: Documents from the End of the Wilhelmine Empire to the Rise of National Socialism*. The Documents of Twentieth-Century Art. Boston: G. K. Hall, 1993.

Weiss, J. *The Popular Culture of Modern Art: Picasso, Duchamp and Avant Gardism*. New Haven: Yale University Press, 1994.

CHAPTER 28. ART BETWEEN THE WARS, 1914–1940

Adams, A. *Ansel Adams: Images, 1923–1974*. Foreword W. Stegner. Boston: New York Graphic Society, 1974.

Ades, D. *Photomontage*. Rev. and enl. ed. London: Thames & Hudson, 1986.

Arbaïzar, P. *Henri Cartier-Bresson: The Man, the Image and the World: A Retrospective*. New York: Thames & Hudson, 2003.

Bayer, H., et al., eds. *Bauhaus, 1919–1928*. Reprint of 1938 ed. Boston: New York Graphic Society, 1986.

Blaser, W. *Mies van der Rohe*. 6th exp. and rev. ed. Boston: Birkhauser Verlag, 1997.

Campbell, M., et al. *Harlem Renaissance: Art of Black America*. New York: Harry N. Abrams, 1987.

Chadwick, W., ed. *Mirror Images: Women, Surrealism, and Self-Representation*. Cambridge, MA: MIT Press, 1998.

Corn, W. *The Great American Thing: Modern Art and National Identity, 1915–1935*. Berkeley: University of California Press, 2001.

Curtis, W. *Modern Architecture Since 1900*. 3rd ed. New York: Phaidon, 1996.

Durozoi, G. *History of the Surrealist Movement*. Chicago: University of Chicago Press, 2002.

Fer, B., et al. *Realism, Rationalism, Surrealism: Art Between the Wars*. Modern Art—Practices and Debates. New Haven: Yale University Press, 1993.

Fiedler, J., ed. *Photography at the Bauhaus*. Cambridge, MA: MIT Press, 1990.

Foster, S. C., ed. *Crisis and the Arts: The History of Dada*. 10 vols. New York: G. K. Hall, 1996–2005.

Gale, M. *Dada & Surrealism*. Art & Ideas. London: Phaidon, 1997.

Gössel, P., and G. Leuthäuser. *Architecture in the Twentieth Century*. Cologne: Taschen, 1991.

Greenough, S., and J. Hamilton. *Alfred Stieglitz: Photographs and Writings*. New York: Little, Brown, 1999.

Haskell, B. *The American Century: Art & Culture, 1900–1950*. New York: W. W. Norton, 1999.

Hight, E. M. *Picturing Modernism: Moholy-Nagy and Photography in Weimar Germany*. Cambridge, MA: MIT Press, 1995.

Hitchcock, H. R., and P. Johnson. *The International Style*. With a new forward. New York: W. W. Norton, 1996.

Hochman, E. S. *Bauhaus: Crucible of Modernism*. New York: Fromm International, © 1997.

Hopkins, D. *Dada and Surrealism: A Very Short Introduction*. New York: Oxford University Press, 2004.

Kandinsky, W. *Kandinsky: Complete Writings on Art*. Orig. pub. in The Documents of Twentieth-Century Art. New York: Da Capo Press, 1994.

Krauss, R. *L'Amour Fou: Photography and Surrealism*. New York: Abbeville Press, 1985.

Kultermann, U. *Architecture in the Twentieth Century*. New York: Van Nostrand Reinhold, 1993.

Lane, B. *Architecture and Politics in Germany, 1918–1945*. New ed. Cambridge, MA: Harvard University Press, 1985.

Le Corbusier. *Towards a New Architecture*. Oxford: Architectural Press, 1997, © 1989.

Lodder, C. *Russian Constructivism*. New Haven: Yale University Press, 1983.

McEuen, M. A. *Seeing America: Women Photographers Between the Wars*. Lexington, KY: University Press of Kentucky, 2000.

Miró, J. *Joan Miró: Selected Writings and Interviews*. The Documents of Twentieth-Century Art. Boston: G. K. Hall, 1986.

Mondrian, P. *The New Art, the New Life: The Complete Writings*. Eds. and trans. H. Holtzmann and M. James. Orig. pub. in The Documents of Twentieth-Century Art. New York: Da Capo, 1993.

Motherwell, R., ed. *The Dada Painters and Poets: An Anthology*. 2d ed. Cambridge, MA: Harvard University Press, 1989.

Nadeau, M. *History of Surrealism*. Cambridge, MA: Harvard University Press, 1989.

Pevsner, N. *Pioneers of Modern Design: From William Morris to Walter Gropius*. 4th ed. New Haven: Yale University Press, 2005.

Phillips, C., ed. *Photography in the Modern Era: European Documents and Critical Writings, 1913–1940*. New York: Metropolitan Museum of Art; Aperture, 1989.

Roskill, M. *Klee, Kandinsky, and the Thought of Their Time: A Critical Perspective*. Urbana: University of Illinois Press, 1992.

Silver, K. E. *Esprit de Corps: The Art of the Parisian Avant-Garde and the First World War, 1914–1925*. Princeton, NJ: Princeton University Press, 1989.

Spiteri, R., ed. *Surrealism, Politics and Culture*. Aldershot, Hants., England and Burlington, VT: Ashgate, 2003.

Wood, P., ed. *Varieties of Modernism*. New Haven: Yale University Press in association with the Open University, 2004.

Wright, F. L. *Frank Lloyd Wright, Collected Writings*. 5 vols. New York: Rizzoli, 1992–1995.

CHAPTER 29. POST–WORLD WAR II TO POSTMODERN, 1945–1980

Archer, M. *Art Since 1960*. World of Art. New York: Thames & Hudson, 2002.

Ashton, D. *American Art Since 1945*. New York: Oxford University Press, 1982.

Atkins, R. *Artspeak: A Guide to Contemporary Ideas, Movements, and Buzzwords, 1945 to the Present*. New York: Abbeville Press, 1997.

Baker, K. *Minimalism: Art of Circumstance*. New York: Abbeville Press, 1989.

Battcock, G., comp. *Idea Art: A Critical Anthology*. New ed. New York: Dutton, 1973.

———, ed. *Minimal Art: A Critical Anthology*. Berkeley: University of California Press, 1995.

———, and R. Nickas, eds. *The Art of Performance: A Critical Anthology*. New York: Dutton, 1984.

Beardsley, J. *Earthworks and Beyond: Contemporary Art in the Landscape*. 3d ed. New York: Abbeville Press, 1998.

———, and J. Livingston. *Hispanic Art in the United States: Thirty Contemporary Painters and Sculptors*. Exh. cat. New York: Abbeville Press, 1987.

Burgin, V., ed. *Thinking Photography*. Communications and Culture. Houndsmills, England: Macmillan Education, 1990.

Carlson, M. A. *Performance: A Critical Introduction*. 2d ed. New York: Routledge, 2004.

Causey, A. *Sculpture Since 1945*. Oxford History of Art. New York: Oxford University Press, 1998.

Crane, D. *The Transformation of the Avant-Garde: The New York Art World, 1940–1985*. Chicago: University of Chicago Press, 1987.

Crow, T. *The Rise of the Sixties: American and European Art in the Era of Dissent*. London: Laurence King, 2005, © 1996.

Frascina, F. *Pollock and After: The Critical Debate*. 2d ed. New York: Routledge, 2001.

Gilbaut, S. *How New York Stole the Idea of Modern Art*. Chicago: University of Chicago Press, 1983.

———, ed. *Reconstructing Modernism: Art in New York, Paris, and Montreal, 1945–1964*. Cambridge: MIT Press, 1990.

Greenberg, C. *Clement Greenberg: The Collected Essays and Criticism*. 4 vols. Chicago: University of Chicago Press, 1986–1993.

Griswold del Castillo, R., ed. *Chicano Art: Resistance and Affirmation, 1965–1985*. Exh. cat. Los Angeles: Wight Art Gallery, University of California, 1991.

Hopkins, D. *After Modern Art: 1945–2000*. New York: Oxford University Press, 2000.

Joselit, D. *American Art Since 1945*. The World of Art. London: Thames & Hudson, 2003.

Landau, E. G., ed. *Reading Abstract Expressionism: Context and Critique*. New Haven: Yale University Press, 2005.

Leggio, J., and S. Weiley, eds. *American Art of the 1960s*. Studies in Modern Art, 1. New York: Museum of Modern Art, 1991.

Leja, M. *Reframing Abstract Expressionism: Subjectivity and Painting in the 1940s*. New Haven: Yale University Press, 1993.

Linder, M. *Nothing Less Than Literal: Architecture After Minimalism*. Cambridge, MA: MIT Press, 2004.

Lippard, L. R., ed. *From the Center: Feminist Essays on Women's Art*. New York: Dutton, 1976.

———. *Overlay: Contemporary Art and the Art of Prehistory*. New York: Pantheon, 1983.

Livingstone, M. *Pop Art: A Continuing History*. New York: Thames & Hudson, 2000.

Lucie-Smith, E. *Movements in Art Since 1945*. The World of Art. New York: Thames & Hudson, 2001.

McCarthy, D. *Pop Art*. Movements in Modern Art. New York: Cambridge University Press, 2000.

McEvilley, T. *Sculpture in the Age of Doubt*. New York: School of Visual Arts; Allworth Press, 1999.

Meisel, L. K. *Photorealism at the Millennium*. New York: Harry N. Abrams, 2002.

Ockman, J., ed. *Architecture Culture, 1943–1968: A Documentary Anthology*. New York: Rizzoli, 1993.

Orvell, M. *American Photography*. The World of Art. New York: Oxford University Press, 2003.

Pincus-Witten, R. *Postminimalism into Maximalism: American Art, 1966–1986*. Ann Arbor, MI: UMI Research Press, 1987.

Polcari, S. *Abstract Expressionism and the Modern Experience*. New York: Cambridge University Press, 1991.

Rosen, R., and C. Brawer, eds. *Making Their Mark: Women Artists Move into the Mainstream, 1970–85*. Exh. cat. New York: Abbeville Press, 1989.

Ross, C. *Abstract Expressionism: Creators and Critics: An Anthology*. New York: Harry N. Abrams, 1990.

Sandler, I. *Art of the Postmodern Era: From the Late 1960s to the Early 1990s*. New York: Icon Editions, 1996.

———. *The New York School: The Painters and Sculptors of the Fifties*. New York: Harper & Row, 1978.

———. *The Triumph of American Painting: A History of Abstract Expressionism*. New York: Praeger, 1970.

Sayre, H. *The Object of Performance: The American Avant-Garde Since 1970*. Chicago: University of Chicago Press, 1990.

Seitz, W. *Abstract Expressionist Painting in America*. Cambridge, MA: Harvard University Press, 1983.

Self-Taught Artists of the 20th Century: An American Anthology. Exh. cat. San Franciso: Chronicle Books, 1998.

Sontag, S. *On Photography*. New York: Picador; Farrar, Straus & Giroux, 2001, © 1977.

Weintraub, L. *Art on the Edge and Over*. Litchfield, CT: Art Insights; Dist. by D.A.P., 1997.

Wood, P., et al. *Modernism in Dispute: Art Since the Forties*. New Haven: Yale University Press, 1993.

CHAPTER 30. THE POSTMODERN ERA: ART SINCE 1980

Barthes, R. *The Pleasure of the Text*. Oxford: Blackwell, 1990.

Belting, H. *Art History After Modernism*. Chicago: University of Chicago Press, 2003.

Broude, N., and M. Garrad., eds. *Reclaiming Female Agency: Feminist Art History After Postmodernism*. Berkeley: University of California Press, 2005.

Brunette, P., and D. Wills, eds. *Deconstruction and the Visual Arts: Art, Media, Architecture*. New York: Cambridge University Press, 1994.

Capozzi, R., ed. *Reading Eco: An Anthology*. Bloomington: Indiana University Press, © 1997.

Derrida, J. *Writing and Difference*. London: Routledge Classics, 2001.

Eco, U. *A Theory of Semiotics*. Bloomington: Indiana University Press, 1976.

Foster, H., ed. *The Anti-Aesthetic: Essays on Postmodern Culture*. New York: New Press; Dist. by W. W. Norton, 1998.

Ghirardo, D. *Architecture After Modernism*. New York: Thames & Hudson, 1996.

Harris, J. P. *The New Art History: A Critical Introduction*. New York: Routledge, 2001.

Jencks, C. *New Paradigm in Architecture: The Language of Post-Modernism*. New Haven: Yale University Press, 2002.

———., ed. *The Post-Modern Reader*. London: Academy Editions; New York: St. Martin's Press, 1992.

———. *What Is Post-Modernism?* 4th rev. ed. London: Academy Editions, 1996.

Lucie-Smith, E. *Art Today*. London: Phaidon, 1995.

Mitchell, W. J. T. *The Reconfigured Eye: Visual Truth in the Post-Photographic Era*. Cambridge, MA: MIT Press, 1992.

Norris, C., and A. Benjamin. *What Is Deconstruction?* New York: St. Martin's Press, 1988.

Papadakes, A., et al., eds. *Deconstruction: The Omnibus Volume*. New York: Rizzoli, 1989.

Paul, C. *Digital Art*. New York: Thames & Hudson, © 2003.

Pearman, H. *Contemporary World Architecture*. London: Phaidon, © 1998.

Risatti, H., ed. *Postmodern Perspectives*. Englewood Cliffs, NJ: Prentice Hall, 1990.

Senie, H. *Contemporary Public Sculpture: Tradition, Transformation, and Controversy*. New York: Oxford University Press, 1992.

Steele, J. *Architecture Today*. New York: Phaidon, 2001.

Thody, P. *Introducing Barthes*. New York: Totem Books; Lanham, MD: National Book Network, 1997.

Tomkins, C. *Post to Neo: The Art World of the 1980s*. New York: Holt, 1988.

Wallis, B., ed. *Art After Modernism: Rethinking Representation*. Documentary Sources in Contemporary Art, 1. Boston: Godine, 1984.

Credits